California Art

450 YEARS OF PAINTING & OTHER MEDIA

Nancy Dustin Wall Moure

California Art

450 YEARS OF PAINTING & OTHER MEDIA

DUSTIN PUBLICATIONS ❧ LOS ANGELES 1998

CALIFORNIA ART: 450 YEARS OF PAINTING
AND OTHER MEDIA
by Nancy Dustin Wall Moure
Los Angeles: Dustin Publications, 1998

Editors: Jeanne D'Andrea; Sue Henger; Helen Abbott

Unless otherwise indicated all photos are reproduced
courtesy of the lenders.

Front cover: William A. Griffith, *Diver's Cove* (detail).
Inset (details, left to right): Ferdinand Deppe, *San Gabriel
Mission*; Granville Redmond, *A Foothill Trail*; Richard
Diebenkorn, *Ocean Park #36*.
Back cover (details, top to bottom, left to right): Albert
Bierstadt, *The Grizzly Giant Sequoia, Mariposa Grove,
California*; Stanton MacDonald Wright, *The Muse*; Craig
Kauffman, *Green, Red*; Agnes Pelton, *Messengers*; Robert
Williams, *Hot Rod Race*.

Printed in Korea.

ISBN 0-9614622-4-8 hard cover
ISBN 0-9614622-5-6 soft cover

The paper used in his publication meets the minimum
requirements of American National Standard for
Information Sciences—Permanence of Paper for
Printed Library Materials, ANSI Z39.48-1984.

Dustin Publications
935 West Mountain Street
Glendale, California 91202
818-242-7000

Contents

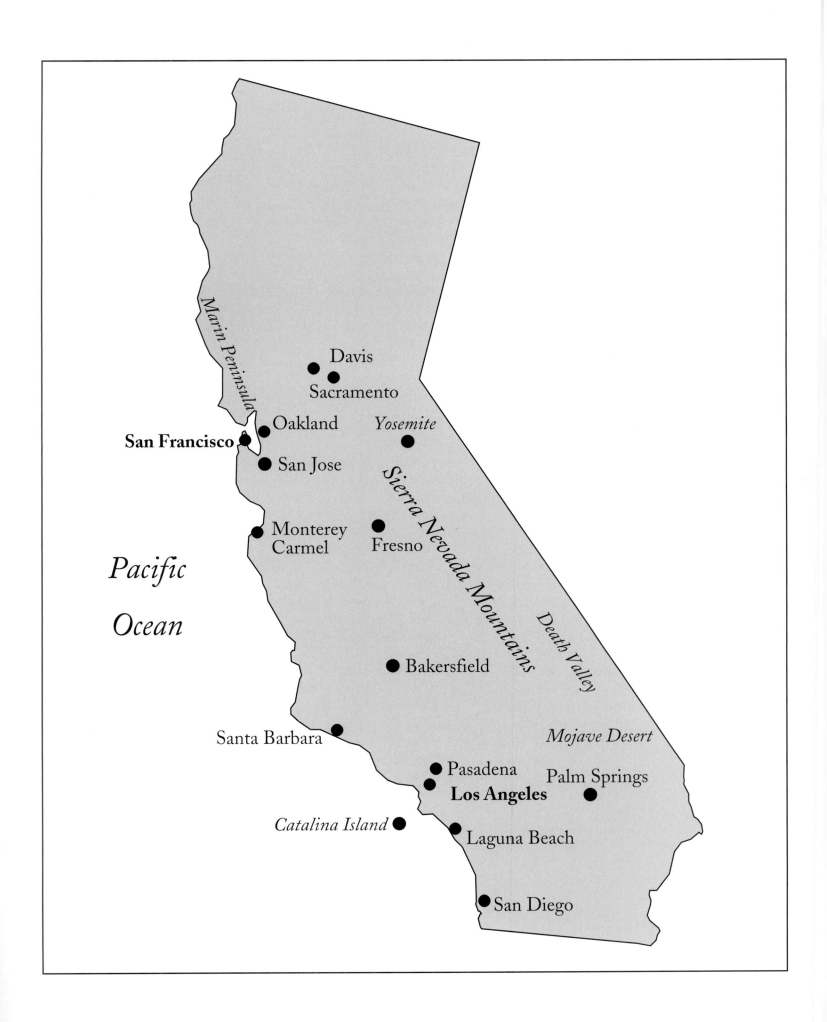

Davis

Sacramento

Marin Peninsula

Oakland

San Francisco

San Jose

Yosemite

Monterey
Carmel

Fresno

Sierra Nevada Mountains

Death Valley

Pacific

Ocean

Bakersfield

Santa Barbara

Mojave Desert

Pasadena

Palm Springs

Los Angeles

Catalina Island

Laguna Beach

San Diego

Acknowledgments

As recently as 1968, when I was hired as a Curatorial Aide at the Los Angeles County Museum of Art, there was no discipline called "California art." A few historians revered the very early drawings and paintings of the state as illustrations of its history. Contemporary art historians admired what the state's living artists were doing, *but no one cared much about what happened in between.* Thirty years later, California art of all periods is being studied, collected, and appreciated. That phenomenal interest has opened the way for this first comprehensive survey.

The idea of writing a history of art for one of America's largest states and for one that has had such a rich and varied art output is daunting. While several early twentieth-century writer/historians contemplated such a history, none of their efforts reached book form. In more recent times, the goal has become easier thanks to the great number of publications on California art that have appeared in the last thirty, and especially the last twenty years. These texts have defined or clarified certain aspects of the field and thus enable a writer to construct a whole.

I certainly did not intend to take up such a project. It evolved from a series of lessons on California art that a private collector, Edwin Gregson, asked me to give. The teaching project interested me, because it meant that I would be able to learn about those areas of California art outside my immediate specialty—Southern California painting and sculpture before 1945. Little did I know that a year-and-a-half later I would own an extensive library of books on California art, several thousand slides, roughly written notes for each of the thirty-six "lessons" I had presented Gregson, and that I would realize that he and I were perhaps the only people in the world with a clear picture of the entire history of California art. I felt very responsible. And somehow the idea arose to put the material into book form. Gregson provided much needed moral support.

During the past two years I have condensed this material into concise chapters that will, I hope, convey the story of California art without inundating the reader with excessive facts, theory, or analysis.

I would like to thank, first and foremost, Edwin Gregson whose emotional and financial support, advice, encouragement, and friendship have made this book possible. Joe Moure, as always, deserves thanks for his faith in me, for editing portions of the manuscript, and for alerting me to the uses of the Internet. My thanks also to those many California art historians and art critics who have worked tirelessly in their own specialties, doing tedious groundwork, analyzing and summarizing, and most important, publishing material for me to reference. Notable among these are Alfred Harrison of the North Point Gallery in San Francisco, Janice Driesbach of the Crocker Art Museum, Bruce Kamerling of the San Diego Historical Society, Susan M. Anderson formerly of the Laguna Art Museum, Ilene Fort of the Los Angeles County Museum, Harvey Jones of the Oakland Museum, Patricia Trenton, Curator of the Los Angeles Athletic Club collection, Susan Ehrlich of the University of Southern California, Susan Landauer, Jan Butterfield, Louise Katzman, Thomas Albright, and others.

For their specific help on this book, my extreme gratitude goes to art historians such as Jay Belloli and Bolton Colburn for reviewing the last two chapters and providing me with substantive input. The last twenty years have not previously been summarized in print, and these experts who have lived this contemporary art scene saved me from making many errors. For their help on specialty areas I want to thank: Norman Neuerburg (for help on mission art), Nancy Boas (for correcting the section on Society of Six), Jack Chipman (for help on ceramics of the 1930s), Michael Brown (for helping with Asian American artists), Tom Akawie (for setting me straight about the environment at the San Francisco Art Institute in the mid 1960s), Tim Drescher (for looking over the section on post-1970 murals) and Jonathan Katz (for invaluable help on the Gay and Lesbian entry). I am also very appreciative of the help given me by the staff at the Archives of American Art and the Art Library at the Henry E. Huntington Library, the staff of the library at the Los Angeles County Museum of Art, the librarians at the Brand Art Library, and those at the UCLA Research Library. I also want to thank the individual artists mentioned in the book who have been good enough to read their entries and to enhance or correct them. A great deal of help in locating useful publications also came from book dealers such as Ken Starosciak, Dawsons, Arcana Books on the Arts, and Hennessey and Ingalls.

And, I would like to thank Brooke Gregson for her research on Abstract Expressionism; Diane Lucero for searching out and xeroxing bibliography; Susan Anderson, Ana Sapatino, and Evelyn Badalian for typing editorial changes; and Lisa Buck for adding missing information to bibliographic entries.

Because commercial publishers saw this book as having a "limited audience" and being too big and expensive to be financially viable, its publication was made possible only when certain private collectors contributed financially to the printing of their art works in color and when certain art dealers paid to have their names listed. These contacts were made after the manuscript was completed and in no way affected the book's contents. Thanks to these financial contributors, thousands of readers have the benefit of seeing California art in color rather than black and white. In cases where the author was not able to secure important art works for reproduction, and no equivalent work existed, those works are discussed in the text and readers pointed to books where the art is reproduced.

I would also like to thank the editors Jeanne D'Andrea, Sue Henger, and Helen Abbott for their crucial help in making the manuscript read smoothly. My thanks, too, to Lilli Colton whose beautiful design will give readers their first incentive to pick up this book and then to keep turning the pages. It has been my pleasure to work with her for more than twenty-five years.

Nancy Dustin Wall Moure
April 1998

The publication of this book is an occasion for celebration by all who care about California's unique art history. For more than a quarter century, Nancy Dustin Wall Moure has worked tirelessly to bring the contributions of California's art and artists to the attention of the scholars, collectors, curators, students, critics, and historians who comprise the art world. She has worked to enable this work to be seen for what it is—diverse, sophisticated, insightful, and not at all "regional" in the pejorative sense of that term. Since 1972 Ms. Moure has been making this case convincingly through a series of thoughtful exhibitions and essays. Now, with the publication of *California Art: 450 Years of Painting and Other Media,* she has once again advanced the enterprise, providing a thoroughly researched narrative of California's art history that is more complete and more compelling than any other publication to date.

The Orange County Museum of Art is honored to be associated with Nancy Dustin Wall Moure in this effort, to which she has devoted a number of years as well as her considerable knowledge and scholarly expertise. In conjunction with the publication of this book, we are delighted to present *Gold Rush to Pop,* an exhibition selected by Ms. Moure that brings together for the first time many key works of California art. Viewers of the exhibition will gain a fresh understanding of the significance of California's art—in the context of global history as well as from the singular perspective of the American West Coast.

For making possible the presentation of this exhibition, we are deeply indebted to The Irvine Company, whose generous support has benefited California's artists and art viewing public for many years. We are grateful too, to our own Exhibitionists Council for providing additional underwriting for this show. And Nancy Dustin Wall Moure has earned our most sincere thanks for her years of dedication and her perceptive research and scholarship.

Naomi Vine, Director
Orange County Museum of Art

Foreword

Why a book about California art? The answer isn't difficult—because the material warrants it. One of the largest states, and with a gross product that equals that of many countries, California has produced a rich and varied output of highly important paintings that reflect unique local conditions. And what are these conditions? Some might cite the magnificent scenery of Northern California that has generated grand and profound landscapes. Some might cite a start-anew mentality that enabled the "loners, mavericks and dreamers" to actualize their dreams without the disapproval or suffocation of a cultural establishment. Some might cite an attitude, a state of mind that is open, young, positive, ambitious, and opportunistic. Others might believe in a gestalt resulting from the cohabitation of diverse ethnic groups or from the many cultural goods and ideas flowing through the state's ports from lands around the Pacific. Whatever the sources, California art is something special.

But we should also write about California art because Californians are curious about themselves. The human psyche has an underlying need to document, to codify, to analyze, and to understand itself. Where do Californians really stand when assessed objectively? Is the East Coast correct in looking down on California as an upstart, inferior, insincere, devoted to recreation rather than serious pursuits such as the cultural arts. A book on California art could make comparisons between East and West Coast art that would show what the state's artists have accomplished. A book on California art might prove, despite the state's late start, that its artists have always been among the top ranks of American artists and, at least once in the 1960s, have even taken the artistic lead for the entire country, perhaps the world.

Why address the entire history of California art? Isn't the whole history of California art from the Native Americans and the first map makers in 1542 to the computer-generated art of the 1990s too vast a subject, too bulky, too varied in theme to hold together, too comprehensive, too confusing? Why not bite off smaller portions—divide it at 1945, the year traditionally used to separate representational art from abstraction and nonobjective art? Thirty years ago, one might have treated the two territories cleanly: representationalism/modernism. But the past thirty years

have shown that post-1945 modernism did not cleave cleanly and separately from representationalism, never to look back, but instead peaked only briefly in the 1950s and 1960s with "pure" formal art values before cycling back to representationalism and human values. For too long those interested in representational art have been separated from those interested in nonobjective art both by their own tastes as well as the compartmentalization established by publishers and courses in art history. Art is a continuum, although it's pendulum may swing between the classic and the romantic, between the representational and the nonobjective. Fans of both fields should have the opportunity (or even be forced) to understand the other side. Seemingly far apart, these poles, in fact, relate to each other.

Or, why not separately study the two very distinct California traditions of the north and the south. They represent quite different responses to two entirely different sets of local conditions. One area is well-watered with ravishing scenery while the other is arid with subtle pastoral beauty; the north has cold weather as opposed to the south's heat; the north claims intellect versus the south's recreation; old money and values in opposition to new wealth, to cite just some of the differences. To study these two responses side by side and to understand why each region gave birth to its own particular aesthetic proves fascinating and fruitful.

At some point the whole has to be treated and analyzed using the same language for the representational as for the nonobjective. Perhaps, with this approach, those lovers of representationalism willing to read about post-1945 art will not be put off by the abstruse language often associated with writing about such art. And, conversely, modernists may come to understand that the representational works they scorn as "illustrative" actually provided the crucial basis for post-1945 art. Perhaps Northerners will finally read about Southerners.

Why do I personally wish to write the story of California art? Because for twenty-five years I, like others, have been studying, documenting, and writing about narrow aspects. I believe it is time to write a complete history, to document and afford access to the whole story in one book. It's time for a text on California art that can be used in art history classes and that can also speak to the non-specialist.

What media should be covered by such a book? Its core should consist of painting, the most frequently encountered medium and the one that most people study or collect. To provide a setting for painting, it would be preferable to also include chapters on other arts, such as sculpture, printmaking, photography, and the crafts. Why even treat the other media? Why not focus on just painting? Because all the arts interrelate and are born of the same set of social, economic, and political circumstances. They are simply different technical ways of expressing the same creative urge. Each takes on more significance when seen in relation to the others.

Beyond the scope of this book are several important areas of artistic production: the utilitarian arts of California's Native Americans, the constructions of the state's architects, and the gardens designed by landscape designers. Native Americans, in their Edenic existence, hunting and gathering, living in small clans and tribes throughout California, produced beautiful utilitarian and religious objects. Their highest artistic expression was in basketry, although they also carved and decorated steatite and bone utensils. Their rock paintings provide the basis for the state's mural tradition (chapter 20).

California's builders have given two native materials to world architecture: redwood, found in the many board buildings of Northern California, and sun-baked adobe bricks, used in the missions and early casas of Southern California. As for contributions in style, one can point to the fantasy architecture of Hollywood and the concept of patio and outdoor living. Assimilating architectural styles from other areas of the world, California architects tailored them to fit local conditions, resulting in several unique hybrid adaptations: the Victorian houses of San Francisco, the turn-of-the-century shingle-sided arts-and-crafts bungalows accented with river boulders, the Spanish-revival tract houses of the 1920s, and even the concept of suburbia itself.

California's generally temperate climate and multiple climate zones (ranging from the seashore, to the mountains, to the desert) can nurture almost any plant that can be irrigated. Gardens of all kinds flourished in the state: the early mission gardens, grand private estates with botanical exotica or formal water gardens, commercial flower fields, corporate vegetable farms, as well as plots of cactus or drought-resistant plants. Added to these are the suburban patio gardens that Californians enjoy thanks to the state's mild temperatures and insect-free conditions.

To study California art is a chance to see the state in its most positive light, as a place where men and women have repeatedly created something vital and new out of the state's unique local conditions. ❧

Bibliography

Native American Basketry & Sculpture

Bibby, Brian, *The Fine Art of California Indian Basketry,* Sacramento: Crocker Art Museum in association with Heyday Books, 1996. 113 p.

Jacknis, Ira, *Carving Traditions of Northwest California,* Berkeley: Phoebe Apperson Hearst Museum of Anthropology, 1995.

Kelly, Isabel Truesdell, *The Carver's Art of the Indians of Northwestern California,* Berkeley: University of California Press, 1930. (*University of California Publications in American Archaeology and Ethnology,* v. 24, no. 7)

Kroeber, A. L., *Handbook of the Indians of California,* Berkeley, Ca.: California Book Co., 1970 (originally published by the Government Printing Office, Washington, D. C. in 1925 as *Bulletin* 78 of the Bureau of American Ethnology of the Smithsonian Institution).

Lopez, Raul A. and Christopher L. Moser, eds., *Rods, Bundles & Stitches: A Century of Southern California Indian Basketry,* Riverside, Ca.: Riverside Museum Press, 1981. 240 p.

Moser, Christopher L., *Native American Basketry of Southern California,* exh. cat. for "Coils in Time: A Century of Southern California Indian Basketmakers and Their Baskets," at the Riverside Municipal Museum, October 12, 1992–May 30, 1993. 155 p.

Moser, Christopher L., *Native American Basketry of Central California,* exh. cat., Riverside Municipal Museum, July 1, 1986–June 28, 1987. 112 p.

Moser, Christopher L., *American Indian Basketry of Northern California,* exh. cat., Riverside Municipal Museum, December 12, 1989–December 30, 1990. 93 p.

Sherwin, Janet, *Face and Body Painting Practices Among California Indians* (originally published as *Reports of the University of California Archaeological Survey* No. 60, Berkeley, Ca.: Department of Anthropology, University of California Archaeological Research Facility, 1963), Berkeley, Ca.: California Indian Library Collections Project, 1989.

Architecture

Banham, Reyner, Los Angeles *The Architecture of Four Ecologies,* Harmondsworth, England: Penguin Books, 1973. 256 p.

Gebhard, David and Robert Winter, *A Guide to Architecture in Southern California,* Los Angeles County Museum of Art, 1965. 164 p.

Woodbridge, Sally Byrne, *California Architecture: Historic American Buildings Survey,* San Francisco: Chronicle Books, 1988.

Landscape Gardening

Padilla, Victoria, *Southern California Gardens: An Illustrated History,* Santa Barbara, Ca.: Allen A. Knoll, 1994. 359 p. [Originally published by Berkeley: University of California Press, 1961]

Streatfield, David C., *California Gardens: Creating a New Eden,* New York: Abbeville Press, 1994.

Sunset Western Garden Book, Menlo Park, Ca.: Lane Magazine & Book Company, 1973. 448 p.

*Note: The bibliography following each chapter includes general books only. The monographs listed at the end of the book concern only the artists featured in the text. An *following a citation means that reference could not be checked against the actual book or article. This bibliography does not claim to be exhaustive.*

BEFORE 1890

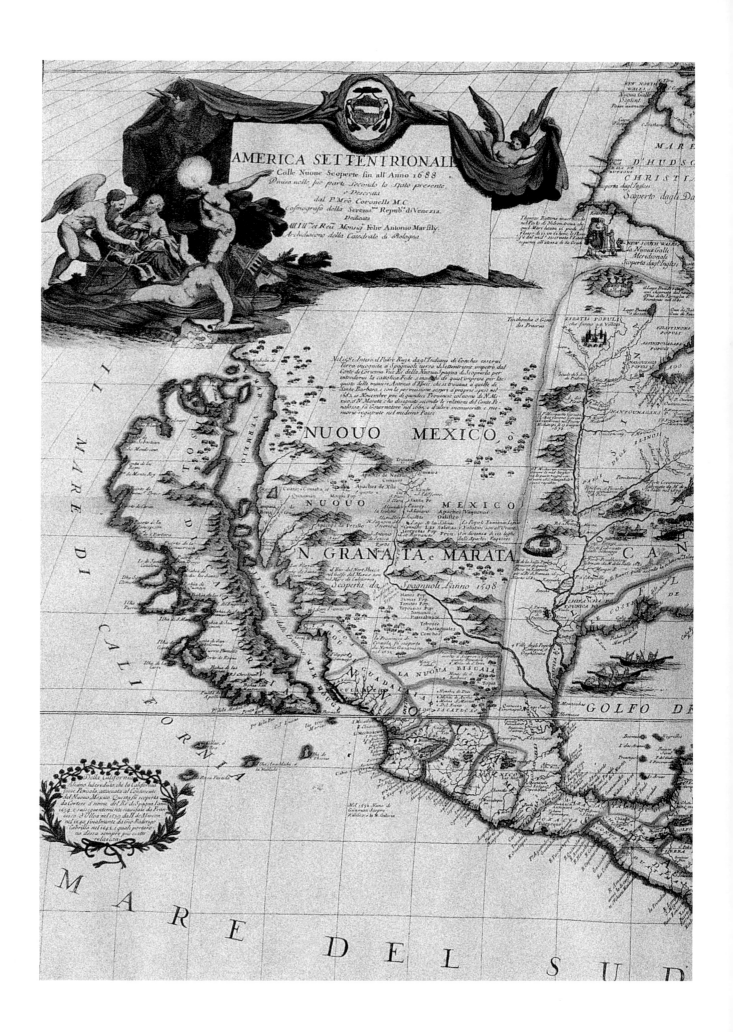

The Beginnings: Works on Paper to 1900

I

Wavelets slapped against the prows of Juan Rodríguez Cabrillo's two wooden galleons as they pushed northward up the coast of California in fall 1542. Cabrillo was one of many explorers sent out by European kingdoms during the Renaissance (1450–1600) to chart unknown areas of the world. The knowledge these explorers gathered proved to Europeans that the earth was round and introduced them to whole new land masses—first southern Africa, then the east coasts of the New World, then the entire continent of South America, and finally the islands and lands of the Pacific Ocean. But Cabrillo stands out for Californians because he and his scurvy-ridden crew were the first to chart the western coast of North America. He reached Point Reyes, just north of San Francisco, and the following winter off Santa Barbara, ingloriously died of gangrene from a broken arm.

But why mention Cabrillo in a study of California painting when there was no painter aboard his ships? Cabrillo's crew probably were the first Europeans to depict California in traditional European media—in this case pen on paper. Cabrilllo's survey charts, along with those of later explorers who refined his measurements, were in turn used to make maps. The Golden Age of Exploration roughly overlapped the Golden Age of European Cartography (1500–1800), and the first images of California are thus maps of its coastline. *America Settentrionale*, engraved on copper by the Jesuit priest and cartographer **P. Coronelli** (active about 1685–1700) in 1696 (fig. 1-1) is an example. Maps vary in artistry. The best, such as this one, have many colors as well as decorative vignettes enclosing scenery, people, animals, and flora of the exotic lands. Coronelli's is also finely engraved. Showing California as an island, it is an example of the geographical error that was perpetuated for about 150 years—beginning in 1622—based on a rumor that a Northwest Passage had been found north of California (near current-day Seattle).

Spain, which claimed all of California as part of New Spain, was having enough problems with the territory's remoteness and the resources required to missionize and colonize Baja California to think seriously about colonizing the north. But in the late 1760s, when Spain learned that Russian fur trappers in search of sea otter pelts were advancing down the West Coast of North America, the Spanish viceroy was instructed to guard the realm from these intruders. An ambitious viceroy decided to interpret "guard" as "colonize," and from that development a new phase of art resulted.

The Spanish Period 1769–1822

Gaspar de Portóla, an unmarried soldier of noble ancestry, was appointed governor of Baja California in 1767. Bored, hoping to achieve a signal service for Spain that would promote him out of his "exile," he volunteered to lead an expedition to establish Spanish outposts for the eventual settlement of Alta California. Marching north in the spring of 1769, he arrived at current-day San Diego where he established a mission on July 16 and then continued north looking for the other promising harbor the surveyors had named Monterey, intending to build a second base there. During the years of Spanish control (1769-1822), twenty-one missions were established, along with presidios (military outposts) and pueblos (towns for settlers).

One would hardly expect that a land with a population barely exceeding 1500 Europeans and Mexicans would produce anything that Europeans would call art, but it did, thanks to the mission phenomenon. The mission priests were excellent businessmen, and the mission complexes, meant to train the Indians to be independent within the Spanish system, developed into impressive business enterprises. The complexes oversaw herds of longhorn cattle on thousands of surrounding acres, cultivated olives, grains, grapes, figs, dates, and citrus brought from Europe, and oversaw manufacturing that included spinning, weaving, woodcarving, soap manufacture, and hide processing. However, the priests were also educated and often artistically sensitive men who worked to make their new homes in the wilderness as much as possible like those they had known in either Mexico or Spain.

Art in traditional European media produced in California during Spanish domination was primarily made for or at the various missions. As patrons of the arts, the local priests followed centuries of European church precedent. Since each mission complex was run almost as an independent fiefdom, its artistic output reflected the personalities of those in charge.

Apart from the architecture of the missions themselves, the most widespread art form was the

Fig. 1-1
P. Coronelli
(active c. 1685–1700)
America Settentrionale, 1696
copperplate engraving
23¾ x 17¾ in. plus borders
Robert Ross Antiquarian
Maps, Views, Globes and
Related Books, Calabasas

painted decoration inside the churches. A detail of the side altar at Mission San Miguel de Arcangel, north of Paso Robles (fig. 1-2), shows how most of the designs were architectural— painted columns, capitals, and arches, meant to relieve the starkness of the white-washed adobe walls. The painted decoration also allowed the priests to re-create in a limited way the architecture of the wealthier Spanish and Mexican churches. The repeated pattern on the wall shows how the artisans made use of stencils. Many of the designs were copied from the oft republished *De Architectura* by Marcus Vitruvius, a first-century B.C. Roman architect and engineer. The most elaborate decoration appeared on the focal wall behind the altar, where columns and arches mimicked the carved and gilded wood *reredos* of the more prosperous churches.

The most interesting mission murals, however, are those few that were painted inside and on the exterior of secular outbuildings. An example is the *Vintage Scene, Interior of Sala, Priest's Quarters, San Fernando Mission* (fig. 1-3) created about 1820 by neophytes. Native Americans are picking grapes, and the huge vines and bunches of fruit literally dwarf the workers. In another scene at San Fernando, Native Americans hunt deer, and in still another a hunter holds his bow. All of these blend native line drawing with European three-dimensional perspective and a storytelling element.

The mission priests also oversaw other art forms, including carved wooden furniture and stone. The latter usually accented the bulky adobe construction around doors, on the fronts of churches, and along nave walls. Both forms are relatively rare. Carved stone is found in the big, caved-in church at San Juan Capistrano and at the missions in Carmel and Santa Barbara.

One of the rarest extant forms of indigenous California art is easel painting. Many paintings were imported from Europe or Mexico, but those painted in California may be limited to the fourteen stations of the cross created at San Fernando Mission about 1820 and now housed at San Gabriel Mission. Among these paintings is the *Fourth Station of the Cross, Jesus Meets his Mother* of about 1820 (fig. 1-4). One can imagine a brother ordering instructional books from mother churches in Mexico or Spain and then assigning talented neophytes, in this case **Juan Antonio** (active c. 1820), and others to copy engravings or illustrations from the books onto the canvas. Fourteen images resulted, made powerful with primitive and raw forms, bright colors, and a rudimentary understanding of anatomy and perspective.

Apart from church-generated paintings, artists employed by European expeditions sent out to collect scientific data on the Pacific Ocean and the countries that bordered it made pictorial images of California. Science continued to displace religion as an explanation for the universe, and European countries that formerly had competed for territorial conquest now competed

Fig. 1-2
Esteban Munras
(active 1821–22)
Side altar, Mission San Miguel Arcangel, San Miguel
polychrome and plaster
San Miguel Arcangel
Mission, San Miguel
Photo: Norman Neuerburg

Fig. 1-3
Mission Indian neophytes
(active c. 1820)
Vintage Scene, interior of Sala, Priest's quarters, San Fernando Mission, as restored in 1942
polychrome and plaster
San Fernando Mission
Photo: Norman Neuerburg

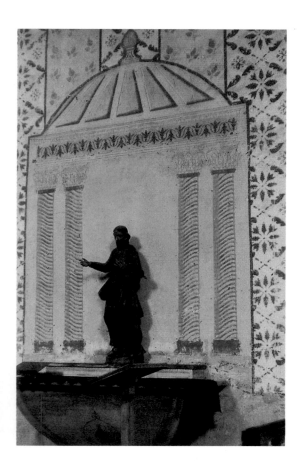

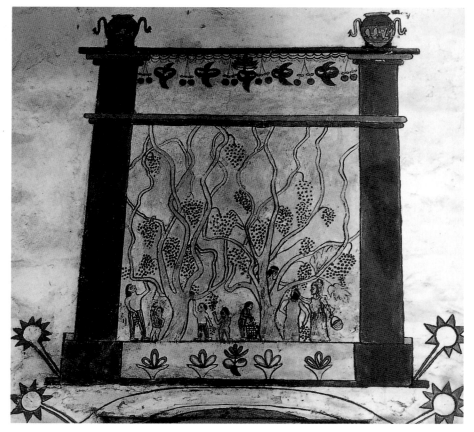

for scientific discoveries. Traveling by sea, most expeditions had at least one artist on staff whose job was to make sketches of the terrain where the expedition anchored as well as drawings of local inhabitants, animals, and plants. Since many of their drawings were made to illustrate published journals of the expeditions, and others (such as the sketches of animals and plants) for use by zoologists and botanists to classify new species, the drawings had to be accurate. A few of the originals survive today in national archives in Spain, England, Germany, and France, but most are known only through published lithographic or engraved versions.

For most of the New World countries, a region's European-introduced art history began in just this way—with a period in which visitors made images for scientific purposes. Such moments are littered with art historical "firsts" and "greats." The Spanish era can boast the first expeditionary artist, Gaspard Duche de Vancy (?-1788), who arrived from France with the La Perouse party in 1786 (fig. 1-5) and made the first view of Monterey. Tomás de Suria (1761–?) and **José Cardero** (1768–after 1791), who came from Spain with the Malaspina expedition in 1791, made the first views of the Presidio of Monterey and of Mission San Carlos Borromeo in nearby Carmel; and, John Sykes (1773–1858), with the Vancouver expedition from England, from 1790–95, made the first views of Point Conception (1792) and inland from Monterey (1794).

Early visual records fascinate us for what they tell us of California before the encroachment of many Europeans. We see the tenuous hold that the Spanish had on the land—a handful of poor adobe missions and presidios, rangy cattle, and ramshackle farms. Images are principally of the area around the Spanish capital, Monterey, where some of the expeditions anchored or wintered. Because these artists strove to be accurate and objective, their work has greater uniformity than that of artists interested in developing their personal styles. Most of them used the easily portable media of pencil, pen and ink, and watercolor on paper. And, although they considered themselves scientists, most tried to make their works artistic, striving for good composition, three-dimensional perspective, correct proportions, and balance of light and dark. Ideally, personal artistic style was suppressed, but a discerning eye can recognize individual hands.

Images of the land's native population are extremely rare, and they stem primarily from the work of artists with two Russian expeditions: George Heinrich von Langsdorff (1773–1852), with the Rezanov expedition in 1806, and Louis Choris (1795–1828), with the von Kotzebue expedition in 1815-16. **W. G. Tilesius von Tilenau**'s (1769–1857) copy of *Dance of the Indians at the Mission of St. Joseph in New California* (fig. 1-6), made to illustrate von Langsdorff's *Voyages and Travels* (1813–14), and other surviving images of natives, have supplied important ethnographic information.

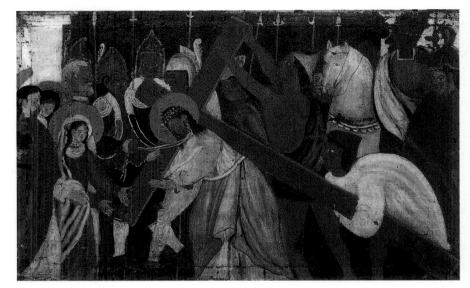

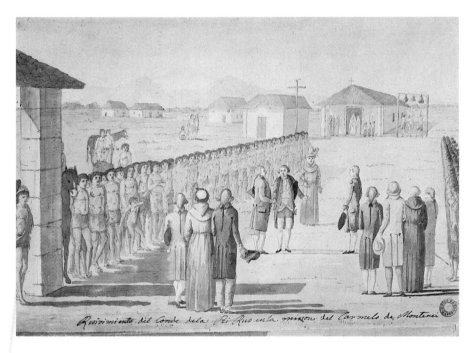

Fig. 1-4
Juan Antonio and other neophytes (active c. 1820)
Fourth Station of the Cross, Jesus Meets his Mother, c. 1820
oil on canvas, 30 x 50 in.
San Gabriel Mission Museum,
San Gabriel, California
Photo: American Photo Repro

Fig. 1-5
José Cardero (1768–after 1791)
Reception of La Perouse at Carmel Mission, 1786 (copy after Gaspard Duche de Vancy (?–1788)
pen and sepia watercolor
13½ x 18¾ in.
Museo Naval, Madrid,
ms 1723 (1)

Fig. 1-6
W. G. Tilesius von Tilenau
(1769–1857)
Dance of the Indians at the
Mission of St. Joseph in New
California
engraving, 6½ x 8 in. (image)
from George Heinrich von
Langsdorff, *Voyages and*
Travels, London: H. Colburn,
1813-14, v. 1.

Fig. 1-7
Ferdinand Deppe (active
1828–1836)
San Gabriel Mission, c. 1832
oil on canvas, 27 x 37 in.
Collection of Orange County
Museum of Art, OCMA/LAM
Art Collection Trust; Gift of
Nancy Dustin Wall Moure

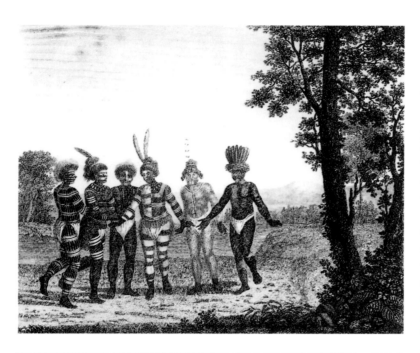

The paucity of images of California natives, compared to the wealth of depictions of the Plains tribes, resulted largely from the small number of artists who reached California and the California Indians' lack of picturesqueness in European eyes. Added to this was the native's quick assimilation into the mission system with a consequent loss of much of their own culture and the tribes' rapid decimation by disease and starvation.

The Mexican Period 1822–1847

Between 1810 and 1821 Mexican revolutionaries joined by former royalist soldiers broke Spain's rule over New Spain (Mexico). Mexico became an empire in summer 1821, and the remote Alta California finally became an official dependency on April 11, 1822.

For several years, life and art in Alta California went on as usual. But soon private citizens began to demand ownership of land, and that meant mission-held and government-held lands had to be broken up. Missions, stripped by the Secularization Act of 1834 of almost all their grazing and farming lands, not to mention their neophyte labor force, soon had all they could do to keep their complexes from falling into ruin. Wealth, and with it the financial ability to purchase art, swung to the owners of the new kingdom-sized cattle ranchos that some Mexican citizens gained either through grants from the Mexican government or through unscrupulous acquisition of lands that had been returned to the Indians. These rancho owners became the land's aristocracy. Interested more in animal husbandry than "culture," their tastes ran to decorative arts such as tooled and silver-mounted saddles and embroidered clothing.

The pictorial arts were thus kept alive only by artists coming from outside California. Besides those arriving with the continuing scientific expeditions, a few independents showed up under the protection of trading expeditions. Some were professional delineators; others were wealthy gentlemen who had cultivated an interest in drawing and enjoyed travel. Nine artists from this period are known, including the first to arrive under the protection of the United States flag—Titian Ramsay Peale (1799–1885), who came with the United States South Seas Surveying and Exploring Expedition of 1841.

How did their work compare to that of the Spanish period? Stylistically most of it continued to be objective and reportorial. Only its subject matter changed. First to disappear were images of California's Native Americans. With their cultures destroyed by the mission system, they lost any appeal to artists. Drawings of flora and fauna also lost relevance, leaving the landscape to dominate. Because the more lenient

Mexican laws now allowed foreigners to land at all California ports, artists began to make images of areas outside the core area of Monterey. Bernard Duhaut-Cilly made wash drawings of *Mission San Luis Rey* (fig. 10-1) north of San Diego and a *View of the Russian Establishment at Bodega (Fort Ross)* north of San Francisco in 1827–28. There are also the first views of Yerba Buena (San Francisco) by Jean-Jacques Vioget in 1837 and the first views of the Klamath River, Mount Shasta, and the upper Sacramento River by Thomas Agate in 1841. William Henry Meyers made gouache drawings of hide houses at San Diego and of San Pedro harbor in about 1842-43. Since most artists still arrived by ship, their views are primarily confined to the coast. These painters liked to depict those sites that showed man's presence or handiwork. Towns, missions, and ranchos represented islands of hospitality and civilization in a sparsely inhabited land. They symbolized man's ability to conquer the wilderness and, for people with secret hopes of seizing the seemingly rich territory, potential opposition to armed invasion.

The cattle business was now reason for at least two amateur delineators to penetrate inland. **Ferdinand Deppe** (active 1828–1836), an agent for a German hide trader in Mexico City, and Alfred Robinson (1806–1895), who worked for a Boston firm of hide traders, rode along El Camino Real (the king's highway), sometimes together, more often separately, stopping at missions and ranchos and in towns, setting up trade, taking orders for goods, and, in their spare time, sketching for amusement. Deppe's *San Gabriel Mission* of about 1832 (fig. 1–7), the earliest-known oil painting of Southern California, is an example of the conscientious but somewhat primitive work amateurs often produced. Still another amateur, professional traveler Emmanuel Sandelius (?–about 1845), toured California in 1842 and 1843 making shorthand pen-and-ink sketches of missions and settlements.

Some of the first truly sophisticated renderings belong to the Mexican years. This can best be seen by comparing the *View Taken Near Monterrey* [sic] of 1826 (fig. 1-8) by **Richard Brydges Beechey** (1808–1895) with *The Mission of San Carlos, Upper California* of 1827 (fig. 1-9) by **William Smyth** (1800–1877). Both artists arrived with the English exploring expedition led by Captain Frederick William Beechey during 1826–27. While Smyth, the official expedition artist, produced typically objective topographical views, the captain's younger brother, Richard Beechey, who inherited artistic talent from his more famous portraitist father and was a guest on the ship, could take artistic license. Because his execution is creative, expressive, and lively, his California landscapes began to look very

Fig. 1-8
Richard Brydges Beechey
(1808–1895)
View Taken Near Monterrey,
1826
watercolor over pencil
9⅞ x 16⅜ in.
Courtesy, The Bancroft
Library, University of
California, Berkeley,
1963.002.1306-FR

Fig. 1-9
William Smyth (1800–1877)
*The Mission of San Carlos,
Upper California,* 1827
watercolor, 9½ x 14 in.
Peabody Museum,
Harvard Univeristy
Photo: Hillel Burger

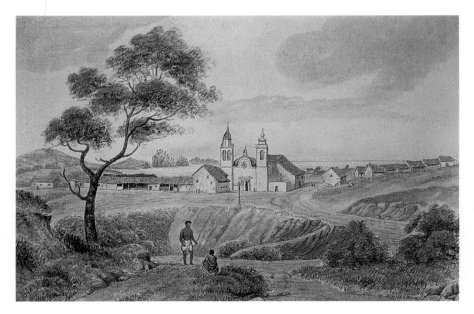

19

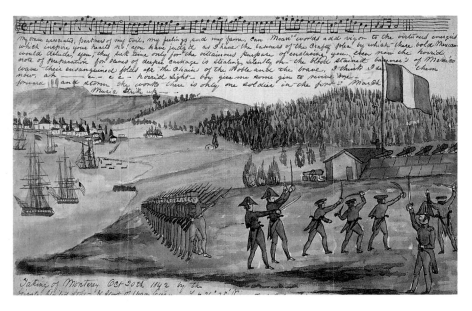

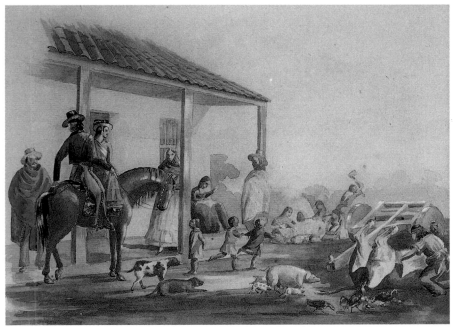

Fig. 1-10
William Henry Meyers
(1815–?)
The Taking of Monterey,
October 20, 1842
pencil and watercolor on white
wove paper, 10¼ x 15½ in.
Courtesy, The Bancroft
Library, University of Cali-
fornia, Berkeley, C-F 92, v. 2

Fig. 1-11
Alfred Sully (1821-1879)
Monterey, California Rancho
Scene, c. 1849
watercolor on paper
8 x 10¾ in.
Collection of the Oakland
Museum of California, Kahn
Collection

much like European pastoral views. Foliage is more luxuriant than normal for California, scrawny California cattle become fat and content European cows, and the inhabitants are "peasants," strolling paths and roads that pass picturesque adobes and shanties. Views from the Mexican period show the growing European presence on the land, the expanded towns and ports, and the prevalence of private ranching.

The Mexican-American War, 1846-47

Visitors to Spanish and Mexican California occasionally remarked in their journals and letters about the fertility of the land and the area's great potential; they also noticed how thinly populated it still was and how easily it might be seized. The United States was not the least of these countries. Aggressively imperialistic in the early 1800s, the young United States purchased the Louisiana Territory from France in 1803. After finally fending off England in the War of 1812, it began casting covetous eyes westward, convinced by its belief in "Manifest Destiny" that all the land to the Pacific coast and possibly in the North American continent should belong to the United States. And that included California.

Through the early 1840s U. S. warships cruised California's coast, conscious of the ferment between the states and Mexico, waiting for news that actual hostilities had broken out. In an embarrassingly premature move, Commodore Thomas Catesby Jones, commander of the Cyane, mistakenly believing that war had been declared, sailed into Monterey harbor and seized the town. Later he apologized, but not before **William Henry Meyers** (1815–?), an amateur artist on his ship, documented the "conquest" in *The Taking of Monterey, October 20, 1842* of 1842 (fig. 1-10).

When war actually was declared in spring 1846, U. S. forces were in place, some with artists attached. General John C. Fremont with his so-called exploratory party of soldiers, who had arrived overland in Northern California in late 1845, seized the northern part of the territory. America's Pacific Squadron commanded by John Drake Sloat took Monterey in July. Then, replacement Commander Robert F. Stockton carried the war to Southern California, and in August took San Diego, Los Angeles, and Santa Barbara.

Battle images vary from those made on the spot by military personnel and illustrators to those made after the fact by sophisticated painters. The first type is generally reportorial, notes by eye-witnesses in pencil or watercolor on paper. Such works depict both the climactic military engagements as well as the quieter life in camp. Most of the extant images of Mexican-American actions in California are of the first variety,

executed by military men attached to an expedition who either were trained in topographical drawing or who were amateur artists. Joseph Warren Revere (1812–1880), an officer on the *Portsmouth* in San Francisco Bay when hostilities commenced with Mexico in July 1846, made some sketches of California. Six of them appeared as lithographs in his book *A Tour of Duty in California.* William Henry Meyers, then a gunner on the *Dale,* made a series of watercolors in a primitive style of life aboard ship, a number depicting military engagements, and several landscapes of California.

One battalion with artistic significance was that of General Stephen Watts Kearney. Kearny's one hundred men arrived in California in the last days of 1846 via the "southern" route (Fort Leavenworth, Santa Fe, San Diego). With them were John Mix Stanley (1814–1872), a topographical draftsman and professional painter, and William Hemsley Emory (1811–1887), a lieutenant and amateur draftsman. Upon entering northern San Diego County from the desert, Kearny engaged a body of Californios (residents of California, as they were called then) at a place called San Pasqual, resulting in one of the definitive battles of the war. Some of Emory's pencil sketches appeared as lithographs in his *Notes of a Military Reconnaissance 1846–1847.* So far, none of Stanley's many described paintings seem to have survived. Three weeks later, Kearney merged forces with Commodore Stockton, who had reached San Diego by ship, and the two units marched north to Los Angeles. There, the final battles took place in January 1847, and there additional images were made, especially by Meyers. A few of these became illustrations in books, but the Mexican-American war occurred too early to capitalize on the great fashion for illustration that caused so many artist-reporters to document the Civil War only fifteen years later.

No paintings of the second type of military painting, the Grand Manner historical tableau, were created of the war in California. Professional painters usually made such large paintings from imagination after the event, working in permanent studios in which they could develop large-scale, complex, and often emotionally stirring images. California had neither a resident art community to paint such work nor any strata of wealthy individuals or institutions to commission such works. The war was over too quickly with no particularly heroic or noble acts.

Art Under American Occupation, 1847–1900

When California came under United States jurisdiction in 1847, for a few years life changed little. The Mexican rancho lifestyle prevailed, and inhabitants simply accommodated the new American military units as well as the occasional newly arrived Anglo trader and settler. For about three years, the military continued to serve as the impetus for new artists to come to the territory. **Alfred Sully** (1820–1879), son of the American portraitist Thomas Sully, assumed duties as chief quartermaster of the U. S. troops at Monterey in April 1849; William Rich Hutton (1826–1901) arrived in April 1847 to serve as a clerk to his uncle, a paymaster of the U. S. Volunteer Troops; and George Douglas Brewerton (1827–1901) arrived with the Volunteers in the spring of 1847.

Sully was the most talented of the three, creating watercolors and oils of his social life at Monterey where he married into a Californio family. An example is *Monterey, California Rancho Scene* of about 1849 (fig. 1-11). The scene shows the persistence of the Californio lifestyle after the United States occupation, and the wealth lavished by Californios on colorful costumes. It also shows the bounty of the land and the importance given to family and to beautiful steeds. In Sully's works, figures dominate, while in the pencil sketches of the other two amateurs, Hutton and Brewerton, landscape is foremost. Hutton's drawings, however tight and unassuming, provide an extensive and rare record of early Southern California.

The discovery of gold in January 1848 brought a flood of humanity into Northern California and changed everything. Along with Yankee attitudes came a new set of social conditions and the state's first sophisticated artists, who affected both the form and subject of art. Although the changes wrought by these professionals were significant, they did not suddenly eclipse the amateurs, who continued to make topographical drawings and other works on paper. Nor did the new medium of photography, invented by Daguerre in 1839, bring an end to hand-rendered landscape and portraiture. Important works on paper continued to be produced.

The Gold Rush brought in miners, some of whom were also amateur artists. After spending the week prospecting, mining, panning, and sluicing, they occupied Sundays and other leisure hours making pencil sketches of their surroundings either to amuse themselves or to show folks back home what life was like in California. Like their predecessors, the scientific illustrators, their intent was to render a scene accurately. The style remains tight and primitive, while the medium is still most often pencil, or pen and ink, on paper. Because more people—some quite talented— were making sketches, there is a greater variety of approaches, techniques, and media. No subject was overlooked. After almost a century in which the number of images of California can be counted on the fingers of two hands, there are suddenly hundreds recording

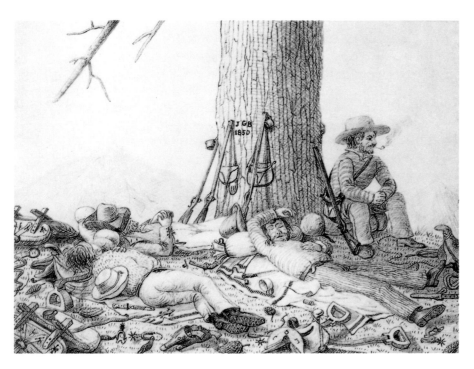

the variety of activity that proliferated in Northern California after 1849. Yankee board buildings shouldered out adobes, Yankee dress succeeded the colorful Mexican costume, and new occupations such as gold mining, building construction, commerce, shipping, and merchandising quickly overshadowed ranching. Most drawings, such as *Repose of Tired Adventurers* (fig. 1-12) by **J. Goldsborough Bruff** (1804–1889), are of scenes that the miners personally experienced, either along the route to the gold mines or at camp. These include the miners' dwellings, their claims, the processes they used to obtain gold, life in camp and nearby gold-mining towns, and the surrounding landscape. Although many are not of high artistic quality, the miner-artists' straightforward approach has left important documents of the life of the time.

Topographical art, the professional, almost photographic drawings and watercolors of landscape made for expeditions, also continued to be produced in the 1850s. This time it was by artists accompanying U. S. government reconnaissance expeditions inquiring into the newly obtained territory. A Mexican American Boundary Expedition employed the amateur artist John Russell Bartlett (1805–1886) and the professional Henry Cheever Pratt (1803–1880). A Coastal Survey brought in William Birch McMurtrie (1816–1872), Henry S. Stellwagon (active in California about 1849), and James Madison Alden (1834–1922). And three railroad surveys to determine the best railroad routes into and through California utilized the talents of artists such as Charles Koppel (active in California in 1853), William Phipps Blake (1825–1910), Heinrich B. Mollhausen (1825–1905), and Friedrich W. Egloffstein

Fig. 1-12
J. Goldsborough Bruff
(1804–1889)
Repose of Tired Adventurers
pencil
The Huntington, San
Marino (HM 8044 # 188)

Fig. 1-13
James Madison Alden
(1834–1922)
*San Pedro, Cala., June 12,
1859 (1:30 p.m.), 1859,* from
Sketchbook, 1858–59
watercolor and graphite on
paper, 8 ⅝ x 22 ¾ in.
California Historical Society,
Gift of Henry R. Wagner

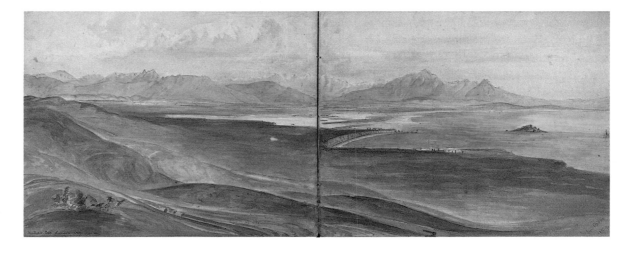

WHERE TO BUY CALIFORNIA ART

BAY AREA

ART BEFORE 1945
CHRISTOPHER QUEEN GALLERIES, Duncans Mills
KERWIN GALLERIES, Burlingame
MAXWELL GALLERIES, San Francisco
REPRESENTATIONAL ART SINCE 1945
CHRISTOPHER QUEEN GALLERIES, Duncans Mills
MAXWELL GALLERIES, San Francisco
CUTTING EDGE ART OF THE LAST 30 YEARS
EBERT GALLERY, San Francisco
Emphasis on Bay Area artists
WASHINGTON SQUARE, San Francisco
Bay Area artists from the Pacific Rim, Latin America and the Caribbean

CARMEL

ALL ART BEFORE 1945
WILLIAM A. KARGES FINE ART
TROTTER GALLERIES

San Francisco

Carmel

Pacific

SANTA BARBARA

ALL ART BEFORE 1945
GARY BREITWEISER STUDIO 2
MAUREEN MURPHY

CLAREMONT

WATERCOLORS, REPRESENTATIONAL ART OF THE 1930s AND SINCE 1945
CLAREMONT FINE ARTS

Santa Barbara

Pasadena Claremont

LOS ANGELES

Los Angeles

Laguna Beach

ALL ART BEFORE 1945
EDENHURST GALLERY, Los Angeles
GOLDFIELD GALLERIES, LTD., Los Angeles
WILLIAM A. KARGES FINE ART, Los Angeles
KELLEY GALLERY, Pasadena
GEORGE STERN FINE ARTS, Los Angeles
MID CENTURY, 1940s-1960s
HERITAGE GALLERY, Los Angeles
TOBEY C. MOSS GALLERY, Los Angeles
CUTTING EDGE ART OF THE LAST 30 YEARS
PATRICIA CORREIA GALLERY, Santa Monica
Contemporary West Coast art; Mid career established artists, emerging artists

LAGUNA BEACH

ALL ART BEFORE 1945
CALIFORNIA ART GALLERY
DAVID & SONS FINE ARTS
DE RU'S FINE ARTS
JOAN IRVING SMITH FINE ARTS
REDFERN GALLERY
WATERCOLORS, REPRESENTATIONAL ART OF THE 1930s
CALIFORNIA ART GALLERY
STARY SHEETS FINE ART
REPRESENTATIONAL ART SINCE 1945
CALIFORNIA ART GALLERY
JOAN IRVING SMITH FINE ARTS
STARY-SHEETS GALLERY

WHERE TO BUY CALIFORNIA ART

ART CREATED BEFORE 1945

CALIFORNIA ART GALLERY
305 North Coast Hwy., Suite A
Laguna Beach, Ca. 92651
California representational art (historic and contemporary),
American Scene watercolors and oils
Contact: Sandy Hunter, Tel. 949-494-7270; Fax. 949-494-7267

CHRISTOPHER QUEEN GALLERIES
#4 John Orr's Gardens (P. O. Box 28)
Duncans Mills, Ca., 95430
Early California (1870-1940) oils, watercolors; contemporary
representational artists specializing in the California landscape
Contact: Nancy Ferreira, Tel 707-865-1318; Fax. 707-865-0208
Website: gallery CD Rom available

DAVID & SONS FINE ART
451 South Coast Hwy.
Laguna Beach, Ca. 92651-2403
All pre-1945 California art with a special interest in
Impressionist and Post-Impressionist paintings
Contact: David O'Hoy, Tel. 949-494-8610; Fax. 714-730-4839

DE RU'S FINE ARTS
1590 South Coast Hwy.
Laguna Beach, Ca. 92651
All pre-1945 California art
Contact: De McCall, Tel 949-376-3785; Fax. 949-376-9915
Website: www.artnet.com/derus.html
Email: derusgal@aol.com

DE RU'S FINE ARTS
9100 Artesia Blvd.
Bellflower, Ca. 90706
19th and early 20th century California Impressionist paintings
Contact: De McCall, Tel. 562-920-1312; Fax. 562-920-3077
Website: www.artnet.com/derus.html
Email: derusgal@aol.com

EDENHURST GALLERY
8920 Melrose Ave.
Los Angeles, Ca. 90069
19th and 20th century American paintings with a focus on the
California School
Contact: Tom Gianetto, Tel. 310-247-8151; Fax. 310-247-8167
Website: www.artnet.com/edenhurst.html
Email: edenhurst@earthlink.net

GARY BREITWEISER, STUDIO 2
925 Calle Puerto Vallarta
Santa Barbara, Ca. 93103
All California art
Contact: Gary Breitweiser, Tel. 805-965-8100
Website: www.west.net/~studio2/
Email: studio2@west.net

GOLDFIELD GALLERIES, LTD.
8380 Melrose Ave.
Los Angeles, Ca. 90069
California art; special interest in American Impressionism,
and paintings of the American West
Contact: Ed Goldfield, Tel 323-651-1122; Fax. 323-651-1168
Website: www.artbrowser.com and www.fineartstrader.com

JOAN IRVING SMITH FINE ARTS
1550 South Coast Hwy.
Laguna Beach, Ca. 92651
All paintings before 1945 and contemporary plein air artists
Contact: Pam Ludwig, Tel. 949-494-0854; Fax. 949-494-0564
Website: http://jisfinearts.com

[KARGES] WILLIAM A. KARGES FINE ART
9001 Melrose Ave.
Los Angeles, Ca. 90069
All pre-1945 California art
Contact: Whitney Ganz, Tel. 310-276-8551; Fax. 310-276-7980
Website: www.kargesfineart.com

[KARGES] WILLIAM A KARGES FINE ART
5th & Dolores (P. O. Box 222091)
Carmel, Ca. 93922
Tel. 831-625-4266; Fax. 831-625-9649

KELLEY GALLERY
770 East Green Street, Suite 102
Pasadena, Ca. 91101
All pre-1945 California Paintings;
Impressionist/Post-Impressionist
Contact: Michael Kelley, Tel. 626-577-5657
Email: Mkelleyart@aol.com

KERWIN GALLERIES
1107 California Dr.
Burlingame, Ca. 94010
All California art before 1945
Contact: Richard Kerwin, Tel. 650-340-8400; Fax. 650-340-8466

MAUREEN MURPHY FINE ARTS
1187 Coast Village Road, Suite 3A
Montecito, Ca. 93108
All pre-1945 California art
Contact: Maureen Murphy, Tel. 805-969-9215
Website: www.mmfa.com

MAXWELL GALLERIES, LTD.
559 Sutter St.
San Francisco, Ca. 94102
19th & 20th century American and European paintings and sculpture, with a special interest in art of California from all time periods and all areas of the state, including contemporary realists
Contact: Mark & Colleen Hoffman, Tel. 415-421-5193;
Fax. 415-421-4858
Website: www.artnet.com/maxwell.html

REDFERN GALLERY
1540 South Coast Hwy.
Laguna Beach, Ca. 92651
All pre-1945 California art
Contact: Ray Redfern, Tel. 949-497-3356; Fax. 949-497-1324
Website: www.redferngallery.com
Email: redferngal@aol.com

[STERN] GEORGE STERN FINE ARTS
8920 Melrose Ave.
Los Angeles, Ca. 90069
Paintings: Impressionist and Post Impressionist
Contact: George Stern, Tel. 310-276-2600; Fax. 310-276-2622
Website: www.sternfinearts.com
Email: gsfa@sternfinearts.com

TROTTER GALLERIES
San Carlos near 7th/ Box 3246
Carmel, Ca. 93921
Pre-1945 California art/ Paintings, Impressionist and Post-Impressionist
Contact: Terry & Paula Trotter, Tel. 831-625-3246;
Fax. 831-625-1456
Email: trotter_galleries@ juno.com

WATERCOLORS, REPRESENTATIONAL ART OF THE 1930s

CALIFORNIA ART GALLERY
305 North Coast Hwy., Suite A
Laguna Beach, Ca. 92651
California representational art (historic and contemporary); American Scene watercolors and oils
Contact: Sandy Hunter, Tel. 949-494-7270; Fax. 949-494-7267

CLAREMONT FINE ARTS
206 Yale Ave.
Claremont, Ca. 91711
American Scene watercolor and oils; Works on paper (aft. 1945) ; Paintings general Southern California (aft. 1945)
Contact: Mike Verbal, Tel. 909-624-5078; Fax. 909-624-5078
Website: www.citylimits.com/artist/finearts
Email: Mikeverbal@aol.com

STARY-SHEETS FINE ART
1590 South Coast Hwy., #1
Laguna Beach, Ca. 92651
American Scene watercolors and oils; contemporary Representational watercolors and oils
Contact: Susan and David Stary-Sheets, Tel. 949-497-3797 and 800-262-7779, Fax. 949-497-4417
Website: www.fineartdealer.com
Email: starysheets@ioc.net

ART CREATED AFTER 1945

CALIFORNIA ART OF THE MID CENTURY

HERITAGE GALLERY
718 North La Cienega Blvd.
Los Angeles, Ca. 90069
Postwar artists—paintings, general, Southern California
Contact: Charlotte Sherman, Tel. 310-652-7738;
Fax. 310-454-0313
Email:chashe@worldnet.att.net
(Alternate address: 1300 Chautauqua Blvd., Pacific Palisades, Ca. 90272 (by appt.); Tel. 310-454-5000)

TOBEY C. MOSS GALLERY
7321 Beverly Blvd.
Los Angeles, Ca. 90036
1930s-1960s California Modernism
Contact: Tobey Moss, Tel. 323-933-5523; Fax. 323-933-7618
Website: http://artscenecal.com/Moss.html

REPRESENTATIONAL ART SINCE 1945

CALIFORNIA ART GALLERY
305 North Coast Hwy., Suite A
Laguna Beach, Ca. 92651
California Representational art (historic and contemporary)
Contact: Sandy Hunter, Tel. 949-494-7270; Fax. 949-494-7267

CHRISTOPHER QUEEN GALLERIES
#4, John Orr's Gardens (P. O. Box 28)
Duncans Mills, Ca. 95430
*Contemporary representational artists specializing in the
California landscape*
Contact: Nancy Ferreira, Tel. 707-865-1318;
Fax. 707-865-0208
Website: gallery CD Rom available

CLAREMONT FINE ARTS
206 Yale Ave.
Claremont, Ca. 91711
*Works on paper (aft. 1945); Paintings, general Southern
California art (aft. 1945)*
Contact: Mike Verbal, Tel. 909-624-5078; Fax. 909-624-5078
Website: www.citylimits.com/artist/finearts

JOAN IRVING SMITH FINE ARTS
1550 South Coast Hwy.
Laguna Beach, Ca. 92651
Contemporary and historic plein air artists
Contact: Pam Ludwig, Tel. 949-494-0854; Fax. 949-494-0564
Website: http://jisfinearts.com

MAXWELL GALLERIES, LTD
559 Sutter St.
San Francisco, Ca. 94102
*20th Century American and European paintings
and sculpture*
Contact Mark & Colleen Hoffman,
Tel. 415-421-5193; Fax. 415-421-4858
Website: www.artnet.com/maxwell.html

STARY-SHEETS GALLERY
1590 South Coast Hwy. #1
Laguna Beach, Ca. 92651
*Contemporary representational watercolors
and oils*
Contact: Susan & David Stary-Sheets,
Tel. 949-497-3797; Fax. 949-497-4417
Website: www.fineartdealer.com
Email: starysheets@ioc.net.

CUTTING EDGE ART OF THE LAST THIRTY YEARS

EBERT GALLERY
49 Geary St., 4th floor
San Francisco, Ca. 94108
*Paintings general, Northern California; Bay Area modern
painting (Abstract Expressionism/ Bay Area Figurative)*
Contact: Dick Ebert, Tel. 415-296-8405
Website: www.ebertgallery.com
Email: dickebert@sprynet.com

PATRICIA CORREIA GALLERY
2525 Michigan Ave., Building E2
Santa Monica, Ca. 90404
*Contemporary West Coast art, emerging artists, mid career
established artists active during the last 20 years*
Contact: Patricia Correia, Tel. 310-264-1760;
Fax. 310-264-1762
Email: correia@earthlink.net

WASHINGTON SQUARE GALLERY
1821 Powell St.
San Francisco, Ca. 94133
*Contemporary California art; focus on SF
and Bay Area artists from the Pacifc Rim,
Latin America and the Caribbean*
Tel. 415-291-9255; Fax. 415-834-1910
Email: jule@sirius.com

(1824–1898). Because these surveys penetrated all of California, rather than limiting themselves to the main scene of action around the gold fields, views of other parts of the state were made.

Probably the most artistically accomplished images to come out of these surveys were the many drawings, transparent watercolors, and gouaches (opaque watercolor) made by **James Madison Alden** (1834–1922), who served with the Coast Survey (and later the U.S.-Canada Boundary Survey). For almost a decade, Alden traveled up and down the West Coast, recording scenes from the survey ship as well as some inland areas (near Santa Barbara, in the Sierras, and in Yosemite) that he saw on side trips. Since many of his pictures are extant and many are published, his artistic growth is visible, from the tight renderings he made before 1854 to the stylized watercolors he painted by 1859. Watercolors such as *San Pedro, Cala.* of 1859 (fig. 1-13), in which Alden simplifies land contours into flowing lines, represent his highest artistic achievement.

With occupation by the United States came capitalism and entrepreneurs who quickly realized that money could be made from art. The Gold Rush represented an exciting and romantic enterprise, of which East Coast urbanites were eager to see images. Professional illustrators flocked to the area. Some of them arrived on their own to look for gold, and failing, turned their experiences into illustrated books. William Redmond Ryan (1823–1855), William McIlvaine (1813–1867), George Victor Cooper (1810–1878), Francis Samuel Marryat (1826–1855), and **John David Borthwick** (1825–c.1900) (fig. 1-14) wrote popular illustrated narratives of life in the gold fields. Other artists were sent by the East Coast's large commercial publishers to create illustrations for magazines and books.

Illustrated publications were a new genre in the mid-1850s. Illustrations in the form of woodcuts, lithographs, or engravings were meant to help a popular audience visualize a scene described in words, or to teach or instruct. Often contrived, these scenes emphasize figures over landscape, tell a story, or show an action, and fictionalize the real. The earliest illustrations of California were instructions for potential gold seekers. They show the means of travel to California, the equipment and clothing needed, the pitfalls the traveler should be wary of, and the various modes of gold mining--panning, sluicing, dredging, and excavating. Others showed off-duty life in the gold fields: miners at "household chores," such as writing letters, reading (sometimes the Bible), sketching, cooking, and washing, or even dancing as in Borthwick's work. Some illustrations pictured abstract ideas and emotions, such as greed, eternal hope countered by sour disillusionment, as well as disappointment, happiness, and boredom. Other illustrations show the human toll brought about by illness, accidents, and death; or the miners' rampant destruction of nature. And still other illustrations romanticize the free and loose male-dominated frontier society that entertained itself with horse racing, card playing, and drinking—a society fraught with banditry, murder, and deceit, which called for settling disputes through gunplay.

Money could also be earned from making panoramas—scenes painted on long rolls of canvas that could be viewed like today's motion picture. An audience sat in a darkened room with music playing and perhaps someone reading aloud from a narrative. Viewers could watch a panorama unwind like a scroll and actually imagine they were traveling to some interesting or exotic place. Especially popular were trips to

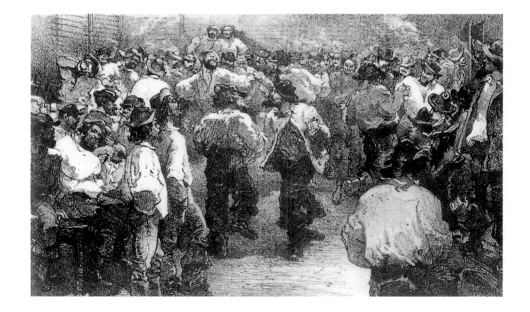

Fig. 1-14
John David Borthwick
(1825–c. 1900)
A Ball in the Mines, 1857
lithograph - two color
4 x 6½ in. (image)
Illustration in J. D. Borthwick, *Three Years in California 1851–54*, Edinburgh & London: W. Blackwood and Sons, 1857.

California and the gold fields. One of the most notable artists in this medium may not have completed his panorama but did leave an entire set of preparatory pencil sketches for it. Henry Miller (active in California 1856–1857) traversed the state on mule back, leaving some of our earliest views of otherwise little-rendered Southern California.

The most important result of the profit-from-art idea was the development of a professional resident art community in San Francisco. Many of the disillusioned hopefuls who had set out for gold settled instead for quieter, less sensational jobs in a back room of one of the city's newly established businesses. They produced art forms that the state's new residents needed—scenic headings for writing paper, certificates with pictorial borders, architectural views of the growing towns, and illustrations for the city's growing publishing industry.

One of the most popular products of this community of artists was the town view. Demand for it swept the nation in the 1800s, taking off with a slow start about 1825, peaking in the 1850s through the 1870s, and then dwindling by the end of the century. Town views combined the newly invented technique of lithography with the subject of America's westward settlement and the consequent establishment of towns. Makers of town views usually traveled to each new town, sketched it from a nearby hill, made individual drawings of important buildings, and returned to their shops where they redrew the image on a lithographic stone. They then printed from the stone in editions of various sizes in either black and white or color (chromolithography). These entrepreneurs sold their mass-produced products to immigrants who were looking for places to settle, to chambers of commerce or land developers who were promoting their areas, to proud residents of the towns to hang on their walls, and to young men away from home wanting to show their families where they now lived.

Like views of the Mexican period that showed "civilization" being established in the former wilderness, these views graphically showed Yankee ingenuity, hard work, ambition, and enterprise "civilizing" the frontier. Most are of Northern California's coastal and gold-field towns, where the main human activity was taking place. One example is *San Francisco* of 1849 by the relatively little-known artist **Henry Firks** (active 1849) (fig. 1-15). The usual format was an overview of the town, seen from a slightly elevated perspective. Physically larger and more elaborate views added to the central town image a "frame" of vignettes of prominent commercial, private, or civic buildings. California's two most important artist-lithographers of the 1850s were Charles C. Kuchel (1820-1866) and Emil Dresel (1819-1869), who together made fifty views of California towns between 1855 and 1859. Joseph Britton (1825–1901) and his brother-in-law Jacques Joseph

Rey (1820–1892) printed many of their views; Britton and Rey's lithography shop in the growing printing and publishing center of San Francisco made some of America's most beautiful and notable lithographs of the nineteenth century.

Many images of nineteenth-century California were made with cameras. In the 1850s, the popularity of the recently invented daguerreotype led to the establishment of studios in towns of any reasonable size throughout California. Most were in Northern California where the largest population resided. Daguerreotypists primarily took portrait photographs, but occasionally they ported their bulky and clumsy equipment outside to take views around large cities, such as San Francisco, country towns, and the gold fields. Outdoor photography was facilitated in the mid 1850s with the technological development of the glass negative and its resultant paper print, known as the wet-plate process. This allowed photographers such as Carlton Watkins (1829-1903) to hike into the Sierra Nevada and capture its magnificent scenery. They also documented the growth of cities, the various occupations (mining, lumber, and agriculture), and the progress of man over the land. From photography's beginning, its accuracy and objectivity were trusted over images made by artists of any type, even by topographical artists. Images were sold to adorn parlor walls and formatted to be viewed through a stereoscope. Toward the end of the century, when printers discovered the technique of photolithography, photographs were increasingly used to illustrate books and magazines. California's scenic beauty made it a tourist destination, and many photographers earned their livings taking photographs for the railroads and other organizations that published them in their promotional materials and guidebooks. **Eadweard Muybridge** (1830–1904), one of these scenic photographers, made a major contribution to photography when, in the 1870s, commissions from railroad magnate Leland Stanford caused him to take sequential photographs of horses in motion, such as *Animal Locomotion, Plate 622* of 1887 (fig. 1-16). Not only did the project reflect the world trend toward scientific investigation of phenomena, such as motion, but the sequential imagery has been called by some the forerunner of the turn-of-the-century invention of the motion picture.

California's numerous and often anonymous artists who produced utilitarian art works on paper formed a broad, stable base for San Francisco's young and growing community of painters in oil and watercolor. The next chapter will show how some of these painters not only managed to survive on California's raw frontier but to discover unique subject matter that immediately distinguished their art from that of the East Coast. ❧

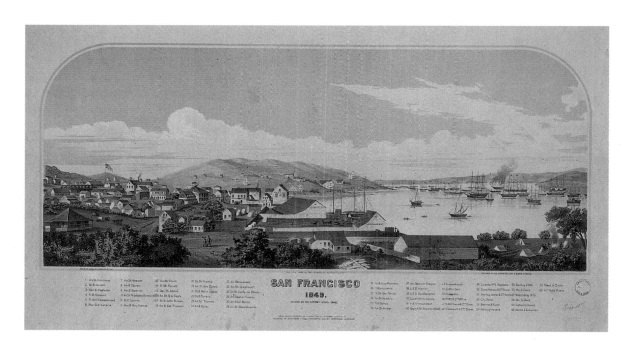

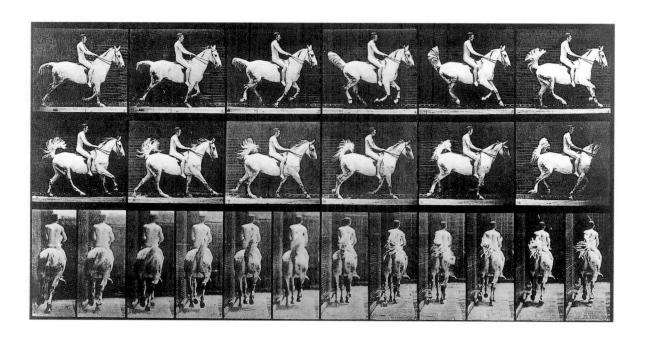

Fig. 1-15
Henry Firks (active 1849)
San Francisco, 1849
lithograph
12 ⅞ x 31 ¾ in.
Prints and Photographs
Division, Library of
Congress, Washington, D.C.

Fig. 1-16
Eadweard Muybridge
(1830–1904)
Animal Locomotion, Plate 622,
1887
collotype
7 ¾ x 15 ¼ in. (image)
Gail and Edwin Gregson

Bibliography

General California History, 19th Century

Baird, Joseph Armstrong, Jr. with Ellen Schwartz, *Northern California Art: An Interpretive Bibliography to 1915,* Davis, Library Associates, University Library, University of California, 1977.

Roske, Ralph J., *Everyman's Eden, A History of California,* New York: Macmillan, 1968. 624 p.

Maps of California—1536–1769

Gardner, Frances Tomlinson, *Early California Navigators and their Maps,* San Francisco: The National Society of Colonial Dames of America Resident in the State of California, 1941.

Leighly, John, *California as an Island: An Illustrated Essay,* San Francisco: Book Club of California, 1972. 155 p., 25 plates.

McLaughlin, Glen, *The Mapping of California as an Island: An Illustrated Checklist,* Saratoga, Ca.: California Map Society, 1995.

Portinaro, Pierluigi and Franco Knirsch, *The Cartography of North America 1500–1800,* New York: Facts on File, 1987.

Ruhge, Justin M., "Jose Maria Narvaez...Explorer and Map Maker," *California Historian* (publication of the Conference of California Historical Societies), v. 40, no. 1, September 1993, pp. 24–26.

Tooley, R. V., *Map Collectors' Circle: Map Collectors' Series No. 8: California as an Island,* London: Map Collectors' Circle, 1964.

Surveys of Pictorial Art to 1900

California: the Centennial of the Gold Rush and the First State Constitution, exh. cat., Library of Congress, Washington, D. C., November 12, 1949–February 12, 1950. 97 p. (Published by the U.S. Government Printing Office.)

California Pictorial 1800–1900, essays by Paul Mills and Donald C. Biggs, exh. cat., Santa Barbara Museum of Art, Santa Barbara, Ca., August 9–September 9, 1962. 28 p.

Catalogue of Original Paintings, Drawings and Watercolors in the Robert B. Honeyman, Jr., Collection, compiled by Joseph Armstrong Baird, Jr., Berkeley: The Friends of the Bancroft Library, University of California, 1968.

Early Paintings of California in the Robert B. Honeyman Jr., Collection, exh. cat., Oakland Art Museum, Archives of California Art, 1956. 47 p.

Early Prints and Drawings of California from the Robert B. Honeyman, Jr., Collection, exh. cat., Los Angeles County Museum, December 10, 1954–January 16, 1955. 44 p.

Gerdts, William H., *Art Across America: Two Centuries of Regional Painting, 1710–1920,* New York: Abbeville Press, 1990, v. III, "Northern California" and "Southern California," pp. 223–335.

Honour, Hugh, *The European Vision of America,* exh. cat., Cleveland Museum of Art, April 28–August 8, 1976 and at two other venues between 1975 and 1977.

Hough, Katherine Plake, *California's Western Heritage,* exh. cat., Palm Springs Desert Museum, March 8–June 8, 1986. 112 p.

Howell, W. R., "Pictorial California [R. B. Honeyman Collection in Los Cerritos Museum]," *Antiques,* v. 65, January 1954, pp. 62–65.

Kirk, Anthony, "In a Golden Land So Far: The Rise of Art in Early California," *California History,* v. LXXI, no. 1, Spring 1992, pp. 2–23.

Kirk, Anthony, *Visions of a Golden Land: California Art and Artists from the Age of Exploration to the Great Earthquake and Fire of 1906,* unpublished manuscript.

Moure, Nancy Dustin Wall, *Loners, Mavericks & Dreamers: Art in Los Angeles Before 1900,* exh. cat., Laguna Art Museum, November 26, 1993–February 20, 1994 and one other venue.

Tarshis, Jerome, "California: the Art of the State," [survey from discovery to 1970] *American Heritage,* v. 36, pt. 1, 1984, pp. 86–99.

Van Nostrand, Jeanne and Edith M. Coulter, *California Pictorial: A History in Contemporary Pictures 1786 to 1859,* Berkeley: University of California Press, 1948.

Van Nostrand, Jeanne, *The First Hundred Years of Painting in California 1775–1875,* San Francisco: John Howell Books, 1980.

Van Nostrand, Jeanne, *A Pictorial and Narrative History of Monterey, Adobe Capital of California 1770–1847,* San Francisco: California Historical Society, 1968.

Van Nostrand, Jeanne, *San Francisco 1806–1906: in Contemporary Paintings, Drawings and Watercolors,* San Francisco: Book Club of California, 1975.

Art During Spanish Occupation 1769-1823—Exploration

Cutter, Donald C., "Artists and Art from California," in *Malaspina in California,* San Francisco: J. Howell, 1960, pp. 11–24.

Larios, Rodolfo, *Three Papers on Hispanics in California History* [including Art, Education, Culture, and Wine in Hispanic California], Sonoma, Ca.: R. Larios, 1983. 3 v. in binder.

Wagner, Henry R., "Journal of Tomas de Suria of His Voyage with Malaspina to the Northwest Coast of America in 1791," *Pacific Historical Review,* v. 5, September 1936, pp. 234–276.

(See also publications of the various expeditions by George Vancouver, Georg Heinrich von Langsdorff, Louis Choris, Jean Laperouse, etc.)

Maps and Surveys

Harlow, Neal, *Maps and Surveys of the Pueblo Lands of Los Angeles,* Los Angeles: Dawson's Book Shop, 1976.

Harlow, Neal, *Maps of the Pueblo Lands of San Diego, 1602–1874,* Los Angeles: Dawson's Book Shop, 1987.

Reps, John W., *Cities of the American West: A History of Frontier Urban Planning,* Princeton, N.J.: Princeton University Press, 1979.

Robinson, W. W., *Maps of Los Angeles from Ord's Survey of 1849 to the End of the Boom of the Eighties,* Los Angeles: Dawson's Book Shop, 1966.

Ruhge, Justin M., "Jose Maria Narvaez...Explorer and Map Maker," *California Historian,* v. 40, no. 1, September 1993, pp. 24–26.

Sparks, V. K., "Sleuthing for Humboldt Bay Maps," *California Historian* (publication of the Conference of California Historical Societies), v. 39, no. 1, September 1992, pp. 8–11.

Art of the Spanish Missions—Religious and Secular

Baer, Kurt, *Painting and Sculpture at Mission Santa Barbara,* Washington, D. C.: Academy of American Franciscan History, 1955. 244 p.

The California Missions: A Pictorial History, Menlo Park, Ca.: Lane Publishing Co., 1979.

Holway, Mary Gordon, *Art of the Old World in New Spain and the Mission Days of Alta California,* San Francisco: A. M. Robertson, 1922. 172 p.

Moure, Nancy, *Loners, Mavericks & Dreamers: Art in Los Angeles Before 1900,* exh. cat., Laguna Art Museum, November 26, 1993–February 20, 1994 and one other venue, Chapter 1 and bibliog.

Neuerburg, Norman, *The Decoration of the California Missions,* Santa Barbara: Bellerophon Books, 1987. 80 p.

Neuerburg, Norman, "The Function of Prints in the California Missions," *Historical Society of Southern California Quarterly,* v. LXVII, no. 3, Fall 1985, p. 263+.

Neuerburg, Norman, "The 'Why?' and the 'How?' of the Indian Via Cruces from Mission San Fernando," *Quarterly of the Southern California Historical Society,* v. 79, no. 3, Fall 1997.

Neuerburg, Norman, "Painting in the California Missions," *American Art Review,* v. IV, no. 1, July 1977, pp. 72–88.

Nolan, James, *Discovery of the Lost Art Treasures of California's First Mission,* La Jolla, Ca.: Copley Books, 1978.

Tac, Pablo, *Indian Life and Customs at Mission San Luis Rey,* San Luis Rey, Ca.: Old Mission, 1958. 33 p.

Art of the Mexican Period—1822–1847

Becker, Robert H., *Disenos of California Ranchos: Maps of Thirty-Seven Land Grants, 1822–1846,* San Francisco: Book Club of California, 1964. 100 p.

Becker, Robert H., *Designs on the Land: Disenos of California Ranchos and their Makers,* San Francisco: Book Club of California, 1969. 112 p.

Hornbeck, David, *Rancho Disenos: A Source for Mapping Hispanic Settlement of California, 1833–1846,* Presented at the Association of American Geographers Meeting, New Orleans, 1978.

(See also publications of the various expeditions by F. W. Beechey, Auguste Bernard Duhaut-Cilly, Cyrille Laplace, Charles Wilkes.)

Art of U.S. Government Surveys of California—1850s

Taft, Robert, *Artists and Illustrators of the Old West 1850–1900,* Princeton, N.J.: Princeton University Press, 1982. [reprint of New York: Scribner, 1953.] 400 p.

The Gold Rush - Illustrators—1849–1860

"California—special issue," *Antiques,* v. 64, November 1953, (Robert G. Cleland, "California the Spanish-Mexican Period"; H. Comstock, "California Adobes"; "[Californians] Living with Antiques") pp. 368–95; v. 65, January 1954, C. I. Wheat, "Antiques in California: the Gold Rush and After," pp. 36–65.

Driesbach, Janice T., Harvey L. Jones and Katherine Church Holland, *Art of the Gold Rush,* exh. cat., Berkeley, Ca: University of California Press, 1998. Jointly organized by the Crocker Museum of Art in Sacramento and the Oakland

Museum, and shown at both museums and at the National Museum of American Art, Washington D. C. between January 24, 1998 and March 7, 1999.

Egenhoff, Elisabeth L., *The Elephant as They Saw It: A Collection of Contemporary Pictures and Statements on Gold Mining in California*, Centennial Supplement to the *California Journal of Mines and Geology*, San Francisco, October 1949.

Kowalewski, Michael, "Imagining the California Gold Rush: The Visual and Verbal Legacy," *California History*, v. LXXI, no. 1, Spring 1992, pp. 60–73.

Wheat, Carl I., *Maps of the California Gold Region, 1848–1857: A Biblio-Cartography of an Important Decade*, San Francisco: The Grabhorn Press, 1942. 152 p.

Daguerreotypes

Heyman, Therese, *Mirror of California: Daguerreotypes*, exh. cat., Oakland Museum, November 6, 1973–January 27, 1974. 32 p.

Latour, Ira H., ed., *Silver Shadows: A Directory and History, Early Photography in Chico and Twelve Counties of Northern California*, exh. cat., Chico Art Center, Chico, Ca., 1993.

Palmquist, P. E., "The Daguerreotype in San Francisco," *History of Photography*, v. 4, June 1980, pp. 207–38.

Palmquist, Peter E., *The Photographers of the Humboldt Bay Region, vol. I, 1850–1865, vol. II, 1865–1870*, Arcata, Ca.: P.E. Palmquist, 1985–1989.

Silver and Gold: Cased Images of the California Gold Rush, exh. cat, Oakland Museum of California, January 24–July 26, 1998 and two other venues. [Published by Iowa City: University of Iowa Press.]

(For bibliography on other nineteenth-century photography, see Chapter 9)

Illustrators

Dinnean, Lawrence, *Nineteenth Century Illustrators of California Sights & Scenes*, Berkeley, Friends of the Bancroft Library, University of California, 1986.

"Early California," *Southwest Art*, v. 22, June 1992, pp. 111–12.

Foster, Jacob J., "Artist Illustrators of California," *Pacific Historian*, v. 19, no. 3, Fall 1975, pp. 213–14.

Grunwald Center for the Graphic Arts, *The American Personality: The Artist-Illustrator of Life in the United States, 1860–1930*, exh. cat., Amon Carter Museum of Art, Fort Worth, Tx., July 8–August 22, 1976, and Frederick S. Wight Art Gallery, University of California, Los Angeles, October 12–December 12, 1976. 184 p.

Holmer, Richard P., "Currier & Ives: The California Prints," *California Historian* (publication of the Conference of California Historical Societies), v. 42, no. 2, Winter 1995, pp. 5–9.

Holmer, Richard, "Currier & Ives Do California," *The Californians*, v. 12, no. 6, c. 1995 or 96, pp. 8–11+.

Hornung, Clarence P. and Fridolf Johnson, *200 Years of American Graphic Art: A Retrospective Survey of the Painting and Graphic Arts and Advertising since the Colonial Period*, New York: Braziller, 1976.

Huffman, Robert E., "Newspaper Art in Stockton, 1850-1892," *California Historical Society Quarterly*, v. XXXIV, no. 4, December 1955, pp. 341–56.

Olmsted, R. R., ed., *Scenes of Wonder and Curiosity from Hutchings California Magazine, 1856–1861*, Berkeley: Howell-North, 1962, 2 vol.

Pennoyer, A. Sheldon, compl. and ed., *This Was California: A Collection of Woodcuts and Engravings Reminiscent of Historical Events, Human Achievements and Trivialities from Pioneer Days to the Gay Nineties*, New York: G. P. Putnam's Sons, 1938. 224 p.

Peters, Harry Twyford, *California on Stone*, Garden City, N.Y.: Doubleday, Doran and Company, Inc., 1935.

San Francisco, Newspaper Artists League, *First Annual Exhibition of the Newspaper Artists League 1903*.

Sperry, Baxter, *Western Engravers & Artists of the 19th Century*, Galt, Ca.: Laurel Hill Press, 1978. 31 p.

Town Views

Baird, Joseph A., "California's Pictorial Letter Sheets," *Antiques*, v. 96, September 1969, pp. 412–17.

Reps, John W., *Views and Viewmakers of Urban America: Lithographs of Towns and Cities in the United States and Canada, Notes on the Artists and Publishers, and a Union Catalogue of their Work, 1825–1925*, Columbia: University of Missouri Press, 1984.

Watson, Douglas S., *California in the Fifties, Fifty Views…by Kuchel and Dresel*, San Francisco: J. Howell, 1936.

Panoramas

McDermott, John Francis, *Lost Panoramas of the Mississippi*, Chicago, Il.: University of Chicago Press, 1958.

Oettermann, Stephan, *The Panorama: History of a Mass Medium*, New York: Zone Books, 1997. 407 p.

Fig. 2-1
Charles Christian Nahl
(1818–1878) and August
Wenderoth (1819–1884)
Miners in the Sierras, 1851–52
oil on canvas, 54¼ x 67 in.
National Museum of
American Art, Smithsonian
Institution, Washington, D.C./
Art Resource, N. Y.

Artists of the Gold Rush

2

Gold! Many savored the word on their tongues. Gold! Flecks of the precious metal caught the eye of James Marshall on the morning of January 24, 1848, in the tailrace of a sawmill that John Sutter ordered dug on the south fork of the American River. Excitement mounted slowly. That spring a few hopefuls began arriving at the site. By June 1 half of San Francisco reportedly had left for the fields, and by June 15 three-quarters. By fall, aspirants began to flock in from the Pacific Rim countries, and the following spring ships began to bring more from the Atlantic shores.

Northern California changed instantly from a land of sleepy *ranchos* to a place of adventure, excitement, and greed. San Francisco became an overnight "boom town" of "houses" built of wood and ship's canvas on sand dunes. Up the Sacramento River to the city of the same name, possibly ten thousand hopefuls fanned out over California's Sierra Nevada foothills, eventually concentrating in gold-rich pockets dotting an area that stretched for 120 miles from north of Coloma to south of Mariposa. They dug, panned, sluiced, wrote letters home to families and sweethearts, read, gambled, sometimes penciled scenes of their surroundings, and even occasionally found gold. Males of all races mixed together: Caucasians, Chinese, blacks, Native Americans; they came from many countries and spoke numerous languages. There was no law. Banditry, murder, and claim jumping were stopped only by vigilantism. Towns sprang up overnight to supply and service the miners. The main port, San Francisco, was built, burned, built again, and burned five more times. All the while ships, whose crews had deserted for the gold fields, accumulated in the harbor. Soon, however, disillusioned men with blistered hands and ragged clothes began to wander out of the mountains and into the cities. Hungry, they looked for ways to earn money for food, and then possibly for passage back home.

The enterprising and the lucky found jobs, because Sacramento and San Francisco had grown rapidly and had prospered through commerce as well as gold. The semi-established society that arose in these cities demanded the same variety of services it had enjoyed at its points of origin. Artists were able to pick up a portrait commission here, an engraving job there, and sometimes an order to illustrate a magazine article.

Most artists eventually gravitated to San Francisco. Just three years after the Gold Rush began, the city was becoming a sophisticated cultural center. Vigilantes drove out the worst of the criminals, and the succession of fires cleared away wooden shanties and canvas tents. These events were incentives to rebuild, and the fires themselves urged more durable, nonflammable materials such as brick and stone. A publishing industry arose that employed those with artistic skills to draw bird's-eye town views, to create illustrations for magazines and books, and to design headings for lettersheets, which were printed from engraved metal and wood "plates" as well as lithographic stones. Daguerreotypists set up portrait studios.

Within a few years San Franciscans founded an academy of science and three libraries. Newspapers almost immediately began to announce artists' arrivals and departures and to detail their activities. Their work was exhibited in front windows of commercial shops, primarily those with cultural associations—such as book and stationery stores, music houses, and dealers in artists' materials. Even saloons and gambling halls boasted art displays. And in 1857 both the California State Agricultural Society and the Mechanics' Institute commenced presenting annual fairs; their art exhibits provided the first official sites for these artists to display their work. Although fortunes were still in the process of being made and women (whose presence usually encouraged a settled state and culture) constituted only a small percentage of the population, there was some art patronage.

San Francisco's few resident professional painters began to turn out oil paintings and watercolors in the full range of subjects seen in more established towns: portraits, landscapes, still lifes, and genre paintings. As recent immigrants from all corners of the world, they brought in art styles practiced in the cities from which they had come. Their varied approaches reflected the mixed immigrant society of the Gold Rush itself.

Genre

Given California's small and recently arrived population, could the state boast any artists of real significance? A quirk of California art history is that, thanks to Gold Rush money and instant population, painting

began full-blown "overnight." Standing above all the others, sometimes called *the* artist of the Gold Rush, indeed one of California's most outstanding artists of the nineteenth century, is **Charles Christian Nahl** (born Carl Christian Heinrich Nahl) (1818–1878). Born and trained in Germany, he faced a promising future as an artist until his mother's need to escape from debt caused her to take her family first to Paris, then to New York, and, finally, after catching gold fever in the spring of 1851, to California.

The Nahls' experiences in the gold fields were typical. Not striking it rich, the formerly upper-class Henriette Nahl soon resorted to baking prune cakes and taking in laundry to help the family survive. Forced to give up their dream of a quick fortune, they moved to Sacramento, the nearest large town, where they looked to Charles's talent to support them. Their few months in the gold fields were not wasted. Nahl had filled a sketchbook with the life he observed there, and he used it for the rest of his life to create images ranging from wood-engraved illustrations to full-scale tableaux in oil on canvas.

If all of California's early artists brought with them painting styles learned elsewhere, is there anything "Californian" about what they produced? Perhaps it is Americans' feelings of inferiority to Europe that leads to such questions, that compels Californians to look for qualities that distinguish its art. Indeed, California artists have made a unique contribution to American art, even, and especially, at this early date. This becomes clearer in looking at a canvas painted by Nahl and **August Wenderoth** (1819-1884), an artist friend, who came with Nahl and his family to America and to California.

In Nahl and Wenderoth's *Miners in the Sierras* of about 1851–52 (fig. 2-1, p. 28) four miners are at work in a sluicing operation. This is a genre painting, a kind of painting that shows ordinary people involved in everyday activities. How is this work "American" or even "Californian"? America, in general, is often identified with a realistic, practical attitude toward life as well as with plain-spokenness, independence, and democracy. When these qualities appear in paintings they give them an "American" feel.

In this sense, Nahl's early Gold Rush scenes of the 1850s are very "American," not only in their subject but also in their honesty and realism. *Miners in the Sierras,* for example, has almost the qualities of a candid photograph. The men, in natural poses, occupy a three-dimensional space, and the vegetation and geography could portray an actual site. Colors are natural, and the work contains no underlying philosophical or editorial comment. Why does Nahl drop the elaborate artistic conventions learned in Germany and suddenly paint in an "American" manner? Is this proof of the leveling quality of America that forced immigrants to give up their old ways and adapt to the tastes of their adopted country? The painting's authenticity no doubt comes from Nahl's recent first-hand experiences. And perhaps Nahl instinctively realized that his artwork had to appeal to the average American. No doubt his need to earn money quickly to support a hungry and impractical family denied him the luxury of working in the elaborate process and technique he had learned in Europe.

To demonstrate more clearly the "Americanness" of *Miners,* it can be compared to a much later painting by Nahl, *Sunday Morning at the Mines* of 1872 (fig. 2-2). This later type of Gold Rush painting, made when genre painting was in fashion (chapter 6), was usually an imaginary creation, made by artists who never had experienced the Gold Rush directly. Nahl painted *Sunday Morning at the Mines* in San Francisco during a time when he enjoyed the patronage of Edwin Bryant Crocker and other men who aspired to European taste. This gave the artist the luxury to develop a painting in the laborious manner he had learned in Europe, i.e., from detailed individual drawings that he later built into a complex composition, dramatically lighted and with a slick, perfect finish. The result is a large-scale painting full of numerous tightly drawn and carefully composed figures and groupings, clearly "posed" and meant to present a composite view of mining life. At the same time, Nahl separates the activities of the miners into two categories. To the left of the cabin are the rowdy aspects of mining life: fights, inebriation, smoking, and horse racing; to the right are

the quieter pursuits: reading the Bible (by a bearded philosopher type), letter writing, and washing clothes. The whole is arranged in the theatrical manner at the height of its popularity when Nahl studied art in Germany. The scene is played as if by actors on a stage: in the foreground is a darkened "proscenium" made up of a still life of mixed gold-mining gear; behind it is a brightly lit central "stage" where the important action takes place; and this is backed by a middle-toned distant cabin and mountain range. Despite Nahl's actual experience at the mines, his figures have become "types," and the scene has become an editorial statement on the moral conditions in the gold fields.

One of these approaches cannot be said to be superior to the other. Some art historians point to the first as being more honest and truer to the plainspoken American personality, while admirers of things European might compliment the second for its Grand Manner and for bringing together the many meanings of the Gold Rush in a single canvas.

The Gold Rush proved a popular theme for artists. Not only were people eager to see images of it, but the rush also symbolized the American "dream," which promised people from all walks of life equal status and the opportunity to make quick wealth. **Alburtus Del Orient Browere** (1814–1887), a New York landscape and genre painter, made two extended trips to California in the 1850s (1852–56 and 1858–61) to gather material for paintings of such themes. He based his *The Lone Prospector* of 1853 (fig. 2-3) on a lithograph made by Nahl a year earlier. The art academies of the 1800s taught artists to look back to earlier paintings for successful compositions or figural poses, and several San Francisco artists of the 1850s looked to Nahl's compositions and themes as a guide for developing their own work. Other Gold Rush subjects by Browere depict a miner enthusiastically embraced on his return to his eastern home; a miner accompanying a wagonload of supplies; miners playing cards; and miners in a stream bed working at various tasks involved in obtaining gold. Browere's work provides an authentic record of actual events he witnessed.

The third major figure to paint Gold Rush scenes was **Ernest Narjot** (1826–1898), who came from France in search of gold in 1849. After three years mining in the Mother Lode and another ten searching for precious metals along the Arizona-Mexico border, he settled in San Francisco and returned to painting. Artists' personalities and attitudes are often reflected in the mood established in their paintings. Narjot's modest personality is expressed in the soft contours, the sense of atmosphere, and the relaxed poses of the men, which project an aura of calm and naturalness. *Miners—a*

Fig. 2-3
Alburtus Del Orient Browere
(1814–1887)
The Lone Prospector, 1853
oil on canvas
25 ⅛ x 30 in. (frame)
Courtesy of the Oakland Museum of California, Lent by Hideko Goto-Packard

Fig. 2-4
Ernest Narjot (1826–1898)
Miners: A Moment at Rest (Gold Rush Camp), 1882
oil on canvas
39 x 49 ³/₁₆ in. (sight)
Autry Museum of Western Heritage, Los Angeles

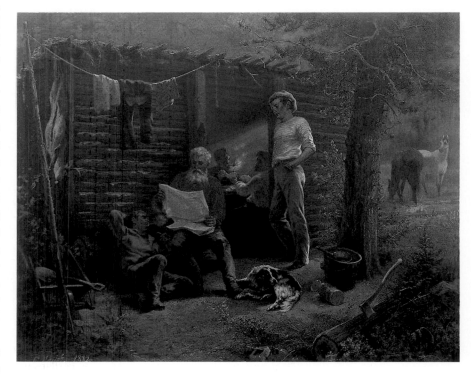

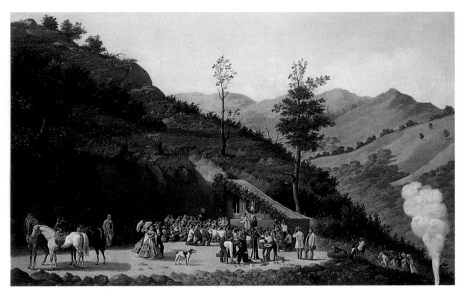

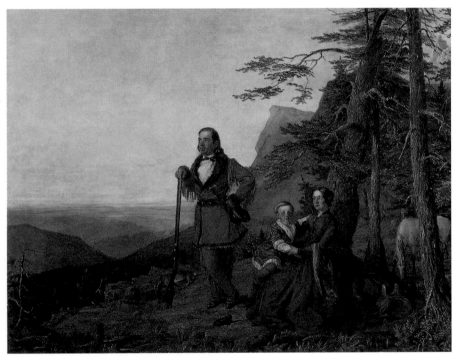

Fig. 2-5
Alexander Edouart
(1818–1892)
Blessing of the Enrequita Mine,
New Almaden, 1860
oil on canvas, 29½ x 47½ in.
Courtesy, The Bancroft
Library, University of
California, Berkeley,
1963.002.1360-FR

Fig. 2-6
William Smith Jewett
(1812–1873)
The Promised Land—The
Grayson Family, 1850
oil on canvas
50¾ x 64 in.
Daniel J. Terra Collection,
5.1994; Photo courtesy of
Terra Museum of American
Art, Chicago

Moment at Rest (Gold Rush Camp) (fig. 2-4) was made very late, in 1882, during the fashion for genre paintings and when the Gold Rush was being depicted by artists who had not experienced it directly. Academically trained like Nahl, Narjot organized his composition using many of the same devices that Nahl had used in *Sunday Morning at the Mines.* Narjot grouped his main characters into a triangle, utilized a bearded, venerable "philosopher" type as the newspaper "reader," and treated the foreground as a still life of mixed mining implements. Yet his presentation is not so academic and contrived as to be artificial.

A Gold Rush picture that is also a history painting was made by **Alexander Edouart** (1818–1892). Born in England and trained in Scotland and Italy before immigrating to New York, Edouart in 1852 moved to California where he painted landscapes and portraits as well as genre subjects. His most famous work is probably *Blessing of the Enrequita Mine, New Almaden* of 1860 (fig. 2-5). Following the tradition established in Catholic countries, this quicksilver mine was blessed by a priest when it was dedicated in 1859. Typical of historical pictures (chapter 5) *Blessing of the Enrequita Mine* portrays a specific event as well as the individuals who were actually present: Father Goetz, who had traveled from San Jose to conduct the ceremony, and the owner of the mine and his guests. Edouart's slightly primitive style gives this work great charm.

Gold Rush subject matter not only makes California art unique but supplements the list of American activities captured by East Coast and Midwest genre painters of the mid century.

Portraiture

Although gold mining themes received great attention from the press, portraiture was the main source of income for artists of the 1850s. Throughout history, even very young communities have supported portrait painting, because it serves the practical purpose of recording likenesses. If well conceived and executed, some portraits also reach the level of fine art.

Despite the invention of photography in 1839 and the presence of daguerreotype studios in many California towns, the newly wealthy still preferred the status conferred by a painted likeness. Private portraits were commissioned by people who desired likenesses of themselves or their families. State portraits, meant to honor statesmen and public figures or to present images of persons with admirable traits to be emulated, were commissioned by private parties or groups as well as by various government entities.

Most portraits held to the business at hand—a likeness—and thus consisted of a minimal figure, usually

bust- or waist-length, a plain usually dark background, and an emphasis on the face, with clothing given secondary importance. But the portraits that deserve particular mention in an art history text are a handful of privately commissioned works in the Grand Manner. These are grand in every sense of the word. Often extremely large in size, they represent figures full length (rather than bust-, half-, or three-quarter length). Some of them portray groups rather than single persons, and at times they have elaborate background settings. In Europe, Grand Manner portraits were usually reserved for the very wealthy—for royalty or aristocrats, holders of high political office, or heroes of military engagements. America's democratic ideals allowed the format to extend to self-made millionaires and anyone else who could afford them.

The two most outstanding portraitists of the 1850s in San Francisco were William Smith Jewett and Charles Nahl. **William Smith Jewett** (1812–1873) had spent fifteen years as a portrait painter in New York before joining the Gold Rush of 1849. He was one more artist who soon came to realize that mining was incompatible with his personality and who returned to his earlier vocation. An exceptionally shrewd businessman, he was the preferred portraitist among California politicians and the newly rich for twenty years. Jewett's most outstanding work is *The Promised Land—The Grayson Family* of 1850 (fig. 2-6), a privately commissioned portrait of the noted artist-naturalist Andrew Jackson Grayson, his wife, and their son. Sitters who commissioned such grand portraits usually chose a setting with some personal relevance. For Grayson this was the crest of the Sierra Nevada, which he and his westward-traveling family reached in 1846. From its height they could see the Sacramento Valley, their "Promised Land." For authenticity, Jewett traveled with Grayson to the exact spot on Hotchkiss Hill to make sketches. Many of the elements in this picture are predictable. Grayson, like other self-made men, chose to be shown in the humble attire he wore before attaining success. Mrs. Grayson herself had sewn him the buckskin outfit. Letters reveal it was Grayson who wanted the work to also include lofty ideals, such as the success of pioneers emerging from the symbolically threatening mountains into a smiling valley. This work follows the "conversation group" format for portraiture developed in England from earlier Renaissance and Baroque models. Instead of a single figure in a formal pose at the picture's center, several figures are arranged asymmetrically in relaxed poses, as if conversing. Jewett's task was to make a workable composition out of three portraits. Grayson becomes the center, the obvious leader of his family. Portrait painters often borrow poses

developed by earlier portraitists, and Grayson is posed much as George Washington was in Charles Willson Peale's (1741-1827) *George Washington at Princeton of 1779* (Pennsylvania Academy of the Fine Arts, Philadelphia). Mrs. Grayson's seated pose implies her femininity and her deference to her husband as leader as well as stability for a clinging, adoring young son. Art historians who have analyzed the composition subdivide it into four quarters. In the upper left, Grayson stares into the distance as if to demonstrate his far-sighted pioneering vision, the triumph of man over nature with God's help, and the universal hope for a better life through westward migration. At the upper right, the mountain represents peril; at the lower right the mother and child are symbols of domesticity, civilization, and a settled future; and in the lower left is "The Promised Land."

Jewett's main competitor was the versatile **Charles Christian Nahl**, who painted many stunning, highly finished portraits, often from daguerreotypes. His work can be identified by its refined drawing, bright colors, and minute attention to detail. *Peter Quivey and the Mountain Lion* of 1857 (fig. 2-7) represents Peter Quivey, one of America's self-made men of the nineteenth

Fig. 2-7
Charles Christian Nahl
(1818–1878)
Peter Quivey and the Mountain Lion, 1857
oil on canvas
26 x 33 in.
Private Collection; Photo courtesy of Hirschl & Adler Galleries, New York

Fig. 2-8
Charles Christian Nahl
(1818–1878)
Sacramento Indian with Dogs, 1867
oil on canvas
42 x 49¼ in.
The Fine Arts Museums of San Francisco, Gift of Mrs. Milton S. Latham

century. Quivey was born in New York. Receiving little or no education, he moved westward in search of opportunities, settling first in Kentucky, then Indiana, and finally in California in 1846. Setting up as a farmer and stock raiser in the Santa Clara valley, he eventually became a prominent citizen of San Jose and established that city's first hotel. Like Grayson, Quivey, a noted hunter, opts to be represented as a frontiersman. Man as a successful hunter displaying trophies of the hunt was a popular role for male sitters. This portrait was based on a photograph taken after Quivey's dog had treed a mountain lion and Quivey had shot it with his revolver. Nahl typically filled his more elaborate portraits with objects that related to or enhanced the sitter. Here they are the knife, the gun and the dog, among other things. Although the photograph gave Nahl the likeness and composition, he was a master at mimicking multiple textures in oil and must have worked from a real animal pelt and pistol to render the fur, wood, and metal so faithfully.

Photography was edging increasingly into the portrait market, but until the end of the century portraits continued to be an important source of income and a valid subject for painters. Nahl's *Sacramento Indian with Dogs* (fig. 2-8) reverses Grayson's and Quivey's pioneer stances by presenting a Native American in the trappings of a gentleman. Wahla, chief of the North-

ern California Yubu Indian tribe, was taken under the wing of California Governor Milton S. Latham in the 1860s. The Yubu chief was first educated and then employed as the governor's personal coachman. Latham was very interested in art and filled his San Mateo mansion with sculptures and paintings by artists working in California. This interest presumably led him to commission Nahl to paint this image of Wahla as a gentleman in the European style, wearing a fine suit and surrounded with well-bred coach dogs. Unlike Nahl's genre scenes in which Indian faces are often represented with wild eyes and quasi-Negroid features, Wahla's visage seems to be an actual and sensitively rendered portrait. Again Nahl demonstrates his technical versatility with textures in rendering the dogs, a chicken, and foliage.

California's ties to countries south of the border remained strong even after the Mexican-American War. Many Californians had served in the war or had crossed the Isthmus of Panama on their ways to California. The circumstances surrounding **Fortunato Arriola**'s (1827–1872) *Tropical Landscape* of 1870 (fig. 2-9) are very mysterious. The two couples are clearly portraits. Their wealth is obvious: instead of the typical mule or burro used on the isthmus crossing, they are shown on fine steeds, possibly favorite horses, whose bridles and saddles are finely tooled and set with silver; all four people are well dressed. Since they were painted by a Californian/Mexican and are represented crossing a river in the tropics, we might assume they came west via the isthmus and made their fortunes. However, based on the shield of the United States that appears on the breastplate of the white horse, the staff of the Oakland Museum of California speculate that the leftmost figure is Ulysses S. Grant. The gold-buttoned "Marseilles" style vest identifies the rightmost figure as General Winfield Scott, under whom Grant served in the Mexican War. The two women (identified by comparing the painted faces to photographs) seem to be Grant's fiancée and Scott's wife. Although the men's military campaigns had taken them through tropical sections of Southern Mexico, the two women had not been in those areas. For many years this group portrait had another scene painted atop it—three sombreroed horsemen. Recent restoration revealed the original. Why would Arriola paint such a subject and then cover it with another? Sometimes an artist painted a portrait on speculation hoping the sitter would find it so appealing that he would purchase it. At other times an artist would paint a portrait of a famous person to demonstrate his talent to prospective sitters. This subject obviously lost its relevance for Arriola, and one must assume the sombreroed horsemen represented an

attempt to salvage an otherwise unsaleable painting.

Portrait painters also captured the likeness of successful San Franciscans other than financiers or politicians. **Joseph Harrington** (1841–1890), an Irish immigrant who settled permanently in San Francisco in 1870, painted *Jules Harder, First Chef of the Palace Hotel* in 1874 (fig. 2-10). Wearing his chef's uniform, Harder holds one of his culinary masterpieces, an aspic of langouste. The Palace Hotel, opened in the 1870s, was the most opulent lodging west of the Mississippi River. Commensurate with its standing, the management hired Harder who had twenty-six years of restaurant and hotel experience and had worked for the famous Delmonico's in New York. The chef's outfit is "colorful," and he holds his aspic in regal fashion with the pride of a general wearing medals or royalty bearing its symbols of office.

Portraits were also important elements in pictures commemorating historic occasions. In the 1870s, **Thomas Hill** (1829–1908), prompted by conversations with Leland Stanford, one of the Big Four owners of the Central Pacific Railroad and in 1869 its president, began a large work to commemorate the completion of the Transcontinental Railroad at Promontory Point, Utah, on May 10, 1869. *Driving the Last Spike* was finished in 1881 (fig. 2-11). Its center of interest is Leland Stanford, posing with the sledge hammer he would raise to symbolically drive the last

Fig. 2-10
Joseph Harrington
(1841–1890)
Jules Harder, First Chef of the Palace Hotel, 1874
oil on canvas, 36¼ x 29 in.
Collection of the Oakland
Museum of California, Gift
of Mrs. Donald Helett and
Mr. George Clark in memory
of George Casey Clark and
Lydia J. Clark

Fig. 2-11
Thomas Hill (1829–1908)
Driving the Last Spike, 1881
oil on canvas
8 ft. ⅜ in. x 12 ft. ½ in.
State of California,
Department of Parks and
Recreation, California State
Railroad Museum

spike joining the east and west rails. A central figure surrounded by a crowd of important people follows a compositional form commonly used for pictures that commemorated events such as coronations or the signing of important treaties. (John Trumbull used it for the signers in his *The Declaration of Independence, July 4, 1776* of 1787–20 (Yale University Art Gallery, New Haven).) Hill painstakingly portrayed seventy of the four hundred or so people in the picture either from life or from photographs or other pictorial sources.

After the Civil War, the nature of portraiture changed. Individuals who had risen to wealth in California strove to forget their frontier origins by adopting European tastes and manners that would demonstrate their cultural accomplishments. They built huge mansions and commissioned large-scale paintings of themselves to display their fortunes and social station, often choosing the "conversation group" format. This format had been revived by England, then at the peak of empire, to depict its own aristocracy. In America it was promoted by influential East Coast "aristocrats" like the Vanderbilts, who were emulated, in turn, by Californians. A prime example of this portrait type is **Thomas Hill**'s *Palo Alto Spring* of 1878 (fig. 2-12). Mansion and servants form a background for the Leland Stanford family enjoying the fruits of their labors on their park-like grounds. Wealth is evident in the clothing, the painting that Stanford admires, and the leopard skin that protects the toddlers from the ground. This picture served the purposes of a family portrait but also proved that Californians had made a successful transition from the raw frontier to a high level of luxury.

Another portrait of Stanford elevates the railroad

baron's stature by a different means—association with other illustrious persons. Among the recognizable guests in *Leland Stanford's Picnic, Fountain Grove, Palo Alto, California* (Elisabeth Waldo-Dentzel, Multicultural Arts Studio, Northridge, California) by Ernest Narjot (1826/7–1898), are the naturalist John Muir, philosopher and teacher Josiah Royce, geologist and teacher Joseph LeConte, and author Charles Warren Stoddard. Although Stanford no doubt knew these men personally, to have himself painted in their company clearly meant that he was equating his capitalist success with their intellectual and scientific achievements. The picnic theme was popular among artists in the late nineteenth century.

Portraits were also painted in Southern California, but the towns there had neither the population nor the wealth to support resident art communities until about 1880. Portraits were made by itinerants who traveled from town to town, or by artists who made brief attempts at residence before they admitted failure and moved on. Two artists stand out: **Henri Penelon** (1827–1885), who managed to survive as a lone painter and daguerreotypist in the flea-ridden, dusty adobe town of Los Angeles from about 1853 to his death, and **Leonardo Barbieri** (c. 1810– c. 1873), an itinerant Italian who executed commissions in San Francisco, Monterey, San Diego and Santa Barbara from late 1849 to about spring 1853.

Most of Penelon's and Barbieri's sitters came from the Spanish and Mexican aristocracy that constituted the upper class in the South until the 1870s. Although they were the best artists in the South, neither approached the sophistication of their contemporaries in San Francisco. Their mainstay was the bust- or waist- length portrait of Spanish and Mexican men and women dressed in black and posed against a dark brown or black background. Occasionally, a gold chain and locket or a bit of lace hinted at the sitter's wealth.

At least one Grand Manner portrait is known by each of these painters. Penelon boasts two that take the form of equestrian portraits. Although a rider mounted on a spirited steed was the traditional pose used for a military hero, the pose also lent itself to the Californios who expended much of their wealth on fancy horses. In *Don Vicente Lugo* of about 1855 (fig. 2-13), Henri Penelon depicts Lugo on a prancing white charger with a silver-mounted bridle and saddle and intricately embroidered saddle blanket. Lugo's clothing, too, is decorated with silver and embroidery, and the background of swirling clouds romanticizes the scene. Penelon did not have a high command of technique; proportions and perspective fall short, and there is a slightly primitive quality in the hard-edged

Fig. 2-12
Thomas Hill (1829–1908)
Palo Alto Spring, 1878
oil on canvas, 7 x 11½ ft.
Stanford University Museum of Art 14945; Stanford Family Collections

contours and the emphasis on repeated pattern and stylization. These "failings," however, give the picture an overall charm.

Barbieri had greater technical ability than Penelon. His Grand Manner example is the *Padré José Maria de Jesus González Rubio* of 1850 (fig. 2-14). Barbieri set up a portrait studio in Santa Barbara during the summer months of 1850. That fall, a group of citizens asked him to paint Father Rubio, a much-loved priest at the Mission Santa Barbara who had been resident since 1842 and in 1850 was named administrator of the Diocese and Vicar General. Barbieri presents Father Rubio in the habit and tonsure of the Franciscan order. The priest's pose, at a table, holding a quill pen, with his other hand on an open book, is a pose usually reserved for scholars. The inscription in the lower right corner additionally commends Rubio's "eminent virtues" and his "unquenchable charity towards the poor and his love for everyone."

If there is a distinctly California quality in portraiture, it seems to be most evident when Spanish-Mexicans and Anglo-Europeans are shown in their regional or pioneer clothing. Daguerreotypists even provided studio props such as gold pans, picks, pokes, and so on for people who asked to be portrayed as miners. This "California" character disappears, however, in the latter nineteenth century as the wealthy, who could afford painted portraits, tried to lose their regional identity in a cosmopolitan image.

California is blessed with some of the most spectacular scenery in America, and its discovery by Anglos in the mid-nineteenth century conveniently coincided with America's great age of landscape painting. The next chapter will discuss the landscape school that arose in Northern California and how the state's natural beauties attracted America's greatest landscapists. ✻

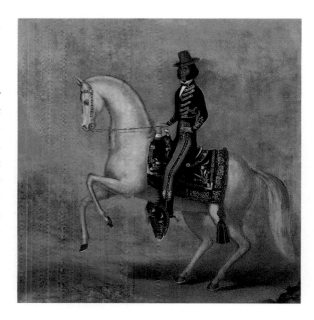

Fig. 2-13
Henri Penelon (1827–1885)
Don Vicente Lugo, c. 1855
oil on canvas, 40⅛ x 40¼ in.
History Collections, Los Angeles County Museum of Natural History

Fig. 2-14
Leonardo Barbieri
(c. 1810–c. 1873)
Padré José Maria de Jesus González Rubio, 1850
oil on fabric, 39 x 31 in.
Santa Barbara Mission Archive-Library, Santa Barbara, California

Bibliography

Gold Rush Themes

Arkelian, Marjorie, "An Exciting Art Department Find," *Art* (The Oakland Museum), v. 2, January-February 1974. [re: E. Hall Martin]

Driesbach, Janice T., Harvey L. Jones and Katherine Church Holland, *Art of the Gold Rush,* Berkeley, Ca: University of California Press, 1998, exh. cat., Oakland Museum of California, January 24–May 31, 1998 and two other venues.

Kirk, Chauncey Anthony, *California Painting in the Nineteenth Century: a Cultural History,* Ph.D. Thesis, University of California, Santa Barbara, 1977. 325 leaves.

Kowalewski, Michael, "Imagining the California Gold Rush:

The Visual and Verbal Legacy," *California History,* v. LXXI, no. 1, Spring 1992, pp. 60–73.

"Northern California," in William H. Gerdts, *Art Across America: Two Centuries of Regional Painting, 1710-1920,* New York: Abbeville Press, 1990, v. III, pp. 223–92.

"Painting in Eldorado, 1849-1859," in Jeanne Van Nostrand, *The First Hundred Years of Painting in California,* San Francisco: John Howell-Books, 1980, pp. 27–64.

Portraiture—1849–1890

American Portraiture in the Grand Manner: 1720–1920, essays by Michael Quick, Marvin Sadik, William H. Gerdts, exh. cat., Los Angeles County Museum of Art and the National Portrait Gallery, Washington, D. C. in 1981 and 1982.

"Portrait Painting," in Jeanne Van Nostrand, *The First Hundred Years of Painting in California: 1775–1875,* San Francisco: John Howell-Books, 1980, pp. 43–50.

San Jose Historical Museum, *19th-Century San Jose Portraits,* exh. cat., Pacific Hotel, San Jose, Ca., April 13–October 9, 1978.

Fig. 3-1
Albert Bierstadt (1830–1902)
Looking Up the Yosemite Valley,
1863
oil on canvas, 35 ⅞ x 58 in.
(sight)
Haggin Collection, The
Haggin Museum, Stockton,
California

The Golden Age of Landscape Painting: Wilderness Subjects

Yosemite can be entered from several points, but none can compare to the breathtaking drama of the southern entrance. A traveler, after winding through pine-clad mountains, enters a long tunnel. After almost a minute in darkness, he emerges into brilliant daylight, high on the side of a cliff. Below him, spread out in an expansive panorama, appears a deep valley lush with pines, banked with dramatically vertical granite walls, and overstretched with a crystal blue sky. The first sight of Yosemite is one few can forget. Yosemite's extraordinary beauty was one of the main reasons for San Francisco's first art efflorescence—California's Golden Age of Landscape Painting, which took place in the 1860s and 1870s.

By the late 1850s, San Francisco was entering a twenty-year economic boom that remained undamped by the Civil War that raged in the East and South (1861–65). The bay city was beginning to develop an upper class whose millions had come from the gold fields, the Comstock Lode silver strike in Nevada in 1859, real estate, and, by the end of the 1860s, the Central Pacific Railroad. During the 1860s and until the depression of the late 1870s, the newly rich spent their money on mansions in Sacramento and San Francisco and, proud of their California sources of wealth, they purchased and commissioned works from San Francisco's growing resident community of artists. Landscapes, still lifes, portraits, and genre scenes that celebrated the state's history and natural resources were favorite subjects. Many of these pictures were huge in size to match the scale of the grand rooms in which they hung. Patronage also came from the new first-class hotels, such as the Lick House and the Palace, as well as from organizations such as the Society of California Pioneers and the Bohemian Club.

Where there is art patronage and scenery there are landscapists, and over the next twenty-five years several highly talented artists moved to the Bay Area and enriched San Francisco's art community that had begun to develop all the complexity of the established art worlds in the East. Newspapers carried notices on art and artists as did the city's new monthly magazines: *Hutchings' Illustrated California Magazine* (1856–?), *Pacific Monthly*, and *Overland Monthly* (1868+). Two magazines specializing in art were published in 1873—the *California Art Gallery* (issued for five months) and

The Album (offered briefly by the Graphic Club). And the art critic Benjamin Parke Avery (brother of the well-known New York art dealer Samuel P. Avery) provided sympathetic criticism from the Gold Rush onward. Some of his articles even appeared in the New York art periodical *Aldine*.

Organizations were formed to educate the public in art and to encourage the growing taste for the fine arts. Two of these were idealistic and short-lived: the California Art Union (1865) and the San Francisco Artists' Union (1868). But with increasing pace more organizations were started, and some of them are still extant. The most important, the San Francisco Art Association, was formed in spring 1871 by a group of artists who met at the home of the landscapist Juan Wandesforde (1817–1902). Through the boom years of the 1870s the association presented semiannual exhibitions. The all-male Bohemian Club for artists, writers, and journalists was started in 1872. A year later the informal Graphic Club began to meet weekly at the studio of Stephen William Shaw (1817–1900) and briefly published *The Album*, a magazine of art news. And in 1874, following the East Coast trend of establishing art academies, the San Francisco Art Association began the School of Design, the first art school on the West Coast (today the San Francisco Art Institute).

Prosperous times resulted in steady art sales: from artists' studios on "at home" days, from exhibitions sponsored by the Art Association, from Mechanics Institute shows, and from various local fairs. Newly established commercial art galleries included Solomon and G. Gump on Sansome Street, Snow & Roos, Cobb & Davis, Morris & Schwab on Post Street; and D. Nile on Kearney Street. Entire art collections occasionally were sold at auction galleries, such as H. M. Newhall & Co. and Edward S. Spear & Co.

Although some San Francisco artists felt geographically isolated, when the Transcontinental Railroad was completed in 1869 they could move easily between the coasts. Sometimes they maintained studios in San Francisco for a few years, moved briefly to New York or Boston, or traveled to Europe for further study. But most of them returned to California to take advantage of its healthful climate and magnificent scenery.

Landscape proved the greatest draw for these

painters. By the 1840s, landscape had become the primary theme for most emerging American artists. In the East this interest resulted in the country's first major school of art, the Hudson River School, so named because many artists derived their subjects from the scenery along that river. American interest in landscape grew out of the Romantic Movement, which had arisen in Europe and England about the time of the American Revolution. Romanticism displaced Neoclassicism's orderly, serene compositions of perfect trees balanced with ideal meadows and set with pristine Greek architecture. Romantic landscapists strove for just the opposite—awesome compositions made up of sheer, vertical mountains, stormy clouds, cataclysmic gorges, lightning-struck trees, dramatic lighting, atmospheric effects, rustic cottages, wind-whipped seas, and so on. The Romantic aesthetic suited the American landscape well, itself still a wilderness. Americans were proud of the Edenic, untamed nature of their land, just as they were proud of their own independent natures and the country's freedom from royal rule. (Paradoxically, they also looked forward to subduing nature to create farms and cities for their own sustenance and enrichment.)

Through the 1840s and 1850s, America's landscapists, having lost interest in depicting the familiar subjects of the East Coast and Europe, pushed ever further westward, searching for novel and picturesque scenery. Learning about the West through articles in magazines and books, they were eager to see for themselves the Rockies and the Sierra that some claimed were equal in beauty to Europe's Alps and the Pyrenees. They recognized the importance of being the first to write or paint on a subject, especially an unusual one that might establish their reputations. Riding horseback along narrow wilderness trails, paddling upriver in canoes, accompanying wagons across the prairies, they sought out America's great natural wonders: Niagara Falls, the Mississippi River, the seemingly limitless prairies, the intimidating Rocky Mountains, and the vicious scar of the Grand Canyon. At the extreme west in California were the incredibly beautiful Yosemite Valley, the rugged Sierra Nevada, the Big Trees, Seal Rocks, and Lake Tahoe.

The most important of these landscapists was **Albert Bierstadt** (1830–1902). In the 1850s he had sought new subject matter in Europe, and in 1859 he made his first trip as far as the Rockies, returning to New York with sketches of spectacular views. In the early 1860s he was vying for position as America's top landscapist with fellow painter Frederic Edwin Church (1826–1900). Since the mid-1850s Church had enjoyed an enviable reputation based on his paintings of South America's lush tropical foliage and awesome erupting volcanoes. Bierstadt felt a need to find a subject that would be grand enough to overpower that imagery. In December 1862 he chanced across a New York exhibition of photographs taken of Yosemite by Carleton Watkins (1829-1916). The painter soon became convinced that the valley was a spectacular subject worthy of his brush and that painting it would enhance his reputation. With his friend, the writer Fitz Hugh Ludlow, he took the train to Saint Louis. From there the two men traveled for a month and a half via wagon and horse to San Francisco.

Yosemite

Although the first sight of Yosemite stirs human emotions as much today as it did 150 years ago, when people of European background first encountered it, its meaning was very different to them than it is to us today. Mid-nineteenth-century thought was filtered through the biblical interpretation of the world. Yosemite and other spectacular sites were considered the finest examples of God's handiwork on earth. Ironically, the emerging importance of science led the U.S. Government and other bodies to send out study expeditions to discover the *scientific* basis of the valley. In the late nineteenth century the site became a philosophical and political battleground. As John Muir and other ecologists wrote articles praising Yosemite's untouched beauty, hoping to convince people to protect it, entrepreneurs seeking financial profit raced to develop it through tourism.

Bierstadt was not the first person of European background to visit the valley. Two men hunting for game in 1849 chanced upon it, and in 1851 it was entered by a detachment of the Mariposa Battalion. The battalion was on assignment to corral the valley's Indians in retaliation for their attacks on gold miners and settlers. Both Anglo groups were struck by the valley's beauty. Their praises induced the miner-turned-writer James M. Hutchings to organize the first tourist party in 1855. He brought along the topographical artist Thomas Ayres (1816–1858) to make views, giving Ayres the distinction of being the first artist to depict it. When Hutchings published the first issue of his *Hutchings' California Magazine* in July 1856, it contained four engravings based on Ayres's work. Other artists followed. Antoine Claveau (active San Francisco, 1854-1872) was commissioned in 1855 to paint a panorama of the valley, and the landscapists James Madison Alden and Frederick Butman arrived independently of each other in 1859.

Yosemite Valley is located in the Sierra Nevada mountain chain about 150 miles east of San Francisco.

Bierstadt probably traveled there via the San Joaquin River to Stockton and then by horseback along the old Mariposa trail. On his first trip he and Ludlow were accompanied by a scientist and two fellow artists and longtime friends who were now residents of San Francisco: Enoch Wood Perry (1831–1915) and Virgil Williams (1830–1886). The party spent seven weeks camping at various spots and making copious sketches.

In the 1860s painters still sketched in the field and then composed their pictures in the studio. Unlike the topographical artists, who had preceded Bierstadt and were devoted to on-the-spot objective transcriptions of terrain, Bierstadt and others of similar backgrounds depended on artistic license to convey the *sense* of the place as much as its physical reality.

Yosemite's beauty is so naturally spectacular that it is difficult to believe anyone would attempt to improve on it. Indeed, many of the early painted views were questioned because people could not believe that such a dramatic site was real. Only the photographs of it were trusted! It was Bierstadt's mission, however, to visualize the valley for others who had neither the opportunity to see it nor the imagination to sense its divine quality.

In *Looking Up the Yosemite Valley* of 1863 (fig. 3-1, p. 38), Bierstadt used every trick of the Romantic artist to dramatize the scene—he heightened valley walls, inserted tiny animals and humans to maximize the immensity of nature, and added the magic of light.

Bierstadt was one of several second-generation Hudson River School artists who could be called Luminists. Luminists' works are identified by crystal-clear, glowing skies achieved by meticulous brushwork, infinitely subtle gradations of tone, and the use of newly developed chemical pigments that offered more brilliant colors (especially reds and yellows). To people worldwide light is associated with spirituality, and with light the Luminists turned an objective study of nature into a manifestation of God's grand plan, a visual counterpoint to the philosophy of contemporary writers such as Ralph Waldo Emerson and the transcendentalists. In this work, a darkened foreground causes the eye to jump immediately to the sunlit middle meadow. Light dissolves distant valley walls, heightening the illusion of infinitude. The technique is detailed, delicate, and minutely exacting. Although not as large in size as some of the landscape panoramas Bierstadt painted later, this canvas still conveys the awesome scale of the site.

Light also plays a dominant role in *Sunrise, Yosemite Valley* (fig. 3-2). In this case, a warmly glowing sunrise becomes the artist's means of showing God's approval, and it suggests the dawning of yet another glorious day in virgin nature.

Often an art group or movement coalesces around a single charismatic individual. During Bierstadt's first brief visit to San Francisco, he received major news coverage. San Franciscans were flattered that

Fig. 3-2
Albert Bierstadt (1830–1902)
Sunrise, Yosemite Valley,
c. 1870
oil on canvas, 36 ¼ x 52 ¼ in.
Amon Carter Museum, Fort Worth, Texas

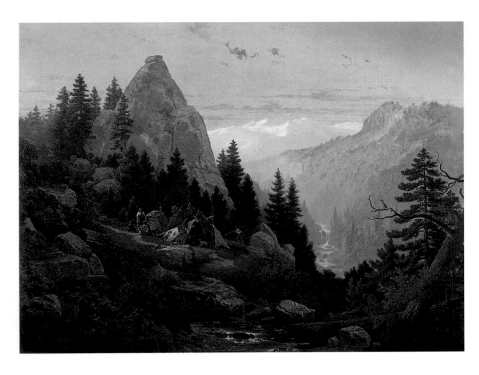

America's foremost landscapist had chosen to work in California. The results of his excursion to Yosemite—small oil-on-paper sketches—were shown privately. Interestingly, the first reaction of local painters was to adopt not his subject matter but his technique of oil on paper. Only after Bierstadt exhibited his large *Looking Down Yosemite Valley* at the National Academy of Design in New York in 1865, where it received wide acclaim, were California artists assured the scenery they had started to paint was worthy. In increasing numbers they made trips into the valley. In an August 1868 article in the *Overland Monthly,* the art critic Benjamin P. Avery remarked on the "violent outbreak of Yosemite views" in local exhibitions.

The view that was most frequently painted is a panorama of the entire valley seen from Inspiration Point near the southern entrance tunnel. Other compositions focus on the double Yosemite Falls, the vapid Bridal Veil Falls, and the robust, paired Nevada and Vernal Falls. More prosaic are those scénes of the placid Merced River and Mirror Lake in contrast to the monumental views of the granite wall of El Capitan. In the early 1870s, after trails were built up to Glacier Point on the valley's rim, a new view came into being—the aerial—that looks down on the valley and Half Dome (fig. 3-8).

Two important California artists who capitalized on the fashion for grand panoramas as well as the state's natural geographic wonders were **Thomas Hill** (1829–1908) and William Keith (1838–1911). Hill was a Massachusetts landscapist who had come to San Francisco in 1861 for his health. Keith, who had settled here in 1859 and taken up wood engraving, slowly taught himself how to paint. Some historians place the two men in Yosemite in 1862, a year before Bierstadt, but no finished paintings of the valley are extant. Hill, however, recognized the potential of California's Sierra Nevada, and in summer 1864 he penetrated its rugged areas by horseback. This trip resulted in canvases of places such as the Russian River and Lake Tahoe. Hill's early style was that of the Hudson River School, described by some historians as detailed, finicky, and topographic—like Bierstadt's but less Romantic. An example is *Sugar Loaf Peak, El Dorado County* of 1865 (fig. 3-3). Although the scene is flushed with a rosy glow, the light is neither luminiscent nor "transcendental."

Hill, however, soon realized that detail was going out of fashion and that more poetic interpretations of place were the coming style. In 1866 Hill went to Paris to update his work, and he absorbed other modern ideas as he sketched in the countryside along with some of the Barbizon painters. He returned to America with a broadened style. After a few years in Boston, where he painted New England scenery, he once again moved west, and by 1872 he had his family settled in San Francisco.

Fig. 3-3
Thomas Hill (1829–1908)
Sugar Loaf Peak, El Dorado County, 1865
oil on canvas, 40 x 54 in.
Crocker Art Museum, Sacramento, Ca.,
E. B. Crocker Collection

Fig. 3-4
Thomas Hill (1829–1908)
Yosemite Falls
oil on canvas, 60½ x 36 in.
Collection of the Oakland Museum of California,
bequest of Dr. Cecil E. Nixon

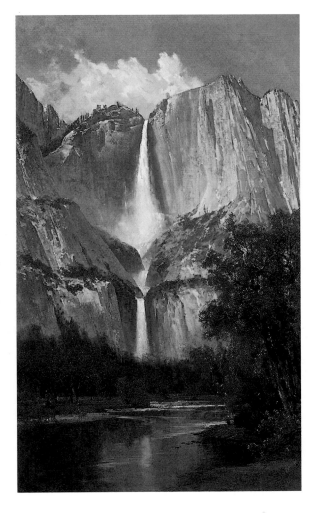

In the 1870s Hill enjoyed great success, riding the art boom and painting huge canvases of Sierra Nevada scenery. Yosemite increasingly dominated his work, and in 1883 he built a studio in the valley. After the studio was demolished by wind in 1884, he lived for increasingly longer periods at Wawona, just outside the valley, where his daughter's husband ran the Wawona Hotel and built a studio for Hill.

Hill is now best known for his Yosemite scenes. His style evolved over time, and the paintings of the 1870s and 1880s are the most favored. Some recent art historians have called Hill's post-1880 landscapes "impressionist." This does not mean they were inspired by the Impressionist movement that arose in France in the 1870s but that they were painted with broken brushstrokes and lightened colors. An example is the undated *Yosemite Falls* (fig. 3-4), which captures light not as a Luminist would—through imperceptible gradations of color—but through juxtaposition of different tones that produce a shimmering effect. The aesthetic quality of a Hill canvas is most apparent in his handling of the valley walls. In his best work, he renders them with a multiplicity of tones, sharp brushwork, and details such as projections and indentations in the rock. In his less successful landscapes, cliffs sometimes look bland, mushy, or muddy.

Hill's contemporary **William Keith** (1838–1911) made a similar transition from detail to a more poetic interpretation. He started out in the exacting profession of wood engraving and then moved to painting in the 1860s. Like Hill, Keith was not content with his technique and decided to seek additional training in Europe. He wanted to improve his drawing, which he had learned by studying the work of the leading San Francisco artists Charles Nahl and Frederick Butman. For this reason he chose Duesseldorf, but once there, he found himself learning instead to "suggest" shapes with expressive brushwork. The experience also led him to quieter, more natural colors and to the Barbizon predilection for late-afternoon scenes of tranquil melancholy, pictorial qualities that seemed also to reflect his personal spiritual outlook. After a brief period of work in Boston, he returned to California in 1872.

In fall 1872, on a fateful trip to Yosemite, Keith met the poet-naturalist John Muir, and this began a relationship that would last for many years and further shape Keith's art. Muir enjoyed giving tours through the wilderness to aficionados, and he led Keith on a twelve-day trip into the mountains above Yosemite. Other trips followed, and their friendship deepened as Muir realized Keith's ability to capture in visual form the country Muir loved. He encouraged Keith to paint

Fig. 3-5
William Keith (1838-1911)
Kings River Canyon, 1878
oil on canvas
72 x 120 in.
Collection of the Oakland
Museum of California, Kahn
Collection

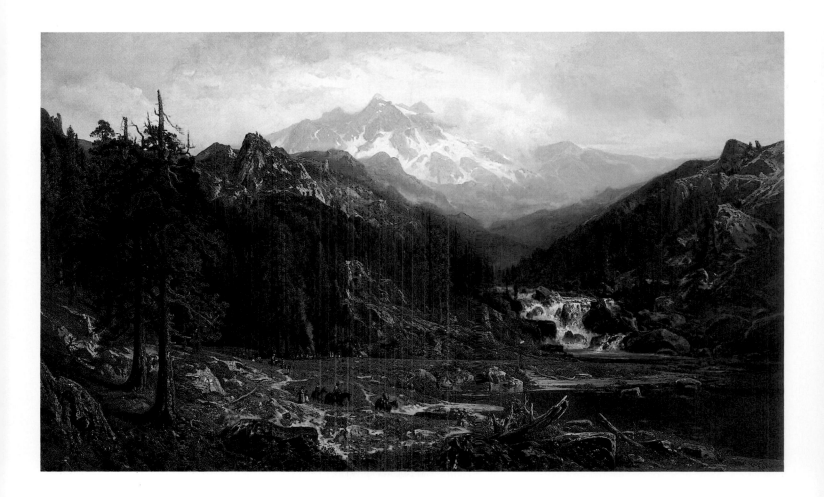

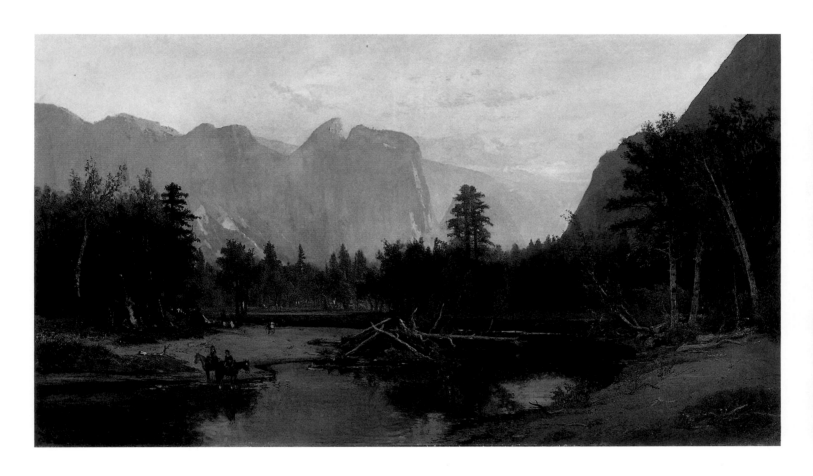

Fig. 3-6
William Keith (1838–1911)
Yosemite Valley, 1875
oil on canvas, 40^{5}/$_{16}$ x 72 ½ in.
Los Angeles County Museum
of Art, A. T. Jergins Bequest

realistically. Through the 1870s the artist produced epic paintings of Sierra canyons, replete with dramatic cloud formations, frothy rivers cascading over tumbled boulders, and forests choked with uprooted and twisted pines, such as *King's River Canyon* of 1878 (fig. 3-5). Most often these canvases show mountains to both the right and the left with the intervening valley leading back to distant peaks. As time went on, his work became more poetic. For example, in *Yosemite Valley* of 1875 (fig. 3-6), objects are reduced to flat, simplified shapes, tonalities are cool, and emphasis is placed on the horizontal valley floor and a placid river, creating a Yosemite basking in late-afternoon calm and peace. Keith's increasingly poetic strain made him one of the earliest West Coast proponents of the Tonalist style (chapter 7).

The site also lured East Coast painters for brief sketching trips. Two stand out: **Herman Herzog** (1831–1932) and Thomas Moran. Herzog, a Bremen artist who settled in Philadelphia about 1870, had an incredible natural talent and seemingly unquenchable energy. He began to travel the United States in search of inspiring landscapes, and on his first trip to the West, in 1873–74, he reached California, where he painted Yosemite Valley as well as sites in Southern California. At Yosemite he seems to have taken advantage of the new horse trail that entrepreneur James McCauley

completed in 1872 to convey tourists from the two hotels at the foot of Sentinel Rock to the valley's rim at Glacier Point. Herzog's *Mirror Lake, Yosemite* of 1874–75 (fig. 3-7) is one of the earliest to represent the valley from the rim. This aerial vantage allows a straight view up a valley past Half Dome. Herzog, who had painted in Norway and Switzerland, was well versed in rendering magnificent scenery, and rather than adopting American Luminist or French Impressionist styles, he seems to have preferred a relatively accurate topographical treatment to which he imparted drama with shadows and ethereality with haze.

Another "tourist" who painted Yosemite and ultimately retired to Southern California was the Long Island painter **Thomas Moran** (1837–1926). He had made his reputation with magnificent panoramas of Yellowstone, the Grand Canyon, and the Rockies; Mount Moran in the Tetons and Moran Point in Yosemite are named for him. Some of Moran's watercolors along with William H. Jackson's photographs of 1871, placed on the desks of influential congressmen, helped to gain Yellowstone its designation as America's first national park. Moran's style, influenced by the English artist Joseph M. W. Turner, who is known for his colorful atmospheres, is easily recognizable. Moran's subtle tints and shades turn any landscape into a beautiful and fragile rainbow of pinks,

mauves, buffs, and tans. He first visited Yosemite in 1872 but continued to paint views of the valley, including a waterfall and an expansive panorama titled *Domes of the Yosemite* (formerly Museum of Western Art, Denver, and reproduced in *California's Western Heritage,* exh. cat., Palm Springs Desert Museum, March 8–June 8, 1986). This shows the valley from about the same vantage point on the rim where Herzog stood. This breathtaking panorama in which a darkened foreground cradles the distant Sierra peaks seems like a God's-eye view of the range.

Although Yosemite became a public trust of California in 1864, through an act signed by President Abraham Lincoln, the pure wilderness that some naturalists and ecologists hoped to preserve lost ground to pressures from a growing population hungry to experience the valley's beauties. Tourism escalated after the completion of the Transcontinental Railroad in 1869, and it increased again when two stagecoach roads were cut into the valley, one from the north in 1874 and the other in 1875, from Wawona to the south. Even more people came when the Yosemite Valley Railroad opened service to El Portal in 1907, and still more when the park opened to automobiles in 1914. In response to the increasing numbers of visitors, hotels sprang up in the valley, with expansions and new construction of four hotels in 1869 and 1870. Before the end of the century, four more hotels (some with campgrounds) were erected, including Mountain House on the rim. Tourism spread to other scenic spots of the Sierra, also opened up by roads and hotels.

With the invasion of excursionists into Yosemite, artists began to people their views of Yosemite with pioneer campers instead of Indians. One of the first artists to represent tourists was the German-born **William Hahn** (1829–1887). Hahn met William Keith in 1869 in Duesseldorf, and Keith persuaded him to come to the United States. After a brief period in Boston, in 1872, Hahn followed Keith to San Francisco. In Germany, Hahn had mastered the painting of figures and animals; in California, he immediately applied his talents to local subjects. His 1874 *Yosemite Valley from Glacier Point* (fig. 3-8) shows a party of well-dressed tourists enjoying the view from the same spot where Herzog and Moran painted their pure landscapes. (Tandem smaller-size pictures by Hahn show the same party on horseback starting up the trail and returning from the rim.) This picture reveals an important philosophic change of attitude toward America's landscape. Hahn and artists of his generation were no longer fascinated by untouched nature but rather with the contemporary human activity in it. The dominant size of the tourists (compared to the tiny figures

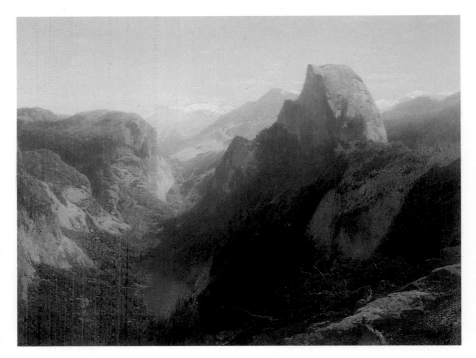

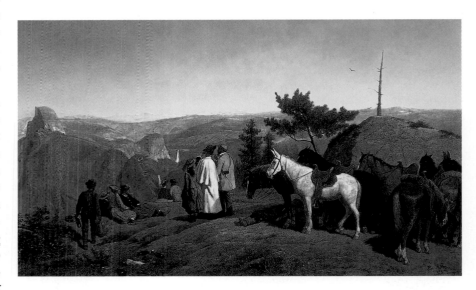

Fig. 3-7
Herman Herzog
(1831–1932)
Mirror Lake, Yosemite,
c. 1874–75
oil on canvas, 25 x 34 in.
Collection of the
Birmingham Museum of Art,
Birmingham, Alabama; Gift
of Coe-Kerr Gallery, Inc.

Fig. 3-8
William Hahn (1829–1887)
Yosemite Valley from Glacier Point, 1874
oil on canvas, 27¼ x 46¼ in.
California Historical Society,
Gift of Albert M. Bender

Fig. 3-9
Frederick Ferdinand Schafer
(1839–1927)
Mount Shasta, also known as
Mountain Composition,
c. 1880
oil on canvas, 30 x 50 in.
Formerly Collection of James
L. Coran and Walter A.
Nelson-Rees. Destroyed by
fire, October 1991.

Fig. 3-10
William Keith (1838–1911)
Upper Kern River, 1876
oil on canvas
75⅛ x 123¼ in.
Stanford University Museum
of Art 12057; Stanford
Family Collections

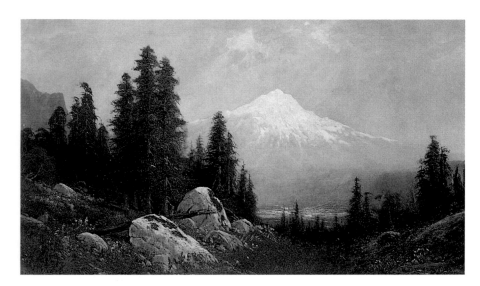

Bierstadt represented in his valley views) reveals Hahn's belief in man as conqueror. Not only have these individuals succeeded in scaling the dizzying heights of the valley to survey their domain, but the figures physically dominate the landscape backdrop. Hahn's colors and approach are less Romantic than Bierstadt's, reflecting the growing interest in realism by nineteenth-century artists. Realism was stimulated by photography as well as the increasing importance put on science over the Bible in explaining the mysteries of nature.

Other Wilderness Subjects

Although Yosemite probably attracted more artists than any other California site, spectacular scenery abounded throughout Northern California. Mountains, in particular high or steep and rugged peaks, have fascinated people for centuries. Regarded as the abodes of gods or of spirits, mountains have served as

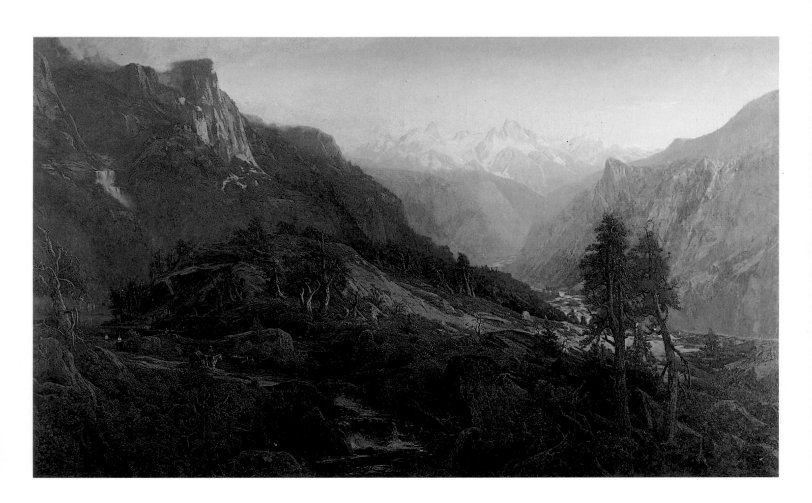

landmarks to early explorers, were seen as treacherous barriers to westward expansion, represented places of solitude and sometimes terror, and have provided challenges for hikers or the curious. Scaled, a mountain's height raises an individual above the multitude and offers a godlike overview of both humanity and the surrounding terrain.

California's most notable mountainous feature is the entire uplifted granite Sierra Nevada chain that extends for about four hundred miles down the length of the state. Individual peaks outside the chain include the solitary volcanic cone of Mount Shasta and the weather-rounded Mount Tamalpais on the peninsula north of the Golden Gate. Each had its own personality and historical associations. Painters capitalized on the personalities and popularity of these peaks, both to increase their own reputations as well as to assure the salability of their work. Mount Shasta's 14,161-foot elevation made it a beacon to early explorers. Alfred Agate and James Dwight Dana, with the Wilkes-Emmons expedition of 1841, were the first to sketch it. The snow-capped cone, often compared to Japan's Mount Fuji, also inspired Bierstadt, Hill, Keith, and a host of others in the late nineteenth century. **Frederick Ferdinand Schafer** (1839–1927) rendered its perfect point in *Mount Shasta* of about 1880 (fig. 3-9). Mount Tamalpais, visible from ships off the coast, was one of the first California mountains to be represented in art, since it served as a landmark for the coastal explorer George Vancouver and appeared on an early map. Its heights and contours are featured in numerous late-nineteenth-century landscapes.

Waterways, such as the rushing streams that poured out of the Sierra, swelled by heavy winter snowfalls, also inspired many painters. **William Keith** made these streams his focal point in landscapes such as *Upper Kern River* of 1876 (fig. 3-10). Herzog, too, was a master of rushing, churning water. Others were intrigued by King's River Canyon, Hetch Hetchy Valley, and Donner Pass.

Two favorite lakes for painters were Tahoe and Donner, both in the Sierra. Artists who painted bodies of water had only limited compositional options. Depictions from water level emphasized the horizontal, which in turn imparted a serene and placid mood to a work. **Albert Bierstadt** used this perspective in *Lake Tahoe, California* of 1867 (fig. 3-11). The darkened and silhouetted foreground sets off a glowing, pearl-toned sky dramatized by steel gray clouds. The horizontal format was also used for Lake Tahoe when John Ross Key (1837–1920) created several views in 1869 and 1870, and for Clear Lake (about one hundred miles north of San Francisco) painted by several artists. In a slight twist on this format, Emerald Bay, an intimate section on the southwest shore of Lake Tahoe, famous for its striking emerald green color, was often represented from the lake itself looking toward the shore.

Lakes could also be pictured from above, if there were high mountains nearby as there were at Donner Lake. Such a compositional format was established for Donner by **Bierstadt** in his *Donner Lake from the Summit* of about 1873 (fig. 3-12). His composition in turn may have been derived from formats established by earlier artists in Europe and on the East Coast. The painting was commissioned from Bierstadt during his second sojourn in California (1871–73) by Collis Huntington, one of the Big Four railroad barons. The Central Pacific lines had been constructed through the pass once identified with the tragedy of the Donner party. Huntington wanted to celebrate the engineering triumph as

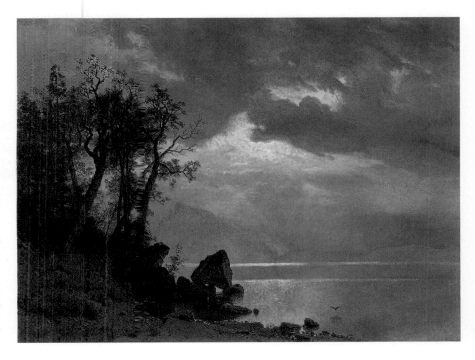

Fig. 3-11
Albert Bierstadt (1830–1902)
Lake Tahoe, California, 1867
oil on canvas, 21 ⅞ x 30 in.
Gift of Martha C. Karolik for
M. and M. Karolik Collection
of American Paintings,
1815–1865, Courtesy,
Museum of Fine Arts, Boston

well as to show how a once-treacherous pass could now be crossed in comfort by train. Sunrise was chosen to symbolize the dawn of a new era brought about by the railroad. Despite Huntington's expectations, Bierstadt almost negated the presence of the train in favor of his own preference for the magnificence of nature. Other artists who followed Bierstadt in rendering Donner, including Thomas Hill, Gilbert Munger, and William Keith, adopted similar viewpoints.

Artists also depicted the state's botanical wonders, particularly the Sequoia, a genus of conifer. The *Sequoia gigantea* (big tree) is the rarer of the two, growing only in scattered groves on the western slopes of the Sierra. The *Sequoia sempervirens* (redwood), the tallest tree in existence, sometimes reaches more than three hundred feet and grows in a narrow strip along California's coastline near the Oregon border. The trees most often represented by artists of the 1860s and 1870s grew in the Mariposa Grove just off the road that enters Yosemite from the south. A favorite, Grizzly Giant, is estimated to be the oldest of the approximately two hundred in the stand--more than 2,500 years. It has a girth of 96.5 feet and a height of 209 feet. **Bierstadt** sketched it on his first trip to Yosemite in 1863. The oil-on-paper *The Grizzly Giant Sequoia, Mariposa Grove, California* (fig. 3-13) was painted from this sketch on Bierstadt's second trip to California in about 1872–73, and a photograph of the time shows the painting hanging on the wall of Bierstadt's San Francisco studio. It was difficult for artists to convey the huge scale of these trees. Bierstadt takes almost the same viewpoint as did the photographer Carleton Watkins in his *Grizzly Giant, Mariposa Grove, California, no. 110* of about 1862, when he stood not far from the base and looked upward. Later artists showed the scale of the trees by posing people, horse-drawn vehicles, or automobiles at their bases. At the end of the century, lesser artists, under pressure of the tourist industry, turned out hundreds of paintings of redwood trees, or paintings on slices of redwood.

Ironically, the appreciation for and celebration of pure, undefiled nature became largely lip service as the century progressed. As gold veins became exhausted, the growing California population looked to the state's natural resources as a means for making a living. Sites such as Yosemite, King's Canyon, Lake Tahoe, certain areas of the Sierra, and some redwood groves, fortunately, were set aside as national forests and parks before entrepreneurs could ravage them. But other areas, especially farmlands, along important transportation routes such as rivers, were almost immediately "put to use." The landscape paintings discussed in the next chapter celebrate man's conquest and subjugation of the land for agriculture, cities, industry, and commerce. ❧

Fig. 3-12
Albert Bierstadt (1830–1902)
Donner Lake from the Summit,
c. 1873
oil on canvas, 72 x 120 in.
© Collection of The New
York-Historical Society

Fig. 3-13
Albert Bierstadt (1830–1902)
*The Grizzly Giant Sequoia,
Mariposa Grove, California,*
c. 1872–1873
oil on paper mounted on
cardboard, 30 x 21½ in.
Los Angeles County
Museum of Art, purchased
with funds provided by Dr.
Robert G. Majer

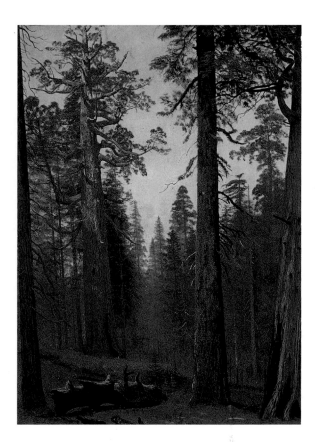

Bibliography

Landscape, General Works

The Beautiful, the Sublime, and the Picturesque: British Influences on American Landscape Painting, exh. cat., Washington University Gallery of Art, St. Louis, Mo., February 18–April 8, 1984.

Goetzmann, William H., *The West of the Imagination,* New York: Norton, 1986.

The Romantic Vision in America, exh. cat., Dallas Museum of Fine Arts, October 9–November 28, 1971.

Wilmerding, John, *American Light: The Luminist Movement 1850–1875: Paintings, Drawings, Photographs,* Princeton, N. J.: Princeton University Press, 1989.

Development of San Francisco's Art World 1860–1877 and Painting in General 1860–1900

Avery, Benjamin Parke, "Art Beginnings on the Pacific," *Overland Monthly,* v. 1, July 1868, pp. 28–34 and August 1868, pp. 113–19, and his "Art in California," *Aldine,* v. 7, April 1874, pp. 72–73.

Berney, Charlotte, "The Light on the Land," *Antiques & Fine Art,* v. 5, no. 6, October 1988, pp. 84–91.

California Arts Commission, *Horizon: A Century of California Landscape Painting,* Sacramento, 1970.

California Historical Society, *Pictorial Treasures,* San Francisco, 1956.

California Landscape Painting, 1860–1885: Artists Around Keith and Hill, exh. cat., Stanford Art Gallery, Palo Alto, Ca., December 9, 1975–February 29, 1976.

California Landscape Painting [paintings date from 1860–1915 and are from the collection of the Oakland Museum]: an exhibition circulated by the Western Association of Art Museums, 1978.

California Pictorial, 1800–1900, essays by Paul Mills and Donald C. Biggs, exh. cat., Santa Barbara Museum of Art, Santa Barbara, Ca., August 9–September 9, 1962.

"California's Own Art World, 1860–1875," in Jeanne Van Nostrand, *First 100 Years,* San Francisco: John Howell Books, 1980, pp. 65–77.

Christmas Sale: Catalogue of Elegant, Parlor, Chamber, Library, Office and Fancy Rosewood Furniture, Oil Paintings, by California Artists....to be sold at auction, Wednesday and Thursday December 22 and 23, 1869, H. M. Newhall & Co., San Francisco, 1869. 47 p.

A Classified Catalogue of the Paintings on Exhibition at the Room of the California Art Union, no. 312 Montgomery Street, with the Constitution and By-laws and list of Officers, San Francisco: Art Union, 1865.

Everett, George E., "The Grizzly Bear in California Art," *Noticias del Puerto de Monterey,* v. 33, no. 3, September 1990.

From Frontier to Fire: California Painting from 1816 to 1906, ed. by Joseph Armstrong Baird, Jr., exh. cat., University of California, Davis, May 22–June 2, 1964. 24 p.

Gerdts, William H., *Art Across America,* New York: Abbeville, 1990, v. 3, pp. 231–251.

Harlow, Ann, "Bicoastal Artists of the 1870s," *Art of California,* v. 5, no. 3, July 1992, pp. 10–13.

Harrison, Alfred C., Jr., "Albert Bierstadt and the Emerging San Francisco Art World of the 1860s and 1870s," *California History,* v. LXXI, no. 1, Spring 1992, pp. 75–83.

Harrison, Alfred, *The San Francisco Art Community,* in process, 1999?

Jones, Harvey L., "Early California Art," [A Brief History of the Evolution of American Art in California] *Art of California,* v. 1, no. 1, October/November, 1988, pp. 11–19.

Kahn, Gerrie E., "Images of the California Landscape, 1850–1916, Highlighting the Collection of the California Historical Society," *California History,* v. 60, Winter 1981–82, pp. 318–31.

Louis Sloss, Jr., Collection of California Paintings, essay by Jean Martin, exh. cat., California Historical Society, San Francisco, April and May, 1958. 18 p.

One Hundred Years of California Painting from 1849, exh. cat., Maxwell Galleries, Ltd., San Francisco, Ca., March 4–26, 1966. 17 p.

Perry, Claire, *Pacific Arcadia: Images of California, 1600–1915,* Ph.D. thesis, Stanford University, Palo Alto, Ca., 1993. 619 p.

A Selection of American Paintings by Artists of the 19th Century Working in Northern California, exh. cat., Mission San Francisco Solano de Sonoma, July, 1976. 44 p.

Shuck, Oscar T., compl., "Science and Art," in *California Anthology; or, Striking Thoughts on Many Themes, Carefully Selected from California Writers and Speakers,* San Francisco: A. J. Leary, 1880, pp. 9–47.

Various essays in *California History,* v. LXXI, no. 1, Spring 1992.

Wilson, Raymond L., "Artists and Bohemia," [discusses Bohemian Club] *Antiques and Fine Art,* v. 3, May 1986, pp. 14–17.

Wilson, Raymond L. "The First Art School in the West: The San Francisco Art Association's California School of Design," *American Art Journal,* v. 14, no. 1, Winter 1982, pp. 42–55.

Wilson, Raymond L., "Painters of California's Silver Era," *The American Art Journal,* v. 16, Autumn 1984, pp. 71–92.

Wilson, Raymond L., "Railroad Builders and the Golden Age of California Art," *Nineteenth Century* (The Victorian Society in America), v. 7, no. 2, Summer 1981.

Museum Collections that Feature Landscapes Painted Between 1850 and 1900

Arkelian, Marjorie, *The Kahn Collection of Nineteenth-Century Paintings by Artists in California,* Oakland Museum Art Department, 1975. 63 p.

The Art of California: Selected Works from the Collection of the Oakland Museum, Oakland Museum Art Department and Chronicle Books, 1984.

Denenberg, Beverly B. and Gerrie Kahn, "Paintings of California in the California Historical Society," *Antiques,* v. 124, November 1983, pp. 1030-42.

Driesbach, Janice T., "The Crocker Museum," *Art of California,* v. 3, no. 3, May 1990, pp. 36–41.

Harrison, Alfred C., Jr., "The Crocker Art Museum: 1860s and 1870s Landscapes Compared," *Art of California,* v. 2, no. 1, February/March, 1989, pp. 28–36.

Harrison, Alfred C., Jr., "The Haggin Museum, A Review of Early California Paintings in the Stockton, California Museum," *Art of California,* v. 1, no. 2, December/January 1989, pp. 10–19.

Harrison, Alfred C., Jr., "Paintings from the Society of California Pioneers," *Art of California,* v. 2, no. 3, June/July 1989, pp. 21–28.

Harrison, Alfred C., Jr., "Saint Mary's William Keith Collection," [Hearst Art Gallery, Saint Mary's College] *Art of California,* v. 1, no. 1, October/November 1988, pp. 41–45.

Osborne, Carol M., *Museum Builders in the West: The Stanfords as Collectors and Patrons of Art 1870–1906,* Stanford: Stanford University Press, 1986.

Timberman, Marcy, "E. B. Crocker: Pioneer Patron of California Painting," *Antiques & Fine Art,* v. 6, no. 3, March–April 1989, pp. 51–2.

Wilson, Raymond L., "The Oakland Museum," [A review of the California Collection] *Art of California,* v. 1, no. 1, October/November 1988, pp. 23–27.

Private Collections that Feature Art of 1860–1900

Harrison, Alfred C., Jr., "California Paintings in the Collection of Dr. Albert Shumate," *Art of California,* v. 2, no. 4, August/September 1989, pp. 30–36.

Harrison, Alfred C., Jr., "The Charles E. Noble Collection," *Art of California,* v. 3, no. 1, January 1990, pp. 53–59.

Harrison, Alfred C., Jr., "The James Harvey California Collection," *Art of California,* v. 4, no. 2, March 1991, p. 42–47.

Yosemite

Arkelian, Marjorie Dakin, "Artists in Yosemite," *American West,* v. 15, pt. 4, 1978, pp. 34–47.

Harrison, Alfred, Jr., "Yosemite Painting, the Golden Age, 1850-1930," *Art of California,* v. 4, no. 1, January 1991, pp. 12–16.

Ogden, Kate Nearpass, "God's Great Plow and the Scripture of Nature: Art and Geology at Yosemite," *California History,* v. LXXI, no. 1, Spring 1992, pp. 89–108.

Ogden, Kate Nearpass, *Yosemite Valley as Image and Symbol: Paintings and Photographs from 1855 to 1880,* Ph. D. Dissertation, Columbia University, N.Y., 1992.

Robertson, David, *West of Eden: A History of the Art and Literature of Yosemite,* Yosemite Natural History Association and Wilderness Press, 1984.

Rogers, Thomas, "A Matter of Perspective: Thomas Hill's Yosemite Valley Panorama," *The Californians,* v. 7, no. 6, March/April 1990, pp. 44–49.

Views of Yosemite: The Last Stance of the Romantic Landscape, essay by Joseph Armstrong Baird, exh. cat., Fresno Arts Center, Fresno, Ca., June 12–August 8, 1982. 43 p.

Other Wilderness Subjects

"Art and Literature on Mt. Tamalpais," in Lincoln Fairley, *Mount Tamalpais: a History,* San Francisco: Scottwall Associates, 1987. 201 p.

"Art: Fine Arts," in William C. Miesse, *Mount Shasta: An Annotated Bibliography,* Weed, Ca.: College of the Siskiyous, 1993, pp. 213–219.

Gerdts, William H., "A Painter's Paradise," *American Art Review,* v. VIII, no. 6, December 1996, pp. 110–23.

Harrison, Alfred C., Jr., "The Tradition of Donner Lake Paintings," *California History,* v. LXXI, no. 1, Spring 1992, pp. 83–87.

Latimer, L. P., "The Redwood and the Artist," *Overland Monthly,* v. 32, October 1898, pp. 354–56.

Sonoma County Museum, "Scenes of the Russian River," *Art of California,* v. 3, no. 3, May 1990, p. 61.

Fig. 4-1
William Hahn (1829-1887)
Harvest Time, 1875
oil on canvas
36 x 70 in.
The Fine Arts Museums of
San Francisco, Gift of Mrs.
Harold R. McKinnon and
Mrs. Harry L. Brown

The Golden Age of Landscape Painting: Valley & Shore

Even as the Gold Rush was in its decline, hoards of immigrants continued to flow into Northern California. Settling along the shoreline and in the fertile valleys, they established farms and businesses and built towns. As fashion in landscape painting moved away from huge, Romantic panoramas of dramatic wilderness scenery toward smaller canvases of more intimate pastoral themes, California artists increasingly depicted lowland activity. This included life in California's inland farms and towns (including the Sacramento Valley and the towns of Stockton and Oakland) as well as the daily business conducted along rivers, the oceanfront, and around San Francisco Bay. Whereas paintings of California's wilderness had once celebrated the state's untouched quality, paintings of California's settled areas now celebrated man's taming of the land. It was California's spectacular wilderness scenery that gave a unique quality to the state's landscape painting. It is California's people and their fashions in clothing, architecture, and occupations that impart a unique quality to its lowland scenes. Regions can even be identified by their distinctive characteristics.

The Sacramento Valley extends northeastward from San Francisco Bay, cut by a major navigable river of the same name that drains into the bay. Early gold seekers often booked passage on steamers that plied the river up to the city of Sacramento ninety-eight miles inland, which served as a jumping-off spot for the gold fields sixty miles farther east. Sacramento grew rapidly, supplying provisions to gold seekers, becoming the state capitol in 1854, and finally serving as the valley's center for farming and commerce. As the state's second most important city (next to San Francisco), it had wealth that attracted both art patrons and artists. Paintings soon documented the activities in its vicinity. Popular themes include life within the growing city, along the river, and on the area's farms. Farming was the work adopted by many "retired" gold miners in the 1860s, and farm scenes range from landscapes of rustic farmsteads to genre pictures of people at farm tasks, such as harvesting hay.

William Hahn, the German artist who resided in California for several periods between 1872 and 1882, left two of the finest views of the area: *Sacramento Railroad Station* of about 1874 (Fine Arts Museums of San Francisco), which shows the bustle of the city's station, and *Harvest Time* of 1875 (fig. 4-1). The harvest picture is a composite of the various steps in wheat processing: the arrival of a wagon with cut hay, unloading the hay into a thresher, stacking grain bags, and horses turning a mill wheel. Farm scenes were a popular mid-nineteenth-century subject on both the East and West Coasts. They symbolized the taming of the land, the bounty of America, the rewards of diligence, and the happy life of independent Americans. The East Coast had a litany of images particular to it: black fiddlers playing in barns, corn husking, sledge gathering, apple picking, cider making, and so forth. When California artists took up the theme, they added to this repertory activities that were particular to their state, such as cattle ranching and haying. The emphasis on human activity in Hahn's harvest scene qualifies it as a genre picture. While East Coast artists often overlaid their genre with simple, anecdotal country humor, California artists rarely did. Even though *Harvest Time* was painted well after the Civil War, when farm scenes on the East Coast had become images of nostalgia, in California these scenes still represented the "civilizing" of the West. In style, Hahn's painting also reveals the greater interest in realism evident in the second half of the nineteenth century.

The city of Stockton lies south of Sacramento and seventy-six miles inland from San Francisco, at the head of tidewater on the San Joaquin River. Like Sacramento, Stockton became an outfitter for miners on their way to the gold fields and later the state's only deep-water inland port. As the hub for commerce to and from San Joaquin Valley farms, it also became the state's third wealthiest town and an important early center for California art. **Albertus Del Orient Browere's** *Stockton* of 1856 (fig. 4-2) depicts fishermen tightening a seine against a backdrop of Stockton's eclectic mix of buildings. Browere, like Hahn, chose a realistic over an anecdotal approach.

On the eastern shore of San Francisco Bay, the cities of Oakland and Alameda, both incorporated in 1852, also became subjects for painted views. Oakland became the seat of Alameda County, and its courthouse, the most imposing building in the infant town, is realistically delineated in *Alameda County Courthouse, East Oakland* of 1882 (fig. 4-3) by **Marius Dahlgren** (1844–1920). With the painting's bald realism, its

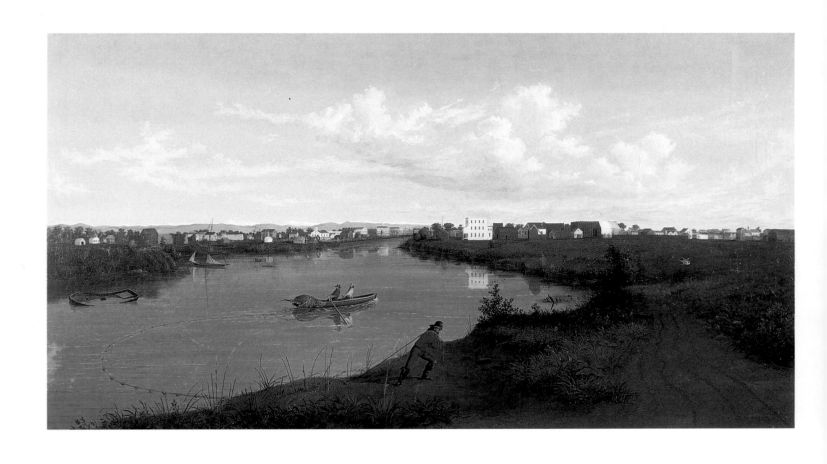

Fig. 4-2
Alburtus Del Orient Browere
(1814–1887)
Stockton, 1856
oil on canvas, 36⅞ x 69⅞ in.
The Fine Arts Museums of
San Francisco, Museum
Purchase, 39.3

Fig. 4-3
Marius Dahlgren
(1844–1920)
Alameda County Courthouse,
East Oakland, 1882
oil on canvas
11 x 17½ in.
Collection of the Oakland
Museum of California, Kahn
Collection

emphasis on the horizontal, and its clear atmosphere, it is another example of Luminism in California.

Another subject for early artists was country estates of the rich. "Portraits" of houses and other possessions, like portraits of people, were documents for posterity. House "portraits" celebrated the new material wealth of Americans and attested to the Protestant belief that material rewards followed hard work. Americans inherited the theme of house portraits from England, where it had been popular among the eighteenth-century aristocracy. By the 1840s, prosperous farmers along America's eastern seaboard were commissioning views of their possessions, and by midcentury, urban owners of country estates were following suit. This inclination to document material success existed among all levels of Americans. Witness the photographs of mid-nineteenth-century prairie pioneers standing in front of their sod huts, surrounded by all of their important possessions (the family horse, sewing machine, butter churn, etc.). In California some of the earliest paintings on this theme show Sutter's Fort; *Hock Farm* (Oakland Museum of California) was painted by William Smith Jewett in 1851. By the 1860s country residences in California had become more luxurious. *Belmont: The Estate of William Chapman Ralston* of 1874 (fig. 4-4) by **George Albert Frost** (1843–1907) shows the owner's mansion, twenty miles south of San Francisco. Ralston's money came from his Bank of California, which controlled several of the Comstock Lode's most profitable mines. Until the bank failed in 1875, Ralston lavished money on his house (which soon grew large enough to accommodate 120 people comfortably), his stables, and spectacular enterprises such as the Palace Hotel in San Francisco. Similarly, Leland Stanford, proud of his Palo Alto estate, had it figure prominently in the family portraits he commissioned from Thomas Hill and Ernest Narjot (chapter 2).

Marine Paintings

It is logical that California's extended Pacific shoreline would give rise to a major marine painting tradition. Not only was the shore picturesque, but the human activity at the state's major ports in San Diego, San Pedro, Santa Barbara, Monterey, and San Francisco made for fascinating genre pictures. San Francisco's huge bay with its connections to inland farming valleys via the Sacramento and San Joaquin Rivers, as well as to the entire Pacific Rim, rivaled, even exceeded the commercial importance ascribed to East Coast harbors such as Boston, New York, and New Orleans. More than fifty miles long and from three to twelve miles wide, San Francisco bay offered California's nineteenth-century artists great scenic variety—the busy wharf life of the San Francisco docks, the quiet, picturesque fishing villages dotted along its shore, the oyster beds of its shallows, and its isolated stretches of shore.

Landscapes that include even a bit of ocean are alternately referred to as seascapes, marinescapes, or oceanscapes. The appeal of seascapes lies in their interesting shore activities as well as the universal appeal of the open sea. Historically, the sea has been regarded as a place of opportunity, laced with adventure and promising new prospects; its vast unoccupied stretches provided a natural respite from urban crowding and social chaos. Water itself suggested cleanliness, and sea breezes were looked upon as cool, fresh, and healthy.

Seascapes became a separate painting category from landscapes in the 1600s, when the Netherlands "ruled" the oceans through trade and when Dutch painters developed the theme of harbors nestled low on the horizon under vast skies. With England's domination of the oceans in the 1700s, British artists took supremacy in marine painting and added a topographical element. About the time of the American Revolution, painters in Marseilles, France, developed the genre of ship portraits, which showed ships in various poses: resting peacefully in harbors, in full sail on the open ocean, or tossing in romantically turbulent seas. And when America achieved world dominance of the seas

Fig. 4-4
George Albert Frost
(1843–1907)
Belmont: The Estate of William Chapman Ralston, 1874
oil on canvas, 15 x 30¼ in.
California Historical Society

in the 1800s, its artists took the lead in marine painting. Although they assimilated and repeated all the earlier styles and themes, American artists added themes of their own: American naval battles, scenes relating to whaling, and portraits of newly developed ship types—such as the sleek clippers and steam-powered vessels.

Although Californians began producing sophisticated marine paintings only in the mid-nineteenth

Fig. 4-5
Charles Christian Nahl
(1818–1878)
Fire in San Francisco Bay, July 24, 1853, 1856
oil on canvas, 26 x 40 in.
Private Collection, Courtesy
Montgomery Gallery, San
Francisco
Photo: Cecile Keefe

Fig. 4-6
Frederick A. Butman
(1820–1871)
Chinese Fishing Village, 1859
oil on canvas, 23½ x 36 in.
California Historical Society,
Gift of Albert M. Bender

century, the state had a seascape tradition that was more than three hundred years old— extending from the maps that resulted from seagoing exploring expeditions begun in 1542 through the landscapes produced in conjunction with the U. S. Coast Survey of the 1850s (chapter 1).

When California's first sophisticated painters arrived with the Gold Rush and looked around for possible subjects, much of the state's human activity was still near the seashore. While these artists may have brought with them marine painting styles and themes developed elsewhere, they soon realized that themes that were popular in Europe and the East Coast were not relevant to Californians. California marine artists began to render the state's own unique and interesting themes, such as the flotillas of sailing ships abandoned in San Francisco Bay by crews defecting to the gold fields, steamers on the rivers, hay scows on the bay, and Chinese fishing villages.

The finest marine painting of the Gold Rush period is undoubtedly **Charles Nahl**'s *Fire in San Francisco Bay, July 24, 1853* of 1856 (fig. 4-5). On July 24, 1853, two abandoned ships converted to warehouses, took fire. A sketch of the event was made by the delivery boy for a San Francisco grocer. Three years later Charles Nahl and his brother Arthur used that sketch as the basis for their painting. Although the flames and smoke give this picture drama, like Nahl's other early (1850s) work, the style is more realistic than Romantic. Because it documents a specific event, it is also a history picture.

Frederick A. Butman (1820–1871) chose as his marine subject one of Northern California's several Chinese fishing villages. Butman was probably a self-taught painter. He moved to San Francisco in 1857 and over the next ten years produced more than eighty oil paintings. *Chinese Fishing Village* of 1859 (fig. 4-6) reveals how many Chinese, who had come to try their luck in the gold fields, settled instead on the occupation of fishing. Pictures of manual laborers and "picturesque" settlements had great appeal to late-nineteenth-century urban dwellers (chapter 6). Chinese manners and dress as well as the insubstantial board shacks were regarded as exotic, rustic, and picturesque. (Iconographically, these shacks supplied California with a rustic architecture equivalent to the East Coast's log cabins or the South's slave shanties.) The villages were established at places such as Steamboat Point, Hunter's Point, and four or five other departure points around the bay used by shrimp fishermen. The Chinese villages diminished after 1860, when local fishermen of Italian heritage succeeded in getting legislation passed for taxes to be imposed on Asian competitors.

Many seascapes made during California's Golden Age of Landscape (1860-77) contain no human presence. Visiting artist **Albert Bierstadt** was one of the earliest to recognize the artistic potential of San Francisco's broken and rugged coastline, particularly the group of seal rocks offshore from Cliff House (built 1863), which became a tourist attraction. Pictures of seals basking on stony offshore shelves frequently illustrated travel magazines and books such as *Picturesque California* (San Francisco, 1889). During Bierstadt's 1872–73 trip to the West, he painted several views of these seal colonies as well as those on the Farallon Islands some twenty miles offshore. His best is *Seal Rocks, San Francisco* of about 1872 (Private Collection; reproduced in William H. Gerdts, *Art Across America*, New York: Abbeville Press, 1990, v. 3, p. 244). The left side of the canvas is taken up by a jagged, arched sea girt monolith and the right is filled with a towering wave about to hurl itself against the sawtooth profile. In typical Bierstadt style, the picture is strongly Romantic. He enhances the natural drama of the bare basalt jutting up from the sea by viewing it from sea level so that it seems to loom above the viewer; he silhouettes the rock's arch against a cloudy and troubled sky, and makes the approaching wave towering and threatening. Seals cling to the outcropping's sunlit crest. Many other artists painted seal rocks, but never with such grandiloquent optimism.

Most marine landscapes painted between 1860 and 1880 are of a quieter disposition, adhering to composition and style established by the second-generation Hudson River School artists on the East Coast. In the 1850s and 1860s, these East Coast landscapists increasingly turned away from the rugged wilderness views that had fascinated them in the first part of the century, choosing to paint shore views. They ignored the bustling harbors favored by America's few earlier marine painters and their merchant clients, and they painted instead the deserted shore where city-weary individuals could look for solace.

A prime California example is **Raymond Dabb Yelland**'s (1848–1900) *Golden Gate* of 1882 (fig. 4-7). Shorelines provided a variety of geographic features that could be arranged and rearranged into endlessly varied compositions. The sea supplied a composition's horizontal element, while shore cliffs, tall-masted ships, islands, lighthouses, and escarpments could provide a vertical counterpoint. Yelland's is a typical solution—an extended sweep of sand and quiet ocean balanced with a bold vertical outcropping of land. This compositional type is common to some of the second-generation Hudson River School painters of marine scenes, including John Frederick Kensett (1818–1872),

Fig. 4-7
Raymond Dabb Yelland
(1848–1900)
Golden Gate, 1882
oil on canvas mounted to
cradled panel, 28 x 48 in.
Robin and Elliott Broidy
Photo: Casey Brown

Alfred T. Bricher (1837-1908), and William Stanley Haseltine (1835-1900), whose works Yelland may have seen. Some of these late Hudson River School seascapes are so simple compositionally that today's historians describe them as minimal and abstract, terms usually reserved for discussions of twentieth-century modernist paintings. A sense of stillness is enhanced by a luminous glow that pervades the scene with a serene, crystal-clear light—a quality art historians call Luminist. Yelland's picture, with its late afternoon light striking the cliff and its translucent sky, clearly fits into this tradition.

Fig. 4-8
Gideon Jacques Denny
(1830–1886)
Hay Scow on San Francisco Bay, 1871
oil on canvas, 23¼ x 41 in.
Courtesy San Francisco
Maritime National Historic
Park, Catalog # SAFR 3646

Just as East Coast marine painters came to agree on the most picturesque spots found along the eastern shoreline, so too did San Francisco artists began to isolate and identify the West Coast's most attractive bays and outcroppings. One of the favorite sites was the Golden Gate, the gap through which San Francisco Bay opens to the sea. The drama of precipitously descending cliffs has always appealed. And bay openings carry overtones of the passage from calm to rough waters, from known to unknown, from containment to boundless freedom, and from safety to danger. In the 1850s, Americans convinced of Manifest Destiny believed they could accomplish anything by just trying, and the bay opening to the Pacific Ocean symbolized opportunity.

Artists of every level, including amateurs and folk painters, painted the gap. **Charles Roos** (active 1881) provided a folk version in *The Jeannette Sails for the Arctic [July 8, 1879]* of 1881 (current location unknown: reproduced in Jeanne Van Nostrand, *San Francisco, 1806–1906,* San Francisco: The Book Club of California, 1975, plate 45). The *Jeannette,* under the command of Lieutenant George W. DeLong of the U. S. Navy, was bound for the Arctic in search of the Northwest Passage. So high was the interest in the expedition that the ship was escorted by a flotilla of steamers, yachts and sailboats to the Golden Gate, where spectators lining the shore and wharves sent it on its way with waves and cheers. Like many naïve or folk painters, Roos copied the scene from a known, professionally made lithograph, this one issued immediately following the ship's departure. While Roos's style is primitive—its perspective is faulty, the waves are reduced to a pattern, and the colors localized rather than used for a unifying atmosphere--the whitecaps and billowing

clothes of well-wishers give the picture zest and capture the sense of adventure that marks the beginning of a voyage.

As the century progressed, California's cities grew and spread outward, consuming raw nature in their paths. Harbor activity proliferated, and specialties developed: stevedores working on the wharves, ship construction, sail making, and commerce. At the same time, artists increased in number, and some began to specialize in marine painting. San Francisco's first full-time marine painter was **Gideon Jacques Denny** (1830–1886), a failed gold seeker who trained as a painter in the Midwest and returned to San Francisco in 1858 to establish a career in art. Denny specialized in painting all kinds of ships from clippers in full sail to shipwrecks. His pictures that most interest Californians are of ships specifically associated with California, such as his *Hay Scow on San Francisco Bay* of 1871 (fig. 4-8). Historic photographs exist of these unusual hay scows—as unique to California as whalers are to New Bedford or riverboats to the Mississippi. Denny lightens this cumbersome craft with a wind-whipped bay and places sailors atop the bales of hay in a variation of the *Jolly Flatboatman* theme made popular by the Missouri artist George Caleb Bingham (1811–1879). Other marine subjects specific to California were Morgan's Oyster House, which sat on pilings in San Mateo Bay, painted several times by Charles Dormon Robinson (1847–1933), and Fisherman's Wharf, painted by Charles Rollo Peters (1862–1928) and others.

Toward the end of the century, as America's population crowded into cities to take advantage of factory work, cities became congested, dirty, confining, and corrupt. With newly earned leisure from jobs created by the industrial revolution, urbanites escaped to the country where they sought quiet and naturalness, or they spent their holidays at the newly fashionable beach resorts, strolling the sands and shore cliffs, "taking the sea air," and communing with nature. In the period 1870–1900 the most well known resorts in California were the Hotel Del Coronado (near San Diego), the town of Avalon on Catalina Island, and the Cliff House and beach near San Francisco. Bierstadt had emphasized the primeval aspect of seal rocks in his early 1870s Romantic view, but by the 1880s artists began to portray seal rocks as just an offshore feature in a broad panorama showing beach and Cliff House as a genteel tourist spot. Well-dressed people promenade along the sands, implying how domesticated this shoreline has become, yet the Cliff House, so perilously perched atop the cliffs, hints at the still tenuous hold civilization has on this outermost point.

Fig. 4-9
Thomas Hill (1829-1908)
Land's End (Land's End, San Francisco)
oil on canvas, masonite
15⅛ x 22 in.
Collection of the Oakland Museum of California, Gift of Grace Decker Meyer in memory of her husband, Victorien Melville Meyer

Artists also liked the theme of Land's End. Each continent seems to have its own projecting point of land surrounded by sea, and artists everywhere have painted this theme as much for its philosophic overtones as for the visual drama of land beaten by waves. San Francisco's Land's End was the craggy promontory on the Pacific Ocean west of Lincoln Park. The theme was painted by William Keith and **Thomas Hill**. It is not certain that Hill's undated *Land's End* (fig. 4-9) represents the well-known point in San Francisco, but like Keith, he treats it as a landscape, rather than philosophically; the rugged, wave-thrashed promontory becomes a marine counterpart to his Sierra wilderness scenes. Like Maine artist Winslow Homer (1836–1910), who painted several views of storm waves buffeting Prout's Neck sea cliffs, Hill matches nature's energy with his artistry, keeping to one monumental form and spreading paint in bold strokes across the canvas. By placing small figures on the rocks, bravely withstanding buffeting winds to contemplate the vastness of the sea, both artists reinforce the insignificance of man in the face of raw nature. Blessed with late-nineteenth-century confidence, these individuals are neither frightened nor threatened by nature but stand firm, thrilled by her awesome power and beauty.

Scenes of shipwrecks, which enjoyed great popularity in Europe and the East Coast, were only occasionally depicted by California artists—fortunately, the state suffered relatively few shipwrecks. Shortly after the Gold Rush spurred increased shipping activity, the Coast Survey of the 1850s (chapter 1) produced updated coastal charts, resulting in fewer accidents. The Pacific Ocean was aptly named for its gentle personality, and the new steamers had more control over their courses than sailing ships at the mercy of contrary winds. In the early-nineteenth century, paintings of wrecks of anonymous ships often symbolized philosophical issues, such as the moral collapse of society, biblical retribution, or the decline of a state. By the latter nineteenth century a beached and broken boat painted by a San Francisco artist was more often a document of an actual event and evoked sadness at the destruction of a beautiful man-made object. (Most late-nineteenth-century wrecks were captured by photographers rather than painters.)

As for ship "portraiture," by the time marine painting became an established genre in San Francisco, the great age of portraiture had passed. Early San Francisco had no major shipbuilding yards to generate new vessels for proud owners to document in paintings. Steamboats were replacing sailing ships, and they did not inspire the same love from their builders, owners, and captains as did the old clippers. Traditions persist,

however, and San Francisco marine painters occasionally were called upon to paint ship portraits. One of these, **William Coulter** (1849–1936), combined a natural talent for drawing with a knowledge of square riggers gained from several years as a sailor.

Coulter painted a number of panoramic views of the bay wherein were anchored a variety of ship types. Several of the compositions recorded notable historic events. *General Grant's Return to America* of 1879 (fig. 4-10) was painted only five years after Coulter's first known painting and immediately upon his return from a three-year European trip where he studied with several marine painters. It records the return to America in September 1879 of two-term President Ulysses S. Grant, who was ending a round-the-world voyage of many months. Coulter dramatizes the scene with a romantic sky.

After steam vessels made sailboats obsolete, pictures of sailing vessels were still painted on the East Coast by James Buttersworth (1817–1894), who capitalized on the fashion for the racing yachts that many of the new class of millionaires were purchasing. Californians did not take up yachting so avidly; her millionaires preferred to invest their money in racehorses.

Steamboats were put to many uses in California—in San Francisco Bay they were used as tugboats, as ferries between San Francisco and either Sausalito or Oakland, or as transporters of cargo and passengers up the Sacramento and San Joaquin Rivers. They also carried mail and passengers up and down the coast. The San Francisco artist **Joseph Lee** (1827/8–1880) emulated the ship portrait composition established by the East Coast steamboat painters James and John

Fig. 4-10
William A. Coulter
(1849–1936)
General Grant's Return to America, 1879
oil on panel, 26 x 40 in.
Courtesy San Francisco Maritime National Historic Park

Bard when he painted a broadside view of *The Alameda* about 1870 (fig. 4-11). It was a ship portraitist's job to present the ship in its most favorable light. The standard format was a broadside view backed by a bay or open ocean. The ship (usually a sailing ship) was shown at its most magnificent, with all sails unfurled and puffed with wind. Architecturally correct dimensions were crucial. Lee shows the *Alameda* dashing across the painter's vision in a sprightly manner, smokestack billowing, wheels churning froth, and flags blown taut.

As the century came to a close, the concern for realism in marine paintings lessened; scenes became less documentary and more poetic. This reflected not only a general stylistic change in painting but also the fact that, as some historians claim, people become reflective at the ends of centuries. Both metal-sided steamers and square-riggers were treated in a Romantic manner, shown sailing in thick atmospheres of fog, moonlight, sunrises, or sunsets. In **Charles Dormon Robinson**'s (1847–1933) *Passing Through the Golden Gate, Fort Mason* of 1918 (fig. 4-12), the sunset symbolizes the end of the century, the end of the sailing ship era, and the end of the day.

Although most marine paintings represented locales in Northern California, in the last two decades of the century a few were painted in the southern part of the state. **Henry Chapman Ford**'s (1828–1894) *Santa Barbara Harbor* of 1884 (fig. 4-13) is rare for its focus on the harbor, as opposed to the town. Paintings of Southern California's shoreline usually showed recreational activities. Bathing beaches fostered by the area's balmy climate included the Silver Strand near the Hotel del Coronado in San Diego and several in the vicinity of Los Angeles, including Avalon on Catalina Island (off San Pedro), Long Beach, and Santa Monica Beach. Turn-of-the-century beach activities included strolling the sands, looking for shells and rocks, and occasionally wading into the water up to the ankles or knees. Two outstanding examples were painted by northern Californian **Ernest Narjot**, who spent the summer of 1889 in the Los Angeles area, much of it apparently at the beach, if paintings from the trip reflect his activities. His paintings of the coastal resorts of *Avalon* (fig. 4-14) and *Santa Monica* (fig. 4-15) are not only extraordinary for their refined style, but their truthful depiction makes them important historical documents. The Avalon view shows tents, which were a common feature of Southland beaches in the summers, and the

Fig. 4-13
Henry Chapman Ford
(1828–1894)
Santa Barbara Harbor, 1884
oil on canvas, 14 x 26 in.
Private Collection

Fig. 4-14
Ernest Narjot (1826–1898)
Avalon, 1889
oil on canvas, 14 x 24 in.
Private Collection

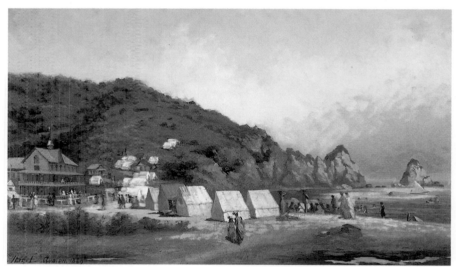

Santa Monica view shows the beach houses where visitors changed clothes. A stylistically different interpretation is **Charles Walter Stetson**'s (1858–1911) *Water Play* of 1859 (fig. 4-16). Stetson's best-known theme is Grecian-dressed women frolicking in idealized landscapes (chapter 8), but Southern California's beach-goers provided a convenient and logical alternative subject. Other South Coast landscape features that attracted Southern California painters were Santa Barbara's Castle Rock and its neighboring beachfront as well as San Diego's great bay (see Lemuel Wiles, *San Diego Bay*, fig. 10-9).

Views of waves crashing against rocks, a theme common with painters today, did not become fashionable until the early twentieth century (chapter 15).

Fig. 4-15
Ernest Narjot (1826–1898)
Santa Monica, 1889
oil on board
14 x 24 in.
Private Collection

Fig. 4-16
Charles Walter Stetson
(1858–1911)
Water Play, 1895
oil on canvas
29 ¾ x 36 in.
Museum of Art, Rhode
Island School of Design,
Bequest of Isaac C. Bates
Photo: Erik Gould

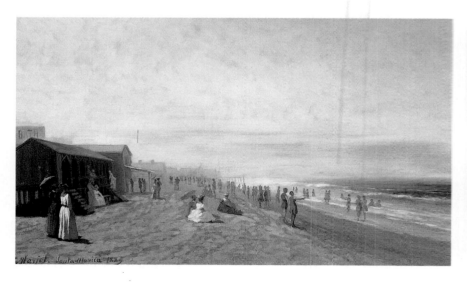

Californians Paint the Tropics

In the mid-nineteenth century the United States began to view Central and South America as brothers in a shared hemisphere. To entrepreneurs who believed in Manifest Destiny, these lands promised capitalistic opportunity such as veins of gold and other metals, guano, and transportation concessions at the Isthmus of Panama. To the religious-minded, Latin America represented a Garden of Eden still in formation through the action of volcanoes and earthquakes, lands inhabited by naked natives and fertile with lush foliage and abundant with wildlife. Charles Darwin's trip to the tropics in the late 1830s resulted in his 1859 *Origin of the Species,* which advanced the principle of natural selection. Other scientists saw Central and South America as lands to be explored, classified, and explained. And, of course, romantics were attracted by the continent's mystery.

By the 1840s American artists had already begun to wander outside their country looking for new subject matter. Most of them had gone to Europe or the Mediterranean. In 1845 the book *Kosmos* (a summary and exposition of the laws and conditions of the physical universe), by the Prussian naturalist, scientist, and explorer Alexander von Humboldt, urged travelers (including artist travelers) to see South America. Humboldt believed paintings of the continent and its flora and fauna could add to the data then being collected by scientists and that the accumulated information could ultimately explain the creation of the world. Although travel in Central and South America was extremely rudimentary, with access limited primarily to areas around seaside ports and along rivers, beginning in the late 1830s, a few East Coast artists did journey to Ecuador, Peru, Chile, Brazil, and Argentina.

The most accomplished of these painters was Frederic Church (1826–1900), the great rival of Albert Bierstadt. Church made his first trip to South America in 1853 and returned with sketchbooks full of material. Over the next several years, he developed his sketches into over-size landscapes of looming Andean peaks, smoking volcanoes, thundering waterfalls, lush vegetation (palm trees, orchids, vines), colorful birds, and tropical fruits. Exhibited in 1859, his *Heart of the Andes* (Metropolitan Museum of Art, New York) was so replete with detail that visitors were advised to bring opera glasses to study it properly. It was also a financial "blockbuster," and people lined up for blocks to pay twenty-five cents to see it.

California's painters of tropical scenes fall into two general groups: forty-niner artists whose scenes derived from their travels across the Isthmus of Panama on their ways to and from California and post-1860s artists, who painted the tropics following the fashion begun by Frederic Church.

Probably the most important of California's tropical painters in the first group is **Charles Christian Nahl**. Like many gold seekers, Nahl decided to travel to California via the Central American route, both to save precious months on the journey as well as to avoid the danger of going around the Horn or overland through Indian Territory. Opting to cross at the Isthmus of Panama (rather than the optional Vanderbilt route that followed rivers and lakes through Nicaragua), Nahl and his family traversed the forty-odd miles from Chagres on the Atlantic to Panama on the Pacific, partly by boat on the Chagres River and partly by horse and foot on narrow trails. Like other travelers, the Nahls were physically drained by the tropic's humid temperatures, beset by swarms of insects carrying malaria and yellow fever, and threatened by mud slides. On the journey Nahl sketched. His *Incident on the Chagres River* of 1867 (fig. 4-17) represents an actual moment on the journey. Painted before the 1880s, it is exemplary of his realistic/naturalistic style rather than his later, melodramatic style.

Another forty-niner, **Albertus Del Oriente Browere** (1814–1867), traveled the isthmus twice. In 1856, he chose the route for his return to the East Coast after four years in California, and in 1858 he used it again, going both to and from California. His second trip inspired several landscapes, including *Crossing the Isthmus* of about 1859 (fig. 4-18). By 1855 the danger of the isthmus journey was relieved by the forty-nine-mile Panama Railway, completed between Panama City and its eastern terminal at Aspinwall. This reduced the crossing to a matter of hours.

Inspired by the highly favorable reception given Church's *Heart of the Andes* in New York in 1859, a few California artists attempted similar subjects and exhibited their work in early Mechanics' Institute shows (initiated in 1857). The theme was encouraged in 1869, when the seventh Mechanics' Institute Fair honored the birth centennial of Baron Alexander von Humboldt (1769-1859). And, it was further stimulated by the prosperous 1870s, where sales and commissions made it financially possible for many artists to make sketching trips to Mexico and Central and South America to garner raw material from which to construct views.

California painters of tropicals were not as concerned with the philosophical questions that propelled East Coast landscapists such as Frederic Church. And, because they entered the field about the mid-1860s when large Romantic tableaux were going out of fashion, their views were more often smaller in size. They

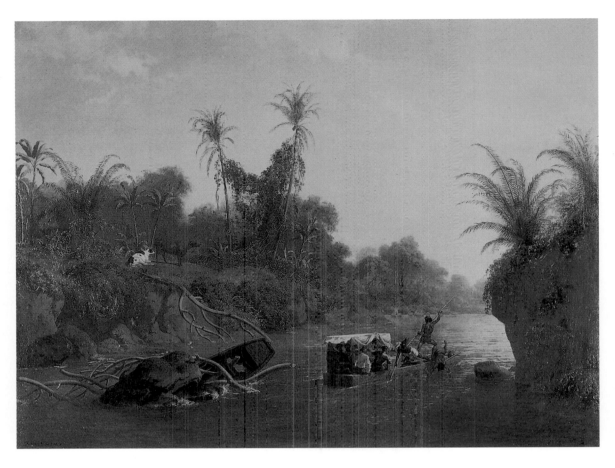

Fig. 4-17
Charles Christian Nahl
(1818-1878)
Incident on the Chagres River,
1867
oil on canvas, 27 x 37 in.
Courtesy, The Bancroft
Library, University of
California, Berkeley,
1963.002.1361-FR

Fig. 4-18
Albertus Del Orient Browere
(1814–1887)
Crossing the Isthmus, c. 1859
oil on canvas, 33 x 48 in.
Crocker Art Museum,
Sacramento, Ca., Gift of the
Crocker Art Museum
Association

Fig. 4-19
Norton Bush (1834–1894)
View of Mountains in Ecuador,
1868
oil on canvas, 24 x 36 in.
Private Collection
Photo: Art Works, Pasadena

painted fewer volcanoes and more placid lake and riverscapes overhung with luminescent skies.

The California artist who most consistently painted tropical scenes was **Norton Bush** (1834–1894). Bush began his career in New York City where Frederic Church encouraged him to take up the subject. He made his first trip to Latin America in 1853, and then went on to San Francisco by way of Vanderbilt's route through Nicaragua. In 1868 a commission from the San Francisco banker and art patron William C. Ralston sent him to Panama to paint scenes related to Ralston's business interests. And in 1875 Bush returned again to the tropics on a commission from Henry Meiggs, a San Francisco businessman, who wanted painted views of his recently completed railway in the Peruvian Andes. *View of Mountains in Ecuador* of 1858 (fig. 4-19) is one of Bush's earlier tropical paintings when he was working in a Hudson River School style and producing landscapes replete with detail. Its title, even its subject—a tiny village dwarfed by the immensity of nature—is very reminiscent of what Church and others were doing at the time. His inventive mind has created a wild Eden of dramatic gorges and verdant foliage against a backdrop of towering mountains. In his later years his compositions became formalized into a central river or lake encircled by hills lush with greenery. Sometimes a native South American poles a boat, reinforcing the foreign theme and

providing scale. Bush produced tropical scenes for many years; his later commissioned work, which includes railroad trains, reveals the increasing European presence in "Eden."

Several other California landscapists who essayed an occasional tropical scene include Granville Perkins (1830–1895), Juan Wandesforde (1817–1902), Ransom G. Holdridge (1836–1899), and Frederick Ferdinand Schaeffer (1839–1927). **Edwin Deakin** (1838–1923), one of California's few artists to specialize in painting views of architecture (including European cathedrals and California missions), provided a variation on the tropical theme in his *Old Panama* of about 1883 (Private Collection; reproduced in *Tropical*, exh. cat., Oakland Museum, October 5–November 14, 1971, p. 31). With his predilection for picturesque architecture, it was a given that Deakin's "tropical picture" would be a study of crumbling and mildewed buildings rather than a panorama of flora. Deakin may have visited Panama in 1877 on his way to Europe for a prolonged visit; the West Coast port was a standard port of call for most ships.

On the East Coast, tropical subjects extended to still lifes of tropical plants and animals. Martin Johnson Heade (1819–1904), in particular, became known for his paintings of hummingbirds and orchids. Although botanically accurate, they are also fine art thanks to their excellent compositions, narrative element, and

refined brushwork. In California, the only artist to approach this theme was **Charles Nahl**, who painted *Bengal Tiger* in 1877 (present location unknown; reproduced in *Tropical,* op. cit., p. 40) as well as several studies of hummingbirds. The hummingbird paintings were done about 1876, inspired perhaps by Heade's 1875 visit to California. Nahl, however, had a long history of incorporating plants and animals into his compositions, even when a subject did not demand it, and his technical facility for painting any number of surface textures was superior to that of Heade. Although he was not a naturalist, he had a scientist's curiosity about the natural world, and his sketchbooks are filled with pencil and watercolor studies of plants and animals so accurately rendered that they approach scientific illustration.

Photographers, too, took advantage of the tropical rage. In 1875, San Franciscan **Eadweard Muybridge** (1830–1904) secretly left California for South America to avoid arrest and imprisonment for allegedly poisoning his wife and murdering her lover. Once safe in Guatemala, he became enchanted by the unusual scenery. Muybridge made many photographs of Guatemala coffee plantations. After he returned to San Francisco, a number were reproduced in his book *The Pacific Coast of Central America and Mexico: The Isthmus of Panama, Guatemala and the Cultivation of Coffee, a Series of Photographs Executed for the Pacific Mail Steamship Company,* San Francisco, 1876.

Tropical scenes sold well to Californians. Many patrons bought them as mementos of their trips across the isthmus; romantics bought them because their imaginations were stimulated by the exotic theme.

The tropics continued to symbolize the natural, the uncomplicated, and the innocent—qualities that provided a respite from urban living. But as the century neared its end, the geography of people's dreams shifted to Hawaii and the South Pacific. These "tropicals" will be discussed in a later chapter. The next chapter will show how only twenty years after the Gold Rush began, San Francisco was already a cosmopolitan city, where artists and residents were eager to lose their frontier trappings and aspire to European tastes that, in turn, changed the look of their art. ❀

Bibliography

Landscapes of California's Settled Areas
Sacramento Valley Landscapes, exh. cat. Davis Art Center; Memorial Union Gallery and Richard L. Nelson Gallery, University of California, Davis, April 23–June 1, 1979.

Marine Paintings—1850–1900
Berney, Charlotte, "Art of the Sea," *Antiques & Fine Art,* v. 5, no. 5, July/August 1988, pp. 62–69.

"Northern California," in William Gerdts, *Art Across America,* New York: Abbeville Press, 1990, v. 3, with marine paintings discussed pp. 232, 244-48.

Stein, Roger B., *Seascape and the American Imagination,* New York: Clarkson N. Potter, Inc., 1975.

Van Nostrand, Jeanne, *San Francisco, 1806–1906, in Contemporary Paintings, Drawings and Watercolors,* San Francisco: Book Club of California, 1975.

Wilmerding, John, *American Marine Painting,* New York: Abrams, 1987.

Tropical Scenes
Manthorne, Katherine Emma, *Tropical Renaissance: North American Artists Exploring Latin America, 1839-1879,* Washington and London: Smithsonian Institution Press, 1989.

Tropical: Tropical Scenes by the 19th Century Painters of California, an exhibit at the Oakland Museum, Santa Barbara Museum of Art and the E. B. Crocker Art Gallery, between October 5, 1971 and March 19, 1972.

Fig. 5-3
Toby Rosenthal (1848–1917)
Elaine, 1874
oil on canvas
38 ⁹/₁₆ x 62½ in.
The Art Institute of Chicago,
Gift of Mrs. Maurice
Rosenfeld, 1917.3;
photograph © 1997,
The Art Institute of Chicago.

German Study and the Fashion for Figural Compositions & Still Life

A popular cartoon from the early nineteenth century shows travelers on a stagecoach. A plainly dressed Yankee sits comfortably inside, while a touring European aristocrat in full dress is forced to ride outside in the weather. Americans were proud of having won their freedom from royal rule, and in the first half of the nineteenth century the themes of democracy, independence, and equality run high as Americans conquered the western wilderness and extended their country from the Atlantic to the Pacific. But attitudes continually change. In the second half of the century, some Americans, having forgotten the tyranny of royal rule, and having made themselves millionaires, now aspired to elegant tastes and aristocratic lifestyles. For them, "culture" came from Europe. Thus, it was to the Continent that American artists flocked to study, while wealthy Americans made the "grand tour" to develop their tastes and to buy paintings, sculpture, and furniture to enhance their newly-constructed mansions.

Among the post-Civil War escapees to Europe in search of culture were several Northern California millionaires, including the Edwin Bryant Crockers of Sacramento and the Leland Stanfords of Sacramento/ San Francisco and Palo Alto. They and many others not only emulated East Coast money barons such as the Vanderbilts but also competed with each other locally for social position. This competition included collecting art. In the early 1870s, Mrs. E. B. Crocker built an "entertainment center" annex to her Sacramento house that was, in effect, an art gallery. In 1885 she left it to the people of Sacramento as California's first public art museum—now the Crocker Art Museum. In 1885, Mrs. Leland Stanford, distraught over the death of her son from typhoid fever in Florence, Italy, founded the Stanford University museum dedicated to the collection of a wide variety of antiquities and art.

The country-wide depression that began in the mid-1870s was exacerbated in San Francisco by the 1877 collapse of the silver-issues market, but while the tightened money depressed the local art scene, it did not totally destroy it. During the lull, until patronage revived in the 1890s, San Francisco continued to experience growth in the arts.

During the 1870s and 1880s many of the city's first generation of San Francisco-born and trained artists went on to Europe for advanced study at the popular centers of Duesseldorf (considered the top European art center from about 1830 to 1870) and Munich (which assumed the lead from about 1865 to 1885). This European exposure changed the look of their art.

Does it really matter where an artist studies? Isn't art training standard throughout the world? The answer is respectively "yes" and "no." For, besides a center's style and techniques, an artist also assimilates its attitudes and ideas. The ideas put forth in Duesseldorf and Munich were not created in an artistic vacuum but grew out of a changing Western European society, democratization, and an expanding middle class. Rapidly losing validity was the Renaissance-established hierarchy of acceptable subjects—at the top historical compositions and in descending order portraits, landscapes, genre, and still lifes. By the mid-nineteenth century, fewer works of art were being purchased by the church and royalty (that traditionally enlisted art to transmit their ideas and glorify their triumphs or inherited rights) and more by the rising middle class. Self-made American millionaires might still buy pretentious European tableaux to demonstrate their taste, but many of them also wanted canvases that related to themselves, paintings that showed average people. They understood straightforward qualities such as realism and technical proficiency.

German ideas in art dominated American art through the 1880s, especially in Northern California where many Northern Europeans had immigrated as early as the Gold Rush. By the early 1890s, German-born artists were numerous enough to form their own association—the Allotria Club. Northern Europeans also imported the guild system, and San Francisco (in contrast to Los Angeles) remained pro-union through the early-twentieth century.

The 1870s and 1880s are San Francisco's glory days for producing subjects promoted in Duesseldorf and Munich, subjects such as history and literary painting, still life, and genre.

History Painting

Every nation feels a need to memorialize its important historical events in painted form. In America, history painting enjoyed its prime from just after the American Revolution until the mid-nineteenth century, a

period when the new republic was commissioning images for its recently constructed capitol in Washington, D. C. Many factors kept the theme alive through the end of the century: tradition, such celebrations as America's centennial in 1876, civic-minded philanthropic patrons, and the need for paintings to decorate the many new state capitols being constructed in western territories.

History painting was a minor theme in California. Although the state's capitol building in Sacramento was completed in 1874, murals (let alone of historical subjects) did not become a part of the decorating scheme until 1914, when a set of twelve was installed by Arthur Mathews. When a rare history painting was made, it usually sprang from an artist's personal interest or a commission from a private party. Although many historical subjects may have been painted, no more than a dozen important works survived the 1906 earthquake and fire.

When California artists began to produce history paintings in the second half of the nineteenth century, the format had gone through considerable evolution. The eighteenth century's over-size tableaux in the Grand Manner style showing events enacted by idealized people in Greek costumes had already been usurped by the trend for historical accuracy. From the early-nineteenth century artists conducted lengthy research to determine the exact landscape setting of an event and the appropriate clothing for the figures. Artists relied on old portraits, or new ones taken from life, to create faces for the people they portrayed.

San Francisco's earliest history paintings were made in the 1850s, at a time when the Duesseldorf style dominated Western European art. Yet, Charles Nahl's *Fire in San Francisco Bay* of 1856 (fig. 4-5), painted by an artist so skilled in the Duesseldorf style that he might have been trained there, is very straightforward and realistic. In the 1850s, Nahl was the main support of an extended family, and he opted for practicality. While the naturalistic approach of *Fire in San Francisco Bay* might not impress some viewers, those who look for what is "American" in American art and "Californian" in California art will applaud the work's honesty and realism. It is a prime example of how artist immigrants from all countries and all levels of society were forced to drop their former habits and tastes and adapt themselves to their new environment and clients, assimilating and creating a common new "American" look.

By the late 1860s, however, the patronage that Nahl began to enjoy from Northern California's newly rich gave him leisure to work in the manner he had learned in Germany.

The German procedure was to first make fine and precise drawings of individual people and objects and then to assemble them into a grand and complex tableau. Usually history pictures illustrated a noble theme derived from the Bible, history, poetry, fiction, or drama. Possibly because Duesseldorf's art students had close ties to the local theater, their style had theatrical qualities. Duesseldorf characteristics are the sharpness of line and contour, the theatrical presentation on a shallow stage, exaggerated facial expressions and gestures, "spotlighting" of figure groupings, and bright, localized colors. Three history pictures in which Nahl employed the Duesseldorf style are *Joaquin Murietta* of 1868 (present location unknown), *Massacre of the Oatman Family* of about 1856 (once owned by Mr. and Mrs. Stephen V. Nahl), representing an event that took place near Yuma in 1851, and *Sheridan's Ride* (current owner unknown), an episode of the Civil War (all reproduced in *Charles Christian Nahl*, exh. cat., E.B. Crocker Art Gallery, Sacramento, 1976).

History painting is essentially conservative, and it was standard practice for its artists to borrow compositional formats used successfully by earlier artists. A history painting that looks to English and early American precedents is Thomas Hill's *Driving the Last Spike* of 1881 (fig. 2-11), which commemorates the driving of the last spike in the Transcontinental Railroad at Promontory Point, Utah, on May 10, 1869. This "group portrait" format was also used by Charles Nahl for his *South Idaho Treaty* of 1866 (Thomas Gilcrease Institute of American History and Art, Tulsa) in which Idaho Governor Caleb Lyon speaks to an encircling crowd of Shoshone Indians.

By the end of the nineteenth century, the Grand Manner style was looked upon as too patriotic, naive, contrived, and romantic, its portrait approach too stiff and formal. A new interest in realism as well as the popularity of genre painting led to more natural compositions and greater realism. Some later history paintings even focused on a peripheral event rather than the main one.

Demonstrating this new approach are two history paintings made for an 1896 competition sponsored by James D. Phelan, a San Francisco mayor sympathetic to the arts. Both commemorate the discovery of San Francisco Bay by the Spaniard Gaspar de Portola in 1769: William Keith's *Discovery of San Francisco Bay* of 1896 (Private Collection) and, the winner, Arthur Mathews's (1860–1945) *Discovery of the Bay of San Francisco by Portola* of 1896 (Private Collection). (Keith's is reproduced in *American Narrative Painting*, exh. cat., Los Angeles County Museum of Art, October 1–November 17, 1974, p. 153, and Mathews's is reproduced in

O California!, San Francisco: Bedford Arts, Publishers, 1990, p. 3.) The landscapist Keith, seems to take his cue from Albert Bierstadt's history painting *Expedition under Vizcaino Landing at Monterey,* 1601 (U. S. Capitol, Washington, D.C.) in that he has painted a landscape populated by small figures. These tiny figures remain the focus, however, because Keith has strung out the party in a line from the foreground, causing the viewer's eye to proceed "into" the picture until it stops at a distant figure pointing a sword toward a cross on the crest of a hill. The silhouetted cross as well as the light-filled sky imbue the eventful moment with a spiritual quality. In contrast, Mathews, a figure painter trained in Paris, gives more emphasis to the individuals involved. Occupying the right foreground, they look toward a distant body of water representing the bay. Taking his cue from the then current trend of history painting to adopt a more genre like attitude, he places the sickly and peripheral figures of the party in the important foreground, and it is difficult even to identify Portola. In Mathews's stylistically up-to-date picture, noble emotions have given way to anecdotalism, moral purpose to objective reportage, a climactic event to the incidental, pretension to realism, and heroism is accorded the average person.

Literary and Religious Themes

The art principles taught at Duesseldorf and Munich were also applied in America to large-size, multi figured tableaux of literary themes: themes from the Bible and non-Christian religions, mythology, plays, poems, and novels. Many of the stories were selected because they taught moral truths. California artists often attempted at least one such picture during studies in Europe. Many hoped that such pictures would pass the strict juries for one of Europe's prestigious competitive exhibitions and, in turn, establish their artistic reputations. Northern California millionaires purchased literary paintings by both Europeans and Californians, but as mentioned earlier, few survived the 1906 fire that consumed the Nob Hill mansions where most of these paintings hung.

For San Franciscans, Munich was the art center that had the greatest influence on their literary pictures. Munich had already succeeded Duesseldorf when art students began to flock to the city between 1865 and 1885. Work issuing from Munich represents a one-step advance from that taught in Duesseldorf. The classic Munich product is a portrait or figure study painted with loose expressive brushwork inspired by an Old Master painter, such as Franz Hals. But over the twenty years that Munich held the top position in the art world, there were actually three distinct phases

or substyles. The earliest is very Duesseldorfian, and it is that style that had the greatest impact on California's literary painting. Two Californians who studied in Munich and eventually settled there are prime exponents of this first-phase style. David Neal (1838-1915) first developed his talents in San Francisco, working as a wood engraver and portrait artist in the late 1850s. But after being sent to Munich by a patron for formal art study, he married the daughter of one of his teachers and remained there. Eventually, he became known for his historical paintings and portraits.

The second "San Francisco" artist to settle in Munich was **Toby Rosenthal** (1848–1917). Prussian born, his family had immigrated to America about 1853 and settled in San Francisco about 1858, where he studied under Fortunato Arriola (chapter 2). In 1865 Rosenthal returned to Europe for study at the Royal Academy in Munich. He, too, married a local girl and stayed in Germany, although he returned to San Francisco for periods of six to seven months to visit family and friends, to paint portraits, and to take on commissions for literary pictures. Rosenthal was extremely helpful to San Francisco artists who traveled to Munich for study.

Rosenthal's *The Trial of Constance de Beverly* of 1883 (fig. 5-1) was commissioned by the San Francisco industrialist Irving M. Scott in 1879. Scott

Fig. 5-1
Toby Rosenthal (1848–1917)
The Trial of Constance de Beverly, 1883
oil on canvas, 57 5/8 x 91 in.
Los Angeles County Museum of Art, Gift of Joseph J. Szymanski in memory of Renate Lippert Szymanski

requested a scene from *Marmion* (1808), a romantic narrative poem by Sir Walter Scott, who was popular with the middle-class reading public. In the story, a beautiful young novice is seduced and persuaded to leave her convent by Lord Marmion, a handsome but faithless suitor. Rosenthal could have selected any "scene" from the poem, but he chose the courtroom in which Constance is being judged by a clerical tribunal. He singles out the trial's most dramatic moment— when a monk plucks the cloak from a figure who appears to be Lord Marmion's page and reveals, instead, the former nun. The complex composition is well organized and drawn, and from the single scene the entire story can be surmised. The torch-lit, smoky room reflects the oppressive society of the Middle Ages. In the background, two monks prepare a niche; once the judgment is leveled they will seal Constance alive inside. The painting's moral is that an awful fate awaits anyone who strays from righteousness.

Rosenthal's main competitor in San Francisco was **Domenico Tojetti** (1806–1892), who arrived in California in 1871 at the age of sixty-five. Tojetti left a successful career in Rome, where he had received commissions from popes and was decorated by kings. Although he was already advanced in age and ill, once in San Francisco, he and his two sons seem to have found new energy. They made many portraits, painted frescoes in local mansions and altar decorations in churches, and even taught art. Just a few of Tojetti's paintings survived the 1906 fire. *The Progress of America* of 1875 (fig. 5-2), probably painted for America's Centennial in 1876, is a literary theme inspired by the famous line by Bishop Berkeley, "Westward the path of empire takes its way." American progress is symbolized by the central female figure who points her chariot westward. Cherubs herald her advance as she rides down heathen Indians, and in her wake she draws in female figures symbolizing European achievements in science and culture: medicine, learning, art and architecture, music and agriculture, and there is even a railroad train. Tojetti celebrates America's glory and its triumphant right to carry progress westward.

Once, when Rosenthal and Tojetti each produced a canvas titled *Elaine,* the competition between the two artists made national front-page news. The theme derived from Alfred Tennyson's (1809–1892) poem *Idylls of the King* (1859), four legends from the time of King Arthur, one of which was "Elaine" (later titled "Lancelot and Elaine"). The art patron Tiburcio Parrott first commissioned the subject from Rosenthal when the artist was in San Francisco in 1871-72. **Rosenthal's** *Elaine* (fig. 5-3, p. 64), completed in 1874, was

Fig. 5-2
Domenico Tojetti
(1806–1892)
The Progress of America, 1875
oil on canvas, 71½ x 102 in.
Collection of the Oakland
Museum of California, Kahn
Collection

considered outstanding enough to be given three special public exhibitions before it disappeared into its private collection. The artist showed it in Berlin and Boston, then in San Francisco at the Snow and May gallery. The morning of April 2, 1875, the picture was stolen. Until the painting was recovered, two days later, the incident received national press. When it came time to deliver the painting to Parrott, who had commissioned it, Rosenthal sold it instead to another San Francisco collector for a higher price. Parrott retaliated by asking Tojetti to "do a better one." The following year, when Tojetti's *Elaine* (Private Collection) was completed and exhibited at Snow and May, the press naturally compared it to Rosenthal's. Critics noted that the two artists represented differing schools of artistic thought: Rosenthal "interpreted" the poem by emphasizing mood and showing the expired heroine lying at dusk on a flower-bedecked barge rowed by a black-cloaked figure. Tojetti followed the poem's description to the letter and chose to emphasize the exquisite surface textures of cloth and other stuff. Each treatment had its enthusiasts.

Many other San Francisco artists painted a literary picture on occasion, especially during their residences in Europe. But by the beginning of the twentieth century, literary painting as such had died out.

Still Life

Through the second half of the nineteenth century, still lifes—those paintings featuring inanimate objects from nature as well as manufactured objects—enjoyed great popularity. This would have caused Sir Joshua Reynolds great dismay. He stood stalwartly behind the Renaissance ranking that placed still life at the bottom of a list of subjects worthy of painting. Still lifes seemed to teach no moral virtues, and their apparent goal—the eye-fooling rendering of surface textures—was entirely superficial. But, indeed, some European still lifes were meant to make people question their existence—rusted arms and armor signified the futility of war, human skulls the inevitability of death, and crumbling sculpture and architecture the transitory nature of human achievements. And Reynolds could not have predicted a changed society in which the middle class and the newly rich would become the major art patrons. Their materialism fostered realism and the painting of objects that had beautiful and interesting surface textures. The more realistic, the more complex the composition, and the greater the variety of textures, the more impressed these patrons were, and the better a painting suited their cluttered Victorian rooms.

By the time the first still lifes were painted in San Francisco, in the 1850s, East Coast artists had already brought about America's still life "renaissance." Flower pictures were produced for the drawing room, fruit, and vegetable still lifes for the dining room, dead game and hunting implements as well as other masculine subjects such as tobacco and beer steins for the study. But, when California artists first began to paint still lifes, they showed little interest in adopting such East Coast themes as piles of used books, paper money, oysters, and musical instruments. Both artists and patrons preferred objects that reflected their region—grapes and oranges grown in California, fish and ducks caught in local streams and marshes, wines and brandies produced in the state, and items from import shops such as ceramic vases and figures from China and Japan.

Hundreds of small- to medium-size still lifes were produced by competent painters, and an increasing number of these painters were women. In the simplest form of still life a few objects are displayed on a shallow shelf or tabletop in front of a plain or dark background. Sometimes objects are hung or tacked against a flat backdrop—often a wooden door or a brick or ashlar stone wall. Both compositions allowed the painter to present objects against the surface of the picture where their textures were easily visible. No attempt was made to develop deep, three-dimensional space.

The most impressive still lifes are highly complex and elaborate ones. Composed of multiple objects with a great variety of surface textures and arranged on several tiers, some even have a landscape background or include people in order to tell a story. While realistic rendering was the goal of most still-life painters, especially at midcentury, subtle stylistic differences hint at European sources, at personal capabilities, and at the social changes that continued to modify the look of still life through the end of the century.

Apart from the scientific illustrations of California plants and animals that a number of the state's early expedition artists rendered in watercolor in the late 1700s and early 1800s, California's earliest outstanding still lifes were painted in the 1850s by the energetic and multitalented Charles Nahl. Like the earliest "still lifes" created on America's East Coast during colonial times, Nahl's appeared in the corners and backgrounds of more practical subjects, such as portraits. His reasons for adding these seemingly unnecessary details to his portraits and certificates are unknown. It is assumed that he enjoyed demonstrating his technical abilities, that the flowers, fruit, and animals added richness, and that their execution may have made the duty of painting endless portraits more interesting. Nahl crafted still-life objects with the meticulous draftsmanship, tight drawing, and enamel-like colors of the Duesseldorf painters of the mid-nineteenth century.

Fig. 5-4
Samuel Marsden Brookes
(1816–1892)
Steelhead Salmon, 1885
oil on wood panel
40 x 30 in.
Collection of the Oakland
Museum of California, Kahn
Collection

Fig. 5-5
Theodore Wores
(1859–1939)
The Chinese Fishmonger, 1881
oil on canvas
34¾ x 46 in.
National Museum of Ameri-
can Art, Washington D. C.
/Art Resource, N.Y.

San Francisco's first full-time painter of still lifes and the one who remained its most important until the 1890s was **Samuel Marsden Brookes** (1816–1892). Brookes had trained in the Midwest as a portraitist but began to paint still lifes just before his move to the Bay Area in 1862. He became best known for his pictures of fish and later of grapes, both plentiful in California.

In the mid-nineteenth century, still lifes of hunting implements and dead game comprised a major category. Society was gravitating from a frontier lifestyle, where men hunted to help feed the family, to urban living, where hunting was regarded as a sporting pastime. Northern California was a hunter's paradise, rife with big game including mountain lions, bear, and deer, and where ducks and fish teemed in its many sloughs and streams. Brookes's two favorite compositions show fish either lying flat or hanging up (usually in front of a painted brick wall). A painting of Brookes at work by his studio-mate, Edwin Deakin (reproduced in Butterfield & Butterfield, *American & California Paintings and Sculpture, June 15, 1995*, lot 4168, p. 67), shows how Brookes suspended real fish next to his easel in order to copy them. Experts generally agree that his rendering of fish scales and his ability to portray the sagging weight of fish exceeded even that of his presumably more sophisticated East Coast counterparts. His work, however, is not *trompe l'oeil* (the French term for "fool the eye"). Unlike many East Coast artists, this was not a goal of California artists. *Steelhead Salmon* of 1885 (fig. 5-4) is one of Brookes's most impressive pictures not only because the fish are masterfully rendered but because it has a three-dimensional landscape background and a "story line"—suggested by the fishing pole handle. The English pre-Raphaelite style emulated in America at mid-century, encouraged placing still-life objects in outdoor settings. Sometimes flies, bees, and butterflies were added for veracity. The exactness of Brookes's title indicates pride in California's unique and abundant wildlife, as well as society's increased respect for science and botanical classification.

When Brookes realized that he was gaining a reputation only as a painter of fish, he took up the painting of fruit. California was a center for the cultivation of grapes harvested for the table, dried for raisins, fermented into wine, or distilled into brandy. Some of Brookes's more complex pictures of grapes include bottles bearing labels of California wineries.

If Nahl reflects the influence of Duesseldorf and Brookes the influence of England, then Munich influence is best seen in **Theodore Wores**'s (1859–1939) *The Chinese Fishmonger* of 1881 (fig. 5-5). Wores was one of San Francisco's most important artists to take

graduate training in Munich, where Toby Rosenthal helped him get settled. Wores did not adopt the first period Munich style of which Rosenthal was a master but rather became a friend of two American art students, William Merritt Chase (1849-1916) and Frank Duveneck (1848-1919), both of whom worked in the "classic" or middle-period Munich style. Noted for its slashing virtuoso brushwork, this style was inspired by Old Masters, such as Franz Hals, and was used primarily on portraits and figure studies. This style initiates the transition from interest in draftsmanship to painterliness, from an emphasis on subject matter to creating a "work of art."

Wores returned to San Francisco in 1881 to start his career, determined to paint a subject that would make San Franciscans take notice. Artists returning to San Francisco from European study often complained that there were no interesting subjects to paint in the city. But Wores merged the picturesque theme of Chinatown (a subject that no artist had yet specialized in) with a still life of fish (made popular by Edwin Deakin) to arrive at *The Chinese Fishmonger*. Wores then followed the practice he had learned in Munich—first gaining inspiration from a painting or an artist of the past and then infusing his own work with a dynamic balance between realism and virtuoso brushwork. *The Chinese Fishmonger* seems to derive from William Merritt Chase's *The Yield of the Waters* of 1878 (Detroit Institute of Arts, Founders Society), which shows a mound of mixed sea life heaped on a table. Wores may have seen this picture in Europe before Chase painted out the fishmonger that was once in the upper right background. If so, the two compositions become almost identical, and both demonstrate the new fashion for including a person as a peripheral element in a still life. True to his Munich training and to changing attitudes about art, Wores shows no interest in eye-fooling technique but uses expressive brushwork to create a "painting." California-specific are the Chinese fish seller, his basket, and the calligraphic labels on the boxes in the background. The variety of sea life celebrates the bounty of California's coastal waters. Outstanding are the picture's large size, the slipperiness of the fish—that surpasses even Brookes's fish scales—the variety and quantity of items and textures, the elaborate "room type" setting, and the storytelling aspect provided by the fish seller.

Other Munich-trained artists, such as **Henry Raschen** (1854–1937), who may have traveled to Europe with Wores in 1875, at least once produced similar large-scale and painterly still lifes. At first glance one wonders if Raschen's *Pomo Interior, Fort Ross, California* of 1884 (fig. 5-6) is a still life or a genre

Fig. 5-6
Henry Raschen (1854–1937)
Pomo Interior, Fort Ross, California, 1884
oil on canvas
40¼ x 30 in.
Autry Museum of Western Heritage, Los Angeles
Photo: Lawrence Reynolds

scene. It is really both, and it is outstanding for the same pictorial reasons as Wores's painting: style, complexity, and a narrative element. Raschen painted pictures of Indians in northern California and Arizona. His early works (1884–90) such as these are tight and realistic. This particular work was one of a group he made of the Pomo in the vicinity of Fort Ross. It is ethnographically accurate, revealing details of the redwood hut interior and of Pomo food types and cooking methods that only someone on the spot could observe. It is also interesting as a still life for its detail, the objects' varieties of texture, and the work's narrative. The combination of redwood hut and seafoods suggest these Pomo are from the coast (as opposed to those from the valley). However coastal Pomo also foraged inland, which explains the presence of acorns and small mammals and birds. The basket shows the fine coiling and feather-work for which the Pomo were known. The large basket on the floor is made by the twining method, and the metal cooking pot is a trade item. The representation of racial groups in Wores's

Fig. 5-7
Emil Carlsen (1853–1932)
Still Life with Game and Radishes
oil on canvas, 24 x 30 in.
Oakmont Corporation
Photo: Victoria Damrel
(Clique Studio, Long Beach)

Fig. 5-8
Edwin Deakin
(1838–1923)
A Tribute to Santa Barbara,
1907
oil on canvas, 42 x 32 in.
Phila Witherell Rogers

and Raschen's still lifes reflects a late-nineteenth-century interest in so-called primitive peoples (chapter 6).

As these pictures demonstrate, late-nineteenth-century still lifes discarded the *trompe l'oeil* goals of midcentury and took on the new interest in pictorial values. A further step was made by **Emil Carlsen** (1853–1932), who taught briefly in San Francisco (at the School of Design from 1887 to 1889 and privately from 1889 to 1891) but whose impact was tremendous. Just before arriving in San Francisco he had spent two years in France painting still lifes on contract for a New York City art dealer. In Paris he studied the work of Jean-Baptiste-Simeon Chardin (1699–1779), the well-known eighteenth-century French painter of kitchen interiors and raw foodstuffs. When Carlsen arrived in San Francisco he already was painting simple arrangements of a few homely objects. One favorite composition combined dead birds and copper kitchen bowls on a shallow ledge in a deep brown atmosphere. A prime example is *Still Life With Game and Radishes* (fig. 5-7). The simple arrangement of a few common (rather than luxurious or exotic) objects reflects Chardin's work, while the abstract, off-center balance derives from the Far Eastern aesthetic that was then being assimilated into Western art. Carlsen's limited color scale and expressive brushwork seem a legacy of Munich. His teaching can be seen in the numerous still lifes of common garden vegetables, such as artichokes, asparagus, eggplants, onions, and squash, against brownish black backgrounds, produced by his students.

As the century came to a close, pictures of the state's many cultivated and wild flowers assumed dominance. California, and especially Southern California, was heralded as a garden land; almost any plant from any region or climate of the world could grow there, as long as it could be irrigated. Middle-class homeowners planted their own private flower plots, and wealthy individuals laid out multi-acred gardens of unusual botanical specimens from all corners of the earth. Commercial flower and seed growers developed huge, profitable enterprises. In the spring, wildflowers turned whole hillsides gold from poppies, blue from lupines, and yellow from mustard. Flower painting was also spurred by hybridization that developed larger and more spectacular blooms (especially roses), by Victorian sentimentality, which attributed symbolic meaning to different kinds of flowers, and by the entry into the painting arena of women artists. (Many women artists painted series of California wildflowers using the traditional format for botanical renderings—a flower sprig floating against a plain background.)

Edwin Deakin's *A Tribute to Santa Barbara* of 1907 (fig. 5-8) is an exceptional flower still life. Although the artist shared a studio with Brookes, Deakin developed his own still-life talents only after Brookes died in 1892. This elaborate composition is redolent with California references: against a California mission and garden, he paints masses of roses and an Indian pot (which is actually Southwestern). Southern California was particularly proud of its roses, lavishing and even flaunting them at public events such as Pasadena's Tournament of Roses parade (begun in 1889). These particular blooms may have come from the garden of Deakin himself who cultivated roses at his Berkeley home. Rather than painting a simple vase of roses, Deakin turns the vase and flowers into a narrative, an offering to Saint Barbara, whose image is seen in the niche on the upper right. California sunlight streams in from the arch to illuminate the multitiered composition.

At the end of the century California's still-life movement was further influenced by the entrance of Southern California artists into the state's art history, by the emergence of women artists, and by the acceptance of the watercolor technique into the realm of "fine" art. Both styles and techniques for rendering still-life objects multiplied in variety. One of the most talented of San Francisco's women still-life painters was **Alice Chittenden** (1859–1944), who shared the admiration of her decade for two flowers—chrysanthemums and roses. *Still Life with Chrysanthemums* of 1885 (Private Collection; reproduced in Butterfield & Butterfield, *Selected California Paintings*, sale October 14, 1987, lot. 2066) is her finest known painting. Although only a one-ledge arrangement, it is rendered complex by the massed flowers and made "Californian" by the inclusion of Oriental objets d'art, such as the pot, the raffia-like drapery, and the woven mat. (Chittenden also produced a series of botanical studies of California wildflowers [Coll. Huntington Library and Art Gallery].)

In Los Angeles, the preeminent woman still-life painter in oil was **Alberta Binford McCloskey**

(c. 1855–c. 1911). Because her parents lived in Los Angeles, she and her husband, also a painter, moved there in the mid-1880s to launch their careers. The two painters continued to move in and out of Los Angeles, San Francisco, New York, and other art centers throughout the 1890s. Alberta McCloskey was one of the growing number of highly talented and liberated women who transcended the scornful term "woman artist" and led successful careers at the end of the century. Her speeches before womens' and civic clubs show her to be a self-made artist and an independent thinker. If California ever had a painter of *trompe l'oeil* still life, McCloskey held the claim. The McCloskeys are best known for their paintings of oranges wrapped in tissue paper. Orange groves abounded in Southern California, and many local still-life artists painted the fruit. An example by Alberta McCloskey is *Untitled (Oranges in Tissue with Vase)* of 1889 (fig. 5-9), which follows the formula invented by the couple in New York about 1888—oranges atop a mahogany table against a dark, usually Prussian blue, background. (McCloskey arrived at her color schemes by conducting experiments, holding up different colored panels behind the sitters in her portraits, and possibly her still-life objects, to decide which colors were best.) Her arrangements are simple, and the stunning color and the spare quality of the few tightly arranged fruits leads some writers to term them "modern" and "abstract." Like Nahl fifty years earlier, she seemed to enjoy the challenge of rendering new and complex textures, such

as the cloisonne surface seen on Chinese vases, an exotic object available in local import shops. McCloskey was an incredible technician who consistently turned out high-quality work that won praise from reviewers.

Southern California could also boast of **Paul DeLongpre** (1855–1911), the self-proclaimed "roi des fleurs," who was active in Los Angeles from his arrival for health reasons in 1898 until his death. *Wild Roses* of 1898 (fig. 5-10), one of the artist's most spectacular presentations, is rendered in DeLongpre's favorite medium, watercolor, with his characteristic light and delicate touch. He cultivated most of his subjects in his own Hollywood garden, and many are indigenous to California, such as the golden poppy and various cacti. Although his flowers are rendered with such reality that their botanical species can be identified, they are at the same time incredibly beautiful art objects. While they convey a Victorian sentimentality they never descend to sweetness.

Duesseldorf and Munich had far-reaching influence. The next chapter will show how they also lent their styles to some of California's best genre paintings. ✶

Bibliography

Northern California Art World, 1877–1890

Addresses at the Inauguration of W. T. Reid as President of the University of California, and the Dedication of the Bacon Art and Library Building, Berkeley, August 23, 1881, Sacramento: State Printing Office, 1881. 100 p.

Catalogue of the Art Loan Exhibition for the benefit of the Society of Decorative Art of California at the rooms of the San Francisco Art Association, San Francisco: C. A. Murdock & Co., Printers, 1881. 87 p.

Crocker Art Museum: Handbook of Paintings, edited by Richard Vincent West, Sacramento: Crocker Art Museum, 1979.

Feallock, Kay, "The Kingsley Art Club: One Hundred Years of Support for the Arts," *California History,* v. LXX, no. 4, Winter 1991/92, pp. 392–95.

Schwartz, Ellen, *Nineteenth-Century San Francisco Art Exhibition Catalogues,* Davis, Ca: University of California, Library Associates, 1981.

Schwartz, Ellen Halteman, *Northern California Art Exhibition Catalogues (1878–1915),* La Jolla: Laurence McGilvery, 1990.

The Stanford Museum Centennial Handbook: 100 Years 100 Works of Art, Stanford, Ca.: Stanford University Museum of Art, 1991.

Duesseldorf and Munich Influences

Baird, Joseph Armstrong, Jr., *Theodore Wores and the Beginnings of Internationalism in Northern California Painting: 1874–1915,* exh. cat., University Library, University of California, Davis, 1978.

The Duesseldorf Academy and the Americans, exh. cat., High Museum of Art, Atlanta, Ga., n. d., 1972. 135 p.

Gerdts, William H., "The Duesseldorf Connection," in William H. Gerdts and Mark Thistlethwaite, *Grand Illusions: History Painting in America,* Fort Worth, Tx.: Amon Carter Museum, 1988.

The Hudson and the Rhine die Amerikanische Malerkolonie in 19 Jahrhundert, exh. cat., Kunst-Museum, Duesseldorf, April 4–May 16, 1976.

Quick, Michael, *Munich and American Realism in the 19th Century,* exh. cat., Cincinnati Art Museum, April 20–May 28, 1978 and two other venues. 127 p.

History Painting

Arts and Antiques of the State Capitol, Sacramento, California, Sacramento: California State Legislature Joint Committee on Rules, 1984.

Gerdts, William H. and Mark Thistlethwaite, *Grand Illusions: History Painting in America,* Fort Worth, Tx.: Amon Carter Museum, 1988.

Still Life

Driesbach, Janice T., *Bountiful Harvest: 19th Century California Still Life Painting,* exh. cat., Crocker Art Museum, November 15 - December 29, 1991 and one other venue. 88 p.

Gerdts, William H. and Russell Burke, *American Still Life Painting,* New York: Praeger, 1971.

"Northern California," in William H. Gerdts, *Art Across America: Two Centuries of Regional Painting, 1710–1920,* v. 3, New York: Abbeville Press, 1990.

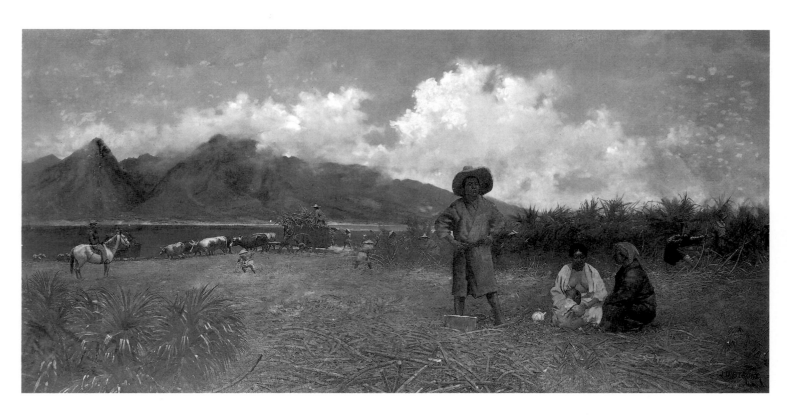

Fig. 6-7
Joseph Strong (1852–1899)
Japanese Laborers on
Spreckelsville Plantation, 1885
oil on canvas, 39⅜ x 78¾ in.
Taito Co., Ltd., Tokyo

Art, The Industrial Revolution & Urban Living

Genre (1870-1900)

To most people the word "genre" simply means "type" or "category," but in the art world it refers to pictures of ordinary men and women engaged in everyday activities, sometimes presented with overtones of humor or cynicism.

Genre painting reached its first peak in seventeenth-century Holland and Belgium, but it has sporadically cycled back to popularity with later generations. One of its high points occurred in nineteenth-century America. Americans were not intimidated by Europe's elitist hierarchy of the arts that placed genre near the bottom of a list of worthy subjects. Because genre dealt with ordinary people and events, it appealed to a country proud of its freedom from royal rule, proud of its democracy, and respectful of the worth of the average man. Americans enjoyed looking at scenes in which they saw themselves happily gathering sap from maple trees, picking apples, husking corn, dancing in barns, hunting, going to school, and so forth. Genre painting was further spurred in the second half of the nineteenth century by the fashion for studying art in Duesseldorf and Munich, where such subjects were popular, as well as by a growing middle class with excess money to spend on scenes of people like themselves. As all corners of America were settled, painters began to depict the life unique to each region.

San Francisco artists entered the genre arena vigorously with their scenes of gold-mining activities (chapter 2). But as immigrants from all lands swelled the population between the 1860s and the 1880s, the California lifestyle became more complex, and California artists saw around them more diverse subjects. Certain themes enjoyed greater popularity than others.

A popular theme for American, and also California genre painters was American life as it was lived in earlier times. Interest in this theme was prompted, no doubt, by America's Centennial celebration of 1876, an event that caused the nation to reflect on its own history. Scenes of "simpler" eras also appealed to people in the second half of the nineteenth century who were seeking escape from conflicts (some as grave as the Civil War) and from the rapidly increasing social pressures of the industrial revolution and urban life.

American artists often depicted history from their own regions. East Coast artists gravitated toward subjects such as the daily life of the Pilgrims, while Californians turned to painting scenes of rancho life. Californians, observing the rapid disappearance of their Spanish-Mexican heritage under the flood of immigrants from Northern Europe, wanted to preserve it in images. They also found the rancho era picturesque, an escape into a romanticized past. The leading exponent of Spanish-Mexican California subjects was, once again, the multitalented **Charles Nahl.** In the 1870s patronage from men like Judge Edwin Bryant Crocker of Sacramento gave Nahl leisure to plan and execute canvases as large as *The Fandango* of 1873 (fig. 6-1). Although this huge painting contains numerous figures, Nahl's training taught him how to simplify the visual confusion by grouping elements into triangular arrangements and highlighting key parts of the scene. He has striven for a composite view, one that shows the full variety of social intercourse attributed to California festivities. The dancing couple is made the focal point by strong lighting and is further set off by darkened, enframing vignettes: figures engaged in courting, horseback riding, fighting, playing music, and conversing. Nahl has captured the feel of this period, a time when life presumably was relaxed (an easy living could be made from raising cattle and selling hides) and dark-eyed senoritas and handsome caballeros had

Fig. 6-1
Charles Christian Nahl
(1818–1878)
The Fandango, 1873
oil on canvas, 72 x 108 in.
Crocker Art Museum,
Sacramento, Ca., E. B.
Crocker Collection

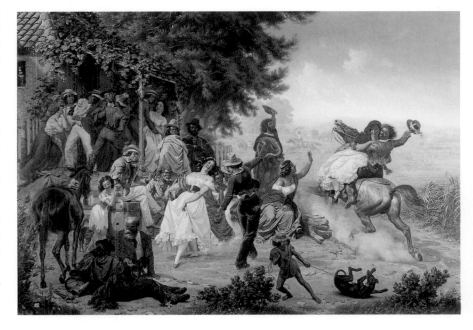

Fig. 6-2
William Hahn (1829–1887)
Convalescent, 1873
oil on canvas
30½ x 24¾ in.
Alvin and Muriel Rosow

Fig. 6-3
Ernest Narjot (1826–1898)
Quail Hunting in Marin,
1877
oil on canvas, 29¼ x 19¼ in.
Dr. and Mrs. Edward H.
Boseker

only to flirt, wear colorful clothing, and ride spirited horses. The exuberant joy, the fine draftsmanship, the brightly colored costumes, the lively activity, all make this a happy picture carried off with a great technical facility. By the date this picture was painted, most Northern California vestiges of the Spanish-Mexican ways had been wiped out by Yankee "progress," and many of San Francisco's genre artists in search of material to sketch were forced to travel to sleepy Los Angeles to find adobes still standing and rancho life intact.

The most popular subjects for genre painters were scenes of contemporary life, and the artist most adept at recognizing interesting, California-specific subjects was the German immigrant **William Hahn.** Active in Northern California for only ten years on and off, beginning in 1872, his industriousness resulted in a number of fine tableaux that show how complex California society had become only twenty years after the Gold Rush. Hahn's themes include rural views of logging, stage coaching, bear hunting, and touring in Yosemite, but he also painted urban life in Sacramento and San Francisco. *Convalescent* of 1873 (fig. 6-2) depicts an infirm late-nineteenth-century woman in the elegant Victorian surroundings enjoyed by San Francisco's wealthier residents. What a difference from the rough cabins inhabited by gold miners only twenty years earlier! This image of a pampered woman hints at a theme that grew to major proportions at the turn-of-the-century —an idealized, sheltered, fragile being that society placed on a pedestal. The growing, affluent middle class, represented by this woman and her visiting friend, was a major source of patronage for local painters.

This comfortable middle class also had time for leisure activities, which resulted in the late-nineteenth-century rise of the recreation movement. In Northern California this revolved around the mountain wildernesses where sports enthusiasts hunted, fished, hiked, and camped. (By contrast Southern Californians gravitated to the seashore, cycled, played tennis, and rode horses.) Among the Northern California genre scenes of recreation are: Thomas Hill's *Thomas Hill and Virgil Williams with Wives, Fishing* of about 1873 (Private Collection); Ernest Narjot's *Glen Ellen* of 1878 (California Department of Parks and Recreation, Shasta State Historic Park) that shows ladies bathing in a lake; and **Ernest Narjot**'s *Quail Hunting in Marin* of 1877 (fig. 6-3). Other paintings demonstrate the fashion for camping by picturing tents among pines or redwoods. Northern California was a hunter's paradise replete with game birds, fish, and wild game. In *Quail Hunting,* Narjot implies depth by zigzagging huntsmen down the hill and by increasing their size.

San Francisco-born **Henry Alexander** (1860–1894) was one of the few West Coast practitioners of a particular category of genre painting that portrayed individual craftsmen at work in their homes or shops. This subject originated in Munich near the end of that city's art dominance and was developed there by artists who derived their inspiration from the little masters of seventeenth-century Holland and Flanders. Alexander no doubt came upon this theme when he studied in Munich and then brought it back to San Francisco. *In the Laboratory* of about 1887 (fig. 6-4) is a prime example. Following Munich practice, the canvas is small, the palette limited almost to a monochrome, and the main figure placed in a room crowded with the instruments of his profession. (At the time, Thomas Price, the scientist, was California State Mineralogist and Chemist.) Alexander's minutely detailed environments are not only a tour de force of miniature still-life painting but are fascinating for the information they give us about nineteenth-century occupations. Alexander painted taxidermy shops, shoe repair shops, a bachelor's quarters, and the interiors of Chinese restaurants, among other things. Only about two dozen of his paintings survive. Alexander committed suicide at the age of thirty-three, and all of his work that had been gathered for a memorial exhibition was lost in the San Francisco fire of 1906. Two more pictures were destroyed in the Oakland fire of 1991.

"Primitive" Peoples as Subjects

Americans of European descent were the subjects of most genre pictures, but the late nineteenth century saw artists become increasingly interested in so-called primitive peoples—gypsies, peasants, workers at manual tasks (such as farmers and fishermen), as well as peoples from non-European countries. Just as the Western world's urban-weary escaped into the painted worlds of historic eras, they also escaped into canvases picturing their contemporaries who had retained uncomplicated lifestyles. Paintings of simpler ways of life were first produced in Europe in the mid-1870s when city-bound artists, summering in the country, discovered not only a peaceful place to work but also picturesque subject matter of peasants and fishermen. Americans adopted this interest, substituting racial groups, such as blacks from the South and Native Americans from the Southwest. Northern California artists added two "colorful" subcultures of their own: the Chinese of San Francisco's Chinatown and the Pomo Indians of the peninsula north of San Francisco.

The Chinese, who first came to California to try their luck in the gold fields, arrived in even greater numbers to work on the railroads. Eventually they settled

Fig. 6-4
Henry Alexander
(1860–1894)
In the Laboratory, c. 1887
oil on canvas
36 x 30 in.
The Metropolitan Museum
of Art, Alfred N. Punnett
Fund, 1939; photograph
© 1981 The Metropolitan
Museum of Art

Fig. 6-5
Theodore Wores
(1859–1939)
*New Year's Day in San
Francisco Chinatown,* c. 1881
oil on canvas, 20 x 22 in.
Dr. A. Jess Shenson

in enclaves within West Coast cities. The best-known Chinatown was San Francisco's that developed around Portsmouth Square. Its dark and mysterious alleys, doorways leading to exotic quarters, tangles of remodeled buildings, sidewalks crammed with vendors' stalls, signs painted with calligraphy, and, reputedly, a parallel subterranean city with opium dens, gambling houses, and female slaves, seemed romantic and picturesque to those of European background.

The first artist to represent San Francisco's Chinatown may have been William Hahn in 1872. Other artists began to be attracted by the colorful dress and exotic customs of the inhabitants. The most important of these is **Theodore Wores** (1859–1939). Between his return from Munich in 1881 and his departure for Japan in 1885, Wores depicted the "Celestials" (as they were then called) in several genre scenes, including *New Year's Day in San Francisco Chinatown* of about 1881 (fig. 6-5). The Chinese New Year usually falls between January 21 and February 19 and is one of the most important traditional Chinese celebrations, usually involving a parade with a man-made dragon and fireworks. Chinatown residents were suspicious of any Caucasian in their midst until Wores befriended a young Chinese art student who accompanied him into the quarter. An interesting stylistic leap occurs in Wores's paintings of the early 1880s. While his *Chinese Fishmonger* of 1881 is pure Munich in its brown tonality and slashing brushwork, within months he picked up the modern traits seen in *New Year's Day.* These include, in addition to a pleasant subject, perspective that runs off one side of the canvas, an asymmetrical composition, broken brushwork, and lightened colors, all usually associated with the Impressionist style. Although there was countrywide resentment against the increasing numbers of Chinese entering America, both legally and illegally, Wores's work sold well, probably because of its pleasant themes, bright colors, and romantic and exotic subject matter.

Wores's success inspired a host of other San Francisco artists to take up this theme in the late 1880s and 1890s, including Amedee Joullin (1862-1917), Henry Alexander, Edwin Deakin, Henry Nappenbach (1862-1931), and especially Charles Rogers (1848-1918). A few artists painted views of Los Angeles's Chinatown in the 1890s, including Alexander Harmer (1856-1925)

(fig. 11-5) and Frederick Schafer (1839-1927), although that enclave was much smaller and less picturesque. Chinese and other Far Eastern objets d'art sold in curio shops throughout America were highly regarded by still-life artists for their decorative qualities and surface textures.

California's Native Americans offered another population group. Unlike the romantic and glamorous Plains Indians who hunted buffalo from horseback, California Indians were pacific, primarily gatherers who lived in temporary tule or redwood bark huts. Mission life had stripped them of their culture, and their population had been sharply decimated by disease and starvation. Except for artists with expeditions during the Spanish period, few painters had shown an interest in depicting them. Interest resurfaced at the end of the nineteenth century when artists sought out peoples who led simple lives and when others, concerned about the possible extinction of the Native Americans and their unique culture, wished to preserve them in paint. There was a rush to document what remained of California's Native Americans and their culture before both disappeared.

Henry Raschen (1854-1937), who returned from eight years of study in Munich to make his living as a portrait painter in San Francisco in the mid-1880s, began to paint Northern California's Pomo Indians. To find subjects to sketch he sometimes traveled up to Fort Ross with fellow landscapist Carl von Perbandt (1832–1911) and to his family's ranch in Sonoma County. (See *Pomo Interior Fort Ross, California,* fig. 5-6.) Raschen, like several other painters of Native Americans who circulated through Los Angeles at the turn of the century, ultimately turned to depicting the Pueblo Indians of Taos and Santa Fe.

The painter best known for her representations of the Pomo Indians is **Grace Hudson** (1865–1937), who worked in Ukiah, almost in the center of the area occupied by the tribe. Growing up on a farm in Potter Valley, Hudson had known some of the Pomo as a child. During her study at the San Francisco School of Design, she undoubtedly learned of the current art world interest in "primitive" peoples. But her specific devotion to documenting the Pomo developed only after she returned to Ukiah and married a physician, who shared her interest in the tribe and ultimately

Fig. 6-6
Grace Hudson (1865-1937)
The Seed Conjurer, 1896
oil on canvas
25 x 15 in.
Courtesy of the Grace
Hudson Museum, Ukiah,
California

turned to collecting ethnographic material for museums. Hudson was one of several turn-of-the-century artists who, either on commission or for personal reasons, documented Native Americans in hope of preserving their culture. Her *The Seed Conjurer* of 1896 (fig. 6-6) shows her typical composition—a known individual, posed in some personal or tribal activity for which he or she was known. Hudson was very much a product of her time—a woman artist whose primary subject was women and children. She might be accused of Victorian sentimentality, except that her figures are sympathetically rendered, and their ethnographically accurate gestures and dress make her almost 700 paintings important scientific records.

East Coast American art is replete with transatlantic influences starting as early as colonial times. With Anglo settlement of the West Coast, America established commercial and cultural ties to Pacific Rim cultures. The Far East had influenced the Americas for hundreds of years. (Historians of pre-Columbian art believe they can identify Chinese and Japanese stylistic influences and iconography in Mexican art of two thousand years ago.) But beginning in the 1880s and 1890s the crossovers became numerous, and the important cultural tide that had formerly ebbed and flowed across the Atlantic began to be superseded by

that surging back and forth across the Pacific. San Francisco's port served as the main embarkation point for many venturesome artists (some with creditors on their heels) traveling to South America, Hawaii, Japan, China, and the South Sea islands.

Halfway across the Pacific, the Hawaiian Islands have always provided a safe harbor for Pacific Ocean sailors to drop anchor on their way between continents. But it was only in the 1880s that the islands developed the infrastructure to support painters working in the European style. Some San Francisco painters went there, intent on escaping the Bay Area's economic doldrums of the 1880s, while others hoped to take advantage of patronage from an increasing number of sugar-plantation millionaires.

One of the earliest California artists active in Hawaii was **Joseph Strong** (1852–1899), who had trained at the San Francisco School of Design and then in Munich for four years. In Hawaii, he and his

artist-writer wife enjoyed royal patronage. His masterpiece may be *Japanese Laborers on Spreckelsville Plantation* of 1885 (fig. 6-7, p. 76), commissioned by Hawaii's king to show that imported Japanese laborers on Maui were not ill treated. (Spreckelsville was owned by the San Francisco brewer and businessman Claus Spreckels [Spreckels Sugar], who also profited from Hawaii's growing tourist trade through part ownership in a shipping line.) Painted far from the intellectual arena of Munich, with that city's sometimes stilted and pretentious figure compositions, this work excels by being less formal and staged, more realistic and naturalistic, less concerned with moralizing and teaching, and fully reflective of the sunny climate and the geography of the islands.

Other San Francisco artists noticed the growing Hawaiian market for paintings. Hawaii's sugar millionaires, building and furnishing mansions, purchased decorations from residents to avoid the newly instituted Hawaiian import tax on luxuries. The economic situation gave birth to Hawaii's first art movement, the Volcano School (1880–90), named for the painters' favorite theme and one of the islands' main tourist attractions, Hawaii's active volcanoes. The main painter of the Volcano School was **Jules Tavernier** (1844–1889), a San Francisco artist who had fled to Hawaii in 1884 to escape his creditors. Tavernier and other early artists identified picturesque scenes such as *Sunrise over Diamond Head* of 1888 (fig. 6-8), islands floating in calm seas, palm huts on long stretches of sandy beach backed by the imposing Diamond Head, and palm trees silhouetted against brilliant sunsets. *Sunrise over Diamond Head* capitalizes on the beautiful sunsets for which tropical islands are known and glorifies an ideal place that has become a "dream" vacation destination for millions. Many landscapes of Hawaii were carried home by tourists as records of their visits to the tropics.

San Francisco artists continued to render Hawaiian scenes, sometimes making the islands their ultimate destination and at other times using them as stopover points to more distant places across the Pacific. But by the end of the nineteenth century, subjects had shifted from landscape to the people. Hawaiians constituted one more "primitive" culture blessed with a simple lifestyle, envied by Anglos who were trapped by jobs in large cities. Like the Native Americans,

Fig. 6-8
Jules Tavernier (1844–1889)
Sunrise over Diamond Head,
1888
oil on canvas. 11¾ x 17¾ in.
Private Collection
Photo: Tibor Franyo

Fig. 6-9
Theodore Wores
(1859–1939)
*A Japanese House, Nikko,
Japan*, c. 1889
oil on canvas, 26 x 34 in.
Dr. A. Jess Shenson

Hawaiian ethnicity was threatened with extinction through interracial marriage, and their culture was losing ground to pressure from missionaries and an increasing number of foreign settlers. San Francisco artists typically depicted women in native dress—wearing mumus and leis—and at manual occupations such as stringing flowers into the ubiquitous leis. Important San Francisco artists who painted Hawaiians through 1910 include Theodore Wores, Matteo Sandona (1881–1964), Grace Hudson, and as late as the end of the 1930s, Los Angeles's Mabel Alvarez (1891–1985).

California artists also traveled across the Pacific to the islands of Japan. Until 1854, Japan had barricaded its ports to all foreigners (except for one small port open to Dutch traders). That year American Commodore Oliver Hazard Perry and his naval fleet forced the country to open to trade. The consequent flow of Japanese goods to Western Europe and America brought about important stylistic changes in Western art. With the opening of Japan, tourists arrived. Although the first American painter known to reside in Japan (1877–c. 1881) was Winckworth Allan Gay (1821–1910) from Massachusetts, the next was a San Franciscan, Harry Humphrey Moore (1844–1926), in 1881. After gaining fame with his groundbreaking views of San Francisco's Chinatown, San Franciscan **Theodore Wores** also went to Japan. He arrived in the spring of 1885 and remained until the end of 1887; on a second trip he stayed from summer 1892 through January 1894. In Japan, he was privy to many scenes not witnessed by other visiting foreigners, because he made extended stays, took time to learn something of the language and customs, taught art to a number of Japanese, and wrote many sympathetic articles about Japan, which were published in America and Europe. Although Japan was becoming quickly westernized in dress and customs, Wores portrayed the earlier costumes and ways that were both traditional and reflective of the sensitive and refined aspect of the Japanese character. *A Japanese House, Nikko, Japan* of about 1889 (fig. 6-9) is one of his several masterpieces. In one composition we see an indoor and outdoor scene with their respective activities. Wores's paintings focus on the beautiful aspects of the Japanese lifestyle—pretty ladies at leisure, people strolling amid flower gardens,

arranging flowers in vases, visiting shrines, attending festivals, drinking tea, playing music, dancing, or viewing the wares of candy vendors or toy sellers. Wores's work exhibits many advanced stylistic traits, including a light and colorful palette, sometimes oblique angles, and broken brushwork.

By the turn of the century Japan had also attracted painters Albert and Adele Herter, who eventually settled in Santa Barbara. The country's expertise in color wood-block printing also attracted two California women pioneers of wood-block printing: Helen Hyde and Bertha Lum (chapter 9).

Other Pacific lands had fewer, yet still important, cultural links to California. Several artists who became major names in California art originally came from Australia, including the watercolorist Francis McComas (chapter 7). And, as the twentieth century progressed, some Californians followed Paul Gauguin to the South Sea Islands in search of subject matter.

Meanwhile, the Western world's art center had shifted from Munich to Paris, and the work of American painters would soon reflect the new ideas from France. That will be the subject of the next chapter. ✿

Bibliography

Duesseldorf and Munich Influences
(See also bibliography for chapter 5.)
"Artistic High Jinks—Allotria Club of German-San Francisco Artists," *San Francisco Call,* November 18, 1891, p. 8, col. 4.
"German Painters—San Francisco's Colony of Artists," *San Francisco Chronicle,* March 20, 1892.
"San Francisco's German artists organize," *San Francisco Call,* May 28, 1891 p. 7, col. 1.

Genre Painting, American
Hills, Patricia, *The Painters' America: Rural and Urban Life, 1810–1910,* New York and Washington: Praeger, 1974.
Johns, Elizabeth, *American Genre Painting: The Politics of Everyday Life,* New Haven & London: Yale University Press, 1991.
Williams, Herman Warner, *Mirror to the American Past, A Survey of American Genre Painting: 1750–1900,* Greenwich, Ct.: New York Graphic Society, 1973.

Chinese and Chinatown Themes
Bell, Mary, "The Chinese Motif in Current Art," *Overland Monthly,* v. 31, March 1898, pp. 240–41.
China and California (The Impact of Nineteenth and Twentieth Century Chinese Art and Culture on California), ed. by Joseph Baird, Jr., exh. cat., Art Department, University of California, Davis, May 15–July 1, 1966.
"Chinese as Subjects," *San Francisco Chronicle,* March 6, 1892, p. 17, col. 5.

Native Americans as a Theme before 1900
"California: The California Culture Area, Henry Raschen, Grace Hudson, Pomo Culture in the Raschen and Hudson," in Patricia Trenton and Patrick Houlihan, *Native Faces: Indian Cultures in American Art From the Collections of the Los Angeles Athletic Club and the Southwest Museum,* exh. cat. Southwest Museum, July 13–September 15, 1984.
Kroeber, Theodora and Albert B. Elsasser and Robert F. Heizer, *Drawn from Life, California Indians in Pen and Brush,* Socorro, N. M.: Ballena Press, 1977. 295 p.

Pacific Basin Themes
"The Volcano School 1880–1890," in David W. Forbes, *Encounters with Paradise: Views of Hawaii and its People, 1778–1941,* exh. cat., Honolulu Academy of Arts, January 23–March 22, 1992, pp. 173–200.
Gerdts, William H., "American Artists in Japan," in *Theodore Wores: An American Artist in Meiji Japan,* Pasadena, Ca: Pacific Asia Museum, 1993.

THE TURN OF
THE CENTURY
1890–1915

Fig. 7-3
Julian Rix (1850–1903)
*Twilight Scene with Stream
and Redwood Trees,* n.d.
oil on canvas, 83½ x 46½ in.
Collection of the Oakland
Museum of California,
Bequest of Dr. Cecil E.
Nixon

California Artists Bow to Paris

France. Most American artists of the 1800s dreamed of going there—to experience the art world of Paris and to view the countryside, with its family farms, narrow roadways lined with trees, patches of ancient oak forests, charming stone villages, and workers tilling fields or driving sheep.

Although French ideas began to dominate American (and California) art after 1870, in effect they had been influencing it from the time of California's early explorers, some of whom were French. In the 1850s French-born Edward Jump (1832–1883) portrayed San Francisco life in humorous caricatures, and Jacques Rey (1820–1892) and Joseph Britton (1825–1901) worked as partners in San Francisco's most successful art lithography shop. When wealthy San Franciscans began building mansions in the 1870s, many chose the architectural style of France's Second Empire. And several San Francisco painters were of French background, including Ernest Narjot, Jules Tavernier, and Amadee Joullin (1862–1917).

Barbizon Style

In the 1860s two of California's leading landscapists, Thomas Hill and William Keith, began to assimilate some of the stylistic qualities of contemporary French art. Both decided to take advanced training in Europe, in 1866 and 1869 respectively (chapter 3). In France they were exposed to the Barbizon style, originated by a handful of artists active in the village of Barbizon at the edge of the forest of Fontainebleau outside Paris from about 1825 to 1850. Considered revolutionary in their day, Barbizon artists scorned the government- and Salon-sanctioned grand tableaux that were produced in studios and devoted to moral, religious, and historical themes. Instead they advocated landscapes of truth and poetry painted directly from nature. Keith, especially, was drawn to their poetic interpretation of nature, probably inspired by his own emotional makeup as well as by his later friendship with the Reverend Joseph Worcester of Oakland's Swedenborgian Church and with the East Coast Tonalist painter George Inness. In *Yosemite Valley* (fig. 3-6) Keith demonstrated that by 1875 he was already eliminating finicky detail in favor of simplified shapes, a trend that accelerated as he moved to full Tonalism.

The Barbizon style reached its peak in America

in the 1890s. By that time America was a country with many large urban centers, some of whose residents were enjoying sophisticated devices such as the telephone, electric lights, cable cars, and horseless carriages. The industrial revolution put extra money in the pockets of a rising middle class and made millionaires of entrepreneurs. The arts flourished as never before. California followed national trends to establish art schools and art museums. The San Francisco Art Association opened its School of Design in 1874; Mrs. Crocker gave her house and art collection to the city of Sacramento in spring 1885; and Mrs. Stanford founded a university and general museum in Palo Alto in November 1885. At the World's Columbian Exposition in Chicago in 1893, California had a major building; and San Francisco held its own Midwinter Exposition of 1894. The exposition's art gallery, built in Egyptian style, was retained as the city's first museum.

America's new and expanding network of trains not only enabled people to winter in warm California but also allowed Californians to cross desert barriers with ease to partake of the culture of the East Coast. Europe was brought closer thanks to the transatlantic cable and the shift from sail to steam power. Travel across the Atlantic was made more comfortable and convenient when ocean steamers became floating hotels and established frequent and regular schedules. Americans (and Californians) in ever increasing numbers flocked to the Continent, which was regarded as the home of high culture, and took the obligatory Grand Tour from England to the Holy Land.

At the center of everything was Paris—spacious, tree-lined boulevards, imposing edifices and monuments, outdoor cafes, artists sitting at easels facing the River Seine and Notre Dame Cathedral, and, of course, the Eiffel Tower, built for the Paris World's Fair of 1889. The city housed the Latin Quarter, on the opposite bank of the Seine the Institut de France with its Academie des Beaux-Arts and, nearby, the Ecole des Beaux-Arts. It also boasted the Louvre, with its unrivaled collections, the Musée du Luxembourg, devoted to contemporary art, and the Petit-Palais, filled with work purchased from the yearly Salons.

Hungry for the finer things of life, with pretensions to art connoisseurship, American steel and railroad magnates, real estate tycoons, bankers, businessmen,

and their families strolled through picture galleries and visited artists' studios. **Arthur F. Mathews**'s *Paris Studio Interior* of about 1887 (fig. 7-1) shows the "new" woman, freed from labor, nudged by personal inclinations and society toward refined interests, and eager for knowledge, who admired, collected, and sometimes wrote about art. Mathews's studio contains all the eclectic paraphernalia expected of artists' studios in the Victorian 1890s: dark canvases with fat, gilded frames, ornately carved furniture, kaleidoscopically colored rugs, skins of exotic animals, sculptures of snow white marble and dark bronze, sumptuous pillows and draperies, and tabletops cluttered with antique brasses, Oriental bric-a-brac, and objets d'art.

By the 1890s the city had also become a Mecca for American art students. In 1888 it was estimated that there were more than a thousand American artists and art students (half of them permanent residents) out of a total of seven thousand Americans in Paris. An American artist was considered a success if he could study there under a first-rate French artist, learn the craft of painting well enough to have a canvas accepted by the official Salon, and perhaps even win a medal or have a picture purchased by the French government. And when his student days were over, if he chose not to remain in Europe as an expatriate, he could return to the United States and command almost the same respect that would have been accorded to a French artist.

Why did Paris have such a high cultural lead? A number of positive factors came together at the same time. The Franco-Prussian War of 1871, although disastrous from a military point of view, freed the country from inherited rule and ushered in the Third Republic with its burst of republican enterprise. Americans could live more cheaply in France than in America, and in Paris artists' materials were less expensive. The city and country were picturesque, with unlimited vistas and beauty. France, unlike provincial America, officially sanctioned and supported art. The French government funded academies of art and architecture, sponsored Salons and exhibitions and, most important, purchased the work of artists. Paris in particular gained its cultural credibility from the prevalent belief that contemporary production should be based on the best examples from the past, and everyone could see that Paris's art collections and buildings embodied the best of centuries of history and style. All of this, along with a concentration of creative individuals from America as well as from other countries, resulted in a vital exchange of ideas. The art market thrived, attracting collectors as well as producers of art, and commercial art galleries came into being.

The art world of Paris had many levels. Central and most dominant was the "establishment" art world of the officially sanctioned academies, ateliers, and salons to which most Americans gravitated. They attended the private Academie Julian or, rarely, the

Fig. 7-1
Arthur F. Mathews (1860-1945)
Paris Studio Interior, c. 1887
oil on canvasboard
20 x 24 in.
Collection of the Oakland Museum of California, Gift of the Art Guild

Fig. 7-2
William Keith (1838-1911)
After the Storm
oil on canvasm 22 x 18 in.
Collection of the Oakland Museum of California, Gift of Thomas Winslow

government's Ecole des Beaux-Arts. But at the fringes the ever more important avant-garde kept inventing new, maverick styles, such as Impressionism, post-Impressionism, and abstraction.

American art students in Paris were generally conservative and felt "advanced" if they took up the Barbizon style (although its avant-garde status had been eclipsed by Impressionism in the 1870s). One of the first California artists to learn the Barbizon style in France was probably **William Keith,** and a prime example of his exposure is his undated *After the Storm* (fig. 7-2). Barbizon painters differed sharply from their Romantic predecessors who preferred sweeping panoramas, drama, and meticulous detail. The Barbizon style focused instead on intimate parts of the forest—modest meadows, rugged gullies, or clumps of trees. Instead of false drama and heightened illusion, they looked for the natural in rustic landscape or for weather conditions with particular charm or beauty. And instead of fine detail, they used broader, looser brushwork to suggest basic forms and convey the sense of an object rather than its photographic appearance. Their broken brushwork also conveyed a feeling of light and air. Keith's *After the Storm,* like most Barbizon pictures, depicts an intimate forest glade; his scene is meant to be universal rather than specific and to represent a mood rather than an illusionistic scene. Diffused lighting conveys notions of tranquility, timelessness, and transcendence. The work is completely introspective and subjective; even the title is nonspecific and poetic. By comparing this work to Keith's earlier *King's River Canyon* (fig. 3-5) and *Yosemite Valley* (fig. 2-6), the stylistic progression that brought Keith to a full Barbizon style by about 1890 becomes evident.

Julian Rix (1850–1903) was another early artist in the Barbizon style but one who picked up his knowledge in New England before moving to California. His undated *Twilight Scene with Stream and Redwood Trees* (fig. 7-3, p. 86) is an example of how cautiously artists made the transition from one style to another. Rix stays within the popular California subject—redwood trees (associated with grandeur and Romantic landscapes)—but he bows to the Barbizon style by simplifying the trees into soft shapes of muted colors. California had a variety of flora that answered the particular needs of the Barbizon aesthetic; trees included the native live oaks, sycamores, pines, and eucalyptus. The state also had horizontal terrain preferred by painters wanting to convey a placid mood—marshes, sandy beaches, quiet pools, and meandering tributaries in the low-lying areas around the San Francisco Bay and along the Sacramento and San Joaquin Rivers. California's cattle grazing on rolling hills were perfect subjects for Barbizon artists wanting a lazy, pastoral theme. Rix has used the long foreground favored by some of the Barbizon painters and keeps it interesting by breaking it into simple abstract shapes with the meandering stream. He chooses sunset, when nature casts a quiet mood over the land.

California finally adopted both the Barbizon style and its offshoot, Tonalism, even though adopting these styles meant rejecting the very successful earlier Romantic style and turning away from the spectacular California landscape. With William Keith, the grand old man of landscape, leading the way with paintings of gloomy forests and moody glades and pools, and with pressure from an increasingly sophisticated crowd of collectors demanding up-to-date art with a European flair, a few of the younger San Francisco artists began to turn out pastoral views of the area around San Francisco Bay.

In California, the Barbizon and Tonalist styles coexisted from about 1885 until about 1915. (In Europe, the Barbizon style had *preceded* the even more poetic Tonalism.) Northern California's two long-term Barbizon-style painters—**Thad Welch** (1844–1919) and Henry Percy Gray (1869–1952)—produced their work relatively late—in the twentieth century.

Thad Welch lived the "Bohemian" lifestyle that California, particularly San Francisco, adopted from Paris in the 1890s. The term originally described Western Europe's anti-Academy artistic rebels of the first half of the nineteenth century, usually artists or writers who lived an unconventional, often impoverished gypsy-like life. The lifestyle was cultivated by many creative people. In San Francisco, as early as 1872, a group of journalists established the Bohemian Club and then extended membership to those interested in the arts. By the turn of the century, San Francisco had become the West Coast's publishing center, and it supported a colony of writers and illustrators. Many worked for William Randolph Hearst, whose newspaper empire spread their work and ideas coast to coast. San Francisco's "Bohemian" writers and artists congregated in popular cafes (especially Coppa's on Telegraph Hill), made fantastic costumes for artists' fancy-dress balls, sponsored jinks, went on country outings with the Bohemian Club, gathered at fellow artists' homes for wine and spaghetti parties, experimented with opium and free sex, and committed suicide. The quintessential Bohemian was painter Jules Tavernier, who wore his hair shoulder length and lived in the poorer area of Telegraph Hill, a neighborhood inhabited primarily by Italian immigrants. (Also considered "Bohemian" for their picturesque squalor were San Francisco's Chinatown, the infamous Barbary Coast, and the Ten-

derloin district.) In 1884 Tavernier's unpaid bills forced him to flee from his creditors to Hawaii, where he drank himself to death.

Thad Welch had been exposed to the Barbizon style in Paris about 1880. His first pictures in this mode employ the grey tones of Jean Baptiste Camille Corot (1796–1875), one of the school's founders. But after he returned to Northern California and discovered the Marin hills, Welch opted for California sunshine and

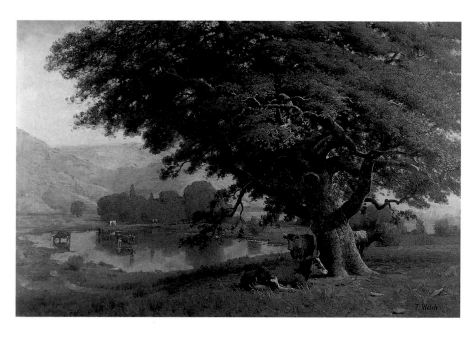

California terrain. Marin is on the peninsula north of the Golden Gate. Impoverished, Welch built a cabin there with lumber brought in by schooner, and often he and his wife survived by eating wild greens gathered from the mountain slopes and fruit washed up on the nearby ocean shore. In the 1890s, after Welch was "discovered" by some members of the Bohemian Club on an outing, his work began to sell, and the scene he painted most often was cows grazing on Marin hills. The undated *Cows Resting Under a Tree* (fig. 7-4) is his translation of the typical French Barbizon subject—cattle knee-deep in moist, flat, French pastures—

into typically California cattle wandering tawny hills. Welch repeated this successful formula for the rest of his life, even after he and his wife moved to picturesque Santa Barbara in 1905 for his health. Cattle drinking in a gully stream, cattle grazing, cattle returning home down a road darkened by late-afternoon shadows were all common themes for California Barbizon paintings.

The second major practitioner of the Barbizon style in Northern California was **Henry Percy Gray** (1869–1952). Gray had trained at the San Francisco School of Design in the mid-1880s when the Barbizon style was just coming into vogue in California. He went on to become a newspaper illustrator and worked in New York for a time. In 1906 he returned to San Francisco to cover the earthquake and remained. Even though by 1906 the most avant-garde young artists entering careers were adopting an even newer style—Impressionism—three factors may have caused Gray to stay with the older style. He had learned it during his student years, the style was comfortable for him, and at the moment he decided to become a landscapist, the Barbizon style (especially the Tonalist form) dominated Northern California painting.

Gray's signature subjects, like Welch's, immediately identify him. The two most common are rolling hills dotted with California oaks and intimate meadows bordered by stately, lacy eucalyptus. *Mount Tamalpais* (fig. 7-5) is an example of the first type. Gray found his subjects on his walks through the rural hillsides surrounding the bay—in Marin County, north of San Francisco, and around Burlingame on the peninsula south of San Francisco, where he moved in 1910. (Later, he expanded his repertory to include Yosemite, the desert, and the Monterey shoreline.) While his paintings still retain a great deal of detail, these softly painted views with their muted coloration nonetheless personify the Barbizon pastoral ideal.

Francis McComas (1875–1938) also adopted the Barbizon style for a time. An Australian who arrived in San Francisco in 1898 as a merchant seaman, he studied with Arthur Mathews before he went briefly to London and Paris. McComas was always too much his own man to be absorbed into a group or movement, but some of his early watercolors, such as *The Mountain* of 1908 (fig. 7-6), clearly show Barbizon stylistic attributes. McComas had excellent drawing skills and at heart was a representationalist, but over the many years of his production he experimented with the style then in fashion. Although in *The Mountain* his particular handling of watercolor is crisp and representational, his theme is Barbizon—the small slice of nature, the shadowed foreground, and the trees silhouetted against a lighted background.

In Southern California a modified form of the Barbizon style served as the dominant mode for a generation of landscapists. During the years that the style was becoming prominent in Northern California

(1885–1906), Southern California was developing its first resident art communities in the towns of Los Angeles, Santa Barbara, and San Diego. Although these towns were still cultural backwaters compared to San Francisco, artists there aspired to the same lofty goals as their northern brethren. The Barbizon style was a natural for pastoral Southern California. Lacking the spectacular peaks and trees of the North, its landscape features were "Barbizon"—semi-wooded arroyos (the dry stream beds that ran down precipitous gullies from the rugged mountain chains), rolling hills, placid beaches, and natural pastures of grasses dotted with live oaks. Barbizon pictures from Southern California usually evinced a wider range of color than the grey-green tones that dominated paintings of Northern California.

Although a handful of talented landscapists were working in the Barbizon style, four stand out: Elmer Wachtel (1864–1929), his wife Marion Kavanagh Wachtel (1876–1954), Granville Redmond (1871–1935), and Carl Oscar Borg (1879–1947).

Elmer Wachtel moved to Los Angeles in the early 1880s. Primarily self-taught, he was among the first to develop compositions that later became stereotypes in the hands of the ubiquitous landscapists of the 1920s. Above all, he was the painter of arroyos, the only naturally watered areas in the arid Southland. Wachtel's most typical view is a shadowy dry streambed, sycamores, and boulders backed by distant rolling hills and lavender mountains. *Malibu Canyon* of about 1905 (fig. 7-7) is not an "arroyo" picture, but its composition also depends on a central declivity backed by higher elevation, and it is equally descriptive of Southern California's densely foliated canyons. It has the unexpected but desirable feature of a house. Elmer's wife, Marion, painted primarily in watercolor. Her poetic late-afternoon landscapes such as the undated *San Gabriel Canyon* (fig. 11-9) often present a view from the crest of a hill across a valley. In typical Barbizon format, foreground is in shadow, while distant peaks are touched by the sun.

Granville Redmond pursued his career at various times in both Northern and Southern California. Deaf from a childhood bout with scarlet fever, he received his first art training at the Institution for the Deaf, Dumb and Blind, in Berkeley, where he was inspired by two teachers, Douglas Tilden (1860-1935), a sculptor, and Theophilus Hope d'Estrella (1851–1929), a painter and photographer. Redmond then went on to the California School of Design in San Francisco. During five years of study in Paris, Redmond proved his talent with a painting that was accepted by the highly competitive annual Salon. His natural moodiness inclined him to paint tonal, evening, or moonlit landscapes. By 1898, when he settled in Los Angeles, he was a highly trained artist who found himself catering to an audience limited in size and tastes, an audience that would

Fig. 7-6
Francis McComas
(1875–1938)
The Mountain, 1908
watercolor, 20½ x 27 in.
Mrs. Justin Dart
Photo: Dennis Wyszynski

Fig. 7-7
Elmer Wachtel
(1864–1929)
Malibu Canyon, c. 1905
oil on canvas, 24 x 32 in.
DeRu's Fine Arts, Laguna
Beach, California

not purchase his complex Salon compositions but could understand Barbizon-style landscapes.

In Redmond's *Passing Shadows, Back Bay, Newport* of 1907 (fig. 7-8), a shepherd oversees his flock as it grazes on the lowlands near Newport, a coastal town about fifty miles southwest of Los Angeles. (Sheep raising succeeded cattle ranching in Southern California after the vast herds of cattle were decimated by a mid-1860s drought.) The picture's many classic Barbizon elements include a blue sky filled with puffy clouds, cloud shadows thrown on the land, and a long foreground of flat land. Like the most successful translations, the pastoral subject is both Barbizon and Californian. Emotionally Redmond's Barbizon work lies halfway between his optimistic, sun-filled pictures with highly textured surfaces (see his poppy pictures, chapter 13) and his pensive Tonalist pieces that usually have slick, glazed finishes.

In 1903 **Carl Oscar Borg,** a penniless Swede who wanted to become an artist, disembarked from his ship at San Francisco and walked to Los Angeles. There he worked as an interior decorator while he developed his talents as a landscape painter. Although he later painted the Southwest's Indians (chapter 16), during his first decade in California he made Barbizon-style landscapes, the best of which is *California Landscape* of about 1915 (fig. 7-9). Probably derived from one of the sketching trips he made to Santa Barbara, it depicts the predictable grazing cows and employs the Barbizon shadowy foreground. This scene is made California-specific by the eucalyptus, the coastline, and the background range of lavender hills. Landscapes were the dominant theme in Southern California for the first thirty years of the century. The more robust Barbizon landscapes can be distinguished from the later light-filled Impressionist landscapes by the solid shapes of the flora—for example oaks rather than the lacy eucalyptus—by the geographical features, and by the subdued coloration.

Tonalism

The word "tonalism" has traditionally been used to describe music, but in 1972 art historian Wanda Corn used it to characterize certain paintings that she isolated from the broader Barbizon style and claimed as a separate movement. Tonalist work shares Barbizon subject matter but depicts it in a more poetic and idealistic way. The artist's handling of a scene becomes extremely soft and broad, and the entire color scheme is sublimated to one prevailing shade or tone. Tonalism allowed artists to continue painting landscape, which had become an outdated subject, and still remain stylistically up-to-date. Most often the style was employed by artists who had studied in Paris or had trained under artists who had studied there.

Tonalism received validation in California when **George Inness** (1825–1894), America's preeminent Tonalist landscape painter, visited William Keith in 1891 and was lionized in the local press. The trip

Fig. 7-8
Granville Redmond
(1871–1935)
Passing Shadows, Back Bay, Newport, 1907
oil on canvas, 33 x 53 in.
Formerly Collection of James L. Coran and Walter A. Nelson-Rees. Destroyed by fire, October 1991.

inspired Inness to paint *California* of 1894 (fig. 7-10). Its title, however, is the only thing that distinguishes this "universal" view from his New Jersey pastures. As in other Tonalist canvases, the flat horizon and vertical trees of Inness's composition balance each other perfectly, and the limited range of hues creates a soft and restful mood. One of the most important aspects of Tonalism is that the artist, by reducing real objects to soft shapes, creates a composition based on purely formal values—that is, he arranges pure shapes, colors, and lines—and this leads some writers to call Tonalism the first of the modern styles. Indeed, art as pure formal design (rather than photographic imitation) was a major interest of James A. M. Whistler (1834–1903), an American expatriate residing in London, who is looked upon as the originator of American Tonalism. He was fascinated with the decorative aspect of painting and used pure shapes and colors to evoke human emotions. His "nocturnes," "harmonies," and "symphonies" that sometimes entailed as little detail as the glowing remnants of fireworks in a night sky, inspired many American artists to become Tonalists.

But the artist who may have been most responsible for the popularity of Tonalism in the Bay Area was **Arthur Mathews** (1860–1945). As a youth, Mathews developed sound drawing skills while working in his father's architectural office and as a designer and illustrator for San Francisco's printing firm of Britton & Rey. In 1885 he traveled to Paris to study at the Académie Julian. For three consecutive years his works were excellent enough to be accepted by the Salon.

When Mathews returned to San Francisco in 1889, he joined the faculty at the California School of Design (formerly the San Francisco Art Association School of Design) and in 1890 became its director. Twenty years earlier, he might not have gone into teaching as a career, but in the late-nineteenth century America was not only establishing its first art academies, it was also adopting the French attitude that teaching was an honorable profession for artists. Mathews, following Emil Carlsen, who had directed the school in the latter 1880s, took over as the main purveyor of French ideas into Northern California. Although described as rude, scornfully insolent, egotistical, and opinionated, surprisingly he never insisted that students adopt his personal style. Instead he encouraged them to find their own artistic "voices." Ironically, Mathews's finest pictures, those treating universal themes enacted by robust female figures, did not spawn a school of look-alikes; instead Mathews's secondary theme, landscapes, had the greatest impact. He established a tonal approach that dominated landscape painting in Northern California for more than twenty years, beginning in the mid-1890s.

Fig. 7-9
Carl Oscar Borg
(1879–1947)
California Landscape, c. 1915
oil on canvas, 36 x 43 in.
Peter and Gail Ochs

Fig. 7-10
George Inness (1825–1894)
California (In California),
1894
oil on canvas, 60 x 48 in.
Collection of the Oakland Museum of California, Gift of the Estate of Helen Hathaway White and the Women's Board

Part of Mathews's interest in tonal treatment came from his admiration of the French master Pierre Puvis de Chavannes (1824–1898), who underlaid his murals with grey to tie together his color schemes. For Mathews, color was the compositional unifier. He once said, "I never work outside until after 4 o'clock in the afternoon…for to me the most extraordinary color effects that we find here in the West come only in the diffused afternoon lights" (Harvey Jones, *Mathews,* The Oakland Museum in conjunction with Gibbs M. Smith, Inc., Layton, Ut., 1985, p. 46). His undated *Monterey Pines* (fig. 7-11) is Tonalist in subject—a simple clump of pines—and in its golden tone and soft brushwork, but Mathews never dissolved his forms to the same extent as some other Tonalists.

Tonalism manifests itself in California art in both color and subject. Across America, Tonalists employed a wide range of tones, including the cool grey of cloudy or foggy days; the blue tones of late afternoon, early evening, or a rainstorm; the rosy or orange tones of sunset; the silvery and black tones of moonlight; or the white of a snowstorm. In contrast, Northern California Tonalists seem to limit themselves to a brown-green coloration. Still unanswered is whether this resulted from Arthur Mathews's personal influence or whether the collective mind found that Northern Californians

Fig. 7-11
Arthur F. Mathews
(1860–1945)
Monterey Pines
oil on canvas, 23 x 26 in.
Collection of the Oakland
Museum of California, Gift
of Concours d'Antiques, the
Art Guild

Fig. 7-12
Lucia Kleinhans Mathews
(1870–1955)
Red and White
oil on canvas, 26 x 19 in.
Collection of the Oakland
Museum of California, Gift
of Mr. Harold Wagner

would buy Tonalist pictures as long as the colors were not too far from those natural to California. Rare color variations are the blue-black nocturnes by artists such as Charles Rollo Peters and Will Sparks. As for subjects, East Coast Tonalists often represented winter thickets of leafless trees or snow scenes, while California Tonalists favored situations found in their state: moons over marshes or long sandy beaches or eucalyptus and Monterey cypress emerging from heavy fogs. Tonalism reigned supreme in San Francisco and Monterey/Carmel through 1915.

Among the rare Tonalists to paint figures was **Lucia Kleinhans Mathews** (1870–1955), who married her teacher Arthur Mathews in 1894 and traveled with him to Europe in 1898, where she trained briefly with Whistler in Paris. Lucia Mathews stands out in the Tonalist crowd not only for being a woman but also as someone who preferred the subjects of flowers and figures, as in *Red and White* (fig. 7–12). Figural Tonalist works were rare in California (although Arthur Mathews and Xavier Martinez also painted a few). Isolated in the center of the canvas, women or little girls are presented as modest individuals. Their passive attitudes may reflect Lucia's own personality, the kind needed to live with a domineering individual like Arthur Mathews, or it may reflect her opinions on feminine propriety. In either case, the sitter's demeanor meets Tonalism's requirements for a placid subject. If we compare her work to that of two Tonalist figure painters from the East Coast, her individuals have as much strength as the muted and shaped figures of John White Alexander (1856–1915), and they are as poetic as the evanescent women produced by Thomas W. Dewing (1851–1938).

Xavier Martinez (1869-1943), born in Guadalajara, Mexico, moved with his parents to San Francisco in the early 1890s and became a pupil of Arthur Mathews at the School of Design. He went on to Paris in 1897 and remained studying art until 1901. One day at the Louvre, Martinez was copying a picture, an established method of art study at the time, when Whistler happened across him and remarked that Martinez had great talent. When Martinez returned to San Francisco, he began painting both landscapes and figures in the Tonalist style. In *Afternoon in Piedmont (Elsie at the Window)* of about 1911 (fig. 7-13),

Fig. 7-13
Xavier Martinez
(1869–1943)
Afternoon in Piedmont (Elsie at the Window), c. 1911
oil on canvas, 36 x 36 in.
Collection of the Oakland Museum of California, Gift of Dr. William S. Porter

Fig. 7-14
Charles Rollo Peters
(1862–1928)
*Untitled (Gable end of
Victorian house),* 1891
oil on canvas, 35½ x 51½ in.
Michael & Cynthia Roark

Fig. 7-15
Giuseppe Cadenasso
(1858-1918)
Early Morning
oil on canvas, 26½ x 21½ in.
Peter and Liz Cadenasso

Martinez intentionally or not portrays his wife, Elsie, in profile, similar to the pose of Whistler's mother in *Arrangement in Gray and Black No. 1* (Louvre, Paris). Martinez opts for San Francisco's heavy brown-grey-green color scheme; his tones are harmonious and, while broadly brushed, his forms remain robust, substantial and solid. One of San Francisco's real Bohemians, Marty, as his friends called him, dressed in baggy corduroy trousers, a colorful sash, and a flowing crimson cravat, and wore his thick hair long. He hosted wild wine parties at his studio.

Among the Tonalist landscapists, **Charles Rollo Peters** (1862–1928) is distinguished by his night scenes. Of the same generation as Mathews, Peters studied in Paris in almost the same years. He also admired Whistler and even knocked at Whistler's studio door several times but without success. Reportedly Whistler stated that Peters was the only artist other than himself who could paint nocturnes. Peters began his career painting complex nighttime views, such as *Untitled* of 1891 (fig. 7-14). The gable end of the Victorian clapboard house is bathed in an overall soft blue light, and the composition achieves balance from the evenly placed horizontal and vertical lines of the building, its porch and fence. After he inherited great wealth, Peters's interest swung to developing a thirty-acre estate complete with a mansion that had numerous guest rooms and an art gallery, and he fell into producing nocturnes of adobes. At the turn of the century, nocturnes enjoyed

great popularity. Although Peters's fine talent seemed to go to waste as he slipped into profligate spending and alcoholism, he was a generous promoter of his friends and helped many obtain patronage within his wealthy circle.

The quintessential Bay Area Tonalist is probably **Giuseppe Cadenasso** (1858–1918). Cadenasso studied with Arthur Mathews at the Mark Hopkins Institute of Art in the mid-1890s, and from 1902 to 1918 he headed the art department at Mills College across the bay in Oakland. He specialized in softly brushed landscapes in which a pool or meadow is encircled with trees, as in *Early Morning* (fig. 7-15). Cadenasso found his subjects in the marshes and eucalyptus of Berkeley, Oakland, and Alameda, in the glades and groves on the Mills College campus, and in San Francisco's Golden Gate Park. The lacy eucalyptus proved appropriate for pictures of a poetic mood. To avoid the temptation of detail, Cadenasso often spread his colors with his fingers. His lyrical landscapes earned him the title "the Corot of California."

Gottardo Piazzoni (1872–1945) has the distinction of blending Tonalism and Symbolism. Piazzoni also studied with Arthur Mathews in the early 1890s and in Paris in the second half of the decade. On his return to San Francisco he started the Piazzoni Atelier d'Art. He is considered one of the Bay Area's first modernists for his adaption of Tonalism to Symbolist subjects. *Untitled, Decorative Landscape with Architectural Forms* (fig 8-5) introduces a depersonalized figure into an idealized California landscape. For some historians his quiet, Spartan views embody the "true spirit" of California in their celebration of the elemental themes of earth and water. They are "modern" in that they are essentially abstract arrangements of shapes and tones. Piazzoni later became known for his mural paintings in which his tonal approach worked to his advantage by allowing him to create pictorial scenes on a wall that didn't overly call attention to themselves or visually break down the two-dimensionality of the wall surface.

At the midpoint of San Francisco's Tonalist movement, the city was rocked by the 1906 earthquake. With the core of the art and collecting community reduced to ashes, artists fled to unaffected locales on the periphery of the blackened city where they could resume their work. Some went to Oakland/Piedmont, others to towns in Southern California, but a large number resettled in the Monterey/Carmel area.

Monterey had been growing in popularity with artists since the mid-1870s when Jules Tavernier was attracted by its natural beauty and settled there briefly, enticing other artists with tales of its splendor. It was sporadically visited by Barbizon-influenced artists, such as William Keith (1867, and 1891 with George Inness) and Julian Rix (1876), and it became the home of Charles Rollo Peters (1900). The peninsula's artist

population was fortified by the development of neighboring Carmel (1903), which began as a community for intellectuals, and by Pacific Grove, a religious retreat. But the Monterey peninsula's art colony really got its start when Tonalist painters, fleeing from burned-out San Francisco, relocated there to second homes or stayed with friends. The influx inspired the owners of the nearby Hotel Del Monte, a huge tourist resort and primary destination for railroad travelers, to open an art gallery. In February 1907 the hotel's manager gathered San Francisco's prominent artists (most of the Tonalist landscapists mentioned above) to draft gallery operation guidelines. Over the next twenty or so years, the gallery not only lent "class" to the hotel and provided an extra enticement to guests but helped support local artists through sales and introduced many easterners to some of California's talented artists.

Were these softly rendered Tonalist landscapes simply reflections of the Monterey/Carmel fogs, or did they result from the desire to interpret a scene poetically? One prime work about which there is no question is *The Secret* of about 1920 (fig. 7-16) by **E. Charlton Fortune** (1885–1969). Fortune was a latecomer to California Tonalism, and in the 1920s she

Fig. 7-16
E. Charlton Fortune
(1885–1969)
The Secret, c. 1920
oil on canvas, 26 x 30 in.
The Buck Collection, Laguna Hills, California
Photo: Cristalen and Associates

Fig. 7-17
Charles Walter Stetson
(1858–1911)
An Easter Offering, 1896
oil on canvas
40 x 50¼ cm.
Spencer Museum of Art,
The University of Kansas:
Museum Purchase

turned to Impressionism. However, her training in 1905 with Arthur Mathews, at the Art Students League in New York, and the copying of works by Puvis de Chavannes in Paris during a 1910–11 tour, inclined her toward restful themes and colors. Establishing a summer studio in Monterey in 1913, she remained there until 1921. Throughout history artists have represented women in various guises including the earth mother and the femme fatale, but Tonalists portrayed them as idealized: passive, graceful, gentle, and untainted by vulgar associations. Fortune uses a stable arrangement of horizontal and vertical elements and the color celadon to convey a quiet, poetic mood.

Southern California collectors seemed unable to appreciate Tonalism, except for those few who purchased Keith's dark forests, and no early Southern California artist dedicated himself to the style. Pasadena artist **Charles Walter Stetson** (1858-1911), however, best known for his nudes frolicking in nature, was so taken with the region's beautiful moonlit nights that he painted several nocturnes. Some show eucalyptus standing like quiet sentinels around still pools, but *An Easter Offering* of 1896 (fig. 7-17) stands out for its

representation of one of the city's commercial fields of calla lilies. Stetson achieves a hushed and reverential silence through the pure moonlight that bathes the white callas and balances the composition perfectly by placing the horizon exactly midway in the picture.

Although the Barbizon and Tonalist styles had many advocates, critics saw them as irrelevant imports, unrelated to American history or cultural values and even contaminating the verve and honesty of native American art. Complaints like these accelerate as the twentieth century advances, as Americans are increasingly asked to accept Europe's modern imports, and as the inevitable backlash occurs. However, in California's complex art world of the turn of the century there are several more important movements to discuss before progressing on to modernism, and those will be addressed in the next few chapters. ✸

Bibliography

French Influence

Baird, Joseph Armstrong, Jr., ed., *France and California*, exh. cat., University of California, Davis, Library, May 29–June 12, 1967. 61 p.

Turn-of-the-Century San Francisco

"Art Department," in *Final Report of the California World's Fair Commission...Chicago, 1893*, pp. 53–55, 125–7, 168–70, Sacramento, 1894.

Bohemian San Francisco, San Francisco: Paul Elder and Co., 1914.

"Bohemian Shores," in Kevin Starr, *Americans and the California Dream 1850–1915*, New York: Oxford University Press, 1973.

Crocker Art Museum Handbook of Paintings, Sacramento, Ca.: Crocker Art Museum, 1979.

Dinnean, Lawrence, *Les Jeunes: An Account of Some Fin De Siecle San Francisco Authors and Artists*, Berkeley: Friends of the Bancroft Library, University of California, 1980.

Donnovan, Ellen D., "California Artists and Their Work," *Overland*, n. s., v. 51, January 1908, pp. 25-33.

Driscoll, Marjorie C., *The M. H. deYoung Memorial Museum, Golden Gate Park, San Francisco, California*, San Francisco: Golden Gate Park Commission, c. 1921.

Hall, Kate Montague, "The Mark Hopkins Institute of Art," *Overland*, n. s. v. 30, December 1897?, pp. 539–48.*

Index to the San Francisco Call 1894–98 and 1899–1903 and 1904–1913 (microfilm at Bancroft Library, University of California, Berkeley and at California State Library, Sacramento).

Jones, Idwal, *Ark of Empire: San Francisco's Montgomery Block*, Garden City, N.Y.: Doubleday & Co., 1951.

Lewis, Oscar, *Bay Window Bohemia: an Account of the Brilliant Artistic World of Gaslit San Francisco*, Garden City, N.Y.: Doubleday & Company, 1956.

Murtha, N. L., "The Sketch Club: 'Art for Art's Sake'," *Overland Monthly*, v. 29, June 1897, pp. 577–90.*

Osborne, Carol M., *Museum Builders in the West: The Stanfords as Collectors and Patrons of Art, 1870–1906*, Stanford, Ca.: Stanford University Museum of Art, 1986.

Sanders, Patricia B., *The Haggin Collection*, Stockton, Ca.: The Haggin Museum, 1991.

Scharlach, Bernice, *Big Alma: San Francisco's Alma Spreckels*, San Francisco: Scottwall Associates Publishers, 1990.

The Stanford Museum Centennial Handbook: 100 Years, 100 Works of Art, Stanford, Ca.: Stanford University Museum of Art, 1991.

"Successful California Scenic Artists," *Overland*, n. s. v. 45, February 1905, pp. 171–75.

"Successful Californians in New York," *Overland*, n. s. v. 60, August 1912, pp. 105–16.

Unna, Warren, *The Coppa Murals: A Pageant of Bohemian Life in San Francisco at the Turn of the Century*, San Francisco: Book Club of California, 1952.

Wilson, Raymond L., "Artists and Bohemia: The Romance of Turn-of-the-Century California," *Antiques and Fine Art*, May 1986, pp. 14-17.

The American Barbizon Style

Bermingham, Peter, *American Art in the Barbizon Mood*, exh. cat., National Collection of Fine Arts, Smithsonian Institution, Washington, D. C., January 23–April 20, 1975.

California Artists of the Barbizon Style

Boas, Nancy and Marc Simpson, "Pastoral Visions at Continent's End: Paintings of the Bay Area 1890 to 1930," in Steven A. Nash *Facing Eden: 100 Years of Landscape Art in the Bay Area*, exh. cat., The Fine Arts Museums of San Francisco, June 25–September 10, 1995, pp. 31–60. 216 p.

Moure, Nancy Dustin Wall, *Loners, Mavericks & Dreamers: Art in Los Angeles Before 1900*, exh. cat., Laguna Art Museum, November 26, 1993–February 20, 1994 and one other venue.

Westphal, Ruth, *Plein Air Painters of California: The Southland*, Irvine, Ca.: Westphal Publishing, 1982.

American Artists Study in Paris

Fink, Lois Marie, *American Art at the Nineteenth-Century Paris Salons*, Washington, D.C.: National Museum of American Art, Smithsonian Institution, 1990.

The Julian Academy, Paris, 1868–1939, exh. cat., Shepherd Gallery, N. Y., Spring 1989. 252 pp.

Weinberg, H. Barbara, *The Lure of Paris: Nineteenth-Century American Painters and Their French Teachers*, New York: Abbeville Press, 1991. 295 p.

Tonalism, American

Corn, Wanda, *The Color of Mood: American Tonalism 1880–1910*, exh. cat., San Francisco: California Palace of the Legion of Honor, January 22–April 2, 1972. 46 p.

Arthur Mathews and his Influence

Artist-Teachers & Pupils: San Francisco Art Association and California School of Design: The First Fifty Years, 1871–1921, essay by Kent L. Seavey, exh. cat., California Historical Society San Francisco, June 1–September 4, 1971.

Hall, Kate Montague, "The Mark Hopkins Institute of Art," *Overland Monthly* v. 30, December 1897, pp. 539–48.

Mulford, Henry, "History of the San Francisco Art Institute," *San Francisco Art Institute Alumni Newsletter*, 7 parts, May 1978-Spring, 1980.

Tonalism, California

Art Gallery, Hotel Del Monte, California [the pictures here reproduced were among those shown during the first year of the exhibition] San Francisco: Bolte & Braden Co., printers, 1908. 17 pl.

Jones, Harvey, *Twilight and Reverie: California Tonalist Paintings 1890–1930*, exh. cat., Oakland Museum, February 11–May 14, 1995.

Martinez, Elsie Whitaker, *San Francisco Bay Area Writers and Artists*, Berkeley, Ca.: University of California, Bancroft Library, Regional Oral History, 1969.

Neuhaus, Eugen, *Drawn from Memory, A Self Portrait*, Palo Alto, Ca.: Pacific Books, 1964.

Painters of the California Landscape: Cadenasso, Cuneo, Piazzoni, exh. cat., Museo Italoamericano, San Francisco, April 6–May 27, 1990.

Westphal, Ruth, *Plein Air Painters of California: The North*, Irvine, Ca.: Westphal Publishing, 1986.

Monterey and Artists of the Barbizon/Tonalist Style

Branch, Josephine Mildred, "The Barbizon of California—Some Interesting Studios of Old Monterey," *Overland Monthly*, v. 50, July 1907, pp. 63–68.

Del Monte Revisited, exh. cat., Carmel Museum of Art, June 6–August 29, 1969. 24 p.

The American Renaissance Style & Worlds of the Imagination

Just as humor ranges from slapstick to satire, art, too, has its degrees of sophistication. Placing art on the familiar bell curve, the "low" art of caricature and cartoons could fit happily on one of the flanges, the center could be swelled by the large body of representational landscapes, genre, and portrait paintings, while the opposite phlange could be devoted to the small quantity of art of an intellectual, spiritual, or abstract variety. *Fin-de-siecle* Europe, eager to escape the ills of urban society began to find refuge in painted worlds of the mind and the imagination, and America (including California) sought to keep step. Therefore, paralleling mainstream landscapists working in the Barbizon and Tonalist styles (chapter 7), other painters created work in the cerebral categories of American Renaissance art and Symbolist art.

What is the American Renaissance movement? The previous chapter described how late nineteenth-century American students flocked to Paris, accepting the premises that the art of their time should be inspired by the important art of the past and that its themes should teach high moral values. For American Renaissance painters two new factors come into play: the emergence of architectural design as a discipline and architecture's need for mural paintings and sculpture to complete interior and exterior decorative schemes.

American Renaissance was America's term for the Beaux-Arts style. The Beaux-Arts style of architecture and decoration developed in the second half of the nineteenth century in Paris's famous architectural school, the Ecole des Beaux-Arts. Basic to the school's philosophy was the conviction that the Greeks and Romans had perfected architectural elements and proportions and that this vocabulary could be used by late-nineteenth-century artists and architects with the same success as the Italians, who had revived it during the Renaissance.

Just as American painters flocked to Paris to study art, American architects traveled there to study architecture and the related arts: mural painting, decorative arts, sculpture, and landscape gardening. Not only was study at the Ecole des Beaux-Arts de rigueur, but the city itself was an education, with its rich examples of architecture and art of all ages. There were French Medieval and Renaissance churches as well as Greek, Roman, and Egyptian monuments carried back by

Napoleon from his conquests in the Mediterranean. Paris was admired for the broad boulevards and parks that Napoleon cut through the tangle of buildings that had made up the city in the early nineteenth-century. Paris was a pleasant and beautiful place to live, because city planners had added special architectural features such as triumphal arches at the ends of long vistas. Tall obelisks served as centers for traffic circles, and pristine white Greek-looking buildings provided focal points and housed government offices and cultural institutions, such as concert halls, museums, and universities.

Young America was assuming world leadership, and Americans particularly liked the Beaux-Arts concept that art and life was a continuum. New civilizations could link themselves to the past by building great cultures of their own on the best ideas of earlier societies. This premise gave legitimacy to a youthful America and to a people who had only recently emerged from the rough life of farms and Indian battles to reside in cities. Their aspirations to culture propelled the American Renaissance movement, which lasted from about 1870 to 1915.

American Renaissance Painting

Painters were brought into the American Renaissance movement to provide murals and easel paintings for the mammoth architectural projects undertaken by American architects at the end of the nineteenth century. Huge projects not only replaced urban slums with grand cultural and civic complexes but also provided palatial mansions for America's money barons. Although the most important architects had their headquarters in New York and Boston, they often were awarded commissions for projects as far away as the West Coast. On the surface the American Renaissance style seems to have little relevance to rustic California, and yet there were a few buildings created in the style in the state. Most were commissioned by the Bay Area's upper class, which aspired to Parisian tastes. Examples are the Nob Hill mansions that San Francisco's wealthy had been building since the 1870s. An 1896 competition to redesign the University of California, Berkeley, was won by a Parisian architect with a Beaux-Arts design; the buildings were erected after 1903. And politicians, believing that the city's magnificent bay would qualify it to take commercial leadership away

Opposite:
Fig. 8-7
Reginald W. Machell
(1854–1927)
The Path, 1894–95
oil on gesso
7 ft. 5 in. x 6 ft. 2 in.
The Theosophical Society,
Pasadena, California

Fig. 8-1
Arthur F. Mathews
(1860–1945)
Sacred and Profane Love, 1915
oil on canvas, 38½ x 50¾ in.
Collection of the Oakland
Museum of California, Gift
of Concours d'Antiques, the
Art Guild

Fig. 8-2
Arthur F. Mathews
(1860–1945)
Youth, c. 1917
oil on canvas, 39 x 50 in.
Collection of the Oakland
Museum of California, Gift
of Concours d'Antiques, the
Art Guild

from the East Coast, looked to the style to upgrade San Francisco's city plan. A City Beautiful movement, intended to eradicate the "Bohemian" squalor of Telegraph Hill and the Barbary Coast, resulted in a 1902 commission to the East Coast architect Daniel Burnham to redesign San Francisco. (His plan, submitted the day before the earthquake, was never realized.)

The earliest San Francisco painters who worked in the American Renaissance style created murals and paintings for the city's mansions and churches. The Italian born and trained **Domenico Tojetti** (1806–1892) and his sons, painted many frescoes in local mansions (Fair, Hopkins, etc.) and altar decorations in Catholic churches. Tojetti's literary painting *Progress of America* (fig. 5-2) is one of the earliest examples of American Renaissance style and theme. Traditionally murals served a dual purpose: to decorate walls and to convey public messages, usually of a religious or political nature to people who could not read. American Renaissance murals usually expressed universal themes, such as a great moral truth, or they symbolized noble abstract ideas such as art, progress, or education. Abstract ideas and messages were usually conveyed through scenes in which figures in classical dress enacted a story from literature or history that allegorized the message. By depicting Greek or Roman dress, artists intended to universalize their ideas and tie current history to ancient cultures. Tojetti's chiton-robed charioteer, for example, symbolizes American progress in its noble westward advance. Although Tojetti continued an artistic tradition he had learned in Italy, where Renaissance-inspired decoration had never died out, in America his timing makes him an early practitioner of the American Renaissance style.

San Franciscan **Arthur Mathews** (chapter 7), however, was the most prominent California artist to work in the American Renaissance style and also the one who created the most profound work. During his Paris training in the late 1880s, Mathews proved his ability to render figural compositions with the repeated acceptance of his student work in the Salon exhibitions. After his return to San Francisco, while working as an art teacher, he accepted his first mural commission, in 1896, to decorate the library of the Horace L. Hill mansion. More private commissions and a public commission followed. Many of Mathews's murals were destroyed in the 1906 earthquake and fire, but the disaster generated more commissions as the city was rebuilt. Mathews was the undisputed leader of California mural painting as late as 1915, far outdistancing his few competitors.

Every artist's work is a composite of his training, his life experiences, his subconscious likes and dislikes,

and his visual experiences, funneled into his art via his technical abilities. Mathews had a made-to-order background for success in the American Renaissance style. Not only had he worked as an architectural draftsman, but he was exceptionally talented at rendering figures. His style was influenced by his admiration of the muralist Puvis de Chavannes and of Japanese prints. He used the same basic format in both mural and easel paintings: large-scale figures engaged in an activity close to the surface of the picture plane, against a California landscape background. *Sacred and Profane Love* of 1915 (fig. 8-1) is typical of his work. Mathews preferred female figures to act out his messages. More than two thousand years of literature has given the female form extensive and varied symbolic meanings. It can equally be the White Lady representing purity and innocence as well as the opposite, a seductress (femme fatale) embodying much of the evil in the world. In this painting Mathews's women symbolize the two traditional sides of love: the romantic and the carnal. Although he idealizes his figures, his women are never nymphs, dryads, fairies, witches, or sprites -- the frequent choices of less profound artists. They are corporeal beings universalized by their Greek robes. Mathews rarely represented specific females with their identifiable symbols. He did, however, often pair a female figure with objects such as flowers, musical instruments, dancers, birds, and swans that symbolized generic female qualities such as gentleness, gracefulness, or artistic or intuitive qualities. In this work, profane love is seated with her nude back to the artist—modesty seemed to dissuade Mathews from painting frontal nudity, a pose popular with his European confreres. The artist frequently included peacocks, as he does here, for the elegance of the bird itself and for its colorful feathers. His work balances areas of pattern (peacock feathers, dress designs, or foliage) with solid areas (such as nude bodies).

Mathews's *Youth* of about 1917 (fig. 8-2) expresses a theme now commonly identified with California—healthy young women, comfortable with their bodies, active in California's out-of-doors. This view contrasts with that seen in East Coast paintings of the American Renaissance period in which women are often active in Arcadian landscape settings, or they are wan and fragile beings occupying dream worlds. Also "California" is their clothing (that seems to be a blend of the white Greek robe and the newly popular patterned Japanese kimono) and the figures' unconventional boisterous exuberance. The theme of *Youth* applies equally to California itself, that was young in age compared to the eastern United States and that had a lifestyle marked by outdoor living and greater social freedom. Although *Youth* is an easel painting, it is stylistically

103

very much like a mural painting. Colors are muted and harmonious, and human activity occurs close to and parallel to the surface. There were two basic ways in which figures could be arranged in murals: the procession (often used on a long wall) and the symmetrical grouping (in which a large central figure is flanked by smaller, kneeling or reclining figures). The composition in *Youth* is closest to the first. However, Mathews breaks free from the usual, regularly spaced profile or frontal-facing figures, to give life and gayety through unusual poses and complex interrelationships of one figure to the other. (In this way his work is reminiscent of the procession on the frieze of the porch of the Parthenon in Athens.)

Arthur Mathews was one of the few California artists invited to contribute art to the Panama Pacific Exposition of 1915. He painted a lunette over the main doorway of The Court of the Palms. Titled *The Victorious Spirit* and now destroyed, it depicted a golden winged "angel of light" protecting a youth and his guardians from a brutal equestrian figure, the "spirit of materialism" (reproduced in Harvey L. Jones, *Mathews*, The Oakland Museum with Gibbs M. Smith, Inc., 1985, p. 28). Although Mathews inspired no school of painters of American Renaissance subjects, an occasional Bay Area painter depicted female figures in compositions.

Symbolist Painting (1890–1925)

Painting truly enters the cerebral realm when it becomes Symbolist (sometimes referred to as imaginative painting), when it plumbs the mysterious realm between waking and sleeping. On the surface, many Symbolist paintings look very much like American Renaissance paintings. Both can feature idealized figures engaged in some activity; and these figures can be either nude or dressed in loose, flowing costumes, like those worn by the Greeks, Romans, and medieval Europeans. But Symbolist paintings differ in that they express *personal inner visions* and draw their inspiration from a wide variety of world religions and literary influences that range from classical mythology to macabre contemporary literature.

Symbolism originated in Europe and was generally regarded by plain-speaking Americans as decadent. From the 1860s Boston's "aristocratic" class had been seeking a sympathetic cultural climate in Europe and absorbing its ideas. By the 1890s Boston had become the American center for the search for alternatives to "impotent and aimless" living. Searchers went to the imagination and dreams, as well as to drugs such as hashish, opium, morphine, absinthe, and mescal.

Others looked to prophets, such as the theosophist-occultist Madam Blavatsky (1831-1891) who had a branch of her Theosophical Society near San Diego, and the scientist-religionist Emmanuel Swedenborg (1688-1772), who had a strong following in California's East Bay. Others espoused Far Eastern religions and philosophies with their meditative and introspective bent, and still others were attracted to mysticism and pantheism. The new "worlds" created by Symbolist painters often had an ethereality, a dreamlike quality, or a sense of fantasy, and these worlds provided one more escape from society's increasing materialism, mechanization, and dependence on science.

Symbolic themes spring from many inspirations and have different intents. **Arthur Mathews**'s work, *The Wave (Marine)* (fig. 8-3), for example, visualizes universal and elemental truths. Compositionally, his Symbolist paintings follow the same general format as his American Renaissance pictures—large females active on a shallow "stage." *The Wave* no doubt reflects the turn-of-the-century fascination with the newly revealed undersea world, with its related female symbols of mermaids and Mother Nature. As the discipline of psychology developed, Sigmund Freud (1856–1939) and others linked water, especially rushing water, to sex. In California, surf bathers are a common sight, and their arms rise naturally to counterbalance the forceful blow of the oncoming wave. Such a sight may have been Mathews's initial inspiration, but no actual woman could have braced herself as eloquently as Mathews's maiden, whose willowy body assumes the curve of the wave and whose outstretched arms rise above the curl in a lilting Art Nouveau shape. Artists have long responded to the sensual curves of a woman's torso and arms, and Mathews frequently paints women with their arms held horizontally. He also favors a high horizon (formed here by the arms and wave crest). The design is flat like the Japanese color woodblock prints that provided inspiration for so many Western painters of the late-nineteenth and early-twentieth centuries.

Charles Rollo Peters's source for the symbols in his *Visitation* (fig. 8-4) was the New Testament. Peters (chapter 7) was among the few California painters of nocturnes. *Visitation* represents the moment when the angel informs the shepherds of Jesus's birth. The work was probably painted early in Peters's career, either in Europe or immediately after his study there, judging from the complexity of the composition, the range of shades and tones, and the Brittany peasant dress of the shepherds. The appeal of this particular biblical subject to Symbolists derives from the mystical quality of the event (as opposed to other biblical tales that report secular historical happenings), and moonlight adds to the sense of mystery.

The third artist to produce a quantity of Symbolist pictures was **Gottardo Piazzoni** (1872–1945). As an end-of-the-century landscapist, he regarded nature as a respite from an increasingly mechanized society. Piazzoni's *Untitled, Decorative Landscape with Architectural Forms* (fig. 8-5) reduces landscape elements to flat, silhouetted soft-edged shapes that retreat far from naturalism into an ideal, dreamlike world of muted and restful colors. By adding passive, idealized figures (like the standing shepherdess in this painting) he creates a reverential and vaguely religious mood. Some art historians describe his work as "plumbing the soul of the land."

Fig. 8-5
Gottardo Piazzoni
(1872–1945)
Untitled, Decorative Landscape with Architectural Forms
oil on canvas, 23½ x 49¾ in.
The Buck Collection, Laguna Hills, California
Photo: Cristalen and Associates

In the realm of Symbolist painting, comparatively sparsely populated Southern California more than holds its own with the north. Southern California Symbolist painting, however, was of a completely different character. In Pasadena of the 1890s **Charles Walter Stetson** (1858–1911) painted idyllic figures in shadowy woodsy settings like those popular in the European Salons. A well-read gentleman of a dreamy, romantic disposition, his ambition was to be a painter of historical or religious themes. Throughout the 1880s he moved away from his salable Barbizon-style landscapes, toward figure compositions. Unable to afford European art study, he taught himself, combating the moral prejudices of his day to acquire nude models, often working from photographs of figures made in Europe for the use of artists. His admiration of things Greek culminated in a series of pictures of pagan ritual processions made up of ecstatic, nude or diaphanously dressed women. The most admired of these is *In Praise of Dionysus* of 1899 (fig. 8-6). With its cascade of dancers, it exhibits the same *joie de vivre* as Mathews's *Youth* but takes its inspiration directly from Greek mythology, the story of Bacchus, the god of wine. Disinterested in the strict academic drawing of his peers in Europe, Stetson sought only the mood of the antique. In an era of grey-toned landscapes, his jewel-like, Old Master color stood out.

Despite San Diego's relative lack of sophistication, the city's artists produced a surprising amount of Symbolist painting thanks to the Universal Brotherhood and Theosophical Society, established on Point Loma in 1897 by followers of the Russian-born society founder Helena Petrovna Blavatsky. The Society had three aims—to form a brotherhood of all races, creeds, sexes, casts, and color, to study all world religions and philosophies, and to investigate the Laws of Nature. It taught certain universal truths extracted from Eastern and Western theology and philosophical thought. Followers believed that there was no single god but a universal spirit and that humankind was one with the universe. The Point Loma community attracted a number of artists and offered art instruction at its Raja Yoga Academy.

Certain of the resident artists at Point Loma, particularly **Reginald Machell** (1854–1927) produced Symbolist work. Machell's most important picture, *The Path* of 1894-95 (fig. 8-7, p. 100), shows the route the human soul must traverse before it reaches full spiritual self-consciousness. Like a Buddhist tonka, this work is a complex and highly esoteric religious diagram, its myriad elements organized with symmetrical balance. Filling the central hexagon is the faintly painted supreme condition (in human form). Across

Fig. 8-6
Charles Walter Stetson
(1858-1911)
In Praise of Dionysus, 1899
oil on canvas
39 x 49 1/2 in.
Marian Bowater

Fig. 8-8
Rex Slinkard (1887–1918)
My Song, c. 1915–16
oil on canvas
38 x 51½ in.
Stanford University Museum
of Art 1955.1028; Bequest of
Florence Williams

his breastbone is superimposed a winged Isis, the Mother or Oversoul, whose outspread wings block the face of the Supreme from the eyes of those below. Superimposed on his stomach is a Christ-like figure who represents an individual who has reached full spiritual self-consciousness. To his left and right are other aspirants whose purity (symbolized by the tiny white flames above their heads) either allows them to pass the gauntlet of red-colored Medieval garbed guardian figures or whose interest in money or ambition causes them to meet their destruction on the rocks. Superimposed on the ankles of the supreme being is a child protected by the wings of Mother Nature. This child receives the "equipment of the Knight, symbols of the powers of the Soul, the sword of power, the spear of will, the helmet of knowledge, and the coat of mail, the links of which are made of past experiences," which will arm him for his life's journey. (Kamerling, Bruce, "Theosophy and Symbolist Art: The Point Loma Art School," *Journal of San Diego History*, v. XXVI, no. 4, Fall 1980, p. 253.) Generally, artists who espoused Theosophy were self-effacing, and if a work was signed it was followed by "Point Loma Art School." Because they believed that every object had innumerable aspects, they looked upon so-called realism in art as only a rendering of external appearances. Although this image is too filled with esoteric references to be readable to the uninitiated, it stands alone as an artwork of rich and complex imagery, subtly organized and rendered.

Unlike the American Renaissance style that came to its end with the Panama-Pacific Exposition, Symbolism, in new forms, continued as a minor and peripheral thread through the early 1900s, especially in Los Angeles. Symbolism arrived late in the city, appearing first in the early 1910s in the work of artists who had studied in New York, and World War I gave new reason to escape to imaginary worlds. These artists differed from earlier Symbolists in that they plumbed their own souls for subject matter. Not only were they intent on resolving their feelings about themselves and the universe but also on finding a new visual language that would express those feelings to others. Their imagery swung away from classically dressed figures to more modern motifs, derived from psychology, abstraction, and non-Christian religions.

In Los Angeles in the early 'teens, **Rex Slinkard** (1887-1918), who had studied in New York with the Ash Can painter Robert Henri (1865–1929), taught at Los Angeles's Art Students' League and evolved his own personal form of symbolic modernism. His softly colored and brushed figures, like those in *My Song* of about 1915–16 (fig. 8-8), establish a mood rather than enact any specific action. His letters (Stanford Museum

of Art) record his feelings. "It's wonderful to work. To work with the inside of oneself…Imagination—that's the one thing I can paint with. I am lost without it." His work clearly shows his admiration for earlier painters such as Puvis de Chavannes, whose coloration and soft forms he adopted. He also revered the Italian Renaissance artists Botticelli and Giotto for their treatment of figures, and his New York contemporary Arthur B. Davies (1862–1928) for his idealized female nudes romping in nature. The figures in *My Song* are not specific but rather generic and idealized, bound to each other as one melted organic mass, as components of a whole unified through their muted color and spiritual kinship.

Southern California is notable for the work of several women Symbolist artists. Some readers might claim that women had an edge in creating Symbolist works, arguing that women are more intuitive by nature or financially freer to indulge themselves in self-revelation that has little or no public market. They might claim women painters were often financially independent or unmarried and unburdened by families to support. Other readers might believe that the less socially restrictive California lifestyle allowed all artists to be individualists and that the state's pleasant climate made artists' oneness with nature more evident. Most of the followers of Los Angeles's many exotic religious cults were women.

Active in the 1910s, the Pasadena artist, **Adele Watson** (1873–1947), was first inspired by her close friend and associate the philosopher-author-artist,

Fig. 8-9
Adel Watson (1873–1947)
Untitled (Anthropomorphic Series), 1931
oil on canvas, 34 x 27 in.
Kelley Gallery, Pasadena, California

Fig. 8-10
Mabel Alvarez (1891–1985)
Dream of Youth, 1925
oil on canvas
58 x 50¼ in.
Adamson-Duvannes
Galleries, Los Angeles
Photo: Christopher Grandel

Opposite:
Fig. 8-11
Agnes Pelton (1881–1961)
Messengers, 1932
oil on canvas
28½ x 20½ in.
Robidoux Foundation

Kahlil Gibran, whose most famous book, *The Prophet,* was first published in 1923. Frequent trips from her Pasadena home to New York brought her into contact with the paintings of Arthur B. Davies. Her earlier Symbolist paintings (1916 to the mid-1920s) mimic his diaphanously dressed women dancing in a natural setting. About 1925 Watson's viewpoint expanded to present man and nature as one. An example is *Untitled (Anthropomorphic Series)* of 1931 (fig. 8-9) in which human forms are embedded in and an intrinsic part of towering rock outcroppings and peaks. By integrating human forms with the granite, Watson expressed the universal theme that man is made of the same elements as earth and finally returns to the earth. Viewing the crags from below, she silhouettes them against the sky and monumentalizes them. Lines carry the eye to the peaks that seemingly rise in aspiration. Watson's palette changes in these latter works, moving from the dusky twilight world of the spiritual to the full light of everyday reality, yet her shades of purple, a color often associated with melancholy, remain.

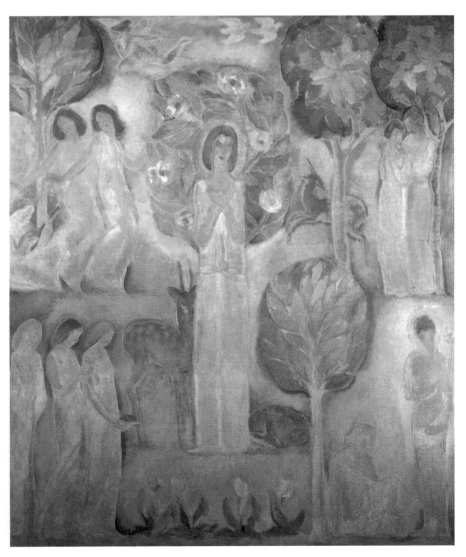

Mabel Alvarez (1891–1985), unlike Adele Watson, lived in two parallel artistic worlds, the practical world of her Impressionist and post-Impressionist figure compositions, and the imaginative world of her Symbolist pictures, which she called "decorative." Religion had always been important to Alvarez, and for a long period she was influenced by Will Levington Comfort (1878-1932), a Southern California novelist and the messiah of a Hollywood cult that advocated meditation as a means of finding one's inner self. Through the 1920s, Alvarez, along with several other artists, including fellow Symbolist Agnes Pelton, attended meetings at Comfort's home, and her diaries record her new-found feelings of harmony and her ability to "let go" in painting.

Beginning about 1925 Alvarez painted several Symbolist canvases. The most important of these is *Dream of Youth* of 1925 (fig. 8-10). Its celadon green coloration is reminiscent of that of Rex Slinkard, whose work fascinated her. His soft colors and forms seemed all emotion, a dream world of the spirit, with nothing of the material world. Her composition is much more literal, however, and tantric in its symmetry. The central figure in white robes is probably an idealized Alvarez; the surrounding vignettes represent aspects of femininity: music, dance, love, maternity, and grace; and the interspersed deer symbolize the gentleness of women's spirit. Alvarez frequently chose motifs from Persia and India that she had seen in books, such as seated Buddhas, and animals, including lions and deer. Compositional stability comes from the balance of the large central image with its encircling vignettes. Alvarez continued to paint these "decorative" canvases through at least 1933, giving them dreamlike titles such as *I Walked in Elysian Fields* (1927) and *On the Shores of Sleep* (1929).

Agnes Pelton (1881–1961), who lived in New York before moving to California in the mid-1920s, also gained the initial inspiration for her Symbolist works from Arthur B. Davies. But the works she is best known for today are her Abstract Symbolist paintings first conceived in the second half of the 1920s, during her isolated residence in a windmill on Long Island. She produced the bulk of these after her 1931 move to Cathedral City (a desert community east of Los Angeles). Abstract Symbolism is the most esoteric of all the types of Symbolist paintings for it avoids identifiable motifs and tries to represent inner emotions as vaporous shapes and colors. Pelton's lifelong daily routine included twilight rest in her garden, where the humidity-free desert atmosphere gave her an unimpeded view of the heavens and its host of stars. In the mornings she resumed her daylong work in her stu-

dio. Although she, too, had a practical side—she produced conventional desert landscapes to support herself—her "children," her "own things," such as *Messengers* of 1932 (fig. 8-11), were the most important to her personally. Pelton's imagination conjured shapes that seemed to convey light as well as sound. Her abstract work is sensual, almost erotic, full of curving almost three-dimensional vaporous forms crafted with subtle nuances of color that are vaguely reminiscent of the earth's Northern Lights, with their iridescent, and moving, diaphanous colored gasses. Pelton's shapes sometimes take configurations that more literal minds make into vases or trumpets or stars. Part of her works' appeal lies in their rich, velvety blacks and their light-infused colors.

This study of American Renaissance and Symbolist art has taken the reader well into the twentieth century. The next chapter will return to the nineteenth century, to dusty and flea-ridden Southern California to pick up the trail of art there and to see the very different art history that evolved in the Southland. ✳

Bibliography

American Renaissance/Beaux Arts Architecture and Decoration

Feldman, Eddy S., *The Art of Street Lighting in Los Angeles,* Los Angeles: Dawson's Book Shop, 1972.

Murray, Richard N., *The American Renaissance 1876–1917,* exh. cat., Brooklyn Museum, October 13–December 30, 1979.

Mills, Sally, "The Framemaker's Art in Early San Francisco," *Art of California,* v. 3, no. 6, November 1990, pp. 54–59.

Tracy, Robert Howard, *John Parkinson and the Beaux Arts City Beautiful Movement in Downtown Los Angeles, 1894–1935,* Ph. D. Dissertation, University of California, Los Angeles, 1982. 540 p.

Visionary San Francisco [City plans], exh. cat., San Francisco Museum of Modern Art (with Prestel, New York), June 14–August 26, 1990. 175 p.

Mural Painting

"Murals," in Harvey L. Jones, *Mathews Masterpieces of the California Decorative Style,* exh. cat., Oakland Museum (reprinted Layton, Ut.: Gibbs M. Smith, Inc., 1985).

Unna, Warren, *The Coppa Murals,* San Francisco: The Book Club of California, 1952.

Van Hook, B., "From the Lyrical to the Epic: Images of Women in American Murals at the Turn of the Century," *Winterthur Portfolio,* v. 26, Spring 1991, pp. 63-80.

William Gerdts, *The Great American Nude: A History in Art,* New York: Praeger, 1974.

Panama Pacific Exposition (Murals and Paintings)

Art in California: A Survey of American Art with Special Reference to California Painting…Particularly as those Arts Were Represented at the Panama Pacific International Exposition, San Francisco, 1916. [reprinted by Westphal Publishing, 1988]

Calder, A. Stirling, *The Sculpture and Mural Decorations of the Exposition,* San Francisco: Paul Elder & Co., 1915.

Flagg, Peter Joyner, "The Well-Painted Painting: Northern California's Academic Tradition and the Panama-Pacific International Exhibition," in Joseph Armstrong Baird, Jr., ed., *From Exposition to Exposition: Progressive and Conservative Northern California Painting 1915–1939,* Sacramento: Crocker Art Museum, 1981.

Michelle Kloss, *The Murals of the 1915 Panama-Pacific International Exposition,* M. A. Thesis, University of Maryland at College Park, c. 1996.

Symbolic Painting

Dillenberger, Jane and Joshua C. Taylor, *The Hand and the Spirit: Religious Art in America 1700–1900,* exh. cat., University Art Museum, Berkeley, June 28–August 27, 1972.

Dreams, Visions and Imagination: an Exhibition of Symbolic and Imaginative Paintings by California Artists 1910–1930, exh. cat., Maureen Murphy Fine Art Gallery, Montecito, Ca., September 16–October 14, 1990. 12 p.

Eldredge, Charles, *American Imagination and Symbolist Painting,* exh. cat., Grey Art Gallery and Study Center, New York University, October 24–December 8, 1979 and one other venue.

Hine, Robert V., *California's Utopian Communities,* San Marino, Ca.: Huntington Library, 1953.

Kamerling, Bruce, "Theosophy and Symbolist Art: The Point Loma Art School," *Journal of San Diego History,* v. XXVI, no. 4, Fall 1980, pp. 230-55.

Tuchman, Maurice, org., *The Spiritual in Art: Abstract Painting 1890–1985,* Los Angeles County Museum of Art and Abbeville Press, New York, 1986.

Fig. 9-13
Charles Greene (1868–1957);
Henry Greene (1870–1954)
Gamble House, Pasadena,
1908, Entry Hall
dark Burma teak, teak,
mahogany, white oak
Gamble House, University of
Southern California
Photo: Tim Street Porter

1890–1915:
Growth of the Arts & Non-Painting Media

As the year 1900 approached, life began to speed up. Creative individuals in the sciences had provided the world with the telegraph, the telephone, the railroad train, the electric trolley, the automobile, and countless other laborsaving devices. As the pace of life accelerated, painters, who had prided themselves for a century on their ties to academies and tradition, now were attracted instead to the cult of the new, to experimentation and self-expression. Painting began to lose ground to other media. Media that had formerly been considered commercial or less elevated were being brought into the realm of "fine arts" by artists who were intrigued not only by the techniques themselves but by the new ways of expression they offered. These media included sculpture, printmaking, photography, and arts and crafts.

Sculpture

Sculpture was the last of the traditional fine-arts media to take hold in California. The late settlement of the state caused it to miss out on America's great "marble resurrection," i.e., the proliferation of Neo-classical white marble sculpture that occurred on the East Coast between about 1830 and 1870. San Francisco boasted one sculptor active from about 1857 until the late 1870s, Pietro Mezzara (1823–1883) from Italy, who produced cameos, medallions, and portrait busts for the city's social elite. He worked primarily in marble, which, like stone media in general, lent itself to simple, bold shapes and smooth surfaces, characteristics that came to be identified with the Neo-classical style. All the other California towns had a "farm center" character, and their contact with sculpture was limited to the purchase of white marble statuary carved in Italy and hawked by itinerant salesmen.

A late worker in the Neo-classical tradition was California's earliest major sculptor, **Rupert Schmid** (1864–1932). Typical of this tradition, his *California Venus* of 1894 (fig. 9-1) was idealized in appearance and symbolized a public ideal—California womanhood. The late date and idealized form of the Venus place her in the Beaux-Arts time period, but her slightly "frozen" look ties her spiritually to Neo-classical statuary.

California's first sizable number of sophisticated sculptors appeared in the Bay Area about 1890, near the end of America's post-Civil War cultural explosion. The American Renaissance urge for civic improvements had stimulated the construction of public buildings and parks, which, in turn, demanded sculpture. This sculpture usually took the form of allegorical scenes in relief on building facades or of free-standing monuments to America's heroes in parks. Bronze had usurped marble as a medium. With bronze, sculptors could add as much detail as they chose to the clay original, even allowing their finger marks to show, and the molten metal would flow into every pit and cavity of the mold. Bronze liberated sculpture, just as photography liberated painting, freeing sculptors from making stiff statues and opening up sculpture to greater self-expression.

California's most important turn-of-the-century sculptor was the deaf-mute **Douglas Tilden** (1860–1935). Tilden's *Memorial to the California Volunteers* dedicated in 1906 (fig. 9-2), situated at the corner of Market and Van Ness Streets in San Francisco, displays in one sculpture the two parallel aesthetic styles that enjoyed favor from about 1880 to about 1915. The naturalistic style can be seen in the almost photographic soldier, while the Beaux-Arts style (chapter 8) is evident in the allegorical figure, the goddess of war Bellona astride the winged horse Pegasus. Tilden surpassed his peers because he gave energy and originality to his basically traditional compositions. He was especially important as a teacher, training others who became the core of San Francisco's sculptors through World War I.

Sculpture flourished in San Francisco during the massive rebuilding the city undertook following the earthquake and fire on April 18, 1906. (See **Edwin Deakin**'s *Despair* of 1906 [fig. 9-3]). In two days the fire consumed central San Francisco from the wharves to the dynamite line at today's highly trafficked cross-city Van Ness Street. It was especially devastating to the art community because it destroyed the downtown, where many artists had their studios (except the Montgomery block building where a few of them worked), and Nob Hill, where many of the wealthy art collectors had built their grand houses and where the Art Institute was housed in the Mark Hopkins mansion.

In the rest of the state the making of sculpture was limited. Although most of California's small towns aspired to the City Beautiful ideal, it was not until the early twentieth century, as those towns grew to cities, that there was enough patronage to encourage a few carvers and casters to settle. In Los Angeles the best

known and most important sculptuor was Julia Bracken Wendt (1871-1942). A few Los Angeles sculptors traveled to San Diego to carry out commissions.

The crowning glory of Beaux-Arts architecture and art was the Panama-Pacific International Exposition held in San Francisco in 1915. The Panama-Pacific is usually considered both the last of the great expositions held in American cities following the successful 1876 Centennial in Philadelphia as well as America's last great expression of the Beaux-Arts style. The exposition celebrated the completion of the Panama Canal and announced San Francisco's coming of age, its emergence from a frontier to a cosmopolitan center, its rise from the ashes of the earthquake and fire, and its debut as the premiere doorway to the emerging Pacific trade.

Most of the architecture and art of the exposition site was executed by East Coast architects and artists hired, according to the practice of the time, by the architect of the complex. One of the exposition's three California sculptors, **Alexander Stirling Calder** (1870–1945) (father of Alexander Calder, the inventor of mobiles), directed a corps of forty-four in the making of monuments and bas-reliefs. Calder regarded sculpture as a decorative element to enhance architecture, and his *Star Figure* of 1914 (fig. 9-4), which crowned the Colonnade of Stars, Court of the Universe, was a completely new type of finial, "a human figure conventionalized to become architecturally static, yet not so devitalized as to be inert" (*Art in California,* Irvine, Ca.: Westphal Publishing, 1988, p. 147).

Just after the turn of the century, a few of California's sculptors embraced the Romantic style. In the late nineteenth century the French sculptor Auguste Rodin (1840–1917) changed the look of sculpture when he eliminated surface detail in order to capture the essence of forms. In this style Southern California could boast Gutzon Borglum (1867–1941) and Solon Borglum (1868–1922), who later rose to fame as two of America's greatest early-twentieth-century sculptors. San Diego and San Francisco could claim the sculptor **Arthur Putnam** (1873-1930), who though lesser known to America in general proved to be the state's most important for the style. Putnam is best known for his small bronzes of animals. Typical of his work is *Big Combat: Pumas Fighting over Deer and Snake* made between 1904 and 1911 (fig. 9-5). Animal subjects developed in France where sculptors found that animals were a neutral theme to which everyone could relate, that animals could serve as allegories of human situations, and that they could provide an animated composition. In the early twentieth century, as the American Renaissance movement waned and commissions fell off for architectural sculpture and large sculpture in public parks, tabletop sculptures for private homes took their place, and animals proved an acceptable subject. Although Putnam worked and studied sculpture and bronze casting in Italy and France about the time of the 1906 earthquake, he arrived at his Romanticism not after seeing Rodin's work in Europe but before his continental trip, by observing animals in the wild near his San Diego back-country home. His technique was to study their movements and then to return to the studio where he modeled their essence. (Most city-bound animal sculptors were forced to observe their subjects at zoos or to copy stuffed animals.) Putnam modeled only American animals. He was slated to head the corps of sculptors at the Panama Pacific Exposition when a brain tumor was discovered; an operation early in 1912 left him alive but unable to control his hands or ever work again.

Below:
Fig. 9-4
Alexander Stirling Calder
(1870–1945)
Star Figure, 1914
cast bronze, 51 x 15¼ in.
Collection of the Oakland Museum of California, cast courtesy of Oakland Museum Founders Fund from the original plaster model, Gift of Dr. William S. Porter

Below, left:
Fig. 9-5
Arthur Putnam (1873–1930)
Big Combat
bronze
18⅜ in. x 33 in. x 23 in.
San Diego Museum of Art
(Gift of Mrs. A. B. Spreckels, Alma Emma Spreckels, Adolph B. Spreckels and Dorothy Spreckels)

Printmaking

Many artists were reluctant to adopt printmaking as a medium. Prints are produced on an ephemeral material—paper—and printmaking was associated with the "second-class" field of illustration. However, artists began to realize that some of printmaking's techniques offered intriguing expressive and technical opportunities.

Etching. Etching is the intaglio technique most natural for painters to adopt because it can be so much like drawing. In an etching an artist "draws" an image on the surface of a metal plate by scratching through an acid-resistant coating with a sharp-pointed metal needle or stylus. (Engraving entails using a burin to carve into a metal plate.) After the design is scratched, the plate is submerged in an acid bath that etches or eats away the parts of the metal that have been exposed. Ink is then rubbed into the "bitten" areas, and the plate is pressed under considerable force against paper to make the print. In the 1880s many artists of the Western world began to take up the new medium, sharing technical secrets and bending over printing presses late into the night. Americans made many innovations in this medium. Printmaking had traditionally been an elitist medium: intimate in size, issued in small editions, and its artists concerned with esoteric questions, such as beauty of line. Americans took etchings beyond this tradition by working in large scale (sometimes 2 x 3 feet), by stressing subject over "beauty of line," and by using certain commercial printing techniques—including electroplating copper plates with steel to increase edition sizes without deterioration of the image. The medium was fostered in America by Sylvester Rosa Koehler, the New York publisher of the *American Art Review,* who not only purchased work that he reproduced in his magazine but advised aspiring etchers. The revival of etching conveniently coincided with the rise of armchair travel books, many of them lavishly illustrated with etchings. The artist who set the world standard for etching was the American expatriate painter and etcher James Abbott McNeill Whistler (1834–1903). He was admired for his concise and varied use of line, his range of line type (from bold and strong to delicate and refined), his effective contrasts of light and shade, his choice of subjects, and his keen observation.

California was not far behind in adopting etching. In the 1880s a small group of artists associated with the San Francisco Art Association imported a press from France and pulled a number of prints. Between 1887 and 1893, the San Francisco print dealer W. K. Vickery sent drawings by California artists to the East to be translated into etchings, and occasionally an East Coast artist was assigned to etch California scenes for an upcoming publication, such as *Picturesque America.*

However, Southern California, by chance, produced the most advanced work. In 1883 the painter **Henry Chapman Ford** (1828–1894), who had made drawings of all twenty-one California missions in the summers of 1880 and 1881, traveled to New York to turn them into chromolithographs. In a last-minute decision he chose to make etchings from them instead. This proved the perfect choice. Not only was the etching process artistically up to date but it was the favored medium for representing picturesque buildings. Inexpensive, multiple images such as the *Mission San Gabriel* of 1883 (fig. 9-6) were not only beautiful art works in their own right, but served California's new tourist industry. Prints could be bought either in a portfolio or individually.

California's first organization for etchers formed only years later, in December 1912, as San Francisco was preparing for the Panama Pacific Exposition of 1915. On a visit to San Francisco about that time, the great American illustrator-painter-etcher Joseph Pennell (1860–1926), captivated by the city, made etchings of it that were exhibited at Vickery, Atkins and Torrey, a San Francisco gallery with a particular interest in works on paper. This inspired the scattered Bay Area etchers to organize as the California Society of Etchers (later Printmakers). Los Angeles did not form its Printmakers of Los Angeles until late in 1914, despite the existence of the Ruskin Art Club organized in 1888 by a group of women interested in studying printmaking. Most of California's etchings of representational subjects were produced between 1915 and 1935 (chapter 12).

Monotypes. Monotypes are an even more intriguing medium for painters because they are technically almost identical to painting. A monotype is made when an artist uses fingers, brushes, or a rag to spread ink or oil paint on a flat "plate" (such as a pane of window glass). A sheet of paper is pressed against the plate to make the print. For this reason Joseph Pennell called monotypes "squashed paintings." Since the paper picks up most of the ink or paint, there is no question of making multiple copies, hence the word "mono" (one) "type" (print). Most turn-of-the-century monotypes were made in color. Monotypes were especially popular with Bay Area painters working in the Barbizon and Tonalist styles because the technique yielded the same moody nuances of color and soft-edged shapes and forms as did painting. Monotypes were made by several Tonalist painters, including Xavier Martinez, Gottardo Piazzoni and, an artist who print aficionados regard as the master, **Clark Hobart** (c.1870–1948). His *Spirits of the Cypress* of about 1915 (fig. 9-7) takes up the allegorical or dreamlike subject matter also favored by painters in those styles.

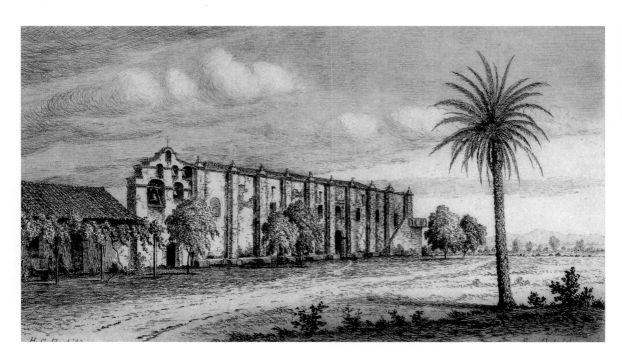

Fig. 9-6
Henry Chapman Ford
(1828–1894)
Mission San Gabriel, 1883
etching, 7 x 13 in.
Joan Irvine Smith Fine Arts,
Inc.

Fig. 9-7
Clark Hobart (c. 1870–1948)
Spirits of the Cypress
monotype
8⅜ x 13 in. (image)
Roger Genser, Prints & the
Pauper, Santa Monica

Woodcuts. Few painters attempted woodcut prints, perhaps because carving a block of wood is closer to sculpture than painting. In woodcuts (and the related technique of wood engravings) the print results from the ink that adheres to the high parts of the block, the parts that are not cut away. Although the medium had been in use for many years in Western Europe, its aesthetic changed drastically in the second half of the nineteenth century when European artists were influenced by the beautiful color woodcuts that came out of Japan as protective wrappers for exported products. Many Europeans and Americans took up the technique, but in California two were in the vanguard: **Helen Hyde** (1868–1919) and Bertha Lum (1869–1954). Typical of America's very early color woodcut artists, both went to the Far East to study with masters, and many of their early subjects are Asian or concern women and children. Hyde's *Moonlight on the Viga Canal* of 1912 (fig. 9-8) is a Western subject, but the silhouetting recalls some of the compositions seen in Japanese prints. In a woodcut, each color requires a separately carved block, which then has to be carefully registered with the others as the print is made. (Lum is credited with inventing a unique type of print that is reminiscent of Chinese Coromandel screens. The paper is first embossed by pressing it into a carved block, and then it is colored by hand.)

European and American woodcuts share the Arts and Crafts ideal in which the artisan himself performs all the steps in making an object. In contrast, the Japanese delegated the designing, cutting and printing to separate artists.

Fig. 9-8
Helen Hyde (1868-1919)
Moonlight on the Viga Canal,
1912
color woodblock
11 ⅞ x 13 ⅞ in.
The Buck Collection, Laguna
Hills, California
Photo: Cristalen and
Associates

Photography

Photography made rapid technical strides after its birth in 1839, progressing from daguerreotypes to glass plate negatives from which positive prints could be made. Almost immediately the medium influenced painting. Photography's ability to record accurately any visual scene or event freed painters from being illustrators or portraitists and allowed them to pursue personal subjects and explore pure formal aesthetics. Photography also freed painting from the world of reality, releasing painters to explore imaginary climes (see Symbolism, chapter 8). By the turn of the century George Eastman's popularization of roll film (1883–84) and his development of the relatively lightweight hand-held Kodak camera (1888) provided a portable and an affordable creative avenue for thousands, especially women. Many of these photographers, who wanted to distance their work from earlier nineteenth-century documentary and commercial photographs, borrowed aesthetic principles from painting. And, thus, photography entered the realm of fine art.

Documentary. Two types of photographs stand out in turn-of-the century California. In the 1890s, some of the new "amateur" photographers in Southern California were still interested in documentation. Sharing their fellow painters' romantic interest in exotic cultures (chapter 6), along with the concern that Native Americans and their cultures were rapidly disappearing, these photographers endured hot and dusty trips to the Southwest, first by train and then by horse and wagon, to record the Pueblo Indians. Among California's amateur archaeologists and photographers were Charles Lummis, who started Los Angeles's Southwest Museum; George Wharton James, a writer on Southern California; and the most accomplished of all, the bookstore owner **Adam Clark Vroman** (1856–1916). Some of Vroman's contemporaries, both painters and pictorialist photographers, arranged their Native American models into storytelling tableaux or presented them as stereotypes and symbols. Vroman, however, was unusually sensitive in capturing candid, natural situations, and even intimate moments. Although *Hopi Towns, Men of Sichimovi* of 1901 (fig. 9-9) is spontaneous, it is aesthetically well composed with a full range of blacks and whites. These are individuals as opposed to stereotypes.

Camera Pictorialists. The most artistically advanced photographers were the Camera Pictorialists. To counteract any documentary impulse in their photos, many Pictorialists contrived narrative compositions with costumed people posed before prearranged backdrops. Then, to offset the camera's propensity for detail, they made their pictures "fuzzy" by shooting out of focus and/or modifying the print in the darkroom. California's foremost Pictorialist photographer was probably **Anne Brigman** (1869–1950), the young wife of a sea captain, who occupied herself while he was on voyages by taking pictures of herself and friends posing in California's back country. *The Storm Tree* of 1911 (fig. 9-10) is an example. In Brigman's images, figures intertwine their limbs with twisted tree trunks, or the curves of their bodies mirror weathered boulders. Epitomizing the Camera Pictorialist ideal, Brigman's photographs were romantic, her figures idealized and spirit-like, and her themes invented. Like the American Renaissance painters, Brigman wanted to exalt the good, the beautiful, and the spiritual in life and to demonstrate man's affinity to nature. This seemed especially relevant to California, with its sweetly invigorating Pacific climate, which gave it a reputation for uninhibited natural, outdoor living. When the shy Californian showed her photos to Alfred Stieglitz, whose "291" gallery in New York (opened 1905) served as the American center for experimental photography, he immediately recognized her talent and exhibited her work.

Other California Pictorialists added to the national wealth of photographic techniques. They produced their own papers, experimented with unusual chemicals, and generally preferred a matte over a glossy finish. Laura Adams Armer (1874–1963) was particularly innovative in her exploration of selective toning, oil transfers, and gum-bichromate. The Pictorialist subjects, like those of the state's painters and sculptors, favored an idealization of reality over the contrivance of elaborately staged narrative scenes. In the 1890s almost every California town, no matter how small, had its contingent of photographers. The field offered a lucrative career opportunity for those women who chose to work outside the home. San Francisco spawned several important photographic organizations and the two publications *The Pacific Coast Photographer* (1892–94) and *Camera Craft Magazine* (1900–20). Los Angeles

Fig. 9-9
Adam Clark Vroman
(1856–1916)
*Hopi Towns, Men of
Sichimovi*, 1901
black and white print from
original glass plate negative
Seaver Center for Western
History Research, Los
Angeles County Museum of
Natural History

Fig. 9-10
Anne Brigman (1869–1950)
The Storm Tree, 1911
gelatin silver print
7½ x 9¼ in.
Collection of the Oakland
Museum of California, Gift
of Mr. and Mrs. Willard M.
Nott

was not far behind with its Los Angeles Camera Club, begun in 1900, and its *News*, about 1901. Northern California dominated art photography in California before World War I, but after that time Los Angeles challenged its lead as the city developed into the center of the film industry.

Arts and Crafts to 1915

The Arts & Crafts movement may have originated in England in the 1860s and 1870s, but once the aesthetic spread to California, it found a natural home. The movement constituted a backlash to the late-nineteenth-century industrial revolution. As such, its artists returned to handmade objects, the idea of craftsmanship, and the use of natural and organic raw ingredients. This respect for handmade objects and craftsmanship meshed with California's lack of industrial development. The movement's goal—living a natural outdoor life—was compatible with the state's year-round comfortable climate. The state had abundant natural materials for craftsmen to use: ubiquitous clay deposits as well as a tradition of the Spanish-Mexican period to make building walls and roof tiles from earth. Northern California had unique local woods, notably the redwood, for building houses and furniture. Along the coasts could be found shells and pebbles used for centuries by the Native Americans to decorate their wares. The state's flora and fauna inspired decorative designs. The Arts & Crafts ideal was evident everywhere: in the architecture of the California bungalow with its extended porches; in the use of native plants in the hillside plantings of the Bay Area and in the patios and courtyards of Southern California; in the effusive production of ceramic pottery and tiles; and in furniture and decorative household objects of gold, silver, copper, and lead. Indeed, California enjoyed one of the richest, most prolific, and unique Arts & Crafts movements of any state.

California's Arts & Crafts movement had two phases. In the first (1890–1915) pottery vessels were the major product. Small, private manufactories started up throughout the state near clay deposits, which provided clay in a wide range of colors from white to red and from high to low fire. Much of the earthenware was cast in molds, a technique that ultimately gave way to wheel throwing in the 1940s. Most California ceramics were more organic and natural in style than those produced in the East, such as *Vase* of 1902–09 made by **Redlands Pottery** inland from Los Angeles (fig. 9-11). Rather than being glazed with bright colors or decorated with idealized scenes, they are burnished and unglazed, their California origin discernible in the motifs of their carved decoration, here, the slim eucalyptus leaf. California potters were experimental, applying their curiosity to mixing clay bodies, to inventing unique surface embellishments, and to developing formulas for unusual glazes.

Woodworking was more prevalent in Northern California where the traditional building material was redwood. **The Furniture Shop,** owned by painter Arthur Mathews, flourished in the aftermath of the San Francisco earthquake and fire (1906–20). There Matthews made drop-front desks, tables, and chests of drawers in a style that blended American Renaissance with the California Arts & Crafts aesthetic. Mathews's innovation was to cover the flat surfaces with painted decorative designs, as in the frames shown in chapters 7 and 8. He sometimes employed traditional European motifs, such as urns and strap work, but his *Desk* of about 1910 (fig. 9-12) reveals his special achievement—designs derived from California flowers and plants. Because Mathews put so much emphasis on surface design, his style has been labeled the California Decorative Style. In Pasadena, the architects **Charles Greene** (1868–1957) and **Henry Greene** (1870–1954) built elegant natural-wood bungalows and furniture in a style that combined Japanese timber-frame construction with that of the East Coast Arts and Crafts furniture maker Gustave Stickley (1858–1942). The Greene brothers' masterpiece is the *Gamble House* in Pasadena of 1908 (fig. 9-13, p. 110). Farther south, at the Theosophical Society on Point Loma, Reginald Machell (chapter 8) carved complex, symbolic decorations on furniture and architecture.

In metalwork, Northern California craftsmen produced a large quantity of work in silver, reflecting the area's close ties to Colorado's Comstock Lode as well as the presence of San Francisco millionaires who made fortunes from trading its stock. More in keeping with the Arts & Crafts movement's emphasis on common materials are the works of Dirk van Erp (1860–1933), who made hand-hammered copper vessels with blood red patinas termed "warty reds." Lillian Palmer (1872-1961) ornamented her metalwork with beach pebbles where others had used precious gems. In Santa Barbara the father-daughter team of **Charles Frederick Eaton** (1842–1930) and Elizabeth Eaton Burton (1869–1937) were the best known of the handful of craftsmen at work in enclaves on Montecito estates or living in the downtown area. Eaton and Burton led Southern California artisans in incorporating local materials such as streaked abalone shell, beach pebbles, red cedar, sequoia woods, and scales of giant pine cones. *Guestbook* of about 1904 (fig. 9-14) combines natural suede with cut and hammered copper.

The next chapter begins the discussion of painting in Southern California, which is fascinatingly different from that produced in the north. And that discussion will eventually lead into the twentieth century with its rich variety of styles and themes. 🐝

Fig. 9-12
Arthur Mathews, The
Furniture Shop, Lucia K.
Mathews (1906–1920)
Desk, c. 1910
wood, carved, painted
59 x 48 x 20 in.
Collection of the Oakland
Museum of California, Gift of
Mrs. Margaret R. Kleinhans

Fig. 9-11
Redlands Pottery (Wesley H.
Trippett)
*Vase (California eucalyptus
leaves),* 1902–09
ceramic, 6¾ in. ht.
The Buck Collection, Laguna
Hills, California
Photo: Cristalen & Associates

Fig. 9-14
Charles Frederick Eaton
(1842–1930)
Guestbook, c. 1904
copper, suede, parchmnt, ink,
watercolor, 18¼ x 12½ in.
Collection of the Oakland
Museum of California,
purchased with funds from
the Timkin Fund

Bibliography

General

Blair, Karen J., *The Torchbearers: Women and their Amateur Arts Associations in America, 1890–1930,* Bloomington: Indiana University Press, 1994. 259 p.

Art Infrastructure 1890–1915

(See also bibliography for chapters 5, 7, 11.)

Apostol, Jane, *Museums along the Arroyo: A History and Guide,* Los Angeles: Historical Society of Southern California, 1996.

Feallock, Kay, "The Kingsley Art Club: One Hundred Years of Support for the Arts," *California History,* v. LXX, no. 4, Winter 1991/92, pp. 392–95.

Kamerling, Bruce, *100 Years of Art in San Diego,* San Diego: San Diego Historical Society, 1991. 108 p.

Moure, Nancy Dustin Wall, *Loners, Mavericks & Dreamers,* exh. cat., Laguna Art Museum, November 26, 1993–February 20, 1994.

Beaux-Arts Sculpture

Berney, Charlotte, "Western Sculpture in a Time of Change," *Antiques & Fine Art,* v. VI, no. 1, November/December 1988, pp. 76-83.

Cheney, Sheldon, *An Art Lover's Guide…Explanation of the Architecture, Sculpture and Mural Paintings* [of the Panama Pacific Exposition], Berkeley: At the Sign of the Berkeley Oak, 1915.

Dinwiddie, C., "American Animaliers," *National Sculpture Review,* v. 26, Winter 1977-78, pp. 8-19.

Gerdts, William, *American Neo-Classic Sculpture: The Marble Resurrection,* New York: Viking Press, 1973.

Hardy, Lowell, "Sculpture and Color at the Panama-Pacific International Exposition," *Out West,* n.s. v. 8, December 1914, pp. 321–30.

James, Juliet, *Sculpture of the Exposition,* San Francisco: H. S. Crocker Co., 1915.

Moure, Nancy Dustin Wall, *Painting and Sculpture in Los Angeles, 1900–1945,* exh. cat., Los Angeles County Museum of Art, September 25–November 23, 1980.

100 Years of California Sculpture, exh. cat., Oakland Museum, August 7–October 17, 1982.

Perry, Stella George, *The Sculpture and Mural Decorations of the Exposition,* San Francisco: P. Elder & Co., 1915.

Peterson, Richard H., "Junipero Serra and Thomas Starr King: California's Statuary Monuments in Washington, D. C." *Southern California Quarterly,* v. LXXV, Spring 1993, pp. 65–84.

White, Lucy, "Sculpture & Sculptors at the Panama Pacific Exposition," *Overland,* n.s. v. 64, September 1914, pp. 277–86.

Wilson, Raymond L., "Sculpture in San Francisco: The City Beautiful Era," *Sculpture Review,* v. 43, Summer 1994, pp. 29–30.

Printmaking 1890–1915

Etching

Cheney, Sheldon, "Notable Western Etchers," *Sunset,* v. XXI, no. 8, December 1908, pp. 737–44.

Feinblatt, Ebria and Bruce Davis, *Los Angeles Prints, 1883–1980,* exh. cat., Los Angeles County Museum of Art, September 4–November 30, 1980 and June 25–September 20, 1981.

Lemos, Pedro J., "California and its Etchers, What they Mean to Each Other" and Robert B. Harshe, "The California Society of Etchers," and Hill Tolerton, "Etching and Etchers," in *Art in California,* San Francisco: R. L. Bernier, 1916 (republished Irvine, Ca.: Westphal Publishing, 1988).

Moure, Nancy Dustin Wall, *Loners, Mavericks & Dreamers,* op. cit.

O'Brien, Maureen C. & Patricia C. F. Mandel, *The American Painter-Etcher Movement,* Southampton, N. Y.: The Parrish Art Museum, 1984.

Pennell, Joseph, *San Francisco: The City of the Golden Gate,* Boston: L. Phillips, 1916.

Picturesque California and the Region West of the Rocky Mountains: from Alaska to Mexico, San Francisco and New York: J. Dewing, 1888. 2 v.

Pratt, Harry Noyes, "The Beginning of Etching in California," *Overland Monthly and Out West,* v. 82, March 1924, p. 114.

Watrous, James, *A Century of American Printmaking 1880–1980,* Madison: University of Wisconsin Press, 1984.

Wilson, Raymond L., "Early Days of the Fine Print in the American Far West," *Prints of the American West: A Survey of One Hundred Years,* New York: Pratt Institute, 1987. 24 p.

Wilson, Raymond L., "Prints of Early California," *Art of California,* v. 2, no. 4, August/September 1989, pp. 20–26.

Monotype

Monotypes in California, introduction by Therese Thau Heyman, exh. cat., Oakland Museum, October 17–December 17, 1972.

Moser, Joann, *Singular Impressions: The Monotype in America,* published for the National Museum of American Art by Smithsonian Institution Press, Washington, D.C., 1997.

Reed, Sue Welsh, *The Painterly Print: Monotypes from the Seventeenth to the Twentieth Century,* exh. cat., Metropolitan Museum of Art, New York, May 1–June 29, 1980 and one other venue.

Woodblock

Hosley, William N., *The Japan Idea: Art and Life in Victorian America,* Hartford, Ct.: Wadsworth Atheneum, 1990.

Gerdts, William H., "American Artists in Japan," in *Theodore Wores An American Artist in Meiji Japan,* Pasadena: Pacific Asia Museum, 1993.

Meech, Julia, *Japonisme Comes to America: the Japanese Impact on the Graphic Arts 1876–1925,* New York: H. N. Abrams, 1990.

Photography

Crain, Jim, *California in Depth: A Stereoscopic History,* San Francisco: Chronicle Books, 1994.

Misrach, Myriam Weisang, "Developing History: Photography of A. C. Vroman and Edward S. Curtis," *Antiques & Fine Art,* v. IX, no. 2, January/February 1992, pp. 76–83.

Camera Pictorialism 1895–1920

Bonnett, Wayne, *A Pacific Legacy: A Century of Maritime Photography, 1850–1950,* San Francisco: Chronicle Books, 1991.

Breck, Henrietta S., "California Women and Artistic Photography," *Overland Monthly,* v. 43, no. 2, February 1904, pp. 89–97.

California Pictorialism, exh. cat., organized by Margery Mann for the San Francisco Museum of Modern Art, January 7–February 27, 1977 and three other venues.

Callarman, Barbara Dye, *Photographers of Nineteenth Century Los Angeles County: a Directory,* Los Angeles, Ca.: Hacienda Gateway Press, 1993.

Camera Craft a Photographic Monthly San Francisco 1900 +.

Camera Club News, San Francisco, October 1898+.

Images of El Dorado: A History of California Photography: 1850–1975, exh. cat., University of California, Davis, May 12–29, 1975.

Kurutz, Gary F., "Portrait of the Golden State—The California State Library Photography Collection," *California History,* v. 60, Fall 1981, pp. 290+.

Los Angeles Camera Club News, c. 1902-1903.

Mangan, Terry William, *California Photographers 1852-1920: An Index of Photographers in the…California Historical Society,* San Francisco: California Historical Society, 1977.

Pahl, Nikki, *Camera Craft, Commercial Photography of the Sacramento Valley 1900–1945,* Sacramento: Sacramento History Center, 1982. 28 p.

Palmquist, Peter E., *A Directory of Women in California Photography before 1901,* Eureka, Ca.: Peter E. Palmquist, 1990.

Palmquist, Peter E., *A Directory of Women in California Photography 1900–1920,* Eureka, Ca.: Peter E. Palmquist, 1991.

Palmquist, Peter, "Pioneer Women Photographers in Nineteenth-Century California," *California History,* v. LXXI, no. 1, Spring 1992, pp. 110–27.

Palmquist, Peter, "Women Photographers in Nineteenth-Century California, USA," *Photoresearcher,* no. 2, June 1991, pp. 12–21.

Pictorialism in California: Photographs 1900–1940, with essays by Michael G. Wilson and Dennis Reed, exh. cat., published jointly by The J. Paul Getty Museum and The Henry E. Huntington Library and Art Gallery, 1994.

Picturing California: A Century of Photographic Genius, San Francisco: Chronicle Books, 1989.

Watkins to Weston: 101 Years of California Photography 1849–1950, exh. cat., Santa Barbara Museum of Art, February 29–May 31, 1992 and other venues.

Arts and Crafts 1890–1915

Bowman, Leslie Greene, *American Arts & Crafts: Virtue in Design: A Catalogue of the Palevsky/Evans Collection and Related Works at the Los Angeles County Museum of Art,* exh. cat., Los Angeles County Museum of Art, September 23, 1990–January 6, 1991.

Bray, Hazel V., *The Potter's Art in California, 1885–1955,* exh. cat., Oakland Museum, August 22–October 1, 1978 and at Lang Gallery, Scripps College, Claremont, November 5–December 18, 1978.

Buckle, Laurie, "Greene & Greene," *Antiques and Fine Art,* v. 8, no. 6, September/October 1991, pp. 70–75.

Burt, Sarah L., *The Swedenborgian Church of San Francisco: Art and Antimodernism in California, 1890–1915,* Ph.D. Dissertation, University of Kansas, c. 1996.*

California Design, 1910, exh. cat., Pasadena Center, October 15–December 1, 1974.

The California Furniture Company (N. P. Cole & Co.) Catalog, San Francisco: The Company, c. 1900. 158 p.

Cleek, Patricia Gardner, "Arts and Crafts in Santa Barbara: The Tale of Two Studios," *Noticias,* v. XXXVIII, no. 4, Winter 1992, pp. 61–77.

Hamilton, William L., "California Arts and Crafts Unveiled," *Art & Antiques,* v. 7, no. 7, September 1990, pp. 82–87.

Herr, Jeffrey, *California Art Pottery, 1895–1920,* exh. cat., California State University, Northridge, October 31–December 2, 1988.

Kamerling, Bruce, "Anna & Albert Valentien: The Arts and Crafts Movement in San Diego," *Journal of San Diego History,* v. XXIV, no. 3, Summer 1978 and revised in *Arts & Crafts Quarterly,* v. I, no. 4, July 1987.

Lakeman, John, "Bonanza in Berkeley: The James E. Birch Collection of Moore/Tiffany Silver Pt. 1," *Silver,* v. 25, no. 5, September–October 1992, pp. 20–5; and "Pt. 2," *Silver,* v. 25, no. 6, November-December 1992, pp. 10–15.

Mochary, Alexandra, "Gamble House, Pasadena," *Antiques & Fine Art,* v. V, no. 6, September/October 1988, pp. 76–83.

Schulz, Peter D., et al., *The Bottles of Old Sacramento: a Study of Nineteenth-Century Glass and Ceramic Retail Containers, Part I* (California Archaeological Reports, no. 20), Sacramento, Ca.: State of California—the Cultural Resources Management Unit, Department of Parks and Recreation, 1980. 197 p.

Silver in the Golden State…the History and Art of Silver in California, exh. cat., Oakland Museum History Department, 1986.

So Here Cometh: California & the Arts & Crafts Ideal, exh. cat., Sonoma County Museum, Santa Rosa, Ca., January 26–April 21, 1991. 22 p.

Thomas, Jeanette A., *Images of the Gamble House: Masterwork of Greene & Greene,* Los Angeles: Balcony Press, 1994.

Trapp, Kenneth R., et al., *The Arts and Crafts Movement in California: Living the Good Life,* New York: Abbeville Press in conjunction with the Oakland Museum, 1993.

Trapp, Kenneth R., "The Arts and Crafts Movement in San Francisco and the Bay Area," *Art of California,* v. 5, no. 5, November 1992, pp. 36–39.

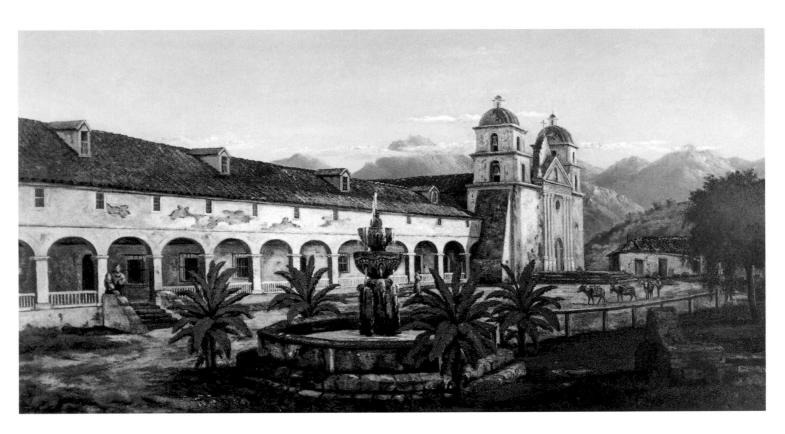

Fig. 10-3
Henry Chapman Ford
(1828–1894)
Mission Santa Barbara, 1884
oil on canvas, 19 x 36 in.
Jonathan Club, Los Angeles

Art Begins in Southern California

In the 1840s those travelers who arrived at Los Angeles by land from the East would have endured several months on foot and/or horseback traversing lands bereft of "civilization." Imagine one of these is an artist approaching the pueblo in a Mexican carreta, jostled against its rough wooden sides as it lurches along a pot-holed wagon track through tawny hills dotted with long-horned cattle. Ahead he can see a broad, sandy riverbed down the center of which runs a trickle of water; on either bank are square green plots suggesting cultivated fields. Across the river lies a strung-out village of single-story, flat-roofed adobes and shacks with only one two-story brick building and a white church rising above them. This, he is informed, is Los Angeles. Although the town's main street bears an optimistic sign, "H. Penelon and Co. Photograph Parlors," the artist, used to the more sophisticated metropolitan centers of the East, cannot but be doubtful that this dusty, flea-ridden backwater called Los Angeles is any place for a hopeful artist to set up shop.

Southern California is discussed separately from Northern California in this book because the region is distinct geographically, climatically, and culturally. Although the area has no legal boundaries, for the purposes of this study, Southern California generally refers to the lower third of the state. Its primary metropolitan areas, from south to north, are San Diego, Los Angeles, and Santa Barbara. Each was founded during the Spanish period. The presidios of San Diego and Santa Barbara had missions, while the pueblo of Los Angeles had a church and the nearby San Gabriel Mission. The area receives considerably less rainfall than Northern California, which means that many crops have to be irrigated, but at the same time temperate weather has made the area a magnet for health seekers and winter tourists. The terrain is also physically different from the north, with less spectacular mountains, scenery, and fauna. At various times differences have inspired political movements to divide the state in two.

But the differences in culture are of most interest here. Southern California has continually suffered at the hands of Bay Area intellectuals. Just as Europe has long felt culturally superior to America, and the East Coast to the West Coast, San Francisco has looked down on Los Angeles. San Franciscans saw themselves as old wealth, as opposed to Los Angeles's nouveau riche; they felt they had more "class," a more varied culture, truly sophisticated art patronage, and more as well as better cultural institutions.

Southern California, nonetheless, has enjoyed a unique and valid art history. From the United States's conquest of California up to the completion of the two railroad links into Los Angeles—the Southern Pacific in 1876 and the Santa Fe in 1885—the area was dominated by Mexican culture and an economy based primarily on grazing and farming. Art was rare, restricted to documentary landscape drawings in pencil or watercolor by itinerants (chapter 1) and to portraits of the Spanish-Mexican aristocracy (chapter 2). Although the art seems minor compared to what was being produced in cosmopolitan San Francisco, nevertheless the work is crucial to the art history of the southern part of the state.

Although each of Southern California's three main towns was like an "island in the land" in that its art developed independent of the others, each was also influenced by two phenomena. The most enduring and pervasive was the Spanish-Mexican heritage, which even after American occupation marked the region. The other was the effect the railroads had on the region.

Mission Paintings

"Mission" paintings are a ubiquitous phenomenon in California. The standard composition presents a low-slung white building, often with an arcade of thick columns and a massive bell tower, set in a variety of landscape backgrounds. However, mission paintings are *not* all alike; they have evolved in style and subject over the two hundred years of their production depending on the social and artistic attitudes of the time as well as the physical state of the buildings themselves. A mission painting can be closely dated by its composition and style alone.

In the earliest mission pictures made during the Spanish and Mexican periods, the missions were newly constructed and thriving business complexes, often with adjoining Indian brush-hut villages. Therefore artists portrayed the missions as proud, recently painted, and standing out from the dusty cattle lands that surrounded them. To weary travelers along El Camino Real (the king's highway) they represented comfort,

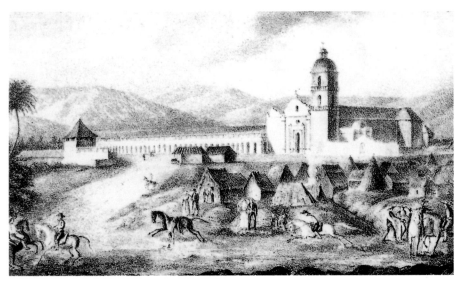

CHAPEL and PRINCIPAL BUILDINGS of the EX-MISSION SAN FERNANDO.

Fig. 10-1
Bernard Duhaut Cilly
(1790–1849)
Vue de la Mission de San Luis Rey in Californie
lithograph, 4 x 6½ in. (image)
from Auguste Bernard
Duhaut Cilly, *Voyage Autour du Monde,* Paris: A. Bertrand,
1834-35, v. 1.

Fig. 10-2
Edward Vischer (1809–1878)
San Fernando, 1865
pencil, ink, watercolor on
white paper, 5 ⅓ x 9 ⅞ in.
Courtesy, The Bancroft
Library, University of
California, Berkeley,
19xx.039.32

security, and even "civilization" in a land relatively bereft of European-style accommodations. The first images, such as **Bernard Duhaut-Cilly**'s *Vue de la Mission de San Luis Rey in Californie* of 1827 (fig. 10-1) or Ferdinand Deppe's *San Gabriel Mission* of about 1832 (fig. 1-7), emphasized the mission structures' architectural importance and beauty. The Native Americans and priests striding purposefully across the foreground or otherwise engaged in some business reiterated the missions' roles as active business centers. Pictures of the successful conquest and "civilizing" of new territory were popular with Western Europeans of the 1700s and 1800s, who were more interested in profiting economically from New World territories-for-the-taking than in appreciating the abundant scenery that they took for granted. Deppe is an amateur, his transcription semi primitive, but the rarity of images from this period—this and a copy are the first and only oil paintings for twenty years—as well as his firsthand experience and literal, documentary approach make this work extremely valuable, both as an art object and a historical document.

Although Spain had issued secularization orders for the California missions several times from the early 1800s, the effective proclamation was issued by Governor Figueroa in August 1834—that ten missions would be secularized that year and ten in each of the two following years. Secularization allowed the church to retain the mission buildings along with a small plot of encircling land. But after the church returned the vast grazing and farming lands to the Indians and no longer had the use of their labor, many of the missions were unable to survive economically. Over the ensuing years most declined. Some that were located far outside urban centers fell into complete ruin. As a result, travelers along El Camino Real after 1835 sometimes found themselves passing brutish-shaped adobe mounds and pinnacles, worn remnants of collapsed domes, and once-proud arches. Because Native Americans left no monuments in California and because there was no comparable number of Spanish ruins in other states, the California missions gave frontier California a "history" and America its own "antiquities." For the next thirty years, through the mid-1800s, the artists who depicted the missions were documentarians, individuals who regarded the missions as curiosities but recognized their uniqueness and believed they should be recorded in visual form. Since photography was still a cumbersome medium, they resorted to pencil, pen, or watercolor on paper. The first to document a sizable number of inland buildings in Southern California was probably William Rich Hutton (1826–1901); but the first to make a series of California's missions

was Henry Miller (active 1856–1857). In 1856–57 Miller traveled south from San Francisco by mule, making tight and literal pencil sketches of nineteen of the twenty-one missions, as well as the state's towns (Collection Bancroft Library, University of California, Berkeley). He intended to use the sketches as references for a panorama and a set of engravings from which he hoped to make money, but they were never realized. Through the 1860s, Bavarian-born **Edward Vischer** (1809–1878) also made drawings and watercolors of all the missions, but he was propelled by an archival concern that the remnants of California's frontier days were rapidly disappearing and should be recorded before they were lost altogether. Most "documentary" artists made conscientious literal transcriptions, but Vischer was more ambitious, and his work, such as *San Fernando* of 1865 (fig. 10-2), exhibits lively, energetic brushwork. Miller did not travel north of San Francisco to render the two missions there, but Vischer showed great dedication and responsibility in rendering all of the missions, no matter how decrepit or how isolated their sites.

As the century advanced and more artists took up residence in California, professionals took notice of the uniqueness of the missions. Between 1870 and 1900, these artists contributed sophisticated ideas such as an interest in the picturesque aspect of ruins, the ability to create illusionary space, and in many cases, the technique of painting in oil. Their paintings were finished with elaborate gold frames and were meant to decorate the drawing rooms of upper-class Victorian houses in California, as well as in those belonging to the many tourists who visited the state.

Henry Chapman Ford (1828–1894), a Civil War illustrator and veteran as well as a Chicago landscapist, moved to Santa Barbara in 1875 because of failing health. Ford is the first artist to make a set of mission images in two media—oil and etching. In summer 1880 he toured California south of Santa Barbara, making pencil drawings and oil sketches of each of the mission sites; the following summer he visited those to the north. *Mission Santa Barbara* (fig. 10-3, p. 122) continues the documentary tradition established by Miller and Vischer, but with more artistry. Ford models with light and shadow, and in cases as here, his heavy brush lightens and becomes expressive. He documented most of the sites as they actually looked, choosing the most aesthetically pleasing viewpoint and always depicting the entire mission complex. If a mission had been reduced to rubble, he re-created it from earlier paintings or photographs. Ford emphasized the abandoned state of a complex by giving prominence to the ruined sections, by eliminating people and ani-

mals, and by "landscaping" with weeds. The Santa Barbara mission was unusual in that it was continuously occupied and never fell into ruin. This view shows the mission with dormer windows, a feature it had only briefly between remodelings.

Mission paintings became even more skillful when Ford's contemporary **Edwin Deakin** (1838–1923) began to paint them. Deakin, raised in England, received his training there at the end of the Romantic Movement. Romantic writers and painters were attracted to the unusual and to unique subjects they deemed "beautiful," "sublime," or "picturesque." Ruins, for example, were considered picturesque. After immigrating to San Francisco in 1870, Deakin sketched Mission Dolores, then located on the fringes of the city, and before 1873 painted several views of it. In 1875 he sketched Mission San Buenaventura and Mission Santa Ines. Ultimately he sketched every mission. Although he had not originally intended to make an entire set, he eventually completed two sets of oil paintings, a set of watercolors, and many more individual images. In 1900 he published a book on the missions illustrated with his paintings.

Deakin's compositions, such as *Mission San Francisco de Asis (Dolores)* (fig. 10-4), also depict the entire mission. Placed in the center of the canvas, the building

Fig. 10-4
Edwin Deakin (1838–1923)
Mission San Francisco de Asis (Dolores), c. 1900 (one of a set of 21)
oil on canvas, 28½ x 42¼ in.
Santa Barbara Mission Archive-Library, Santa Barbara, California

Fig. 10-5
J. Henry Sandham
(1842–1912)
*Call for Sunrise Mass, Pala
Mission*, 1889
oil on canvas, 48 x 28 in.
Dr. and Mrs. Edward H.
Boseker

is surrounded by just enough landscape to provide a realistic setting. Like Ford, Deakin emphasized the most attractive and unique feature, usually the facade. Both men took some artistic license in "restoring" the missions, basing their reconstructions on old photographs, historic drawings, and oral reminiscences. Deakin, however, uses more sophisticated stylistic and technical means to create a romantic mood of desolation and melancholy. His rough, irregular paint application mimics the actual irregular, eroded surface of the adobe walls. Strong contrasts of sunlight and shadow create drama, and the occasional foggy background evokes a mood of solitude and loneliness.

Concern for saving and preserving California antiquities from natural deterioration and from Yankee enterprise and greed burgeoned in the 1890s. Beginning in 1895, societies such as the Landmarks Club raised money and solicited volunteers to stop the pilfering of building materials from the mission structures and to erect roofs to prevent further deterioration from rain.

In the 1880s and 1890s the missions became subjects for illustrators. Illustrators were interested in "story pictures," and they used mission architecture primarily as a backdrop for human activity. Often only an angle or a section of a building was shown. **J. Henry Sandham** (1842–1912) visited the missions before 1883 to make illustrations for Helen Hunt Jackson's magazine articles (republished in book form as *Glimpses of California and the Missions*, Boston: Little Brown & Co., 1883). One example is *Call for Sunrise Mass, Pala Mission* of 1889 (fig. 10-5). As a fine artist commissioned to make illustrations, Sandham focused on the action of the bell ringer and the drama of the arched bell tower touched by the early morning sun. A favorite theme with illustrators was that of priests and brothers strolling in mission gardens or cloisters (reminiscent of compositions that artists painted of European abbeys). Other illustrators of California missions pictorialized contemporary stories or re-created historical incidents that ostensibly occurred in mission settings.

Mission pictures were also made by California's resident illustrators. One Southern Californian who specialized in re-creating Spanish-Mexican scenes and events, many of them in mission or adobe settings, was **Alexander Harmer** (1856–1925) of Santa Bar-

bara, who took the direction after marrying into a local California family. *Mission San Juan Capistrano* of 1886 (fig. 10-6) is conscientiously crafted with the central human action nicely framed in a wedge of sunlit ground bordered by the mission's arcade and its cast shadow. Anecdotes about his wife's family along with paraphernalia they had preserved gave Harmer's work authenticity and historical accuracy.

Yet another approach to depicting missions is seen in the work of California's Barbizon landscapists of the 1890s and early 1900s. Interested primarily in intimate, pastoral landscapes that interpreted nature poetically (chapter 7), these painters occasionally included missions as small features within vaster landscapes, or they devoted entire paintings to picturesque portions of certain buildings. They interpreted a scene by showing it diffused by atmospheric or lighting conditions, as did Los Angeles's **Sydney Laurence** (1865–1940) in his moonlit *Evening Star, Mission Capistrano* (fig. 10-7). Night scenes, or nocturnes, were particularly popular with romantic-minded Victorians who were entranced by the mystery created when pale light, like that from the moon, obscures details. Laurence emphasizes the enigma of ruins by dissolving the arcade in a fog, and adds a spiritual element in the single shining star, a feature frequently seen in his work. At the turn

of the century many nocturnal views of missions as well as humble private adobes were painted by Northern Californians Will Sparks (1862–1937) and Charles Rollo Peters (1862–1928).

So many artists of the 1880s and 1890s joined the craze for painting the missions that it is impossible to name them all. Spanning a wide range from amateur to professional, they depicted the entire mission chain. Some of the sites, however, were painted more often than others, such as those near towns or railroad depots and those in good physical condition. The mission theme was most popular with artists south of Monterey, but some Northern California artists such as Chris Jorgensen (1860–1935) and William Keith (1838–1911) also painted them. Missions were one of the main subjects that brought Northern California artists to the southern part of the state. Women, especially, liked to paint mission pictures, making sets or multiple views in watercolor.

During the first three decades of the twentieth century the missions became increasingly important as both tourist attractions and objects of civic pride, and the Catholic church and historic groups worked together to restore them. Buildings were reconstructed based on historic documents, attempts were made to gather up dispersed paintings and sculpture, masses were revived in the chapels, and gardens replanted.

In the early 1910s, the mission image changed again. With the advent of the Impressionist style in California (chapter 13), the colors in mission paintings became lighter and brighter, and the attention of artists moved to the mission gardens. In urban Europe and on the East Coast, a favorite Impressionist theme was the city's formal cultivated gardens. Gardens offered painters a busy mix of elements such as fountains, ponds, trees, and flower beds, "organized" by architecture and formal walkways and given life by colorfully dressed people. Formal gardens did not exist in California cities until the turn of the century when they were developed around some of the large tourist hotels in Monterey and Santa Barbara, on private estates in Montecito, and at other wealthy enclaves. California cities finally established formal public parks about 1915 in the form of grounds around the Panama-Pacific International Exposition in San Francisco and the Panama-California Exposition in San Diego.

Fig. 10-6
Alexander Harmer
(1856–1925)
Mission San Juan Capistrano,
1886
oil on canvas, 22 x 32 in.
Joan Irvine Smith Fine Arts, Inc.

Fig. 10-7
Sydney Laurence
(1865–1940)
Evening Star, Mission Capistrano
oil on canvas, 20 x 16 in.
Joan Irvine Smith Fine Arts, Inc.

In Los Angeles, rose gardens adjoined the Museum of History, Science and Art, which opened in 1913, but the city's artists invariably chose to paint the intimate cloister gardens of San Juan Capistrano mission, about fifty miles to the south. The mission could be conveniently reached via the Santa Fe railway or the newly popular automobile. Restoration of the mission and replanting of its gardens were undertaken by Father Saint John O'Sullivan, the resident priest from about 1910. O'Sullivan was also supportive of the arts. He befriended many of the artists who came there to paint. Several canvases exist that are inscribed to Father O'Sullivan, and when he died in the early 1930s, numerous paintings were left in his estate.

California's most accomplished painter of garden scenes was **Colin Campbell Cooper** (1856–1937), and a prime example of his work is his *Mission Courtyard* (fig. 10-8). Impressionists especially liked to paint flower gardens because of their bright and varied colors. Architecture gave the shapeless growth a structured backdrop. Flickering light was increased by dappled shadows against whitewashed walls, garden borders of river boulders, and lily pads and ripples on the surface of ponds. Cooper succeeded where others failed because of his ability to render architecture convincingly, including the very difficult-to-paint arcades, and his brushwork and colors captured the busy look of the gardens without becoming clumsy or garish. Here, the oblique angle of the mission corner, a compositional device the Impressionists adopted from Japanese prints, gives structure and dynamics to the jumble of light and color.

Fig. 10-8
Colin Campbell Cooper
(1856-1937)
Mission Courtyard
oil on canvas, 18 x 22 in.
Joan Irvine Smith Fine Arts, Inc.

Fig. 10-9
Lemuel M. Wiles
(1826–1905)
San Diego Bay, 1874
oil on canvas, 15 x 22 in.
History Collections, Los
Angeles County Museum of
Natural History

The Railroads

Equally important to the history of Southern California art were the railroads. Artists accompanied most of the survey teams sent out in the 1850s to establish rail routes, and when the expeditions ventured into seldom-traversed territory, these artists became the first to depict those areas.

Railroads also carried in artists from out of state. The state's first railroad, the Transcontinental, which terminated in Oakland in 1869, brought west two highly accomplished Eastern artists. After viewing the scenic wonders of Northern California, they made their ways south. In 1874, Herman Herzog (1831–1932) and **Lemuel M. Wiles** (1826–1905) independently painted Hudson River School style landscapes around Los Angeles. Wiles traveled on to San Diego, and his *San Diego Bay* of 1874 (fig. 10-9) shows the school's typical viewpoint—from an eminence looking down on a panorama of lowlands. Being the first professional landscapists in the area, Herzog and Wiles set precedents for paintable subjects and established viewpoints and compositions that were repeated by later artists. Both painters recognized and depicted the picturesque Spanish-Mexican adobes and missions.

The railroad's full impact on Southern California art came when tracks joined Los Angeles with the outside. In the early 1870s, the Southern Pacific was simultaneously laying tracks south from the Bay Area and constructing a network of tracks within the Los Angeles basin. In 1876, the two sections were joined at the north end of the San Fernando Valley. This through-line to Northern California resulted in a small influx of new residents, including a number of art teachers. But the greatest change came ten years later when, the Atcheson, Topeka and the Santa Fe (AT&SF) built competing tracks into Los Angeles. They brought rate competition that broke the Southern Pacific's stranglehold over Southern California. When the Southern Pacific tried to crush the AT&SF with a rate war, it succeeded instead in lowering the fares so far (at one moment the fare from the Midwest to Los Angeles was only a dollar) that East Coast and Midwestern residents could not resist making the trip. New residents and tourists flooded in. Growth exploded in Southern California. Within a few years the AT&SF completed both an inland and a coastal link to San Diego, and the first railway line into Santa Barbara was the Southern Pacific's branch from its Los Angeles-Bakersfield line at Saugus, completed in mid August 1887. With rail links to the north and east, Southern California's once-isolated towns began to grow into cities, and artists arrived in greater numbers than ever before.

Among the first artists to use the trains to reach Southern California were illustrators. From the very first, Southern California was built by promoters, and illustrators created views for every variety of promotional

publication. Illustrators were hired to make images for the brochures issued by the railroads that touted the railroad as a comfortable way to travel and Southern California a good place to tour as well as to settle. Illustrators were also sent out by East Coast magazines eager to print articles on the newly opened area. When the state began to publish its own magazines and books, such as the San Francisco-based *Overland Monthly* and the multisectioned book *Picturesque California* (San Francisco, 1888), they employed illustrators.

Illustrators, along with writers, singled out the views that came to symbolize Southern California: pastoral rolling hills, peaceful valleys carpeted with orange groves, drives lined with stately eucalyptus, gardens overflowing with flowers, the Fiesta de Los Angeles, beach resorts, and the area's Spanish-Mexican heritage seen through its missions and other old adobe buildings. In these images, California was a land that could grow any kind of plant from natural cacti and poppies to those imported from the tropics and arctic zones, rose gardens, and commercially cultivated flowers and seeds.

The railroads also made it easier for artists from all parts of America and the world to investigate Southern California's potential as a subject for painting.

Beginning in the 1870s, several artists came south from San Francisco. Their primary interest was in the old adobes and missions, remnants of the Spanish-Mexican rancho days, which had been generally eradicated in the north by "progress."

Why were these subjects suddenly of interest to late-nineteenth–century Californians? Artists of the Romantic period sought out the "picturesque," and in California this meant quaint, unusual adobe ruins and the colorful dress of the Spanish-Mexican periods. But the Spanish-Mexican era also satisfied the requirements of those inspired by America's 1876 Centennial celebration, who looked for interesting incidents from America's history. Rancho life conjured positive and exciting images, such as spirited horses, dark-eyed senoritas in colorfully embroidered dresses, and dashing vaqueros. The lazy, agrarian, cattle-based lifestyle highlighted with festive fandangos was very appealing to an urban public that yearned to escape back to simpler times.

Among the first to address this new subject was **James Walker** (1819–1889). A frequent guest at Rancho Santa Margarita y Las Flores near Oceanside and at General Beale's Rancho Tejon north of the San Fernando Valley, he was a firsthand witness to the cattle

Fig. 10-10
James Walker (1819–1889)
Vaqueros in a Horse Corral,
1877
oil on canvas, 24¼ x 40 in.
The Thomas Gilcrease
Institute of American
History and Art

ranching scenes that he began to depict. *Vaqueros in a Horse Corral* of 1877 (fig. 10-10) is one of Walker's best. The lively action counters his usual flat horizon. This work's slightly primitive quality is charming, and its details are the result of first-hand observation.

William Hahn (1829–1887), trained in Europe and a resident of San Francisco for ten years off and on from the early 1870s to the early 1880s, had an eye for California's uniqueness. He instinctively recognized the universal appeal of the Mexican rancho period. After a sketching trip to Los Angeles in 1875, he painted *Mexican Cattle Drivers in Southern California* of 1883 (fig. 10-11). Hahn has created a scene of romance and excitement—hairy, half-wild, long-horned cattle, dashing vaqueros astride prancing horses—and a dynamic composition with a diagonally descending path.

While some of the most important canvases depicting Mexican rancho subjects were painted by San Franciscans who went to the Los Angeles area, the greatest number of San Francisco's post-1887 artists seem to have taken the spur into Santa Barbara. At least it is Santa Barbara titles, especially of its mission, that appear most frequently in the San Francisco Art Institute annual exhibition catalogues.

San Diego received few artistic visitors from the north, possibly because it was just too distant to warrant the additional train ride. Those who put forth the effort primarily made landscapes—favorite subjects were Coronado Beach, Old Town, the San Luis Rey and the San Diego missions, and the cliffs and caves at La Jolla.

The railroads also brought in artists traveling as tourists or intent on escaping the snowy winters of the East Coast and Midwest. The railroads boasted that tourists could not only ride, eat, and sleep comfortably on trains but that on arrival in California they would find a host of grand resort hotels with facilities equal in quality to the best in the East. In Monterey there was the Del Monte; in Santa Barbara the Arlington; in San Diego the Hotel Del Coronado; and in Pasadena the Raymond. Raymond and Whitcomb's package tours to California allowed travelers to purchase only the train fare or to also buy vouchers for hotels that could be used at the traveler's discretion as he moved at his own pace from city to city. Some tourists and artists spent the entire cold season in the balmy climate of Southern California.

Fig. 10-11
William Hahn (1829–1887)
Mexican Cattle Drivers in Southern California, 1883
oil on canvas, 34½ x 60 in.
Dr. and Mrs. Edward H. Boseker

Fig. 10-12
Joseph Foxcroft Cole
(1837–1892)
Mission San Juan Capistrano,
c. 1887
oil on canvas, 18 x 26 in.
Walter & Jeanne Kirk

Fig. 10-13
Samuel Colman (1832–1920)
Mount San Antonio, San
Gabriel Valley, c. 1887
oil on canvas
11 ¾ x 26 ½ in.
Anonymous Collector

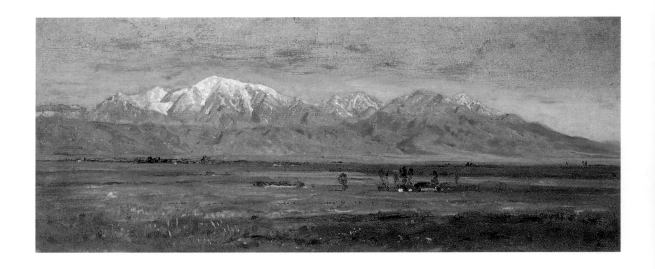

Touring artists often occupied their hours by sketching and, if they had a new Kodak box camera, by taking photographs. Because Raymond and Whitcomb were headquartered in Boston, many of Boston's artists visited and made images of Southern California. Their favorite resorts were Pasadena and Santa Barbara with occasional visits to San Diego and Riverside. Bostonians include Ellen Day Hale (1855–1940), Philip A. Butler (active 1892–1893 and winter 1900), Henry Plympton Spaulding (1868–1938), Charles Walter Stetson (1858–1911), **Joseph Foxcroft Cole** (1837–1892) and Jane Hunt (1822–1907). Foxcroft Cole likened Pasadena's beauty to that of rural France and claimed he had found sufficient pastoral loveliness to occupy him for years. Cole's *Mission San Juan Capistrano* of about 1887 (fig. 10-12) is a pastoral subject whose poetic treatment clearly places it in the Barbizon style. Among New York's touring artists to render views of Southern California were **Samuel Colman** (1832–1920), who produced *Mount San Antonio, San Gabriel Valley* in about 1887 (fig. 10-13). Colman stayed in Pasadena, and this view of the neighboring valley was taken from one of the town's several hills. Like fellow Hudson River School painter Lemuel Wiles before him, Colman is an artistic documentarian who records an area's actual color and terrain but whose technical facility and sensitivity give his transcription aesthetic value as well. Colman also painted several Santa Barbara landscapes.

The settlers brought by the railroads also influenced the region's art. The towns they built became subjects for makers of bird's-eye views, and the settled populations provided economic support for permanent art communities. The next chapter will look at each of the Southern California towns in turn to see how its art community grew and to see how it was both similar to and different from other towns in the region. ✤

Bibliography

Mission Paintings

The California Missions: A Pictorial History, Menlo Park, Ca.: Sunset Publishing Corp., 1979.

Cole, George Watson, "Missions and Mission Pictures: A Contribution Towards an Iconography of the Franciscan Missions of California," *News Notes of California Libraries,* v. 5, July 1910, pp. 390–412.

Early California Reflections, exh. cat., San Juan Capistrano Regional Branch of Orange County Public Library, August 30–October 11, 1986.

Egenhoff, Elisabeth L., *Fabricas: A Collection of Pictures and Statements on the Mineral Materials Used in Building in California Prior to 1850* (Supplement to the *California Journal of Mines and Geology* for April 1952).

Geiger, Maynard J., *Pictorial History of the Physical Development of Mission Santa Barbara, from Brush Hut to Institutional Greatness, 1786–1963,* Oakland, Ca.: Franciscan Fathers of California, 1963.

Neuerburg, Norman, "As Artists Saw Mission San Luis Rey," *Masterkey,* v. 56, no. 4, October–December 1982, pp.147–49.

Neuerburg, Norman, "The Old Missions A Popular Theme in Southern California Art before 1900," in Nancy Dustin Wall Moure, *Drawings and Illustrations by Southern California Artists before 1950,* exh. cat., Laguna Beach Museum of Art, August 6–September 16, 1982.

Neuerburg, Norman, "Painting Mission Santa Barbara," *Noticias,* v. XLII, no. 4, Winter 1996, pp. 69–87.

Romance of the Bells: The California Missions in Art, exh. cat., Mission San Juan Capistrano and The Irvine Museum, June 17 - October 14, 1995.

The Railroads

The American Personality: The Artist-Illustrator of Life in the United States, 1860–1930, exh. cat., Grunwald Center for the Graphic Arts, University of California, Los Angeles, 1976.

Eitel, Edward, *Southern Pacific Sketch Book,* San Francisco: W. B. Bancroft, 1887.

Moritz, Albert F., *America the Picturesque in Nineteenth Century Engraving,* New York: New Trend, 1983.

Muir, John, ed., *Picturesque California and the Region West of the Rocky Mountains, from Alaska to Mexico,* New York and San Francisco: J. Dewing Co., 1888. 2 v.

Taft, Robert, *Artists and Illustrators of the Old West 1850–1900,* Princeton, N. J.: Princeton University Press, [1953] 1982.

Williamson, Lt. R. S., *Report of Explorations in California for Railroad Routes to Connect with the Routes Near the 35th and 32nd Parallels of North Latitude, 1853,* 1856 (*Reports of Explorations and Surveys…,* v. 5).

(For art in individual Southern California cities, see bibliography, chapter 11.)

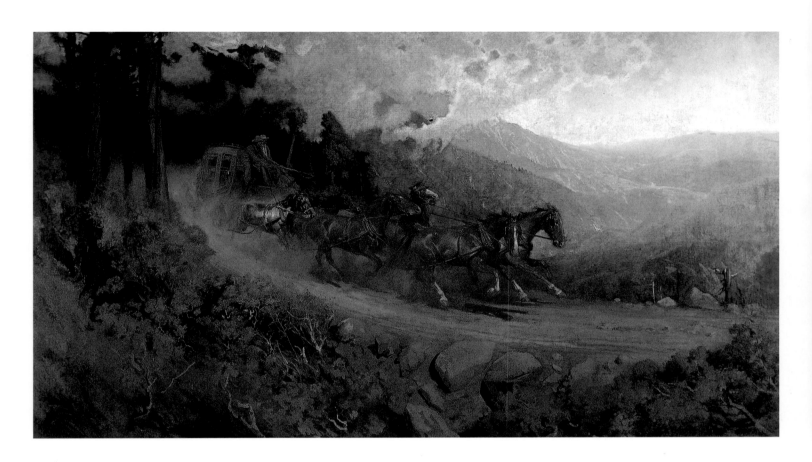

Fig. 11-1
John Gutzon Borglum
(1867–1941)
Runnin' Out the Storm,
c. 1896
oil on canvas, 60 x 108⅝ in.
San Antonio Museum of Art,
Gift of Mrs. Anna Borglum
Carter

Southern California's Cities Develop Art Communities

Between 1885 and 1914 Southern California's towns went from serving as supply centers for ranches to large cities trading with Pacific Rim countries and developing businesses in real estate, oil, and manufacturing. Although each has its own distinct history, they share the arrival of the railroads, boom times, the growth of sizable populations, and the development of their first resident art communities. Artists, studio buildings, art exhibitions, art reviews in newspapers and magazines, commercial art galleries, art collectors, and patrons all appeared. And the period also witnesses the first locally developed aesthetic, a communal way of representing the local landscape.

Los Angeles

In the late 1880s boom times brought Los Angeles to a boil. Several times a day the air was rent with train whistles and the cadence of metal wheels clacking across the joints in tracks. Horses, private carriages, and utility wagons jammed streets lined with new three-, four-, even five-story brick and granite buildings. Women in ankle-length dresses with leg-of-mutton sleeves rubbed shoulders with men in upturned collars, vests, and stiff felt hats. Real-estate promoters rushed up to passengers as they stepped off trains, offering tally-ho trips to view new subdivisions.

Art germinated in the general prosperity that followed the 1885 Santa Fe link. In a town that was more interested in real-estate speculation than art, the first artists worked diligently to have their work noticed. They arranged to hang their paintings in well-trafficked places such as the Nadeau House or at the yearly agricultural fairs. They banded with friends to hold special shows (such as that held by artists who had studios in the Bryson block). In 1887 the energetic Louisa Garden (later MacLeod) (1857–1944), just out of English art schools, established the Los Angeles School of Art and Design. Not only did her school flourish through 1919, but within a year or two Garden was organizing a club for artists. Her Art Association included lay members, held lectures, and maintained a permanent exhibition in its gallery of either loaned work or work by the school's students. In 1894 the school was located directly next door to the new Chamber of Commerce, which for a year gave space on its upper floor to a permanent show of local artists' work.

Art classes began to be offered in many locations. In Los Angeles's grade and high schools as well as at Throop Polytechnic Institute in nearby Pasadena, the Sloyd method of drawing and woodcarving was taught. Some of the newly instituted universities, such as the University of Southern California, offered a standard academic art program to a handful of students. Los Angeles's yearly Chautauqua in Long Beach also included art classes. Housewives chafing for additional education could join one of several women's clubs. Among them was the Ruskin Art Club, which offered a self-conducted art study program in the then-fashionable field of prints. The club also sponsored a couple of public exhibitions and published a brochure on wood-engraving art and techniques. Also offered were lectures illustrated with stereopticon slides and art tours to Europe (such as those offered by Mrs. Caswell, principal of the private Marlborough School). Articles on local artists appeared sporadically in the *Herald* and the *Times*.

As fortunes were made, and spent on large Victorian-style homes on Bunker Hill and along lower Figueroa Street, a few dollars dribbled out for paintings to decorate them. But most artists had to struggle for patronage. Some made occasional illustrations for *Land of Sunshine* and other publications; some taught art; others painted portraits. Only a small number found patronage among the few local millionaires interested in art.

Amidst this activity two broad artistic philosophies struggled for precedence. Some artists were "Americanophiles." These artists believed that a new, great, uniquely American art could result if American artists spurned European training and academic ideas and derived their inspiration directly from America's landscape and life, especially that of the American West. The other group advocated taking their ideas from Europe.

The Western Myth. Los Angeles's most important artist believing in the myth of the West was **John Gutzon Borglum** (1867–1941), who later became famous as the sculptor of Mount Rushmore. Borglum arrived from Nebraska with his parents in the spring of 1885. Boom town Los Angeles was looked upon as a place unrestrained by East Coast establishment ideas and institutions, a free place where an artist who had

ability and drive could devise something really "American" and new. Through apprenticeship in a lithography studio, minor instruction from Elizabeth Jaynes Putnam (1848-1922), a local still-life painter who became his first wife, as well as brief training at the San Francisco Art Association School and with William Keith (1838-1911), Borglum developed into a powerful painter of "big" subjects. In the early 1890s he was commissioned by the Northern California art patron Leland Stanford to paint a number of stagecoach pictures. The best of these, *Runnin' Out the Storm* of about 1896 (fig. 11-1), has the lively excitement we have come to expect from subject matter of the American West, except that it is more sophisticated in approach than the overt storytelling found in illustrations. With dark storm clouds threatening in the upper left, the coach dashes toward blue skies. The backdrop probably derives from California's Santa Cruz Mountains where Borglum sketched redwood trees and stage roads about 1892. The convincing anatomy and leg positions of the horses indicate close observation of equines and masterly drawing. Typical of compositions of that time, the foreground is made up of a tumble of elements—in this case rocks and brush—that frames the mid-ground action. The large size (60 x 108 in.) reveals the grand scale to which Borglum already aspired in his twenties.

The western image—Indians, missions, Spanish/Mexican rancho life, local landscape—was supported by some powerful local romantics, among them Charles Lummis, a newspaperman-turned-editor of the *Land of Sunshine* magazine. Lummis dressed in corduroys, at times carried a revolver, made frequent trips to the Southwest, where he took photographs,

collected recently unearthed pottery and artifacts, and started the Southwest Museum to preserve them. To illustrate his *Land of Sunshine,* he gave sporadic commissions to local artists of western subject matter, including Edward Borein (1873–1945), John Bond Francisco (1863–1931), Maynard Dixon (1875–1946), and Alexander Harmer (below).

Los Angeles's resident "western" artists were augmented by several others who moved around the Southwest and the West painting Native Americans or frontier life. The train provided convenient connections between Los Angeles and Albuquerque (Santa Fe/Taos). Some of these artists held exhibitions in Los Angeles, while others, such as Warren Rollins (1861–1962) and Charles Russell (1864–1926), maintained brief residences in the area.

Those who Bowed to Paris. At the opposite pole from the western advocates were the majority of Los Angeles artists who bowed to Paris as the source of all that was excellent in art. A few had grown up in Los Angeles and had gone to Europe to hone their skills and earn valued European credentials. But most were newcomers from the Midwest or East Coast, or even from England or France, who brought with them European ideas and training. Many were skilled in what Europe then revered—scenes featuring the human figure, whether the subjects were historical, allegorical, genre, figure studies, or portraits. **Fannie Duvall** (1861–1934) painted *Confirmation Class, San Juan Capistrano Mission* in 1897 (fig. 11-2). Duvall learned to admire and to paint figurative subjects in Paris, and she was clever enough on her return to Southern California not to repeat French themes but to find local counterparts. Here she has taken up the French Impressionist theme of attractive young girls dressed in white

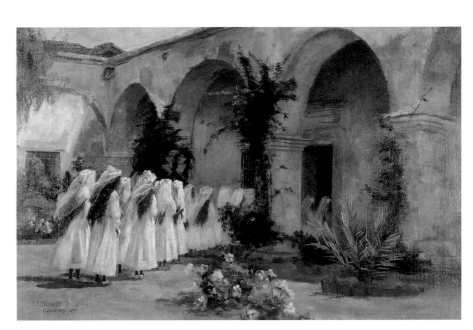

and involved in pleasant occupations in a pretty setting, and she has applied it to girls receiving their first Holy Communion at San Juan Capistrano Mission. This is one of the earliest Southland canvases to explore Impressionism's light colors and broken brushwork (chapter 13). But Los Angeles's figure painters soon found that while Angelenos might be impressed by a grand figural tableaux they saw in one of the rare local art exhibits, few had mansions large enough to hold them or the inclination to buy them. Those with a taste for such works often simply purchased work by Europeans they admired.

Artists did find that practical-minded Angelenos would spend money for a portrait, and the most sensitive portraits were produced by the husband-wife team of **Alberta Binford McCloskey** (1855–1911) and **William J. McCloskey** (1859–1941). *Untitled (Portrait of Unknown Woman)* of 1895 (fig. 11-3) is an example. Most sitters were content with a likeness and only a minimal background. The McCloskeys' favorite pose showed the sitter either waist-length, facing the viewer, or in three-quarter length, seated. (No large-size, i.e., "Grand Manner" portraits are known from the 1890s, although one that Guy Rose (1867–1925) painted of his father fulfills many of the requirements—he is shown three-quarter length seated comfortably in an overstuffed chair in his study surrounded by books.) The McCloskeys had great technical facility, and they prided themselves on the accuracy of their likenesses. Even more important, they succeeded where most portraitists failed—in capturing the inner personality of a sitter.

Los Angeles also had a number of still-life painters, most of them women, whose main subjects were fruit and flowers. Several factors coincided to cause this: women were entering the job market; art was considered an acceptable profession for them; there was pride in locally grown fruits and flowers; and Victorians exhibited a taste for "sweet" subjects, such as flower still lifes. Women still-life artists include Pasadenans Ellen B. Farr (1840–1907), known for her branches of the lacy pepper tree dotted with red berries, and Edith White (1855–1946), known for her roses. Los Angeles boasted Elizabeth Jaynes Putnam Borglum (1848–1922), known for boughs of oranges, and Alberta Binford McCloskey, a master of delicately painted flowers and fruit. (For McCloskey's picture of oranges, see chapter 5.)

Most prolific and technically accomplished, however, was **Paul DeLongpre** (1855–1911), known as "le roi des fleurs." DeLongpre came to California for his health in 1898 and settled in Hollywood, where he built a large Moorish-style mansion in the heart of the city, turning the house, its gardens, and his display of paintings into a sightseeing attraction. Artistically, he had incredible control of transparent watercolor, which was just then gaining respect as a fine-art medium. An example is *Spring, No. 5* of 1896 (fig. 11-4). Typical of his style, transparent washes with subtle shading give shape to petals and body to a vase, and they imply a background. Stronger but selectively employed opaque colors delineate or suggest the smallest details of flowers down to individual petals, stamens, and thorns. DeLongpre worked with four basic compositions: bouquets in vases and baskets (as here), floating sprigs (in the manner of botanical illustrations), flowers strewn horizontally on shallow shelves or ledges, and growing flowers (sometimes on a lattice background). The most sought-after subjects by California collectors today are flowers identified with the state, such as the golden poppy or cactus flowers. *Spring, No. 5* ranks high in DeLongpre's oeuvre for its complexity—the variety of blooms and the interesting supporting paraphernalia (in this case a vase). The artist frequently included bees in his compositions. Still-life painters historically used the device of insects buzzing around fruit or flowers to give life to the composition and to demonstrate that the items were painted so close to nature as to fool even insects. DeLongpre's watercolors are as accurate as botanical illustrations, and yet the beauty of their execution places them clearly in the realm of fine art.

Fig. 11-4
Paul DeLongpre
(1855–1911)
Spring, No. 5, 1896
watercolor
22 x 34¼ in.
David & Holly Davis
Photo: Art Works

available within a short train ride. They were grateful for the pleasant weather that allowed them to spend many days *en plein air,* tramping the backcountry, filling sketchbooks with views that could be developed in their studios.

The earliest landscapists faced a problem, however. No professional painter had yet depicted the area. There was no precedent, no favored themes established or compositions to follow. Artists looking about them to identify paintable views, must have struggled to correlate their European training with what they saw. Certainly downtown Los Angeles itself would have made for some outstanding cityscapes. But only a few have surfaced, including **Alexander Harmer**'s *Chinatown, Los Angeles (Nigger Alley)* of 1886 (fig. 11-5), a view of the main street in Los Angeles's former Chinatown. The late-nineteenth-century backlash against urbanization seems to have led most Southern California artists to render pure countryside. Los Angeles's dry, brush-covered hills and mustard-covered plains weren't that picturesque. **John Hardwicke Lewis**'s (1842–1927) *Near Camp on the Switzer Trail* of about 1888 (fig. 11-6) records exactly the chaparral-covered foothills that border most of the Los Angeles basin's many valleys and that make up about half its terrain. Lewis transforms them into an artistic composition with his delicate technique (some art historians use the term "jewel like") and by introducing drama with light and shadow. The viewer steps into the picture via the artistic device of alternating patches of sunlight and shadow.

Most artists, however, mixed Barbizon (and sometimes Impressionist) ideas with the local landscape. A prime example is Paris-trained **Granville Redmond** (1871–1935). During his study in France he painted the standard European Barbizon subjects—forests and glades, rows of poplars, and expanses of desolate shoreline and marshes. Settling in Los Angeles, he looked around for Southern California equivalents. One result is *Shepherd and Flock* of 1900 (fig. 11-7), which takes the Barbizon theme of a peasant driving his flock home in late afternoon. In Europe, the peasant would have traversed a shadowy forest trail or crossed a lush pasture. In the Los Angeles basin, he has turned into one of the Basque shepherds imported by local sheep farmers to look after their stock. One oak tree and some brush replace a forest, and the area's usually blanched coloration is enriched by late-day shadows and dramatized by the setting sun's rays that set aglow a bank of red adobe.

Paralleling Redmond were other artists who did not have the advantage of European training but who realized they had to paint in a style that was acceptable to potential collectors. These artists also utilized

Fig. 11-5
Alexander Harmer
(1856–1925)
Chinatown, Los Angeles (Nigger Alley), 1886
oil on canvas, 19 x 30 in.
The Irvine Museum

Fig. 11-6
John Hardwicke Lewis
(1842–1927)
Near Camp on the Switzer Trail, 1888
oil on canvas, 9 x 16 in.
Redfern Gallery, Laguna Beach

Landscape. Most artists who took up residence in Los Angeles eventually turned to landscape. Since the region had no natural resources to interest would-be industrialists (coal, iron, timber, etc.), promoters of the area seized on its other qualities: its landscape and climate. Southern California was advertised as a healthy place for invalids of all kinds, a fruitful place for farmers if they irrigated, a respite from cold winters of the Midwest and East, and an Eden for retirees. Artists either found it good business to repeat these claims or, after wandering the hills in search of subjects, they actually fell under the area's subtle spell. They soon began to praise the dry grasses that covered the hills nine months of the year as nuanced with rose and gold. They considered it their good fortune to have such a variety of landscape features--snow-capped mountains, seashore, desert, arroyos, farming valleys—always

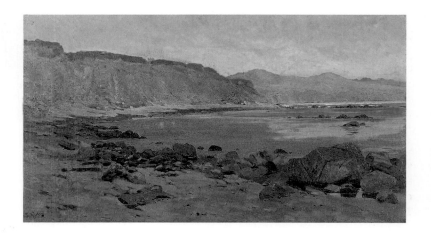

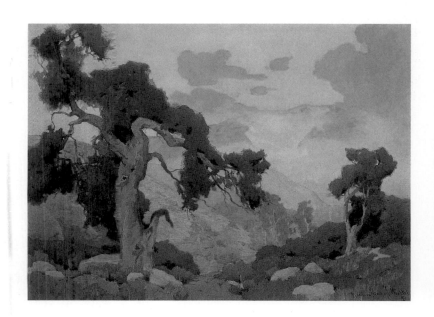

Barbizon stylistic elements. **Elmer Wachtel** (1864–1929) must have picked up his knowledge of the Barbizon style through book illustrations, since he had trained only briefly with the Northern California artist William Keith and for short stints at schools in New York and London. Independent, never a club man, he tramped California's back country penciling paintable scenes in his sketchbooks. Wachtel may have originated many of the compositions and subjects that later artists repeated. *San Juan Bluffs* (fig. 11-8) is an early work made before the artist settled on his arroyo theme and his favorite range of colors (blues, browns, greens and lavenders). The bluffs are located south of Dana Point. Wachtel has applied his faculties to making an aesthetic composition, filling the foreground with an interesting jumble of rocks that balance the distant curve of the cliffs and then dramatizing the scene with sunlight hitting the mid-ground cliffs.

After Wachtel's marriage in 1924 to **Marion Kavanagh** (1876–1954), the two artists traveled the state together. Her favorite subject became blue-toned panoramas of valleys seen from the height of the encircling hills, as in *San Gabriel Canyon* (fig. 11-9). Late afternoon was a popular time with Barbizon artists because of the reflective, poetic tone established by the cool light of fading day. But local artists must have also appreciated late afternoon for its more saturated colors that brought character to a Southern California

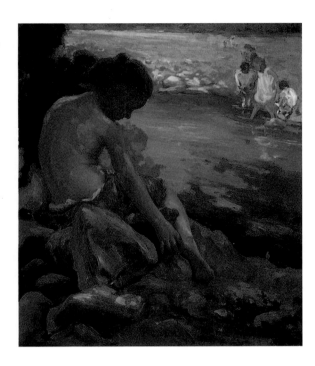

Fig. 11-10
Jean Mannheim (1863–1945)
Children Bathing
oil on canvas, 39 x 34 in.
Marcel Vinh & Daniel
Hansman

Fig. 11-11
Franz Bischoff (1864–1929)
Roses, c. 1912
oil on canvas, 40 x 50 in.
Private Collection

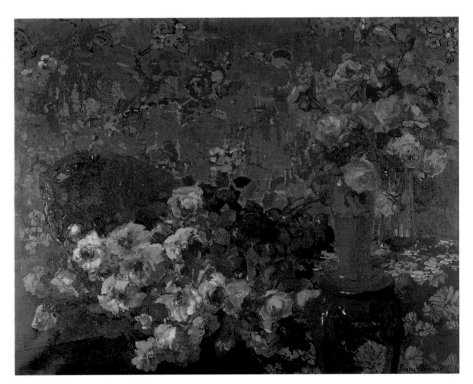

often blanched by sun and haze. Both Wachtels depended on a similar compositional device—a darkened foreground, sometimes with a silhouetted tree, and beyond it a distant landscape touched by sun. Both were consummate craftsmen: Marion working in watercolor, Elmer in oil. During their prime period of 1904 to 1917 Marion standardized her formula to muted blue and pink color schemes, while Elmer retreated from the wide range of colors he had used at the turn of the century and moved to a palette of saturated blues, browns and greens that remained relatively unchanged to the end of his life. In the mid-1910s, both painters reacted to the Impressionist style by lightening their palettes and enlivening their brushwork.

As the twentieth century advanced, art expanded exponentially. In Los Angeles, Santa Barbara and San Diego the art worlds were invigorated after the April 1906 San Francisco earthquake and fire. Bay Area artists, some with studios and inventories reduced to ashes, most with their wealthy Nob Hill clientele burned out and uninsured fortunes dented, fled to all corners of the state to start anew. Perhaps because some settled in Los Angeles and increased the size and sophistication of the local art community, that same year the *Los Angeles Times* began a regular Sunday art review column, an Art Students League was started, and a Painters Club formed. Downtown could almost boast a colony of artists, and other painters and craftsmen started to build redwood and boulder houses along the Arroyo Seco, the rustic canyon that ran between Los Angeles and Pasadena. The arroyo also served as home to many craftsmen in the Arts & Crafts movement. Art events centered at the private downtown Blanchard Music and Art Building and at various Pasadena tourist hotels, but in 1906 a Fine Arts League was formed to obtain an art museum for the city. The work of the league culminated in the Museum of History, Science and Art, opened in 1913. By the teens, enough artists had settled that they could specialize: art teachers, painters, sculptors, newspaper artists, illustrators, and craftsmen of pottery, metal, and wood.

Los Angeles's location, far from art centers such as Paris and New York, its youth, and its Midwestern population base kept the city artistically conservative through 1914. The outstanding figure painter of the time was probably **Jean Mannheim** (1863–1945). Extensive study with several Parisian artists made him a strong portrait and figure painter long before he settled in Pasadena in 1908. Locally, Mannheim posed his own children to create California versions of the nudes popularly shown in Salon exhibitions. An example is *Children Bathing* (fig. 11-10). Still retaining the

brown tones of his European training, he nevertheless managed to turn an effete Salon theme into a scene of healthy children wading in a stream. Mannheim also uses the device of a shadowy foreground with a silhouetted object, in this case a child, to set off a sunlit background.

As for still life, the early-twentieth-century star was **Franz Bischoff** (1864–1929), a former decorator of ceramics who switched to oil painting on canvas. Although Bischoff attempted landscape, his pretty colors and rich brushwork succeeded best in his flower paintings; his favorite species were chrysanthemums and roses. *Roses* of about 1912 (fig. 11-11) is his finest. The picture's importance is based on its large size, its inclusion of numerous objects, and the variety of their textures. By the early twentieth century, when Bischoff turned to oil, still lifes had passed beyond the fashion for trompe l'oeil. However, through 1916, he conservatively held to two of the Victorian still-life artist's goals—abundance and textural richness—seen here in the brocade backdrop, the basket, the profusion of roses, the patterned vase, and the highly carved wooden stand. Although his broken brushwork seems to suggest he had progressed on to the Impressionist style, it is not until the latter part of the decade that he adopts the favorite Impressionist composition of the table set with a tea service viewed from above and the Impressionist interest in bright colors and light effects.

Many landscapists were active in Los Angeles between 1900 and 1912, a time when the conservative Barbizon style reigned. The most talented of these was William Wendt (1865–1946), whose style was actually more Impressionist (chapter 13). But a host of others included Benjamin Brown (1865–1942), Hanson Puthuff (1875-1972), Jack Wilkinson Smith (1873–1949), John Bond Francisco (1863–1931), William Lees Judson (1842–1928), and George Gardner Symons (1861?–1930). Most translated the local scene with the Barbizon aesthetic, reaching their own compromise between the darker and more saturated Barbizon tones and the natural light and color of Southern California.

Within a 100-mile distance of Los Angeles were many small towns where a few artists lived and worked. Although most of these towns were farming centers, some were also wintering spots for wealthy Easterners, and thus had sizable cultural offerings. Most important for the arts was Pasadena, just an eleven-mile train ride up the Arroyo Seco from downtown Los Angeles. Pasadena artists included those who resided in the city as well as some from the Arroyo Seco who identified with the town. This small cluster of artists showed their work in the front windows of shops along the main street, Colorado Boulevard, and joined together to hold group exhibitions. They even started an artists' union, and at the end of the century they gained the use of the Stickney Memorial Art Hall wing of the Shakespeare Club. Pasadena's most important but probably least visible artist was the figure painter Charles Walter Stetson (chapter 7). Also living in Pasadena were the still-life painters Ellen Farr and Edith White, the landscapist Benjamin Brown, figure painter Jean Mannheim, and still-life painter Franz Bischoff.

The Los Angeles basin's second most important town for art was the inland orange-growing center of Riverside.

San Diego

San Diego grew in a similar manner to Los Angeles. The arrival of the two Santa Fe rail lines, one inland in 1885 and one along the coast in 1888, brought San Diego a population that could support artists. And the construction of the grand Hotel Del Coronado in 1887 brought in wealthy individuals capable of purchasing art. The expected bird's-eye view lithographs were made of the town, and for about five years, until the boom collapsed with the nationwide depression, San Diego enjoyed the beginnings of an art world—city directories listed eight or so landscapists and still-life painters. The best of these painters was probably Ammi Farnham (1845–1922).

What gave San Diego art its distinction was the activity at Lomaland, the international headquarters of the Theosophical Society. Lomaland was established by Katherine Tingley on Point Loma, the spit of land on the western side of the entrance to San Diego Bay. Much has been written about exotic religious cults and Los Angeles, some about their effect on its art (chapter 8), but Lomaland had the greatest direct effect on California art. At a very early and crucial period in the development of the arts in San Diego, the society attracted sophisticated artists who believed in Theosophy. They created paintings for the center and also made work that was sold to raise money for the sect. The Point Loma Art School that developed as part of the Society's Raja Yoga Academy employed artists **Reginald Machell** (1854–1927), Edith White (1855–1946), and others to teach a relatively standard course of art

Fig. 11-12
Charles Fries (1854–1940)
Point Loma from Logan Heights, n.d.
oil on canvas, 11 x 20⅞ in.
San Diego Museum of Art
(Gift of Rie Anderson)

Fig. 11-13
Edith White (1855–1946)
Roses on a Fence, c. 1915
oil on canvas, 32¼ x 23 in.
Collection of the San Diego
Historical Society
Photo: Nick Juran

to the children of disciples living at Lomaland. Maurice Braun (1877–1941), enticed to San Diego by Theosophy in 1909, became the town's first important landscapist (chapter 13).

Apart from Lomaland, San Diego proper also was developing an art community. On August 19, 1904, a group of artists gathered to found the San Diego Art Association, whose goal was to "encourage art in all its higher branches." Like associations formed by artists across the nation, this one held group exhibitions and sponsored lectures on art. San Diego also had a respectable Arts & Crafts movement among whose major members were Albert Valentien (1862–1925) and Anna Valentien (1862–1947). In the very early years of the century Arthur Putnam made highly sophisticated bronzes of animals in the style of Auguste Rodin (chapter 9). The town's major benefactor was the Scripps family. The Theosophical Society's Isis Theater in downtown San Diego brought music and art to the public and provided studio space for Maurice Braun. After 1910 many artists and craftsmen were employed as muralists and sculptors for San Diego's Panama-California Exposition, which opened in Balboa Park in 1915.

Probably the most important painter of the pre-1914 period apart from Maurice Braun (chapter 13) was **Charles Fries** (1854–1940), who settled in San Diego in the very late 1890s. Although Fries was an excellent figure painter, he eventually put his energies into landscapes painted in an easily recognizable palette of subtle greens and browns. His early work is exemplified by *Point Loma from Logan Heights* (fig. 11-12).

Point Loma is almost abstract in its simple arrangement of bald landforms and ocean, and almost Barbizon in its subtle harmonies and sense of restfulness achieved with a low and dominant horizon. San Diego's best still-life painter was Lomaland resident **Edith White** (1855–1946), who moved there from Pasadena. White spent the first three decades of the twentieth century on Point Loma teaching art and painting pictures of flowers. Her arrangements ranged from tabletop still lifes to flowers in gardens, such as the large pink tea roses in *Roses on a Fence* of about 1915 (fig. 11-13) with its backdrop landscape of eucalyptus trees.

Santa Barbara

Santa Barbara's small art community shares many characteristics with Los Angeles and San Diego, including a boom brought by the completion of the rail line in August 1887. But the town also had its unique aspects. With its grand tourist hotel, the Arlington, and its temperate winter weather, Santa Barbara soon became a winter outpost for wealthy Easterners, especially refugees from Boston and, to a lesser extent, New York. Some visitors even built grand estates in neighboring Montecito, and on some of these arts and crafts communities were started.

Santa Barbara's benign climate, the old-world Spanish atmosphere established by the town's many extant adobe buildings, and the small size of its art community, attracted artists with health problems and those who wanted to retire. The town's first two major painters, Henry Chapman Ford (1828–1894) and Alexander Harmer (1856–1925), were "Americanophiles," working with themes of California's western heritage. Ford was in his late forties when he moved to Santa Barbara for his health. His background included illustration and landscape painting, and he is best known for his paintings of the entire chain of California missions (chapter 10).

Alexander Harmer, in contrast, became Southern California's counterpart to the several San Francisco-based artists of the 1870s and 1880s who painted genre scenes of early Californio life. Harmer, who had always been interested in "American West" subjects, such as Native Americans and Anglo frontier activities, turned, after his marriage to a daughter of a patrician family in 1893, to Spanish/Mexican subject matter. Such paintings as *What Saint is This?* of 1897 (fig. 11-14) authentically portray actual events, some from family history. The room in this work is Harmer's own studio and the incident an actual one. A vaquero looking at Harmer's cast of the Venus de Milo asked, "What Saint is This?" Harmer pictures himself at the easel in the background. The costumes in Harmer's paintings are based on clothing preserved by his wife's family. Many California history painters chose cattle ranching themes, but Harmer preferred the daily life of the town, the ranch house, and the home, and celebrations such as festivals, weddings, and dances. His usual format presented an activity upon a shallow stage—often the porch of an adobe house or a mission patio or cloister.

Santa Barbara's first wave of Paris-influenced landscapists began to settle in 1905. Almost unanimously they seem to have chosen Santa Barbara as a pleasant retirement place rather than for its scenery or the challenges offered by its art community. Thaddeus Welch (1844–1919), who with his artist wife Ludmilla (1867–1925) moved to Santa Barbara in 1905 for his health, had already made a name in the Bay Area for his paintings of cows grazing on Marin County's grassy rolling hills. Although Santa Barbara offered paintable subjects, Welch continued to produce Marin hills until his death.

Fig. 11-14
Alexander Harmer
(1856–1925)
What Saint is This?, 1897
watercolor on board
14¾ x 11½ in.
Leslie & Harry Hovey
Photo: William B. Dewey

Fig. 11-15
Fernand Lungren
(1859–1932)
Death Valley, Dante's View
oil on canvas, 26 x 60 in.
University Art Museum,
University of California,
Santa Barbara, Fernand
Lungren Bequest

Fig. 11-16
John Marshall Gamble
(1863–1957)
Evening Shadows
oil on canvas, 20 x 30 in.
Private Collection

Fernand Lungren (1859–1932) also chose Santa Barbara as a retirement city, a place where he could turn his back on the world of illustration and pursue a second life as a painter. He found his main themes in the deserts on California's eastern borders, such as Death Valley and the Mojave. Just after the turn of the century, California's deserts were exceedingly remote, and to sketch them Lungren had to make trips of several months traveling by mule and wagon. His favorite composition was an extended horizontal with a high horizon, and he varied his coloration depending on the mood he wished to cast on the scene. In his undated *Death Valley, Dante's View* (fig. 11-15) he shows the full range of subtle buffs and tans of the area's exposed, eroded soils but gives the muted colors snap with a few well-placed dramatic shadows. The composition is further dramatized when Lungren angles the valley floor in an oblique direction toward the horizon. Some of

Lungren's canvases of the Southwestern deserts in Arizona and New Mexico include Indians; but his California work rarely has any sign of human presence. Although this may have been the actual situation, the lack of inhabitants emphasizes the empty loneliness of the vast arid spaces. He captures the stark and uncompromising character of the desert that some later landscapists treat as pretty and pastoral.

The third major artist in Santa Barbara at this time was **John Marshall Gamble** (1863–1957), a refugee from the San Francisco earthquake and fire of 1906. In San Francisco he had gained a reputation as a painter of California's backcountry covered in spring wildflowers. He continued to elaborate on this theme during his long residence in Santa Barbara, each spring heading out in his brown roadster to obtain fresh material. *Evening Shadows* (fig. 11-16) displays the vibrant natural colors of California's rural lands, when, after the spring rains, the ground is blanketed with golden poppies and blue lupine. Gamble prefers a high horizon that leaves him a large foreground in which to present the profusion of flowers. Space is implied by the distant mountains or a shoreline.

Curiously, those artists of the first decade of the twentieth century who did paint Santa Barbara subject matter were not permanent residents. **Henry Joseph Breuer** (1860–1932), after retiring as an art editor in San Francisco in 1902, started making painting trips to remote spots in California. He traveled in a specially built studio-wagon drawn by two horses. Among his straightforward landscapes of the area's boulder-strewn hills is *In Mission Canyon, Santa Barbara* of 1902 (fig. 11-17). Brewer also spent the entire year of 1906 in the town. **George Elbert Burr** (1859–1939), a Denver artist, visited Santa Barbara in spring 1907 and recognized the pictorial appeal of the gardens and

estates in Montecito. *Whitlow Garden—Santa Barbara* of May 1907 (fig. 11-18) is a pleasing arrangement of garden elements—trees, multicolored flower beds, and grassy plots as well as a rare California reference to an orange tree. Although descriptive, at the same time it reflects the Impressionist interest in lighter colors and garden subjects. **Carl Oscar Borg** (1879–1947), who first visited Santa Barbara in 1903, spent most of 1907 and 1908 painting in its vicinity, sometimes with the Los Angeles landscapist William Wendt (1865–1946). To gain access to the Channel Islands, Borg took a job on a seal-hunting ship. There he camped and painted the unique terrain as well as the activities of the seal hunters. *California Landscape* (fig. 7-9), the most outstanding of Borg's early Barbizon-style landscapes, is thought to be a view of the mainland coast near Montecito. In typical Barbizon style, its shadowy foreground frames a lighted background panorama; it has muted saturated colors, emphasizes solid and compact forms such as boulders and oaks rather than eucalyptus, and has a high horizon.

The painters who settled in Santa Barbara from the mid-teens onward will be discussed with Santa Barbara's art world of the 1920s (chapter 13).

By 1915 both Southern and Northern California had healthy and complex art communities, and the artistic differences between the two halves of the state were rapidly decreasing. The next chapter will introduce the art era of 1915 to 1930 and its many non-painting media (sculpture, printmaking, photography, and arts and crafts) that were attracting increasing numbers of proponents. It will show how California artists began to make innovations that interested the rest of the western world. 🌸

Fig. 11-17
Henry Joseph Breuer
(1860–1932)
In Mission Canyon, Santa Barbara, 1902
oil on canvas
42¼ x 36½ in.
Collection of the Oakland Museum of California, Anonymous Donor

Fig. 11-18
George Elbert Burr
(1859–1939)
Whitlow Garden—Santa Barbara, May 1907
watercolor on paper
20 x 14 in.
William A. Karges Fine Art, Los Angeles

Bibliography

General, 1885–1914

Moure, Nancy Dustin Wall, *Publications in Southern California Art 1, 2, 3,* Los Angeles: Privately Printed, 1984.

"Southern California," in William H. Gerdts, *Art Across America: Two Centuries of Regional Painting, 1710-1920,* v. 3, New York: Abbeville Press, 1990.

Westphal, Ruth Lilly, *Plein Air Painters of California: The Southland,* Irvine, Ca.: Westphal Publishing, 1982.

Los Angeles

"Art and Life in the Turn-of-the-Century Southland" and "Pasadena and the Arroyo: Two Modes of Bohemia," in Kevin Starr, *Inventing the Dream: California Through the Progressive Era,* New York: Oxford University Press, 1985.

Faye, Tom, *California Dreaming: the Golden Age of Label Art,* Anaheim, Ca.: A. R. Collins, 1993.

A Guide and Catalogue of the California Hall at the Los Angeles County Museum (History Division *Bulletin,* No. 1), Los Angeles County Museum of Natural History, 1964. [reproduces some paintings]

McClelland, Gordon T., and Jay T. Last, *California Orange Box Labels: An Illustrated History,* Beverly Hills: Hillcrest Press, 1985.

Moure, Nancy Dustin Wall, *Loners, Mavericks & Dreamers: Art in Los Angeles Before 1900,* exh. cat., Laguna Art Museum, November 26, 1993–February 20, 1994 and one other venue.

Moure, Nancy Dustin Wall, *Painting and Sculpture in Los Angeles, 1900–1945,* exh. cat., Los Angeles County Museum of Art, September 25–November 23, 1980.

Municipal Art Commission, *Report of...for the City of Los Angeles, California,* Los Angeles: W. J. Porter, 1909. 45 p.

Splitter, Henry W., "Art in Los Angeles Before 1900," *Historical Society of Southern California Quarterly,* 1959, serialized through various issues, v. 41, March 1959, pp. 38-57; June 1959, pp. 117–38; September 1959, pp. 247–56.

Treib, M., "Sun Kissed [orange crate labels]," *Print,* v. 31, January 1977, pp. 69–72.

San Diego

Boettger, Suzaan, *The Art History of San Diego to ca. 1935,* M. A. Thesis?, City University of New York, 1985.*

Kamerling, Bruce, "Early Sculpture and Sculptors in San Diego," *Journal of San Diego History,* v. XXXV, no. 3, Summer 1989.

Kamerling, Bruce A., *100 Years of Art in San Diego: Selections from the Collection of the San Diego Historical Society,* exh. cat., San Diego Historical Society Gallery, Summer, 1991.

Kamerling, Bruce, "Painting Ladies: Some Early San Diego Women Artists," *Journal of San Diego History,* v. XXXII, no. 3, Summer 1986.

Kamerling, Bruce, "The Start of Professionalism: Three Early San Diego Artists," [Chapin, Black, Farnham], *Journal of San Diego History,* v. XXX, no. 4, Fall 1984.

Kamerling, Bruce, "Theosophy and Symbolist Art: The Point Loma Art School," *Journal of San Diego History,* v. XXVI, no. 4, Fall 1980.

Lytle, Rebecca, "People and Places, Images of 19th Century San Diego in Lithographs and Paintings," *Journal of San Diego History,* v. XXIV, no. 2, Spring 1978.

Nolen, John, *San Diego, a Comprehensive Plan for its Improvement* [municipal art], Boston: G. H. Ellis Co., 1908 and another version in 1926.

See also "Associated Artists of San Diego," "Contemporary Artists of San Diego," "San Diego Art Guild," and "San Diego Society of Arts and Crafts," listed in Nancy Moure, *Artists' Clubs and Exhibitions in Los Angeles before 1930* (*Publications in Southern California Art,* No. 2), Los Angeles: Privately Printed, 1974.

Santa Barbara

Carlisle, Lynn, "The Santa Cruz Island Collection," *Art of California,* v. 3, no. 1, January 1990, pp. 35–41.

Cleek, Patricia Gardner, "Arts and Crafts in Santa Barbara: The Tale of Two Studios," *Noticias,* v. XXXVIII, no. 4, Winter 1992, pp. 61–77.

Early Santa Barbara Pictorially, an exhibit commemorating the sixtieth anniversary of County National Bank and Trust Company of Santa Barbara, 1935.

Moure, Nancy Dustin Wall, "History of Art in Santa Barbara to c. 1918," *Publications in Southern California Art 4, 5, 6, 7,* Los Angeles: Dustin Publishing, 1998.

WORLD WAR I
AND THE BOOM
OF THE 20s

Fig. 12-1
Bernard Maybeck
Palace of Fine Arts, Panama
Pacific Exposition
Photo: Victoria Damrel

1915–1930:
Growth of the Arts & Non-Painting Media

How do the years 1915, 1930, 1945, and 1960 serve California art historians? Each represents a tidy turning point at which social, economic, and technological changes drastically altered the look of the state's fine arts. The result is that twentieth-century art divides naturally into convenient periods for discussion.

What events caused the break at 1915? The most important was World War I. Lasting from summer 1914 until fall 1918, the war disrupted European culture and ended Europe's reign as head of the Western art world. America profited as her expatriates, who had been living in Europe, and European-born intellectuals fled to the United States in search of a refuge. Even California, the farthest American state from Paris, benefited. These refugees not only bolstered California's intellectual and artistic circles but brought modernism.

A second event of importance to the arts was San Francisco's Panama-Pacific Exposition, which opened in February 1915. This mammoth enterprise was erected on once marshy ground reclaimed from the bay (today's Marina District) to celebrate the completion of the Panama Canal. The waterway promised to profit California as the midway port between the East Coast and Asia. Most important to the course of California art, the exposition offered the largest display of up-to-the-minute art ever shown in the state.

While an art exhibition may not seem an earth-shaking event today, California's situation was much different in 1915. San Francisco's turn-of-the-century art world had been moribund since the 1906 earthquake and fire. From that year until 1915 the city had been the site of few displays of art other than a small permanent show at the M. H. de Young Memorial Museum and the annuals of the San Francisco Art Association. The Panama-Pacific Exposition rekindled San Francisco's art world. It brought in East Coast architects, landscape designers, interior designers, sculptors, painters, and so on, to design, construct, and decorate the site. It attracted East Coast artists, either as tourists or to help install their work in the fair's huge art exhibition. The fair's Beaux-Arts-style, travertine-faced buildings arranged around open courtyards and patios gave painters a subject never before available in rustic California—urban parks. And, the exposition left the city its first art museum—the Palace of Fine Arts (fig. 12-1).

Also influencing the change in art was San Diego's Panama-California Exposition, opened at the stroke of midnight December 31, 1914. Smaller than the Panama-Pacific, it nonetheless stimulated San Diego's infant art world and proved more prophetic than the San Francisco fair. Its Spanish Colonial style of architecture inspired the first of California's many Spanish revivals. Columned arcades, patios, and red-tiled roofs have since become synonymous with the southern half of the state. San Diego's display of art, while much smaller than San Francisco's, complemented and supplemented the larger exhibition. It showed work by New York modernists—the Ash Can School of artist Robert Henri and his circle—as well as works by contemporary Southern California artists gathered by the then-powerful California Art Club of Los Angeles. Any California artist attending both expositions would have seen contemporary art from most of the Western world.

Financially supporting the growth of culture was the economic boom that followed the signing of the armistice on November 11, 1918, and the return of two million "doughboys" to the States. Like any release from confinement, the war was followed by excess—a ten-year economic boom, known retrospectively as the Roaring Twenties. Flappers with bobbed hair, nightclubs (associated with prohibition and bootlegging), jazz, crossword puzzles, and tabloids were suddenly fashionable. It was a time of material prosperity and rampant consumption, resulting from cheap, mass-produced objects promoted by salesmanship and advertising and made affordable with installment buying. The proliferation of the automobile prompted a federal highway program. Los Angeles's growth was bolstered particularly with money from the movie industry, the oil industry, and another real-estate boom. The audacious 1913 Owens aqueduct brought water from Northern California just in time to support a wave of more than a million new settlers in a decade.

Between 1915 and 1930 art throughout the state advanced rapidly, reducing its twenty-year time lag with the East Coast to less than five. Art flourished in every way. Each of California's major cities (except Santa Barbara) opened its first art museum. Painting and sculpture was shown in sites managed by clubs or special interest groups, and in response to the decade's

Fig. 12-2
Ralph Stackpole
(1885–1973)
Man's Inventive Genius
Figures for San Francisco
Stock Exchange, 1931
California granite, 21 ft. ht.
Photo: Victoria Damrel

consumerism, many commercial galleries opened. Each major city now had at least one art school. Some California magazines initiated art review columns, and a few magazines were solely devoted to art. Artists grew in numbers. Many arrived with the new flood of settlers, and prosperity encouraged even nonprofessionals to explore their creative urges. With more artists came more specialization and then organizations for those specialties. In the 1920s clubs were formed for and by newspaper artists, illustrators, cartoonists, watercolorists, sculptors, art teachers, modernists, and women.

Most important for this discussion was the great change that came about with the introduction of European modernism. The war had broken the hold of tradition. Everyone now sought the "new." Painters adopted Impressionism, and artists increasingly moved into non-painting media.

Sculpture

Between 1915 and 1930 both sculpture and sculptors increased in number. As the state's most sophisticated art city, San Francisco continued to lead in commissions. Los Angeles generated a few public commissions (such as the facade sculpture for the new Public Library and the City Hall) as well as a few privately funded projects. San Diego attracted a few sculptors from the outside to execute the rich Plateresque entranceways around the individual exhibition halls at the Panama-California Exposition. In each of the major cities, sculpture courses were added to art school curriculums. There were now enough sculptors to command their own organizations and exhibitions, although their numbers were not large enough nor had sculptors been in the state long enough to meld their disparate styles into a "California" style.

Stylistically, California sculptors were conservative. None went so far as to adopt the kind of abstraction developed by Europeans such as Picasso, a level of abstraction that even bypassed most East Coast sculptors. Californians preferred human or animal subjects. The more conservative modeled their work in clay and then cast it in bronze, as did Maude Daggett (1883–1941) of Pasadena. She gained a reputation in the 1920s for her bronze garden figures of naked babies or toddlers, idealized human figures, and animals. California's climate encouraged the making of outdoor

works, either commemorative public sculptures of heroic scale, or lifesize or smaller, decorative bronze figures for private gardens. Bronze casting enjoyed great popularity in the 1920s, when some California cities acquired foundries and when casting techniques began to be taught in local art schools. The Santa Barbara School of the Arts was particularly effective in teaching bronze casting, and some of its students carried the technique to San Diego.

The technique that eventually displaced modeling was carving. Pristine white marble gave way to plainer natural materials, such as wood, granite, and limestone. The Arts & Crafts movement instilled artists with a respect for the intrinsic qualities of their materials and a belief that an artisan should do his own carving rather than leave it to a corps of assistants. This philosophy imbued sculpture with personal expression and integrity. Sculptors also gained new strengths by looking to the art of so-called primitive peoples.

One of California's earliest sculptors in stone was San Franciscan **Ralph Stackpole** (1885–1973). In his figures for the San Francisco Stock Exchange of 1931 (fig. 12-2) he retained representational subject matter but abstracted and stylized it. He was highly successful with his many commissions for architectural sculpture and spread his interest in the *taille directe* method of stone carving through his teaching at the San Francisco Art Institute, thus influencing a generation of students. Also advanced for his time was Beniamino Bufano (1898–1970), who by the early 1920s was producing ceramic sculpture. His choice of the medium probably stemmed from experiences gained during his travel in China in the late 1910s, and his use of ceramic in America placed him ten years in advance of the medium that became fashionable for sculpture in the 1930s.

Printmaking (Etching and Woodblock)

Between 1915 and 1930 printmaking "took off" in California. Joseph Pennell's temporary presence in town (chapter 9) inspired San Francisco's scattered printmakers to organize, and the Panama-Pacific Exposition enabled them to display their etchings and woodcuts as well as to view those of others, bringing them immediately up-to-date with the print world's most recent advances.

Both the California Society of Etchers in San Francisco (founded 1913) and the Printmakers of Los Angeles (founded 1914) devoted themselves to experimentation, and their members unselfishly shared their discoveries and techniques with fellow print enthusiasts through lectures and demonstrations. Both organizations soon became international in membership,

Fig. 12-3
Mildred Bryant Brooks
(1901–1995)
Benediction
etching and aquatint
8¼ x 8¼ in. (image)
Collection of Joseph L. Moure

and their annual exhibitions attracted prints from all quarters of the globe. Although the most prominent of Northern California's etchers from 1915 to 1930 learned the technique while out of state, from 1912 on etching was taught at the California School of Design in San Francisco. In Los Angeles, etching entered the curriculums of some art schools or college and university art departments in the 1920s. During the 1920s the first group of print collectors appeared; the most publicized was the Los Angeles music impresario Merle Armitage. In Los Angeles, prints were usually shown in bookstore "galleries"; by the late 1920s San Francisco had at least one commercial gallery exclusively devoted to selling prints.

The favored printmaking techniques between 1915 and 1930 continued to be etching and color woodblock prints, but they are stylistically different from those made in the 1900–1915 period. The favorite subject for etchers worldwide was landscape, and California etchers distinguished themselves by representing their own state. They frequently chose mission facades, pastoral countryside, local trees (including the redwood, Monterey cypress, eucalyptus, and live oak), San Francisco's Chinatown and Telegraph Hill, as well as ships and wharves. But after 1915 their techniques grew more sophisticated. In the north the most important etcher was Armin Hansen (1886–1957), who produced views of wharves and ships with beautiful line, rich blacks, and asymmetrical compositions. In Los Angeles, **Mildred Bryant Brooks** (1901–1995) learned etching at the University of Southern California, and her work is notable for its meticulously delineated trees, as seen in images such as *Benediction* (fig. 12-3). Through the 1930s at Stickney School in Pasadena, Brooks used her own etching press to print her work as well as that

of friends. Certain Los Angeles etchers, such as Benjamin Brown (1865–1942), were among the earliest Americans to bring color into the medium.

Woodblock printing rivaled etching in popularity. The pre-1915 work of pioneers Bertha Lum and Helen Hyde was displayed at the Panama-Pacific Exposition and no doubt had some influence upon a sizable "second generation," which thrived until 1940. In Northern California this generation included the important teacher Pedro Lemos (1882–1954), William Rice (1873–1963), and Chiura Obata (1885–1975); in Los Angeles, **Frances Gearhart** (1869-1958) and Anders Aldrin (1889–1970); in Santa Barbara, Frank Morley Fletcher (1866–1949), and visiting from New Mexico, Gustave Baumann (1881–1971), not to mention many others. Each California artist had his or her own style and, with an understanding of his or her subtleties, one can identify their work. *When Summer Comes* of about 1925 to 1930 (fig. 12-4) by Gearhart suffices as an example. Second-generation color woodblock artists discarded Far Eastern characteristics, such as Asian subject matter and wiry line, which had been popular with turn-of-the-century artists. Here, Gearhart renders a western subject with visual depth and, influenced by the Arts & Crafts movement, has adopted a rough-hewn look. She also rejects the Japanese taste for subtle color tints in preference for solid blocks of bright color. In woodblock printing, each color requires a separate carved block that has to be inked and registered with the others at the time of printing. The final block prints the dark blue outline of the shapes.

Photography

Camera Pictorialism (chapter 9) persisted through the early 1930s. Between 1915 and 1930, however, it was significantly modified by a group of Japanese-American photographers in Los Angeles as well as by the Angeleno Pictorialist Edward Weston (1886–1958).

To date, this history of California's art has not addressed work made by so-called ethnic "minorities." California's post-1850 flood of immigrants from all over the world almost instantaneously established a society composed of a majority of people of Western European background and "minorities" (Native Americans, Central and South Americans, and Asians). Until about 1914 the state's minority peoples usually produced art in their own ethnic traditions and for their own use. But as these groups increased in size and their American-born children attended American schools, they began to assimilate into mainstream American society. Artists from these groups began to adopt the styles of the majority as they competed with the larger population. One of the first and most successful instances occurred in Los Angeles when a number of Issei, or first-generation Japanese immigrants, turned to photography as a pastime. In 1923 they began their own club, the Japanese Camera Pictorialists of California. Like most camera clubs, this one provided its members with photography outings and with social situations that allowed them to share techniques and ideas. This particular group was important because of its avant-garde ideas. Nationally, Camera Pictorialism of the 1915-1930 period was gravitating toward modernist subjects such as city architecture and industrial buildings, but Los Angeles's Issei took a further step toward abstraction. Their unique blend of Eastern and Western aesthetics was inspired by the uncompromising **Kaye Shimojima** (active Los Angeles 1920s). His *Edge of Pond* of about 1928 (fig. 12-5) adopts a traditional Japanese viewpoint—a bird's-eye perspective that eliminates the horizon and brings the subject up flat against the picture plane. Although the subject is real, the angle at which it is photographed, or the parts selected, turns it into an abstraction. Shimojima's example led club members to excel in "still lifes" that were more modern in their emphasis on geometric shapes and pattern than anything produced in the Western art world at the time. When the work of

members appeared in exhibitions on the East Coast and in Europe, it was praised for its advanced spatial and abstract concepts. These photographers remained active through the 1930s.

By the 1910s a new philosophy of photography began to displace Camera Pictorialism—the German "straight" (unmanipulated) photography. Reaching America through Alfred Stieglitz's *Camera Work* magazine and through exhibitions of photographs, this approach stimulated the mind of **Edward Weston** (1886–1958) of Tropico (now Glendale), in Southern California as early as 1916. Its basic premise was that instead of trying to turn photography into a fine art, as the Camera Pictorialists were doing, photographers should accept the inherent qualities of the camera and film—such as clarity and exactitude. If a photographer wanted his work to be "artistic," he should achieve this through his choice of subject and viewpoint. Weston was one of the earliest California artists to espouse this philosophy, although he later found that several artist-photographers in the Bay Area had been taking the same direction at about the same time.

California photographers explored this approach through the subject of the state's landscape. (This contrasts with East Coast photographers who favored scenes of city dwellers infused with political, commercial, sociocritical, or philosophical stances.) Weston ultimately became known for his close-up and very precise photographs of natural objects with interesting textures—rocks, shells, grasses, female nudes, sand, vegetables, and others—to which his aesthetic approach gave sensual, even erotic overtones. While today there seems nothing extraordinary about *Shells* of 1927 (fig. 12-6), Weston and the f.64 group (named after one of the diaphragm settings on the camera lens) established this direction in the early 1930s. In an era when science was first revealing the limitlessness of both the macrocosmic and microcosmic universes, and organized religions were being challenged by the theory of a universal spirit, certain natural objects, like shells, were meant to symbolize the universe at large. Although f.64's loose group of friends that included Ansel Adams (1902–1984) and Imogen Cunningham (1883–1976) dissolved in 1935, individual members continued to follow the philosophy in their photographs through the 1940s.

Arts and Crafts

By 1915 the isolated rustic bungalow nestled in a wooded arroyo beside a seasonal stream had become a thing of the past. The Arts & Crafts colonies that had flourished in the Arroyo Seco-Pasadena area and

Fig. 12-5
Kaye Shimojima (active Los Angeles 1920s)
Edge of Pond, c. 1928
bromide photograph
13 $^7/_{16}$ x 10½ in.
Los Angeles County Museum of Art, Gift of Karl Struss

Fig. 12-6
Edward Weston (1886–1958)
Shells, 1927
gelatin silver print
7½ x 9½ in.
© 1981 Center for Creative Photography, Arizona Board of Regents

Fig. 12-7
Ernest Batchelder
(1875–1957)
Tile, c. 1916
hand-molded, fired clay,
colored with pigmented slip
18¼ x 12 x 1 in.
Courtesy of the Tile Heritage
Foundation
Photo: M. Lee Fatherree

Fig. 12-8
Malibu Potteries, Malibu,
Ca., 1920s
"Peacock" Fountain,
Adamson House, Malibu
Lagoon State Beach, Malibu,
California
cuerda seca
6 ft. 4 in. ht. x 12 ft. 5 in. lg.
x 5 ft. 4 in. dp.
Malibu Lagoon Museum;
Photo courtesy Joseph A.
Taylor, Tile Heritage
Foundation

in Santa Barbara had succumbed to natural deaths, and in the years between 1915 and 1930 even the style slowly faded away. During this time the handicrafts adopted some mechanical production methods to make themselves commercially viable, before they were finally usurped by the Machine Age and the Art Decoratif movement that dominated between 1925 and 1945.

Clay, a natural material that California had in abundance, remained the most important medium of the 1920s. The industry, however, changed. Several of the small and medium-size hand manufactories were bought out by large commercial firms, and many of the emerging "craftsmen" had been trained in academic institutions that inculcated more commercial attitudes. Clay vessels gave way to tiles, created in two basic types. Artists such as **Ernest Batchelder** (1875–1957) of Los Angeles's Arroyo Seco craftsman community designed scenic tiles in bas-relief. Their muted colors and mellow character fit perfectly into the subdued decorating scheme of the rustic, natural wood bungalow where they were often used around fireplaces. An example is *Tile* of about 1916 (fig. 12-7) made in the press-molded technique with colored slip. Much more in evidence, however, were the brightly painted and geometrically patterned, glazed tiles in the Hispano-Moresque tradition made by larger, sometimes commercial, manufactories for the increasingly popular Spanish-Colonial bungalows. *Fountain, Adamson House* (fig. 12-8) shows one use of these tiles in an outdoor living space. They were also used as exterior architectural decoration and in interiors, on floors, walls, and around door and window openings. During the height of the fashion, about 1930, it is estimated that more than fifty factories in California were producing them. Most worked directly with the architects of housing projects or individual commercial buildings and mansions to integrate the tile design with the overall construction.

Metal was never a major medium for Californian craftsmen, and during World War I, when metals were commandeered for the war effort, crafts workers stopped working with them entirely. In the 1920s however, San Francisco coppersmith Dirk Van Erp (chapter 9) resumed production of bowls and other objects, and in the Los Angeles-Pasadena area two silversmiths, Douglas Donaldson (1882–1972) and Porter Blanchard

(1886–1973), created objects such as dinnerware and trophies for wealthy wintering Midwesterners and Hollywood personalities.

California enjoyed an especially rich Arts & Crafts movement, and its artisans introduced many innovations. But, because the artists were widely separated with little contact among them and most of the factories were short-lived, no pan-California style developed. In addition, California work was rarely seen out of state, and as a consequence, the excellent Arts & Crafts production of the state had little effect on Midwestern or East Coast traditions.

The the next chapter will start the discussion of painting with the Impressionist style. This was the first of the many modern styles that advanced California painting in the twentieth century and that eventually led to California cities challenging New York as top art city of America. 🦋

Bibliography

Panama Pacific Exposition

Benedict, Burton, *The Anthropology of World's Fairs: San Francisco's Panama Pacific International Exposition of 1915,* Berkeley, Ca.: Lowe Museum of Anthropology, 1983.

Berney, Charlotte, "The Panama-Pacific International Exposition," *Antiques & Fine Art,* v. V, no. 1, November/December 1987, pp. 61–65.

Brechin, Gray, "Sailing to Byzantium: The Architecture of the Panama Pacific International Exposition," *California History,* v. LXII, no. 2, Summer 1983, pp. 106–21.

Panama-California Exposition, San Diego

Brinton, Christian, *Impressions of the Art at the Panama-Pacific Exposition,* New York: J. Lane, 1916. [with a chapter on the Panama-California Exposition]

Neuhaus, Eugen, *The San Diego Garden Fair,* San Francisco: P. Elder & Co., 1916.

San Diego, Ca., *Panama-California Exposition, A Catalogue of Paintings 1915,* published by the Woman's Board, Fine Arts Committee.

Stern, Jean, "Robert Henri and the 1915 San Diego Exposition," *American Art Review,* v. 2, no. 5, September-October 1975, pp. 108-17.

Winslow, Carleton Monroe, *The Architecture and the Gardens of the San Diego Exposition,* San Francisco: P. Elder, 1916.

Los Angeles Infrastructure

Angelino, M., "Nelbert Chouinard Founder of the Chouinard Institute of Art," *American Artist,* v. 32, May 1968, pp. 28–32.

Dominik, Janet Blake, "Patrons and Critics in Southern California, 1900–1930," in Patricia Trenton and William Gerdts, *California Light 1900–1930,* exh. cat., Laguna Art Museum, October 12, 1990–January 6, 1991 and two other venues, pp. 171–76.

Froelich, Finn Haakon, "Tales of Los Angeles Bohemia," [Hollywood, 1920s, Norse Studio Club] *The Californians,* v. 7, no. 6, March/April 1990, pp. 17+.

Harris, Neil, "William Preston Harrison: The Disappointed Collector," *Archives of American Art Journal,* v. 33, no. 3, 1993, pp. 13–28.

"Introduction" in Ilene Susan Fort and Michael Quick, *American Art: A Catalogue of the Los Angeles County Museum of Art Collection,* Los Angeles County Museum of Art, 1991.

Jarrett, Mary, *The Otis Story of Otis Art Institute since 1918,* Los Angeles: The Alumni Association of Otis Art Institute, 1975.

Karasick, Norman, *The Oilman's Daughter: A Biography of Aline Barnsdall,* Encino, Ca.: Carleston Publ., 1993. 268 p.

Moure, Nancy D.W., "The California Art Club to 1930," in *Impressions of California,* Irvine, Ca.: Irvine Museum, 1996, pp. 81–103.

Moure, Nancy D.W., *Painting and Sculpture in Los Angeles, 1900–1945,* exh. cat., Los Angeles County Museum of Art, September 25-November 23, 1980. 111 p.

Moure, Nancy D. W., "Politics Behind an Art Museum for Los Angeles," *Southern California Quarterly,* v. LXXIV, no. 3, Fall 1992, pp. 247–75.

Moure, Nancy Dustin Wall and Joanne L. Ratner, *A History of the Laguna Art Museum 1918–1993,* Laguna Beach, Ca: Laguna Art Museum, 1993.

Perine, Robert, *Chouinard: An Art Vision Betrayed: The Story of the Chouinard Art Institute 1921–1972,* Encinitas, Ca.: Artra, 1985.

Smith, Kathryn, *Frank Lloyd Wright, Hollyhock House and Olive Hill: Buildings and Projects for Aline Barnsdall,* New York: Rizzoli, 1992. 224 p.

San Francisco Infrastructure

Albright, Thomas, "Before the Storm: The Modernist Foundation," in Thomas Albright, *Art in the San Francisco Bay Area 1945–1980,* Berkeley and Los Angeles: University of California Press, 1985.

Baird, Joseph Armstrong, Jr., ed., *The Development of Modern Art in Northern California: Part II: From Exposition to Exposition: Progressive and Conservative Northern California Painting, 1915–1939,* exh. cat., Crocker Art Museum, Sacramento, Ca., 1981.

California Group of Contemporary American Artists and Tobey E. Rosenthal Memorial Exhibition, exh. cat., California Palace of Fine Arts, San Francisco, 1919. 70 p.

Morley, Grace Louise McCann, "Art, Artists, Museums and the San Francisco Museum of Art," Regional Oral History Project, Bancroft Library, University of California, Berkeley, 1960. 246 l.

Neuhaus, Eugen, "Reminiscences: Bay Area Art and the University of California Art Department," Regional Oral History Project, Bancroft Library, University of California, Berkeley, 1961. 48 l.

Painting and Sculpture in California: The Modern Era, essay by Henry T. Hopkins, exh. cat., San Francisco Museum of Modern Art, September 3–November 21, 1976 and the National Collection of Fine Arts, Washington, D. C., May 20–September 11, 1977.

Pissis, Emile M., *Art in California: Reminiscences,* San Francisco: E. M. Pissis, 1920.

Santa Barbara Infrastructure

Curtis, Christine Turner, "The Community Arts Association of Santa Barbara," *The American Magazine of Art,* v. 17, August 1926, pp. 415–19.

Dominik, Janet Blake, "The Arts in Santa Barbara," in Ruth Westphal, *Plein Air Painters of California: The North,* Irvine, Ca.: Westphal Publishing, 1986, p. 20.

McFadden, Hamilton, "Community Arts Association, Santa Barbara, Calif.," *The American Magazine of Art,* v. 15, June 1924, pp. 300–03.

Marquis, Neeta, "From the De La Guerra Home," *Los Angeles-Saturday Night,* June 30, 1928, p. 17.

Martin, Gloria Rexford and Michael Redmon, "The Santa Barbara School of the Arts: 1920–1938," *Noticias,* v. XL, nos. 3, 4, Autumn & Winter 1994, pp. 45-80.

"Santa Barbara Art Club," "Santa Barbara Art Association," "Santa Barbara Craftworkers Association," in Nancy Moure, *Artists Clubs and Exhibitions,* Los Angeles: Privately Printed, 1974.

Wilson, L. W., "Santa Barbara's Artist Colony," *American Magazine of Art,* v. 12, December 1921, pp. 411–14.

San Diego Infrastructure

Boettger, Suzaan, *The Art History of San Diego to ca. 1935,* Thesis, City University of New York, 1985.

Kamerling, Bruce, *100 Years of Art in San Diego,* San Diego: San Diego Historical Society, 1991.

Petersen, Martin E., "San Diego Museum of Art," *Art of California,* v. 3, no. 5, September 1990, pp. 41–45.

Other Cities Infrastructure

Fifty Years of Crocker-Kingsley [50th annual art exhibit of work by Northern California artists], exh. cat., E. B. Crocker Art Gallery, Sacramento, April 5 - May 4, 1975. 120 p.

Sculpture

Armstrong, Tom, et al., *200 Years of American Sculpture,* New York: David R. Godine in assoc. with the Whitney Museum of American Art, 1976.

Bissell, Laurie, "San Diego Cemeteries: A Brief Guide," *Journal of San Diego History,* v. XXVIII, no. 4, Fall 1982, pp. 268–91.

Elsner, William H., "Four San Francisco Sculptors: Part I," *California Palace of the Legion of Honor Bulletin,* v. XXV, nos. 1–2, May–June 1967 and "Part II" n. s. v. 1, no. 1, July–August 1967.

Kamerling, Bruce, "Early Sculpture and Sculptors in San Diego," *Journal of San Diego History,* v. XXXV, no. 3, Summer 1989, pp. 148–205.

Kamerling, Bruce, *100 Years of Art in San Diego,* exh. cat. San Diego Historical Society, Summer 1991.

Katz, Bernard S., *Fountains of San Francisco,* Lagunitas, Ca.: Lexikos, 1989.

Moure, Nancy Dustin Wall, *Painting and Sculpture in Los Angeles 1900–1945,* op. cit.

100 Years of California Sculpture, exh. cat., The Oakland Museum, August 7–October 17, 1982.

Regnery, Dorothy F., *The Serra Statue at the Presidio Monterey,* 1988. 53 leaves.

Rubin, Barbara, et al., *Forest Lawn* [L. A. in Installments], Santa Monica, Ca.: Westside Publications, 1979. 89 p.

Rubin, Barbara, "The Forest Lawn Aesthetic: A Reappraisal," *LAICA Journal,* no. 9, January/February 1976, pp. 10-15.

Printmaking

Annex Galleries, Santa Rosa, Calif., various sales catalogues on California prints issued in the 1980s and 1990s.

"Block and Brayer Club," "Los Angeles Print Group," and "Printmakers of Los Angeles/Printmakers Society of California," in Nancy Dustin Wall Moure, *Artists' Clubs and Exhibitions,* Los Angeles: Dustin Publications, 1975. [v. 2 of *Publications in Southern California Art 1, 2 & 3*]

California Society of Printmaker's *Quarterly*

Printmakers of Los Angeles, *Annual Exhibitions* and their *Newsletter.*

Printmakers Society of California, *Print Letter,* v.1, no. 1, October 1922–April/May 1938.

Purcell, Robert M., *Merle Armitage Was Here!,* Morongo Valley, Ca.: Sagebrush Press, 1981.

Talbot, Clare Ryan, *Historic California in Bookplates,* Athens: Ohio University Press, 1936, 1964, 1983.

Tyler, Ronnie C., *Prints of the West,* Golden, Co.: Fulcrum Publ., 1994. 197 p.

Williams, Lynn Barstis, *American Printmakers 1880-1945,* Metuchen, N. J.: Scarecrow Press, 1993.

(See also bibliography for chapter 9, Printmaking.)

Etching

["Etchers of Santa Barbara"], *Noticias* (publication of the Santa Barbara Historical Society) *Occasional Papers* no. 9 (1967) and *Occasional Papers* no. 12 (1969).

Lemos, Pedro J., "California and its Etchers, What they Mean to Each Other," Robert B. Harshe, "The California Society of Etchers," and Hill Tolerton, "Etching and Etchers," in *Art in California,* San Francisco: R. L. Bernier, 1916. [republished Irvine, Ca.: Westphal Publishing, 1988]

Selkinghaus, Jessie A., "Etchers of California," *International Studio,* v. LXXVIII, February 1924, pp. 383–91.

Wilson, Raymond, "The Rise of Etching in America's Far West," *Print Quarterly* (London), v. II, no. 3, September 1985, pp. 194–205.

Wilson, Raymond, "Rise of Etching in the American West: Armin Hansen, Roi Partridge, John Winkler," (articles appearing serially in *Journal of the Print World* beginning Winter 1985).

Woodblock Prints

Dailey, Victoria, *California Woodblock Prints,* book in preparation.

Dailey, Victoria, "Early California Color Prints," *Antiques & Fine Art*, v. VI, no. 2, January/February 1989, pp. 86–95.

LeJeune, Arnold and Gladys, "Woodblock Printing in Santa Barbara," *Noticias*, v. XVI, no. 1, Winter 1970, n.p.

Photography

Heyman, Therese, "Seeing Straight, The Bay Area's Group f.64," *Art of California*, v. 6, no. 1, January 1993, pp. 22–25.

Heyman, Therese Thau, *Seeing Straight: The f.64 Revolution in Photography*, exh. cat., Oakland Museum and many other sites, 1992.

Japanese American Photography in Los Angeles, 1920–1945, exh. cat., Art Gallery, Los Angeles Valley College, Van Nuys, Ca., April 23–June 3, 1982.

Kismaric, Susan, *California Photography, Remaking Make-Believe*, New York: Museum of Modern Art, 1989.

Oren, Michael, "On the Impurity of Group f.64 Photography," *History of Photography*, v. 15, Summer 1992, pp. 119–27.

Pictorialism in California: Photographs 1900-1940, Los Angeles: The J. Paul Getty Museum and San Marino: The Henry E. Huntington Library and Art Gallery, 1994.

Reed, Dennis, *Japanese Photography in America 1920-1945*, Los Angeles: Japanese American Cultural and Community Center, 1985.

Tucker, Jean S., *Group f.64*, exh. cat., University of Missouri, St. Louis, April 3–30, 1978.

Arts & Crafts

Kurutz, Gary F., *Architectural Terra Cotta of Gladding McBean*, Sausalito, Ca.: Windgate Press, 1989. 139 p.

Malibu Potteries, *Decorative Floor and Wall Tile*, Malibu, Ca.: Malibu Lagoon Museum, 1990.

Rindge, Ronald L., *Ceramic Art of the Malibu Potteries 1926–1932*, Malibu: Malibu Lagoon Museum, 1988.

Rosenthal, Lee, *Catalina Tile of the Magic Isle*, Sausalito, Ca.: Windgate Press, 1992.

Tamony, Katie, "A Blaze of Glaze: The Story of Malibu Potteries," *Antiques & Fine Art*, v. IX, no. 2, January/February 1992, pp. 84–89.

Trapp, Kenneth R., et al., *The Arts and Crafts Movement in California: Living the Good Life*, Oakland, Ca.: Oakland Museum and New York: Abbeville Press, 1993.

(See also Arts and Crafts bibliography in chapter 12.)

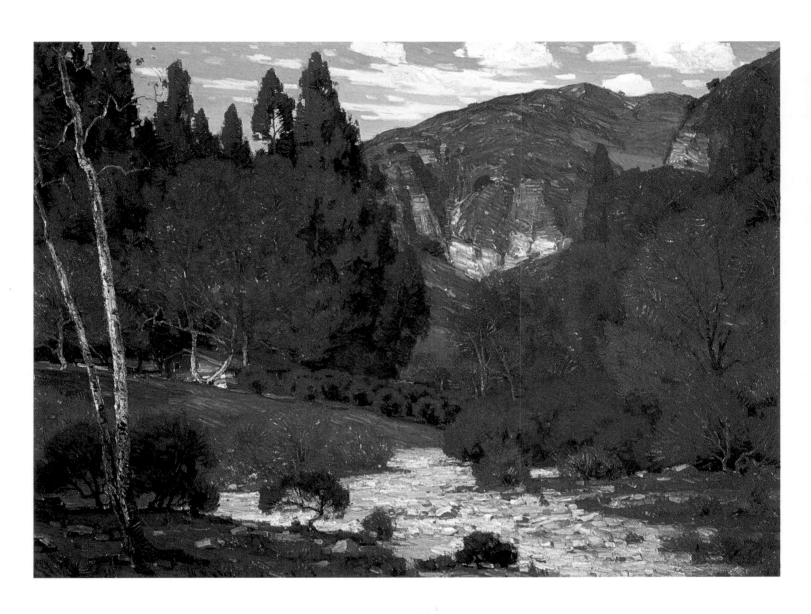

Fig. 13-2
William Wendt (1865–1946)
Hermitage, 1919
oil on canvas, 40 x 55 in.
Private Collection

Impressionism—The Art of Light

Impressionism

Traversing the crowded grounds of San Francisco's Panama-Pacific Exposition in 1915, painters must have marveled at the sheltered courts and open quadrangles nestled among massive Beaux-Arts style buildings. The golden color of the man-made travertine marble mirrored the tones of California's foothills in the dry season, and its pitted surface mimicked antique ruins; at night, hidden lights colored the building facades. At the far, west end of the complex was the Palace of Fine Arts, the most Romantic building of all with its thick columns and bulbous dome reflected in a still lagoon hedged by lush vegetation. Gathered within were more than 4,500 works of art from the United States alone and an equal number from other countries. The work represented almost all the important styles of the recent past. But most important for California painters were the several galleries of French and American Impressionist paintings.

A California painter's reaction to seeing a mass of Impressionist paintings for the first time must have been overwhelming. Despite art reproductions in magazines and books and reports from friends who had studied in Paris and could describe French Impressionism first hand, a California artist who had not traveled outside the state and seen examples must have been stunned by the lively color and the sense of light and air. Yet, by 1915 Impressionism was hardly avant-garde. It had been developed nearly forty years before in France by Claude Monet and his circle. And a handful of California artists had even worked in the Impressionist style in the 1890s. What impressed artists was the impact of entire rooms full of paintings of light and air.

Timing was on the side of acceptance. By 1915 conservative Californians were ready to assimilate this "modern" style, and the exposition's display validated it. Acceptance was reinforced by those American expatriate artists who had returned to California at the outbreak of World War I and who were now practicing their Impressionism on California soil. The lay public seemed receptive, and California artists saw the style as bright, colorful, and upbeat in feeling, appropriate for interpreting the state's attitude, color, and sunlight. California artists had vague fears of not "keeping up" and remaining competitive, and they were curious about

how the style might be adapted to the California landscape. They grabbed their paint boxes and headed for the hills.

Ironically, it was the ostensibly art-poor southern part of the state that produced the earliest, most consistent, and greatest number of "Impressionist" paintings. The earliest had been painted in the 1890s, when several artists tested out the aesthetic. Two of the earliest long-term practitioners were the painting comrades **George Gardner Symons** (born Simon, 1861/6–1930) and **William Wendt** (1865–1946). Their adoption of the style can almost be dated to 1896–97 when they were painting together on the Malibu Rancho near Los Angeles.

At the time, Symons and Wendt were very much in the avant-garde. In the 1890s Impressionism was just starting to make inroads in America, fighting the same prejudices it had faced in France in the 1870s. Establishment artists, rigidly trained in impeccable drawing and morally uplifting themes, found Impressionism's bright colors offensive, its "suggestion" of objects the antithesis of their compulsion to draw, and its interest in light effects and optics too scientific for the emotional world of painting. In retardataire California, these objections were multiplied.

But the Impressionist style proved eminently legitimate for representing Southern California landscape. Since 1915 many pages have been written about how appropriate Impressionism's bright colors are for transcribing the various atmospheric conditions of the region, how its broken brushwork captures the shimmering light as well as the glare of sunshine, and how its positive attitude matches that of the area's inhabitants. But the question remains: did California's early twentieth-century landscapists adopt a sympathetic French style or did they reinvent the style by simply transcribing the Southland's natural light and color?

In the case of George Gardner Symons's *San Juan Capistrano Mission* of June 1900 (fig. 13-1), the broken brushwork and high-keyed palette are strikingly different from the romantic, brown-toned canvases he had painted of Mount Lowe only five years earlier. We must conclude Symons's abrupt change to lighter colors was a conscious adoption of Impressionism.

Symons's Impressionist style, however, is very different from the French version that is associated with

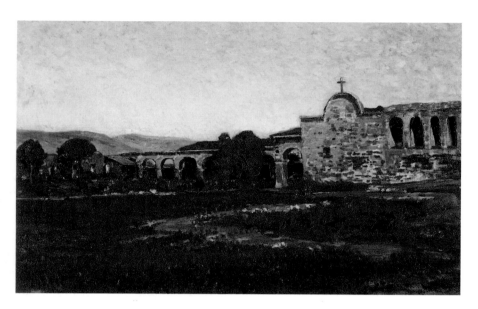

a dense aerial perspective, feathery brushwork, and qualities such as femininity, grace, and delicacy. The character of American Impressionism varied greatly depending on the geographic and climatic differences of the regions where it was practiced. Most California artists did not assimilate some of the more sophisticated compositional aspects of French Impressionism, such as the Oriental-inspired asymmetry, the bird's-eye viewpoint, high horizon lines, dramatic diagonals, or oblique angles. Also, Americans incorporated elements from many other styles. In the American West, the style became more "masculine." In Symons's case this is reflected in his more robust brushwork and brighter colors than those used by the French Impressionists. In Southern California the masculine quality derived from the arid climate and a terrain that was not obscured by surplus vegetation. Southern California's "bones" showed. Californians were less interested in dissolving a scene with light than in simply rendering any subject with broken brushwork and bright color. Also, like many Californians, Symons painted rural landscapes in preference to the urban scenes so popular with city-bound French artists.

Fig. 13-1
George Gardner Symons
(1861–1930)
San Juan Capistrano Mission,
June 1900
oil on canvas, 19 x 30 in.
Dr. and Mrs. Edward H.
Boseker

Fig. 13-3
William Wendt (1865–1946)
*Where Nature's God Hath
Wrought,* 1925
oil on canvas
50 $^5/_{16}$ x 60 $^1/_{16}$ in.
Los Angeles County
Museum of Art, Mr. and
Mrs. Alan C. Balch
Collection

While Symons and Wendt painted together and shared ideas as they developed their styles in tandem, Wendt became more important for California painting. Symons gravitated toward permanent residence in the East, while in 1906 Wendt bought a studio in Los Angeles and settled. The quality that makes Wendt's work outstanding is its character, and that, in turn, is probably due to his reverence and respect for the land itself. Instead of composing ideal works in the studio, he ventured into the wilderness, identified locations where pleasing compositions existed naturally, and transferred the terrain directly to canvas—hills, clumps of trees, bushes, rocks (and rarely signs of man's presence, such as dirt trails, farm buildings, fences, and cattle). His feelings about nature are mirrored in many of his titles including *Where Nature's God Hath Wrought,* below. The title *Hermitage* that he gave to a work of 1919 (fig. 13-2, p. 158) reveals his opinion that nature is a place of solitude and for contemplation. This work is important for its large size, for being almost a composite of geographical features and colors found in California, and for the presence of a building.

The work of all artists evolves. Unlike many Southern California landscapists, Wendt's canvases grew in strength and boldness over his forty years of painting. He soon began to "draw" with his brush, to carve out the underlying structure of the mountains, delighting in the folds of the earth. In the early 1920s, his brushwork widened from the comparatively delicate strokes in *Hermitage* to the much broader and bolder work in the 1925 *Where Nature's God Hath Wrought* (fig. 13-3). His colors also moved away from the organic to stronger and purer tones; for a period he seems fascinated with a brilliant green. Additionally he rejected three–dimensionality, bringing the landscape elements up to the surface of the canvas. These changes can be interpreted as personal growth or an attempt to update his style with the arrival of European Impressionists in Southern California. What makes Wendt's work superior is its spirit, a natural result of his respect for and religious attitude toward the beauty of California's undefiled backcountry. The peak in this canvas becomes not just a mountain but an inspiration.

Wendt was an important figure in Los Angeles's art world. Between 1906 and the mid-1910s he shared his techniques with those who asked, and, through his presidency of the California Art Club (intermittently between 1911 and 1919) and his initiation of its traveling shows, he was the first to obtain recognition for Los Angeles's painters outside their region. As Los Angeles grew, however, and as Wendt aged, the quiet man eventually withdrew from the activity of the city. He built a studio/residence in rural Laguna Beach,

where he settled permanently in 1919, and continued to escape into undefiled nature for his inspiration and spiritual renewal.

Another very early Southern California Impressionist was **Benjamin Brown** (1865–1942). *The Joyous Garden* (fig. 13-4), generally considered his most successful work, was probably produced in the late 1890s, during a brief peak in Brown's abilities. With all

the early writings about the region's rose-covered cottages and luxuriant private gardens, this remains one of the few ever represented in a painting, a distinct example of where literature and art do not coincide. Southern California painters almost universally depicted undefiled nature. This garden may have belonged to a house in Pasadena, the city where Brown lived.

Although Southern California art buyers were conservative and wanted pictures that would fit compatibly in their dimly lit bungalows, Impressionism was such a natural vehicle for transcribing the local landscape that it could not be suppressed. About 1909 Impressionism again invaded the Southland. National art publications, such as *International Studio,* that contained reproductions of Impressionist paintings were

Fig. 13-4
Benjamin Brown
(1865–1942)
The Joyous Garden
oil on canvas, 30 x 40 in.
Joan Irvine Smith Fine Arts, Inc.

received by local artists and libraries. At the Blanchard Gallery the visiting artist Jack Gage Stark exhibited a picture described as a "snowstorm of colored confetti," leading us to guess that he was working in the Pointillist style. And in 1911 Helena Dunlap (1876–1955) returned from study in Paris, bringing Impressionist ideas and exhibiting her works in the highly visible California Art Club exhibitions.

Possibly as a result of these and other influences, Los Angeles's Granville Redmond (1871–1935) began painting poppy pictures. French Impressionists like Claude Monet had led the way by painting cultivated beds as well as fields of wildflowers. Flowers supplied Impressionists with a spectrum of bright colors, and Southern California had abundant counterparts. The earliest landscapes of poppy fields were painted in the 1890s, the theme being a popular subject in Northern as well as Southern California. An early northern example is *A Golden Harvest* (fig. 13-5) by **Charles Chapel Judson** (1864–1946), made even more appealing by the white-dressed figures picking flowers. In the southern part of the state both William Wendt and Benjamin Brown independently painted a few around the turn of the century, but about 1906 Wendt gave up the subject. The theme was carried on by a number of artists, including John Marshall Gamble (chapter 11), but the best known is **Granville Redmond.** Southern California landscapists of the 1920s tended to create ideal scenes, and it is probable that *A Foothill Trail* from 1919 (fig. 13-6), was composed by Redmond in

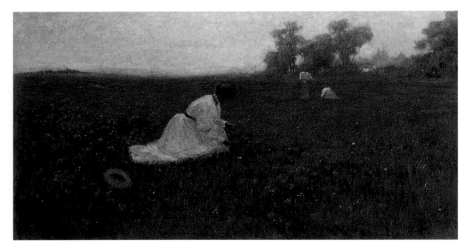

the studio. This painting's large size, compatible colors, and attractive composition make this one of his most important pieces.

About 1914 Southern California Impressionism received an infusion of energy from American expatriates returning at the onset of World War I. The most important arrival was **Guy Rose** (1867–1925). Rose had been raised on the family ranch just to the east of downtown Los Angeles (now the town of Rosemead), and after study in Paris from 1888 to 1891 he chose to pursue his career in New York and France. In contrast to William Wendt's "masculine Americaness" Rose's work can be said to display a "feminine Frenchness." This is most clearly evident in the landscapes Rose created during his 1904 to 1912 residence in Giverny, France; these exhibit a brushstroke similar in shape to Claude Monet's "fishhook" and an atmospheric perspective compatible with the Giverny region's moist atmosphere and delicate colors. Rose continues this style when he turns to painting California landscapes after 1914 but updates the soft tones with brighter colors as seen in the dryer atmosphere of the state. In California's shoreline he found a counterpart for the coastal views he had been painting in France, and in California's sycamores, eucalyptus, and cypresses he found counterparts for his French polled willows, poplars, and tamarisk trees. In *Shoreline* of about 1920 (fig. 13-7), Rose's delicate brushwork builds land forms with tiny prisms of light and color that critics described as "jewel-like."

Since many of the returning Impressionists taught painting in the mid-teens, their influence on local artists was even greater. Rose, his friend from his Giverny years, Richard Miller (1875–1943), and Channel P. Townsley (1867–1921), from William Merritt Chase's Shinnecock School in Long Island, taught at the Stickney Memorial Art School in Pasadena. The former Boston residents John Hubbard Rich (1876–1954) and William V. Cahill (1878–1924) started their own School for Illustration and Painting.

The final impetus for Southern California artists adopting Impressionism came from the paintings shown at the 1915 Panama-Pacific Exposition in San Francisco. The large display had the same artistic shock value to California artists as the 1913 Armory Show of modern art had to East Coast and Midwest artists. Many Southern Californians traveled north by train to see it. Besides inducing local artists to update their styles, the exposition brought in some East Coast Impressionist painters as workers, exhibitors, or tourists. These visitors painted an occasional California landscape, and some, liking what they saw, retired to California. After the exhibition closed, Everett C. Maxwell, art

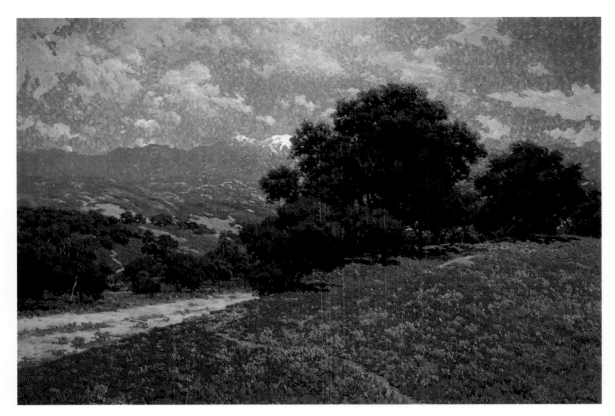

Fig. 13-6
Granville Redmond
(1871–1935)
A Foothill Trail, c. 1919
oil on canvas
40 x 60 in.
Private Collection

curator of Los Angeles's Museum of History, Science and Art, opened 1913, borrowed thirty-eight pictures, most by contemporary American Impressionists, to display in Los Angeles.

Bombarded from all sides, Los Angeles artists were almost forced to react. Those who had been painting in the Barbizon style lightened their colors. Those who had just arrived in the area and were already using the style, adapted to local subjects. Students just entering the field learned it in the newly established art schools. The critic Antony Anderson said about the spring 1917 exhibition of the California Art Club, "…there was a time when artists thought they could paint without light and when air was hardly considered. That time seems prehistoric to us now, but it was really only a few years ago. Today the search for light and air is pursued with enthusiasm and we refuse to consider seriously the picture that is without them. It is a dead thing." (*Los Angeles Times,* April 8, 1917, pt. 3, p. 4, col. 4)

Landscape painting flourished in the 1920s, encouraged by boom times, the relatively easy and cheap living conditions in Southern California, and the region's "unfettered" art environment, which boosters claimed gave free rein to creativity. It was fostered by organizations such as the California Art Club and the Laguna Beach Art Association, by exhibits at the local museums, and by Antony Anderson's supportive reviews in the *Los Angeles Times.* The result was several hundred landscapists, ranging from a few professionals to legions

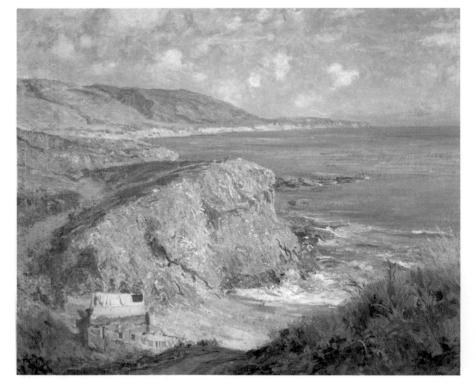

Fig. 13-7
Guy Rose (1867–1925)
Shoreline, c. 1920
oil on canvas
23 x 29 in.
Private Collection

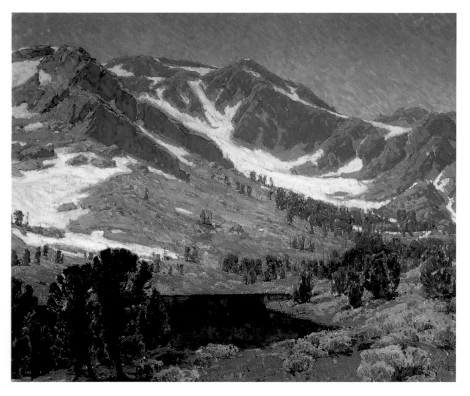

Another artist who consistently produced Impressionist-style landscapes in the 1920s was **Sam Hyde Harris** (1889–1977). An illustrator turned landscapist, he distinguished himself by rendering views of Chavez Ravine (a rustic canyon on the hilly fringes of the city of Los Angeles), points around the San Pedro harbor, and, later, the area's deserts. Harris's work can be identified easily by his palette of subtle pale greens, lavenders, muted blues, and buffs, colors associated with the haziest of Southern California days. His best work is *Hillside* of about 1920 (fig. 13-9). His soft handling of paint tilts his work toward the French/feminine pole of the Impressionist scale, and, rare among Southern California artists, he adopts some sophisticated French Impressionist compositional devices, such as the extended

Fig. 13-8
Edgar Payne (1883–1947)
Slopes of Leevining, 1921
oil on canvas, 48 x 58 in.
Private Collection, Courtesy
George Stern Fine Arts
Photo: Casey Brown

Fig. 13-9
Sam Hyde Harris
(1889–1977)
Hillside, c. 1920
oil on canvas, 28 x 34 in.
Collection of Joseph L.
Moure

Fig. 13-10
John Frost (1890–1937)
Near Lone Pine, California,
1924
oil on canvas, 30 x 36 in.
Joan Irvine Smith Fine Arts,
Inc.

of talented housewives and businessmen. Were they all painting true Impressionist pictures? No. Only the older artists, who had learned their craft in Europe or the East Coast, retained Impressionism's goal of dissolving forms in light and the style's interest in asymmetrical compositions. Most of the others simply adopted Impressionism's bright colors and broken brushwork to render the local landscape.

Among the top echelon of artists was **Edgar Payne** (1883–1947). After taking up residence in the teens and exploring several themes, he settled on California's Sierra seen from the east. Accessible in the late teens only after miles of desert travel, this subject made his work unique. *Slopes of Leevining* of 1921 (fig. 13-8) represents a town in the Sierra near the eastern entrance to Yosemite National Park. In most of Payne's Sierra landscapes a foreground lake is ringed by meadow and pines and that is backed by lavender mountains. Over the many years that Payne pursued the theme, his brushwork grew in width and his compositions simplified. In this important early work his brushwork is delicate and fine, the mountains are complex, and there is a sense of three-dimensionality. Payne even produced a book, *Composition of Outdoor Painting,* that reveals his sound understanding of the many compositions and color schemes that artists could employ to make a successful painting. Other subjects he favored include views of European fishing boats, the Alps, and, in the 1930s, views of the Southwestern desert.

foreground, an asymmetrical composition, and a focal point on a high horizon. **John Frost** (1890–1937) in *Near Lone Pine, California* of 1924 (fig. 13-10) shows how Californians did not hesitate to apply the delicate Impressionist technique to as uncompromising a place as a desert. Frost succeeds because this desert is grown over with brush rather than cacti.

One happy result of the Impressionist presence in Southern California was the proliferation of figure painting. Figure subjects had risen in popularity in the late nineteenth century. Like still lifes, figures could be painted indoors in an artist's studio and the human body could be posed according to compositional needs. American Impressionists usually painted only fully clothed, attractive, upper class, pampered young women and posed them in leisure or domestic activities—seated or lounging at home, reading, pouring tea, resting, writing letters, arranging flowers, or daydreaming. The "Victorian" attitudes of Americans disinclined them to paint certain figural themes popular with the French, such as nudes, and the home-based lifestyle of most Americans kept artists from painting women at public entertainments, such as the theater. **Guy Rose,** for example, who had occasionally painted nudes in Giverny, once in Southern California almost invariably painted fully dressed figures, such as *Marguerite* of about 1900–10 (fig. 13-11). Impressionists favored two types of clothing for their female figures: lacy or gauzy white dresses that conveyed the Victorian ideal of woman as pure and innocent and the newly fashionable highly-patterned Japanese kimonos worn by many Western women as dressing gowns.

If Rose represented the French aesthetic in Southern California, **John Hubbard Rich** and his partner William V. Cahill (see above) represented the Boston variant. A woman posed in an interior was one of the favorite themes of Boston Impressionists. In *The Blue Kimono,* painted before 1915 (fig. 13-12), Rich follows the Boston penchant for posing the figure against an architectural background broken up by horizontal and vertical elements. This painting is clearly about light. Light can affect a subject in many different ways. Outdoor light is all encompassing or all dissolving, while under trees it becomes dappled. Indoor light ranges from natural to man made and may come from many directions. Here the figure is backlit, silhouetted against

Fig. 13-11
Guy Rose (1867–1925)
Marguerite, c. 1900–1910
oil on canvas, 15 x 18 in.
From the Collection of The Bowers Museum of Cultural Art, Gift of Mr. Sherman Stevens, Martha C. Stevens Memorial Art Collection, BMCA F7693

Fig. 13-12
John Hubbard Rich (1876–1954)
The Blue Kimono, bef. 1915
oil on canvas, 25 x 20 in.
Courtesy Maureen Murphy Fine Arts

a door that opens to a more brightly lit room. Other variations of back lighting include an individual placed in front of an open window or a lighted fireplace. In both cases, light creates a halo around the figure. Impressionists were also fascinated with light coming from below a figure, as when light is reflected off the surface of water (such as a fish bowl) or from theater stage lights. In this situation, light illuminates the underside of noses and chins.

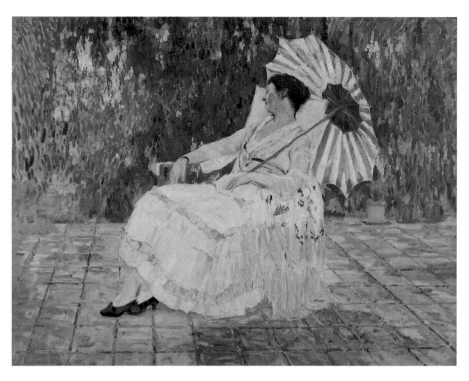

In Southern California, where people do much of their living out-of-doors, figures are frequently posed on porches or in gardens where they are dappled by light filtering through trees or through colorful parasols. A prime example is *Medora on the Terrace* of 1920 (fig. 13-13) by **Alson Clark** (1876–1949), one of many artists who came to California for his health. Well into a successful career painting views of architecture, which he encountered on the East Coast and during travels to Europe and Panama, he brought a sophisticated eye and technique to California. Artists frequently used family members as models, and Medora is Clark's wife. Although he poses her in the filmy dress and with a parasol, common props for Impressionists, other elements, such as the patio tiles, the potted plants, and the eucalyptus background mark this work as Californian. This particular scene was posed on the patio of Clark's own home in Pasadena.

One beneficiary of Rich and Cahill's training was **Mabel Alvarez** (1891–1985). Her *Portrait of a Young Girl* of about 1918 (fig. 13-14) is pure Impressionist in its subject of an attractive young woman, wearing a patterned dress, rendered with light colors, and dissolved in brushwork. The figure's compelling and direct regard, however, is unusual for Impressionists whose models usually look self-absorbed or unaware of being observed.

Fig. 13-13
Alson Clark (1876–1949)
Medora on the Terrace, 1920
oil on canvas, 36 x 46 in.
Rose Family Art Collection

Fig. 13-14
Mabel Alvarez (1891–1985)
Portrait of a Young Girl,
c. 1918
oil on canvas, 25 x 30 in.
Collection of Joseph L.
Moure

San Diego

In San Diego **Maurice Braun** (1877–1941) was the preeminent Impressionist landscapist. Braun had received sound training at the National Academy of Design in New York and enjoyed nearly ten years of career experience painting figures and portraits in the East before his interest in Theosophy and his desire for artistic freedom prompted his move to San Diego in 1909. Recognizing his talent, Katherine Tingley of the Theosophical Society encouraged him not to enmesh himself in the cult's activities at its Lomaland headquarters but to take studio space in her Isis Theater building in downtown San Diego. There Braun founded the San Diego Academy of Art in 1910. His specialty became the local landscape of valleys and hills dotted with brush and eucalyptus trees. He generally worked with two palettes: one based on the cool colors of blue and green, the other on the warm tones of

salmon, tan, and lavender. *California Valley Farm* (fig. 13-15), which favors the blue and green colors, is generally regarded as Braun's best painting. Its superiority is based on its complexity, including a bird's-eye perspective, a darkened foreground, a variety of geographic elements, as well as several species of trees. Most California landscapes of the 1920s avoided signs of man, which makes the presence of farm buildings in this work unusual. Some of Braun's work declines to idealization or decoration, becoming more a symbol of California than California itself, but this work excels with its sound drawing and solid forms.

Arriving home to the environment of San Diego, at the conclusion of the Panama-California Exposition was **Alfred Mitchell** (1888–1972). He had taken his first training from Maurice Braun, but subsequent study at the Pennsylvania Academy of the Fine Arts turned him away from Braun's "feminine" Impressionism and toward the Pennsylvania school's more robust brushwork and saturated color. *Summer Hills* of 1929 (fig. 13-16) is probably his best fully Impressionist work. (Most of Mitchell's work, because of its strong color, falls into the category of Post-Impressionism.) Unlike most of the Southern California landscapists of the 1920s who composed ideal scenes in their studios, Mitchell continually produced unique compositions derived from sites within a fifty-mile radius of San Diego, and he frequently included manmade structures. Besides being beautiful works of art, his paintings leave a valuable record of the growth of San Diego's population over its parched hills.

Santa Barbara
Santa Barbara, a repository for retiring artists of all vintages, began to accumulate landscapists in the mid-1910s. These included painters such as Lockwood de Forest (1850–1932), who continued to work in a Hudson River School style; Albert Herter (1871–1950), a muralist and a painter of American Renaissance subjects; his wife Adel Herter (1869–1946), a muralist; several painters of western themes (chapter 16); and academic painters such as DeWitt Parshall (1864–1956).

The only true Impressionist active in Santa Barbara during the years Impressionism reigned on the West Coast was **Colin Campbell Cooper** (1856–1937). Cooper had studied in Philadelphia and at several

Fig. 13-15
Maurice Braun (1877–1941)
California Valley Farm,
c. 1920
oil on canvas, 40 x 50 in.
Collection of Joseph L.
Moure

Fig. 13-16
Alfred Mitchell (1888–1972)
Summer Hills, 1929
oil on canvas, 40 x 50 in.
Fleischer Museum

Top left:
Fig. 13-17
Colin Campbell Cooper
(1856–1937)
Pergola at Samarkand
oil on canvas, 29 x 36 in.
Joan Irvine Smith Fine Arts,
Inc.

Top right:
Fig. 13-18
Jules Pages (1867–1946)
Sonoma County Landscape
oil on canvas, 12 x 18 in.
Courtesy of the Oakland
Museum of California,
Lent by Mr. and Mrs. Victor
Reiter

Right:
Fig. 13-19
Joseph Raphael (1869–1950)
*Gathering the Horses, Uccle
Town Square*, 1915
oil on canvas
34¼ x 47 in.
Private Collection

Parisian academies. Since about 1910 he had been working in an Impressionist style, painting a full range of architectural subjects including New York skyscrapers, French cathedrals, and Indian temples and mausoleums. Cooper first came to California when his work was included in the Panama-Pacific Exposition; six years later, after his wife's death, he retired to Santa Barbara. There he taught painting at the School of the Arts, continued to paint up and down the West Coast, and even made painting trips to foreign countries. In *Pergola at Samarkand* of about 1925 (fig. 13-17) Cooper turns his talents for painting architecture to a California subject, the gardens around Santa Barbara's Samarkand Hotel. At this early date, there were few formal gardens to paint in Californian cities, but Cooper investigated all possibilities, including the private gardens surrounding Montecito mansions and Santa Barbara hotels, the grounds of the Panama-California Exposition in San Diego's Balboa Park, and the courtyard gardens of the missions. Cooper was blessed with the drawing and perspective skills needed to render architecture accurately. Combining rigid walls with lush plantings and California sunshine, he achieved some of the happiest and most sophisticated Impressionist landscapes in the state.

The Bay Area

The Bay Area's earliest Impressionist paintings might be the views of Chinatown that Theodore Wores made in the 1880s (chapter 6) if one judges only on stylistic qualities such as broken brushwork, bright colors, oblique perspective, and pleasant subject matter.

But at the turn of the century, the dominance of Tonalism in the Bay Area prevented wholesale adoption of the Impressionist style. Exceptions are those members of the all-woman Sketch Club, whose 1906 exhibition was notable for the majority of its paintings that embodied Impressionist ideas. Also excepted is the work of those artists whose study in the East or abroad had allowed them to break free of Tonalism. **Jules Pages** (1867–1946), born and reared in San Francisco, was educated in Paris at the Julian Academy. Although Pages took up residence in Europe, he was still looked upon as a Northern Californian because he made frequent and extended trips back to the Bay Area. Studying and then teaching in Paris (from 1902), he adopted the pure (i.e., French) form of Impressionism, with its softer brushwork, more complex compositions and Parisian subjects. In the undated *Sonoma County Landscape* (fig. 13-18) he transfers this French style to local subject matter, exposing his "purity" in the high horizon and an obliquely retreating path.

California-born **Joseph Raphael** (1869-1950) also remained in Europe after study in Paris, taking up residence in Laren, Holland, and after his marriage, in 1912, in Belgium. But like Pages, he is still considered a Bay Area painter because he frequently returned to California for visits and sent paintings there for exhibition. In Belgium, Raphael turned away from the somber Dutch-influenced genre pictures he had been painting and began to use brighter colors and broader brush strokes. As in *Gathering the Horses, Uccle Town Square* of 1915 (fig. 13-19), his favorite palette consisted of mauves balanced with golds and whites. His European residency led him to sophisticated compositions, such as the bird's-eye viewpoint seen here, and an interest in design that goes beyond the simple prettiness or frivolity of some Impressionist paintings.

Even before the Panama-Pacific Exposition, a few Bay Area artists were painting Impressionist-type canvases. The area's cooler weather caused its artists to work in their studios more often than Southern California "plein air" painters. This resulted in their production of a larger proportion of "studio" subjects, such as figures and still lifes. Clarence Hinkle (1880–1960), who was exposed to Impressionism and Pointillism during his six-year study in Paris, exhibited *A Portrait* (Oakland Museum of California) at the Panama-Pacific Exposition; this was clearly Impressionist in its broken brushwork, lively colors, and female subject. **Matteo Sandona** (1881–1964) had the advantage of being raised on the East Coast and being trained there and in Paris as an Impressionist before settling in San Francisco in 1901. He created two outstanding undated figure studies of women, *In Her Kimono* (fig. 13-20) and

Fig. 13-20
Matteo Sandona (1881–1964)
In Her Kimono
oil on canvas, 35 x 28 in.
Joan Irvine Smith Fine Arts, Inc.

Gertrude (Michael Johnson Fine Arts). His *Untitled (Still Life)* (fig. 13-21) so closely applies the principles of pure French Impressionism with its tabletop subject, bird's-eye perspective, high horizon, off-center balance, oblique angles of the table, and soft femininity that it could have been produced in France.

For Northern California the Panama-Pacific Exposition's exhibition of art becomes most important not for introducing Impressionism but for creating the significant emotional experience that broke the domination of Tonalism and freed artists to use Impressionist principles. One artist who unquestionably was inspired by the work at the exposition was **Armin Hansen** (1886-1957). Until 1912, when he returned to Northern California, he had been making Tonalist marine paintings derived from firsthand experience as a sailor on boats shipping out of Nieuport, Belgium. He had reportedly been exposed to Impressionism while in Europe, but only after seeing the exposition did he produce any Impressionist work. Although they are

his only forays in this style, *The Farm House* of about 1915 (fig. 13-22) and *My Worktable* of 1917 (fig. 13-23) are two of the most outstanding Impressionist paintings created in the state. At a very sophisticated level, they blend the brushwork and interest in the incidental of French Impressionism with the American preference for an evenly balanced horizontal/vertical composition. The building in *The Farm House* is probably one of the Mexican-period adobes in the Monterey valley that was still being used at the time of its painting.

One idiosyncrasy of California Impressionism was its rapid evolution away from the "pure" or French version. Although some art historians and collectors attach greater importance to Impressionist work that approaches the French style, with its more complex subjects and compositions, Western buffs praise the evolved version, which is franker, more forthright, and truly reflects California's terrain and coloration. For them it is more "honest" and more "American."

Once Californians ascribed to the cult of the new, nothing could stop their progress. By as early as 1920 the most advanced Southland landscapists were adopting the even bolder Post-Impressionism. The next chapter will explore how artists begin to subjectively "interpret" California's landscape using emotion, abstraction, and color. 🌸

Bibliography

Panama Pacific Exposition

Art in California: A Survey of American Art with Special Reference to Californian Painting...Particularly as those Arts Were Represented at the Panama Pacific International Exposition, San Francisco: R. L. Bernier, 1916 (reprinted Irvine, Ca.: Westphal Publishing, 1988).

Baird, Joseph Armstrong, Jr., *Fifteen and Fifty: California Painting at the 1915 Panama-Pacific International Exposition,* San Francisco, exh. cat., University of California, Davis, May 10–June 1, 1965.

Berry, Rose V. S., *The Dream City: Its Art in Story and Symbolism,* San Francisco: W. N. Brunt, 1915.

Brinton, Christian, *Impressions of the Art at the Panama-Pacific Exposition,* New York: John Lane, 1916.

Catalogue Deluxe of the Department of Fine Arts, Panama-Pacific International Exposition, ed. by John E. D. Trask and J. Nilsen Laurvik, San Francisco: Paul Elder, 1915.

Cheney, Sheldon, *An Art-Lover's Guide to the Exposition,* Berkeley: At the Sign of the Berkeley Oak, 1915.

Flagg, Peter Joyner, "The Well-Painted Painting: Northern California's Academic Tradition and the Panama-Pacific International Exhibition," in Joseph Armstrong Baird, Jr., ed., *From Exposition to Exposition: Progressive and Conservative Northern California Painting 1915–1939,* exh. cat., Crocker Art Museum, Sacramento, 1981.

Neuhaus, Eugen, *The Galleries of the Exposition,* San Francisco: Paul Elder, 1915.

Neuhaus, Eugen, *Painters, Pictures and the People,* San Francisco: Philopolis Press, 1918.

Williams, Michael, *A Brief Guide to the Department of Fine Arts, Panama-Pacific International Exposition,* San Francisco: Wahlgreen Co., 1915.

Wilson, Raymond L., "Towards Impressionism in Northern California" in Ruth Lilly Westphal, *Plein Air Painters of California: The North,* Irvine, Ca.: Westphal Publishing, 1986.

Impressionism, General

American Impressionism, California School: Selections from the Permanent Collection and Loans from the Paul and Kathleen Bagley Collection, exh. cat., Fleischer Museum, Scottsdale, Az.: FFCA Publishing Co., 1989. 111 p.

California Impressionists, text by Susan Landauer, Donald D. Keyes and Jean Stern, a presentation of the Atlanta Committee for The Olympic Games (ACOG) Cultural Olympiad, organized by the Georgia Museum of Art and The Irvine Museum, 1996.

Gerdts, William H., *American Impressionism,* New York: Abbeville Press, 1984.

Gerdts, William H., *Art Across America: Two Centuries of Regional Painting 1710–1920,* New York: Abbeville Press, 1990, v. 3.

Gerdts, William H. et al., *All Things Bright and Beautiful,* Irvine, Ca.: Irvine Museum, 1998.

Impressions of California: Early Currents in Art 1850–1930, exh. cat., The Irvine Museum, September 6, 1996–January 18, 1997.

Marias, Julian, "California as Paradise," in Leonard Michaels, David Reid and Raquel Scherr, eds., *West of the West: Imagining California,* New York: Harper Collins Publ., 1989.

Masterworks of California Impressionism: The FFCA Morton H. Fleischer Collection, Phoenix: FFCA Publishing, 1986.

Moure, Nancy, "California Garden Scenes," *Art of California,* v. 4, no. 5, September 1991, pp. 52-57.

Painter's Paradise: Artists and the California Landscape, exh. cat., Santa Barbara Museum of Art, November 29, 1996–February 16, 1997.

Palette of Light: California Paintings from the Irvine Museum, exh. cat., The Irvine Museum and four other venues, 1995–1996.

Plein Air, exh. cat., San Jose Museum of Art, May 28 - July 10, 1988.

Ratcliff, Clifford, "Art: California Odyssey," *Architectural Digest,* v. 41, October 1984, pp. 188–93.

Reflections of California: The Athalie Richardson Irvine Clarke Memorial Exhibition, exh. cat., The Irvine Museum and three other venues, 1994–1996.

Selections from The Irvine Museum, essays by Jean Stern, Janet Blake Dominik, Harvey L. Jones, exh. cat., The Irvine Museum and two other sites, 1993–1994.

South, Will and William Gerdts, *California Impressionism,* New York: Abbeville Press Publishers, 1998.

Walker, Ronald E., *Early California Impressionists,* Portland, Or.: Masterpiece Publications, 1993 (published in conjunction with an exhibition at the Nevada Museum of Art, Reno, May 28–July 18, 1993).

Impressionism, Los Angeles

Moure, Nancy Dustin Wall and Phyllis Moure, *Artists' Clubs and Exhibitions in Los Angeles before 1930,* Los Angeles: Privately Printed, 1975.

Moure, Nancy Dustin Wall, *Dictionary of Art and Artists in Southern California Before 1930,* Los Angeles: Privately Printed, 1975.

Moure, Nancy Dustin Wall, *Loners, Mavericks and Dreamers: Art in Los Angeles Before 1900,* exh. cat., Laguna Art Museum, November 26, 1993–February 20, 1994.

Moure, Nancy Dustin Wall, *Painting and Sculpture in Los Angeles 1900–1945,* exh. cat., Los Angeles County Museum of Art, September 25–November 23, 1980.

Trenton, Patricia and Wiliam H. Gerdts, *California Light 1900–1930,* exh. cat., Laguna Art Museum and other venues, 1990-1991.

Westphal, Ruth Lilly, *Plein Air Painters of California: The Southland,* Irvine, Ca.: Westphal Publishing, 1982.

Impressionism, San Diego

Dijkstra, Bram, "Regionalism and Ambition: San Diego Art to 1950," in Robert Perine, et al., *San Diego Artists,* Encinitas, Ca.: Artra Publishing, Inc. 1988.

"Fine Arts Number," *San Diego Magazine,* v. 3, no. 10, September 1927 (numerous articles on local artists and art-related topics).

Petersen, Martin E., "Contemporary Artists of San Diego," *Journal of San Diego History,* v. XVI, no. 4, Fall 1970.

Petersen, Martin, *Second Nature: Four Early San Diego Landscape Painters,* [Fries, Reiffel, Braun, Mitchel] exh. cat., San Diego Museum of Art, June 1–August 18, 1991.

Westphal, Ruth Lilly, *Plein Air Painters of California: The Southland,* Irvine, Ca.: Westphal Publishing, 1982.

Impressionism, Santa Barbara

(See bibliography for Santa Barbara infrastructure in chapter 12.)

Martin, Gloria Rexford and Michael Redmon, "The Santa Barbara School of the Arts: 1920–1938," *Noticias,* v. XL, nos. 3, 4, Autumn & Winter 1994.

Martin, Gloria Rexford, "Then and Now: Two Generations of Santa Barbara Landscape Painters," *Antiques and Fine Art,* v. IX, no. 1, November/December, 1991, pp. 85–93.

Westphal, Ruth Lilly, *Plein Air Painters of California: The North,* Irvine, Ca.: Westphal Publishing, 1986.

Impressionism, Northern California

California Art Research [Matteo Sandona, Lee Randolph], San Francisco: Works Progress Administration, 1936.

Impressionism: The California View: Paintings 1890–1930, essays by John Caldwell and Terry St. John, exh. cat., Oakland Museum and two other venues, 1981–1982.

Nash, Steven A., *Facing Eden: 100 Years of Landscape Art in the Bay Area,* exh. cat., The Fine Arts Museums of San Francisco and University of California Press, 1995.

Schapiro, Mark, "The Bay Area: the Persistence of Light," *Art News,* v. 88, December 1989, pp. 132-37.

Westphal, Ruth Lilly, *Plein Air Painters of California: The North,* Irvine, Ca.: Westphal Publishing, 1986.

Fig. 14-1
Selden Connor Gile
(1877–1947)
Arks Along Lagoon, c. 1926
oil on canvas, 24 x 30 in.
The Buck Collection, Laguna
Hills, California
Photo: Bliss

Post Impressionism
—The Art of Color & Expression

Why separate Impressionism from the style called Post-Impressionism? Aren't they almost the same thing?

Although both styles developed in France just before the turn of the twentieth century, they are actually two different steps in the stairway of modernism that culminated in complete nonobjectivity about 1912. Impressionism was "modern" because it brought an end to verbatim copying of nature and opened the door to interpretation of a scene or an object—through light effects. Post-Impressionism is a *period* following Impressionism and lasting from about 1880 to about 1906. It, too, is "modern" in that the various styles that arose during the period "interpret" a subject through expressive brushwork, bright colors, and stylization. The umbrella term includes the French groups now known as the Pointillists, the Fauves, and the Nabis. Most people are familiar with the names of the three best-known European Post-Impressionists: Paul Cézanne (who investigated the structure of forms), Vincent Van Gogh (who used emotionally expressive brushwork), and Paul Gauguin (who abstracted shapes and gave form to symbolic ideas).

Were there any Americans or Californians active during the period of Post-Impressionism who interpreted realistic subject matter with color and brushwork? Some American art historians point to America's Tonalists as Post-Impressionists. Tonalists indeed interpreted reality with color and emotion. America's purest example is probably the San Francisco painter Arthur Mathews (chapter 8) whose figural works are based in reality yet qualify as modern in that they are abstracted and flattened.

No other California artists qualify between about 1880 and 1906. But taking into account California's standard time lag, and shifting the period of Post-Impressionism forward to the years from about 1906 to about 1930, we do find some. Although the new set of dates may seem late, California's Post-Impressionists were valid in that their experimentation grew out of the state's also-late Impressionism. Any painting made during this period that has representational subject matter interpreted with color, emotion, or stylization will be considered Post-Impressionist. If America and California have been criticized for *following* art styles rather than developing their own, then that

criticism must stop with Post-Impressionism. California's Post-Impressionism was not a regional mistranslation of Impressionism but the result of dedicated experimentation. If California's artists share any unified aesthetic, it is a reverence for color and joyful emotion more akin to the work of Van Gogh or the Fauvist Henri Matisse than to any of France's "scientific" experimenters such as Seurat.

Northern California

The event that triggered California's Post-Impressionism was San Francisco's Panama-Pacific Exposition. This may surprise some who have been told that the exposition inspired Impressionism. However, as we have seen in chapter 13, several artists were producing Impressionist work before the exposition, and in California, pure Impressionism almost immediately evolved into Post-Impressionism. The exposition was probably more important for opening Tonalist-oriented Northern California to new ideas than it was for Southern California, where artists were already exploring the effects of light and color. The fair's display of Impressionist paintings inspired the work of Oakland's Society of Six.

The **Society of Six** was the Bay Area's first official group of modern artists. (Some historians start the history of California modernism with the early twentieth-century Symbolist Gottardo Piazzoni.) The society developed out of the mutual friendships of six East Bay artists who, between 1910 and 1917, drifted into a circle whose center was the painter **Selden Connor Gile** (1877–1947), a hearty individual who attracted friends. Gile was self-taught and had been painting his beloved California in muted colors until he saw the Impressionist art at the Panama-Pacific Exposition. His response was immediate, and his *Arks Along Lagoon* of about 1926 (fig. 14-1) demonstrates the group's preference for shoreline views as well as its use of bright, joyful colors and design that capture the idea or spirit of a place rather than its physical appearance. Gile's work retains a sense of three-dimensionality, and he often spoke about the "swing" of a composition, i.e., the diagonals that carry the eye into the distance. In his use of color and his expression of joy he was a true descendant of the Fauves in France, but in typical California fashion he applied these qualities to landscape

Fig. 14-2
August Gay (1890–1949)
Old Marsh's Studio, 1931
oil on board, 13 x 15 in.
Private Collection
Photo: Cecile Keefe

Fig. 14-3
Maurice Logan (1886–1977)
Corinthian Island, 1928
oil on canvas, 15 x 18 in.
Kern County Library
Foundation, Kern County
Library, Beale Memorial,
Bakersfield

rather than to figural or symbolic subjects. His favorite color was red.

The Society's members made weekend sketching expeditions to the Oakland hills and along the Bay's shoreline, especially up to the Marin peninsula with its picturesque towns of Tiburon and Belvedere. With paints loaded in their backpacks, the midday sun in their faces, the comrades sought out intimate scenes set with humble structures such as farms and fishermen's shacks, usually without people or animals. Their mobility led them to paint on small-size supports that were easy to carry into the field; often pieces of cardboard and cigar box lids. Unlike the work of most early groups of modernists in California, the members shared a similar aesthetic: bright color used expressively and applied "alla prima" (at one sitting) outdoors rather than in the studio. Their unified aesthetic can probably be attributed as much to Gile's enthusiastic and opinionated personality as to the formal critiques that the group held at his home, where they gathered for hearty post-excursion meals of steak and potatoes washed down with wine.

The first artist to join Gile was **August Gay** (1890–1949), who lived with Gile on and off for nine years (1910–1919). Gay had his first experience with art during his three-year recuperation from tuberculosis at his uncle's ranch in Imperial Valley (in Southern California's desert). He took scattered art classes in Berkeley and San Francisco. In his early years Gay shared the group's taste for drawing and for bright Fauve colors, his work being distinguished by a heavy impasto. In 1919, he moved to Monterey where he met the artist C.S. Price (chapter 15), who also rented rooms in the Stevenson House. The two shared a close friendship until Price moved to Portland, Oregon, in 1928. In Monterey, Gay began to paint local views. Old Marsh's studio, seen in *Old Marsh's Studio* of 1931 (fig. 14-2), could be seen from the Stevenson House, and its stepped gable is visible in at least one of Gay's other paintings. Many consider his 1919–28 stylistic period to be his best. *Old Marsh's Studio* shows how Gay's art changed from the bright colors and sunny, upbeat attitude of his Oakland work. Some believe his move to the darkly evocative colors of the expressionists was a reaction to the work of the Blue Four that was shown at the Oakland Art Gallery in 1926. Others believe it came from his absorption of the colors preferred by his associates in Monterey. In any case, he simplified the Monterey area's houses and structures into flat shapes of solid color, adopted a palette of darker, saturated greens, blues, and reds, and projected a haunting mood in many of his works. After Price's move to Portland in 1928, Gay all but gave up

painting, executing only an occasional canvas and one mural for the local Federal Art Project.

The next artist to join the Society of Six was Gile's neighbor **Maurice Logan** (1886–1977), described as a man who wore a three-piece suit and had the manners of an English gentleman. With extensive formal training from 1907 to 1913 at the San Francisco Institute of Art and a successful commercial art practice, he nonetheless happily joined the bohemian group on its excursions. Under its influence, he dropped the Tonal style he had learned in school and adopted the bright color and expressive brushwork seen in *Corinthian Island* of 1928 (fig. 14-3). Corinthian Island lies off the picturesque town of Belvedere on the Marin peninsula north of San Francisco. Logan's admiration of the virtuoso brushwork of John Singer Sargent is evident in the speed, confidence, ease, and unctuous quality of his own strokes. In the 1930s, after the group broke up, Logan, under the aegis of the Regionalist aesthetic, made an almost complete 180-degree turn. He moved to watercolor and to color schemes dominated by somber ochres and browns. However, he retained his interest in bayfront subjects: sloughs, mud flats, boatyards, and estuaries.

Louis Siegriest (1899–1989) and Bernard von Eichman were the youngest of the Six. Unlike the others, they were young enough to have escaped art training in the Tonalist style. When Siegriest showed artistic talent in high school, his parents supported his interest, and he was given advanced art training at the California School of Arts and Crafts in Berkeley and then at the California School of Fine Arts on Nob Hill in San Francisco. *Tiburon Buildings* of about 1923 (fig. 14-4) shows how Siegriest "drew" with the brush. (Tiburon is a charming seaside town on the peninsula north of San Francisco.) His rejection of perspective results in all elements coming to the surface of the canvas where their lines and textures form a tapestry-like pattern. Siegriest's purposefully minimal use of oil leads to a "dry" brush that creates texture as he drags the pigment across an irregular surface. His work can often be identified by what seems to be a favorite color scheme of red, ochre, dark blue, and white.

Bernard von Eichman (1899–1970), nicknamed "Red" because of the color of his hair, was an art school chum of Siegriest. After his father abandoned the family and before his mother remarried, he suffered extreme poverty. His most important art training probably came from Frank Van Sloun, a former student of Robert Henri of New York who passed on Henri's realism and expressive brushwork to his students at the California School of Fine Arts and afterwards at his own school. As a teen, von Eichman earned money

Fig. 14-4
Louis Siegriest (1899–1989)
Tiburon Buildings, c. 1923
oil on board
11¼ x 15¾ in.
Private Collection

Fig. 14-5
Bernard von Eichman
(1899–1970)
China Street Scene # 2, 1923
oil on cardboard, 21 x 14 in.
Collection of the Oakland
Museum of California, Gift
of Louis Siegriest

working on merchant ships as an oiler or a fireman, and during World War I he worked as stoker. In 1921 he was an oiler on the merchant ship *S.S. Edgehill* when the shipping line's bankruptcy stranded him in Hong Kong. In the two years before he was able to return home, he spent his time between residences in jails and poorhouses painting watercolors similar to *China Street Scene #2* of 1923 (fig. 14-5). These were primarily scenes of many-tiered buildings where color was provided by laundry, banners, and street activity. Like

Siegriest, his rapid record of the scene rejects illusionistic space. He brings the elements up to the surface, reduces them to colorful lozenges, and succeeds in making some of the most abstract works of any of the Six. His fellow painters were inspired not only by von Eichman's paintings but by the color reproductions of avant-garde art works he brought back from his voyages to Atlantic ports. They occasionally painted him at his easel.

The last member to join the Society of Six was **William Henry Clapp** (1879–1954), who arrived in Piedmont in 1917 with a reputation as an Impressionist already established in Montreal and Paris. Clapp was in Paris at the time of the 1905 Salon d'Automne in which the Fauves made their historic debut. After studying for four years at several Parisian art schools, he became a devout Impressionist and acquired a taste for painting idealized nudes in landscapes. After joining the Six he continued his fully developed Pointillist style and his preference for lavenders and greens. The delicate character, the lightness and airiness of his works and his unique palette, exemplified in the undated *Poplars at Hayward* (fig. 14-6), make his work distinct from that of the other members of the group; he never attempted to adopt their style. Impressionism's broken brushwork and interest in light provided him a sufficient challenge. One of the most forward-looking arts administrators in the United States for his day, in his position as director of the Oakland Art Gallery, he was the first to show the work of the Blue Four in the United States and he was able to present many shows of the Society of Six and to bring their art to public attention.

The Six did not formally organize until shortly after its first exhibition at the Oakland Art Gallery in March 1923. Gile suggested they call themselves the Society of Six, and Clapp wrote their manifesto. Their claim that "We have much to express, but nothing to say" placed the group squarely at the expressive pole of modernism rather than the intellectual.

Whenever we compare California art to work from Europe or the East Coast, one of the recurring differences is Californians' rejection of intellectual content. Californians were proud of their preference for spontaneity and emotion. As Clapp, the spokesman for the Society of Six wrote, "We are not trying to illustrate a thought or write a catalogue but to produce a joy through the use of the eyes." The group's first show was met with enthusiastic response by art critics in Oakland, who gloated over the fact that Oakland's artists were far ahead of San Francisco's. Their radical departure from Tonalism succeeded because, in Oakland, they were physically and intellectually separated from the influence of San Francisco art; most supplemented their livings from other sources and so were not totally dependent on art sales to provide their livings; most were not molded by formal training that might have closed their eyes to new influences; and they went directly to nature for their inspiration. The group continued to show together through 1928, although by that time several had moved to other locales.

The term "Post-Impressionist" aptly characterizes the Society of Six because the work of the group displays many of the stylistic traits identified with the Fauves. The Society is unusual among modern art groups in that its members shared somewhat the same aesthetic. Most modernists are too independent to take a single direction.

The Bay Area had a few unaffiliated artists whose work could be classed as Post-Impressionist. **Anne Bremer** (1868–1923) was one of the earliest. Study in Paris in 1901 with the modernist painter Andre L'Hote and membership upon her return to San Francisco in the Sketch Club continually associated her with people who were working in advanced styles. The Sketch Club's 1906 exhibition, a month before the famous earthquake and fire, was praised for the Impressionist ideas revealed in its canvases. Her undated *White Leghorns* (fig. 14-7) treats the hens as solid but flat shapes in a design and reveals the brighter colors she adopted following the Panama-Pacific Exposition in 1915. Also to be mentioned is Clark Hobart (1868–1948), who seems to follow the painting style called "cloisonnism," named after the metalwork technique, because he outlines his figures and objects in black. Rinaldo Cuneo (1877–1939) painted cityscapes and crafted solid-looking trees, houses, and mountains with saturated colors. Post-Impressionists of the 1920s associated themselves with San Francisco's more avant-garde galleries: the East-West Art Society (founded in 1921), the Modern Gallery (lasting only a few months in 1926), and the cooperative Galerie Beaux-Arts (active 1925–33).

Southern California

Southern California was home to the largest number of Post-Impressionists and other modernists, and their history unfolds in a radically different way than that of modernists in the Bay Area. Los Angeles's so-called Post-Impressionists arrived in the city independently of each other throughout the 1910s, already fully committed to their personal styles. The earliest was probably Jack Gage Stark (1882–1950). In 1909 he exhibited work described by one reviewer as a snow-storm of colored confetti, probably indicating Stark was working in a Pointillist style. The next to gain press notice was Helena Dunlap (1876–1955). In 1911 Dunlap returned to Los Angeles from study in Paris with L'Hote, exhibited some of her paintings, and was immediately labeled a modernist. Spots of sunlight on a tablecloth in one of her figure paintings were described by the local art critic as looking like "pools of spilt milk." Through the decade others came: in 1910 Karl Yens (1868–1945); in 1914 John Hubbard Rich, Bert Cressy (1883–1944) and Meta Cressey (1882–1964), as well as Edouard Vysekal (1890–1939) and Luvena Vysekal (1873–1954); in 1915 Henrietta Shore (1880–1963); in 1916 the earlier visitor Jack Gage Stark (1882–1950) settled; in 1917 Edwin Roscoe Shrader (1878–1960) and Clarence Hinkle (1880–1960); and in the mid-1920s Vernon Jay Morse (1898–1965).

Los Angeles was not the most fertile soil for a modernist. In the early 1910s the dark Barbizon and Tonalist styles still dominated. There was one museum, which opened in 1913, and one club for painters, the California Art Club. The bright colors and expressive brushwork of the new arrivals shocked the local art world. Looked upon as radicals, they had difficulty gaining entrance for their works into California Art Club exhibitions. But, like modernists anywhere, they made friends with other artists who thought as they did and exchanged art theories and advice. As distant as Los Angeles was from the world's avant-garde art centers, its artists kept in touch by subscribing to the major art journals of the day. Each artist also probably had access to one of the many theoretical and practical books on color and composition that were available in the early twentieth century. And a few displays of "modern" art were presented at the Museum of History, Science and Art and at a handful of galleries. Many Southern California artists took the train to San Francisco to view the Panama-Pacific International Exposition and to San Diego to see the Panama-California Exposition. Although most of Los Angeles's Post-Impressionists worked separately from the returned Synchromist painter Stanton MacDonald Wright (chapter 21) and the Art Students' League with which

Fig. 14-6
William Henry Clapp
(1879–1954)
Poplars at Hayward
oil on canvas, 20 x 24 in.
Marcel Vinh & Daniel Hansman

Fig. 14-7
Anne Bremer (1868–1923)
White Leghorns
oil on canvas
28½ x 24 in.
Courtesy Alvaro and Gloria Luna

Fig. 14-8
Henrietta Shore (1880–1963)
Little Girls
oil on canvas, 38½ x 28½ in.
Stephen & Suzanne
Diamond Collection

Fig. 14-9
Edouard Vysekal
(1890–1939)
Mood, 1916
oil on canvas, 40 x 30 in.
William & Geraldine Scally
Photo: American Photo
Repro Corporation

he associated, they were no doubt in general sympathy with that crowd's modernist goals and aware of their artistic progress. From the mid-1910s through the 1920s, Post-Impressionists jointed with other modernists briefly under various names in order to hold group exhibitions. (Modernist groups have been historically short-lived, their manifestos often idealistic, and their members independent to a fault.)

One of the most important of the early Post-Impressionists was **Henrietta Shore** (1880–1963), whose undated *Little Girls* (fig. 14-8) was accepted into the highly competitive art exhibition at the Panama-Pacific International Exposition. Shore's study with Robert Henri in New York is evident in the subject—almond-eyed, red-cheeked children—as well as the expressive brushwork, but she is not an Ash Can School painter. Her bright colors make her a Post-Impressionist. She exhibited in Los Angeles's very first modernist exhibition, the Modern Art Society show of 1916. As a pioneer, along with Helena Dunlap, her road was particularly rocky. Both painters fought battles that benefited later artists. Their conflict climaxed in 1919 when Shore and Dunlap petitioned the Los Angeles Museum for exhibition space for a group of modernists calling themselves the California Progressives. The California Art Club considered these artists disloyal to "the one" organization of painters in Los Angeles. Tempers flared, and the CAC-friendly museum refused to grant the Progressives exhibition space. The incident was likely painful to Shore and Dunlap. The following year Shore returned to New York, and Dunlap began a seven-year odyssey of painting trips to various parts of the world. Ironically, the travel proved beneficial for both: in Shore's few years in New York City she developed a reputation that more than vindicated her ill treatment in Los Angeles, and Dunlap returned from her world travels with brightly colored canvases of many exotic places.

Most of Los Angeles's modernists endured and were able to capitalize on Los Angeles's culture boom of the 1920s. Postwar prosperity and a flood of new residents sent art on a spin (chapter 12). The Los Angeles Museum received many gifts of contemporary American and French art from benefactor William Preston Harrison, which were placed on exhibition. During the decade, modernist groups formed repeatedly and held exhibitions. The Group of Eight exhibited in 1921, 1922, and 1928. Another group of artists who called themselves the Free Lance Art League came together in 1923, 1924, and 1925 and as the Los Angeles Art League in 1926, 1927, and 1928. Some of the Group of Eight joined with several Cubist painters in 1925 and 1926 to exhibit as the Modern Art Workers,

and in 1928 others working in the Regionalist style banded together as the Younger Painters

Most of Los Angeles's 1920s Post-Impressionists were associated officially or unofficially with Otis Art Institute. Edwin Roscoe Shrader (1878-1960), who started as a teacher, was managing director by 1922 and in 1924 became dean of the faculty, a position he held until he retired in 1949. Onto his staff came John Hubbard Rich, Donna Schuster, and Edouard Vysekal. They drew into their circle artist-friends such as Mabel Alvarez and Clarence Hinkle (although he taught at the competing Chouinard Art Institute). These artists continued their memberships in the California Art Club through the 1920s, submitting work to its annual exhibitions. Although their "modernism" by that time was conservative and acceptable, they were still regarded as the club's avant-garde.

Edouard and Luvena Vysekal came to California in 1914 to paint murals in a hotel in El Centro and remained in the state. **Edouard Vysekal**'s *Mood* of 1916 (fig. 14-9) is proof of the artistic integrity of his handling of figures in the 1910s. In the 1920s his brushwork became looser and lusher, and like most artist-immigrants to Southern California, he turned to landscape. He remained unique, however, in his choice of unusual urban views of Los Angeles such as the oil pools of the La Brea tar pits. Luvena Vysekal's favorite subjects were figures and robust still lifes of flowers, such as geraniums. She was a strong personality, and in 1922 and 1923 wrote a series of satirical biographies of her fellow artists under the pseudonym of Benjamin Blue. Her personality attracted a following, and after Edouard's death in 1939, she operated the Vysekal Studio Gallery in Hollywood, which also served as a kind of salon.

Many of Los Angeles's Post-Impressionists started out as Impressionists. **John Hubbard Rich** is a prime example. If we compare *The Blue Kimono* of before 1915 (fig. 13-12) to *Miss Harvey* of about 1920 (fig. 14-10)—both views of a woman in an interior—we see he treats the later painting in a more masculine manner. Forms are much more solid, colors darker, and the Indian basket is a reference to the Southwest. Seeing Rich's style change leads one to ask whether he was merely updating his style (as we see him do again in the 1930s with Regionalism), or was his more virile and robust Post-Impressionism the result of an "Otis" aesthetic, or perhaps of his residence in the American West?

The same transition is seen in Rich's pupil, and later his close friend, **Mabel Alvarez.** *Self Portrait* of 1923 (fig. 14-11), which won a prize at the Painters and Sculptors annual exhibition in 1923, is very different

Fig. 14-10
John Hubbard Rich
(1876–1954)
Miss Harvey, c. 1920
oil on canvas, 30 x 25 in.
Private Collection, Courtesy
of Kelley Gallery

Fig. 14-11
Mabel Alvarez (1891-1985)
Self-Portrait, 1923
oil on canvas, 24 x 20 in.
Private Collection
Photo: M. Lee Fatherree

Fig. 14-12
Vernon Morse (1898–1965)
Building the Bridge, 1926
oil on board, 22 x 28 in.
Courtesy Jean Stern

Fig. 14-13
Belle Baranceanu
(1902–1988)
*Sunset Boulevard at Everett
Street,* c. 1928
oil on canvas, 24 x 22 in.
The Buck Collection, Laguna
Hills, California
Photo: Cristalen and
Associates

in style from her *Portrait of a Young Girl* (fig. 13-14) of a few years earlier; it depends on rich color and sensitively rendered shapes rather than light dissolving its subject. Many European and American modernists explain their theories in published form, but California modernists rarely chose to do this. Modernism in California seemed more a desire than an exploration of specific theories or principles. Alvarez was typically vague when she noted in her diary in 1918, "I want to take all this beauty and pour it out on canvas with such radiance that all who are lost in the darkness may feel the wonder and lift to it" (diary, collection Archives of American Art).

Among the many other artists whose bright colors and bolder styles ally them with Los Angeles's Post-Impressionists are **Vernon Morse** and Jack Gage Stark. Because so little is currently known about either of these artists little can be said about them other than what we can see in their work. Morse's residence in San Francisco between 1919 and 1925, when the Society of Six were exhibiting, may explain why some of his work, such as *Building the Bridge* of 1926 (fig. 14-12), depicts harbor subjects, why he uses bright colors, and why he "draws" with the brush. Hopefully more of his work will surface, for it exhibits strong character and good construction. A body of Stark's works is in the collection of the Santa Barbara Museum of Art but has yet to be analyzed by an art historian.

The Chicago artist **Belle Baranceanu** (1902–1988), exiled between 1927 and 1929 to her uncle's house in Los Angeles by a father wanting to get her away from an undesirable potential husband, worked independently of the Los Angeles community, building strong landscapes from massive, flat shapes, as she does in *Sunset Boulevard at Everett Street* of about 1928 (fig. 14-13). Henri DeKruif (1882–1944) made his living as a commercial artist but took late training with the modernist Stanton MacDonald Wright and exhibited brightly colored works with the Group of Eight. Conrad Buff (1886–1975) was drawn into the modernist crowd through his friendships with Clarence Hinkle, Mabel Alvarez, and others. His desertscapes are composed of massive landforms built with tiny crosshatched brushstrokes; he often uses shades of purple (chapter 16). Many other artists deserve mention, including Joseph Greenbaum (1864–1940), Lawrence Murphy (1872–1948), and Frederick Schwankovsky

(1885–1974). In the relatively young world of California art history, they need further study. (The Chouinard teacher Clarence Hinkle, and other modernists active in Laguna Beach, will be discussed in the next chapter.)

San Diego's Post-Impressionists appear very late—in the mid-to-late 1920s (unless we count Alfred Mitchell (chapter 13), who returned from art study in Pennsylvania and Europe in 1922). Like artists in Los Angeles, they were independents who brought with them styles they had learned and developed elsewhere. Thus the Ash Can School artists shown at the Panama-California Exposition in 1915 did not trigger Post-Impressionism in San Diego. The first to arrive may have been **Otto Henry Schneider** (1865–1950), a portrait painter from Buffalo, New York, with European training who moved to San Diego about 1924. Schneider became an instructor at San Diego's Academy of Fine Arts and went on to produce his best work. Noteworthy in his paintings is the use of black, a "color" that was anathema to Impressionists (who rendered shadows as blue rather than black). *Luxembourg Gardens* (fig. 14-14) is typical of a Southern California Post-Impressionist's use of a conservative Impressionist theme—urban dwellers amusing themselves in the park —delineated in a subjective way with strong colors.

Fig. 14-14
Otto Henry Schneider
(1865–1950)
Luxembourg Gardens
oil on paper on Masonite
25 x 20 in.
San Diego Museum of Art
(Museum Purchase)

In November 1925 **Charles Reiffel** (1862–1942) and his wife came to San Diego, diverted by a storm from a leisurely trip they had planned to New Mexico and Nevada. Reiffel had many years behind him as a successful landscapist in the East, but during his forced stay in San Diego he fell in love with the city. The arid terrain of the rolling backcountry, unobscured by vegetation, supplied Reiffel with boulder-strewn hills and dry valleys, which he turned into paintings infused with emotion. *To Wander—In San Diego Back Country* of 1938 (fig. 14-15) is a magnificent panorama marked with rhythmic lines that undulate through the composition. His most satisfactory paintings, as here, have a spot of warm color, often red or orange, to counteract his favorite blue/green coloration.

Schneider and Reiffel were among the eleven male artists who banded together to form the Associated Artists of San Diego (renamed the Contemporary Artists of San Diego) in June 1929. This mixed group of sculptors and painters worked in a variety of styles that were avant-garde for their place and time, and they held exhibitions through 1936.

Beginning with Post-Impressionism, women began to find a place in San Diego's art world. The first arrival was **Anni Baldaugh** (1881–1953) about 1929, who had practiced art in Europe, on the East Coast of the United States, and in San Francisco and Los Angeles. She brought with her a fully developed Post-Impressionist style. Her most outstanding figure painting is *Murial* of about 1925 (fig. 14-16), a portrait of the artist-wife of Los Angeles modernist Henri DeKruif, made while Baldaugh was active in Los Angeles. The portrait succeeds in its deft, broad brushwork, bright colors, and the sense of intimacy conveyed by the sitter's direct gaze at the viewer. San Diego also became the longtime home of Belle Baranceanu (above). Through the 1930s, while working on government art project murals, Baranceanu continued to produce strong figural works. Also active there were Elliot Torrey (1867–1949) and Marius Rocle (1897–1967).

Many of California's Impressionists and Post-Impressionists resided in the state's several art colonies, and it is these art colonies that form the subject of the next chapter. ✺

Fig. 14-15
Charles Reiffel (1862–1942)
To Wander—In San Diego Back Country, 1938
oil on board, 42 x 48 in.
Private collection, Photo courtesy of the San Diego Museum of Art

Fig. 14-16
Anni Baldaugh (1881–1953)
Murial, c. 1925
oil on board, 21 x 23 in.
Collection of the San Diego Historical Society
Photo: Nick Juran

Bibliography

Post-Impressionism, General

(See also books on California Impressionism cited in chapter 13.)

The Advent of Modernism: Post-Impressionism and North American Art, 1900–1918, exh. cat., High Museum of Art, Atlanta, Ga., 1986.

Post-Impressionism: Cross-Currents in European and American Painting 1880–1906, exh. cat., National Gallery of Art, Washington, D. C., May 25–September 1, 1980.

Westphal, Ruth, *Plein Air Painters of California: The North,* Irvine, Ca.: Westphal Publishing, 1986.

Westphal, Ruth, *Plein Air Painters of California: The Southland,* Irvine, Ca.: Westphal Publishing, 1982.

Bay Area

Berney, Charlotte, "A Look at the Society of Six," *Antiques & Fine Art,* v. 4, no. 3, March–April 1987, pp. 42–47.

Boas, Nancy, *The Society of Six: California Colorists,* San Francisco: Bedford Arts, 1988.

"Expatriates from California," and "California and the Armory Show of 1913," in Joseph Armstrong Baird, Jr., ed., *Theodore Wores and the Beginnings of Internationalism in Northern California Painting: 1874–1915,* Davis: Library Associates, University Library, University of California, 1978.

Szymanski, Gary, "The Society of Six," *Art of California,* v. 1, no. 1., October/November 1988, pp. 30–37.

Various essays on Galka Scheyer, Society of Six, Modernism, and Modern patrons in Joseph Armstrong Baird, Jr., ed., *From Exposition to Exposition: Progressive and Conservative Northern California Painting 1915–1939,* Crocker Art Museum, Sacramento, 1981.

Los Angeles

Anderson, Susan, *California Progressives 1910–1930,* exh. cat., Orange County Museum of Art, Newport Beach, Ca., October 26, 1996–January 12, 1997.

Anderson, Susan M., "California Progressives, 1910-1930," *American Art Review,* v. 8, no. 5, November 1996, pp. 130–37.

Moure, Nancy Dustin Wall, *Painting and Sculpture in Los Angeles, 1900-1945,* exh. cat., Los Angeles County Museum of Art, September 25–November 23, 1980.

Seares, Mabel Urmy, "Modern Art and Southern California," *American Magazine of Art,* v. 9, December 1917, pp. 58–64.

Various modern art societies listed in Nancy Moure, *Artists' Clubs and Exhibitions in Los Angeles Before 1930,* Los Angeles: Privately Printed, 1974.

San Diego

Dijkstra, Bram, "Early Modernism in Southern California: Provincialism or Eccentricity?," in Paul J. Karlstrom, ed., *On the Edge of America: California Modernist Art, 1900–1950,* Berkeley: University of California Press, 1996.

"Fine Arts Number," *San Diego Magazine,* v. 3, no. 10, September 1927.

Kamerling, Bruce, "Modern Perspectives: Three Women Artists of the 1920s and 1930s," [Anni Baldaugh, Margot Rocle, Belle Baranceanu] *Journal of San Diego History,* v. 40, no. 3, Summer 1994.

Kamerling, Bruce, "Painting Ladies: Some Early San Diego Women Artists," *Journal of San Diego History,* v. XXXII, no. 3, Summer 1986, pp. 147-91.

Petersen, Martin E., "Contemporary Artists of San Diego," *Journal of San Diego History,* v. XVI, no. 4, Fall 1970, pp. 3–10.

Petersen, Martin, *Second Nature: Four Early San Diego Landscape Painters,* exh. cat., San Diego Museum of Art, June 1–August 18, 1991.

Reiffel, Charles, "The Modernistic Movement in Art," *The Modern Clubwoman,* v. III, no. 4, January 1930.

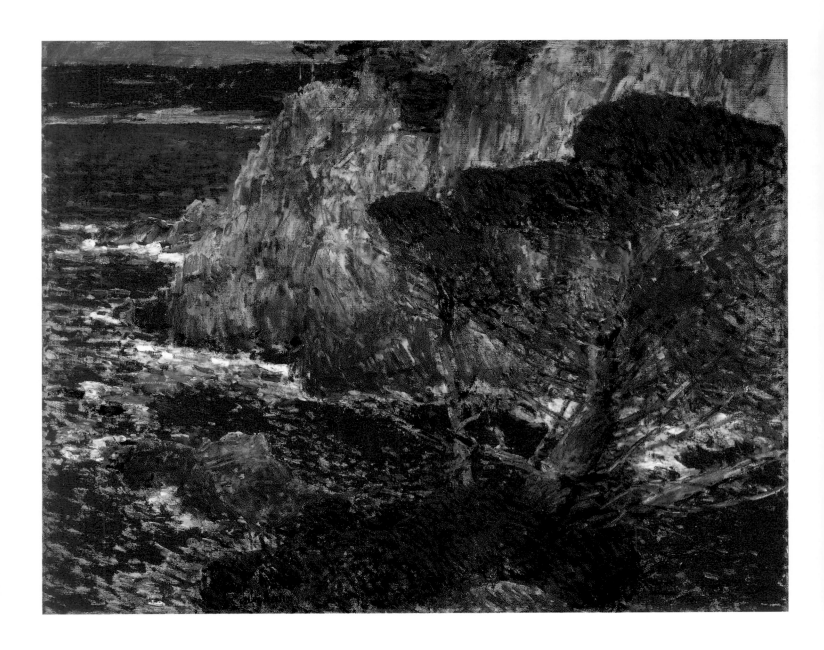

Fig. 15-2
Childe Hassam (1859–1935)
Point Lobos, Carmel, 1914
oil on canvas
28 $\frac{1}{16}$ x 36 $\frac{1}{16}$ in.
Los Angeles County
Museum of Art, Mr. and
Mrs. William Preston
Harrison Collection

Seaside Art Colonies of California

Occasionally everybody feels the need to escape the pressures and routine of daily life. Artists especially require quiet in order to concentrate and create. Their need increased in the late nineteenth century as the urban environments in which most artists lived expanded and became noisier and more frenetic in pace.

The first art "colonies" evolved in cities such as Paris, where art students from all corners of the Western world congregated with their fellow countrymen or with those who spoke their language and could share ideas and offer advice. The first "colony" based on an art style or theme coalesced at the rural town of Barbizon in the Forest of Fontainbleau, formed by those painters we now call the Barbizon School. These painters preferred not to conceive their compositions in studios but to transcribe directly from nature in the open air *(en plein air)*. Soon, plein air painting became a standard part of an art student's training, and artists began to look for other picturesque spots in the French countryside. Giverny, where Monet settled, became an important gathering place for American Impressionists, including the Californian Guy Rose and two other painters who spent brief periods in Southern California, Richard Miller and Lawton Parker.

Rural art colonies offered a kind of utopia, an Eden, away from "immoral" cities. Paintings of the countryside and "simple" rustic peasants or fisher folk provided a mental respite for the city dwellers who purchased them. As time passed, colonies began to form for other reasons. Arts and crafts workers found it practical to locate near clay beds, while idealists sought a life in utopian, socialistic communities. As art students returned from their studies on the continent to their homes in England and America, they brought with them the art colony concept. The idea proved especially popular in the United States, where artists felt alienated by the smoke-belching complexes of the Industrial Revolution and ostracized by a philistine government that did not care about or support art. Between 1880 and 1930, colonies formed at picturesque sites in New England (along the coast at places like Provincetown, Gloucester, and Cape Ann, as well as inland at Cornish and Old Lyme), in rural Pennsylvania (at New Hope), in Indiana, and in New Mexico (at the Indian village of Taos and at nearby Santa Fe).

Even in the non-industrial, mostly rural state of California artists felt the necessity to "escape," and colonies began at the seaside resorts on the Monterey Peninsula and at Laguna Beach.

Art Colonies of Northern California (Monterey, Carmel, Pacific Grove, Santa Cruz)

The former Spanish capital of Monterey, on the Pacific Ocean about one hundred miles south of San Francisco, enjoys the longest history of art activity of any California city. During its years as the Spanish capital, images of the city were made by topographical artists attached to scientific voyages while their ships wintered in the protected harbor. Documentary artists through Mexican times, the Mexican-American War of 1846–47, and the Gold Rush years continued to depict Monterey (chapter 1).

Monterey the art colony, however, only began in the mid-1870s, after the town declined into a port for Chinese fishermen. A series of economic disasters had brought it to its knees, including the relocation of the state's capital to Sacramento in 1854, the loss of the county seat to Salinas in 1872, and the bankrupting of the 1874 Monterey and Salinas Valley railroad through a rate war with the giant Southern Pacific. Into this rustic town of crumbling adobes, strung out along the mid-ground between the harbor and pine-capped hills, came Jules Tavernier, San Francisco's Bohemian of Bohemians (chapter 6). In the area to make sketches for a commissioned painting of the mission at Carmel, he became fascinated with the peninsula's beauty: its sheer cliffs thrashed by foaming breakers, its serene stretches of sand, its tall stands of pine, its fogs clearing to postcard-sunny days, and the rolling countryside of the Monterey and Carmel valleys. His preference for modest slices of nature (compared to panoramas of the Sierras) put him in the forefront of California's Barbizon movement. The "colony" itself began after Tavernier's glowing reports induced San Francisco artist friends to join him. For a few years in the second half of the 1870s, he served as unofficial head of a handful of landscapists (Juan Wandesforde, William Hahn, Raymond Yelland, Julian Rix, Joseph Strong, and Henry Cleenewerck) who either visited the area or took up brief residences. Their days passed in true

Bohemian manner—relaxed afternoons in their studios or among Monterey's rustic adobes, dinners at the jail-converted-into-restaurant of Jules Simoneau, drinks at the Bohemia Saloon of Alejandro and Adolfo Sánchez, and banter and intellectual discussions with writers like Robert Louis Stevenson. But this indolent existence came to an end shortly after 1878, when Tavernier returned to San Francisco and when Monterey's economy received an infusion from the 1878 Southern Pacific spur and a new 1880s grand resort hotel, the Del Monte.

Fig. 15-1
William Merritt Chase
(1849–1916)
Monterey, California, 1914
oil on panel, 15 x 20 in.
Collection of the Oakland
Museum of California, Gift
by exchange through
Maxwell Galleries, Ltd.

1880-1912. The Monterey Peninsula, and the large bay to its north, supports four separate towns, each with its own group of artists and its own personality. These include, from south to north, Carmel, Pacific Grove, Monterey and on the north side of the Monterey Bay, Santa Cruz. The rapid development of these cities after 1880 resulted from improved access provided by the Southern Pacific spur. The Monterey area's coastal towns satisfied several needs for art colonies. During the years in which it was the fashion for art students to paint *en plein air,* the towns provided scenic destinations for teachers and students of San Francisco's School of Design. The rural location allowed cheap living and a chance to escape the moral decay that philosophers identified with a large metropolis like San Francisco. The shore's Chinese and Portuguese fishermen provided a counterpart to Europe's peasants, simple people whose poverty and social backwardness artists saw as quaint and picturesque and to whom they assigned the qualities of innocence and high moral values.

During the waning years of the nineteenth century two retreats were established on the Monterey Peninsula. The first—in 1869—now known as Pacific Grove, was begun by Methodists on the westernmost tip of the peninsula as the Christian Seaside Retreat. Participants at their chautauquas were first housed in tents that, after the turn of the century, gave way to single-walled beach cottages where artists such as Bruce Porter (1865–1953) and Eugen Neuhaus (1879–1963) took up residence. In 1887, on the south side of the peninsula, near the old Mission San Carlos Borromeo de Carmelo, two entrepreneurs tried to start a Catholic resort called Carmel. Although they built a hotel and a glass-walled bathhouse, their dream for development succeeded financially only in 1902, in the hands of a seasoned real estate agent-developer. The developer set up temporary cabins, and through circulars addressed to the "School Teachers of California and other Brain Workers," promoted it as a retreat for intellectuals and creative people. Carmel was an instant success. Artists' studios began to appear the very first year. Meanwhile, on the north side of Monterey Bay, the small seaside town of Santa Cruz was becoming a popular destination for artists from San Francisco. Several of them, personal friends of William Chauncey Bartlett, a well-known San Francisco newspaper journalist, stayed as guests at his Isbel Grove Ranch. In the 1880s a few artists took up permanent residence in the town, and about 1895 Frank L. Heath (1857–1921) opened a studio on Beach Hill. By the early twentieth century Heath had become a kind of leader for the growing community of artists.

Along with Monterey, the three younger communities grew in population as San Francisco artists established second homes at the seashore. The biggest boost to the area, however, was the April 1906 San Francisco earthquake and fire. Because it destroyed the Bay Area's art center, it drove some artists to seek refuge in second homes on the peninsula, while others chose to relocate there. The fledgling community (most of them Barbizon-style landscapists) was proffered financial support when an art gallery to show their work opened in April 1907, in the Hotel Del Monte. Not only did the gallery give the hotel cachet and support the artists, it also introduced tourists from the East Coast and Midwest to the fine paintings produced by California artists, particularly Tonalists from Northern California (chapter 7).

1913-1930. The heyday of Northern California's coastal colonies coincided with the popularity of the Impressionist and Post-Impressionist styles in California (1913–30). Although pure Impressionism was espoused only briefly in Northern California by a few artists (chapter 13), most of them lived on the Monterey Peninsula. This is not a coincidence, since its colonies were enjoying their prime at the time of the Panama-Pacific Exposition, with its big display of Impressionist art. Also, two of America's top Impressionist painters

were active in Carmel/Monterey. In 1913, **William Merritt Chase** (1849–1916), one of the most famous of the East Coast Impressionists, arrived to teach at the summer school initiated by the Carmel Arts and Crafts Club (a forerunner of the Carmel Art Association). Chase's *Monterey, California* of 1914 (fig. 15-1) is particularly interesting to art historians attributing environmental influence to art. The painting is strangely Tonalist—did the experienced Impressionist momentarily succumb to the popular Monterey style, or does the painting simply reflect a particular atmospheric condition he witnessed on the coast? (After all, Impressionist paintings made in Northern Europe were more somber in palette than those made in the Mediterranean.) The other Impressionist, **Childe Hassam** (1859–1935), took a side trip to Carmel when he came west to oversee the display of his paintings at the Panama-Pacific Exposition. Hassam painted *Point Lobos, Carmel* in 1914 (fig. 15-2, p. 184). Although he already had considerable experience rendering seaside cliffs on Appledore, an island off the coast of Maine, the lustier, more spontaneous brushwork of Point Lobos seems to reflect the less fettered western atmosphere that Californians touted. Some of the peninsula's newly settling artists, including William Ritschel (1864–1949) in 1911 and Armin Hansen (1886–1957) in 1913, also were Impressionists and Post-Impressionists.

Without question, an artist's place of residence affects his art, and because the peninsula's attraction was its scenery, its artists produced a greater proportion of shore and sea views than figure or still-life paintings. And these views looked different from the marine paintings of the mid-nineteenth century. Harbor views, for example, were no longer meant to celebrate Yankee industry and enterprise; in an age of machines they became escapist, picturesque places where men (fishermen) still worked with their hands. Shore views mirrored the shoreline's growing importance as a place for leisure and recreation and an escape from the city.

Consider the work of **William Ritschel** (1864–1949), a former sailor who had painted maritime subjects and Tonalist views in Europe and New England before settling in Carmel. He was well versed in the standard marine themes ranging from human activity on ships and in harbors to seascapes of open oceans, stretches of sand, and waves breaking against cliffs. In Carmel he dropped his tonal approach and adopted the sunny colors of Impressionism. While his Carmel marinescapes still vary widely in subject, he is probably best known for his views of the meeting of sea and shore, as in *Moon Path across the Sea* of 1924 (fig. 15-3). Scenes of waves breaking on rocks can be traced to one of America's great painters, Winslow Homer (1836–1910). Living in Maine in the late nineteenth century, Homer produced powerful images of gale-driven waves lashing the state's coastal cliffs and of fishermen and sailors struggling against violent, unsympathetic seas to earn their livings. When other artists emulated him, the

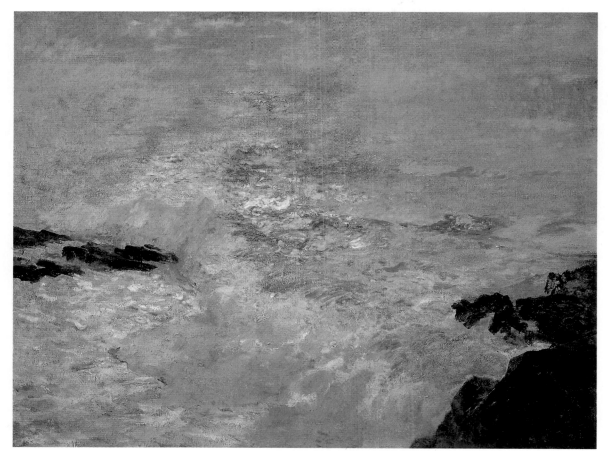

Fig. 15-3
William Ritschel
(1864–1949)
Moon Path Across the Sea,
1924
oil on canvas, 30 x 40 in.
The Buck Collection, Laguna Hills, California
Photo: Cristalen and Associates

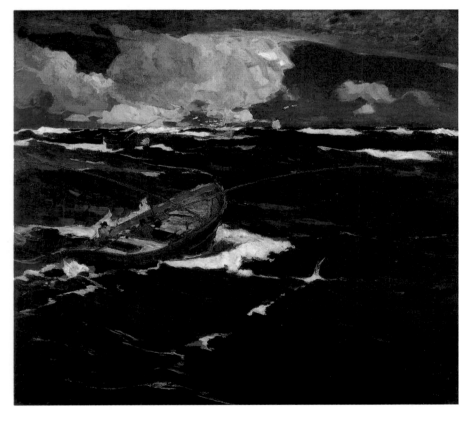

result was a kind of waves-on-rocks school that flourished in America's seaside art colonies through the first thirty years of the twentieth century. Although Ritschel's *Moon Path* is clearly descended from Homer's lusty Prout's Neck pictures, its tamer nature reflects both the more pacific conditions of the California coast and Impressionism's preference for joy over somberness. Such views of sparkling, unpolluted waters provided visual escape, a kind of mental "vacation" or "cleansing" for urban dwellers. It is difficult to remain emotionally untouched by the beauty of sunlight (and sometimes moonlight) reflected off the broken surface of the sea. Ritschel's slight bird's-eye perspective tips up the horizon, bringing the composition flat against the picture plane and turning it into an almost abstract arrangement of outcroppings, surging water, and ribbons of sea foam.

Canvases painted at and of California's seaside art colonies are distinct in both spirit and subject from those created in the seaside art colonies in other parts of America, simply because they transcribe the local scene. For the same reason, seascapes made in Monterey/ Carmel/ Pacific Grove differ from those painted in Laguna Beach. The Monterey Peninsula's cliffs are steeper and more rugged than Laguna's; its commercial fishing industry had no counterpart in Laguna, where the major activity was sunbathing. Its native forest of pines and its wind-twisted cypresses contrast with Laguna's thin grasses and planted eucalyptus. Its chilly and deserted stretches of beach, with their occasional towering dunes crowned with flowering shrubs, differ from Laguna's flat sands hugged by intimate coves. Its cool fogs contrast with Laguna's haze; its solid adobe buildings and board fishing shacks differ from Laguna's board-and-batten recreation cottages; and its storm-whipped breakers scorn Laguna's tame and neatly curling waves.

Most artists took up residence in California's seaside art colonies in order to paint the area's landscape. They also wanted rural retreats where they could congregate with others of like mind. Living at the shore, they could choose to paint the sea, the land, or both. If Ritschel represents artists who painted the sea, then **E. Charlton Fortune** (1885–1969), who settled in Monterey in 1913 and painted bright and colorful landscapes through 1921, represents artists who focused

Fig. 15-4
E. Charlton Fortune
(1885–1969)
Monterey Bay, 1916
oil on canvas, 30 x 40 in.
Collection of the Oakland
Museum of California,
Museum Donors Acquisition
Fund

Fig. 15-5
Armin Hansen (1886–1957)
Salmon Trawlers, 1918
oil on canvas
47½ x 53½ in.
Collection of the Monterey
Museum of Art

on the land. Her indisputably best painting is the sunlight-filled *Monterey Bay* of 1916 (fig. 15-4). Its panorama encompasses Monterey's wharves and the whole bay north to Santa Cruz, a view that Fortune enjoyed from her house in the Monterey hills. The picture-postcard day on which this view must have been painted offered the Impressionist hues that span the entire spectrum. Like many California artists, in her earliest works Fortune closely follows Impressionist tenets down to the small brushwork and high horizon, although she soon gravitates, like many others, to a bolder style verging on Post-Impressionism.

Most Carmel landscapists of the 1920s leaned toward Post-Impressionism (chapter 14), although **Armin Hansen** (1886–1957) produced two outstanding Impressionist pictures (fig. 13-22 and fig. 13-23). After he took up residence in Monterey in 1913 and began painting views of fishermen and mariners on the open water or at work along the docks or shoreline, he settled on a bolder style that can best be described as Post-Impressionist. Although *Salmon Trawlers* of 1918 (fig. 15-5) has Impressionist attributes—a high horizon and a long foreground—its treatment is Post-Impressionist—solid flat shapes of strong colors. This bolder treatment was clearly a more appropriate means of conveying the serious topic of man's struggle for survival with the sea. California artists were rarely attracted to such serious themes, and Hansen probably acquired his taste for them during his youth as a mariner in Northern Europe. He often dramatizes his work by silhouetting foreground figures.

Seaside art colonies rarely harbor modernists. However, **Clayton S. Price** (1874–1950), a former rancher, lived in Monterey through the 1920s, absorbing various influences and developing his mature style. A fellow renter in Monterey's Stevenson House was Society of Six member August Gay (chapter 14). Price combined the Six's love of color with his personal love of rural ranch subjects, but he bypassed Post-Impressionism for modernism. The angled, abstract shapes in *By the River* of 1927 (fig. 15–6) are Price's own invention, not a legacy from any of the well-known European forms, a rare feat and an object of pride for any American who can achieve it.

Fig. 15-6
Clayton S. Price (1874–1950)
By the River, 1927
oil on board, 36½ x 43 in.
Collection of Arlene and
Harold Schnitzer

The South (Laguna Beach)

In 1878, the poet, writer, and painter Isaac Frazzee (1858–1942) drove his two-horse wagon down Laguna canyon's dirt road and emerged to camp on a sandy cove. Frazzee was the first artist known to visit Laguna Beach. (A naive-style watercolor documenting his campsite is in the collection of the Bowers Museum.) By the 1880s, the beach had been homesteaded, and its owners, alert to Southern California's real estate boom, subdivided their property and offered lots for sale. The first artists to buy were George Gardner Symons and William Wendt, who purchased lots in 1903 and 1906 respectively, although they did not immediately build on them.

What caused this particular beach, of the many that surrounded Los Angeles, to become an art colony? Its main attraction was its scenic beauty: intimate coves, sandy beaches contrasted with vertical bluffs, and waves crashing against black lava rocks. Artists also prized its isolation. The train line that brought people from the hot inlands of Redlands and San Bernardino ended at Newport Beach, where pleasure seekers were drawn to that area's entertainments and amusements; there was no reason to travel on to Laguna. However, some artists began to settle in Laguna, and still others were attracted by the several summer art schools of the 1910's. During World War I, when European art colonies were sealed off to Americans, California artists escaped to Laguna instead. Activity increased in the 1920s when access to the town was improved by roads and increased automobile ownership.

Yearly, the tiny village of board buildings grew, attracting increasing numbers of artists. Living was cheap, there was a chance for mutual criticism of paintings, and there was socializing. The presence of other creative individuals—writers, actors, and musicians—as well as the absence of radio, led to self-entertainments such as high jinks and impromptu musical and theatrical entertainments.

Laguna's art heyday occurred in the 1920s. By 1918 the village was a permanent home to about fifteen artists. Their cottages and studios strung out along a mile of coast, and they were always open to tourists interested in buying art. One of the artists, Edgar Payne (1882-1947), who had just remodeled his beach cottage, thought the community should have a single place to display the artists' work to tourists. He suggested remodeling a multipurpose board-and-batten

Fig. 15-7
Frank Cuprien (1871–1948)
Tranquility—Laguna Beach, Cal.
oil on canvas, 27 x 30 in.
Oakmont Corporation
Photo: Victoria Damrel
(Clique Studio, Long Beach)

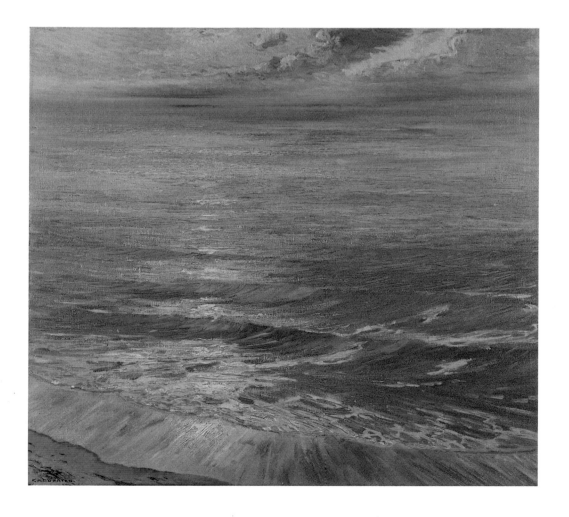

building called "The Pavilion" into an art gallery. The artists pitched in, closing up the windows to provide more hanging space and inserting skylights. Others drafted the charter that claimed the name Laguna Beach Art Association and laid out exhibition rules for the member artists. Still others helped to hang paintings or man the gallery. Unwittingly, this small group of painters gave a personality to the fledgling beachside community. The gallery in turn attracted even more tourists to the resort. The association's greatest achievement occurred in 1929. After almost ten years of fundraising, it opened a fireproof art gallery of sophisticated design on the cliffs overlooking the Pacific. The main gallery measured sixty by thirty-six feet and was lit by a skylight, the preferred source of illumination at the time. Not a penny came from federal, state, county, or city money. It was a building worthy of any major metropolitan center, not to mention Laguna, which even in 1929 only had 994 water meters.

It is difficult to define a "Laguna" artist. Few resided there year round, but many from Los Angeles owned second homes or raw property and spent summers there. Others felt psychologically tied and drove down from Los Angeles on weekends or for stays of a fortnight during the hotter months of August and September.

The sea was the primary attraction. As in Carmel, views ranged from the cliff top habitations (more popular before 1920) to those of the sea and shore. The most artistic were made while the Impressionist and Post-Impressionist styles prevailed. A rare "pure" Impressionist translation is *Shoreline* (fig. 13-7) by Pasadena visitor Guy Rose.

The best-known resident to focus on the sea was the colorful **Frank Cuprien** (1871–1948), known, in part, for his costume of knickers, puttees, and belted jacket, and his neatly trimmed white hair and beard. Cuprien's enthusiasm was typical of most of the town's artists. He boasted of joining everything except the women's club. His studio-residence, named the "Viking," a mile south of the town's center, was the scene of Sunday "at homes." On his death, his entire estate went to the Art Association, providing a nest egg that inspired further giving and enabled a major expansion of the gallery in 1950–51. Many of Cuprien's views were painted from the bluff-edge garden adjacent to his residence. His *Tranquility—Laguna Beach, Cal.* (fig. 15-7) depicts Southern California's relatively tame surf. It is Tonalist in its emphasis on horizontals and the color harmonies established by the twilight opalescent glow, but it is Impressionist in its tipped-up composition, high horizon, interest in shimmering light, and abstract patterns of ripples in the foreground. Cuprien,

like Monet, was fascinated with light effects at different times of day and never tired of sketching the sunsets he saw from his studio. Although his work ranges widely in quality, Cuprien is the best of Laguna's many painters of seascapes, which includes Edgar Payne and Jack Wilkinson Smith (1873–1949).

Sunbathers today are so much a symbol of Southern California that it is hard to imagine a time when they weren't portrayed. In that crucial period just after the turn of the century when people began to shed their clothes and sunbathe in Southern California, most local artists were too much in love with pure landscape and too hostile to the intrusion of people in the landscape to represent them. Sunbathing was too contemporary an activity to have a nostalgic appeal. **William A. Griffith**'s (1866–1940) *Diver's Cove* of 1930 (fig. 15-8) is an exception in its subject matter and medium, a "painting" made with colored pastels. The medium was brought into the realm of fine art by the French Impressionist Edgar Degas (1834–1917), who found that the eye blended side-by-side strokes of pure pastel color in the same way it did strokes of oil paint. Sunbathing, an outdoor activity associated with recreation and pleasure, is an appropriate Southland translation of the boating and park themes painted by French Impressionists.

The most powerful artist to depict bathers is **Joseph Kleitsch** (1882–1931) whose Laguna townscapes and beachscapes are accurate enough to be matched to his-

Fig. 15-8
William A. Griffith (1866-1940)
Diver's Cove, 1930
pastel, 15½ x 19½ in.
Private Collection
Photo: Christopher Bliss

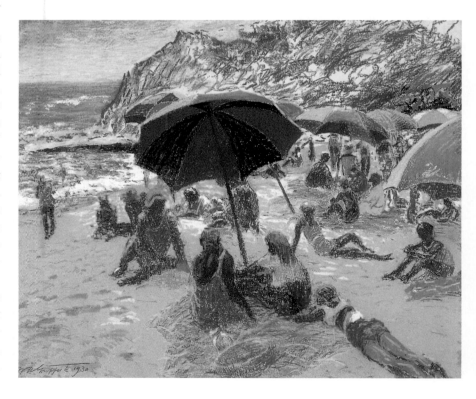

torical photographs. His recognition of the potential offered by buildings and people over pure landscape may be due to the fact he was a recent immigrant without local prejudices. Older residents still remember him seated before his easel in the very center of one of Laguna's dirt streets painting away. *Laguna Beach* of about 1918 (fig. 15-9) is a faithful transcription with little compositional restructuring to fit the parameters of some popular style. One can almost smell the heady scent of the eucalyptus on this warm, dry day and feel driven by the hot sun to the cooler shadows thrown by the town's flimsy shacks. While the ponderous "brown-sauce" technique Kleitsch learned in Europe crops up in some of his interior views, his beach scenes employ strong, bright colors that qualify him as a Post-Impressionist.

Other 1920s artists occasionally represented bathers. The most important of these include Alson Clark, who painted vacationers' tents at Mission Beach near San Diego; Duncan Gleason with his views of his children playing at the seashore; and Elliot Torrey, who painted children at the beach in San Diego.

Although art colonies are an unlikely place to find modernists, from about 1918 Laguna harbored a number of them. Their styles ranged from Post-Impressionism and Regionalism (considered modernist in its day) to figural works composed using Dynamic Symmetry.

One of the earliest modernist residents was **Clarence Hinkle** (1880–1960), a teacher at Los Angeles's Chouinard Art Institute. Hinkle had produced some true Impressionist paintings in his early years in San

Francisco, but after his move to Los Angeles in the late 1910s, he rapidly evolved an expressive style all his own. Although he was employed in Los Angeles, in 1924 he built a studio in Arch Beach where he began to spend much of his time. He is probably best known for his panoramas of Laguna's town center, such as the undated *Laguna* (fig. 15-10). This is not a delicately brushed view, like those made by Guy Rose, but a boldly expressive statement. Hinkle shows no fear in employing black (usually avoided by Impressionist painters) to accent his predominantly white landscapes built with lozenge-like strokes. The reds, oranges, and yellows provided by the beach umbrellas break the coldness associated with his more typical black/white and blue color schemes.

Sometimes an artist warrants discussion in a history of art on the basis of one or two exceptional works. This is true of **Thomas Hunt** (1882–1938), who like many Southern California artists was a "Sunday" painter (he earned most of his living from real estate). Hunt's favorite subject was Newport Harbor (a resort and fishing and shipping port a few miles north of Laguna), but his most aesthetically exciting pictures, are a few like *The Grape Arbor* (fig. 15-11), where reality almost disappears under abstraction. Not "decorative," the word many reviewers used to describe his harbor scenes, these are sophisticated treatments. Like Hinkle, Hunt freely applies the often deadly black, which here enhances his bright colors. While he represents a grape arbor, his work is also about formal art principles such as respect for the picture plane, color, balance, and composition.

Two other modernists were the painter **Elanor Colburn** (1866–1939) and her daughter, **Ruth Peabody** (1898–1967). Colburn had been trained in Chicago, and after divorcing her husband, she came to Laguna with Peabody about 1924. Colburn's primary interest from the mid-to-late 1920s was the compositional theory of Dynamic Symmetry. Its advocate was Jay Hambidge, a mathematician and painter, who after measuring many ancient Greek buildings and paintings, concluded that the Greeks utilized principles found in nature to achieve especially dynamic compositions. Colburn's favorite themes dealt with women and children. By following the lines set up in the composition of her *Bathing Baby* of 1930 (fig. 15-12), the viewer can see

how the artist spiraled inward—a situation that occurs naturally in some plants and seashells.

Peabody inherited her mother's penchant for experimentation but had her own artistic "voice." *Little Pig in New Mexico* (fig. 15-13) may have been painted in the mid-1930s, but stylistically it follows Peabody's Post-Impressionist pictures of the twenties, a representational subject interpreted through her particular approach to design and color. The New Mexico subject, however, reveals the painting's 1930s date, for in that decade it became the fashion among some Southern California artists to work in Arizona and New Mexico. The fact the figure is from an ethnic minority, assumes a madonna-like pose, and is associated with a "common" animal, are all elements associated with the Regionalist style.

About 1930 art colonies began to lose their relevance. Outdoor painting was no longer important, and landscape themes were eclipsed by the human concerns of the Great Depression. Most important, artists were now caught up with questions of style and expression rather than the picturesque. The period from 1930 to 1950 in Laguna was particularly fraught with disagreements and decline. Formerly subtle differences between conservatives and modernists erupted into full-scale, organized, vocal conflicts. Laguna's experience is typical.

While they were still in the minority, Laguna's small number of modernists were able to live companionably with the colony's many conservative landscapists. In the early 1930s, those practicing Post-Impressionism and advocating the new American Scene style (chapter 18) banded together with others from the nearby inland farming town of Santa Ana in order to exhibit their work. In 1931 they organized as the Contemporary Painters and held their first show in Santa Ana. Approximately the same group, but calling itself the Salon des Independents, exhibited at Laguna's Community Clubhouse a few months later.

As the Depression deepened, however, art sales dropped, and to conservatives the Laguna Beach Art Association seemed to be more and more overrun with "modernists." Conservative landscapists began to feel threatened. A major question became whether the gallery should remain dedicated to showing conservative, landscapes or advance with the times and show Regionalism and other forms of modernism. Through

Fig. 15-10
Clarence Hinkle
(1880–1960)
Laguna, oil on board
18 x 22 in.
Private Collection
Photo: Budd Cherry

Fig. 15-11
Thomas Hunt (1882–1938)
The Grape Arbor
oil on canvas, 28 x 30 in.
Collection of Lyn and James
Sweeney; Photo courtesy
William A. Karges Fine Art,
Los Angeles

the 1930s the pendulum swung back and forth according to the personal tastes of the officers. During the presidency of Louis Danz (1932–34), a modernist composer who owned Danz Music Company in Santa Ana and wrote books on the psychology of modern art, exhibitions and lectures of a modernist nature were presented. During the presidency of the dentist-artist George Brandriff (1934-36), programs and exhibitions swung back to conservative landscapes.

Laguna was one of only several California towns where modernism was impinging sufficiently on the establishment to raise tempers. Wherever there was a juried annual exhibition, rejected artists, desperate for sales, complained that the jury was unfair or biased against their style of art. Sponsors of these exhibitions, such as the Oakland Museum and the Los Angeles Museum of History, Science and Art, eventually "solved" their problems by dividing their shows into three sections, each selected by its own sympathetic jury: modernist, semi-modernist, and traditional.

In Laguna, the conflict came to a boil under the presidency of the modernist Wesley Wall (1937–38). Just before the annual election in 1938, the bylaws were changed to give more power to local resident artists (the conservatives) and keep it away from out-of-town members (mostly modernists), and the election voted the modernists out of office.

Although ousted, the modernists survived, and in spring 1939 they started the Progressive Art Center.

Located in Pomona College's Marine Laboratory in Laguna Beach, members were provided studio space, held art classes, and could exhibit their work. Shortly afterward, the Dana Point Art Guild began. The guild was dedicated to all forms of creativity, not only the fine arts, and its art lectures were remarkable for their sophistication and their selection of modernist speakers.

Monterey/Carmel and Laguna Beach are just two of the best known of the many artists' colonies in California. (There were many other smaller enclaves throughout the state dedicated not just to the visual arts but also to writing and music.) And while colonies lost their relevance for the visual arts about 1930, the communities did not disappear. Their reputations as picturesque areas peopled with colorful types turned them into popular tourist destinations for a newly mobile American public. The artists who still associated with these colonies were no longer students eager to experiment but rather retirees or even amateurs who liked living in an artistic ambiance and catering to tourists.

But the shore wasn't the only place artists went to find peace and new subject matter. The next chapter will show how as California's growing population spread over its once undefiled land, artists went wider afield in their search for untouched nature, leading some in the 1930s to go all the way to the desert. 🎋

Fig. 15-12
Elanor Colburn (1866–1939)
Bathing Baby, 1930
oil on canvas, 36 x 33 in.
The Irvine Museum

Fig. 15-13
Ruth Peabody (1898–1967)
Little Pig in New Mexico,
c. 1934
oil on canvas, 24 x 20 in.
Private Collection

Bibliography

Art Colonies, American

American Impressionism: The New Hope Circle, exh. cat., Museum of Art, Fort Lauderdale, Fla., December 5, 1984–January 27, 1985.

Art Colony at Old Lyme 1900–1935, ed. by Jane Hayward and William Ashby McCloy, exh. cat., New London, Ct.: Lyman Allyn Museum, 1966.

Artists and East Hampton: A 100 Year Retrospective, exh. cat., Guild Hall of East Hampton, N. Y., 1976.

A Circle of Friends: Art Colonies of Cornish & Dublin, exh. cat., Thorne-Sagendorph Art Gallery, Keene State College, Keene, N.H., March 9–April 26, 1985.

En Plein Air: The Art Colonies at East Hampton and Old Lyme, 1880–1930, exh. cat, Florence Griswold Museum, Old Lyme, Ct., June 20–July 30, 1989 and one other venue.

Gloucester: Views of the Art Colony by American Masters, exh. cat., R. H. Love Galleries, Chicago, Il., October–November, 1991.

Jacobs, Michael, *The Good and Simple Life: Artist Colonies in Europe and America,* Oxford: Phaidon, 1985.

Kuchta, Ronald A., et al., *Provincetown Painters 1890's–1970's,* exh. cat., Everson Museum of Art, Syracuse University, 1977.

Lawrence Park: Bronxville's Turn-of-the-century Art Colony, Bronxville, N.Y.: Lawrence Park Hilltop Association, 1992.

Musick, Archie, *Musick Medley: Intimate Memories of a Rocky Mountain Art Colony,* Colorado Springs: Jane and Archie Musick, 1971.

Old Lyme, The American Barbizon, Old Lyme, Ct.: Florence Griswold Museum, 1982.

Portrait of a Place: Some American Landscape Painters in Gloucester, exh. cat., Cape Ann Historical Association, Gloucester, Ma., 1973.

Stryker, Catherine Connell, *The Studios at Cogslea,* exh. cat., Delaware Art Museum, Wilmington, 1976.

Taos and Santa Fe: The Artists' Environment 1882–1942, exh. cat., Amon Carter Museum, Fort Worth, Tx., 1963.

Tragard, Louise, *A Century of Color 1886–1986: Ogunquit, Maine's Art Colony,* exh. cat., Ogunquit, Me.: Barn Gallery Association, 1987. 131 p.

Woodstock: An American Art Colony 1902–1977, exh. cat., Vassar College Art Gallery, Poughkeepsie, N. Y., January 23 - March 4, 1977.

Art Colonies, California

Sayre, F. Grayson, "California Artists and Their Colonies," *California Graphic,* v. 2, no. 7, November 15, 1924, p. 12.

Telberg, Val, "Creative Paradise in California," *American Artist,* v. 18, no. 8, October 1954, pp. 41-3, 71.

Monterey

Artists of the Monterey Peninsula 1875–1925, exh. cat., Monterey Peninsula Museum of Art, September 4–November 2, 1981.

Berney, Charlotte, "Art of the Sea," *Antiques & Fine Art,* v. 5, no. 5, July/August 1988, pp. 62–69.

Blanch, Josephine Mildred, "The 'Barbizon' of California: Some Interesting Studios of Old Monterey," *Overland Monthly,* v. 50, July 1907, pp. 63-68.

Boundey, Burton S. et al., *Plein Air Paintings: Landscapes and Seascapes from Santa Cruz to the Carmel Highlands, 1898–1940,* exh. cat., Mary Porter Sesnon Art Gallery, University of California, Santa Cruz, April 14–May 12, 1985. 16 p.

Culmer, H. L. A., "The Artist in Monterey," *Overland Monthly,* v. 34, December 1899, pp. 514-24.

Hoag, Betty Lochrie, *Del Monte Revisited,* exh. cat., Carmel Art Association, June 6–August 29, 1969.

Kirk, Chauncey A., "Bohemian Rendezvous: Nineteenth-Century Monterey: Sanctuary and Inspiration for Early Western Artists," *American West,* v. 16, November-December 1979, pp. 34–44.

"Monterey" and "Carmel" in William H. Gerdts, *Art Across America: Two Centuries of Regional Painting 1710–1920,* New York: Abbeville Press, 1990, v. 3, pp. 285-90.

"Monterey Interlude," in Eugen Neuhaus, *Drawn From Memory A Self Portrait,* Palo Alto: Pacific Books, 1964.

Monterey: The Artist's View, 1925–1945, essay by Kent Seavey, exh. cat., Monterey Peninsula Museum of Art, November 6–December 31, 1982.

Spangenberg, Helen, *Yesterday's Artists on the Monterey Peninsula,* Monterey, Ca.: Monterey Peninsula Museum of Art, 1976.

Westphal, Ruth Lilly, *Plein Air Painters of California: The North,* Irvine, Ca.: Westphal Publishing, 1986.

Santa Cruz

Art and Artists in Santa Cruz: A Historic Survey, essay by Nikki Silva, exh. cat., Santa Cruz City Museum, Santa Cruz, Ca., June 22–August 15, 1973.

Heath, Lillian, "History of Art in Santa Cruz," *News Notes from the Santa Cruz Historical Society,* no. 29, June, 1967, p. 2, 3, 4.*

The Western Woman: Presenting Artists of the Santa Cruz Area, v. 13, no. 4, Los Angeles: Ada King Wallis, 1948. [A copy is in University of California, Santa Cruz, special collections library.]

Carmel

Berry, Rose V. S., "The Cypresses at Carmel: Artists at Carmel," *Wasp,* September 8, 1917, p. 10.*

Bostick, Daisy F. and Dorothea Castelhun, *Carmel at Work and Play,* Carmel: The Seven Arts, 1925 (reprint: Monterey, Ca.: Angel Press, 1977).

The Botkes, The McComases, The Seidenecks, exh. cat., Carmel Art Association, August 4 - September 6, 1988.

Heyman, Therese T., "Carmel: Beneficial to Bohemia," in *EW:100: Centennial Essays in Honor of Edward Weston,* (*Untitled 41*), Carmel, Ca.: The Friends of Photography, 1986, pp. 37–49.

Johnson, Dorothy, *Artists of Carmel: 15 Profiles,* Carmel-by-the-Sea, Ca.: D'Angelo Publ. Co., 1968.

McGlynn, Betty Hoag, *Carmel Art Association: A History,* Carmel-by-the-Sea, Ca.: Carmel Art Association, 1987.

Montague, N., "What Sells at Carmel," [Carmel Art Assn.] *American Artist,* v. 14, March 1950, pp. 62-64.

Our First Five National Academicians: Paul Dougherty, Arthur Hill Gilbert, Armin Hansen, William Ritschel, Howard E. Smith, exh. cat., Carmel Art Association, August 3–September 5, 1989.

Six Early Women Artists: A Diversity of Style: Rowena Meeks Abdy, Jeannette Maxfield Lewis, Eunice Cashion MacLennan, Laura Wasson Maxwell, M. Evelyn McCormick, Mary deNeale Morgan, exh. cat., Carmel Art Association, August 8–September 3, 1991.

Laguna Beach

Anderson, Susan M. and Bolton Colburn, "Painting Paradise: A History of the Laguna Beach Art Association 1900-1930," in *Impressions of California: Early Currents in Art 1850–1930,* Irvine, Ca.: Irvine Museum, 1996, pp. 109-33.

Dominik, Janet, *Early Artists in Laguna Beach: The Impressionists,* exh. cat., Laguna Art Museum, September 23–November 5, 1986.

"Laguna Beach," in Ruth Lilly Westphal, *Plein Air Painters of California: The Southland,* Irvine, Ca.: Westphal Publishing, 1982.

McFadden, Michael, *Only in Laguna: A Pictorial Essay on the Highlights, History and Humor of Southern California's Famed Art Colony Produced by Local Residents,* South Laguna, Ca.: John Hardy, c. 1972. [a copy is located at the library, University of California, Irvine]

Moure, Nancy Dustin Wall and Joanne L. Ratner, *A History of the Laguna Art Museum 1918–1993,* Laguna Beach, Ca.: Laguna Art Museum, 1993.

Moure, Nancy Dustin Wall, "A History of the Laguna Beach Art Association to 1955," *Publications in Southern California Art 4, 5, 6, 7,* Los Angeles: Privately Published, 1998.

Ramsey, Merle and Mabel, *The First 100 Years in Laguna Beach 1876–1976,* Laguna Beach, Ca.?: Privately Printed (Hastie Printers), 1976.

Southern California Artists, 1890–1940, biographies by Nancy Moure, exh. cat., Laguna Beach Museum of Art, July 10–August 28, 1979.

Dynamic Symmetry

Dynamic Symmetry, exh. cat., Museum of Art, Rhode Island School of Design, February 5–March 12, 1961 and two other venues.

McWhinnie, Harold J., "A Review of the Use of Symmetry," [including Dynamic Symmetry] *Leonardo* (U.S.A.) v. 19, no. 3, 1986, pp. 241-45.

Other Art Colonies

"The Arts and the Out-of-Doors: Idyllwild Arts Foundation," *Palm Springs Villager,* v. XII, no. 7, April 1958, pp. 18–21.

Hatch, Valeria E., "Spanish Village Art Center," *West Art,* v. 8, no. 9, January 23, 1970, p. 16.

The Western Woman: Ventura County, Ca. (Souvenir edition), Los Angeles, July 1931

Fig. 16-2
Conrad Buff (1886–1975)
Jawbone Canyon, c. 1925
oil on canvas, 47 x 66 in.
The Buck Collection, Laguna
Hills, California
Photo: Cristalen and
Associates

Artists of the Desert, Cowboys & Native Americans

Artists of the Desert

Funk & Wagnalls's *Dictionary* defines the word "desert" as "a region so lacking in rainfall, moisture and vegetation as to be almost uninhabitable by any plant or animal population." True deserts are rare. In the New World they exist only in Chile and in America's Southwest. The Great American Desert, an old-fashioned umbrella term for the several small deserts in America's Southwest, is roughly triangular in shape, and its scorching sands include most of Nevada, Arizona, New Mexico, and the eastern and southeastern parts of California. This desert exists because the area is blocked from rain clouds by the Rocky Mountains on the east, the Sierra Nevada on the west, the Salmon Mountains on the north, and Mexico's Sonoran Desert on the south. The American desert is not as arid as some deserts of the world that consist only of sand dunes (although it has patches of them), and in its many subecologies it supports a wide variety of plant and animal life.

Artists have depicted California's several deserts ever since these wastelands were first crossed by United States armies traveling to California to fight the Mexican-American war of 1846 to 1847. More topographical artists arrived with the government's exploration and survey expeditions of the 1850s. These artists inevitably reflected their personal views of the land. Early artists, such as **George Douglas Brewerton** (1827–1901), who crossed the desert several times between 1848 and 1852 in his work for the U.S. Army, depict campsites, life on the trail, floundering and abandoned animals, and bones bleaching in the sun. In *Jornada del Muerto* of 1853 (fig. 16-1) (Spanish for "journey of the dead man"), Brewerton depicts one of the driest stretches that he experienced—the old Spanish route across the Mojave (that parallels today's Interstate 15 between Barstow and Las Vegas). At one point, travelers had to trek sixty miles without encountering water (the average traveling speed was twenty miles a day), and many attempting the trip died. Brewerton's work is somewhat primitive; his Romantic training led him to emphasize eroded buttes bereft of vegetation, cracked former mud sinks, and the sterility of the rocks. One small human emphasizes the vastness of the desert, which Brewerton presents as a hell-like environment, inhospitable to man.

For years California's deserts formed a barrier for those trying to enter, making the state an island within America. In 1869, however, the Central Pacific completed its rails between Oakland and Promontory Point, Utah (on the north shore of the Great Salt Lake), and joined rails from the east to create the Transcontinental Railroad. In the late 1870s the Southern Pacific eradicated the threat of the southern desert (the Colorado) when it laid rails near Palm Springs to Yuma, Arizona, and points east. Yet a third crossing was provided by the Atchison, Topeka and Santa Fe between 1880 and 1890 when its rail-laying crew sweated its way across the northern parts of New Mexico and Arizona (approximately along Route 66 of recent history), entering California at Needles. From 1869, and certainly by 1890, travelers who wished to cross to California could do so in comfort.

Until the 1920s, few California artists followed the loners, the prospectors, the infirm, and those interested in Native Americans into the sandy wastes. Pencil records, such as those made by the solitary artist of German background, Carl Eytel (1862-1925) are rare. Eytel roamed the inhospitable stretches of the Southwest's deserts, particularly around Palm Springs, between about 1898 and his death.

As the years passed, however, the deserts came

Fig. 16-1
George Douglas Brewerton
(1827–1901)
Jornada del Muerto, 1853
oil on canvas, 30 x 44 in.
Collection of the Oakland
Museum of California, Kahn
Collection

197

into their own as fitting subjects for artists. The first subjects to be recognized as aesthetically interesting were those geographic wonders such as the Grand Canyon in Arizona. In the 1890s the financially faltering Santa Fe Railroad began to promote tourism to the canyon to spur travel on its lines. Many of the images in the railroad's tourist brochures were painted by famous American artists who traded free passage for paintings. Sometime between 1900 and 1906, Southern California plein air landscapists Carl Oscar Borg, William Lees Judson, Hanson Puthuff, Marion Kavanagh Wachtel, and others participated in the Santa Fe program, either painting the Grand Canyon itself or other western sights, the canvases to be hung in passenger stations. Apart from these, Santa Barbara's Fernand Lungren spent the first two decades of the twentieth century traveling the Mojave Desert and Death Valley painting such scenes as *Dante's View* (fig. 11-15).

California's deserts began to attract general attention in the 1920s, when Palm Springs, once a thermal springs area on an Indian reservation, was developed into a luxury getaway resort frequented by Hollywood personalities and the wealthy. With increasing ownership of automobiles, new highways and roads were built (many constructed in the 1930s under federal projects), and travel promotions were launched. By the 1930s deserts had become a favorite springtime tourist destination for Southern Californians. With spring rains came the spectacular displays of wildflowers that made the most of their brief existence before the annual drought obliterated them.

Desert paintings became fashionable from the 1920s and enjoyed special popularity in the 1930s and 1940s, although they are still painted today. The subject has always been most popular with Southern California's artists. Most of California's deserts occur in the southern and eastern portions of the state, and interest in representing them coincided with tourist demands for their depiction and the rise of the Impressionist and Post-Impressionist styles in the Southland. One might question whether the soft French Impressionist style could sympathetically capture a harsh uncompromising environment, such as a desert. In fact, the desert offered hot, scintillating sunshine, a prime interest of Impressionists, and some ecosystems supported plant growth that could be effectively rendered with short, dashed brushstrokes. Two exponents of the "purer" French Impressionism essayed the subject: Guy Rose with a view of palm trees and Alson Clark with numerous sketchy suggestions of white sand, purple verbena, and lavender mountain chains. Impressionist translations, however, usually make the desert "pretty," and turn it into a prosaic landscape, abloom with vibrantly pink flowering verbena.

The desert is a sear, uncompromising land, and the most interesting sites to paint are those that demonstrate its awesome character as a primitive and forbidding place. Death Valley with its blistering sands and rocks (which only Fernand Lungren seemed able to tolerate), along with the less dramatic Vásquez Rocks and Red Rock Canyon, appear to be the only points within California that offer such drama. Thus during the 1920s and 1930s California's most important artists of the desert traveled out of state to depict the wonders of Arizona's Grand Canyon, the buttes and red rocks around Sedona and Canyon de Chelly, Utah's Bryce Canyon, and New Mexico's terrain around Taos and Santa Fe. **Conrad Buff** (1886–1975), like most modernists whose personal experimentation advanced art, plied his way alone. From an oral interview, we know that he grew up in Switzerland amid dramatic mountains and coming to America was impressed with the huge size of the western landforms. Perhaps that is why, when he settled on Southwestern desert subjects, he sought out muscular, naked buttes, arroyos, cliffs, and mesas, terrain that he could rearrange on the canvas like abstract shapes. His Post-Impressionist, cross-hatched style, which gives shape to these giant land forms with tiny dashes of pure, hot colors, projects power and is not to the liking of the timid. Pictures such as *Jawbone Canyon* of about 1925 (fig. 16-2, p. 196) grasp the land's inner elemental strength, dramatize it with light and shadow, swell the forms to the point of bursting, and seize the compositional space. In his later career this modernist carried his interest in abstraction to the point of reducing landforms to single broad, expressive sweeps of a wide brush.

During the 1930s Southern California artists treated the California and Southwestern deserts in two very different ways. *Plein air* landscapists, caught up in the new fashion for traveling to Arizona and New Mexico, captured the Southwestern landscape in softly brushed and pleasantly colored views. Following the lead of the now well-known artists of the Taos-Santa Fe circle, Californians also painted views of pueblos and Indians.

More important was the work of California's Regionalists who, in need of a subject that would reflect

the mood of the Great Depression, turned to depicting the desert. Deserted mining towns with their abandoned shacks and sterile mounds of excavated dirt became California's counterpart to the East Coast's huge, ecologically destructive industrial complexes. (Northern California artists found similar material in the deserted gold-mining operations of the Mother Lode country.) Los Angeles artists, with no local industrial sites to depict (except for a few concrete or sand and gravel plants), looked to places such as the mining town of Randsburg (in the Mojave Desert between the town of Mojave and Death Valley). **Paul Sample**'s (1896-1974) *Randsburg* of 1935 (fig. 16-3) shows how the Regionalist taste for smooth shapes, rounded contours, and outline was perfectly adapted to representing the desert's weather-worn mounds of volcanic ash and sedimentary deposits. While New Mexico's Georgia O'Keeffe (1887–1986) has gained the greatest fame for paintings of rain-sculpted hills, several California landscapists also treated this subject, including Northern California's Helen Forbes (1891–1945) and Southern California's Clyde Forsythe (1885–1962). Another Regionalist, Phil Dike (1906–1990), painted dramatic views of mines around Miami, Arizona, on the frequent trips he made with his wife to visit her family in the area. (Easterners, used to terrain covered by vegetation, are fascinated at seeing the earth's geology laid bare and at the surprising range of color, from rust reds to ochres to blue-green coppers, exposed in the eroded deposits.)

In the 1930s a fashion arose for painting cactus and succulents. California had a long tradition of artists depicting its flora. Scientific illustrators accompanying the earliest seagoing expeditions to California had made botanical drawings of the new species they encountered. During San Francisco's golden era of landscape painting, Northern California redwoods captivated many painters, while the first sophisticated artists working in Southern California in the 1880s juxtaposed cacti and tropical palms to show the area's fecundity. With the growing interest in the desert and the Regionalists' preference for objects of large, smooth, solid shape, several artists of the 1930s began to specialize in views of desert flora. Los Angeles's **Louise Everett Nimmo** (1899–1959) was the best of them as can be seen in her *Desert Scene with Saguaro* of about 1933 (fig. 16-4). Nimmo's work might be termed Post-Impressionist, but she seems less interested in what she can say with colors and shape than in the subjects she represents. This common plant mirrors Regionalist taste for common subjects.

An artist who employed cacti and other natural objects for their deeper symbolical and psychological

Fig. 16-3
Paul Sample (1896–1974)
Randsburg, 1935
oil on canvas, 20 x 30 in.
Paula and Irving Glick

Fig. 16-4
Louise Everett Nimmo
(1899–1959)
Desert Scene with Saguaro
oil on canvas, 43 x 33 in.
Trust Company of the West
Photo: Victoria Damrel
(Clique Studio, Long Beach)

meaning was **Henrietta Shore** (1880–1963). She may have seen the work of the more famous Georgia O'Keeffe while both were active in New York in the early 1920s. Shore's iconized natural animate and inanimate objects, however, as in *Maguey* of 1928 (fig. 16-5), are more elementally symbolical than O'Keeffe's spiritually elevated interpretations. Like an earth mother, to whom some historians have compared her, she regarded all things on earth (animal, vegetable, and mineral) animated with a single spirit.

Inevitably, the interest of artists in the desert and its plants was picked up by the world of high fashion. Only a few of California's artists had the frame of mind to work in the semiabstract Art Decoratif style that rose to almost instant popularity in mid-1920s Europe. The desert's bald hills, stark buttes, and drought-resistant, leathery-surfaced plants, however, provided simply shaped yet easily identifiable subject matter for "Art Deco's" sleek stylization. In **Adele Herter**'s (1869–1946) *Desert Mural* (dining room of Casa del Sueño, Montecito, California) of the 1920s (reproduced in Patricia Trenton, et al., *Independent Spirits,* Autry Museum of Western Heritage in association with the University of California Press, 1995, p. 56), the artist has reduced the desert's mesas and the flowering yucca to simple silhouettes that are quickly and accurately "read" by viewers. Metallic gold provides a flat decorative background, while the shapes made up of muted-colors enframed by wiry black lines are sufficient to suggest three-dimensional objects but still comply with the wall surface.

Since the beginning of human history, the desert has been a universal symbol for starkness and loneliness. Although its silence, aridity, and isolation repel some, peoples such as the Native Americans and the biblical prophets saw these qualities as assets and the desert as a place to undergo deprivation in the hope of receiving mystical revelations. In the twentieth century these same qualities still bring a sense of peace and provide a chance for people to search inside themselves for the answers to life's questions. In 1932 **Agnes Pelton** (chapter 8) took up residence in Cathedral City, not far from Palm Springs. The desert's moisture-free air provides such clarity that the heavens seem touchable. Her *Messengers* of 1932 (fig. 8-11) is an abstract but sensual record of images that her imagination conjured up after contemplation of the desert twilight and night sky. Near the end of the 1930s, Pelton learned of others in Santa Fe and Taos on similar artistic quests and joined their Transcendental painting group. Her style, however, was fully developed long before her association with them. Pelton is now recognized not only as one of the most original and sincere of the group, but also as one of America's most significant Symbolist painters.

Artists who Painted Cowboys

Hooves pound on baked earth as two cowboys *Race for the Chuckwagon* (fig. 16-6) in a scene recreated from the Old West by San Franciscan **Herman Wendelborg Hansen** (1854–1924) about 1905. Noticeable immediately is the difference between this image and earlier California "western" subjects of the nineteenth century (chapters 2, 10, and 11). Earlier works reference the Gold Rush, Mexican rancho life, vaqueros herding cattle, bandidos, stagecoaches, Spanish missions, and the Pomo Indians. In the twentieth century, California artists began to treat the "West" of the Mississippi basin.

Why? The United States Census of 1890 acknowledged the disappearance of the American frontier. The exciting period of cowboys and Indians on which people today look back with nostalgia lasted only a little more than sixty years (1830–90), from the time when fur trappers penetrated the wilderness by working their ways up the Missouri River, to covered wagons rumbling across the plains, through cattle ranching and homesteading, to corralling Native Americans onto reservations. By the end of the nineteenth century the frontier was gone. Increasingly, from the 1860s, those artists who created images of the "Old West" were likely to be urban illustrators who had not experienced the region firsthand but who conjured images from their imaginations to illustrate the flood of magazine articles and books that capitalized on the popular, nostalgic theme. Their preferred subjects were cowboys of the type active in the Texas-Wyoming cattle-raising corridor and the picturesque Indians of the Great

Fig. 16-5
Henrietta Shore (1880–1963)
Maguey, 1928
oil on canvas, 26 x 30 in.
Arroyo Galleries/Edwin J. Gregson

Plains. When some of these illustrators retired, they turned to the "fine arts," painting the same subjects in oil on canvas. Many were driven by their personal infatuation with the West.

California's turn-of-the-century western painters congregated in San Francisco, the West Coast's publishing center, where many worked as cartoonists, quick sketch artists, and illustrators, supplying images for the city's newspapers, periodicals, and books. They include Maynard Dixon and Jimmy Swinnerton (1875–1974). Through the twentieth century America's "Wild West" continued to stir many hearts. Stories of the period of romantic adventuring actually induced Herman Wendelborg Hansen to immigrate to America in 1877. He first set foot in the West when the Northwestern Railroad commissioned him to paint scenes along its route. Although Hansen settled in San Francisco in 1882, he continued to make trips into other parts of the West to gather subject matter for scenes of the period, also referred to as Days on the Range. An extremely accomplished watercolorist who achieved an almost photographic sharpness, his most frequent subject was galloping horses with all four hooves off the ground, a convention associated with the Romantic style. (It was years before artists learned from the photographs of Californian Eadweard Muybridge that at any gait horses have at least one hoof on the ground.) As an illustrator interested in action, Hansen gives his cowboys and horses prominence and minimizes landscape. His painting embodies many of the appealing qualities associated with cowboys and the West: youthful exuberance, energy, irresponsibility, freedom, fast action, romance, opportunism, and excitement.

Some Southern California artists residing in Los Angeles and Santa Barbara maintained a long-term interest in cowboy and Indian themes. **Edward Borein** (1873–1945) taught himself to draw during childhood and while he worked on some of California's large cattle ranches. His love and "hobby" led him to a career as an illustrator in the Bay Area and in New York. Retiring to Santa Barbara in 1921, he turned his honed drawing skills to making etchings and watercolors. With their training and early careers based in realism, Borein and other painters of cowboy and Indian themes had little use for the abstract styles that were evolving around them, or for "interpreting" their subject. Accuracy was crucial when the paintings were geared to former cowboys or to western aficionados who disdained poorly drawn anatomy, illogical equipment and clothing, and unreal situations. In *The Pinto Horse/Cutting Back A Stray* (fig. 16-7), Borein uses a watercolor style that is anchored in realism, but is less photographic than Hansen's, and more expressive in its freshness and spontaneity.

Borein became a galvanizing figure among a growing group of Santa Barbara artists, residents, and

Fig. 16-6
Herman Wendelborg Hansen
(1854–1924)
Race for the Chuckwagon,
c. 1905
watercolor, 20 x 30 in.
John R. Gangel Collection

Fig. 16-7
Edward Borein (1873-1945)
*The Pinto Horse/ Cutting Back
a Stray*
watercolor, 6 ⅞ x 9 ⅜ in.
The Katherine H. Haley
Collection

visitors interested in the American West. Pasadena and Santa Barbara, the late nineteenth-century outposts of Boston's wealthy travelers, provided, in the 1920s, a haven for retiring cowboys-turned-artists, such as Borein, Joe DeYong (1894–1975), and Charles Russell (1864–1926), for cowboys-turned-actors with artistic talents, such as Leo Carrillo, (best known as the "Cisco Kid"), as well as for artists employed by Los Angeles's motion picture studios. Many of these notables first met in New York in the first twenty years of the century where they were employed as illustrators or were on the entertainment circuit. All artists who rose to their profession after working as cowboys were proud of being self-taught and of having experienced western life firsthand; they spurned the art world's academic circles. Their common interests brought them together socially to reminisce about their days on the range. In his New York studio Borein welcomed artists James Swinnerton, Charles Russell, Maynard Dixon, Olaf Seltzer (1877–1957), and C. O. Borg; his circle extended to cowboy actors Will Rogers, Buck Jones, and Guy Weadick, to writer-artist Will James, and to President Theodore Roosevelt, to mention only a few. When retirement or careers brought these men to the West Coast, their friendships continued in both Hollywood and Santa Barbara. In Santa Barbara, Borein's studio and later his home, an Indian-style adobe overlooking the Pacific, which he named La Barranca (now demolished), became the site of gatherings for individuals interested in the American West: businessmen collectors, novelists, historians, actors, amateur artists, and even saddle makers. Borein, DeYong, and others continued to provide illustrations for the ever-popular fictional stories of the West. These artists were also consulted by motion picture executives who wanted authenticity in the equally popular cowboy films of the 1930s, and they developed a following of art collectors. In 1929 Borein organized the now prestigious Rancheros Visitadores. This group of horse owners met annually in the spring to ride through the neighboring Santa Ynez Valley. (The organization still exists.) In addition to DeYong, a former cowboy who trained with the Montana painter Charles Russell (1864–1926), other artists of American Western subjects who settled in California from the 1930s include the illustrator Don Perceval (1908-1979), C. O. Borg (chapter 7, and below), and the painter Nicholas Firfires (b. 1917).

Pasadena was the winter home of the Montana

Fig. 16-8
Frank Tenney Johnson
(1874–1939)
Riders of the Dawn, 1935
oil on canvas, 48 x 60¼ in.
Courtesy of The Anschutz
Collection
Photo: James O. Milmoe

artist Charles Russell, who was attracted both by the balmy winter climate and by the fellowship of a smaller pocket of aficionados of the Southwest, including the writer Charles Lummis who lived in the nearby Arroyo Seco. In the early 1920s the neighboring suburb of Alhambra became the retirement home for the New York illustrators Clyde Forsythe and **Frank Tenney Johnson** (1874–1939). Forsythe produced many views of the desert's bald hills, sometimes peopled with grizzled prospectors leading pack burros. Johnson, who did not completely settle in Alhambra until about 1930, specialized in nocturnes, not the inky versions produced by turn-of-the-century Tonalists such as Charles Rollo Peters, but blue-toned views of cowboys and cattle under a full moon. As opposed to the fast action favored by earlier artists such as Herman Wendelborg Hansen, Johnson's subjects were quiet—pack trains patiently wending their ways, night herders passively regarding their bedded-down cattle, or lone cowboys in philosophical contemplation. *Riders of the Dawn* of 1935 (fig. 16-8) is therefore unusual (and outstanding) for its lively action as well as the dramatic sunrise that illuminates the four men riding abreast. Los Angeles devotees of western subjects formed such groups as the Westerner's Los Angeles Corral. In 1923 the Biltmore Salon was established in the prestigious Biltmore Hotel in downtown Los Angeles to display western art. While it soon expanded its offering to include landscapes, the Salon maintained its commitment to the western theme through several owners until it closed just a few years ago. It survives in a Scottsdale, Arizona, branch.

Artists who Painted the Native Americans

California artists made extended train trips to depict the pueblo-dwelling Indians of the Southwest even though the state had indigenous Native American tribes. Californians were attracted to the art colonies of Taos and Santa Fe in New Mexico, especially in the 1930s after news about them was spread by magazine articles. Reaching the Southwest was not that rigorous for Californians, who could ride the Santa Fe and the Southern Pacific Railroads. Even before 1900 artists such as Elbridge Ayer Burbank (1858–1949), Warren Rollins (1861–1962), Frank P. Sauerwein (1871–1910), Joseph Henry Sharp (1859–1953), and Ira D. Gerald Cassidy (1879–1934) had been using the train to travel freely between Taos/Santa Fe and the Southwest's closest major metropolitan center, Los Angeles. On the West Coast they found galleries to show their work and a cool place to wait out the desert's burning summers.

In place of the fast action of "cowboy" pictures, artists of the 1930s who painted America's Pueblo Indi-

ans preferred a passive scene. "Action" consisted of Indians conversing in groups, bargaining at trading posts, making pottery, weaving rugs, playing flutes by mountain pools, and dancing in ceremonies. Replacing the compulsive detail of cowboy pictures were a few large elements, treated in a broad, almost poetic fashion. These changes not only reflected the more pacific nature of pueblo dwellers but also the end-of-the-century fashion for "mood" paintings. One of the earliest and most important of California's painters of Indians was **Maynard Dixon** (1875–1946). Dixon began his career in San Francisco and New York as an illustrator, specializing in cowboy as well as Indian themes. His best work was produced in the 1920s and early 1930s, with many strong works in the 1940s, but his output was diminished by his declining health. *The Wise Men* (fig. 16-9) was begun in 1923, reworked in 1927, and finished in 1935. Early-twentieth-century illustrators were trained to emphasize human action over landscape, to use a few large figures to tell a story that could be quickly understood by all viewers, and to depict scenes that had universal appeal. Dixon's painting style was no doubt additionally influenced by his turn-of-the-century work on posters and magazine covers in which he used large, eye-catching shapes and the then fashionable Art Nouveau style. In *The Wise Men*, Dixon has ennobled and monumentalized the Indians by

Fig. 16-9
Maynard Dixon (1875–1946)
The Wise Men, 1923–27–35
oil on canvas, 36 x 42 in.
John Dixon Collection

viewing them from ground level and then poetically setting the scene at twilight. The silhouetted procession advances rhythmically, its dignity enhanced by sensuous curves that reflect the natural and earthy character of his subject. The men's striped blankets provide varied and interesting patterns yet are subdued to the overall tonality. The somber atmosphere conveys both a reverential mood and the oneness of the Native American with his natural environment. Dixon's strength derived from his underlying respect for his subjects and led him to emphasize their noble qualities.

Carl Oscar Borg, a painter of Barbizon-style landscapes (chapter 7), was introduced to Southwestern subject matter in 1916, as a result of a commission from the University of California, Berkeley, and the United States Bureau of Ethnology. His job was to paint and photograph the Hopi and Navajo before their cultures were completely destroyed by European contact. While on assignment he had an epiphany, and through 1932 he made annual spring trips to obtain material for a subject that became an obsession for him. *The Niman Kachinas* of 1926 (fig. 16-10) relies on the same large, monumentalized figures silhouetted against the sky that are seen in Dixon's work, but it is more three-dimensional. Borg's presentation is dramatic with the bold, white stripe on the central blanket providing a focal point. His approach is objective rather than illustrative or narrative. The viewer feels like part of the scene, someone who has chanced on a serious consultation between these costumed dancers, the details of which are unimportant, a human situation universal to all peoples and cultures.

Dixon and Borg were among the earliest artists to paint several themes that became popular with later and lesser western artists. These include the tiny horseback rider traversing a vast desert or riding between the towering red walls of Canyon de Chelly. Both men painted hogans, pueblos, Indian dances, and landscape features such as buttes, pinnacles, and the Grand Canyon.

Once Native Americans were relegated to reservations and became less threatening to settlers of European background, fear turned to sympathy. This, in turn, became guilt as tourists noted the Native's wretched living conditions and as armchair travelers read articles and books that spoke out feelingly about the United States government's mistreatment of the country's original inhabitants. Americans of European background realized they had forcibly taken the Indians' land and thus were responsible for the destruction and loss of Native American culture.

Ever since artists began traveling into Indian land west of Saint Louis in the early 1830s, western artists have also been ethnologists, capturing in their portraits and genre scenes the condition of the Indians at a particular moment in history. As the century drew to a close, and as Native American culture seemed about to disappear, artists and ethnological institutions raced to preserve anything Native American. In California, Grace Hudson's lifelong documentation of the Pomo is one of the earliest examples in paint of this impulse (chapter 6).

Among the twentieth-century California artists who took on the goal as a personal quest was **Kathryn Leighton** (1876–1952). Clubwoman and wife of a lawyer, she was a gregarious individual who was able to pursue her love of painting only after her son was grown. In 1919, on a holiday in Banff, Canada, she witnessed the roundup of the Stony Indians and was so moved by it that she decided to make a painted record of the Native Americans. Although Leighton chose an occasional subject from the Southwest, her real love was the Plains Indians, former buffalo hunters, such as the Blackfeet, the Bloods, and the Piegan, who were now confined to reservations in Alberta, Canada, and northwest Montana. She painted in her Glacier National Park studio on summer trips with her family as well as in her Los Angeles studio. Leighton was essentially a portraitist, employing a variety of traditional compositions, including bust and three-quarter length poses as well as the pose in the undated *Indian with Tom Tom* (fig. 16-11) that is specifically appropriate for Native Americans—a figure seated cross-legged. As with traditional Western European portraits, the background elements give us more information about the subject than we can read in his face. Leighton, like many painters of cowboys and Indians, collected artifacts, clothing, adornments, and implements, and was even formally accepted into a tribe and given an Indian name. In her Los Angeles studio she not only painted Indian and non-Indian models posed in ethnic regalia that she had collected (many Indians worked

as extras in the motion picture studios) but also hosted lavish parties for society friends and honored Indian guests.

After 1940, artists continued to paint subject matter identified with the desert, cowboys, and Native Americans. In the 1940s, when still-life painting enjoyed a fashion in the greater Los Angeles area, many artists looked to the desert for objects with interesting textures. Such items as animal skulls, Southwestern pottery, dried desert plants, and weathered wood entered their repertoire. An example is Henry Lee McFee's *Bouquet from the Desert* (fig. 22-7). In the 1950s, the western image underwent yet another transformation. In the hands of Hollywood moguls, cowboys and Indians solidified into stereotypes, and corporate America capitalized on the images by making souvenirs, children's toys, clothing, and interior furnishings, to name a few. In the post-1970s era, this commercialized image of cowboys and Indians became fodder for makers of "high" art. Native American artists investigated their personal identity through exposing stereotypes and through making sympathetic portrayals of their own peoples (chapter 33). Other artists explored the *myth* of the West that had been created by Hollywood and corporate America. The Abstract Expressionist Hassel Smith borrowed the title *Buffalo Dance* (fig. 26-2) for his nonobjective painting. William Allan was among the group of Northern California artists of the 1960s who made imaginative scenes based on the West, such as his *Shadow Repair for the Western Man* (fig. 31-11), and broached the issue of ecology.

The next chapter will orient the reader to the years 1930 to 1945, during which monumental social changes, particularly the Great Depression, changed the look of California's art once again. ✣

Fig. 16-10
Carl Oscar Borg
(1879–1947)
The Niman Kachinas, 1926
oil on canvas, 44⅛ x 54¼ in.
Courtesy of The Anschutz
Collection
Photo: James O. Milmoe

Fig. 16-11
Kathryn Leighton
(1876–1952)
Indian with Tom Tom
oil on canvas, 44½ x 36 in.
City Art Collection, City of
Los Angeles Cultural Affairs
Department

Bibliography

The West

Goetzmann, William H. & William N. Goetzmann, *The West of the Imagination*, New York: W. W. Norton & Co., 1986.

Kovinick, Phil, *The Woman Artist in the American West 1860–1960*, exh. cat., Muckenthaler Cultural Center, Fullerton, Ca., April 2 - May 31, 1976.

Kovinick, Phil and Marian Yoshiki-Kovinick, *Encyclopedia of Women Artists of the American West*, Austin, Tx.: University of Texas Press, 1998.

Trenton, Patricia, ed., *Independent Spirits: Women Painters of the American West, 1890–1945*, Autry Museum of Western Heritage in association with the University of California Press, 1995.

Desert Artists

Ainsworth, Ed., "Artists: Desert Painters," series of 12 articles in *Palm Springs Villager*, v. XI, no. 2, October 1956—v. XI, no. 11, June/July 1957. [Swinnerton, Forsythe, Dixon, Hilton, Proctor, Fechin, Buff, Lauritz, Pelton]

Ainsworth, Ed, *Painters of the Desert*, Palm Desert: Desert Magazine, 1960.

Art Gems: *Twentynine Palms Artists Workshop of Morongo Valley Basin*, Twentynine Palms, Ca.: Artists Workshop, 1973. 33 p.

Capturing the Canyon: Artists in the Grand Canyon, exh. cat., The Mesa Southwest Museum, Mesa Ar., May 23–July 26, 1987.

D'Emilio, Sandra and Suzan Campbell, *Visions & Visionaries: The Art & Artists of the Santa Fe Railway*, Salt Lake City, Ut.: Gibbs-Smith, 1991.

Desert Art Center, *Art and Artists*, Palm Springs, Ca.: The Center, 1965. 128 p.

Desert Art Center (Palm Springs) Twenty-Fifth Anniversary, Santa Barbara, Ca.: Artfame Ltd., 1975. 64 p.

"Desert Painters" in Nancy Dustin Wall Moure, *Painting and Sculpture in Los Angeles, 1900-1945*, exh. cat.., Los Angeles County Museum of Art, September 25–November 30, 1980.

Growdon, Marcia Cohn, *Artists in the American Desert*, exh. cat., Sierra Nevada Museum of Art, Reno, Nv., November 29, 1980–January 11, 1981 and ten other venues. [covers the period 1920-1980] 40 p.

Hollon, W. Eugene, *The Great American Desert, Then and Now*, New York: Oxford University Press, 1966.

Kovinick, Phil, *Canyons, Arroyos & Oases: Desert Landscapes in Southern California 1900–1985*, exh. cat., Saddleback College Art Gallery, March 8–April 18, 1985. [3-fold brochure]

Pickering, Lee Lukes, *Colorful Illusion: 18 Years in a Desert Art Gallery*, Twentynine Palms, Ca.: Decade Press, 1982. 204 p.

Westphal, Ruth Lilly and Janet Blake Dominik, *American Scene Painting: California, 1930s and 1940s*, Irvine, Ca.: Westphal Publishing, 1991.

Artists of Cowboys

Ainsworth, Ed, *The Cowboy in Art*, New York and Cleveland: World Publishing Co., 1968.

"Painters of Cowboys and Indians," in Nancy Dustin Wall Moure, *Painting and Sculpture in Los Angeles 1900–1945*, exh. cat., Los Angeles County Museum of Art, September 25–November 23, 1980.

Artists of Indians 1900–1940

Berkhofer, Robert F., *The White Man's Indian: Images of the American Indian from Columbus to the Present*, New York: Alfred A. Knopf, 1978.

"California: The California Culture Area, Henry Raschen, Grace Hudson, Pomo Culture in the [sic.] Raschen and Hudson," in Patricia Trenton and Patrick Houlihan, *Native Faces: Indian Cultures in American Art: From the Collections of the Los Angeles Athletic Club and the Southwest Museum*, exh. cat., Southwest Museum, Los Angeles, July 13–September 15, 1984.

The Desert, Indians, and Cowboy Images after 1940

Hough, Katherine Plake and Michael Zakian, "Modernism and the West," *Antiques & Fine Art*, v. 9, no. 4, May/June 1992, pp. 58–65.

McAlpine, Barbara, "Transforming the Western Image: 20th Century American Art," *Art of California*, v. 5, no. 2, May 1992, pp. 32-33.

Transforming the Western Image in 20th Century American Art, exh. cat., Palm Springs Desert Museum, February 21–April 26, 1992 and three other venues.

The West As Art: Changing Perceptions of Western Art in California Collections, exh. cat., Palm Springs Desert Museum, February 24–May 30, 1982.

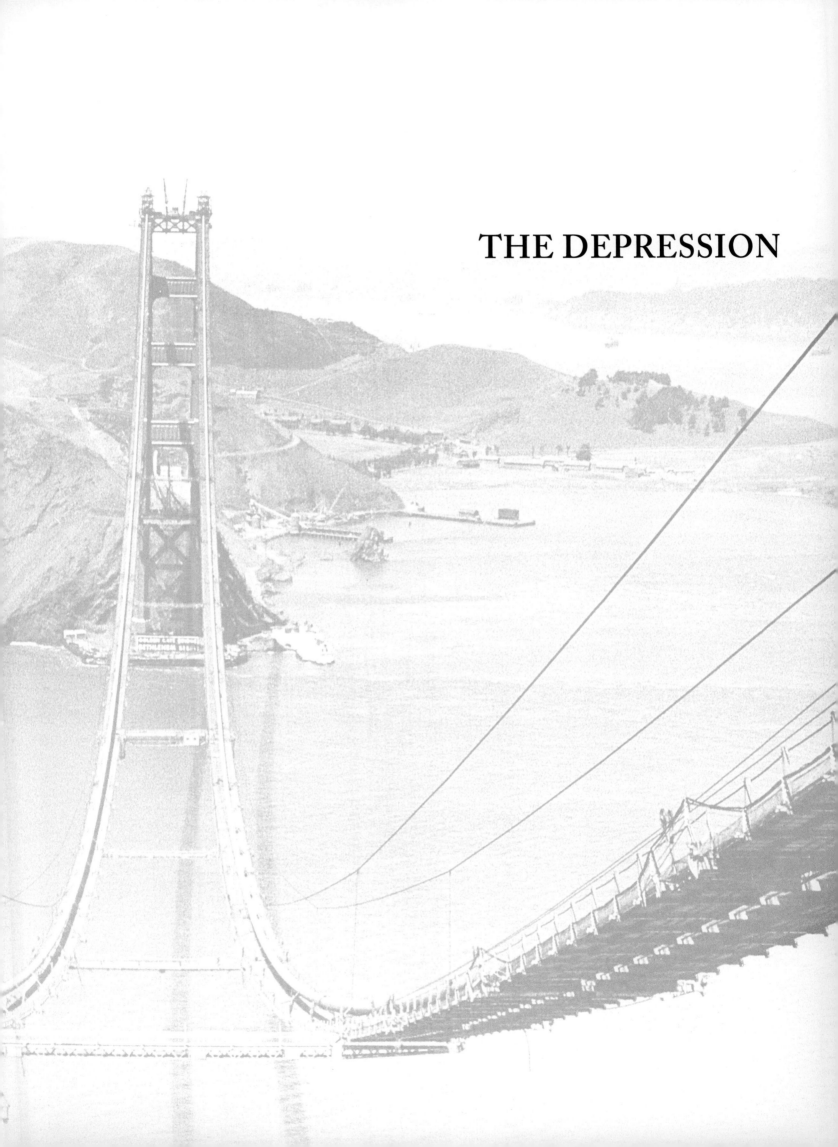

THE DEPRESSION

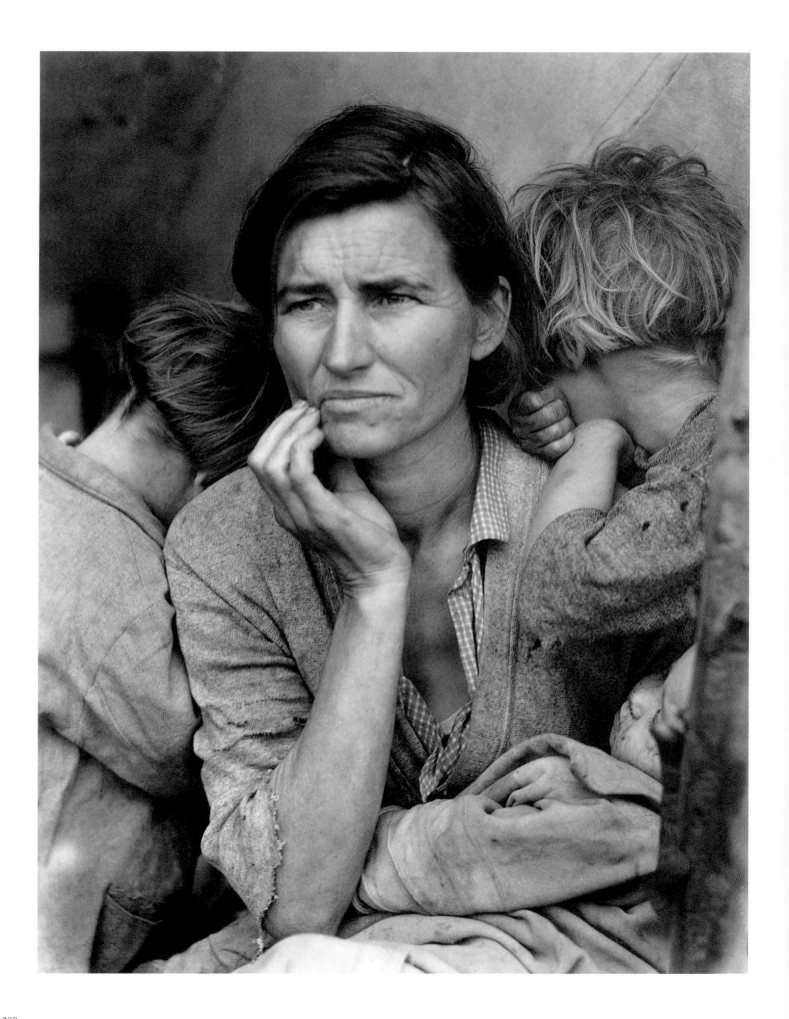

1930–1945:
Growth of the Arts & Non-Painting Media

Art Infrastructure, 1930–1945

In retrospect the stock market crash on Black Thursday, October 24, 1929, was a highly predictable aftermath of the post-World War I economic boom. Since every living thing is genetically programmed to go full bore when times are good, nature also has a way of curtailing excessive growth. The Great Depression is almost unnecessary to describe, since photographs and publications have preserved the period's direst aspects: labor strikes, soup lines, and people riding the rails or tramping the highways as hoboes. In fact, most people clung to modest jobs and lived reasonable lives. Media attention went to those who jumped out of brokerage firm windows high above Wall Street.

In financially difficult times, the first entities to be jettisoned are so-called nonessentials such as art. Collectors stopped buying. Once-prosperous galleries folded. Museums couldn't raise sufficient funding to stay open. The slide to the bottom took three years. Through it all, artists remained hopeful, trying to preserve their routines, to keep their communities intact. Faced with a lack of cash, they resorted to special citywide art promotions, cooperative art galleries, and barter. Most tried for nine-to-five jobs, the luckiest finding work related to art or requiring art skills. Others, after 1934, not wanting the shame of taking relief funds, were thankful to get on the rolls of one of the government art projects and to feel useful by painting murals or easel pictures to decorate government buildings. Economic troubles and changing world politics tempted Americans toward alternate forms of government, and Communism became a panacea for some and a threat for others. In California there were branches of the American Artists' Congress, a group of artists opposing Fascism, as well as the John Reed Club, an American cultural organization sympathetic to Communism established in 1929.

In Los Angeles the population was expanding westward, carrying with it the center of art activity to the Westlake Park area (now MacArthur Park). Within blocks of its shores clustered several framers and commercial art galleries, both Otis and Chouinard art schools, and the Foundation of Western Art (a private, nonprofit exhibition space founded by wealthy Max Wieczorek). Here also the Federal Art Project Art Center administered and exhibited art. Longtime dis-

satisfaction on the part of those who backed the art department of the Museum of History, Science, and Art resulted, in 1933, in the breakaway group forming the Los Angeles Art Association. Acting as a museum until 1938, it acquired art and staged exhibitions, including the very important *Loan Exhibition of International Art* in 1937.

In San Francisco in 1933 the cooperative Galerie Beaux-Arts, which had supported modern art since 1925, finally folded. Yet in January 1935 the San Francisco Museum of Art was able to open on the top floor of the new Veterans' Building. Art continued to be shown at the city's general museum, the M. H. de Young, and the city's other art museum, the California Palace of the Legion of Honor. And, although artists' sales were few and far between, there was one active "angel"—Albert Bender, a financially successful, independent insurance agent, who purchased the work of young artists and made gifts of them to the city's various museums. In the East Bay, the Oakland Art Gallery, Mills College Art Department, and the California College of Arts and Crafts remained strong, while in 1923 the University of California at Berkeley finally established a Department of Drawing and Art, the forerunner of the current Department of Art. In 1936 and 1937, respectively, the Bay and Golden Gate bridges were completed and immediately became subjects for painters and photographers. The biggest display of art took place at the 1939 Golden Gate Exposition held on Treasure Island.

In San Diego, the Fine Arts Gallery continued to function, and in the early 1930s a new exhibiting group, the San Diego Moderns, was formed. San Diego's biggest art event was the exhibition at the California-Pacific International Exposition of 1935 to 1936, held at the same site in Balboa Park as the 1915 Exposition but with additional buildings. The display presented a show of art from the Southwest and devoted a gallery to San Diego artists. At its close, the exposition's mock-Spanish Village was retained as studios for artists and artisans.

Santa Barbara's 1920s art boom bottomed out in the early 1930s. Nevertheless, the small city's superior economic basis as a resort and home for wealthy retirees placed it in a privileged situation. In 1930 the library obtained a wing called the Faulkner Memorial Art

Opposite:
Fig. 17-8
Dorothea Lange
(1895–1965)
Migrant Mother, Nipomo,
1936 (FSA-OWI file)
Courtesy of the Library of Congress

Fig. 17-1
Donal Hord (1902–1966)
The Aztec, 1937
diorite quarried in Escondido
52½ x 26 x 24 in.
Joint project of San Diego
State University and U. S.
Treasury Department,
Washington, D. C.

Fig. 17-2
Beniamino Bufano
(1898–1970)
Sun Yat Sen, 1937, St. Mary's
Plaza, San Francisco
red granite and stainless steel
12 ft. ht.
Commissioned by Northern
California Art Project, WPA

Gallery, where the work of local artists was exhibited. And when the city's main post office moved into new and larger quarters, citizens organized to turn its abandoned Spanish-style building into the town's first museum. After remodeling, it opened in 1941 as the Santa Barbara Museum of Art.

The hard times of the Depression changed art in several major ways. Patronage shifted. In place of private clients who acquired landscapes to decorate their houses, various government welfare and art projects now commissioned works of art to decorate new public and civic buildings. Los Angeles's motion picture industry employed hundreds of photographers, painters, and sculptors in the making of films and animated cartoons. Hollywood's stars and executives hired artists privately to decorate their homes, paint their portraits, and supply intellectual and bohemian friendships.

Artists looked for ways to produce good but inexpensive art for the masses, and thus multiples took on importance—inexpensive forms of printmaking (including lithography and serigraphy) and cast ceramic figurines. Gone were expensive raw materials. Painting, for example, moved away from imported ground oil pigments and sable brushes toward water-based casein and tempera applied to a base of castoff materials including Celotex. Subjects changed too. They were no longer derived from the life of the upper classes but delineated instead the ordinary man. Artwork now carried a message. The various media shared a common aesthetic and subject matter. This was partly due to the practice of artists working in several different media; painters, for example, also made lithographs and book illustrations, hoping to tap into a mass audience.

Although painting continued to be the most important medium of expression, work in all the other standard media previously discussed continued to be produced. The aesthetics of each changed as a result of the economic situation.

Sculpture

In the best of times, sculpture does not sell popularly, but in the Depression, deprived of middle- and upper-class private patronage, sculptors suffered financially. Some adjusted to new markets by making sculptures in multiples, such as cast ceramic figurines and machine-made Art Decoratif pieces for a mass audience, while others were lucky to create individual pieces under government patronage. Raw materials changed. Expensive traditional materials, such as bronze, silver, and marble were replaced by cheap and commonly available materials, including terra cotta, wood, stone, cement, newly invented media such as petrochrome (cement and stone aggregate), as well as salvaged items.

Within the broad category of sculpture, several very different types were pursued through the 1930s. Possibly eighty percent was in the so-called Regionalist style, about fifteen percent was the sleekly elegant Art Decoratif (primarily supported by the motion picture industry), and a very small portion was avant-garde or abstract.

Regionalist. So-called Regionalist sculpture shared many attributes with Regionalist painting (chapter 18). Its themes concerned ordinary people, objects, or animals, and sylistically its representational imagery was simplified into a few, compact rounded volumes. Technically and stylistically "conservative," Regionalist sculpture had two patrons with different needs. If it was for private consumption, it was usually tabletop size and its subjects were usually a single animal or a person. If it was for government patronage, it was usually large—either a freestanding sculpture for a park or an attached bas-relief on a building—and its subject was dictated by the message the government wanted conveyed. Subjects included scenes or figures from American history or people who symbolized laudable American values.

California's greatest sculptor in the Regionalist style was probably **Donal Hord** (1902–1966) of San Diego. Small and frail, handicapped from a childhood bout with rheumatic fever that permanently damaged his heart, Hord was able to execute monumental pieces in incredibly hard stone, such as diorite, by using an air hammer to rough out the shapes and the help of his lifelong assistant, Homer Dana, to carry out much of the heavy work. In a work such as *The Aztec* of 1937 (fig. 17-1) Hord, like many California Regionalists, derived his thematic and stylistic inspiration from so-called primitive cultures—in his case those of Mexico and the Pacific. The work represents a joint effort of the local Federal Art Project and students at San Diego State College who raised some of the funds. Since the early 1920s the school had identified itself with the Southwest and adopted as its theme the Mexican Pre-Columbian Indians. In 1936, a two-and-a-half ton block of diorite (a stone chosen because it had been used by the Aztecs) was quarried in nearby Escondido. The stone was so hard (seven on a scale of one to ten) that Hord reportedly broke all his hand tools on it before he turned to a compressor and pneumatic drill. The sculpture shows the figure wrapped in his blanket, and its placement in a prominent inner court was meant to symbolize the college's high ideals. In San Francisco, a similar aesthetic of large simplified shapes was employed by **Beniamino Bufano,** who advanced sculptural history by incorporating into his granite pieces the nontraditional sculptural material of stainless steel. An example is his *Sun Yat Sen* of 1937 (fig.

17-2). This red granite piece commemorates the revolutionary leader that Bufano met about 1920 while on a several-year trip to China. Bufano shared Sun's revolutionary ideas, stayed at his home in Canton, and created several portrait busts of him in clay.

In the 1930s a few artists from ethnic and racial minorities entered mainstream art for the first time. Possibly as a result of the important black cultural revolution of the 1920s called the Harlem Renaissance, San Francisco can boast sculptor **Sargent Johnson** (1888–1967). One of the qualities that makes art by America's ethnic subgroups so vital is the blend of aesthetic ideas from their own backgrounds with those of the American mainstream (chapters 33, 34). In *Forever Free* of 1933 (fig. 17-3) Johnson has beautifully combined black subject matter and a "folk art" style with the Regionalist aesthetic. His work has universal appeal. The black woman is ennobled by her bearing and implied strength, and as a mother, she symbolizes the stable core that anchors the American family.

Fig. 17-3
Sargent Johnson
(1888–1967)
Forever Free, 1933
wood with lacquer on cloth
36 x 11½ x 9½ in.
San Francisco Museum of Modern Art, Gift of Mrs. E. D. Lederman

Abstract/Avant-Garde. The most interesting sculptures to art historians are the rare pieces that advance sculpture thematically, stylistically, or technically. A few sculptures of this type were made in the 1930s. For centuries, sculpture had consisted of a representational subject (usually human but sometimes animal) that enacted a scene from history, commemorated an important individual, or was allegorical. Sculpture was made from natural materials: either carved from stone or wood or modeled in clay, then cast in metal. It was solid and compact in shape, and if freestanding it was usually elevated on a plinth so that it could be viewed from all sides. This description changed rapidly in the first thirty years of the twentieth century. First, under the impulse of Cubism, subject matter was jettisoned, and shape and texture became subjects in their own rights. Then, new techniques entered. Dada constructions of the teens added a new method called "assembling." One of the greatest sculptural advances was made about the time of the stock market crash by an East Coast American artist working in Paris, Alexander Calder (1898–1976). By manufacturing his works of wire and allowing them to move (the works we now call "mobiles"), he destroyed the old concepts that a sculpture had to be solid and stationary.

Were any California artists using these avant-garde ideas? Among the long-term resident sculptors, the most advanced was probably Los Angeles's **Peter Krasnow** (1886–1979). Between 1935 and 1940 he made nonobjective carvings from tree trunks as well as assembled sculptures that he termed "demountables." Krasnow may have brought back his advanced ideas from Europe where he had lived from 1931 to 1934, but they conveniently coincided with his need to clear out a tree-choked garden at his Atwater, California, home. *Untitled* of 1942 (fig. 17-4), a monumental abstract made from the trunk of a walnut tree, is "totemic." The term, borrowed from the carved totem poles produced by the Northwest Coast Indians, signifies a vertical object, sometimes monolithic, sometimes assembled from parts, usually abstract, and imbued with primitive forces. Totems were the avant-garde shape of the 1930s and 1940s. In shaping his tree trunks, Krasnow followed the philosophy originated during the Arts & Crafts period that materials have their own inherent forms and that these forms need to be brought out by a sculptor, rather than imposed on them. Abstract artists such as Knud Merrild also "assembled" shaped pieces of wood into wall-hung, open-fronted boxes, in the manner of the American Abstract Artists of New York.

One of the most avant-garde sculptors active in California in the 1930s was the Russian-born and Paris-trained Alexander Archipenko (1887–1964), who taught briefly at both Mills College in Oakland and Chouinard Art Institute in Los Angeles. Although Archipenko was in California for only a few years, he made his best-known piece here, the streamlined *Torso in Space* of about 1936 (not illustrated), which reduced the human figure to an elongated curve. In the Art Decoratif style is the *Oscar* award of the motion picture industry (see below).

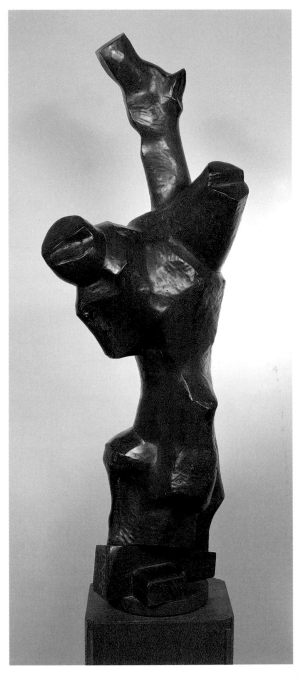

Fig. 17-4
Peter Krasnow (1886–1979)
Untitled, 1942
walnut
51 x 20 x 20 in.
Collection of Orange County
Museum of Art,
OCMA/LAM Art
Collection Trust; Gift of
Helen and Alex Finkenstein

Printmaking

Printmaking was one medium that actually benefited from the economic downturn of the Depression. When people could not afford an oil-on-canvas but still needed or wanted art for their walls, they turned to cheaper art objects such as multiples. In the 1930s, Americans finally began to appreciate the inexpensive but once esoteric medium of prints. Prints, like drawings, historically had appealed to a small group of collectors who did not object to the limitations of the medium, i. e., the restriction to black and white, the small size, and the necessity of displaying them under glass, whose reflections sometimes obscured the image. But the style and media range of prints was also affected by the Depression. Certain traditional printing techniques that had permitted only small editions—etchings and copper plate engravings—were usurped by techniques that could yield many prints—lithographs, wood engravings, and linoleum blocks. The last three also had the advantage of necessitating only inexpensive raw materials and equipment to produce.

Lithographs and wood engravings are not "new" techniques. Both were used extensively by commercial printers in the mid-nineteenth century. But in the 1930s these media exited the world of commercial art and reached their apogee in the hands of "fine-art" printmakers. Printmakers of the 1930s contributed new techniques. In nineteenth-century lithography an artist drew his image with a waxy crayon directly on a special, finely grained piece of sandstone available from only one site in the world—Bavaria. Once the stone was wet with water, the only parts that would retain ink were the greasy pencil lines. Although "purist" lithographers of the 1930s still worked with stones, others bowed to practicality and to the new commercial technique of offset lithography. This allowed them to draw on zinc plates (textured with a pebbled surface to mimic the grain of sandstone) and to print on mechanical presses. Offset lithography proved especially popular in Los Angeles, encouraged by the commercial printer Lynton Kistler, who printed many of the plates made by local printmakers.

Many painters took up the newly fashionable medium. They already had the ability to draw, which lithography demands, and they hoped to supplement their meager incomes by tapping into a mass audience with the inexpensive multiples. Often they utilized the same themes they used in painting. As with handwriting, their drawing styles reveal authorship. One artist might express himself with line, while another, such as **Ivan Messenger** (1895–1983) of San Diego, who worked on stones, favored shading and toning. He used this to good effect in his humorous *Coronado*

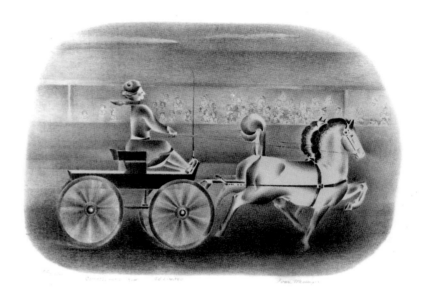

Fig. 17-5
Ivan Messenger (1895–1983)
Coronado Horse Show
lithograph
8½ x 12¾ in. (image)
G. Breitweiser

Horse Show (fig. 17-5). An element of 1930s art was humor, directed especially toward human foibles or, as in this case, toward the foibles of the rich. Wide ranges of grays and nuances of shading can be achieved by dragging a waxy crayon across the grain of a stone or the pebbled surface of a plate. This makes lithographs very different aesthetically from wood engravings and linoleum blocks that are restricted to solid colors and sharp edges.

"Plates" made for wood engravings and linoleum blocks depend on the principle of relief, that is, the background is cut away and the ink is applied to the parts of the plate left in relief. *Wood engravings* differ from *woodcuts* in that wood engravings are carved out of the end grain of a block of wood and are tight and precise, while woodcuts are cut from the long grain and are raw and expressive. Wood engravers of the 1930s followed commercial techniques established in the nineteenth century, but instead of printing on commercial presses, they pulled their prints by hand, one at a time, and issued them as individual art objects. Nationally, New York's Rockwell Kent (1882–1971) is the best-known wood engraver of the 1930s, but Los Angeles's **Paul Landacre** (1893–1963) has an almost equal reputation. Successful wood engravers required the mentality of an engineer and the patience and steady hand of a silver engraver. Understandably

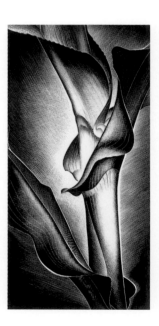

Fig. 17-6
Paul Landacre (1893–1963)
Growing Corn, 1938
wood engraving
9 x 4½ in.
Courtesy Claire de
Heeckeren d'Anthes and The
Estate of Paul Landacre
Photo: Wayne McCall

Fig. 17-7
George Hurrell (1904–1992)
Tyrone Power, Loretta Young,
1937
silver gelatin photograph
Courtesy Allan Rich

Fig. 17-9
Peter Stackpole (1913–1997)
*Untitled (Golden Gate Bridge
During Construction),* 1935
gelatin silver print
Ursula Gropper Associates,
Sausalito, California

the medium had few practitioners. Landacre's *Growing Corn* of 1938 (fig. 17-6) illustrates some techniques used by wood engravers. Parallel lines suggest the sweep of the leaf while crosshatching creates a textured background. One mistake, or slip, with the burin becomes noticeable, irreparable. In the printing, the goal is solid dense blacks to contrast with the pure white of the paper. Kent's work was very stylized, somewhat Art Decoratif; but Landacre, reflecting the different interests and attitudes in California, stayed with naturalism and the state's landscape.

Linoleum block "plates" can produce prints with the look of either wood engravings or woodcuts, depending on the way the linoleum is carved. Linoleum was invented in 1863 as a floor covering made up of ground cork, oxidized linseed oil, waterproofing resins, and colored pigments. It became widely used for prints in the 1930s because it was easier to carve than wood and because it didn't have a grain; it was also cheap and readily available.

Printmaking was promoted by government art projects, which distributed sets of the completed prints to libraries and other government institutions. Although printmakers were active throughout the state, at this writing, Southern California seems to have produced the greatest number and variety of prints as well as the most interesting works.

Photography
Several different styles of photography coexisted through the 1930s. The f.64 group that explored the German "straight" photography (chapter 12) continued to shoot natural objects—grains of sand, sections of fruit and vegetables, the human body, and landscapes. The decade also saw the rise of three important new categories, each the result of some practical need.

Hollywood glamour photography. Hollywood, which probably consumes more feet of 35mm movie film than any other center in the world, gave rise to a unique type of still photography—the publicity photo. As early as 1920 some motion picture studios recognized the need for their own photography departments to make still-portrait photographs of celebrities to answer a growing demand from movie fans. During the "Golden Years" of the studios (1925–40) photographers, epitomized by **George Hurrell** (1904–1992), created slick and iconic images. Discarding the 1920s fashion for Camera Pictorialist soft-focus portraits, Hurrell established a colder and cleaner look, reflecting the parallel style of Art Deco that was so popular with the studios. Combining such devices as "Rembrandt" lighting (highly contrasted areas of light and

shadow) with "butterfly" lighting (spotlights placed to produce a butterfly-shaped shadow under the subject's nose) and using his own invention, the portable boom light, he created photographs, such as *Tyrone Power, Loretta Young* of 1937 (fig. 17-7) that are at once sensitive and ruthless. Disinterested in psychology, Hurrell and other Hollywood still-portrait photographers strove for glamorous external appearances and the creation of idols that fans could worship.

Social documentary photography. A totally different kind of photograph resulted when **Dorothea Lange** (1895–1965) of San Francisco depressed her shutter. Some people joked that she couldn't shoot anything without trying to show its political implications. Her opportunity for greatness came in 1934, when her friendship with a young economics professor (whom she soon married) brought her into contact with the migrant farm workers of California's Central Valley. Equaling the power of John Steinbeck's well-known novel *Grapes of Wrath* are her photographs of the Okies, Arkies, and workers of Mexican background who streamed into California looking for jobs and who sweated among the rows of vegetables and grapes of California's agribusinesses. Compared to Hollywood's carefully posed glamour photographs, Lange's were spontaneous, real, humanist, and carried subtle social messages. In the now famous image *Migrant Mother, Nipomo* of 1936 (fig. 17-8, p. 208), she captured the despair felt by all migrant workers reduced to the bare essentials for survival, living out of their cars or in makeshift tents. Lange's Social Realist posits held little interest for Californians (New Yorkers by comparison were very Marxist) and were made possible only as a result of government funding.

Photojournalism. A special breed of photographer arose in the 1930s to supply illustrations for the media. While today we take paparazzi for granted, the profession of freelance or magazine photographer only came into being with the rise of photo-based periodicals such as *Life* (begun 1936) and *Look* (begun 1937). Photojournalism was facilitated by the newly popular use of miniature cameras (such as those that used 35mm movie film), which could be carried in the hand and had fast shutter speeds. These allowed photographers to escape their studios and capture ordinary people and events in natural and spontaneous situations. One of California's most famous photojournalists is **Peter Stackpole** (1913–1997), who began his career photographing the first stages of construction of the Golden Gate and Bay Bridges (1930–32). Photojournalists often risked their lives to get a shot as spectacular as Stackpole's *Untitled (Golden Gate Bridge During Construction)* of 1935 (fig. 17-9). In Hollywood by the late 1930s, Stackpole and other photojournalists soon eclipsed the glamour portraits of Hurrell and his compatriots with candid shots showing celebrities living average lives at home.

Artists and Hollywood

Hollywood! The word itself has worldwide significance and evokes many images: the crossed spotlights of a movie premiere, bleached-blonde actresses swathed in furs and jewels, limousines, cigar-chomping moguls, fast living, and glamour. Few realize that this giant and sometimes crass money machine was one of the greatest supporters of California art in the otherwise depressed 1930s.

Los Angeles got its start as a center for year-round filmmaking in 1909 when the Bison company began making "westerns" at Edendale (between Glendale and Los Angeles). The little town of Hollywood became important when the Nestor Film Company moved there from New Jersey in about 1911. In the preceding thirty years, most of the technical hurdles for the making of motion pictures had been overcome. Emulsions had been applied to celluloid, celluloid images were lined up on a strip of film, light was projected through film, film strips were advanced in a projector at forty frames a second, and images were projected on a screen. The first "Electric Theater" was opened in Los Angeles in 1902, and the first one-reeler with a sustained, suspenseful plot, *The Great Train Robbery*, was made in 1903.

From the earliest days, artists were crucial to the making of films. Although the first films were no more than shots of actors on stages taken by a stationary camera from the position of the audience, artists were needed to paint the flat backdrops and scenery. Soon, directors realized they could move the camera around the action, and artists were needed to design and build realistic three-dimensional sets; films began to be shot outdoors. In an attempt to improve the artistic quality of movies, filmmakers turned to the fine arts and to painting to borrow tricks of lighting, composition, dramatization, and so forth. Movie companies often hired visual artists to establish such things as camera positions and lighting. As movies became more complex by the mid-1920s, the position of art director came into being. Sometimes art directors were practicing artists and at other times artistically inclined individuals who oversaw a corps of painters, sculptors, draftsmen, set designers, costume designers, scene designers, as well as lighting and cameramen. Usually the art director gave an identifiable aesthetic to a film. In the 1920s and very early 1930s, for example, the "look" that many strove to achieve was romantic, sometimes dark and "Germanic." In the 1930s the "moderne" (i.e., the streamlined look of Art Decoratif) was preferred for movies about the wealthy, and in the 1940s the industry settled on naturalism. At every stage in the making of a film, artists produced original drawings and watercolors in the form of story boards, continuity sketches, set designs, costume designs, and so forth, many of which survive today in studio archives or with collectors. Before the late 1930s most of these draw-

Fig. 17-10
Alexander Golitzen (b. 1908)
Sketch for Metropolitan, 1933
charcoal and Wolf pencil
with white gouache
10 x 17 in.
Alexander Golitzen

Fig. 17-11
Disney Studios
*Night on Bald
Mountain/Fantasia*, before
1940
© Disney Enterprises, Inc.;
Courtesy Walt Disney
Archives, Burbank

Fig. 17-12
Disney Studios
Saludos Amigos, before 1943
© Disney Enterprises, Inc.;
Courtesy Walt Disney
Archives, Burbank

ings were in black and white, such as **Alexander Golitzen**'s (b. 1907) *Sketch for Metropolitan* of 1933 (fig. 17-10). With the perfection of color emulsions for films, sketches began to be executed in color. As sets became more expensive to build, painters began to paint matte shots—*trompe l'oeil* miniature backgrounds (often landscapes) which were photographed and then merged with a film of the foreground action. Special-effects artists were not far behind.

Animated films demanded a vast pool of artists. **Walt Disney** mounted national talent campaigns and then ran trainees through courses at Chouinard Art Institute to make their styles uniform. (Disney came to the financial rescue of the school in 1956 and over the next fifteen years took over its administration, finally merging it with music and theater interests. In 1971 it moved to a new campus in the "suburb" of Valencia, where it is known as the California Institute of the Arts.) In the 1930s Disney needed art directors, sketch artists, inkers, in-betweeners, and a number of other unusual sounding classifications to make character studies, model sheets, story continuity sketches, layouts, background paintings, and animation drawings. Employment with the studios supported many of Los Angeles's Regionalist-style painters, and the two disciplines were aesthetically reciprocal. For example, animation and expression seen in cartoon characters appeared in Regionalist watercolors and oils (chapter

18), while sophisticated styles flowing from the fine-arts community made Disney's "cartoons" into art works in their own right. Examples are the Teutonic *Night on Bald Mountain* sequence from *Fantasia*, released in 1940 (fig. 17-11), and the "Deco" *Saludos Amigos*, released in 1943 (fig. 17-12). Most motion picture and animation sketches were not signed by individual artists but were considered products of the studios, although experts can sometimes identify the artist who made a sketch by its drawing style.

Hollywood supported photographers of all kinds, from those who took still shots to those who wielded motion picture cameras. On their own time, many of these photographers made reputations as fine artists. One of the most inventive and one who had a sense of humor was **Will Connell** (1898–1961). His background in cartooning, advertising, and fine-arts photography merges in *Walt Disney* of 1935 (fig. 17-13). Connell manipulated his images both during photography and in the darkroom to achieve highly original results. Sculptors, too, were sometimes employed by the studios. **George Stanley** (1903–1973) was hired to give shape to the *Oscar* trophy of 1927 (fig. 17-14) that Metro-Goldwyn-Mayer's chief art director **Cedric Gibbons** (1893–1960) had sketched on a napkin in a local restaurant. It is in Hollywood's preferred style of the 1930s, the streamlined moderne, and represents a knight holding a crusader's sword, standing on a reel

Fig. 17-13
Will Connell (1898–1961)
Walt Disney, 1935
black and white print
41 x 34 cm.
Department of Special
Collections, University
Research Library, UCLA,
Call No. 893, Box 38

Fig. 17-14
Cedric Gibbons (1893–1960)
and George Stanley
(1903–1973)
Oscar, 1928
14 karat gold plate
10½ in. ht. + 3 in. base
Courtesy Academy of
Motion Picture Arts and
Sciences

of film. In the late 1930s and through the 1940s, Hollywood also hired well-known American painters from the East and the Midwest to create paintings that appeared either in films or in promotional material associated with films. The Surrealist Salvador Dali (1904–1989), for example, was employed by David Selznik to visualize the dream sequence for *Spellbound* of 1945 (Museum of Modern Art Film Stills Archives). Extensive publicity campaigns linked the reputations of these celebrated painters with Hollywood's in an attempt to overcome the movie colony's "nouveau" status.

There was continual social and economic interchange between the greater Hollywood community of

Fig. 17-15
Eloy Torrez (b. 1954)
Hollywood Boulevard, 1982
acrylic on canvas
60 x 50 in.
Collection of Lizardi/Harp,
Los Angeles

actors, producers, and technicians and the fine-arts community. Hollywood celebrities commissioned portraits, creating a late florescence of the painted portrait, which had been made obsolete by photography in the late nineteenth century. During Hollywood's Golden Years (1925–40) the movie community became a refuge for Los Angeles's artistic avant-garde, providing home and employment to many European refugees of modernist persuasion in music, writing, architecture, design, and painting. Actors, such as Vincent Price and Edward G. Robinson, developed some of Los Angeles's first important art collections; they socialized with painters; some were amateur painters themselves; and some actors liked the fine arts so much that they entered into partnership with art gallery owners. Elizabeth Taylor's father ran the Taylor Gallery in Beverly Hills, and Price as well as others ultimately bequeathed money and collections to museums in Los Angeles.

Ironically, as important as Hollywood was to the fine arts, it was rarely the subject *of* painters or sculptors. One would expect that Regionalists wanting to show the average man at work might have generated images of people making movies. It can only be guessed that Hollywood was too identified with glamour and wealth to qualify as blue-collar. Only a few images appear in watercolors, oils, or murals. Hollywood as a subject becomes fashionable only after 1960, when artists such as Ed Ruscha depict objects such as the Hollywood Hills sign (chapter 32). Since 1970 a nostalgia for early Hollywood as well as the fashion for appropriation has led increasing numbers of artists to reuse imagery identified with the film industry: portraits of celebrities, architecture and logos, and images from animated films, among other things. A pioneer is **Eloy Torrez** (b. 1954), whose *Hollywood Boulevard* of 1982 (fig. 17-15) places Marilyn Monroe on the curb of the famous Hollywood Boulevard sidewalk that is inset with star designs highlighted with the names of celebrities. Torrez also painted a mural composed of famous actors and actresses, *Legends of Hollywood,* that was unfortunately destroyed by the 1994 earthquake. In the 1990s a whole group of artists has arisen who paint narrative works using imagery from old Hollywood films, particularly animated, horror, science fiction, monster, and noir films of the 1940s (chapter 37).

Crafts (Ceramics)

Crafts grew closer to the fine arts as the twentieth century progressed. In the arena of ceramics Californians made unique contributions to the national scene in the 1930s. Two of Southern California's commercial ceramics factories, Bauer and Catalina, almost simultaneously came out with dinnerware in a revolutionary design. **Bauer Pottery**'s *California Pottery* (fig. 17-16), issued in a rainbow of solid-colored opaque glazes, was a distinct departure from the prissy, flower-decorated plates and cups in the European tradition available at the time. Proclaiming California sunshine and outdoor patio living, the line was an instant success. Its popularity derived from a depression-era willingness to adopt a more casual (and less expensive) lifestyle and from a romance associated with California living. Dinnerware could be purchased as sets or as individual pieces, and colors could be mixed. The innovation caught America's other potteries by surprise, most of them in the Midwest and on the East Coast. But with the commercial success of California's potteries, others soon began to emulate the look.

Apart from California's many commercial manufactories, the state had a thriving cottage industry making slip-cast figurines, inspired by the success of pioneers such as Brayton in Laguna Beach. Slip-cast pieces are made by mixing water and clay to a creamy consistency and then pouring the mixture into a plaster mold. Plaster has the property of absorbing water, leaving only the leathery clay. Demand for the products issuing from entrepreneurs' kitchens and garages in the 1930s and from professional manufactories in the 1940s exploded during World War II, when American gift shop owners were cut off from former sources in war torn Europe and Japan. They "discovered" the potteries of Southern California, especially the cluster in Laguna. Laguna's advantage was its great number of resident painters, some of whom turned their talents to hand-decorating the ceramics. Shapes ranged from cute little animals, to sweet or pretty ladies, or men in comedic situations. Some were updates of Oriental figurines or European porcelains. If one is looking for a very "California" example, then one can point to the Pinocchio figurines that Disney contracted Brayton Laguna Pottery to make. Or one can point to objects designed for these manufactories by some of the area's

Fig. 17-16
Bauer Pottery
Selection of early 1930s
Bauer Pottery
ceramic
Collection of Gary and
Caroline Kent

Fig. 17-17
Various California Potteries
Pinocchio figurines by Brayton
Laguna Pottery; *platter*
painted by Tyrus Wong
manufactured by Winfield
Pottery; *"Plated Lizard"*
modeled by Carl Romanelli
issued by Metlox Pottery
ceramic, painted
Pinocchio 4½ in. ht.; *Plated
Lizard* 3 in. ht.; *platter* 14 in.
diam.
Collection of Jack Chipman

219

artists from the fine arts community. In fig. 17-17, the platter was hand painted by **Tyrus Wong** (b.1910) and issued by Winfield Pottery; and the *Plated Lizard* was sculpted by **Carlo Romanelli** (1872–1947) for Metlox Pottery. The painter Dorr Bothwell (discussed with Post-Surrealism) made some humanoid vases in the mid-1930s for Gladding McBean, and the ceramic sculptress Susi Singer (1895–1949) made one-of-a-kind fanciful and joyous figurines. Although the items were decorative in intent, they were in essence sculptural, and they foreshadow California's great innovation of the 1960s—ceramic sculpture.

The advance of ceramics toward fine art was aided in the 1930s, when Federal Art Project programs taught ceramics, when a growing number of museums exhibited the work, and when professional publications began to discuss ceramic techniques and aesthetics. Two Californians made important beginning steps in the studio pottery movement that would peak after World War II. **Glenn Lukens** (1887–1967) of Orange County independently conducted experiments mixing raw materials obtained in California's Mojave and Death Valley Deserts with clays and glazes. His discoveries

shortened the firing process and revolutionized the commercial ceramics industry. The brightness of his crackle glazes over a white clay body, as shown in the two vessels in fig. 17-18, and his works' natural rawness and solid color, earned him first prize in the Fifth National Ceramic Exhibition at the Syracuse Museum in 1936. It was the first time a Californian had been so honored, and it marked the beginning of California ceramists as national contenders. Lukens was also known for his extra-thick glazes, and he was the first to *partially* glaze a vessel, leaving some of the clay body exposed. His "organic" look dominated after World War II. Albert H. King (1900-1982) was an independent experimenter who also worked closely with Los Angeles-area commercial ceramics manufactories. King, however, directed his energies to porcelain, a high-fire clay usually associated with Chinese ceramics or the commercial dinnerware industry. His best-known achievement is the ceramic-tile mosaic mural *Typical Activities of a Beach and Harbor City* of 1938 (fig. 20-18), sponsored by the Federal Art Project.

Golden Gate International Exposition (Treasure Island)

Historians find the Golden Gate International Exposition of 1939 (celebrating the completion of the Golden Gate and the San Francisco-Oakland Bay Bridges) a convenient event to end discussion of Depression-era art. Although the Great Depression had been a severe trial, by fostering American isolation and introspection it caused Americans to look at and gain respect for their own achievements. The Golden Gate International Exposition reflected this break from Europe by rejecting the Beaux-Arts style of architecture for the newer Art Decoratif style and by taking its mural and sculptural themes not from Greek mythology but from the ancient and ethnic cultures of the New World and the Pacific Rim.

The Golden Gate International Exposition also worked to take art off its pedestal and tried to make it understandable to the average person through a series of continuing, on-site demonstrations. WPA artists, for example, spent the duration of the exposition completing three large-scale projects: Herman Volz's (1904–1990) great mosaic mural, Diego Rivera's fresco mural, and Fred Olmsted's (b. 1911) carved limestone

Fig. 17-18
Glenn Lukens (1887–1967)
Two bowls: White crackle glaze and Blue crackle glaze (latter before 1937)
ceramic
3⅜ in ht. x 6⅞ in diam.;
4½ in. ht. x 9 in. diam.
Gary Keith

sculpture. Artists, the WPA contended, were not beings apart, patronized by a wealthy elite class and unable to fit into normal society but normal people intensely interested in giving material expression to their feelings. Even in an age of machines and mass production, artists were necessary to society.

The fair brought together famous paintings and sculpture from around the world valued at more than $20,000,000. Differing from earlier displays of art, the European paintings were not presented as objects of reverence and admiration but rather to allow comparison with the American and Californian accomplishments. These were contained in a show of American paintings (that included some California artists), a survey of California art from 1850 to 1915, and a show called *Contemporary California Art*. The country's interest in America's own achievements and how they measured up to Europe's had been growing since the mid-1930s when American museums began to mount some of the first retrospective shows of American art. They assessed its character, tried to define its particular qualities, and sought to determine whether America had made a contribution to world art. The work shown at the Golden Gate International Exposition, however, had been selected by conservative juries and consisted primarily of Regionalist art, even the so-called Contemporary American and California Art shows. Thus, it was not a true measure of California's avant-garde. Critics could say only that, compared to the stylistic advances of the Europeans, Americans had achieved a fair portrait of their people, adding that the California section was "up to date."

The next few chapters will address the various painting styles and themes that arose in the 1930s. Most of this art is Regionalist/American Scene. Regionalist art has mass appeal because it depicts the lives of the average American, and it allows today's Californians to see how those of the 1930s lived out the hard years of the Depression. But parallel to this ran a small strain of modernism. Although the modernists rocked the status quo, their work provided a crucial foundation for California's important post-World War II modernist movements. Both will be introduced in the next chapter. ✠

Bibliography

Infrastructure 1930–1945

Art Lover's Club of Metropolitan Oakland, California, Records [ca. 1937-1982], archival material contained in the Bancroft Library, University of California, Berkeley.

Art of Our Time: Dominant International Trends Painting and Sculpture in the Bay Region, Growth of Museum Collections 1935–1945, San Francisco Museum of Art, 1945. 56 p.

Baird, Joseph Armstrong, Jr., ed., *The Development of Modern Art in Northern California, Part II: From Exposition to Exposition: Progressive and Conservative Northern California Painting, 1915–1939*, Sacramento, Ca.: Crocker Art Museum, 1981.

"California Museums, Art Associations and Other Organizations," in *American Art Annual*, New York: MacMillan Co., 1898-1948.

Gardena High School Art Collection, exh. cat., Art Gallery, California State University, Dominguez Hills, January 1999.

Kamerling, Bruce, *100 Years of Art in San Diego*, San Diego: San Diego Historical Society, 1991. 108 p.

Lewis, Oscar, *To Remember Albert M. (Mickey) Bender*, Oakland: R. Grabhorn and A. Hoyem, 1973. 37 p.

The Making of a Modern Museum: San Francisco Museum of Modern Art, San Francisco: Museum of Modern Art, 1994.

Moure, Nancy Dustin Wall, *Painting and Sculpture in Los Angeles 1900–1945*, exh. cat., Los Angeles County Museum of Art, September 25–November 23, 1980.

Moure, Nancy, "The Struggle for a Los Angeles Art Museum, 1890–1940," [L. A. Art Association] *Southern California Quarterly*, v. LXXIV, no. 3, Fall 1992, pp. 247–75.

Selections from the Drawing and Watercolor Collection, exh. cat., Mills College Art Gallery, Oakland, February 1972. 111 p.

Southern California Competitive Festival of the Allied Arts, Music, Drama, Dance, Art, Poetry, sponsored by the Women's Community Service Auxiliary of the Los Angeles Chamber of Commerce, Los Angeles, 1934. 32 p.

Sculpture

duPont, Diana C., Katherine Church Holland, Garna Garren Muller, and Laura L. Sueoka, *San Francisco Museum of Modern Art: The Painting and Sculpture Collection*, New York: Hudson Hills Press, 1985.

Kamerling, Bruce, "Early Sculpture and Sculptors in San Diego," *Journal of San Diego History*, v. XXXV, no. 3, Summer 1989, pp. 148–205.

Kamerling, Bruce, *100 Years of Art in San Diego*, op. cit.

Kath, Laura, *A Place for the Living*, Glendale, Ca.: Forest Lawn Memorial Park Association, 1994. 79 p.

Katz, Bernard S., *Fountains of San Francisco*, Lagunitas: Lexikos/Don't Call It Frisco Press, 1989. 139 p.

Moure, Nancy Dustin Wall, *Painting and Sculpture in Los Angeles 1900–1945*, op. cit.

100 Years of California Sculpture, exh. cat., The Oakland Museum, August 7–October 17, 1982.

Painting and Sculpture in California: the Modern Era, exh. cat., San Francisco Museum of Modern Art, September 3–November 21, 1976 and National Collection of Fine Arts, Washington, D. C., May 20–September 11, 1977.

Peterson, Richard H., "Junipero Serra and Thomas Starr King: California's Statuary Monuments in Washington, D. C.," *Southern California Quarterly*, v. LXXV, Spring 1993, pp. 65-84.

Regnery, Dorothy F., *The Serra Statue at the Presidio Monterey*, n. p., n. d. 53 leaves.

Printmaking, American

Acton, David, *A Spectrum of Innovation: Color in American Printmaking 1890–1960*, New York: W. W. Norton & Co., 1990.

Watrous, James, *A Century of American Printmaking 1880–1980*, Madison: University of Wisconsin Press, 1984.

Printmaking, California

Fifty Years of California Prints 1890–1940, exh. cat., Annex Galleries, Santa Rosa, March 6–April 16, 1983. 14 p.

Fifty Years of California Prints 1900-1950 [second annual exhibition], exh. cat., Annex Galleries, Santa Rosa, June 2–July 21, 1984. 16 p.

Fifty Years of California Prints 1900–1950 [third annual exhibition], exh. cat., Annex Galleries, Santa Rosa, December 1986.

Fifty Years of California Prints 1900–1950 [fourth exhibition], exh. cat., Annex Galleries, Santa Rosa, November 1997. 20 p.

Los Angeles Prints 1883–1980, essays by Ebria Feinblatt and Bruce Davis, exh. cat., Los Angeles County Museum of Art, Part I (1883-1959), September 4–November 30, 1980 and Part II (1960-1980), June 25 - September 20, 1981.

Sandback, Amy Baker, "Galka Scheyer: Print Emissary," *The Print Collector's Newsletter*, v. XXI, no.1, March-April 1990, pp. 47-49.

Lithographs

Adams, Clinton, "Lynton R. Kistler and the Development of Lithography in Los Angeles," *Tamarind Papers I*, Winter 1977–78, pp. 100–109.

Edelstein, J. M., ed., *A Garland for Jake Zeitlin*, Los Angeles: Grant Dahlstrom and Saul Marks, 1967.

Peters, Mary T., "The Lithographs of California," *Prints*, v. 5, March 1935, pp. 1-9.

Wood engravings

Print Makers Society of California Newsletter, v. 1–15, 1922–1938. [copies at Pasadena Public Library]

Photography

Clark, Orville, *FAP Photography in Los Angeles*, in process.

Documenting America, 1935–1943, ed. by Carl Fleischhauer and Beverly W. Brannan, Berkeley: University of California Press, 1988.

Fulton, Marianne, ed., *Eyes of Time: Photojournalism in America*, Boston: Little, Brown, 1988, organized by the International Museum of Photography at George Eastman House, Rochester, N. Y. 326 p.

Picturing California: A Century of Photographic Genius, exh. cat., San Francisco: Chronicle Books in association with The Oakland Museum, August 26–November 5, 1989.

Southern California Photography, 1900-65: An Historical Survey, exh. cat., organized by The Photography Museum, exhibited at Los Angeles County Museum of Art, December 18, 1980–March 15, 1981. 24 p.

Street, Richard Steven, "Paul S. Taylor and the Origins of Documentary Photography in California, 1927–1934," *History of Photography*, v. 7, October/December 1983, pp. 293–304.

Street, Richard Steven, "Salinas on Strike," [1936 news photos], *History of Photography*, v. 12, no. 2, April–June 1988, pp. 165-74.

Watkins to Weston: 101 Years of California Photography 1849–1950, exh. cat., Santa Barbara Museum of Art in Cooperation with Roberts Rinehart Publishers, February 29 - May 31, 1992 and two other venues.

(See also the general books cited in earlier chapters and under Hollywood photography below.)

Hollywood
Art of Film

Arts of Southern California III: Art in Film, exh. cat., Long Beach Museum of Art, May 1958.

Campbell, Russell, *Cinema Strikes Back—Radical Filmmaking in the U. S. 1930–1942*, Ann Arbor, Mi.: UMI Research Press, 1982.

Higham, Charles, *Hollywood Cameramen*, Bloomington: Indiana University Press, 1970.

Hurlimann, Annemarie, ed., *Film Stills: Emotions Made in Hollywood*, exh. cat., Museum fur Gestaltung, Zurich, 1993.

Maltin, Leonard, *The Art of the Cinematographer*, New York: Dover, 1978.

Moritz, William "Visual Music and Film-as-an-Art before 1950," in Paul Karlstrom, ed., *On the Edge of America: California Modernist Art 1900–1950*, Berkeley: University of California Press, 1996, pp. 211–42.

"Motion Pictures," in *American People's Encyclopedia*.

Norden, Martin, "Film and Painting," in Gary R. Edgerton, ed., *Film and the Arts in Symbiosis*, New York: Greenwood, 1988.

Rosen, Robert, "Notes on Painting and Film" in Kerry Brougher, *Art and Film Since 1945: Hall of Mirrors*, Museum of Contemporary Art, Los Angeles and Monacelli Press, New York, 1996.

Slide, Anthony, ed., *The Best of Rob Wagner's Script*, Metuchen, N. J.: Scarecrow Press, 1985.

Wagner, Rob, *Picture Values from an Artist's Viewpoint*, Hollywood, Ca.: Palmer Photoplay Corp., 1923.

Art Directors

Barsacq, Leon, *Caligari's Cabinet and Other Grand Illusions: A History of Film Design*, Boston: New York Graphic, 1976.

Bigwood, James, "Solving a Spellbound Puzzle [Salvador Dali designed dream sequence in Hitchcock's film]," *American Cinematographer*, v. 72, June 1991, pp. 34–40.

Drawing into Film—Director's Drawings, exh. cat., Pace Gallery, New York, March 26–April 24, 1993.

Hagopian, Kevin J., "The Future in the Past: Hollywood and the Art Deco Utopia," *Quarterly Review of Film and Video*, v.11, October 1989, pp. 93–97.

Haver, Ronald, *David O. Selznick's Hollywood*, New York: Alfred A. Knopf, 1980.

Heisner, Beverly, *Hollywood Art: Art Direction in the Days of the Great Studios*, Jefferson, N. C.: McFarland & Co., 1990.

LoBrutto, Vincent, *By Design: Interviews with Film Production Designers*, Westport, Ct.: Praeger, 1992.

"Motion Picture Studio Sketches" and Herbert Ryman, "Artist-Designers in Hollywood's Motion Picture Studios," in Nancy Dustin Wall Moure, *Drawings and Illustrations by Southern California Artists before 1950*, exh. cat., Laguna Beach Museum of Art, August 6–September 16, 1982, pp. 25–28 and pp. 38–42.

Schultheiss, John, "The Noir Artist," *Films in Review*, v. 40, January 1989, pp. 33–35.

"Set Design" in *The Film Index: A Bibliography* (WPA Writer's Project), v.1, 1941.

Thames Television's *The Art of Hollywood: Fifty Years of Art Direction*, exh. cat., Victoria & Albert Museum, 1979.

Webb, Michael, "Cedric Gibbons and the MGM Style," *Architectural Digest*, v. 47, April 1990, p.100+.

Costume Design

Bailey, Margaret J., *Those Glorious Glamour Years*, Secaucus, N. J.: Citadel Press, 1982.

Maeder, Edward, org., *Hollywood and History: Costume Design in Film*, Thames and Hudson in conjunction with Los Angeles County Museum of Art, 1987.

McConathy, Dale, *Hollywood Costume: Glamour, Glitter, Romance*, New York: H. N. Abrams, 1976.

Motion Picture Posters

Basten, Fred E., *The Lost Artwork of Hollywood: Classic Images from Cinema's Golden Age*, New York: Watson-Guptill,

1996.

Kobal, John, *50 Years of Movie Posters*, New York: Bounty, 1973.

Morella, Joe, et al., *Those Great Movie Ads*, New Rochelle, N. Y.: Arlington House, 1972.

Rebello, Stephen, *Reel Art, Great Posters From the Golden Age of the Silver Screen*, New York: Abbeville Press, 1988.

Animation Art

Beck, Jerry and Will Friedwald, *Warner Brothers Animation Art*, Southport, Ct.: Hugh Lauter Levin Assoc., 1997. 240 p.

Bendazzi, Giannalberto, *Cartoons: One Hundred Years of Cinema Animation*, Bloomington and Indianapolis: Indiana University Press, 1994.

Canemaker, John, *Drawings for Animated Films 1914–1978*, New York: Drawing Center, 1978.

Canemaker, John, *Before the Animation Begins: The Art and Lives of Disney Inspirational Sketch Artists*, New York: Hyperion, 1996.

Canemaker, John, *Treasures of Disney Animation Art*, New York: Abbeville, 1982.

"The Dream Makers Cash In," in Robert Perine, *Chouinard: An Art Vision Betrayed*, Encinitas, Ca.: Artra, 1985. [discusses Disney's take-over/bail out of Chouinard and turning it into Cal Arts]

Finch, Christopher, *The Art of Walt Disney*, New York: Abrams, 1973.

Heraldson, Donald, *Creators of Life: A History of Animation*, New York: Drake Publishers, 1975.

Hoffer, Thomas W., *Animation: A Reference Guide*, Westport, Ct.: Greenwood Press, 1981.

Horn, Maurice, *World Encyclopedia of Cartoons*, New York: Chelsea House, 1980.

Lotman, Jeff, *Animation Art: The Later Years, 1954–1993*, Alglen, Pa.: Schiffer Publ., Ltd., 1996. 420 p.

Schneider, Steve, *That's All Folks! The Art of Warner Brothers Animation*, New York: H. Holt, 1988.

Sennett, Ted, *The Art of Hanna-Barbera: Fifty Years of Creativity*, New York: Viking, 1989.

Solomon, Charles, *The Disney that Never Was: The Stories and Art from Five Decades of Unproduced Animation*, New York: Hyperion, 1995.

Solomon, Charles, *Enchanted Drawings: The History of Animation*, New York: Knopf, 1989.

Thomas, Frank and Ollie Johnston, *Disney Animation: The Illusion of Life*, New York: Abbeville, 1981. 575 p. [Written by long term (1930s–1978) animators; inside story of the development of animation technology.]

Walt Disney's Snow White and the Seven Dwarfs: An Art in Its Making—Featuring the Collection of Stephen H. Ison, Martin Krause and Linda Witkowski, Indianapolis Museum of Art, 1994. 194 p.

Hollywood Portrait Photographers

Fahey, David and Linda Rich, *Masters of Starlight: Photographers in Hollywood*, exh. cat., Los Angeles County Museum of Art, 1987.

Hollywood, Hollywood: Identity Under the Guise of Celebrity, exh. cat., Pasadena Art Alliance, October 20–December 20, 1992. 88 p.

Kobal, John, *The Art of the Great Hollywood Portrait Photographers 1925–1940*, New York: Knopf, 1980.

Hollywood Art, Miscellaneous

(See also, extensive bibliography in Footnote 43 in Nancy Dustin Wall Moure, *Drawings and Illustrations by Southern California Artists before 1950*, exh. cat., Laguna Beach Museum of Art, August 6–September 16, 1982, pp. 30–31.)

Brosnan, John, *Movie Magic: The Story of Special Effects in the Cinema*, New York: St. Martin's Press, 1974.

Doss, Erika Lee, *Regionalists in Hollywood: Painting, Film, and Patronage, 1925–1945*, Ph.D., University of Minnesota, 1983.

Hollywood Collects, An Exhibition from April 5—May 15, 1970, exh. cat., Otis Art Institute, Los Angeles, 1970. 176 p.

Kahan, Mitchell Douglass, "Corporate Collecting and American Art," in *Art Inc., American Paintings from Corporate Collections,* exh. cat., Montgomery, Alabama: Montgomery Museum of Fine Arts, 1979. [late 1930s and 1940s corporations that collected art]

McMullan, Jim and Dick Gautier, *Actors as Artists,* Boston: Charles E. Tuttle, 1992.

Creative Exiles in World War II Hollywood

Artists in Exile 1939–46: USA, Paris: American Center for Students and Artists, 1968.*

Barron, Stephanie, ed., *Exiles + Émigrés: The Flight of European Artists from Hitler,* exh. cat., Los Angeles County Museum of Art, February 23–May 11, 1997 and two other venues. 432 p.

Heilbut, Anthony, *Exiles in Paradise: German Refugee Artists and Intellectuals in America, from the 1930's to the Present,* New York: Viking, 1983.

Horak, J. C., "Palm Trees were Gently Swaying: German Refugees from Hitler in Hollywood," [writers, movie directors, actresses] *Image,* v. 23, June 1980, pp. 21–32.

Horak, Jan-Christopher, *Middle European Émigrés in Hollywood,* Beverly Hills, Ca.: American Film Institute Oral History, 1977.

Merrill-Mirsky, Carol, ed., *Exiles in Paradise,* [musicians, architects, writers] exh. cat., Hollywood Bowl Museum, Los Angeles Philharmonic Association, 1991.

Taylor, John Russell, *Strangers in Paradise: The Hollywood Émigrés 1933–1950,* New York: Holt, Rinehart and Winston, 1983.

Hollywood as a Subject for Fine Arts

Deen, Georganne and Charles Desmarais, "The Take of the Town," [modern art addressing Hollywood lifestyle], *Grand Street,* v. 13, no. 1, Summer 1994, pp. 23+.

Doss, Erika L., "Edward Hopper, Nighthawks, and Film Noir," *Post Script: Essays in Film and the Humanities,* v. 2, no. 2, Winter 1983, pp. 14–36.

Doss, Erika L., "Paramount Pictures: Reginald Marsh and the Image of the American Woman in the 1930s," *American Studies Exchange,* v. 1, no. 2, Fall 1982, pp. 3–11.

Doss, Erika Lee, *Regionalists in Hollywood: Painting, Film, and Patronage, 1925–1945,* Ph.D., University of Minnesota, 1983.

Lee, Doris, "Hollywood Gallery, A Painter's Portfolio of Impressions of Movie City," *Life,* v. 19, no. 16, October 15, 1945, pp. 84–89.

Santa Monica Library Murals, Los Angeles: Angelus Press, 1935. [re: Stanton MacDonald Wright images of Hollywood]

"Speaking of Pictures: Actor's Drawings Satirize Hollywood," *Life,* v. 16, no. 8, February 21, 1944, pp. 12-14.

Steen, Ronald E., *Hollywood: The Muse: Motion Picture Imagery in Art,* exh. cat., Palos Verdes Art Center, June 29–August 22, 1984.

Thomson, David, "Hockney's Hollywood," *Film Comment,* v. 25, no. 4, July/August 1989, pp. 53+.*

"A Tour of Hollywood Drawings by Thomas Benton," *Coronet,* 7, no. 4, February 1, 1940, p. 34.*

Crafts: Ceramics

(See also ceramics in Laguna during WWII in Nancy Moure, "History of the Laguna Beach Art Association," in *Publications in Southern California Art 4, 5, 6, 7,* Los Angeles: Privately Published, 1998.)

Chipman, Jack, *The Collector's Encyclopedia of Bauer Pottery,* Paducah, Ky.: Collector Books, 1997.

Chipman, Jack, *Collector's Encyclopedia of California Pottery,* Paducah, Ky.: Collector Books, 1992.

Chipman, Jack, *The Collector's Encyclopedia of California Pottery* (Second Edition), Paducah, Ky.: Collector Books, 1998.

Golden Gate International Exposition, San Francisco, *Decorative Arts: Official Catalogue,* San Francisco: San Francisco Bay Exposition Co., 1939.

Kardon, Janet, ed., *Craft in the Machine Age 1920–1945,* New York: Harry N. Abrams, Inc., in assoc. with the American Craft Museum, 1995.

Schneider, Mike, *California Potteries, the Complete Book,* Atglen, Pa.: Schiffer Publ. Ltd., 1995. 239 p.

Southern California Industrial Ceramics, Part II: 1927–1942, Southern California Pottery, exh. cat., Downey Museum of Art, March 12–April 30, 1978. Approx. 40 p. mimeographed

(See also general books on ceramics cited in earlier chapters.)

Golden Gate International Exposition

"Expositions," in *American People's Encyclopedia.*

Frankenstein, Alfred, "Art on Treasure Island: The Obituary of an Art Era," *San Francisco Chronicle, This World,* October 29, 1939, p. 25.

French, Patricia Sheldahl, "California Painting at the Golden Gate International Exposition," in Joseph Armstrong Baird, Jr., ed. *From Exposition to Exposition,* exh. cat., Crocker Art Museum, Sacramento, 1981, pp. 61–70.

Golden Gate International Exposition, San Francisco, Art: Official Catalogue: [contains "California Art in Retrospect - 1850-1915" and "California Art Today,"] San Francisco: San Francisco Bay Exposition Company, 1940.

Golden Gate International Exposition, San Francisco, Illustrated Catalogue: Art Exhibition by California Artists in the California Building, exh. cat., February 18–December 2, 1939.

James, Jack and Earle Weller, *Treasure Island: "The Magic City," 1939–1940: The Story of the Golden Gate International Exposition,* San Francisco: Pisani Printing and Publishing Co., 1941.

Neuhaus, Eugen, *The Art of Treasure Island: First-hand Impressions of the Architecture, Sculpture, Landscape Design, Color Effects, Mural Decorations, Illumination and Other Artistic Aspects of the Golden Gate International Exposition of 1939,* Berkeley: University of California Press, 1939.

Schnoebelen, Anne, "Relics of Ephemeral Glory: the Treasure Island Murals of Maynard Dixon," *Art of California,* v. 5, no. 4, September 1992, pp. 53–55.

Fig. 18-5
Maynard Dixon (1875–1946)
Forgotten Man, 1934
oil on canvas, 40 x 50 in.
© Courtesy Museum of Art,
Brigham Young University.
All Rights Reserved
Photo: David W. Hawkinson

Modernism and American Scene Oil Painting

Modernism

Why start a chapter on American Scene art with a discussion of modernism? And, what is modernism?

"Modernism" can be a very confusing term since it can mean so many different things. Writers have used it to signify the whole history of Western art since about 1840; to describe the various abstract or non-representational styles conceived in Western Europe between 1906 and 1914; to describe the art period in America between 1945 and 1970; and even to describe any style that is an advance over the previous mainstream style.

In the first decade of the twentieth century, America had one "modernist" who had arrived at his style free of any influence from Europe, where most of the modern styles were born. That artist was Robert Henri (1865–1929) of New York. His "modernism" was conservative in that it remained representational, but it was "modern" in its expressive brushwork and its experimentation with the properties of color. Henri's primary impact in California was on Southern California's Post-Impressionists (chapter 14). Closest aesthetically and spiritually to Henri was San Francisco's **Frank Van Sloun** (1879–1938). In his *The Critics* of about 1920 (fig. 18-1) is seen Henri's expressive brushwork, his brown/white color scheme, an "Ash Can" interest in average people, and humor.

The most avant-garde "modern" ideas were generated in Europe. Impressionism and Post-Impressionism started the move away from representationalism and illusionism by interpreting reality with light, color, and brushwork, but it was the various modern styles that arose between about 1906 and 1913 that took the definitive steps into nonobjectivity. Artists such as Pablo Picasso, Giacomo Balla, and Franz Marc were feature players in the styles now known as French Cubism, Italian Futurism, and German Expressionism. In turn, their breakthroughs led to the most nonobjective forms of all—paintings *totally without subject matter*, such as the flat lines and squares of artists like Piet Mondrian and Kazimir Malevich. When paintings enter the realm of the nonobjective they can no longer be described in the traditional terms of perspective, illusion, and theme, to name a few. Modernism is discussed in "formal" terms, i.e., using the formal aesthetic rules that guided the painting's arrangement of line, color, and shapes. The terms "formal," "formalism," "formalist," etc., appear with greater frequency through the twentieth century as the production of nonobjective art increases and is discussed.

A few American artists who had studied in Europe or seen Europe's advanced work in the Armory Show of 1913 were inspired to follow similar directions. But most artists soon found that abstraction simply did not reflect the American experience. Almost the only pre-World War I American for whom abstraction was such a natural thing that he (along with Morgan Russell, 1886–1953) invented an abstract style as important as those invented by the French was the Californian **Stanton MacDonald Wright** (1890–1973). Wright's early study took place at Los Angeles's Art Students League, a night class for sketching from nude models, which in the 1910s and 1920s became the center of Los Angeles's avant-garde art world. In 1909 he traveled to Paris for further study. He arrived at a time when styles such as Impressionism, Fauvism, Pointillism, Neo-Impressionism, and Cubism were widely practiced and when artists in the avant-garde were pursuing still other

Fig. 18-1
Frank Van Sloun
(1879–1938)
The Critics, c. 1920
oil on canvas, 22 x 28 in.
The Delman Collection, San Francisco

directions. Wright took up study with the Canadian Ernest Percyval Tudor-Hart (1911–13), who taught that a mathematical analogy existed between color and music. In the class, Wright met another aspiring modernist, Morgan Russell. Collaborating, the two painters arrived at Synchromism.

Most new styles build on older styles. Wright and Russell were both intrigued with Cezanne's idea of creating structured solidity out of color rather than with shading or perspective. Taking advantage of the psychological fact that red and yellow seem to approach the viewer while blue recedes, they used colors to model both still-life objects and human figures derived from Michelangelo's heavily muscled, robust, twisted bodies. Wright's and Russell's French contemporaries Sonia and Robert Delaunay argued that Synchromism was no different from Orphism, which the Delaunays had invented earlier. But, Synchromism's intent was to use color to create recognizable three-dimensional forms on the canvas, while Orphism created flat, rhythmic abstract shapes. The purest examples of Synchromism are found in the work that Wright and Russell exhibited at their debut in Germany in 1913. Inveterate experimentalists, like most modernists, they moved on quickly to other variations. After Wright returned to New York in 1914, he produced a number of works that have proved the most appealing to collectors. As in *The Muse* of 1924 (fig. 18-2) these are male and female figures shaped by prismatic rainbows on a white background. These reject the weighty blue/yellow/red coloration of 1913 and even introduce line at key points to suggest contours.

Fig. 18-2
Stanton MacDonald Wright
(1890–1973)
The Muse, 1924
oil on canvas, 30 x 25 in.
Harriette & Gerald Goldfield
Photo: Matt Goldfield

Wright returned to Southern California in 1919 to find his old "school," the Art Students League, still the center of Los Angeles's avant-garde. After a brief period of leadership under the Symbolist Rex Slinkard (chapter 8) (1910–13) the league had been headed through most of the 1910s by the now little-known Val Costello (1875–1937). Wright assumed leadership in 1923, and his magnetic personality and international reputation led to the school's expansion from a handful of friends who met three nights a week to a full-fledged art school with a branch in San Pedro by 1929. Wright's contribution after 1919 seems to be as a teacher and, in the 1930s, as one of two heads of the local Federal Art Project. His followers can be identified by their adoption of his rainbow coloration and sinuous line.

Apart from Wright, modernism based on European prototypes hung on by a thread in California. In the early teens, a few resident artists excited by European ideas essayed some of the styles. Their ranks were supplemented by the arrival of European-born and trained modernists fleeing World War I. Through the 1920s most of these modernists worked without any community appreciation, supporting themselves at some non-art occupation and pursuing their solitary quests in the evenings and on weekends. But Wright's presence galvanized those in Los Angeles, and in 1923 several local modernists joined to exhibit, calling themselves the Group of Independent Artists. Included were the longtime Los Angeles residents Nick Brigante (1895–1989) and Val Costello, pre-World War I arrival Lawrence Murphy (1872-1947), and several Europeans who had immigrated after the war, including Ben Berlin (1887–1939), Boris Deutsch (1892–1978), and Peter Krasnow (1886-1979). There was no group aesthetic; typical of modernists, who tend to be loners and experimenters, each man was exploring his own artistic line of thought inspired by Expressionism, Cubism, Symbolism, or any number of color theories. Only their common interest in experimentation held them together. After a tepid public response, the group never exhibited together again. Working apart from their group, but also interested in Cubism, was Knud Merrild (1894–1954).

Museums are expected to be the arbiters of taste and to support the avant-garde. Although Los Angeles's only museum was receiving gifts of "contemporary" American and French paintings from its benefactor William Preston Harrison, these acquisitions were stylistically conservative. The museum did hold a few exhibits of modern art: in 1920 a show of American modernists, for whose tiny catalogue Stanton MacDonald Wright wrote an introduction; in 1921 an

exhibit of five artists who were to later join The Group of Independent Artists; and in 1923, a traveling exhibition of contemporary French artists (primarily of the conservative and representational variety). However, the greatest support in Los Angeles for the most avantgarde of the European products came from Louise and Walter Arensberg, wealthy collectors of the work of artists such as Marcel Duchamp, the painter of *Nude Descending a Staircase, No. 2* of 1912 (Philadelphia Museum of Art). The Arensbergs began visiting Los Angeles in 1921 and finally took up residence in Hollywood in 1927. They allowed people to view their collection, and they hosted "salons" for others of like mind. Of the many galleries that flourished in Los Angeles's prosperous twenties, two specialized in modern art—the Stone International Gallery in suburban Monrovia (established 1925) and the Salon of Ultra Modern Art, established by the wife of artist Frank C. Wamsley (1879–1953) in their Hollywood residence in January 1929. In 1929 Galka E. Scheyer (1889–1945), a teacher, lecturer, playwright, painter, and friend and promoter of the German group the Blue Four settled in Hollywood. Scheyer originally traveled to Los Angeles to put on a show of the Blue Four at the Braxton Gallery of Hollywood. Her permanent move from the Bay Area was probably prompted by her realization that in Hollywood's moneyed atmosphere and its enclave of European intellectual refugees from World War I she would find a more fertile soil for sales of Blue Four paintings.

Although Bay Area institutions put on a great outward show of supporting modern art, the area had a negligible number of practicing abstractionists. In the post-exposition years and before 1930, two separate art communities led parallel lives—one in San Francisco and the other in Oakland and Berkeley. In San Francisco the rise of modernism split the art community into two groups—the conservatives who associated themselves with the Bohemian Club and the more experimental artists who settled in the inexpensive North Beach area and associated with the more avant-garde galleries. By 1919 the peninsula boasted the art critic Willard Huntington Wright (brother to Los Angeles's Stanton MacDonald Wright), who was sympathetic to and promoted modern art in his weekly column in the *San Francisco Bulletin.* In the early 1920s the California School of Fine Arts (renamed from the San Francisco Art Institute in 1917) dismissed the academics on its staff and took on some Post-Impressionist artists who had recently returned from European training. And, in 1925, Beatrice Judd Ryan created Galerie Beaux-Arts specifically to showcase San Francisco's more stylistically progressive artists.

San Francisco's museums frequently and proudly showed the work of European modernists.

Meanwhile, Gertrude and Leo Stein, who had grown up in Oakland, were advancing modern art at their residence in Paris (1903–13). They purchased art from many of the city's most stylistically radical artists, including Cezanne, Gauguin, Matisse, and Picasso, and held influential salons that introduced their American friends to the Parisian modernists. While neither Stein permanently returned to the United States—Gertrude lived on in Paris and Leo moved to Settignano, Italy—their brother Michael and his wife, Sarah, who joined them in 1903, did return. In 1906, 1911, and then permanently in 1935, Michael and Sarah Stein brought with them canvases by Matisse and others. At their Palo Alto home they established a "salon" for intellectuals. This atmosphere, however, did not generate a school of San Francisco painters in the European modernist vein. Only a few peninsula artists of the 1920s, including Lucien Labaudt (1880–1943), Hamilton Wolf (1883–1967), and **Yun Gee** (1906–1963), experimented with some of the European modernist styles. Gee's *San Francisco Chinatown* of 1927 (fig. 18-3) shows the eclectic way Americans assimilated European modernist styles. His painting's color is bright and Fauvist; it has the emotional distortion of German Expressionism; and it is crafted with the prismatic parallel brush strokes associated with Picasso's and Braque's Cubism.

Fig. 18-3
Yun Gee (1906–1963)
San Francisco Chinatown,
1927
oil on paperboard, 11 x 16 in.
Collection of the Oakland
Museum of California, Gift
of Mrs. Frederick G. Novy, Jr.

Meanwhile, in Oakland, William Clapp's sympathy for modernism led him to invite Galka Scheyer, then on the East Coast, to give the Blue Four its first museum showing on the West Coast, in 1925. The center for European-style modernism in the Bay Area is usually cited as the University of California at Berkeley. The University had been slow to establish an art department. While it had always found drawing courses crucial for students in architecture and engineering classes, the creation of an actual art department was stalled in the late nineteenth century when the university looked upon the Mark Hopkins Art Institute as its department. In the first two decades of the twentieth century various art courses were tucked into other disciplines, such as engineering, graphic arts, and domestic arts by an administration that did not feel that "art" (except for art history) was a valid university subject. In 1923 the Department of Drawing and Art was finally founded. In a decade when Post-Impressionism was raging in California, the university art department took on several teachers of European modernist persuasion. Guest Wickson (1888–1970) had returned from Europe in 1919 impressed with Picasso. Worth Ryder (1884–1960) arrived in 1926 fresh from summer school with Hans Hofmann (1880–1966) in Europe. In 1928 Vaclav Vytlacil (1892–1942), another Hofmann devotee, taught at intercession and summer session. Friends invited friends, and in 1930 Vytlacil and Ryder arranged for the American modernist Glenn Wessels (1895–1982) and the German expressive abstractionist Hans Hofmann to teach summer session at the university. Hofmann returned in the summers of 1931 and 1932 and while in Berkeley completed his *Creation in Form and Color: a Textbook for Instruction in Art*. Hofmann, whose own work of the 1930s could be described as a merging of German Expressionism and the not-yet-invented Abstract Expressionism, taught painting as two-dimensional design rather than the creation of illusionistic space, a revolutionary idea for its day. His famous "push-pull" theories, geared to achieving greater dynamics and energy, applied to the arrangement of abstract elements on the surface of a canvas, visual movement across it, and volume and spatial planes. When the advance of Nazism forced Hofmann to close his Munich school, he spent the rest of his life teaching in America, principally on the East Coast. His brief presence in Berkeley was followed by the hiring of the modernist watercolorists John Haley and Erle Loran (chapter 19).

Modernism may have been welcomed by some, but not by most. To intellectuals and the artists who espoused it, modernism was the only valid route. For those who enjoyed socializing with bohemians and the cultural avant-garde, modernism represented excitement. For art historians, modernism represented new blood, evolution, even revolution, and something to write about. But conservative and academic artists perceived modernism as a threat to their established worlds. And to the average person, abstraction and nonobjectivity evoked derision and inspired statements such as, "My child can paint better than that."

American Scene

As Americans retreated from the horrors of World War I and became increasingly isolationist, the art world also retreated from European modernism. Abstraction began to be regarded as decadent and without any direct relevance to America. A backlash drove American artists in the opposite direction, toward representational subject matter and specifically American themes. The result was the movement we call American Scene. American Scene became the main art style practiced by American artists in the 1930s. Its subjects were the activities of ordinary Americans, particularly as they were experienced in a specific area or region of the country, and it exhibits certain stylistic traits, such as somber colors and solidity of volumes.

The move toward American Scene painting started in the late 1910s. The style took shape through the 1920s, led by New York artist Thomas Hart Benton (1889–1975), who applied the emotional style of Spain's Diego Velasquez (1599–1660) to the New York artists' favorite theme—activities of the average urban dweller. The American Scene style was spread nationally through magazines such as *Art Digest*, and Los Angeles artists began to adopt it about 1928 or 1929. It was the most important movement from about 1928 until about 1934, and while it was eclipsed by the government art projects, its practitioners continued to work in the style through World War II. During the Depression it was propelled as much by the psychological need of Americans to reject European ideas as it was by the need to find something of value in their own country. And finding local subjects was much more economical than looking for picturesque subjects in an exotic country. California artists had always produced a form of American Scene by depicting views of their state, but by the late 1920s "pride in locale" was no longer considered provincial. It was a nationally sanctioned attitude of a country that was developing a growing respect for its own culture and diversity.

All of California's urban art centers produced American Scene paintings, although the products were very different, reflecting each center's climate, lifestyles, and attitudes. Generally, the Southern half of California (including Los Angeles, San Diego, and Santa Bar-

bara) had a greater number of artists, but their choices of subjects were more conservative than those selected by Northern California artists. Of the two types of American Scene painting, Regionalism and Social Realism (as defined by Matthew Baigell in his book *American Scene,* New York: Praeger, 1974), Southern Californians more frequently chose Regionalist themes, scenes of people engaged in pleasant activities or landscapes. The handful of American Scene painters in Northern California more frequently painted Social Realist art, i.e., socially critical genre and city scenes. Artists did not "belong" to Regionalist or Social Realist camps; rather, a painting was categorized after the fact by art historians who interpreted the artist's intent.

Bay Area. In the 1930s, if you asked an Angeleno his opinion of San Francisco artists, he would say they were all Bolsheviks. A San Franciscan commenting on Los Angeles artists of the same decade would probably respond that Southern Californians turned out work that was bland and conformist. The smoldering competition between the two towns erupted openly in 1934 when the Los Angeles Art Association refused to accept some San Francisco canvases for its All-California Art Exhibition at the Biltmore Salon. The San Franciscans had little right to complain, however, since for years they had rejected the work of Angelenos from their annual exhibitions.

Why did the Bay Area and Southern California produce such very different versions of American Scene art, the one making Social Realist statements while the other celebrated the simple pleasures of the average American and focused on landscapes? Certainly, the cooler northern weather that led San Francisco artists to work indoors and to paint figures more often than landscapes was an important factor. Added to this were the northern city's strong union bent and the ready availability of ghettos of poor immigrants of various nationalities—a popular subject for American Scene painters. There were the strikes and conflicts along the waterfront. The presence in town of Diego Rivera (1886–1957), who painted several murals in 1930 and 1931 led to several artists adopting his style and becoming sympathetic to his revolutionary politics.

In the many hierarchies that exist in the world of art, the serious nature of Social Realist themes leads some to regard them as more important than the lighter-hearted Regionalist themes. Two San Francisco painters, compelled by their sympathies for the plight of the common man as well as their admiration for Rivera's Communistic ideas, criticized society in their paintings. In the early 1930s, **John Langley Howard** (b. 1902) and his first wife, Adelaide Day,

were living in Monterey when he became involved with the local John Reed Club, an organization of creative individuals with ties to Communism. Seeing evidence of the Great Depression all around him, he decided to dedicate himself to working for social change through depicting Depression conflicts and social issues. *The Anchor Block* of 1938 (fig. 18-4) shows a confrontation between a worker on a ship and a person on the dock; between them is the large cement anchor block that will be set in the bay to anchor ships. Howard's study in New York with neoclassical Social Realist figure painter Kenneth Hayes Miller (1876–1952) is clearly recognizable in the tubular bodies he gives working men. For him their gross, coarse physiques with thick necks and bestial facial features symbolize the common worker. *The Anchor Block* is a particularly appropriate subject for San Francisco, where some of the most violent encounters between unions and employers occurred on the docks. Howard's messages are usually very clear, not because his characters act out their roles but because the social situations seem natural and they are universally understandable. Howard often shows the disparity between the wealthy and blue-collar laborers. Here, the painted lady tourist gawks at an encounter to which she obviously cannot relate.

Fig. 18-4
John Langley Howard
(b. 1902)
The Anchor Block, 1938
oil on canvas, 40½ x 42½ in.
Private Collection, Courtesy
of Tobey C. Moss Gallery
Photo: Tobey C. Moss
Gallery

A number of important Social Realist paintings were produced by **Maynard Dixon** (1875–1946). (For his themes of the American West see chapter 16.) In spring 1934, Dixon's assignment to document the construction of Boulder Dam for the Public Works of Art Project took him to the site, and there he observed labor strife first hand. Three months later he witnessed the San Francisco maritime strike that culminated in violence and rioting along the Embarcadero, where two men were killed and scores injured. Brooding over the continued conflicts between longshoremen, police, California National Guardsmen, vigilantes, and scabs, Dixon began to paint canvases that documented the faceless terror of poverty, oppression, and conflict. Like *Forgotten Man* of 1934 (fig. 18-5, p. 224), most of these feature a few large-sized faceless figures. As a former illustrator and muralist Dixon kept his message simple: anonymous men in dark clothing walking a picket line, anonymous individuals beating an unseen victim, a rabble rouser giving the thumb-up gesture, a down-and-out bum collapsed on a curb, a hobo with no place to go. These figures symbolize ideas rather than depict actual incidents. Dixon makes his presentations dramatic through the use of silhouettes, back lighting, and the compositional device of diagonals. He carries

out their sober message by restricting himself to a tan and blue color scheme. Dixon also was virtually the only California artist to depict the state's agricultural workers, whose wretched conditions were made famous by writer John Steinbeck in his *Grapes of Wrath* (1939). Dixon was introduced to the plight of the migrant workers through his wife Dorothea Lange with whom he went to Nipomo in February 1934, where she was engaged in photographing the pea pickers and other workers. (For her photography, see chapter 17.) On another trip, to the south end of the San Joaquin Valley with fellow artist Ray Strong (b. 1905) to paint landscape, Dixon executed a picture of a camped migrant family.

In a lighter, Regionalist vein was the work of **Otis Oldfield** (1890–1969). Like many artists, he lived in San Francisco's then low-rent Bohemian quarter atop Telegraph Hill. The area had long been home to the city's poor Italian community, placing at his doorstep a "perfect" Depression-era subject. Dated 1925, exceptionally early for an American Scene subject, *Telegraph Hill* (fig. 18-6) records the life Oldfield saw from his window: children playing on the staircases, women feeding sheep and goats, laundry hanging on lines, all against a backdrop of the city and the bay. A distillation rather than a sketch from nature, the scene involves many isolated incidents organized into a patchwork balanced by buildings and woven together by the meandering staircase. The charm lies not only in the sympathy and humor with which Oldfield observes his neighbors but in the warm colors. His wry sense of humor shows up in other works, notably a back view of his wife wearing nothing but her blossomy silk panties (*Figure* of 1933; fig. 22-4). The latter painting caused a minor sensation when it was given its first public exposure.

Los Angeles. Los Angeles's American Scene art differed from San Francisco's in several ways. At the top of the list was its aesthetic, influenced by Mexico. The Mexican aesthetic entered Southern California in numerous ways. David Alfaro Siqueiros (1898–1974) and Jose Clemente Orozco (1883–1949), two of the three great Mexican muralists, painted in the area for a time. Exhibitions of Mexican art, including the prestigious First Pan American Exhibition organized by the Los Angeles Museum in 1925, were held at local galleries; Mexican prints were collected locally; and a number of Mexican easel painters took up residence in Los Angeles or taught there briefly. Mexican art was also championed by New Yorker Walter Pach, who frequently traveled between New York, Mexico, and Los Angeles on his mission.

Fig. 18-6
Otis Oldfield (1890–1969)
Telegraph Hill, 1925
oil on canvas, 40 x 30 in.
The Delman Collection, San Francisco

An important Mexican painter even settled permanently in Los Angeles—**Alfredo Ramos Martinez** (1872–1946). In the twenties he had headed Mexico's Academia de San Carlos, and he started a stylistic revolution with his decision to move away from European ideas and toward a Mexican style based on painting in the open air and using indigenous subjects and primitive forms. *La India con Callas* of 1929 (fig. 18-7), possibly his most outstanding picture, shows the qualities that so greatly influenced Californians: the black outline, simplified and smoothly contoured surfaces, and a concern for the common man. Ramos Martinez's pleasant, noncritical themes (frequently Indian women carrying fruit or gathering flowers, here calla lilies) coincided with the preferences of Southern California Regionalists.

Californians also absorbed Mexican influences by traveling into the still primitive country itself, either to study with admired artists like Diego Rivera or to obtain material. Thus, paintings like **Henrietta Shore**'s *Women of Oaxaca* of about 1927 (fig. 18-8) were produced. This is one of several pictures that resulted from a six-month trip Shore made to Mexico with her modernist painter friend, Helena Dunlap, beginning in August 1927. In the semiprimitive environment, Shore found many objects of rounded shape and simple form (such as large white flowers, black gourds, and seals) that contained the elemental life rhythms that she believed flowed through all organic and inorganic objects. Like some other painters, she made pilgrimages to view Rivera's murals, and she met Orozco, whose portrait she painted. At one point she must have traveled to Oaxaca, a state more than one hundred miles south of Mexico City, to get the material for this picture. In the procession of water carriers Shore sets up a rhythm with the sway of their graceful bodies and matches it in the skirts, the jugs, and the landscape, reflecting her personal conviction that the life force flows through all things in nature. She also made a lithograph from the oil.

With Southern California artists' reputations for favoring landscape, how did they adjust to the American Scene's dependence on the figure and human themes? Humanist themes are usually a product of city-bound individuals, and in the early 1930s Los Angeles's new generation of painters *had* become city bound, held there by jobs either as art teachers or with the motion picture studios. Many were without automobiles, and they moved about by riding Los Angeles's streetcars. For the first time, it was natural and convenient for artists to represent the city, and they were aware that painting figurals made them up-to-date. In their relatively compact environment, as well

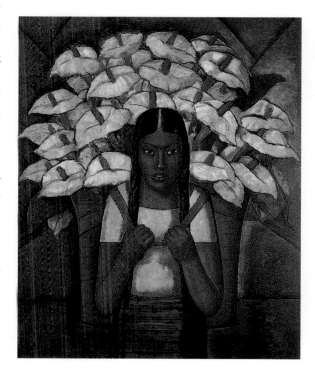

Fig. 18-7
Alfredo Ramos Martinez
(1872–1946)
La India con Callas, 1929
oil on canvas, 45¾ x 36 in.
Gail and Edwin Gregson

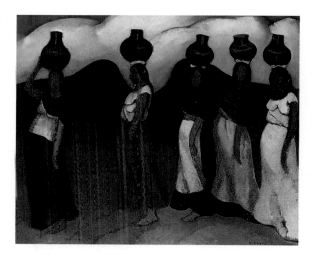

Fig. 18-8
Henrietta Shore (1880–1963)
Women of Oaxaca, c. 1927
oil on canvas, 16 x 20 in.
The Buck Collection, Laguna Hills, California
Photo: Cristalen and Associates

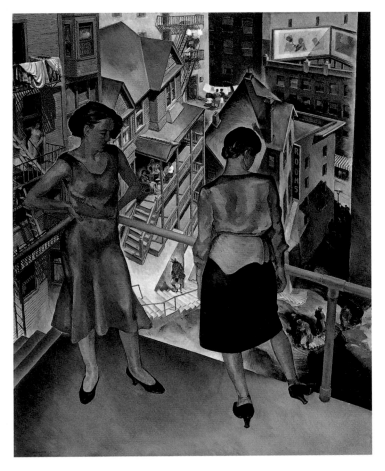

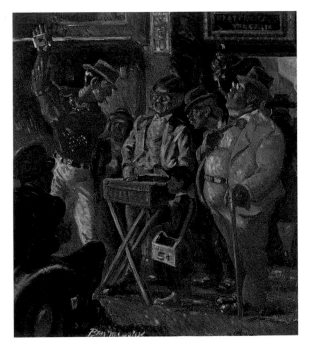

Fig. 18-9
Millard Sheets (1907–1989)
Angel's Flight, 1931
oil on canvas
50 7/16 x 40 5/8 in.
Los Angeles County
Museum of Art, Gift of Mrs.
L. M. Maitland

Fig. 18-10
Ben Messick (1891–1981)
Pitchman, aka *The Low
Pitchman*, 1939
oil on canvas
34 x 30 in.
The Buck Collection, Laguna
Hills, California
Photo: Cristalen and
Associates

as in their jobs at teaching institutions, they found themselves in group situations exchanging ideas, being challenged by the interaction among artists, and feeling a sense of competition. Why did Southern California artists show such little interest in painting Social Realist subjects? This is probably due to the area's relatively pleasant living conditions and the general absence of social conflict—the city was a non-union town and had few large industries. The main local art critic, Arthur Millier, discouraged Social Realism, branding its painters "reds" and Communists.

Los Angeles's universally acknowledged leader of American Scene painting was **Millard Sheets** (1907–1989). Sheets was a precocious student at Chouinard Art Institute who, even before graduation, was put in charge of a landscape class. As the decade progressed, his charismatic personality attracted other artists, and he began to lead sketching excursions around Los Angeles. He reached his artistic peak early and brilliantly between 1930 and 1933, painting *Angel's Flight* in 1931 (fig. 18-9). Angel's Flight is named after the funicular railway that formerly ascended Los Angeles's Bunker Hill at Third Street. (It was recently reconstructed.) Sheets's wife Mary posed for both of the female figures that stand atop the platform called Angel's View and look down on the stairway built for people who could not afford the funicular. In one canvas are all the elements of a typical American Scene picture: ordinary people at ordinary tasks captured with sound drawing, toned-down coloration, solid forms, firm contours, and a hint of emotional distortion. Considered extraordinary for its time is Sheets's bird's-eye viewpoint.

Ben Messick (1891–1981), also a Chouinard student in the 1920s, was a keen observer of life around the plazas and parks of downtown Los Angeles. Messick had grown up among the kinds of people that it became popular to paint during the depression. His mother was a hymn-singing churchgoer, his father ran a country store in Missouri, and his mother's second husband was a preacher. As a youth, Messick seemed always to be drawing people, and while serving in World War I he drew the action on the battlefields. His sense of humor comes to play in most of his scenes, as in *Pitchman* of 1939 (fig. 18-10). This occupation that combines theatricality with salesmanship in a street setting primarily addresses a blue-collar audience. Messick's presentation is anecdotal and narrative, as are most genre and Regionalist scenes, and the figures' gestures and expressions make the action easy to "read." In some other canvases, Messick's style broaches caricature, but his sympathy is always with humanity.

Paul Sample (1896–1974), a teacher at the University of Southern California, was acquainted with

the Millard Sheets group at Chouinard. He started his American Scene career by painting circus subjects, and then moved into a mild form of Social Realism when he made pictures of unemployed men. Then he painted *Celebration* of 1933 (fig. 18-11). One of the hurdles faced by artists working in Los Angeles was the lack of important historical canvases in museums from which to learn. Sample's earliest American Scene work seems stylistically derived from George Bellows's (1882–1925) *Cliff Dwellers* (Los Angeles County Museum of Art) a major Ash Can school canvas showing immigrant living conditions on New York's Lower East Side, a work that would have been on view locally. By the time Sample painted *Celebration* he was deriving compositional ideas from Pieter Brueghel the Elder (c. 1525–1569), the Flemish painter of peasant life, whose pieces he could have seen reproduced in books. The composition of *Celebration* is very similar to that of *Land of Cockaigne* (Alte Pinakothek, Munich), which shows farmers resting from their labors. Sample turns this into a condemnation of big business by showing the way oil extraction has eroded and destroyed the natural environment; he also shows the way liquor has eroded workers' minds. He makes the presentation pictorially striking by silhouetting the black derricks against the buffs and tans of the eroded hills.

One way to disguise Social Criticism is with humor. Sometimes this is obvious, as it is in caricature; at other times it is subtle and requires situational knowledge to be understood. **Barse Miller** (1904–1973), who painted *Apparition over Los Angeles* in 1932 (fig. 18-12), was known for his sense of humor. In *Apparition…*he makes use of a well-known composition from religious painting. A cloud floats in the sky above the Church of the Four-Square Gospel, one of the many local religions that gave Los Angeles its reputation as a city of bizarre cults. In the cloud is the church's evangelist, Sister Aimee Semple McPherson, portrayed as an angel among a band of cherubim clutching moneybags. To people aware of the large amounts of money collected from devotees by the charismatic Sister Aimee, the meaning was more than clear. Miller unveiled the work at the annual exhibition at the Los Angeles Museum. Its closeness to the truth earned it space in the local papers; but when the evangelist's husband (pictured to her right wearing the straw hat), threatened to sue, show organizers withdrew the picture from the exhibition.

Fletcher Martin's (1904–1979) background as a high school dropout, fruit picker, harvest hand, lumberjack, printer, and United States Navy boxer provided him with a wealth of useful material that he could use when he became a painter. Martin gained instant success with several subjects from his United States

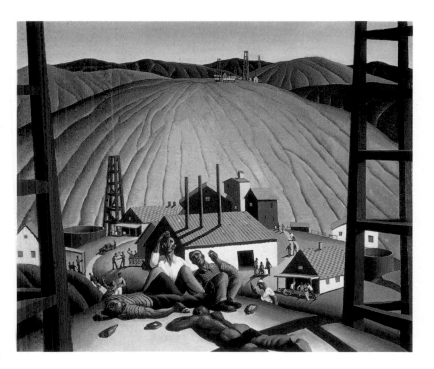

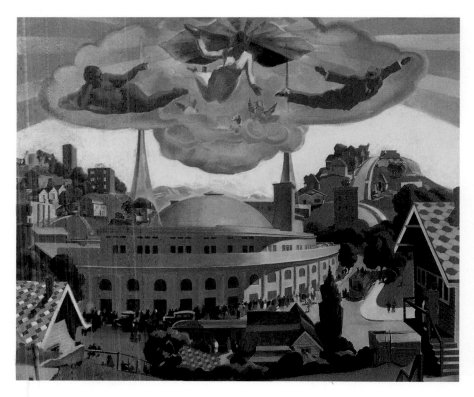

Fig. 18-11
Paul Sample (1896–1974)
Celebration, 1933
oil on canvas, 40 x 48 in.
Paula and Irving Glick

Fig. 18-12
Barse Miller (1904–1973)
Apparition over Los Angeles, 1932
oil on canvas, 50 x 60 in.
The Buck Collection, Laguna Hills, California
Photo: Cristalen and Associates

Navy days, the best of which is *Lad from the Fleet* of 1935 (Private Collection), which shows a boxer seated in his corner of the ring just before a fight. (This work is reproduced in *A Time and Place,* exh. cat., Oakland Museum, 1990, p. 153.) Boxing pictures enjoyed minor popularity among American artists, some of the most famous scenes being the aggressive and energetic encounters portrayed by the Ash Can artist George Bellows as early as 1907. Martin's interest, however, is not in fast action but in the fighter as a symbol of the common man. This man's expression shows he is anxious about the bout to come, but his concern is countered by a ready-to-spring stance, indicating his readiness to face what life might bring him. Martin's greatest stylistic influence and inspiration came from conversations with and working alongside David Alfaro Siqueiros when the Mexican muralist was in Los Angeles in 1932. Martin's admiration of Renaissance artistic conventions is reflected in the twisted pose of the uniformed trainer and in the tiny brushstrokes (like those used in early egg tempera paintings) that mold body and drapery.

The majority of Los Angeles's American Scene artists painted rural themes, especially after about 1934. In his early career, Chouinard student and teacher **Phil Paradise** (1905–1997) taught and lived in Los Angeles, where he painted city subjects: Social Realist scenes of Los Angeles's night court as well as the seedy transient area around the East Fifth Street slum. But like most of Southern California's Regionalists, Paradise eventually settled on a theme that became particularly popular with artists in the Sheets circle—California farms and horses. Californians' farms were very different from the Depression-era farms portrayed by Midwestern artists whose typical complex consisted of a house and barn, silos, corn fields, and an ungainly plow horse, which reflected the decade's interest in common things such as manual labor. Paradise and several other artists who had fond memories of their youths growing up on California farms, with horses as pets, turned to portraying rolling grasslands, unpainted weathered barns, and quality livestock. He recalls that his teacher at Chouinard, Lawrence Murphy, who used racehorses as models, encouraged him to paint refined animals. In *Horseshoer* from about 1938 (fig. 18-13), Paradise seems to have been influenced by the great Midwestern Regionalist John Steuart Curry (1897–1946), whose *Belgian Stallions* (National Academy of Design) also shows handlers trying to control excited horses. At the same time, he adheres to Regionalist precepts in depicting the manual labor of horse shoeing. The canvas is really two scenes: to the left the sweaty, toiling men at anvil and hoof and to the right the beautiful equines, whose action is shaped into a vortex, a common compositional device of the 1930s.

A favorite Los Angeles theme was the beach recreation for which the southern part of the state is famous. **Phil Dike**'s (1906–1990) *California Holiday* of 1933 (fig. 18-14) incorporates in one painting several types of coastline activity (sunbathing, sailing, and rock fishing). The site is an actual spot near Newport Beach where Dike's family often spent part of the summer. This work uses a favorite Regionalist perspective—the bird's-eye view—and the alternating sandy coves and rocky promontories set up an undulating rhythm and the vortex composition popular with some American Scene artists. Beach scenes were painted across America wherever artists encountered the shore. Californians of the 1930s tended to represent the beach as joyous, innocent, and healthy, in contrast to an artist like the New Yorker Paul Cadmus (b. 1904), who produced cynical and satirical views of bathers on Coney Island.

Fig. 18-13
Phil Paradise (1905–1997)
Horseshoer, c. 1938
oil on tempera on canvas
28¾ x 39⅝ in.
Arroyo Galleries/Edwin J. Gregson

Fig. 18-14
Phil Dike (1906–1990)
California Holiday, 1933
oil on canvas, 30 x 36 in.
The E. Gene Crain Collection

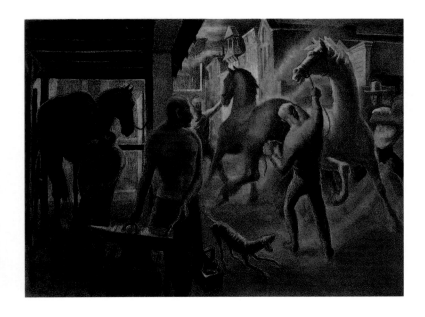

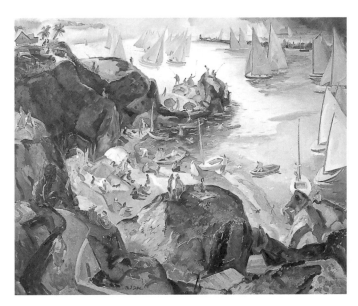

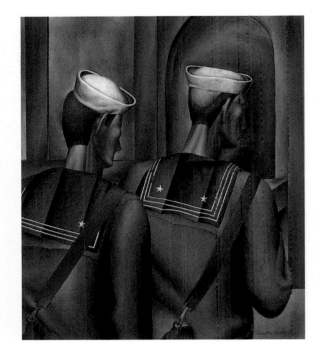

sunbathing, volleyball, or track and field events. One example is *Figures on a Beach* of 1932 (Private Collection) that shows a man in bathing trunks and a woman in a shapeless dress seated on a beach. Another is the mural *Young Athletes* (fig. 20-20) that portrays several athletes at a track and field event.

Santa Ana/Laguna Beach, Fillmore, Claremont. With increased population throughout the state of California and American Scene's democratic philosophy, painters emerged in many small communities and received attention from the press.

Art activity accelerated particularly in the small farming town of Santa Ana in Orange County, south of Los Angeles. The most outstanding American Scene artist of the Progressive Painters of Southern California (renamed from Contemporary Painters, see chapter 15) was **Robert Gilbert** (1907–1988). Gilbert had studied briefly at Chouinard in Los Angeles and with George Luks, the Ash Can School artist of New York. In 1929, looking forward to a career in art, Gilbert began teaching at the Orange County School of Fine Art. But, like many artists of the Depression, the economics of supporting a young family forced him into a full-time job in a non-art occupation. Gilbert turned his move to the Santa Ana Gas Company into an art benefit. His contact with an industrial situation in a region where industry was generally limited to oil wells or sand and gravel plants provided him with a unique subject. His Regionalist subjects fall into two broad categories: female figures in orange groves (Santa Ana was a center for citrus ranching) and male figures active in industrial plants (probably the Gas Company plant). In *Welders* of 1941 (fig. 18-16) he employs the period's popular vortex composition. His industrial scenes are not Social Realist, however. They do not condemn big business's oppression of the blue-collar worker; rather they use its elements in a composition about average people engaged in average occupations.

Although Social Realism was almost nonexistent in Orange County in 1931 and 1932, the Impressionist landscapist **George Brandriff** (1890–1936) painted a series of symbolic still lifes he called "allegories"; these contained hidden social and economic messages. His ideas came from newspaper headlines as well as from his own private life experiences and feelings. *Holiday*

Fig. 18-15
Everett Gee Jackson
(1900–1995)
Mail Orderlies, U. S. N., 1934
oil on canvas
16 x 20 in.
United States Government
Treasury Department, Public
Works of Art Project,
Washington, D. C.
Photo courtesy Los Angeles
County Museum of Art

San Diego. San Diego's American Scene painters, like those in Los Angeles, chose Regionalism over Social Realism. The San Diego area provided three unique Regionalist subjects: activities of Navy men (the town was headquarters for the 11th U. S. Naval District), family recreation in Balboa Park, and the life of Mexico (only twenty-one miles south). **Everett Gee Jackson** (1900–1995) retained a lifelong fascination for Mexico, making many trips there from the early 1920s and painting canvases of its country people at simple occupations. But during the Depression years, he produced Regionalist works based on Navy subjects. *Mail Orderlies, U.S. N.* of 1934 (fig. 18-15) was among the first of these, while *Sea Duty* of 1939 (Collection San Diego Historical Society), showing a sailor saying good-bye to his family, marks the last in the series. These capture average situations lived by Navy men not engaged in battle and are sympathetic in their portrayal.

Santa Barbara. In Santa Barbara, perhaps the most important American Scene artist was **Douglas Parshall** (1899–1990). Parshall came to Regionalism from a different direction than most—as a natural outgrowth of his academic training. He had studied first with his father (DeWitt Parshall, 1864–1956), at the Art Students League of New York, and at the Julian Academy in Paris. Through the 1920s he had turned out highly finished academic portraits. In the 1930s, with the nation's artistic return to figuration and solid forms, his academic experience gave him an advantage. Parshall began to produce scenes based on his experiences and observations of the life around him in the recreation-oriented, retirement community of Santa Barbara. His subjects are often recreational activities—

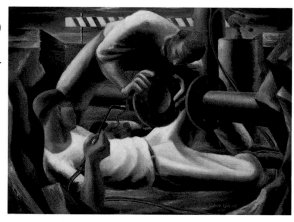

of 1934 (fig. 18-17) shows two Red Cross men carrying the body of a person away from a toy bank vault. Originally, the frames that Brandriff made for his paintings were covered with newspaper clippings, which, along with the title, helped explain his meanings. Unfortunately the frames were discarded by an art dealer in the late 1960s. The meanings of some, however, can be reconstructed. *Holiday* may refer to the "holidays" declared by banks during the Depression to avoid runs on their cash, and the collapsed figure may be a person who has learned that the vault to which he entrusted his life's savings is empty. Often, as here, a monkey observes the scene. Since Brandriff had only recently returned from studying art in European museums, the

idea for the monkey may have come from vanitas still lifes, some of which show a simian contemplating a human skull.

Fillmore, a farming community a few miles south of Santa Barbara, was part of a greater artistic area that included several farming towns: Ojai, Santa Paula, Oxnard, and Ventura, where a few artists who preferred to live on ranches plied their trade. In a typical situation found during the Depression, a couple of enthusiastic people—in this case, the fledgling artist Lawrence Hinckley (1900-1987) and his wife Mildred—put forth a tiny bit of money and a lot of effort and turned a family barn into an art gallery that eventually became the pride of the community. The Artists' Barn opened in Fillmore in November 1936, but its timing and progressive presentations made it more than a local art-on-a-shoestring cooperative. Although it showed the art of the several important painters and craftspeople who lived in the area, including Jessie Arms Botke (1883–1971), the Hinkleys also brought in exhibitions and lecturers from Los Angeles, sophisticated shows of Disney art as well as California-style watercolorists and modernists. Their shows were not only reviewed in the Los Angeles and Santa Barbara newspapers, but even made the national publication *Art Digest.* For more than twenty-five years the gallery gave Hinckley the financial freedom to paint as well as the enjoyment of organizing exhibitions, holding lectures, giving art classes, and hosting bus tours.

In the farming town of Claremont about thirty miles east of downtown Los Angeles, Millard Sheets, in 1932, accepted the one and only position of art teacher at Scripps (a college now associated with Pomona as one of the Claremont Colleges). With his usual energy and enthusiasm he set about developing an art department of formidable strength. He first obtained a donation to construct an art building (built between 1937 and 1939), and he attracted important painters and craftspeople to the expanding faculty. Since World War II the school has been a major force in art education in Southern California. Also, between 1931 and 1956 Sheets organized the annual art exhibition for the Los Angeles County Fair in neighboring Pomona.

California had many strong oil painters of American Scene subject matter, but the state is equally distinguished for its watercolor painters of the same theme. The next chapter will investigate how and why watercolor themes differ from those rendered in oil and will reveal how innovations by California artists began to attract notice in East Coast art centers. ✺

Bibliography

Modern Art, American, 1890–1914

Lears, T. J. Jackson, *No Place of Grace: Anti-Modernism and the Transformation of American Culture 1880-1920*, New York: Pantheon, 1981.

Piron, Alice O'Mara, *Urban Metaphor in American Art and Literature, 1910–1930*, Thesis, Northwestern University, 1982.

Read, Herbert, *A Concise History of Modern Painting*, London: Thames and Hudson, 1974.

Stangos, Nikos, ed., *Concepts of Modern Art*, New York: Thames & Hudson, 1991.

Watson, Steven, *Strange Bedfellows: The First American Avant-Garde*, New York: Abbeville Press, 1991.

Modern Art, Southern California, before 1930

Agee, William C., *Synchromism and Color Principles in American Painting, 1910–1930*, exh. cat., M. Knoedler & Co., N. Y., October 12 - November 6, 1965.

Ball, Maudette M., "Expressions in Color: Synchromism — America's First Modernist Movement," *Antiques & Fine Art*, v. 8, no. 1, November/December 1990, pp. 96-103.

Butterfield, Jan, "Made in California," *American Art Review*, v. 4, no. 1, July 1977, pp. 118–144. [synopsis of the exhibit, *Painting and Sculpture in California: The Modern Era*]

Ehrlich, Susan, "Southern California's Modernist Dawn," *Artspace*, v. 16, pt. 6, Fall 1991, pp. 78-82.

Funston, Janet, "Problems in Synchromism," *Artforum*, v. 16, pt. 10, Summer 1978, pp. 57–61.

Hertz-Ohmes, Andrea, "Modernism: Galka Scheyer & the Blue Four," *Art of California*, v. 2, no. 3, June/July 1989, pp. 33–39.

Levin, Gail, *Synchromism and American Color Abstraction 1910–1925*, New York: George Braziller, 1978.

Macdonald-Wright, S., "Los Angeles [brief history of the development of the arts in Southern California]," *Art News*, v. 54, October 1955, pp. 8+.

Moure, Nancy Dustin Wall, *Painting and Sculpture in Los Angeles 1900–1945*, exh. cat., Los Angeles County Museum of Art, September 25 – November 23, 1980, pp. 30-34.

Moure, Nancy Dustin Wall, *Publications in Southern California Art 1, 2 & 3*, Los Angeles: Dustin Publications, 1984.

Painting and Sculpture in California: The Modern Era, exh. cat., San Francisco Museum of Modern Art, essay by Henry T. Hopkins, September 3–November 21, 1976 and National Collection of Fine Arts, Washington, D. C., May 20–September 11, 1977.

Sawelson-Gorse, Naomi, "Hollywood Conversations: Duchamp and the Arensbergs," in *West Coast Duchamp*, ed., by Bonnie Clearwater, Miami Beach: Grassfield Press, 1991.

Modern Art, Northern California, before 1930

(See also bibliography for infrastructure in chapter 17.)

Albright, Thomas, "Before the Storm: The Modernist Foundation," in Thomas Albright, *Art in the San Francisco Bay Area 1945–1980*, Berkeley and Los Angeles: University of California Press, 1985.

Albright, Thomas, "California Art Since the Modern Dawn," *Art News*, v. 76, January 1977, p. 68–72.

Baird, Joseph Armstrong Jr., ed., *From Exposition to Exposition: Progressive and Conservative Northern California Painting 1915–1939*, Sacramento: Crocker Art Museum, 1981.

Baker, M. C., *The Art Theory and Criticism of Willard Huntington Wright*, Ph. D. Dissertation, University of Wisconsin, Madison, 1975. 484 p.

Four Americans in Paris: The Collections of Gertrude Stein and her Family, exh. cat., Museum of Modern Art, New York, 1970.

Illustrated Catalogue of the Post-Exposition Exhibition: In the Department of Fine Arts, Panama-Pacific International Exposition, San Francisco, California, January First to May First Nineteen Hundred & Sixteen, San Francisco, San Francisco Art Association, 1916. 112 p.

Morley, Grace Louise McCann, "Art, Artists, Museums, and the San Francisco Museum of Art," oral interview conducted by Suzanne B. Riess, Bancroft Library, University of California, Berkeley, 1960. 246 l.

Neuhaus, Eugen, "Reminiscences: Bay Area Art and the University of California Art Department," oral interview, Bancroft Library, University of California, Berkeley, 1961.

American Scene Painting, General

The Artist at Ringside, exh. cat., Butler Institute of American Art, Youngstown, Oh., March 29–May 10, 1992.

Baigell, Matthew, *American Scene: American Painting of the 1930s*, New York: Praeger, 1974.

The City in American Painting: A Selection of 19th and 20th Century Works by Artists Who Employed the Urban Scene as a Principal Theme, Either Specifically, i.e. or Implied, exh. cat., Allentown Art Museum, Allentown, Pa., January 20 –March 4, 1973. 41 p.

Danly, Susan and Leo Marx, eds., *The Railroad in American Art: Representations of Technological Change*, Cambridge: Massachusetts Institute of Technology, 1988.

Doezema, Marianne, *American Realism and the Industrial Age*, Cleveland Museum of Art/Indiana University Press, 1980.

Gambone, Robert L., *Art and Popular Religion in Evangelical America 1915–1940*, Knoxville: University of Tennessee Press, 1989.

Government and Art: A Guide to Sources in the Archives of American Art, Washington, D. C.: Archives of American Art, Smithsonian Institution, 1995.

The Highway, exh. cat., Institute of Contemporary Art, University of Pennsylvania, January 14 - February 25, 1970.

Whiting, Cecile, *Antifascism in American Art*, New Haven and London: Yale University Press, 1989.

The Working American: An Exhibition, organized by District 1199, National Union of Hospital and Health Care Employees and the Smithsonian Institution Traveling Exhibition Service, Washington, D. C.: Smithsonian Institution, 1979.

American Scene Painting, California

(See also bibliography for watercolor painting in chapter 19, for government art projects in chapter 20, and for Golden Gate International Exposition in chapter 17.)

Art Exhibition by California Artists in the California Building, exh. cat., Golden Gate International Exposition, San Francisco, May 25–September 29, 1940. 40 p.

Ferbrache, Lewis, *Interviews with Bay Area Artists: Typescript, 1964–1965*, Bancroft Library, University of California, Berkeley. 1 box.

Hailey, Gene, ed., *California Art Research*, San Francisco: Works Progress Administration, 1936-37, 20 vol.

Moure, Nancy Dustin Wall, "Themes in California Scene Paintings," extended essay bound into some copies of *Scenes of California Life 1930–1950*, exh. cat., Todd Madigan Gallery, California State University, Bakersfield, March 9–April 10, 1991.

Perret files, Archives of American Art, Huntington Library, San Marino.

Trenton, Patricia, ed., *Independent Spirits: Women Painters of the American West, 1890–1945*, Autry Museum of Western Heritage, Los Angeles, in association with University of California Press, Berkeley, 1995.

Westphal, Ruth Lilly and Janet Blake Dominik, eds., *American Scene Painting: California, 1930s and 1940s*, Irvine, Ca.: Westphal Publishing, 1991.

Mexican Influence on California Painting of the 1930s

Cancel, Luis R., et al., *The Latin American Spirit: Art and Artists in the United States, 1920–1970*, The Bronx Museum of the Arts in association with Harry N. Abrams, Inc., N. Y., 1988.

Nieto, Margarita, "Mexican Art and Los Angeles, 1920–1940," in Paul J. Karlstrom, ed., *On the Edge of America: California Modernist Art, 1900–1950*, Berkeley: University of California Press, 1996, pp. 121–38.

Nieto, Margarita, "The Mexican Presence in the United States, Part I," *Latin American Art*, v. 2, no. 4, Fall 1990, pp. 28–34.

Oles, James, *South of the Border: Mexico in the American Imagination 1914-1947*, Washington, D.C.: Smithsonian Institution Press, 1993.

American Scene Painting, Los Angeles

Dominik, Janet B., "The American Scene in Southern California," *Art of California*, v. 4, no. 5, September 1991, pp. 48–51.

Dream and Perspective: The American Scene in Southern California, 1930 to 1945, exh. brochure, Laguna Art Museum, August 23–November 3, 1991. [brochure for exh. by Susan Anderson to accompany Paul Bockhorst video]

Perine, Robert, *Chouinard: An Art Vision Betrayed: The Story of the Chouinard Art Institute 1921–1972*, Encinitas, Ca.: Artra, 1985.

"Regionalism," in Nancy Moure, *Painting and Sculpture in Los Angeles 1900–1945*, op. cit., pp. 54-59.

American Scene Painting, Bay Area

duPont, Diana C., et al., *San Francisco Museum of Modern Art, the Painting and Sculpture Collection*, New York: Hudson Hills Press, 1985.

Giles, Christine, "Patrons and Collectors" and Jackson M. Dodge, "B. Albert Bender and the Early Years of the San Francisco Museum of Art," in Joseph Armstrong Baird, Jr., *From Exposition to Exposition: Progressive and Conservative Northern California Painting, 1915–1939*, Sacramento: Crocker Art Museum, 1981.

Thiel, Yvonne Greer, *Artists and People*, New York: Philosophical Library, 1959.

American Scene Painting, Carmel/Monterey

Hethcock, Ann, *Visions of their Own: Four Monterey Bay Artists of the Depression Era*, exh. cat., Octagon Museum, Santa Cruz Historical Trust, n.d., 1990. 31 p.

Monterey: The Artist's View 1925–1945, exh. cat., Monterey Peninsula Museum of Art, November 6 - December 31, 1982.

American Scene Painting, San Diego

Catalogue of the Official Art Exhibition of the California Pacific International Exposition, exh. cat., The Palace of Fine Arts, Balboa Park, San Diego, May 29–November 11, 1935. 44 p.

Dijkstra, Bram, "Regionalism and Ambition: San Diego Art to 1950," in Robert Perine, *San Diego Artists*, Encinitas, Ca.: Artra Publishing, 1988.

Illustrated Catalogue, Official Art Exhibition California-Pacific International Exposition, 1936, exh. cat., The Palace of Fine Arts, Balboa Park, San Diego, February 12–September 9, 1936. 57 p.

Jackson, Everett Gee, "Modernism Without Apologies," *The Modern Clubwoman*, v. IV, no. 1, September 1930.

Mallory, John A., *Spanish Village*, San Diego, 1939.

"San Diego's Art Scene Comes of Age," in Bruce Kamerling, *100 Years of Art in San Diego*, San Diego: San Diego Historical Society, 1991.

Spanish Village Quarterly, v. 1, nos. 1 & 2, Spring and Fall 1941.

Stewart, Maud Merrill, "Women Artists of Ocean Beach," *The Modern Clubwoman*, v. IV, no. 2, November 1931.

American Scene Painting, Other Areas

Hinckley, Mildred, *The Artists' Barn: A Twenty-Five Year Pioneering Adventure in Art*, Ventura County Historical Society, 1985.

MacNaughton, Mary Davis, *Art at Scripps: The Early Years*, exh. cat., Lang Art Gallery, Scripps College, Claremont, Ca., January 23–February 28, 1988.

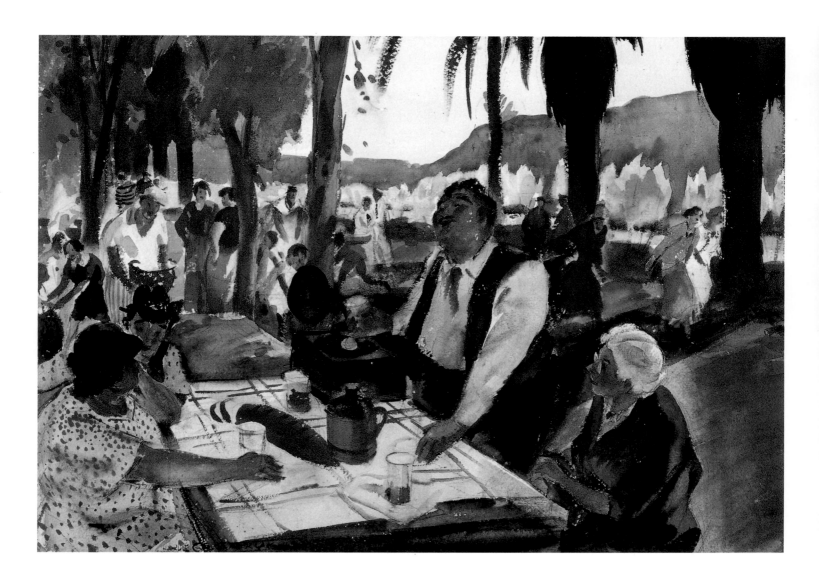

Fig. 19-12
Hardie Gramatky
(1907–1979)
Cider, 1936
watercolor
15⅛ x 22 in.
Private Collection

Watercolor Painting to 1950

Watercolor—ground pigments mixed with water—is an older medium than oil paint and was used by various cultures around the world as early as the murals in the prehistoric caves of Altamira and Lascaux, dating to 30,000 B.C. But when oil paints, with their robust colors and durability, became popular among artists during the Renaissance, the watercolor medium was relegated to field sketches and scientific illustrations, to tinting maps and photographs, to painting miniature portraits, in other words, to minor types of art.

Watercolor as we know it today, was re-introduced into the realm of the "fine" arts by the English in the late 1700s. By the 1800s there was a sizable school of English landscape painters whose almost photographic watercolor paintings are now regarded as one high point of the medium's history. Within ten years of Portola's establishment of settlements at San Diego and Monterey (1769–70), the English company of Whatman's began making tough, sized paper that was specifically prepared to receive watercolor paints. About the same time another English firm, William and Thomas Reeves, began commercially manufacturing cakes, or pans, of pigment. Because watercolor materials were lightweight and therefore easily portable, the medium became the preferred choice of artists on voyages of exploration and of topographical draftsmen working for United States government surveying expeditions in the 1850s. Thus, most of California's documentary images before 1850 are in watercolor (chapter 1).

By the late nineteenth century, watercolor painting had become an accepted aspect of the American fine art scene. This acceptance began in the mid-nineteenth century when artists noted the special properties of the medium and began to experiment with it. For example, transparent watercolor (resulting from pigments thinned with water alone) promised incredible beauty from subtle tints and hues, while gouache (pigments mixed with water and Chinese white) was opaque and could be handled somewhat like oil. Most watercolor paintings combine the two techniques to a greater or lesser degree.

Although California's most important end-of-the-century painters preferred oil, both San Francisco and Los Angeles boasted a small number of painters who worked in watercolor. Logically, California's watercolorists turned to the experts, the English, for techniques and aesthetics. Influences came via English artists settling in California, California artists trained in England, and self-taught artists who availed themselves of some of the rising number of instructional books written by English and American watercolorists. Among the increasing numbers of practitioners was a high percentage of women, freed from housework by mechanical appliances and the wealth generated by the industrial revolution to explore formerly suppressed creative urges.

In Northern California, the best known of the late-nineteenth-century watercolorists were Sydney J. Yard (1855–1909), Lorenzo P. Latimer (1857–1941), and Christian A. Jorgensen (1860–1935). Each generally ascribed to the English techniques and goals, first drawing the image on a piece of paper with a pencil and then carefully filling in the lines with color. To them we can add the previously unheralded **William S. Rice** (1873–1963), an art teacher in the East Bay for thirty years who is best known as a maker of color woodblock prints. Rice focused on landscapes, traveling into California's backcountry whenever he had a break from teaching at Mills College to work directly from nature. He was intrigued with mountains that had been volcanoes, and in *Mt. Lassen* of 1914 (fig. 19-1), he represents a site he visited with his brother-in-law, Bert Fitch. His style is unique for the time. Influenced as it was by his parallel interest in woodblock printing, Rice has partially dropped the English "detail" he shared with his colleague Latimer and has reduced this Northern California landscape to highly-pleasing simple areas of modulated color.

One of California's finest watercolorists in the so-called English style is undoubtedly the Swedish-born bachelor and wanderer **Gunnar Widforss** (1879–1934). Widforss is best known for his images of the Grand Canyon, but he also worked in California in the 1920s, at the very end of the popularity of the English style. In *The Ahwahnee Hotel and Half Dome* of about 1927, a scene in Yosemite (fig. 19-2), Widforss daubs on his paint rather than spreads it with a stroke of the brush. This, along with watercolor's transparency, which exposes the underlying white paper, makes his works

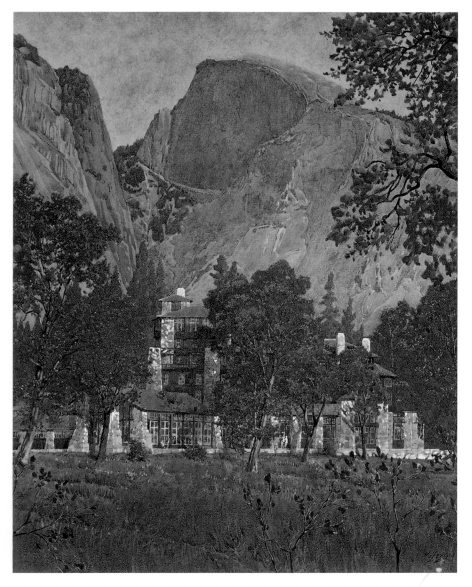

seem alive with flickering light. Like many watercolorists, he accents or highlights his works with selective dabs of opaque paint. Some of his largest and most important paintings of Yosemite still hang in the Ahwahnee, which commissioned them in the 1920s.

At the turn of the century several California watercolorists worked in the Barbizon style (chapters 7, 11). Artists such as John Francis McComas and Marion Wachtel were not interested in photographic realism but strove for a subjective and poetic interpretation of nature's moods, which they achieved with broad washes and muted colors.

When did artists break free to use watercolor for its own expressive qualities? American art historians usually point to the East Coast artist Winslow Homer (1836–1910) as the first to use watercolor with the force of oils. Not only did he essay serious subjects usually reserved for oil, but he also used dark colors as opposed to the traditional delicate transparent washes. By applying the paint with a loose and expressive stroke, he gave equal value to the brushwork and the subject. His contemporary John Singer Sargent (1856–1925) was also a brilliant watercolorist. The willingness of both of these artists to jettison the tight English style and to move toward expressiveness and spontaneity was part of a general relaxation that occurred in the Western art world about 1880. There were hints of this earlier (see discussion of Munich art in chapter 5) when quick oil studies, previously regarded as preliminary or unfinished sketches, came to be appreciated as finished paintings in their own right.

Pre–World War II Californians are willing to admit that their art history suffered a time lag in relation to Europe and the East Coast. As early as the mid-1800s, more populous New York already had two clubs devoted to watercolorists (one begun in 1850, the other in 1866), while California's population didn't support an equivalent organization until 1921, when the California Water Color Society was founded in Los Angeles. In the early years of the twentieth century the most avant-garde East Coast watercolorists, such as New York's John Marin (1870–1953), were painting abstractions, while Californians were still painting representational Barbizon landscapes. However, when Southern Californians finally turned to watercolor in the 1920s they were quick to catch up.

During the 1920s, as interest in watercolor was fostered by the infant California Water Color Society and its annual shows, California artists practiced all manner of techniques and styles, depending on their individual training and backgrounds.

Watercolor is an especially interesting medium to artists because of its endless technical challenges. Watercolor paper can be used dry or wet. Dry paper absorbs strong color and leaves crisp, stainlike edges, while wet paper picks up tints and allows paint to bleed into the surrounding paper. Most watercolors begin with a generalized drawing of a scene sketched on the paper with pencil. The artist then wets the paper, tapes it to a board for support and to prevent it from wrinkling, and begins laying in a background with very thin washes. As the paper dries, the artist adds more detail and, when it is almost completely dry, finishes it off with highlights of opaque pigment.

One artist whose Impressionism falls about midpoint between the tight English style and the expressive abstraction of John Marin is the Los Angeles art teacher **Donna Schuster** (1883–1953). Occasionally, she painted a brilliant work such as *Oranges and Branches* of about 1925 (fig. 19-3). This piece is important as much for the rarity of its subject (oranges) as it is for showing the way one artist expressively combines transparent washes with opaque Chinese white pigment.

Two painters in gouache who deserve particular mention are Colin Campbell Cooper, whose oil *Mission Courtyard* was reproduced in chapter 10, and **John Jay Baumgartner** (1865–1946). Baumgartner pursued his career in San Francisco for more than fifty years but made extended visits to Southern California. Many of his scenes, such as *Abalone Point* of about 1920 (fig. 19-4) were painted while he was a guest on the Irvine Rancho; he later painted a number of scenes on Rancho Santa Margarita (now part of Camp Pendleton). All of these scenes demonstrate his excellent compositions and talented brushwork.

California Style

Watercolor enjoyed great popularity across America during the Depression. Not only did the medium satisfy the decade's need for cheap materials, but a finished painting could be produced in one sitting and be immediately ready for sale at a modest price. The

Opposite, top:
Fig. 19-1
William S. Rice (1873–1963)
Mt. Lassen
watercolor, 8¾ x 12 in.
Roberta Rice Treseder

Opposite, bottom:
Fig. 19-2
Gunnar Widforss
(1879–1934)
The Ahwahnee Hotel and Half Dome, c. 1927
watercolor, 22½ x 18½ in.
Edward B. McLaughlin

Left:
Fig. 19-3
Donna Schuster (1883–1953)
Oranges and Branches, c. 1925
watercolor, 18½ x 14 in.
Private Collection
Photo: Budd Cherry

Above:
Fig. 19-4
John Jay Baumgartner
(1865–1946)
Abalone Point, c. 1920
gouache on paper
9⅞ x 13⅞ in.
The Buck Collection, Laguna Hills, California
Photo: Bliss

rise of watercolor in Los Angeles coincided with the fascination of Chouinard Institute artists for the medium. In a synergism that occasionally occurs in the art world, these artists, painting together in the field, generated innovations of national importance. The style they developed spread throughout the state and is known simply as the California Watercolor Style.

The mature qualities of the California Watercolor Style are evident in Rex Brandt's (b. 1914) *Rain at Box Springs Camp* of 1938 (fig. 19-5). Brandt has lived and taught painting at the Southern California seaside town of Corona del Mar since World War II. This large work contains paint applied with broad sweeps of a loaded brush, ponderous dark colors, and strong subject matter, all qualities not usually associated with a "timid" medium. While American watercolors had generally become more loosely and broadly brushed by the 1930s, Californians took expressiveness one step further, daring to rival oil painting. Their achievement inspired applause from New York critics when the Californians exhibited at the Riverside Museum in 1941.

Millard Sheets (chapter 18) is credited as the force behind the style. Precocious, selected to teach a painting class while he was still a student at the Chouinard Art Institute (1928), he possessed charismatic personality that made him the default leader of group sketching expeditions around Los Angeles. Many of the world's most important inventions have been made by people who didn't know it was impossible to make them, and the innocence and naivete of this group seem to have been major factors in their creation of a distinctive watercolor style. These companionable friends, unhampered by academic training, open to experiment, willing to help each other, took advantage of Southern California's pleasant weather, and went out into the field to paint. Looking over each other's shoulders, excitedly sharing a technical discovery, happily competing with each other, heady with the satisfaction obtained by the rapid release of a creative urge, they acknowledged no bounds.

An early watercolor by Millard Sheets, such as *Sanctuary* of about 1932 (fig. 19-6), is almost Precisionist in its tightness, far from the expressive style that Sheets is said to have originated. But between about 1931 and 1933 Sheets seems to have been fascinated with Precisionism, evidenced by his use of

Fig. 19-5
Rex Brandt (b. 1914)
Rain at Box Springs Camp,
1938
watercolor on paper
22½ x 29⅞ in. (sheet)
The E. Gene Crain
Collection

Fig. 19-6
Millard Sheets (1907–1989)
Sanctuary, c. 1932
watercolor on heavy wove
paper, 14⅝ x 22 in.
The Buck Collection, Laguna
Hills, California
Photo: Cristalen and
Associates

clean, clear washes controlled within pencil guidelines. He also comes as close as he ever did to addressing a Social Realist theme, although the transients who make their homes in the shadowy foreground of this work are almost overlooked by an eye attracted to the sun-lit sand-and-gravel plant on the horizon. Ironically, while art historians consider Sheets's finest personal contribution to watercolor to be these "Precisionist" works, it was the energy and sense of abandon evident in his pieces after 1934 that probably gave birth to the "school." In broadly brushed works such as *Black Horse* of 1934 (fig. 19-7), he quickly took up subjects, such as California's rural farmland, a theme that many others soon adopted.

Most artists restrict themselves to one medium, either watercolor or oil, but Southern California is unique in that its most important American Scene watercolorists were also its best painters in oil. No doubt their knowledge of oil contributed to the strength of their watercolors and led them to almost the same subjects in both media. However, the two media treat those subjects differently. Most of the serious Social Realist themes were carried out in oil, while the more lighthearted and optimistic Regionalist subjects seemed more appropriately rendered with the spontaneity and broken brushwork of the California Watercolor Style.

How did California artists select their subject matter? The philosophy of Regionalism held that all areas of the country had equally valid subject matter and that artists should draw their material from their local region. The typical American Scene artist asked himself, "What are some of the nationally important themes, and what local situations can I paint that will satisfy those themes?" Not all themes were appropriate to all areas of the county. For example, the Social Realist themes that so absorbed New York artists (tattoo parlors, burlesque halls, and jazz clubs) were generally *not* popular with Angelenos who had little exposure to such things. A few, however, were essayed by Chouinard student and instructor **Phil Paradise.** His *Flophouse, Taxi, Whore* of the 1930s (Private Collection) is a rare record of individuals frequenting Los Angeles's East Fifth Street slums, one of the city's few rundown areas. (This work is reproduced in *A Time and Place,* exh. cat., The Oakland Museum, December 1, 1990–March 3, 1991.) In another case, Chouinard student and

Fig. 19-7
Millard Sheets (1907–1989)
Black Horse, 1934
watercolor on paper
15 ¹³/₁₆ x 22 ¹¹/₁₆ in.
Collection of Whitney Museum of American Art, Purchase; © 1997 Whitney Museum of American Art, New York
Photo: Geoffrey Clements

Fig. 19-8
Lee Blair (1911–1993)
Untitled (Boxer in a Ring Between Rounds), 1937
watercolor on paper
14½ x 21½ in. (sight)
Private Collection

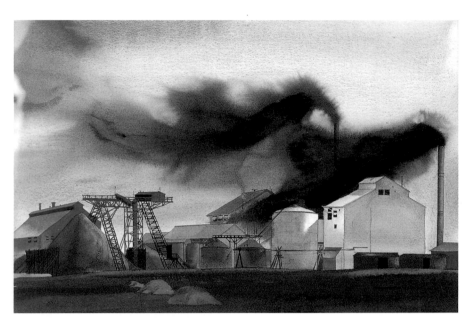

Fig. 19-9
James Patrick (1911–1944)
The Sulphur Plant, c. 1940
watercolor, 14½ x 22 in.
Oakmont Corporation
Photo: Victoria Damrel
(Clique Studio, Long Beach)

Disney artist **Lee Blair** (1911–1993) painted *Untitled (Boxer in a Ring Between Rounds)* of 1937 (fig. 19-8) based on boxing events that took place at Los Angeles's Olympic Auditorium. Californians rarely treated industrial themes. While manufacturing and shipbuilding were in evidence in the East Bay and on the peninsula south of San Francisco, Southern California had only sand and gravel plants, cement and clay manufactories, and some oil drilling. In *The Sulphur Plant* of about 1940 (fig. 19-9), **James Patrick** (1911–1944), also a student and then a teacher at Chouinard, exaggerated the dingy, oppressive, and polluted atmosphere of the complex. His was the typical 1930s artist's view of big business as an exploiter of labor and a destroyer of the environment. At the same time his handling of the watercolor in this work is exquisite.

In both the northern and southern halves of the state, artists depicting city subject matter most often painted pleasant themes: people relaxing in city parks and downtown areas, or at entertainments designed for ordinary people. County fairs or circuses, as in **Ben Messick**'s *Circus Barker* (fig. 19-10), were favorites. **Emil Kosa, Jr.** (1903–1968), a motion picture studio artist who was a compulsive producer of easel works on the weekends and between films, was unusual in painting panoramas of downtown Los Angeles. *From Boyle Heights,* painted in the early 1950s (fig. 19-11), contains key landmarks such as the pyramid-topped skyscraper of city hall and the gas company tanks that identify the scene specifically as Los Angeles. Kosa was one of the earliest artists to paint the freeways when the first ones were completed between Los Angeles and Pasadena and between Los Angeles and Hollywood in 1940.

Fig. 19-10
Ben Messick (1891–1981)
Circus Barker
watercolor on paper
15 x 18⅜ in. (paper)
The Buck Collection, Laguna
Hills, California
Photo: Cristalen and
Associates

Fig. 19-11
Emil Kosa, Jr. (1903–1968)
From Boyle Heights, early
1950s
watercolor on paper
22¼ x 30 in.
Private Collection

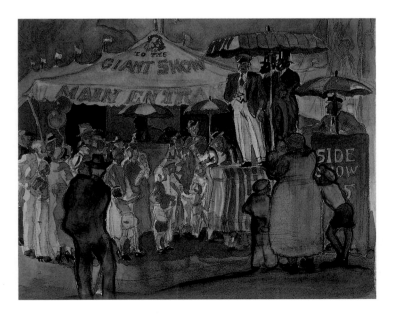

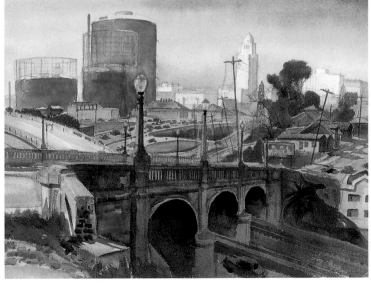

The popular American painting category of holiday celebrations (a theme that symbolized family unity and national pride) was usually represented by East Coast artists with indoor events, such as Thanksgiving dinners. Southern Californians painted what they knew—outdoor picnics in eucalyptus groves or wiener roasts on the beach. An example is *Cider* of 1936 (fig. 19-12, p. 238) by **Hardie Gramatky** (1907–1979), another Chouinard teacher. Farming scenes, too, were popular nationally because they symbolized the rich resources of America as well as a return to nature from the 1920s excesses associated with Europe and big cities. New England artists often painted apple orchards, Midwesterners wheat or corn farms, and Californians the typical farms of their state: large cattle ranches, dairy farms, or walnut groves, such as **Barse Miller**'s *Walnut Tree* of 1938 (fig. 19-13). Rarely painted were the large agribusinesses of California's central, San Joaquin valley with their gasoline-powered tractors and corrugated tin sheds. Nor were artists that attracted to California's mile-square groves of orderly orange trees or its vineyards that blanketed hill after hill. The decade was unsympathetic to big business and wanted nostalgic images of manual labor, such as farmers using horse-drawn plows. The state's preference for pleasant Regionalist subjects also discouraged artists from representing Social Realist subjects, such as the impoverished hand-to-mouth existence and violent labor strikes of migrant workers against these agribusinesses (chapter 18).

Southern California artists often showed people engaged in outdoor recreation, especially activities at the beach (see Phil Dike's *California Holiday,* chapter 18). California Scene watercolorists also had a particular affinity for trains, not as a vehicle to symbolize escape nor a carrier of transients that so fascinated East Coast intellectuals, but as a nostalgic object complete with the clacking of wheels on rails and the haunting whistle. In 1935, before University of Southern California art teacher **Paul Sample** gained artistic fame and was enticed into an artist-in-residence at Dartmouth College in New Hampshire, he painted *Santa Fe Station* (fig. 19-14). Its isolated Victorian structure, the absence of human inhabitants, and the strong contrasts of sunlight and shadow demonstrate that the influence of the East Coast painter Edward Hopper

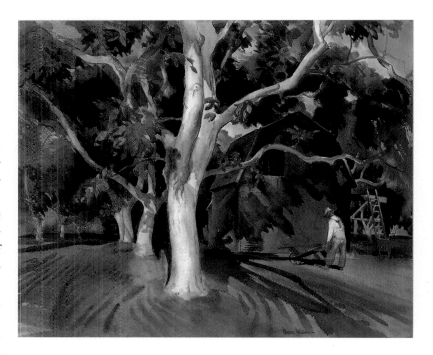

Fig. 19-13
Barse Miller (1904–1973)
Walnut Tree, 1938
watercolor, 21¾ x 26¾ in.
The E. Gene Crain
Collection

Fig. 19-14
Paul Sample (1896-1974)
Santa Fe Station (detail)
watercolor with pencil
indications
12¼ x 19¼ in.
Hood Museum of Art,
Dartmouth College,
Hanover, New Hampshire;
Gift of the Artist

(1882–1967) had spread to the West Coast. Another popular subject with Southern Californians was Hoover Dam, the awe-inspiring federal project built to regulate the flow of the Colorado River from a point near Las Vegas, Nevada. *Hoover Dam* of 1938 (fig. 19-15) by the wealthy Santa Barbara painter **Standish Backus** (1910–1989) exhibits the strong contrasts of light and shadow that were popular with California Style watercolorists. Phil Paradise attributes his use of this device to his teacher at Chouinard, the illustrator Pruett Carter (1891–1955).

The best of California's depression-era genre paintings were produced at the height of the American Scene movement (about 1928–35), before it was eclipsed by the Works Progress Administration's (WPA) art projects and before Los Angeles watercolorists began their wanderlust around the state in search of farmscapes. By the mid-1930s the subjects painted by California's watercolorists were changing. The Depression was easing, and some Southern California artists were driving up newly constructed WPA highways, penetrating the rural heart of the state between the metropolitan centers of Los Angeles and San Francisco. Soon

views of rolling farmland or cattle grazing land, dotted occasionally with a weathered barn or horses, began to replace city views. An example is Millard Sheets's *Black Horse,* above. Always pleasing, the psychologically neutral, non-controversial theme had nostalgic appeal and provided mental escape from the city.

In the 1930s, because several Los Angeles-area watercolorists earned their livings by working in the Hollywood animation and film studios, many cross-influences existed between the film industry and California watercolors. Both animated films and American Scene paintings dealt with simple, human themes and were designed to be quickly understood. The rigorous studies of human and animal locomotion and facial expressions made by animators for cartoons provided valuable background when these artists turned to making Regionalist watercolors containing figures. And, in turn, a painter's observation of the average person proved useful in creating animated stories. Hollywood money, from Walt Disney and others, kept the Chouinard Art Institute teaching practical techniques applicable to movies, such as animation, fashion design, and technical illustration.

Fig. 19-15
Standish Backus
(1910–1989)
Hoover Dam, 1938
watercolor, 15 x 22 in.
Collection of Nancy and
John Weare

The Berkeley School

While most of the practitioners of the California Watercolor Style lived in Southern California, several Northern California artists also adopted it. Bay Area artists took up the watercolor technique more slowly and were fewer in number. They enjoyed community support through such exhibitions as the *First Annual Exhibition of Water Colors, Pastels, Prints and Drawings* initiated by the Oakland Museum in the fall of 1933 and the *San Francisco Art Association, Watercolors, Pastels, Tempera on Paper* at the San Francisco Museum of Art in November 1936.

Even more important, the Bay Area developed styles of its own. The first might be called the "Berkeley School" style because its two main practitioners taught art at the University of California, Berkeley. Very different from the California Watercolor Style, its aesthetic was "modern" in that it was based on two-dimensional design (as opposed to Southern California's interest in three dimensions), the use of gouache (instead of transparent watercolor), and a preference for urban and industrial themes (as compared to genre and agrarian landscapes). An example is *Gas; Eleven-Nine* of 1942 (fig. 19-16) by **John Haley** (1905–1991).

Searching for precedents for their style, some art historians see similarities between the lighthearted, shorthand style of the French painter Raoul Dufy (1877–1953) and the way in which Haley and his fellow teacher Erle Loran (b. 1905) "draw" with gouache. Others see thematic precedents in the work of New York modernist Stuart Davis (1894–1964), whose 1930s cityscapes are really two-dimensional designs composed of buildings and signage. The Berkeley school acknowledged contemporary elements of modern American cities such as billboards, gas stations, trucks, warehouses, and so forth, that most Southern Californians avoided as jarring and unattractive. Haley might refuse the credit for originating this "school" by saying that he just painted the industrial scene adjacent to his residence in Point Richmond, north of Berkeley. But in an era of escapism and nostalgia, his choice took courage and made his work unique. **Erle Loran**'s *The Bridge at Elk* of 1942 (fig. 19-17) retains the "Berkeley" style but conforms more to Californians' love of their rural landscape, in this case the redwood logging outlet to the sea at Elk, on the coast above San Francisco. Before the Depression, redwood was the principal lumber used in San Francisco's Victorian-style frame buildings. With the industry's demise came abandoned shacks, equipment, and logs that contained the element of decay, hard work, and nostalgia, which satisfied American Scene requirements. But Loran also painted urban scenes around San Francisco's Bay.

Fig. 19-16
John Haley (1905–1991)
Gas; Eleven-Nine, 1942
watercolor, 18 x 22 in.
McClelland Collection

Fig. 19-17
Erle Loran (b. 1905)
The Bridge at Elk, 1942
watercolor, 15 ½ x 19 ½ in.
Oakmont Corporation
Photo: Victoria Damrel
(Clique Studio, Long Beach)

Fig. 19-18
Dong Kingman (b. 1911)
Coit Tower, c. 1949
watercolor on paper
22⅜ x 14⅞ in. (paper)
The Buck Collection, Laguna
Hills, California
Photo: Cristalen and
Associates

Fig. 19-19
George Post (1906–1997)
Embarcadero, 1945
watercolor, 15 x 19 in.
McClelland Collection

Both men passed their unique styles on to students, one of the most famous of which is Mine Okubo (b. 1913). Surface design as seen in the work of Haley and Loran became a national direction in the post World War II years (chapter 22) as artists strove to merge illusionism with abstraction. Hong Kong-trained San Francisco artist **Dong Kingman** (b. 1911) painted *Coit Tower* of about 1949 (fig. 19-18) in which San Francisco is suggested in a shorthand way as a stacked-up, two-dimensional arrangement of signs, shops, and human activity. At the time, Kingman was fascinated with the look of the contemporary American city, particularly New York, with its visually exciting interplay of skyscrapers, human activity, and signage. His staccato presentation almost conjures up the sounds of the city. The San Francisco peninsula artist **George Post** (1906–1997) also "drew" his scenes, but *Embarcadero* of 1945 (fig. 19-19) has a very different effect resulting from his use of darker colors and large, simple forms. It is important to note that the Southern Californian Rex Brandt, who studied under Haley at the University of California, Berkeley, in 1934, carried a version of Haley's "drawing" technique back to Southern California. He passed it on, in turn, through his several teaching posts, especially after 1947, when he and fellow watercolorist Phil Dike started the Brandt-Dike Summer School of Painting at Brandt's studios in Corona del Mar.

The Bay Area's other favorite watercolor style, the "wet-on-wet," had almost opposite qualities. It depended on soaking-wet papers and large amorphous shapes of intense colors with bleeding edges, and it was characterized by an emotional, even brooding feeling. An example is *Farm and Tree* (fig. 19-20) by the San Francisco State College art teacher **Alexander Nepote** (1913–1986). The San Francisco artist Tom Lewis (1909–1979) also frequently worked in this manner.

Asian Influences

Extensive literature documents probable and known trans-Pacific ties between Asian countries and California, Mexico, Central America, and South America. Similarities in art and religion suggest that Chinese and Japanese ideas have influenced art in the Americas since before the beginning of the Common Era (i.e., the time of Christ). Some believe this occurred when Japanese and Chinese fishing craft were blown off course and were carried by prevailing winds and tides to American shores. Asian influence escalated from the mid-nineteenth century when many Chinese came to work in the gold fields (1849) and to construct the railroads (1869). After 1882, Japanese began arriving to work in the agricultural fields.

Ever since they arrived, immigrant artists of Chinese and Japanese background produced art, but primarily in their traditional formats (scrolls and folding screens) and traditional aesthetic (wiry outline, oblique perspective, two-dimensional design, landscapes obliterated with heavy "fogs" or mists, and calligraphic brushwork). Colors ranged from the monochromatic Zen hues of white/gray/brown/black to extremely bright colors and patterns and gold backgrounds. In the 1930s, as California's Asian artists began to compete in the mainstream, many applied their traditional techniques and attitudes to Western subject matter. Dong Kingman's *Coit Tower* of 1949 (fig. 19-18), for example, reveals his study of calligraphy.

Artists of Japanese background proved unusually open to modernist ideas. **Chiura Obata** (1885–1975) received his training in Japan before immigrating in 1903 to San Francisco, where he worked for more than twenty years as an illustrator. Although his teaching at the University of California, Berkeley, from 1932 to 1954 put him in close proximity to the potent work of Haley and Loran, the paintings that Obata began to exhibit in 1928 are instead a blend of modernism and traditional Japanese art. In *New Moon, Eagle Peak* of 1927 (fig. 19-21) Obata combines *sumi* (Japanese ink painting), which he learned as a child, with Western watercolor technique. Steeped in Zen philosophy, he is less eager to copy scenery than to interpret it subjectively, giving it a sense of serenity. The soft nuances of the granite cliff are achieved by sopping the paper with water and then dragging a brush loaded with paint across it, allowing the color to bleed into the wet paper.

Many non-Asian Californians were impressed with Asian art and techniques and either studied in Japan or tried to learn the techniques in America. In Los Angeles of the 1920s the Synchromist Stanton MacDonald Wright became fascinated with Asian art. Its subjects and aesthetic crop up in his work and in the paintings of his students and followers. The Los Angeles modernist **Nick Brigante** (1895–1989) exposes his interest in the Chinese aesthetic in the tour de force *Implacable Nature and Struggling Imperious Man* of 1935–37 (fig. 19-22). Although this is an American Scene theme, complete with the standard boisterous presentation, it is rendered with classic Chinese painting techniques, including a wiry black outline and mists among the enfolding hills.

Fig. 19-20
Alexander Nepote
(1913–1986)
Farm and Tree
watercolor, 15 x 19 in.
Collection of Nancy and
John Weare

Fig. 19-21
Chiura Obata (1885–1975)
New Moon, Eagle Peak, 1927
sumi and watercolor on paper
15¾ x 11 in.
Collection of the Obata
Family
Photo courtesy the Yosemite
Association
Photo: Brian Grogan

Independents

California had a number of independent artists whose watercolor styles are not related to any of those discussed above but that are aesthetically outstanding enough to be noted.

Interestingly, two of the three independent watercolorists are women. Women often seem able to shut themselves off to the demands of the crowd, to go off into a corner, and to come up with highly individual solutions that express their personal creativity. **Z. Vanessa Helder** (Paterson) (1904–1968) could be classified as a Precisionist, a style associated with the East Coast and a term used here only briefly in regard to Millard Sheets. Precisionism is characterized among other things by precise paint application, sharp edges, simple shapes, and industrial subjects. Helder had been working in this style in her native state of Washington in 1943, when she married and moved to Los Angeles. Remaining aloof from the dominant California Watercolor style, she continued her austere translation in *San Pedro Barns* of about 1945 (fig. 19-23). The crisp edges and absence of bleeding suggest that her paper was almost dry when she applied the pigments. In addition to a sizable proportion of gouache, she employs the dry-brush technique. In this, a brush, almost devoid of pigment, is dragged lightly across the high points of the paper's texture, leaving trails of texture rather than pools or swaths of pigment. Helder willingly uses favorite Depression-era colors such as browns and blacks, and although her trademark is the black-limbed,

bare-branched tree, her scenes do not come across as depressing.

Albert Sumner Marshall's (1891–1970) independent wealth allowed him to live and work totally apart from any art group. When he was not looking after his real-estate holdings, he made extended painting excursions into California's unpopulated backcountry to paint landscapes such as *Banner Peak* of about 1940 (fig. 19-24). He delighted in crisp edges and control but synthesized California's landforms into sinuous and emotional patterns.

The peak years of the California Watercolor Style were the 1930s. Typically, however, even after the fashion passed most artists committed to the style continued to work in the same vein for the rest of their lives. Because it was the prevailing national style when several California watercolorists were hired by the armed forces during World War II, it was used to render scenes of the war (chapter 23).

The Great Depression is primarily known for its government art projects. They supported thousands of artists of varying capabilities and left the nation with murals, sculpture, easel paintings, and many other kinds of art works gracing post offices, government buildings, and schools. The next chapter will reveal how the government initiated these projects and how it capitalized on American Scene subject matter to demonstrate America's goodness. 🎋

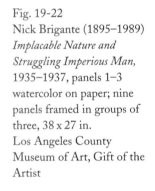

Fig. 19-22
Nick Brigante (1895–1989)
Implacable Nature and Struggling Imperious Man,
1935–1937, panels 1–3
watercolor on paper; nine panels framed in groups of three, 38 x 27 in.
Los Angeles County Museum of Art, Gift of the Artist

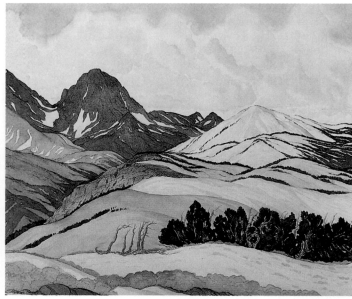

Fig. 19-23
Z. Vanessa Helder (Paterson)
(1904–1968)
San Pedro Barns, c. 1945
watercolor on paper
17½ x 21½ in.
Private Collection

Fig. 19-24
Albert Marshall (1891–1970)
Banner Peak, c. 1940
watercolor, 20 x 24 in.
Jonathan Club, Los Angeles

Bibliography

Watercolor Painting, American

Stebbins, Theodore E., Jr., *American Master Drawings and Watercolors: A History of Works on Paper from Colonial Times to the Present,* Minneapolis Institute of Arts, Minneapolis, Mn., 1976. 464 p.

Watercolor Painting in California Prior to 1930

"Chapter One" in Alfred C. Harrison, Jr., *William Keith: The Saint Mary's College Collection,* Moraga: Hearst Art Gallery, Saint Mary's College of California, 1988.

Harrison, Alfred C., Jr., "California Watercolors: Paintings in the Collection of Edward McLaughlin," *Art of California,* v. 3, no. 6, November 1990, pp. 46-53.

Watercolor Painting, California, 1930s

(See also bibliography for American Scene in chapter 18.)

Anderson, Susan M., "California Watercolors 1929–1945," *American Artist,* v. 52, August 1988, pp. 48-53+.

Anderson, Susan M. and Robert Henning, Jr., *Regionalism: The California View: Watercolors 1929–1945,* exh. cat., Santa Barbara Museum of Art, June 25–August 14, 1988.

Annual Exhibition of the California Watercolor Society, various venues, 1921–present.

Brown, Michael D., *Views from Asian California 1920–1965,* San Francisco: Michael Brown, 1992.

"California School" from the Private Collection of E. Gene Crain, essay and artists' biographies by Janet Dominik, exh. cat., Gualala Arts Center, Gualala, Ca., May 24–July 20, 1986.

California White Paper Painters, 1930's–1970's, exh. cat., Art Gallery, California State University, Fullerton, April 25 - May 20, 1976.

Dominik, Janet B., "The E. Gene Crain Collection," *Art of California,* v. 2, no. 1, February/March 1989, pp. 43–49.

Hines, Thomas S., "Art: Early California Watercolors," *Architectural Digest,* v. 46, May 1989, pp. 296-301+.

McClelland, Gordon T. and Jay T. Last, *The California Style: California Watercolor Artists 1925–1955,* Beverly Hills: Hillcrest Press, 1985.

McClelland, Gordon, *California Watercolors (1860-1960),* Beverly Hills: Hillcrest Press, in process.

McClelland, Gordon, "Toward Diversity: California Postwar Watercolors 1945–1965," *Antiques and Fine Art,* v. 8, no. 2, January/February 1991, pp. 94–101.

Moure, Nancy Dustin Wall, *The California Water Color Society: Prize Winners 1931–1954; Index to Exhibitions 1921–1954,* Los Angeles: Privately Printed, 1975.

Perine, Robert, *The California Romantics Harbingers of Watercolorism (Catalogue to the National Watercolor Society Past President's Invitational),* exh. cat., Brand Library, Glendale, Ca., March 7–April 7, 1987.

Scenes of California Life 1930–1950, exh. cat., Todd Madigan Gallery, California State University, Bakersfield, March 9–April 10, 1991.

Sibenman, Barbara, *A Critical Analysis and Survey of the California School of Watercolor Painting, 1930–1948,* Thesis, Stanford University, 1949. 47 l.

West Coast Watercolor Society, exh. cat., Otis Art Institute, November 13–December 23, 1966. [Annuals held at various venues including E. B. Crocker Art Museum in Sacramento (1970, 1971) and Wortsman Stewart Galleries, San Francisco (1977). The latter contains a history of the Society begun 1962.]

Westphal, Ruth Lilly, ed., *American Scene Painting: California, 1930s and 1940s,* Irvine, Ca.: Westphal Publishing, 1991.

Whitaker, Frederic, "Watercolor in California," *American Artist,* v. 32, May 1968, pp. 34-45.

Watercolor Painting, Southern California

(See also bibliography for Disney artists and Chouinard Art Institute in chapter 17.)

Anderson, Thomas R., "Looking Through Artists' Eyes: Los Angeles in the 1930s and 1940s," *Antiques & Fine Art,* v. 6, no. 6, September/October 1989, pp. 90–99.

"Watercolorists," in Nancy Moure, *Painting and Sculpture in Los Angeles, 1900-1945,* exh. cat., Los Angeles County Museum of Art, September 25–November 23, 1980, pp. 59–62.

"Watercolors," in Ilene Susan Fort and Michael Quick, *American Art: A Catalogue of the Los Angeles County Museum of Art Collection,* Los Angeles: The Museum, 1991.

Watercolor Painting, Asian Influence

Denker, Ellen, *After the Chinese Taste: China's Influence on America, 1730–1930,* Salem, Ma.: Peabody Museum of Salem, 1985. 80 p.

Wichmann, Siegfried, *Japonisme: The Japanese Influence on Western Art in the 19th and 20th Centuries,* New York: Harmony Books, 1981

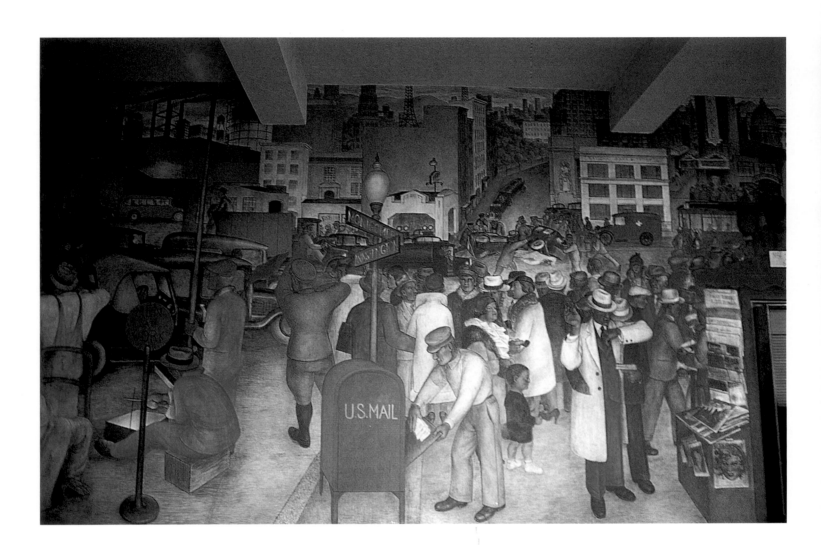

Fig. 20-9
Victor Arnautoff
(1896–1979)
City Life, 1933–34 (detail)
fresco, 10 x 36 ft. overall
Coit Tower, San Francisco,
PWAP, 1933–34
Photo: Victoria Damrel

Mural Painting to 1960

Man's earliest paintings were probably applied to flat surfaces such as cliff faces and cave walls. In prehistoric times, such paintings became associated with ownership of territory and religious rites. The earliest known wall paintings appear in caves, such as those at Altamira, Spain, and date between 30,000 and 10,000 B.C. The first murals to use compositional ideas that we still employ today appeared on the walls of Egyptian tombs. These were narrative scenes of religious and secular content. Long before writing was invented, walls were considered a viable surface to receive imagery and paintings that carried symbolic messages.

Mural Art to 1930

California's earliest "mural" painting is its Native American rock art. Rock art was widely practiced in the United States, with most surviving sites found west of the Rocky Mountains. American rock paintings are difficult to date. The earliest may be no more than 4,000 years old, and those in California probably date to within the last 1,000 years. Most of California's rock art occurs south of San Francisco, and the most outstanding examples were created by the **Chumash**, whose territorial center was near Santa Barbara. Native Americans made both pictographs (paintings) and petroglyphs (chipped designs) on rocks and cliffs. Californian Indians, along with their sedentary Southwestern neighbors extending into Texas, generally employed geometric designs. (In contrast, the Northwest and Plains groups, who led a nomadic existence hunting migrating herds, painted naturalistic animal designs.) Californians usually painted in one color, often red or black, with natural pigments. Their symbols (geometric designs, such as spirals and circles) usually appear scattered over a surface or clustered and overlaid, since they were often painted repeatedly atop one another at sacred sites over many years as ceremonies demanded. That is why a pictograph such as that from the San Emigdio Mountains, Kern County, painted by various Chumash (fig. 20-1), seems so superior. It incorporates many different colors, and one artist has arranged numerous elements within a larger compositional scheme.

Wall painting in the Western European mode was introduced into California by priests during Spanish times. To make their blocky adobe churches more attractive, they had the interiors painted with familiar European decorative motifs: elements of architecture, such as columns and entablatures, flowers, symbols of Christ and God, and so forth (fig. 1-2). By today's standards these murals seem crude and folk-like, stylistically not unlike the contemporaneous landscape murals painted on the walls of private homes in colonial New England. The most interesting were those painted by Native American neophytes depicting mission life, such as the *Vintage Scene* from San Fernando Mission of about 1820 (fig. 1-3) that blended their stick-figure art with European pictorial concepts.

More sophisticated mural painting began to appear in the late nineteenth century, when settlers of European background swelled the populations of San Francisco and Los Angeles, and when enough private wealth had been accumulated to build mansions or to endow churches decorated in the American Renaissance style (chapter 8). Most California Renaissance murals were painted in San Francisco by artists such as Domenico Tojetti and Arthur Mathews, but, unfortunately, most were destroyed in the fire that followed the 1906 earthquake. Reconstruction of the city after the earthquake, however, provided even more work for Mathews and other muralists, including Gottardo Piazzoni. American Renaissance/Beaux-Arts murals culminated in the decorations at the Panama-Pacific Exposition of 1915 (chapter 9).

Fig. 20-1
Chumash
Untitled Pictograph, San Emigdio Mountains, Kern County, between 1–1900 AD natural pigments, polychrome, on rock
c. 6 ft. x 30 in.
Photo courtesty Santa Barbara Museum of Natural History, from Campbell Grant, *The Rock Paintings of the Chumash,* 1993.

Post-exposition murals of the 1920s were made in a variety of styles. During that decade, a heady nation raced through boom times. Businesses that wanted to portray their success overtly or to aspire to importance, wealth, or glamour built and decorated edifices in imitation of the imposing civic monuments and private palaces of the turn of the century. Conservative clients stayed with Beaux-Arts images and themes, while more daring patrons hired Post-Impressionist artists such as Conrad Buff to paint vivid, dramatic desertscapes. California had no dedicated muralists, and thus most murals were executed by easel painters who had the ability to work in large scale and overcome the medium's technical difficulties, or by muralists or decorators who came from out of state.

Most murals of the 1920s were decorative or they repeated the ideal themes and messages of the American Renaissance but without figures in classical costume. Murals graced banks, movie theaters, luxury hotels, and high-class department stores. The decorations that the New Yorker **Albert Herter** (1871–1950) made with the help of **Jessie Arms Botke** (1883–1971) for the Grill of the Saint Francis Hotel in San Francisco in 1914 conveniently show us two styles in one. *The Orient* and *Persia* of 1914 (fig. 20-2) are two of seven paintings on the theme "Gifts of the Old World to the New." Since viewers of the decorations were to be well-to-do diners, and the grill wanted its clientele to feel at ease and surrounded by luxury, the theme was optimistic and opulent. The central scene is three-dimensional, normally avoided in mural painting in which the goal is to decorate and yet still retain the integrity of the wall surface. Herter gets away with this three-dimensionality because he uses no atmospheric perspective and thus brings all of the pictorial elements up to the surface of the wall. While the characters are not idealized, nor do they wear Greek robes, they are still the best physical specimens of their respective types. Herter was a tapestry designer, and here he strives for a sumptuous tapestry-like effect, dressing his figures in rich attire. The decorative border, painted by Jessie Arms (later Botke), supports this sumptuous effect by using well-known European decorative motifs and ideas, probably derived from design books. Several of these design books were in publication and made centuries of European motifs—urns, bowls, and

cornucopia overflowing with fruit, latticework, birds, and flowers—available to contemporary artists. Botke frequently visited museums as well for source material. The lush band acts as a frame and also enriches the overall effect. Through the experience of such work Botke developed her later specialty of bird subjects (chapter 21). Gottardo Piazzoni and Ray Boynton (1883–1951) painted other important murals in San Francisco.

In Los Angeles, a city that could boast only a handful of murals before the 1920s, the biggest government art project of the 1920s was the decoration of the new main public library; the various murals were executed by Albert Herter, **Dean Cornwell** (1892–1960), and Julian Garnsey (1887–?). Cornwell's selection as painter for the coveted rotunda murals was highly controversial—he was from out of state and had only an illustration background. But after receiving the commission he took a "crash course" in mural painting with the prominent British artist Frank Brangwyn (1867–1956), and the library murals succeeded admirably. *The Rotunda Murals* (fig. 20-3) summarize California's history with a composite of characters gathered close to the wall surface. The figures seem "illusionistically real," yet the work does not break down the surface of the wall—Cornwell's colors are muted, the figures arranged in a shallow "frieze," and elements such as the ship prow and flags are "stacked up" instead of made to recede. Cornwell chose to create his works on canvas and then glue them to the wall, an option available to muralists. Murals also decorated the interiors of motion picture theaters. In order to emulate the gold- and velvet-decorated Victorian concert halls and legitimate theaters, motion picture houses lavishly embellished their walls inside and out, justly earning the title "movie palaces." Institutions such as banks strove to make themselves seem permanent, substantial, and trustworthy by emulating the architecture and decoration of government buildings. Churches continued to demand interiors that suggested the imagined glory of heaven and provided sufferers a beautiful refuge. Government buildings were often the sites for historical or instructive murals.

While early commissions follow the styles imposed on California by artists trained on the East Coast, **Maynard Dixon,** commissioned at the end of 1912 by Anita Baldwin McClaughry to make four murals for

Fig. 20-2
Albert Herter (1871–1950);
Jessie Arms Botke
(1883–1971)
"The Orient" and *"Persia,"*
two of seven murals in the
Grill, St. Francis Hotel, San
Francisco, 1914, from hotel
menu cover
Menu collection of the Botke
Family Archive
Photo courtesy William A.
Karges Fine Art

Fig. 20-3
Dean Cornwell (1892–1960)
Los Angeles Public Library
Rotunda Murals, 1929–32
(detail)
oil on canvas
dimensions unknown
Photo courtesy Hearst
Newspaper Collection,
Special Collections,
University of Southern
California Library

Fig. 20-4
Maynard Dixon (1875–1946)
Victory Song, 1912
Anita Baldwin McClaughry
house, Sierra Madre (detail)
oil on canvas, 4 x 18 ft. overall
Photo courtesy Donald J.
Hagerty
Photo: Casey M. Brown

the Indian Hall of her new mansion, Anoakin, near Pasadena, pursued a more liberal interpretation of traditional artistic rules. *Victory Song* of 1912 (fig. 20-4) generally complies with traditional mural concepts. The colors are muted, the figures are close to the surface plane, and the procession strides with energy and a sense of purpose across the viewer's line of sight. Dixon's murals differ in that they are more scenic, more three-dimensional, less "cluttered," and less a composite of many ideas than a single summarizing event. They also reveal Dixon's personal philosophy of the West as a place for physical and mental freedom and Native Americans as a noble and poetic race in touch with their environment. (Dixon's later murals adopted an Art Decoratif look, flat and silhouetted figures against a flat backdrop.)

In both Los Angeles and San Francisco, mural painting was taught in art schools. At the Chouinard Art Institute, the classically trained F. Tolles Chamberlin passed on his ideas in after-school classes to Millard Sheets and others. In San Francisco, Ray Boynton taught a class in mural painting through the 1920s at the California School of Fine Arts and a special class in fresco in 1926.

In the 1920s murals blossomed throughout California. In Santa Barbara, where Albert and Adele Herter retired, the Herters painted several. Among others, in 1929 Adele painted desertscapes on the walls of the Desert Room at El Mirasol, the family estate briefly turned into a hostelry for wealthy travelers, and in two private homes in 1931. One example is the Art Decoratif desert mural in the Casa del

Sueno, Montecito (described in chapter 16). In the late 1920s Dan Sayre Groesbeck (1878-1950) painted impressive murals of California's history in the Santa Barbara County Courthouse. In Sacramento, historical murals were painted in the State Library (by Maynard Dixon) and in the capitol (by Arthur Mathews). In Redlands, Dean Cornwell painted the interior of the Lincoln Shrine. These are just a few.

The 1920s in California were preparatory years for the mural revival that peaked in the 1930s. Much of what gave 1930s murals stylistic unity in California is directly attributable to the Mexican aesthetic (chapter 18). All three of Mexico's great muralists of the twentieth century painted in the state.

In San Francisco, aspiring muralists of the 1930s looked to **Diego Rivera** for style as well as for political attitudes. In 1930 and 1931, Rivera was in the Bay Area painting his *Allegory of California* on the walls of the old Pacific Stock Exchange Club; his *Still Life and Blossoming Almond Trees* for the Stern residence at Atherton (since relocated to Stern Hall at the University of California, Berkeley); and his *The Making of a Fresco Showing the Building of a City* at the California School of Fine Arts (fig. 20-5). *Making of a Fresco* shows artists on scaffolding at work on a mural whose theme is the construction of a city. Rivera's political leanings are exposed when he makes the worker-engineer the center of interest by placing him in the apex while he relegates the overseers (the figures holding plans) to an insignificant position at the bottom center of the image. Each of the figures is modeled after a known individual. Not only did the school's students

have a chance to observe Rivera at work, and some of them even to assist him, others, such as the Russian Victor Arnautoff, had been able to work on murals in Mexico with Rivera before arriving in San Francisco about 1930. Although Rivera was branded a Communist, this did not trouble the union-oriented artists of San Francisco. Most ignored his politics and adopted his stylistic traits or techniques (fresco among them).

In Los Angeles, **David Alfaro Siqueiros** (1896–1974), arriving in May 1932 as a political exile from Mexico, touched the students at the Chouinard Art Institute. In his year in Los Angeles, Siqueiros painted four murals, including *Tropical America* of 1932 (fig. 20-6) on a second floor exterior wall on Olvera Street, and *Workers' (Street) Meeting* in the courtyard of Chouinard Art Institute. At Chouinard, Siqueiros taught fresco painting, one of several historic techniques that were revived in the 1930s. "Students" included some professionals, such as Millard Sheets and Phil Paradise, as well as ten or so others (the reported number varies). Siqueiros was particularly interested in discovering a way to create long-lasting murals on building exteriors, where he felt they could be appreciated by a greater number of people. And instead of following the traditional method of making preliminary drawings and then transferring them to the wall in a variety of time-consuming ways, he pioneered the projection of 35mm slides and applied paint with the newly fashionable airbrush. His politically explosive subject matter, usually on the theme of the downtrodden worker, which he often added at the last minute in the secrecy of night, found no sympathy in the eyes

Fig. 20-5
Diego Rivera (1886–1957)
The Making of a Fresco Showing the Building of a City, April–June 1931
true fresco
22 ft. 7 in. x 29 ft. 9 in.
San Francisco Art Institute
Photo: David Wakely

Fig. 20-6
David Alfaro Siqueiros (1896–1974)
Tropical America, 1932
(exterior Italian Hall, El Pueblo de Los Angeles Historical Monument)
fresco on white cement
16 x 80 ft.
Photo courtesy University of Southern California

Fig. 20-7
Jose Clemente Orozco
(1883-1949)
Prometheus, 1930
fresco, 25 x 30 ft.
Pomona College, Claremont,
California
Photo: Schenck & Schenck,
Claremont

of anti-Red Los Angeles. Several of his murals, including *Tropical America,* in which the central figure of a worker appears crucified on a cross, were almost immediately painted over by the same patrons who commissioned them. His legacy remains in his students' enthusiasm for dynamics and for colorful aesthetics, although his political opinions may have awakened generally apolitical Southern Californians to an occasional Social Realist subject (chapter 18). Ironically, among the artists who worked with Siqueiros on the highly controversial *Tropical America* on Olvera Street was "establishment" muralist Dean Cornwell, just after he completed the rotunda at the Los Angeles Public Library.

Mexico's third great muralist, **Jose Clemente Orozco** (1883–1949), painted only one work in California, the *Prometheus* arch at Pomona College in 1930 (fig. 20-7). Orozco's work had little immediate influence on California artists, although it was probably the most revolutionary in style. Its expressive brushwork and three-dimensional perspective challenged accepted conventions that wall decoration should be flat, pleasant, decorative, and impersonal. Orozco created his work directly on the wall (as opposed to designing it first on paper), and his work exudes tremendous energy, heralding Abstract Expressionism, which would evolve in another ten years.

Los Angeles also benefited from the residence of easel painter Alfredo Ramos-Martinez after 1929.

New Deal Murals/Government Art Projects 1933–1943

Economics often determine the direction taken by art, and that is certainly true in the 1930s. Mural painting's efflorescence was entirely the result of the federal government's decision to support what it regarded as inexpensive decoration for a new spate of government buildings. The government believed murals could deliver a nationalistic message and at the same time give employment to needy artists. Funding came from five separate programs, beginning with the Public Works of Art Project (PWAP), initiated in mid-December 1933. Most murals were created under the Federal Art Project (FAP), a subsection of the Works Progress Administration (WPA). The WPA functioned from 1935 to 1943 and employed more than 5,000 financially needy artists nationwide—teachers, painters, muralists, sculptors, printmakers, and poster makers—for eighteen-month periods. Thanks to Regionalist attitudes and to government participation, all communities, no matter how small, received artwork, usually in the form of murals for new post offices and schools.

San Francisco. In San Francisco, the project that most art historians discuss is the series of murals in Coit Tower (fig. 20-8) painted in early 1934 by a group of artists supported by PWAP funds. Part of the fascination of this project stems from the controversy over certain political details in some of the scenes.

In 1929, well before the inception of the government projects, "Firebelle" Lillie Hitchcock Coit died and left $118,000 to the city of San Francisco to be used for its beautification. After much consideration, in 1931 it was decided that a memorial would be constructed on Telegraph Hill, and the 180-foot Coit Tower resulted. Two years later, when the PWAP was initiated, administrators looking for appropriate buildings to be decorated, noticed the newly finished tower. The interior offered several unadorned, mural-size walls in the first-floor lobby, in the stairwells, and on the second floor. Although twenty-six artists working in different styles eventually participated in the tower's painting, Victor Arnautoff, the group foreman, was able to keep the scale and palette unified and to limit the themes to the contemporary American scene, particularly as it was lived in Northern California. The artists seem to have worked in harmony, possibly because of their common interest in the fresco technique and the excitement of this first government art project.

Virtually all of the Coit murals, like **Victor Arnautoff**'s *City Life* mural (fig. 20-9, p. 252), presented benevolent themes. The government, to ensure that murals would have positive messages, "suggested" abstract themes such as speed, responsibility, intelligence and courtesy, scenes from American history, or views of contemporary citizens leading useful, contented lives. Encouraged by the Regionalist movement to respect the traditions of their own area, the artists usually selected subjects derived from their own locales. In spite of all the grimness history tells us about the Great Depression, these murals were generally optimistic, showing Californians leading productive lives. In Coit Tower, workers are shown in jobs related to Northern California. Rural work includes panning for gold, farming, and dairying. Among the urban work subjects are newspaper publishing, banking, the oil industry, work at hydroelectric plants, meatpacking, and the packing and processing of California's agricultural products. People walk on city streets, visit libraries, purchase goods at stores, and are involved in collegiate sports. Children play, men hunt, and people vacation in the country. Stylistically, most of these murals bow to Diego Rivera's "peasant figure" look and his style of black outline, smooth modeling, and muted coloring, much a result of the natural pigments demanded by the fresco technique.

Fig. 20-8
Coit Tower, San Francisco,
exterior
concrete, 180 ft. tall
Photo: Victoria Damrel

Fig. 20-10
Jane Berlandina (1898–1970)
Home Life, 1933–34 (detail)
egg tempera, 9 x 34 ft. overall
Coit Tower, San Francisco,
PWAP, 1933-34
Photo: Victoria Damrel

Fig. 20-11
Bernard Zakheim
(1896–1985)
Library, 1933-34 (detail)
fresco, 10 x 10 ft. overall
Coit Tower, San Francisco,
PWAP, 1933–34
Photo: Victoria Damrel

Most of the murals were executed in true Italian fresco technique. On the first rough coat of plaster a simplified drawing of the image is sketched. The finish plaster (made of fine marble dust and slaked lime) is spread on small areas on the wall, as much as can be painted in a day's work and ending at a logical contour of dress, or body, or building. While the plaster remains wet, the colors are applied. The next day another area of finish plaster is applied and the painting continues until the entire mural is completed. Such a technique works best with large, bold, and simple designs. Fresco is a very permanent medium, since the pigment becomes part of the wet plaster. With luck, over time the marble dust forms a crystalline surface to protect it further. Some of the other tower murals are painted in oil on canvas (those by Otis Oldfield, Rinaldo Cuneo, and others), and one is executed in egg tempera applied to dry plaster (a view of home life by **Jane Berlandina**, 1898–1970; fig. 20-10).

The conflict that arose stemmed not from the murals but from some of the details in the scenes. Just as the Coit muralists were rushing to complete the two-month job, certain events occurred that caused them to add political content to their art. In mid-February, Diego Rivera's mural in Rockefeller Center featuring a large portrait of Lenin was white washed, causing the newly formed San Francisco Artists' and Writers' Union to lead a sympathetic protest. The union believed if such censorship of artistic freedom could happen in New York, it could happen anywhere and must be stopped. At the same time, at the foot of the hill on which Coit Tower stood, dissension was growing along the waterfront between the Waterfront Employers and the International Longshoreman's Association. In May a strike that affected the entire West Coast—from Seattle to San Diego—closed down the port of San Francisco.

Moved by these events and sympathetic to the workers, the artists inserted subtle left-wing details into four frescoes on the first floor. **Victor Arnautoff** incorporated an edition of *The New Masses* and another of *The Daily Worker* in his *City Life*. A miner reading *Western Worker* and a group of militant unemployed workers and gold miners glaring at wealthy tourists appear in John Langley Howard's fresco *California Industrial Life*. Books such as *Das Kapital* are shown

on the shelves of **Bernard Zakheim**'s *Library* mural (fig. 20-11). Symbolically most overt was the three-part mural painted by **Clifford Wight** (c. 1900–1960s), a former assistant to Diego Rivera. Flanking each of three first-floor windows, he painted single standing figures and overarched each window with a symbol. (An example is *Steelworker* (fig. 20-12), matched by *Surveyor*, whose window was overarched with a hammer and sickle.) While the worker-figures represented occupations that reflected sound American values, the symbols over the windows seemed to identify them with the three politico-economic alternatives of the 1930s. "Rugged Individualism" was topped with the words "In God We Trust" (clearly symbolizing capitalism); "The New Deal" with the blue eagle of the NRA (National Recovery Act, suggesting socialism); and "Communism" with the hammer and sickle. Some people believed the artist was inviting the average citizen to make a choice among the three.

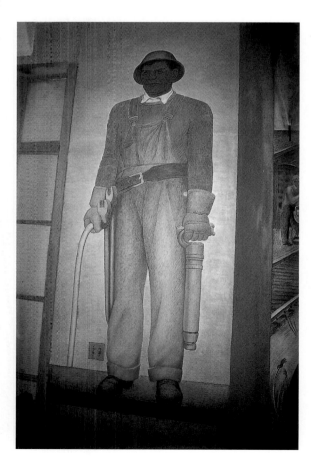

Fig. 20-12
Clifford Wight
(c. 1900–1960s)
Steelworker, 1933–34
fresco, 10 x 4 ft.
Coit Tower, San Francisco,
PWAP, 1933-34
Photo: Victoria Damrel

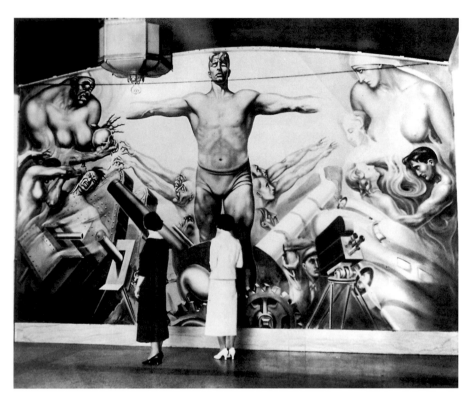

Newspaper publishers were aware that some of the as-yet-unveiled Coit Tower murals contained Communistic details. Wanting to swing public sympathies away from the San Francisco maritime unions, they decided to expose the murals as an example of the artists' (i. e., workers') disrespect for their source of funds (i.e., the federal government). Tower administrators, made aware of the offensive details, insisted the paintings be completed as they had been designed and approved, without the last-minute additions of the Communist references. At the same time, a private tour of the as-yet-unopened tower informed the San Francisco Art Commission of the murals' content. The commission, as caretaker of the park and tower, judged the murals unpatriotic, locked up the building, and refused to open it on the scheduled date of July 7, 1934, unless the offending symbols were removed. A vigilante group of artists, not employed in the tower and unsympathetic to what the Coit artists had done, formed with the intention of obliterating the symbols, but they were stopped by a picket line thrown up around the tower by the Artists and Writer's Union. To make matters worse, an enterprising newspaper reporter created a *composite* photo from two separate murals, making the Wight murals look even more Communistic than they actually were. The photograph was published July 5, on the morning of the bloody wharf strike that left two persons dead. The revealed fraud, along with the deaths of the two dock workers, caused public sentiment to swing away from the pro-management newspapers and toward the workers and artists. The dispute over the murals was quietly resolved. After much discussion, the committee allowed the Arnautoff, Howard,

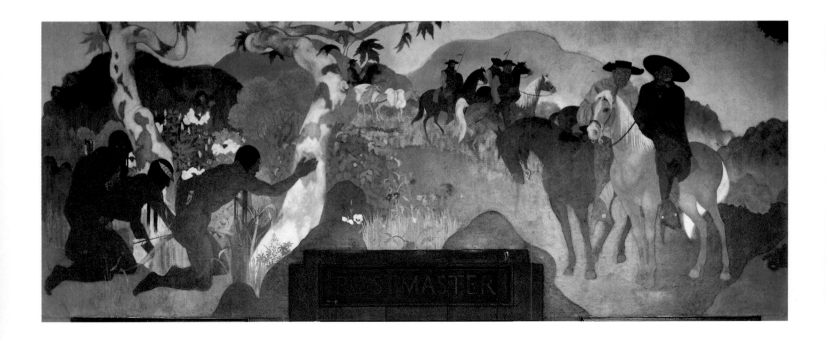

and Zakheim frescoes to remain intact. And although Wight argued forcibly to keep his symbolism, on October 20, 1934, when the tower opened to the public, the offending symbols had disappeared.

Because of the interest in mural painting prompted by government art projects, the San Francisco Mural Artists Society was formed in late 1934 and held weekly meetings in the studios of its members.

Los Angeles. The Los Angeles situation was very different. Although Siquieros did paint some of the most politically controversial subjects of the three Mexican artists, and the city also had its John Reed Club, the social environment of Los Angeles discouraged artists from painting any kind of controversial material. In addition, the city's main art critic, Arthur Millier, soundly denounced anything Communistic or Fascistic. Understandably, **Leo Katz**'s (1887–1982) *Man Amid His Inventions* of 1935 (a PWAP mural, possibly destroyed) (fig. 20-13), which shows a blind youth groping his way among weapons of war, did not remain long on the wall.

Los Angeles artists were primarily interested in Regionalist (pleasant) themes. A favorite was the area's Spanish-Mexican heritage, and **James Redmond**'s (1900–1944) *Early California* of 1936 is an example (SECTION with TRAP assistants) (fig. 20-14). Redmond's mural was funded by the U. S. Treasury Department, which oversaw two funding sources: the Section on Painting and Sculpture (SECTION) and the Treasury Department Art Project (TRAP). The Treasury Department gained a reputation as "elitist," since its administrators selected artists for government buildings on the merit of sketch designs. The second source

for mural funds, the Federal Art Project (FAP), was part of the huge Works Progress Administration, whose funds went to the "needy," and artists were chosen irrespective of talent.

Most Los Angeles artists avoided Social Realist subjects, which makes a mural by **Charles Kassler** (1897–1979) unusual. *PWA Paymaster* of 1936 (TRAP) (fig. 20-15) is one of six panels on the theme *PWA Payments Help Trade* in the Beverly Hills Post Office. The mural celebrates a contemporary situation—people on relief lining up for their paychecks. Industrial themes were also unusual, in part because of the area's lack of industry, but there is an occasional scene of oil wells in murals painted in suburbs where industry existed, such as Long Beach, San Pedro, and Venice. Although motion-picture production was one of the city's best-known "industries," only one mural featured it: *Studio Lot* by George Samerjan (b. 1915) in the Culver City Post Office (SECTION), and Stanton MacDonald Wright included a panel on filmmaking in his *Invention and Imagination* of 1935 for the Santa Monica Library (PWAP).

The largest funding source for murals was the Fedral Art Project. Its Southern California jurisdiction was one of sixteen national geographical divisions, and it was headed by two important modernist painters, Stanton MacDonald Wright and Lorser Feitelson (1898–1978). The mark of their highly individual styles can be discerned in some of the paintings made by their workers. Hints of Wright's sinuous Oriental line and subtle, airbrush-like shading can be seen in Redmond's *Early California* (above). More obvious is the use of Lorser Feitelson's Post-Surrealist style in

Opposite, top:
Fig. 20-13
Leo Katz (1887–1982)
Man Amid his Inventions,
1935 (PWAP mural formerly at Frank Wiggins Trade School, L. A.)
medium and dimensions unknown
Photo courtesy of Hearst Newspaper Collection, Special Collections, University of Southern California Library

Opposite, below:
Fig. 20-14
James Redmond (1900–1944) assisted by Don Totten
Early California, 1936
Compton Post Office, 1936 (SECTION with TRAP assistants)
Photo courtesy Steve Totten
Photo: Susan Einstein

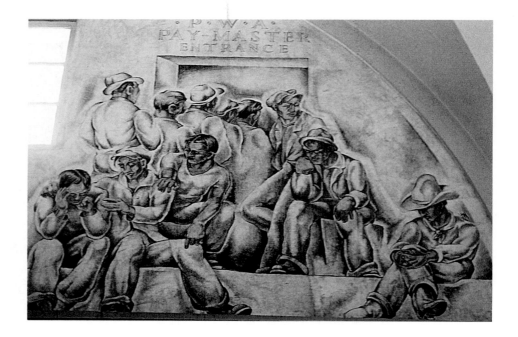

Fig. 20-15
Charles Kassler (1897–1979)
PWA Paymaster (one of eight lunettes "P.W.A. Payments Help Trade," 1936) (detail)
fresco, dimensions unknown
Post Office, City of Beverly Hills, SECTION and TRAP
Photo: Victoria Damrel, Clique Studio

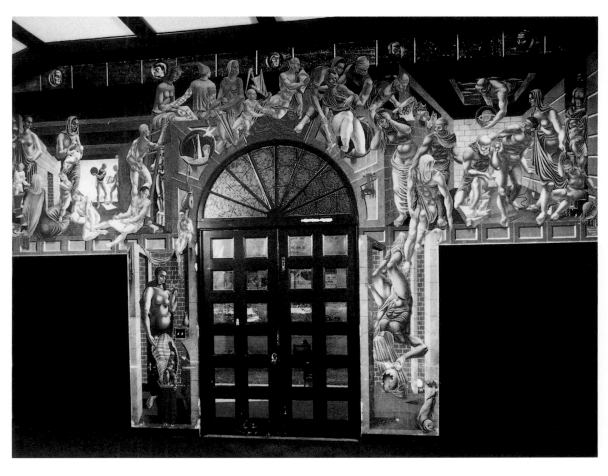

Fig. 20-16
Reuben Kadish (1913–1992);
Philip (Goldstein) Guston
(1913–1980)
Untitled, 1935–36
fresco, 163 square feet
City of Hope National
Medical Center and
Beckman Research Institute,
FAP

Fig. 20-17
Helen Lundeberg (b. 1908)
*George Washington: Valley
Forge 1777,* 1941
petrochrome
George Washington
Preparatory High School,
Los Angeles, FAP
Photo: Casey Brown

the untitled mural at the Los Angeles Tubercular Sanitorium (now the City of Hope) painted by **Reuben Kadish** (b. 1913) and **Philip (Goldstein) Guston** (1913–1980) (fig. 20-16).

Southern California's arid climate encouraged outdoor murals. This led to the use of two new media—petrochrome and mosaic—that could withstand the area's persistent sunshine. Both media were based on ancient techniques updated by the Depression-era artists' need for cheap materials. The Roman medium *opus sectile* consisted of jigsaw-like pieces of marble in various colors assembled to create a scene. Being expensive, the FAP head Stanton MacDonald Wright found that he could create a similar effect by substituting terrazzo (a commercial product of colored concrete laced with crushed marble and stone aggregates). A finished example by **Helen Lundeberg** (b. 1908) is *George Washington: Valley Forge 1777* of 1941 (fig. 20-17). First, the image was drawn on Masonite, dikes were built along the pencil lines, and the appropriate color of terrazzo poured in. Once the concrete dried, the dikes were reformed and the next color cast. On completion, the Masonite was removed, the face polished, and the piece

attached to the wall. Not only was the medium almost indestructible but the object became an integral part of the wall.

Los Angeles's FAP artists also modified the ancient technique of mosaic, the art of assembling thousands of tiny pieces of variously-colored marble to make a picture. The FAP's interest in mosaic coincided with the rise of Los Angeles's ceramics industry and innovative ceramists such as **Albert H. King** (1900–1982). Instead of using the traditional marble, stones, or glass, these ceramists used glazed ceramic tiles. The most outstanding example of mosaic work is King's *Typical Activities of a Beach and Harbor City* of 1938 (originally on the exterior of the Long Beach Municipal Auditorium) (fig. 20-18). Thirty-eight feet high and twenty-three feet wide, it contains more than 466,000 tiles. (The labor-intensive cutting and setting was assigned to the ninety percent of FAP artists who were hired from relief roles.) In another innovation, the tiles were laid not following the *contours* of the individual shapes, but in intricate formal *patterns,* a different one for each shape. The brightly colored glazes and the theme of citizens at leisure partaking of abundant food reflected the "good" life enjoyed by Southern Californians.

As for interior murals, the decade was characterized by a revival of old techniques. In Los Angeles, four artists who had worked under Siqueiros on the Chouinard mural started "The Fresco Block," hoping to paint frescoes in various Los Angeles sites. Los Angeles's FAP artists also experimented with many new materials, such as painting on asbestos curtains, Celotex (a sound-absorbing board made of pressed sugar cane fibers), plywood, and acoustical plaster. Of particular importance was Los Angeles's development of a casein tempera (pigment mixed with a milk or cheese product), which when applied in thin stain washes preserved the acoustic advantages of the wall. (It was used in Kassler's *PWA Paymaster,* fig. 20-15.)

Outside Los Angeles and San Francisco. Outside of San Francisco, the subjects of government-sponsored murals were generally the predictably pleasant Regionalist themes. San Diego's most outstanding muralist was probably **Belle Baranceanu,** the modernist painter active in both Los Angeles and San Diego (chapter 14). In 1933 Baranceanu settled permanently in San Diego, where she turned from easel painting to murals. Between 1934 and 1940, she was awarded six commissions from various government funding agencies. Her most outstanding mural is the scenic view *California Landscape* of 1935–36 (TRAP) (for the La Jolla Post Office) (fig. 20-19). It is superior in that it is not simply a landscape but is a modernist painting of great strength and character, reminiscent

Fig. 20-18
Albert H. King (1900–1982)
Typical Activities of a Beach and Harbor City, 1938
tile mosaic
approx. 38 x 22 feet
WPA/FAP mural, City of Long Beach
Photo: Victoria Damrel, Clique Studio

Fig. 20-19
Belle Baranceanu (1902–1988)
California Landscape
oil on canvas mural
approx. 12 x 8 ft.
La Jolla Post Office, TRAP, 1936
Photo: John Durant

Fig. 20-20
Douglass Parshall
(1899–1990)
Young Athletes, c. 1935
(detail)
oil on canvas mural,
dimensions unknown
Santa Barbara Junior
High School, FAP
Photo: Orville Clarke

Fig. 20-21
Henrietta Shore
(1880–1963)
Artichoke Pickers, 1936–37
(formerly Old Customs
House)
oil on canvas mural
29 x 74 ft.
Courtesy of California
State Parks, State Museum
Resource Center

of her easel style in its blocked-out shapes and strong composition.

Santa Barbara's small coterie of artists enjoyed both PWAP and FAP funding; its position of local district supervisor went to **Douglass Parshall**. Extrapolating his academic figure studies into scenes that satisfied FAP parameters, Parshall produced a mural on various kinds of field sports for the Santa Barbara Junior High School (fig. 20-20). Trained by his father and academically minded art schools, his figures are classical in style.

In the Monterey/Carmel/Santa Cruz area, the most outstanding murals were painted by **Henrietta**

Shore for the Santa Cruz Post Office in 1936–37 (TRAP). Her four lunettes, one of them *Artichoke Pickers* (fig. 20-21), treat several occupations in the Santa Cruz area. Like the best murals, her scenes transcend mere illustration to make universal statements about man and toil. Her style is vaguely reminiscent of that of Diego Rivera, who was so influential for muralists in Northern California. But it was actually developed by Shore herself in the late 1920s and is described by some as "organic precisionism." Shore painted the works on canvas in her studio, and they were glued to the walls of the public buildings.

The initiation of government art projects was hailed as an important commitment. American artists were aware of the support that countries such as France gave their artists and had long hoped that the U. S. government would take a similar interest in art. Those artists selected to receive funding from the first project, the PWAP, felt justifiably honored. They extended themselves artistically, and some of the best paintings ever received by the government came from this brief period. Government art projects, however, soon became tainted by "relief" and "welfare," and the most successful artists shunned them. Programs became mainstays for artists who were newly emerging from art schools and the modestly talented. The Treasury Department's SECTION and TRAP, with their high-status image, did continue to attract excellent artists. The FAP, however, the government's largest project, fell victim to the typical abuse of many government-funded programs. Despite the effort to assign unskilled workers to assistants' roles, the easel division ended up with yards of incompetently painted canvases. In spite of the negatives, the projects were a tremendous boost to the arts and left more good art than bad.

Murals for the Golden Gate International Exposition of 1939

If the Panama-Pacific Exposition of 1915 is seen as the culmination of mural painting for the American Renaissance period, then the 1939 Golden Gate International Exposition on Treasure Island can be regarded as the ending point for mural painting in the 1930s. (Officially, the FAP projects did not end until 1943, and in some unusual cases, such as Anton Refregier's (1905–1979) Rincon Annex Post Office mural that was tabled during World War II, they were not actually completed until the late 1940s.) The Golden Gate International Exposition was the last big celebration before the austerity imposed by World War II. Several California artists were hired to decorate buildings and courtyards, including Jacques Schnier (1898–1988), Millard Sheets, Adaline Kent (1900–1957), Hugo Ballin (1879–1956), and Robert Howard. Maynard Dixon painted murals for the facades of two buildings fronting on the Court of Pacifica, *Plowed Land* and *Grass Land,* that symbolize California's farming and cattle ranching, respectively. (Painted directly on the buildings, the murals were destroyed when the Navy dismantled the structures during its move to the island in 1941.) Like all the exposition's murals, they reflect the Art Decoratif style (chapter 21). Landscape, vegetation, animals, and humans are reduced to silhouette, and the format is an extended horizontal. As such they demonstrated America's stylistic move away from American Scene. Since farming and grazing are "protected" not by Greek gods (the Beaux-Arts ideal) but by Native American sun and rain gods, they are also evidence that by the end of the 1930s America had thrown off the old ideas of Europe.

Murals of the 1940s and the 1950s

After 1940 the impetus went out of the mural movement, and the few murals that were produced between 1945 and 1965 took on a completely different aesthetic. Following the stylistic changes in easel painting, they sought to resolve the opposites of realism and abstraction, resulting in a variety of solutions (chapter 22). The least representational, such as Grace Clements's (1905–1969) murals in the Long Beach airport, executed in 1942, are surrealistic bits of architecture floating in an imaginary space. **Rico Lebrun**'s (1900–1964) mural *Genesis* of 1960 (fig. 20-22), painted in the loggia of Frary Hall, Pomona College, Claremont, has realism and abstraction meeting half way; it breaks up volumetric corporeal bodies inspired by Michaelangelo in a manner reminiscent of Picasso's *Guernica.* The mural is less a painting than a drawing on a monumental scale—composed of lines and washes and

Fig. 20-22
Rico Lebrun (1900–1964)
Genesis, Frary Dining Hall loggia, Pomona College, Claremont, 1960
diluted vinyl acetate resin on curtain wall, 29 x 25 ft.
Pomona College, Claremont, California

Fig. 20-23
Millard Sheets (1907-1989)
Untitled, Home Savings of
America, Palos Verdes, Ca.
mosaic
Home Savings of America
Photo: Victoria Damrel

restricted to blacks, grays, and whites. Painted in the same building as Orozco's *Prometheus* (fig. 20-7), Lebrun's goal was to make it compatible with that of the earlier artist, whom he greatly admired. The central figure of Noah is enframed by ribs of the arc, while vignettes beside and above him show Adam and Eve, their children, the destruction of Sodom and Gomorrah, Job, and people struggling to escape the flood. In the 1950s, **Millard Sheets**'s design firm executed numerous mosaics and murals to decorate branches of H. F. Ahmanson's Home Savings and Loan (fig. 20-23) (now Home Savings of America). Abstraction slightly alters his realistic forms.

In spite of the dominance of American Scene painting and the government art projects, a handful of 1930s artists pursued various modern styles. Most of these artists were located in Southern California, and most had some association with Hollywood. It is their very different artistic concerns that form the subject of the next chapter. ✦

Bibliography

Native American Rock Art

Grant, Campbell, *The Rock Paintings of the Chumash,* Berkeley: University of California Press, 1965 (reprinted Santa Barbara: Santa Barbara Museum of Natural History, 1993).

Heizer, Robert F., *Prehistoric Rock Art of California,* Ramona, Ca.: Ballena Press, 1973. 2 v.

Hershey, A. Fiona, "It Doesn't Chip Off," [Chumash arts in Southern California] *Whole Earth Review,* no. 76, Fall 1992, pp. 108–11.

Knaak, Manfred, *The Forgotten Artist: Indians of Anza-Borrego and Their Rock Art,* Borrego Springs, Ca.: Anza-Borrego Desert Natural History Association, 1988.

Meighan, Clement W., ed., *Messages from the Past: Studies in California Rock Art,* Los Angeles: Institute of Archaeology, University of California, 1981. 185 p.

Smith, Gerald A., *Indian Rock Art of Southern California with Selected Petroglyph Catalog,* Redlands, Ca.: San Bernardino County Museum Assocation, 1975.

Sonin, Bill, *California Rock Art: An Annotated Site Inventory and Bibliography,* Los Angeles: Rock Art Archive of the Institute of Archaeology, University of California and Bay Area Rock Art Research Association, 1995 (University of California, Los Angeles, Institute of Archaeology, *Occasional Paper* no. 17). 307 p.

Von Werlhof, Jay C., *Rock Art of Owens Valley, California,* Salinas, Ca.: Coyote Press (distrib. by Berkeley, Ca.: California Indian Library Collections), 198-?. [Reprint of *Reports of the University of California Archaeological Survey,* no. 65, Berkeley: University of California Archaeological Research Facility, Department of Anthropology, 1965]

Whitley, David S., *A Guide to Rock Art Sites: Southern California and Southern Nevada,* Missoula, Mont.: Mountain Press Publ. Co., 1996. 218 p.

Murals before 1920

Neuhaus, Eugen, *The Art of the Exposition,* San Francisco: Paul Elder & Co., 1915.

Perry, Stella, *The Sculpture and Mural Decorations of the Exposition,* San Francisco: Paul Elder & Co., 1915.

Wright, Hamilton M., "Mural Decorations at the Panama-Pacific International Exposition," in *Art in California,* San Francisco: R. L. Bernier, 1916, reprinted Irvine, Ca.: Westphal Publishing, 1988.

(For murals in the Spanish missions see bibliography in chapter 1. For American Renaissance murals and those at the Panama-Pacific Exposition see chapter 8 as well as additional books listed in Joseph Armstrong Baird, Jr., *Northern California Art: An Interpretive Bibliography to 1915,* Davis: University of California, Library Associates, 1977, pp. 34–5.)

Murals of the 1920s, Los Angeles

"Art of Mural Painting in California," *Touring Topics,* v. 22, no. 3, March 1930, Roto. [C. Buff, H. Ballin, A. Clark]

California 1826–1926, Catalogue of Paintings hung in the Tower Room of the Carthay Circle Theatre; issued by the Historical Committee of Carthay Center, Los Angeles: Printed by Guy W. Finney Co., Inc., 1926.

"California murals," *Art Digest,* v. 5, September 1931, p. 8.

Clarke, Orville O., Jr., "Love of Learning," [F. T. Chamberlin's mural at Pasadena's Foothill Private Industry Council] *Pasadena Magazine,* Winter 1995, pp. 14–16.

The Farmer John Collection, Los Angeles: Farmer John Meats, 1982. 32 p.

Gage, Merrill, "The Art of the Los Angeles Public Library," *Artland,* v. 1, no. 6, August 1926, pp. 3-8.

Los Angeles County Museum of History, Science and Art, *Catalogue of the Sketch Designs Submitted in the International*

Mural Competition, The Dynamic of Man's Creative Power, Los Angeles: Los Angeles Museum, 1930.

"Mural painting," in Nancy Moure, *Painting and Sculpture in Los Angeles 1900-1945,* exh. cat., Los Angeles County Museum of Art, September 25–November 23, 1980, pp. 34–37 and bibliog.

Murals and Sculpture, Los Angeles: Los Angeles City Public Library, 195–? 12 p.

"Murals in Southern California," *California Arts & Architecture,* v. 44, July 1933, p. 2.

Murals of the 1920s, San Francisco

Clarke, Orville O., Jr., "Lost Art of the Pacific Stock Exchange Club," *Antiques & Fine Art,* v. 5, no. 4, May/ June 1988, pp. 49–53.

Daniels, M., "New Mural Room, St. Francis Hotel, S. F.," *California Arts & Architecture,* v. 48, December 1935, pp. 14–16+.

DeBerniere, G., "Mural Art As Seen by Ray Boynton," *California Arts & Architecture,* v. 42, December 1932, pp. 20–1+.

The Fable Room of the Hotel Saint Francis: Decorated by Mrs. Edgar deWolfe, San Francisco, n. p.: 193–? * 21 p.

Murals of the 1920s, Other Cities

Crain, Mary Beth, "Beauty in the Background," [painters of the dioramas in the Santa Barbara Natural History Museum], *Santa Barbara Magazine,* January/February 1993, pp. 20+.

Fender, R., "Creator of the new Del Monte Murals, Moira Wallace," *California Arts & Architecture,* v. 42, September 1932, pp. 22–3.

The Lincoln Shrine, Redlands, Ca., An Account of its Conception, Execution, and the Works of Art which It Contains, Dedicated February 12, 1932, Los Angeles: McCallister, 1932.

Meixner, Mary L., "Lowell Houser and the Genesis of a Mural" and "The Ames Corn Mural" *The Palimpsest,* v. 66, no. 1, January/February 1985, pp. 2–40.

"Murals by D. S. Groesbeck in Santa Barbara Court House," *Writer's Program,* Santa Barbara, 1941, p. 96.

van Horsen, Lloyd, "Visions of Spain," [Groesbeck's mural in the Santa Barbara courthouse], *Santa Barbara Magazine,* Winter 1995, pp. 20–21.

Wilson, Katherine, "The Murals in the State Library [by M. Dixon]," *California Arts & Architecture,* v. 36, November 1929, pp. 33-4, 75.

Mexican Muralists in California

Goldman, Shifra M., "Siqueiros and Three Early Murals in Los Angeles," *Art Journal,* v.33, Summer 1974, pp. 321-27.

Goldman, Shifra M., "Siqueiros in Los Angeles," in Hurlburt, Laurance P., *The Mexican Muralists in the United States,* Albuquerque: University of New Mexico Press, 1989.

Scott, David W., "Orozco's Prometheus," *College Art Journal,* v. XVII, Fall 1957, pp. 2-18.

California Federal Art Projects

Acord, Nancy Odessky, *WPA Women Muralists in California 1933–1943,* M. A. Thesis, California State University, Northridge, 1989.

Art in Federal Buildings, vol. 1, *Mural Designs, 1934–1936,* Washington, D.C.: Art in Federal Buildings, Inc., 1936.

Clarke, Orville O., Jr., "Social Statements in Art: W. P. A. Murals," *Antiques & Fine Art,* v. 5, no. 1, November/December 1987, pp. 55–59.

Decorative Art of Spanish California, Selected by the Index of American Design, Los Angeles: Southern California Art Project, Work Projects Administration, c. 1938.

New Deal Art: California, essay by Charles Shere, exh. cat., DeSaisset Art Gallery and Museum, University of Santa Clara, Santa Clara, Ca., January 17 - June 15, 1976.

Gelber, Steven M., "Working to Prosperity: California's New Deal Murals," *California History,* v. 58, no. 2, 1979, pp. 98–127.

Hagerty, Donald J., "Hard Times, New Images: Artists and the Depression Years in California," *Pacific Historian,* v. 27, no. 4, Winter 1983, pp. 11–19.

Southern California Creates (n.p.: Works Progress Administration, Southern California Art Project, n. d.)

W. P. A. Artwork in the California State Park System, prepared by the Interpretive Services Section, Interpretive Collections Management Group, State of California, May 23, 1979. [primarily photo copies of biographical material on mural artists]

New Deal Murals, Northern California

"Art in Public Places [Coit Tower]," *Art of California,* v. 4, no. 3, May 1991, pp. 40–41.

Brechin, Gray, "Politics and Modernism: The Trial of the Rincon Annex Murals," in Paul Karlstrom, ed., *On the Edge of America: California Modernist Art, 1900–1950,* Berkeley: University of California Press, 1996, pp. 69–96.

Federal Art Project, *California's Medical Story in Fresco, an Illustrated Account of the Fresco Decorations on the wall of Toland Hall, University of California Medical Center,* San Francisco, 1939.

Fuller, Mary, "Emblems of Sorrow: The W. P. A. Project in San Francisco," *Artforum,* v. 2, November 1963, pp. 34–37.

Haller, Stephen A. "From the Outside In: Art and Architecture in the Bathhouse," *California History,* v. 64, no. 4, Fall 1985, p. 283+.

Ireland, Norma Olin, "Murals in California Libraries," *Pacific Bindery Talk,* v. 13, no. 5, January 1941, p. 74.*

Jewett, Masha Zakheim, *The Art of Medicine: The Zakheim Frescoes at UCSF,* San Francisco: M. Zakheim, 1991. 120 l.

Jewett, Masha Zakheim, *Coit Tower, San Francisco: Its History and Art,* San Francisco: Volcano Press, 1983.

Lloyd, Lueille, *California's Name: Three WPA-Sponsored Murals,* California State. Senate Rules Committee, 1992. 28 p.

"Murals, Sculptures and Other Works of Art in Public Buildings," in *A Survey of Art Work in the City and County of San Francisco,* Art Commission, City & County of San Francisco, 1975.

Osborn, David S., *Mural Projects of the United States Government in the Bay Area of Northern California,* Master's Thesis, University of California, Berkeley, 1956.

Walker, Melissa C., "American Scene Art and Government Murals in Northern California," in Baird, Joseph A., Jr., ed., *From Exposition to Exposition: Progressive and Conservative Northern California Painting, 1915–1939,* Sacramento: Crocker Art Museum, 1981.

New Deal Murals, Los Angeles

Clarke, Orville, O., Jr., *Public Art in Public Places: New Deal Murals of Los Angeles,* in process.

Clarke, Orville O., Jr., "Visions of Our Past," *Southern California Home and Garden,* v. 3, November 1990, pp. 54–61+.

Hinkey, Douglas M., *Federal Art in Long Beach: A Heritage Rediscovered,* exh. cat., FHP Hippodrome Gallery, Long Beach, September - December 1991. 46 p.

Historical Murals in the Los Angeles County Hall of Records Board of Supervisors' Hearing Room: A Federal Project of the Works Progress Administration, Los Angeles, s.n., 1939.

King, Albert H., *Mosaic and Allied Techniques,* Los Angeles: Southern California W.P.A. Art Project, c. 1940. 70 p.

Koppany, Bob, *The Murals of Griffith Observatory,* Los Angeles: Bob Koppany, 1979. 12 p.

Morsell, Mary, "California Mosaicists," *Magazine of Art,* v. 30, October 1937, pp. 620-25.

"New Deal Art," in Nancy Moure, *Painting and Sculpture in Los Angeles 1900-1945,* exh. cat., Los Angeles County Museum of Art, September 25–November 23, 1980, pp. 43–54.

Silberberg, Susan, "New Deal Murals in Los Angeles: Federal Ideals and the Regional Image," *LAICA Journal,* no. 11, May-June 1976, pp. 18-23.

Stein, Pauline Alpert, *A Vision of El Dorado: The Southern California New Deal Art Programs,* Ph.D. Dissertation, University of California, Los Angeles, 1984.

Wyman, Marilyn, *A New Deal for Art in Southern California: Murals and Sculpture under Government Patronage,* Ph.D. dissertation, University of Southern California, Los Angeles, 1982.

New Deal Murals, Other Areas

Clarke, Orville O., Jr., *Milford Zornes' Treasury Relief Art Project Murals for the Claremont California United States Post Office,* Thesis, California State University, Fullerton, 1990. 188 p.

Cleek, Patricia Gardner, "Santa Barbara Muralists in the New Deal Era," *Noticias,* v. XLI, no. 3, Autumn 1995, pp. 45–67.*

Dijkstra, Bram and Anne Weaver, *Belle Baranceanu—A Retrospective,* exh. cat., Mandeville Gallery, University of California, San Diego, November 8–December 15, 1985. 64 p.

Lorenz, Richard, "Henrietta Shore: The Mural Paintings," in *Henrietta Shore: A Retrospective Exhibition, 1900–1963,* exh. cat., Monterey Peninsula Museum of Art, December 12, 1986–January 25, 1987. 72 p.

Mehren, Peter William, *The WPA Federal Arts Projects and Curriculum Project in San Diego,* Master's thesis, University of California, Davis, 1972.

Murals, Treasure Island/Golden Gate International Exposition

"The Mural Decorations," in Eugen Neuhaus, *The Art of Treasure Island,* Berkeley: University of California Press, 1939.

Schnoebelen, Anne, "Relics of Ephemeral Glory: The Treasure Island Murals of Maynard Dixon," *Art of California,* v. 5, no. 4, September 1992, pp. 53–55.

Mural Art of the 1940s and 1950s

Clever, D., "Permanent Mural in Board of Director's Room, Rexall Drug, LA," *Architect & Engineer,* v. 171, October 1947, p. 29.

"Entrepreneur," in Janice Lovoos, *Millard Sheets: One Man Renaissance,* Flagstaff, Az.: Northland Press, 1984.

Harth, Marjorie L., "Revisiting *Genesis,*" *Pomona College Magazine,* Spring 1998, pp. 2–7.

"Hollywood Canteen Muralized," *Art Digest,* v. 17, November 1, 1942, p. 18.

Langsner, J., "Genesis— a Mural by Rico Lebrun," *Arts & Architecture,* v. 78, September 1961, pp. 17+.

"Long Beach Municipal Airport Administration Building; with Murals and Mosaics by G. Clements," *California Arts & Architecture,* v. 59, December 1942, pp. 31–3.

Magnin, Rabbi Edgar F., *The Warner Murals in the Wilshire Boulevard Temple,* Los Angeles, California, Los Angeles: Wilshire Boulevard Temple, 1974.

"Murals for San Leandro Naval Hospital by Claire Falkenstein," *Architectural Forum,* v. 85, September 1946, p. 152.

Selz, Peter, "The Genesis of *'Genesis,'* " [by R. Lebrun] *Archives of American Art Journal,* v. 16, pt. 3, 1976, pp. 2–7.

Sewell, E. K., "Joseph L. Young Creates a Unique Mosaic Mural for new Los Angeles Police Facilities Building," *American Artist,* v. 19, September 1955, pp. 30-33+.

Modern Art Styles of the 1930s

Modernism of the 1930s

Some people, hearing the word "modern" in reference to art, simply turn on their heels and walk away. Modern usually refers to things the average person does not like: abstraction as opposed to realism, or something unfamiliar as opposed to habitual. The term has been used in a confusing variety of ways (chapter 18). It can be legitimately applied to a variety of styles that have nothing in common other than being innovations in their respective eras. In the 1930s, when California got its first serious dose of modernism, not only was the term applied to a movement that we now consider conservative—American Scene—but it was equally applied to California's several modern styles that descended from aesthetic "breakthroughs" made in Europe in the first thirty years of the century.

Art styles usually proceed through a predictable evolution. There is a short period when the style enjoys avant-garde status, a longer period as followers take it up, and finally a very long time during which it is alternately forgotten and rediscovered. Each revival or regeneration infuses the original style with ideas from the current era. By the 1930s, many scientific discoveries, mechanical inventions, and social changes had occurred that made that decade's various takes on Europe's modern styles different from the originals. Psychology had offered a new way to look at and interpret life. Machines had diverted man's attention from the natural order toward mechanization, orderliness, and power. Microscopes revealed a fascinating world of microbes, viruses, bacteria, and atoms (microcosmic), while telescopes had opened up the study of the universe (macrocosmic). Airplanes allowed people to view the landscape from the sky. Just before World War I Albert Einstein came forth with his theories of a fourth dimension (time) and relativity (speed is relative to the viewer, who himself is not absolutely still, either in time or space).

Modernism encompasses a wide spectrum of styles. Authors at various times have tried to organize them by setting up opposite poles based on brushwork (hard edged versus painterly) and emotional content (reserved/classical versus expressive/romantic). Employing this scale, on one end are the abstractions that descended from Cubism, as well as styles related to the Machine Aesthetic and to Germany's Bauhaus School. This art is often classical, subdued, and balanced. On the other end of modernism's stylistic scale is art based on the more ebullient emotions, brighter colors, and painterly, expressive brushwork. Into this category falls the expressive abstraction that descended from the Fauves and Matisse and nonlogical art from such movements as Dada of the teens and Surrealism of the 1920s. There are many variations in between.

In the 1930s, modernists comprised only a small percentage of all artists active in California. Most could not earn a living from their art alone and so supported themselves with other jobs and pursued their painting privately. Occasionally they banded together to hold exhibitions, but California artists were not inclined to form groups and issue manifestoes.

Abstraction

Although the average person regards any modern style as anarchical and decadent, some artists' personalities will aways induce them to work nonobjectively. In the 1930s abstraction grew in America nurtured by a new wave of influences entering from France (where the group Abstraction-Creation was founded in 1931) and by the foundation of institutions in New York that supported the genre. These included the Société Anonyme in the 1920s and the three museums for modern art that opened there between 1927 and 1936: the Gallery of Living Art at New York University, the Museum of Modern Art, and the Guggenheim. Although America's abstractionists of the 1930s were criticized for pursuing modernism and ignoring their country's social and economic problems, ironically, the government art projects of the 1930s supported a large contingent of such painters. In 1937 there were enough abstract artists in New York to form the American Abstract Artists.

In California of the 1930s, most Cubist-derived abstraction was practiced in the Los Angeles area. This avant-garde aspect of Los Angeles, a metropolis that San Franciscans preferred to judge as nouveau, crass, nonintellectual, and commercial, was directly attributable to the Hollywood community (chapters 17 and 18). Hollywood served as a refuge and place of employment for expatriate Northern and East European intellectuals—artists, musicians, and writers—during the 1930s and through World War II. Tangential to the

Opposite:
Fig. 21-2
Elise Cavanna Seeds
(Armitage Welton)
(1905-1963)
Elevation, 1936
oil on canvas
25 1/16 x 30 1/16 in.
Collection of Whitney
Museum of American Art
Purchase, with funds from
the Katherine Schmidt
Shubert Purchase Fund;
© 1998 Whitney Museum of
American Art
Photo: Sheldan C. Collins,
N. J.

Fig. 21-1
Knud Merrild (1894–1954)
*Volume and Space
Organization*, 1933
paint, wood, metal
31½ x 23½ in.
Collection of the Oakland
Museum of California, Gift
of Mrs. Else Merrild

Fig. 21-3
Rolph Scarlett (1889–1984)
Abstraction, 1929
oil on canvas, dimensions
unknown
Photo courtesy Harriet
Tannin
Photo: Johan Hagemeyer

studios existed modernist collectors such as Louise and Walter Arensberg, the dealer for the Blue Four, Galka Scheyer (chapter 18), and the art critics Merle Armitage and Sadakichi Hartmann. As a result of the interest in modernism, the decade saw the foundation of several short-lived galleries, including the Centaur Gallery (c. 1934), one in the Stanley Rose book shop (1935 through about 1940), the book shop of Jake Zeitlin in downtown Los Angeles (active through the 1930s), and Lorser Feitelson's Hollywood Gallery of Modern Art (open 1935-37). Through the 1930s, Stendahl Galleries increasingly dropped impressionist-style landscapes for the newly collectable European modernism and Pre-Columbian art. Although Los Angeles's modernist painters, like modernists in general, tended to be loners and consumed by their own personal quests, most were acquainted with each other through the Hollywood community, where they met at social gatherings and sometimes sold a work. Not only did Hollywood intellectuals and the motion picture community collect modern paintings, but the Moderne style (popularly termed Art Deco) was the favored style for movies about America's wealthy. Hollywood producers and directors hired architects (such as the Austrian expatriates Rudolph M. Schindler and Richard Neutra) to design private homes in the tradition of Germany's Bauhaus School; this was a no-nonsense, clean look with plain white, rectangular plaster walls and glass, vaguely reminiscent of Mondrian's paintings.

Although Hollywood's several modern painters may have been acquainted with one another, each pursued his or her personal path inspired by his favorite European modern style and arrived at his individual interpretation and solution.

Knud Merrild (1894–1954) is the first major Los Angeles abstractionist after Stanton MacDonald Wright. Merrild explored several modern styles, the first of which was Cubism. Exposed to it at a show in Copenhagen in 1913, he practiced it in his native Denmark, making him one of that country's earliest modernists. After he settled in Los Angeles in 1923, he made his primary living as a painter/decorator. In the evenings and between contracts, supported by friendships that he developed with the Arensbergs and with modernist artists such as Lorser Feitelson, he pursued his interest in modern art. In *Volume and Space Organization* of 1933 (fig. 21-1), the flat shapes broken apart and re-arranged in a two-dimensional design show Merrild is exploring ideas broached by Picasso in Synthetic Cubism. He also restricted his colors to Picasso's preferred grays, browns, blacks, and whites. However, Merrild's work is equally reflective of his status as a journeyman decorator. It exhibits craftsmanship and

finish, and it uses cast off materials from his workshop: bits of wire mesh, corrugated materials, woven cloth, and jigsaw cuts of wood. Analysts of both writing and painting often refer to a work as having "layers of depth." Usually this is used figuratively or describes the work's meaning. In painting it can also describe physical phenomena, such as underlayers of paint discerned through a transparent wash. In Merrild's case "layers of depth" also refers to physical dimensionality. His surface is pierced by cutouts and raised by added pieces of wood, creating an intriguing and complex movement not only around the flat shapes in the composition but in and out of openings and over superior shapes. A shallow box, *Volume and Space Organization* has sufficient dimension to qualify it as a sculpture, and its use of cast off materials places it in the forefront of California's important Assemblage movement of the 1950s.

The painter **Elise** (Cavanna Seeds Armitage Welton) (1905–1963), a six-foot-tall part-time actress/dancer with purple hair, who for a brief period was married to the art critic Merle Armitage, created some of Los Angeles's purest abstractions. Nonobjective abstraction can be traced back to Wassily Kandinsky (b. Russia, 1866–1944), who in 1908, catching a glimpse of one of his paintings lying on its side, realized that a fully satisfactory painting could be made from lines, shapes, and colors alone. Elise studied art in Philadelphia and for a few years was active in artistic and literary circles in New York before the comedian W. C. Fields induced her to move to Hollywood to act in his films. Elise's abstractions were inspired by natural forms in which she noticed an innate rhythm and balance. She reduced these to their essence. Nonobjective painting is usually described in formal terms, i.e., color, line, movement, design, and composition; for Elise's work Armitage uses the terms melody, harmony, progression, sequence, tempo, and dynamics. (Kandinsky also saw a link between music and art, titling many of his abstractions "Improvisation," a reflection of his one-time ambition to be a musician.) Although *Elevation* of 1936 (fig. 21-2, p. 270) is precisely controlled in its sharp edges and smooth gradients of color, it is also emotionally expressive. Its curved lines of varying width give it a lyrical grace and beauty similar to dance movements; the parallel dashes are reminiscent of the Machine Age's "speed" lines, and yellow is a warm, positive, and happy color.

Hollywood also supported **Rolph Scarlett** (1889–1984). Scarlett was self-taught and a committed painter from the time he was six years old. Born in Canada, he relocated to the United States when he was eighteen. While he pursued his easel art he supported himself with inventions and designs for items as dissimilar as parts for a guided missile, gun sights, furniture, rugs, lighting, radios, and electrical appliances. On a business trip to Switzerland in 1923 he met Paul Klee (1879–1940) and, as a result, dedicated himself to abstract art. For five years in Toledo, Ohio, he painted abstractions and designed stage sets before moving to Hollywood in 1928 to briefly design sets for Pathé Studios. His activities on the West Coast are as yet little known. He did receive recognition in 1929 when the "abstract constructivist" settings he designed for the Pasadena Playhouse production of George Bernard Shaw's *Man and Superman* (archival material Huntington Library) were reviewed as "brilliant." He also pursued his easel art, but Scarlett rarely dated works, and at this writing no extant pieces can be definitely tied to his Los Angeles period. *Abstraction* of 1929 (current location unknown; reproduced in the *Los Angeles Times*, February 9, 1930, pt. III, "Art and Artists") (fig. 21-3), is probably exemplary of the "two galleries" of oils and watercolors he exhibited at the studio of photographer Johan Hagemeyer (1884–1962) in Pasadena. In the *Los Angeles Times* review, the critic Arthur Millier described these works as based on "realistic ingredients," what seemed to him to be parts of a camera and an automobile or objects from a metal foundry. In Scarlett's own words, he found a much greater challenge in creating abstractions than copying illusionistic scenes. In 1933 the artist moved to Long Island where he worked as a designer and made sets for Radio City Music Hall. Several of his abstractions were purchased by the Guggenheim Museum in New York.

The word "design" repeatedly surfaces in the discussion of abstraction. In the 1930s design was a new field. Los Angeles's newest art school—Art Center, established in 1930—was founded specifically to teach design. Some purists insist that to qualify as fine art, an abstract work must represent some profound idea, such as purity, spirituality, infinity, or classical perfection and that design as an end in itself makes a work lowly, practical, and commercial. However, many of California's abstractionists were both easel painters and designers—of motion picture or theater sets or industrial products. With her bobbed hair and short skirts, the Oklahoma-born **Olinka Hrdy** (1902–1987) already

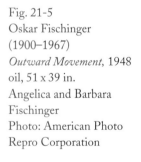

had a reputation as a designer and muralist, an eccentric, and a forward thinker when she moved from Tulsa to Los Angeles about 1936. In Los Angeles she was employed by the Southern California Art Project for which she painted several murals through 1940. During World War II she contributed to the war effort by working as a designer for Douglas Aircraft, and after the war she executed private commissions for murals and stage curtains. In the 1960s she was chief designer for the State of California. Hrdy gained her taste for modernism through her association in Oklahoma with the visionary architect Bruce Goff. In New York in the early 1930s she studied art, and her interest in modernism may have induced her to seek out some of the city's several abstractionists or to view one of the shows of abstract art. The motifs in Hrdy's *Games* of 1936 (fig. 21-4) reveal no direct artistic antecedents, although their arrangement is said to reflect her interest in Dynamic Symmetry. The work reveals its 1930s date through its "mechanistic" techniques of templates and airbrush (or spray paint). The sprayed areas that suggest depth make the work intellectually paradoxical, since it appears both two- and three-dimensional at the same time.

Practicality mixed with theory and idealism is also seen in the work of Hollywood painter **Oskar Fischinger** (1900–1967). A pioneer of abstract animation in Germany in the late 1920s and early 1930s, his avant-garde thinking put him on the Nazi blacklist. In 1936 an offer of employment with Paramount Pictures allowed him to escape to Hollywood. There, animation was on the rise. However, Fischinger soon found that his idealism and Hollywood's commercialism did not mesh. Starting work at Paramount full of hope, he soon became frustrated when his ideas were quashed. He received intermittent grants from the Guggenheim Foundation in New York, which was funding avant-garde film, allowing him to actualize many of his ideas.

When Fischinger began his career after World War I, the German avant-garde art community believed that abstract painters, such as Mondrian and Kandinsky, had brought painting to its final resolution and that static easel painting was dead. The only way to keep it alive and fresh was to merge it with the new medium of film and make "motion paintings." Because of the stigma against easel painting, Fischinger made

animated films with wax figures and other non-painting techniques. However, in the United States, at moments when he had spare time on his hands, he turned to painting for his own pleasure, employing some of the motifs (lines, circles, squares) he had used in his films. Fischinger finally merged actual painting with film in his *Motion Painting No. 1*, finished in August 1947. Starting with a plain board, he applied a few colored strokes and then captured them on one frame of film. Continuing this process, and shooting approximately 1500 times to make one minute of film, he arrived at a completed piece of ten minutes in length. Fischinger's film is a time-lapse document of an abstract painting in progress. The brush is never seen making its dabs of paint; shapes seem to grow organically and magically into circles and other geometric shapes; lines spiral upward or shoot across the composition to take root and grow afresh. Sound was added, and the abstract forms in the paintings appear choreographed with Bach's *Brandenburg Concerto # 3.*

When Fischinger's Guggenheim grants ended, he could not afford to make any more films and turned exclusively to easel painting. *Outward Movement* of 1948 (fig. 21-5), begun immediately after his final film, is a static easel painting that contains the essence of Fischinger's animated films. Although frozen, the geometric grids appear to expand and advance in three-dimensional space. It is one of a set of large canvases of uniform size (51½ x 39 in.) that all share a similar composition—emanation of geometrical shapes from a point just above the center. The viewer's eye is attracted to the vortex, opening up speculation as to whether this work is simply a geometric composition or reflects Fischinger's fascination with many of the non-Christian religions and philosophies that were then being adopted by the avant-garde.

In the 1940s a host of other Los Angeles artists painted abstract works. Frederick Kann (1886–1965) moved to Los Angeles in 1942 at which time he associated with the city's other modernists, started the Circle Gallery to show modern art, and shortly afterward opened the Kann Institute of Art in West Hollywood. Although he arrived in California at a late date for abstraction, he had been creating abstract works through the 1930s, when he had been a member of the French group Abstraction-Creation as well as a founding member of the American Abstract Artists in 1937. Also making hard-edged abstractions in the 1940s was Peter Krasnow (chapter 23). Jules Engel's (b. 1918) abstractions are reminiscent of Synthetic Cubism. Realists who made excursions into abstraction include Ruth Peabody (1898–1966) in the late 1930s and Emil Kosa, Jr. (1903–1968) after the mid-1940s.

A few California artists painted abstractions that contained biomorphic shapes and worked more painterly than hard edged. These include Knud Merrild and Ben Berlin (1887–1939). The abstractionist who created the most beautifully emotive pieces was Agnes Pelton, whose *Messengers* was discussed under Symbolist painting in chapter 8. Hans Burkhardt (1904–1994) carried Arshile Gorky's expressive abstraction to Hollywood when he emigrated from New York in 1937. (See his *War Agony in Death,* fig. 23-2.)

Art Decoratif

The style variously called Machine Art, Moderne, and Art Deco[ratif] that flourished in the 1930s, was also a European invention. Showcased at the Exposition International des Arts Decoratifs et Industriels Modernes in Paris in 1925, it received its abbreviated and better-known appellation Art Deco in 1966. Taking its cue from Cubist paintings and from machines, it took recognizable motifs and simplified them, even streamlined them. Two of the best known motifs are the machine and skyscraper shapes. Others include zigzags, lightning flashes, chevrons, stripes, circles, diagonals, and parallel horizontal lines. Treated in low-relief, often these were repeated in bands. Most significant to California were motifs that came from the Southwest (such as the cactus), from American Indian designs (such as the chevron), and from the Pre-Columbian cultures of Mexico. The style was applied most often to architecture, sculpture, furniture, and mechanical objects. Deco's emphasis was on the surface, the skin and on materials that had a rich quality such as Bakelite and Vitrolite (some of the earliest forms of plastics), exotic woods (ebony, amboyna, zebra wood, and satinwood), chromed tubular metal, and glass. California had many nationally respected architectural examples including the San Francisco Bay bridges of the mid-1930s, the Hollywood and Pasadena Freeways (1937-40), and Los Angeles's Pan Pacific

Auditorium and Coca Cola Bottling Plant. Art Deco took America by storm, and by the late 1920s it was dictating the design of graphics, furniture, architecture, and machines.

Art Deco *painters* were rare. One who deserves discussion is **Jessie Arms Botke** (1883–1971). She began painting her specialty—birds—about 1912, during her employment with Herter Looms in New York. After her move to California in 1919, she turned almost exclusively to easel paintings based on foliage, flowers, and birds, such as *Crested Cranes* (fig. 21-6). She favored three very different compositional types, each an updated version of a historic type: domestic ducks and geese (similar to those seen in English book illustration of the turn of the century); elegant birds, such as peacocks, amid urns of mixed flowers (similar to the type developed by Flemish artists of the sixteenth century); and birds silhouetted against gold-leaf backgrounds (in the manner of the painted folding screens made by Japanese artists in the Edo period). *Crested Cranes* is of the latter type. It is Art Deco in its smooth modeling of simple shapes (such as the birds and the reeds), sensuous surface textures, dramatic colors, sharp contours, use of silhouetting, and decorative gold background. Botke's goal was a sumptuous decorative effect, and she succeeds handily in this work.

One Art Deco artist associated with both the theater and Hollywood film is **Hubert Stowitts** (1892–1953). Stowitts, a true Renaissance man, distinguished himself as a scholar and was a natural athlete who was at home both on the running track and in the dance studio. He was so talented as a painter that shows of his easel works toured the world. California can claim Stowitts since he obtained his education at the University of California, Berkeley, was first attracted to Asian culture after exposure to San Francisco's Chinatown, and achieved his first sports and dance distinctions in the Bay Area. But his painting style was developed while touring the world for six years with Anna Pavlova's dance company as a dancer and a designer of costumes and sets. Stowitts gravitated to a style evincing Art Deco qualities, as seen in *HRH Prince Mas Suki of Java* of about 1928 (fig. 21-7). He had a dual interest in painting such a work. With a natural affection for the decorative, he created a stunningly beautiful composition using tempera's intense colors, a wiry outline, pattern, silhouette, and sometimes a gold background. At the same time, as a scholar of ethnography, he documented the look and dress of Javanese royalty. Not only do his Java and India series (numbering more than two hundred) record the visages of many important personalities, some also document the occupations of the working class, such as cloth dyeing, shoemaking, and cotton carding. After returning to California in 1935, Stowitts worked for motion picture studios as a choreographer, dancer, and costume and set designer. He also embarked on another painting series, *The American Champions,* fifty lifesize portraits of American athletes training at the University of California, Los Angeles, and University of Southern California for the 1936 Olympics.

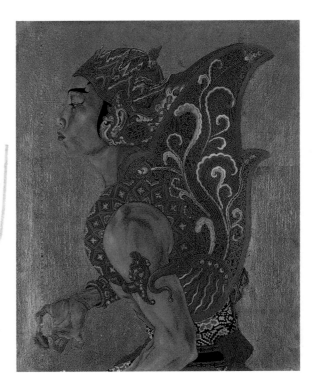

Precisionism

Tangentially related to Machine Art is the American painting style of Precisionism, but this style's sharp contours, clean lines, and smooth shading conveys serious rather than decorative posits. It is often used to render industrial subjects like factories, machinery, and architectural constructions (skyscrapers, bridges, and dams). The best-known East Coast practitioner was Charles Sheeler (1883–1965). The style was never widely practiced in California. Industries were not a dominant visual aspect of the state, nor did the style's severe lines satisfy the state's agrarian/recreation-minded/ humanist painters. The California artist who came closest to painting in a Precisionist vein was **Edward Biberman** (1904–1986), who had begun painting architectural themes such as bridges and skyscrapers while in New York (1929–36), before his move to Hollywood to join his brother, a writer for the motion picture studios. In Los Angeles he was immediately fascinated with the city's unique architecture, its sunny colors, the Spanish-revival bungalows, the freeways, and after World War II, the increasing number of International Style buildings. His *C.B.S.* from the mid-1940s (fig. 21-8) represents an Art Deco building whose clean, spare lines were favored by Precisionists. Biberman's California contribution was to combine the precise contours and flat shapes of architecture with broken brushwork in the sky to re-create California's sparkling atmosphere. This work also demonstrates one of the ways that late 1940s artists reconciled three-dimensional illusionism with two-dimensional pictorial values (chapter 22)—by painting flat objects, like Art Deco or International Style architecture, up close and flat on.

Northern California. In the Bay Area, most modernist energy in the 1920s and 1930s went into Post-Impressionism and Regionalism and the development of an infrastructure to support the Surrealism and Abstract Expressionism that would come in the 1940s (chapters 24, 26). The bastion for Cubist-oriented modernism was the East Bay. The University of California, Berkeley, employed modernist artists such as Worth Ryder (1884–1960), John Haley, and Glenn Wessels (1895–1982). The latter also taught at the California College of Arts and Crafts. They, in turn, hired respected modernist-painting refugees from Nazi Europe, including Hans Hofmann (1880–1966) and Alexander Archipenko (1887–1964), to teach special sessions (chapter 18). However, no "school" of Cubist-inspired modernism arose at Berkeley unless one counts the design-oriented watercolors of the "Berkeley style" (chapter 19). Some of California's Asian-American artists, such as George Matsusaburo Hibi (1886–1947), in his *Three Muses* of about 1928–30 (fig. 23-14), used the silhouetting, simplification, and linear outline of Art Decoratif.

Fig. 21-8
Edward Biberman
(1904–1986)
C.B.S.
acrylic on board
33½ x 43½ in.
Courtesy of Suzanne W. Zada, Gallery "Z"
Photo: American Photo Repro Corp.

Post-Surrealism

Surrealism is usually traced back to the European painters Giorgio de Chirico (1888–1978) and Marc Chagall (1887–1985), who arrived independently in Paris about 1910 with an interest in disconnected dream images, fantasy, and imagination. De Chirico expressed these dream states in pictures containing stage-like architecture, and Chagall in childlike visions of love. Their emotional approach was continued in the teens by the Dada artists. Like de Chirico and Chagall, the Dadaists created an anti-art that was illogical, dramatic, sensational, and unplanned. After the Dada movement died in 1922, the Surrealists, with their interest in the new discipline of psychology, took up the banner.

Surrealism, whose manifesto was issued in Paris in 1924, advocated going directly to the subconscious for artistic ideas. Surrealists expressed themselves in two types of painting: illusionistic dream images (scenes of real objects presented in abnormal contexts) and automatism, i.e., techniques that allowed an artist to transmit his subconscious directly into art without interference from the intellect. Within these two broad categories perhaps twenty identifiable Surrealist substyles were developed over the twenty-five years that the original style survived.

Surrealism arrived in America in the early 1930s. The first Surrealist exhibition took place at the Wadsworth Atheneum in Hartford, Connecticut, in December

1931. It was shown again two months later at the Julien Levy Gallery in New York, where it included two additional artists, Man Ray and Charles Howard, both of whom have special relevance to California (chapter 24). The style was disseminated through magazines, shows at the Julien Levy Gallery, Levy's book *Surrealism* (1936), and the exhibition *Fantastic Art, Dada, and Surrealism* at the Metropolitan Museum of Art in 1936.

In California, Surrealism first blossomed in Los Angeles in the early 1930s. Modernist painter **Lorser Feitelson** (1898–1978), who had been exposed to the style during his 1920s Parisian residency, along with his student and wife Helen Lundeberg (b. 1908), developed a Surrealistic variant that was different enough to deserve its own appellation—New Classicism—or, as it came to be termed, Post-Surrealism. The style was showcased at the Centaur Gallery in Hollywood in 1934, where it was accompanied by a manifesto.

In Post-Surrealism Feitelson merged Surrealism with his longtime love, Classicism. Feitelson's *Flight over New York at Twilight* of 1935 (fig. 21-9), a rarely seen Post-Surrealist piece, demonstrates how Post-Surrealism differed from Surrealism. The French Surrealists painted objects that spontaneously came into their minds, didn't plan juxtapositions, and were content with any response that their images might evoke

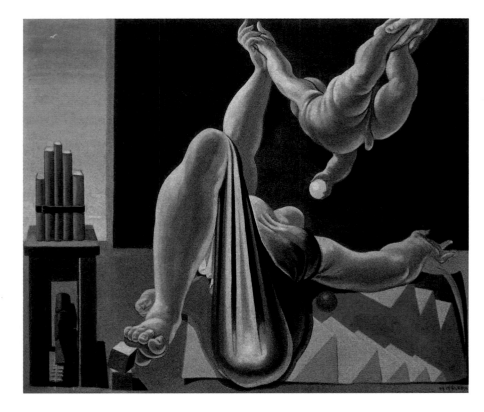

in the viewer. In contrast, Feitelson consciously selected objects and carefully arranged them to elicit thoughts on a specific idea or theme. *Flight* shares with his other Post-Surrealist paintings the general theme of life, procreation, and ecstasy. There are two scenes in one. On the left is an exterior city scene consisting of the open door exposing sky and a bird; a tabletop holding some books bound with a strap so that they look like skyscrapers; below the table, as if under the streets of New York, a child's train suggests a subway. On the right, the interior scene echoes the exterior. The mother lies on a carpet whose stepped design is reminiscent of gables on city row houses, and the swooping child echoes the flying bird. Not only does Feitelson make the parallels easy to recognize, but other of his paintings go so far as to introduce dotted lines and arrows to direct the viewer's "reading." Feitelson and Lundeberg termed their subjects "idea-entities." Such works have a "gestalt," i.e., the combined objects take on a meaning over and above their individual meanings. Also defying French Surrealism's sometimes strident, harsh, or dramatic coloration is Feitelson's conscious use of soothing tones and shades that encourage meditation, almost as if he were speaking with a librarian's hushed voice. The Post-Surrealist style, in direct opposition to its parent Surrealism, boasted rational logic, control, and a classical feel. The substantial forms of the mother and child as well as their abrupt foreshortening reveals Feitelson's enduring admiration for Classical and Renaissance prototypes. The 1970s art historian Joe Young called Post-Surrealism "the first American response to European Surrealism which represented a contribution to the continental art movement."

Helen Lundeberg (b. 1908) is receiving increasing credit for her role in the invention of Post-Surrealism. The style suited her quiet personality and her perfectionism. She continued working in the style longer than did Feitelson, who in the latter 1930s turned his energies to heading the local Federal Art Project with MacDonald Wright. An example of Lundeberg's Post-Surrealism is the painting *Poetic Justice* of 1942 (fig. 21-10). Many people prefer Lundeberg's pieces to those of Feitelson. Her paintings are small, intimate, delicate, detailed, colorful, and personal. While Feitelson may have "taught" universal concepts such as human procreation or love, Lundeberg, like some of the women Symbolists discussed in chapter 8, reveals these ideas in a highly personal way. *Poetic Justice* may be a summation of the life cycle with its references to birth and death. Birth seems to be symbolized by the iris (a flower with vaginal and thus procreative associations), while death is represented by a desert landscape and a snail on a half-eaten leaf. Many of Lundeberg's

works contain a reference to herself either through self-portraits, a shadow, one of her paintings hanging on a wall, or parts of her body, such as her hand holding a paintbrush or a flower. In *Poetic Justice,* where a hand touches a broken seashell from which dainty flowers spring, the hand may represent the artist's creativity. Other favorite motifs not included in this picture are images of her mother, flowers and shells (an object common to many California women Symbolists), and references to planets and the universe. A horizontal version of this work, painted in 1945, is in the collection of the Oakland Museum of California.

Feitelson was a magnetic personality, a teacher who attracted a small band of followers. Although artists such as Knud Merrild, Grace Clements (1905–1969) and Dorr Bothwell painted a few Post-Surrealist works, most made their names with other styles. Post-Surrealism received a showing at the Brooklyn Museum in 1936, and some of its artists were included in the Museum of Modern Art's groundbreaking exhibition *Fantastic Art, Dada, and Surrealism* of 1936. The style was even used in one Federal Art Project mural painted by Feitelson admirers and short-time Post-Surrealists Philip (Goldstein) Guston (1913–1980) and Reuben Kadish (1913–1992) in 1935 to 1936 at the Los Angeles Tubercular Sanitarium (City of Hope), Duarte (chapter 20).

Many variations of Surrealism were practiced by American and California artists. **Dorr Bothwell** (b. 1902), although mentioned above in connection with Post-Surrealism, would be considered by most art historians to be more of a Magic Realist because of the mystery that pervades her paintings. Bothwell herself prefers the term Symbolist. She met Feitelson and Lundeberg while briefly employed on Los Angeles's Federal Art Project, and most of her Symbolist paintings were produced immediately following her departure from the FAP, between approximately 1938 and the end of World War II. In *Family Portrait* of 1940 (fig. 21-11), Bothwell is not trying to teach us anything, nor, as with some pure Surrealist works, does this work tap universal human fears with macabre or sinister allusions. Rather, like many other women artists, Bothwell delves into her personal background for material. While conventional portraitists tell us about their sitters through clothing, expression, and room setting,

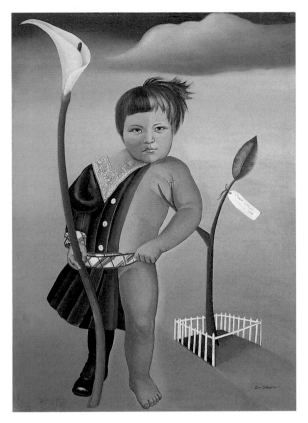

Fig. 21-11
Dorr Bothwell (b. 1902)
Family Portrait, 1940
oil on canvas, 34 x 24 in.
Perlmutter Fine Arts, San
Francisco

Bothwell gives us this same information in a Surrealist manner. Taking the image of her brother Stuart, as a child, from a family photograph, she divides him in half with color to show his dual background: his genetic descent from the early Britons (who painted themselves blue with a plant called woad) and his social persona of the Victorian era (represented by the hunting-plaid sash of his Scottish Stuart clan). Stuart's humorless and conventional personality is represented by the gray cloud over his head as well as by the scentless calla lily, while his position as last male of the clan is represented by the tree with the single leaf. Above all, the mauve coloration and amorphous setting imparts the sense of mystery that fascinates Bothwell (who explained these very personal and esoteric meanings in an interview with the author.)

Other Los Angeles artists broached different versions of Surrealism. Some of Grace Clements's rare montages of urban architecture fit into the category of Social Surrealism (in which a scene appears real but has overtones of social criticism). Knud Merrild briefly painted organically shaped objects floating in voids—a kind of biomorphic Surrealism. Other forms such as Romantic Surrealism, Abstract Surrealism, and some of the automatic techniques were more frequently seen in the 1940s when European Surrealists fleeing World War II brought them to the United States (chapter 24).

Society for Sanity in Art

Modernists have a tendency to align themselves with avant-garde political ideas. As underpaid craftsmen they identify with the poorer classes. This tendency was stronger on the East Coast, especially in New York, which had always been a hotbed of socially active artists. In the 1930s America's modern artists found themselves unwittingly associated with Communism. Most of the world was unsympathetic to Communism, but when the Soviets became frightened of Hitler's and the Fascist's growing power, they devised a strategy to get sympathy for their side. In 1935 they launched the Popular Front. Downplaying their Communism, they claimed that they, too, were interested in democracy and human rights and that everyone around the world who cared about freedom should unite with them to fight the Fascists. In 1936, New York artists formed the American Artists Congress for just such purpose. Although this was a Popular Front organ, the artists saw it only as a way to fight Fascism. It was distinguished politically and artistically from the strongly leftist John Reed clubs that were also forming around the United States. Los Angeles's branch of the American Artists Congress held several exhibitions of easel works in the late 1930s at the Stanley Rose Bookshop. Local artists didn't feel a need to pictorialize strikes, destitution, and revolution as did artists in New York. They felt they could express their anti-Fascist ideas by painting abstractly or in a modern vein (styles opposed by Fascists) and by refusing to paint in an American Scene style (which they felt echoed the extreme nationalism of Hitler's slogan "Only German Art").

In the 1920s modernism had been easy for Californians to tolerate—the style had few practitioners, and it did not threaten the status quo. In the 1930s, however, there were more modernists, and times were economically hard. Modern paintings were crowding out the paintings of conservatives from the competitive, annual juried exhibitions. Getting paintings exhibited or mentioned in the press was crucial to generating sales; artists fought to earn enough money to survive. Conservative artists began taking umbrage at the prevalence of modernist works. Wherever there were important juried exhibitions the squabbling erupted. Not only did the Oakland Museum and the Los Angeles Museum both ultimately go to a three-jury system (one jury each to judge conservative works, middle-of-the-road, and modern), but the conflict also rocked smaller towns such as Laguna Beach. People feared what modernism implied—Communism, radical ideas, and anarchy.

In the late 1930s, Josephine Logan, a socialite from Chicago, started her Society for Sanity in Art, an organization for painters in traditional styles. Branches were established in the California cities of Los Angeles, San Francisco, and Fresno. The groups gained additional members in the post-World War II era from

persons opposed to Abstract Expressionism or seized by the Cold War paranoia about Communism.

The fight against modernism and Communism in art peaked about 1950. Artists such as J. Duncan Gleason (1881–1959), the 1948 president of the Los Angeles chapter of Artists of the Southwest, appeared on television's "Hollywood Talks it Over" show (KTTV, April 1949), was interviewed on radio talk programs, and lectured before women's clubs against modernism, linking it to the breakdown of traditional society, to anarchy, and to Communism. About 1950 local art clubs seeking solidarity formed an umbrella organization, the Coordinating Committee for Traditional Art. However, by the mid-1950s the protest lost energy. It ✤

became evident that modernism had become a valid component of the art world and that traditional artists would not be able to stop it.

Although the 1930s was a time of economic struggle, the period turned out to be amazingly rich in art—American Scene, the California Watercolor Style, government art projects, and various kinds of modernism. There is yet one more strain to discuss. The next chapter will review how still-life and figure painting existed as a subordinate theme through the first half of the twentieth century, taking many different and interesting forms as its artists tried to resolve reality with pictorial values.

Bibliography

Infrastructure

Modern Artists in Transition: Opening Exhibition, exh. cat., Modern Institute of Art, Beverly Hills, Ca., February 13–March 28, 1948.

Schools of Twentieth Century Art, exh. cat., Modern Institute of Art, Beverly Hills, April 22–May 30, 1948. 28 p.

Abstract Painting and Sculpture, America

Lane, John R. and Susan C. Larsen, eds., *Abstract Painting and Sculpture in America, 1927–1944*, Museum of Art, Carnegie Institute in association with Harry N. Abrams, N. Y., 1983.

Larsen, Susan C., "The American Abstract Artists: A Documentary History, 1936-1941," *Archives of American Art Journal*, v. 14, no. 1, 1974, pp. 2–7.

Marquardt, Virginia Hagelsteen, "New Masses and John Reed Club Artists 1926–1936," [not California] *Journal of Decorative and Propaganda Arts*, no. 12, Spring 1989, pp. 56–75.

Meloy, Garnett, "The John Reed Club," *Archives of American Art Journal*, v. 35, no. 1–4, 1995, pp. 87–89.

Abstract Painting and Sculpture, Southern California

Clearwater, Bonnie, ed., *West Coast Duchamp*, Miami Beach, Fla.: Grassfield Press in association with Shoshana Wayne Gallery, Santa Monica, Ca., 1991.

Ehrlich, Susan, "Los Angeles Modernists 1920–1956," *Art of California*, v. 3, no. 5, September 1990, pp. 32–39.

Ehrlich, Susan, "Southern California's Modernist Dawn," *Artspace*, v. 16, pt. 6, Fall 1991, pp. 78–82.

Gebhard, David and Harriette von Breton, *L. A. in the Thirties, 1931–1941*, Layton, Ut.: Peregrine Smith, Inc., 1975. [primarily architecture]

Heisler, Barry M., "The Forgotten Generation: Modernist Painters of Los Angeles, 1920-1956," *Antiques & Fine Art*, v. 7, no. 5, July/August 1990, pp. 90-97.

Henstell, Bruce, *Sunshine and Wealth: Los Angeles in the Twenties and Thirties*, San Francisco: Chronicle Books, 1984. [social history]

Hertz-Ohmes, Andrea, "Modernism: Galka Scheyer & the Blue Four," *Art of California*, v. 2, no. 3, June/July 1989, pp. 33-39.

Karlstrom, Paul, ed., *On the Edge of America: California Modernist Art, 1900–1950*, Berkeley: University of California Press, 1996.

Selz, Peter, "The Impact from Abroad: Foreign Guests and Visitors," in Paul J. Karlstrom, ed., *On the Edge of America: California Modernist Art, 1900–1950*, Berkeley: University of California Press, 1996, pp. 97–119.

Turning the Tide: Early Los Angeles Modernists 1920–1956, essays by Paul J. Karlstrom and Susan Ehrlich, exh. cat., Santa Barbara Museum of Art and other venues, 1990, bibliog.

Hollywood and Modernism
(See bibliography in chapters 17 and 18.)

Art Decoratif and Precisionism, America

Greif, Martin, *Depression Modern: The Thirties Style in America*, New York: Universe Books, 1975.

Wilson, Richard Guy, et al., *The Machine Age in America 1918–1941*, New York: The Brooklyn Museum in association with Harry N. Abrams, Inc., 1986.

Art Decoratif, Los Angeles

Bel Geddes, Norman, *Horizons*, Boston: Little, Brown, 1932.

Brodsly, David, *L.A. Freeway: An Appreciative Essay*, Berkeley: University of California Press, 1981.

Gebhard, David and Harriette von Breton, *Kem Weber: The Moderne in Southern California, 1920 through 1941*, Santa Barbara: Art Galleries, University of California, 1969 and 1976.

The International Style in Southern California: Selections from the Architectural Drawing Collection, University of California, Santa Barbara, exh. cat., University Art Gallery, University of California, Riverside, March 1–April 19, 1987. 12 p.

Pildas, Ave, *Art Deco: Los Angeles*, New York and San Francisco: Harper & Row, 1977. [color plates of architectural details]

Abstraction, Bay Area

Dodge, Jackson, "The San Francisco Museum of Art," *Art of California*, v. 2, no. 1, February/March 1989, pp. 50–57.

Foley, Cynthia Charters, "Modernism in the Bay Area: The Role of Art Schools," in Joseph Baird, *From Exposition to Exposition*, exh. cat., Crocker Art Museum, Sacramento, Ca., pp. 29–35.

Ryan, Beatrice Judd, "The Rise of Modern Art in the Bay Area," *California Historical Society Quarterly*, v. 38, no. 1, March 1959, pp. 1–5.

Art Decoratif, Northern California

Clarke, Orville O., Jr., "Lost Art of the Pacific Stock Exchange Club," *Antiques & Fine Art*, v. 5, no. 4, May/June 1988, pp. 49–53.

Rollins, Pauline J., "International Art Deco in Northern California, 1915–1939," in Joseph Armstrong Baird, Jr., ed., *From Exposition to Exposition*, exh. cat., Crocker Art Museum, Sacramento, Ca., 1981, pp. 55–60.

Schnoebelen, Anne, *Treasures: Splendid Survivors of the Golden Gate International Exposition*, Berkeley, Ca.: GGIE Research Associates, 1991. 16 p.

Wilson, Mark, "Oakland's Art Deco Treasures," *San Francisco Examiner and Chronicle, California Living Magazine*, September 24, 1978, pp. 26–32.*

Wilson, Richard Guy, "Machine Age Iconography in the American West: The Design of Hoover Dam," *Pacific Historical Review*, v. 54, November 1985, pp. 463–93.

Post-Surrealism

Alcuaz, Marie de, *Ceci n'est pas le Surrealisme: California: Idioms of Surrealism*, exh. cat., Los Angeles: Fisher Gallery, University of Southern California and Art in California Books, 1983.

Leonard, Michael, "The Dada and Surrealist Roots of Art in California," *Art of California*, v. 5, no. 2, May 1992, pp. 8–12.

"Modernism of the 1930s" in Nancy Dustin Wall Moure, *Painting and Sculpture in Los Angeles, 1900–1945*, exh. cat., Los Angeles County Museum of Art, September 25–November 23, 1980, pp. 62–66.

Pacific Dreams: Currents of Surrealism and Fantasy in California Art, 1934–1957, exh. cat., UCLA at the Armand Hammer Museum of Art and Cultural Center, February 25–June 11, 1995 and two other venues.

Wechsler, Jeffrey, *Surrealism and American Art 1931–1947*, exh. cat., Rutgers University Art Gallery, March 5–April 24, 1977.

(See also bibliography in chapter 24.)

Abstraction vs. Representationalism

Exhibition of Painting and Sculpture by the San Francisco Chapter of the Society for Sanity in Art, Inc., exh. cat., California Palace of the Legion of Honor, San Francisco, August 10–October 6, 1940. 41 p.

Exhibition of Painting and Sculpture by the San Francisco Chapter of the Society for Sanity in Art, Inc., exh. cat., California Palace of the Legion of Honor, San Francisco, November 1–December 31, 1942. 37 p.

First Exhibition of Paintings, Sculpture and Miniatures, The Los Angeles Branch of the Society for Sanity in Art, Inc., Directory and Catalog, Los Angeles: State Building, Exposition Park, 1940. 16 p.

Illustrated Catalogue: 7th Annual Exhibition of Painting and Sculpture, Society for Sanity in Art, exh. cat., California Palace of the Legion of Honor, San Francisco, November 4–December 31, 1945.

Illustrated Catalogue, 8th Annual Exhibition of Painting and Sculpture by the Society for Sanity in Art, exh. cat., California Palace of the Legion of Honor, San Francisco, December 7, 1946–January 26, 1947. 39 p.

Logan, Josephine Hancock, *Sanity in Art*, Chicago: A. Kroch, 1937.

Whiting, Cecile, *Antifascism in American Art*, New Haven: Yale University Press, 1989.

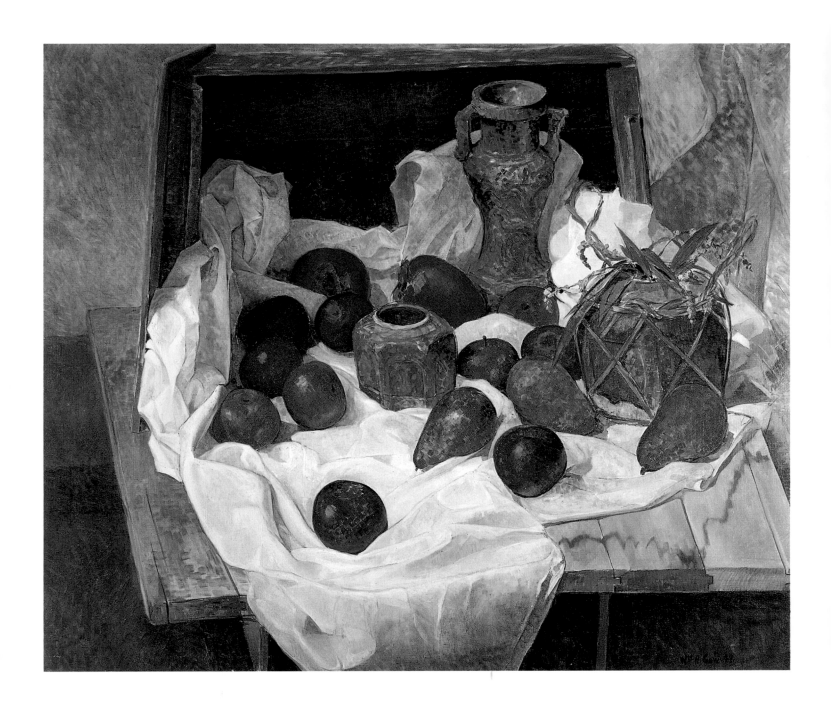

Fig. 22-3
William Gaw (1891–1973)
Fruit and Ginger Jar, 1949
oil on canvas, 30 x 36 in.
Marcel Vinh & Daniel
Hansman

Still Life and Figure Painting through the First Half of the Twentieth Century

Academic Figure and Still Life (1915-1950)

Each time an artist composes a picture he or she takes into consideration *formal* issues including choice and placement of line and color, arrangement of shapes, dynamics, and balance to name a few things. For some the solution is intuitive; for others it is the end product of following strict rules and preparing countless preliminary drawings. Formal rules have been the mainstay of art academies since the modern-day institution first arose in Renaissance Italy. Academy descendants in France, England, and finally America established a standard progression of classes, the first step of which is drawing inanimate objects, i. e., still lifes. When students have mastered that, they progress to the "life" class, where they draw clothed figures and eventually nudes. With these abilities mastered, a student is assumed to have acquired the tools to create paintings of any topic and size. Still life and figure painting have thus come to be identified with art academies and with formal training.

A classic academic still life is *Fruit and Majolica* of 1940 (fig. 22-1) by **Frank Tolles Chamberlin** (1873–1961). A lone academic among Los Angeles's many 1920s "plein air" landscapists, Chamberlin was revered by his pupils as one of their most important teachers. He is only now being given credit for his role. His classic style was formed during study at the American Academy in Rome and during his association with the Beaux-Arts Institute of Design in New York. Like most twentieth-century artists, Chamberlin rejected the nineteenth-century goal of verisimilitude in still-life painting and restricted himself to a few basic forms that he shaped with painterly brushwork and with light and shadow. Although the composition of *Fruit and Majolica* seems extremely simple and the objects carelessly strewn, the whole has been strictly planned to achieve balance and harmony. The pottery was chosen for its simple geometric shapes and lack of decoration, and the objects are arranged within a triangle (considered the most stable of the basic geometric shapes). The selected colors—red, blue, yellow-green/cream (the three primary colors)—are equidistant from each other on the color wheel. An object of each color has been placed at one point of the triangle to distribute the colors evenly throughout the composition. The cloth and background are neutral to set off the colored objects. To complete the harmony, the items are subordinated to an overall tonal atmosphere. The result is an understated work that has a sense of simplicity and repose.

For centuries, still lifes and figure studies were restricted to training purposes or relegated to minor and peripheral roles in paintings devoted to what were then considered more important themes. However, by the mid-nineteenth century, still lifes came to be respected as a main subject in their own right, and shortly before the turn of the twentieth century, after photography had made painted portraiture obsolete, figure painting also came into its own (chapters 5, 6). In California, the state's growing sophistication, as well as art fashions that increasingly favored subjects other than pure landscape, caused a rise in these two subjects in the first half of the twentieth century.

This chapter looks at still life and figure painting between about 1920 and 1950, how the themes were depicted in a variety of styles, how the artists reconciled illusionism with formal values, and how they selected objects based on the tastes and interests of their different eras.

Fig. 22-1
Frank Tolles Chamberlin (1873–1961)
Fruit and Majolica, 1940
oil on canvas, 20 x 24 in.
Collection of Orange County Museum of Art,
OCMA/LAM Art Collection Trust; Gift of the Virginia Steele Scott Foundation

and 1940s, who usually "studied" his theories by producing at least one still life in his style. Many merely borrowed his tabletop composition and bird's-eye viewpoint, but others experimented with the way he broke down form and then built it up again with brushwork and color. Gaw has adopted Cezanne's composition and painting techniques. He has also drawn on other sources—the bright colors that he used in the fruit and bowls are reflective of some of the color theories then circulating. Here the juxtaposition of the complementary hues of blue-green and pinkish-red (complementary colors are opposite each other on the color wheel) increase the richness of both. Gaw's picture contains all the elements considered essential to a 1930s still life: objects selected for various shapes and textures, a cloth or drape, and an arrangement on a tabletop (or some other flat surface).

In the 1930s, still-life and figure paintings were made in two styles: American Scene and Formalist Realism. A prime example of an American Scene figure painting is *Figure* of 1933 (fig. 22-4) by the Bay Area artist **Otis Oldfield** (1890-1969). In it, Oldfield has rejected centuries of female symbolism—woman as ideal, woman as temptress, woman as mother, woman

Fig. 22-2
Joseph Kleitsch (1882–1931)
Highlights, c. 1925
oil on canvas, 38 x 46 in.
Private Collection
Photo: Budd Cherry

Fig. 22-4
Otis Oldfield (1890–1969)
Figure, 1933
oil on canvas, 60 x 34 in.
Collection of the Oakland
Museum of California, Gift
of the Estate of Helen Clark
Oldfield

In the 1920s, without one dominant movement, excellent still lifes and figure paintings were produced in a range of styles. These include the romantic, exuberant and lush still life *Highlights* of about 1925 (fig. 22-2) by Laguna's **Joseph Kleitsch** as well as the figural *Bathing Baby* (fig. 15-12) by **Elanor Colburn**, who employed the rules of Dynamic Symmetry. Most still-life and figure painters of the period, however, executed their work in the colorfully expressive Impressionist or Post-Impressionist styles (chapters 13–16).

Art teachers and conservative intellectuals especially liked to paint still lifes and figures. The themes supplied neutral subjects that could be reworked conveniently in the studio in infinite ways to study the effects of color and shape. In fact, the term "academic" came to be associated with these themes. This does not imply that they were actually painted within the walls of a teaching institution but that they were governed by shared formal rules and values. Frank Tolles Chamberlain was one such teacher/artist, as was Bay Area artist **William Gaw** (1891–1973). Throughout his lifetime Gaw experimented with the styles of various artists. His vases of flowers have been compared to those of the French mystical Impressionist Odilon Redon (1840-1916), while his *Fruit and Ginger Jar* of 1949 (fig. 22-3, p. 282) clearly echoes the work of Paul Cezanne (1839-1906) in its tabletop arrangement. The Post-Impressionist Cezanne was regarded as an artistic god by almost every art student of the 1920s, 1930s,

as romantic figure—and has complied with American Scene tastes by painting a corporeal being, an average housewife. While she is largely undressed, her nudity is not meant to entice. This human body is simply an object the artist used for its volumes and arranged into a composition according to some formal principles. To deemphasize the personality, the face is shown averted; to deemphasize any erotic overtones, the figure is shown from the back. The scene is also a still life complete with a table and a drape (the subject's undergarments). Reflecting its Regionalist period and style, the composition emphasizes volumes and uses a sober brown-black color scheme. The work also contains an element of wit. Prior to Dada art of the 1910s, wit was a quality associated with art forms such as caricature and cartooning, forms considered of a lower order than so-called "fine art." In this picture the humor is a natural outgrowth of Oldfield's own wry view of life. Humor, irony, punning, satire, and caricature grow to become features in "high" art from the late 1940s. In 1933 when *Figure* was first shown publicly, it shocked audiences and attracted considerable media attention.

A Los Angeles American Scene painter of still lifes and figures was **Ejnar Hansen** (1884–1965), a Danish immigrant who supported himself painting wall decorations while he made his name in the fine-arts community with works such as *Mexican Still Life* of 1943 (fig. 22-5). Paintings made during the Great Depression often employ the somber colors of brown and black. Still lifes of the era usually feature common items of simple and volumetric shape, such as garden-variety fruits and vegetables, cheap kitchen crockery, old and worn wooden tables and chairs, and other worn-out or well-used items. Although Hansen's *Mexican Still Life*, with its arrangement of objects on a flat surface and its draped garment, is compositionally close to Cezanne's "tabletop" still lifes, it is decidedly a California Regionalist interpretation. Generally, California's contribution to the American still-life tradition lies in the objects depicted: her own native flora (calla lilies, cacti, dried desert plants, squash), manufactured items associated with the state (rusted gold-mining equipment), and items of Mexican heritage or manufacture. Specifically, *Mexican Still Life* reveals the area's Spanish/Mexican heritage in the pomegranates and chayote squash as well as the coarsely woven fabric, the raw wood "Mexican" chair, and the sombrero. Since still lifes and figures were both products of the studio, artists who painted the one often painted the other. **Hansen**'s *Cello Player (Frode Dann)* of 1937 (fig. 22-6) may be a *portrait* of his friend, the artist Frode Dann (1892–1984), who actually played the cello, but it is also a masterful formal figure study. Careful thought has been put into the architectural breakup of the background and the visual directions set up by the position of the bow, the sitter's arms, and the strings on the cello.

Still lifes of the 1930s were also painted in other styles such as Post-Surrealism (chapter 21) and by California Watercolor Style artists (chapter 19).

Fig. 22-5
Ejnar Hansen (1884–1965)
Mexican Still Life, 1943
oil on canvas, 37 x 30 in.
Private Collection

Fig. 22-6
Ejnar Hansen (1884–1965)
Cello Player (Frode Dann), 1937
oil on canvas, 50 x 40 in.
Courtesy Arlington Gallery

Fig. 22-7
Henry Lee McFee
(1886–1953)
Bouquet from the Desert, 1941
oil on canvas, 40 x 30 in.
Private Collection, Courtesy
of Claremont Fine Arts

Formalist Realist Still Life and Figures (1940s)

In the 1940s, still-life and figure painting enjoyed a fluorescence in Southern California. This was the result of several coincidental factors: the arrival of three artist/teachers who specialized in the subjects (Henry Lee McFee, Francis de Erdeley, and Rico Lebrun), California's postwar boom in art schools, and another wave of modernist influence from Europe.

Each of the three artists approached still life and the figure from his own personal direction. **Henry Lee McFee** (1886–1953) was America's foremost proponent of Formalist Realism on the East Coast between 1923 and 1936. Formalist Realist artists wanted to paint realistically but shared a modernist interest in the formal rules of art. They started with representational subject matter, usually a still life or a figure, but rather than breaking down the objects into flat, abstract shapes, as did Picasso, the Formalist Realists retained three dimensions and restricted their modernist impulses to arranging the objects. McFee's favorite format was a Cezanne-like tabletop arrangement. During his peak years of 1930 to 1936, he placed solid objects in a relatively deep space and viewed them from oblique angles or a bird's-eye perspective. By the time McFee "retired" to California, the East Coast Formalist Realist still-life movement had passed its prime, and McFee was gravitating to an aesthetic that was to become

common across America in the 1940s—a flattening of forms and an interest in designing the picture surface. Although the arrangement in *Bouquet from the Desert* of 1941 (fig. 22-7) looks spontaneous and natural, careful inspection shows the almost compulsive attention to detail and the mental games that compositional puzzle-solvers like McFee enjoyed. Drapery has been folded to focus attention on the twigs, and shadows have been added to shape objects into three dimensions and to set off the "bouquet." The earthenware jug and the dried desert plants reflect McFee's adopted interest in things Southwestern as well as a Depression-era appreciation for the beauty of natural and commonplace objects. McFee had never been interested in iconography (the symbolic significance of the objects), but in the 1940s he took into his repertory items such as dried plants and cow's skulls. Some art historians have interpreted this as more than a culling of his adopted Southwest for challenging new subject matter, suggesting that it may be reflective of his own aging and of his early 1940s brush with death during a bout with colon cancer.

Some critics considered it a backward step for an artist to lapse into representationalism after working abstractly (as McFee had worked in the teens). However, proponents of Formalist Realism argued that the move was an advance—that artists returned to representationalism with a purpose, i. e., to resolve the complex interrelationships between three-dimensional illusionism and two-dimensional design principles.

McFee's California peers, Lebrun and De Erdely, approached still lifes and especially figure painting from a humanist (as opposed to McFee's intellectual) direction. As European refugees, both artists had seen atrocities against humanity first hand. Additionally, they were caught up with the general concerns of postwar Americans who saw man as a victim—in fear of his own technology (the atomic and hydrogen bombs) and of losing his democratic rights by Communism. Man was caught up unwillingly in America's entry into yet another war (Korea) and trapped in the nine-to-five world of business just to earn the money to buy the new laborsaving devices issuing from American manufactories.

Rico Lebrun (1900–1964) was a physically small but charismatic Italian who had progressed from

technical fields such as stained-glass design and commercial illustration to the painting of murals for the WPA and finally teaching. A colleague invited him to the West Coast in 1938, where he taught at Chouinard (about 1938–39) and at the Jepson Art Institute (from 1945). Although some of Lebrun's students and colleagues considered him dogmatic and egotistical, all agreed he was immensely talented, and Herbert Jepson's (b. 1908) school soon became marked with Lebrun's personality. Because the Jepson student body consisted of former GI's, mature individuals intent on establishing civilian careers, instructors tended to think of the students as colleagues. There were lively debates and discussions on aesthetics and contemporary topics along with art history lectures—an environment similar to that of the California School of Fine Arts in San Francisco at the same time (chapter 26). Herbert Jepson's personal tastes put the school's emphasis on drawing (a medium that came into its own after World War II; chapter 25) and toward an intuitive approach to making art. Lebrun's tastes led the school toward a baroque sense of the monumental and to humanist subjects. As in *Seated Clown* of 1951 (fig. 25-10), Lebrun urged his students to create bold, assured, muscular works marked by emotion and passion. To break their preconceived ideas, he encouraged them to look at their subjects from above, like a bird,

or from below, like a bug. Stressing the gestural, he encouraged students to use bold and forceful lines but to retain their subject's three-dimensionality. He was a "romantic" in that he preferred subjects of melodrama and tragedy, such as beggars in tatters, Christ on the cross, cripples, and clowns.

Francis de Erdely (1904-1959), son of a respected Hungarian military officer, learned his craft in various European academies and pursued his career in Europe through the 1930s. His depictions of the horrors he had experienced as a teenager in World War I and of 1930s wartime atrocities eventually angered the Gestapo and forced de Erdely to flee, first to London and then the United States. After brief stints in New York and Detroit, he arrived in Los Angeles about 1944. Always one to champion the underdog, the peasant, and the worker, in America he depicted minorities, such as blacks and, in California, people of Mexican heritage. A romantic with strong emotions, he presented figures as pensive, morose, or despondent. His *Fish Market* of 1947 (fig. 22-8), shows how his volumetric painting had given way to flat shapes and the angularity of Cubism. De Erdely was extremely influential on an entire generation of his students. He first served as dean for the Pasadena Art Museum School (1944–46) and in 1945 joined the faculty of the University of Southern California, where he remained until his death.

Fig. 22-8
Francis de Erdely
(1904–1959)
Fish Market, 1947
oil on canvas, 40 x 50 in.
From the Collection of
Mr. and Mrs. Patrick Duffy

Fig. 22-9
Mischa Askenazy
(1884/88–1961)
Sky Writer, 1938
oil on canvas, 32 x 28 in.
George Stern Fine Arts

Nudes

Possibly ten percent of the figure studies made in California in the 1930s and 1940s were nudes, but nudes have never been popular with Americans. An ingrained Puritanism had led them to see nudes as pornographic, sexual, and private. However, to artists the human body is a fascinating source of poses, curves, volumes, and shapes, and they know they must master the rendering of the nude body before they can cover it with clothing or use it in a composition. In the nineteenth century, when American artists wanted to employ nudes in figural compositions, they felt compelled to justify their figures' lack of clothing by some excuse. The subject was sleeping and his or her clothing fell away; the subject was a captive and deprived of clothing by captors; or the subject was doing battle and his clothing had become ripped away in the act of the fighting, etc. Prior to the 1960s, nudes by "fine-arts" artists were rarely erotic. However, some of the first nudes seen in California, such as the imported paintings that hung over bars in Gold-Rush San Francisco, emphasized flesh and were meant to give the bar a sophisticated, cosmopolitan air. As the nineteenth century progressed and the population became more accepting, American artists were less frequently required to justify their figures' nudity. In the second half of the nineteenth century, more American artists studied art in Europe, where nudes were the standard in life drawing classes and where paintings of nudes were frequently seen in the Salon exhibitions. As art academies were established in America, they incorporated "life" classes, even for women students. And as America's new wealthy class traveled the Continent and aspired to Europe's more cosmopolitan ideas, they showed their sophistication by buying paintings that depicted nudes and displaying them in their homes. By the turn of the century, nudes and partially draped figures were given government sanction when they regularly appeared in the popular and ubiquitous American Renaissance/Beaux-Arts murals and sculpture displayed in public spaces (chapter 8).

In Southern California, the road to accepting nudes was paved in the 1920s by the large number of figure painters in the Impressionist and Post-Impressionist styles, many of whom had been painting the subject in Europe before they fled World War I to America.

They exhibited such pieces in the local annual exhibitions. An artist of nudes who combines broken Impressionist brushwork with an equal interest in academic and formal composition is **Mischa Askenazy** (1884/88–1961), a Russian-born New Yorker who moved to Southern California in 1926. *Sky Writer* of 1938 (fig. 22-9) has a narrative element—two artists' models temporarily diverted from posing to watch a pilot writing in the sky. But this "action" is only a ruse for a formal composition. From Impressionism, Askenazy borrows the idea of oblique angles to frame his figures, and he places his main subject, the prominent but inanimate easel, off center. While the main elements are placed within a stable triangular shape (the apex at the top of the easel), the models' stances and gestures lead the viewer's eye toward the window and up to a point in the sky outside the image. The architecture of the room gives a firm structure to the background.

For some artists, such as the Synchromist Stanton MacDonald Wright, figures (including nudes) provided a departure point for abstraction. In *The Muse* of 1924 (fig. 18-2) the corporeal body becomes almost invisible as Wright dissolves its twisted trunk and limbs into rainbows.

Nudes painted in the 1930s followed the Regionalist style—they are "real" humans in everyday settings. However, Regionalism, having solid "American" values, usually demanded that nudes be partially clothed or their lack of clothing explainable by some socially acceptable excuse. Examples mentioned in previous chapters include the boxer in Fletcher Martin's *Lad from the Fleet* (chapter 18), the competitors in Douglass Parshall's *Young Athletes* (fig. 20-20), and Otis Oldfield's *Figure* (above). Careful study of these works shows how each artist rigidly planned his composition, arranging the figure(s) so that lines of direction set up by the limbs result in a tight composition with dynamic angles. Regionalist figure painters often selected models from ethnic minorities, such as blacks, Latinos, or Asians, to represent the era's ideal—the common man. Occasionally the subject was a woman with a child to show "woman" in the combined guise of Madonna and earth mother. No Californian specialized in taking the nude in unusual directions such as those that brought notoriety to certain East Coast and Midwestern artists—the erotic, voluptuous figures of

Gaston Lachaise (1882-1935), the putrefying flesh in the bodies painted by Ivan Albright (1897-1983), or the perversion in the individuals depicted by Romane Brooks (1874-1970). Parallel to and contrasting with the mainstream depression style was the Art Decoratof style of an artist such as Matsusaburo Hibi. His *Three Muses* (fig. 23-14) with its Grecian theme, idealized anatomy, and interest in surface design is just about as far as one can get from the earthy Regionalist works discussed above.

In the post-World War II period, the painting of nudes in California became common. Not only did many art schools offer courses in life drawing (from the nude figure), but the subject was fostered by another wave of European modernism, one of whose favorite subjects was nudes. Americans wanting to prove themselves sophisticates adopted European tastes. In Southern California such works were sold most frequently at galleries such as Vigeveno in Brentwood, which catered to Hollywood personalities and to other sophisticates and intellectuals of the wealthy area that extended from Hollywood to the ocean. Many paintings of nudes were also carried by Dalzell Hatfield Galleries. The war brought in as refugees a number of European artists, such as Grigory Gluckmann (1898–1973), who were used to painting nudes in their home countries and continued to do so in California.

In the 1950s, in Northern California, nudes were often the departure point for the Bay Area figurative painters (chapter 26).

Merging Realism with Abstraction in the Post-War Period

In the wake of World War II, illusionistic still-life and figure painting was battered by two new modernist forces: the second wave of European modernism that surged in after the war and the American-generated Abstract Expressionism. Between 1940 and 1960 the major goal of American artists grounded in realism was to resolve the conflict between three-dimensional subject matter and the two-dimensional picture surface, between illusionistic reality and pictorial values. Constituting perhaps seventy percent of the active painters, this body of artists was sizable enough to be mistaken for a "movement," although it has not yet been treated as such by art historians. In most areas of

the country (except in New York and San Francisco, where Abstract Expressionism was taking hold) these artists were viewed as *the* avant-garde.

Artists reached their own compromise or resolution of the three-dimensional/two-dimensional question by varying the proportions of the two depending on personal tastes and stylistic goals. The most conservative mixture might be exemplified by **Roger Kuntz**'s (1926–1975) *Baldwin Avenue Overpass* of 1965 (fig. 22-10). This work is basically realistic, but Kuntz found a way to present it in a two-dimensional manner. Artists like Kuntz resurrected all the methods that their predecessors in history had devised to bring realistic scenes up against the picture surface. These include observing the subject from a bird's-eye perspective, placing the subject on a shallow stage against a flat backdrop, surrounding the subject with stacked-up elements, and presenting the subject as emerging from a dense fog. The best-known American example of the first technique is *Christina's World* of 1948 (Museum

of Modern Art, New York) by Andrew Wyeth (b. 1917) that shows a single figure against an expansive field of grass. Kuntz was already halfway to his goal when he selected contemporary subject matter that was flat and abstract: freeway underpasses and embankments, freeway signs, and tennis court backboards, to name a few.

Other artists gave equal weight to representationalism and to formal issues (half realism and half abstraction). One way an artist could paint representationally and abstractly at the same time was to select a realistic subject that already looked abstract. In *Wrecked Automobiles* of 1949 (fig. 22-11), **Howard Warshaw** (1920–1977) presents a realistic rendering of crumpled metal that is also an abstraction. The subject was particularly relevant to the era, simultaneously referencing the destructiveness of World War II, America's dependence on the automobile, and the country's consumer-driven, throw-away society. Other artists selected subjects such as the sides of cliffs where sedimentary rock layers of various textures presented a flat but

Fig. 22-10
Roger Kuntz (1926–1975)
Baldwin Avenue Overpass,
1965
oil on canvas, 60 x 72 in.
Collection of Orange County
Museum of Art,
OCMA/LAM Art
Collection Trust; Gift of
Mary Kuntz

"abstract" original. Or, they represented flat objects, such as doors, turning the grain of wood or defects into subjects in their own right. Artists such as Edward Biberman solved the dimensionality question by painting the flat sides of buildings, as in *C.B.S.* (fig. 21-8).

Another way to paint representationally and abstractly at the same time was to "break apart" objects and rearrange them, as Picasso and Braque had done in their Synthetic Cubism. McFee, Lebrun, and de Erdely frequently employed this technique. Southern Californian **Bentley Schaad** (b. 1925), a student at Art Center, Jepson, and Claremont, and later a dean and instructor at Otis Art Institute, went so far as to produce an instructional book, *The Realm of Contemporary Still Life Painting* (New York: Reinhold, 1962). It was illustrated with his solutions and those of his California colleagues. He speaks of "building" a painting, as compared to "painting a picture". Crucial to the success of a still life such as Schaad's *The Red Table* of before 1957 (fig. 22-12), is drawing. Irrespective of whether an artist worked objectively or nonobjectively, for Schaad and his peers drawings allowed an artist to jot down ideas, to decide a point of view, and to compose the final design. Sketching still-life objects forced an artist to look at the objects and to consider their structure, shape, and surface texture. Of the two types of setups acknowledged by Schaad, *The Red Table* is of the formal or controlled type. (The other is the informal, a natural situation in which artistic properties are recognized at a glance by the artist, for example Warshaw's *Wrecked Automobiles*.) Schaad preferred the formal setup because he could control the relationships of the objects and the space. He selected objects that were simple; elaborate objects called too much attention to themselves and destroyed the overall harmony. He avoided combining objects that implied a story. He usually included drapery—its versatility allowed it to be used as a backdrop, to cover or reveal body parts, to provide areas of color or pattern, and when folded or rumpled, to become an intricate, labyrinthine sculptural form in itself. Schaad recognized three types of compositions: a central image, multiple views of an image, and architectonic. *The Red Table*, with its rigid structure of vertical and horizontal elements and no central motif, is of the architectonic type. In painting the picture, Schaad first designed the picture plane

Fig. 22-11
Howard Warshaw
(1920–1977)
Wrecked Automobiles, 1949
gouache, 23 x 47 in.
Los Angeles County
Museum of Art, Museum
Purchase

Fig. 22-12
Bentley Schaad (b. 1925)
The Red Table, before 1957
oil on canvas, 44 x 24 in.
Glen and Pam Knowles
Collection
Photo: Robert Stanley

with a linear framework, added masses of dark and light, and then detail. Inserting color, he adjusted it to the dark or light end of the scale to harmonize with the other values in the composition. Although the colors are made to work together, he never allowed them to lose their local distinction.

In the early 1950s, representational artists were further pressured toward abstraction by the popularity of Abstract Expressionism (chapter 26). This style, which arose simultaneously in New York and San Francisco, was almost as far as an artist could go toward the abstract pole, revealing no subject matter and consisting only of expressive brushwork unleashed on the canvas in a flurry of emotion. Not every artist felt satisfied painting pure abstraction. One reaction in Northern California was the Bay Area Figurative Painting movement of the 1950s (chapter 26). Its core group of artists retained Abstract Expressionism's energy and vitality, its spontaneous brushwork, its delight in paint texture, and its method of creating directly on the canvas, but they applied these qualities to recognizable subject matter. Their canvases exhibit approximately ten percent realism and ninety percent abstraction. Although their primary subject matter was figures, as it was with the formalist still-life and figure artists of the 1930s, they were not interested in the figures themselves, only in how the human body could be posed to suggest directions in which to apply strokes of paint. Their subjects are marked by neutrality: most have blank expressions or turn away their faces, and they lack psychological content. Some critics saw Bay Area Figurative as a backward step from Abstract Expressionism. Others prefer to think of the move as a vital application of Abstract Expressionism's potent brushwork to representational subjects.

Most of Southern California's realist abstractionists of the 1950s agreed with the Bay Area Figure painters—that a composition was not satisfying unless it had some basis in reality, especially in humanism. (In Southern California this attitude may have reflected the tastes of Rico Lebrun.) Southern California had a huge contingent of such artists, many of whom were

also teachers. At Chouinard worked Richards Ruben (b. 1925); at Otis, Bentley Schaad, Richard Haines (b. 1906), Herbert Jepson, Douglass McClelland (b. 1921) and Edgar Ewing (b. 1913). At Claremont taught Jack Zajac (b. 1929), Paul Darrow (b. 1921), Robert Frame (b. 1924), and Phil Dike; at University of Southern California was Francis de Erdely; and at Laguna Beach School of Art (now Art Institute of Southern California), was Sueo Serisawa, just to name a few.

One of many examples that demonstrates their thinking is **Ed Reep**'s (b. 1918) *Grey Pier* (fig. 22-13). Reep taught at Art Center and Chouinard. From the title and the general shape of the abstract design, it is clear that Reep started his composition with a real location—in this case the Santa Monica pier. The period's goal, however, was to use reality only for inspiration, to keep those elements of the original subject that were useful for the design, to discard the rest, and to arrange the design on the surface of the canvas. Surprisingly Reep painted this work in the manner of a traditional landscapist—*en plein air*—from a position under the pier, and he was intent on capturing the scene's light. Many Southern California abstractionists did not ascribe to Abstract Expressionism's allover field approach and, as here, "built" a single central abstract motif that they presented against a solid color background. Typical of Southern California is the architectonic structure of this motif, its horizontal and vertical elements achieved by "drawing" with the brush. In *Grey Pier* Reep has succeeded in reducing the recognizable subject matter to almost pure abstraction, in building a well-structured composition, and in giving emphasis to expressive brushwork over subject.

Southern California's abstractionists of the 1950s did not form a true "movement." Artists simply shared similar goals: dedication, discipline, and a desire to resolve representationalism in a painterly way. Although the "community" was spread out over many miles and artists worked almost in isolation from each other, they were aware of each other's progress. Los Angeles's several major art schools—Otis, Chouinard, Jepson, Art Center, and University of Southern California—were all within walking distance of or a short drive from each other. Many of the teachers had trained the other teachers. Teachers discussed the work of students; students discussed teachers. Painters exhibited in competitive exhibitions against each other (at the Los Angeles County Museum, at the Pasadena Art Museum, at Barnsdall Park) and ran into each other on La Cienega, where galleries such as Esther Robles and Felix Landau dared to show their work.

The question of how to resolve three dimensions with formal pictorial qualities has continued to challenge artists, who arrive at new solutions. In the 1960s Joe Goode (chapter 32) created a series of works in which he placed an actual milk bottle on the floor in front of a monochrome painting on which he painted an outline or shadow of the milk bottle. His goal was to tie the object and image together visually and to physically extend the pictorial surface. In another series on clouds, Goode painted an illusionistic sky on a canvas, then tore the canvas to expose a second canvas behind it that was also painted with an illusionistic sky. In the 1970s Ed Moses (b. 1926) made a series of nonobjective drawings consisting of diagonal lines, whose overlaps gave the impression of three dimensions.

Although this chapter began in the 1920s and ran into the 1970s, the next chapter will return to 1940 to see how World War II affected California artists. Rather than dropping art completely, many artists used their talents on behalf of the allies and, in doing so, gave art several potent new directions. ❧

Bibliography

American Art Schools

Fink, Lois Marie and Joshua C. Taylor, *Academy: The Academic Tradition in American Art,* Washington, D. C.: National Collection of Fine Arts, 1975.

In this Academy: The Pennsylvania Academy of the Fine Arts, 1805–1976, Philadelphia: Pennsylvania Academy of the Fine Arts, 1976.

Landgren, Marchal E., *Years of Art: The Story of the Art Students League of New York,* New York: R. M. McBride, c. 1940. 267 p.

California Art Schools

(Also see bibliography for Faculty and Student exhibitions in chapter 35, for CalArts in chapter 36, and public school art education in chapter 37.)

Art at Scripps the Early Years, exh. cat., Lang Art Gallery, Scripps College, January 23–February 28, 1988.

"Art Center College of Design," *Studio Magazine* (Canada), v. 6, pt. 6, November–December 1988, pp. 48–53.*

Artist-Teachers and Pupils at the San Francisco Art Association and California School of Design: the First Fifty Years, 1871–1921, exh. cat., California Historical Society, San Francisco, 1971.

Beebe, Marjorie Harth, *Art at Pomona 1887–1987: A Centennial Celebration,* exh. cat., Galleries of the Claremont Colleges, 1988.

Brown, David R., "Art Center College of Design," *Graphis,* v. 48, July/August 1992, pp. 18–31.

Chambers, Nancy Sue, *The Department of Art at the University of California at Davis: its History and Reputation, Art and Artists, with Emphasis on the Art Practice Division,* Ph.D. Dissertation, University of California, Davis, 1975.

DeMars & Reay, *Preliminary Development Program for the California College of Arts and Crafts, Oakland, California,* Berkeley, Ca.: DeMars and Reay, 1964. 30 l.

"The Development of an Art Community," in Nancy Dustin Wall Moure, *Loners, Mavericks & Dreamers,* exh. cat., Laguna Art Museum, November 26, 1993–February 20, 1994, pp. 39–50.

Ehrlich, Susan, "The Jepson Group," in Nancy Dustin Wall Moure, *Drawings and Illustrations by Southern California Artists before 1950,* exh. cat., Laguna Beach Museum of Art, August 6–September 16, 1982.

Foley, Cynthia Charters, "Modernism in the Bay Area: The Role of Art Schools," in Joseph Armstrong Baird, Jr., *From Exposition to Exposition,* Sacramento: Crocker Art Museum, 1981.

Goodman, Calvin J., *Long-Range Planning at Otis Art Institute,* Los Angeles: The Author, 1971. 149 p.

Group in Support of Otis Art Institute Presents Otis '73, Los Angeles: The Group, 1973. 50 p.

Jarrett, Mary, *The Otis Story of Otis Art Institute since 1918,* Los Angeles: Alumni Association of Otis Art Institute, 1975.

Jones, Mady, "The San Francisco Art Institute," *San Francisco Magazine,* June 1980, pp. 50-57. *

Kamerling, Bruce, "Theosophy and Symbolist Art: The Point Loma Art School," *Journal of San Diego History,* v. XXVI, no. 4, Fall 1980, pp. 230–55.

Los Angeles School of Art and Design, Los Angeles: The School, c. 1918.

Marks, Ben, "Growing Pains at Cal Arts," *Artweek,* v. 21, March 8, 1990, pp. 20–1.

Martin, Gloria Rexford and Michael Redmon, "The Santa Barbara School of the Arts: 1920-1938," *Noticias* (publication of the Santa Barbara Historical Society), v. XL, nos. 3, 4, Autumn/Winter 1994, pp. 45–83.

Moure, Nancy Dustin Wall, *Publications in Southern California Art, 1, 2, 3,* Los Angeles: Dustin, 1984.

Mulford, Harry, "A History of the San Francisco Art Institute," *San Francisco Art Institute Alumni Association Alumni Newsletter,* v. 1, nos. 1–4, v. II, nos. 1–2, Pt. I, May 1978; Pt. II, August 1978; Pt. III, November 1978; Pt. IV, February 1979, Pt. V, May 1979, Pt. VI, August 1979.

Neuhaus, Eugen, *Bay Area Art and the University of California Art Department* [Typescript of an oral history conducted by Suzanne B. Riess], Berkeley: University of California, Regional Oral History Office, The Bancroft Library, 1961.

Pepper, Stephen, *Art and Philosophy at the University of California, 1919–1962* [Typescript of an oral interview conducted by Suzanne B. Riess], Berkeley, University of California, Regional Oral History Office, The Bancroft Library, 1963.

Perine, Robert, *Chouinard: An Art Vision Betrayed: The Story of the Chouinard Art Institute 1921–1972,* Encinitas, Ca.: Artra Publishing, Inc., 1985.

S. J. B., "Art Schools in Southern California," *Argus,* v. 3, no. 4–5, July–August 1928, p. 11.

Smith, Beverly Bush, "A Touch of Classes," [Laguna Beach School of Art] *New Worlds of Orange County,* Christmas 1977, pp. 39+.

Sooy, Louise P., "Work of the Southern Branch of the University of California at Los Angeles," *School Arts Magazine,* v. 25, March 1926, pp. 395-403.

University of California, Irvine, 1965–75, exh. cat., La Jolla Museum of Contemporary Art, November 7–December 14, 1975.

Wilson, Raymond L. "The First Art School in the West: The San Francisco Art Association's California School of Design," *The American Art Journal,* v. 14, Winter 1982, pp. 42-55.

Still Life

Baker, John, *Henry Lee McFee and Formalist Realism in American Still Life, 1923–1936,* London and Toronto: Associated University Presses, 1987, exh. cat., The Center Gallery of Bucknell University, Lewisburg, Pennsylvania and five other venues including Galleries of the Claremont Colleges, January 18–February 19, 1987.

Schaad, Bentley, *The Realm of Contemporary Still Life Painting,* New York: Reinhold, 1962.

"Still Life by the American Impressionists," and "Twentieth-Century Still Life," in William H. Gerdts and Russell Burke, *American Still life Painting,* New York: Praeger, 1971. 263 p.

Figure

Banta, Martha, *Imaging American Women; Idea and Ideals in Cultural History,* New York: Columbia University Press, 1987.

Kohn, Michael, "The Figurative Style of the Early Sixties: Brice, Lebrun, Warshaw," *LAICA Journal,* no. 34, Fall 1982, pp. 56–60.

Maxwell, Everett Carroll, "Genre and Figure Painters of the Southwest," *Fine Arts Journal,* v. 25, April 1911, pp. 242–51.

Nude

Gerdts, William H., *The Great American Nude: A History in Art,* New York: Praeger, 1974.

1940s, 1950s Realism, Conservative Modernism

(For the various competitive annual exhibitions held in California in the 1940s, see bibliography in chapter 25; for collections of 1940s and 1950s art, see bibliography in chapter 38.)

Artists of Los Angeles and Vicinity annual exhibition, Los Angeles Museum, 1951+.

Arts of Southern California II: Painting, exh. cat., Long Beach Museum of Art, January 5 - February 2, 1958.

California Painting 40 Painters, exh. cat., Municipal Art Center, Long Beach, Ca. and San Francisco Museum of Modern Art, 1956. 80 p.

Carmean, E. A., Jr. and Eliza E. Rathbone, *American Art at Mid-Century: The Subjects of the Artist,* exh. cat., National Gallery of Art, Washington, D. C., June 1, 1978–January 14, 1979.

A Decade in the Contemporary Galleries, 1949/1959, exh. cat., Pasadena Art Museum, July 19–September 15, 1959. 76 p.

Festival of Arts and Pageant of the Masters, Laguna Beach, Ca.: The Festival, 1949. 31 p.

50's Abstract, a Summary of Los Angeles Painting from 1957 through 1960, exh. cat., Conejo Valley Art Museum, September 28–November 9, 1980. 18 p.

Pacific Coast Art: United States Representation at the IIIrd Biennial of Sao Paulo, exh. cat., San Francisco Museum of Art, 1956. 24 p.

Painting and Sculpture in the San Francisco Art Association (a Catalogue of the Art Bank with Information on Traveling Exhibitions) published in conjunction with Artist Members' Exhibition at the M. H. De Young Memorial Museum, San Francisco (issued in 1958 and for 1959/60, 1962/63 and 1964/66).

Persistent Academy: a Review of Contemporary Conservative Painting in Southern California, exh. cat., Los Angeles Municipal Art Gallery, n. d., 1966. 14 p.

Seldis, Henry J., "Artists of the West Coast: A Family of Painters [Lebrun, Warshaw, Brice, Peake]," *Art in America,* v. 44, Fall 1956, pp. 37–40+.

Seldis, Henry J., "Regional Accents: Southern California," *Art in America,* v. 48, Winter 1960, pp. 56-59.

Southern California 100, exh. cat., Laguna Beach Museum of Art, September 21–October 30, 1977. 103 p.

Ward, John L. *American Realist Painting 1945–1980,* Ann Arbor, Mi.: UMI Research Press, 1989.

WORLD WAR II
& THE POSTWAR ERA

1945–1960

Fig. 23-11
George Samerjan (b. 1915)
*Japanese Evacuation
(Terminal Island),* c. 1942
watercolor on paper
19⅜ x 25 in.
The Buck Collection, Laguna
Hills, California
Photo: Bliss

Art During World War II

War! Portents appeared in American newspapers as early as the mid-1930s. Once Adolph Hitler took the helm of the Nazi party in 1933, Germany began to rise. One by one, military restrictions that had been placed on the country after World War I were repudiated or ignored, not enforced by England and France, who wished to avoid another war at any cost. Germany first established liaisons with like-minded countries, supporting General Franco's takeover of Spain and finding an ally in Fascist Italy, which was also seizing countries. Next, Germany began "acquiring" countries itself: Austria (March 1938), Czechoslovakia (1938–39), the western half of Poland (late fall 1939), and some Scandinavian countries (late spring 1940).

Californians, far from the Nazi threat, had their minds diverted with their own problems: an influx of "dust bowlers" as well as the general financial constraints of the Great Depression. To the state's art community, reports of Nazi suppression of artistic freedom, the confiscation of art galleries and of art collections belonging to Jews, and the incidental wartime destruction of monuments were distressing but far away. However, when Southern California aircraft plants geared up to make fighter planes for the Allies and when California began to receive artists fleeing the European conflict, California artists realized that they, too, were involved.

On December 7, 1941, Japan bombed Pearl Harbor, effectively crippling five of the eight U.S. Navy ships in port and almost destroying the U.S. military presence in the Pacific. Germany and Italy, joining Japan, declared war against the United States.

Art and World War II

On the surface, war and art have little in common— the one is essentially destructive while the other is creative. But, the two have many meeting points.

Generally speaking, artists' first reaction toward any war is to be repelled. As peace-loving, nonviolent, sensitive, and creative people, most look upon war as violent, ugly, and a threat to their settled environment. In the case of World War II, their second reaction was to voice their opposition to it through art. Even before Hitler began his military advances, American and California artists went on record as opposing Germany's

Fascism, a totalitarian, military-minded governing system seen as unsympathetic to creative freedom. Protesting artists joined the American Artists Congress (chapter 21), and several California artists also became members of the John Reed Club, a "Red" or Communist organization that had chapters throughout the country. San Francisco artists, with their history of unionization, were especially open to such platforms, and it was membership in the John Reed Club that led Northern California artist John Howard to paint Social Realist subjects. Los Angeles, by contrast, was a nonunion town whose most prominent art critic, Arthur Millier, discouraged subject matter that was critical of the United States or seemed Communistic. Understandably Angelenos looked upon San Franciscans as "Bolsheviks."

Artists' primary way of expressing their opposition to the Nazi spread was through paintings. Art has always conveyed messages. However, as the twentieth century progressed, art messages evolved from those expressing the opinions of a *group* (political, social, religious) to those of the *individual.* Picasso in his *Guernica* of 1937 (Museo del Prado, Madrid) and other European artists (including Francis deErdely, chapter 22) set the precedent with pictures that protested World War II. American artists followed. The language varied with individual artists. In *Crucifixion* of about 1940 (fig. 23-1), **Nick Brigante**, one of Los Angeles's modernist artists, presents a montage of easy-to-read symbolism: humanity as Christ on the cross, cruelly wrapped and constricted with barbed wire, toy wooden soldiers as the non-thinking legions of trigger pullers, partial newspaper headlines summarizing war events, and a globe shrouded in dark clouds. The work's artistic values exist in the sensual watercolor technique and the aesthetically successful "collage" organization of the various components. Other artists created Regionalist-style narrative scenes whose only reference to war might be the headlines on a newspaper somewhere in the composition. Still other artists referred to war metaphorically, as did ex-Navy boxer and artist Fletcher Martin in his *Air Raid* (Los Angeles County Museum of Art). It shows a rabbit running for his hole at the sight of a bird of prey in the sky. Eugene Berman's *Nike* (chapter 24) treats war allegorically by showing the goddess of victory with slumped shoulders.

Fig. 23-1
Nick Brigante (1895–1989)
Crucifixion, c. 1940
watercolor
dimensions unknown
Present location unknown,
formerly Immaculate Heart
College, Los Angeles

Fig. 23-2
Hans Burkhardt (1904–1994)
War, Agony in Death, 1939–40
oil on canvas, 78 x 114 in.
Collection Jack Rutberg Fine
Arts, Los Angeles
Photo courtesy Jack Rutberg
Fine Arts, Los Angeles

Most California artists expressed their frustrations and protest in only one or two images before they returned to their usual subjects. **Hans Burkhardt** (1904–1994) is unique in being the only American modern artist to create an extensive body of work in response to war. Burkhardt moved to Los Angeles in late 1937 after almost a decade of living in New York and sharing a studio with the nonobjective painter Arshile Gorky (1928–37). Between 1938 and 1947 he completed more than forty paintings and numerous drawings on the theme of war. His first major statements were his visual responses to the German bombing of the Basque town of Guernica, followed by his monumental *War, Agony in Death* of 1939–40 (fig. 23-2). These semiabstractions capture the violence of war in slashing brushwork, red and black coloration, embedded motifs (tombstones and skeletal forms in surreal battle-strewn landscapes), and angular, explosive lines of direction. In *War, Agony in Death*, Burkhardt symbolically transformed the figures into agonized half-human, half-machine forms. While the *War Series* was not derived from firsthand experience, the red horizon seen in many of these paintings was a memory Burkhardt retained from his World War I childhood in Basel, Switzerland, when he had seen the glare of bombs dropping across the mountains in Germany. The color also represents Burkhardt's symbolic reference to peace and renewal. Burkhardt was drafted into the U. S. Army in 1943 but, due to his age, was allowed an early military discharge to work in a civilian defense

plant. He worked long days producing airplane parts for the war effort and spent his nights in the studio creating antiwar paintings. Simultaneous to the *War Series,* he created paintings celebrating nature and the renewal of life, underscoring the duality that marked his artistic career through his final paintings of 1993.

Some artists responded to the horrors of war by painting worlds of their own making. San Franciscan Clay Spohn (1898–1977) went in the direction of folk art when he painted imaginary military encounters, as in his *Fantastic War Machine* of 1942 (fig. 24-5). His use of whimsy robs the machines of their power. Angeleno Peter Krasnow (1886–1979) exerted his control over the chaos by creating a perfect and orderly world of hard-edge abstractions (chapter 30).

When the United States entered the war, most artists turned defensively patriotic and looked for ways they could contribute to America's war effort. Many who were not of the age or gender to enlist worked on the home front as volunteers: designing war posters, beautifying military bases with murals, entertaining soldiers with art shows set up at bases, entertaining wounded servicemen in hospitals by drawing their portraits without charge, and teaching therapeutic art and crafts to recuperating soldiers. Other artists took jobs in aircraft plants where they devised easily readable charts and drawings that enabled workers to assemble airplanes at a rapid rate. Film industry artists turned to making military training films.

During war, innovation in art, occurs, if at all, in the form of subject matter. Style becomes more conservative, photographic, or illustrative. Themes critical of the government decline, while patriotic and nationalistic subjects increase; idealistic themes give way to practical ones. Although most artists remaining stateside during World War II gave up easel painting to put their efforts to war work, many did take an occasional moment to record some local sight.

In California war was evident everywhere. In 1943 the San Francisco *Chronicle* characterized the influx of new workers to the state's factories as California's second Gold Rush. The state's extensive coast with major ports opening onto the Pacific, and its important U.S. Navy installations—at Mare Island (in San Francisco), at Treasure Island (in Oakland), as well as at Long Beach and San Diego—made it a natural center for collecting and transferring military personnel, supplies, and ordnance to Pacific Operations. California shipyards turned to building warships. Huge military bases, such as Camp Roberts, Fort Ord, and Camp Pendleton, trained soldiers and marines. There were large airbases at Sunnyvale, Hamilton Field, El Toro, and Alameda. Southern California had long been a center

for aircraft production, and plants that had geared up to supply European allies soon began producing for America. The war stimulated the development of and gave business to many electronics and small manufacturing plants. California's huge agribusinesses worked overtime to supply food to the massive operation.

California's war-related activity offered a cornucopia of subjects to those artists who had been painting American Scene subject matter since the 1930s. But military bases and plants that manufactured sensitive materials were rarely depicted—they were protected by wartime security regulations, and anyone who rendered them could be suspected of providing information to the enemy. Before **Dong Kingman** was drafted, he had fulfilled an assignment from *Fortune* magazine to make a series of paintings of the war industry in San Francisco, and he also had depicted the war work going on at Solar Aircraft in San Diego. *Jack Thrasher Welds for America* of about 1944 (fig. 23-3) is Regionalist in that it shows a blue-collar worker at a manual occupation, but the title clearly identifies it as

Fig. 23-3
Dong Kingman (b. 1911)
Jack Thrasher Welds for America, c. 1942
watercolor
20½ x 15½ in.
Collection of Jonathan Q. Weare

Fig. 23-4
James Patrick (1911–1944)
Untitled World War II,
Railroad Station, c. 1944
watercolor on paper
15 x 23 in. (paper)
The Buck Collection, Laguna
Hills, California
Photo: Cristalen and
Associates

Fig. 23-5
Phil Paradise (1905–1997)
Evening on the Home Front,
1942
watercolor on paper
17 x 23 in.
Sally and David Martin
Collection
Photo: Bill Dewey

a World War II event, giving it overtones of patriotism. The United States government recognized Kingman's artistic abilities and assigned him to the Office of Strategic Services in Washington, D.C. Rare is a work such as **James Patrick's** *Untitled World War II, Railroad Station* of about 1942 (fig. 23-4). Between 1942 and 1944 Patrick worked with fellow California Scene painter Phil Paradise for the Office of Civil Defense and as a civilian instructor on camouflage for the Army Air Corps. It is likely that Patrick painted this image of tanks during one of his teaching stints. His overexertion on behalf of the war effort exacerbated a chronic respiratory problem and he died at the age of thirty-three. Another artist known to depict a California base is Milford Zornes (b. 1908) whose watercolor *Reveille* of 1943 (Mike and Susan Verbal/ Claremont Fine Arts) shows March Field in Riverside, where he was training as an Army engineer.

Most former American Scene artists depicted civilian activity. **Phil Paradise's** *Evening on the Home Front* of 1942 (fig. 23-5) is one of four paintings the artist made for the American Red Cross. It shows some of the ways people at home helped the war effort. In a letter to the present owners of the work the artist stated, "In early 1942 the Red Cross sent an artist's flier asking for war and disaster relief paintings they might use in a traveling show to arouse interest in their projects. I was intrigued and challenged—first I made a list— selected the most challenging subjects and painted the four [four paintings on the theme of the Red Cross] hoping that at least one would be considered worthy. The Red Cross chose all four, [and] used them in more than one show during the war years." For his imagery Paradise looked back to 1933 when he observed such scenes following the disastrous Long Beach earthquake. Paradise was one of more than ten thousand stateside artists who joined the newly organized Artists for Victory, Inc., to use their talents "in the prosecution of World War II and the protection of this country." In this regard he made posters, built models, advised on questions of camouflage, made editorial illustrations, and exhibited art works of pro-American themes.

American Scene artists also rendered scenes of servicemen while on leave in California. **Charles Payzant** (1898–1980) shows sailors having innocent fun in *The Merry-Go-Round* of 1940 (fig. 23-6). In prewar years, New York artists such as Charles Demuth (1883–1935) and Reginald Marsh (1898–1954) had depicted sailors on leave but portrayed them critically as inebriated, irresponsible, and troublesome. World War II patriotism led California's artists to present American servicemen as healthy, honest, lonely young

men, away from home for the first time, nervous about actual conflict, and using their leaves to sightsee and to meet women. Like American Scene works in general, wartime scenes usually represented actual situations and extended to such unpredictable themes as a blimp patrolling the coast for enemy ships or sailors sleeping on couches in the Hollywood USO.

American Scene artists were also hired to depict events at the various theaters of war. Commissions came from two sources: from photojournalistic magazines, such as *Life,* and from the military. *Life* used watercolors to illustrate articles and hired a number of California artists, including Fletcher Martin, Paul Sample, Edna Reindel (1894–1990), Barse Miller, Tom Craig (1909–1969), and Millard Sheets. These artists, adhering to their American Scene training, depicted the daily, humdrum, human side of war: soldiers at the front in recreation or at rest, eating, on duty at idle guns, swabbing the decks of ships, responding to reveille, moving munitions, and other such activities. An example is **Paul Sample**'s *Canton Island* of 1943 (fig. 23-7). For several of these artists, the jump from an easy lifestyle

to the starvation and blood-soaked battlefields was unnerving, disillusioning, and frightening. Yet, California artists, once faced with deep subject matter, were able to rise to the occasion. **Millard Sheets**'s *Dead Tank Captain, Burma* of 1944 (fig. 23-8) represents an actual incident. Sheets was with British forces when they stormed Bamboo Hill; the captain leading the attack was standing on the turret of a tank when his head was blown off by "friendly fire" from air support.

Artists were also hired by the military to paint scenes of the war. Some might question why the military would hire artists when the camera could supply faster and more accurate images. The U.S. military was following the example set by the British during World War I and by the British, Russians, and Chinese in the

early days of World War II. Painters, they believed, could manipulate their images to achieve drama and to stir emotions. Why hire so many American Scene artists? The military did not want "propagandistic" art per se but rather what the country was used to—scenes of the average citizen going about his daily duties. Pictures of the individual serviceman's patient and steady plodding inspired as much patriotism back home as images of warriors in the heat of battle. Why hire watercolorists from California? California watercolorists were at the height of their reputations. Watercolor materials were easy to carry into the field, and watercolorists could execute a finished painting in one sitting.

World War II pictures differed from traditional "battle" art, which was usually commissioned after the fact by conquerors who wanted to commemorate their triumphs. Artists viewing war in retrospect had the time to distill the *idea* of war as a romantic conflict replete with ideals and heroism. But, as early as America's Civil War, artists began to picture "real" war. Many resided at the front, witnessed clashes firsthand, and thus became reporters of *actual* events. Their images exposed the humanism in camp as well as the barbarism, atrocities, needless bloodshed, and stupidities of battle. People back home, visually confronted with

the realities of war, began to see conflict not as glorious but as senseless and destructive. Such images started the shift toward the antiwar attitudes of today. World War II artists inherited these ideas. Historically, World War II provided California's artists their first opportunity to produce war art.

The most "glamorous" position held by artists employed by the military was the job of "war artist." Such artists were sent to a theater of war and given great independence and freedom, their only "orders" being to paint the scene around them. Los Angeles's Milford Zornes joined the Army Air Corps Engineers in 1941 where he worked with a camouflage outfit until he was selected for the Army Art Program and sent to China, Burma, and India. The Santa Barbara millionaire **Standish Backus, Jr.** (1910–1989), who had joined the U. S. Naval Reserve as ensign in 1940, advanced to commander and official naval combat artist, and in 1945 was transferred to the Pacific. There he witnessed and painted the formal surrender of Japan as well as the destruction wrought by the atomic bombs dropped on Hiroshima and Nagasaki. His *At the Red Cross Hospital, Hiroshima, series no. 33* of 1945 (fig. 23-9) was painted at a Red Cross hospital in Hiroshima shortly after the bombing. War experiences led to his adopting action and narrative into his postwar watercolors.

Art produced by war artists served many purposes. Artists circulating among soldiers engaged in battle relieved their tension; art exhibitions at military bases amused soldiers with their human interest scenes; war art exhibitions circulating to civilians gave them a look at the lives led by loved ones in the service; paintings showing atrocities against Americans roused patriotic fervor.

Art was also employed as a propaganda tool. Idealists ask, "Isn't imbuing art with political stances destroying art's right to exist as a purely beautiful thing whose sole purpose should be to give aesthetic pleasure?" Ironically, the world has had 30,000 years of art, and it has only been since the mid-nineteenth century that some artists have created it just to give aesthetic pleasure. Generally "art" has been linked to a practical purpose. Walls were decorated with paintings to break up their plainness. Murals contained implicit or explicit messages, told religious stories, commemorated military triumphs, or propagandized governments for people who couldn't read. Illustrations visualized stories. Portraits recorded the likenesses of wealthy or notable citizens and established them as persons worthy of admiration.

California's **Arthur Beaumont** (1890–1978) was the quintessential artist to portray U.S. Navy ships as mighty protectors of the oceans. Beaumont's rela-

Fig. 23-9
Standish Backus, Jr. (1910-1989)
At the Red Cross Hospital, Hiroshima, 1945; *series no. 33*
watercolor
30¼ x 22¼ in. (format)
Navy Art Collection; U. S. Naval Historical Center Photograph, Washington, D.C.

tionship with the Navy was unusual. In the very early 1930s, his portrait commissions of top Navy officers led to friendships and requests to paint "portraits" of ships in the nearby harbors of San Pedro and Long Beach. Beaumont proved particularly adept at showing a warship as a "muscled" defender of America, bearing down on the viewer, its prow looming overhead, and sea foam spewing dramatically behind. He was invited to join the U.S. Naval Reserve in 1933, where he remained for one and a half years. But most of his subsequent ship and war pictures were a result of one-time commissions, for a Los Angeles newspaper as an artist-correspondent, or for the Navy, thanks to the continued beneficence of friends in top positions, who gave him passage on warships. Following World War II, Beaumont was named official artist for "Operation Crossroads," the two atomic bomb drops conducted by the United States on Bikini atoll in the South Pacific. To obtain precise data on the ramifications of nuclear explosions, decommissioned Naval ships were anchored throughout Bikini's twenty-five-mile-long lagoon and loaded with instrumentation. In the first test (Abel), a bomb was exploded above ground. However, the mushroom cloud familiar to most Americans from film footage represents the second test (Baker), in which the bomb was detonated under water. *Baker Bomb Test, Bikini Atoll* of 1946 (fig. 23-10) shows how Beaumont romanticizes scenes with rich color and atmospheric effects. Beaumont ignored orders and did not protect his eyes during the blast in order to portray the colors accurately. In his own words, he saw the mushroom cloud expanding "upward, changing color from yellow to salmon pink…from mauve to molten iron." His transcriptions also recorded an ice cap at the top of the cloud that was only later confirmed by aerial instruments.

Apart from war paintings, less spectacular but equally important contributions were made by artists in other ways. The Berkeley modernist John Haley joined the U. S. Navy and produced terrain models for invasion before becoming part of a photo reconnaissance interpretation unit. The Hollywood film artist Lee Blair joined the U. S. Navy in 1942 and, like many watercolorists formerly associated with the motion picture studios, made training films.

After the war, the military occasionally hired California artists. Beaumont continued to paint portraits of U.S. Naval ships and to depict the Navy's land installations. In 1939 and 1940 Leland Curtis served as official artist to the U.S. Antarctica Expedition and in 1957 to the U.S. Navy Operation Deepfreeze III in Antarctica. Many of the war artists' images are preserved in military archives in Washington, D.C.

Japanese Californian Artists and the War
One of the poignant images of World War II shows persons of Japanese heritage standing in lines clutching a few bundled possessions while awaiting transportation to a relocation camp. **George Samerjan's** (b. 1915) American Scene watercolor *Japanese Evacuation (Terminal Island)* of 1941 (fig. 23-11, p. 296) is a variant of this theme. Internment camps, now regarded as one of the barbarisms of the war, were a sad but inevitable result of human nature and of wartime paranoia.

Ever since large numbers of Chinese arrived in America to try their luck in the gold fields and then to help build the railroads, public opinion had seesawed between how Americans could take advantage of the inexpensive Asian labor and how they could protect themselves from the growing "yellow peril." After Californians passed the Chinese Exclusion Act of 1882, Japanese filled the labor void. Then, in 1907, Japanese immigration was limited by a Gentlemen's Agreement between the United States and Japan. Other exclusionary devices followed. When Japanese Americans' hard work and industry resulted in their improvement and ownership of huge tracts of farmland, envious and fearful residents of non-Asian ancestry pushed through the 1913 California Alien Land Act, which barred certain aliens from owning property. Still, in the 1920s and 1930s, Japanese immigrants tilled vast acreages, much legally held by their American-born children or by corporations.

Fig. 23-10
Arthur Beaumont
(1890–1978)
Baker Bomb Test, Bikini Atoll,
1946
watercolor, 13 x 17 in.
Dr. and Mrs. Robert
Dreibelbis

The first artists of Asian background to make significant impact on California's art world were the Japanese, specifically the Pictorialist photographers of Los Angeles (chapter 9). Prior to the 1920s, people of Asian descent living on California soil did not mix much with the non-Asian community, nor did the Chinese associate with the Japanese, reflecting long-standing resentments between the two mother countries. Rare instances to the contrary occurred when San Francisco's Theodore Wores taught art to some of the city's Chinese as early as 1884, and when Toshio (Turshui) Aoki (1854-after mid 1920s) made news in San Francisco and Pasadena in the 1890s for teaching and for drawing portraits of non-Asians wearing Oriental costume. Between 1910 and 1920, Los Angeles's Japanese formed their own art clubs, increasing the visibility of Asian artists in the community.

In the Bay Area, in spite of the large Chinese population, artists of Japanese heritage, along with non-Asians, in 1921 founded the East West Art Society devoted to discovering the shared values in the art of the two cultures. The Chinese entered the picture in 1926 when the modernist painter **Yun Gee** (1906–1963), who had studied with Paris-trained Otis Oldfield, formed the Chinese Revolutionary Artists' Club to teach modernist Western painting to Chinatown's emerging artists. Gee was one of the most stylistically advanced of the Bay Area's modernists of the 1920s, since he worked in a Cubist/Synchromist-inspired style, an example of which is *Artist Studio, August 31, 1926* (fig. 23-12). He called his particular blend of modernism and Chinese tradition "Diamondism." In this work Yun Gee paints Miki Hayakawa, who in turn

is painting a black model. The work demonstrates the racially mixed student bodies that peacefully intermingled in California's art schools—in contrast to the segregation in many of the state's public schools.

Artists of Japanese and Chinese backgrounds moved fully into California's art mainstream in the 1930s. Not only did the artists themselves begin to interact outside their communities, but there was a nationwide appreciation for the common man and for the richness of America's multiethnic makeup. In San Francisco in 1935, the Chinese Art Association, most of whose members (whether of Asian or European descent) worked in the Western tradition, held their first exhibition at the M. H. de Young Memorial Museum. In Los Angeles, artists of Asian background submitted works to mainstream venues and were sometimes given one-person exhibitions, such as the shows of Asian artists at the Foundation of Western Art in 1934, 1935, and 1937 and at the Los Angeles Museum in 1936. Chinese artists, such as Los Angeles's Tyrus Wong (b. 1910) and Keye Luke (b. 1911), worked in the motion picture industry. They socialized in 1935 at the Dragon's Den restaurant in the basement of the F. Suie One Company in Chinatown. The Dragon's Den was started by artists Tyrus Wong and Benji Okubo (1904–1975) as a place to show art, supported through the sale of food.

With California's large population of Asian residents, it was a given that Eastern and Western aesthetics would merge on California soil. In the 1920s, those Japanese choosing to work in Western styles surprisingly proved more avant-garde than their non-Asian confreres. Many chose Cubism over Impressionism and city street scenes over rural landscapes. In San Francisco **Miki Hayakawa**'s (1904–1953) cubistically rendered *Sleeping Man* of 1926–28 (fig. 23-13) shows her to be one of that city's few modernists. In reverse, several artists of European background adopted Eastern aesthetics. The most important was the Synchromist Stanton MacDonald Wright, who used both Chinese and Japanese iconography and aesthetics in his art, socialized with Los Angeles's Asian artists, and passed his acquired tastes to his many non-Asian students. (See James Redmond's mural, fig. 20-14)

No single statewide "style" resulted from this mix of the Asian and the American, but the Eastern aesthetic reveals itself in individual paintings, if one knows what to look for. Stylistically Asian art is identified with a wiry outline or calligraphic brushwork. Although the San Francisco-trained **George Matsusaburo Hibi** (1886–1947) uses a Greek theme in *Three Muses* of about 1928 (fig. 23-14), one can see his Japanese heritage in his sinuous black outline, his

Fig. 23-12
Yun Gee (1906–1963)
Artist Studio, August 31, 1926
oil on paperboard, 12 x 9 in.
The Michael D. Brown Collection

general disinterest in Western rules of perspective, and in emphasis on surface design. In *Sewing* of 1932 (fig. 23-15), **Chee Chin S. Cheung Lee** (1896–1966) of San Francisco works in a style and subject we define as Regionalist. However, he exposes his Chinese background through the ethnicity of his subject and the newspaper printed with calligraphy. San Francisco's **Wing Kwong-Tse** (1902–1993) broaches Precisionism in his exquisitely rendered *Chinese Family* of about 1935 (fig. 23-16), but Chinese attitudes are revealed in the work's reverence for the aged, its adoration of children, and its background depiction of a traditional dragon—the mythical "vehicle" by which the Seven Immortals rode to heaven. Following World War II, Westerners became particularly intrigued with the Japanese philosophy of Zen Buddhism and its artistic associations: monochrome coloration, meditative subjects, and a general preference for the organic and natural.

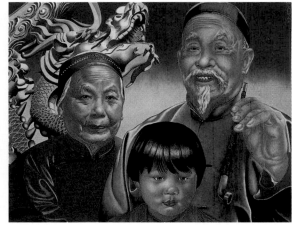

Fig. 23-13
Miki Hayakawa (1904–1953)
Sleeping Man, 1926–28
oil on canvasboard
15¾ x 19¾ in.
The Michael D. Brown
Collection

Fig. 23-14
Matsusaburo Hibi
(1886–1947)
Three Muses, c. 1928
oil on canvas, 56 x 46 in.
The Michael D. Brown
Collection

Fig. 23-15
Chee Chin S. Cheung Lee
(1896–1966)
Sewing, 1932
oil on canvas, 48 x 38 in.
Susie Tompkins Buell
Collection

Fig. 23-16
Wing Kwong-Tse
(1902–1993)
Chinese Family, c. 1935
watercolor, 20½ x 26½ in.
The Michael D. Brown
Collection

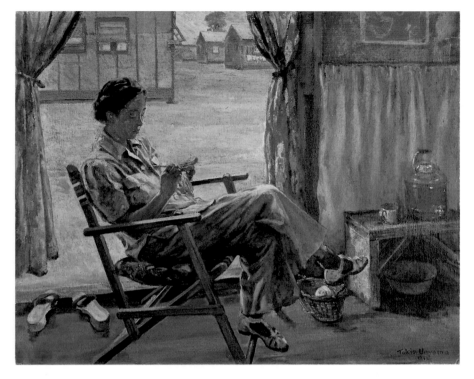

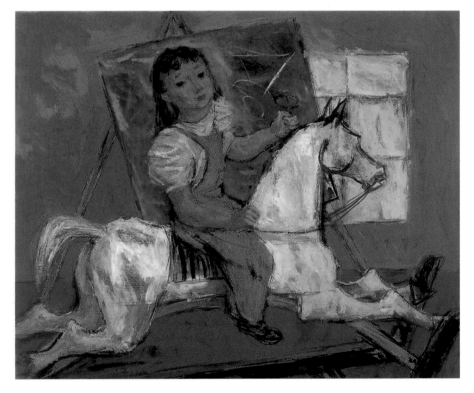

Fig. 23-17
Tokio Ueyama (1889–1954)
The Evacuee, 1942
oil on canvas, 24 x 30¼ in.
Japanese American National
Museum, Gift of Kayoko
Tsukada (92.20.3)
Photo: Norman H. Sugimoto

Fig. 23-18
Sueo Serisawa (b. 1910)
The Hobby Horse, 1947
oil on canvas, 27 x 37 in.
Collection of Orange County
Museum of Art,
OCMA/LAM Art
Collection Trust; Gift of the
Virginia Steele Scott
Foundation

After the Japanese bombing of Pearl Harbor on December 7, 1941, California's non-Asians grew fearful that the state's Japanese residents might act as spies for their homeland or, in the event of an invasion, aid Japanese forces. Some Californians coveted the fertile acreage controlled by the Japanese. By stages, California's Asians of Japanese heritage were registered and encouraged to relocate to a non-West Coast state or enlist in the armed forces, until those remaining were forcibly assigned to relocation camps away from the coast and metropolitan centers. While many of the camps were located outside California—in Arizona, Utah, Idaho, Wyoming, Colorado, and Arkansas—the art produced by former California residents during internment can still be considered "Californian."

The internment camps fostered a large quantity of art. Artists, while still in staging centers, relieved their boredom by recording their surroundings in pencil and watercolor and by organizing art classes. Once at the camps and no longer concerned with generating food and shelter for themselves, many inmates turned former leisure activities into occupations. Creation in traditional media flourished—miniature gardens, flower arranging, and origami—as did painting in the Western tradition.

Professional artists ending up in these camps had usually been trained in the American Scene aesthetic. It became natural for these artists to turn their eyes on camp life and record the activity. Sometimes they would paint their poor tarpaper shacks ironically overfurled with a glorious sunset. But most frequently they captured the drama of everyday human life: people passing time in domestic occupations, such as the woman crocheting in **Tokio Ueyama**'s (1889–1954) *The Evacuee* of 1942 (fig. 23-17). Ueyama had been trained in various schools in California, at the Pennsylvania Academy of the Fine Arts, and in Europe. After settling in Los Angeles about 1920, he had been instrumental in organizing a group of Japanese artists devoted to modern art. Relocated to Amache, Colorado, he taught art classes and captured scenes of the camp in a realistic Regionalist style. The woman crocheting is his wife. Other artists portrayed children playing baseball or flying kites, adults in art classes or tending gardens, women doing laundry, people eating at the mess hall, high schoolers at commencement, and people at dances.

In spite of the Japanese artists' forced incarceration, theirs was never an art of protest. As the war progressed, most inmates eventually made contacts or earned employment that allowed them to leave the complexes. By war's end only a few stragglers remained who, unable to readjust, had to go onto welfare roles.

After the war, many of the interned Japanese returned to California. A few were able to regain property seized by greedy or opportunistic Anglos, but most had to start from scratch. **Sueo Serisawa** (b. 1910) returned to Los Angeles from the East Coast, where he had been pursuing his career during the war. His *The Hobby Horse* of 1947 (fig. 23-18) is typical of most work by Asian Americans after the war in that it reflects no bitterness or resentment and instead concentrates on art issues. In the immediate postwar scene, few Asian American artists stand out, other than the Chinese Dong Kingman, who enjoyed a huge popular following for his shorthand, calligraphic watercolors of New York and San Francisco (chapter 19). Serisawa soon dropped his interest in representation, becoming one of the few Southern California painters of pure nonobjective abstraction. The momentum and spirit of the pre-1940 Japanese-Californian art movement had been broken. Ironically, the postwar years saw America absorbing a second wave of aesthetic from Japan, which put its mark on the rising studio crafts movement (chapter 25).

Yes, war did affect the look of California art. But this chapter has only addressed American artists' reactions to the conflict. What about the refugee artists driven out of Europe by the war? What did they paint once they reached the land of freedom, and how did American artists react to the foreign infusion? Those questions will be answered in the next chapter, which will discuss California's postwar art scene. ✺

Bibliography

Art and WWII

"Aircraft Illustrations," in Nancy D. W. Moure, *Drawings and Illustrations by Southern California Artists before 1950*, exh. cat., Laguna Beach Museum of Art, August 6–September 16, 1982, p. 23.

Landauer, Susan, "Painting under the Shadow: California Modernism and the Second World War," in Paul J. Karlstrom, ed., *On the Edge of America: California Modernist Art, 1900–1950*, Berkeley: University of California Press, 1996, pp. 41–68.

Marquardt, Virginia Hagelstein, "New Masses and John Reed Club Artists 1926–1936," [not California] *Journal of Decorative and Propaganda Arts*, no. 12, Spring 1989, pp. 56–75.

McCormick, Ken and Hamilton Darby Perry, *Images of War: The Artist's Vision of World War II*, New York: Orion Books, 1990.

Millier, Arthur, "How Some Artists Work for Victory," *Pacific Art Review*, v. 2, nos. 1 & 2, Summer 1942, pp. 1–4.

Neuhaus, Robert, "Corrado Cagli's Camp San Luis Obispo Murals," *Pacific Art Review*, v. 1, nos. 3 & 4, Winter 1941–42, pp. 31–34.

"Out of the Depression into War, 1938–1945," in Nancy D. W. Moure, *Painting and Sculpture in Los Angeles 1900–1945*, exh. cat., Los Angeles County Museum of Art, September 25–November 23, 1980, pp. 74–78 and footnote 9.

Asian-Californian Artists to 1950

(See also bibliography for Camera Pictorialism in chapter 12.)

Brown, Michael D., *Views from Asian California 1920–1965*, San Francisco: Michael Brown, 1992.

"Dragon's Den 1934–35," in Lisa See, *On Gold Mountain*, New York: St. Martin's Press, 1995.

"Out of the Depression," footnotes 16–20 in Nancy D. W. Moure, *Painting and Sculpture in Los Angeles 1900–1945*, exh. cat., Los Angeles County Museum of Art, September 25–November 23, 1980.

Tsutakawa, Mayumi, ed., *They Painted from their Hearts: Pioneer Asian American Artists*, exh. cat., Wing Luke Asian Museum, Seattle, Wa., September 9, 1994–January 15, 1995.

Various artists and art clubs listed in Nancy D. W. Moure, *Publications in Southern California Art 2* and "Japanese Artists" in *Publications in Southern California Art 3*, Los Angeles: Dustin , 1984.

With New Eyes: Toward an Asian American Art History in the West, exh. cat., San Francisco State University Art Department Gallery, September 24–October 26, 1995.

Wright, Stanton MacDonald, "Chinese Artists in California," *California Arts & Architecture*, v. 56, October 1939, pp. 20–21.

Japanese-American Artists through WWII

Gesensway, Deborah and Mindy Roseman, *Beyond Words: Images from America's Concentration Camps*, Ithaca, N. Y.: Cornell University Press, 1987.

Higa, Karin M. *The View from Within: Japanese American Art from the Internment Camps, 1942–1945*, exh. cat., Japanese American National Museum/UCLA Wight Art Gallery and the UCLA Asian American Studies Center, October 13–December 6, 1992.

"Russell Lee: Japanese Relocation," [photography] in Carl Fleischhauer, ed., *Documenting America, 1935-1943*, Berkeley: University of California Press, 1988.

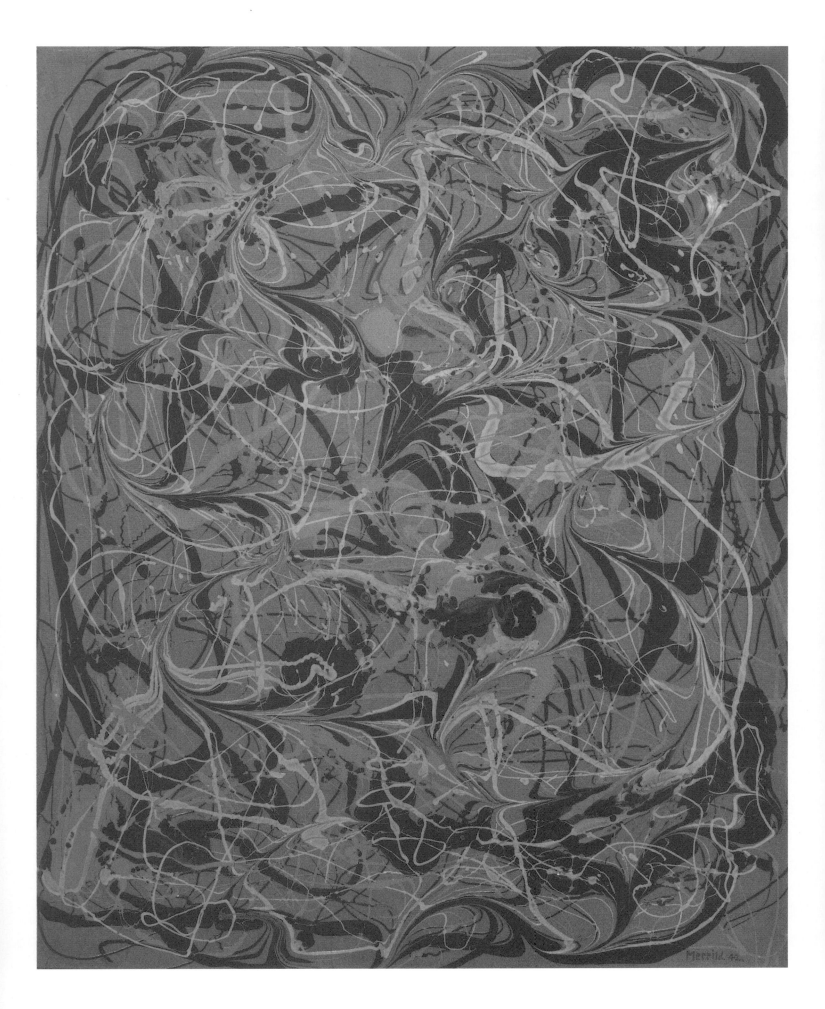

308

Surrealism of the 1940s

Who is the quintessential Surrealist? Most Americans would name **Salvador Dali** (1904–1989). But the Spanish-born artist, who is best known for his realistic painting *Persistence of Memory* (Museum of Modern Art, New York), which features melting pocket watches, was not an originator of the movement. He learned about it from its Parisian members. He just happened to make it popularly known in America through his flamboyant personality. He has particular relevance to California, however, because his interest in the medium of film (he jointly created the classic *Le Chien Andalou* in Paris, 1928) attracted him to Hollywood in 1937 in the hope of creating other work. He became one of several European refugees who chose to wait out World War II in California.

In the 1930s the Surrealist art shown in America was made primarily by Europeans. (Los Angeles's Post-Surrealism (chapter 21) was an early exception.) However, by the 1940s, Americans across the nation were working in what had become a "style." The largest contingent was centered in the New York-Connecticut-New Jersey area, where most of Europe's Surrealist exiles settled and where New York's Julien Levy Gallery promoted the style. Apart from a few Surrealists resident in the northern Midwestern States and the Northwest, the next largest concentration outside the East Coast was in California. California seemed to attract those modernists and Surrealists who couldn't bring themselves to click with the small group who took refuge in New York.

Since this book devotes an entire chapter to California Surrealism from 1940 to 1951, one might assume that the style was a major movement in the state. This is not the case. But, while the quantity of resident exiles was not large, the state was notable for the wide variety of Surrealistic responses and for the important effect that Surrealism had on later artists.

How do we make clear the confusion of surrealistic variations? The original European Surrealists evolved two basic ways to express their inner psychological thoughts (chapter 21). Simplistically speaking, they either worked illusionistically (by portraying realistic objects in unusual juxtapositions) or nonobjectively (by using some automatic technique). As the 1930s progressed and new acolytes took up the style, many varieties of Surrealism developed.

Southern California Surrealism

It is no surprise that Surrealism would take different forms in the northern and southern regions of the state. Most Southern California Surrealists followed the naturalistic/illusionistic branch. In the early 1930s this form manifest as Post-Surrealism (chapter 21). In the late 1930s it was represented by the works of Salvador Dali. Although Dali resided at times in Pebble Beach (adjacent to Carmel in Northern California), he was frequently in Hollywood, tied by his personality and tastes to the movie city's bizarre and trendy fashions, its tendency toward fantasy and imaginative works, and its interest in photography and film as media. Associating with other high-profile celebrities, he painted several portraits, such as *Mae West* of about 1934 (fig. 24-1). Such psychological profiles were fascinating to an American public intrigued with Dali's quirky personality, his novel and bizarre imagery, and the puzzle-like psychical meanings of his compositions.

Opposite:
Fig. 24-4
Knud Merrild (1894–1954)
Perpetual Possibility, 1942
enamel on composition
board, mounted on plywood
20 x 16⅛ in.
The Museum of Modern
Art, New York. Gift of Mrs.
Knud Merrild; Photo © 1998
The Museum of Modern
Art, New York

Left:
Fig. 24-1
Salvador Dali (1904–1989)
Mae West, c. 1934
gouache over photographic
print, 11⅛ x 7 in.
Art Institute of Chicago, Gift
of Mrs. Gilbert W. Chapman
in memory of Charles B.
Goodspeed, 1949.517;
Photo © 1996, The Art
Institute of Chicago. All
Rights Reserved; © 1998
Demart Pro Arte (R)
Geneva/ Artists Rights
Society (ARS) New York

In the 1940s Los Angeles's illusionistic Surrealism took the form called Romantic Surrealism. In a way, all Surrealism is "romantic" in that it is emotional rather than rational. But Romantic Surrealism specifically featured objects that the literary world considered "romantic," objects that were irregular, imperfect, and ruined, such as tattered clothing, pock-marked buildings, rock-strewn beaches, weather-worn driftwood, as well as tumbled columns, broken pediments, and statues from the Greek and Roman civilizations. Romantic Surrealism was developed in Paris in the mid-1920s concurrent with Surrealism by **Eugene Berman** (1899–1972), a refugee from the Russian revolution. He blended elements of Surrealism with ideas from the Romantic Movement. In 1936 Berman moved to New York, and in 1938 he traveled to Santa Barbara to execute a mural. Three years later he moved permanently to Hollywood, where he became friends with other creative exiles including the composer Igor Stravinsky, for whose productions he designed sets and costumes. His *Nike* of 1943 (fig. 24-2) looks Surrealist in that the figure stands in a vast, sere, metaphysical environment, with strong cast shadows. However the painting is also romantic in that it projects an overall tone of melancholy rather than psychosis. Painted at the height of World War II, Nike, the Greek god-

dess of victory, could hardly be described as triumphant. Her sagging posture, as she gazes at a ravaged landscape, a destroyed world, symbolizes the 1940s disappointment and disillusionment with war. Even the painting technique is "romantically" rough (as opposed to Dali's mirror-like finish). In Southern California Berman discovered the desert and its weather-worn buttes, a landscape of space and desolation similar to that the Surrealists had been creating from their imaginations.

Hollywood's other famous Surrealist exile of the 1940s was **Man Ray** (born Emmanuel Radnitsky, 1890-1976). Nationally, Man Ray is known for co-initiating American Dada in the teens and being America's most famous practitioner of the style. He is specifically known for his Rayographs, "photographs" produced by laying objects atop photographically sensitive paper and exposing the whole to light (chapter 25). Ray was born in Philadelphia but spent the 1920s and 1930s in Paris among his artistic and intellectual peers, the Dadaists and Surrealists. In 1940, just in advance of the Nazis, Ray escaped to New York and then came on to Hollywood, which to him had the sunshine and relaxed lifestyle he associated with the French Riviera.

Each Surrealist produced his own variant. Feitelson, the consummate classicist, created the highly controlled Post-Surrealism. The moody Berman tinged his Surrealism with romance. Man Ray, a Dadaist at heart, delighted in wordplay, pictorial double takes, and deadpan humor. In California, freed from the labor of commercial photography, with which he had been earning his living, Man Ray returned to painting. Some of his canvases were recreations of works he had been forced to abandon in Paris as the Nazis advanced. Some new canvases contained references to the game of chess—he was also fabricating chess pieces to supplement his income. In the second half of the 1940s, he developed two themes that took imagery from photographs he had taken, in effect a cannibalization of his own material for subject matter, a trend that would become popular with artists later in the century. One of the themes pertained to watercolors he had made of cacti in Pasadena in 1945. The cactus is a ubiquitous plant in Southern California, growing naturally in the desert or cultivated in pots or special gardens in the cities. Typical of Ray's turn of mind, the cactus stimulated unusual connections. In *Desert Plant* of 1946 (fig. 24-3), he turns a cactus's smoothly shaped leaf into a biomorphic abstraction. In *Diamond Cactus* of 1948 (location unknown), a cactus is rendered cubistically and becomes a faceted, circular-cut gemstone. In spite of the great respect shown him and exhibitions of his work in Southern California, Ray ultimately became

Fig. 24-2
Eugene Berman (1899–1972)
Nike, 1943
oil on canvas, 58⅜ x 38⅜ in.
Hirshhorn Museum and Sculpture Garden, Smithsonian Institution, Gift of Joseph H. Hirshhorn, 1972
Photo: Lee Stalsworth

disenchanted with the provincialism and smog of Los Angeles and in 1951 returned to Paris.

One exception to the practice of Illlusionistic/Naturalistic Surrealism among Los Angeles artists is Knud Merrild, who practiced Automatist Surrealism or Automatism. Automatism was achieved through techniques that allowed an artist to transmit his subconscious emotions directly to paper or canvas, bypassing control of the logical part of the brain. The form had been preferred by the French Surrealists at the inception of the movement in the mid-1920s, but it was superseded in the early 1930s by the popularity of illusionistic Surrealism. It only regained importance in the late 1930s when the young Chilean artist Sebastian Antonio Matta Echaurren (b. 1912), known as Matta, joined the French group and rejuvenated it. As the core French Surrealist group turned to this method, the rest of the world followed.

Using the techniques that the various Surrealists devised to achieve an Automatist painting can be a lot of fun. An artist can close his eyes and draw. He can doodle, letting his pencil go where it might. If he is right-handed, he can draw or paint with his left hand. If he is a photographer he can, as did Man Ray, lay objects down on a piece of photographic paper and expose it in various ways, looking for the happy accident. He can cut pictures out of magazines and paste them together in unusual juxtapositions (collage). Instead of brushing paint on a surface, he can spray it or throw it or pour it. Once paint is on a surface, he can manipulate it with his fingers or rags or scrape it off. Many artists used several different techniques in one painting. Acceptance of Automatism rang the death knell for academic training, and legitimized chance. It was almost "American" in its "something for nothing" philosophy.

Since Automatism is always cited as the progenitor of Abstract Expressionism (chapter 26), art historians look closely at those artists who advocated it hoping to find the one who was the first Abstract Expressionist. Identifying seminal figures and giving credit to the right person are important issues for art history. For example, was the inventor of Cubism really Picasso, who gets all the credit, or his Montmartre peer Georges Braque (1882–1963)? Was the inventor of Post-Surrealism Lorser Feitelson or his wife Helen Lundeberg? Did **Knud Merrild**'s invention of the "Flux" technique, as seen in *Perpetual Possibility* of 1942 (fig. 24-4, p. 308), make him the real inventor of the drip technique for which Jackson Pollock (1912–1956) gets all the credit?

Flux not only makes Merrild one of the earliest California practitioners of Automatism but almost the only one of such a pure form. Merrild was a Danish-born modernist who settled in Los Angeles in the early 1920s (chapter 18). Throughout the 1920s he worked in a Cubist vein, but in the 1930s he gravitated to Surrealism. To achieve Flux, Merrild laid a surface (usually cardboard or Masonite) on the floor and poured paint on it using various amounts of force. He claimed that he had been aware of the possibility of such a technique since 1909, which would mean he had the idea even before the Dada artists of the teens, to whom its invention is usually attributed. However, he was not actually able to overcome its technical problems until 1942. Because this work evinces many qualities that art historians now identify with Abstract Expressionism—the drip technique, the allover design, emotion, and the act of creation on the canvas itself—California art historians could argue that Knud Merrild was America's earliest Abstract Expressionist. However, the most objective historian must acknowledge that several early-1940s American artists were experimenting with the newly introduced drip technique, that none of these artists lived in a vacuum, and through one means or another each had heard about or had seen drip paintings. Merrild, for example, whose activities are vague between 1938 and 1942, is known to have traveled in Europe in 1939. It is logical that his interest in Surrealism would have led him to contact other Surrealists. Merrild's paintings appeared in New York exhibitions where Pollock could very well have seen them. But we also know that Pollock had many other exposures to the drip technique before he produced

Fig. 24-3
Man Ray (1890–1976)
Desert Plant, 1946
oil on canvas, 24½ x 20 in.
Robert Berman Gallery:
© Man Ray Trust/Artists Rights Society, N. Y./ ADAGP, Paris

Top:
Fig. 24-5
Clay Spohn (1898–1977)
Fantastic War Machine, 1942
watercolor, gouache
15 x 20 in.
Collection of the Oakland
Museum of California, Gift
of the Estate of Peggy
Nelson Dixon

Bottom:
Fig. 24-6
Ynez Johnston (b. 1920)
Lion in the Forest, 1953
casein on board
27 x 37½ in.
Private Collection, Courtesy
of Tobey C. Moss Gallery
Photo: Tobey C. Moss
Gallery

his first exclusively dripped painting in 1947. There is no one sure answer. Merrild remains important in this field, however, because Flux was not a passing fancy, but his main technique and style throughout the 1940s.

Surrealism's method of obtaining its subject matter from the subconscious mind legitimized fantasy as a subject for painting, overturning centuries of opinion that high art was too important to chronicle dream visions. (The works of the Dutch painter Hieronymus Bosch (c. 1450–c. 1516) are an exception.) The 1940s interest in fantasy was reinforced by the growing appreciation of folk and naive painting. One of California's seminal fantasy painters was the irrepressible, prankish San Franciscan **Clay Spohn** (1898–1977). Individuals reach their creative peaks at different times in their lives—most avant-garde artists while youthful and daring. Even though Spohn spent a year in Paris (1926-27) and is the person who suggested to Alexander Calder that he make his sculptures of wire, he plodded through the Great Depression generally conforming to the Federal Arts Projects' conservative guidelines. Toward the end, however, his own maturity and the increasing acceptance of Surrealism and naive painting seem to have freed up his natural wit. In 1941 and 1942, disturbed by nightmares about World War II, he began to exorcise his fears through drawings and gouaches. These works, which he called Fantastic War Machines and Guerrographs (war drawings), were shown in 1942 at the San Francisco Museum of Art. In *Fantastic War Machine* of 1942 (fig. 24-5), Spohn mixed imaginary machines, such as the balloon-levitated ship, with up-to-date motor-powered boats. His naive style neutralized explosions and frightening objects such as pointy grappling hooks. In other works he addressed the dislike that many people had of machines—their noise, their metallic coldness, their potential for robbing man of work, and ultimately their power to control man—by shaping them like men and pitting one against the other in combat. Spohn's fantastic sculptures compiled from junk, which were displayed at the California School of Fine Arts in 1949, are universally acknowledged by art historians as pivotal stepping stones between European Dada of the teens and California's important Assemblage movement of the 1950s (chapter 25).

In the late 1940s, other California artists also began to produce worlds from their imaginations, gaining their courage from the acceptance of Surrealism, Spohn's fantasy paintings, and folk art. Many derived ideas also from the art of tribal peoples (Native Americans as well as those from third world countries). Los Angeles's **Ynez Johnston** (b. 1920) was romantic-minded from childhood. She vividly remembers growing up in

Berkeley, admiring the San Francisco Bay fogs that cast mysterious veils over the familiar scene, traveling to peninsula museums with her father (where she saw fascinating art such as Persian miniatures), and amusing herself with drawing. Her art heroes were Picasso and the Surrealists Miro and Klee. In the late 1940s, she began to evolve her personal style. Johnston chooses subjects that inspire her with their magically obsessive character. *Lion in the Forest* of 1953 (fig. 24-6) comes out of feelings she experienced in 1952 while on fellowship in Rome; each evening she used to walk by a park, really a small forest, in which a lion sculpture stood. That inspired the "forest" and the "little buildings" in this work. As a late-1940s artist, Johnston solved the formal aesthetic conflict between illusionism and abstract pictorial qualities (chapter 22) by inscribing her imagery on the surface of the picture and by giving equal attention to all parts of the "canvas." Johnston's classic works are more graphic than painterly. As a child she drew; she studied etching at the University of California, Berkeley; and in early 1950s Los Angeles, she made prints with a group of artist friends who used the press of their peer Leonard Edmondson. The artist admits her works have a narrative quality and that they can be described in formal terms, but to her their most important aspect is the overall mood that gives them inner life. In the 1960s, myth and fantasy emerge as major elements in California painting (chapter 31).

Northern California Surrealism

Most San Francisco Surrealists merged Automatist Surrealism with abstraction, blending the two very opposed philosophies of emotion and logic.

Surrealism had enjoyed wide and early acceptance in the Bay Area. In 1934, the same year Post-Surrealism made its debut in Southern California, Howard Putzel put on a show of Surrealism in the private commercial East-West Gallery and another at the Paul Elder Gallery. In mid-decade, Surrealist works were seen at the San Francisco Museum of Art in the form of one-person exhibitions and the major New York production *Fantastic Art, Dada, and Surrealism,* 1937. The museum also purchased Surrealist work in a variety of styles. In spite of this activity, about the only practitioner of Surrealism in the 1930s was the modernist Lucien Labaudt (1880–1943), who briefly toyed with the style.

It wasn't until about 1940 that Bay Area artists began to produce serious bodies of work in the Surrealist mode. That year, Berkeley-raised **Charles Howard** (1899–1978) returned from England, where he had been working for several years. In 1931, Howard had been in the forefront of the American Surrealist movement as one of three Americans included in the first commercial show for Surrealism held at New York's Julien Levy Gallery. At the time, his work consisted of arrangements of shapes still grounded enough in reality to be recognized as rocks, seashells, and driftwood set against a solid-color background and having an implied horizon and stylized clouds. Today, art historians would describe these as proto-biomorphic Surrealism. Howard's marriage to the British painter Madge Knight and their subsequent move to England placed him among a group of English hard-edge abstractionists. By 1939 he had absorbed enough abstraction that his natural biological shapes had become ungrounded in the realistic world and "floated" in space without a horizon. In 1940 the advance of the German army in Europe drove him back to San Francisco, where he worked for two years in one of the Bay Area's ship-building plants. His association there with streamlined shapes and twisted metal may have encouraged his further move toward metallic forms. Certainly his paintings became darker in color and colder, changing from his earlier organic browns and blacks to more metallic blues and blacks.

Many critics in Howard's own day were undecided whether to call him an abstractionist or a Surrealist, but in the 1990s there is a tendency to tie him to European biomorphic Surrealists such as Hans Arp (1887–1966) and Joan Miro (1893–1983). There are many interesting purposeful contradictions in Howard's work, as in *Double Circle* of 1950 (fig. 24-7), probably executed in England after the war. His goal was to balance the opposed poles of logic and emotion, artistic

Fig. 24-7
Charles Howard
(1899–1978)
Double Circle, 1950
oil on canvas, 24 x 34 in.
Collection of Fannie and
Alan Leslie

design and human psychology. His two-dimensional abstractions are given three dimension through subtle gradations of color and the inclusion of hair like "appendages" that seem to rest atop a background. Pattern contrasts with solid color, and rounded organic shapes oppose those with hard, angular metallic edges. This work is particularly stunning with its central yellow shape. As design supervisor of the WPA, with his works exposed continuously in Bay Area exhibitions and his 1945 lecture at the California School of Fine Arts, Howard influenced many other artists of the region.

Equally influential in introducing Surrealism to San Francisco was **Stanley William Hayter** (1901-1988), an experimental printmaker from Paris who was also driven into exile in America during World War II. Hayter was essentially an Automatist Surrealist. In the late 1920s in Paris he had taught the European Surrealists Miro, Arp , and Tanguy the techniques of printmaking. By 1933 he was exhibiting his own Automatist paintings along with the official Surrealist group. Although he spent most of the war heading his experimental printmaking workshop in New York, he taught for the summer of 1940 at the California School of Fine Arts. His promotion of nonobjective subject matter and chance effects, such as splattered inks and acids and layered networks of "singing" auto-

matic lines suggestive of space and motion, changed American printmaking (primarily etching) from a technical craft to a medium of artistic expression. An example is *Cinq Personages* of 1946 (fig. 24-8).

Dynaton. Surrealist activity increased in San Francisco after the war when two of the official members of the Surrealist group, Gordon Onslow Ford (b. 1912) and Wolfgang Paalen (1905–1959), arrived from Mexico where they had been independently pursuing their work. While still in Europe, both had succeeded in the Surrealist rite of passage—inventing a new automatist technique. The English-born Onslow Ford came up with poured paint *(coulage)* while the Austrian-born Wolfgang Paalen realized that passing a smoking candle across a freshly primed canvas would create accidental smoke and soot patterns *(fumage).*

Onslow Ford's move to San Francisco in 1947 was prompted partly by his poet wife Jacqueline Johnson, a Californian, and partly by his desire to return to nature – he fell in love with the wilds of the state. He brought with him a huge collection of paintings by the Surrealists that he had painstakingly amassed while in Europe, and he generously began to lend these out to San Francisco exhibitions, particularly the San Francisco Museum of Art. A year or so later, he was followed to the Bay Area by Wolfgang Paalen, who was persuaded by Jacqueline Johnson's claim that the city was "the creative hub of the nation."

Johnson was correct in describing postwar San Francisco as an artistically exciting place. Not only were Pacific contacts becomingly increasingly important to America, but San Francisco institutions were open to all forms of modern art. The San Francisco Museum of Art actively collected Surrealist paintings, photographs, film, and sculptures, and Surrealists were asked to lecture and lead classes at the California School of Fine Arts. Both Paalen and Onslow Ford, as well as Lee Mullican (below), were honored with one-person exhibitions at the San Francisco Museum of Art. Additionally, Abstract Expressionism, the "other" art form to come out of Automatism, was then evolving on the West Coast.

In the late 1940s, Onslow Ford and Paalen were responsible, along with newcomer Lee Mullican, for creating the art that some have called Surrealism's last stand in America, San Francisco's **Dynaton** exhibition of 1951. Onslow Ford himself prefers to think of the Dynaton as a new beginning, a new phoenix arising from the ashes of Surrealist Automatism. The Dynaton group consisted of three artist friends with shared ideas who expressed them in their own styles.

Dynaton is a Greek word that translates as "The Possible." It derived from the title of a six-issue peri-

Fig. 24-8
Stanley William Hayter
(1901–1988)
Cinq Personages, 1946
engraving, 15 x 23¾ in.
© 1998 Artists Rights
Society (ARS) New York,
N.Y./ADAGP, Paris; Photo
courtesy Laguna Art
Museum

odical *Dyn* that Wolfgang Paalen, the intellectual of the group, published in Mexico (1941–46). As opposed to the Paris-based Surrealists of the 1920s and 1930s, whose art visualized dreams, the Dynaton artists used their art to visualize the greater cosmic consciousness. In the early twentieth-century, discoveries by Albert Einstein and others had overturned the traditional Bible-based Christian and Jewish views of the universe. Science proved, through the study of quantum mechanics and astronomy, that the universe was composed of ever more complicated and larger-sized building blocks, ranging from particles that made up atoms to a universe that was so macrocosmic it was not even fathomable to humans. Scientific discoveries contributed to the early-twentieth-century spiritual flight from Christianity; artists turned to exploring Eastern philosophies, including Zen, as well as the religions and art of the world's so-called primitive peoples. The Dynaton artists, depending on their particular interests, read various texts forwarding alternative spiritual philosophies. Paalen was particularly interested in native peoples of the Americas while Onslow Ford was more attracted to Zen.

These artists faced a formidable task—to give visual form to the spirit or energy that underlies the cosmos. The artists saw themselves as working hand in hand with science to reveal the mystery of the universe: the scientists with quantifiable facts and figures to prove the existence of things invisible to the human eye, the artists with visual images and emotions. Each artist came up with his own aesthetic language. If they agreed on anything it was to work with strokes rather than flat color areas; the universe had no surfaces, only layers of depth whose transparency was best suggested by overlapping lines.

Wolfgang Paalen's aesthetic of mosaics of bright color was developed while in tropical Mexico. In the 1947 *Keylords of the Prismatic Situations* (fig. 24-9), the dots and dashes representing energy form into a great winged personage, one physical manifestation of many that could be taken by the amorphous being invented by Paalen that he called a Cosmogon. The Cosmogons were persons of a superior consciousness with parabola eyes who could "see" and know everything at once. They arrived on earth to announce the coming of a new era of greater consciousness. Paalen even wrote a play about them, *Beam of the Balance.* He also expressed his artistic ideas in the book *Form and Sense.*

Just before the Dynaton exhibition in 1951, on a walk through a redwood forest, **Gordon Onslow Ford** experienced an artistic revelation. Looking for iconography with which to visualize the invisible, he was struck with the fact that the line, circle, and dot were

Fig. 24-9
Wolfgang Paalen
(1905–1959)
Keylords of the Prismatic Situations, 1947
oil on linen canvas
81½ x 31¼ in.
University of Kentucky Art Museum. Gift of Richard B. Freeman. 76.13

Fig. 24-10
Gordon Onslow Ford
(b. 1912)
Constellations and Grasses,
1957
oil on canvas, 38 x 56 in.
The Buck Collection, Laguna
Hills, California
Photo: Cristalen and
Associates

Fig. 24-11
Lee Mullican (b. 1919)
Ninnekah Calendar, 1951
oil on canvas, 30 x 45 in.
Collection of the artist

the building blocks of the universe and the basis of all art. In works such as *Constellations and Grasses* of 1957 (fig. 24-10) he creates a psychic space with circles that "float" at many distances from the viewer within an "atmosphere" of tempestuous clouds, wild energy lines, and vertical elements representing space/time. Although Onslow Ford does not consider his artwork "spiritual," he does liken himself to a shaman who reveals the unseen to those who cannot see it on their own. He achieves his representations of the cosmos by delving into his unconscious intuitive self through an automatist technique of painting more rapidly than his mind can think. His rapid paint application coupled with his control of the brush, learned through the study of Chinese calligraphy, charges his abstractions with energy. A theoretician, Onslow Ford explained some of his ideas in the book *Towards a New Subject in Painting* (1948) and *Painting in the Instant* (1964). Today the artist lives in a 400-acre redwood grove near Mill Valley. He is among a number of artists who are pursuing mind art (echomorphology) and visualizing "inner worlds," a goal he regards as art's new direction. Many artists at the current end of the century are exploring spiritual ideas through their art (chapter 37).

The third member of the Dynaton group was **Lee Mullican** (b. 1919), an American, much younger than Onslow Ford and Paalen. His art study had been cut short when he was drafted into the army in World War II, but while working as a topographical engineer he took every advantage on his various assignments to expose himself to art. While assigned to a base in Indio, California, he explored Los Angeles and Palm Springs; in Hawaii he discovered Paalen's journal *Dyn;* and from other bases in America he visited museums. Aimless at the close of war, he ended up in San Francisco. Mullican also bases his paintings such as *Ninnekah Calendar* of 1951 (fig. 24-11) on strokes of color. He invented a technique that involved picking up paint on the end of a wide bladed knife (a printer's ink knife) and applying it to the canvas. As the youngest painter of the group, he seems most freed from the Dynaton need to visualize cosmic space. Light and energy are suggested by his dominant yellow color scheme and by the scintillation set up by the juxtaposition of his varicolored striations. In some works the strokes radiate out from a center, causing the human imagination to interpret

them as explosions of energy, while other works, where the lozenges run parallel to each other, cause a sensation of pulsating energy.

In the late 1940s the Dynaton artists worked parallel to the Abstract Expressionists in San Francisco. Both groups based their art on Automatism. The Abstract Expressionists used it to resolve formal aesthetic questions on the surface of the canvas, whereas the Dynaton artists used its ability to tap the unconscious and to give pictorial form to the collective unconscious. The canvases of the Abstract Expressionists were filled with personal angst, while those of the Dynaton expressed the emotionally neutral cosmos.

Apart from paintings, Surrealists also expressed themselves in photography (see Man Ray's *Rayograph*, chapter 25) and in sculpture (see Clay Spohn's room full of inventively quirky assemblages, *The Museum of Unknown and Little Known Objects*, reproduced in Thomas Albright, *Art in the San Francisco Bay Area 1945–1980*, Berkeley: University of California Press, 1985, p. 43). Surrealism introduced many elements into American art—fantasy, invention, tongue-in-cheek humor, weirdness, sexuality, and the element of chance, to name just a few. These become crucial ingredients in California's postwar art movements.

In the wake of World War II's destruction, the art world flowered, jumped forward, and went full bore in every creative direction and with every known medium. The next chapter will survey some of the exotic new nonpainting media devised by artists. It will show how artists increasingly mixed media, and how the sensuous medium of crafts entered the world of fine art. ✾

Bibliography

Surrealism
(See also bibliography for early modernists and Surrealists in chapters 18 & 21 and for artists and exiles in Hollywood in chapter 17.)

de Alcuaz, Marie, *Ceci n'est pas le Surrealisme: California: Idioms of Surrealism,* Los Angeles: Fisher Gallery, University of Southern California and Art in California Books, 1983. [cat. for exh. at various sites 1983–1984]

Ehrlich, Susan, "Los Angeles Modernists 1920–1956," *Art of California,* v. 3, no. 5, September 1990, pp. 32–39.

Ehrlich, Susan, *Pacific Dreams: Currents of Surrealism and Fantasy in California Art, 1934–1957,* exh. cat., Armand Hammer Museum of Art and Cultural Center, University of California, Los Angeles and two other venues between February 25 and December 11, 1995.

Heisler, Barry M., "The Forgotten Generation: Modernist Painters of Los Angeles, 1920–1956," *Antiques & Fine Art,* v. 7, no. 5, July/August 1990, pp. 90–97.

Henderson, Linda Dalrymple, "Mysticism, Romanticism, and the Fourth Dimension," in Maurice Tuchman, et al., *The Spiritual in Art: Abstract Painting, 1890–1985,* exh. cat., Los Angeles County Museum of Art, November 23, 1986–March 8, 1987 and two other venues, in association with Abbeville Press, New York, 1986. 435 p.

Leonard, Michael, "Dada and Surrealist Roots of Art in California," *Art of California,* v. 5, no. 2, May 1992, pp. 8–12.

Petta, Robert R., "Surrealism in Northern California," in Joseph Armstrong Baird, Jr., *From Exposition to Exposition,* exh. cat., Crocker Art Museum, Sacramento, Ca., 1981, pp. 45–49.

Dynaton
Anderson, Susan M., *Pursuit of the Marvelous: Stanley William Hayter, Charles Howard, Gordon Onslow Ford,* exh. cat., Laguna Art Museum, October 5, 1990–January 13, 1991.

Dynaton Before & Beyond: Works by Lee Mullican, Gordon Onslow Ford and Wolfgang Paalen, exh. cat., Frederick R. Weisman Museum of Art, Pepperdine University, Malibu, December 5, 1992–February 21, 1993.

Fink, Sylvia, "The Dynaton: Three Artists with Similar Ideas," in *California: 5 Footnotes to Modern Art History,* exh. cat., Los Angeles County Museum of Art, January 18–April 24, 1977, pp. 35–43.

Hopkins, Henry T., "Visionaries: The Art of the Dynaton," *Antiques & Fine Art,* v. 9, no. 3, March/April 1992, pp. 72–81.

Onslow-Ford, Gordon, *Towards a New Subject in Painting,* San Francisco: San Francisco Museum of Art, 1948.

Paalen, Wolfgang, *Form and Sense* [essays from *Dyn*], New York: Wittenborn and Co., 1945. 64 p.

Winter, Amy, Wolfgang Paalen, *"DYN," and the American Avant-Garde of the 1940s,* Ph. D. Dissertation, City University of New York, Graduate Center (UMI Dissertation Services, 1996, 2 v.), 1995. 948 l.

Fig. 25-11
Max Yavno (1911–1985)
Muscle Beach, 1949
silver gelatin photograph
Photograph courtesy Jan
Kesner Gallery, Los Angeles;

1945–1960: Growth of the Arts & Non-Painting Media

As the springboard for the U. S. offensive against Japan during World War II, California became the leading industrial growth area of the nation. In the first six years of 1940, the state grew faster in population than any other, becoming the third largest. (See art of World War II, chapter 23.)

After the atomic bomb was dropped on Hiroshima, August 6, 1945, and Japan capitulated, many U. S. veterans settled in California. While the state's unemployment rose, new jobs were created in its expanded aircraft industry, in residential construction, and in the service and retail trades. House building boomed. Maple furniture, Grandma Moses, "ranch" or international style tract houses, square dancing, and food freezers became faddish. Los Angeles resumed construction on its network of freeways, initiated in the late 1930s. Atomic power, soon in the hands of the Russians, raised fears of nuclear war and Communism. Senator Eugene McCarthy headed hearings to rout out subversives, and the Berlin airlift was put in operation. Scientists turned to finding cures for tuberculosis, cancer, and polio. On June 27, 1950, America entered the Korean War.

The post-World War II years were marked with materialism and inflation. Deprived during the war of material goods, Americans began to consume at an incredible rate. More and more people with higher educations garnered higher paying jobs and found themselves with more leisure time and excess money. They filled their new homes with washing machines, TVs, and refrigerators and bought new cars. They took vacations to Europe on the new commercial airline tours and to Disneyland, opened in Anaheim in 1955. As wealth increased for some, so did poverty for others. Burglaries were up; narcotics use became news. Generally, morals declined; Protestant church attendance decreased while interest in exotic religions, such as Zen Buddhism and Scientology, increased. Hollywood promoted "sex." The invention of the birth-control pill facilitated promiscuity. Against this mainstream developed a counterculture called the Beats, who scorned establishment "values," dropped out, hung around in coffee houses, quoted Zen poetry, wrote poetry, and experimented with drugs.

Peace and an increased standard of living caused culture to expand exponentially. Californians put money into public education, building one of the largest, most respected, and economically accessible university, college, and junior-college systems in the nation. The state continued as a haven for fiction and nonfiction authors; journalism grew in strength. With the decline in William Randolph Hearst's San Francisco-based newspapers came the rise of the *Los Angeles Times*. California also developed as a center for music, initially giving haven to avant-garde European musicians fleeing World War II, then evolving toward jazz. Hollywood continued as the center for the motion picture and television industries.

Art Infrastructure

America came out of the war as the world's top economic power and political leader and soon became its artistic leader. Hand in hand with artistic innovations grew an infrastructure to support the new interest in culture.

Museums. In California, thanks to postwar affluence, existing museums expanded and new ones were founded. In Los Angeles, a 1938 structural reorganization of the Museum of History, Science, and Art finally gave the art department equal status with history and science, and enticed back its former art support group, the Museum Patrons. (Their Los Angeles Art Association continued as an independent cooperative of artists.) In 1941 the Pasadena Art Institute acquired the Grace Nicholson Galleries on North Los Robles and the following year merged with a young institution, the Pasadena Art Museum. As the Pasadena Art Museum it gained national significance in 1951 when it was deeded the Galka Scheyer Collection of 600 pictures; most of these were by Germany's Blue Four. Many smaller art galleries were started in the area's existing and newly built colleges and universities. With the rise of nonobjective art, museums placed emphasis on contemporary art. Existing institutions hired curators for modern and contemporary art, devoted permanent galleries to its display, acquired cutting-edge works for their permanent collections, and held annual competitive exhibitions. The American Contemporary Gallery was established in Hollywood about 1943, and the Modern Institute of Art that opened in Beverly Hills in 1948 survived for about a year. Los Angeles's leading art critic was Henry Seldis (1925–1978) of the *Times*, who remained an important voice to his

death. In San Francisco, established institutions flourished, including the San Francisco Museum of Art that had supported modernism since its opening in 1935. Also showing California's modern artists were the California Palace of the Legion of Honor and the M. H. de Young Memorial Museum. In the East Bay the California College of Arts and Crafts, Mills College, and the University of California at Berkeley all expanded. Paul Mills, who became curator of the Oakland Art Gallery in 1953, immediately changed the name to The Oakland Museum and gave it a unique mission—the presentation and acquisition of California material; in 1954 he established the Archives of California Art. The Bay Area's primary art critic was Alfred Frankenstein (1906–1981) of the *San Francisco Chronicle*.

In San Diego, the Fine Arts Gallery saw steady growth. And in nearby La Jolla, in 1941, the La Jolla Art Center opened in a former home of the art benefactress Ellen Browning Scripps. A combined teaching facility and museum, it prospered in the 1950s through the financial aid of the actor Vincent Price, among others. In Santa Barbara, the Museum of Art that had opened in 1941 went through a major expansion in the summer of 1958.

Art Schools. The G.I. Bill, which was passed to re-train servicemen for civilian careers, set up a financial environment that fostered education of all kinds, including art. Existing schools were swamped, leading to the foundation of many small, private institutions to fill the gaps. In Los Angeles the large and established art schools—Otis, Chouinard, and Art Center—expanded. In San Francisco the California School of Fine Arts remained strong. However, the new trend was for art teaching to be taken over by colleges and universities. Through the 1950s, studio art and art history departments grew up in Southern California at the Claremont Colleges, the University of Southern California, the University of California at Los Angeles, and San Diego State College. In Northern California they were formed at California State College in San Francisco and the University of California at Davis. Art instruction's move to institutions of "higher learning" changed art from a practical, career-oriented discipline to one concerned with ideas. Educators began to use the new medium of television to reach their audience, as Lorser Feitelson did in his program "Feitelson on Art."

Collectors and Galleries. Postwar affluence enabled many individuals to adopt the hobbies of the rich—the enjoyment of fine food, wine, music, the theater, as well as the collecting of art. Although art of all styles and eras was amassed, the period from 1945 to 1960 is notable for collectors of modern art. Differing from modern collectors of the late 1930s and 1940s, who had purchased early-twentieth-century European art, the new generation was equally open to acquiring contemporary American, including Californian, art.

Collecting prompted commercial art galleries to open. In Los Angeles, the art community (along with the city itself) continued its migration westward, pausing in the West Hollywood/Beverly Hills area. Top commercial galleries offering both European and American modernist art included Esther Robles and Felix Landau on La Cienega Boulevard, Paul Kantor and Frank Perls in Beverly Hills, and James Vigeveno in Brentwood. Two avant-garde showplaces were Syndell Studio in Brentwood, started by Walter Hopps in 1954, and the democratic, first-come, first-served Now Gallery, opened by Edward Kienholz in 1953. By 1957 owner/directors Hopps and Kienholz pooled their interests and founded the now-famous Ferus Gallery on La Cienega, where, in the early 1960s, Los Angeles's most avant-garde artists made international news.

San Francisco was slow to develop commercial galleries, but those that arose understandably supported the Bay Area's two innovative movements, Abstract Expressionism and Bay Area Figurative Painting (chapter 26). Galleries were of two types: serious commercial undertakings (where establishment art was displayed) and underground, i.e., alternative galleries (where Beat art was displayed). A blend of both was the late-1940s cooperative Metart Gallery founded by the students of Clyfford Still to show Abstract Expressionism. It survived one and a half years. In the 1950s came the Rose Rabow Gallery. Just south of the Marina, near the crossing of Union and Fillmore, in an area settled by Beats, several underground galleries opened, including the King Ubu (1953). Reopened in 1955 as the Six Gallery, it was artist-operated with irregular hours. It promoted poetry, dance, music, and experimental photography, and its openings were events on the level of "happenings." In 1955, the East-West Gallery was founded by the artist Sonia Gechtoff and

became one of the most "established" (if short-lived) of the avant-garde galleries and a showcase for Abstract Expressionism.

The postwar years witnessed a revolution in art styles and media that the art world now terms "modernism". Between 1945 and 1965 artists adopted non-representational subject matter and wrestled with the formal questions of art. Although modernism extended to all media, that getting the most publicity was painting, which ran the gamut from the highly emotional and expressive Abstract Expressionism of the late 1940s (chapter 26) to the flat, geometric Minimalism of the 1960s (chapter 30). Modernism had many traits. These included an American art world dominated by an elite class of white male artists, art critics, art historians, art curators, art galleries, and art publications, centered in New York. Inbred, nevertheless they brought art from an entity peripheral to mainstream society to one making front-page news; the art establishment made celebrities out of artists and created a market for art among America's postwar affluent citizens. Modernism was driven by innovation and through the 1950s, modernist painters, fulfilling the advice and predictions of the New York art critic Clement Greenberg, eliminated all the "unnecessary" aspects from their art until they ended up with not much more than an object consisting of a simple geometric shape and flat unmodulated color.

Non-painting media followed the same aesthetic goals. Representational subject matter and illusionism were usurped by nonobjectivity and the solution of formal issues. The act of painting and the medium of paint lost importance as artists in search of new ways to express themselves turned to other media.

Sculpture

After the war sculpture veered dramatically away from the traditional static, volumetric, representational object on a pedestal. By the 1950s innovations made in the 1930s in Europe and America (chapter 17) had disseminated to a wider artist base. California sculpture was now nonobjective, moved around in space, was created by welding, or was assembled—and it contained "ideas."

Kinetic. Today, sculpture that moves hardly seems revolutionary, but when Alexander Calder made his first "mobile" in the early 1930s, its movement was startling. Art historians describe sculpture that moves as "kinetic," a word that means "of or pertaining to motion." Movement can be induced artificially (with a motor driven by electricity or fossil fuel) or naturally (propelled by wind, sun, water, earth motion, gravity, etc.). Calder's friendships with many Parisian modernists, including the Surrealists, induced him to use biomorphic forms, and his mobile sculpture's random movement was meant to replicate how thoughts constantly change in a person's consciousness. California had a few kinetic sculptors, including San Francisco's **Robert Boardman Howard** (1896–1983). After 1945 Howard made "articulated" pieces composed of separate, skeleton-like wooden members that delicately balanced atop one another, as in *Study for "Custodian"* of 1950 (fig. 25-1). Historians like to cite the origins of these in his marionettes of the early 1930s rather than in the work of Alexander Calder. Like some other artists, he favored Surrealism's biomorphic or crablike forms. And, following the interests of his era, his sculpture lays no claim to volume itself, but to the space that its appendages and their movement encompasses.

Fig. 25-1
Robert Boardman Howard
(1896–1983)
Study for "Custodian", 1950
wood, metal and gypsum
16 x 17½ in.
Courtesy of the Oakland Museum of California, Lent by the Howard Family Estate

Fig. 25-2
Ernest Mundt (1905–1993)
Desire, 1945
brass and copper wire
20 x 18 x 12 in.
Mrs. Ernest Mundt
Photo: Victoria Damrel

Fig. 25-3
Claire Falkenstein
(1908–1997)
*Structure and Flow # 2
(Wave),* 1965
copper tubing with fused
glass, 18 x 14 x 37 ft.
California Federal Savings,
Los Angeles, no longer
extant; Photo courtesy Claire
Falkenstein

Metal. For centuries sculpture has been made from metal, including lead, bronze, gold, and silver. But, in the 1930s, artists began to use new minerals and alloys: steel, stainless steel, aluminum, and chrome. Until now, **Ernest Mundt** (1905–1993), a German exile in San Francisco, has remained little-heralded, primarily due to his own desire for privacy. In the late 1940s, however, he was probably the Bay Area's most avant-garde sculptor, with his polished heavy-wire sculptures such as *Desire* of 1945 (fig. 25-2). Some have the springiness to be twanged into motion. This particular piece has an élan stemming from the wire's singing curves and varying width. Mundt made sculpture during a brief period in the late 1940s. A Renaissance man, he excelled in a number of fields, even wrote a cookbook, and in the early 1950s was caught up with his duties as the director of the California School of Fine Arts and his responsibilities for a new family.

Although welding via the forge had been known for thousands of years, by the 1920s welding with the electric or gas (oxyacetyline) torch began to interest artists; the technique was invented in the 1880s. Between 1945 and 1960 it was taken up by many sculptors, causing the period to be jokingly called the "era of welding." Just as skyscrapers were liberated with the

development of riveted I-beams, so, too, was sculpture by welding. **Claire Falkenstein** (1908–1997), who began her career in San Francisco in the late 1940s, surfaced in the 1950s as one of California's most avant-garde workers in this medium. Although her break-through wire sculptures were conceived and executed during her expatriate years in Paris (1950–63), she eventually returned to California. One of her most outstanding pieces is *Structure and Flow #2 (Wave)* of 1965 (fig. 25-3), commissioned for the plaza in front of the California Federal Savings and Loan building in Los Angeles. *Structure and Flow* captures space both within the welded wire shapes and the areas enveloped by those shapes. This piece has the added attraction of water shot from below in a manner original to Falkenstein. To welding she added her own innovation— "fusions"—in which she used the high heat of a furnace to bond chunks of molten glass to copper rods.

Two California sculptural movements were to stamp their names on the decade of the 1950s: assemblage and ceramic sculpture.

Assemblage. For thousands of years, tribal peoples around the world have "assembled" sculpture, adding shells, feathers, bones, and any manner of other found objects with perceived fetishistic power to carved wooden masks and effigies. But the process of assembling only entered the Western fine-arts community with Picasso's "collages" and Dada sculptures of the second half of the 1910s.

In the mid-to-late 1950s, assemblage developed into a major sculptural movement in California, primarily propelled by California's large contingent of Beats, who created sculpture with society's castoffs to voice their protest of the materialistic and acquisitive mainstream. Assemblages vary widely in content (ranging from natural organic materials to manufactured items) and in size (from pedestal-scale to room-size). California artists were inspired by the work of Kurt Schwitters (1887–1948), the German Dada artist, rather than Joseph Cornell (1903–1972), the East Coast maker of "boxes," of whom most were unaware. The most important California assemblage artist is unquestionably **Wallace Berman** (1926–1976), who worked in both Southern and Northern California and lived his belief that "Art is Love is God." The bearded, sandal-wearing intellectual, whose 1957 show at the Ferus Gallery was closed by the Vice Squad because one of the assemblages included a photograph of a couple copulating, decided never to exhibit publicly again and made art only for those who understood it. Between 1957 and 1964 he produced a small magazine titled *Semina* that consisted of photographs, original art, text, and poetry created by himself and friends. (One

example is reproduced in *Proof: Los Angeles Art and the Photograph 1960–1980,* exh. cat., Laguna Art Museum, October 31, 1992–January 17, 1993, pp. 36-39.) *Semina* editions were limited to 150 to 300 copies, and issues were mailed only to friends. Highly autobiographical, the magazine was laced with Hebrew lettering and symbolism and was realized with unusual typography, photography, and the new reproduction technique of Verifax (a precursor to xerography). Berman's many followers shared his belief that an artist's quest should be spiritual rather than material. They admired his general questioning of the relationship between art and life as well as his investigation of human perceptions and how they determine man's understanding of his existence. In the work of Berman and other Beats lay the seeds of many concepts and techniques that rose to prominence in the years after 1960: the collage-type composition, the technique of appropriating premade images, the incorporation of photography into other media, and the emphasis on concept and idea over aesthetic issues.

Assemblage was a pan-California art movement and occurred at a rare moment in time when artists in both Northern and Southern California pursued the same goals. Southern California contemporary galleries presented shows of Northern California art, and artists moved freely between cities. One of the most important assemblage artists in Northern California was **Bruce Conner** (b. 1933). His works are what everyone imagines an assemblage to be: an artistic grouping of discarded objects marked with signs of age and deterioration. Arriving at his signature style in the early 1960s, he produced *Cross* of 1961 (reproduced in *75 Works 75 Years: Collecting the Art of California,* exh. cat., Laguna Art Museum, Laguna Beach, Ca., April 2–July 11, 1993, p. 87). It incorporates items unique to his work: tattered nylon stockings stretched like cobwebs, items associated with women (such as costume jewelry, dried flowers, brocades, lace, fur, feathers), photographs, as well as leather, wood, and nails. Conner's selection of components marks his work with a Gothic romanticism. In *Cross* he has brought together images that reflect the romantic melodrama of self-sacrifice and martyrdom. The cross references the biblical story of the Crucifixion, the candle suggests devotion and the Catholic religion, and the expression on the face of the Pre-Columbian figure in the photograph projects a kind of detached suffering. Also included is an object wrapped in old newspaper that suggests the medicine bags carried by tribal peoples for spiritual protection. The work's religious-erotic fetishism reflects Conner's interest in themes of repressed sex, eroticism, pornography, and violence against women. Viewers accustomed to traditional formats may have difficulty understanding assemblages. Such accumulations of objects that seem salvaged from junkyards may have

unpleasant connotations or give rise to unhappy memories. However, assemblage artists intentionally use the emotions associated with the objects. As the twentieth century advances, traditional art's pursuit of "beauty" loses out to concept and meaning.

The most infamous assemblage artist may be **Edward Kienholz** (1927–1996), whose room-size, carefully scripted narrative pieces, such as *Back Seat Dodge '38* of 1964 (fig. 25-4), shocked the 1960s establishment with their frank presentation of the "not-talked-about" subjects of contemporary society. Kienholz began his art career as a painter, but toward the end of the 1950s he started to add objects to his paintings, and by 1959 he had moved into three-dimensional works. Although Kienholz did not consider himself a Beat, he shared their anger toward mainstream society. The idea for *Back Seat Dodge '38* comes out of Kienholz's own history, although the result is meant to be archetypal rather than personal. The theme is obviously adolescent sex, the figures—Harold and Mildred—an Everyman and Everywoman. This work contains all the elements of Kienholz's mature work: it is made from found objects, is narrative, presents an archetypal situation, and the viewer becomes both voyeur and participant. There is a crucial difference between assemblage made by New Yorkers and that by Californians; New Yorkers used their objects to stimulate esoteric ideas while Californians used theirs for social protest or to spoof and spurn the establishment.

Some historians also include within the category of assemblage such things as outdoor folk environments. California has achieved particular distinction in this area. Outdoor environments are living spaces created by artistically untrained individuals from objects discarded by society; examples are bottle houses, hubcap villages, and driftwood homes. The most famous artist in this category is **Simon Rodia** (1875–1965), whose concrete and ceramic tile *Watts Towers,* in process between about 1925 and 1954, is located in Los Angeles (fig. 25-5). Outdoor art works of this scale were made possible by California's mild climate, which allows artists to work out of doors almost year round and does not destroy the creations with excessive precipitation and extreme temperatures. The trend flourished particularly in the 1950s as new roads opened up rural areas and families began to tour the countryside in automobiles. Such roadside attractions as hubcap villages lured tourists in for a minimal admission price. In recent years many of the structures have fallen into disrepair or have been dismantled. Some have survived

Fig. 25-4
Edward Kienholz
(1927–1994)
Back Seat Dodge '38, 1964
paint, fiberglass and flock,
1938 Dodge, chicken wire,
beer bottles, artificial grass,
cast plaster figure
66 x 240 x 144 in.
Los Angeles County
Museum of Art, Purchased
with funds provided by the
Art Museum Council

in pieces and are preserved in public collections, while others have been reduced to salable quantities and have been dispersed through commercial art galleries. Historians cite these large-scale projects as examples of American individualism. And, since most were developed over many years, receiving almost daily input, they demonstrate strong-willed determination. (See also Folk Art, chapter 31.)

Ceramic Sculpture. While ceramic sculpture is not a new medium—after all, early man modeled animal and human figures out of clay and hardened them in campfires—the ceramic sculpture that evolved in California in the late 1950s was a new development. It evolved, amazingly enough, from the crafts tradition. The studio crafts movement that arose after the war (see below) had a particularly outstanding member, **Peter Voulkos** (b. 1924), who had the physical strength to wrestle huge globs of clay into magnificent large-scale, wheel-thrown pots. Trained at Montana State College and the California College of Arts and Crafts in Oakland, in 1954 he joined the staff of the Los Angeles County Art Institute (now Otis College of Art and Design) as ceramics instructor and prepared to teach students traditional concepts of wheel-thrown vessels. But Voulkos unpleasantly surprised the school's director by applying Abstract Expressionist concepts to his work. Working with students, many of whom were his own age, including Paul Soldner (b. 1921) and John Mason (b. 1927), and who were just as interested in pushing the limits of clay, Voulkos began modifying his huge pots. Waiting until they dried to a leather-like consistency, at which time he could manipulate them without their collapsing, he would add cutout shapes to the surface, stick several together, then punch or slash holes in the clay. Up to 1959 it was possible to discern the original thrown forms that composed the huge (some were more than five feet tall), bulbous-looking, monolithic, often monochromatic pieces that are his signature work. The 1959 *Camelback Mountain* (fig. 25-6) is also constructed from stacked up cylinders, but some of the vessels are disguised by flattening and squaring, while others have their interiors exposed by slicing away the outer surface. The result is a muscular monument imbued with primitive forces. Like Abstract Expressionist paintings, Voulkos's sculptures are energetic, profound, nonobjective, and completely original. An article on his work in the September/October 1956 issue of *Craft Horizons* elicited cries of "foul" from conservative studio potters. However, today Voulkos is looked upon as the artist who initiated the Abstract Expressionist clay sculpture movement and is thus the father of today's widespread ceramic sculpture movement.

Fig. 25-5
Simon Rodia (1875–1965)
Watts Towers, 1925–54
ceramic and cement
City of Los Angeles
Photo: Victoria Damrel

Fig. 25-6
Peter Voulkos (b. 1924)
Camelback Mountain, 1959
stoneware, iron slip, clear
glaze, 45½ x 19½ in.
Gift of Susan W. and
Stephen D. Paine, Courtesy,
Museum of Fine Arts,
Boston

Fig. 25-7
F. Grayson Sayre
(1879–1939)
Canyon Gateway, Arizona
oil serigraph, 17¼ x 12¼ in.
Trust Company of the West
Photo: Victoria Damrel
(Clique Studio, Long Beach)

Fig. 25-8
Corita (Sister Mary Corita
Kent) (1918–1986)
This Beginning of Miracles,
1953
serigraph, 16 x 20 in.
Los Angeles County
Museum of Art, Gift of Mr.
and Mrs. Fred Grunwald;
Reprinted with the
permission of the Corita Art
Center, Immaculate Heart
Community

Printmaking

Prior to World War II, most printmakers considered themselves craftsmen whose job was to master a technique and to maximize its particular qualities when rendering a subject. Techniques fell neatly into the categories of relief (woodcuts, wood engravings, linoleum cuts), intaglio (etchings and engravings) and planographic (lithographs and serigraphs). Prints were usually rectangular in shape, with colors restricted to black and white, and made on some form of paper. All this changed in the 1940s. The most innovative fields became silkscreen and etching.

Serigraphy/Silkscreen. It was only a matter of time before inquisitive artists got around to testing the artistic potential of the commercial medium of stencil/silkscreen. In stencil printing, a shape is cut out of a sheet of paper. This stencil is laid down on some object, and paint is brushed or sprayed over it, creating a design except where it is blocked by the stencil. Some art historians believe stencil printing was first used in China and Japan, but by the fifteenth century it was being used in Europe to print wallpapers. By the nineteenth century stencil printing had evolved into the technique of silkscreen, because stencils had become so intricately cut that they had to be supported on fine meshes of silk cloth stretched on wooden frames. Silkscreen first appeared in America in San Francisco, where it was used in the 1910s to print banners, posters, and other commercial products. The technique obviously lent itself to flat, hard-edged shapes such as lettering. At the same time John Pilsworth of that city developed a variant that used fabric screens to print many colors – he called this Selectasine. (He was finally given a patent on it in 1918.) Throughout the 1920s several California companies used his technique to make cheap reproductions of oil paintings for a mass market. Many collectors of California *plein air* landscapes have accidentally purchased one of these thinking it was an oil painting. An example is **F. Grayson Sayre's** (1879–1939) *Canyon Gateway, Arizona* (fig. 25-7) made by the Van Ton Company of Los Angeles (active 1925–35).

By the mid 1930s, silkscreen had become accepted as a fine-art medium. Guy Maccoy (1904–1981) made the first American silkscreen as a work of art in New Jersey in 1932. As is common in the invention of new art forms, his use of the medium arose out of necessity. Asked to help his future wife Geno Pettit (?–1982) fulfill a commission to print decorative covers for candy boxes, he suggested using the commercial medium of silkscreen. He was also aware of pochoirs, the stencil technique used by French artists. The inexpensive medium from which limitless prints could be produced

without degradation of the "plate" turned out to be the perfect medium for the Great Depression when people wanted inexpensive but "real" art for the masses. It was promoted by the government art projects. In the early 1940s it was renamed "serigraphy" to give it legitimacy with the conservative print world, and it reached an artistic peak in America in the 1940s.

The earliest, most experimental California serigrapher was the Post-Surrealist Dorr Bothwell (chapter 21). She taught herself the technique from one of the several instructional manuals then circulating. Following the decade's predilection for experimentation, possibly inspired by Stanley Hayter (chapter 24 and below), she blocked the silk mesh not with cut stencils but in a number of innovative ways. She drew on it (literally clogging it) with a waxy lithograph crayon, and she blocked it with flat manufactured items, such as netlike fabrics and lace. Her subject matter was abstract and surrealistic. After World War II, Bothwell, as well as the U. S. government that sponsored books and traveling exhibitions on serigraphy, spread the technique to England and Europe.

Sister Mary Corita (1918–1986) was California's most popularly known silkscreen artist. A nun and art teacher at Immaculate Heart College in Los Angeles, she achieved such success that she gave up her religious vows. By the latter 1940s, many discoveries in how to block the silk mesh had enabled serigraphy to evolve away from a few simple flat shapes to complex designs. Corita shared painters' interest in resolving the two opposites of realism and abstraction (chapter 22), and in her earliest work she created almost nonobjective works by distributing imagery throughout her field and scattering bright and shocking colors across it. An example is *This Beginning of Miracles* of 1953 (fig. 25-8) in which images of Christ converting water into wine appear with contemporary icons, such as Eames-like chairs and a TV antenna, are almost dissolved in hot pinks and oranges. Serigraphy's flat quality was sympathetic to painting's interest in two-dimensional design and formal aesthetic questions. Later in the decade Corita reflected the fashion for alphabetical lettering in art and her own preference for uplifting subjects by making compositions composed solely of words, as in "LOVE." (Serigraphy peaks again in the 1960s with prints of Pop subject matter.)

Southern California enjoyed a particular efflorescence of serigraphy when Guy Maccoy and his wife Geno Pettit settled in the state in 1947. He taught screen printing at Los Angeles's Jepson Art Institute and, after the mid 1950s, at the Otis Art Institute. In the early 1950s he started the Western Serigraph Institute and served as its first president. In 1954 the group of more than thirty members received national attention when selected works from their exhibition at the Los Angeles County Museum were circulated by the Smithsonian Institution.

Intaglio (Etching, Engraving, and Mixtures). Just as silkscreen was given the new name of serigraphy to bring it up to date with its new role as a "fine art" medium, so too were the old techniques of etching and engraving renamed intaglio. Intaglio, the generic term that had covered all the printmaking techniques based on biting or gouging pits, depressions, and lines into a plate, was now employed to describe the wealth of new prints that combined all the old intaglio processes into one. (In a similar way, the 1940s print explosion caused the Society of American Etchers, Gravers, Lithographers and Woodcutters to rename itself to the more generic Society of American Graphic Artists in 1951.)

The brilliant innovator in intaglio was **Stanley William Hayter** (1901–1988), an experimental printmaker from Paris (active 1928–38) who waited out World War II in New York. In the decade prior to his arrival, the medium of printmaking had been fostered by the Federal Art Projects and promoted by the commercial Associated American Artists gallery of New York. It was Hayter who provided the encouragement and some of the techniques that made etching exciting for artists. As seen in *Cinq Personnages* (fig. 24-8), Hayter brought automatism to bear on printmaking; he approached the medium as a creative (rather than a technical) experience. He advocated using color, mixing different techniques (such as etching and silkscreen) on one plate, adding opaque watercolor, cutting holes in his plates, shaping their perimeters, printing on materials other than paper (such as plaster plaques), and working in enormous sizes. After a 1944 Museum of Modern Art, New York, traveling exhibition titled *New Directions in Gravure,* Hayter was deluged with applications from potential students. In turn, his students spread his revolutionary ideas to printmaking departments in schools across America. His influence in California was heightened by visits there. In the summer of 1940 he taught printmaking at the California School of Fine Arts and held a one-person exhibition at the San Francisco Museum of Art. In the late 1940s he was back in the state with several exhibitions

in major cities and a summer 1948 teaching assignment at the California School of Fine Arts.

It was in Southern California that Hayter's attitudes and techniques took greatest hold. California's most advanced printmakers, such as **Leonard Edmondson** (b. 1916), turned to abstraction and nonobjectivity, as in *Heralds of Inquiry,* 1951 (fig. 25-9). Because so many painters began to express themselves in prints, subject matter often mirrored that of painting, including Surrealist biomorphic forms, space-time, and fantasy worlds. Humor, once considered sacrilegious to "high" or "fine" art, entered in the form of lampoon, mockery, and satire. Artists also began to use the alphabet in art—words, phrases of poetry, or quotes from classic literature—which added new visual elements as well as literary meaning to the pictorial images. Color, formerly anathema to printmaking, was achieved by rubbing colored inks into parts of the plate and printing in one run or by printing one color during each of several runs.

With the rise of interest in printmaking there naturally followed print organizations and exhibitions. California saw print annuals started at the University of Southern California in Los Angeles in 1952, Bay Area Printmakers at Oakland in 1955, and at the Pasadena Art Museum in 1958.

Fig. 25-9
Leonard Edmondson
(b. 1916)
Heralds of Inquiry, 1951
color etching/aquatint
11 x 13¼ in.
Collection of Orange County
Museum of Art,
OCMA/LAM Art
Collection Trust; Gift of
Nancy Dustin Wall Moure

Drawing

Drawing is probably man's oldest art medium, first seen in prehistoric cave art in Southern France and inscribed lines on fired ceramics. For centuries, drawing was restricted to ink applied to vellum and papyrus or to marks made in wax or on slate. Papermaking's secret, wrested from the Chinese during an attack on Arabs in the middle of the eighth century, was only finally disseminated in Europe proper when the Moors introduced it to Spain in the twelfth century. During the Renaissance, some of the first drawing implements that artists commonly use today were manufactured; these include sticks of compressed charcoal, chalks, clays, and pastels (ground pigments mixed with white chalk). Today's ubiquitous pencils were invented after the discovery of graphite in Barrowdale, England, in 1564.

Drawings have enjoyed a minor but continuous production in California since the earliest European artists voyaged to the state (chapter 1). By the end of the nineteenth century, drawing was an established part of the state's art school curriculum and was employed in *sloyd* programs at public schools. (Sloyd was an educational program that originated in Sweden and sought to develop a child's manual dexterity through drawing and sculpting, while it developed his mental acumen.) Turn-of-the-century San Francisco, as a center of the publishing industry, was a hotbed of quick-sketch artists, cartoonists, and book illustrators whose work had national impact through publication in the Hearst newspapers.

In the early twentieth century, drawing was crucial to architects, to Hollywood's motion picture industry (where sketches visualized sets, costumes, and the overall look of a film), and to the creation of animated cartoons (chapter 17). In the 1930s, while the Federal Art Project did not have a special drawing unit per se, many "cartoons" (small-scale drawings) were produced preliminary to full-scale murals, and drawing talents were expended in the lithography unit. Many talented draftsmen were hired by the FAP's Index of American Design to make trompe l'oeil copies (sometimes tinted with watercolor) of historical items designed and manufactured in America before 1890. In California these items were usually decorative arts and furniture from the Spanish/Mexican times. A special project at the Southwest Museum in Los Angeles documented Native American pottery. During World War II, Los Angeles draftsmen working in the area's many aircraft plants developed easily understood perspective drawings that replaced the difficult-to-read blueprints and allowed plane parts to be assembled at a more rapid rate. Prior to 1950 more than

fifty nationally syndicated cartoonists chose balmy Southern California for their residence, including the creators of Krazy Kat, Maggie and Jiggs, and Napoleon.

In the 1940s, drawing "took off" as a fine-art medium. Coincident with the G. I. Bill, which enabled many small art schools to open, the local artist Herbert Jepson started his Jepson Art Institute (active September 1945–January 1953). While drawing was a standard part of the curriculum in all art schools, Jepson encouraged students to regard the medium as a main form of artistic expression. His top instructor was the charismatic **Rico Lebrun** (1900-1964), who was a master of the medium, as is evident in *Seated Clown* of 1941 (fig. 25-10). Lebrun was trained in Naples, where he was exposed to the "picturesque" beggars, musicians, cripples, and clowns of the streets. His romantic nature was disturbed by the atrocities of World War II. Emerging as a humanist, he struggled throughout his life to combine his "Baroque" representationalism with the new wave of Cubism that arose after the war. (See his *Genesis*, fig. 20-22.) He urged his students to create bold, assured drawings marked by strong emotion and passion.

With increasing numbers of practitioners came a coterie of organizations and exhibitions devoted to the medium. From the mid 1930s, exhibitions of drawing began to appear at museums and commercial galleries. In Los Angeles the most enduring was the drawing section added to the major annual exhibition *Artists of Los Angeles and Vicinity* from 1948.

Photography

Photography benefited from a number of technical advances in the 1940s. Color emulsions were perfected in the late 1930s. World War II brought advances in lenses, in films that needed less light, in automatic exposure meters, and in simpler printing systems. In the late 1940s, Land developed the "instant" camera (marketed under the Polaroid name). Postwar Japanese manufacturers incorporated many of the war innovations into 35mm cameras, making them a major trade item with the United States in the 1950s.

In the 1950s photography became an increasingly important element in the lives of Americans. Photographs provided illustrations in pictorial magazines such as *Life* and *Look*. Motion pictures and newsreel films took on greater prominence, and television brought film right into the average living room. Photographs soon came to be the main way Americans experienced life. Many G.I. s who had been exposed to photography in the service (in fields such as aerial photo surveillance or the making of training films) used the G.I. Bill to train for civilian careers in the medium. The

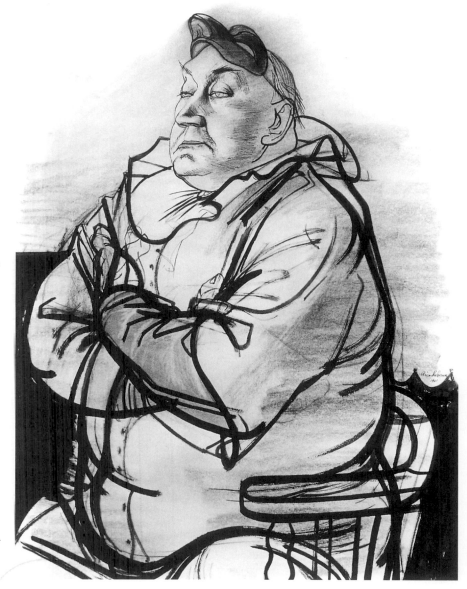

discipline began to be taught in art schools, colleges, and universities. (In Los Angeles, Art Center School of Design reigned supreme, followed by the Mortensen School of Photography in Laguna Beach. In the Bay Area, the California School of Fine Arts was followed in importance by San Francisco State College. In Santa Barbara, Brooks Institute, founded after the war, remains a major world force in the medium.) Photography organizations came into existence, including the short-lived Bay Area Photographers of 1955 and the American Society of Magazine Photographers (ASMP) in Southern California. The magazine *Aperture*, started in San Francisco by photographer Minor White (1908–1976) in 1952, was the first critical magazine on photography published since Alfred Stieglitz's *Camerawork* (1903–17). Exhibitions of photography were held in museums and at county fairs, and the medium was particularly supported by the San Francisco Museum of Art.

Fig. 25-10
Rico Lebrun (1900–1964)
Seated Clown, 1941
ink and wash, 39½ x 29 in.
Santa Barbara Museum of Art, Gift of Mr. and Mrs. Arthur B. Sachs

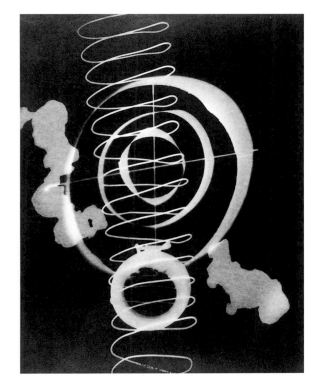

Northern and Southern California followed different photographic philosophies. In Northern California, where photographers lived in relatively close quarters in either the Bay Area or in Monterey/Carmel, there was considerable interaction and give and take, and photography was looked upon as "art." The "straight" photography of the f.64 group (chapter 17) dominated, led by Ansel Adams and Brett Weston (1911–1993), the son of Edward Weston. Northern Californians adhered to precepts such as Adams's "Zone system" (a 10-step scale of tones between pure black and white). Southern California photographers, on the other hand, were physically spread out, and there was little interaction. Surrounded by commercial advertising and motion picture work, they tended to view photography as a vocation. Still, Southern Californians are responsible for many aesthetic and technical innovations as a result of the competitive need to make their commercial assignments more dramatic, dynamic, or interesting.

Photography's most important achievement between 1945 and 1960 was its change of emphasis from documenting a physical subject to conveying a concept. The greater public was aware of the first category through the popular field of photojournalism. Photojournalists' goals were to capture everyday scenes reflective of their times. Southern California boasted **Max Yavno** (1911–1985), who captured scenes such as *Muscle Beach* of 1949 (fig. 25-11, p. 318) or rows of tract houses, while the Bay Area looked with pride to the works of John Gutmann (b. 1905). The primary goal of photojournalists, as with the documentary photographers of the 1930s, was to take candid snapshots of the human experience. The genre was honored with the exhibition *Family of Man* in 1955 at the Museum of Modern Art, New York. The popularity of the theme led to entire books devoted to photographs on specific themes or by particular photographers.

Almost unknown to the public, but reflective of what was to come, was photography of experimentation and ideas. The Parisian Dada artist **Man Ray** (1890–1976), who waited out the 1940s in Hollywood, continued to produce Rayographs, such as *Untitled* of 1945 (fig. 25-12). A Rayograph is a photographic image made without a camera, produced by laying objects atop photographically sensitive paper and exposing the

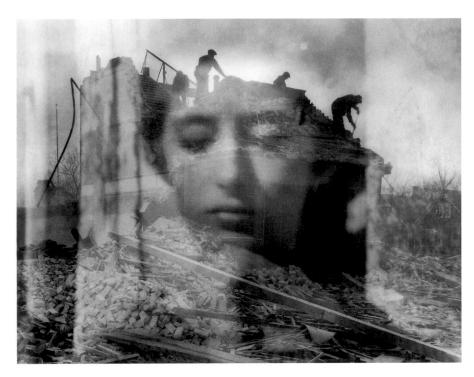

grouping to light. While the basic process of Rayographs had been discovered in the 1830s, Man Ray rediscovered it in 1921 and turned it into an art form by manipulating his light source and by shifting objects around in space above the paper, thus achieving a full range of grays and a sense of three dimensions. The technique was automatist in its dependence on chance effects. Ray's invention changed a photograph from an object that recorded "reality" into an art medium in which the subject is created from the imagination. **Edmund Teske** (1911–1996), also of Los Angeles, began experimenting with photography in the 1950s, manipulating his negatives in the darkroom and exploring such techniques as multiple printings, negative/positive reversals, and offset lithography. He created *Untitled* of 1956 (fig. 25-13) by superimposing the face of a woman (Shirley Berman, wife of the artist Wallace Berman) on the scene of a demolition (Teske's grammar school in Chicago). This is one of several solutions Teske arrived at using slightly different negatives of both scenes.

California photographers were highly respected. They received wide exposure in national exhibitions, such as the University of Kentucky's *Creative Photography* of 1956, where ten of the show's seventeen artists were from the Golden State. Californians continued to distinguish themselves from their East Coast counterparts by preferring still lifes and landscapes over urban scenes.

Studio Crafts Movement (Ceramics, Furniture, Jewelry)

During the 1930s the hand crafting of items had all but disappeared, replaced by machine production and by Machine Age design. But typical of the cyclical nature of art, the postwar period witnessed a return to hand work. The trend germinated in the 1930s and was in evidence at San Francisco's Golden Gate International Exposition of 1939, where there was not only a display of modern and Scandinavian crafts but live demonstrations by American craftsmen. After the war, artists wanting to "escape" from industrialization retired to rural studios. Their aesthetic was shaped by ideas from craftsmen refugees from World War II and Zen ideas from Japan. As the craftsman population grew within California, aesthetics and technical information was disseminated through publications such as *Craft Horizons* (begun 1941) and *Ceramics Monthly* (begun 1953). Crafts began to be displayed in shows at county fairs. Museums began to hold annual design exhibitions, including the comprehensive and highly respected annual-then-triennial *California Design* at the Pasadena Art Museum. Organizations for crafts-

men were started. In ceramics, woodworking, and jewelry, Californians made nationally important advances paralleling those in America's other innovative craft centers: the Cranbrook Academy of Art in Bloomfield Hills (Michigan), Alfred University in New York, and Black Mountain College near Asheville, North Carolina.

Studio Ceramics. The studio pottery movement that grew steadily from about 1930 reached its peak about the mid 1950s. Studio pottery is marked by throwing clay on the wheel (as opposed to casting, modeling, or slab work), the reemergence of the vessel over figurines, the rejection of surface decoration for classic simplicity, and the preference for stoneware over earthenware. The changes began to occur in the 1930s when California independents, such as Glen Lukens, set an aesthetic of massive and elementally simple forms, bold and solid color, and naturalness (chapter 17). They continued in the early 1940s, spurred by ideas brought in by European refugees. In Los Angeles, the most important European émigrés were the Viennese **Gertrud Natzler** (1908–1971) and **Otto Natzler** (b. 1908), and in Northern California it was Germany/Holland's Marguerite Wildenhain (1896–1985). In Austria the Natzlers had already placed themselves in advance of the prevailing trend with their classically shaped hand-thrown and glazed vessels. Once in Los Angeles, Gertrud gained a reputation for her ability to throw notoriously thin walls (frequently one to two millimeters). Otto devised glazes whose beauty resulted from a complex balance of variables including chemical ingredients, the color of the clay over which the glaze was applied, and the temperature and manner of firing and cooling. An example is *Bowl* of 1948 (fig. 25-14). *Bowl* sports Blue Tiger Eye glaze, named by the Natzlers, a reduction glaze that results from starving the kiln of oxygen during firing. Reduction firing

Fig. 25-14
Gertrud Natzler (1908–1971);
Otto Natzler (b. 1908)
Bowl, 1948 (Blue Tiger Eye glaze)
earthenware, $3^{9}/_{16}$ x 5½ in.
Los Angeles County Museum of Art, Gift of Rose A. Sperry 1972 Revocable Trust

results in many accidental but beautiful and natural effects, such as the smoke and flame marks and the iridescence seen in this work. Making equally important innovations were longtime Southern California residents Laura Andreson (b. 1902) and William Manker (b. 1902) and Northern Californians F. Carlton Ball (b. 1911) and Antonio Prieto (b. 1912), to name a few.

An equally important influence on California's postwar studio ceramics and crafts movement came from an unlikely source—the United States' former enemy, Japan. Its Zen aesthetic was informal, direct, organic; it revered accidental effects and strove for subtle asymmetry and random abstract decoration. The Japanese aesthetic was spread in America and California by the now classic *A Potter's Book* (London: Faber & Faber, 1940), written by English potter Bernard Leach (1887–1979), and by the demonstration seminars he set up throughout the country for Japanese master potter Shoji Hamada (1894–1978).

In the 1950s, studio ceramics flourished at all levels. In the "do-it-yourself" era, it was taught as a "hobby" in adult schools and community centers and as part of the art curriculum at many of the state's colleges, universities, and professional art schools. Northern California centers existed in Oakland at the College of Arts and Crafts and at Mills College; Southern California centers were located in Claremont at Scripps

College and in Los Angeles at the Otis Art Institute, the University of Southern California, and the University of California. In the postwar period, ceramics went from being objects produced by artisans to a means of personal expression for "fine" artists. The trend culminated in the late 1950s when Peter Voulkos began using wheel-thrown vessels to make sculptures (see *Ceramic Sculpture* above). Voulkos's "revolution" gave ceramics a new direction and resulted in California's post-1960s ceramic sculpture movement (chapter 27).

Furniture. In the postwar period, the Machine Aesthetic was replaced by Scandinavian design. Slim, clean-lined, organically shaped, with their hand sanding and rubbing the pieces were more like sculptures than furniture. Such works were usually crafted out of solid pieces of wood (as opposed to the decorative veneers preferred by makers of Art Decoratif furniture), and craftsmen opted for exotic woods, delighting in their grains, colors, and tactile qualities. Varnish and high-polish finishes gave way to surfaces treated with natural wax and oil. One of California's best-known postwar studio furniture designers is **Sam Maloof** (b. 1916), still living and working in Alta Loma (about twenty miles east of Los Angeles). In designing such works as *Rocking Chair (No. 33)* of 1986 (fig. 25-15), he treats furniture as sculpture. Besides taking ergonomics (bodily comfort) into consideration, he gives careful attention to proportions, spatial divisions, and articulation of parts, especially the flow of shapes from one member to another. Exquisite craftsmanship shows up in butterfly joints, box joints, dovetails, finger joints, and dado/rabbet joints.

Jewelry. Jewelry moved away from its role as a fashion accessory (as with formal jewelry made of precious metals set with faceted gemstones) toward sculpture. In the immediate postwar years, Northern Californians **Margaret De Patta** (Bielawski) (1903–1964) and Bob Winston (active 1950s) were the only California challengers to the handful of innovative metal smiths in New York. They, along with a few others, formed Northern California's Metal Arts Guild in 1948. Winston is known for his cast work, while De Patta followed the advice of her Chicago art teacher, Laszlo Moholy-Nagy (1895–1946), to design her works as if they were sculpture. *Pin* of 1950 (fig. 25-16) is

Fig. 25-15
Sam Maloof (b. 1916)
Rocking Chair (No. 33), 1986
wood—walnut
45 x 26 x 45 in.
Private Collection
Photo: American Photo
Repro Corporation

Fig. 25-16
Margaret De Patta
(Bielawski) (1903–1964)
Pin, 1950
sterling silver, white gold,
amber, coral, malachite, onyx,
moss agate
Collection of the Oakland
Museum of California, Gift
of Eugene Bielawski, The
Margaret De Patta Memorial
Collection

very "Bauhaus" in its formal balance of geometric parts. It also shows how art jewelers preferred unusual and non-precious materials, such as amber, coral, malachite, onyx, and moss agate.

As history unrolled, California's significant art events occurred more rapidly and became more complex. The post-World War II years were very exciting for the emphasis art placed on personal expression, on experimentation, and on concept. At the same time they become very confusing. No longer can a painting be taken at face value; art suddenly contains ideas. The following chapters will show how and why post-World War II styles evolved and how they were as reflective of their social and economic times as paintings made prior to the war. 🌸

Bibliography

Art Infrastructure, 1945-1960

A Decade in the Contemporary Galleries, 1949 /1959, exh. cat., Pasadena Art Museum, July 19–September 15, 1959. 76 p.

Albright, Thomas, *Art in the San Francisco Bay Area 1945–1980,* Berkeley: University of California Press, 1985.

American Water Colors, Drawings and Prints 1952, exh. cat., Metropolitan Museum of Art, New York, December 5, 1952–January 25, 1953. 88 p.

Americans in Paris: The 50s, exh. cat., California State University, Northridge, October 22–November 30, 1979.

Andrea, I., "Since 1950," in Robert Perine, *San Diego Artists,* Encinitas, Ca.: Artra, 1988, pp. 20-23.

An Art of Wondering: The King Ubu Gallery, 1952-1953, exh. cat., Natsoulas/Novelozo Gallery, Davis, Ca., January 6–February 2, 1989.

Artists' Environment: West Coast, exh. cat., Amon Carter Museum of Western Art, Fort Worth, Tx., November 6–December 23, 1962 and other venues.

Arts of Southern California [I. Architecture (June 1957); II. Painting (January 5–February 2, 1958); III. Art in Film (May? 1958); IV. Prehistoric and Indigenous Indian Art (September 1958); V. Prints (February 1959); VI. Ceramics (February 1960); VII. Photography (Spring 1960); VIII. Drawing (October 1960); IX. Interior Design (March 1961); X. Collage (October 1961); XI. Designer Crafts (February 1962); XII. Sculpture (October-November 1962); XIII. Painting (June 1963); XIV. Early Moderns (1964?); XV. Marine Paintings (1965); XVI. Prints (1965); XVII. Painting (Introspective Image) (April 1966); XVIII. Watercolor (June 1966); XIX. Drawing (1966), exh. cats., Long Beach Museum of Art, 1957–66.

Beat Culture and the New America: 1950-1965, exh. cat., Whitney Museum of American Art, New York, November 9, 1995–February 4, 1996 and 2 other venues.

Bradley, Fred, "The Expansive Years: Santa Barbara Art and Artists 1940–1960," *Noticias,* v. XLIII, no. 1, Spring 1997, pp. 1–23.

Brechin, Gray, "Politics and Modernism: The Trial of the Rincon Annex Murals" in Paul J. Karlstrom, ed., *On the Edge of America: California Modernist Art, 1900–1950,* Berkeley: University of California Press, 1996.

"California Issue," *American Artist,* v. 14, March 1950, pp. 26–55+. [Watson, E. W., "Pruett Carter"; Penney, J., "Phil Paradise in Guatemala"; Kosa, E., "Sketching on the California Coast"; Bear, D., "The Drawings of Jack Gage Stark"; Penney, J., "The Natzlers: Masters of Ceramic Art"; Loran, E., "The Watercolor Series"; Millier, A., "The Weathervane"]

"California Special Issue," *American Artist,* v. 32, May 1968, pp. 22-80. [B. Howell, "Twelve California Sculptors"; M. Angelino, "Nelbert Chouinard"; F. Whitaker, "Watercolor in California"; J. Lovoos, "California Ceramics"; V. Shears, "California Painters in Oil and Polymer"; B. Jackson, "Go on a Bus Tour"]

Cherry, Herman, "Los Angeles Revisited," [LA art 1920–56] *Arts,* v. 30, March 1956, pp. 18-22.

Colpitt, Frances and Michael Delgado, "History Repeats Itself (Part 1)," [quotes from UCLA Oral History Program on L. A. art history] *LAICA Journal,* no. 35, Winter 1983, pp. 18-39.

"Culture in Contemporary California," in Ralph J. Roske, *Everyman's Eden: A History of California,* NY: The MacMillan Co., 1968, pp. 540-559.

Ehrlich, Susan, "Los Angeles Painters of the 1940s," *LAICA Journal,* no. 28, September/October 1980, pp. 59–69.

Fink, Jenny, "Bay Area Art Galleries, 1940s–1960s," Vinita Sundaram, "The San Francisco Art Institute, 1940s–1960s," and Jackson Dodge, "The San Francisco Museum of Art, 1940s–1960s," in *Directions in Bay Area Painting: A Survey of Three Decades, 1940s–1960s,* (Part III in the series *The Development of Modern Art in Northern California*), exh. cat., Richard R. Nelson Gallery, University of California, Davis, April 12–May 20, 1983. 36 p.

Guilbaut, Serge, "The Bongo-Bingo Art Scene," [Venice 1950s] *LAICA Journal,* no. 5, April-May 1975, pp. 22-27.

Hauptman, William, "The Suppression of Art in the McCarthy Decade," *Artforum,* v. 12, October 1973, pp. 48–52.

"History Repeats Itself, Part II," *LAICA Journal,* v. 4, no. 37, September/October 1983, pp. 35–40.

Karlstrom, Paul J., "Los Angeles in the 1940s: Post-Modernism and the Visual Arts," *Southern California Quarterly,* v. 69, no. 4, 1987, pp. 301–28.

Los Angeles Art Community Group Portrait, Oral History Program, University of California, Los Angeles, 1977–1982 [interviews of many artists, administrators, gallery owners, curators, 1974–1977]. [Typescripts located at UCLA, Research Library, Special Collections.]

Lyrical Vision: The 6 Gallery 1954–1957, exh. cat., Natsoulas Novelozo Gallery, Davis, Ca., January 12-February 28, 1990.

Maynard, John Arthur, *Venice West: The Beat Generation in Southern California,* New Brunswick: Rutgers University Press, 1991.

Meyer, Michael, "Traditional and Popular Culture: Los Angeles in the 1940s," [introduces 3 articles on art in the 1940s: fine art, film, literature] *Southern California Quarterly,* v. 69, no. 4, Winter 1987, pp. 293-99.

Morrison, Jack, *The Rise of the Arts on the American Campus,* New York: McGraw-Hill, 1973. [Thirteenth of a Series of Profiles Sponsored by the Carnegie Commission on Higher Education]

Mundt, Ernest, "New Program for an Art School," *College Art Journal,* v. 14, no. 3, 1955, pp. 236-40.

Nixon, Bruce A., "The Spatsa Gallery," *Art of California,* v. 4, no. 1, January 1991, pp. 43-45.

"On the West Coast [5 articles]" *Art in America,* v. 52, June 1964, pp. 22-59. [G. Phillips, "Culture on the Coast"; J. Coplans, "Circle of Styles on the West Coast"; P. Mills, "Bay Area Figurative"; H. J. Seldis, "West Coast Collector Wright Ludington"; M. Fuller, "San Francisco Sculptors"]

Pacific Coast Art: United States' Representation at the IIIrd Biennial of Sao Paulo [1955], exh. cat. at four institutions beginning with Cincinnati Art Museum but sponsored by the San Francisco Museum of Art, following the showing in Brazil, 1956. 24 p.

Painting and Sculpture in California: The Modern Era, exh. cat., San Francisco Museum of Modern Art, September 3–November 21, 1976, and one other venue. 272 p.

Painting and Sculpture: The San Francisco Art Association, Berkeley and Los Angeles: University of California Press, 1952.

Plagens, Peter, "From School-Painting to a School of Painting in LA [Plagens at school late 50's]," *Art in America,* v. 61, pt. 2, March-April 1973, pp. 36–41.

Plagens, Peter, *Sunshine Muse: Contemporary Art on the West Coast,* New York: Praeger, 1974.

Rolling Renaissance: San Francisco Underground Art in Celebration, 1945-1968, San Francisco: Intersection / Glide Urban Center, 1968.

Ross, K., "Gold Rush '48 [Opening of the Modern Institute in Beverly Hills]," *Art News,* v. 46, January 1948, pp. 14–17.

Schipper, Merle, "Los Angeles Art Community: Group Portrait (A Year-end Report)," *LAICA Journal,* no. 12, October/November 1976, pp. 6–7.

Seldis, Henry J., "Southern California," *Art in America,* v. 48, Winter 1960, pp. 56–59.

Temko, Allan, "The Flowering of San Francisco," [arts in SF] *Horizon,* v. 1, January 1959, pp. 5-23.

West Coast, 1945–1969, exh. cat., Pasadena Art Museum, November 24, 1969–January 18, 1970 and three other venues. 39 p.

Annual Competitive Exhibitions of the 1940s and 1950s

Annual Art Festival: Art in the Open Square, exh. cat., Union Square and Maiden Lane, San Francisco, September 24 - 27, 1953. 47 p.

Annual California Painting and Sculpture Exhibition, exh. cat., Art Center in La Jolla, 1961. 24 p.

Annual Exhibition of Contemporary American Painting, exh. cat., California Palace of the Legion of Honor, San Francisco, 1946+.

Artists of Los Angeles and Vicinity: Annual Exhibition, exh. cat., Los Angeles County Museum, 1950s.

California State Fair and Exposition, 1954 [Featuring the Permanent Art Collection], Sacramento: California State Fair and Exposition, 1954. 72 p.

50 Orange Show Art–All California Art Exhibition, exh. cat., National Orange Show Grounds, Stadium Gallery, San Bernardino, Ca., 1965. 11 p.

New Modes in California Painting and Sculpture, exh. cat., La Jolla Museum of Art, May 20–June 26, 1966. 32 p.

Pacific Coast Biennial; an Exhibition of Sculpture and Drawings by Artists of California, Oregon and Washington, Santa Barbara Museum of Art, 1955–59.

(See also Peter Plagens, *Sunshine Muse,* New York: Praeger, 1974 bibliography, for details on California's annual exhibitions.)

Sculpture, American, 1940s 1950s

Armstrong, Tom, et al., *200 Years of American Sculpture,* New York: David R. Godine in association with the Whitney Museum of American Art, 1976.

Craven, Wayne, *Sculpture in America,* New York: Thomas Y. Crowell Co., 1968.

Sculpture, California, 1940–1960

Abstract Expressionist Ceramics, exh. cat., Art Gallery, University of California, Irvine, October 28–November 27, 1966. 54 p.

Giambruni, Helen, "Abstract Expressionist Ceramics at the University of California Irvine," *Craft Horizons,* v. 26, November 1966, pp. 16–25.

St. John, Terry, "California Sculpture 1945-1960," in *One Hundred Years of California Sculpture,* exh. cat., Oakland Museum, August 7–October 7, 1982. 48 p.

Collage and Assemblage 1950s

Assemblage in California: Works from the Late 50's and Early 60's, exh. cat., Art Gallery, University of California, Irvine, October 15–November 24, 1968. 59 p.

Ayres, Ann Bartlett, *Los Angeles Modernism and the Assemblage Tradition, 1948–1962,* Ph. D. Dissertation, University of Southern California, Los Angeles, 1983.

Boswell, Peter, *Assemblage in California, 1950–1965,* Stanford University, graduate research project, 1989.

The Continuing Magic of California Assemblage, exh. cat., University Art Gallery, California State University, Dominguez Hills, January 23–February 27, 1986. 24 p.

Forty Years of California Assemblage, exh. cat., Wight Art Gallery, University of California, Los Angeles, and 3 other venues 1989 and 1990.

Lost and Found in California, Four Decades of Assemblage, exh. cat., James Corcoran Gallery, Santa Monica, Ca., July 16–September 7, 1988, at Shoshana Wayne Gallery, Santa Monica, Ca., and at Pence Gallery, San Francisco.

Pincus, Robert L., "The Open Road of Risk: George Herms, Wallace Berman, the Beats and West Coast Visionary Poetics," *LAICA Journal,* no. 34, v. 4, Fall 1982, pp. 50–55.

Solnit, Rebecca, *Secret Exhibition: Six California Artists of the Cold War Era,* San Francisco: City Lights Books, 1990.

Southern California Assemblage: Past and Present [large number of Santa Barbara artists], exh. cat., Santa Barbara Contemporary Arts Forum and College of Creative Studies Gallery, University of California, Santa Barbara, September 20–October 25, 1986 and at another shared venue in Northern California.

Folk Sculpture and Environments

Elsen, Patricia, "And in Eureka–Where will Gabriel's Garden Go?" *Artnews,* v. 78, April 1979, pp. 96-97.

Goldstone, Bud and Arloa Paquin Goldstone, *The Los Angeles Watts Towers,* Los Angeles: The Getty Conservation Institute and the J. Paul Getty Museum, 1997.

Home and Yard: Black Folk Life Expressions in Los Angeles, exh. cat., California Afro-American Museum, Los Angeles, November 7, 1987–April 3, 1988. 32 p.

Rosen, Seymour, *In Celebration of Ourselves,* San Francisco Museum of Modern Art in association with California Living Books, 1979. 176 p.

Sommer, Robert, *Mudflat Sculpture* [SF Bay], Davis, Ca.: Library Associates of the University Library, University of California, Davis, 1979. [Keepsake Number 9]

Printmaking

Acton, David, *A Spectrum of Innovation: Color in American Printmaking 1890–1960,* Worcester Art Museum in association with W. W. Norton & Co. New York, 1990.

Feinblatt, Ebria and Bruce Davis, *Los Angeles Prints 1883–1980,* exh. cat., Los Angeles County Museum of Art, September 4–November 30, 1980 and June 25–September 20, 1981.

Los Angeles Printmaking Society, annual exhibitions, 1973+?

Millier, Arthur, introd., Dr. T. V. Roelof-Lanner, compl., *Prints by California Artists,* [serigraphs, etchings, wood engr.] Los Angeles: Crest of Hollywood, 1954.

Moser, Joann, "The Impact of Stanley William Hayter on Post-War American Art," *Archives of American Art Journal,* v. 1, 1978, pp. 2–11.

Watrous, James, *A Century of American Printmaking 1880–1980,* Madison: University of Wisconsin Press, 1984.

Silkscreen/Serigraphs

"Serigraphy," in David Acton, *A Spectrum of Innovation,* op. cit., pp. 41–46.

Williams, Reba and Dave, *American Screenprints,* New York: National Academy of Design, 1987.

Williams, Reba and Dave, "The Early History of the Screenprint," *Print Quarterly,* v. 3, no. 4, December 1986, pp. 287–321.

Etching/Intaglio

Anderson, Susan M., *Pursuit of the Marvelous: Stanley William Hayter, Charles Howard, Gordon Onslow Ford,* exh. cat., Laguna Art Museum, October 5, 1990–January 13, 1991.

Edmondson, Leonard, *Etching,* New York: Van Nostrand Reinhold Co., 1973.

Drawing, American

Bolger, Doreen, et al., "American Pastels, 1880-1930: Revival & Revitalization," in *American Pastels in the Metropolitan Museum of Art,* New York: Metropolitan Museum of Art, 1989.

Cummings, Paul, *20th Century Drawings from the Whitney Museum of American Art,* National Gallery of Art, Washington, D.C., 1987.

Twentieth-Century American Drawing: Three Avant-Garde Generations, Solomon R. Guggenheim Museum, New York, 1976.

Drawings, Graphics 1930s, 1940s

Ehrlich, Susan, *Five Los Angeles Pioneer Modernists,* Ph. D. Dissertation, University of Southern California, Los Angeles, 1985.

Marsh, Graham and Glyn Callingham, *California Cool: West Coast Jazz of the 50s & 60s, the Album Cover Art,* San Francisco: Chronicle Books, 1992. 111 p

Moure, Nancy Dustin Wall, *Drawings and Illustrations by Southern California Artists before 1950,* exh. cat., Laguna Beach Museum of Art, August 6–September 16, 1982.

UCLA Art Rental Program: Graphic Arts Collection, University of California, Los Angeles, Spring 1965. 18 p.

Photography

Hachem, Samir, "Now You See Them; Now You Don't; the Distribution and Exhibition of the Avant-Garde Film in Los Angeles," *LAICA Journal,* no. 29, Summer 1981, pp. 59–63.

Katzman, Louise, *Photography in California 1945–1980,* exh. cat., New York: Hudson Hills Press in association with the San Francisco Museum of Modern Art, 1984. [catalogue for an exhibition at nine venues]

Rice, Leland, "Los Angeles Photography, c. 1940-60," *LAICA Journal,* no. 5, April/May 1975, pp. 28-37.

Studio Crafts Movement

Art at Scripps the Early Years, exh. cat., Lang Art Gallery, Scripps College, Claremont, January 23–February 28, 1988.

"California Crafts," *Design,* v. 45, May 1944, pp. 12–19.

California Design, annual exh., Pasadena Art Museum, 1955+. [Most collectible catalogues include No. 8 (1962), *California Design 1910* (1974) and *A Bicentennial Celebration* (1976).]

"California—Special Issue," *Craft Horizons,* v. 16, September 1956, pp. 11-39. [includes: Petterson, R., "A Climate for Craft Art"; Brown, C., "Peter Voulkos"; "Northern California: A Center for Experimental Jewelry"; (N. Calif. ceramics, mosaics, textiles, woodwork).

Darrow, Paul G., "The Arts in Western Living [crafts exhibit at Los Angeles County Fair]," *Craft Horizons,* v. 15, November 1955, pp. 22–27.

Golden Gate International Exposition: Decorative Arts, San Francisco: GGIE, 1939. 107 p.

Janeiro, J., "Before the '60s: the Early History of Bay Area Textiles," *Fiberarts,* v. 19, January–February 1993, pp. 32–35.

Nine Decades: The Northern California Craft Movement, 1907 to the Present [very brief history], exh. cat., The San Francisco Craft & Folk Art Museum and 2 other venues, 1993.

"Three Generations of a San Francisco Institution: Gumps," [display of crafts] *Interiors,* v. 115, April 1956, pp. 124–26.

Ceramics

Bray, Hazel V., *The Potter's Art in California 1885 to 1955,* exh. cat., Oakland Museum, August 22–October 1, 1978.

Clark, Garth, *American Ceramics: 1876 to the Present,* New York: Abbeville Press, 1987.

Folk, T. C., "The Otis Revolution," *Ceramics Monthly,* v. 38, December 1990, pp. 26–29.

Fragile Blossoms, Enduring Earth: The Japanese Influence on American Ceramics, exh. cat., Everson Museum of Art, Syracuse, N. Y., May 18–August 27, 1989 and American Craft Museum, New York, January 18–April 1, 1990.

Levin, Elaine, *The History of American Ceramics: 1607 to the present: from Pipkins and Bean Pots to Contemporary Forms,* New York: Abrams, 1988.

Revolution in Clay: The Marer Collection of Contemporary Ceramics, exh. cat., Ruth Chandler Williamson Gallery, Scripps College, October 22–December 4, 1994 and eight other venues.

Steele, Tim Tivoli, "School of the Pond Farm Workshops: An Artists' Refuge," *A Report* (from the San Francisco Craft and Folk Art Museum), v.10, no. 2, 1992.

Glass

The Memorial Windows and Other Stained Glass in the Westminster Presbyterian Church, Sacramento, California, Sacramento: The Church, 1956? 12 p.

Stained Glass Windows, Stewart Memorial Chapel, San Francisco Theological Seminary, San Anselmo, California [windows dedicated May 26, 1955], San Francisco, 1955. 22 p.

Jewelry

Lewin, Susan Grant, *One of a Kind: American Art Jewelry Today,* New York: Harry N. Abrams, Inc., 1994.

Postwar Modernist Painting

It was four o'clock in the morning. The art school was dark except for a single light deep in the basement. It illuminated a man in his mid-twenties wearing dungarees and a blue work shirt. He stood facing a stretched canvas larger than himself. He was no naive, fresh-out-of-high-school idealist—he had seen combat in World War II and horrors to which the traditional art school student had never been exposed. He had returned to civilian life eager to put the atrocities behind him, impatient to prepare for a career. Taking the government up on its G. I. Bill established to educate returning servicemen, he enrolled in art school. He had spent much of the day studying and part of it teaching art on the floors above and was now alternately chugging a beer and looking deep inside his psyche and emotions for inspiration. The room reeked of turpentine and paint, and in the far corner a record player was amplifying a New Orleans Dixieland jazz tune. The canvas was already covered with drips, splatters, wild strokes, and patches of various colors, but the fact that the painter squinted at it implied he did not consider it complete. Mentally reviewing his several years of self-study of the European art movements of the early twentieth century, he assessed whether he could use any of them to make the painting satisfactory. Suddenly he stood alert, stabbed a long-handled brush into a glob of paint, and took a swing at the canvas with the same force a prizefighter might use on his opponent. The red slash that arced across the picture was angry, violent, raw, reflective of his war experiences, his right to freedom of expression, his residence in the American West, his self-torment, his expiation in the act of creation, the proof of his existence. He stood back and judged the result, fascinated with the virile power and emotions revealed on the canvas before him, amazed and thrilled at the shape the image had taken, and satisfied by the release of pent-up creativity.

This description could fit a number of the teachers and students at the California School of Fine Arts (CSFA) in the late 1940s. Between 1946 and 1950 a particular set of circumstances on the San Francisco peninsula established an especially fertile art environment for modernist experimentation. The 1930s had warmed up to this when two of San Francisco's leading art institutions proved especially supportive of modernism. Between 1935 and 1945 the San Francisco

Museum of Art was so progressive it was considered second only to the Museum of Modern Art in New York in its embrace of avant-garde art. In 1941 Grace L. McCann Morley (director from 1935 to 1960) hired Douglas MacAgy as her assistant, and his presence in San Francisco in the summer of 1945 made him a candidate for the directorship of the School of Fine Arts. The rest is history.

The neatly attired MacAgy with his scorn for bohemians—someone whom Clyfford Still regarded as an autocratic "small army officer"—seemed an unlikely choice to provide the liberated environment needed by abstract artists. However, his mandate to update the California School of Fine Arts to national (as opposed to regional) status resulted in his ridding the faculty of the few remaining teachers who were sympathetic to Diego Rivera-type Regionalism and replacing them with artists working in modern and abstract styles. In the 1945 to 1946 school year, he gave full-time appointments to Hassel Smith, David Park, and Clay Spohn and in January 1946 hired Elmer Bischoff. In late 1946 he took on Clyfford Still and in 1947 signed up Jean Varda (1893–1971), Edward Corbett, and Richard Diebenkorn. MacAgy also freed the school from traditional institutional structure (such as giving grades, closing at night, and holding formal administrative meetings); he even organized raucous student/teacher parties at which the faculty's Studio 13 Jazz Band played Dixieland.

While many myths have arisen about the school and its postwar artists, in fact it did provide an especially nurturing environment for self-expression and allowed its teachers and students to be in the American vanguard—some would even say in advance of New York. Putting aside the back-patting rhetoric of New York art critics of the 1950s, who promoted their city's artists and largely ignored or dismissed the creativity taking place in the rest of America, it becomes evident that Abstract Expressionism was a nationwide phenomenon. New York was certainly one of postwar America's main centers for the style—its top artists, such as Jackson Pollock (1912–1956), shared an interest in gestural Action Painting. But San Francisco was definitely the other center. In San Francisco innovations were being made concurrent with those in New York, and San Francisco's abstraction was

Opposite:
Fig. 26-3
Frank Lobdell (b. 1921)
April 1957, 1957
oil on canvas
69½ x 60½ in.
Collection of Judson Lobdell

acknowledged by the Parisian press earlier than by New York's.

While the faculty members of the California School of Fine Arts cited above are now considered pioneers of Abstract Expressionism in their own rights, the most important figure is undoubtedly **Clyfford Still** (1904–1980). Raised in the harsh ranching country of Alberta, Canada, through the 1930s and the war years, Still studied and taught art in various American cities and tried out several modern styles, particularly German Expressionism, looking for a voice that personally worked for him. Following German Expressionism's dictate to look within oneself for inspiration, in the late 1930s he began to simplify his attenuated undulating figures so that, as early as 1944, in at least one canvas, he achieved totally abstracted flat shapes like those we now identify with his work. If Still produced a canvas in his signature style two years before joining the faculty at the California School of Fine Arts, can we claim his "invention" as Californian? In fact, it was in San Francisco, working in the school's basement, that he brought his "field" paintings to fruition. Solitary, secretive, far ahead of his time, his one-person show at the California Palace of the Legion of Honor in San Francisco in 1947 shocked even his contemporaries. *Untitled* of 1945 (San Francisco Museum of Modern Art) is a large canvas almost totally brown except for a "squiggle" of white and a patch of bright yellow in the lower right. (The work is reproduced in Diana C. duPont, et al., *San Francisco Museum of Modern Art: The Painting and Sculpture Collection,* New York: Hudson Hills Press, 1985, p. 151.) It achieved the clean break from European abstract and Surrealist styles for which most post-World War II artists had been struggling—not one hint of recognizable imagery, geometric abstraction, biomorphism, or automatism remained. Still's work contained the qualities that would define a standard Abstract Expressionist painting. It was large in size, nonobjective, expressive, spontaneous, and intuitive; its design continued beyond its borders, and it was free of any title that might conjure up representational images. (First labeled *Self-Portrait,* because it represented Still's inner thoughts, the artist renamed it to *Untitled* in 1979.) Sometimes an arrangement of pure colors and shapes such as this becomes decorative, but Still's forceful personality, along with the somber organic colors, makes this work raw, vigorous, violent, and profound. Not even envious co-workers could deny the work's impact, and even those with negative reactions derived strength from it for their own work.

Although Still's painting became the catalyst and inspiration for fellow faculty members and students, he followed the new method of teaching—not to dictate, but to encourage students toward their own self-realization in art. From Still came many of the ideas that made the San Francisco painters different from the New York School, including the scorn of commercialization and of self-promotion, two aspects he felt "tainted" the New York School. Still's friendship with Mark Rothko (1903–1970) induced that New York painter to teach summer sessions at the California School of Fine Arts in 1947 and 1949; Rothko's quiet personality and his art of soft coloration provided a complement to Still's.

Out of the many first-generation Abstract Expressionists, those who have stayed in people's minds are those who developed unique signature styles about 1947. (Abstract Expressionism peaked in the early 1950s and was already giving way to new styles by the late 1950s.) San Francisco had its own "stars," but their location on the West Coast and their disinterest in publicity and promotion caused them, until recently, to be placed wrongfully in the background. In the forefront of those experimenting with expression and abstraction in 1946 and 1947 were California School of Fine Arts teachers Elmer Bischoff, David Park, Hassel Smith, Clay Spohn, Jean Varda, Edward Corbett, and Richard Diebenkorn. Setting aside for later discussion those artists whose reputations lie primarily in other styles (such as Elmer Bischoff and David Park, who will be discussed with Bay Area Figurative, Clay Spohn, who is mentioned in chapter 24, and Jean Varda, who had an interest in fantasy), this discussion will address the Abstract Expressionist work of Edward Corbett, Hassel Smith, and Richard Diebenkorn.

Edward Corbett (1919–1971) spent the war years with the Merchant Marines and participated in the Battle of the Coral Sea. A brief postwar stint in New York introduced him to the abstractions of Mondrian and to the proto-Abstract Expressionist work of Ad Reinhardt (1913–1967), which led him toward pure abstraction. However, the cold purism of Mondrian was not satisfying to Corbett's poetic soul. After his move back to San Francisco in 1946, emotional and humanistic values began to creep back into his painting, resulting, by 1947, in a signature style. *Mt. Holyoke #2* of 1960 (fig. 26-1) is a late example but still exhibits the simple shapes of beautifully modulated colors that are reminiscent of the soft squares of color produced by Rothko. Corbett prefers browns, blacks, and grays to Rothko's reds and pinks. Art historians frequently refer to Abstract Expressionism as being humanistic and romantic, descriptions some find difficult to attach to nonobjective subject matter. Corbett's work is humanistic in its subtle color nuances, its organic palette, and its vaporous shapes. *Mt. Holyoke's* simplicity and

serenity also reflects 1950s artists' interest in Zen Buddhist concepts. In 1950 Corbett was producing a series of paintings that looked like black fogs parting to expose an illuminated distance. It was this series that inspired Ad Reinhardt to produce his famous black-on-black paintings. During the height of New York's action painting, Corbett's quiet works were criticized, but by the late 1950s they were recognized as precursors to art's swing toward Minimalism. San Francisco's Abstract Expressionists rarely intellectualized their canvases. Their interest in a pure visceral release of emotions and energies allows their works to be appreciated on a purely visual level without verbal rhetoric. Corbett is the one deviant from this mode. He wrote poetry, and his early 1950s use of black to reference night, gloomy thoughts, and the Cold War is now seen as expressing the Beat generation's alienation from an increasingly material society.

If Corbett's work was pillowy and soft, that of **Hassel Smith** (b. 1915) was calligraphic, joyous, witty, and jazz inspired. Unlike many of the California School of Fine Arts' Abstract Expressionists, Smith wanted his work to be affirmative; he wanted to add to life rather than dwell on personal angst. Before moving to Abstract Expressionism, Smith enjoyed comic strips and silent comedy films; his antiestablishment attitude led him to identify and humorously depict American objects that were to become Pop icons in the 1960s, including beauty queens, flags, and ice cream cones. But in 1947 Smith saw Clyfford Still's exhibition at the California Palace of the Legion of Honor, and he was astounded. Briefly, his admiration led him to produce paintings of ragged patches of color. However, Smith's penchant for calligraphic line was irrepressible, and between 1948 and 1960 he increasingly used it to tie together large areas of color. *The Buffalo Dance* of 1960 (fig. 26-2) is a prime example of Smith's mature style that coalesced after he moved in 1955 to a small apple orchard in Sebastopol, a rural community about forty miles north of San Francisco. Like the Dixieland jazz he admired, it is marked by zest. Some viewers claim to see erotic imagery—phallus, breasts, and buttocks—in his shapes, although Smith disclaims having intentionally painted such things. The artist liked to title his works with intriguing phrases he encountered in random sources such as newspapers and magazines. The term "Buffalo Dance" was commonly used in mid-nineteenth-century periodicals as a caption for pictures of Plains Indians dancing in costumes made from buffalo skins and heads. In typical manner the title—along with Smith's signature and the date—appears on the canvas.

Fig. 26-1
Edward Corbett
(1919–1971)
Mt. Holyoke #2, 1960
oil on canvas, 68 x 50 in.
Collection of the Chase
Manhattan Bank

Fig. 26-2
Hassel Smith (b. 1915)
The Buffalo Dance, 1960
oil on canvas, 69 x 68 in.
Gail and Edwin Gregson

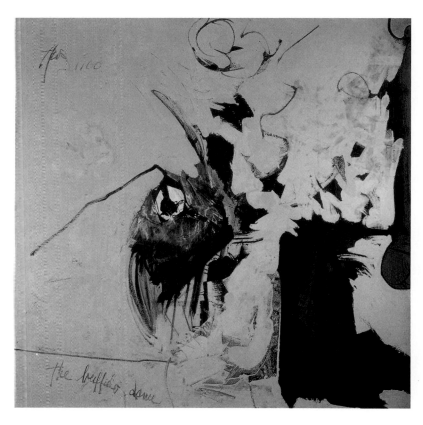

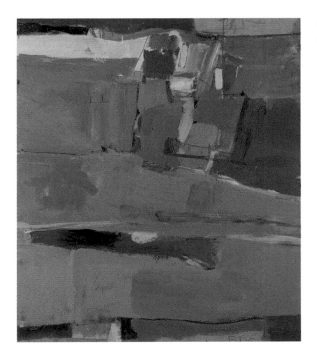

Frank Lobdell (b. 1921), who also reached a signature style before 1950, distinguished himself with predominantly black paintings that are both introspective and spiritual. A later example is *April 1957* of 1957 (fig. 26-3, p. 336). While an art student in St. Paul, Minnesota, in the late 1930s, Lobdell had practiced pure, hard-edge abstraction, but its severity left him unsatisfied. Then he saw how Picasso infused power and emotion into certain of his figural abstracts, and Lobdell decided that he, too, wanted to stir emotions with his art. When he took up his art career following World War II, he was haunted by the hideous memories of maimed and charred humanity that he witnessed while serving as an Army lieutenant. He was attracted to the existential philosophy that was then enjoying general popularity, which regarded the universe as hostile and man's survival in it based on will (as opposed to logic). Both of these influences are reflected in Lobdell's visually mature 1950s paintings that seethe and boil with nebulous spectral forms emerging out of an impenetrable void. For San Francisco's Abstract Expressionists it was important to show themselves untouched not only by styles developed in New York but by the work of their own mentor, Clyfford Still. Although highly impressed by Still, Lobdell evolved his own vocabulary of shapes. The human

mind, in its need to make its world rational, tries to form recognizable objects of these, perceiving a hand and fingers, coiling intestines, bleached pelvic and shoulder bones, or parallel scratches as if with fingernails. Lobdell himself refuses to conjecture about their meaning, if any. His serious message—humanity struggling against an unsympathetic universe—is conveyed with monochromatic "colors," primarily black and white. His lumpy, twisting, Baroque shapes that suggest a questing soul make him the Abstract Expressionist who comes closest to being a philosopher and an existentialist. The physical crudity of his work approaches the "blistered slab" style associated with San Francisco Abstract Expressionism, whose artists became fascinated with the surface textures they could achieve by pooling and dripping paint, by mixing it with sand, and by using rugged brushwork.

Richard Diebenkorn (1922–1993) was a student, then a teacher, at the California School of Fine Arts during Abstract Expressionism's germinal years of 1946 and 1947, but he didn't come into his own style until after a three-year residence in Albuquerque, New Mexico (early 1950 to late 1952). Historians recognize the sojourn as a crucial interlude that freed him from the domination of Still and the style of the San Francisco school and allowed him to take a direction more suited to his personality—toward landscape and brighter colors. Diebenkorn had his breakthrough inspiration in 1951 while observing the landscape between Albuquerque and San Francisco from an airplane. Upon his return to the Bay Area in 1953 he developed his ideas in his Berkeley Series, such as *Berkeley, #4* of 1953 (fig. 26-4). These consist of muted pastel-colored, semi-architectonic shapes vaguely reminiscent of cultivated fields seen from the air. When that series was exhibited in New York in 1956 critics hailed him.

It seems an injustice to California's Abstract Expressionism to say that it ended three years after it started. What about some of the other first-generation West Coast abstract painters who were as timely and as sincere in their attempts to express their emotions on canvas? What about the Sausalito Six, who sometimes get overlooked because they distanced themselves from the group at the California School of Fine Arts, determined to preserve their artistic integrity. In the late 1940s, the Sausalito Six began meeting spontaneously in one another's studios and soon began exhibiting together. They were George Stillman (b. 1921), Walter Kuhlman (b. 1918), James Budd Dixon, Frank Lobdell, Richard Diebenkorn, and John Hultberg (b. 1922). Stylistically unalike, each depended on his own background and personality to give individuality to his Abstract Expressionist canvases.

James Budd Dixon (1900–1967) was almost a generation older than his fellow artists. He, like Hassel Smith, was of a lighter personality than most of San Francisco's Abstract Expressionists; he had been a cartoonist on his college newspaper. Reaching his mature style by 1948, he continued it through the 1950s. Generally, San Francisco's Abstract Expressionists did not ascribe to Action Painting as did the New Yorkers. Possibly because of Still's influence, they expressed their emotions with patches of color rather than runaway gesture and drawing. However, the San Francisco artist who seems to come closest to New York's Action Painting is Dixon, as demonstrated in *Red and Green #1* of about 1948 (fig. 26-5). Like New York's Jackson Pollock he opts for an allover field pattern. While Pollock created pattern by dripping and pouring layers of paint, Dixon achieved his with layer upon layer of brushwork. A San Francisco "look" is evident in this painting's rough surface of thick, clotted paint and raw, vigorous brushstrokes that overlay each other in a dense mat. His colors are a primitive shout of reds, blacks and whites, with a hint of yellow, blue or green.

In summary, San Francisco Abstract Expressionism differed in several important ways from that generated in New York. San Franciscans, inspired by Still, rejected New York's commercialization of painting and looked down on the creation of art personalities. The Californians had contempt for intellectualizing and theorizing, which they believed got in the way of direct emotional expression and moral purity. San Franciscans preferred patches and shapes to the New York School's gestural Action Painting; they liked thick surfaces and dark, angst-ridden colors.

Second Generation Abstract Expressionism and Funk

Around 1950 several changes brought an end to the idyllic situation at the California School of Fine Arts. The G.I. Bill ended, stripping both the school and the students of financial support. MacAgy left the directorship, and the school went into the hands of Ernest Mundt (chapter 25), whose mandate was to put it in a financially viable position. Several of the important Abstract Expressionists left the state, for New Mexico (Spohn, Corbett, Still, McChesney, and briefly Diebenkorn), for New York (Ernest Briggs, Jon Schuller, and Edward Dugmore), and for Paris. In Paris an early-1950s exhibition of the expatriates Sam Francis, Claire Falkenstein, Frank Lobdell, Walter Kuhlman, and Lawrence Calcagno thrilled the Parisian critic Michel Tapié, leading him to call them *école du Pacifique*. Parisian praise prompted New York critics to acknowledge a

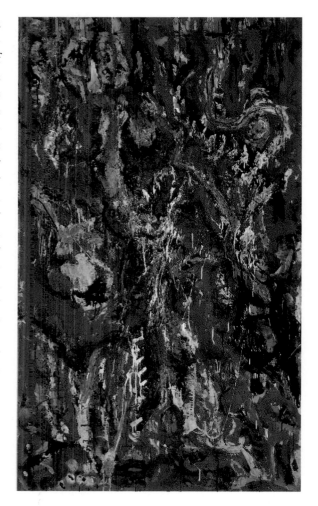

West Coast school of Abstract Expressionism in 1953.

In the early 1950s, when the California School of Fine Arts ceased as the center of Abstract Expressionist activity, artists of that persuasion formed other loci on the San Francisco peninsula—particularly at the studios, galleries, and "Beat" coffee houses and bars in the North Beach area and an area just south of the Marina district, where Union crosses Fillmore. At the time San Francisco's first-generation Abstract Expressionists were producing their classic work, a second generation was rising up. Among the most notable of the latter were Ernest Briggs (1923–1984), Lawrence Calcagno (1913–1993), Edward Dugmore (b. 1915), James Kelly (b. 1913), Robert McChesney (b. 1913), and John Saccaro (1913–1981).

The second generation differed greatly from the first. These artists had learned Abstract Expressionism from local teachers but were also influenced by the Action Painting going on in New York (the latter was promoted by the powerful critics Clement Greenberg and Harold Rosenberg). The second generation accepted women, where previously only ex-servicemen who used four-letter words were among the "initiates." (Actually

Fig. 26-5
James Budd Dixon
(1900–1967)
Red and Green #1, c. 1948
oil on canvas
84¼ x 49⅞ in.
The Buck Collection, Laguna Hills, California
Photo: Bliss

Madeleine Dimond (1922-1991), an ex-U.S. Navy Wave who attended the California School of Fine Arts on the G.I. Bill, was one of very few women active in the first generation.) (See also Jay De Feo, chapter 31.)

Los Angeles Abstract Expressionism

There is no rule that every style executed in New York, had to have California proponents. In fact, Los Angeles can claim no Abstract Expressionist during the style's formative years of the late 1940s. In the early 1950s, Los Angeles's "modern" artists were still tied to representation by their reverence for art leader, such as Rico Lebrun. Most struggled to resolve the formal dichotomy between representation and abstraction (chapter 22), while Lorser Feitelson and a few others explored hard-edge abstraction (see Abstract Classicism, chapter 30). In the generation active throughout the 1950s, only a few were able to achieve complete nonobjectivity, among them Sueo Serisawa (b. 1910), whose paintings reveal a knowledge of Far Eastern calligraphy, and Richards Ruben (b. 1925), who reached profound magnificence in his late 1950s Claremont Series.

In the late 1950s, a few of Los Angeles's rising avant-garde artists began to produce completely nonobjective works. In all the style periods discussed so far, the repeated tendency has been for San Francisco painters to create darker, more serious paintings and for Southern California artists to use sunnier colors and to have a more joyous outlook. The personality trait reveals itself again with Abstract Expressionism. In the mid-to-late 1950s the precocious Craig Kauffman (b. 1932), working on his master's degree in art at the University of California at Los Angeles shared a studio with a fellow student, Ed Moses (b. 1926), and the experienced painter John Altoon (1925-1969). About 1957 all three gravitated to the Ferus Gallery— Kauffman because of his high-school friendship with Walter Hopps, Moses thanks to Kauffman's introduction, and Altoon after meeting Ed Kienholz, one of the gallery's two owners. In the late 1950s and early 1960s, the three artists independently produced expressive, nonobjective canvases. Some attribute the blossoming of Abstract Expressionism in Los Angeles to a show of such painting held at the city's main museum in the mid 1950s, others to the ideas and work of the ceramist Peter Voulkos (chapter 25). However, Los Angeles artists had no doubt seen paintings in the style reproduced in art journals and on visits to the East Coast. It is significant that the work of these three shares a rough similarity: a white field (as opposed to the dark fields prevalent in the Bay Area); floating and brightly colored, nonrepresentational shapes created in a variety of techniques (splotching, staining, dripping, brushing); and no interest in rough texture. Some of this aesthetic may have derived from the admiration Kauffman and Moses had for the work of Sam Francis (1923–1994), the San Francisco Abstract Expressionist then working in Paris. (See fig. 30-7.) (Moses, who also admired Jackson Pollock, understandably ended up with an allover patterned field— his first theme, dainty roses and grasses seen from a bird's-eye view. Kauffman's work is distinguished by vaguely phallic shapes (he will be discussed with plastics, in chapter 30).

John Altoon received a barrage of influences through the 1950s. Briefly and rapidly between World War II and 1956, he studied at several Los Angeles area art schools, enjoyed success as an illustrator, and was exposed to New York's Abstract Expressionists during a residence in that city. After his return to Los Angeles in 1956, he began to seek an individual artistic voice, producing the early-1960s *Ocean Park* series, of which *Ocean Park Series* of 1962 (fig. 26-6) is one. Altoon brushed brightly colored, biomorphically shaped patches on a white ground, sometimes tying them together with a calligraphic line. Historians see precedents in the work of earlier abstractionists, such as Arshile Gorky, also of Armenian heritage like Altoon. But Altoon's colored patches also take on the shapes of recognizable objects. A frequent theme was sex, and some patches look like phalluses, testicles, and vulvae. Others take the shape of hearts and kidneys, while yet others are reminiscent of animals, such as birds and caterpillars. In 1964 his acquisition of an airbrush led to a series of works on paper. In these he adapted the imagery he evolved in his oil-on-canvas works, isolating one or two biomorphic shapes against a colored background.

In the mid 1960s Los Angeles Abstract Expressionists were augmented by two former San Francisco Abstract Expressionists who had always been an anomaly in the north since they worked with light colors. The first to join the growing cluster of artists living in Santa Monica (on the Pacific shore, west of downtown Los Angeles) was Sam Francis in 1962. Returning to California from his sojourn in Paris and stays in Asia, he continued to paint stained and speckled bands of bright acrylic colors on white fields. (See his *Abstraction*, fig. 30-7.) From the mid 1960s to the mid 1970s, the former San Franciscan Richard Diebenkorn created one of his most successful series, the geometric and nonobjective *Ocean Park*, named after the Venice street on which his studio was located (fig. 35-5).

Bay Area Figurative Painting

If an art style doesn't grow, it dies. Most styles evolve, as does the work of individual artists. It is not unexpected, therefore, in the fast-paced environment of the 1950s, to see a movement as important as Abstract Expressionism begin to change after only a few years.

Even while San Francisco's Abstract Expressionism was taking shape in the late 1940s, there were forces at work creating its successors. Some of its proponents began to mix Abstract Expressionist ideas with those of the Beats, and they came up with Beat painting and Funk (chapter 31). Another faction applied its vigorous brushwork to the human figure, and it came up with Bay Area Figurative painting.

David Park (1911–1960), a member of the California School of Fine Arts faculty before Clyfford Still's arrival in late 1946, not only chaffed at the attention and preference accorded Still, but felt like a square peg trying to fit into a round hole when he produced purely nonrepresentational paintings. In 1950, at his peak as one of Abstract Expressionism's first generation, Park heretically exhibited a work containing a recognizable subject, *Rehearsal,* a scene of an orchestra. But it was *Kids on Bikes* of 1950 (fig. 26-7), winner of an award when it was exhibited at the San Francisco Art Association annual in 1951, that elicited cries of astonishment. (Park's first figural paintings had been produced without even telling his close friends Bischoff and Diebenkorn.) Park's colleagues wondered what he could be thinking. Was his figuration a backward step from the nonobjectivity of Abstract Expressionism? Or did it signal the beginning of a new and valid movement reflecting the twentieth-century's repeated pendulum swing between abstraction and representation? Did his return to figuration demonstrate California's natural preference for realism over abstraction; was it a drift back to normalcy?

Kids on Bikes, considered Bay Area Figuration's seminal work, retains some characteristics of Abstract Expressionism—gestural brushwork, the mixing of paint directly on the canvas, and the creation of an image during the act of painting, without preliminary sketches or guidelines. It is new in its representational subject matter. In this work Park resolves the era's conflict between two and three dimension by bringing his figures right up against the picture plane. The illusion of space is created by a "foreground" figure abruptly juxtaposed with a second figure whose small size implies its greater distance from the viewer. The artist provides no atmospheric perspective; and the background is solid color, without horizon line. In regard to color, he continued the tawny, organic hues of his abstract work; and he makes the work striking with the bold white

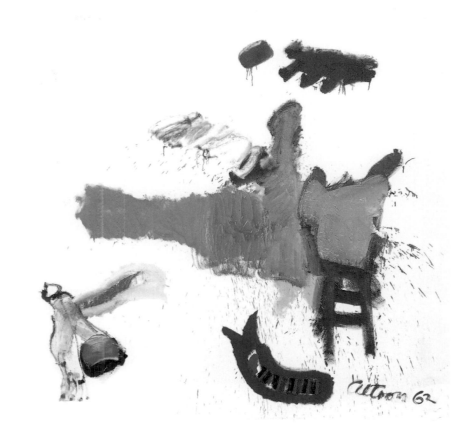

Fig. 26-6
John Altoon (1925–1969)
Ocean Park Series, 1962
oil on canvas, 72 x 84 in.
Collection of Orange County Museum of Art; Museum purchase with additional funds provided by Dr. James B. Pick and Dr. Rosalyn M. Laudati, Mr. Ward Chamberlin, Mrs. E. G. Chamberlin, Patricia Fredericks, Mr. and Mrs. Carl Neisser, Mr. and Mrs. John Martin Shea, Mr. and Mrs. Samuel Goldstein, Zada Taylor, Mr. David H. Steinmetz and Mrs. Bernard McDonald

Fig. 26-7
David Park (1911–1960)
Kids on Bikes, 1950
oil on canvas, 48 x 42 in.
Curtis Galleries,
Minneapolis, Mn.

shape of the cyclist's shirt. Although Park's subjects are engaged in middle-class activities, he employs them not for their narrative value but, like the academic painters described in chapter 22, for their poses that satisfy his compositional needs. In Park's early 1950s paintings the figures are clothed, while in his later 1950s works they are nude. Often their outsize hands and feet make them look like adolescents; their coarse facial features are realized with just a few sweeps of a paintbrush. Although criticized for his figures' neutral facial and bodily expressions, Park strove to create a universal and timeless individual to whom everyone could relate. Figuration proved the solution to Park's personal frustration with Abstract Expressionism. With figures as subject, he found that his painting's form and formal aesthetics were solved naturally.

Park was not the only artist harboring desires to paint figuratively. His former fellow teachers and painting friends Elmer Bischoff and Richard Diebenkorn found that their return to figuration was made easier by the early-1950s upheaval at the California School of Fine Arts. It set them adrift, along with most of the other experimental teachers, and freed them from the domination of Still and the school. At the same time, without jobs, the early 1950s proved a financially difficult time. Diebenkorn continued his career outside California; Park was supported for a few years by his wife, and Bischoff took a job driving a delivery truck until he obtained a teaching position in a rural town. However, all continued painting and exhibiting, and by 1955, when the three former California School of Fine Arts friends rejoined in weekly figure drawing sessions organized by Diebenkorn in Berkeley, figuration was so generally practiced in the Bay Area it was no longer startling. That year and the next, the three obtained important teaching jobs (Park at the University of California, Berkeley; Diebenkorn at the California College of Arts and Crafts in Oakland; and Bischoff back at the California School of Fine Arts in San Francisco). This allowed them to spread their tastes to students on both sides of the bay. In the late 1950s the revitalized California School of Fine Arts became a center for figurative art with teachers Diebenkorn and James Weeks.

Elmer Bischoff (1916–1991) admits to the excitement he felt being part of the Abstract Expressionist

scene at the California School of Fine Arts. But he ultimately found the style's formal goals unsatisfying. After leaving the school and during a brief period when he supported himself as a driver of a delivery truck, he used his coffee breaks and lunch hours to draw, sketching objects that he observed from the cab of his truck. Ultimately he began to paint representationally. In a typical work, such as *Orange Sweater* of 1955 (fig. 26-8), one figure, seen from the waist up, is shown in a room against an architectural backdrop. The figure is passive, motionless, and seems withdrawn and isolated. The scale of the canvas and "room" are immense, but the figure occupies only the lower half of the canvas, and the overtone is one of quiet and intimacy. A viewer may invent a story for this individual, who seems to be studying in a library, but Bischoff's goal was to represent feeling with color and light. For this reason some critics have called him an "abstract impressionist." To deemphasize the identity of the objects, Bischoff simplifies them and blurs them, leaving only the vague shapes and colors; the orange sweater and the gray-green room become color accents in a nonobjective composition

Richard Diebenkorn also had a natural affinity for representation but had been suppressing it to paint abstractly. However, buoyed in 1953 by the defection to figuration of the noted New York Abstract Expressionist Willem de Kooning (1904–1997) and by the rising number of Bay Area artists taking it up, Diebenkorn jettisoned his considerable status as a nonobjective painter and in 1955 began painting figures and landscapes. In 1955 he initiated a weekly session of drawing from the figure at his Berkeley studio, to which he invited Park, Bischoff, and others. By the end of 1956 Diebenkorn was fully committed to figuration. His favorite subject became the single, passive individual presented against an abstracted interior or exterior setting, which he rendered with slashing, expressive brushwork. *Figure on a Porch* of 1959 (fig. 26-9) is immediately distinguishable as his work by the geometric breakup of the setting and by the bright, almost proto-Pop colors. If a viewer squints his eyes, this looks like a completely nonobjective composition. The fabled California sunshine is referenced in the postcard colors and the sharp and contrasting shadows

About 1955 figurative painting was taken up by many Bay Area artists, including James Weeks (b. 1922), Theophilus Brown (b. 1919), Paul Wonner (b. 1920), Nathan Oliveira (b. 1928), the sculptor Manuel Neri (b. 1930), Bruce McGaw (b. 1935), and **Joan Brown** (1938–1990). Brown had an early and brilliant rise to stardom. Without any childhood training in art, some quick sketches gained her entrance to the California School of Fine Arts, where she spent a difficult first year and even contemplated leaving. In the summer of 1956, however, she took a painting class from Elmer Bischoff and was exposed to reproductions of work by Goya, Velazquez, and Rembrandt that made her realize she wanted to be a painter. She immediately began to create figure paintings. In 1959, when Brown was still in her early twenties, the New York art dealer George Staempfli noted the strength of her expression, gave her a one-person show, and got her work into museum venues, resulting in her receiving national awards for achievement. About the time she began painting *Girl Sitting* of 1962 (fig. 26-10), called the

masterpiece of her figurative period for its aggressive use of color and impasto, she turned to her own experiences and surroundings for subject matter. The sitter may be Patty Jordan, the wife of a filmmaker and an instructor at the California School of Fine Arts. She was the quintessential Bay Area Figurative model, recognizable for her pronounced facial features: a large nose, a severe overbite, and an almost negligible chin. A monumental figure of stolid strength, she is recognizable not only in Brown's canvases but in those of other painters affiliated with the school. Brown usually used Bay City paints, an inexpensive brand known for its buttery texture and translucent hues. Her bold brushwork and thick gobs of paint, sometimes applied with a trowel, proved that David Park's style could be extended, and her work served as an inspiration to many others.

Bay Area artists' swing towards figuration was acknowledged in 1957 by the Oakland Museum's exhibition *Contemporary Bay Area Figurative Painting*. The movement was heralded as the first nationally important art style to be generated in Northern California.

Although the painters never formally organized with a manifesto, it was a "movement" in that it consisted of individuals whose work had visual similarity. Unlike New Yorkers, Californians were generally not interested in verbally articulating their aesthetic concerns, nor were they caught up in theorizing or intellectualizing their works.

Even as San Francisco was basking in the importance of Abstract Expressionism and Bay Area Figurative painting, America's postwar lifestyle was propelling artists onward. Life was speeding up. Art critics had placed a premium on innovation. Eager to be rewarded with praise, a place in history, celebrity status, and substantial financial remuneration, artists sought the new. The 1960s became a kind of renaissance as all styles and media were examined in a burst of creativity. The decade's many non-painting media will be investigated in the next few chapters. ✳

Bibliography

Abstract Expressionism

Sandler, Irving, *The Triumph of American Painting: A History of Abstract Expressionism*, New York: Harper & Row, 1970.

Abstract Expressionism, Bay Area 1945–1960

Albright, Thomas, *Art in the San Francisco Bay Area 1945–1980*, Berkeley: University of California Press, 1985.

Art as a Muscular Principle: 10 Artists and San Francisco, 1950–1965: Roots and New Directions, exh. cat., John and Norah Warbeke Gallery, Mount Holyoke College, South Hadley, Ma., February 28–March 20, 1975.

California School: Yes or No?, exh. cat., Oakland Art Museum, February–April, 1956.

The Carlson Gallery, San Francisco, *Abstract Expressionists: An Exhibition and Historical Survey of Northern California Abstract Expressionists Active 1945–1960: Walter Kuhlman* (October 19–November 17, 1989); *Works on Paper 1946–1948 John Grillo* (December 7–January 3, 1990); *The New Geometry including Paintings Exhibited in the Six Gallery Show During the 1950s: Dimitri Grachis* (January 6–30, 1990) 10 sheets; *The Arena Series, Paintings, 1958–1962 Robert McChesney* (February 1–28, 1990); *John Saccaro: Paintings, 1952–1962* (March 3–31, 1990); *Lilly Fenichel, the Early Paintings* (May 5–31, 1990); *Edward Dugmore: Paintings, 1948–1953* (June 9–July 6, 1990) 17 p.

Crehan, Hubert, "Is There a California School?" *Art News*, v. 54, January 1956, pp. 32–35+.

Directions in Bay Area Painting: A Survey of Three Decades, 1940s–1960s, (Part III in the series The Development of Modern Art in Northern California, edited by Joseph Armstrong Baird, Jr.), exh. cat., Richard R. Nelson Gallery, University of California, Davis, April 12–May 20, 1983. 36 p.

Frank, Patrick, *Vanguard Art and Thought at the California School of Fine Arts*, graduate research project, George Washington University, 1989.*

Hurd, Ruth, "Abstract Expressionism," *Art of California*, v. 2, no. 2, April/May 1989, pp. 29–34.

Landauer, Susan, *The San Francisco School of Abstract Expressionism*, exh. cat., Laguna Art Museum, Laguna Beach, Ca., January 27–April 21, 1996 and San Francisco Museum of Modern Art, July 18–September 8, 1996; published by University of California Press.

Leonard, Michael, "The Golden Age of Bay Area Painting [1945–1950]," *Art of California*, v. 2, no. 4, August/September 1989, pp. 12–19.

McChesney, Mary Fuller, *A Period of Exploration: San Francisco 1945–1950*, exh. cat., The Oakland Museum, 1973.

Plagens, Peter, *Sunshine Muse: Contemporary Art on the West Coast*, New York: Praeger, 1974.

Smith, Richard Candida, *Utopia and Dissent: Art, Poetry, and Politics in California*, Berkeley and Los Angeles: University of California Press, 1995.

Abstract Expressionism, Los Angeles

Abstraction 5 Artists: John Altoon, Sam Francis, Craig Kauffman, John McLaughlin, Ed Moses, exh. cat., Nagoya City Art Museum, March 17–April 22, 1990 and two other museums in Japan.

Ball, Maudette W., *Southern California Artists: 1940–1980*, exh. cat., Laguna Beach Museum of Art, July 24–September 13, 1981.

Bay Area Figurative Painting

Bossart, Joan, "Bay Area Figurative Painting," in *Directions in Bay Area Painting: A Survey of Three Decades, 1940s–1960s*, (Part III in the series The Development of Modern Art in Northern California, ed. by Joseph Armstrong Baird, Jr.) exh. cat., University of California, Davis, April 12–May 20, 1983.

Figurative Mode: Bay Area Painting, 1956–1966, exh. cat., Grey Art Gallery and Study Center, New York University, March 27–April 28, 1984 and Newport Harbor Art Museum, June 20–September 15, 1984.

Finch, Christopher, "Art: Bay Area Figurative Painting," *Architectural Digest*, v. 53, March 1996, pp. 120–25.

Jones, Caroline A., *Bay Area Figurative Art 1950–1965*, University of California Press and exh. cat., San Francisco Museum of Modern Art, December 14, 1989–February 4, 1990.

THE ART
RENAISSANCE:
1960–1975

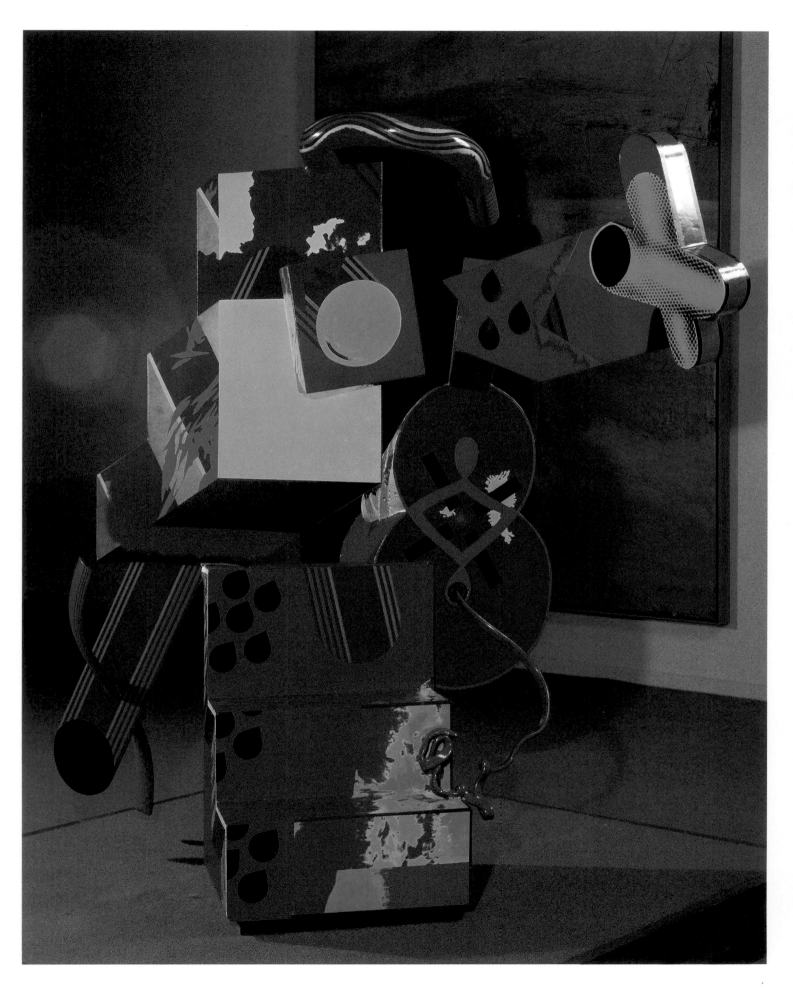

1960–1975: Growth of the Arts & Non-Painting Media—Sculpture

1960–1975

The period between 1960 and 1975 was the most exciting that American art had yet experienced. For the first time culture became an integral part of American life, artistic innovations abounded, and American artists took the lead in the international art scene. For California, it was the decade in which Los Angeles vied with New York for leadership of American art.

When John F. Kennedy assumed the presidency in 1961, a spirit of youth and optimism seized the nation. Intellectuals and liberals were given posts in the administration. Californians embraced Rolfing and est, cruised Sunset Strip and Hollywood, surfed at Malibu Beach, luxuriated in hot tubs, cooked with crock pots, and acted sexy in mini skirts. People of means had more leisure time and filled it with cultural pursuits. At the same time, America's racial minorities were not enjoying the same privileges as their white counterparts. Crime increased, and the trendy illegal drugs were no longer the mild marijuana but the vision-inducing LSD and mescaline. In the middle of the decade, the assassinations of Kennedy and Martin Luther King, Jr., shook political confidence. As the United States took it upon itself to police the rest of the world, the country became embroiled in several unpopular wars, principally in Vietnam.

Replacing the Beats of the 1950s were the hippies (or flower children), who drove beat-up Volkswagons, lived communally, dispensed free love, and attended open-air rock and folk music concerts. The generation that had grown up in the 1950s knowing security and affluence, suffered a collective guilt for the inequities of the system. Like the Beats, hippies advocated dropping out, but at the same time they believed they could change conditions. Youth volunteered for social reform programs—such as the Peace Corps. Protesters called for the end of the Vietnam war by holding parades, demonstrations, sit-ins, and love-ins. Blacks, Chicanos, and Native Americans demanded equality with the Anglo-Saxon majority. Many of the important protests took place in the Bay Area at the University of California, Berkeley, and in Golden Gate Park. The hippies' philosophy of "do your own thing" resulted in many young people going into artistic fields rather than business.

Art

In the 1960s, art world activities accelerated, propelled by the Kennedys and their image to Americans—an attractive couple, both from wealthy families, who espoused art and culture. Jackie Kennedy began redecorating the White House with fine art and antiques, and the couple sponsored cultural programs and dinners to honor America's creative elite. The administration changed tax laws to support culture. Incentives encouraged corporations to invest in art, entrepreneurs to open commercial art galleries, and the wealthy to donate money and art to nonprofit institutions. Besides the growth of a number of important public, corporate, and private collections of contemporary art, many new museums were established, almost half specifically for modern or contemporary art. Older museums and college art departments were improved and expanded, new ones established. "Minorities" entered the mainstream, creating uniquely individual themes and styles and banding together to start their own "alternative" spaces, community centers, and co-op sales galleries. Art history became a popular discipline in institutions of higher learning. With technical improvements in the printing of color illustrations, there followed a flood of beautifully printed, expensive picture books and exhibition catalogues. For the first time, intense scholarly attention was devoted to American art. The National Endowment for the Arts, the California Arts Council, and any number of newly established private and corporate nonprofit foundations increasingly supported art publications, exhibitions, and artists. Abstract Expressionism had brought American art to the forefront of the international art world and turned artists into celebrities. Critics and museums convinced collectors to purchase art, and, in turn, collectors' money fanned the rise of prices and the opening of new galleries. As art quickly increased in value, it began to be regarded as an "investment."

For artists, innovation became the goal. Although Walter Keane (b. 1920) and his wife Margaret (b. 1927), both of San Francisco, who painted waifs with doe-like eyes, were the most popularly known artists of the decade, America's exciting avant-garde would soon ascend to public attention. Art experimentation became possible because many artists not only earned their

Opposite:
Fig. 27-6
Robert Hudson (b. 1938)
Double Time, 1963
painted metal, 58¾ x 50 in.
Collection of the Oakland Museum of California, Gift of the Women's Board

livings as art teachers but did so at colleges and universities where ideas, rather than craft or popular appeal, counted. Other artists supported themselves with a variety of lectureships, grants, scholarships, stipends, and residencies. In turn, the flood of art graduates spread their idealist philosophy through their teaching positions at new campuses. California artists joined a world community and moved in and out of New York and Europe as equals to their East Coast counterparts.

Art Infrastructure in California after 1960
Between 1960 and 1990 California cities clanged with the sounds of construction on cultural complexes. Because many of the largest towns already had a *general* art museum, most new institutions adopted a specialized focus. Almost thirty museums/galleries were established to display contemporary art; much of this was by Californians, who had suddenly stepped to the forefront of art. As interest grew in historic California art, more than thirty-two new museums/university galleries identified their mission as some aspect of the state's art. Another thirty specialized in formerly minor media or disciplines, such as craft and folk art, photography, art by "special interest" groups, cartoons, or ceramic tiles, to name a few. Numerous historical societies, which formerly concentrated on non-art aspects of history, developed an interest in local *art* history. Museums were supplemented with a new form of gallery—"alternative spaces." These group-run, grant-funded exhibition sites supported and fostered work that appealed to a small part of the populace, such as radical avant-garde art or art by special-interest groups.

Los Angeles. In the late 1950s, the center of California's avant-garde shifted from San Francisco to Los Angeles, where artists connected with the Ferus Gallery (1957-66) were leading the nation with art that was made of glass and plastic and that explored human perception. Postwar population growth had turned the megalopolis of Los Angeles into a fifty- by seventy-five-mile wide patchwork quilt of communities, each with its own personality, tied together by ribbons of freeways. Los Angeles was awash with "new" money stimulated by artists' innovations and eager to ride the chic bandwagon of contemporary art. By the 1970s, the city was acknowledged nationally as America's Second Art City as well as the New Art Capitol, expanding its old identity as the media capitol of the world.

Across the megalopolis, culture sprouted like sown seed. As Los Angeles' art world burgeoned, its center moved westward, and artists began to cluster in low-rent areas in the canyons of the Santa Monica mountains and in the then seedy beach town of Venice (which some authors compared to Greenwich Village

Fig. 27-1
Los Angeles County
Museum of Art, 1965,
exterior
Los Angeles County
Museum of Art

Fig. 27-2
California Institute of the
Arts, Valencia, from the air,
1997
Courtesy California Institute
of the Arts, Valencia
Photo: I.K. Curtis Services,
Inc.

in New York or Montmartre in Paris). Art museums increased in numbers: in 1965 the Los Angeles County Museum of Art (LACMA) broke off from the Museum of History, Science and Art (of which it had been part since 1913) and moved into new facilities in Hancock Park (fig. 27-1). The Pasadena Art Museum, although beset by funding problems, opened an innovatively designed new structure on its Carmelita site in 1969. Other museums expanded, including the wealthy Getty Museum in Malibu. Many museums were dedicated to contemporary art: California artists were excelling in the field, it was relatively inexpensive to collect, and exhibitions could be put together easily from the works of local artists and the holdings of local collectors. Museums that specialized in pre-1960 contemporary American and California art included LACMA and the Virginia Steele Scott Gallery of American Art at the Henry E. Huntington Museum in San Marino. Contemporary artists were given shows at Long Beach Museum of Art, the Los Angeles Municipal Art Gallery, and the Otis Art Institute, to name a few. College and university galleries played a crucial role by presenting "fringe" shows of works by emerging artists or of esoteric aspects of American and California art. Especially important were the new Art Galleries at the University of California at Los Angeles, headed by Frederick S. Wight, as well as the galleries at state college campuses in Fullerton and Long Beach, the galleries of the Claremont Colleges, the University of Southern California Art Galleries, and those at Pepperdine College and Immaculate Heart College.

Commercial galleries clustered along La Cienega Boulevard where, in the first half of the 1960s, Monday night "Art Walks" brought out as many as 2,000 people to stroll, eat at local restaurants, and ogle the bizarre modern styles. Art schools grew, and in 1961 the Chouinard Art Institute joined with the Los Angeles Conservatory of Music under the title California Institute of the Arts (CalArts). By 1971, a substantial bequest from Walt Disney enabled it to move into an extensive new campus in Valencia, about thirty miles north of Los Angeles (fig. 27-2). Employing many avant-garde teachers from the East and with visual art existing on the same site as music, dance, and theater, CalArts became a center for and promulgator of conceptual art. It billed itself as the Bauhaus of the West and compared itself to the avant-garde Black Mountain College in North Carolina (chapter 36). Otis merged with Parsons, but few commercial art schools were established, as the teaching of art was taken over by the state's college and university system.

Bay Area. In the Bay Area the most important museum for collecting and showing contemporary art continued to be the San Francisco Museum of Art (SFMMA). When the museum's longtime director Dr. Grace L. McCann Morley stepped down in 1960, her successor, George D. Culler, supported by the museum's Society for the Encouragement of Contemporary Art, put even greater emphasis on contemporary art from the region. Second in importance was the San Francisco Art Institute (renamed in 1960 from the California School of Fine Arts). The California Palace of the Legion of Honor and the M. H. de Young Memorial Museum joined under one administration and took the new name The Fine Arts Museums of San Francisco. Pockets of art emerged throughout the city. The North Beach area, just north of Chinatown and south of Coit Tower, had always been a bohemian stronghold; there, avant-garde galleries such as the Dilexi rubbed shoulders with alternative showplaces for Funk and performance, with the City Lights bookstore, and with coffeehouses, restaurants, and bars. Other galleries clustered south of the Marina along Fillmore, and art galleries for historic art grouped in the downtown area. In the East Bay, in 1969 and 1970 respectively, The Oakland Museum (fig. 27-3) and the

Fig. 27-3
Aerial View of Oakland Museum
Courtesy Oakland Museum of California

351

Fig. 27-4
University of California,
University Art Museum (now
the Berkeley Art Museum
and Pacific Film Archive)
Courtesy Berkeley Art
Museum and Pacific Film
Archive
Photo: Ben Blackwell

University of California (fig. 27-4) opened architecturally significant new complexes. New art centers were established in towns such as Richmond and Berkeley. The Bay Area's long-term art schools remained strong and were joined in importance by the art department at San Francisco State College.

Santa Barbara. The Santa Barbara Museum of Art added a wing in 1961 and in 1983 underwent a massive renovation that included a six-story addition. In 1960 the city gained a second art gallery at its new University of California campus, and in 1976 the private, nonprofit Contemporary Arts Forum was begun to showcase the growing number of avant-garde artists in the Santa Barbara area. In 1960 commercial art galleries were almost nonexistent; to fill this gap local artists opened the cooperative Gallery 8, and Esther Bear opened a gallery for contemporary art (in her own home) that lasted until 1975. In the 1970s Santa Barbara was becoming a weekend getaway for Los Angeles's wealthy, and antique shops, crafts galleries, and art galleries proliferated. The most important art schools in the area were at the University of California in neighboring Goleta, the Brooks Institute in the Riviera (for

photography), Westmont College in Montecito, and the short-lived (1967–73), private Santa Barbara Art Institute.

San Diego. The Fine Arts Gallery in San Diego opened its Timken Gallery and its west wing in 1965 and 1966 respectively. In 1979 the gallery's name was changed to San Diego Museum of Art. The area's main center for contemporary art was the La Jolla Art Center, now the Museum of Contemporary Art, San Diego. In 1972 the Museum of Photographic Arts was begun and in 1983 finally found a home in one of the buildings in Balboa Park. The San Diego Historical Society mounted important exhibitions of historical San Diego art in the 1980s. Art teaching centered at San Diego State College and at the University of California at San Diego, opened early 1960s.

Outside Major Metropolitan Areas. Between 1960 and 1980, as a result of California's growing population, formerly rural towns began to develop art infrastructures. East of the Bay Area one of the most important schools to emerge was the University of California, Davis, near Sacramento. South of the Bay Area important research/exhibition spaces opened at San Jose State University as well as at deSaisset Art Gallery and Museum in Santa Clara. In Monterey, Carmel, and Santa Cruz, galleries run by the Monterey Peninsula Museum of Art, the Carmel Art Association, and the Santa Cruz Art League professionalized and expanded. Southward from Los Angeles, the asparagus and tomato fields of Orange County began to be replaced by a massive "planned community" whose upper-middle-class residents had an appetite for the arts that provided the impetus for the construction of cultural complexes. In Newport Harbor, art supporters incorporated in 1961 to show contemporary art and in 1968 took the name Newport Harbor Art Museum. The Laguna Beach Art Association took the name of the Laguna Art Museum and by the early 1980s decided to focus on California art. In 1992 the Bowers Museum in Santa Ana opened an addition making it six times its original size. The area currently has many important college and university galleries, in particular the progressive University of California at Irvine. In the inland deserts, a new building for the Palm Springs Desert Museum opened in the fall of 1974, and significant expansion has occurred since then.

Art in California 1960–1975/80

After two centuries on the periphery of the western art world, California began to shed its provincial identity and even to assume a place in the front ranks of American art. This move to front and center began in the late 1940s, when San Francisco's Abstract Expressionists challenged those of New York. It continued in the 1960s when Los Angeles artists innovated with "Glass and Plastics," and it persisted in the 1970s when Northern Californians generated the figurative ceramics movement. California's *Artforum* (1962) became the most respected national magazine covering avant-garde art.

California's cultural worth was acknowledged after 1960 as the nation, in general, dropped its ramrod-up-the-back attitudes and began to admire the touted "laid-back" California lifestyle. California artists were able to innovate precisely because they were unimpressed and unintimidated by things held sacred in the East, including East Coast "art heroes," art historical pressures, tradition, wealth, and ancestry, to name a few. And, without a documented local art historical tradition on which to base their art, California artists turned to new sources for inspiration: to the motion pictures, the car culture, a fast-paced popular culture, the technology of the aerospace industry, nature, and their own souls. California artists had their own take on life that was reflected in their art as fantasy and humor.

In the period 1960–75 modernism declines while postmodernism emerges. (For a discussion of modernism, see p. 321.) Through the 1950s, modernist painters, fulfilling the advice and predictions of the New York art critic Clement Greenberg, eliminated all the "unnecessary" aspects from their art until they ended up with not much more than a canvas covered with a flat unmodulated color—the Minimalism discussed in chapter 30. By the late 1960s, some critics considered painting dead. Certainly art could take no more reduction or elimination.

Artists reacted in various ways. Some artists turned back to all those aspects of art that the modernists had eliminated: realism, emotion, human themes, narrative, and so forth. After 1960, any art that contains any of these qualities is considered "postmodern." This term can be confusing because it has a dual meaning. Postmodern not only covers the *individual art styles* that arose in opposition to modernism of 1945-65, but to *the whole period* after modernism met its demise, i. e., from about 1970 onward. The postmodern period is also termed "post-studio," meaning that much of the important art (performance, video, sculpture, site installations, public art, etc.) is made outside the studio, on site. The period is also called "*post-object*," because artists objecting to the commercialization of art in the 1960s turned to art forms that were *not* "object like" and could *not* be marketed, such as conceptual art, performance, site installations, and earth art.

These two basic philosophies—modernism and postmodernism—are reflected in all the media in which artists worked. Painting continued to have its advocates, but many artists found it more rewarding and interesting to work in media that had not been exhausted by experimentation and innovation, such as sculpture (below), printmaking, photography, and crafts (chapter 28), and even new media that came into being in the 1960s (chapter 29).

In discussing art after 1960 art historians enter a difficult area. Most of the art now contains "ideas." The meaning behind each artwork and movement can be very complicated, and artists, critics, teachers, and historians involved in it hold very strong opinions. It is *not* in the scope of this book to go into depth regarding the nuances of meaning and social and political ramifications of the myriad styles and hybrid media that developed after 1960. This book's goal is to present in an orderly fashion the main trends, to explain each simply so that it can be distinguished from the others, and to reproduce one or two examples of each. This is a *descriptive* rather than a *theoretical* presentation.

The Golden Age of California Sculpture 1955–1975

Forever gone were modest, naked figures on pedestals. After 1960, sculpture took off in many directions and was taken up by so many artists that sculpture grew to rival painting in importance. Generally speaking, the early 1960s were dominated by Minimalist sculpture, often in the form of huge outdoor pieces associated with newly constructed high-rise buildings. In the mid-to-late-1960s a few Los Angeles artists explored the perceptual properties of glass and plastics, while Bay

Fig. 27-5
Alvin Light (1931–1980)
November 1964, 1964
wood with pigmented epoxy
98⅜ x 59 x 61⅛ in.
San Francisco Museum of
Modern Art, Gift of the
Women's Board
Photo: Phillip Galgiani

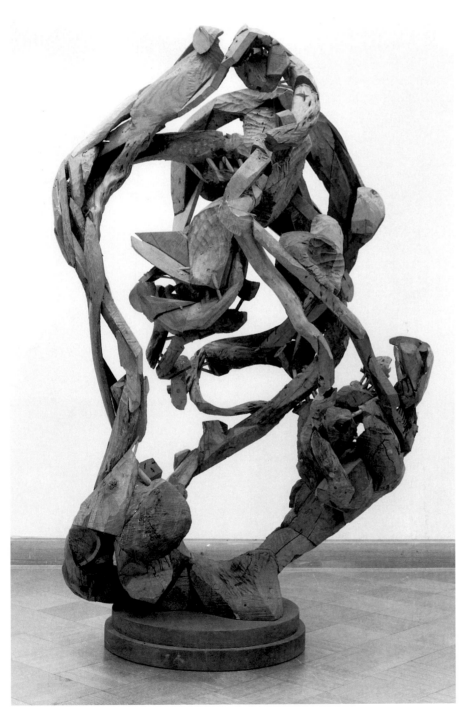

Area artists moved into the realm of small-scale ceramic sculpture. Starting in the late 1960s, sculptors who rejected the commodification of art turned to making "non-object" "sculpture," i.e., temporary or non-physical works that could not be sold. These were often site installations (chapter 29) and included works by of Los Angeles's important Light and Space artists as well as earthworks.

In the 1970s, known as the "pluralist" decade for the many art styles and media that were pursued parallel to each other, many sculptural forms that came into being in the latter 1960s enjoyed their fluorescence. Generally speaking, sculpture evolved in size, style, and ideas. The large earthworks of the late 1960s and early 1970s that destroyed the land gave way to the ecology movement and to projects that healed the land. When large-scale sculpture became too costly, many sculptors returned to making smaller pieces. Traditional representational, object-oriented sculpture re-emerged. The art form of assemblage became, in the hands of Latinos, home altars, and for others, such as the black artist Betye Saar (b. 1926), a purveyor of social statements. Since about 1980, assemblage sculptures made by artists such as Nancy Rubins (b.1952) have become statements on ecology. Sculptors also have taken advantage of new electronic devices, such as computers, to make their works move, emit sound, and/or respond to viewers. The elitist sculpture gardens of the 1960s gave way to "art for public spaces."

Abstract Expressionist Sculpture. In the late 1950s and early 1960s a few California artists essayed sculpture that shared aesthetic qualities with the earlier Abstract Expressionist painting: nonobjective subject matter, raw energy, expression, organic shapes, and allover treatment. San Franciscan **Alvin Light** (1931–1980) made his in wood. In *November 1964* of 1964 (fig. 27-5), he joined his rawly cut pieces of wood into a lattice work. Not only is the work expressive, but the matted mass of components follows the allover treatment of space (as opposed to one center of interest) preferred by Abstract Expressionist painters. Sculpturally, the mass *encompasses*, rather than takes up, space. Mark di Suvero (b. 1933), who trained in the Bay Area in the 1950s but who took up residence in New York in 1957, meshed abstraction and expression with the era's predilection for reusing detritus when he made industrial-scale sculpture out of discarded timbers and girders.

Small-scale Wood, Metal, and Ceramic Sculpture. In the 1960s, large-scale sculpture may have attracted most of the attention, but small-scale sculpture was made in greater quantities. Large-scale sculpture was primarily Minimalist in style, while smaller sculpture

was made in all the traditional styles, shapes, and themes, plus some new ones. Materials of all kinds were explored and ranged from traditional media such as ceramics, metal, and wood, to new substances such as plastic and all the former matter identified with crafts (glass, jewelry, wood, and fiber). Whereas large-scale sculpture was frequently abstract, small-scale sculpture was more frequently representational and sometimes relaxed to humor, social comment, or narrative. The small-to-modest size and less expensive materials allowed more artists to realize their ideas more quickly and cheaply.

In the early 1960s modernism's dominance led artists to work in forms of abstraction and to explore formal aesthetic questions. In San Francisco, **Robert Hudson** (b. 1938), who worked and taught at the San Francisco Art Institute, merged the area's tradition of assemblage with his personal talent at welding metal to arrive at a unique type of painted metal sculpture in which he explored how color could define or distort form. The concept of colored sculpture may seem like a departure from tradition, but throughout history sculpture has been colored, whether it was "intrinsic" (the natural color of wood, stone, metal, etc.) or "extrinsic" (applied after the fact to the exterior). The 1960s fashion for bright, painted sculpture paralleled the employment of bright colors in Geometric Abstraction and Pop painting (chapters 30, 32). Hudson applies color to his metal abstraction *Double Time* of 1963 (fig. 27-6, p. 348) not as a traditionalist, to bind the eccentric, angled parts together, but to further disassemble them. He breaks down solid shapes with stripes or other decoration and uses paint's matte or shiny finish to change the surface quality of whatever material it covers. Color distinguishes one part of a sculpture from another, makes the parts visually advance or recede, and establishes mood.

Hudson developed his sculpture in the early 1960s, a time when San Francisco was touting a homegrown style that critics called "Funk." A difficult term to define, Funk wasn't a "movement" but more a general antimodernist (anti-New York Minimalism; anti-Los Angeles Glass and Plastics) attitude that led Bay Area sculptors of the early 1960s into many different antimodernist paths and provided them with a cause they could call their own. If modernism (and Minimalism)

advocated a single unified object and geometric motif, purity of form, and freedom from any intrinsic idea or message (chapter 30), Funk was just the opposite. Funk attitudes led artists to representationalism, to eccentricity, to take up personal themes, and to imbue their work with humor, wit, and irreverence. Funk's materials and techniques were also antimodernist. They derived from the Bay Area movements that immediately preceded Funk—Beat assemblage's preference for used and nostalgic materials—as well as the ceramic medium's recent expansion into sculpture. Funk was spurred by the Bay Area's then weak gallery scene, which offered no "reward" to artists who catered to a moneyed audience, allowing Bay Area artists to produce art for themselves and friends. Funk was first shown at the artist-originated *Slant Step* show, held at the Berkeley Gallery in San Francisco in 1966, and received art historical christening and definition at the *Funk* show at the University Art Museum, Berkeley in 1967. Almost immediately afterward, it lost steam as a "movement." At the time, writers wishing to support their arguments for the Bay Area having its own movement gathered under Funk's umbrella any sculptural object that showed antimodernist qualities. This included Robert Hudson's anti-Minimalist *Double Time*, with its eccentric shape and its humor. Today, historians do not interpret Funk so liberally. In retrospect they recognize it as one of the earliest of the backlashes to modernism. Funk has left its permanent label on only certain of the Bay Area's early 1960s sculptors, primarily those makers of ceramic sculptures marked with a Dada irreverence, such as Robert Arneson. Funk's label has also been removed from most of the ceramic sculptors of the second half of the decade, who prefer to be identified with the area's strong post-1965 ceramic object movement. Early writers and scholars describe Funk as having two generations—the junk-based Funk of Beat assemblage and the more refined Funk of the early 1960s, made with new and more permanent materials. Two artists, both teachers at the University of California, Davis, have been labeled leaders in early 1960s Funk—William Wiley, who promulgated "Dada" Funk, and Arneson, who promoted "Pop" Funk.

William Wiley (b. 1937) started out as an Abstract Expressionist painter but by 1962 was adding found

objects to his paintings and eventually worked only with the objects themselves, making pieces like *Thank You Hide* of 1970–71 (fig. 27-7). This wall-hung sculpture/construction is made up of six watercolor paintings as well as objects accumulated from various sources. The hide came from a rummage sale; the book by Nietzsche was a gift from a friend, and the title was a spontaneous utterance made by Wiley himself while reading the Nietzsche book. One day Wiley assembled these objects in his studio, working intuitively, spontaneously selecting interesting objects with shapes or colors that seemed to satisfy what the composition needed. The concept of "assembling" obviously descends from the Beat assemblage tradition (chapter 25) that

immediately preceded Funk, but Wiley's components are of a newer, more finished, more permanent quality, reflective of second-generation Funk. Since the grouping is usually displayed in a room, the artwork could also be described as an installation. Wiley's work is narrative and autobiographical. He used the hide as a "net" to join objects that had personal relevance: the Indian artifacts refer to his childhood occupation of sifting the ground for them in Washington State; the broken bottle was brought to him by a friend. The hide seemed shaped like a map of the United States; at the time, Wiley equated maps with the idea of travel. A New York critic deemed Wiley's work in this vein a version of the neo-Dada art that was then being practiced by a few artists in New York. Because it took place in the West and had an intentionally corny rather than profound basis, the critic coined the term Dude Ranch Dada. Wiley's unprejudiced attitude toward what could be art was extremely liberating to his students.

Much of Funk sculpture was made of ceramic, and the leader in that movement was Wiley's fellow teacher at the University of California, Davis, **Robert Arneson** (1930–1992). Arneson began his artistic career as a potter, but in the early 1960s, aware of Peter Voulkos's reintroduction of ceramic as a *sculptural* medium, he began to make objects. An example of his early art is the fired and glazed stoneware *Pisser* of 1963 (fig. 27-8). Like the fabric hamburgers of New Yorker Claes Oldenburg (b. 1929), this ubiquitous item rendered as an art object becomes Pop. Its medium of ceramic, its grotty (funky) appearance, and its irreverence are clearly Northern California. To carry out his ideas, Arneson switched from the high-fire stoneware he used during his vessel-making period to low-fire earthenware that could carry colored glazes. He experimented chemically with glazes to achieve finishes that helped convey his meaning. Arneson's brief Pop phase was succeeded by a longer and better-known *non*-Funk phase in which he depended on his self-portrait and his facial expressions to comment metaphorically on the human condition. To his students he passed on his interest in ceramics and representational subject matter, his humor (puns and surreal juxtapositions), and his interest in personal mythology.

As early as the mid 1960s, thanks to Arneson's instruction, there was a budding group of ceramic

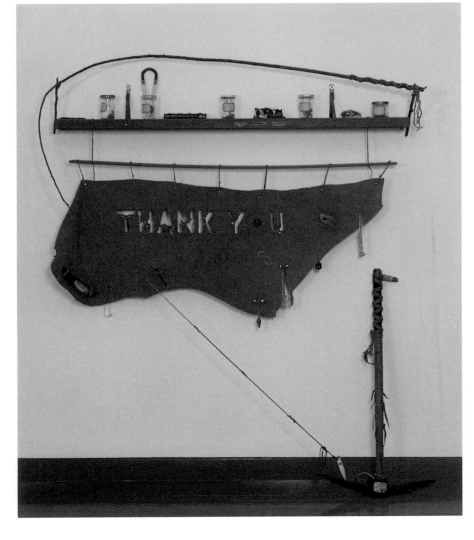

sculptors at the University of California, Davis. Once unleashed on the medium, artists took it in all directions, some toward fantasy and myth (a predilection or taste that pervaded Northern California in the 1960s and 1970s; see chapter 31), some toward miniature tableaux, and still others in the direction of the "super object." So many artists made valuable contributions to the field that it is impossible to do them justice here. Several general statements might describe this work. It is *not* Funk, but it does retain certain of Funk's qualities—interest in representationalism, irreverence, and a sense of humor. It appropriates imagery from many eras and regions, and it brings into the realm of "high" art motifs from Pop and kitsch. Most ceramic sculptors employed Arneson's techniques of earthenware and colored glazes, while some went on to use porcelain clay. In the1970s, small-scale ceramic sculpture exploded as the new and exciting sculptural medium and continues to be popular today.

By the mid 1970s, the *trompe l'oeil* "super object" emerged. The art form originated in the early 1970s when **Richard Shaw** (b. 1941) and Robert Hudson began making molds of actual, everyday objects into which they cast porcelain, a very fine-grained, high-fire, white clay. They combined their casts with other objects they had thrown on the wheel to arrive at a grouping. At the same time, their experiments with underglazes and china paints on porcelain's matte white surface allowed them to achieve a *trompe l'oeil* skin. Shaw soon added photo silkscreen to their techniques. Shaw's interest in fantasy and in fabricating objects to look real began during his childhood in Hollywood and visits to Disney studios, where his father worked. Super objects such as *Stack of Books Jar #2* of 1978 (fig. 27-9) caught the imaginations of ceramic sculptors across the United States. Through the 1970s, ceramic sculpture began to be documented in publications and collected by and exhibited in museums.

Meanwhile in the Los Angeles area, students of Voulkos were taking ceramics in their own direction and spreading their ideas through teaching positions at area college and university art departments. Southern California artists frequently retained the vessel shape, although they made it unusable by piercing its walls, by flattening it, by cutting it up, and by "pasting" the parts back onto the surface. Ceramic artists, like

Fig. 27-8
Robert Arneson (1930-1992)
Pisser, 1963
stoneware
51 x 27 ½ x 11 in.
Collection of Orange County
Museum of Art,
OCMA/LAM Art
Collection Trust; Gift of the
Contemporary Collectors
Council; © Estate of Robert
Arneson/ Licensed by
VAGA, New York, NY

Fig. 27-9
Richard Shaw (b. 1941)
Stack of Books Jar #2, 1978
porcelain with decal
overglazes, 9¼ x 10¾ x 9 in.
Richard Shaw and
Braunstein/Quay Gallery

Fig. 27-10
Peter Voulkos (b. 1924)
Mr. Ishi, 1969
cast bronze
216 x 592 x 246 in.
Oakland Museum of
California, Gift of Concours
d'Antiques, Art Guild and
the National Endowment for
the Arts

painters, began to "appropriate" in their case vessel profiles, decorative appendages, and painted surface decoration from traditional ceramics and to use them in new ways. (See appropriation, chapter 36; crafts, chapter 28.)

Bronze Sculpture. Bronze, superseded by newer sculptural materials after 1915, made a comeback in the 1960s in the hands of **Peter Voulkos.** In 1959, after he left the Los Angeles County Art Institute ("Otis") for a teaching position at the University of California at Berkeley, and frustrated with the size limitations of ceramic sculpture, he turned to casting bronze. Starting with small pieces cast at a foundry on campus, he soon took over a corner in a commercial foundry on the Berkeley waterfront that came to be called Garbanzo Works, and before 1970 he expanded again. Without real experience with cast bronze, he and his fellow artists learned the art as they went, striving for larger and larger pieces. Voulkos's earliest works are reminiscent of Assemblage—bronze casts of existing objects that could be burned out of a mold—items such as dead birds, which Voulkos displayed altar like on tables. Others, such as *Mr. Ishi* of 1969 (fig. 27-10), named after the last surviving Yahi living an aboriginal existence and discovered in 1911, may resemble

large-scale Minimalist sculpture, although that was not the artist's goal. In these, Voulkos again derived his shapes from found objects, but the shapes were simple geometric forms. These include a dome cast from a large cooking kettle, a cube, a "doughnut" derived from an old inner tube, and flat sheets. The "doughnut" was sometimes cut in half and reassembled like loopy toothpaste, causing some critics to describe his sculpture as Baroque. Often, parts would be cast ahead of time and the final work assembled on the spot. Placements of his works at their permanent sites became "happenings," with forklifts, crowds of assistants, an audience, and the "performance" complete with welding torch that brought the piece to its final form. Bronze intrigued Voulkos for twenty years.

A contemporary sculptor who has employed bronze in *representational* sculpture is **Robert Graham** (b. 1938). The dominant sculptural trend in the first half of the twentieth century was toward abstraction, but, predictably, in the postmodern period some sculptors returned to realism. Graham is one of several across the nation who concentrate on making highly realistic human figures. He began in the mid 1960s making miniature (less than one foot tall) figures of clay, then wax, which he assembled into narrative tableaux

that he "preserved" under a Plexiglas box cover. Even on the tiny scale, his anatomy was perfect. Since then his scale has increased, and he has progressed through figures the size of *Heather* of 1979 (fig. 27-11), which are displayed on tall pedestals, to lifesize sculptures, such as the gateway that he fashioned for the Olympic Games held in Los Angeles in 1984. Today's realist sculptors of the human figure are distinguished from their forerunners by their insistence on specific rather than idealized realism. Graham's peers in New York, sculptors such as Duane Hanson (b. 1928) and John DeAndrea (b. 1941), go to the extent of making casts from real humans and employ new materials such as vinyl, plastic, and real clothing to give their figures a *trompe l'oeil* appearance. Graham may use new technology, such as a video camera, to record the movement of his models—by studying each "frame" he can "freeze" a pose he prefers—but he primarily models from life. Graham makes "portraits" of the human figure. He prefers to model from dancers and athletes whose physical training has developed their bodies to a certain level of perfection from which his art takes off. He strives for reality—the proportions of these figures show they belong to specific individuals rather than some ideal—but then he idealizes the volumes by stripping them of hair and blemishes. Although the figures are nude, neither their nudity, poses, nor treatment of flesh is meant to be erotic. His figures are neutral, dispassionate, detached, and self-contained.

Plastic and Glass. Southern California, for years the bastion of the conservative, finally made the art world take notice in the 1960s when some Los Angeles artists began to work with the relatively new material of plastic. Why did it happen in Los Angeles? The city was home to manufactories associated with the surfing world and the aerospace industry, and these plants were fabricating plastics. While many plastic pieces are small, **DeWain Valentine** (b. 1936) and others, who apprenticed with commercial factories and then purchased their own (expensive) equipment, eventually learned to cast huge pieces, such as *Concave Circle* of 1970 (fig. 27-12). Plastics (among them Lucite and acrylics) introduced totally new aesthetic qualities to sculpture. They were transparent and contained or refracted light. Plastics had "inherent" color that varied not only with the natural qualities of the various polyesters and resins but with thickness and with the way light was refracted within the object. Plastics could be cast or vacuum formed as well as carved, sanded, and polished. The perfection and purity of Los Angeles's plastic sculptures almost make them icons to technology itself. Valentine's lens-shaped pieces become

Above:
Fig. 27-11
Robert Graham (b. 1938)
Heather, 1979
cast bronze, oil paint
68 x 9 x 4 in.
Malcolm Lubliner, Courtesy
Robert Graham Studio

Left:
Fig. 27-12
DeWain Valentine (b. 1936)
Concave Circle, 1970
cast polyester resin
70½ x 72½ in.
Milwaukee Art Museum,
Gift of Friends of Art; © De
Wain Valentine

Fig. 27-13
Fletcher Benton (b. 1931)
Balanced/Unbalanced Wheels,
1982
steel (painted)
30 x 25 x 6 feet
Collection Mr. and Mrs.
Eugene Klein
Photo: Lee Fatherree

perceptual fields of color. Various names have been given to Los Angeles's innovators of the 1960s, including "Glass and Plastic," "Finish Fetish," and the "L.A. Look" (chapter 30). These innovations made Los Angeles a serious challenger to New York as first art city in America. When the Ferus artists realized the dangers to their health that came from working with plastics, they transferred their exploration of human perceptions and of light and space to glass and to room installations.

Large-scale Sculpture. Large-scale sculpture seemed to be the arena that an artist needed to enter if he or she wanted to garner notice. It was also the sculptural form most frequently used for public situations. Not only was America itself identified with the big and vigorous, but large sculpture came into being to complement America's new multistory highrise buildings. While the sleek-sided, post-1960s International style buildings left no surface for traditional facade sculpture, they often used freestanding sculpture in the lobby, on an entry plaza, within the exterior landscaping, or in associated sculpture gardens. For Californians who travel by car, large-scale sculpture could be perceived easily from a freeway or city street and at high speeds. Large-scale discrete sculpture differed from traditional sculpture in that it was no longer raised up on a pedestal to be admired from the perimeter. Generally it was set at ground level (or even hung on a wall), and it was sometimes made up of parts (multiples or sections, sometimes referred to as serial) that the viewer could walk among and within. Sculpture became "site specific," that is, concerned with how it fit into its particular site, and grew to mammoth size (as in earthworks) or became multimedia (as in installation and scatter art).

Minimalist Sculpture (also called "Primary Structures" and "ABC Sculpture"). In the late 1960s, following the move of modernist painters toward simplification, sculptors in both halves of the state, particularly in Southern California, began to produce Minimalist sculptures. Minimalism's pure geometric shapes and occasional color represent the last step in modernism's evolution, where all things extraneous to a medium were jettisoned. **Fletcher Benton** (b. 1931) provides a prime example with his *Balanced/Unbalanced Wheels* of 1982 (fig. 27-13). Many Minimalist sculptures were similar to assemblages in that they were "additive" or "constructive" (as opposed to carved or modeled). Here Benton has "assembled" basic geometric forms such as cylinders, triangles, and rectangles. According to the theories of perception in Gestalt psychology, simple geometric shapes were most easily understood by the mind. The Bauhaus identified three

perfect forms: cube/square, sphere/circle and cone/triangle. Minimalist sculptures were also "classic" in that they strove for order, stability, permanence, balance, and stasis. This particular piece is made from the decade's popular medium, steel (favorites were Cor-Ten, painted or stainless). Minimalist sculptors further purified their art by keeping color homogeneous and opting for smooth and well-fabricated surfaces. The materials came to be appreciated for themselves. The well-known cubes of glass (not illustrated) made by sculptor Larry Bell show how California artists conformed to national movements but gave them their own twist—in Bell's case, the material of glass and the issue of visual perception. In a way, large-scale Minimalist sculptures made from industrial materials of ceramic, steel, and plastic (as well as the bronze works by Voulkos) idealized and romanticized America's industrial landscape, as had Precisionist paintings of the 1920s and 1930s.

Sculpture Gardens

The traditional sculpture garden consists of a plot of land upon which sculpture is distributed. Some gardens contain pre-made sculpture, while others hold sculpture specifically commissioned for a particular spot. Gardens usually provide walkways and benches so that viewers can contemplate the pieces. Sculpture gardens have been in existence since ancient times but proliferated in America and California in the 1960s, thanks to the trend for corporations and municipalities to improve their communities' "quality of life" through city beautification with art. (Many cities require one percent of any new building's cost to be spent on art.) Several of California's sculpture gardens are located on the campuses of the state's colleges and universities. Others are associated with high-rise complexes, such as the Noguchi Sculpture Garden at South Coast Plaza or the Syntex Corporation headquarters near San Francisco, where gardens provide a place for those employed in skyscrapers to enjoy a respite while on work breaks and at lunch. Still others result from city and county urban beautification projects (such as Esprit Park and Estuary Park in the Bay Area). One of the few cities to create a garden for sculpture is Oakland. Its garden snakes along a twenty-two acre corridor stretching from Lake Merritt in downtown to Estuary Park on the San Francisco Bay. It functions not only to display sculpture in highly trafficked areas but provides open areas around bayfront upscale housing sites that can also be used for recreation. The small inland city of Brea in Southern California has distinguished itself with its aggressive city beautification program that has added many sculptures (fig. 27-14). The balmy weather in California, especially Southern California, makes it an ideal geographical area for establishing complexes for outdoor art. 🐾

Fig. 27-14
Sculpture, City of Brea

Bibliography

Infrastructure, American, General 1960–1980

Atkins, Robert, *Art Speak: A Guide to Contemporary Ideas, Movements, and Buzzwords,* New York: Abbeville Press, 1990.

Bonito Oliva, Achille, *Europe/America: the Different Avant-Gardes,* Milano: Deco Press (a branch of Franco Maria Ricci editore), 1976. 304 p.

Brown, K., "About California [Claes Oldenburg's opinions on working in the state]," *Vision,* no. 1, September 1975, pp. 5–7.*

Lucie-Smith, Edward, *Late Modern: The Visual Arts since 1945,* New York: Oxford University Press, 1975. 288 p.

Morrison, Jack, *The Rise of the Arts on the American Campus,* New York: McGraw-Hill, 1973.

Seitz, William C., *Art in the Age of Aquarius 1955–1970,* Washington, D. C.: Smithsonian Institution Press, 1992.

Infrastructure, California, General

(See also bibliography for public school art education in chapter 37)

Art in Public Buildings Report, Office of the State Architect, State of California, July 1978.

Arts in California: A Report to the Governor and the Legislature by the California Arts Commission on the Cultural and Artistic Resources of the State of California, 1966.

Baum, Hank. ed., *The California Art Review,* Millbrae, Ca.: Celestial Arts, 1981.

California Arts Commission, *Touring Art Exhibitions: the California Experience,* Sacramento?, 1972. 32 p.

"California Special Issue [7 articles]," *Art News,* v. 72, Summer 1973: Esterow, M. "The Los Angeles Art Scene"; Kinnard, J., "New Museums in Southern California"; "In the Southern California Galleries"; Wilson, W., "The L. A. Fine Arts Squad"; Tarshis, J., "Blossoming of the Bay Area"; Selz, P., "Six Artists in Search of a Definition of San Francisco"; "Marmer," "Womanspace," pp. 21–39.

"California—Special Section," *Art News,* v. 74, January 1975: "Vasari Diary: Superstar picks Top 40"; P. Gardner, "Hollywood Collectors"; J. E. Young, "Nicholas Brigante"; E. K. Canavier, "California Design 1910"; "California Reviews," pp. 16+, 38–56.

"California - Special Section," *Art News,* v. 75, January 1976: E. Perlmutter, "Hotbed of Advanced Art [U of C, Irvine]"; A. Frankenstein, "Ceramic Sculpture of Robert Arneson"; T. Albright "Spirit of Santa Cruz [International Institute of Experimental Printmaking]"; E. Perlmutter, "California Reviews."

De Neve, R., "West Along the Freeway/ Up the Coast to City," *Print,* v. 30, March 1976, pp. 50-58.

Gallo, Albert, project director and Dianne Sachko principal investigator, *Development and Implementation of the California Arts Commission's Touring Art Gallery for the Sighted and Blind,* Sacramento: The Commission, 1971. 115 p.

Institute of Creative Arts [of the University of California]: a Traveling Exhibition of Painting and Sculpture [of Grant Winners], exh. cat., Art Gallery, University of California, Santa Barbara, 1969.

Karlstrom, Paul J., "The Archives of American Art in California," *American Art Review,* v. 4, pt. 3, December 1977, pp. 94–99+.

Linhares, Philip W., *Resource/Reservoir, CCAC: 75 Years,* San Francisco: San Francisco Museum of Modern Art, 1983. 7 p.

National Research Center for the Arts, *The Nonprofit Arts Industry in California,* Sacramento: California Arts Commission, 1975. 45 p.

New Artsspace, *A Summary of Alternative Visual Arts Organizations, Prepared in Conjunction with a Conference, April 26–29, 1978,* Los Angeles: Los Angeles Institute of Contemporary Art, 1978. 157 p

Painting and Sculpture in California: The Modern Era, exh. cat., San Francisco Museum of Modern Art, September 3–November 21, 1976 and National Collection of Fine Arts, May 20–September 11, 1977.

Plagens, Peter, *Sunshine Muse: Contemporary Art on the West Coast,* New York: Praeger, 1974.

Pollock, Duncan, "All Quiet on the Western Front," *Art in America,* v. 61, March-April 1973, pp. 54-58.

Rather, Lois, *Bohemians to Hippies: Waves of Rebellion,* Oakland, Ca.: Rather Press, 1977. 166 p.

Rosing, L., "Update on California's Art Council," *New Art Examiner,* v. 4, pt. 8, May 1977, p. 5.

Scott, Mel, *The Arts in the San Francisco Bay Area; an Inventory of Private Organizations and their Activities* [Scott is executive director of the Regional Council of the San Francisco Bay Area], 1965.

Scott, Mel, *Partnership in the Arts: Public and Private Support of Cultural Activities in the San Francisco Bay Area,* Berkeley: University of California Press, 1963.

Scott, Mel, *The States and the Arts; the California Arts Commission and the Emerging Federal-State Partnership,* Berkeley: Institute of Governmental Studies, University of California, 1971. 129 p.

Ver Meulen, M., "Bitter Suite," [artist royalties] *New Art Examiner,* v. 5, pt. 3, December 1977, pp. 13, 22.

Infrastructure, Los Angeles

"Art L. A.: The 60s," *Images and Issues,* v. 2, pt. 2, Fall 1981 including F. Danieli, "Setting the Scene for the Sixties"; J. Hugo, "The Sixties Were…"; J. Butterfield "Those were the Days: Los Angeles in the Sixties"; F. Danieli, "Seventeen Artists?"; J. Jacobs, "Agent Orange: Notes from a Woman Artist of the Sixties"; R. Weisberg, "Visiona Narrowsa and the Cowgirl Commandos"; M. McCloud, "Museum Curator Stonewalls Crusading Reporter"; S. Ballatore, "Private Dialogue Public Nuisance"; R. L. Pincus, "An Ode and an 'Odious' for Neo-Dada: Edward Kienholz' Assemblages and Tableaux, 1959–1965."

Baum, Hank, ed., *Los Angeles Art Review,* Chicago, Il: Krantz Co., 1981. 119 p.

Bengston, Billy Al, "Los Angeles Artists Studios," *Art in America,* v. 58, November 1970, pp. 100–109.

Ceeje Revisited [1960s LA gallery that showed Calif. expressionism], exh. cat., Los Angeles Municipal Art Gallery, April 10–May 13, 1984.

Coplans, John, "Pasadena's Collapse & the Simon Takeover, Diary of a Disaster," *Artforum,* v. 13, February 1975, pp. 28-45.

Hazlitt, Gordon J., "Venice, California: Unique Among the World's Bohemias," *Art News,* v. 79, January 1980, pp. 94–98.

Ianco-Starrels, Josine, "General Comments and a Report from the LAICA Exhibitions Committee," *LAICA Journal,* no. 2, October 1974, pp. 24–27.

LACE: 10 Years Documented, Los Angeles: Los Angeles Contemporary Exhibitions, 1988.

Langsner, Jules, "America's Second Art City," *Art in America,* v. 51, April 1963, pp. 127–31.

The Last Time I Saw Ferus 1957–1966, exh. cat., Newport Harbor Art Museum, March 7–April 17, 1976. 68 p.

Los Angeles Institute of Contemporary Art Oral History Transcript: the First Ten Years, oral history program, UCLA, 1986. 172 l.

Lytton Center of the Visual Arts Contemporary California Art from the Lytton Collection, exh. cat., Lytton Center, Summer 1966. 24 p.

Lytton Center of the Visual Arts Selects California Art From American Museums, exh. cat., Lytton Center of the Visual Arts, Los Angeles, October 1–November 30, 1967 and at Lytton Centers in Palo Alto and Oakland. 32 p.

Owens, Craig, "Back to the Studio [California Institute of the Arts 10th Anniversary]," *Art in America,* v. 70, pt. 1, January 1982, pp. 99–107.

Perkins, Constance M., "Los Angeles the Way You Look at It," *Art in America,* v. 54, March 1966, pp. 112-18.

Plagens, P., "L. B. M. A., M. O. C. A., P. M. M. A., L. A. C. M. A.," *Artforum,* v. 12, pt. 2, October 1973, pp. 82–84.

Plagens, P., "Los Angeles: the Market Street Program," [alternative space] *Artforum,* v. 10, pt. 5, January 1972, pp. 77–78.

Perbetsky, Patricia, *The Ferus Gallery, 1957–1961,* Master's thesis, University of California, Riverside, 1991. 73 l

Painting and Sculpture in California: The Modern Era, op. cit..

Pasadena Art Museum Oral History Transcript, Oral History Program, Transcripts at Special Collections, University Research Library, UCLA, 1989–1990.

Rose, Barbara, "Los Angeles the Second City," *Art in America,* v. 54, January 1966, pp. 110–15.

Schipper, Merle, "On the Beach: Artists in Venice and Santa Monica, 1955–1975," *Antiques & Fine Art,* v. 7, no. 6, September/October, 1990, pp.114–121.

Seldis, H. J., "West Coast Milestone [opening of LACMA]," *Art in America,* v. 53, April 1965, pp. 92–109.

Smith, Bob, "Evolution of the Institute," *LAICA Journal,* no. 1, June 1974, pp. 26-29.

"Special Report: Southern California" [4 articles implying the city is no longer competitive in art], *Art in America,* v. 66, pt. 5, September–October 1978: [Plagens, P., "Play it as it L. A.'s"; Rubinfien, L., "Through Western Eyes"; Frank, P., "Unslick in L. A."; Marmer, N., "Proposition-13"] pp. 70–94.

"Special Section: Los Angeles, " *Art in America,* v. 70, January 1982, [including C. Rickey, "Studs and Polish: L.A. in the Sixties"; P. Plagens, "Site Wars (LACMA museum as site)"; C. Owens, "Back to the Studio"; W. Gabrielson, "Westward Ha!"]

Tribute to Henry Seldis (1925–1978), exh. cat., Laguna Beach Museum of Art, November 1–December 18, 1978. 24 p.

Welchman, John, "Cal-Aesthetics," *Flash Art* (Italy), no. 141, Summer 1988, pp. 107–8.

Wilson, Malin, *Last Chance for Eden: Selected Art Criticism by Christopher Knight 1979–1994,* Los Angeles: Art Issues, Press, 1995.

Wurdemann, Helen, "A Stroll on La Cienega," *Art in America,* v. 53, October 1965, pp. 115–18.

Infrastructure, Bay Area

Adams, Robert Bradley, *Adaptive Reuse in West Oakland: Feasibility Study of Redevelopment of the Clawson School Site for Artists Live/Work and Affordable Senior Housing,* M. A. thesis, University of California, Berkeley, 1988. 72 l.

Albright, Thomas, *Art in the San Francisco Bay Area 1945–1980,* Berkeley: University of California Press, 1985.

Burnham, J. W., "Metacritique and Misalliance," [San Francisco Art Institute symposium] *New Art Examiner,* v. 5, pt. 5, February 1978, pp. 10–11.

The Dilexi Years: 1958–1970, exh. cat., Oakland Museum, October 13–December 16, 1984.

DuCasse, Micaela, *Renaissance of Religious Art and Architecture in the San Francisco Bay Area 1946–1968,* Berkeley: Regional Oral History Office: Bancroft Library, University of California, 1985. 2v.

duPont, Diana C., et al., *San Francisco Museum of Modern Art: The Painting and Sculpture Collection,* New York: Hudson Hills Press, 1985.

Rascon, Armando, *Art After Eden, An Un-Natural Perspective,* San Francisco: Southern Exposure Gallery, 1986. 44 p.

Richmond Art Center, Thirtieth Anniversary Exhibition, exh. cat., Richmond Art Center, May 25 - June 25, 1967. 64 p.

Rudolph Schaeffer—the Rudolph Schaeffer School of Design; Art in San Francisco Since 1915, oral interview, Regional Oral History Office, Bancroft Library, University of California, Berkeley, 1982. 184 p.

San Francisco Art Institute Centennial Exhibition [juried exhibition of painting, photography, prints and sculpture exhibited concurrently at California Palace of the Legion of Honor and other sites], exh. cat., San Francisco Art Institute, January 15 - February 28, 1971. 35 p.

San Francisco Museum of Art, *Annual Exhibition of the San Francisco Art Association; San Francisco Art Institute Annual Watercolor Exhibition; San Francisco Art Institute, Drawing and Print Exhibition*

San Francisco Museum of Modern Art, *50th Anniversary Commemorative Program*, San Francisco, 1984.

XXV Years: An Exhibition Celebrating the 25th Anniversary of John Berggruen Gallery, exh. cat., John Berggruen Gallery, San Francisco, September 7–October 11, 1995.

Infrastructure, Orange County

Boyd, Kerry, *58F Plaza: A Time Remembered* [history of gallery], exh. cat., Main Art Gallery, Visual Arts Center, California State University, Fullerton, February 9–March 10, 1985.

Felton, James, "An Audacious Art Museum," (Newport Harbor Art Museum), *New Worlds*, February/March, 1975, pp. 17+. *

Friis, Leo J., *Anaheim's Cultural Heritage*, Santa Ana, Ca.: Friis-Pioneer Press, 1975.

Friis, Leo J., *The Charles W. Bowers Memorial Museum and Its Treasures*, Santa Ana, Ca.: Pioneer Press, 1967.

Gregory, John S., "Orange County Culture: What's Out There," *Forum Fifty*, July 1975, pp. 16+.

Lee, Doris, "Culture Under the Avocados: The Muckenthaler Center," *Forum Fifty*, January 1978, pp. 16+.

Moffet, Penelope, "Bowers? Museum," *New Worlds*, June/July, 1979, pp. 75+.

Moure, Nancy Dustin Wall and Joanne L. Ratner, *A History of the Laguna Art Museum 1918–1993*, Laguna Beach: Laguna Art Museum, 1993.

Moure, Nancy Dustin Wall, "Art in Orange County," in *Publications in Southern California Art 4, 5, 6 7*, Los Angeles: Privately Published, 1998

Our Own Artists: Art in Orange County, exh. cat., Newport Harbor Art Museum, October 6 - November 25, 1979. 176 p.

[Push Pin's New Line]: Push Pin Studio at California State University, Fullerton, exh. cat., Art Gallery, California State University, Fullerton, November 8–December 12, 1974. 56 p.

Runbeck, Kathryn, "Irvine Museum," *Southwest Art*, v. 25, February 1996, pp. 78+.

Smith, Elizabeth, "OC Artist Directory," *Orange Coast Magazine*, August, 1985, pp. 27+.

"XIII The Cultural Scene," in *Newport Beach 75, 1906–1981*, Fullerton: Sultana Press, 1981.

"USArts Strategies for the 80's: Orange County," *Horizon*, January/February, 1987, pp. 49+.

Walsh, Daniella B., "The Gallery Scene Tries New Attack," *Orange County Register*, August 19, 1994, SHOW, pp. 1+.

Infrastructure, Other Cities

American Association of Museums, *Official Museum Directory*, New Providence, N. J.: R. R. Bowker, published annually 1960+.

Art Center in La Jolla, Annual of California Painting and Sculpture, 1959+.

Commemorating the 50th Anniversary of the Palm Springs Desert Museum, 1938–1988, Women's Committee of the Palm Springs Desert Museum, 1988. 224 p.

Desert Art Center, Inc.: 25th Anniversary, Palm Springs, Ca.: Desert Art Center, 1975. 60 p.

Fitz Gibbon, John, "Sacramento!" *Art in America*, v. LIX, no. 6, November-December, 1971, pp. 78–83.

Millier, Arthur, "The Valley Verdant Now With Art," *Los Angeles Magazine*, v. 4, September 1962, pp. 58-61.

Moure, Nancy Dustin Wall Moure, "So What's So Great About Santa Barbara Art after 1930?," in *Publications in Southern California Art 4, 5, 6 7*, Los Angeles: Privately Published, 1998.

Newspace in San Diego [1972–79], exh. cat., University Gallery, San Diego State University, dates unknown, 1979. 29 p.

Perine, Robert, et al., *San Diego Artists*, Encinitas, Ca.: Artra, 1988.

Sacramento Sampler 1, exh. cat., E. B. Crocker Art Gallery, Sacramento, April 1– May 7, 1972 and Oakland Museum, May 23–July 2, 1972. 36 p.

Sacramento Sampler II, exh. cat., E. B. Crocker Art Gallery, Sacramento, January 27 - February 25, 1973. 36 p.

San Diego Museum of Contemporary Art: *Selections from the Permanent Collection*, La Jolla, Ca.: The Museum, 1990, published on the occasion of the exhibition *On the Road* circulated to Duke University Museum of Art, Durham, N. C., September 7–November 4, 1990 and 6 other venues. 119 p.

Twenty-Five Years of the Artists Contemporary Gallery, exh. cat., Crocker Art Museum, Sacramento, November 12, 1983–January 1, 1984. 60 p.

Young, Patricia M., *Desert Dream Fulfilled: the History of the Palm Springs Desert Museum*, 1983. 80 p.

Collections of Contemporary Art

(See also collectors in chapter 38, bibl.)

Barry Lowen Collection, exh. cat., Museum of Contemporary Art, Los Angeles, June 16–August 10, 1986. 168 p.

A Bay Area Connection: Works from the Anderson Collection 1954–1984, exh. cat., Triton Museum, Santa Clara, November 1, 1995–January 28, 1996. 79 p.

California Paintings and Sculpture from the Collection of the Capital Group, exh. cat., Gallery at the Plaza, Security Pacific National Bank, Los Angeles, September 23–December 1, 1985. 10 p.

Clothier, Peter, "Eli Broad: a Cool Head About Hot Art," *Art News*, v. 87, pt. 1, January 1988, pp. 142–45.

A Decade of Ceramic Art 1962–1972 from the Collection of Professor and Mrs. R. Joseph Monsen, exh. cat., San Francisco Museum of Art, October 14–December 3, 1972. 60 p.

Driesbach, Janice T., "Northern California Art Since 1945 [in the collection of the Crocker Art Museum]," *Art of California*, v. 3, no. 5, September, 1990, pp. 14–19. [most is by teachers at UC Davis and California State College Sacramento including Wonner, Thiebaud, Arneson and others]

A Focus on California: Selections from the Collection, 6-fold sheet, Los Angeles County Museum of Art, July 7–September 9, 1984.

Frederick R. Weisman Foundation, *Frederick R. Weisman Foundation of Art*, Volume One, 1984, Volume Two, 1985. (California and American painters 1960+).

Nelson, Harold, "Independent Visions: California Modernism, 1940-1970," [Long Beach Museum of Art Collection] *American Art Review*, v. 6, no. 5, October–November, 1994, pp. 156–59.

Otis Permanent Collection: Selected Work M. F. A. Graduates: 1956-1967, exh. cat., Otis Art Institute of Los Angeles County, January 18 - March 3, 1968. 18 p.

Pasadena Collects: Art of Our Time, exh. cat., initiated and sponsored by the Pasadena Art Alliance in cooperation with Art Center College of Design, June 16–July 19, 1986. 48 p.

Selections from the Frederick R. Weisman Collection, exh. cat., Baltimore Museum of Art and six other venues, 1987.

Selz, Peter and Paul Mills, "Regional Art at Oakland," *Art in America*, v. 57, September 1969, pp. 108-109.

"Smits Collection," [ceramics donated to LACMA], *Ceramics Monthly*, v. 36, p.1, January 1988, pp. 26-7.

Tuchman, Maurice, et al., *The Michael and Dorothy Blankfort Collection*, exh. cat., Los Angeles County Museum of Art, April 1–June 13, 1982.

Art, 1960s

Baker, Elizabeth C., "Los Angeles, 1971," *Art News*, v. 70, September 1971, pp. 27–39.

Ball, Maudette W., *Southern California Artists: 1940–1980*, exh. cat., Laguna Beach Museum of Art, July 24–September 13, 1981.

California Painting The Essential Modernist Framework, essay by Paul Karlstrom, exh. cat., Fine Arts Gallery, California State University, Los Angeles, November 8–December 3, 1992 and one other venue. 61 p.

California '66: Painters & Sculptors, exh. cat., E. B. Crocker Art Museum, Sacramento, September 16–October 16, 1966. 48 p.

Coplans, John, "Circle of Styles on the West Coast," *Art in America*, v. LII, no. 3, June 1964, pp. 22-63.

Culler, George D., "California Artists [at Whitney]," *Art in America*, v. 50, no. 3, Fall 1962, pp. 84-89.

Current Painting and Sculpture of the Bay Area, exh. cat., Stanford Museum, Stanford University, October 8–November 29, 1964. 24 p.

D'Ambrosio, Nancy, "Bay Area Artists," *Horizon*, v. 31, no. 2, March 1988, pp. 49–54.

Edgarton, Anne Carnegie and Maurice Tuchman, *Modern and Contemporary Art Council Young Talent Awards, 1963–1983* (Los Angeles County Museum of Art, *Bulletin*, v. XXVII, 1983). 63 p.

11 Los Angeles Artists, sponsored by Arts Council of Great Britain, exh. cat., Hayward Gallery, London, September 30–November 7, 1971. 60 p.

Fifty California Artists, exh. cat., Whitney Museum of American Art, New York, October 23–December 2, 1962 and three other venues through June 23, 1963. 110 p.

Forty Now California Painters, exh. cat., Tampa Bay Art Center, Tampa, Fla., April 8–May 14, 1968. 48 p.

Fuller, Mary, "Was there a San Francisco School?," *Artforum*, v. 9, January 1971, pp. 46–53.

Knight, Christopher, "Is There a California School?," *Portfolio*, v. 3, September/October 1981, pp. 54–61.*

Kompass—West Coast USA, exh. cat., Van Abbemuseum, Eindhoven and two other venues, November 21, 1969–January 4, 1970 and two other venues. 50 p.

LA: Hot and Cool—the Eighties [and] Pioneers, exh. cat., List Visual Arts Center, Massachusetts Institute of Technology, December 19, 1987–February 7, 1988 and Bank of Boston Art Gallery, November 23, 1987–January 15, 1988. 72 p.

Lagoria, Georgianna M. and Fred Martin *Northern California Art of the Sixties*, exh. cat., de Saisset Art Gallery, University of Santa Clara, October 12–December 12, 1982. 56 p.

Leider, Philip, "California After the Figure," *Art in America*, v. 51, October 1963, pp. 73–83.

Microcosm '69 Introduction, organized by the Long Beach Museum of Art and circulated by the Western Association of Art Museums, January, 1969. 38 p.

Northern Ten, exh. cat., Palm Springs Desert Museum in conjunction with the Hobart Galleries, February 14–March 16, 1969. 42 p.

Paul Brach, Newton Harrison, Donald Lewallen, David Rifat, Miriam Schapiro, exh. cat., University of California San Diego, Department of Visual Arts, October, 1967. 28 p.

Plagens, Peter, "Golden Days," [LA 1960s] in Kirk Varnedoe, ed., *Modern Art and Popular Culture*, New York: Abrams (in association with the Museum of Modern Art), 1990, pp. 218–29.

Portraits of Artists: Photographs by John Waggaman, [photographic portraits of California artists], exh. cat., La Jolla Museum of Art, May 17–June 18, 1967.

Raffaele and E. Baker, "Way-out-West: Interviews with four San Francisco Artists," *Art News,* v. 66, Summer 1967, pp. 38–41.

Seldis, Henry J., *Pacific Heritage,* exh. cat., Los Angeles Municipal Art Gallery, March 17–April 11, 1965 and three other venues. 29 p.

Selections from the Works of California Artists, exh. cat., Witte Memorial Museum, San Antonio, Tx., dates unknown, 1965. 16 p.

Selz, Peter, and Jane Livingston, "Two Generations in L. A.," *Art in America,* v. 57, January 1969, pp. 92–97.

Some Points of View—'62: an Invitational [Bay Area painters and sculptors], exh. cat., Stanford University Art Gallery, Palo Alto, October 30–November 20, 1962. 52 p.

Sunshine & Noir—Art in L. A. 1960–1997, exh. cat., Louisiana Museum of Art in Humlebaek, Denmark, May 16–September 7, 1997 and three other venues. 237 p.

Ten From Los Angeles, exh. cat., Seattle Art Museum, July 15–September 5, 1966. 71 p.

Third Alumnae Art Exhibition, exh. cat., Mills College Art Gallery, Oakland, dates unknown, 1969. 38 p.

Transparent Watercolor Paintings by Members of the West Coast Watercolor Society, exh. cat., Otis Art Institute of Los Angeles County, November 13–December 23, 1966.

Tuchman, Phyllis, "Sunshine Boys," [N. Calif. artists] *Connoisseur,* v. 217, February 1987, pp. 63–69.

The West—80 Contemporaries, exh. cat., Art Gallery, University of Arizona, Tucson, March 19–April 30, 1967.

West Coast, 1945–1969, exh. cat., Pasadena Art Museum, November 24, 1969–January 18, 1970. 26 p.

The West Coast Now: Current Work from the Western Seaboard, exh. cat., Portland Art Museum, Portland, Ore., February 9–March 6, 1968. 168 p.

Winners 1953–1974: Purchase Award Winning Works by Los Angeles Artists from the All-City Outdoor Art Festivals: Selections from the Collection of Home Savings and Loan Association, exh. cat., Los Angeles Municipal Art Gallery, May 7–June 1, 1975.

Art, 1970s

"California: Art and Design of About a Decade," [14 article anthology] *Studio International,* v. 195, June 1982, pp. 2–79. [articles on photography, sculpture, performance, vernacular, environment, architecture, interview with Pontus Hulten, studio visit to Sam Francis, graphic design, travel, theme park, starsteps, video]

A View Through [an exhibition on 1960s transparency organized by the 1975 Museum Studies Program and the Art Galleries, California State University, Long Beach], exh. cat., Art Galleries, California State University, Long Beach, September 22–October 19, 1975. 19 leaves

Funk Sculpture

Albright, Thomas, "Mythmakers," *Art Gallery,* v. XVIII/5, February 1975, pp. 12–17+.

"The Beat Era: Bay Area 'funk,'" "The Watershed: Funk, Pop and Formalism," and "Personal Mythologies" in Thomas Albright, *Art in the San Francisco Bay Area 1945–1980,* Berkeley and Los Angeles: University of California Press, 1985.

Jacopetti, Alexandra, *Native Funk & Flash: An Emerging Folk Art* [Hippie embroidery], San Francisco: Scrimshaw Press, 1974. 111 p.

Lagoria, Georgianna, *Northern California Art of the Sixties,* exh. cat., with an essay by Fred Martin, University of Santa Clara, DeSaisset Museum, October 12–December 12, 1982. 56 p.

Merback, Mitchell, "Beat Funk, Ceramic Funk, Defunct Funk: A Critical Flashback," *American Ceramics,* v. 10, no. 4, 1993, pp. 32-37.

Novakov, Anna, "Funk Art: A San Francisco Phenomenon," in *Directions in Bay Area Painting: A Survey of Three Decades, 1940s–1960s,* (Part III in the series *The Development of Modern Art in Northern California,* ed. by Joseph Armstrong Baird, Jr.), exh. cat., University of California, Davis, April 12–May 20, 1983. 36 p.

Selz, P., "Funk Art," and H. Paris, "Sweet Land of Funk," *Art in America,* v. 55, March 1967, pp. 92-93, 95-99.

Selz, Peter, *Funk,* exh. cat., University of California, Berkeley, University Art Museum, May 18–29, 1967. 59 p.

Temko, Allan, "The Flowering of San Francisco," *Horizon,* v. I, no. 3, January 1959, pp. 4-23.

Welcome to the Candy Store: an Exhibition of Paintings, Drawings and Sculpture from the Candy Store Gallery, [gallery founded 1962, Old Folsom, Ca.] exh. cat., Crocker Art Museum, Sacramento, November 7–December 27, 1981. 26 p.

Ceramics, American

Axel, Jan and Karen McCready, *Porcelain: Traditions and New Visions,* New York: Watson-Guptill, 1981.

Clark, Garth, *American Ceramics: 1876 to the Present,* New York: Abbeville Press, 1987.

Everson Museum of Art, Syracuse, N.Y., *American Ceramics— The Collection of the Everson Museum of Art,* New York: Rizzoli, 1989.

Levin, Elaine, *The History of American Ceramics: 1607 to the Present: from Pipkins and Bean Pots to Contemporary Forms,* New York: H. N. Abrams, 1988.

Ceramic Vessels of the 1960s and 1970s

Ballatore, S., "The California Clay Rush," *Art in America,* v. 64, pt. 4, July-August 1976, pp. 84-88.

Bettelheim, Judith, "Ceramic Art in California: the 1970s," *NCECA: San Jose 82,* Alfred, NY: National Council on Education for the Ceramic Arts, 1982, pp. 7-41.

Bettelheim, J., "Pacific Connections [Japanese/California crossover]," *American Craft,* v. 46, April/May 1986, pp. 43–50.*

"California Baulines Guild," [Bolinas, Ca.] *Ceramics Monthly,* v. 36, pt. 10, December 1988, pp. 41-43.

Clay: The Medium and the Method, exh. cat., University Art Gallery, University of California, Santa Barbara, April 7 - May 9, 1976.

Clay & Glass, Alameda, Ca.: The Association of California Ceramic Artists, 1993. 108 p. [brief history of California ceramics; reproductions by member artists]

DiMichele, David, "Ceramics and Art: Crafts in a Post-Conceptual Climate," *Art of California,* v. 5, no. 4, September 1992, pp. 30–32.

Foundations in Clay, exh. cat., LAICA [Los Angeles Institute of Contemporary Art], May 3–June 8, 1977. 13 p.

Levin, E., "Definition Clay L. A.," *Ceramics Monthly,* v. 25, November 1977, pp. 40–42.

Lynn, Martha Drexler, *Clay Today Contemporary Ceramists and Their Work: A Catalogue of the Howard and Gwen Laurie Smits Collection at the Los Angeles County Museum of Art,* Los Angeles County Museum of Art and Chronicle Books, San Francisco, 1990.

Orange County Clay, exh. cat., Laguna Beach Museum of Art, April 22–May 26, 1983. 36 p.

Overglaze Imagery: Cone 019-016, exh. cat., Art Gallery, Visual Arts Center, California State University, Fullerton, November 11–December 15, 1977. 206 p. *

Pacific Connections [exchange of clay ideas], exh. cat., Los Angeles Institute of Contemporary Art, November 19–December 21, 1985 and 4 other venues.

Revolution in Clay: The Marer Collection of Contemporary Ceramics, exh. cat., Ruth Chandler Williamson Gallery, Scripps College, October 2–December 4, 1994 and eight other venues.

Romero, Frank, et al., "Hispanic Ceramic Artists: Los Angeles/Miami," *Studio Potter,* v. 17, June 1989, pp. 6–19.

"San Diego Sixteen [profiles of 16 ceramists]," *Studio Potter,* v. 21, December 1992, pp. 73–89.

30 Years of TB-9 [ceramic artists of the University of California, Davis], John Natsoulas Gallery, Davis, June 8–July 8, 1991. 158 p.

"West Coast Clay," [5 articles on: Post-Modern pottery, Voulkos, Arneson, Walker, etc.] *Artweek,* v. 26, May 1995, pp. 14–20.

West Coast Clay Spectrum, exh. cat., Security Pacific Bank, L. A., June 25–September 2, 1979.

Ceramic Sculpture

(See also bibliography for Funk art in Chapter 31.)

Abstract Expressionist Ceramics, exh. cat., University of California, Irvine, October 28 - November 27, 1966. 54 p.

Ceramic Sculpture: Six Artists, exh. cat., Whitney Museum of American Art, New York, 1981. 144 p.

Illusionistic Realism as Defined in Contemporary Ceramic Sculpture, exh. cat., Laguna Beach Museum of Art, January 4 - February 3, 1977. 38 p.

MacNeil, Tonia, "Balancing Multiple Concerns," [rev. of *Pacific Currents/Ceramics '82*] *Artweek,* v. 13, no. 15, April 17, 1982, p. 4.

Marshall, Richard and Suzanne Foley, *Ceramic Sculpture: Six Artists (Peter Voulkos; John Mason; Kenneth Price; Robert Arneson; David Gilhooly; Richard Shaw),* exh. cat. Whitney Museum of American Art, New York in association with the University of Washington Press, Seattle and London, December 9, 1981–February 7, 1982.

Milman, Barbara, "Thirty Ceramic Sculptors [at] Natsoulas/Novelozo Gallery, Davis, Ca.," *Ceramics Monthly,* v. 38, no. 1, January 1990, pp. 26–30.

Nine West Coast Clay Sculptors: 1978, exh. cat., Everson Museum of Art of Syracuse and Onondaga County, September 29–December 3, 1978 and one other venue.

Northern California Clay Routes: Sculpture Now, San Francisco Museum of Modern Art, 1979. 33 p.

Roder, Sylvie, "Clay Avalanche Hits Bay Area," [rev. 3 clay exhs. in N. Calif. *Porcelain: The White Heat* at Sunnyvale Creative Arts Center, *Ceramics '82* at the California Crafts Museum, and 1 more] *Artweek,* v. 13, no. 13, April 3, 1982, pp. 1+.

West Coast Ceramics [sculpture], Stedelijk Museum, Amsterdam, 1979. 44 p.

Zack, D., "California Myth Making: Ceramic Sculptors," *Art and Artists* (Monterey), v. 4, July 1969, pp. 26-31.

Sculpture

Anderson, Isabel, "The Power in Things," *Artweek,* v. 24, June 17, 1993, p. 18.

Architectural Sculpture, exh. cat., Los Angeles Institute of Contemporary Art, site specific exhibition held at nine local museums and galleries in greater Los Angeles, 1980. 2 vol. (v. 2 on California)

Armstrong, Richard, "Sculpture in California 1975-1980," [all media] *LAICA Journal,* no. 28, September–October 1980, pp. 85–93.

Bay Area Sculptors of the 1960's Then and Now, exh. cat., Braunstein/Quay Gallery, San Francisco, June 5–July 7, 1990. 48 p.

California Sculpture Show, exh. cat., Fisher Gallery, University of Southern California, Los Angeles, June 2–August 12, 1984 and other venues through September 1985. 168 p.

"Contemporary Figurative Sculpture," [7 articles] *Artweek*, v. 24, no. 7, April 8, 1993, pp. 18–25.

Curtis, Cathy, "Impermanent Sculpture Comes of Age," [rev. of *Between the Lines: Lightweight Structures*, at the Civic Arts Gallery, Walnut Creek] *Artweek*, v. 13, no. 7, February 20, 1982, p. 1.

DiMichele, David, "Stiff Competition: LA Area Sculpture Exhibitions," *Artweek*, v. 25, March 24, 1994, p. 25.

Dome Studio Group: An Exhibition of Works by the Artists from Peter Voulkos, "Dome" Complex of Oakland, Ca., exh. cat., University Gallery, University of Nevada, Las Vegas, September 29–October 20, 1979. 20 p.

Figurative Sculpture: Ten Artists—Two Decades, exh. cat., University Art Museum, California State University, Long Beach, March 12–April 29, 1984. 48 p.

First Annual California Sculpture Exhibition, exh. cat., Fine Arts Gallery, California State University, Northridge, dates unknown, 1974. 16 p.

Five Los Angeles Sculptors: Larry Bell, Tony DeLap, David Gray, John McCracken, Kenneth Price, exh. cat., Art Gallery, University of California, Irvine, January 7–February 6, 1966. 36 p.

Forgotten Dimension: a Survey of Small Sculpture in California, exh. cat., Fresno Arts Center, n. d., 1982. 47 p.

14 Sculptors: The Industrial Edge, exh. cat., originated by Walker Art Center and held at Dayton's 8th floor auditorium, Minneapolis, May 29–June 21, 1969.

Fuller, Mary, "San Francisco Sculptors," *Art in America*, v. 52, June 1964, pp. 52–59.

The Growing Edge of California Sculpture, exh. cat., Marin County Civic Center, San Rafael, Ca., May 1965. 34 p.

The House that Art Built, exh. cat., Main Art Gallery, Visual Arts Center, California State University, Fullerton, October 28–December 7, 1983. 106 p.

Hugo, Joan, "Pandora and the Rattle," [reversion to primitive] *Artweek*, v. 18, May 23, 1987, p. 1.

Imaginative Sculpture [Southern California], exh. cat., Gallery at the Plaza, Security Pacific National Bank, June 20 - August 15, 1982. 28 p.

Pagel, David, *Plane/Structures*, exh. cat., Otis Gallery, Otis College of Art and Design, Los Angeles, September 10 - November 5, 1994 and other sites. [20th cent, LA, visual perception]

"Portfolio of California Sculptors," *Artforum*, v. 2, August 1963, pp. 15–59.

Private Spaces: an Exhibition of Small Scale Sculpture: Anthony Berlant, Joseph Cornell, David Furman, Robert Graham, Roland Reiss, Horace Clifford Westermann, exh. cat., Art Gallery, University of California, Irvine, November 5–29, 1975. 17 p.

Robinette, Margaret A., *Outdoor Sculpture: Object and Environment*, [general American, not California] New York: Whitney Library of Design, 1976. 191 p.

San Francisco Museum of Modern Art, The Painting and Sculpture Collection, New York: Hudson Hills Press, 1985. 402 p.

Santa Barbara Artists: 1978—Richard Aber, Doug Edge, Jud Fine, Santa Barbara Museum of Art, June 2–July 9, 1978. 16 p.

Scarborough, James, "Funk is Here to Stay," [rev. of *Sculptural Perspectives for the Nineties* at Muckenthaler] *Artweek*, v. 22, December 12, 1991, pp. 9-10.

Sculptors at U C Davis, Past and Present, exh. cat., Richard L. Nelson Gallery, University of California, Davis, September 20–October 29, 1982. 36 p.

"Sculpture," *Visual Dialog*, v. 2, no. 4, June-August 1977.

"Sculpture in California," [anthology of articles on sculpture in the early 1960s including assemblage, bronze casting, welded metal, etc.] *Artforum*, v. 2, April 1963, pp. 3-59.

Sculpture in California, 1975–80, exh. cat., San Diego Museum of Art, May 18 - July 6, 1980. 96 p.

"Sculpture of the Sixties," in Thomas Albright, *Art in the San Francisco Bay Area 1945–1980*, Berkeley and Los Angeles: University of California Press, 1985, pp. 135-164.

Sharp, Willoughby, "New Directions in Southern California Sculpture," *Arts*, v. 44, Summer 1970, pp. 35-45.

Sperry, A., "Women and Large Scale Sculpture," *Women Artists Newsletter*, v. 2, pt. 10, April 1977, pp. 1, 5.*

Stover, Donald L., *American Sculpture: The Collection of the Fine Arts Museums of San Francisco*, California Palace of the Legion of Honor, San Francisco, 1982.

"Surveying Sculpture," [5 articles] *Artweek*, v. 27, no. 12, December 1996, pp. 12–17.

Weisberg, Ruth, "Ten Sculptors Working with the Figure," [rev. of *Figurative Sculpture: Ten Artists/Two Decades* at the University Art Museum, CSU, Long Beach] *Artweek*, v. 15, no. 15, April 14, 1984, p. 1.

Sculpture Gardens

(See also bibliography for Public Art in chapter 37.)

"Art in Public Places [City Center, Oakland]," *Art of California*, v. 4, no. 4, July 1991, p. 45.

"Art in Public Places [Esprit Park near S. F. for large scale sculpture]," *Art of California*, v. 4, no. 2, March 1991, p. 29.

"Art in Public Places [Gure Etxea III at La Jolla]," *Art of California*, v. 3, no. 4, July 1990, p. 49.

Banham, Reyner, "Orange County Satori [Isamu Noguchi's Sculpture Garden]," *California Magazine*, v.11, no. 10, October 1986, pp. 84–85+.

Brea City Council, *The City of Brea Presents "Art in Public Places," A Self-Guided Tour*, Brea, 1983. 20 p.

"Brea; the Art in All the Right Places," *Orange County*, v. 4, no. 6, June 1983, pp. 81, 87.

Burgess, Michele, "A Private Solution—for Art's Sake," [Brea] *Westways*, v. 79, no. 2, February 1987, p. 28.

Burlingham, Cynthia and Elizabeth Shepherd, eds., *In the Sculptor's Landscape: Celebrating Twenty Five Years of the Franklin D. Murphy Sculpture Garden*, Wight Art Gallery, University of California, Los Angeles, 1993.

Burstein, Joanne, "Sculpture '82: The Parallel Current," [review of exh. at Sonoma State University] *Artweek*, v. 13, no. 14, April 10, 1982, p. 1.

Christensen, Judith, "The City of Carlsbad: A Community's Art Legacy," *Art of California*, v. 5, no. 5, November 1992, pp. 60-61.

Christensen, Judith, "The Stuart Collection [sculpture at UCSD]," *Art of California*, v. 4, no. 5, September 1991, pp. 39-43.

"Estuary Park Sculpture Project," in Oakland Museum, *100 Years of California Sculpture*, August 7–October 17, 1982. 48 p.

Ewing, Robert, "The Artistic Age: Noguchi and Pacific Mutual," *Orange Coast*, v. 8, no. 11, November 1982, pp. 26-33.

Firor, Cathi, "Brea the Art of Innovation," *Orange County Illustrated*, August 1979, p. 34.

Freudenheim, Susan, "Under the Singing Eucalyptus Tree," [sculpture at UCSD] *Artforum*, v. 26, April 1988, pp. 124–30.

Houk, Walter, "The Stunning Sculpture Gardens of Los Angeles," *San Diego*, v. 31, no. 5, March 1979, p.144–51+.

Joselit, David, "Lessons in Public Sculpture," [Stuart Collection, University of California, San Diego], *Art in America*, v. 77, no. 12, December 1989, pp. 130–35.

Kelley, Jeff, "The Site-Specific Game," [10 works commissioned by Sacramento Metropolitan Arts Commission] *Artweek*, v. 13, October 16, 1982, p. 3.

Miller, Elise, "A Fresh Approach to Campus Art," *San Diego Magazine*, v. 35, no. 5, March 1983, p. 109.

Muchnic, Suzanne, *Art & Environment: South Coast Plaza*, Costa Mesa, Ca.: The Plaza, 1985.

Sculpture for the Campus, California State College, Fresno, 1969. 20 p.

Van Doren, Phyllis, "Museum Without Walls" [UCSD Sculpture Garden], *Westways*, v. 75, no. 7, July 1983, pp. 48–51.

Fig. 28-1
June Wayne (b. 1918)
At Last a Thousand II, 1965
lithograph
24 x 34 in.
© June Wayne/ Licensed by
VAGA, New York, NY

The "Fine Arts" Absorb Other Traditional Art Forms

28

Printmaking

If a printmaker of the late 1950s could ask, "How can anyone improve upon an etching, lithograph, or woodcut?" then he or she would have never succeeded in the revolutionary 1960s, when innovation became the byword. Printmaking moved away from solitary individuals bending over home presses toward group workshops. Printmakers (many of them painters trying out printmaking for the first time) tested just how far they could push traditional media, how they could combine media, and, indeed, how they could join printmaking with entirely different media, including paper-making and sculpture. They explored all printmaking techniques, preferring commercial forms not formerly addressed by the fine arts. Prints grew to huge size; black and white gave way to color. So-called limited edition prints, were sought after by a new American elite—Yuppies with college educations, discretionary money, and an ambition to be "art collectors."

California's first printmaking workshop was Tamarind, founded in 1959 in Los Angeles and opened in 1960. It was started by **June Wayne** (b. 1918), who had noticed in the 1950s that lithography was becoming a lost art. She hoped to form a workshop where the old skills could be passed on to a new generation of master printers and obtained a grant from the Ford Foundation to pursue this goal.

Tamarind's road was not easy. An upstart on the West Coast, Wayne's aspirations for it were repeatedly blocked by the closed print world of New York, which was nurturing two new printmaking centers of its own: Pratt-Contemporaries Graphic Arts Center in Manhattan and Tatyana Grosman's Universal Limited Art Editions, in West Islip, Long Island. Wayne had to fight to get recognition in the press and in museum and print circles. Her shop, however, achieved its goal of teaching lithography to a new generation of artists by awarding two-month stipends to promising individuals. Tamarind artists worked virtually on a one-to-one basis with the workshop's professional printmakers and had the use of its sophisticated equipment to realize their ideas. Because the working situation was so intense and many of the aspiring printmakers were painters, lithography's traditional techniques were extended and new ones invented. In Wayne's *At Last a Thousand II* of 1965 (fig. 28-1), which commemorates

the one-thousandth lithograph produced at Tamarind, the artist used the innovative technique of scattering salt particles on the plate (in other cases she used pebbles, twigs, and beans) to block the water-tusche washes that were sprayed over it. The result is an almost Abstract Expressionist work achieved in an automatist manner. The complex textural effects are one of the hallmarks of Tamarind. When the Ford grants ended in 1970, Tamarind relocated to the University of New Mexico at Albuquerque, where it has continued in the forefront of printmaking.

In addition to producing prints, Tamarind's educational responsibility led it to collect and preserve lithographic stones. (The German quarry from which they came had become exhausted.) The workshop issued many publications describing lithographic tools and methods and others on how to document and catalogue prints. It led the crusade to legally define what constituted a true print as compared to the many fraudulent "limited edition prints" that were issued in the 1960s. And Wayne personally helped women artists gain recognition, teaching them how to negotiate the male-run art world of the 1960s via her "Joan of Art" seminars. Tamarind had national impact through the three-score master printers that it trained, who, in turn, started workshops throughout California and in other parts of the nation. More than one hundred visiting artist-fellows and more than fifty guest artists benefited from their experiences. Two of Tamarind's most important Los Angeles offspring were Gemini Ltd. (started in 1965 by Kenneth Tyler and expanded in 1966 to become Gemini G.E.L.) and Cirrus Editions, Ltd. (founded in 1970).

Gemini, established as a commercial enterprise (Tamarind was nonprofit), invited only internationally recognized artists with established reputations to use its facilities. It was therefore responsible for bringing into Los Angeles many artists who, in turn, had an impact on the local art world. Some introduced experimental techniques that had been developed on the East Coast, among them drawing or painting with tusche (particularly useful to Abstract Expressionist painters-turned-printmakers) and photographic transfer. At Gemini and other second-generation printmaking workshops, experimentation became particularly wild. Two of Gemini's innovations were printing on

367

Lucite (Man Ray in 1966) and creating prints huge in size. In 1967 Gemini produced the largest print ever made, *Booster* by **Robert Rauschenberg** (b. 1925), a four-color lithograph/silkscreen that measured 72 by 35½ inches (fig. 28-2). When Rauschenberg printed at Universal Limited Art Editions on Long Island, his innovations included printing on Plexiglas, brushing three-dimensional objects with paint and pressing them against paper, and soaking printed images off products or from magazines and then applying them to the lithographic stone. *Booster* employs the then new technique of photographic transfer in which photographic images of all kinds are imprinted on the plates. Rauschenberg's "self-portrait" results from a combination of his own x-rays, the red-lined chart showing the movement of heavenly bodies for 1967, the blue-print of a chair suggesting the solitary state of man, all tied together by scumblings with tusche and crayon. The "collage" look seen in this work was to proliferate through the end of the twentieth century as artists increasingly depended on appropriated imagery to build their compositions. The print's monumental size forever negated prints' reputation as intimate.

Gemini also became known for its "multiples"—three dimensional objects, which some would define as sculpture, that the workshop issued in editions. These ranged from lead bas reliefs created like an embossed print by running a soft lead sheet through a press, to multimedia objects, like assemblages, that *contained* a traditional print. Others were objects that seemed to have no relationship at all to prints or the printmaking process—such as cast acrylics and metal cutouts.

Los Angeles's Cirrus Editions, which worked solely with California artists, housed equally innovative artists who produced torn and double layer lithographs (Joe Goode), screen prints on Plexiglas (Greg Card), used fruit juices and Metrecal (a liquid meal for dieters) in place of the traditional printing inks (Ed Ruscha, 1971), and made multiples (Eric Orr and Joel Bass).

Northern California artists stepped to a different beat. They, too, were innovative and worked in all variety of printmaking media, but with their traditions of Tonalism and the area's history as the nation's West Coast publishing center, they excelled in monotypes and etchings. The Bay Area boasted many presses,

including Crown Point, which specialized in the printing of fine books illustrated with original etchings; Original Press/Collector's Press, which specialized in lithographs; the Institute of Experimental Printmaking in Santa Cruz, known for its handmade paper and its large scale prints (see below); and Arion Press (1976), which still publishes artists' books.

In the area of monotypes, one of the first and most influential of the artists was the Bay Area figurative painter Nathan Oliveira (b. 1928). While still a student in the late 1940s, he had protected wet paintings by laying paper against them. Recognizing the artistic validity of the paint stuck to the paper, he retained the images. Nearly twenty years later, after on-and-off work in lithography, he turned to making transfers from glass, essentially monotypes. Although he experimented on his own, in 1972 he was seriously inspired to take up the medium after perusing a catalogue for a traveling show of *Degas Monotypes;* he spread his enthusiasm to his students and friends. A monotype is a painter's print. Inks are usually spread on a plate, just as paint is spread on a canvas, except that the first is accomplished with rags or fingers while the second is most often executed with a brush. The monotype process beautifully translates the sensitivity, intimacy, softness, and emotional quality of Oliveira's figurative paintings. He was the first to exploit the medium's serial possibilities. Other innovations in this medium made by Northern California artists include the use of inks with differing chemical properties that repelled each other as well as the merging of monotypes with handmade paper and with etching.

Serigraphy also enjoyed a revival in the 1960s. Its flat colors and hard edges were perfect for rendering the popular new painting styles (Pop, Geometric Abstraction, and Op) utilized by the many painters-turned-printmakers. It was also the best medium for making posters. From its infancy in New York in the 1930s, serigraphy had been identified with a leftist political orientation. Its inexpensive nature made it accessible to universities, community groups, cooperatives, and artists from minority groups. With the Civil Rights Revolution of the 1960s, it was revived, especially by California's emerging Latinos (chapter 34), who made it the primary medium for posters of social subject matter. The Bay Area is considered the center

of this movement—at its hub the Berkeley Art Center & Alliance Graphics—but Los Angeles can boast Self Help Graphics. In *Sun Mad* of 1982 (fig. 28-3), **Ester Hernandez** (b. 1944) has turned a well-known commercial package design into a social indictment of California's agribusinesses, which many believed made agricultural field workers sick with pesticides. Serigraphy and offset lithography were also used to produce some psychedelic posters for rock music events.

San Francisco is notable for its Achenbach Foundation for the Graphic Arts (now the Department of Prints and Drawings of the Fine Arts Museums of San Francisco), which is the largest holder of graphics in the western United States. The city also hosted the World Print Council (founded in the early 1970s) that mounted international exhibitions in 1973, 1977, and 1980.

After 1980, the "classic" but time-consuming traditional printmaking techniques continued to be practiced, but many artists in the avant garde turned to new processes opened up by electronic devices, including verifax, xerography (the making of images on a photocopy machine), photo silkscreen, and computer printouts.

Opposite:
Fig. 28-2
Robert Rauschenberg
(b. 1925)
Booster, 1967
four color lithograph/silkscreen
72 x 35 ½ in.
© 1967 Robert Rauschenberg/
Gemini G.E.L./Licensed by
VAGA, NY

Left:
Fig. 28-3
Ester Hernandez (b. 1944)
Sun Mad, 1982
serigraph, 22 x 17 in
© 1982 Ester Hernandez
Photo: Bob Hsiang

Artists' Books

In the 1960s the frenetic search for new media led some artists to explore books as a medium. Los Angeles's Ed Ruscha (chapter 32) became one of the first when he produced *Twentysix Gasoline Stations,* a book of his photographs, in 1963. Since then many artists have tried the form at least once, while a few have made it their main medium. Artists' books are difficult to define since they come in such a wide variety of formats and are made for so many different purposes. Unlike the average book, which centers on a writer's text and is edited, designed, printed, and bound by others, with artists' books most of these tasks handled or overseen by the artist. When text forms the main component, it is often written by the artist. This can be fiction, nonfiction, or poetry; conceptually based artists explore language/semantics and word play. As for physical properties, books can range from the traditional offset printing with soft and hard binding to nontraditional printing (Xerox, rubber stamp) and nontraditional bindings (flip books, scrolls, and books that are accordion-folded, hinged, stapled, or spiral bound). In California the highly experimental, one-of-a-kind books made from nontraditional materials—sheet metal and screws, corrugated cardboard, rubber, shellacked slices of bread, leaves of plants, synthetics, to name a few—are rare. The general trend since 1980 has been toward traditional printing techniques and bindings employed in nontraditional ways. Some books exist as unique art objects while others are issued in small editions.

Susan E. King (b. 1947) saw her first artists' book in the early 1970s at Los Angeles's Feminist Studio Workshop and knew she had found her medium. For two decades she has worked in Los Angeles at her Paradise Press. She involves herself in all aspects of the process. In *Lessonsfrom the South* of 1986 (fig. 28-4), a work made while she was an artist-in-residence at Nexus Press in Atlanta, she exploits a book's reputation for intimacy (they are usually read by one person at a time) and its potential for autobiography by creating a text based on her memories of childhood in the South filtered through her Feminist sympathies. She has been called one of the best writers among those artists currently making books. *Lessonsfrom the South* is hard bound, accordion fold, with each "fold" consisting of a sheet of paper folded in three and printed on both sides with words and text. King uses the physical properties of the book to enhance the text. For example, the covers, made of translucent corrugated plastic, admit light with a quality King equates to late afternoon light in the South. In the folds of the accordion spine she prints lists of stereotypical Southern words and phrases. In the main body she uses various colored inks to set off differing text sources as well as pastel papers to evoke the softness associated with Southern women. Other artistic considerations include placement of script on a page, selection of type faces and lettering (some book artists even use non-Roman Cyrillic, Sanskrit, Chinese or Japanese calligraphy), and the balance of text with illustrative material (such as photographs, scientific diagrams, topographic charts, and anatomical diagrams, to name a few). King regards her finished books as sculptures.

Paper and Pulp

Paper-making has long been regarded as an art form in Asia, but only became so in Western countries in the highly experimental 1960s. Paper is nothing more than macerated fibrous material stirred in water until soupy and caught up on flat screens to allow the water to drain away. Through the centuries, it has been made from a wide variety of natural and organic materials including flax, wheat, and rice stalks, but in the United States it is most frequently made from ground-up trees or old rags of cotton or linen. Because the late-nineteenth-century industrial revolution led to machine-made papers, for the first half of the twentieth century, the craft of making paper by hand was almost lost. Although commercial manufacturers turned out many different kinds of paper—including colored papers, absorbent papers, metallic surface papers, papers with foreign and decorative objects embedded in them; papers that were tissue thin or cardboard thick; as well

Fig. 28-4
Susan E. King (b. 1947)
Lessonsfrom the South, 1986
offset, die-cut accordion fold
book, 10¾ x 7 in.
Susan E. King

as papers that were transparent or opaque—they all looked as if they had been produced by a machine. In the 1950s, with the general revitalization of crafts (chapter 25), the hand making of paper reemerged. A decade or so later, when artists sought new media in which to express themselves, the craft was absorbed into the "fine" arts.

Paper can be creatively manipulated in a variety of ways. Artists making flat sheets can embed objects in the pulp, layer the sheets, pierce holes in them, and color them. Paper can be cut or folded into shapes, torn, embossed, woven, stained, pasted, or bonded by pressure. **Neda Al-Hilali** (b. 1938), a paper artist with an extensive background in textiles, employs a mixture of techniques in her *Island Vegetation* of 1981 (fig. 28-5) that transforms neutral, nondescript industrial paper into an object of complexity. She begins with paper-towel-quality or brown wrapping paper, rolls it, crumples and dyes the rolls, then plaits them in a particular way that leaves an excess flange of paper at regular intervals, which she terms "leaves." The whole paper weaving is then run through two steel rollers and pressed to varying degrees of flatness. She then enhances the piece with paint, dyes, and stains. The result is a complex, richly textured, and highly tactile object that achieves an interplay between physical and illusionistic structure and rhythms. Other artists incorporate paper into multimedia objects or cast paper pulp into three-dimensional shapes, making items such as wall reliefs and "sculptures." In the early years of paper art, three important San Francisco sculptors—Robert Arneson, Harold Paris (1925–1979), and Manuel Neri (b. 1930)—worked with Garner Tullis and his Institute of Experimental Printmaking making three-dimensional paper sculptures.

In the 1970s papermaking workshops sprang up throughout California. (The main American centers for paper art remain the Bay Area and New York.) Besides the International Institute of Experimental Printmaking established about 1972 by Garner Tullis in an old lumber mill in Santa Cruz (it has subsequently moved several times), Oakland is home to Farnsworth and Serpa, Santa Monica houses Atelier Royce (opened 1976), and San Diego became home to Maple Creek Studio in 1980. One of Royce's innovations was "prints" made by hand-pressing paper pulps into carved and

inked wooden panels. Through the 1970s paper art was exhibited in museum and commercial shows, and in 1978 the World Print Council's conference on Paper-Art & Technology was held at the San Francisco Museum of Art.

Since 1980 paper artists have extended their experiments in every way imaginable. With the general breakdown of media barriers in the 1980s, paper is now incorporated into other art forms: into painting and sculpture as well as performance and site installations. Some artists have abandoned organic materials and techniques and have adopted high technology processes: vacuum-forming of "sculptures," stitching with sewing machines, and decorating with heat transfer and color Xerox. Generally today's paper artists have moved away from an interest in paper's tactile qualities and raw materials as "content" and are fabricating paper to convey messages.

Fig. 28-5
Neda Al-Hilali (b. 1938)
Island Vegetation, 1981
plaited, pressed paper, mixed media, 53 x 52 in.
Courtesy of the artist

Collage

The word "collage" derives from the French *coller,* which means to paste or to glue. In its broadest definition, the term covers any artwork composed of items or images culled from a variety of sources. The collage concept has been in existence for hundreds of years, but the medium did not become a meaningful art form in the Western European tradition until the twentieth century when it was employed by the Cubists and Surrealists. Two very different types of collage artists are active today: those interested in the *physical properties* of their materials (texture, color, size, and shape) and those interested in the *meaning of the imagery.*

California's most important early collage artist is Knud Merrild (chapter 21). While his bas relief sculpture *Volume and Space Organization* (fig. 21-1) is a bas relief that investigates the paradox between a flat "pictorial" surface and three-dimensional "sculpture," Merrild seems equally interested in the varying textures of the individual components. The artist also produced a few Surrealist collages on paper in which he employed recognizable imagery cut from magazines.

In the 1950s American artists turned to collage in sizable numbers. San Francisco's **Jess (Collins)** (b. 1923) is the acknowledged master of collages containing *ideas.* He utilized printed images—from nineteenth century engravings as well as contemporary mass-market publications—to build new, fantastical compositions. Jess traces his interest in old art to his childhood in the late 1920s and early 1930s when his great-aunt entertained him with clipping-filled scrapbooks. He also recalls a trip to the Mojave Desert with his father, at which time he visited a prospector's shack constructed of cast-off scrap wood whose interior walls were papered with pictures cut from old magazines and calendars. Although he received his degree as a chemist, he soon gravitated to the California School of Fine Arts and to a full-time career as an artist. Jess is best known for his *Tricky Cad* series made from re-assembled Dick Tracy comic strips. A collage that is also a painting is *The Mouse's Tail* of 1951–54 (fig. 28-6). *The Mouse's Tail* is "Funk" (chapter 31) in its re-use of cast off materials, its humor—the title is a twist on the children's fairy tale "The Mouse's Tale"—its narrative content, and its disinterest in commercial potential. The intricacy and care put into such a work reveals Jess's scientific perfection and intellectual bent. Jess used preprinted imagery in this work like a painter uses brushstrokes: here he has pasted up pictures of tiny naked men cut from skin magazines and male model photos to build the large squatting man.

A collage artist with interests in the *tactile* qualities of paper was Santa Barbara's **William Dole** (1917–1983). He first employed the medium in the 1950s when he acquired a large collection of interestingly textured Japanese papers. Investigating how they accepted watercolor paint, he glued the thinner pieces to supports of thicker paper. In the late 1950s, while browsing in a second-hand bookstore in Florence, Italy, he ran across a portfolio that included letters, maps, marbleized paper, and additional Japanese papers. Through the 1960s he created nonobjective collages composed of rectangularly cut papers, pasted at right angles, and enhanced with watercolor. The works are sensual, tactile, and delicate in color.

After 1970 collage becomes widely practiced. Not only did paper gain credence as a fine-art medium and artists turn to mixing media, but it became fashionable for artists to re-use old imagery (see appropriation, chapter 36). Since 1970 artists have made collages with many goals in mind. In the Bay Area, Jess was followed by rock poster artists and Wilfried Satty (1939-1982); both used nineteenth-century engravings in their art. The poster artists mixed them with Art Nouveau lettering and psychedelic colors (fig. 31-5), while Satty combined them into illusionistic scenes. [See his *San Francisco Series* of about 1980, reproduced by Thomas Albright in *Art in the San Francisco Bay Area 1945–1980* (Berkeley: University of California

Press, 1985, p. 180).] In the past thirty years, collages made for tactile qualities have incorporated new paper products, such as x-rays, radiographs, bumper stickers, Polaroid photographs, discarded coffee filters, maps, charts, and photographs. In Southern California, Tony Berlant (b. 1941) makes collages of printed metal recycled from items like old signs. With the breakdown of media barriers, many painters have begun to collage bits of paper to their oil paintings. (See Raymond Saunders, fig. 35-6) Electronic technology has also affected the medium. Some collages are made on the photocopier, and the ability to digitize images now enables collage artists to "assemble" their collages on a computer then print them out on a sheet of paper. The image-and-text compositions of conceptual artists are essentially collages.

Drawing

In the 1950s, the Abstract Expressionist practice of creating directly on the canvas literally killed the need for preliminary (or working) drawings. Some feared drawing was dead. Instead, drawings emerged as a final art form in themselves. But the look of drawing changed. New methods of marking were developed, including felt-tip pens, magic markers, and ball-point pens, and Ed Ruscha used organic "inks," such as berry juice. Some artists followed the trend toward multimedia by combining drawing with photography and sculpture. Because many painters also made drawings, drawings often took on the style, aesthetic, and subject matter of those artists' paintings. Subject matter ranged from nonobjective Abstract Expressionism (John Altoon, 1925–1969) to Pop (Ed Ruscha, b. 1937) and Photorealism (Robert Bechtle, b. 1932). Stylistically, drawing was all over the board, and drawing incorporated ideas. Young collectors began to acquire drawings, partly because they had reached a sophistication to appreciate them and partly because, like prints and photographs, they were reasonably priced.

Only a few artists made drawing their primary medium. Drawing's modest nature continued to keep it in the shadow of painting and sculpture. An artist who used drawings to pursue formal aesthetic issues is **Martha Alf** (b. 1930). Her art is shaped by her precocious talent for drawing, a propensity to study a scene or image thoroughly, a degree in psychology, and an admiration for the works of certain European Old Master painters. *Drawing of Arrangement* of 1975 (fig. 28-7) takes as its main subject a roll of toilet paper. A commercial product isolated in the center of a composition immediately brings to mind Pop's elevation of the banal to fine art, but to Alf the roll is simply a cylinder. Beginning in the early 1970s she produced a

Fig. 28-7
Martha Alf (b. 1930)
Drawing of Arrangement,
1975
pencil on bond paper
14 x 11 in. (paper size)
Courtesy Newspace, Los Angeles

series of oil paintings and drawings that explore its compositional potential. In the various works she varied the proportions of the roll to its background, placed it in various parts of the composition, and arranged it with other rolls or objects. In her standard piece, she bathes the roll with light from the right side to explore chiaroscuro. By dissolving the object in atmosphere she creates a religious aura around it, turns it into an icon, raises a mundane object to authoritative power, transforms a humble object into one of mystery and reverence. Alf thinks long and hard about each composition, seeking perfect balance of shapes and background, refining the already pure geometric shape to its essence by eliminating any surface detail. In some of her drawings, strokes of pastel or graphite are applied in a diagonal left-to-right direction, reflecting her natural hand movements. In this work she depends on the natural grain of the bond paper to create an overall texture. Her composition is elegant, spare, immaculate, refined, logical, contemplative, and controlled, reflecting her search for reality and the meaning of life.

As the 1970s progressed, drawings absorbed influences from the parallel discipline of conceptual art and became infused with ideas. **Raymond Pettibon** (b. 1957) majored in economics at the University of California, Los Angeles, but long before matriculating he realized his affinity for art, philosophy, and literature. At UCLA he drew political cartoons for the school newspaper. Upon graduation in 1977, he started his current work, ink on paper "drawings" such as *I*

Fig. 28-8
Raymond Pettibon (b. 1957)
I Thought California Would Be Different, 1986
india ink on paper
14 x 18 in. approx.
Private Collection; Photo
courtesy Ed Boswell

Thought California Would be Different of 1986 (fig. 28-8) in which he combines phrases with imagery. Most of Pettibon's words are appropriated from classic literature by authors such as Henry James, John Ruskin, and Marcel Proust, whose lyrical prose or turn of a phrase Pettibon admires. He doesn't recall the exact source of "I Thought California Would be Different" but sees rolled up in it all the disappointed hopes held by dream seekers lured to the state by the myths and promises of promoters. Most of his figures come from his own imagination. The running figure in this work is meant to represent the blind panic experienced by an immigrant upon realizing that California's reality doesn't truly intersect with the myth. Although writers have classed Pettibon's image-and-text works with didactic conceptual art (chapter 36), he equates himself instead to artists who suggest ideas and emotions in a psychological or lyrical way. His drawing style owes a debt to comics, cartoons, and black-and-white illustration.

In the 1970s and 1980s, draftsmen continued to use traditional media, such as pastel, graphite, and charcoal, but almost ignored conte crayons, which had enjoyed such popularity in the 1940s with artists like Rico LeBrun. Some works on paper became huge in size, countering drawing's former reputation as intimate. Computers supplemented and then usurped

hand drawing in the making of preparatory sketches for art works and animated films. The definition of drawing expanded to include new media, such as drawings on the land (as when Michael Heizer used his motorcycle to "draw" designs in a Nevada dry lake), marks cut with oxyacetylene torches or laser beams in slabs of steel, and drawings on the exteriors of buildings (graffiti) or the interior walls of art galleries. New drawing materials, such as powdered asphaltum, were tested out, and many drawings became multimedia: graphite on ficus leaves, marks on slate and wire mesh, and calligraphic marking atop photographs or pages from books, charts, and graphs.

Photography

Since 1950, Americans obtain so much of their knowledge of the world from photographic images (television, illustrated publications, motion pictures, and video) that many philosophers question whether today's Americans have any touch left with reality at all.

In the 1960s, photography, like other media, experienced intense artistic experimentation. Californians advanced the medium along four broad paths: photographs were mixed with other media to make multimedia objects, subject matter was selected or staged in order to convey a conceptual message or idea, film or photographs themselves were physically manipulated, and color began to compete with black and white. For all these forms, *concept* was of primary importance.

In the area of photographs used in multimedia objects, the Art Department of the University of California at Los Angeles (UCLA) became the American leader. Unhindered by the heritage of the f.64 style that dominated Northern California, Southern California's open-mindedness to experimentation was aided by the city's spread-out nature, artists' sense of individualism, and the fact that **Robert Heinecken** (b. 1931), who had been hired to teach photography at the university, had also been trained as a printmaker. That he had never owned a camera himself may explain why he encouraged his students to incorporate extant photographs into multimedia objects rather than taking photographs themselves. He urged them to experiment with photo-sensitized fabrics and high-contrast copy film, to print on transparent acrylic sheets, to add collage elements, to reproduce photographs with offset lithography, and to use the historic technique of hand-coloring. A typical work is *Figure Sections/Beach* of 1966 (fig. 28-9), a photograph pasted to nine movable wooden blocks. Heinecken and his students used their art and wit to make social statements. This work is conceptual in that the photos and blocks compare human body parts to objects in nature.

UCLA's experimental lead was followed by photography departments at Orange Coast College in Costa Mesa, at California State University at Fullerton, at California State University in Northridge, and after 1971 at CalArts in Valencia. In 1970 the Museum of Modern Art in New York produced an exhibition titled *Photography Into Sculpture* in which Heinecken's students and former students from Los Angeles were prominent. Many of Los Angeles's multimedia solutions were documented in *Proof: Los Angeles Art and the Photograph 1960–1980* (Laguna Art Museum, 1992).

Some Los Angeles artists followed the fashion for using Polaroid's SX-70 camera, first marketed in 1972. Although the Polaroid print was limited in size, artists such as David Hockney (b. 1937) made large art works from it by affixing multiple shots to a support. Conceptual artists, such as John Baldessari (b. 1931), combined photographs with text to convey ideas, while others made photographic *series*. Ed Ruscha's *Every Building on the Sunset Strip*, published in book form in 1966, documented every building on the strip through abutted snapshots printed in an accordion folded book.

About 1970 the Bay Area freed itself from the grip of f.64 and also turned to experimentation. Generally, the Bay Area's artists were still interested in taking a photograph *of* some subject, but the main point of the photograph lay in the ideas it conveyed. Color

began to usurp black and white when new color processes and film types became popular in the 1970s and when artists turned to hand-coloring photographs. A number of the Bay Area's photographers became abstractionists when they took close-up shots of international-style buildings or plain industrial architecture where the spatial breakup created by doors and windows gave the photo the appearance of a "nonobjective" composition.

Of the "idea" photographers, the most important was **Lew Thomas** (b. 1932). In the early 1970s, Thomas employed a conceptual approach to photographic practice exploring fundamental structures of time and space and the way language influences visual perception. In *Bibliography* of 1977 (not illustrated), a photograph of the bibliography page from a book, the viewer's curiosity is engaged by the fact certain entries are crossed out. This leads the viewer to compare the entries and, in turn, to look at something (a page of bibliography) that is routinely taken for granted. In *Sink* of 1972 (fig. 28-10) the act of filling and draining a sink is shown in a sequence of twelve photographs that reference not only the visible object but the underlying process of

Left:
Fig. 28-9
Robert Heinecken (b. 1931)
Figure Sections/Beach, 1966
black and white photograph adhered to nine movable wood units, 8⅝ x 3 x 3 in.
Pace Wildenstein MacGill Gallery, N. Y. C.

Above:
Fig. 28-10
Lew Thomas (b. 1932)
Sink (Filling, Filled, Draining, Drained), 1972
12 gelatin silver prints
32 x 30 in.
Charles Barca, San Francisco

Fig. 28-11
Richard Misrach (b. 1949)
*Waiting, Edwards Air Force
Base*, 1983
dye coupler photograph
40 x 50 in.
Courtesy the artist and
Fraenkel Gallery, San
Francisco

the act. Thomas's work inspired others to make photographs that were derived from entities formed in the mind rather than the outward aspect of things. In 1976 there were enough photographers exploring the semiotic understanding of images for Thomas to co-curate *West Coast Conceptual Photographers* at La Mamelle. This was followed by the watershed exhibition and highly acclaimed catalogue *Photography and Language* at Camerawork gallery. (Bay Area conceptual photographers became popularly known as the Photography and Language group, and the influence of their work extended to New York.) In 1978, Thomas issued his influential book *Structural(ism) and Photography*, which documented his sequential photographs, photographic installations, and theoretical writings of this period. Other Bay Area conceptual photographers conveyed their ideas through *fabricated subject matter*—by staging scenes, as on a movie set. In a work such as *Eating* of 1982/3 (reproduced in Louise Katzman, *Photography in California 1945–1980*, New York: Hudson Hills Press, 1984, p. 79) that shows a pretty woman secretly stuffing herself with iced cupcakes, Judy Dater (b. 1941) references today's compulsion with food and diets

Other photographers shot objects from new angles or with unusual lighting that made reality look unreal. When **Richard Misrach** (b. 1949) began his career, he turned to subjects that had not been greatly addressed by photography. He first pursued the theme of the desert at night, to which he gave eerie lighting by leaving his shutter open for extended periods and by setting off a portable strobe to illuminate only certain parts of the landscape. He next began photographing in color, a quality that "purist" fine-art photographers had formerly avoided. Color work became a particular interest for Bay Area photographers, who investigated unusual processes including dyes (diazotype, Ozalid) and salts (Ektacolor, Carbro, cibachrome and cyanotype) that had super-real qualities. Art photographers used color to heighten mood, to alter reality, or as a subject in itself. Although Misrach's works such as *Waiting, Edwards Air Force Base* of 1983 (fig. 28-11) are stunningly beautiful, they also carry ecological messages—the despoliation of a "pure" environment (the desert) by its users, principally the United States military, which regarded it as a useless area. Here the message is subtle. One hardly notices the lines marking the dry lake bed where the space shuttle lands, but in others Misrach records scars caused by bombs as well as thoughtlessly tossed human detritus. A number of photographers produced giant-size prints, if the occasion called for it—Misrach's work measures almost 27 x 34 inches. Bay Area photographers wanted viewers to recognize that while a camera was nonselective in what it recorded on film, it could still interpret reality depending on how the artist used it.

Particularly innovative photography departments existed at San Francisco State College, at Lone Mountain College in San Francisco (1970–1978), and at the University of California, Davis. A sub-area of photographic activity existed in the Carmel/Monterey area. In Santa Barbara photography was taught from shortly after World War II at the Brooks Institute of Photography (although this had a vocational bent) and since 1979 at the University of California, Santa Barbara.

Art photography provided an affordable medium for new collectors, and increasing sales led to the opening of commercial outlets throughout the state. Photography shows were mounted in museums and in "alternative spaces." During the 1970s, California's experimental photographers were featured in national and local art periodicals as well as in numerous specialty photography magazines. Several artists had books of photographs or photographic essays published. Museums devoted exclusively to photography were founded in San Francisco, Riverside, and San Diego. The most recent technological invention to impact photography

is the computer. Photographs are digitized, allowing images to be modified on a cathode-ray-tube (CRT).

Crafts as Fine Art

There was once a rule that if a hand-fashioned object served a utilitarian purpose, it was a craft. If it was displayed on a pedestal, it was art. In the 1950s that was no longer necessarily true. By 1960, the Studio Craft movement that arose in the wake of World War II (chapter 25) had split into two parallel paths. These have persisted through the second half of the twentieth century. One path has been trod by artisans making the traditional utilitarian object, while the other was taken by an increasingly large number of artists who learned craft techniques in college and university classes and used the media as a fine art form. The division between the two paths was never sharp, and artists have continually crossed from one path to the other. Growing patronage induced commercial galleries to sell crafts, and crafts began to be shown in art museums. In 1973, Los Angeles gained a Craft and Folk Art Museum.

Ceramics. Although some ceramists defected to the world of small-scale ceramic, sculpture (chapter 27), many continued to create usable vessels. However, their vessels changed in look. Stoneware, the preferred medium from 1945 to 1960, lost ground to earthenware and porcelain that could carry brightly colored surface glazes reminiscent of both Pop art and souvenirs. Wheel throwing gave way to other forms of manufacture, such as slab, coil, modeling, and casting. Paul Soldner (b. 1921), who became particularly interested in the ancient Japanese ceramic form of Raku, spread his ideas at Scripps College, while other vessel-makers began to appropriate physical details as well as painted decoration from historical ceramics (see appropriation, chapter 36) and re-use them in their own work. In the last few years, the tendency to treat ceramics as sculpture has led to a fear that not enough emphasis is being placed on traditional techniques, such throwing pots on a wheel. Some schools, such as Otis, have dropped it all together.

Jewelry. Jewelry emerged as fine art in America around World War II (chapter 25) when many European craftsmen/jewelers took refuge in the United States and when the teaching of metal-smithing intensified

under the G. I. Bill and as occupational therapy. Through the 1960s and 1970s, the number of the state's art jewelers increased, and they continued to reject materials associated with commercial high-style jewelry (precious metals and gems), while seeking out new materials and styles. Today their components extend to steel, stainless steel, aluminum, and exotic metals such as titanium, tantalum, and niobium, which turn color when exposed to specific electric currents. Thanks to hippie interest in tribal and organic materials, jewelers have expanded from semiprecious stones into natural objects such as seashells, feathers, and eggshells. They employ manufactured materials such as fabrics, plastics and resins, cloisonné, glass, as well as recycled items and electronic parts. Techniques continue to include carving, cutting, casting, welding, kiln work, beading, and linking. Sometimes jewelry reveals humor and irreverence.

Among California's most successful art jewelers of the post-1960s period is **Arline Fisch** (b. 1931), who began the metals program at San Diego State University in 1961. She is probably best known for her adaptation of women's crafts (weaving, knitting, and crocheting) to metal, as in *Egyptian Dream* of 1996 (fig. 28-12). In Northern California, Lynda Watson-Abbott (b. 1940), has taught jewelry for twenty-five years at Cabrillo College in Santa Cruz. Her students' work ranges from pieces inspired by aboriginal art to those stimulated by postmodern abstraction and high-technology. With such rampant experimentation there can be no one "California" style. Today's metalsmiths strive for innovation, usually make one piece of each design, still pride themselves on craftsmanship, and are less concerned than their European peers with whether the pieces are user-comfortable, whether in

Fig. 28-12
Arline Fisch (b. 1931)
Egyptian Dream, 1996
sterling, fine silver, 18 k gold,
black onyx, pearls
6 in wide x 13 in. diam.
Collection of the artist
Photo: Will Gullette

Fig. 28-13
John Cederquist (b. 1946)
Tubular, 1990
Baltic birch, plywood, Sitka
spruce, maple, epoxy resin
inlay, aniline dye, litho ink,
metal hardware
84 x 48 x 16 in.
Robert and Gayle Greenhill
Photo: Mike Sasso

size, weight, or sharpness. They have replaced the "old fashioned" terms for necklaces, pins, brooches and bracelets with new names, including collars, neck rings, torques, and armlets.

Furniture. For years, America's center for furniture making was the Northeast, but more recently the West Coast has offered a serious challenge. San Diego State is currently the only university west of the Mississippi that offers a master of fine arts degree with an emphasis in furniture design. Today, furniture is made by artists for differing reasons: by craftsmen, by "fine" artists who specialize in usable furniture as an art form, and by painters, sculptors, printmakers, etc., who create an occasional chair or table for their own use.

Among those artists whose main medium is furniture is **John Cederquist** (b. 1946) of San Juan Capistrano, who made the chest of drawers *Tubular* of 1990 (fig. 28-13). Like most furniture-makers, wood is his main material, and craftsmanship remains of supreme importance. Contemporary furniture makers have moved away from the "Scandinavian" style of the late 1940s and 1950s. While they still delight in woods for their color differences, grain, and physical strength, today's concerns for ecology lead some artists to avoid rare or endangered species. Cederquist's chest is useable, made of sturdy birch plywood, but is made to look unusable through the three-dimensional painting that he applies to the surface, complete with shading and false perspective. His interest in illusion was inspired by a visit to a motion picture studio set where he saw paint used to create three-dimensionality; he decided to try the chicanery on furniture. He continues to be inspired by cartoons and by the European Surrealist René Magritte (1898–1967).

Los Angeles is home to a host of furniture-makers, who work in a variety of postmodern styles. Their amueblements look like a wedding of shattered glass and Tinker Toys. The intentionally bizarre geometry and Day-Glo colors are loony and cartoonish. Los Angeles furniture-makers' unconventional materials include fiberglass, rubber, cast concrete, Astroturf, and even found objects such as hubcaps and flashlights. Another category of furniture is painted overall with brightly colored patterns and designs. Throughout the state artists concerned about ecology are making furniture from recycled materials, such as cardboard and aluminum soft drink cans.

Furniture made by painters for their own purposes does not exhibit the same interest in craftsmanship or aesthetics as that made by the furniture specialists above, but tends to be interesting for its experimental nature and how it reveals the thought processes of a painter creating a three-dimensional object – for example, furniture made of straw.

Glass. If the question were asked, is it possible for an artist to say something new with a medium that has been in use for thousands of years—melted silicates, i.e., glass—the answer is yes. Contemporary glass artists are of two broad types: "hot" glass artists and "cold" glass artists. In the realm of "hot" (blown or cast) glass, an artist wanting to say something new stops making functional vessels, even if the "function" is decorative, and makes objects that explore glass's many intrinsic characteristics. Glass has great creative potential. It can be made transparent or opaque, any color in the spectrum, thick or thin, convex or concave, and can be embedded with foreign objects. Its surface can be smoked, frosted, silvered, cut and/or polished.

The figure who stands out in this field is **Marvin Lipofsky** (b. 1938). He carried his knowledge of glass, learned at the University of Wisconsin in Madison, to Northern California in 1964. His glass program at the University of California, Berkeley, became the second of its kind in the United States, and he went on to establish a glass program at California College of Arts and Crafts in Oakland in 1967. When Lipofsky began teaching glass art, the medium was in its infancy. Many of the techniques he now applies were actually developed after he left school, on travels he made around the world to work with glass artists of other countries. His sculptures, such as *California Storm Series # 30* of 1982-83 (fig. 28-14), are made in a two-step process. First, the glass is blown into a rough mold made from wooden shapes that lets the glass take on unusual, Baroque forms. Then, sometimes months later, at his studio in Berkeley, he reworks the piece cold, cutting it, hand-shaping it, sandblasting it and acid-polishing it, to enhance the nonobjective, fluid shapes. Each work becomes glass frozen in time at its moment of contact with the wooden mold. The result is elegant abstract shapes.

Most hot-glass artists work in three dimensions, but a number in Northern California have been putting their efforts into platters. The flat shape allows them to arrange color, texture, and pattern just as a painter would on a canvas. Hot-glass artists work throughout the state, but in Northern California there is now enough of a concentration to warrant an organization—Bay Area Studio Art Glass (BASAG). Lipofsky was a founding member of the Glass Art Society, an international glass organization, and the first editor of its *Journal.* Today's glass artists usually come out of colleges and universities (many in Northern California were Lipofsky's students at the University of California, Berkeley, and at the California College of Arts and Crafts in Oakland), and many have their own glass-blowing studios. Northern California hot-glass artists emphasize concept as well as technique.

Under the umbrella of cold-glass, the main art form is stained-glass windows. In the 1970s, the ancient technique was revived and updated and became a fine-art form for many, especially on the West Coast of North America. The modern stained-glass movement traces its origins to post-World War II Germany. There,

Fig. 28-14
Marvin Lipofsky (b. 1938)
California Storm Series # 30, 1982–83
glass sculpture, 10½ x 13 in
Collection of Mr. and Mrs. Boyd Carnick, Southfield, Michigan
Photo: M. Lee Fatherree

artisans intent on replacing the many windows destroyed by bombs looked afresh at the medium that had last reached a high point in color and intricacy in European medieval cathedrals in the 1200s. Contemporary artists adopted contemporary themes and worked with true stained (as opposed to painted) glass.

One of the most innovative of California's post-1960s stained-glass artists is **Paul Marioni** (b. 1941) formerly of Mill Valley. Marioni attributes his incorporation of commercial glass products, such as the chrome two-way mirror and the automobile headlight in his "stained-glass" window *Cadillac* of 1971 (fig. 28-15), to a lack of academic training that might have stymied his attitude. In other pieces he includes x-rays, polarized glass, and glass tubes. An innovation of which he is even more proud is his patented "specific imagery," the technical process that he resolved during a short stint at a glass factory in Germany. This process involves carving a figure out of cameo glass of

Fig. 28-15
Paul Marioni (b. 1941)
Cadillac, 1971
leaded glass
24 x 26 x ½ in.
Paul Marioni
Photo: Jack Fulton

multicolored layers, letting it melt into a glob of hot, clear glass, then blowing the whole. Like a balloon that has been written on, the carved piece swells into an unusual shape. Shapes are additionally modified when the blown glass is heated again and rolled into a sheet. Such a technique eliminated the need for leading between colored pieces of glass and is widely used in the glass industry today. Contemporary cold-glass artists still create windows, but they make them as often for private residences as for public buildings. They also make other forms, including stand-alone panels (that can be hung in front of windows), louvered windows, as well as freestanding sculpture. Since most of their work is displayed *outside* museums, in the community, they feel their work has more connection with the average person.

On the romantic end of the scale is **James Hubbell** (b. 1931) of San Diego's backcountry. Hubbell has worked in stained glass since 1956. Although his windows' organic and flowing designs are beautiful, they become more significant when he incorporates them into grotto-like buildings of his own manufacture, such as *Triton Restaurant* of 1974 (fig. 28-16). The window thus becomes an integral part of a total environment that also includes hand-hewn doors, sculpted plaster walls, specially designed furniture, and other items of decor. Hubbell often opts for natural and organic materials, including abalone shell, forged iron, and exotic woods. Not only has he created a compound of such buildings on his own property, but he has effected commissions for restaurants, homes, and chapels, and has even made palace doors in the United Arab Emirates. He admits his passion for light is his greatest motivation in creating such environments.

Since about 1980 glass has escaped its use as vessels, windows, and small sculpture and is now incorporated into site installations and into small and large sculptures.

Fiber. One of the most ancient art forms is the fabricating of natural materials into useful objects through various techniques including weaving, braiding, knotting, knitting, crocheting, netting, and quilting. Fiberworks entered the fine-art world during the great revival of crafts following World War II. In the 1950s and into the 1960s most artisans focused on hand weaving—making lengths of yardage that were used in individually designed clothing, or as runners for tabletops, napkins, and place mats. Others made wall hangings, hooked or shag area rugs, and quilts. Crafts workers sought an organic look through hand-spinning and hand-dyeing yarns with natural colors. Their interest was in tactile qualities, leading artists to combine several different types of natural fibers (cotton, wool, hemp, jute, paper, bamboo, etc.) in one work. If designs did appear, they often took the form of biomorphic freeform abstractions. Weavers traveled to remote areas in third world countries and to museums of textile art, intent on seeking out and uncovering ancient techniques, to relearn them, perhaps to incorporate them into their own art.

From around 1965 forward, however, as part of the general absorption of the crafts into so-called high art, artists began to see fiber as just one more material that they could use. Fiber became an especially innovative medium in the Bay Area in the 1970s, where it was fostered by Fiberworks Center for Textile Arts, begun by artists in 1973. At first, textile artists looked upon the materials themselves as content. They explored formal (aesthetic) issues, such as

the principles of repetition found in weaving, braiding, and knitting, and they were interested in the tactile qualities. They not only used traditional materials (all kinds of animal fur, various grasses, cotton, silk, and various kinds of wood) but pushed the parameters with new materials (paper, plastic bags, synthetic fibers, industrial vinyl, insect screens, newspaper, sea kelp, and nylon mesh, just to name a few).

A second generation that emerged in the 1980s continued to push barriers. Their fiber works often took shape as multimedia wall-hung objects, three-dimensional sculptures, environments, and even entire site installations. Some incorporate fiber into new media such as performance, video, book arts, and jewelry. Others update the medium with new technologies: photolithography, spray painting, heat fusing and electronics. In the humanist period that has existed since about 1980 (chapter 37), fiber art has been infused with emotions—for example, a knotted hanging of Saran Wrap designed to evoke a mood of poetry, delicacy, and fragility. Fiber art has also been impregnated with ideas, as when fiber artists reuse industrial materials to remark on America's ecological malaise. Fibers' once pejorative link to women has been turned, in recent years, into a positive association as fiber has become an emblem of women's empowerment. Women investigating their personal identities (chapter 37) often use the medium. Many men now also employ it. The field of fiber art is currently split between those artists who pursue traditional craft-type textile techniques and those who use fiber to make sociopolitical statements. In the 1990s, fiber activity has decreased, discouraged by limited sales and lack of exhibition venues.

The media discussed in this and the previous chapter have been in existence for many years; only the artists' treatment was "new." But some artists of the enlightened 1960s were not content with traditional materials and techniques, and they coined new media. The next chapter will reveal the new art forms such as site installations, performance, and video, and will show how they are just as much a product of their generation as the art that has gone before. ✻

Bibliography

Printmaking Workshops/Lithography/Serigraphy 1960–1980

Adams, Clinton, *American Lithographers, 1900–1960: The Artists and Their Printers,* Albuquerque: University of New Mexico Press, 1983. 228 p.

Adams, Clinton, "Lithography and Tamarind—An Informed Energy," *Grapheon* (Prague), v. 1, Spring 1997.

Adams, Clinton, "Lynton R. Kistler and the Development of Lithography in Los Angeles," *Tamarind Technical Papers,* v. 8, Winter 1977–1978, pp. 101, 102. *

Adams, Clinton, "Tamarind and the American Print Establishment," *Print Quarterly,* v. 14, no. 3, Sept. 1997, pp. 252–83.

"The Anderson Print Collection at Stanford," *The Stanford Museum,* v. 20–21, 1992, pp. 2–28.

Antreasian, Garo Z. and Clinton Adams, *The Tamarind Book of Lithography: Art & Techniques,* Los Angeles: Tamarind, 1971.

Art of Collaboration: Monotypes from the Studios of Garner H. Tullis, exh. cat., California State University, San Bernardino, Art Gallery, October 14–November 7, 1985.

"Artweek Focus: Contemporary Printmaking," [8 articles] *Artweek,* v. 23, no. 27, November 5, 1992, pp. 4–5, 16–25.

Beal, Graham, *Made in California,* exh. cat., Mappin Art Gallery, Sheffield, England, March 29–April 23, 1973. 23 p.

Breuer, Karin, et al., *Thirty-Five Years at Crown Point Press: Making Prints, Doing Art,* Berkeley: University of California Press, 1997.

Brown, Kathan, *Ink, Paper, Metal, Wood: Painters and Sculptors at Crown Point Press,* San Francisco: Chronicle Books, 1996. 287 p.

California Graphics, 1974: a Sourcebook of Original Prints by California Artists, Arcadia, Ca.: Graphics Group, 1973. 1v.

California Printmakers: an Invitational Touring Exhibition Sponsored by the Printmaking Center of the San Francisco Art Institute, San Francisco: Art Institute [1964–1966]. 28 p.

Cebulski, Frank, "The Challenge of New Technologies," [rev. conference *Artistic Applications of Contemporary Communications Technology,* Palace of Fine Arts, S.F. May 14–16] *Artweek,* v. 13, no. 20, May 22, 1982, pp. 1+.

Cohn, Terri, "The Look of Singular Impressions," [rev. *Monoprint, CA* at Mendocino Art Center] *Artweek,* v. 18, July 25, 1987, p. 4.

Colburn, Bolton, *Across the Street: Self Help Graphics and Chicano Art in Los Angeles,* exh. cat., Laguna Art Museum, 1995 and three other venues. 64 p.

Contemporary California Prints [Selected works by the California Society of Printmakers], exh. cat., Richard L. Nelson Gallery, University of California, Davis, November 10–December 19, 1982 and at an earlier venue. 24 p.

Contemporary Prints from Northern California for the Art in Embassies Program, 1966–1968, U. S. State Department, Oakland Museum, 1966. 48 p.

Cultural Exchange Center of Los Angeles, *Prints by American Negro Artists* [some from California], Los Angeles: Cultural Exchange Center, 1965. 11 p.

Davis, Bruce, "Los Angeles Prints, 1960–1980," in *Los Angeles Prints 1883–1980,* exh. cat., Los Angeles County Museum of Art, September 4 –November 30, 1980 and June 25–September 20, 1981. 112 p.

Davis, Bruce, *Made in LA: The Prints of Cirrus Editions,* exh. cat., Los Angeles County Museum of Art, October 19, 1995–January 14, 1996. 368 p.

Faberman, Hilarie, *Hine Editions / Limestone Press: The Archive at the Stanford University Museum of Art,* exh. cat., University Museum of Art, Stanford University, February 1–May 1, 1994.

Fine, Ruth E., *Gemini G.E.L.: Art and Collaboration,* National Gallery of Art, Washington, D. C., 1984. 16 p.

Gilmour, Pat, *Ken Tyler: Master Printer and The American Print Renaissance,* New York: Hudson Hills Press in association with Australian National Gallery, 1986.

Goldman, Shifra M., "A Public Voice: 15 Years of Chicano Posters," *Art Journal,* 44, no. 1, Spring 1984, pp. 50–57.

Klein, G., "Bay Area Printmaking Workshops," *Visual Dialog,* v. 4, no. 4, Summer 1979, pp. 23–5.

"LA Print '93," [3 articles] *Artweek,* v. 24, February 18, 1993, pp. 12–15.

Landauer, Susan, *Paper Trails: San Francisco Abstract Expressionist Prints, Drawings and Watercolors,* exh. cat., Art Museum of Santa Cruz County, February 20–April 11, 1993 and other venues.

Los Angeles Printmaking Society 13th National Exhibition, exh. cat., Laband Art Gallery, Loyola Marymount University, Los Angeles, April 26–June 3, 1995. 70 p.

Los Angeles Printmaking Society, *20th Anniversary Exhibition,* exh. cat., Brand Library Art Gallery, January 10–February 1, 1983. [Also Annual National exhibits 1–6, 1973–79 at various sites.]

Made in California: An Exhibition of Five Workshops, Grunwald Graphic Arts Foundation, Dickson Art Center, University of California, Los Angeles, April 19–May 16, 1971. 41 p.

Mayfield, Signe, *Directions in Bay Area Printmaking: Three Decades,* exh. cat., The Palo Alto Cultural Center, September 20, 1992–January 3, 1993. 28 p.

Millier, Arthur, "Return of Printmaking," *Los Angeles,* December 1963, pp. 48–50. *

The Monumental Image, exh. cat., University Art Gallery, Sonoma State University, Rohnert Park, and California State University, Northridge, 1987. 35 p.

Moser, Joann, *Singular Impressions: The Monotype in America,* exh. cat., National Museum of American Art, Smithsonian Institution, April 4–August 3, 1997. 212 p.

New California Printmaking: Selections from Northern and Southern California, exh. cat., Lang Gallery, Scripps College, Claremont, Ca., October 31–December 13, 1987. 20 p.

"New Directions in Printmaking," *Visual Dialog,* v. 4, no. 4, Summer 1979.

Pioneering Printmakers, exh. cat., San Diego: Fine Arts Gallery, November 9–December 15, 1974.

Plous, Phyllis, *Collaborations in Monotype* [Garner Tullis Workshop], exh. cat., University Art Museum, University of California, Santa Barbara, March 4–April 17, 1988 and two other venues. 68 p.

"Printmaking," *Visual Dialog,* v. 1, no. 3, March-May 1976.

"Printmaking," *Visual Dialog,* v. 3, no. 3, March-May 1978.

Prints California: Profile of an Exhibition, exh. cat., co-sponsored by The California Society of Printmakers, the San Francisco Foundation, Administrators of the Phelan Awards, held at Oakland Museum, April 29–July 6, 1975 and at the Santa Barbara Museum of Art. 44 p.

Prints USA: First Overseas Exhibition by the California Society of Printmakers, Sausalito, Ca.: California Society of Printmakers [exhibit held at World Print Council, San Francisco, January 11–February 24, 1984 and various other venues around the world through 1986]. 50 p.

Rosenthal, Mark, *Artists at Gemini G.E.L.: Celebrating the 25th Year,* New York: Abrams and Gemini G. E. L., 1993.

Rossman, Michael, *Speak You Have the Tools, Social Serigraphy in the Bay Area: 1966–1986,* exh. brochure, deSaisset Museum, University of Santa Clara, January 17–March 15, 1987. 4 p.

San Francisco Area Printmakers, exh. cat., Cincinnati Art Museum, Cincinnati, Ohio, January 12–March 18, 1973. 24 p.

Schenck, Marvin, *Fine Art Presses: A Survey of Master Printmaking in the Bay Area,* Walnut Creek, Ca.: N.P. 1978.

Six Printmakers of the Bay Area, exh. cat., Achenbach Foundation for the Graphic Arts, California Palace of the Legion of Honor, San Francisco, circulated to several sites, 1962. 15 p.

Tamarind: from Los Angeles to Albuquerque, exh. cat., Grunwald Center for the Graphic Arts, University of California, Los Angeles, December 4, 1984–January 20, 1985. [Grunwald Center Studies V]

Tamarind: Homage to Lithography, exh. cat., Museum of Modern Art, N. Y., April 29–June 30, 1969. 64 p.

Tamarind Lithography Workshop, Inc., *Catalogue Raisonne 1960–1970,* Albuquerque: University of New Mexico Art Museum, 1989. 284 p.

Tamarind: a Renaissance of Lithography, cat. for exh. circulated by International Exhibitions Foundation, Washington, D.C., 1971–72. 95 p.

Teiser, Ruth, ed., *Printing as a Performing Art* [Selections from interviews conducted by Ruth Teiser for the Regional Oral History Office, Bancroft Library, University of California, Berkeley], San Francisco: Book Club of California, 1970. 145 p.

Ten West Coast Artists [miniature reproductions of ten lithographs from Collectors Press, S. F.] exh. cat., San Francisco: Collector's Press, 1969. 22 p.

View, 1978+, published by Crown Point Press, San Francisco. [Chiefly text of interviews with contemporary artists.]

Wayne, June, *About Tamarind,* Los Angeles: The Workshop, 1969. 32 p.

Williams, Reba and Dave, "The Later History of the Screenprint," [after 1949] *Print Quarterly,* v. 4, no. 4, December 1987, pp. 379–403.

Young, J. E., "Contemporary Southern California Printmaking," *Print Review,* v. 2, 1973, pp. 49-63.*

Young, J. E., *Selections from Cirrus Editions, Ltd.,* Los Angeles County Museum of Art, 1974–75.

Graphic Design

The Altogether Book [All the Best Illustration, Advertising and Design of the West], Los Angeles: Art Director's Club of Los Angeles and Society of Illustrators of Los Angeles, 1975.

Art Director's Club of Los Angeles, *ADLA: 3 Credits* (40th competition), Los Angeles: Art Director's Club, 1987. [*ADLA: 4 Credits* published 1988; *ADLA: 5 Credits* published 1989, etc.]

California Graphics: Idea Special Issue, Tokyo: Seibundo Shinkosha Publishing Co., 1983. 140 p.

Coupland, Ken, "Multimedia by the S. F. Bay," *Graphis,* v. 51, no. 296, March–April 1995, pp. 68–75.

Coupland, Ken, "…Four Bay Area Designers [Calif. Designers, SF MOCA]," *Graphis,* v. 48, no. 282, November-December 1992, pp. 82+.

15 UCLA Design Faculty Artists, exh. cat., Frederick S. Wight Art Gallery, University of California, Los Angeles, February 1–March 13, 1977. 34 p.

Graphic Arts Directory: Los Angeles & Orange Counties, 28th ed., 1981.

Graphics '71: West Coast USA, exh. cat., University Art Gallery, Kentucky University, Lexington, no date, 1970. 43 p.

"The I. D. Forty," [40 article special section on West Coast] *ID* (N.Y.), v. 44, January/February 1997, pp. 52-93.

Institute of Graphic Designers, compl., *Graphic Design San Francisco,* San Francisco: Chronicle Books, 1979. 125 p.

Pacific Wave: California Graphic Design, exh. cat., Museo Fortuny, Venezia, September 27–December 27, 1987. 182 p.

Prendiville, Julie, *Los Angeles Graphic Design,* New York: Madison Square Press, 1993. 264 p.

Society of Illustrators, *LA, Illustration West,* [an example is *Annual 17* publ. 1978].

"Special Issue: New Design in California," [11 article anthology] *Interior Design,* v. 61, April 1990, pp. 156-217.

10th Annual Art Directors Exhibition: San Francisco Advertising Art: sf 58, San Francisco: Art Directors and Artists Club of San Francisco, 1958.

The Workbook (California edition), annual.

Psychedelic and Rock Posters

Bisbort, Alan, *The White Rabbit and Other Delights: East Totem West: A Hippie Company 1967–1969,* San Francisco: Pomegranate Artbooks, 1996. 77 p.

Cohan, Tony, "West Coast Graphics Face the Music," (graphic design of posters and album covers for rock music] *Graphis,* v. 28, 1972–3, pp. 174–93.

Electric Posters: San Francisco Rock Concert Memorabilia, 1966–1968, exh. cat., Memorial Union Art Gallery, University of California, Davis, n. p., 1974. 22 p.

Grushkin, Paul D., *The Art of Rock: Posters from Presley to Punk,* New York: Artabras (a division of Abbeville Press), 1987. 515 p.

Lemke, Gayle, *The Art of the Fillmore 1966–1971,* Petaluma, Ca: Acid Test Productions, 1997.

O'Brien, Glenn, "Psychedelic Art: Flashing Back," *Artforum,* v. 22, March 1984, pp. 73-79.

San Francisco Rock Poster Art, exh. cat., San Francisco Museum of Modern Art, October 6–November 21, 1976. 34 p.

Tomlinson, Sally Anne, *San Francisco Rock Posters 1965 to 1971,* M. A. Thesis, University of Victoria, 1991. [Ann Arbor, Mi.: UMI Dissertation Service, 1994]

Walker, Cummings, ed., *Great Poster Trip: Art Eureka,* Palo Alto: Coyne & Blanchard, Inc., 1968. 79 p.

Artists' Books

"Artweek Focus: The Art of the Artist's Book," [West Coast] *Artweek,* v. 22, no. 21, June 6, 1991, pp. 1, 17–23.

"Artists Books," [5 articles on] *Artweek,* v. 26, January 1995, pp. 16–20.

Castleman, Riva, *A Century of Artists Books,* [not Calif.] exh. cat., Museum of Modern Art, New York, 1994. 263 p.

Curtis, Cathy, "Encompassed in Paper," [rev. exh. Eaton/Shoen, S.F.] *Artweek,* v. 14, no. 2, January 15, 1983, p. 16.

Dialogue/Discourse/Research [artists' books] exh. cat., Santa Barbara Museum of Art, September 1–October 28, 1979. 144 p.

Hoyem, Andrew, "Working Together: Collaboration in the Book Arts," [Arion Press, S. F.] *Visible Language,* v. 25, no. 2–3, Spring 1991, pp. 197–215.

Printed Work: [an exhibition of artist produced books] exh. cat., Union Gallery, San Jose State University, March 22–April 9, 1976. 38 l.

Science Imagined: an Exhibition of the Book as Art, exh. cat., Berkeley Art Center, October 27–December 29, 1996. 32 p.

Seeing Spots, exh. cat., Porter Study Center, Porter College, University of California, Santa Cruz, March 14–April 14, 1995. 34 p.

Solnit, Rebecca, "The Wonder of Books," [rev. of *Book Sculpture* at New Langton Arts, S. F.] *Artweek,* v. 15, no. 43, December 15, 1984, p. 11.

A Southern California Decade: An Exhibition of Contemporary Books Reflecting the Diverse Work of Southern California Book Artists 1980–1989 (sponsored by Los Angeles, Alliance for Contemporary Book Arts), exh. cat., Research Library, University of California, Los Angeles, January–March 1989 and other sites. 16 p.

Words that Burn, exh. cat., Written by the Scripps College typography class, 50 copies printed, Claremont, Ca.: Scripps College Press, 1996. 1 v.

Comix

Estren, Mark James, *A History of Underground Comics,* San Francisco: Straight Arrow Books, 1974. [republished Berkeley: Ronin, 1993] 319 p.

Kurtzman, Harvey, introd., *R. Crumb's Carload o' Comics,* New York: Belier Press, 1976.

Zap to Zippy: the Impact of Underground Comix: a Twenty-Five Year Retrospective, exh. cat., Cartoon Art Museum, San Francisco, January 11 - April 7, 1990. 31 p.

Paper and Pulp

"Drawing & Paper," [5 articles] *Artweek,* v. 26, October 1995, pp. 14–18.

Dunham, Judith, "New Forms in Paper," [International Institute of Experimental Printmaking]," *Craft Horizons,* v. 36, April 1976, pp. 38–43+.

Farmer, Jane N., *Paper as Medium* [half Calif. Artists], exh. cat., Smithsonian Institution Traveling Exhibition Service, 1978–1980. 72 p.

"Fiber and Paper," *Visual Dialog,* v. 2, no. 2, December 1976–February 1977.

Glaubinger, Jane, *Paper Now: Bent Molded, and Manipulated,* Cleveland Museum of Art in cooperation with Indiana University Press, Bloomington, 1986. 76 p.

Kubiak, Richard, *The Handmade Paper Object,* exh. cat., Santa Barbara Museum of Art, October 29–November 28, 1976 and two other venues. 64 p.

Laky, Gyongy, "On Fibers and Papers [Fiberworks, Berkeley],"	*Visual Dialogue,* v. 2, pt. 2, December 1976–February 1977, pp. 3–5.

Making Paper: Papermaking USA, History, Process, Art, exh. cat., American Craft Museum, New York, May 20–September 26, 1982. 64 p.

Nicholson, Chuck, "Engaging Textures," [rev. *Paperwork* at Irvine Fine Arts Center] *Artweek,* v. 14, no. 2, January 15, 1983, p. 4.

Paper/Art: A Survey of the Work of Fifteen Northern California Paper Artists, exh. cat., Crocker Art Museum, Sacramento, January 17–March 1, 1981. 40 p.

"Paper Art," *Visual Dialog,* v. 3, no. 4, June–August 1978.

Paper Art, exh. cat., Lang Art Gallery, Scripps College, Claremont, Ca., November 9–December 21, 1977.

Talley, Charles S., "Plateaus of Invention," [rev. of *Paper Dimensions: Sculptural Paper by Bay Area Women Artists* at Berkeley Art Center] *Artweek,* v. 20, March 18, 1989, p. 1.

Toale, Bernard, *The Art of Papermaking,* Worcester, Ma.: Davis Publ., 1983.

Collage

Arts of Southern California—X: Collage, exh. cat., Long Beach Museum of Art, October 1–29, 1961. 16 p.

California Collage, exh. cat., LRC Gallery, College of the Siskiyous, Weed, Ca., February 3 - March 10, 1981. 32 p.

Contemporary Collage: Extensions, exh. cat., Montgomery Art Gallery, Pomona College, Claremont, Ca., January 23–February 16, 1983. 32 p.

Drawings

Arts of Southern California—XIX: Drawing, exh. cat., Long Beach Museum of Art, shown at six sites, 1966. 31 p.

Butler, Cornelia H., *The Power of Suggestion: Narrative and Notation in Contemporary Drawing,* The Museum of Contemporary Art Los Angeles and Smart Art Press, Santa Monica, 1996. [exh. at MOCA held November 3, 1996–January 26, 1997] 45 p.

"California Letters...California Drawing," *Studio International,* v. 196, no. 1004, 1984, pp. 62–63.

DiMichele, David, "Hand, Eye and Brain," [rev. of *The Elegant, the Irreverent and The Obsessive: Drawings in Southern California* at Dorothy Goldeen Gallery, Santa Monica] *Artweek,* v. 24, July 8, 1993, p. 29.

Drawing: Personal Definitions, exh. cat., University Gallery, California State University, San Diego, dates unknown, 1981. 32 p.

A Drawing Show, exh. cat., Newport Harbor Art Museum, January 26–March 9, 1975. [40 contemporary California artists] 47 p.

Drawings by Painters, exh. cat., Long Beach Museum of Art, January 17–March 7, 1982, and two other venues through 1983. 80 p.

Drawings 1970: California, Arizona, Nevada, Utah, exh. cat., Art Gallery, University of California, Santa Barbara, March 31–April 26, 1970. 28 p.

Johnson, Robert Flynn, *Subjective Realities: Seven Bay Area Artists* [etching, watercolor, drawing], exh. cat., Achenbach Foundation for Graphic Arts, Fine Arts Museums of San Francisco, June 5–August 22, 1982. 44 p.

Martini, Chris, "California Drawing: Taking a Chance with Modernism," *Studio International,* no. 1004, v. 196, 1984, pp. 62–63.

McDonald, Robert, "Surveying Drawing in California," [rev. of *California Drawings* at Modernism Gallery] *Artweek,* v. 15, no. 3, January 21, 1984, p. 1.

Mixed Media on Paper: 30 East Bay Women Artists, exh. cat., Berkeley Art Center, June 2–July 9, 1978. 31 p.

Nadaner, Dan, "Direct Marks and Layers of Mystery," [rev. of *Bay Area Drawing* at Richmond Art Center] *Artweek,* v. 18, May 30, 1987, p. 1.

Prints & Drawings, 1977 [Northern California black artists], African-American Historical & Cultural Society, 1977. 20 p.

Representational Drawing Today: A Heritage Renewed, exh. cat., University Art Museum, University of California, Santa Barbara, March 2–April 17, 1983 and three other venues. [half Calif.] 87 p.

Santa Barbara Drawings 1976, exh. cat., Santa Barbara Museum of Art, June 9–July 11, 1976. 20 p.

Three Directions: Agnes Denes, Channa Horwitz, Joyce Cutler Shaw, exh. cat., Newport Harbor Art Museum, October 23–November 28, 1976. 20 p.

Watercolors and Related Media by Contemporary Californians, exh. cat., Baxter Art Gallery, California Institute of Technology, Pasadena, September 29–October 30, 1977. 46 p.

Young, Joseph E., *Three Graphic Artists: Charles White, David Hammons, Timothy Washington,* exh. cat., Los Angeles County Museum of Art, January 26–March 7, 1971 and at Santa Barbara Museum of Art. 14 p.

Photography

Albright, T., "Photochic: Photography in California 1945-80," [review of Akron Art Museum traveling show] *Art News,* v. 83, April 1984, pp. 73–78.

"America's New Image Capital: L. A.," [4 article anthology] *American Photo,* v. 1, March/April 1990, pp. 47–88, 90.

"California," [9 photographers active 1950–70] *Camera,* v. 50, no. 7, July 1971, pp. 3–42. *

California Photographers 1970, exh. cat., Memorial Union Art Gallery, University of California, Davis, April 6–May 9, 1970 and two other venues. 78 p.

Collected Works [photographs], California Institute of Arts, Valencia, 1978. 55 p.

Contemporary California Photography, exh. cat., Camerawork Gallery, San Francisco, March, April, May, 1978. 66 p.

Cross Currents Cross Country: Recent Photography from the Bay Area and Massachusetts, exh. cat., Camera Work Gallery San Francisco and Photographic Resource Center, Boston, 1988. [San Francisco Camerawork *Quarterly,* v. 15, no. 3, Fall 1988] 64 p.

The Crowded Vacancy: Three Los Angeles Photographers, exh. cat., Memorial Union Art Gallery, University of California, Davis, April 5–May 9, 1971 and Pasadena Art Museum, June 29–August 29, 1971. 32 p.

Desmarais, Charles, *Proof: Los Angeles Art and the Photograph 1960-1980,* exh. cat., Laguna Art Museum, October 31, 1992–January 17, 1993 and five other venues. 142 p.

Desmarais, Charles, "Proof: Los Angeles Art & The Photograph, 1960–1980," *Art of California,* v. 6, no. 2, April 1993, pp. 53–56.

Fabricated to be Photographed, exh. cat., San Francisco Museum of Modern Art, November 16–December 30, 1979. 36 p.

Fischer, Hal, "California Photography: The Tradition beyond Modernism" *Studio International,* v. 195, June 1982, pp. 6–9. *

Focus Santa Barbara, [6 photographers shoot around Santa Barbara], exh. cat., Santa Barbara Contemporary Arts Forum, September 22–October 27, 1985. 58 p.

Garver, Thomas H., *New Photography: San Francisco and the Bay Area,* exh. cat., Fine Arts Museums of San Francisco, April 6–June 2, 1974 and Fine Arts Gallery of San Diego, July 13–September 8, 1974. 80 p.

Invented Images, exh. cat., Art Museum, University of California, Santa Barbara, February 20–March 23, 1980 and two other venues. 76 p.

Johnson, Deborah J., ed., *California Photography,* exh. cat., Museum of Art, Rhode Island School of Design, Providence, January 8–February 7, 1982. 52 p.

Johnstone, Mark, "Documenting Los Angeles," [rev. *Year 200: New Views of Los Angeles*] *Artweek,* v. 12, March 14, 1981, p. 13. [exh. cat. *Camera,* February 1981]

Johnstone, Mark, "Instant Image, Satisfaction Guaranteed," [rev. *One of a Kind* at LAICA re: Polaroid SX-70] *Artweek,* v. 10, no. 40, December 1, 1979, p. 15.

Jutzi, A., "Year 200: New Views of Los Angeles 1981," *Camera,* v. 60, February 1981, pp. 4–42.

Katzman, Louise, *Beyond Color,* exh. cat., San Francisco Museum of Modern Art, January 11–February 24, 1980. 16 p.

Katzman, Louise, *Photography in California 1945–1980,* NY: Hudson Hills Press, 1984.

Kismaric, Susan, *California Photography: Remaking Make-Believe,* exh. cat., Museum of Modern Art, New York, June 28–August 22, 1989. 84 p.

Lawrence, John Eric, *Basic Photography Instruction at the California State Colleges, a Comparative Study of Four Variant Programs,* Ed. D. Thesis, University of California, Los Angeles, 1972. 292 l.

Levinson, Joel David, *An Examination of Contemporary Photography Using the Flea Market of California as a Constant,* M.A. Thesis, University of California, Berkeley, June 1978. 43 plates.

Multicultural Focus: A Photography Exhibition for the Los Angeles Bicentennial, exh. cat., Municipal Art Gallery, Barnsdall Park and Los Angeles Center for Photographic Studies, Santa Monica, January 27–February 22, 1981. 50 p.

Murray, Joan, "Color!," *Artweek,* v. 14, no. 24, July 2, 1983, pp. 11–12.

Noriega, Chon A., *From the West: Chicano Narrative Photography* [half LA artists], exh. cat., Mexican Museum, San Francisco, December 9, 1995–March 3, 1996. 87 p.

Photographic Directions: Los Angeles, 1979, exh. cat., Security Pacific Bank, January 9–February 26, 1979. 45 p.

"Photography," *Visual Dialog,* v. 1, no. 4, June–August 1976.

"Photography," [5 articles on] *Artweek,* v. 26, no. 7, July 1995, pp. 12–17.

"Photography," [3 articles] *Artweek,* v. 27, no. 7, July 1996, pp. 12–16.

Products and Promotion: Art, Advertising and the American Dream, exh. cat., San Francisco Camerawork Gallery, September 4–October 4, 1986 and two other venues. 16 p.

San Francisco Bay Area Photography 1976, compl. by the Society for the Encouragement of Contemporary Art in cooperation with the San Francisco Museum of Modern Art, 1977. 68 p.

The Santa Barbara Connection: Contemporary Photography, exh. cat., Santa Barbara Museum of Art, May 21–July 24, 1994.

[special photography issue], *LAICA Journal,* no. 24, September–October 1979, pp. 20–55.

Studio Work: Photographs by Ten Los Angeles Artists, exh. cat., Los Angeles County Museum of Art, July 22 - October 31, 1982. 1 envelope.

Trowbridge, David and Peggy Wade, *Photographs by Southern California Painters and Sculptors,* exh. cat., University of California, Santa Barbara, College of Creative Studies, June 3–30, 1977. 56 p.

The Turbulent Sixties of the San Francisco Bay Area: Photography of Dissent, exh. cat., Focus Gallery, San Francisco, June 5–July 14, 1984. 23 p.

25 Years of Space Photography, exh. cat., Baxter Art Gallery, California Institute of Technology (in association with New York: W. W. Norton) May 22–July 31, 1985 and one other site. 120 p.

West Coast Conceptual Photographers, San Francisco: La Mamelle, Inc., 1976. 24 l.

Crafts

(See also bibliography for crafts in chapter 25.)

"Artweek Focus," [crafts] *Artweek,* v. 21, no. 41, December 6, 1990, pp. 21–25.

Angelino, M. "Three California Craftsmen," *American Artist,* v. 33, September 1969, pp. 45–53+.

Arts of Southern California—XI: Designer-Crafts, exh. cat., Long Beach Museum of Art, 1962. 23 p.

California Black Craftsmen, exh. cat., Mills College Art Gallery, Oakland, Ca., February 15–March 8, 1970. 24 p.

California Ceramics & Glass, 1974, exh. cat., Oakland Museum, n. d., 1974. 72 p.

California Craftsmen, exh. cat., organized by California Arts Commission, early 1960s. [Government Document A1280.C65] 31 p.

California Design shows at the Pasadena Art Museum, 1955+. [Held approx. every three years, these include *II* (1956), 6 (1960), *Eight* (1962), *Nine* (1965), *Ten* (1968), *Eleven* (1971), '76 (1976).]

California Women in Crafts: an Invitational Exhibition Recognizing Women in Creative and Leadership Roles in Contemporary Craft Forms and Media, exh. cat., Craft and Folk Art Museum, Los Angeles, January 18–February 27, 1977. 30 p.

"Craft Studies," [6 articles] *Artweek,* v. 27, no. 11, November 1996, pp. 12–17.

Craftsmen of the Southwest, San Francisco: American Craftsmen's Council, 1965. 238 p.

Creative Arts League of Sacramento presents *Eighth Biennial Crafts Exhibition,* exh. cat., E. B. Crocker Art Gallery, Sacramento, March 10–April 15, 1973. 76 p.

Creative Arts League of Sacramento presents *Ninth Biennial Crafts Exhibition,* exh. cat., E. B. Crocker Art Gallery, Sacramento, February 8–March 16, 1976. 78 p.

Creative Arts League of Sacramento presents *California Crafts: Tenth Biennial Exhibition of Work by California Craftsmen,* exh. cat., E. B. Crocker Art Gallery, Sacramento, March 12–April 10, 1977. 81 p.

Creative Arts League of Sacramento presents *California Crafts XI: Toys, Games and Other Playthings,* E. B. Crocker Art Gallery, Sacramento, 1979. 52 p.

Creative Arts League of Sacramento presents *California Crafts XIII,* exh. cat., Crocker Art Museum, Sacramento, March 12–April 17, 1983. 40 p.

Creative Arts League [of Sacramento] presents *California Crafts XIV: Living Treasures of California,* exh. cat., Crocker Art Museum, Sacramento, January 19–April 14, 1985. 86 p.

Creative Arts League of Sacramento presents *California Crafts XVI: Selections from One Man's Collection* [Hubert A. Arnold] exh. cat., Crocker Art Museum, Sacramento, February 25–April 2, 1989. 96 p.

"Design Way Out West Style," *Industrial Design,* v. 14, June 1967, pp. 30–51.

Designer/Craftsmen [annual exhibit], Richmond Art Center, Richmond, Ca. [28th held in 1981].

"Designers in California," *Industrial Design,* v. 19, June 1972, pp. 21–45.*

Dunham, J. L., "Made in LA: Contemporary Crafts '81," *American Craft,* v. 41, pt. 1, February–March 1981, pp. 16–23.

Emery, Olivia H., *Craftsman Lifestyle: The Gentle Revolution,* [interviews with 75 craftsmen] Pasadena, Ca.: California Design Publications, 1978. 168 p.

Hays, Joanne Burstein, "California's Senior Craftspeople," [rev. *Living Treasures of California* at Crocker Art Museum] *Artweek,* v. 16, March 2, 1985, p. 1.

Kangas, Matthew, "Nine Decades: The Northern California Craft Movement, 1907 to the Present," *American Craft,* v. 54, no. 1, February–March 1994, pp. 70+.

Kester, Bernard, *Made in LA: Contemporary Crafts '81,* exh. cat., Craft and Folk Art Museum, Los Angeles, January 28–April 12, 1981. 62 p.

"Made in California," *Interior Design,* v. 37, August 1966, pp. 186–97.*

"New Art Forms: Ideas and Materials [primarily former crafts]," *Visual Dialog,* v. 4, no. 2, January-March 1979.

A Show of Hands, exh. cat., California College of Arts and Crafts Gallery, Oakland, Ca., September 9–October 11, 1970. 24 p.

Southern California Designer—Craftsmen, exh. cat., Los Angeles: Otis Art Institute, 1965. 20 p.

Southern California Designer Craftsmen, exh. cat., Laguna Beach Museum of Art, November 18–December 30, 1973. 37 p.

Weingarten, Lila and Kendall Taylor, *Selling Your Crafts and Art in Los Angeles,* Los Angeles: Wollstonecraft Inc., 1974. 143 p.

White, Cheryl, "Cautionary Tales: Writing an Alternative History," [contemporary crafts] *Artweek,* v. 25, September 22, 1994, pp. 12–14.

Clay

(See also clay sculpture, chapter 27.)

Clay & Glass, Alameda, Ca.: Association of California Ceramic Artists, 1993. 108 p.* [contains a brief history of the group and of ceramics in California followed by reproductions and statements by member artists]

Foundations in Clay, exh. cat., LAICA, Los Angeles Institute of Contemporary Art, May 3 - June 8, 1977.

"Works in Clay," *Visual Dialog,* v. 2, no. 1, September-November 1976.

Jewelry

Benesh, Carolyn L. E., "Ornament in Los Angeles," [retail outlets for jewelry], *Ornament,* v. 17, pt. 1, Autumn 1993, pp. 68-73.

Blair, Suzanne, "Art to Wear," *San Diego Magazine,* v. 35, no. 5, March 1983, pp. 124–29.

Cartlidge, Barbara, *Twentieth Century Jewelry,* New York: H. N. Abrams, 1985. 238 p.

Cuadra, Cynthia, "California Metal Forms '90 at California Crafts Museum, San Francisco," *Ornament,* v. 14, Winter 1990, p. 13.

Drutt, Helen and Peter Dormer, *Jewelry of our Time: Art, Ornament and Obsession,* New York: Rizzoli, 1995. 352 p.

Fisch, Arline, "Textile Techniques in Metal," *Craft Horizons,* v. 35, December 1975, pp. 18–23.

Goebel, Erica, "Made in L. A.: Jewelry by Three New Artists," *Ornament,* v. 12, pt. 2, Winter 1988, pp. 49-55.

Johnstone, Mark, *Body Art,* exh. cat., Security Pacific Gallery, Costa Mesa, September 8–October 21, 1990.

Kingsley, Susan, "Alchemy: Metals Made Precious, Lynda Watson-Abbott's 25 Years of Influence," [teacher at Cabrillo College], *Metalsmith,* v. 15, no. 4, Fall 1995, pp. 38–39.

Lewin, Susan Grant, *One of a Kind: American Art Jewelry Today,* New York: Abrams, 1994.

Ornament, v. 1+, 1979+ (publ. in So. California)

School of Fisch; Arline M. Fisch; San Diego State University, exh. cat., Nordjyllands Kunstmuseum, Aalborg, Danmark, November 18, 1994–January 8, 1995. 80 p.

"Site-The Body," [craft, jewelry and clothing, body art] *Artweek,* v. 26, November 1995, pp. 14–18.

Trapp, Kenneth R., "Jewels and Gems: Collecting California Jewelry," *The Oakland Museum: The Museum of California,* v. 18, no. 3, Summer 1994, pp. 20–24.

Furniture

California Woodworking: An Exhibition of Contemporary Handcrafted Furniture, ex. cat., Oakland Museum, December 16, 1980–February 15, 1981. 16 p.

Christensen, Judith, "A Balance Between Design & Craftsmanship," [San Diego furniture] *Art of California,* v. 6, no. 5, October 1993, pp. 51–53.

Cohn, Terri, "Testing Disciplinary Boundaries," [rev. *Functional Sculpture: Six Furniture Makers* at Rena Bransten Gallery, S. F.] *Artweek,* v. 20, April 1, 1989, p. 4.

D'Elgin, Tershia, "Four Imaginative Furniture Designers Who are Making it in San Diego," *San Diego Magazine,* v. 32, no. 11, September 1980, pp. 174–79.

Domergue, Denise, *Artists Design Furniture,* New York: Abrams, 1984. 176 p.

Drohojowska, Hunter, "Post-Hollywood Furniture," *Connoisseur* (USA), v. 217, February 1987, pp. 120-23.

"Furniturism: Four Artists," *LAICA Journal,* no. 36, v. 4, Spring 1983, pp. 60–71.

New Furnishings: A Survey of Post Modern Bay Area Furniture Design, exh. cat., Triton Museum of Art, Santa Clara, Ca.,

June 8–July 28, 1985. 35 p.

Petersen, N., "California Suite: Furniture Design in California," *Craft International,* v. 5, October/December 1985, pp. 20–1.

"Studio Furnituremakers," *Art of California,* v. 4, no. 2, March, 1991, p. 33. [is a PR release concerning the show *New American Furniture* at the Oakland Museum and the museum's companion exhibit, *A California Complement: Recent Studio Furniture from the Bay Area* that showcases the work of 13 Bay Area furniture makers.]

Glass, General

American Glass Art: Evolution & Revolution, exh. cat., Morris Museum of Arts and Sciences, Morristown, N. J., April 3–May 30, 1982. 40 p.

Klein, Dan, *Glass: A Contemporary Art,* New York: Rizzoli, 1989. [contains a chapter on U. S. glass]

Glass, California

Apostol, Jane, *Painting with Light: A Centennial History of the Judson Studios,* Los Angeles: Historical Society of Southern California, 1997. 138 p.

"Bay Area Glass Artists," in *Glass Art Society Journal* (U. S. A.), 1994. [24th American Glass Art Society Conference held in Oakland]

California Ceramics and Glass, 1974, exh. cat., Oakland Museum, dates unknown, 1974. 76 p.

California Contemporary Stained Glass, exh. cat., Fresno Arts Center, December 14, 1976 - January 16, 1977. 24 p.

Cast Glass Sculpture, exh. cat., Main Art Gallery, Visual Arts Center, California State University, Fullerton, April 12 - May 11, 1986. 61 p.

Clay/Glass: a Guide to Clay and Glass Artists of Northern California, San Francisco, Ca.: Association of San Francisco Potters and Glassblowers, 1981. 110 p.

Contemporary American and European Glass from the Saxe Collection, exh. cat., Oakland Museum, June 6–August 24, 1986.

Hoover, Richard L., "The Judson Studios," *Stained Glass Quarterly,* v. 84, pt. 2, Summer 1989, pp. 121–28.

Levine, Melinda, "BASAG: Bay Area Studio Art Glass provides its members an ongoing forum for ideas," *American Craft,* v. 45, August–September 1985, pp. 10–17.

Mukerji, Betty Lou, "Captured for Eternity: the Breath of the Artist in Glass," *Art of California,* v. 6, no. 2, April 1993, pp. 50–52.

Rigan, Otto B., *New Glass: Stained Glass for the Age of Handmade Houses,* New York: Ballantine Books, 1976. 117 p.

Trinity Windows, San Jose: Trinity Episcopal Church, 1977. 32 p.

Fiber

Al-Hilali, Neda, "Fiber as Structure," [review of *Fiber Structure National* at Exploratorium, CSU, Los Angeles] *Artweek,* December 11, 1982, p. 5.

Artists' Quilts: Quilts by 10 Contemporary Artists in Collaboration with Judy Strauss, exh. cat., La Jolla Museum of Contemporary Art, January 23–March 8, 1981 and 3 other venues. 30 p.

Askey, Ruth, "Clothing Constructions," [review of *Clothing Constructions, An Exhibition of Artists who Make Clothes* at Florucci, Beverly Hills] *Artweek,* June 16, 1979, p. 7.

Austin, Joan F., "San Diego Fiber Update," *Fiberarts,* v. 19, January–February 1993, p. 29.

California Fibers 25th Anniversary Exhibition, exh. cat., Downey Museum of Art, Downey, Ca., May 4 - May 28, 1995 and the Lyceum Theater Gallery, San Diego, September 6–October 17, 1995. 36 cards in box.

Cohn, Terri, "Fiber Shows in the Bay Area," *Artweek,* v. 28, March 1997, pp. 30–31.

Dimension of Fiber, exh. cat., California College of Arts & Crafts, Oakland, March 4–29, 1971.

DuBois, Emily, "Charting the Growth of Fiber Art," [review of *6 Fiberworks Alumni] Artweek,* November 12, 1983, p. 8.

"Inspiration & Image: Trends in Contemporary Quiltmaking [San Diego]," *Art of California,* v. 5, no. 4, September 1992, pp. 36–37.

Fiberworks: An Exhibition of Works by Twenty Fiber Artists, exh. cat., Lang Art Gallery, Scripps College, Claremont, Ca., April 3–May 10, 1973. 28 p.

Papa, N., "San Francisco School of Fabric Arts," *Fiberarts,* v. 6, January 1979, pp. 13–14.*

Rowley, Kathleen, "Fiber Interactions," [review of *Exhibits/Projects* at Fiberworks, Berkeley] *Artweek,* August 15, 1981, p. 16.

Rowley, Kathleen, "Fiber—Toward a Contemporary Vocabulary," [review of *Fiber '81* at the de Saisset Museum] *Artweek,* March 7, 1981, p. 16.

Scarborough, J., "Fiber Lover's Guide to the San Francisco Bay Area," *Fiberarts,* v. 11, May–June 1984, pp. 43–45.*

Talley, Charles, "The State of Fiber Art [rooted in Bay Area's history]," *Artweek,* v. 21, December 6, 1990, pp. 21-24.

Transformation: UCLA Alumni in Fiber, exh. cat., Frederick S. Wight Art Gallery, University of California, Los Angeles, April 10–May 13, 1979. 37 p.

Wade, Marcia J., "Fibers of Being," [Bay Area fiber artists] *Horizon,* v. 31, no. 2, March 1988, pp. 21+.*

White, Cheryl, "Fibers in the Modern Sensibility," [review *Tangents: Art in Fiber* at the Oakland Museum] *Artweek,* September 19, 1987, p. 1.

1960–1975: Modernism's New Non-Painting Media

29

The art renaissance of the 1960s gave birth to several new media that have now taken permanent places in the art world. Some were conceived by artists as a conscious backlash to modernism while others represented new technologies pressed into use.

Conceptual Art

Conceptual art is sometimes called "idea" art because its main point is idea or content rather than formal aesthetics or physical form. There is considerable confusion about conceptual art in the wider population— not only is the term frequently misused, but between its emergence in the 1960s and today, it has evolved, and under its umbrella cluster many physically different art forms. (See also conceptually oriented painting in chapter 36 and conceptually oriented photography in chapter 28.) Histories of American art written by East Coast oriented art historians will have us believe that conceptual art originated in New York in the mid-1960s, was defined by artist Sol LeWitt (b. 1923) in articles in 1967 and 1969, and had its history codified by Lucy R. Lippard's *Six Years: The Dematerialization of the Object from 1966 to 1972* (New York: Praeger, 1973). In fact, the term was coined by the California assemblage artist Edward Kienholz but only became widespread when it was used in the title of the first issue of the British publication *Art-Language: The Journal of Conceptual Art,* which appeared in 1969. The art form was propelled by artists reacting against modernism as well as those looking for new ways to express themselves.

In Conceptual Art's initial phase (the1960s) ideas were usually expressed in some nonsalable form: site specific installations, earth art, real-time events (such as performance art), as well as documentation of proposed art objects (in the form of preliminary drawings, written concepts and ideas, scripts, photographs, videos, and correspondence). By producing nonsalable art forms, artists countered the materialism of the 1960s art world in which art dealers had the reputation for turning every art object into a commodity through hyperboles in the press, by making artists into personalities, and by using high-pressure salesmanship. Conceptual Art's first phase is also marked by certain cerebral themes, such as semiotics (the study of speech forms, language, and signs and symbols), the investigation of popular culture, as well as the study of aesthetics. After 1970 conceptual art enters a second generation. In this phase, an idea was frequently attached to a marketable object, such as a painting, and relevant topics expanded to cover an almost unlimited number of themes. California's leader in conceptual art is John Baldessari, first active in the mid-1960s, parallel to New York's early conceptualists. (He will be discussed with conceptual painting in chapter 36.) Most of the art forms discussed in this chapter have a conceptual basis. These are site-specific installations, earthworks, video, and performance.

Site-Specific Installations

Site-specific installations came into being in the 1960s. Basically, they are works of art constructed for a specific physical indoor or outdoor site. Since most site-specific installations are three-dimensional and are composed of several items of varying media, they also fit the formal description of assemblages. They differ in that they are usually larger in size and the components are not always physically attached to each other. Site specific installations take many forms and have evolved over the past thirty years. They range from small groupings, such as Wiley's Dada Funk sculpture (fig. 27-7), to indoor room installations (Scatter Art and Light and Space room environments, below), and large-scale outdoor environments (earthworks and sculpture gardens). Sculpture's change from a single discrete and self-contained object to one that consists of several parts related to the space around it is a revolutionary idea. It resulted from new scientific findings about the nature of reality as well as an American interest in Eastern and non-European philosophies which regard all matter as part of an interrelated universe.

An example of an *indoor* room installation is *Soft Wall (for Fort Worth) Study for Artpark* of 1976 (fig. 29-1) by **Lloyd Hamrol** (b. 1937). Most people make a kind of indoor site-specific installation when they arrange furniture in a room; they unconsciously take into account the individual components, their relationship to each other, the shape of the room, and the space itself. Obviously artists use more sophisticated materials, and their works often have symbolic meaning or answer perceptual questions. Hamrol has set up

Opposite:
Fig. 29-1
Lloyd Hamrol (b. 1937)
Soft Wall (for Fort Worth) Study for Artpark, 1976
cotton bags, sand, 78 x 288 in.
Lloyd Hamrol

similar "sculptures" in different locations, both indoors and out. In each case, how he arranged his modules (the nontraditional sculpture material of cotton or burlap sandbags) was determined by preexisting features of the site—in this case a rectangular white room of a certain size and with certain openings. In *Soft Wall* he layered the bags in an arc segment drawn on a radius from the inside corner of the room. Like performance (below), installations are meant to trigger thoughts in the mind of the beholder, to make the viewer regard his world with new eyes. Visitors to this site perceived the work differently depending on whether they stood within the concave side or out. In the late 1960s and through the 1970s, some installations, like Hamrol's, ascribed to a Minimalist philosophy, although Hamrol countered that style's tendency toward coldness and mechanization with his hands-on approach and by using materials that have a human appeal. His piece was "human" and "organic" in that its edges were soft. The human scale made it inviting.

In the 1970s site-specific installations, along with performance, video, and photography, garnered considerable critical attention. They became popular with galleries that found that static displays were less trouble than one-time performances; and artists realized that the creation of a semipermanent work with its longer and greater public exposure was more advantageous to their careers. Gallery audiences were intrigued at how an empty space could be transformed. In recent years, site-specific installations reflect changing art concerns, and many have become conveyors of or metaphors for personal, social, and political ideas. For example, an alcove of a museum reconfigured to look like a furnished room in a private house might visualize an artist's memories of his or her own past. Recent large, outdoor site-specific installations are showing greater environmental sensitivity—they either reclaim misused land, adopt an organic look to fit with the surroundings, convey an environmental message, or are made from recycled materials. By the late 1980s, with the breakdown of media barriers, site specific installations merged with or were absorbed into other new art media such as video and performance.

Light and Space Movement

A number of artists who used light as a medium were headquartered in Southern California and emerged in the late 1960s. Light as an artistic medium may surprise some, but light has an incredibly rich creative potential. Colors of light affect humans emotionally and psychologically, just as do colors of oil paints or watercolors. Light can be warm (sunlight and firelight) or cool (moonlight and starlight). Blinding and intense red lights can produce anxiety, while soft half-light can evoke a meditative state. Light can be harsh and bright, concentrated (as with lasers) or diffused (as through gauze, scrim [a diaphanous curtain material], or plastic). Humans can be blinded by too little or too much light. Long exposure to certain colors can produce after images of complimentary colors. Too strong light can block out hearing. Darkness and light can be contrasted. Artists working with light usually associate it with a physical vehicle such as a painting-like object hung on the wall (chapter 30), a room installation, a three-dimensional sculpture, or an earthwork. Some writers like to argue that the Light and Space movement was sparked and influenced by Southern California's persistent sunshine and spaciousness; others counter that it came out of scientific experiments in human perception conducted by the aerospace industry and that artists created with *artificial* sources.

In a standard scenario for a light room installation, an artist is presented with an existing space (in an older building, a museum, or a commercial gallery) that is usually stripped and painted white. It is the artist's goal to change the appearance and feel of the room through remodeling and adding light. Natural light can be admitted through doors, windows, skylights, and shutters. Artificial light can be added in the form of incandescent bulbs, strobes, tubes of fluorescent light, or lasers placed along the perimeters of rooms or hidden. While an architect takes light into consideration when designing a room—where to place door and window openings for best illumination and design, etc.—most California artists were interested in perception, in using light to elicit emotions or evoke a psychological state.

James Turrell (b. 1943) was one of the early members of the movement and one of the few of the group who continues to work in the medium to the present day. Turrell, who received a degree in psychology from Pomona College in 1965, participated in the Art and Technology program overseen by the Los Angeles County Museum of Art in the late 1960s. He worked closely with fellow artist Robert Irwin and with Dr. Edward Wortz, an experimental psychologist from the University of Texas who was employed by Garrett Aerospace to conduct experiments in human perceptual response under special conditions. Turrell became

particularly interested in people's physiological responses to different types of light, especially the *aura of light* (as opposed to a beam or an illuminated object). His goal was not to create a tangible art object but an experience. Turrell has used light in a variety of physical situations. Some of his very early works were partial room installations where a viewer moved from one room having a particular light quality to a second room having a different light quality. In such a situation the viewer's eyes, already adjusted to the color or intensity of light in the first room, perceived the light in the second room in a subtly different way than someone entering that second room from a different environment or even someone who had lingered in the second room for some minutes. The retina of the human eye has photoreceptors that "read" light intensity and color. When exposed to one color for an extended period the sensors desensitize to it. This can be demonstrated by staring at a white wall immediately after staring at one intense color; a human will "see" the complimentary color on the wall, "imagined" there by the temporarily burned-out eye receptors. *Rondo* of 1969 (Orange County Museum of Art, not pictured) consists of a room bathed in intense blue light emanating from fluorescent tubes lining the sides and tops of two side walls. Called a shallow space construction, it is the only work by Turrell that can be "entered into" as opposed to looked into. Intense light, as used here, is perceived by humans to have density and weight. A viewer's first impression upon entering this room is a near blindness from the intensity, but as the eye adjusts to the color, just as eyes adjust to a blackened room, the viewer is soon able to see his surroundings. Visitors to Turrell's colored atmosphere experience a range of emotions, from the unsettling fear caused by temporary blindness to the calming state of meditation prompted by long-term residence in a subtly lighted room.

Another Light and Space artist, **Eric Orr** (b. 1939) uses light in a different way. Orr merged two seeming opposites in his art. His scientific interest in up-to-date technology fused with his emotional fascination with ancient magic, mysteries, cults, religions, and his attraction to primal, organic materials. Orr's work has taken many forms, from room installations to performance; *L. A. Prime Matter* of 1991 (fig. 29-2) joins light with a three-dimensional sculpture. It consists of a thirty-five foot vertical column, a conduit for natural gas and water; that is set in a shallow pool of water. Every thirty minutes the vertical channel discharges crackling, roaring flames and hissing steam. Although this particular work is dated 1991, it is a refinement of a sculpture Orr erected at the Los Angeles County Museum of Art in 1981. Primitive man held naturally

Fig. 29-2
Eric Orr (b. 1939)
L. A. Prime Matter, 1991
Brass column with fire and water, 35 ft. high
Permanent Installation,
Mitsui Fudosan Building,
Los Angeles

occurring phenomena such as geysers and volcanoes in religious awe, regarded them as the expression of some inexplicable force, and responded with emotions of fear, wonder, admiration, and reverence. Orr's work has been likened to Wagnerian melodrama, but he is

more a poet-alchemist, exploring the primal responses of humans towards intangibles such as firelight.

Largely unknown to Los Angeles's Light and Space artists, light's artistic potential had been investigated by several previous artists, the earliest being Europe's Laszlo Moholy-Nagy (1895-1946) about 1930. He had not only incorporated light into his kinetic *Light-Space Modulator* but had recognized that light had the ability to encompass space and to demand interpretation from a spectator. In early 1940s Hollywood, several avant-garde filmmakers experimented with light and sound, including the brothers John and James Whitney, who filmed pure light and coordinated it on film with mechanically generated atonal sound. Charles Dockum created a MobilColor Projector that projected various colored lights on a screen cued by the music he played on an electrically attached organ. It was only in the 1960s that light became widely used as a medium. Europe's Groupe de Recherche d'Art Visuel, whose manifesto was issued in 1963, created a Labyrinthe that was interactive—the spectator could activate light works and move about within them. San Francisco's rock music promoters used bright light for entertainment, in the form of colored lasers or strobe lights, to enhance happenings. Of all of these, the work of Los Angeles's Light and Space artists is considered to be on a higher plane because of its esoteric goal of exploring human perception. For many years, the West Coast's Light and Space movement was not acknowledged by New York, where there was no equivalent movement. However, Europeans, who had a long

history of using the latest scientific technology, including light, to make art, recognized it as a valid art form, and Californians were invited to all corners of America and Europe to execute commissions. (See light "paintings" p. 411+.)

Earthworks

Earthworks, the largest form of sculpture (or site-specific art, depending on the term preferred), evolved about 1968 and flourished through the early 1970s. Earthworks occur when some force manipulates or changes the natural environment. There are two types: "natural" (such as craters formed by meteors) and "man-made" (ranging from historic American Indian mounds to the more recent dams, aqueducts, large-scale formal gardens, parks, and golf courses). It was Michael Heizer (b. 1944), a Berkeley-born artist who, dreaming in New York of creating a sculpture on a monumental western scale (similar in size to the heads of the presidents that Borglum sculpted on Mount Rushmore), conceived the idea of modifying the land itself. The Southwestern deserts of the United States, especially those in California and Nevada, proved excellent sites, offering not only vast acres of empty land but the presence of natural geographic forms (such as craters and dry lakes) that could be enhanced. The arid climate prevented nature from "erasing" the artist's efforts with rain or covering them with vegetation. Early earthwork artists, such as Heizer, modified by "cutting away," i. e., by digging ditches and removing dirt, while others "added to" by dumping loads of dirt at a site. Several of Heizer's pieces were executed at Coyote Dry Lake in California's Mojave Desert. Another variant is Walter de Maria's (b. 1935) *Mile Long Drawing* of 1968, which consists of two parallel, ruler-straight, mile-long, three-inch-wide chalk marks in the Mojave Desert.

The 1960s/1970s earthwork movement was a natural response of its time. It fit the avant-garde category of a site-specific installation, and its lack of sales potential made it a valid backlash to the commodification of art. However, the movement was short lived. People began to look upon such despoliation of an untouched landscape as ecologically unacceptable in an era when they were being taught to respect and preserve their wilderness in its pristine form. Soon large-scale works took on positive environmental goals, such as when played-out pit mines were returned to nature or redesigned by artists for human purposes, such as public parks. California's **Helen Mayer Harrison** (b. 1929) and **Newton Harrison** (b. 1932) have earned worldwide renown for helping communities heal ecologically damaged areas by redesigning them to comply with nature's laws and also to be utilized in a range of ways

Fig. 29-4
Christo (b. 1935) and
Jeanne-Claude (b. 1935)
*Running Fence, Sonoma and
Marin Counties, California,*
1972-76
nylon material, steel cable,
steel poles
18 ft. ht. x 24½ miles long
Copyright Christo 1976.
Photo: Jeanne-Claude.

by residents. Their art, consisting of diagrams and hand-worked photographs, helps spread the word about protecting the environment.

Some earth artists create indoor site-specific installations by bringing bits of nature into a gallery where they scatter or arrange them; such art works are also known as scatter or displacement art. An example is *Baja California Circle* of 1989 (fig. 29-3) by **Richard Long** (b. 1945). In scatter art, an artist "scatters" natural materials (such as hay, dust, earth, debris, leaves, logs, sawdust, rocks, etc.) within a site, usually a room. In his arrangement, Long has kept in mind how the scattered items and the space must work as a whole. Scatter pieces depend on the principle of randomness; most are marked by horizontality. Long and fellow English rambler Hamish Fulton (b. 1946) were particularly conceptual in their earth art. Some pieces consisted only of walkabouts in the wilderness of Northern California, their only physical products being the photographs and written essays that document the events.

Earthworks differ from the work of landscape architects in that earthworks are conceptual—to reveal the world anew and to combine symbolic form with the natural landscape to prompt meditation. Earthworks' grand scale also qualifies them as sublime, although they do not pretend to ascribe to any of the historic philosophic approaches to nature treated by earlier painters, such as the Romantic. Earthworks can also serve as environmental statements.

California has also served as the site for important outdoor art works by international artists. The giant-scale art works of the team **Christo** [Javacheff] (b. 1935) and **Jeanne-Claude** [de Guillebon] (b. 1935), which incorporate fabrics into both urban and rural settings, have elements of both a site-specific installation and earth art. Today's media boundaries often overlap. The couple, however, see themselves as environmental artists, that is artists who work out-of-doors but *not* artists with an environmental cause. Christo's long-term interest has been "wrapping" objects. And over the years, from the couple's early career in Paris to the present—they now live in New York with their son, Cyril—their art works have progressed from "wrapped" table-top size objects to large-scale environmental works composed of entire islands or counties to which they *temporarily add* non-natural materials such as fabrics. California projects include *Running Fence,* erected over twenty-four and a half miles of Sonoma and Marin county landscape in the fall of 1976 (fig. 29-4). *Running Fence* was made from 240,000 square yards of heavy woven white nylon fabric hung from steel cable strung between steel poles embedded, rather than concreted, into the earth (for easy removal). After fourteen days, the "foreign objects" were removed, leaving the land visibly untouched. All materials were given to the local ranchers. In 1991 California's Tejon Pass became the site for Christo and Jeanne-Claude's *The Umbrellas, Japan–U.S.A.* The piece was created to

highlight the similarities and differences between how two major countries on opposite sides of the Pacific treat their own landscape. The two-story bright yellow umbrellas, "houses without walls," were arranged like temporary settlements along the hillsides of the pass. The making/process of the projects—involving years of give-and-take designing, the raising of millions of dollars from the sale of preparatory drawings and other "collectable-size" art, the supervision of hundreds of seamstresses and construction workers, as well as the garnering of the approvals from many government agencies and environmental groups—makes the process of their art almost as important as the final product. Jeanne-Claude states, "Our goal is to create art works of joy and beauty." A side benefit, in many cases, has been the renewed appreciation by local residents for the object or the geographical area that Christo and Jeanne-Claude wrap, and this sometimes leads to the object or area's revitalization.

Video

In the early 1960s artists adopted the new technology of video as a medium, and in the 1970s they turned it into a major avenue of expression. During the 1970s video technology rapidly advanced, the commercially "unsalable" art was supported by grants from government and private foundations (such as the Rockefeller Foundation), and both PBS as well as cable television stations helped video artists by giving them access to their expensive equipment and airing videos to a mass audience. Video evolved from black and white to color, from political protest to entertainment, and from naive and unedited shooting of actual events toward more planned pieces, approaching the scripted, costumed, directed, acted, and edited videos of broadcast television. By 1980, video had changed from a relatively inexpensive art form to a big-budget enterprise that required a full gamut of staff. In the 1980s the fashion was for highly technological production. Video broke away from museums and entered the commercial world, particularly in the form of music videos.

San Francisco provided home to California's earliest sizable number of video artists. From the late 1960s, they were chronologically supported by TV station KQED, the nonprofit National Center for Experimental TV, the city's many alternative showplaces (such as Video Free America), and the University of California, Berkeley. The city's early video both documented and was associated with public events—the art world "happenings" as well as the big, commercial, multimedia extravaganzas put on by rock music promoters that included drugs; sound, slide, and light shows; and people spontaneously performing. Privately, video was used by performance artists, who capitalized on its instant replay to study their techniques and document their live performances. In 1979, video/performance artist **Lynn Hershman** (b. 1941) turned to the new technology of videodisks and computers and became the first artist to make an artist's performance video interactive. Interactivity between artwork and viewer increases as an element in art as the century progresses. By 1989–91, the date of *Deep Contact* (fig. 29-5), technology had reached a state where viewers could interact with a computer through tools such as a keyboard, a mouse, or a touch-tone telephone. Hershman set up her program to intermittently query the user for a direction and then to respond accordingly when certain parts of the computer screen were touched. Touching caused the computer to retrieve selected performance segments stored on the videodisk and thus allowed the viewer to control the course of the narrative.

In Los Angeles, video also rapidly evolved, but its history was very different from San Francisco's. The city's earliest video artist was Bruce Nauman (b. 1941) in the late 1960s. Other notable artists include William Wegman (b. 1943)—who made humorous videos of his Wiemeraner, Man Ray—Joel Glassman (b. 1946),

Fig. 29-5
Lynn Hershman (b. 1941)
Deep Contact, 1989–91
interactive video
Lynn Hershman and Sara Roberts
Photo: L. Hershman

Fig. 29-6
Bill Viola (b. 1951)
The Theater of Memory, 1985
mixed media, video sound
installation, 14 x 23 x 30 ft.
Collection of Orange County
Museum of Art, Museum
Purchase
Photo: Kira Perov/Squidds &
Nunns

and Howard Fried (b. 1946). Since 1974 the medium has been particularly fostered by the Long Beach Museum of Art. Not content with the traditional museum role of exhibiting only completed projects, the museum became actively involved in video creation, offering scholarships, coordinating artist access to technical equipment, getting video aired on several cable channels, and holding symposia. Independent video has also been backed by city programs and by the American Film Institute.

In the 1970s and 1980s video (along with performance and site installations) became one of the most innovative, cutting-edge art forms. With the general breakdown of barriers between media that occurred from 1970 onward, video was soon combined with other media. Typical might be the work of **Bill Viola** (b. 1951), whose *The Theater of Memory* of 1985 (fig. 29-6) merges video with a site-specific installation. Viola's presentation is meant to make people reflect on how the human brain calls up memories. (The subject of memory has become a popular topic with artists of the 1990s, who often investigate it to answer questions about personal identity.) In the artist's own words, "There has been much speculation, scientific and philosophical, on the causes and processes of the triggering

of nerve firings in the brain that recreate patterns of past sensations, finally evoking a memory. Central to the brain's operation is the fact that all its neurons are physically disconnected from each other and begin and end in a tiny gap of empty space. The flickering pattern evoked by the tiny sparks of thought bridging these gaps becomes the actual form and substance of our ideas. All our thoughts have at their center this small point of nothingness." Viola recreates this gap and its activity in *The Theater of Memory.* "A large tree leans diagonally across the room, its exposed roots at the floor near the entrance, and its bare branches stretching to the ceiling at the far corner of the space. Fifty small electric lanterns are hung on its branches. Up on the rear wall is a large video-projected image. The picture is dominated by electronic noise and static patterns. Recognizable images are seen trying to break through, but they never come in clearly. Bursts of loud static and noise come through the speakers, as if a loud clear sound were about to come on but never does. There are long silences between the bursts of noise. The only light in the room comes from the flickering lanterns and the violent flashing of the video image. The only continuous sound in the room is the delicate tone of a small wind chime hanging from a tree branch."

Performance Art

One of the earliest types of conceptual art was performance. In performance, artists use their own bodies as a medium for expression. Although man has been performing since the dawn of civilization, today's performance art is usually traced back to the Futurists and Dada artists of about 1916 to 1920 and to "happenings" of the 1950s and 1960s. Most performance art is intended to convey ideas that the artist hopes will make an audience view the world differently.

Performance art varies greatly. It can be impromptu or scripted. A performance can be acted by a single individual or a group, and the setting can be simple or elaborate (with music—sometimes from electronic or novel acoustic instruments—and dance). Performances are usually short (ten to fifty minutes) or sometimes extremely long, if duration is a key element. They are usually written, directed, and sometimes acted by the dominant artist, whose concept for the performance can be narcissistic, novel, humorous, irreverent, and—to an audience accustomed to being able to predict outcomes of movies and television—intriguing and unexpected, even shocking. Performances have been presented in a variety of venues ranging from artists' studios to abandoned warehouses, and in public or commercial galleries, special sites established for live performance, or on any city street or in any public building.

California has a rich heritage of performance art. Although the medium appeared across the state about 1967 to 1968, early performance was inspired by and took different forms in Northern and Southern California. In Northern California it seems to have evolved from the political scene of happenings, demonstrations, and sit-ins and from the Bay Area's predilection for intermeshing dance, music, poetry, film, and theater. Its early centers were the University of California at Berkeley and Davis. Later, in San Francisco, it was supported by the Museum of Conceptual Art (MOCA) and at established institutions such as the San Francisco Museum of Modern Art, the San Francisco Art Institute, and in many new alternative spaces, including La Mamelle.

An example of early Bay Area performance is the improvisational, personal, and ritualistic form exemplified by *Levitation* of 1970 by Terry Fox (b. 1943). In this work, the artist lay motionless for six hours in the center of a room in the Richmond Art Center trying to levitate himself. By laying atop a square of dirt, within a circle drawn with his own blood, and holding four polyethylene tubes filled respectively with blood, urine, milk, and water, which he was metaphorically expelling from his body, he was symbolically releasing his spirit from his physical form. Fox had been diagnosed with Hodgkin's disease, and this "living sculpture" was meant to transmit autobiographical concerns, especially recollections of his days in the hospital

In Southern California, performance was fueled by many sources. The transplanted New Yorkers Eleanor Antin (b. 1935), Simone Forti (active 1960s), and Allan Kaprow (b. 1927), who taught in California in the early seventies, were early influences. Antin had been a performance artist in New York before she moved with her husband to San Diego about 1968. Kaprow had been active as a teacher in New York in the late 1950s where he fostered and was involved in "happenings," New York's multimedia events whose name he coined. Other influences were Claes Oldenburg (b. 1929), Yvonne Rainer (b. 1934), a leading figure at Judson Memorial Church in New York City, as well as dancer Steve Paxton (active 1960s), who started "contact improvisation."

In the early years of performance (between 1967 and 1974), the art form burst out almost simultaneously at several centers. The most important was at the avant-garde California Institute of the Arts (CalArts), where Kaprow, along with other New York event-making artists, began teaching. Performance also flared spontaneously at the art department of the relatively new University of California, Irvine (UCI), where a graduate art program began in 1969. At UCI, although the form was not supported by the faculty, first-year students, including Chris Burden (b. 1946), Barbara Smith (b. 1931), and Nancy Buchanan (b. 1946), started their own alternative gallery, "F Space," in a local industrial complex, also in 1969. In 1970 Judy Chicago started the first feminist art program at Fresno State College, where she used performance as a consciousness-raising tool. The following year, Chicago returned to Los Angeles to begin a feminist program at CalArts (for the feminist movement in California, see chapter 33), bringing with her several of her top students, who were interested in the medium of performance. While performance had existed in San Diego since Antin's arrival, the medium was bolstered in 1974 when Kaprow joined the Visual Arts Department at the University of California (UCSD).

California, particularly Los Angeles, has been in the forefront of performance art for the last twenty-five years. One of the earliest and best-publicized

performances was *Shoot*, which took place when the artist Chris Burden had a friend shoot him in the arm with a gun. Although difficult for most people to understand, this sensationalist event, typical of those presented at "F Space," was part of a series in which Burden challenged the physical limitations of his body. Los Angeles has many individual performance artists; however, two groups closely identified with the medium are feminists (chapter 33) and Chicanos (chapter 34). Feminist artists used performance to call attention to the themes and issues in women's daily lives. In 1972, **Suzanne Lacy** (b. 1945), Chicago, and two others performed *Ablutions* to address the taboo topic of rape. Throughout the seventies, sexual violence was a major theme for the artists Lacy and **Leslie Labowitz** (b. 1946), who were early pioneers of the media performance event. An example is the December 1977 motorcade that carried fifty black-clad women from the Los Angeles Woman's Building to City Hall. *In Mourning and In Rage* (fig. 29-7) protested the tenth victim of the Hillside Strangler, the local rapist and killer of women, and at the same time reflected on the broader question of media portrayals of violence against women. This kind of performance not only provided a personal catharsis for Los Angeles's large contingent of feminists but was directed to raising public consciousness, and, in typical Media City fashion, used the press to spread word of the event.

Some authors identify Los Angeles with a more "Hollywood" and theatrical style of performance, generally following a written script and presented to entertain (most often as a monologue). Serious messages were often conveyed with humor. Performances ranged from monologues to pieces that involved a group of actors, musicians, and dancers. Much of this kind of performance used traditional theater compressed time (as opposed to real time). The best known performance artist of this type is Rachel Rosenthal (b. 1926), whose prolific works eventually won her an Obie award and recognition by a more traditional theater world; also to be mentioned is Whoopi Goldberg (b. 1950), who was known for her biting political humor.

Chicano culture, thriving in California, produced its own brand of performance, including the artist/humorists of Los Angeles's Asco, whose enactments spoofed stereotypical images of Latinos. The Native American artist James Luna (b. 1950) placed his body on display in Balboa Park's Museum of Man to comment on the museum's "cold" presentation of Native American artifacts. In recent years, as art world emphasis has been directed toward society's problems (chapter 37), a performance group—L.A.P.D. (Los Angeles Poverty Department)—has been formed by homeless

people who work with the former New York artist, John Malpede.

In the 1970s and 1980s, with most of art's traditional media seemingly exhausted, so-called "new" media, like those discussed in this chapter, were given extensive press coverage. With the passing of time and the multiplicity of artists taking up the various media, distinctions between Northern and Southern California versions have disappeared. By 1980 some claimed performance art had lost its radical edge. (In some cases it had become so gentrified that tickets could be purchased in advance with a credit card.) To the contrary, its expressions are richer than ever. Like other media, in the last twenty years it has expanded into multimedia, has become interdisciplinary, and has taken up personal, political, or socially relevant themes (chapter 37).

By the mid 1960s and certainly by the early 1970s many people were predicting the end of painting as an art form. Not only had Minimalists eliminated everything about painting except the object (chapter 30), but, the Light and Space artists dematerialized the object, and the conceptualists regaled it as secondary to the idea. But painting was not dead. The next few chapters will cover some of the exciting new directions it took. ❧

Fig. 29-7
Suzanne Lacy (b. 1945) and
Leslie Labowitz (b. 1946)
In Mourning and in Rage,
Dec. 1977
performance and media event
Photo courtesy Suzanne Lacy
Photo: Susan Mogul

Bibliography

Conceptual Art, General, 1960–1980

Smith, Roberta, "Conceptual Art," in Nikos Stangos, *Concepts of Modern Art*, London: Thames and Hudson, 1991.

"10. The Disembodied Idea," in William C. Seitz, *Art in the Age of Aquarius 1955–1970*, Washington: Smithsonian Institution Press, 1992. 250 p.

Conceptual Art

(See also bibliography, chapter 36.)

Bay Area Conceptualism: Two Generations, exh. cat., Hallwalls Contemporary Art Center, Buffalo, N. Y., September 15–November 10, 1989, publ 1992. 39 p.

Colpitt, Frances and Phyllis Plous, *Knowledge: Aspects of Conceptual Art*, exh. cat., University Art Museum, University of California, Santa Barbara, January 8–February 23, 1992 and two other venues. Bibl. (half Calif.) 88 p.

Fluxus, etc., Addenda II: the Gilbert and Lila Silverman Collection, exh. cat., Baxter Art Gallery, California Institute of Technology, Pasadena, September 28–October 30, 1983. 439 p.

A Forest of Signs: Art in the Crisis of Representation, The Museum of Contemporary Art, Los Angeles and MIT Press, Cambridge, Ma., 1989. 176 p. [some Calif. Artists]

Goldstein, Ann and Anne Rorimer, *Reconsidering the Object of Art: 1965–1975*, The Museum of Contemporary Art, Los Angeles and The MIT Press, Cambridge, Ma., 1995. 336 p. [some Calif. Artists]

"9. Conceptualism," in Thomas Albright, *Art in the San Francisco Bay Area 1945–1980*, Berkeley: University of California Press, 1985.

The Umbrella Show [an exhibition of correspondence art], exh. cat., University Art Galleries, University of California at Riverside, 1979. 31 p.

Site Installations

Appleton, Steven, "A Critique from Within," [rev. of *In-Site*] *Artweek*, v. 20, March 4, 1989, p. 1.

Clothier, Peter, "Marking the Urban Landscape," [rev. of *Urban Alterations* spons. by LAICA] *Artweek*, v. 10, no. 42, December 15, 1979, p. 3.

DeOliveira, Nicolas, *Installation*, New York: Thames & Hudson, 1994. 208 p.

"11. Art and Technocracy," in Peter Plagens, *Sunshine Muse*, New York: Praeger, 1974, pp. 162+.

"Fixing the Earth," [several articles on California site artists and the environment] *Artweek*, v. 24, pt. 17, September 9, 1993, pp. 20–1, 24+.

Forbidden Entry: George Geyer, Lilla Locurto, Carol Newborg, Karen Frimkess Wolff, exh. cat., Fisher Gallery, University of Southern California, September 5–October 27, 1990. [room installations] 24 p.

In Site: Five Conceptual Artists from the Bay Area, exh. cat., University Gallery, University of Massachusetts, Amherst, February 2–March 17, 1990. 38 p.

"inSITE94," [4 article special section on temporary projects at sites in the San Diego/ Tiajuana area], *Artweek*, v. 25, October 20, 1994, pp. 12-14.

inSITE 94—Binational Exhibition of Installation and Site-Specific Art, exh. cat., Installation Gallery, San Diego, 1995. 178 p.

Living Spaces [site installations about habitation], exh. cat., Los Angeles Institute of Contemporary Art, May 9 - June 15, 1987. 15 p.

Los Angeles in the Seventies: Michael Asher, Michael Brewster, Guy de Cointet, Judy Fiskin, Lloyd Hamrol, Michael McMillen, Loren Madsen, Eric Orr, Roland Reiss, exh. cat., Fort Worth Art Museum, October 9–November 20, 1977 and two other venues. 40 p.

Proposal I-5, 1977 [an exhibition of proposals for monumental works of art to be located adjacent to California's proposed Interstate Highway 5], exh. cat., Union Gallery, San Jose State University, April 11–29, 1977. 1 vol.

A Report on the Art and Technology Program of the Los Angeles County Museum of Art, 1967–1971, Los Angeles County Museum of Art, 1971.

San Francisco Science Fiction [conceptual], exh. cat., San Francisco Arts Commission Gallery, June 5–30, 1984 and the Clocktower, September 27–October 28, 1984. 50 p.

Smith, Richard, "Environmental Disasters: Some Thoughts on the Current State of Installation Art, Prompted by a Visit to Installations at MOCA," *Artweek*, v. 26, April 1995, pp. 24–25.

Surveillance: an Exhibition of Video, Photography, Installations, exh. cat., LACE (Los Angeles Contemporary Exhibitions), February 27–April 12, 1987. 55 p.

Light and Space

Andre, Buren, Irwin, Nordman: Space as Support, University Art Museum, University of California, Berkeley, [4 treatments of museum interior space], January 17–June 21, 1971. 57 p.

Butterfield, Jan, *The Art of Light + Space*, New York: Abbeville Press, 1993. 271 p.

De Angelus, Michele, "Visually Haptic Space: The Twentieth-Century Luminism of Irwin and Bell," in *Seventeen Artists in the Sixties*, exh. cat., Los Angeles County Museum of Art, July 21–October 4, 1981.

Nixon, Bruce, "Investigating Light and Space," [rev. Perceptual Investigations at MOCA's Temporary Contemporary] *Artweek*, v. 21, no. 34, October 18, 1990, pp. 1, 20.

Smith, Richard, "Tradition and Transition in Southern California Art [1960s Light & Space]," *New Art Examiner*, v. 16, pt. 7, March 1989, pp. 25–27.

Transparency, Reflection, Light, Space: Four Artists, exh. cat., University of California, Los Angeles, Art Gallery, January 11–February 14, 1971. 144 p.

Sound Art

Chattopadhyay, Collette, "Noisemakers [Sound Art in the Nineties]," *Artweek*, v. 23, May 21, 1992, p. 4.

Sound: An Exhibition of Sound Sculpture: Instrument Building and Acoustically Tuned Spaces, exh. cat., Los Angeles Institute of Contemporary Art, July 14–August 31, 1979 and one other venue. 68 p.

"Sound Art," [6 artists, So. Calif. phenomenon] *Artweek*, v. 27, no. 8, August 1996, pp. 11-16.

Earthworks

Beardsley, John, *Earthworks and Beyond: Contemporary Art in the Landscape*, New York: Abbeville Press, 1984.

"Earthworks," in William C. Seitz, *Art in the Age of Aquarius, 1955–1970*, Washington: Smithsonian Institution Press, 1992. 250 p.

16 Projects/ 4 Artists [earth art], exh. cat., California State University, Long Beach and other sites, 1977.

Video

(See also bibliography for Performance Art, below.)

Antin, David, "Video: the Distinctive Features of the Medium," *Video Culture: A Critical Investigation*, Rochester, N. Y.: Visual Studies Workshop, 1986.

"Artweek Focus," [reviews of AFI and Freewaves festivals and Bay Area video] *Artweek*, v. 20, no. 41, December 7, 1989, pp. 17–23.

"Artweek Focus: West Coast Video," [9 articles] *Artweek*, v. 23, November 19, 1992, pp. 4–5, 20–24.

Burnham, Linda, "The Ant Farm Strikes Again," *High Performance*, v. 6, no. 4, 1983, pp. 26–27.*

California Video, exh. cat., Long Beach Museum of Art, June 29–August 24, 1980. 40 p.

Duguet, Anne-Marie, *Be a Musician, You'll Understand Video*, exh. cat., National Video Festival, Los Angeles: American Film Institute, December 1986.*

Electronic Editions [video art], exh. cat., Union Gallery, California State University, San Jose, dates unknown, 1979. 62 p.

"Featuring Video Art," *LAICA Journal*, no. 26, February–March 1980, pp. 14–54.

Fifer, Sally Jo, "Report from the Bay Area Video Coalition," *Art Journal*, v. 54, no. 4, Winter 1995, pp. 79–80.

Fitzsimons, Constance, "The Essayistic in Film and Video," [festival sponsored by LACE, USC School of Cinema-Television and LA Center for Photographic Studies] *High Performance*, v. 12, Fall 1989, pp. 77-78.

Gill, Johanna, *Artists' Video: The First Ten Years (1965–1975)*, Ph.D Thesis, Brown University, published Ann Arbor, Mi.: UMI?, 1977.

Hall, Doug, and Sally Jo Fifer, eds., *Illuminating Video* (anthology), New York: Aperture in association with the Bay Area Video Coalition, 1990, bibliog. 566 p.

Horrigan, Bill, "After Desert Hearts: the Los Angeles International Gay & Lesbian Film/Video Festival," *Afterimage*, v. 14, May 1987, p. 3.

Huffman, Kathy Rae, *Video: A Retrospective, Long Beach Museum of Art 1974–1984*, exh. cat., Long Beach Museum of Art, September 9–November 4, 1984 and November 25, 1984–January 20, 1985.

"Independent Film in Southern California," *LAICA Journal*, no. 29, Summer 1981, pp. 27–72.

Kandel, Susan, "Other Angles," [video program at EZTV, LA] *Arts Magazine*, v. 64, January 1990, pp. 107–8.

Keil, Bob, "Electronic Art," [series on video] *Artweek*, from v. 10, no. 13, March 31, 1979+.

Keil, Bob, "Independents and the Industry I," *Artweek*, v. 10, no. 23, June 30, 1979, p. 5.; "II," *Artweek*, v. 10, no. 25, July 28, 1979, p. 14.

Kelly, Joanne, "The National Center for Experiments in Television KQED," in *Transmission*, ed. by Peter D'Agostino, New York: Tanam Press, 1985.

MacAdams, Lewis, "Guts and Fortitude: Video Art and K. Huffman Put the LBMA on the Map," *High Performance*, v. 7, no. 1, 1984, pp. 40-42.

New California Video: A Five-Year Survey of the Long Beach Museum of Art's Open Channels Television Production Grant Program 1985–1989, exh. cat., Long Beach Museum of Art, 1990.

Norklun, Kathi, "International Video Festival: Home-Grown Venture," [rev. *San Francisco International Video Festival*] *Artweek*, v. 12, no. 39, November 21, 1981, p. 16.

"Pacific Film Archive," *Historical Journal of Film Radio and Television*, v. 16, no. 1, March 1996, pp. 39+.*

Ross, David, "Bay Area Video," *Video 80*, v. 1, no. 1, 1980, p. 5.*

Southland Video Anthology 1976–77, exh. cat., Long Beach Museum of Art, September - October, 1976. 142 p. [Series Title: *Southland Video Anthology* 1, 2, 3, 4]

Tamblyn, Christine, "Lynn Hershman's Narrative Anti-Narratives," *Afterimage*, v. 14, Summer 1986, pp. 8-10.

Tamblyn, Christine, "Hotel California: the 1985 San Francisco International Video Festival," *Afterimage*, v. 13, December 1985, pp. 4–5.

Tamblyn, Christine, "Mill Valley Festival," *Artweek*, v. 16, October 19, 1985, pp. 4-5.

"West Coast Video," [9 article special section] *Artweek*, v. 23, November 19, 1992, pp. 4–5 and 20–24.

Willis, Holly, "Off-road Vehicles: LA Freewaves Festival," [of video art], *Afterimage*, v. 20, no. 6, January 1993, p. 3.

Zippay, Lori, *Artists' Video: an International Guide*, New York: Cross River Press, 1991. 272 p.

magazines in which other articles can be found *Art Com* (San Francisco: Contemporary Arts Press); *Artweek* (Los Angeles/Oakland); *Camera Obscura* (Los Angeles); *LBMA Video* (Long Beach, Calif.: The Long Beach Museum of Art Foundation, Video Council Newsletter, 1981); *SEND*, *Video and the Arts, Video80*, (San Francisco International Video Festival); *Video Networks* (San Francisco: Bay Area Video Coalition).

(See also publications issued by American Film Institute, Long Beach Museum of Art, LACE, Pacific Film Archive, Artists Television Access, and New Langton Arts S. F., etc.)

Performance

(See also: issues of *La Mamelle*, publ. San Francisco, September 1975+; *High Performance*, publ. Los Angeles, 1978+; *New Performance*, publ. San Francisco, 1977+;and *Artweek*, also see some items under Conceptual Art, above.)

Apple, J., "The Romance of Automobiles [performance festival at MOCA]," *Artweek*, v. 15, pt. 32, September 29, 1984, p. 1 and v. 15, pt. 33, October 6, 1984, p. 6.

"Artweek Focus: Performance Art," [Bay Area goes to theater; subjects turn to social activism] *Artweek*, v. 21, no. 17, May 3, 1990, pp. 1, 21-27.

Bargiacchi, E., "Settimana della performance art Americana [California performance compared to Italian]," *Signo* (Italy), no. 15, 1980, pp. 15–16.

Berson, Mischa, et al., "Bay Sayers," *American Theatre*, v. 9, no. 4, July–August 1992, pp. 13+.

Border Art Workshop/Taller de Arte Fronterizo, 1984–1989: a Documentation of Five Years, exh. cat., San Diego: The Workshop, 1988. 93 p.

Burnham, L., "Alternative Histories: Artists Challenge the Official Story," *High Performance*, v. 15, Winter 1992, pp. 52–9.

Burnham, L., "In Dogged Pursuit of the World's Greatest Artist: Thirty-Two Artists Compete in the 5-Minute Performance Olympics [in LA]," *High Performance*, v. 7, pt. 2, 1984, pp. 46–47.*

Burnham, L., "Live Art in L. A. 1984," *High Performance*, v. 7, pt. 2, 1984, pp. 26–29.*

Capp Street Project [a group of artists] San Francisco, Ca.: Capp Street Project, 1984. 38 p. [Publications also issued for years 1985–86, 1987–88, 1989, 1991–93.]

Cohen, Michael, "The City Without Organs: Flux and Fantasy in Five L. A. Artists," *Flash Art*, v. 26, no. 169, March–April 1993, pp. 67–70.

Durant, Mark Alice, "Art and Politics: Activist Art in the Shadow of Rebellion," [3 Southern California groups: LAPD, BAW/TAF and ?] *Art in America*, v. 80, pt. 7, July 1992, p. 31+.

Foley, Suzanne, *Space/Time/Sound/: Conceptual Art in the San Francisco Bay Area: The 1970s*, exh. cat., San Francisco Museum of Modern Art, December 21, 1979–February 10, 1980.

Gamboa, Harry, Jr., "In the City of Angels, Chameleons, and Phantoms: Asco…," in *Chicano Art: Resistance and Affirmation, 1965–1985*, exh. cat., Wight Art Gallery, University of California, Los Angeles, September 9–December 9, 1990 and other venues, pp. 121–30.

Gaulke, Cheri, "Performance Art of the Woman's Building," *High Performance*, v. 3, nos. 3–4, issue 11–12, Fall/Winter 1980, pp. 156–63.

Henry, Rowanne Marie, *Performance on the Los Angeles Uprising: Art as Social Change* [18th Street Arts Complex], M. A. Thesis, University of California, Los Angeles, 1993. 75 l.

Hershman, L., "California Oggi, *California Today* [floating museum]," *Data* (Italy), no. 27, July-September 1977, pp. 51–56.

Heyward, Carol, "San Francisco's Visual Theater," [performance], *High Performance*, v. 9, no. 2, 1986, pp. 39–45.

Irwin, Richard, "Performance Art in San Francisco," *Damage*, v. 1, no. 6, May 1980. *

Kaprow, Allan, "The Education of the Un-Artist, Part I," *Art News*, v. 69, February 1971, pp. 28-31; "Part II," *Art News*, v. 71, May 1972, pp. 34-39; "Part III," *Art in America*, v. 62, January-February 1974, pp. 85–91.

"Los Angeles Festival," *High Performance*, v. 10, no. 3, 1987, pp. 26–38.*

Marioni, T., "Out Front [LA & SF are in avant-garde]," *Vision*, no. 1, September 1975, pp. 8–11.*

Meyer, Moe, "Glamour as Environmental Art: Toward a Definition of Hollywood Performance Art," *High Performance*, v. 7, pt. 2, issue 26, 1984, pp. 34–5+. *

Miller, Elise, "Whats Cooking Now at UCSD: Performance Art," *San Diego Magazine*, v. 32, no. 11, September 1980, pp. 136-39+.

Murphy, Anthony C., "A Showcase of Performance Art," [first Afro-American Performance Festival, San Francisco], *American Visions*, v. 9, no. 3, June–July 1994, p. 11.

New Art in Orange County [includes description of performances at F Space], exh. cat., Newport Harbor Art Museum, October 23–November 14, 1971. 21 p.

New Langton Arts: *The First Fifteen Years*, San Francisco: New Langton Arts, 1990. 90 p.

Oberli, M., "Paul Hoffman—the MOCA Suite," *Camera*, v. 57, November 1978, pp. 24–32.

Performance Anthology, Source Book of California Performance Art, San Francisco: Last Gasp Press, Contemporary Arts Press, 1989. 531 p.

"Remapping Culture: The Los Angeles Festival [7 article anthology]," *High Performance*, v. 13, Winter 1990, pp. 36–45.

Roth, Moira, *The Amazing Decade: Women and Performance Art in America, 1970–1980*, Los Angeles: Astro Artz, 1983. 165 p.

Roth, Moira, "A Star is Born: Performance Art in California," *Performing Arts Journal*, no. 12, v. 4, no. 3, 1980, pp. 86–96.

Roth, Moira, "Toward a History of California Performance: Part One," *Arts Magazine*, v. 52, February 1978, pp. 94–103 and "Part Two," June 1978, pp. 114–23.

San Francisco Performance, exh. pamphlet, Newport Harbor Art Museum, March 12–April 16, 1972.*

Sommers, Laurie Kay, *Alegria in the Streets: Latino Cultural Performance in San Francisco*, Ph. D. Thesis, Indiana University, 1986. 251 l.

Withers, Josephine, "Feminist Performance Art: Performing, Discovering, Transforming Ourselves," in Norma Broude and Mary D. Garrard, eds., *The Power of Feminist Art: The American Movement of the 1970s, History and Impact*, New York: Harry N. Abrams, Inc., 1994. 318 p.

Modernism—Hard Edge/Geometric Abstraction 1940–1970

Art historians would be ecstatic if art developed in a straight line. Then they could discuss how one style unfolded logically from its predecessor, and they could predict art's direction. Unfortunately for them, artistic developments have the irritating tendency to move up and down, to stop and start, to have dark ages and renaissances. The chaos theory of human progress daily gains credence. For instance, in spite of the very strong movements of Abstract Expressionism and Bay Area Figurative Painting, other California artists willingly pursued different styles between 1945 and 1965. If Abstract Expressionists stand at one end of the pole as painterly abstractionists, then the geometric abstractionists, whom we will discuss in this chapter, belong at the opposite end of the pole as advocates of the hard edge. Due to the fashion among curators and critics to coin names for art groups, each of the postwar trends that have been clumped in this book under Geometric Abstraction has been christened with its own appellation. These names include Hard-Edge Abstraction, Abstract Classicism, Color Field, Op, Post-Painterly Abstraction, Minimalism, and L.A. Glass and Plastic, to name a few. Although each of these movements has distinct characteristics, they all have some qualities in common: the works are nonobjective, are often large in size, are brightly colored, and contain shapes that have distinct edges. Each style was the end result of artists working toward different ends.

Mid-twentieth-century Geometric Abstraction breaks down into two general time periods: artists active between 1940 and 1960 and those active during the 1960s. During these two periods, artists came to Geometric Abstraction from opposite directions and had very different goals.

Geometric Abstraction of the 1940s and 1950s

The sharp-edged, nonobjective abstraction practiced between 1940 and 1960 is the last of several abstract styles that descended from Cubism. To quickly recap the history of hard-edge art, there was Synthetic Cubism, Constructivism, and Mondrian's DeStijl of the teens and twenties, as well as the Bauhaus aesthetic and art by New York's Abstract American Artists of the 1930s.

In California, most of the artists who have pursued Geometric Abstraction have resided in the southern half of the state, perhaps because in the 1930s

avant-garde art was supported by the Hollywood community (chapter 21). Through the 1940s and 1950s, the continued support of Hollywood collectors, the pursuit of Hard-Edge Abstraction by one of the area's art leaders, Lorser Feitelson, and the independent interest of other artists, all kept the style viable. The number of practitioners, however, was never large or organized enough to claim group status. Although each artist may have been aware of the work of the others, each pursued his work independently. What they had in common was their desire to solve their aesthetic goals by using flat shapes in nonobjective compositions.

In the 1940s, painters of Geometric Abstraction were rare. As a young man **Peter Krasnow** (1887–1979) fled the pogroms in Russia. Like many Eastern European artists who were persecuted, Krasnow found his art gave him an outlet for his emotions—his early paintings were figurative, dark-colored compositions depicting humanity's downtrodden. World War II and the Holocaust prompted him in other directions. Putting together his admiration for Mondrian with his desire for structure in a chaotic world, Krasnow created his "K-series" paintings. ("K" is the first initial of his last name and the numbers represent the sequence of the paintings.) By arranging pure lines and rectangles, Krasnow was able to create his own well-ordered "world." In *"The Gate," K-1* of 1944 (fig. 30-1), elemental geometric shapes interlock into a rigid structure via subtle "tabs" that seem to clamp the rectangles together. Like any "classic" composition, this work exhibits balance, stability, control, organization, and equality. It betrays its California origins, however, in its quixotically joyous, springtime pastel colors, including yellows, greens, pinks, lavenders, and baby blues.

Northern California, the land of little abstraction, did claim one Geometric Abstractionist in the 1940s— **James McCray** (1912–1993). With a master's degree from Berkeley and graduate work at the Barnes Foundation in Pennsylvania (1937–39), McCray was well versed in modern aesthetics. By the mid 1940s, while teaching at the California School of Fine Arts in San Francisco, he developed a unique geometric style. In many ways *Flotation* of 1945 (fig. 30-2) is reminiscent of Mondrian's work. And, indeed Mondrian may have been its inspiration, since the Dutchman spent World War II in New York, where he updated his

Fig. 30-1
Peter Krasnow (1887–1979)
"The Gate," K-1, 1944
oil on pressed board
47¾ x 36 in.
The Buck Collection, Laguna
Hills, California
Photo: Cristalen and
Associates

Fig. 30-2
James McCray (1912–1993)
Flotation, 1945
(including the frame made by
the artist)
egg tempera on board
16 x 20 in.
Private Collection

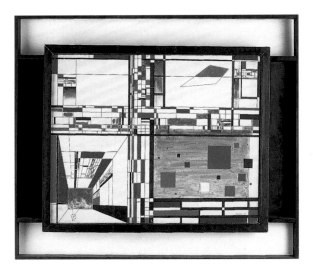

rigidly rectangular black-and-white paintings with "tesserae" of bright colors. McCray's innovation is that he balances large, plain-colored rectangles with others that are textured or patterned with tiny grids. And, while he generally adheres to Mondrian's convention of pure horizontals and verticals, he occasionally dares to insert diagonals and acute angles. McCray regarded his arrangements as visual stimulation devoid of recognizable imagery. His goal is precise visual organization and relationship of parts, influenced by his conceptions of time and space. McCray's style is completely different from anything produced around him in the Bay Area at the time. In the 1950s, while he succumbed to the vogue for painterly expression as exemplified by Abstract Expressionism, he returned in the mid 1960s to the format that gave him the most personal satisfaction—abstract design. The later works, however, have more of the feel of the then popular Post-Painterly Geometric Abstraction.

Abstract Classicism

Southern California's Abstract Classicists were four artists who independently developed versions of Geometric Abstraction between 1948 and 1952. In 1959 they exhibited together in *Four Abstract Classicists* at the Los Angeles County Museum of Art. Jules Langsner, curator of the exhibition, recognized them as "classic" for their shared interest in balance, harmony, unity, and equilibrium. He coined the term "hard-edge painting" to describe their work. The show traveled to London, where Los Angeles art was accorded its first international attention.

The "grand old man" of the Abstract Classicists was **Lorser Feitelson** (chapter 21), the inventor of Post-Surrealism. Feitelson made his transition from Post-Surrealism to pure Hard-Edge Abstraction in the mid 1940s. At the time, he would start with a recognizable object, then proceed to simplify it until it was reduced to a flat shape floating in the space around it. A 1948 oil study on canvas marked the decisive step to complete Hard-Edge Abstraction. What led a committed realist to paint a pure abstraction such as *Magical Space Forms* of 1951(fig. 30-3)? Feitelson saw his inspiration as coming from classroom exercises he set up for his students at Art Center School of Design. But he also must have been aware of parallel canvases produced by New York artists, such as Josef Albers (1888-1976), Barnett Newman (1905–1970), and Ad Reinhardt (1913–1967). Like Feitelson, these artists were free of Mondrian's need to represent spiritual states and were more truly descendants of the Bauhaus with its emphasis on science and experiment, particularly its interest in how humans perceived color and

shape. At first glance, *Magical Space Forms* appears almost too simple: a few lines and shapes and only two unmodulated colors. However, in this work, Feitelson was exploring questions of space/form relationships. His "non-colors" of black and white make it easier for us to concentrate on shape. His point becomes, Which colored shape is the figure and which the background? As the viewer studies the shapes, human perception makes them alternately reverse positions. The shapes are disturbing, optically ambiguous, disorienting, and dynamic. In other works Feitelson experimented with color, investigating the way juxtaposed colors act upon each other, inharmonious color, and how color itself could be a form. He strove for monumental magnificence and mystery. A romantic, he did not restrict himself to right angles but frequently used curves. For the rest of his life, Feitelson advanced every few years into a new hard-edge series.

Although Los Angeles art critics and historians have always acknowledged Feitelson's leadership role in the local abstract movement, their New York counterparts have proved more willing to praise the work of the independent **John McLaughlin** (1898–1976). Art historians often attribute greater importance to art that contains ideas or ideals. McLaughlin, a former dealer in Asian art who had lived in Japan for two years in the 1930s, settled, at the end of World War II, in Dana Point, a seaside town south of Los Angeles. At that time he made what we now describe as a career change, turning to painting and feeling an urgency, because of his age, to find a style in which to work. Intensively studying Europe's modernist artists of the early twentieth century, McLaughlin found himself most moved not by a painting but by its title, the Constructivist Kasimir Malevich's *White on White,* which seemed to blend the simple and the profound. In *Untitled* of 1948 (fig. 30-4, p. 398) McLaughlin froze on canvas a composition that he arrived at by arranging and rearranging shapes of colored paper until the arrangement felt correct. Like Mondrian, he preferred the neutral non-colors of black and white, but also employed muted lemon yellows, avocado greens, and (rarely) blues and reds, which some art writers claim to be the natural colors of the California landscape. His goal was a neutral structure marked by equanimity—sometimes with an eccentric composition—that would prompt meditation. McLaughlin's blend of Constructivist/DeStijl ideas with his knowledge of Asian art and philosophy makes him one more California artist to merge the aesthetics of the Occident and the Orient.

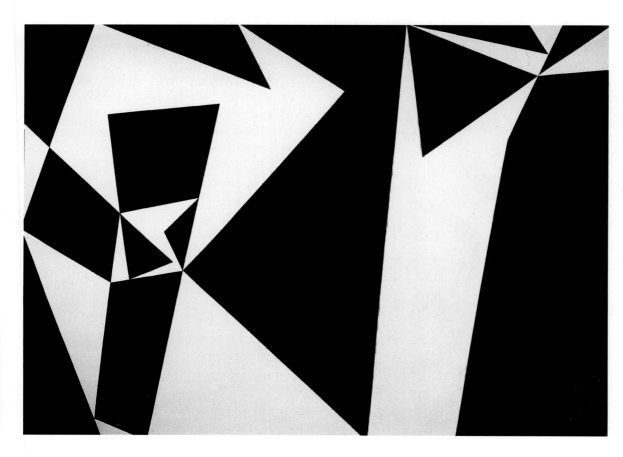

Fig. 30-3
Lorser Feitelson (1898–1978)
Magical Space Forms, 1951
oil on canvas, 57¾ x 81¾ in.
Collection of Whitney Museum of American Art;
Gift of the Los Angeles Art Association Galleries; © 1997 Whitney Museum of American Art, New York
Photo: Geoffrey Clements

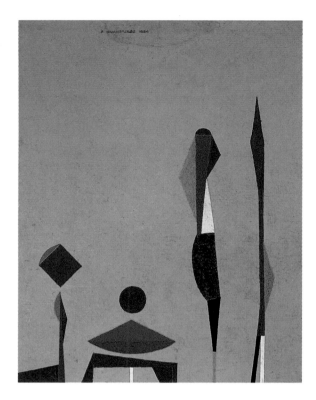

Frederick Hammersley (b. 1919) was also well into his painting career before he turned to Hard-Edge Abstraction. After serving in World War II and taking a postwar year of study in Paris, he returned to Los Angeles and studied at both Chouinard and Jepson Art Institutes (1946–1949). Jepson was known for its academic approach, its emphasis on drawing, and its representational subject matter. Although Hammersley was so successful at this that he briefly taught there, he wanted to break free of his academic bounds. At Jepson, Hammersley had become fascinated with a design experiment, and by 1950 he had made his first hard-edge painting. Between 1953 and 1954, he worked on *Four* (fig. 30-5). Hammersley's abstraction is not burdened with philosophic stances or formalist reasoning. The artist claims to design with "hunches." When the inspiration hits him, even though he has no idea of how he wants a picture ultimately to look, he grabs a canvas that he has prepared for just such an occasion and places on it whatever shape comes to his mind. That, in turn, inspires a second shape and so forth until Hammersley feels the composition is completed. With regard to other works, Hammersley talks about applying particular colors because he "saw" them on the canvas. His activity of "building a painting by inspiration directly on the canvas" is remarkably similar to the method of the Abstract Expressionists working parallel to him. To make use of his impulses at the moment they occur, he keeps many canvases in process at the same time and uses only pure colors from the tube. The lively *Four* has a playful quality when compared to the serious and contemplative works produced by McLaughlin.

Karl Benjamin (b. 1925) was the youngest of the group. He served in World War II, earned a teaching credential, and for twenty-five years after 1949 taught grade school. Benjamin began painting in 1951 and took graduate study at Scripps under Jean Ames (1903–1986). His representational works grew more and more abstract as he studied the techniques of Cezanne and as he simplified his shapes. He matured quickly, and it was not long before he was being given gallery shows. In an early work such as *Abstraction* of 1955 (fig. 30-6), he arrived at his shapes like a Surrealist employing Automatist techniques, letting his charcoal meander at will over a raw canvas. Shapes

formed, and when he was satisfied he put them into concrete form with a ruler and compass. He speaks of kinetics, the inherent energy contained in lines and their relationship to each other. Like other Geometric Abstractionists, his work is "classical"—colors harmonize and shapes are balanced. In *Abstraction* he allows curves among the right angles, and he explores subtle color relationships. In other works he is just as interested in angular shapes and bolder colors, such as reds and blacks. He frequently moved back and forth between canvases featuring curvilinear forms and those based on angular shapes. He banded with the other Abstract Classicists for protection. Critics in the era dominated by Abstract Expressionism didn't know what to think about hard-edged painting and dismissed his and the others' work as derivative of Mondrian. The four's mutual interests led to their showing together in 1959.

Post-Painterly Abstraction of the 1960s

The term "painterly" refers to expressive brushwork. The term Post-Painterly Abstraction was coined to cover any abstract work that arose after the demise of the painterly Abstract Expressionism. It serves as a convenient umbrella to cover the many painting styles of the 1960s that share an interest in hard-edged shapes, flat colors, and non-representational subject matter. These include Minimalism, Color Field, and Op, among others. While these styles occasionally outwardly resemble the Hard-Edge Abstraction created by the Abstract Classicists, the 1960s artists were not inspired by early-twentieth-century modernism but were reacting against painterly abstraction.

East Coast art historians, who have until recently been unchallenged in their definition of American art, see Post-Painterly Abstraction steming from a New York source. They trace it to the 1945 to 1960 work of a few East Coast artists who bucked the Abstract Expressionist tide and painted in a hard-edged style. These include Josef Albers (1888–1965), who painted concentric rectangles of color, and Barnett Newman (1905–1970), who painted sharp-edged fields of color. They also trace it to certain practitioners of Abstract Expressionism who, as the 1950s unrolled, began to reject the expressive and emotional aspects of their abstraction and reduce painting to its essence, i. e., flat

shapes. By 1960, artists such as Ad Reinhardt (1913–1967) in his black-on-black paintings and Frank Stella (b. 1936) in his protractor series had eliminated almost everything from the traditional painting, including subject matter, three-dimensional illusion, emotion, and any sign of the painter's personality (as exposed in brushwork). They succeeded in turning a painting into an object consisting of the support (sometimes canvas, sometimes Masonite or other materials) painted with some solid color or a simple geometric shape.

Does the work of California's artists of the 1950s and 1960s relate at all to the East Coast evolution?

Color Field. In the second half of the 1950s, one of the steps in the evolution toward Minimalism was Color Field painting. The term was coined to describe several painters active in the Washington, D.C. area who made *color* their subject. To avoid exposing their personalities (usually revealed in brushwork), these artists either applied paint as flat and unmodulated color or poured it. Since they frequently painted on unprimed duck canvas, the eddies of poured pigment took on the look of stains or veils of subtle color and became one with the support itself. The texture of the raw woven material became part of the aesthetic.

The Californian closest in sympathy to the Washington, D. C. school, although he arrived at his colors-atop-a-white-ground *before* them, is Berkeley-trained **Sam Francis** (1923–1994). While recuperating from a war-related illness, Francis was introduced to art as occupational therapy. After recovery he studied art at the University of California, Berkeley. By 1947, the same year many of the artists at the California School of Fine Arts were arriving at their Abstract Expressionist styles, Francis produced a canvas that resembled an Arshile Gorky (1904–1948) composition, painted with red, white, and blue. Possibly because he had been trained at the "other" Bay Area school that advocated modernism or because of his own buoyant personality, Francis created abstractions that were bright and colorful, free of the angst so prevalent in the works of artists affiliated with the California School of Fine Arts. Throughout the 1950s, while he lived in Paris, Francis settled on a style that incorporated forms that might be described as colored spaetzel (others have used the terms platelets, corpuscles, and protozoa). In Paris his modern ideas (as well as the lack of fresh ones

coming out of France itself) made him a celebrity. It was only in the late 1950s that he arrived at his signature style—a few patches of primary colors on a white ground, as in *Abstraction* of 1959 (fig. 30-7). By the time he created it, he had begun to reject the brush and oil paint in favor of flinging, pouring, and dripping acrylics or watercolors.

The spontaneously flung paint in *Abstraction* retains the emotion of Abstract Expressionism, yet is upbeat. *Abstraction* tells us many things about Francis. The dominant white ground reveals his interest in light and space. The poster colors and the zesty way they are flung reveal his generally positive personality. (The color blue was to become a favorite after a serious illness in the early 1960s.) After his stopover in Japan on a world tour in 1957, much of Francis's work reflected Zen ideas, i. e., it was asymmetrical and played large empty spaces against areas of detail. This composition is unusual in that the grouped colors at top and bottom seem symmetrically balanced and form around a center. However, in of what was to become a typical Francis, the center or interior is white background or space, while the subject (color) gravitates to the perimeters and sometimes bleeds beyond the edges. The most extreme examples of this are seen in works in which

he has left almost the entire center of his canvas or paper white and has restricted color to the very edges, where it forms a kind of frame. His works have been called spare, delicate, open, joyous, lyrical, and dynamic. After 1962 the artist took up residence in Santa Monica, near the shore west of Los Angeles. He continued to produce in his signature style through the 1960s. Many of his works are in the form of lithographs—his work translated almost perfectly into that medium. Californian are his love of color, his centrally open fields, the works' sense of atmosphere, and the way he allows pure pigments to bleed together.

Optical Art. Optical Art (or "vibe" art as it was called on the West Coast) was a very short-lived movement that arose in the late 1950s and peaked in 1964. It was codified in the *Responsive Eye* exhibition at the Museum of Modern Art, New York, in 1965. Op's subject, like Color Field's, is also color, but Op artists use colors and patterns to cause the brain to see motion where it does not physically exist. The style originated in Western Europe and briefly became a fad in the United States, where it became a vehicle especially for psychedelic artists and an inspiration to the fashion industry. Its origins lie not in the German Bauhaus, but in the work of Victor Vasarely (1908–1997), who used the world's new body of optical and psychological research to experiment with the way color and pattern are interpreted by the brain.

In California, Op Art enjoyed great popularity in San Francisco, where its principles were applied to the design of "psychedelic" posters (chapter 31). Such works theoretically simulated the way reality was perceived after taking drugs. The most popular pattern causing visual distortion was the moiré, in which one line crossed another at an angle of less than thirty degrees. This particular juxtaposition causes the eye sensors and brain to become confused, setting up a mental buzz that makes the lines seem to merge and shift at the junctures. Juxtaposing two saturated shades adjacent to each other on the color wheel, such as hot pink and orange, also had the effect of confusing the brain, one color intensifying the other and the intensity causing afterimages. In Los Angeles, the most important artist to use Op's principles, although possibly unwittingly, was Robert Irwin (below) in his dot paintings. Op, however, proved to be a technique rather than an ideology, and its limited vocabulary ultimately caused it to be dismissed as novelty rather than serious art.

Minimalism. The art "style" that took up most of the 1960s was Minimalism, an umbrella term that covers many substyles. Minimalism is the end result of artists rejecting everything that had formerly defined painting. Reduced to an *object,* painting now consisted

of little more than a support painted with either a solid neutral color or a simple geometric shape. As in Minimalist sculpture (chapter 27), artists preferred basic geometric shapes (such as circles, squares or rectangles) because, as Gestalt psychology claimed, the human mind comprehended them more readily than complex shapes. The Minimalist painters, like the sculptors, wanted their work to be perceived instantly. In Minimal art, what you see is what you get. A consummate New York example is Ad Reinhardt's painting of a black cruciform cross against a black background. This exposed no brushwork or emotion, contained no ideas, and its centrally placed image freed the artist from making a compositional decision. Supposedly this work was so pure that a viewer, deprived of anything else to focus on, was forced to realize that paintings were not windows to the world but *objects*.

Southern California served as home to most of California's Minimalists of the 1960s. Some historians have suggested that Los Angeles's interest in the genre was inspired by the work of the Abstract Classicists of the 1950s (above). Others say it was instigated by the activity in New York. Local artists who painted geometric forms on canvas in the 1960s claim to have had only a passing knowledge of what was occurring in New York and were just pursuing their own paths. Their innovations prove that many were actually in step with New York artists rather than following them.

Untitled of 1963–64 (fig. 30-8) by **Robert Irwin** (b. 1928) fits the physical descriptors of Minimalism because it is monochrome and its only "subject" is two horizontal lines. However, at the time Irwin painted this work, in the early 1960s, Minimalism was just taking shape in New York, and Irwin's goal was totally different from that of the New Yorkers. Realizing color took up both physical and psychic space and that the absence of expressive brushwork could result in even greater energy, he began a series of paintings featuring straight lines. In his mind the line was the most energy-efficient object and was free of associations. Irwin's main interest was perception. After a period of intuitive experimentation with multiple lines (1957–61/62), he settled on two, and between 1962 and 1964 produced ten variations. Each was the result of excruciating hours alone in the studio studying the line placement, testing it against his inner sensibility, moving a line slightly, realizing how greatly that changed the composition, even observing how elements within the studio affected his perception of the painting. Most of the paintings were yellow or orange, the latter appearing to Irwin as the most opaque of colors. The lines

Fig. 30-8
Robert Irwin (b. 1928)
Untitled, 1963–64
oil on canvas
84 x 82½ in.
Private Collection, Courtesy
of Pace Wildenstein, © 1998
Robert Irwin / Artists Rights
Society (ARS), New York;
Photo courtesy Pace
Wildenstein

particles. As for supports, many abandoned the medium of canvas for commercial grounds such as Masonite, Plexiglas, and sheets of metal or fiberglass that were free of canvas's woven cloth texture. In turn, this affected the look of their art.

Boris of 1963 (fig. 30-9) by **Billy Al Bengston** (b. 1934) is one of a series of paintings that feature chevrons/sergeant stripes, a geometric motif Bengston capriciously decided to use while flying back from Europe in 1960. (On a 1958 trip to Europe Bengston had seen Jasper Johns's paintings of targets and flags at the Venice Biennale and liked the idea of reusing well known imagery.) Although *Boris* satisfies the precepts of Geometric Abstraction with its subject of squares and circles in a symmetrical composition, it could likewise be called Pop for its use of the recognizable image of sergeant stripes. Irrespective of classification, this work is Californian in its materials and subject. Since 1959 Bengston had been racing motorcycles, repairing them, painting them, and thus gaining experience with spray paints. He decided to apply this technique to his fine art. Spray satisfied Geometric Abstraction's goal of applying paint without revealing the personality of the artist and at the same time introduced a whole new perceptual quality to painting, different from brushwork, staining and other traditional techniques then in use. On the East Coast, one of Minimalism's unbreakable rules was to respect the picture plane, i.e., to avoid dimensional illusion. Most Los Angeles abstractionists of the Ferus stable broke this "rule" in one way or another. In *Boris,* not only does the translucent paint have depth in itself, but the sprayed, graded colors imply three-dimensionality, and the diffused circles glow like headlights in a fog. Bengston makes the perceptual issue even more complex when he uses a brush to paint the central chevron and its background, causing this area to contrast both perceptually and physically with the gleaming spray. After 1965, in other chevron paintings, Bengston acknowledges the painting as a physical object by shaping his perimeters and denting his metal support. From the early 1960s Bengston responded to his Hollywood surroundings by titling several of his heart paintings with the first names of Hollywood starlets; his chevron paintings on aluminum were often given names from the titles of John Wayne films. However, *Boris* is named after Boris Karloff while its mate *Bela* (recently purchased by the owners of *Boris*) is named after Bela Lugosi. All titles were applied after the fact for identification only and do not correlate with the subject matter. Yet, here, the oval and its beautifully "glowing" circles are reminiscent of incandescent bulbs around a movie marquee.

were created from the same tube of paint. They were laid on by brush (without aids like masking tape) to preserve the nuances of a handmade look. Since the energy could best be sensed in person, for many years Irwin refused to let the paintings be reproduced in publications. Even with today's improved printing methods, the reproduction of *Untitled* can not convey the perceptual qualities of the original. When Irwin's paintings were shown in New York, he was surprised East Coast artists kept trying to interpret his painting activity in a *social* context. It made Irwin realize that New Yorkers were interested in conceptual art whereas Southern Californians were interested in perceptual art.

Other Los Angeles artists made works that superficially fit the description of Geometric Abstraction, but, like Irwin, they also had different goals than New Yorkers and were further advanced in their concepts. The Los Angeles artists' first innovation was to utilize nontraditional materials. New Yorkers had gone so far as to adopt the newly fashionable acrylic paint, a water-based pigment that had a slightly flatter, more matte appearance than oils; New Yorker Frank Stella was using aluminum and copper paint. However, Southern California artists, especially those in the stable of Los Angeles's Ferus Gallery, turned to new technologies. Some used spray paint, achieved either with the newly invented spray gun powered by an air compressor or with aerosol spray cans. They also used acrylics and lacquers as well as paints that contained metallic

Several factors contributed to Los Angeles artists' arrivals at their independent and innovative solutions. The artists claim it was a lack of a regional art history, which might have stymied them or influenced their direction. (Because pre-1960 California art had not been documented in publications to any degree, Los Angeles artists came to the erroneous conclusion that the area had no art tradition.) As large as the city was, it lacked even one dedicated art museum. The art department of the Museum of History, Science and Art rarely showed avant-garde contemporary art. Magazine reproductions in color were yet too poor to give a true idea of what was happening in the East. So, local emerging, innovative artists turned to what they had and knew: spray paints, the investigations by the local aerospace industry of plastics, and human perceptions.

Most of Los Angeles's technologically advanced art was produced by artists associated with the Ferus Gallery, which opened in 1957. Its co-owners were both idealists: Walter Hopps, an art history student who had, since high school, been selling art made by his friends, and Edward Kienholz, a skilled craftsman with boundless energy, who was later to become known for his room-size assemblages of social content. Opening at 736A La Cienega, the gallery was positioned right in the middle of what was becoming "gallery row." At the time Los Angeles had only two or three galleries handling modern art, and they favored European modernism of the early twentieth century. Ferus wanted to exhibit Abstract Expressionism made in San Francisco as well as the most innovative work of Los Angeles's artists.

Around this gallery congregated a group of artists who later became known as the "Cool School." Into any artwork, an artist puts his personality, his life experiences, and his creative abilities. Equally important in Ferus's case seems to be the synergism generated between the gallery's artists as they socialized. Emerging during the sexual revolution they cultivated a macho image based on their attitude toward women. They emphasized physical activities—the physical ability to wrestle huge lumps of clay into pots, to surf, to ride motorcycles, and to wield the technical equipment to create works of glass and plastic. Popular pastimes were drinking beer at Barney's Beanery and talking about women. The artistic synergism occurred when each new breakthrough made by their fellow artists inspired or challenged them to do "better."

The Ferus artists were particularly fascinated with manipulating the new plastics that were even then being developed in the area's several aircraft plants. Plastics brought new aesthetic qualities to Minimalism and Geometric Abstraction. Plastic has permanence (if kept indoors), translucency, and transparency; a smooth surface and shiny high-tech look; an ability to accept paint on its surface as well as to be colored itself; and an ability to be shaped. In the earliest plastic "paintings"—for the purposes of this essay, we will consider any wall-hung work that includes paint as a "painting"—plastic was either incorporated into oils-on-canvas or the plastic object was displayed semi-flat against walls, as if it were a painting. Once the concept of using new materials was accepted, experimentation with all kinds of nontraditional materials proliferated. The Ferus artists tried out fiberglass, anodized glass, aluminum sheets, Plexiglas, Masonite, and anything else they could lay their hands on. The resultant semitechnological, industrially pretty art was given many names. It was called the "L.A. Look" by Peter Plagens in his *Sunshine Muse* of 1974. The critic John Coplans termed it "Finish Fetish," implying the artists' main preoccupation was in craftsmanship. The "school" was also dubbed "L.A. Glass and Plastic." Among the artists using new technology were Robert Irwin, Larry Bell, Craig Kauffman (b. 1932), Ed Ruscha (b. 1937), Billy Al Bengston, Peter Alexander (b. 1939), and DeWain Valentine (b. 1936).

In 1958 **Larry Bell** (b. 1939) was a student at Chouinard Art Institute when his teacher Robert Irwin recognized his abilities and encouraged him to go directly into a painting career and to associate himself with the Ferus Gallery. Bell was in his early twenties when his first show revealed an artist dealing with the most advanced concepts of his day. His Geometric Abstractions took the form of "isometric box" paintings, approximately square canvases with two opposite corners truncated, such as *Magic Boxes* of 1964

Fig. 30-10
Larry Bell (b. 1939)
Magic Boxes, 1964
mixed media painting:
canvas, acrylic, glass
36½ x 36½ in.
Los Angeles County
Museum of Art, Gift of Dr.
and Mrs. Sanders Goodman

Fig. 30-11
Ron Davis (b. 1937)
Roto, 1968
oil on canvas, acrylic resin
and fiberglass
62 x 136 in.
Los Angeles County
Museum of Art, Museum
Purchase, Contemporary Art
Council Funds

(fig. 30-10). Modifying the traditional rectangular shape of the canvas was one of the innovations associated with New York's Geometric Abstraction. By removing the frame, regarding the part of the canvas that wrapped around the side of the stretchers as part of the art work/object, and reshaping the perimeter of the canvas, Geometric Abstractionists were declaring paintings to be objects rather than windows into illusionistic space. Californians, like Bell, took this one step further. Like some New Yorkers, Bell's painted design followed the perimeter shape, but his intent was for entirely different purposes—to play with the sense of human perception. The truncated square canvas creates the optical illusion of a box seen at an angle; this is echoed by the central mirror, but because the mirror reflects its three-dimensional space, the mixed media work becomes a complex interplay of real and imagined two and three dimensions. The fact the mirrored glass reflects the viewer causes the viewer to become emotionally and physically involved with the painting and even to alter its aesthetic. Interaction between artwork and viewer and tailor-making art to "include" viewers become increasingly important issues as the century proceeds.

Ron Davis (b. 1937) was associated with the Nicholas Wilder Gallery rather thatn the Ferus group, but his medium of fiberglass and acrylic places him in this discussion. While Davis was still a student at the San Francisco Art Institute and working in an Abstract Expressionist mode, he became interested in illusion, how a flat object could appear three-dimensional simply as a result of color areas painted on its surface. Teaching himself the theories of perspective from books, by 1963 he was shaping canvases and applying painted sharp-edged fields to fool the eye into seeing them as three-dimensional objects. The first shape he modified was an oval; by adding painted stripes he made it appear to be a cylinder viewed from an angle. His next shape was a hexagon whose checkerboard surface turned it into a cube seen from the end. In Los Angeles in the mid 1960s he was soon testing the properties of colored resins and fiberglass, again teaching himself from books. Created at the height of Minimalism, *Roto* of 1968 (fig. 30-11) fits the definition of a Geometric Abstraction in that its physical and illusionary components create a dodecagon, a polygon having twelve angles. However, Davis's main interest is anti-Minimalist—in creating illusion. To create his

works, the artist builds a shallow mold atop a waxed Formica table. Following an actual-size cartoon, he pencils the Formica table where his lines and colors will be applied. Colored gel-coat resin is his "paint," and he applies this in the traditional way, with a brush. Because the front of the work is facing the Formica, he applies his colored resins backwards starting with the details and "foreground." The finished work is then given additional support with fiberglass and resin before it is pulled off the mold and viewed for the first time! Davis also selects his colors for illusionary purposes. As explained in Johannes Itten's *Art of Color,* to the human eye, blue recedes while red advances. It amuses the artist to reverse these, to place his colored shapes where the illusion of three dimensions visually forces a blue field forward, a red field into the background. Davis creates the illusion of depth in several ways: he creates geometric areas whose hard edges act like perspective lines, he builds up a thick layer of plastic in which color and light are held in physical suspension, he allows the transparent parts of the fiberglass to assume the color of the second fiberglass backing, and in some works of the early 1970s, he pierces his works with holes to incorporate the wall.

The next step in modifying a painting was to give its traditionally flat surface physical depth. Physical depth seems antithetical to the idea of a painting; it seems to turn a painting into a sculpture. However, the barrier between these two disciplines broke down in the 1960s in the environment of rampant experimentation. **Craig Kauffman**'s *Green, Red* of 1965 (fig. 30-12) achieves dimensionality in two ways—physically, through the vacuum cast acrylic, and visually, by the subtle shading of the sprayed acrylic lacquer applied to the reverse. His works of this type epitomize the "Los Angeles look"—they are sensual, rich, technically innovative, sleek, and good looking.

Much myth has arisen about the "L.A. Look." The highly polished surfaces of art objects made with materials associated with industry and technology are often described as "sensual," "lush," "gleaming," and "physical," and the Southern California artists' reported obsession with technique has been termed "perfectionism." Some authors claim the "new" and "clean" look of plastic's light-filled transparency reflects Southern California's sunny atmosphere and spaciousness. Others criticize the L.A. Look as passionless, cold, mechanical, and bereft of the artist's personality. Regardless of these opinions, Los Angeles's Glass and Plastic artists added a new dimension to America's Geometric Abstraction. And, Los Angeles's innovations did not stop there.

Fig. 30-12
Craig Kauffman (b. 1932)
Green, Red, 1965
vacuum cast acrylic
89½ x 45¾ x 5½ in.
George R. Wanlass; Photo Courtesy Newspace, Los Angeles

Fig. 30-13
Robert Irwin (b. 1928)
Untitled (Dot Painting),
1965–66
oil and acrylic on canvas
42 x 43 in.
The Museum of
Contemporary Art, Los
Angeles, Gift of Mr. and
Mrs. Burton Tremaine;
© 1998 Robert Irwin /
Artists Rights Society (ARS),
New York
Photo: Squidds & Nunns

Fig. 30-14
Robert Irwin (b. 1928)
#2221 Untitled, 1968
acrylic paint on cast acrylic
54 in. dia. x 24 in. deep
San Diego Museum of Art
(Gift of the Frederick R.
Weisman Art Foundation);
© 1998 Robert Irwin/
Artists Rights Society (ARS),
New York

Whereas artists in New York progressed from Minimal art to a non-object art form like Conceptual art, some Los Angeles artists extended Minimalism by adopting light as a medium and exploring perception. **Robert Irwin,** after his breakthrough with his line paintings, found he wanted to eliminate even the subtle lines. He didn't want a color field, but a field of energy. His solution was to paint a canvas with pure white paint and then to scatter tiny dots of red and green in the center, as in *Untitled (Dot Painting)* of 1965–66 (fig. 30-13). His choice of the complementary colors of red and green (complementary colors are opposite each other on the color wheel) suggests a knowledge of Op and its technique of using contrasting colors to set up an optical vibration. His intent was not to create an entertaining optical illusion but to push the envelope of human perception. When first viewed, the painting looks entirely white, but after studying it, the viewer begins to see a cloud of colorless energy hovering just in front of the painting's surface. To enhance the effect, Irwin painted some of his dot paintings on convex canvas panels—he stretched his canvas over an elaborate wooden framework constructed like the interior of an airplane wing.

Irwin's next challenge was to eliminate the distracting rectangular edge. Circles were the most neutral shape he could find, so between 1966 and 1969 he painted on convex discs. His earliest discs were made from aluminum by a metal fabricator in downtown Los Angeles, while his later discs were made from acrylic. By applying paint with a spray, Irwin "dissolved" the support in two ways. The slightly grained, faceted surface, achieved when the paint was sprayed from a specific distance, diffused light. And, a grayish shadowy color sprayed around the perimeter reduced the visual impact of the edges. Irwin then took the next step.

Since 1964 he had been aware of how the space around a painting could affect the viewer's perception of that painting, and he decided to modify the area around his discs, as in *#2221 Untitled* of 1968 (fig. 30-14). He mounted the convex disc on a short tube or cylinder extending out from a perfectly white wall of at least 12 x 12 feet, and illuminated it either with even, ambient natural daylight or with four low-intensity spots placed equally around the perimeter. In this environment, the disc's outer edges completely disappeared, and the disc "painting" fused with the space around it, seeming to float ambiguously. Thus, where a painting had once been seen as a self-contained picture window into another world, with Irwin's discs it became a purely perceptual object totally merged with its external environment. For Irwin the disc paintings were the crucial step toward his later room installations.

Light and Space "Paintings"

In the very late 1960s, the natural elements of light and space became media for a handful of Los Angeles artists.

Using artificial light to create art was not a new concept (chapter 29). German artists in particular had explored it. In the late 1920s, Laszlo Moholy-Nagy's (1895–1946) *Light-Space Modulator* investigated light's ability to encompass space, enveloping the viewer as well as its site. More recently, the French Groupe de Recherche d'Art Visuel in Paris (founded 1960) explored both Kinetic and Op ideas. The climax of such interest was the Lumière et Mouvement exhibition in Paris in 1967.

One reason Americans hear little of Kinetic Art and technology in histories of 1960s art is that neither was practiced to any extent by New York artists. New York dismissed light art as trickery and pyrotechnics. Whether Los Angeles artists knew of international developments in these areas or even of the investigations at the Massachusetts Institute of Technology is unknown. It becomes almost a moot point, since the interest of Southern California Light and Space artists seems to have evolved naturally from local sources, including the area's aerospace contractors and their exploration of human perceptions. Europe's long-standing interest in light and kinetics in art explains why European critics were quicker to acknowledge and acclaim the achievements of Los Angeles's Light and Space art (chapter 29) than were those in New York.

Most of the Light and Space artists worked in the media of sculpture or site installations (chapter 29), but two of the top figures created wall-hung objects that this writer prefers to treat as "paintings." In the mid 1960s **Douglas Wheeler** (b. 1939) made "light paintings" he called "encasements." A typical example, *Untitled* of 1966 (reproduced in Jan Butterfield,

The Art of Light and Space, New York: Abbeville, 1993, p. 120), is made up of a traditional stretched canvas painted in tones so pale they appear white; it is encircled with a strip frame of clear Lucite. The Lucite carries the artificial light (from neon or argon tubes affixed to the reverse of the canvas) around to the front, and the bevel reflects it across the canvas surface. In a darkened room Wheeler's light paintings read as glowing squares of subtle color, and the natural flicker of the argon makes the works seem to shimmer and pulse. Wheeler soon eliminated canvas to work completely with plastic. His shallow (2½-inch-deep) plastic boxes were etched on the underside then sprayed with lacquer, both of which diffused the background light from argon-filled glass tubing. Again, the effect was that of a solid, glowing square of subtle color.

Also creating light works that lay flat against the wall was **Hap Tivey** (b. 1947). Tivey's main influences were other Light and Space artists, such as James Turrell (chapter 29) and Wheeler, and his longtime interest in Zen. Many of his early room installations appeared to be interiors of Japanese houses in that translucent panels were set within a rigidly vertical and horizontal encasement of natural wood, and viewings were often preceded by a tea ceremony. In an installation at Otis Art Institute titled the *Asians,* Tivey set cinematic rear-view projection screens into the four corners of a room and lighted them from behind. The softness and abstract shapes that appeared on these were achieved by beaming various kinds of artificial lights through slits and filters; the various hues came from the different kinds of lights employed (fluorescent, tungsten, mercury, sodium, incandescent, to name a few). Sometimes the light on the screens was intentionally modified, achieving an effect similar to the changing colors of the sky as the evening sun descends, thus engaging a viewer with its permutations. The goal was a Zen-like environment meant to inspire meditation.

Distantly related to the Light and Space movement, in that artists use light as a medium, is the large field of Neon art. Using the narrow tubes that most people associate with advertising on the fronts of buildings, artists, such as **Bruce Nauman** (b. 1941) shaped them to convey abstract ideas. Nauman is a difficult artist to discuss since he made important innovations in a number of avant-garde media of the late 1960s including Performance, Conceptual art, and Light and Space, moving quickly from one to the next. An example of his work in neon is *Window or Wall Sign* of 1967 (reproduced in Jan Butterfield, *The Art of Light and Space,* New York: Abbeville, 1993, p. 133), in which blue lettering spirals outward from a center. The wording, "The true artist helps the world by revealing mystic truths," shows Nauman addressing one of Conceptualism's favorite themes of the 1960s—art. (See Conceptual art, chapters 29 and 36.) In 1981 the Museum of Neon Art opened in Los Angeles devoted to contemporary fine art in electric media (neon, electric, and kinetic).

The reductive trend of the 1950s and 1960s that resulted in insubstantial media such as Conceptual art and Light and Space room environments eventually backed its artists into a corner. Although the rumor circulated that painting was dead, the following chapters show that the pendulum was to swing back to painting, thanks to new subject matter and artists' need for paint to convey ideas. 🌾

Bibliography

Abstraction, American

Auping, Michael, *Abstraction—Geometry—Painting: Selected Geometric Abstract Painting in America Since 1945*, New York: Harry N. Abrams, Inc., 1989. 232 p.

Abstraction 1945–1960

Baker, K., "Art Notebook: California Abstractionists of the 1940s and 1950s," *Architectural Digest*, v. 48, May 1991, pp. 66+.

California Hard-Edge Painting, exh. cat., Balboa Pavilion Gallery, Balboa, Ca., March 11–April 12, 1964. 30 p.

Danieli, Fidel, "Nine Senior Southern California Painters," *LAICA Journal*, no. 2, October 1974, pp. 32–34.

50's Abstract, a Summary of Los Angeles Painting from 1957 through 1960, exh. cat., Conejo Valley Art Museum, Thousand Oaks, Ca., September 28–November 9, 1980. 18 p.

Finch, Christopher, "Hard Edge Painting," *Architectural Digest*, v. 54, no. 4, April 1997, pp. 190–93+.

Four Abstract Classicists, exh. cat., Los Angeles County Museum of Art, September 16–October 18, 1959. 70 p.

Harwood, June, "Letter to Editor re Four Abstract Classicists," *LAICA Journal*, no. 5, April–May 1975, pp. 12–15.

"Los Angeles Hard-Edge," in *California: 5 Footnotes to Modern Art History*, exh. cat., Los Angeles County Museum of Art, January 18–April 24, 1977, pp. 51–80.

"Nine Senior Southern California Painters," *LAICA Journal*, no. 3, December 1974, pp. 45–55 [catalogue of the LAICA opening exhibition at the ABC Entertainment Center, Century City, November 23, 1974–January 8, 1975].

Plagens, Peter, "The Soft Touch of Hard Edge," *LAICA Journal*, no. 5, April–May 1975, pp. 16–19.

Abstraction, American 1960s

Carmean, E. A., Jr., *The Great Decade of American Abstraction, Modernist Art 1960 to 1970*, exh. cat., Museum of Fine Arts, Houston, January 15–March 10, 1974. 144 p.

Colpitt, Frances, *Minimal Art: The Critical Perspective*, [Ann Arbor, Mi.: UMI Research Press, 1990] Seattle: University of Washington Press, 1990. 270 p.

Gablik, Suzi, "Minimalism," Cyril Barrett, "Kinetic Art," and Jasia Reichardt, "Op Art," in Nikos Stangos, *Concepts of Modern Art*, New York: Thames and Hudson, 1991.

Greenberg, Clement, *Post-Painterly Abstraction*, exh. cat., Los Angeles County Museum of Art, April 23–June 7, 1964 and two other venues.

Abstraction, 1960s

Abstraction in Los Angeles 1950–1980: Selections from the Murray and Ruth Gribin Collection, exh. cat. California State University, Northridge, September 27–October 23, 1981 and one other venue. 48 p. [*LAICA Journal*, no. 30, September/October 1981, between pp. 36 + 37]

Butterfield, Jan, *The Art of Light + Space*, New York: Abbeville Press, 1993. 271 p.

California Stories. The Paintbox Pioneers, executive producer, Jim Kennedy; producers-writers, Roger Bingham, Teya Ryan, Los Angeles, Ca.: KCET-TV (PBS), 1987. 1 video recording, 30 min.

A Decade of California Color 1960–1970, exh. cat., Pace Gallery, N. Y., November 7–25, 1970. [folder, 17 artists] 14 p.

15 Abstract Artists, Los Angeles, exh. cat., Santa Barbara Museum of Art, January 19–March 10, 1974. 24 p.

Finish Fetish: LA's Cool School, exh. cat., Fisher Gallery, University of Southern California, Los Angeles, March 13–April 20, 1991. 48 p.

Knight, Christopher, "Is There a California School?" [author relates nineteenth century American Luminism to light in 1960s LA art] *Portfolio*, v. 3, September/October 1981, pp. 54–61.

Larsen, Susan, "Los Angeles Painting in the Sixties," and Michele D. De Angelus, "Visually Haptic Space: The Twentieth Century Luminism of Irwin and Bell," in Maurice Tuchman, *Art in Los Angeles: Seventeen Artists in the Sixties*, exh. cat., Los Angeles County Museum of Art, July 21–October 4, 1981 and one other venue. 162 p.

Painting and Sculpture in California: The Modern Era, exh. cat., San Francisco Museum of Modern Art, September 3–November 21, 1976 and National Collection of Fine Arts, May 20–September 11, 1977.

Plagens, Peter, "Abstract Painting in California," *Studio International*, v. 188, July–August 1974, pp. 35–37.

Plagens, Peter, *Sunshine Muse: Contemporary Art on the West Coast*, New York: Praeger, 1974.

Selz, Peter with Jane Livingston, "Two Generations in L. A.," *Art in America*, v. 57, January 1969, pp. 92+.

A View Through [So. Calif. transparent materials], exh. cat., Art Galleries, California State University, Long Beach, September 22 - October 19, 1975. 33 p.

Outside Modernism—
Fantasy & Imagination

At one time or another everyone has felt like an outsider, swimming against the current, alienated from the mainstream. Artists too can be outsiders from the arts community. Some so-called "outsider" artists are highly trained and highly skilled but become outsiders because they work in a style other than the one currently dominant or because they personally reject the values and authority of the establishment art world. Other outsiders are academically untrained—children, the mentally ill, recuperating invalids, clairvoyants, prisoners, the retired, and those living on the fringes of society.

Why bother talking about art by outsiders in a book that addresses mainstream art movements? In the early twentieth century, art made by academically untrained outsiders began to influence the fine art community when art world leaders, such as Picasso, noticed that it contained elemental strengths and character they themselves wanted in their art. Additionally, as the century progressed, the number of academically trained artists who rejected mainstream values increased, and their work often set the pace for the mainstream. "Outsider" art helps us understand society—it emerges from the perceptions of the average person, as opposed to art by academics, which is generated by intellectuals and is imposed on the people.

California is one of the primary geographical areas in America that harbors non-mainstream artists. Loners, mavericks, and dreamers have been attracted by the state's status as a frontier and by its liberal atmosphere. Throughout the twentieth century, California's vast and unpopulated deserts and rural areas have provided refuge to many eccentric recluses. In the 1950s and 1960s San Francisco became a world center for the Beats and their successors, the hippies, as well as a whole group of professional "fine arts" artists who rejected the traditional values of "the establishment."

This chapter discusses two main types of California Outsider Art. The first is produced by artists who had some formal training but who purposefully rejected the establishment. This includes Beat painting, hippie psychedelic fantasy worlds, teacher-artists' "Personal Mythologies," Los Angeles's Car/Surfer Countercultures, and Punk-, Graffiti-, and Tattoo-inspired art. The second type of Outsider Art discussed is legitimate Folk Art—that art created by artists who

had no formal training but whose paintings, sculptures, and folk environments, produced for their own personal satisfaction, have aesthetic strength and charm.

Beat Art and Funk (1950–1965)

Normally the tail does not wag the dog, but in the 1950s and 1960s America's dropouts, the Beats, and their successors, the hippies, as well as a large number of academically trained artists who just enjoyed thumbing their noses at society, created unique types of art that had nationwide impact. Most of this activity occurred in Northern California.

The word Beatnik conjures up a picture of sloppily dressed young adults, the men in goatees and sandals and the women in clothing and jewelry from ethnic cultures. In the 1950s, disillusioned youth drifted away from home to places where they could find others of like mind—principally New York and San Francisco. In the cities, anti-establishment, inarticulate rebels convinced there might be no future for anyone in an A-Bomb and H-Bomb world, lived for the moment. Establishing loose "family" ties with other Beats, and sometimes living in groups, they took up Eastern philosophies and as often as not used drugs such as peyote or methedrine. Those in San Francisco congregated around the artists' studios and coffeehouses along Grant Avenue in the North Beach area, north of Chinatown and south of Coit Tower. Nighttime saw the underground come alive: Beatniks caught up in desperate personal isolation gravitated to bars to meet friends. Beat painters lived in close communion with those who expressed themselves verbally, the writers and poets. Events held at San Francisco galleries like King Ubu (started by the artist Jess and his poet companion Robert Duncan) packed bead-wearing Beats into a smoke-filled room hung with hastily created "paintings" to hear poetry read aloud to the strains of jazz.

Out of this soup of personal frustration, rejection of the mainstream, and drug-induced fantasy came a wealth of creative activity.

What defines Beat painting? Crucial to the heart of Beat art is attitude, a spurning of mainstream society. Many Beats, unable to relate to their fellow man in the standard ways, expressed themselves and tried to communicate through some creative form such as

Opposite:
Fig. 31-6
Bill Martin (b. 1943)
Garden of Life, 1968
oil on canvas, 48 x 48 in. diam.
Current owner unknown;
Photo courtesy Bill Martin

Fig. 31-1
Keith Sanzenbach
(1930–1964)
Mandala
oil, lacquer, burlap
46½ x 52 in.
Collection of the Oakland
Museum of California, Gift
of Dr. Reidar Wennesland

writing, assemblage, dance, theater, and art. Rejecting society's and the mainstream art world's norms, they developed their own. Art innovations included utilizing castoff materials (often the only components they could afford), devising new media (assemblage), and spoofing the mainstream. Although the Beat period ended by the mid 1960s, the attitude persists even now among many of California's artists and has colored the state's art for the last fifty years.

Beat painting is of two general types distinguished by attitude: paintings that are highly sincere, and those that contain tongue-in-cheek humor.

In the sincere realm lies the work of **Keith Sanzenbach** (1930–1964). Sanzenbach was university trained in art but lived the stereotypical Beat lifestyle, drifting through temporary residences in cheap hotels and living in communes with friends, in their studio corners, and in attics. He frequently mixed alcohol with barbiturates and experimented with drugs and hallucinogens. His emotional and psychological troubles were recorded in his *Chaos Notebook,* in which he talks about suicide, death, and the supernatural. Like many Beats, he believed in the archetype theories of Jung (as opposed to the sex of Freud), and he read copiously about Eastern religions. In the early 1960s he produced his most important paintings. *Mandala* of 1960 (fig. 31-1) reveals mixed sources of inspiration: subject matter derived from Eastern religions, imagery reminiscent of Native American sources, and a painterliness associated with Abstract Expressionism. The title refers to a schematic of the cosmos, which was popularly used by Hindus and Buddhists. At its center was the "one" god, and surrounding him/her were pictorial symbols of the different forces in the universe. Mandalas were used as foci of meditation; through studying the image the acolyte absorbed or acquired the energies represented by the various symbols until he attained the power and qualities of the supreme. Advance went from multiplicity, on the exterior, to unity with the one at the center.

Discussions of California Beat art are usually peppered with the word "Funk." "Funk" is a quality that has been variously described as deliberately sloppy, use of ratty materials, grotty, earthy, gutsy, sensual, ugly, and "dumb," as well as absurd, corny, out-of-fashion, nose-thumbing, and filled with black humor, spoof,

tongue-in-cheek parody, satire, or puns. These terms are apt when describing Beat objects—(for Assemblage, see chapter 25; for small-scale ceramic and wood sculpture, see chapter 27)—but only work for a few "paintings." Sanzenbach, for example, utilized castoff burlap wrappers acquired from a nearby carpet dealer, stringing them to rods like a sail to a mast. Some historians imply that the Beat use of detritus or cheap materials was intentional—a way to reject middle-class products and values. While this may be true, much of it was also dictated by economics. Beats created art with ingredients they could afford.

Most of the Beat paintings that have survived time are made of more standard materials. **Jay DeFeo** (1929–1989) and her husband Wally Hedrick (below) have been called the prototypical Beat couple—poor and flamboyant. Since Hedrick ran The Six gallery (open 1954–57), the couple was present at many of the community's and gallery's openings and cultural events. In addition, they held frequent gatherings at their apartment, an old high-ceilinged space located in a Victorian fourplex on Fillmore. "Papered" with paintings (DeFeo also used it as a studio), it was a made-over environment reflective of its owners' tastes rather than of mainstream values. A huge drawing of eyes is one of DeFeo's most reproduced works. Its theme is Beat—all-seeing hypnotic eyes and mysticism. However, her most well-known work is *The Rose* of 1958 to 1966 (fig. 31-2). Like most of her works, it is a neutral monochrome and contains a central representational motif. Her primary interest was texture and direction of paint. There is no arguing that the thick accretions of pigment smeared and spread using some flat, hard object into graceful marbled sweeps reminiscent of floating seaweed can be considered Abstract Expressionist work. The same is true of her manner of developing the work directly on the canvas. But *The Rose* also represents the Beat aesthetic because it is "funky." Not only was the picture created with the cheapest brand of artists' pigments, but embedded in its eventual two-to-eight inch thickness are "found" materials such as wire, beads, and even faux pearls (remaining from a phase when DeFeo created jewelry). The project of painting *The Rose* became an obsession with DeFeo, who would work on it, put it away for months at a time, uncover it again, and try another

Fig. 31-2
Jay DeFeo (1929–1989)
The Rose, 1958–1966
oil on canvas with wood, beads, pearls and mica
128⅞ x 92¼ in.
Gift of the Estate of Jay DeFeo and purchase, with funds from the Contemporary Painting and Sculpture Committee and the Judith Rothschild Foundation; © Whitney Museum of American Art, New York; © 1998 Estate of Jay DeFeo/ Artists Rights Society (ARS), New York
Photo: Ben Blackwell

tack. Its thickness allowed DeFeo to carve it into a bas relief of rays radiating out from a central spot—the rose. With its huge size (129 x 92 inches) and built-up layers of paint, it weighs 2,300 pounds. It stands as the epitome of San Francisco artists' interest in accretion and surface textures.

Parallel with the "sincere" Beat artists were those Beats who produced art with tongue-in-cheek humor. Most of the artists adopting this attitude were intellectuals who also enjoyed creating visual double-talk and paradox.

Wally Hedrick (b. 1928) seems to have had a Beat attitude even before the movement began. He claims he got into art not because he was creatively driven but because it was easier in junior high school to make art projects than to take physical education classes. In the late 1940s he joined the National Guard to avoid the draft, and a few years later was unpleasantly surprised to find his unit called up for the Korean war. While the experience in Korea left him with a lasting distaste for the military, upon discharge he was able to take advantage of the G. I. Bill and enrolled at the California School of Fine Arts. Like Sanzenbach, Hedrick obtained the imagery in *Hermetic Image* of 1961 (fig. 31-3) from philosophies other than mainstream Christian beliefs. Hermeticism was the mystical ideology based on the writings of Hermes Trismegistus. Prevalent in Egypt during the second and third centuries, Hermeticism was contemporary with Hellenistic Alchemy. In *Hermetic Image* Hedrick took up the theme of alchemy, a subject that had fascinated him for several years. The central image is a takeoff of a schematic of the cosmos or universe. In a pre-scientific era, alchemists composed such concrete diagrams to put logical order to the seeming confusion of the world. *Hermetic Image* includes the basic elements: the concept of man as the middle or center; the cosmos above and hell below; the incorporation of the four "elements" (earth, air, fire, water); and the inclusion of mystical numbers. However, Hedrick's spiritual hierarchy is tongue-in-cheek. He liked the mental game of manipulating the letters in a word to turn it into a different word that sounded like the original word but meant something entirely different. The labels he applied to the hierarchy of levels—perverted English and Latin phrases that refer to Satan at the bottom and Imundus Archetypes at the top—satirize Western world religions. Hedrick never considered himself a "Beat," but does remember having a fierce independence, free from any group association, including the Beats and the "art world," and he remembers struggling to support himself and paint at the same time. Besides directing The Six, he earned some income from a clerkship at the

California School of Fine Arts and for most of his life was an art instructor.

An artist who does not consider himself a Beat except for the fact he was active in the 1950s is **Jess**. Jess produced paintings, which he termed "translations." Like his collages (chapter 28), works such as *Ex. 4—Trinity's Trine: Translation #5* of 1964 (fig. 31-4) are based on old, found imagery. But the final product results from Jess's repainting of the image on larger scale. Here an out-of-date laboratory from a black and white illustration in *Scientific American* (5, iii, 1887) is "translated" into color and paint. Jess's fertile imagination overlays the whole with the fantasy aura of a child's book illustration, a style popular among Northern California artists (see also William Wiley). His unctuous, textured surface reflects the general Bay Area predilection for thick surfaces.

Jess was an extremely influential and important artist. Although reclusive, his companionship with the poet Robert Duncan and the fact he and friends were behind the King Ubu Gallery in the early 1950s, made his work well known. Jess was one of the earliest artists to re-use old images in new contexts—to use them to evoke memories and to prompt viewers to consider the old images anew. As the twentieth century unfolded, using known images in new contexts ("appropriation") became a widespread practice fostered by Conceptual Art and its need to convey ideas. Jess's occasional use of images to *subvert* themselves makes him the original deconstruction artist (chapter 36).

Hippie Art

By the 1960s, San Francisco's Beats' time had passed. Their North Beach "bohemian" stronghold had been invaded by Gray Line buses filled with tourists and by teenagers eager to become Beatniks. Their hangouts had been taken over by shopkeeper entrepreneurs catering to tourists, and they had lost their lofts to escalating rents. Beats retreated to peripheral and less costly areas in the city, such as Haight Street or Potrero Hill, and outside the city in Mendocino, Big Sur, New York, and even Mexico.

Replacing the Beats was a new group of "outsiders," a new counterculture, the hippies. Their "enemy" was the mass of lookalike drones who worked for corporations like IBM or churned out advertising on New York's Madison Avenue. Defying the stereotype family of Ozzie and Harriet, hippies lived communally, indulged in drugs, hung about in coffee houses, joined public "love-ins" and attended rock music concerts. This was the era of "flower children" riding around in decrepit Volkswagon vans. Hippies differed from their Beat predecessors in that some, instead of totally dropping out, believed they could improve America's problems, convert society. They became "involved" by participating in the Free Speech Movement at the University of California, Berkeley (1964), and joining in campus sit-ins for civil rights and against the war in Vietnam. Media coverage of the San Francisco area's demonstrations attracted masses of youths with equal sympathies. Others joined the Peace Corps to help the less fortunate in the world's "global village," a geographic concept brought into being by improved communications such as the ubiquitous television.

There are two broad strains of hippie art: the Marxist or revolutionary images that advocate the overthrow of political systems, and the drop-out, dream world images. Unlike Beat art, which was more intellectual and closely associated with Eastern philosophies and with poets and writers, hippie art was visual and sensual and often reflected the experience of mind-expanding drugs.

Marijuana may have seemed the epitome of evil in the years immediately following World War II, but the drug proved to be comparatively mild next to the substances popularly taken up by the American counterculture in the second half of the twentieth century, including peyote, mescaline and LSD. All of these altered the way the mind perceives reality, evoking disjointed collage-type visions made up of objects from unrelated times and cultures, but especially triggering nonobjective subject matter: vivid colors, flowing patterns, and bursting energy. Just as writers and painters of the late nineteenth century utilized the fashionable drugs of their time—opium, morphine, and cocaine—to stimulate their creativity, so too did the hippie artists of the 1960s. The hippie art that arose in the Bay Area in the 1960s can be considered an entirely new American art form, one of San Francisco's true contributions to world art.

Hippie art spanned a wide range of media and sophistication. At the grass roots level, hippies produced a great quantity of personal adornment—jewelry and embroidered or painted clothing—and decorations on automobiles and walls. On a professional level, the two best-known forms are posters and light shows (chapters 28, 29). Both attempted to recreate, within the limits of their individual media, the vivid swirling and flashing colors and unrelated images seen under the effects of drugs. San Francisco light shows achieved this through lasers, strobes, and colored lights. (The medium of light makes San Francisco's light-show artists distant cousins to Los Angeles's slightly later Light and Space group, but the former were distinguished by their goal of entertainment while the latter explored human perceptions.)

Posters achieved a psychedelic look through an eclectic mix of Art Nouveau-style "melting" lettering, optically confusing colors and patterns, and "collaged" images cut from old engravings or illustrations. These so-called "psychedelic" posters were made to advertise rock concerts—San Francisco was home to several famous rock bands. One of the earliest and best known of these artists was **Wes Wilson** (b. 1937) who, contrary to common practice, drew the poster *Captain Beefhart and his Magic Band, Chocolate Watchband* of the mid 1960s (fig. 31-5) entirely with his own hand. Such posters proved so appealing that people began to collect them to display on their walls. Their eye-catching, innovative designs not only put new blood into America's flagging seventy-year-old poster tradition but changed the look of America's graphic arts, particularly in advertising and the design of covers for rock music record albums.

In Visionary art, hippie ideas and fine art come together. Visionary art depicts fantasy worlds but differs from fantasy worlds created contemporary to it (below) in that it envisages serene, imaginary, cosmic places that might be visited on a "good" drug trip.

Visionary art arose at the very end of the 1960s, a time when many young San Francisco artists were looking for paths away from the prevailing Abstract Expressionism and Bay Area Figurative painting. The core group of Visionaries were students at the San Francisco Art Institute (renamed from the California School of Fine Arts in 1960). In the mid 1960s two new teachers, Tom Akawie (see below) and Norman Stiegelmeyer (1937–1984), were added to the staff to bring new blood to an institute dominated by teachers working in the Abstract Expressionist and Bay Area Figurative modes. Akawie brought in geometric abstraction, the technique of spray painting, and an interest in Surrealism and ancient Egyptian symbolism, while Stiegelmeyer painted semi-representational symbolic themes. Most of their students were of the hippie generation and had some experience with mind-expanding drugs and meditation, and had been exposed to "other" religions. They ascribed to the hippie ideal of a brave new world forged by high-minded leaders and were familiar with hippie art forms, such as rock music, psychedelic posters, light shows, etc. Several were exploring art avenues renegade to Abstract Expressionism. Stiegelmeyer recognized the uniqueness of their effort and called the artists to a meeting at his house to discuss ways to promote their art.

The student who stood out was **Bill Martin** (b. 1943), described by teacher Tom Akawie, for whom he worked as a teaching assistant, as a tall, redheaded and bearded man with charisma. Since the age of thirteen, Martin had been creating imaginary worlds on canvas that were very close to reality but that departed slightly in the direction of the surreal. During the winter of 1967–68, while attempting to devise a new artistic direction for himself, he set to painting a very large (48-inch-diameter) circular landscape, the *Garden of Life* of 1968 (fig. 31-6, p. 414). By the spring of 1968 it had taken a format that would become standard for him—an ideal slice of nature presented as terraces and cut through by a stepped waterfall. The only problem was that it was dominated by green. One day, looking out the window of his Chinatown studio, he noticed a flowering magnolia in the neighboring backyard. Soon, he had broken up his green with an amazing display of flowers. For Martin, this encyclopedic and minutely rendered garden was a beautiful, natural place meant to be appreciated for its variety rather than exploited for its natural resources. It was a place where all species could live in harmony. Even man is there— that is, his wet handprint appears on one of the rocks. The flora and geology are as detailed as that in pictures by the mid-nineteenth-century American pre-Raphaelites. However, the hippie Visionary works differ in their airless atmosphere, their hyper-bright, intense colors, their gemlike precision, their often round (rather than rectangular) format, and the artists' belief that the paintings could inspire spiritual and social revolution, i. e., happy, communal living. Following the

Fig. 31-5
Wes Wilson (b. 1937)
Captain Beefhart and his Magic Band, Chocolate Watchband (Fillmore Auditorium), 1966
offset lithograph, 19 x 13¾ in.
Collection of the Oakland Museum of California, Gift of Bill Graham

then-popular hippie fashion for posters, Martin reproduced his work. It became an instant "best seller," and it was picked up by distributors and eventually sold in the thousands.

The Visionary artists never became a formal group. The closest they came to any manifesto were the articles Stiegelmeyer penned on the group. But they did enjoy several early group exhibitions thanks to Stiegelmeyer's intercession, as well as to Martin himself, who turned down one-man shows in favor of group exhibitions. Apart from artists at the San Francisco Art Institute, a handful of others scattered around the Bay Area also took up the theme, importing into it their own personal mysticism. Visionary artists received further attention when Pomegranate Press reproduced their images in a book and in a line of cards and posters.

Each artist devised his own particular Visionary world, some hyper-real and earth-based, others symbolic, others showing the cosmos. A very different vision from Martin's was painted by **Thomas Akawie** (b. 1935), the teacher for whom Martin had been working. (Akawie eventually became identified with the Visionaries, although he regards himself as belonging to an earlier generation than the core artists.) Each of the Visionary artists seems to have had a mystical mindbent since his early teens. This is also true of Akawie. While growing up in Los Angeles in the 1940s, he had been intrigued by the many Surrealist canvases on view in exhibitions around modernist-oriented Hollywood (chapters 17, 21, 24). And he was fascinated with Egyptian motifs seen both in the architecture and decorations of movie palaces and in motion picture spectaculars. In the 1950s he traveled to Europe, where he studied the rigid symmetry seen in European cathedrals, and in the early 1960s he was painting symmetrical, hard-edged church floor plans in shades of gray that had the severe hierarchy of tantric art. About the mid 1960s Akawie made a first step toward his Visionary world when he made spray-painted Geometric Abstractions (chapter 30) with a mystical twist. By the late 1960s his ideas had coalesced into his now well-known mixture of iconography identified with ancient Egypt, the occult, and Art Deco, presented symmetrically against a background of exalted cloud forms or expansive oceans and deserts. The spacious settings, such as that in *Cloud Mirror* of October 1974 (fig. 31-7), may remind some of Surrealist landscapes, but Akawie's interest is in giving visual form to an idealized space that is both reflective of himself as well as universal. Akawie avoids Surrealism's narcissism and morbid delvings of the mind and emphasizes Jungian archetypes and neutral objects such as mandalas. Geometric forms, such as the pyramid, signify harmony to

Fig. 31-7
Thomas Akawie (b. 1935)
Cloud Mirror, October, 1974
acrylic on masonite, 18 x 8 in.
oval
Cloud Mirror by Thomas Akawie © 1975

him. As in other Visionary art, color and light effects play a major role.

Personal Mythologies/Dude Ranch Dada

Northern California attitudes and character traits resulted in yet another distinct form of art that was produced primarily by artist-teachers at local institutions of higher learning. Many California artists who had been involved in the Beat and hippie scenes during their youth and education were now leading outwardly conventional lives as art teachers at places such as the San Francisco Art Institute, the University of California at Berkeley, and the University of California at Davis (the latter about fifty miles inland from Oakland, and a few miles from Sacramento). These artists were financially comfortable with incomes from teaching and ascribed to the area's and era's anticommercial stance. They were highly intelligent, fiercely independent, anti-establishment, and had senses of humor. These characteristics caused them to ignore American mainstream styles and dictates and to create art for themselves rather than a viewing public. The resulting product is very anti-modernist, characterized by representational and illusionistic subject matter, reuse of existing imagery, an interest in myth and fantasy, a surreal quality, and humor in the form of spoof and parody. Bay Area art critic Thomas Albright coined the term "Personal Mythology" to cover the imaginary

Fig. 31-8
William Wiley (b. 1937)
Blame 'N Blind in Eden, 1992
watercolor on paper
30 x 22 in.
Wil and Sally Hergenrader,
Memphis, Tennessee

William Wiley (b. 1937) was open minded as to what constituted art and was a powerful influence on his students. But in 1967 and 1968, after five years of teaching, he was facing a personal artistic crisis. Minimalism and technology were unappealing to him. He believed art was getting too far from the comprehension of the average man, and he wanted to return to using traditional materials, even watercolor, which had suffered a second-class status to oil painting. With other Bay Area artists Wiley shared concerns about ecology, and he wanted his art to have some meaning over and above its surface appearance. A one-year sabbatical allowed him to travel and to devise a new direction. The mythological worlds that Wiley began to paint served not as places to escape into but as metaphors for his state of mind; they became reflections of his life and his day-to-day experiences. He has continued painting them to the present day. *Blame 'N Blind in Eden* of 1992 (fig. 31-8) is stylistically almost identical to the earlier *Lame and Blind in Eden* of 1969 (Private Collection). The artist sees *Blame 'N Blind* as a conscious updating of the earlier work. The "cabin" in this picture is the artists' studio on the wooded peninsula north of San Francisco, but the landscape has been altered to include a body of water; the boat is his, but normally rests on a trailer rather than a shoreline. Both paintings express Wiley's concern for ecology. Watering troughs imply the rural land is being used for grazing; however, a test tube attached to the trough suggests that the waters are being chemically tested. The surveyor's instrument in the first, which hints that Eden is about to be sold off, has been replaced in the second with a telescope. Wiley throws out various meanings for this combination of elements: that man should do more long-range thinking, that humanity should take a deeper view, and, particularly in reference to the telescope, that the Hubbel telescope was being launched into space when Wiley was making the painting. He wants his images to be enigmatic, and he expects the viewer to bring his own logic to them. Stylistically, *Blame 'N Blind in Eden* is reminiscent of a child's book illustration or an artistically upscale comic book, an intentional selection by Wiley, who wants to communicate to the average person. The text mimics Haiku poetry in its succinct, sensual word pictures.

worlds they created. As opposed to the earlier Beat and hippie worlds, inspired by exotic philosophies such as Zen Buddhism or alchemy, Personal Mythology artists looked to the fantasy worlds of children. They were autobiographical, inhabited by personal friends, animals, spirits, talismans, deities, and objects that had special meaning to the artist. The Northern California phenomenon spread to other parts of California and to the East, carried by the popularity of Dude Ranch Dada (below) and the spread of ceramic object-making (chapter 27), many of whose artists also adopted personal themes.

Albright, in his *Art in the San Francisco Bay Area 1945–1980,* sees Personal Mythology as propelled by two teachers at the University of California, Davis: William Wiley and Robert Arneson. Wiley was more influential on painting while Arneson, a ceramist, spawned a whole generation of object makers (chapter 27).

Anticipating the trend toward Personal Mythologies in the early 1960s was **Jeremy Anderson** (1921-1982), a teacher at San Francisco Art Institute who maintained close ties to the Funk worlds at the Universities of California at Berkeley and Davis. Anderson was primarily a sculptor in wood, but also produced a few maps, one of the themes preferred by those Personal Mythology artists pursuing the fantasy realm of travel. A viewer catching his first sight of such a work is confused—appreciative of the craftsmanship but puzzled by the seemingly nonartistic, chartlike subject. Travel, migration or pilgrimage (sometimes forward or backward in time) was a common theme of Personal Mythology worlds. Some of the painted worlds grew to elaborate proportions (like the imaginary world in the decade's popular novel *The Hobbit*) with multiple images depicting various important events or time periods. As anyone who has taken a trip knows, the destinations on a map can evoke a full range of images and emotions based on whatever the viewer preassociates with that destination. For example, Anderson's *Map #3* of 1966 (fig. 31-9) becomes a schematic for daydreaming, allowing a viewer to "travel" and to "explore" through a make-believe world. Bay Area humor is revealed in the "pun"-ish place names on this and other works: "The Living End," "Deep Blue Sea," and "Dire Straits."

Teaching along with Wiley at the University of California, Davis, was **Roy De Forest** (b. 1930). De Forest emerged from the California School of Fine Arts and San Francisco State College painting in an Abstract Expressionist mode. Soon his imagination took over and he began to construct personal fantasy worlds on canvas. By the late 1960s he had come into his signature style—large canvases crowded with childishly rendered humans and dogs. An example is *Canine Point of View* of 1974 (fig. 31-10). Typical of true folk painting by which De Forest was inspired, three-dimensionality is ignored, items are reduced to flat and silhouetted shapes, all are brought up close to the surface of the canvas, and the design is treated equally from edge to edge. Colors are bright and primary. De Forest's art is truly autobiographical since it depicts scenery, people, and animals from the region of his Port Costa home. DeForest's intention was not to mimic folk art but to utilize its stylistic traits to bring strength and power to his own visions.

Fig. 31-9
Jeremy Anderson
(1921–1982)
Map #3, 1966
graphite, ink, colored pencil, watercolor, 16 ⅞ x 20 in.
Collection of the Oakland Museum of California, Gift of Jennifer Anderson

Fig. 31-10
Roy De Forest (b. 1930)
Canine Point of View, 1974
polymer paint on canvas
60 x 73½ in.
Private Collection, Florida,
Photo courtesy George Adams Gallery, New York

Fig. 31-11
William Allan (b. 1936)
Shadow Repair for the Western Man, 1970
acrylic on canvas
90 x 114 in
University of California;
Berkeley Art Museum;
purchased with the aid of
funds provided by the
National Endowment for the
Arts
Photo: Benjamin Blackwell

At the University of California, Davis, where Wiley and Arneson taught, a Personal Mythology sub-theme arose: "Dude Ranch Dada." This descended from Wiley. He had grown up in rural Washington and, after moving to California's suburbs to be closer to his teaching, dropped his Beat trappings and returned to a more conventional, even countrified, laid-back lifestyle. Wiley became known for his attire—faded blue jeans, an old black cowboy hat, and a handlebar mustache. He also enjoyed picking up funky items from flea markets, swap meets, thrift shops, and junk stores and accepting unusual items given him by friends. Since he used corny, commercially directed imagery that dealt with the American West of contemporary myth, one reviewer dubbed Wiley's constructions "Dude Ranch Dada." (The style was also known as the "U.C. Davis Look.") He spread this interest to his fellow teachers and students.

William Allan (b. 1936) grew up in the state of Washington and, with friend Wiley, camped, hunted and fished in its wilderness. Its beauty deeply moved his poetic soul, and it seemed natural, once into an art career in Northern California, that he turn to his background experiences for his subject matter. Allan

typically creates an expansive Western landscape with a foreground object symbolic of man's presence, as in *Shadow Repair for the Western Man* of 1970 (fig. 31-11). There are many ideas embodied in this "surreal" presentation of an empty pair of blue jeans and work boots standing atop a crest overlooking a pristine, snow-covered mountain chain and a clear sky. (William Hahn uses a similar composition for his tourists who view *Yosemite Valley from Glacier Point,* fig. 3-8.) For Allan, the myth of the American West (which has repeatedly changed since Francisco Coronado penetrated the territory in 1539 looking for gold) took another turn in the 1960s. It was no longer a "frontier" for young men like Allan to conquer, but it still had significance for the human soul, and its wilderness beauty had to be protected. He championed this through his paintings. Hinting at the ecology movement that was then arising, the title contains the word "repair." This theme was so important for both Wiley and Allan that two group exhibitions were organized around it in the early 1970s. To Allan, the empty jeans "call to mind the images of ourselves that we project, as well as our suspicions that they are superficial, held up by shaky props, vulnerable." Dude Ranch Dada eventually had national impact when it spread throughout the Southwest, to the Northwest, and finally to the East Coast

Northern California's predilection for myth and fantasy declined in the late 1970s as the formerly anti-establishment style became the "academy." Hundreds of artists still amused themselves parodying kitsch and even each other, but critics believed the style's lack of militancy prevented it from spawning an equally significant descendant.

Southern California Counterculture of the 1950s and 1960s

Between 1950 and 1970 Southern California developed its own countercultural art based on entirely different sources than that of the North. The Southern California craze was for customized cars, surfing, a youthful lifestyle, and themes promoted in Hollywood feature films and cartoons, such as sex and violence. Much of the art was created by highly educated artists who had been unable to find a niche in the establishment art world and supported themselves or supplemented their income from fine art by making posters

(psychedelic, rock, protest, and punk), comix, and record album covers (rock and punk). These art forms reached exceptional heights in California (see above and chapter 28).

Los Angeles was the center of the customized car world. Customizing is the art of remodeling and repainting older model cars. It originated during the Great Depression, when new autos were too expensive for the average person to buy, and continued during World War II, when automobile factories ceased production and put their energies to the war effort. The new generation of skilled workers from the war plants had money in their pockets and no place to spend it; many of them turned to modifying old cars. In the post-World War II period, customizing flourished, especially in Los Angeles, where it was additionally fostered by the need of Hollywood stars and studios for specialty vehicles. These were designed and fabricated by small, imaginative custom car shops, such as Earl Carriage Works. It was the innovative postwar designs by Harley Earl (son of the owner of Earl Carriage Works) for General Motors that led America's car manufacturers to discard boxy, wagon-like shapes and all-black color schemes and adopt Hollywood glamour and flash. Design innovations included sleek, streamlined styling, chrome detailing, two-tone paint jobs, wraparound windshields, hardtops, and tail fins. Over the next twenty to thirty years, the craze for customizing cars (as well as motorcycles) spread out from Los Angeles, across the nation and around the world.

The most famous artist identified with the customized car world was **Von Dutch** (born Kenneth Howard) (1929–1992). The idol of many an acolyte, he lived out of his van, drank heavily, and moved like a nomad from city to city and job to job. Car culture included painting and decorating hippie vans, Chicano low rider cars, establishment race cars, and surfer wagons, to name a few. Von Dutch is universally acknowledged as the first artist to turn the ancient technique of pin striping into an art form by expanding it from simple lines that followed a vehicle's contour to freeform designs. He was possibly also the first artist to airbrush designs on his van and on his wearing apparel. Inspired by painted flames that decorated World War II fighter plane exhaust vents, Von Dutch was also the first artist to apply painted flames to cars. His art expanded from auto pin striping (in the late 1930s) to painted figures, flames, and caricatures, and finally, in the 1960s, into oil paintings. The imagery in such works as *Good-Bye Cruel World* of 1968 (fig. 31-12) was drawn from art of the past with which Von Dutch felt sympathy, particularly Surrealism. To this he added his own iconography—mechanical devices

(such as the meat grinder) and his trademark flying eyeball—to achieve a work that had the desired overtones of "weird" or "gross." The owners of *Good-Bye Cruel World*, who knew Von Dutch personally, say the scene represents Von Dutch's view of the world—as grinding him up with drink, nicotine, and drugs. Although the prestigious avant-garde Ferus Gallery of Los Angeles offered Von Dutch a show in the early 1960s, his outsider attitude led him to spurn the potential notoriety, acclaim, and money, and he continued producing his art for his own satisfaction.

Other counterculture art came out of the surfer and skateboard worlds. Riding ocean surf on specially shaped fiberglass and foam boards is an activity that originated in Hawaii but became a popular alternative lifestyle in Southern California during the 1950s and 1960s, making places like Malibu beach famous around the world. Factories in the Southland brought surfboards to their current high-tech state by replacing heavy wooden boards with foam, by covering them with new products, such as fiberglass, and by sculpting them. Artists not only adopted plastics techniques developed by local surfboard manufacturers but turned surfboards into surfaces for painting. Surfing conveys the essence of the California lifestyle and a Zen feeling with which many artists identified. Skateboarding—a land-based variant of surfing in which a board on roller-skate-type wheels is propelled along a sidewalk by one foot—have also been utilized as a support for paintings.

Fig. 31-12
Von Dutch (Kenneth Howard) (1929–1992)
Good-Bye Cruel World, 1968
oil on canvas, 24 x 20 in.
Collection of Jim and Dan Brucker

Punk / New Wave

California's most recent true counterculture arose in the very late 1970s—punk—an import from England that evolved in the early 1970s when English bands put new energy into rock music by charging it with underground ideas and attitudes. These musicians and their followers, punkers, held the standard counterculture attitudes: they rejected all authority, disdained mainstream ideas and conventions, and held a pessimistic attitude toward the future. They were recognizable by their anti-establishment appearance. A typical punker might sport hair of a green color shaved into a Mohawk and wear clothing identified with the fringes of society: the black leather jackets of bikers, the sexy underwear of prostitutes, the handcuffs, chains, and spikes of criminals, the garb of the military, or simply the torn or unfashionable coordinates of the poor. The body was enhanced with tattoos and with piercing, which allowed the display of ornaments in the manner of so-called "primitive" peoples.

Unlike New York, with its East Village art, California had no actual punk *painting* movement. However, Los Angeles had a punk "scene." Artists congregated at nightclubs like Zero One on Melrose and La Luz de Jesus on Hollywood Boulevard, which displayed art. Artists such as Mike Kelley (b. 1954) and Bob Zoell (active 1980+) spent their early careers designing record album covers for the city's several punk bands, while others, like Gary Panter (b. 1950), gained fame for their comic strips—his Jimbo was a punk Everyman caught up in world events beyond his control.

Punk art is intentionally subversive, abusive and ugly, with the goal of being "bad" in the most extreme. Punk artists' contempt for craftsmanship led them to make art with intentional crudeness, studied carelessness, and deliberate poverty of manufacture. They rejected images, media, and values of the establishment art world in favor of imagery from popular, underground, or alternative cultures: cartoons and comix, skeletons and skulls, perverse or painful or sadomasochistic sex, sexploitation, weaponry, graffiti, street signs, other lettering, as well as society's detritus, such as broken beer bottles and windblown pages of newspapers. Colors are often garish, and blaring. Themes include anecdotes critical of society or surreal terrain reflective of social alienation. The result is art that is rebellious, hip, wild, and fascinating for its bizarre mixture of iconography. When punk artists moved on to the "fine" arts world, they carried their punk tastes with them: themes of antisocial subject matter and violence and art forms like graffiti and tattoo. Powerful, violent, and fresh, the art of this grassroots movement infused new energy into a flagging art world.

Graffiti Art

Graffiti refers to the words, phrases, or images called "tags" that are marked, sprayed, or brushed by rebellious youth on urban walls.

The center for California graffiti is Los Angeles, where its practice began in the 1920s. The painted tags (also called *placas*) are created for various reasons: as marks of a gang's territory, as calling cards belonging to individuals, or as public proclamations. They are usually placed on high-visibility walls. Gang placas appear at boundaries of gang-held territory, and some that are repeatedly painted over by rival gangs indicate disputed territory. For many years the Los Angeles style was deceptively simple, black-colored capital letters. The typeface is said to be based on Old English (Gothic) script, but this is difficult to tell when placas are executed with spray instead of a broad point pen. Most taggers are in their teens; some develop their own tag names or pictorial insignia while others use only that of their gang or group.

Because tagging is illegal and the tag has to be executed quickly, much of the preparation is done ahead of time. Taggers work out compositions in sketchbooks, practice rapid application with their equipment, and then alone or with friends, their pockets filled with chalk, pencils, felt tipped pens, and/or aerosol paint cans, they head out to a preselected spot. Part of the reward of tagging is the emotional rush the tagger gets in doing something prohibited and in overcoming a difficult goal, such as tagging a freeway sign, which necessitates scaling the side of an overpass and hanging above traffic.

Taggers are respected for their neatness and regularity of printing. In Los Angeles, graffiti names and styles are handed down unchanged from generation to generation, while in New York taggers strive for personal name recognition and identifiable individual styles. Angelenos prefer the simple black capitals and restrict them to gang areas, while New Yorkers have developed a wide range of colors and type faces, such as upper and lower case, the balloon style, and free-script and write in all areas of the city, particularly the subways.

In the late 1990s, California's most esteemed graffiti artist is **Chaz Bojorquez** (b. 1949). Bojorquez grew up roaming the avenues where tagging was frequent. Although he never was a gang member, he was fascinated with gang culture and studied their markings. He developed his own tag, *suerte*, a skull wearing a Fedora hat like those worn by the Zoot-suiters of the 1940s. The name means "Mr. Lucky." Gang members believed if a person was tattooed with a skull he would never die. Bojorquez began to apply this to neighbor-

hood walls. A friend who recognized Bojorquez's artistic abilities got him involved with graphic design; designing for the motion picture industry, he created several movie titles. In the last ten years the artist has created his own special format of graffiti easel painting, which merges his graffiti background with his graphics experience. He primes canvases with Zolatone, a speckled paint that Disneyland uses to finish artificial boulders. By wrapping his canvas around the stretchers, he creates what looks like a cement block. On this he places motifs from his graffiti days, guiding his composition by his sense of graphic design.

In *El Vato Loco* of 1985 (fig. 31-13), Bojorquez's Mr. Lucky motif appears at the right. The background and foreground lettering that some might mistake for Oriental calligraphy is actually an example of Los Angeles's "Cholo" style, which utilizes the Old English typeface. It emerged in East Los Angeles in the 1940s from among the Latino Zoot-suiters. The Cholo style is always executed in black capital letters, and although some Los Angeles taggers abstract the letters and arrange them into designs, the letters are never distorted to the point of being totally unreadable. Title letters spell the painting's name, "El Vato Loco," the term used to collectively describe Los Angeles's Chicano gang members of the 1960s. (In the 1940s and 1950s they were called Pachucos and in the 1970s, Homeboys.) In the background of the composition appear running lists of names belonging to friends and people important to Bojorquez: above, "ese," his male friends, and below, "esa," his female friends. The symbols to the right—a fire, a spiral, a triangle, a star, a cross, and a square—signify the flash cards used by psychic researchers to test the mental communication skills of two subjects. These clue viewers that the individuals listed on the canvas are trying to send them a message. Through the painting Bojorquez acts as a spokesperson for his friends. The artist has been able to transfer graffiti from wall to canvas without losing any of its energy, even adding some as a result of his experience in the world of commercial graphics. In reverse, commercial graphics and new design techniques supplied by computers have led to street graffiti artists perfecting their techniques and adopting newer and more complex compositions. Since the mainstream art world has accepted graffiti as a valid art

form, Bojorquez has exhibited frequently. In Los Angeles, the art form has been supported by the Zero One gallery, and a show of graffiti art titled *Post No Bills* appeared at Acme Gallery, San Francisco, in 1995. Bojorquez is also one of the main spokespersons for the art form: penning articles and providing information for books and videos on the subject.

Tattoo Art

Body painting and tattoos are some of man's oldest art forms. Tattoos have been found on the oldest known mummified human, the "Iceman," an unidentified individual who was frozen in a glacier in the Tyrolean Alps about 3300 B.C. Body decoration shows up on Egyptian mummies of about 1400 B.C. Tattoos have been used to identify a person with his tribe, to give a warrior a fierce appearance, to serve as an omen to ward off evil and protect the bearer, and to decorate. For

Fig. 31-13
Chaz Bojorquez (b. 1949)
El Vato Loco, 1985
Mixed media on canvas:
Zolatone paint, acrylic, spray can, 58 x 56 in.
Judy and Stuart Spence
Photo: Ed Ikuta

Fig. 31-14
Don Ed Hardy (b. 1945)
Butterfly Woman, 1995
tattoo
Photo: Don Ed Hardy

centuries in Western Europe, religious laws prohibited body modification, but in the late 1700s, tattooing was reintroduced when British sailors returning from voyages of exploration brought back the first tattoos from the Pacific Islands. Tattooing remained a largely underground art form popular among mariners, bikers, and prisoners until the 1970s. During that decade a number of younger artists became interested in the discipline, and their fine art background and/or artistic interest in the medium led them to expand both technique and subject matter. A worldwide search for techniques, styles, and subjects and a willingness to appreciate all forms has resulted in today's eclectic mix that includes tattoos practiced by the "Old Salts," tattoo traditions of non-Western cultures (particularly those of the island peoples of the Pacific Basin), and the highly complex designs of the Japanese. Widespread interest in the medium and improved artistry and sophistication led to even more enthusiasts and finally to meetings and conventions. By the 1980s, tattooing had become acceptable in mainstream society largely due to popularization by punkers, who saw it as a way to individualize themselves. Since then, tattoos have caught the attention of the fine arts community,

and tattoo imagery is beginning to appear in easel paintings and other traditional fine art forms.

The artists responsible for this renaissance were primarily concentrated in America's western states. Some of the most inventive work had its roots in Southern California, where, from the 1930s to the 1960s, naval bases at Long Beach and San Diego supported a large concentration of tattoo shops. Today's most respected artist is **Don Ed Hardy** (b. 1945), a Southern California native who has made his home in San Francisco since 1963. He has not only developed his own tattoo "voice" but has written and published extensively about the medium, helped others develop their art, and curated a number of widely traveled museum exhibitions on tattooing. Fascinated by tattooing since childhood, and even while still in the B.F.A. program in printmaking at the San Francisco Art Institute, Hardy began exchanging letters with the tattoo artist Sailor Jerry Collins (1911–1973), a Californian who took up residence in Hawaii in the 1930s. Collins was already breaking away from the rather stale prevailing traditions and stock motifs of the European tradition and was willing to share jealously guarded techniques with a handful of tattooists emerging worldwide who shared his interest in experimentation. Collins inspired his acolytes toward an interest in the complex, full-body Japanese tattoo and in developing original imagery in consultation with the client.

The individual who commissioned Hardy to create *Butterfly Woman* of 1995 (fig. 31-14) liked American imagery and chose the female-headed butterfly motif that had enjoyed popularity at the turn of the century. Typical of how contemporary tattooists extrapolate on and reinvigorate traditional images, Hardy changed it from a butterfly with both wings spread, a motif that was usually placed centrally on the chest or upper back, to a butterfly in three-quarter view placed asymmetrically on the bearer's back and shoulder. He gave the face a 1920s look and crowned it with a beaded headdress with a heart-shaped centerpiece bearing a Hebrew character, bay, which according to some interpretations of the Kabbalah has to do with giving of oneself and with thought, speech, and action. Hardy filled the wings with beautifully colored motifs selected from his personal inventory of traditional tattoo designs associated with America of the 1940s and 1950s: an

eagle, a flag, skulls, a rose, and a dagger, to name a few. Before about 1980 these would have appeared as single and isolated tattoos scattered over a recipient's body, but influenced by the Japanese style of overall design, Hardy interlocks the motifs in a lush profusion of imagery bound by the perimeter of the wings. The artist successfully melds the three-dimensionally rendered face with the bolder two-dimensional motifs in the wings. The work's large size places it halfway between the small, localized designs popular in the Western European tradition and the full-body designs practiced by the Japanese. Newly developed colors and an increased range of shades enhance the appearance of contemporary tattoos. Hardy continues to tattoo, but he now spends most of his time painting, drawing, writing about tattooing, and helping to organize exhibitions. He shows his own designs internationally in galleries and museums.

Folk Art

California had not even become a state by the time many of America's early folk art traditions ended. In 1850 California did not yet have the population to engender such important movements as Pennsylvania Dutch furniture, frakturs, Shaker art, or Southern slave crafts. However, most of California's scant art prior to 1850 (chapter 1) would probably qualify as folk art, if the genre is defined solely as art by untrained but sincere and talented individuals working outside the mainstream.

The state's first folk artists were individuals unaffiliated with any "group," and they produced diverse types of art. Their products include the fourteen stations of the cross painted by Indian neophytes at San Gabriel mission about 1820 (fig. 1-4) and the watercolors made by William H. Meyers, U.S.N., from shipboard while on a tour of duty in California in the 1840s (fig. 1-10). Moreover, folk art historians, who had previously considered 1850 as the end of the folk art tradition in America, are now acknowledging that true folk art is still being produced today. Under this umbrella California has many entrants. From the beginning, the state's reputation as a frontier unfettered by the academic and social restrictions of the East and as a place with vast unpopulated spaces has attracted a larger proportion of individualists than other states.

Since folk art is a reflection of the social conditions of its time, and since California entered the tradition after the industrial revolution, a few general statements can be made about California folk art. Its artists were less inclined to produce utilitarian craft objects than easel paintings. Women (emancipated in the Victorian era from strictly household chores) formed a larger proportion of painters. The state's "melting pot" population, which mixed ethnic folk traditions with experiences gained in California, has led to eclecticism and diversity.

Folk paintings are of two general types—those copied from professional artists and those generated from the artist's own imagination. A California example of the first is *Birds of California* by **Smith of Visalia** (active about 1865) (fig. 31-15). Like many folk artists, little is known about Smith except that he lived in Visalia, a town in California's central valley about thirty miles southeast of Fresno. The tip to identifying a copied work is its sophisticated composition but amateur translation. It was a common practice for artists to copy a favorite print. As early as 1865 the Western world's new fascination for illustrated texts provided prospective copyists many options: engravings, woodcuts in magazines, chromolithographs, daguerreotypes, and early glass-plate photographs. The original picture from which this particular work was copied obviously illustrated a book on California. Not only did illustrated books on botany and zoology proliferate in the scientific fervor of the late nineteenth century, but

Fig. 31-15
Smith of Visalia (act. 1865)
Birds of California, c. 1865
oil on canvas, 22¾ x 28½ in.
Courtesy of the Oakland
Museum of California, Lent
by David R. Packard

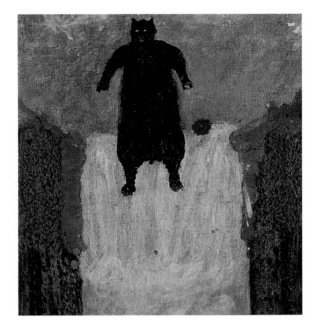

Fig. 31-16
Ursula Barnes (1872–1958)
Cat and a Ball on a Waterfall
oil on canvasboard
14½ x 14¼ in.
Collection of the Oakland
Museum of California,
Museum Donors Acquisition
Fund

Fig. 31-17
Alexander Maldonado
(1901–1989)
*Maldonado Planet—Boxing—
DEQK, 12-17-86*
oil on canvas, 16 x 20 in.
Courtesy The Ames Gallery,
Berkeley, Ca.
Photo: The Ames Gallery

the area where the artist lived was a hunter's paradise for such things as quail, as seen here. Smith has shown great ambition as well as patient craftsmanship in copying the complicated original. However his lack of training is exposed in his faulty perspective, over attention to detail, and colors that are bright and primary. Each bird seems stiffly posed rather than positioned comfortably and naturally in its setting. However, it is exactly this naïve quality that makes the piece artistically charming and strong in character.

An example of a folk painting generated from the artist's imagination is *Cat and a Ball on a Waterfall* (fig. 31-16) by **Ursula Barnes** (1872–1958). Barnes is typical of many folk artists who turn to art after careers in totally different fields. At various times she was a dancer, an actress, a parlor maid and a cook. Most of the approximately thirty paintings found in her home after her death depict the world of the theater. The actual meaning behind this particular work has been lost, but like many folk paintings that reflect a strong personal vision, this piece may have been a vehicle by which the artist worked out personal concerns over religion, family matters, ecology, admiration of media idols, and other issues. Compositionally unsophisticated and crudely painted, the quality is nevertheless evident in the uncompromising presentation, the vitality and directness of the statement, and the subject that magnetically evinces curiosity.

These two works demonstrate the conservative nature of folk art: images are representational and colors are close to natural. The works are frank, honest and genuine, and while sometimes humorous, they are free of such sophisticated forms of humor as punning, irony, and satire. Three-dimensionality is often reduced to design.

One might argue that a true folk artist, one untainted by academic ideas, could not exist after 1900. Ironi-

cally, in spite of the rising number of art academies and "how to" books (and in more recent times adult education and "how to" television programs), some artists just refuse to accept training. In fact, after 1930 folk art proliferated, fostered by Depression-era appreciation for America's homegrown traditions untainted by European ideas. Sidney Janis Gallery in New York, the great supporter of Surrealism, began to promote outsider art. Folk artists began to develop names and reputations. Anna Mary Robertson "Grandma" Moses (1860–1961) became a household word in the 1940s and 1950s. Amateurs as well as academically trained artists capitalized on America's post-World War II need for nostalgia and the reinforcement of the "goodness" of America

Many artists in the years after 1930 are untrained and work with a genuine and personal vision. **Alexander A. Maldonado**'s (1901–1989) *Maldonado Planet--Boxing-DEQK* of 1986 (fig. 31-17) shows how true folk artists portray scenes related to their own lives and times. Maldonado, who was at various times in his life a shipyard worker, a professional boxer, and a worker for Western Can Company, began painting at age sixty when encouraged by his sister, with whom he lived. He is truly of his time and place since his works address issues of the day—pollution, television, and space exploration, to name a few. In typical folk art fashion Maldonado stylized his imagery and reduced some elements to pattern, including the orderly rows of spectators and the designs decorating the perimeter of the television screen.

Even though modernism dominated the mainstream art press from 1945 to 1970, this chapter shows that many artists ignored it and realized their art with representational styles. This trend accelerates from the mid 1960s as establishment artists also reject modernism and return to realism. The next chapter will address Pop, Photorealism, and New Realism, styles denounced by modernists but styles that ultimately supplanted modernism. 🐾

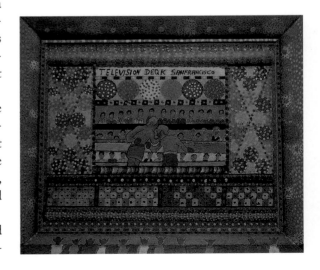

Bibliography

Outsider Art, General
Cardinal, Roger, *Outsider Art*, New York: Praeger, 1972. 192 p.
Parallel Visions: Modern Artists and Outsider Art, exh. cat., Los Angeles County Museum of Art, October 18–December 12, 1993.

Beat Painting
(See also bibliography for Funk [Beat] sculpture, chapter 27.)
"The Beat Agenda [4 articles]," *Artweek*, v. 27, no. 10, October 1996, pp. 13–17.
Nut Art, exh. cat., Art Gallery, California State University, Harward, n. d. 36 p.

Visionary Art
Albright, Thomas, "Visuals," [a three part article on Visionary artists] *Rolling Stone*, August 5, 1971, pp. 50, 52; September 2, 1971, pp. 49–51; September 16, 1971, pp. 50–52.
Alternative Realities: Tom Akawie, Bill Martin, Cliff McReynolds, Sheila Rose, Gage Taylor, exh. cat., Museum of Contemporary Art, Chicago, Il., January 10–February 29, 1976. 14 p.
Davidson, Abraham A., *The Eccentrics and Other American Visionary Painters*, New York: E. P. Dutton, 1978.
Hopps, Walter, introd., *Visions*, Corte Madera, Ca.: Pomegranate Publications, 1977.
Other Landscapes and Shadow Land (Visionary Painting by Ten Bay Area Artists), exh. cat., University of Southern California Art Galleries, November 10–December 3, 1971. 31 p.
"The Utopian Vision" in Thomas Albright, *Art in the San Francisco Bay Area 1945–1980*, Berkeley and Los Angeles: University of California Press, 1985.
Visions of Elsewhere: Drawings by Young San Francisco Bay Artists, exh. cat., San Francisco Art Institute, Spring 1971. 12 p.

Kustom Kulture
"Kar Kulture," [3 articles] *Artweek*, v. 24, no. 16, August 19, 1993, pp. 12–13.
Kustom Kulture: Von Dutch, Ed "Big Daddy" Roth, Robert Williams and Others, exh. cat., Laguna Art Museum, July 17–November 7, 1993 and two other venues. 96 p.
Wolfe, Tom, *The Kandy-Kolored Tangerine-Flake Streamline Baby*, New York: Farrar, Straus and Giroux, 1965.

Punk
Belsito, Peter and Bob Davis, *Hardcore California: a History of Punk and New Wave* [includes album covers], Berkeley: Last Gasp of San Francisco, 1983.
Belsito, Peter, ed., *StreetArt: The Punk Poster in San Francisco 1977–1981*, San Francisco: Last Gasp, 1981. 128 p.
Seidenberg, "Album Art: Current Record Covers Graphically Translate their New Wave Musical Contents into Innovative Designs," *Industrial Design*, v. 32, January/February 1985, pp. 56–61.
Shore, M., "Punk Rocks the Art World," *Art News*, v. 79, November 1980, pp. 78–85.
Wojcik, Daniel, *Punk and Neo-Tribal Body Art*, Jackson: University Press of Mississippi, 1995.

Graffiti
Big Time (Los Angeles), c. 1994 +.
Bryan, Bob, writer, producer, director, *Graffiti Verite*, video recording, Los Angeles: Bryan World Productions, 1995. 1 videocassette, 45 min.*
Can Control (Los Angeles), c. 1990-94.
Cesaretti, Gusmano, *Street Writers: A Guided Tour of Chicano Graffiti*, Los Angeles: Acrobat Books, 1975.
Chalfant, Henry and James Prigoff, *Spraycan Art*, New York: Thames and Hudson, Inc., 1987. 96 p.

Fazzolari, Bruno, "Post no Bills," [exh. at Acme, S. F.] *Artweek*, v. 26, September 1995, pp. 23–24.
"Graffiti Culture and Mural Making," [survey of street art from six American cities: 13 article special section] *Public Art Review*, v. 6, Spring/Summer 1995, pp. 22–45.
Karlen, Peter H., "To Tag or Not to Tab," [legal parameters for the graffiti artist] *Artweek*, v. 22, March 28, 1991, p. 17.
Kuzmanich, Justin, *Bay Area Graffiti*, video, Denver, Colo.: Kuzmanich?, 199?*
Le Brecque, Eric, "L. A. Aftermath," [grassroots graphic response to the Los Angeles Riots] *Print* (NY) v. 47, September/October 1993, pp. 17–27+.
Margolis, Judith, "Glorifying Graffiti," [rev. exh. Michael Kohn Gallery, Santa Monica] *Artweek*, v. 21, June 7, 1990, pp. 13–14.
Night Crawlers (Oakland) irregular, issue # 6, December/January 1995?*
Nixon, Bruce, "What the Walls have been Saying," [rev. exh. at Mexican Museum SF] *Artweek*, v. 22, June 20, 1991, p. 20.
Romotsky, Jerry, *Los Angeles Barrio Calligraphy*, Los Angeles: Dawsons, 1976. 78 pp.
Veneciano, Jorge Daniel, "Spray Cats," [rev. of *Hip Hope: Aerosol Art in Celebration of the Legacy of Martin Luther King, Jr.* at Occidental College] *Artweek*, February 18, 1993, p. 26.
Vigil, James Diego, *Barrio Gangs: Street Life and Identity in Southern California*, Austin: University of Texas Press, 1988.
Walsh, Michael, *Graffito*, Berkeley, Ca.: North Atlantic Books, 1996. 136 p.

Tattoo
A.S.C. Tattoo Directory, Newport Beach, Ca.: Action Publ., 1994.
Forever Yes: Art of the New Tattoo, exh. cat., Bryce Bannatyne Gallery, Santa Monica, March 21–May 3, 1992. 96 p.
McCabe, Michael, "Flash and Flashbacks: the Enduring Art of Tattoo," *Folk Art*, v. 19, Summer 1994, pp. 34–41.
Miller, Jean-Chris, *The Body Art Book: A Complete Illustrated Guide to Tattoos, Piercings, and Other Body Modifications*, New York: Berkley Books, 1997. 182 p.
Rubin, Arnold, ed., *Marks of Civilization: Artistic Transformations of the Human Body*, Los Angeles: University of California Museum of Cultural History, 1988. 288 p.
Sanders, Clinton, *Customizing the Body: the Art and Culture of Tattooing*, Philadelphia: Temple University Press, 1989.
Scarborough, James, "Illustrative Bodies," [rev. of *Forever Yes: Art of the New Tattoo* at Bryce Bannatyne Gallery] *Artweek*, v. 23, May 7, 1992, pp. 16–17.
Tattoo History in New York and California (Pierced Hearts and True Love, a Century of Drawings for Tattoos), exh. cat., Drawing Center, New York, September 16–November 11, 1995.

Folk Art
(For Folk sculpture and environments, see chapter 25.)
Bishop, John Melville, *California Artists: At the Crossroads*, Sacramento, Ca.: Published for the California Arts Council, Traditional Folk Arts Program by Media Generation, 1991. 95 p.
California Visionaries: Three California Self-Taught Artists, exh. cat., Los Angeles Harbor College, San Pedro, October 5–28, 1983.
Cat and a Ball on a Waterfall: 200 Years of California Folk Painting and Sculpture, exh. cat., Oakland Museum Art Department, Oakland, Ca., March 22–August 3, 1986. 111 p.
"Eccentrics," *Visual Dialog*, v. 4, no. 1, September–November 1978.
Living Treasures: Folk Artists of Santa Cruz County, video, produced and directed by Geoffrey Dunn, Mark Schwartz, Santa Cruz, Ca.: Cultural Council of Santa Cruz County, 1991.

Moure, Nancy Dustin Wall, "The California Primitives of Albert Kramer," in catalogue to *The L. A. Art Show*, Friday, October 5…Sunday, October 7… [1991], Santa Monica Civic Auditorium, managed by Caskey-Lees, Topanga, California.
Pioneers in Paradise: Folk and Outsider Artists of the West Coast, by Susan Larsen-Martin, exh. cat., Long Beach Museum of Art and two other venues, November 25, 1984–January 20, 1985. 64 p.
Tromble, Meredith and John Turner, "Striding out on their own [folk art]," *Clarion*, v. 13, Summer 1988, pp. 40–47.
Tromble, Meredith and John Turner, "A Natural Voice," [re: *Not so Naive: Bay Area Artists and Outsider Art*, exhibition at San Francisco Craft and Folk Art Museum], *Art Today*, v. 3, pt. 2, Summer 1988, pp. 12–19.
Visions from the Left Coast: California Self-Taught Artists, exh. cat., Santa Barbara Contemporary Arts Forum, August 26–October 21, 1995. 66 p.

Other "Outsiders"
Art from California Prisons, exh. cat., California State Capitol Building, Sacramento, n. d., 1984. 16 p.
Barrie, Lita, "Art from Inside the Walls," [review of the prison art show *Perimeters: Prints & Poetry* held at California State University, Northridge] *Artweek*, v. 22, January 31, 1991, p. 15.
California Arts Council's Artists-in-Social-Institutions Program: Hearing Transcript, May 9, 1984, Sacramento, Ca.: California Legislature, Joint Committee on the Arts, 1984.
California Legislature. Joint Committee on the Arts. *The Arts of Prevention: Arts Serving Youths at Risk in Human Service and Correctional Settings: Hearing Transcript*, Sacramento, Ca.: California Legislature Joint Committee on the Arts, April 20, 1994. 58 p.
Carlson, Lance, "Madness or Modernism?" [increasing interest in art by outsiders] *Artweek*, v. 22, no. 28, September 5, 1991, pp. 3, 20.
Jacobs, Stanley S., "They're Painting their way to Freedom" [Folsom Prison] *Palm Springs Life*, v. 15, no. 4, December 1972, pp. 102–4.*
Light from Another Country: Art from California Prisons, Arts in Corrections, California Department of Corrections, exh. cat., Art Museum of Santa Cruz County, August 14–September 25, 1988. 12 p.
Plaster, Lani Marie, ed., *People Say I'm Crazy: An Anthology of Art, Poetry, Prose, Photography and Testimony by Mental Health Clients throughout California*, Sacramento: California Department of Mental Health, 1989. 134 p.
Vitality of Vision: An Exhibition of Works by Homeless and Low Income Artists, exh. cat., Hospitality House, Community Arts Program, Center for the Arts, Yerba Buena Gardens, San Francisco, March 17–May 1, 1994. 24 p.
(See also bibliography for art therapy Education in chapter 37.)

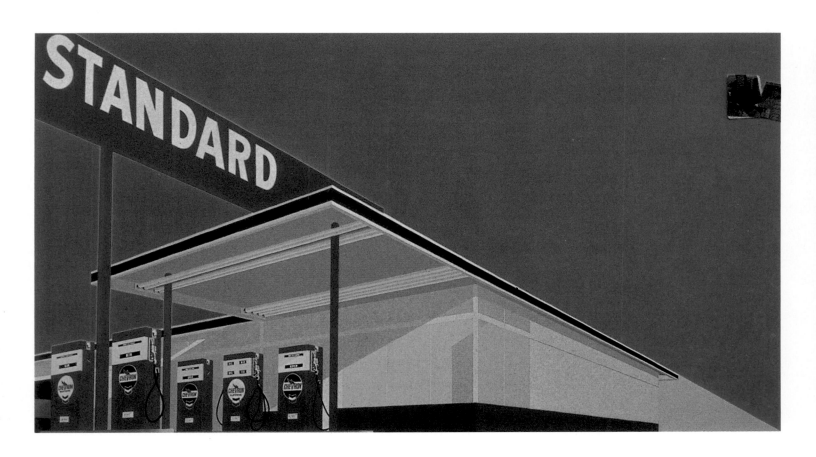

Fig. 32-2
Edward Ruscha (b. 1937)
Standard Station with Ten Cent Western Being Torn in Half, 1964
oil on canvas
65 x 121½ in.
Private Collection, Fort Worth, Texas

Beyond Modernism—Representational Art of the 1960s and 1970s

32

The New York art critics who promoted modernism, seem to have been unable to see that the movement would run its course and eventually come to an end. They failed to realize that artists, in their attempts to reach the purest form of art, would eventually paint themselves into a corner. They overlooked people's emotional individuality and natures and the rising social and Civil Rights revolutions.

Modernism received multiple setbacks through the 1960s and 1970s. The backlash attacked modernism in its principle, its aesthetic, its theory, its pretensions, and even ridiculed its supporters. Against modernists fostering "one" movement, anti-modernists believed in pluralism (chapter 35); against the value they placed on "high" art, anti-modernists absorbed so-called "popular" arts. Against modernism's "hero," the white male artist, anti-modernists backed equality of gender and race; against the lone "genius," anti-modernists acknowledged collaborative or group-produced art. Against modernism's stylistic beliefs in abstraction, minimalism, universal subject matter, reason, and logic, anti-modernists advocated realism, a cluttered look, personal, social and political subject matter, as well as spontaneity and emotion. Through the 1960s the art world transitioned from modernism to postmodernism. The revolt came on slowly but by 1970 consisted of many new styles, all of which had one or more anti-modern qualities. Artists who rebelled against modernism were viewed by modernism's defenders as heretical, contaminated, and "low." To anti-modernists they were heroes.

One of the first ways in which artists defected from modernism was through painting representationally. This chapter will cover three of the early anti-modernist (or postmodernist) styles: Pop art, Photorealism, and New Realism.

Pop Art

Chronologically, modernism's first challenger was Pop art. Historians cite the first true Pop art object as Richard Hamilton's collage *Just What is it that Makes Today's Homes so Different, so Appealing?* of 1956. Images cut from magazines and pasted together created a seemingly realistic scene of two people in a living room furnished with cheap objects associated with mass culture. In 1958, the term Pop art was first used by the British

critic Lawrence Alloway to describe art used by advertising to reach a mass (popular) audience. Alloway expanded the term in 1962 to include the many new "fine" art paintings that adopted the visual aggressiveness, instant communication, and product-oriented subject matter of advertising and the comics. A well-known example is the painting by New Yorker Andy Warhol (1930–1986) that features rows of Campbell's soup cans. Expectedly, the defenders of modernism hated Pop. They considered it kitsch and "low" and common. To their disappointment, baby boomers, raised in the media culture, liked Pop art's familiar images, simplistic message, and upbeat colors. The style enjoyed instant popularity.

California adopted Pop at almost the same time as New York—the early 1960s. However a case could be made for California artists being in advance of the movement, if one counts the collages that Bay Area artist Jess made from Dick Tracy comic strips (chapter 28) and Wayne Thiebaud's (b. 1920) still-life paintings of commercial food displays, both created in the mid 1950s. Los Angeles was the city that most naturally embodied the look and style of Pop with its billboards, Hollywood movie images, press-agents and glitz, used-car lots, hamburger stands, and its canonization of youth culture and materialism. In 1962 and 1963, the city was inundated with a rash of Pop art exhibitions: a one man show of New York's Pop artist Andy Warhol (Ferus Gallery, 1962) and two very early Pop surveys: *New Painting of Common Objects* (Pasadena Art Museum, 1962) and *My Country 'Tis of Thee* (Dwan Gallery, 1962). In 1963 Alloway's exhibition *Six Painters* arrived on tour from the East, and the Los Angeles County Museum of Art responded with *Six More,* an exhibition of Pop artists from California.

Los Angeles Pop artists didn't *adopt* Pop, they *lived* it. They were recipients of a whole barrage of ideas and styles from which they formulated their own look. Whereas New York's Pop artists assayed national icons, such as the American flag, Los Angeles's artists selected national icons that also had regional meaning, for example, iconography related to the car culture. Los Angeles's Pop art showed no interest in irony (as did New York's) but had more of a Surrealistic irrationality, a conceptual basis, and a sense of humor. Los Angeles artists added new techniques and materials (plastics

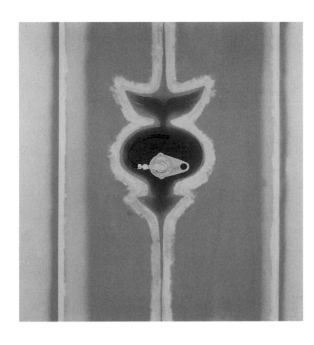

Fig. 32-1
Billy Al Bengston (b. 1934)
Carburetor Floatbowl, 1961
oil on canvas, 42 x 40 in.
Collection of the artist

Fig. 32-3
Joe Goode (b. 1937)
Small Space, 1963
oil on canvas with painted
glass bottle
69 $\frac{1}{16}$ x 67 $\frac{11}{16}$ x 2¾ in.
Gift of the Frederick R.
Weisman Art Foundation,
Los Angeles, California;
Collection of Whitney
Museum of American Art,
New York
Photo: Geoffrey Clements,
N. Y.

and spray paints) as well as a maverick tendency to represent three dimensions.

Billy Al Bengston (b. 1934) was actually making Pop-type paintings before the surveys mentioned above were shown in Los Angeles. Although he denies any intent to make a Pop object, art historians give that label to his oil paintings on canvas that pay homage to the British-made BSA motorcycle. In *Carburetor Floatbowl* of 1961 (fig. 32-1), one of a series of twelve BSA works, the center of a solid color field is given over to one part of a motorcycle. By isolating an object in a flat color field and presenting it neutrally, Bengston is adhering to the standard Pop approach that makes the viewer look at an object that he or she may depend on daily but takes for granted or has probably never noticed. The centrality and symmetrically, he says, stems from his mid-1950s work on the potter's wheel. The subject is a natural outgrowth of Bengston's own life experiences. He grew up in the late 1940s and 1950s living Southern California's outdoor recreational dream lifestyle. He was an avid swimmer and surfer, he raced motorcycles, and he custom painted bikes. When artists isolate a single object in the center of a composition, art historians invariably respond by labeling that object an icon. Yes, motorcycle fans probably do "worship" bikes, and Bengston, who both decorated motorcycles with paint and maintained them mechanically, admits to seeing beauty in their parts. When he was asked to put on a show of his Chevron paintings at Ferus Gallery, he did not feel their painting issues were sufficiently resolved, so he volunteered paintings of his stripped street 350 cc BSA Goldstar. In *Carburetor Floatbowl* Bengston has, intentionally or not, placed this revered object in a womb-like aura and surmounted it with wings, the BSA insignia. His making this object spiritual and transcendental differs from the New York artists' purely objective treatment of commercial items. In spite of all the intellectual interpretation that art historians are tempted to make about Bengston's works, the artist maintains that all he ever intended to do was to create an object of beauty. (See also chapter 30 under Geometric Abstraction.)

Los Angeles's archetypal Pop artist is probably **Ed Ruscha** (b. 1937), who came to the city from Oklahoma with a vague goal of becoming a commercial artist. Ruscha found amusement in the sound of words, and much of his art through the 1960s is a fascinating combination of Pop art's preference for popular imagery, Conceptual art's fascination with wording and word play, mixed with a California sense of humor. He punned with the symbolical meanings of words as well as their typography. For example, his painting of the logo for 20th Century Fox film studios presents the insignia

illuminated by spotlights, reminiscent of a movie premiere. His painting of the word "damage" shows two of the letters on fire. He was the main artist to recognize and utilize the gas station as a symbol of Los Angeles, developing the Pop image in paintings, prints, and as a series of photographs. As in *Standard Station with Ten Cent Western Being Torn in Half* of 1964 (fig. 32-2, p. 432), one of his series on the Standard gasoline stations, he does not paint exact replicas, as do New York's Pop artists, but semiabstract distillations. He exaggerates the dynamics of the station's perspective to suggest the power of mechanized vehicles, and simplifies the shapes to suggest the airless environment and clean precision of a well-run station. His flat colors and almost geometric shapes are reminiscent of the work of his contemporaries, the geometric abstractionists. Yet Ruscha, like others in the Ferus stable, is also proud of his technical ability to create illusion, as he does in this work with the magazine in the upper right corner.

Joe Goode (b. 1937) is frequently discussed as a Pop artist because he employed the ubiquitous milk bottle in a series of paintings between 1961 and 1963, but his primary and long-term interest has been in exploring aesthetic issues related to the picture plane and visual space. In 1961, Goode was just emerging from study at the Chouinard Art Institute in Abstract Expressionism. Trained under teachers such as Emerson Woelffer (b. 1914) and Robert Irwin, who encouraged experimentation, he looked forward to breaking rules and creating a new type of painting. In *Small Space* of 1963 (fig. 32-3), he has covered a canvas with a single color that renders it flat and two-dimensional. But he breaks that down by introducing the simple silhouetted shapes of two milk bottles in the lower right corner and additionally complicates human perception of space by placing an actual milk bottle on the floor in front of the painting. Goode makes us question whether the white bottles painted on the canvas are only shadows thrown from the real bottle or meant to form a group with the real bottle. They certainly have the optical effect of tying the real bottle to painted space—although logically there is no "space" on this flat, single-toned canvas. Since his milk bottle series, Goode has continued to explore questions of visual illusion. His *Torn Cloud Series* of the early 1970s con-

sists of paintings of sky whose canvas is ripped away to reveal another painted sky beneath.

Although **David Hockney** (b. 1937) was British born, he has lived much of his career in Los Angeles (1964 to 1968 and 1976 to the present), and many consider him a California artist. His work cannot be categorized; while he is discussed here under Pop, he has also been described as a realist who imbues his work with Matisse-like colors and joyous optimism. While still in Britain, he had painted California scenes based on images he discovered in books. Once in Los Angeles, he found himself surrounded with all the real Pop subject matter he could handle. His imagery is obtained from his West Hollywood surroundings—his personal friendships as well as the materialistic luxury of those living the California dream life in hillside houses with views and swimming pools. Hockney created a number of pictures on the swimming pool theme, the first in 1964, the year of his arrival in L.A. *A Bigger Splash* of 1967 (fig. 32-4) could refer to the children's pool game in which each child jumps into the water with the intention of making the biggest splash. The painting appeals on two levels. The first is the immediate visual appearance of flat shapes contrasted with the frothy splash, the clean and radiantly clear atmosphere,

Fig. 32-4
David Hockney (b. 1937)
A Bigger Splash, 1967
acrylic, 96 x 96 in.
Tate Gallery, London;
© David Hockney

Fig. 32-5
Robert Dowd (1936–1996)
Van Gogh Dollar, 1965
acrylic on canvas, 18 x 36 in.
Collection of Joni and Monte
Gordon, Los Angeles;
Courtesy, Newspace, Los
Angeles

Fig. 32-6
Wayne Thiebaud (b. 1920)
Penny Machine, 1961
oil on canvas, 24 x 30 in.
Courtesy of the John
Berggruen Gallery, San
Francisco, California

and the emotional overtones of sunny benevolence. But Hockney's paintings of this period also have deeper meanings, such as the Los Angeles hillside home as a haven of peace and privacy above a noisy, throbbing city. Hockney addresses issues of hedonistic luxury and perception and frequently explores the theme of a just-departed individual (signified here by the splash). Although painted in 1967, during the decline of the Pop movement, the whole scene, rather than a single commercial product or logo, qualifies as a kind of Pop image. Like all Pop works, the scene is clearly presented to foster immediate understanding. Hockney's move from oil paints to acrylics made his colors brighter and more akin to the Pop sensibility.

Robert Dowd (1936–1996) and studio-mate Phillip Hefferton (b. 1933) ran contrary to the generalization that California artists used subject matter of only regional identity. Perhaps because they grew up outside California (in Michigan), both chose paper currency, so natural a national symbol that it was also a frequent subject of two New Yorkers, Andy Warhol (1930-1987) and Roy Lichtenstein (1923-1997). However the choices were made parallel to and independent of each other. By representing items like paper money (and stamps), Pop artists chose a subject that was already flat and respected the picture plane. Their paintings forced the public to look at commonplace items that were revered for their purchasing power and ubiquitously handled but whose artistry was rarely noted. In such a work as *Van Gogh Dollar* of 1965 (fig. 32-5), Dowd places the face of Post-Impressionist painter Vincent Van Gogh on the bill. "Purist" Pop art (such as that produced in New York) is rendered using mechanical means or by aping the "style" of the subject and usually by negating expressive brushwork that might reveal the personality of the painter. In Dowd's work, the rich, unctuous brushwork, like that identified with Van Gogh himself, breaks this mold. Dowd carries the design to the painting's actual edge, using the white strip frame to provide the white border seen on all bills. Visual punning comes into play when letters are dropped out of words, such as "America." Most people don't notice the missing "r"—Dowd's comment on people's habit of seeing what they expect rather than what is actually there. In typical California style, these visual puns are meant to be humorous rather than, as the New Yorkers use them, criticisms of society. By painting the Post-Impressionist on the bill, Dowd also references the high prices that were being brought in the 1960s by the paintings of an artist who had spent most of his life impoverished.

Only a rare few San Franciscans produced Pop art works. Understandably, the Bay Area with its strong

1950s and 1960s movements of Abstract Expressionism, Bay Area Figurative, Beat and hippie art, and Funk sculpture, was busy enough with its own styles. Additionally, the city has never had the same identification with commercialism and materialism as does Los Angeles. However, Northern California could lay claim to two of the world's earliest Pop artists, Jess (Collins) (chapter 31) and Wayne Thiebaud. **Wayne Thiebaud** (b. 1920) was an advertising artist who turned to fine arts. In the early to mid 1950s he painted some expressive still lifes of postwar store window displays and meat counters that historians regard as a kind of proto-Pop for their depiction of common commodities. About 1960 his interest in such subjects began to take on more of the aesthetic of standard Pop painting. Nothing can be more "Pop" than the gum ball machines seen in *Penny Machine* of 1961 (fig. 32-6), both for their ubiquitous presence in American life and their bright colors. As with Pop's standard presentation, the objects are isolated against a plain background and shown frontally. Like some other Pop artists, Thiebaud likes to repeat his images. He breaks the Pop mold, however, with a mild illusionism revealed in the thrown shadows and the luscious brushwork. Sacramento and San Francisco art patrons didn't know what to think of this maverick and overlooked him until he was included in *The New Realism* show of Pop Art at the Sidney Janis Gallery in New York in 1962.

Thiebaud made one of his most important contributions as a teacher—at Sacramento Junior College in the 1950s and at the University of California, Davis, afterward—and one of his students, **Mel Ramos** (b. 1935), achieved equal distinction as a Pop artist. By 1961, Ramos had escaped the domination of Abstract Expressionism and Bay Area Figurative painting and begun taking images from his childhood heroes in comic books (Superman, Captain Midnight, Wonder Woman), extracting them from their backgrounds and isolating them on a flat color to increase their heroic status. In 1963 he moved on to "girlie" pin-up figures. Beginning with his "wolf-call" series, Ramos placed the faces of well-known women, such as actress Elizabeth Taylor, on "girlie" bodies. Ramos prefers to think of himself as a figure painter rather than a Pop artist. But paintings such as *Chiquita* of 1964 (fig. 32-7), from his 1964 to 1967 series "consumer odalisque," are pure Pop in that they derive their subjects not from live humans but from mass-media images already flattened by photography. The Chiquita Company is a wholesaler of bananas. By placing a nude woman in place of the banana, Ramos comments on the way American advertising uses women and the element of sex to sell products.

New Yorkers criticize Californians for being less profound than New York intellectuals, but if this regional character trait actually exists, it certainly worked in the state's favor when it came to Pop art. But once Pop reopened the floodgates to representationalism, other forms quickly followed.

Photorealism

Photography and fine art have led an uneasy coexistence since the former was discovered in the mid-nineteenth century. At the turn of the twentieth century, when the Camera Pictorialist style raged, photographers looking for legitimacy for their new art form and ways to aesthetically improve it, borrowed ideas from painting. In the late 1960s just the reverse occurred. Painters took their aesthetic from photography. They wanted their paintings to have even tones, flattened forms, and unselective detail.

The term Photorealism (also called Hyperrealism or Superrealism) was coined by Louis K. Meisel, a New York gallery owner, in 1968 and was first used in print in the Whitney Museum of American Art's exhibition *Twenty-two Realists* (1970). Photorealism, as

Fig. 32-7
Mel Ramos (b. 1935)
Chiquita, 1964
oil on canvas, 70 x 60 in.
© Mel Ramos/ Licensed by VAGA, New York, NY

defined by Meisel, must derive its subject matter from photographs, the photo must be transferred to the canvas by some mechanical means (such as projecting the image or using a grid), and the final work must have the same aesthetic qualities as a photo or reproduction. Photorealists were never a "school." Photorealism is only recognized as a "style" because the technique is aesthetically distinctive, because many artists have adopted it, and because they often show together.

Modernists disdained Photorealism's use of the "borderline" art form of photography. However, Photorealism, like Pop, was greeted by America's broader audience with open arms. The instant and widespread popularity of both styles proved a victory for commercialism, pluralism, and populism over elitism and forced modernists to reckon with them.

While England and New York can boast important first-generation Photorealists, the honor is more than equally shared with California. The state has been the longtime home to three of the thirteen first-generation Photorealists named by Meisel, not to mention five more who were active here for a number of years before settling on the East Coast. Additionally, many more second-generation Photorealists are currently active in the state. The pioneering three, Robert Bechtle, Ralph Goings, and Richard McLean, all live in the north, where, in the early 1950s, Bechtle and Goings attended Oakland's California College of Arts and Crafts, followed by McLean in 1955.

Robert Bechtle (b. 1932) is considered by some to be the first of the "West Coast Photo-Realist Triumvirate." He easily fits under Meisel's definition of a first-generation Photorealist—someone who had exhibited as a Photorealist by 1972 and had produced at least five years' work in the style. His *'56 Chrysler*, painted from a photo and showing some photographic qualities, was finished in 1965 and is possibly the earliest work exhibiting the full characteristics of what Meisel defines as Photorealism. Bechtle admits that the acceptance of Pop and its commercial art techniques freed him up to use a camera. The themes of his predecessors, the Bay Area Figurative Painters, made it "permissible" to use subject matter from middle class Northern California residential neighborhoods. (Diebenkorn's figures on porches were very much in Bechtle's mind when he painted his series of suburbanites relaxing on decks and patios in the 1970s.) Bechtle's standard composition, as in *'60 Chevys* of 1971 (fig. 32-8), is a foreground of asphalt roadway or parking lot, a midground that holds the main subject (often a parked car, sometimes attended by a young couple with small children), and a background of a building facade (a tract house, apartment building, or commercial building). The viewpoint is usually from across a street, sometimes as seen through a window. California's three first-generation Photorealists share a common interest in outdoor scenes, as opposed to the studio-bound New York Photorealists, most of whom prefer still lifes, figures, and portraits. Like the average family snapshot, Bechtle's stance is neutral, objective, and dispassionate, and his subject banal. Bechtle carries through with bland and sun-bleached colors. Although theoretically Photorealists transcribe photographs *verbatim*, Bechtle clearly edits out a quantity of detail, and he adjusts his composition using formal considerations—resulting in simple shapes as rigidly organized as the compositions of Vermeer or Mondrian. He states, "the work's importance…is owed to its awareness and use of the way that photography affects the way we see our world."

In 1962, Sacramento artist **Ralph Goings** (b. 1928) began making paintings from photographs in magazines. In 1966 he began to take his imagery from photos that he took himself, and he painted a series of figure studies of his students. He called these ten works "California Girls." However, during a day's photo shoot around Sacramento in 1969—the city serves as the state's capitol as well as a farming center – Goings noticed the preponderance of pickup trucks. He began a series of works that showed them parked in front of franchise food outlets and other small town businesses. His composition is very similar to Bechtle's, although he did not meet Bechtle and McLean (who had known and painted with each other through the 1960s) until the early 1970s. The three were ultimately drawn

Fig. 32-8
Robert Bechtle (b. 1932)
'60 Chevies, 1971
oil on canvas, 48 x 69 in.
Photo courtesy O.K. Harris
Works of Art, New York

together by their mutual interests. Like Bechtle's work, Goings's midground contains a motorized vehicle and his background a business. His business building, however, is not a flat wall but an entire isolated commercial structure with a sky overhead. In the early 1970s Goings reversed his perspective and began painting the interiors of the franchise lunchrooms, focusing either on the still life items on countertops or capturing the entire room. An example of the latter is *Country Girl Diner* of 1985 (fig. 32-9). While some of these paintings contain people, Goings is not interested in social commentary. If the French Impressionists were interested in the shimmering quality of light, the Photorealists are fascinated with reflections, primarily the light reflected off the mass-produced metal, glass, and plastic items of the 1960s. Everything is new, polished, shiny, and sterilized. Here, like a still life, Goings patiently renders every object. Usually when an artist emphasizes detail, he sacrifices mood. However, the emphasis that Goings and other Photorealists' place on detail is really a comment on the importance that post-1960s society places on materialistic objects. It also shows a tacit agreement with the nonselective quality of photography itself. Goings's paintings reveal beauty in disorder and transcend his subject's inherent commonness.

Richard McLean (b. 1934), a teacher in the East Bay in the 1960s, is unique among American and California Photorealists for his depiction of rural subject matter. When he began painting from photographs in the mid 1960s, he wanted a subject that would distinguish his work. He nostalgically thought back to his youth in the ranch country of the Northwest. Animals have remained a minor subject for fine art paintings in America. McLean found horse subject matter in illustrations in specialty trade journals such as *Thoroughbred of California, Quarter Horse Journal,* and *Appaloosa News.* Since 1973, McLean has been painting from his own 35mm slides that capture his subjects in more relaxed poses than did the earlier, formally posed commercial photographs. Like *Satin Doll* of 1978 (fig. 32-10), both the black-and-white illustrations from magazines and McLean's personal photos usually present a horse in the traditional profile pose in front of a barn, or receiving an award at a horse show or at the race track. McLean took this particular shot of a Southern California equestrienne competing at a Fresno show. While show horses may seem far from America's middle-class experience, for certain of America's urban dwellers with discretionary money, such expensive "toys" were as much a status symbol as were cars or motorcycles. The recreational horse movement was and is especially strong in California. If

Fig. 32-9
Ralph Goings (b. 1928)
Country Girl Diner, 1985
oil on canvas, 48 x 68 in.
O.K. Harris Works of Art,
New York

Fig. 32-10
Richard McLean (b. 1934)
Satin Doll, 1978
oil on canvas, 54 x 60 in.
Collection of the artist

commissioned by the owners, as were the original photos, these would be termed "display" pictures, works that show off possessions. McLean thinks of himself as a still-life artist. For him, the crafting of infinite detail gives creative satisfaction. Here, the horse's healthy coat shines just as the chrome and glass in other artists' scenes.

Critics looked down on Photorealism for basing fine art on photography and frowned on its banal and middle-class urban subject matter as well as its neutral and objective approach that denied an editorial stance. Lovers of brushwork hated the style's perfection, its negation of impastoed paint, and its use of mechanical devices, such as an airbrush. Moralists saw Photorealism as soulless and only a technical accomplishment. Artists who wanted art to express some emotion found Photorealism too factual, illustrative, and reportorial. Others wanted content and "soul" rather than confusing detail. Ironically, the style proved to be one of the harbingers of the representational/humanist trend to come and to foreshadow the great

dependence that art would have on photography and mass media imagery after 1970.

Critics found some of their complaints resolved in the work of the **Los Angeles Fine Arts Squad**, painters of outdoor Photorealist-looking murals. The name was used for the five-year collaboration (1969–1974) between Vic Henderson (b. 1939) and Terry Schoonhoven (b. 1945), whose team was augmented at various times with two to three other artists. It continued to be used by Schoonhoven himself for another five years. The Squad's Photorealism differs from most easel works in that their compositions are derived from a pastiche of photographs and have an *editorial* and *narrative* content. This is clearly seen in their best-known work *Isle of California* of 1971–72 (fig. 32-11), which covers a 42 x 65 foot wall belonging to Village Recording Studios, 1616 Butler Avenue, West Los Angeles. It represents that prophesied day in LA's future when a cataclysmic earthquake will cause much of the basin to fall into the sea, leaving, as suggested here, broken remnants of freeways going nowhere. Other

Fig. 32-11
Los Angeles Fine Arts Squad
(Terry Schoonhoven, Victor
Henderson) (active 1969–74)
Isle of California, 1971–72
enamel on stucco, 42 x 65 feet
Los Angeles Fine Arts
Squad, Terry Schoonhoven,
Victor Henderson

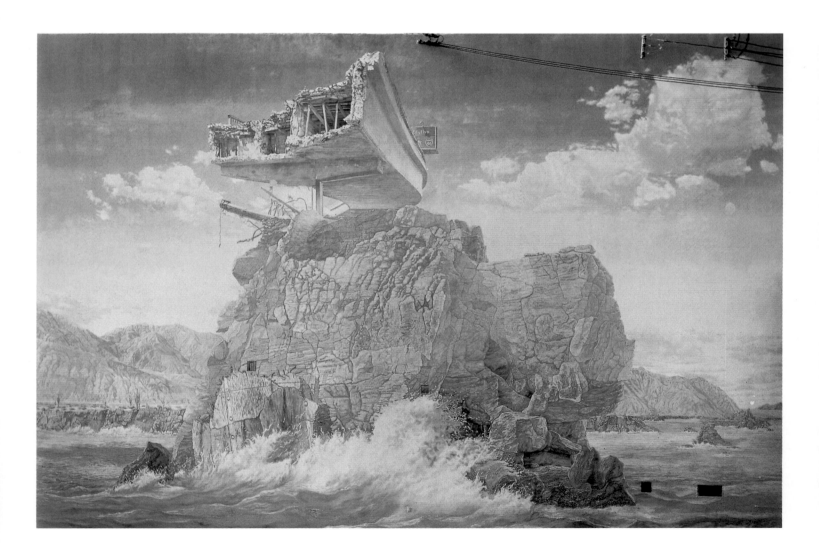

allegories/fantasy environments painted by the muralists include views of the beachside town of Venice under a blanket of snow and an inland shopping mall with desert sands drifted against its glass doors. Like other outdoor muralists who flourished in Los Angeles from the late 1960s (chapter 34), the LA Fine Arts Squad wanted to take art out of the gallery/museum context to the streets, where, in Schoonhoven's words, "We felt the potency of realist painting could be increased."

Many other Photorealists were and still are active throughout California, their techniques and subjects now so varied that few generalizations can be drawn. However, the first-generation Californians mentioned above did have several distinguishing characteristics that made them different from their New York counterparts. The West Coasters preferred the bristle brush to the airbrush, natural and spontaneous outdoor scenes to New Yorkers' contrived and dramatic studio still lifes and figures. They gave all depths of the image the same sharp focus, unlike New Yorkers, who left some areas "unfocused," just as a camera would. First-generation Californians rarely had a "message" to deliver, and they stayed away from satire and social comment.

Although Photorealism is criticized on many counts, it is important—it tells us about ourselves and our era. Like Pop, it reflects the tastes and mores of middle-class society. Taking imagery from photos rather than real life reflects the post-1950s importance of the media (photographs, magazine illustrations, television, video) on society and photography on art in general. And, Photorealists don't just "copy" any photograph, but use their editorial powers to select scenes that reflect what they want their paintings to "say." Close comparison of the original magazine illustration or snapshot to the final painting often shows that Photorealists make small but artistically important modifications. All the Photorealists were formalists, intensely aware of composition and the relationship of parts. Their paintings not only heightened the photographic image, causing viewers to "see" their world with new eyes, but revealed how the photograph had changed people's way of seeing their world.

New Realism

While Pop and Photorealist artists are easy to group together in terms of theme and technique, parallel to them worked a host of other realists. No one has actually computed the statistics, but with human perceptions being grounded in logic and reality, probably seventy percent of California paintings made since 1965 reference reality in some way, that is they are not completely nonobjective. This large body of realist paintings breaks down into two broad groups: traditional

illusionistic landscapes, still lifes, and figure studies (below) and representational paintings by artists under the influence of Conceptual Art, whose purpose is to convey ideas (chapters 36, 37). Parameters are not clear cut, and some illusionistic landscapes, still lifes, and figure studies also contain ideas.

New Realism addresses the same themes that realism has traditionally treated: landscape, figure, and still life. It is not a movement; it has no one style, nor do its practitioners agree on any common points. Generally the artists apply paint (either oil or acrylic) in the usual manner—with brushes onto a flat surface. It is "new" in that the subjects reflect the contemporary scene and values. It is also "new" in that the works adopt some aesthetic qualities from Pop and Photorealism, including dispassionate objectivity, banal subject matter, and presentation of volumes of detailed "information." New Realist paintings also find some way to reconcile three-dimensional illusionism with two-dimensional pictorial qualities.

Landscapes. Californians have always shown a preference for landscapes over other subject matter, but with the disappearance of unconquered wilderness, the recent population explosion, and the fact that most artists now live within cities, a higher percentage of California landscapes represent the urban scene.

There isn't much to distinguish California's late-twentieth-century city from other American cities—a downtown of international-style high rise buildings surrounded by miles of suburban housing crisscrossed by main arteries or "strips" lined with neon signs, gaudy storefront window displays, national franchise gasoline stations, and fast-food establishments. California is different only in that it lacks heavy industry. Cities are a human creation, "earthworks" on a grand scale. Paintings of cities are at once a celebration and a condemnation of man's handiwork. Along with the beauty of gleaming corporate towers are dissonant elements such as corrupt politicians, deteriorating inner-city neighborhoods, jarring signage, as well as the psychological isolation and anonymity experienced by city dwellers.

California urbanscapes have no group look, style, or medium. Responses vary and include the Photorealist views by Robert Bechtle and Ralph Goings that show vehicles parked in suburban and urban Northern California. They also include Frank Romero's unctuous *The Closing of Whittier Boulevard* (fig. 34-8), which represents one Chicano experience, as well as David Hockney's *A Bigger Splash,* which references Southern California's artificially obtained water, its sunshine, and its recreational lifestyle. Other artists select images that specifically evoke California: Hollywood's motion

Fig. 32-12
Peter Alexander (b. 1939)
Cloverfield I, 1988
oil, wax and acrylic on canvas
72 x 84 in.
The Buck Collection, Laguna
Hills, California
Photo: Bliss

Fig. 32-13
Joseph Raffael (b. 1933)
Orange Fish, 1979
oil on canvas, 66 x 90 in.
Courtesy of Nancy Hoffman
Gallery, New York
Photo: Christopher Watson

442

picture industry; Spanish-style housing tracts; the automobile culture, and plants such as palm trees. The artist **Peter Alexander** (b. 1939) in his *Cloverfield I* of 1988 (fig. 32-12) shows Los Angeles from the air at night. Part of his L.A.X. series, titled from the three-letter abbreviation the airlines use for Los Angeles International Airport, it shows the curve of the coast, the suburbs' grids of artificial lighting, as well as clouds lit from the underside. This is frequently the first view that newcomers have of the metropolis. Like many contemporary realist landscapes, this one is not to be taken at face value; Alexander uses stereotypical views to make statements about contemporary culture. Among other things, he has deconstructed "sunsets" and paintings on velvet. Other artists reference smog, making the pollution almost romantic as it glows in a sunset.

Those artists who paint *natural* (as opposed to city) landscapes are not interested, as were earlier artists, in creating an ideal place to which city dwellers can mentally escape. Artists such as Connie Jenkins (b. 1945) now use landscapes symbolically, as metaphors. Her painting *We Shall Never Know Their Names* of 1982 (Koplin Gallery), which shows beach pebbles glistening in the wake of a retreating wave, actually refers to the massacre of peasants in El Salvador in the summer of 1981, and thus has a political message. Northern Californian **Joseph Raffael** (b. 1933) reveals Americans' new respect for ecology when he paints animals in their natural surroundings. He wishes to express the wholeness of nature, the single spirit that makes man and animals one with plants and rocks. In such works as *Orange Fish* of 1979 (fig. 32-13), his minutiae may initially be derived from photographs, but after using a paint application that is transparent rather than mimicking a flat, photo look, this author has chosen to place him in the category of New Realism rather than Photorealism. His stance is neutral and objective, and his scenes gain their power from the tension between reality and design, from the movement and rhythm of patterns across the canvas's surface.

In the 1990s, realist landscapes are painted for every reason under the sun. They range from works that capture real locations to scenes derived from the mind (surreal, imaginary, mythical, fantasy). Landscapes can metaphorically reference ecology, inner city deterioration, and the city as an alienating place (chap-

ter 37), or they can show contemporary man's disorientation and alienation from his world and people in general (chapter 36).

The Human Figure (Portraits, Nudes, Genre/Narrative). Artists will never lose their fascination with the human figure. It is too flexible, too full of symbolic allusions, too beautiful in its form and shape. Not only do clothing fashions change its look, but social fashions change its actions. Within this book alone we have seen California painters present figures as spiritual, symbolic, corporeal, erotic, and as inanimate objects. We have seen figure groupings describe history, illustrate fiction, symbolize ideal qualities, and depict real contemporary events.

In the 1950s, during the height of modernism, figuration almost died out across America. It was kept alive in the 1960s by a few California artists. The Bay Area witnessed a continuance of Bay Area Figurative Painting, while Los Angeles had several individuals who independently pursued figurative work. John Paul Jones (b. 1924) created solo evanescent women vaporously drifting through heavy fogs; James Strombotne (b. 1934) flattened forms and engaged figures in narrative situations; and Joyce Treiman (1922–1991) painted narratives in an expressive three-dimensional style, often including her self-portrait. It is difficult to know where to place these artists in this history—as very late participants in the early-twentieth-century figural trend (chapter 22), as independent realists of the 1960s, or as forerunners of Expressive Figuration of the 1980s (chapter 36).

Portraiture was dead, except for a rare commission or portraits of family and friends that resulted when they acted as models. Self-portraiture survived in the hands of artists looking for a convenient model. Robert Arneson (chapter 27) used his own image as a metaphor, while the Photorealist D.J. Hall (b. 1951) portrayed herself, family, and friends enjoying California's poolside lifestyle. Nudes were occasionally painted. No longer idealized, they were corporeal and presented in contemporary settings and situations. With society's increasing openness about sex, nudes became sexy, erotic, and pornographic. Artists such as California's Mel Ramos (above) presented pretty, sexy women as pinups or trophies, but no major California figural painter went to the pornographic extent of New

Yorker Tom Wesselmann (b. 1931), who exaggerated erotic parts of the body. Beginning in the 1980s, gay artists (chapter 33) painted male odalisques and represented overt sexual acts. Women artists began painting male nudes.

In the late 1960s and early 1970s, when realistic paintings of the figure began to be painted again, they were of two broad types—paintings that continued the traditional themes of figure studies and narrative paintings (below), and figurals influenced by Conceptual Art that were metaphors for ideas (see Expressive Figuration, chapter 36). As with landscapes, the boundaries are not firm, and sometimes illusionistic figurals also contain ideas.

In the 1970s, a number of artists taking up figuration revived traditional academic techniques and styles. Because the dominance of modernism in the 1950s and 1960s had led art schools to focus not on technique but on personal expression and concept, many young artists had to teach themselves the rules of perspective, composition, and color by studying the art of famous artists of the past. These artists also revived the elaborate compositions associated with "literary" or "narrative" themes. Narratives of the 1970s differ from those of the late nineteenth century in that the "story" does not visualize a known literary work but comes from the artist's imagination, and the meaning is often enigmatic.

Richard Joseph (b. 1939) began as a still-life painter of studio objects that he arranged to study formal aesthetic questions like composition, space, and lighting. One day he decided to set up human figures in the same way. In *Arranging Webbing* of 1970–71 (fig. 32-14), several aspects identify this work as New Realist: 1) a narrative situation of enigmatic content acted out by real individuals (often family and friends) who seem also to be caught up in personal concerns, 2) an almost clinical attention to detail, 3) the airless space, and 4) the way one figure looks out of the canvas, making eye contact with the viewer. While some other artists set up enigmatic scenes with no purposeful activity, Joseph fabricates an interaction that seems to be purposeful. Close inspection shows us it really isn't. Joseph discovered that using human figures instead of still-life objects could more concretely demonstrate 1) how objects in a composition are like players in a drama,

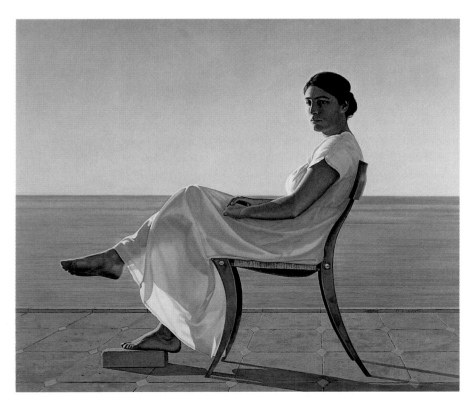

complete with psychological and narrative implications and 2) that a dialog occurs between the objective, outer world and the viewer's inner experience. In the artist's own words, "The ambiguous narratives that resulted reflect contradictions within my experience, as well as what I perceive to be the indeterminate nature of reality." [letter to author, August 29, 1997] Technically, the work is very successful: the figures are anatomically well-rendered; they are skillfully composed in the traditional triangular arrangement; depth is clearly suggested by the foreground figure, who passes the webbing to the man at the rear, and yet the fact that all depths are in equal focus brings the whole scene up to the picture surface. Joseph stands out for his technical expertise and for "thinking big." His physically large and illusionistically complex scenes with narrative content are in the Grand Manner tradition.

A number of figural artists held such respect for the Old Master paintings they studied that they appropriated the compositions, took up the themes, or adopted details, such as Greek architecture, dress, or subject matter. Randall Lavender (b. 1956), David Ligare (below), John Nava (b. 1947), and Jon Swihart (b. 1954) were brought together in the exhibition *Contemporary Humanism: Reconfirmation of the Figure* (California State University, Fullerton, 1987), but many more practice the genre. **David Ligare**'s (b. 1945) intention is to emulate the highest standards of the past. *Penelope* of 1980 (fig. 32-15) takes up the ancient Greek theme of Penelope, who while waiting for her husband Odysseus (Ulysses) to return from the Trojan war, had to fend off suitors. For some of Ligare's paintings the title tells us the Greek myth that the figures are acting out. As here, he often selects a scene in which a "hero" faces some moral decision that results in his sacrificing personal interests for the common good. Ligare shows Penelope seated in profile on a Greek chair, a pose commonly seen on painted Greek pots and carved in bas-relief on grave stele. In spite of the sitter's Greek chiton, we know this to be a contemporary scene. The model is obviously from the late twentieth century with her crossed legs. The bolts on the chair and the rush seat reveal that the chair is a mass-produced version of the ancient Klismos. Aesthetically, by isolating a single figure in the pictorial space, the artist monumentalizes the sitter and turns her into an icon.

Serene and Classical is the lack of action, the perfect balance and the background emphasis on horizontals. Ligare retains the original's shallow space, which is also a goal of modernist artists.

Still Life. Still life seems an old-fashioned theme and hardly relevant to late-twentieth-century California, but it too was updated after 1970. With still life an artist has two levels on which he can express himself—with the selection and arrangement of the objects and with the execution of the painting itself. California's still-life artists of the 1970s generally moved away from representing natural things such as fruit and flowers toward rendering man-made objects. The latter include mechanical items, such as car and motorcycle parts (see Bengston, above), as well as a full range of manufactured and commercially packaged brand-name products. Witness the rolls of toilet paper drawn by Martha Alf (chapter 28). Such commodities offered the painter a myriad of new surface textures to render: plastics, spray-painted metals, printed papers, synthetics, and computer screens, to name a few. New media, such as acrylic paints and airbrush, brightened and hardened the look of still lifes, while the use of photos as source material provided banality and infinite detail.

Still-life artists of the 1970s differed from historic still-life artists who often created their scenes with objects that shared a unified theme or together symbolized some idea. Artists after about 1970 were more likely to compose their still lifes with objects that had interesting surface textures, because they were conveniently at hand, or because they had interesting shapes. **Paul Wonner** (b. 1920), a World War II veteran, attended the University of California, Berkeley, in the 1950s, where he obtained degrees in both art and library science. His early paintings fit cleanly into the Bay Area Figurative style—expressively painted figures seen outdoors or in room interiors. However, in 1961 a guest teachership at the University of California, Los Angeles, brought him to Southern California, where the "cool school" was then gaining acclaim (chapter 30). Over the next few years his work drastically changed in style so that by 1968 he was painting hard-edge still lifes. Wonner admires seventeenth-century Dutch still lifes. But a yen to paint some of his own resulted not in copying Holland's *trompe l'oeil* technique or its boun-

Fig. 32-16
Paul Wonner (b. 1928)
"Dutch" Still Life with Lemon Tart and Engagement Calendar, 1979
acrylic on canvas
47¾ x 96 in. (dyptych)
San Francisco Museum of Modern Art, Charles H. Land Family Foundation Fund Purchase

teous compositions but in compositions of objects scattered evenly over a flat backdrop. In a work such as *"Dutch" Still Life with Lemon Tart and Engagement Calendar* of 1979 (fig. 32-16), Wonner resolves the complex balance between the opposites of illusionism and pictorial surface. Each object may be treated three-dimensionally, complete with shadows, but the overall picture rides on the surface of the canvas, achieved through the flat, unmodulated background and the even disposition of elements throughout the field. Wonner's objects are painted approximately lifesize and "are selected at random from things around the house that I'm familiar with and like or commercial products that I use frequently whose packaging or design interests me" (*50 West Coast Artists,* San Francisco: Chronicle Books, 1987?, p. 77). Wonner first lays in the background then paints the objects one by one with no pre-set arrangement. He unifies the scattered objects by rationally ordering them, aligning them with each other via shadows, shapes, or implied lines of direction. The work is "classical" because it is rational, orderly, calm, and balanced, qualities no doubt derived from the same personality trait that led Wonner to obtain a degree as a librarian.

From the 1980s onward, the popular technique of appropriation (chapter 36) turned many non-still lifes into "still lifes" of images culled from disparate sources. Some of today's still lifes are metaphors for one of the many personal, social, or political issues taken up by contemporary artists. For example, a picture made up of illusionistically painted commercial items relating to women—undergarments, cosmetics, beauty advertising, and so forth—may actually be a statement on the condition of contemporary woman. A number of recent still lifes have surrealistic overtones; they are composed of nostalgic items, such as broken toys and thrift-shop objects, and are meant to be enigmatic or to evoke a sinister mood.

Other artists also found realism the best vehicle for their purposes. The next two chapters will explore how so-called "minority" groups emerging during the Civil Rights revolution of the 1960s used realistic paintings to forward their demands for equality and respect. ✹

Bibliography

General

Seitz, William C., *Art in the Age of Aquarius 1955–1970*, Washington, D. C.: Smithsonian Institution Press, 1992. 250 p.

Wallis, Brian, ed., *Art After Modernism: Rethinking Representation*, The New Museum of Contemporary Art, New York in association with David R. Godine, Publisher, Inc., Boston, 1984.

Pop

Armstrong, Julia, "Pop Art: Wayne Thiebaud and Mel Ramos," in *Directions in Bay Area Painting: A Survey of Three Decades, 1940s–1960s* (Part III in the series The Development of Modern Art in Northern California, ed. by Joseph Armstrong Baird, Jr.), exh. cat., University of California, Davis, April 12–May 20, 1983. 36 p.

Ayres, Anne, *L.A. Pop in the Sixties*, exh. cat., Newport Harbor Art Museum, Newport Beach, Ca. and various other venues 1989–1990.

Coplans, John, *The New Painting of Common Objects*, exh. cat., Pasadena Art Museum, September? 1962 (catalogue reprinted in *Artforum*, v. 1, no. 6, 1962, pp. 26–29).*

Culler, George, "California Artists," *Art in America*, v. 50, no. 3, October 1962, pp. 84–89.

Knight, Christopher, "The Word Made Flesh: L. A. Pop Redefined," in Maurice Tuchman, *Art in Los Angeles: Seventeen Artists in the Sixties*, exh. cat., Los Angeles County Museum of Art, July 21–October 4, 1981 and one other venue.

Marmer, Nancy, "Pop Art in California," in Lucy R. Lippard, *Pop Art*, London: Thames and Hudson, 1966.

"9. Vox Pop," in Peter Plagens, *Sunshine Muse: Contemporary Art on the West Coast*, New York: Praeger, 1974.

Six More [California Pop painters, Bengston, Goode, Hefferton, Ramos, Ruscha, Thiebaud], exh. cat., Los Angeles County Museum of Art, July 24–August 25, 1963. 20 p.

"6. The Watershed: Funk, Pop, and Formalism," in Thomas Albright, *Art in the San Francisco Bay Area 1945–1980*, Berkeley: University of California Press, 1985.

Steen, Ron, *Deja Vu, Masterpieces Updated* [Pop art], exh. cat., Downey Museum of Art, June 25–September 3, 1978 and one other venue. 83 p.

Photorealism

"Artweek Focus: Still Working After All these Years: Conversation with Three Bay Area Photorealists," [McLean, Bechtle, Torlakson] *Artweek*, v. 22, August 1, 1991, pp. 16–17.

East Coast/West Coast/New Realism, exh. cat., San Jose State University, University Art Gallery, April 24–May 18, 1973.

"The Los Angeles Fine Arts Squad," in *Vapor Dreams in L. A.*, exh. cat., University Art Museum, California State University, Long Beach, November 15–December 12, 1982. 40 p.

Macleod, Dianne Sachko, "Super-Realism: The Illusion of Neutrality," in Joseph Armstrong Baird, Jr., ed., *Directions in Bay Area Painting: A Survey of Three Decades, 1940s–1960s* (Part III in the series The Development of Modern Art in Northern California), exh. cat., University of California, Davis, April 12–May 20, 1983, pp. 24–25.

Meisel, Louis K., *Photo-Realism*, New York: Abradale Press, Harry N. Abrams, Inc., 1989.

Meisel, Louis K., *Photorealism Since 1980*, New York: Abrams, 1993.

"The Object Reaffirmed: Photo Realism and the New Abstraction," in Thomas Albright, *Art in the San Francisco Bay Area 1945–1980*, Berkeley and Los Angeles: University of California Press, 1985, pp. 209–30.

Photo-Realist Painting in California: A Survey, exh. cat., Santa Barbara Museum of Art, April 12 - May 11, 1980. 32 p.

Realism, American

Cathcart, Linda L., *American Still Life 1945–1983*, Houston, Tx.: Contemporary Arts Museum, 1983.

Goodyear, Frank H., *Contemporary American Realism since 1960*, Boston: New York Graphic Society in association with the Pennsylvania Academy of the Fine Arts, 1981.

Representational Drawing Today: A Heritage Renewed, exh. cat., University Art Museum, University of California, Santa Barbara, March 2–April 17, 1983 and three other venues. 87 p.

Styron, Thomas W., *American Figure Painting 1950–1980*, exh. cat., Chrysler Museum of Norfolk, October 17–November 30, 1980.

Ward, John L., *American Realist Painting, 1945–1980*, Ann Arbor, Mi.: UMI Research Press, 1989.

Realism

Decade: Los Angeles Painting in the Seventies, exh. cat., Art Center College of Design, Pasadena, Ca., February 17–March 14, 1981. [essays on abstract painting, realist painting and narrative/humanist painting] 108 p.

Directly Seen: New Realism in California: Robert Bechtle [et al.], exh. cat., Newport Harbor Art Museum, March 11–April 12, 1970. 14 p.

Gamwell, Lynn, *The Real Thing: Southern California Realist Painting*, exh. cat., Laguna Beach Museum of Art, April 30–June 10, 1982.

Gamwell, Lynn, *West Coast Realism*, exh. cat., Laguna Beach Museum of Art, June 3–July 24, 1983. 64 p.

Separate Realities: Developments in California Representational Painting and Sculpture, exh. cat., Los Angeles Municipal Art Gallery, September 19–October 21, 1973.

Show: A Comparative Study of Nineteenth Century California Paintings & Contemporary California Realism, exh. cat., University Art Gallery, California State University, Chico, February 28–March 18, 1977. 8 p.

Realist Landscape

Berkson, Bill, "Changes like the Weather: Painting and Sculpture Since 1970," in *Facing Eden: 100 Years of Landscape Art in the Bay Area*, exh. cat., Fine Arts Museums of San Francisco and University of California Press, Berkeley, 1995, pp. 139–162.

Gibson, Dunn & Crutcher, *A Century of California Landscapes*, Los Angeles: the Firm, 1983.

Stofflet, Mary, *California Cityscapes in Contemporary Art*, exh. cat., San Diego Museum of Art, June 1–August 18, 1991. 93 p.

Turnbull, Betty, *California: The State of the Landscape 1872–1981*, exh. cat., Newport Harbor Art Museum, Newport Beach, Ca., March 13 - May 3, 1981 and Santa Barbara Museum of Art, July 25–September 6, 1981. 107 p.

Realist Figure

Artist's Images: Images of Artists by Artists, exh. cat., Security Pacific Corporation, Gallery at the Plaza, Los Angeles, Ca., January 29–March 27, 1988 and one other venue. 24 p.

Chadwick, Whitney, "Narrative Imagism and the Figurative Tradition in Northern California Painting," *Art Journal*, v. 45, no. 4, Winter 1985.

Contemporary Humanism: Reconfirmation of the Figure: Randall Lavender, John Nava, David Ligare, Jon Swihart, exh. cat., Main Art Gallery, California State University, Fullerton, November 7–December 10, 1987.

Dines-Cox, Elaine K., *Everydayland: Imagined Genre Scene Painting in Southern California*, exh. cat., Laguna Art Museum, September 1–October 23, 1988. 96 p.

Seven California Figurative Artists at the Desert Museum by Arrangement with the Felix Landau Gallery, exh. cat., Palm Springs Desert Museum, n. d., 1966. 8 p.

Realist Still Life

Reality of Illusion, exh. cat., The Denver Art Museum, the University Art Galleries, University of Southern California, and four other institutions in 1979 and 1980. 123 p.

Beyond Modernism—The Civil Rights Revolution & the Emergence of "Minority" Artists

33

Almost everyone has seen 1960s newsreel footage of long-haired hippies picketing and holding sit-ins at the University of California, Berkeley, and at Golden Gate Park. Demonstrations occurred frequently in the revolutionary 1960s as each special interest group utilized protest to advance its cause. Students fought for free speech; draftees and moralists protested the Vietnam War, while countercultural dropouts, social and political dissidents, and so-called "minorities" of both genders and many races stood up and demanded respect and equal treatment from the white Anglo-Saxon, Protestant majority. Feminists wanted equality for the sexes; gays and lesbians wanted respect for everyone irrespective of sexual preferences; while racial minorities wanted to gain back a sense of their own identity and roots that had been obliterated by the officially sanctioned "white" history taught in American schools. Initially, youth struggled for democratic rights, but the fight soon evolved to cover economic equity and cultural expression.

Artists added their voices to this movement. Although often considered intellectuals and identified with the members of the elite strata of society who purchased their work, artists were ironically often only paid as much as an unskilled laborer. Many artists wanted equal pay for equal work, but artists from "minority" and other special interest groups mainly wanted to be accepted into establishment circles and to be respected for their own aesthetic and artistic issues.

Taking their future in their own hands, artists within the various special interest groups joined together, created their own support organizations and "alternative" galleries, wrote magazine and newspaper articles promoting their platforms, put on exhibits, started their own publications, and, when the occasion arose, held protests. What is more important, they used their art to advance their aesthetic or political goals, together forming one of the largest groups creating anti-modernist art. Their work was anti-modernist in that it was created outside the modernist mainstream. Most of the art by these groups was representational, emphasized content over "style," and dealt with personal, social, and political themes. The six largest and most visible "minorities" were women, gays and lesbians, African-Americans, Asian-Americans, Native Americans, and Latinos.

Feminist Art

Long before the Civil Rights Revolution, California women had competed in the state's mainstream art world. As a result of the post-Civil War emancipation of women from the home, late-nineteenth-century women began to take up careers as painters and print-makers (chapter 5). They excelled in still lifes of flowers and fruit and in themes featuring women and children. In the early twentieth century California women artists were more innovative than men in certain types of modernism and Symbolism (chapter 8). However, prejudice continued to hold them back.. Men chose to believe women couldn't produce work that was thematically or aesthetically as strong as their own, and women artists were excluded from exhibitions, jobs, and commissions. Feminist Art's goal was to prove that work by women was special and unique, could be as important as that produced by men, and that female imagery was as valid as male imagery. Feminist artists wanted to introduce a woman's perspective into art and to gain equality for women in the art mainstream.

Feminist Art was both a byproduct and an integral part of the Women's Liberation movement. "Women's Lib" was spurred by the publication of Betty Friedan's *The Feminine Mystique* of 1963. The movement was advanced by the addition of the category of "sex" to Title VII of the Civil Rights Act of 1964 and by the foundation of the National Organization for Women in 1966. Some of the earliest recorded Feminist activities took place in New York, but Women's Lib spread rapidly across the nation as one support group spawned another. Art was one means through which Feminists advanced their cause. Although Feminist Art first arose in New York, Los Angeles soon grew to rival New York in the quantity of its output and activities. Los Angeles's two feminist art leaders were Judy Chicago and Miriam Schapiro.

In the early 1960s **Judy Chicago** (b. 1939) had been active in Los Angeles as a sculptor and painter and had produced bold geometric abstractions in the then cutting-edge media of spray-painted metal and plastic. But she was aware of subtle discrimination from her male peers associated with the Ferus Gallery, who, at the time, were cultivating a macho image. Her progressive upbringing had imbued her with a feminist consciousness. Her feminism was triggered at the

Opposite:
Fig. 33-2
Judy Chicago (b. 1939)
The Dinner Party, 1979
mixed media
48 x 42 ft. x 36 in.
© Judy Chicago, 1979
Photo: Donald Woodman

449

University of California, Los Angeles, when her professor for The Intellectual History of Europe explained to his class that women were not discussed because they had made no contributions. She spent hours searching the library for facts to counter him. In the spring of 1970, when she was hired to lecture at Fresno State College, she did so on the proviso that she be allowed to develop a woman's program in the art department.

Miriam Schapiro (b. 1923), a former New Yorker, had her feminist consciousness raised in 1965 when she read Simone de Beauvoir's *The Second Sex,* and she felt prompted to make art of feminist content. When her husband, Paul Brach, was made dean of the newly opened California Institute of the Arts in Valencia (CalArts), on the northwestern periphery of Los Angeles's sprawl, Schapiro talked him into bringing Chicago's Fresno program to CalArts. The two women jointly set it up, and it opened in the fall of 1971.

One of the first things Chicago and Schapiro did was to develop an iconography for women. Rethinking the whole concept of women and art, they asked "What is unique about women?" and "How can we derive strength from that to create a feminine but universal art?" Through consciousness-raising sessions they came up with two sources for iconography: the female body and traditional female social roles. Historically, when the female body was employed in art, it was portrayed as men saw it, or associated with the symbolism men had established for it: woman as sexual temptress, as earth mother, as a bringer of calmity, and as a pure and ideal figure. Chicago and Schapiro had noticed in their study of the art created by women through the ages that many had utilized imagery relating to their procreative abilities, such as eggs, breasts, and plant forms with a cup or vaginal shape (see Henrietta Shore and Helen Lundeberg, earlier chapters). Many also, either consciously or unconsciously, utilized a central image in their art. Chicago and Schapiro believed this reflected women's own sexual orifice and this gave rise to their centralized-core imagery or the "cunt aesthetic." Their research resulted in their codification of a feminist art theory called "essentialism." While Chicago and Schapiro believed women were physically and emotionally different from men and had different social expectations and interactions, at the same time women artists could derive strength

from the female's essentially different nature. Chicago and Schapiro decided to use female iconography to empower women's art, to take something that formerly had pejorative connotations and to turn it into an object of pride.

The most well-known production of the CalArts Feminist Art Program was *Womanhouse* of 1971, an actual house in Hollywood whose rooms CalArts students turned into site installations. One example is **Camille Grey**'s (b. 1972) *Lipstick Bathroom* of 1972 (fig. 33-1). The students' project was to modify each of the rooms in *Womanhouse* using principles and techniques learned in consciousness-raising sessions. (Feminist artists' main contributions were not in the medium of painting but rather in cutting-edge media such as the site installations of *Womanhouse*, performance, and video; see chapter 29.) Twenty-one students made over seventeen rooms.

To help the students develop thematic ideas, Chicago and Schapiro had them consider what each room and its activities meant to a woman. They read feminist literature and looked into their own backgrounds and experiences for themes and iconography. The program taught them to look toward female rather than male role models, gave them "permission" to use female imagery, and provided them with emotional support against the condemnation and disapproval they knew their cutting-edge art would art receive from the mainstream art world. Feminist Art themes were generally autobiographical and narrative. Issues were female biology, sexual roles, and female emotions. Iconography included sexual imagery, such as vaginas, penises, and breasts, as well as feminine things such as cosmetics, dresses, and "pretty" colors. *Lipstick Bathroom* takes up the theme of female beauty. It contrasts with the house's other two bathrooms, *Menstruation Bathroom* and *Nightmare Bathroom* (the latter expressing the vulnerability that a woman feels when she strips naked to bathe). The house was opened to public display for the month of February 1972, during which there were 9,000 visitors.

Chicago became particularly known for her Cunt aesthetic. Her best-known work, a room-size site installation/assemblage called *The Dinner Party* (fig. 33-2, p. 446), made between 1974 and 1979, consisted of a triangular dining table with thirty-nine place settings. For Chicago the dining table (as well as its china and linens) was an object identified with women, whose traditional jobs included, among others, cooking and serving food. In *The Dinner Party*, her intent was to raise commonplace objects associated with women's work to the level of high art. Each setting was made up of a plate, a goblet, and a specially designed tablecloth.

Fig. 33-1
Camille Grey (active 1972)
Lipstick Bathroom,
Womanhouse, Los Angeles,
1972
room in Womanhouse; mixed
media
Courtesy Arlene Raven
Photo: Lloyd Hamrol

Each plate was either fabricated in the shape of the vulva or painted with stylized vulval imagery combined with a butterfly motif. Her use of ceramics was timely and appropriate. In the mid 1970s small-scale ceramic sculpture was a cutting-edge California sculptural art form, and the painted plates brought the traditional feminine hobby of china painting into the realm of high art. The plates' brightly colored, shiny surfaces became a female counterpart to the shiny plastic and spray-painted metal objects made by Chicago's male peers at the Ferus Gallery (chapter 30). Each plate symbolized a real or imaginary woman from history. By honoring women, Chicago did not intend to be anti-male, but rather to celebrate women's achievements throughout history and to present this information in one place so that young women of succeeding

generations would not have to spend hours searching history books for esoteric references to women's achievements, as she had had to do. The floor of *The Dinner Party* is made up of white tiles inscribed with the names of 999 other important women. This work was communally produced, with hundreds of women working together to realize Chicago's conception. The whole was a tribute to women, and the large scale and profound statement disproved the old adage that women artists could not produce monumental work.

Schapiro, besides working hand-in-hand with Chicago to lead the Feminist Art Program, developed her own imagery based on "decorative" patterns. Schapiro had been a painter of geometric abstractions, but in 1972, after moving from the University of California at San Diego to CalArts in Los Angeles and while

working on *Womanhouse*, she created a piece that juxtaposed patterned fabrics. Highly renegade at the time was the concept of basing "fine" art on items traditionally associated with the "female sphere," such as fabrics and wallpapers, flower designs, and objects associated with the home. However, for Schapiro these proved the perfect way to honor the thousands of anonymous women through history who had expended their creative energies in often overlooked handiwork—spinning, weaving, sewing, quilting, and needlepoint. Schapiro's earliest works of this type were made of collaged fabrics. In *Explode* of 1972 (Everson Museum of Art, Syracuse, New York), she achieves her effect through collaged fabrics, acrylic paint, and bright colors. In later works the patterns were painted. Eventually she shaped some of her canvases into "female" objects such as fans, kimonos, houses, and valentines. In Schapiro's hands, "decoration" became a sophisticated and legitimate Feminist Art form, one that avoided the controversial imagery on which Chicago depended and yet made an equal statement on women's behalf. In the mid 1970s, after she returned to New York, Schapiro interacted with other artists, writers, gallery owners, and curators who were sympathetic to decoration, and Pattern and Decoration became an official movement (chapter 35).

Around 1972 the national Feminist Art movement shifted its tactics. Guerrilla strikes gave way to the creation of organizations intent on effecting long-term changes. One of Feminist Art's most important events was the November 28, 1973 opening of the Woman's Building in Los Angeles. Women took over the former Chouinard Art Institute, which had been left empty when the school relocated to the California Institute of the Arts campus in Valencia. The building became a center for Feminist activity. Rooms were let to various concerns interested in women and art, including several art galleries, a workshop, the Center for Feminist Art Historical Studies, the Women's Graphic Center, Gallery 707, the Sisterhood Bookstore, the Los Angeles Feminist Theatre, and the Associated Women's Press. Los Angeles women published various magazines documenting Feminist activities—*Chrysalis* (1977–80), *Womanspace Journal* (1973), *Visual Dialog* (1975–80), and *High Performance* (begun in 1978 and still documenting the rich field of performance art)—adding to Feminist Art literature published primarily in New York.

As with much of the art produced by the special interest groups of the late 1960s and early 1970s, the Feminists first used shock tactics to gain the mainstream's attention; their early art aggressively demanded notice, respect, and equality. As the 1970s progressed and as recognition was gained, protest relaxed; artists took up mainstream styles and topics, and artists became more interested in aesthetics than message. By 1980 the Women's Liberation movement had ceased to exist; Feminist Art even suffered its own backlash. Once notice was earned by women, their protest lost its impetus, and artists tended to go off on their own. The centralized-core imagery theory propounded by Chicago and Schapiro came up for attack by opponents who claimed it did not inspire women but instead limited and pigeonholed them. The 1975 move of the Woman's Building to a structure in downtown Los Angeles made it less accessible to its supporters and placed it in a community that did not relate as well to it. In 1991 the Woman's Building closed; its records were donated to the Archives of American Art. The late 1980s has seen a revival, a kind of second generation Feminist Art movement, but one based on searches for *personal identity* rather than *group revolution* (chapter 37).

The Feminist Art movement did effect major changes in the art world. At first, established women artists were unwilling to be identified with it for fear of becoming categorized as "women" artists. But the movement did succeed in getting women artists more attention from the press, from museums that gave them special shows, and from commercial galleries, where a market for their work began to develop. While some believe the Feminist Art movement did not achieve aesthetic innovations, without question it introduced a new range of subject matter that could be obtained through new methods, such as consciousness-raising. Feminists were in the forefront of the anti-modernist movement most notably in encouraging autobiographical statements; in introducing the principle of artistic collaboration; in acknowledging the wider public as their audience; and in being concerned about social issues like ecology. Most important, it gained women artists and female subject matter an important place in the contemporary art world.

Gay and Lesbian Art

California, for many years the state farthest from the restrictive East Coast, has been a haven to people seeking a fresh unhampered environment. Among the arrivals have been gays and lesbians. Gay activity in California has been known from the time of the Gold Rush, when males greatly outnumbered females. In the late nineteenth-century, when small communities of gays were coming together in Europe's larger cities, especially Paris and London, gays were an acknowledged part of San Francisco's Bohemian circles. In the Victorian era the city had a reputation for its permissive atmosphere and its wide-open moral attitudes. In the early part of the twentieth century homosexuality among men (conservative minds could not believe same sex intercourse occurred between women) was either tolerated or persecuted depending on social conditions—lax in the 1920s but restrictive in the 1930s. In the Thirties, artistically talented gays such as the musician John Cage and architect Philip Johnson associated with Hollywood's creative community.

The modern gay liberation movement actually began in Los Angeles when Harry Hay founded the Mattachine Society in 1951; a branch was also opened in San Francisco. His *One Magazine*, which enjoyed world-wide circulation, carried articles about gays and included reviews of art exhibits. In the 1950s, Beats acknowledged no boundaries between gays and non-gays, and distinction was further reduced among hippies, whose long hair, sometimes bedecked with flowers, was far from the American macho male ideal. In June 1969 a police raid on a New York gay bar called the Stonewall Inn resulted in gays turning rebellious and militant, and the Gay Liberation Movement was propelled into mainstream history. In the 1970s newspaper and magazine articles kept "straight" America abreast of the newly revealed alternate lifestyle, and the decade witnessed some brutal physical conflicts as straights resisted the wider acceptance of homosexuality. Closet gays admitted their sexual preferences, and rumors circulated about the homosexuals' rampant sexual encounters. Large gay communities developed in San Francisco and Los Angeles, each with its own infrastructure of bars, health clubs, public baths, spas, community centers, clothing stores, and art galleries. San Francisco, followed by Los Angeles, mounted Gay Liberation marches and parades.

Throughout history, many important artists have been gay, including Leonardo DaVinci and Michelangelo. During the years *before* homosexual subject matter was deemed acceptable in art (about the 1970s), gay artists revealed their leanings, if at all, by portraying idealized male nudes in scenes of heterosexual love, in narrative and genre pictures of Greeks and Romans, and in pictures of religious theme, such as martyrdoms and depositions. Privately, many homosexual artists made art that verged on the pornographic, which they gave or sold to friends; in these works genitals were exposed or emphasized and sexual encounters portrayed. In 1930s and 1940s America, East Coast gay painters such as Paul Cadmus (b. 1904) and Jared French (1905-1987) employed the idealized male figure in genre scenes typical of the era, where average men—acrobats, sailors, dancers, swimmers, and bodybuilders—were shown in manual occupations.

California was home to important gay art figures long before Gay Liberation. In the first decade of the twentieth century, Oakland-raised Gertrude Stein and her brother, Leo, moved to Paris where their renowned art salons included, along with Picasso and Matisse, many homosexual artists. In Los Angeles the Symbolist artist Rex Slinkard (chapter 8) was bisexual, and as early as the 1930s many gay artists worked in Hollywood, designing sets and costumes, among other art forms. Minor White (1908–1976), while in San Francisco, made beautiful photographs of male nudes, some of which featured his lovers as the models.

In the post-World War II period, as sex began to be openly discussed and as gays felt an increasing desire to go public, gay artists started to make art *about* gays and *for* gays. While many people equate gay art only with images of sex, gay artists cannot be typecast; they work in as wide a range of styles and themes as straight artists. What they have striven to express since the early 1950s is their own lifestyle, a significant aspect of which happens to be sex. There is nothing new about using sex as a theme for art. Love and sexual intercourse have provided subject matter since man began making art. Amorous scenes run the gamut from idealized and romantic themes derived from Greek myths to the perversely sexual late nineteenth-century European Symbolist art, erotic art, and just plain pornography. The most well-known examples of the latter include the sexually explicit pottery of pre-Columbian

Peru, the pornographic color wood blocks of Japan, and the sexual/religious temple sculptures at Khajuraho in India. Intercourse has symbolized many things, from religious experience to fecundity.

Art made for gay viewers was first produced by male homosexuals and appeared in the so-called "skin" magazines of the 1950s, which were put out under the guise of health, nature, art, or weight lifting. Magazines such as *Physique Pictorial,* issued from Los Angeles, contained both photographs and original artwork showing macho males with beautifully proportioned bodies: muscled military men, leather-wearing motorcyclists, cowboys, wrestlers, gladiators, and men who "pump iron." Such art could not legally show genitals, so the organs were discreetly obscured by a twist of the body, hidden with a posing-strap, formfitting jeans, or leather pants. The most important artist in this genre was Bruce of Los Angeles, who initiated the posing-strap genre and the California beach/surfer look. His images and those of other artists, such as Los Angeles's George Quaintance (c. 1915–1957), were ostensibly about bodies but were meant to arouse, and they tested pornography laws in the 1950s.

Homosexual leanings were also apparent in some fine art of the 1950s. The openly homosexual artist Jess (chapter 28) was among the first to make political statements with his art. In the collage *Mouse's Tail* (fig. 28-6) a large image of a crouching man is made up of smaller photographs of male nudes from skin magazines. Jess alludes to the relationship between the straight and gay communities in two places: when the figure looks in a mirror and is presented with how straight people see gays—as clowns—and in the title that references a Lewis Carroll tale in which a character decides to pre-judge a situation without first being presented with the facts.

One of the earliest California artists to unselfconsciously depict the gay experience was **David Hockney** (b. 1937), the English Pop artist who moved to Hollywood in 1964. Hockney's sexual preferences did not instill in him the guilt suffered by some gays, and even while attending the Royal College of Art in the late 1950s, he dared take up the still verboten theme of homosexuality, openly representing himself and his gay friends. Rarely is his subject matter overtly sexual or pornographic. (Hockney did make some candidly

homosexual love scenes to illustrate poems by C.P. Cavafy in 1966.) *Two Men in a Shower* of 1963 (fig. 33-3) is typical of how he shows himself and his friends in commonplace activities, similar to those of heterosexuals: showering, bathing, and swimming. Although he supports gay rights, he has never identified himself with the Gay Liberation movement.

Although Gay Liberation accelerated at the end of the 1960s, *paintings* of gay subject matter did not immediately follow. Gay art of the 1970s lay primarily in the realm of photography, macho male nudes with perfect bodies in the tradition of the "skin" magazines. Descendants of California's f.64 photographers (chapter 17), California's gay photographers emphasized the body's sensual details: its curves, skin and hair texture, and genitalia. However, gay nudes are often sexually explicit, enter the realm of pornography, and treat themes such as sadomasochistic sex. In the 1970s, San Francisco's gay painters went down in history for painting the first public sexually-explicit gay murals since ancient Greece—the idealized nudes on the walls of Bulldog Baths. In the early 1970s Gilbert Baker designed the "Rainbow Flag" that has become the internationally recognized symbol of gay identity.

Lesbians more frequently attached themselves to the cause of Feminist Art. Los Angeles's Woman's Building served as a center for lesbian art activity and provided several galleries where art of feminist and lesbian subject matter, not yet acceptable in mainstream art galleries, could be shown. Historically, lesbians avoided the pornographic scenes preferred by men and, if they chose to treat sexual issues, made portraits of friends, portrayed nude females, or showed scenes of motherhood or romantic lovemaking. In the 1960s and 1970s lesbians generally opted for feminist issues, while lesbians of color often addressed the double prejudice faced by women in general as well as persons of a racial minority. Their preferred media were performance, video, and site installations.

Since 1980 and especially since the AIDS epidemic, another wave of gay militancy has brought art by gays and lesbians into the mainstream. Today's gay artists follow a wide variety of styles and themes. San Francisco and Los Angeles are marked by two entirely separate histories.

To select one artist to represent all gay artists of Los Angeles is impossible, since gay artists work in any style or with any subject that moves them. **Don Bachardy** (b. 1934) admits he does not identify with any core gay art crowd in the city. While studying at Chouinard he met two of the Ferus modernists, Billy Al Bengston and Ken Price (b. 1935), and they remain among his closer friends. Although trained during the height of modernism, Bachardy found himself anti-modernist, more interested in people; his entire career has focused on figure paintings and portraiture. Most of his work is in the medium of acrylic on paper, but for a brief period in the mid-1980s he produced a series of large acrylic paintings on canvas, such as the male odalisque *Dan* of 1985 (fig. 33-4). Bachardy is a committed worker, spending the hours of 10 to 4 almost every day in his studio to take advantage of natural daylight, working feverishly from live models, and completing two to three portraits in a sitting. Models come from Bachardy's friends and acquaintances and from strangers who commission works. Friend Dan, seen in this image, is a frequent choice. Although Dan was painted in the mid 1980s when Neo-Expressionism raged in America, the work should not be considered a product of that movement. Bachardy, who admires the German Expressionists Emil Nolde (1867–1956), Oskar Kokoshka (1886–1980), and Otto Dix (1891–1969), has always utilized expressive brushwork. The artist considers his sitter his main inspiration; he draws strength from direct eye contact and is rewarded with psychologically penetrating portraits. His work has been called honest, truthful, and robust. Bachardy produced large works such as *Dan* only for a short period. He found the large canvas broke his eye contact with his sitter and forced him to crane his neck to see his subject; once the challenge of working in large scale had been surmounted, he returned to an intimate mode.

San Francisco, home to the state's largest population of gays, provides a large consumer base for art *about* and *for* gays. A burst of important activity occurred in the late 1980s and early 1990s. San Francisco had chapters of Act Up and Queer Nation, whose graphics' arms advanced gay rights by plastering beautifully-designed posters around the city. Someone in the San Francisco chapter designed the now well-known AIDS logo, the pink triangle with the legend, "Silence equals

Opposite, top:
Fig. 33-3
David Hockney (b. 1937)
Two Men in a Shower, 1963
oil, 60 x 60 in.
© David Hockney

Opposite, bottom:
Fig. 33-4
Don Bachardy (b. 1934)
Dan, 1985
acrylic on canvas, 53 x 40 in.
Photo courtesy Lizardi/Harp

Death." San Francisco was also home to Boys with Arms Akimbo and Girls with Arms Akimbo, two short-lived AIDS activist groups that used guerrilla tactics to convey their message through posters and street art. Today the gay art scene in San Francisco is so active it is impossible to list everything that is happening. It consists of an elaborate infrastructure of galleries, studios, and performance spaces. Some galleries were devoted exclusively to gays including the now defunct, two-year-open Kiki Gallery, the lesbian Lunacy, and the informal performance space 848, to name a few. The Harvey Milch Institute, a community-based educational facility founded five years ago in Castro, is the largest gay educational facility in the world with its eighty-six classes on topics relevant to gays and lesbians, including many on art and performance. At this book's writing, three courses on gay art are being offered at San Francisco City College; the city is funding exhibitions organized by The Center for Lesbian, Gay, Bi, Transgender Art and Culture; and Queer Arts Resource maintains a cyberspace art gallery that holds changing virtual exhibitions at http://www.queer-arts.org. (See also chapter 37 for the themes of personal identity and AIDS.)

Ethnic Minorities/Multicultural Art
Finding a niche in society's economic and business structure is difficult for anyone, but obviously more so if an individual finds himself or herself blocked by preconceptions of race or gender. Especially in difficult economic times, people join forces and become protective of themselves and others like them and exclude those who are not. The dominant social group (the "establishment") can take on the appearance of a gigantic stone wall, even an enemy, to the minority individual seeking equal opportunity and reward. Fortunately, in America, since World War II, the government has preached equality and backed up its stance with laws. Healthy economic growth has encouraged the majority to be generous and share America's bounty.

Prior to the mid 1960s, many of America's artists of foreign heritage adopted the counry's prevailing aesthetic. However, the Civil Rights movement of the 1960s not only forced mainstream America to take notice of "minorities" but resulted in the passage of laws to assure them equality. Artists in special-interest groups began to think about themselves and their backgrounds, resulting in a renewed respect for their own traditions. Many traveled to the lands of their forbears to discover their roots and their cultures. These artists began to purposefully absorb aesthetics, iconography, and technical traditions from their native cultures and merge them with the styles and techniques

they had learned in the West. Many people believe that the United States's greatest opportunity for a new and vital art lies in its role as a cultural melting pot and the hybrid ideas that emerge from the mix of ethnicity.

Choosing the correct language with which to discuss art by America's various racial groups can be tricky. In the 1960s and 1970s such artists were called "minority" artists, while in the 1980s they were being termed "other," "third world," and "people of color." In the 1990s everyone is working in a "Multicultural" environment. Can we still also call African Americans blacks? or anyone from the "left" side of the Pacific, Asian Americans or Orientals?, Native Americans, Indians? or Latinos and Chicanos, Hispanics and Mexicans? Usually not, but a writer has to vary her language, and so some of those terms will appear in this essay. However, this discussion will try to stay away from terms decreed demeaning in the 1950s, such as "ethnic" and "primitive." The reader should be forewarned that the following discussion is itself "prejudiced"; in order to prove certain points, this writer has purposefully selected Third World artists who have merged social and artistic elements of their native cultures with contemporary American aesthetic ideas. Thus, many fine artists who work in either pure "Western" styles or strictly in their homeland's traditional aesthetic will be ignored.

Normally a discussion about racial groupings would begin with the largest. In California this would be Latinos. However, this author has placed Latinos in the following chapter with murals for two reasons. First, the Latino art contribution is so large and pervasive in California that it requires an entire chapter to do it justice. Second, it is so integrally tied to the mural movement that it could not be separated. (See chapter 34.)

African Americans
California had few black residents before World War II. The great post-World War I mass migration of Southern rural blacks was to northern and eastern urban industrial centers. Thus, it was in the Northeast, in the 1920s and 1930s, where the first great black cultural advances were made. Encouraged by the Negro intellectual Alain Locke to stop aping European art and to derive inspiration from their own traditions, African Americans made major contributions to the fields of literature, art, and music, resulting in a surge of this activity in the 1920s, called the Harlem Renaissance. More advances followed in the 1930s: white artists of Regionalist persuasion sought out black subject matter for their art, blacks were hired by the Federal Art Projects, and exhibitions of black art were

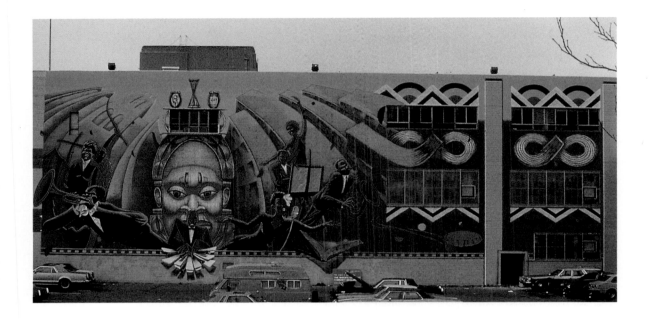

mounted in museums. From California's small coterie of 1930s black residents rose two sculptors of note: Los Angeles's Beulah Woodard (1895–1955) and San Francisco's Sargent Claude Johnson (1888–1967) (chapter 17).

The first large influx of blacks into California came during World War II, when they arrived from the South to work in war plants. Afterward, black residential areas began to grow in South Central Los Angeles. In the Bay Area they arose around the industrial plants that had employed them—in Oakland and in San Francisco in the Hunter's Point area, where the U. S. Navy had a major shipbuilding yard. In the 1960s, blacks rode the Civil Rights movement to recognition. "Afro" haircuts and dress (dashikis and ethnic jewelry) became fashionable. The nationwide outdoor mural movement (chapter 34) was initiated by black artists on Chicago's South Side in the spring of 1967 when they spontaneously painted the Wall of Respect.

Many black painters from the mid 1960s onward worked to mesh ideas and aesthetics from the contemporary black community, from black history in America, and from the art of Africa with those of the American mainstream.

It is in murals that the most complex compositions and themes, as well as the most elaborate incorporated iconography, appear. In the early 1970s, murals began to be painted by blacks in both Northern and Southern California, usually in black residential areas. In San Francisco these were Hunter's Point-Bayview, the Western Addition, and the Fillmore. In Los Angeles, murals showed up in South Central Los Angeles and from

Vernon to Compton. The 1984 *A Celebration of African and African-American Artists* painted by **Dewey Crumpler** (active 1980+) and others on the Western Addition Cultural Center (fig. 33-5) shows how murals differed from easel works. Early on, black symposia considered the role that art could play in the emancipation of blacks. The stereotypical black has a reputation as an achiever in sports (rather than art) and is identified with the troubled areas of society (single-family parenthood, health problems, homelessness, joblessness, weak earning power, failed education) and with suppressed anger, which occasionally erupts in riots. To counter this negative image, black symposia decided that black public art (such as murals) should not promote revolutionary ideas but should "teach" with *positive* values, appeal to the higher emotions, inspire the cultural liberation of the people, and improve and beautify the black community. Crumpler and other artists thus portray successful blacks, such as the musician Duke Ellington. Crumpler surrounds "the Duke" with others who achieved distinction in music, dance and painting. The turn-of-the-century goal for mural paintings to exist quietly on the wall (chapter 8) has given way here to an explosive and dynamic presentation. Much black mural art derives its iconography from the art of African tribes. Blacks have had to work harder at psychologically reclaiming their "roots" than other minorities. Ancestral ties were severed first in Africa, when interior Congolese seized for slaves were identified with the West African ports from which they were shipped, and further lost through many generations of disruptive life in America. Thus, those blacks

Fig. 33-5
Dewey Crumpler (b. 1949) and others
A Celebration of African and African-American Artists, 1984 (Western Addition Cultural Center, San Francisco)
acrylic on concrete
45 x 131 ft.
Dewey Crumpler with Kemit Amenophis, Bonnie Long, Sandra Roberts
Photo: Tim Drescher

who travel to Africa to rediscover their heritage come back with an appreciation not just of their original Congo tribe (if they can trace it) but of African art in general. Specifically they appreciate the rich achievements of sub-Saharan tribes and those along the Ivory Coast, such as the Dogon, the Senufo, and the Benin. Among the African designs that American blacks incorporate into their paintings are patterns from native costumes or painted on wooden sculptures, body scarring, and hair braiding; iconography includes African masks, idols, and architecture. Stylistically and aesthetically, black mural art is often highly energetic with its employment of bright colors and bold designs.

The work of many black artists is not immediately recognizable as "black." These artists are more interested in formal aesthetic issues. For example, *1, 2, 3, 4, 5* of 1978 (fig. 35-6) by Oakland's Raymond Saunders is a typical Post-Modernist abstraction in its merging of abstraction with figuration and paint with other media. At the same time, it references the black experience.

Since 1967, the infrastructure supporting black art has made great advances. In Los Angeles, over a period of twenty years, the artist and educator Samella Lewis (b. 1924) has been responsible for creating many opportunities for black artists. She set up a commercial gallery for black art, Contemporary Crafts; founded the quarterly *Black Art* (now *International Review of African American Art*); and has edited or written books and numerous articles on black art. Los Angeles institutions that teach, sponsor, and exhibit black art include the Watts Towers Art Center and St. Elmo's Village. Two Los Angeles area museums feature black art: the Museum of African American Art and the California Afro-American Museum. The Golden State Mutual Life Insurance Company that is owned and operated by African Americans, has built a sizable collection of black art, has supported black art education, and has sponsored murals. In 1976 the Los Angeles County Museum of Art hosted the first major retrospective, *Two Centuries of Black American Art*. In San Francisco in 1967, the Blackman's Art Gallery was opened by William O. Thomas (active 1960s), a painter and stone carver. San Francisco is also home to the San Francisco African American Historical and Cultural Society.

Asian Americans

In 1965 America's immigration laws, which had long favored Northern and Western Europeans, were altered to accept greater quantities of peoples from the Pacific's eastern rim. Immigrants from Asia grew from 17,000 in 1965 to more than 250,000 in 1981, making them the fastest-growing legal immigrant group. Since new arrivals usually settle near relatives and friends or in a support community, the majority either temporarily or permanently settled in California. (It is simplistic, but convenient for this discussion, to classify Asians under one umbrella term. However, each artist obviously differs from the others not only in background [coming from such distinct cultures as India, Indonesia, the Philippines, Vietnam, China, Japan, and Korea] but also in gender, in personal opinions, and in aesthetic preference.)

Asian American artists didn't need the Civil Rights revolution to gain admittance to America's art mainstream. Long before 1960, California artists of Japanese and Chinese heritage made important contributions to the state's photography and watercolor movements (chapters 12, 19, 23). Europeans had long admired Oriental art and had a history of adopting certain of its ideas into their own products. Another wave of influence arrived in the 1950s. The Zen aesthetic was absorbed by the post-World War II crafts movement, and Eastern philosophies were adopted by Beats and others. What the Civil Rights movement did do was give Asian artists working in America's mainstream "permission" to use a greater amount of aesthetic and imagery from their homelands and, for those who had never used their art for revolutionary purposes, to address political subject matter. This direction was supported by the 1970s emphasis on the individual as well as by the 1980s trend for any artist (irrespective of race) to express personal issues in art.

Several recent books and exhibition catalogues identify the common attributes and concerns shared by post-1960 Asian American artists. With feet in two lands, they find themselves in the predicament of a bicultural existence, balancing Eastern and Western aesthetic and social traditions. A common theme among recent immigrants is the turmoil they experience over fitting into a new culture: the trauma of leaving their

birth countries, moving to a new land with different values, suddenly realizing they are in a minority, and trying to fit in. In their art they are able to express what it is like to float in a nether world, estranged from their native culture and homeland, yet alien in their adopted country.

Masami Teraoka (b. 1936) grew up in Onomichi on the Inland Sea of Japan. When he was in the second grade, his parents arranged for him to take watercolor lessons from a local artist. During his high school years he found himself attracted to Picasso's work and later to Mondrian's work, which reminded him of the aesthetics of Japanese architecture. In 1961 Teraoka embarked for America, attracted by Western contemporary art forms. He entered Otis Art Institute where he received his MFA degree in 1968. His arrival coincided with the beginning of the countercultural revolution, and he was immediately struck by the greater personal freedom he had in America as compared to Japan. In the early 1970s, realizing he was not yet fully acculturated in America, but no longer seeing the world with only a Japanese attitude, in essence caught between two worlds, he decided to merge his experiences—to express American social issues but in the aesthetic manner of a traditional Japanese art form of ukiyo-e woodblock prints. The ukiyo-e woodblock prints made for mass consumption in Japan from the seventeenth to the nineteenth centuries were then out of fashion in Japan. Teraoka, however, admired the old vocabulary and recreated it in watercolor. Often portraying his friends in his compositions, he set up narrative situations that contained subtle references to the meeting of the two cultures, which he presented with wry humor. His first series was *McDonald's Hamburgers Invading Japan,* of which *Geisha and Tattooed Woman* of 1975 (fig. 33-6) is one. The calligraphy in the background spells out the Geisha's question to the blond woman, How does one eat a McDonalds hamburger? (a new delectable just being marketed in Japan). By merging the simple and direct presentation of Pop icons with motifs associated with his ethnic background, and by taking up the theme of the cultural clash between East and West, Teraoka became a pioneer among Asian American artists. His work reveals great technical facility, keen observation, and a wry sense of humor.

Through the 1970s Teraoka addressed contemporary issues such as consumerism, environmental problems, and sexuality. In 1980 he moved to Hawaii and produced several series depicting the awkwardness of encounters between tourists from Japan and the United States. In 1986 he was one of the earliest artists to take up the theme of AIDS, which he did in his *American Kabuki/Oishiiwa,* a watercolor mounted on a traditional Japanese folding screen. *Oishiiwa,* a coined word that merges two Japanese words meaning "delicious" and "oiwa ghost," is a pun referring to the oftentimes deadly aspect of the pleasure of sex. In the 1990s, as the art world in general turned to addressing personal, social, and political concerns, Teraoka moved on to new themes such as human sexuality, religion, gender, sexual harassment, and high-tech culture (including Internet, email, and media invasion of privacy). Most recently he has taken up oil painting and the aesthetic of Renaissance art.

Female artists of color are often as interested in female and feminist issues as in bicultural questions. **Hung Liu** (b. 1948), born in China, was prevented from attending college by the Cultural Revolution that erupted in 1966 and sent her to the countryside to work in the fields. With the normalization of diplomatic relations between China and the United States in the late1970s, she was granted permission to complete her art training in China and later in America, where she decided to remain. She was in her mid-thirties when she received an MFA from University of California, San Diego. Liu experienced somewhat the same liberation as Teraoka, her turning point occurring in 1988 when she worked on the Capp Street

Fig. 33-6
Masami Teraoka (b. 1936)
McDonald's Hamburgers Invading Japan/ Geisha and Tattooed Woman, 1975
watercolor on paper
14¼ x 21½ in.
Masami Teraoka

Project in San Francisco. To fulfill a commission titled *Resident Alien*, she began looking at historical photographs. This developed into a general interest in identity. Liu's *Judgment of Paris* of 1992 (fig. 33-7) juxtaposes photographs of two young Chinese prostitutes from the turn of the century with a vase painted with a well-known scene from Greek mythology that shows the shepherd Paris judging whether Juno, Venus, or Minerva is the fairest of all the world's women. Liu obtained her prostitute photos from two books of famous Chinese "ladies of the night," published about the turn of the century, which she discovered during a 1991 trip to her homeland. Possibly because the shots were taken by a photographer with a Western European "eye" and were meant to attract "Westernized" clients, these girls have been robbed of their Chinese identity and have been made into commodities—they are posed in a Victorian "stage" set, they look directly at the lens in a provocative way, and the captions identify them by their professional names rather than their birth names. Liu was intrigued at these early examples of the coming together of the Oriental and Occidental cultures. Subliminal are the issues of female subjugation and exploitation. By juxtaposing the traditional Chinese stereotypical image

of beauty with that of the European (the Judgment of Paris), Liu causes the viewer to weigh the concepts. Stylistically, Liu is up to date with her re-use of antique photographs and realism.

The most recent Asian American artists to make their presence felt in California's art world are those of Korean, Filipino, and Vietnamese backgrounds. They are now establishing their own art movements distinguished by their own blend of Eastern and Western ideas.

Many of California's museums have large holdings of historic Oriental art; some maintain permanent displays of it, or put on temporary exhibits. Commercial galleries in all cities sell both historic as well as contemporary Asian American arts and crafts. Museums specifically dedicated to showing art from Pacific Rim countries include the Pacific Asia Museum in Pasadena, The Japanese-American National Museum in the Little Tokyo section of downtown Los Angeles, and the Korean American Cultural Center on Wilshire Boulevard.

Native Americans
In the first half of the 1960s Native Americans once again began to stand up to the United States govern-

Fig. 33-7
Hung Liu (b. 1948)
Judgement of Paris, 1992
oil on canvas, lacquered wood
72 x 96 in.
Courtesy of Rena Bransten
Gallery, San Francisco,
California

ment's systematic destruction of their groups and cultures, to land expropriation, to disrespect for sacred sites, and to the topic of violated treaties. They were often supported by their "brothers," the more fiercely revolutionary Chicanos (chapter 34), who believed they shared a common ancestry through Aztlan, the fabled home of the pre-Columbian Indians. Native Americans also have the support of ecologists, who share their respect for nature and their desire to protect it from exploitation by commercial interests.

America's Native Americans still produce traditional pots and baskets, as well as leather and beadwork. (Native American culture does not differentiate between "craft" and "fine art".) However, in the last fifty years, some artists have begun to work in media of European origin. Many turn to their tribal culture for iconography and inspiration. Of all the ethnic groups discussed here, Native American artists have had the most difficult time adjusting to American art mainstream ideas and values. Whereas persons of European descent are by comparison stereotypically aggressive, money-driven, compulsive about "progress" and "innovation," and revere the individual's rights to expression over those of the group, Native Americans have been taught to regard themselves not as individuals but as part of a clan or tribe, even part of a greater universe, to which they have to sublimate their personal needs.

A few Native American artists have been successful in blending their centuries-old heritage of stories and iconography with American mainstream formalist aesthetic ideas. With more than 200,000 Native Americans in California, there are many tribal artists, and they work in all stylistic varieties, from complete realism to full abstraction. The majority of the fine arts activity seems to be taking place in the northern part of the state. **Frank L. Day** (1902–1976) (Konkow Maidu), one of the first of California's Native Americans to work with European media and aesthetic, is looked upon as a guru of sorts. After his father's death in 1922 he led a vagabond life for twelve years, working his way across the country and visiting many Indian groups to learn about their cultures. In Oklahoma, experiencing a kind of epiphany, he trained as a spiritual teacher and returned to California to spread the word. It is the shaman's role to be tribal orator and historian, to transmit that knowledge to his tribe, to serve as a conduit between a higher power and his people. Day had done this through music, but about 1960, while he was recuperating in a hospital from a serious accident, he took up painting. He soon began to render tribal stories and personal experiences. In the history of California's Native American art, he was one of the first to blend traditional oral teachings with

Fig. 33-8
Frank L. Day (1902–1976)
Toto Dance at Bloomer Hill,
1973
oil on canvas, 91.4 x 61 cm.
Collection of Herb and
Peggy Puffer
Photo courtesy Oakland
Museum of California

Western aesthetics, and thus he serves as a bridge between the old generation and the new.

His *Toto Dance at Bloomer Hill,* made about 1973 (fig. 33-8), is in the naive or folk style—it is representational but ignores academic rules of perspective. Native Americans, like Day, are not interested in outward "style" or illusionism but in the concepts behind images: in content, in potency of meaning, and in sacredness. *Toto Dance at Bloomer Hill* tells the story of the creation of Bloomer Hill, the area in Northern California where Day was born and raised. It shows how Deer Dancer helped shape the landscape by stomping his feet and by pounding the earth with his deer-footed staffs. He is aided by Caterpillar, one of the overly large insects and animals of legendary times who also changed the landscape through their natural habits and actions. In this case, his movement across the land burrows a channel for one of the branches of Feather River. The cloud represents the steam driven out of the earth by the pounding and the belief that the sky reflects turmoil on earth. To the Konkow, Bloomer Hill is a place of mystery and spirit, rich in flora and fauna and beautiful changing vistas. The large number of paintings that Day left on his death represents an archive of his tribe's customs and legends.

Fig. 33-9
Franklin D. Tuttle, Jr.
(b. 1957)
*Above the Valley, A
Commotion…*, 1984
acrylic on paper, mixed media
40 x 32 in.
Collection of the artist

Frank D. Tuttle, Jr. (b. 1957) (Yuki/Konkow Maidu) spent the 1980s working in an almost pure abstract style, except that in his *Above the Valley, A Commotion* of 1984 (fig. 33-9) one can discern feather bundles. These are aligned on the right and left sides of the painting into vertical sashes. Throughout California, native peoples often identify sashes and their materials with prestige and wealth. Like flags, sashes may be suspended to announce the occurrence of a special event or ceremony. One of the Native American's most important concerns is the respect for nature and the need to live and learn from Creation. Tuttle's paintings, like the traditional worldview that informs his work, are meant to renew him and the Earth and to acknowledge the interdependence of all life on this planet. The title of this work refers to a tribal belief that the sky often reflects what is happening on earth. The title tells us there is a "commotion," thus making the sky a portent of change. Through this painting, Tuttle reminds people to look at themselves and their relationship to the world, to see the current state of events, and, if necessary, to correct it, to bring humanity back to a unified state with nature. Many Native American artists are also involved with tribal life as singers, dancers, and regalia makers and create art with this relationship in mind, perhaps influenced by its spiritual power. Like an Abstract Expressionist artist, Tuttle embarks on a painting as on a journey. As he develops his composition he comes to new realizations that then affect his decisions and further direction. To use a mainstream word, his interest lies in the "process" of painting, the adventure—an experience he sees as akin to life itself. His colors are often those of natural materials found in ceremonies, or they are the unexpected, unnoticed colors of everyday experience. Red is a favorite, because it is so rare in nature. He often scratches the surface of his work with an etching stylus to reveal hidden layers and to texture it, to make the surface further interact with light. Tuttle also composes free verse that relates to the imagery or process of image building. His writing is often inscribed on the reverse of the canvas with oil paint or India ink. His titles may be phrases taken from these verses. In the 1990s, the artist has turned to making multimedia objects that absorb representational painting into the format of wall-hung shrines.

Several California institutions support and exhibit Native American arts, including the Southwest Museum in Los Angeles; the C. N. Gorman Museum, University of California, Davis; the California State Indian Museum, Sacramento; and the Palm Springs Desert Museum. Such art is also shown at Indian powwows, at special exhibitions, and at many commercial galleries.

The state's largest racial sub-group—Latinos—has been a major factor in the state's art. While Latino artists share many interests and concerns with the groups discussed in this chapter, they have contributed their own unique innovations, and those will be discussed in the next chapter. ❧

Bibliography

America's Civil Rights Movement of the 1960s

Cockcroft, Eva, et al., *Toward a People's Art: The Contemporary Mural Movement,* New York: E. P. Dutton & Co., Inc., 1977. 292 p.

Felshin, Nina, ed., *But is it Art?: The Spirit of Art as Activism,* Seattle: Bay Press, Inc., 1995.

Hayden, Dolores, *The Power of Place: Urban Landscapes as Public History,* Cambridge, Ma.: Massachusetts Institute of Technology Press, 1995. 296 p.

Lucie-Smith, Edward, *Race, Sex, and Gender in Contemporary Art,* New York: Harry N. Abrams, Inc., 1994.

Women Artists before 1960

Berney, Charlotte, "Appreciating Women Artists," *Antiques & Fine Art,* v. 7, no. 4, May/June 1990, pp. 43-44.

Dominik, Janet B., "Women Artists of California: Late 19th to Early 20th Century," *Antiques & Fine Art,* v. 4, no. 3, March/April, 1987, pp. 32–37.

Irwin, E. P., "San Francisco Women Who Have Achieved Success," *Overland Monthly and Out West Magazine,* v. 44, November 1904, pp. 512–20.

Kamerling, Bruce, "Modern Perspectives: Three Women Artists of the 1920s and 1930s," *Journal of San Diego History,* v. 40, no. 3, Summer 1994, pp. 83–141.

Kamerling, Bruce, "Painting Ladies: Some Early San Diego Women Artists," *Journal of San Diego History,* v. XXXII, no. 3, Summer 1986, pp. 147–191.

Moore, Sylvia, ed., *Yesterday and Tomorrow, California Women Artists,* New York: Midmarch Arts Press, 1989.

Six Early Women Artists: A Diversity of Style, exh. cat., Carmel Art Association, August 8–September 3, 1991.

Trenton, Patricia, et. al., *Independent Spirits: Women Painters of the American West 1890–1945,* Autry Museum of Western Heritage in association with University of California Press, 1995. 304 p.

A Woman's Vision: California Painting into the 20th Century, essay by Raymond L. Wilson, exh. cat., Maxwell Galleries, San Francisco, November 30, 1983–January 31, 1984.

Women Artists and Feminist Art after 1960

(See also bibliography for Performance Art and Video in chapter 29; See also bibliography for Neo-Feminism in chapter 37.)

All Our Lives: 500 Years of Making Art: A Retrospective of Seven Monterey Bay Women Artists, exh. cat., organized by Monterey Bay Women's Caucus for Art and held at Michaelangelo Gallery, Santa Cruz, February 3–24, 1995. 35 p.

Anonymous Was a Woman: A Documentation of the Women's Art Festival: A Collection of Letters to Young Women Artists, Valencia: California Institute of the Arts, Feminist Art Program, 1974. 137 p.

Art: A Woman's Sensibility, Valencia, Ca.: California Institute of the Arts, Feminist Art Program, 1975.

Bad Girls West [response to *Bad Girls* exhibit at the New Museum, N. Y.], brochure, Wight Art Gallery, University of California, Los Angeles and New Museum, Jan 25–March 20, 1994. 20 p.

Bovenschen, Silvia, "Is There a Feminine Aesthetic?" *Heresies,* v. 1, no. 4, Winter 1977-78, pp. 10-12.

Broude, Norma and Mary D. Garrad, eds., *The Power of Feminist Art: The American Movement of the 1970s, History and Impact,* New York: Abrams, 1994.

Chicago, Judy and Arlene Raven, *Anonymous Was a Woman,* Valencia, Ca.: California Institute of the Arts, Feminist Art Program, 1974.

Contemporaries: 17 Artists [Southern California women], exh. cat., Security Pacific Bank, Los Angeles, Ca., January 29 - March 31, 1980. 48 p.

Demetrakas, Johanna, *Womanhouse,* [forty minute independent documentary color film] New York: Women Make Movies, between 1990 and 1996.

Dickinson, E., "The Statue of Liberty Disrobes," [feminist conference in San Francisco] *Women Artists News,* v. 7, pt. 1, April-May 1981, pp. 12-19.*

Dropped Lines [20 Women artists from UCSD], exh. cat., CWSS Seneca Falls Gallery, June 17–July 29, 1983. 32 p.

Exploring a Movement: Feminist Visions in Clay: A Multi-Site Exhibition of Feminist Ceramics Presented in Four Themes, exh. cat., Laband Art Gallery, Loyola Marymount University, Los Angeles, October 27 – December 9, 1995 and other locations. 52 p.

Fifteen Years and Growing: Celebrating the Fifteenth Anniversary of the Woman's Building, the History and Programs of the Woman's Building, a Public Center for Women's Culture Founded in 1973, Los Angeles: Woman's Building, 1988.

The First Decade, Celebrating the Tenth Anniversary of the Woman's Building: A Pictorial History and Current Programs, Los Angeles: Womans Building, 1983.

Frankel, Dextra, *Invisible/ Twenty-One Artists/ Visible,* exh. cat., Long Beach Museum of Art, Long Beach, Ca., March 26–April 23, 1972. 60 p.

Gear, Josephine, "Some Alternative Spaces in New York and Los Angeles," *Studio International,* v. 195, 1980, pp. 63–68.

Generation of Mentors, [sponsored by the Southern California Council of the California Committee of the National Museum of Women in the Arts, Washington, D. C.], exh. cat at three venues including Art Gallery, Mount Saint Mary's College, Los Angeles, January 25–April 8, 1995. 79 p.

Ianco-Starrels, Josine, *25 California Women of Art,* exh. cat., Lytton Galleries of Contemporary Art, Hollywood, 1968.

Kerr, Joanne, *Art and Community: A Sociological Study of Contemporary Feminist Art,* [Southern California] Ph. D. dissertation, University of California, Irvine, 1980. 248 l.

Litman, Lynn, *Womanhouse.* One-hour film made for Los Angeles Educational Television (KCET-TV), February 1972.

Mayer, Laura Dawn, *Central Core Imagery and the Language of Fetishism in Womanhouse and The Dinner Party,* M. A. Thesis, University of California, Riverside, 1994. 178 l.

1989 Annual Exhibition (Guadalupe Garcia, Reiko Goto, Mildred Howard, Hilda Shum), exh. cat., Walter/McBean Gallery, San Francisco Art Institute, August 29–September 30, 1989. 21 p.

Nochlin, Linda, "Why Are There No Great Women Artists?" in Vivian Gornick and Barbara K. Moran, eds., *Woman in Sexist Society,* New York: Basic Books, 1971.

Raven, Arlene, *At Home,* exh. cat., Long Beach Museum of Art, late fall, 1983. 65 p.

Rindfleisch, Jan, *Staying Visible: the Importance of Archives: Art and "Saved Stuff" of Eleven 20th Century California Artists,* [women artists], exh. cat., Euphrat Gallery, DeAnza Community College, Cupertino, Ca., September 22–October 23, 1981.

Rosen, Randy, *Making their Mark: Women Artists Move into the Mainstream 1970–85,* New York: Abbeville, 1989 [exh. at four museums beginning with Cincinnati Art Museum, February 22–April 2, 1989].

Rosenbach, U., "Woman's Culture in Los Angeles," [Woman's Building] *Heute Kunst,* no. 14-15, May-August 1976, pp. 32–4.*

Rosler, M., "The Private & the Public: Feminist Art in California," *Artforum,* v. 16, pt. 1, September 1977, pp. 66–74. [state of the Woman's Building; feminist performance]

Roth, Moira, ed., *Connecting Conversations: Interviews with 28 Bay Area Women Artists,* Oakland: Eucalyptus Press, 1988. 200 p.

Roth, Charlene, "Parafeminism," *Artweek,* v. 27, no. 7, July 1996, pp. 18–19.

San Francisco Women Artists, exh. cat., Art Department Gallery, California State College, Sonoma, n. d., 1969. 31 p.

Schapiro, Miriam, "The Education of Women as Artists: Project Womanhouse," *Art Journal,* v. 31, Spring 1972, pp. 268–70.

Schapiro, Miriam, "Recalling Womanhouse," *Women's Studies Quarterly,* v.15, Spring/Summer 1987, pp. 25–30.

Self-Portraits by Women Artists, exh. cat., Security Pacific Bank, Los Angeles, Ca., January 26–April 7, 1985. 44 p.

Showcase 86: Contemporary Works by 23 California Women Artists, exh. cat., ASI University Union Gallery, California State Polytechnic University, Pomona, February 19–March 26, 1986. 49 p.

Showcase 87: Contemporary Work by 21 California Women Artists, exh. cat., California State Polytechnic University, Pomona, March 5–20, 1987.

Southern California Women Writers & Artists, Los Angeles: Books of a Feather, 1984. 158 p.

Stofflet-Santiago, M., "Feminist Art Program in San Francisco," *Feminist Art Journal,* v. 4, pt. 4, Winter 1976, pp. 38–39.

Tough—Second Annual Juried Exhibition of the Southern California Chapter of the Women's Caucus for Art, exh. cat., Fine Arts Gallery, California State University, Northridge, 1980. 24 p.

Von Blum, Paul, *Other Visions, Other Voices: Women Political Artists in Greater Los Angeles,* Lanham, Md.: University Press of America, 1994. 200 p.

Wilding, Faith, By *Our Own Hands/The Women Artist's Movement. Southern California 1970-1976,* Santa Monica: Double X, 1977. 111 p.

Women Painters East-West, exh. cat., Pacificulture-Asia Museum, Pasadena, Ca., July 17–September 30, 1974. [half Joryu Gaka Kyokai and half Women Painters of the West] c. 100 pps.

Womanhouse, Valencia, Ca.: California Institute of the Arts, Feminist Art Program, 1972. 32 p.

Woman's Building Records 1973–1991, Archives of American Art, Smithsonian Institution, Washington, D. C.

"Women's Design Program, California Institute of the Arts," *ICOGRAPHIC* (U. K.) no. 6, 1973, pp. 8–11.*

"Women in the Visual Arts," *Visual Dialog,* v. 1, no. 2, December 1975–January/February 1976.

"Women in the Visual Arts (No. 2)," *Visual Dialog,* v. 2, no. 3, March–May 1977.

Gay and Lesbian Art, American

Cameron, Daniel J., *Extended Sensibilities: Homosexual Presence in Contemporary Art,* exh. cat., New Museum, New York, October 16–December 30, 1982. 60 p.

Cooper, Emmanuel, *The Sexual Perspective: Homosexuality and Art in the Last 100 Years in the West,* London: Routledge and Kegan Paul, 1986. 324 p.

Davis, Whitney, ed., "Introduction," in *Gay and Lesbian Studies in Art History,* New York: Haworth, 1994. (*Journal of Homosexuality,* v. 27, no. 1–2, 1994)

In a Different Light: Visual Culture, Sexual Identity, Queer Practice [exh. cat., California and American artists, University Art Museum, University of California, Berkeley], ed. by Nayland Blake, San Francisco: City Lights Books, 1995. 351 p.

Weinberg, Jonathan, *Speaking for Vice: Homosexuality in the Art of…and the First American Avant-Garde,* New Haven: Yale University Press, 1993.

Gay and Lesbian Art

(See also bibliography for personal identity and AIDS in chapter 37.)

Against Nature: A Group Show of Work by Homosexual Men, exh. cat., Los Angeles Contemporary Exhibitions, January 6–February, 12, 1988. [Reviewed Fred Fehlau, "Whose Nature," *Art Issues,* no. 4, May 1988, p. 18.]

All but the Obvious: Writing, Visual Art, Performance, Video by Lesbians, exh. cat., Los Angeles Contemporary Exhibitions, November 2–December 23, 1990.

Duncan, Michael, "Queering the Discourse," [gay and lesbian art, University Art Museum, Berkeley] *Art in America,* v. 83, no. 7, July 1995, pp. 27+.

Elliot, M. T., "Lesbian Art and Community," *Heresies,* no. 3, Fall 1977, pp. 106–7.

Guerilla Girls Talk Back: the First Five Years, exh. cat., Falkirk Cultural Center, San Rafael, May 16–August 25, 1991. 48 p.

Ischar, Doug, "Parallel Oppressions," [installation by 2 Calif. artists] *Afterimage,* v. 16, pt. 7, February 1989, pp. 10–11.

"Lesbian Art and Artists," *Heresies a Feminist Publication on Art and Politics,* v. 1, issue 3, 1977.

Marks, Laura U., "Boy's Guide to Anarchy," [re: SF activist group, Boys with Arms Akimbo] *Afterimage,* v. 17, pt. 9, April 1990, p. 3.

Mills, Jerry and Dwight Russ, "Hard-On Art," [re: Gay "skin" magazines], *In Touch for Men,* no. 31, pp. 60-69.

Pervert [Art by Gay and Lesbian Artists, half from Calif.], exh. cat., Art Gallery, University of California, Irvine, April 11–May 6, 1995. c. 40 p.

Raven, Arlene, "Los Angeles Lesbian Arts," *[Atlanta] Art Papers,* v. 18, November/December, 1994, pp. 6–8.

Situation: Perspectives on Work by Lesbian and Gay Artists, exh. cat., New Langton Art, San Francisco, June 18 - July 13, 1991.

Stryker, Susan and Jim Van Buskirk, *Gay by the Bay: A History of Queer Culture in the San Francisco Bay Area,* San Francisco: Chronicle Books, 1996.

Tamblyn, Christine, "Boy's Club, Craft Hut, Carnival or Cyberspace? [art scene SF]" *High Performance,* v. 16, Summer 1993, pp. 56-63.

(For bibliography on Lesbians, see also Feminist.)

Ethnic Minorities/Race, General

Beelick, Susan A., "American Women of Color Artists: A Selected Annotated Bibliography," [all races] *Visual Arts Research,* v. 19, no. 2, Fall 1993, pp. 68-76.

Bhabha, Homi K., "Beyond the Pale: Art in the Age of Multicultural Translation," *Kunst & Museumjournaal* (English edition), v. 5, no. 4, 1994, pp. 15–23 [fringe position allows artists to better observe mainstream]

Lippard, Lucy R., *Mixed Blessings: New Art in a Multicultural America,* New York: Pantheon Books, 1990.

Ethnic Minorities/Race

Blaine, J., "Finding Community Through the Arts," [minorities in LA] *Arts in Society* (USA), v. 10, pt. 1, Spring–Summer 1973, pp. 125–37.

Hale, Sondra and Joan Hugo, *Counterweight: Alienation, Assimilation, Resistance* [half Calif. artists] exh. cat., Santa Barbara Contemporary Arts Forum, November 7, 1992–January 23, 1993. 52 p.

Mistaken Identities, essay by Abigail Solomon-Godeau, exh. cat., University Art Museum, University of California, Santa Barbara, November 11–December 20, 1992 and four other venues. 80 p.

Only L.A.: Contemporary Variations: 27 Los Angeles Artists, exh. cat., Los Angeles Municipal Art Gallery, June 10–July 20, 1986. 30 p.

Other Sources: An American Essay, exh. cat., San Francisco Art Institute, September 17–November 7, 1976. [about half Calif.]

Staying Visible, The Importance of Archives: Art and "Saved Stuff" of Eleven 20th-Century California Artists, exh. cat., Deanza College, Cupertino, Ca., September 22–October 23, 1981. 46 p.

A Third World Painting /Sculpture Exhibition, exh. cat., San Francisco Museum of Art, June 8–July 28, 1974. 70 p.

Villa, Carlos and Moira Roth, "Coming Together: Multi-cultural communities in the Bay Area," *Artweek,* v. 20, November 9, 1989, pp. 2--3.

Black Artists, American

Black Art: Ancestral Legacy: The African Impulse in African-American Art, Dallas Museum of Art and Harry N. Abrams, Inc., N.Y., 1989. 305 p.

Chinweizu, *The West and the Rest of Us: White Predators, Black Slavers and the American Elite,* New York: Vintage Books, 1975.

Driskell, David C., *Two Centuries of Black American Art,* Los Angeles County Museum of Art and Alfred A. Knopf, New York, 1976.

Lewis, Samella, *African American Art and Artists,* Berkeley: University of California Press, 1990. 302 p.

Lewis, Samella and Ruth Waddy, *Black Artists on Art,* 2 vols., Los Angeles: Contemporary Crafts, 1971.

Black Artists

(See also extensive bibliography in publication by Samella Lewis.)

"Beulah Woodard" in Nancy Moure, *Painting and Sculpture in Los Angeles 1900-1945,* exh. cat., Los Angeles County Museum of Art, September 25–November 23, 1980, p. 74 and footnote.

California Black Artists, New York: Studio Museum in Harlem, 1978. [Pref. by Leonard Simon] 16 p.

California Black Craftsmen [Exhibition of Nineteen Black Craftsmen Living and Working in California], exh. cat., Mills College Art Gallery, Oakland, February 15–March 8, 1970. 22 p.

Carter, Francine R., "The Golden State Mutual Afro-American Art Collection," *Black Art,* v. 1, pt. 2, Winter 1976, pp. 12–23.

Drescher, Tim, "'Our History is No Mystery,' New Mural in S. F.," *Left Curve* (SA), no. 6, Summer-Fall 1976, pp. 62-66.

Dunitz, Robin, "The African-American Murals of Los Angeles," *American Visions,* v. 9, December 1994–January 1995, pp. 14–18.

Emerging Artists: Figurative Abstraction, exh. cat., California Afro-American Museum, Los Angeles, August 6, 1988–January 1, 1989. 38 p.

Flamming, Douglas, *History of African American Art and Culture in Los Angeles* [1996–7 Huntington Research Fellowship given to Assoc. Prof. Cal Tech.] in process.

Gubert, Betty Kaplan, "Black Women Artists in California," in Sylvia Moore, ed., *Yesterday and Tomorrow: California Women Artists,* New York: Midmarch Arts Press, 1989, pp. 193–201.

Harris, Peter J., "Leimert Park Village," [area of LA for black art and food] *American Visions,* v. 7, no. 3, June/July 1992, pp. 26+.

In the Black, exh. cat., Irvine Fine Arts Center, Irvine, Ca., December 2, 1994–February 26, 1995. 74 p. [not exclusively California artists]

Lark, Raymond, *Art West Associated, Inc.,* [14 biographies of black artists] Los Angeles: Art West Associated, 1973. 36 p.

Los Angeles Collects, by Paulette S. Parker, exh. cat., Museum of African American Art, Los Angeles, October 9–December 27, 1987. 35 p.

Los Angeles Murals by African-American Artists: A Book of Postcards, Los Angeles: RJD Enterprises, 1995.

"Los Angeles Street Graphics," *Black Graphics International* (USA), Fall-Winter 1975, pp. 71–73.*

The Media, Style, and Tradition of Ten California Artists: The Inaugural Exhibition of the California Museum of Afro-American History and Culture, exh. cat., MAAHC, October 2–November 14, 1981.

No Justice, No Peace? Resolutions…. [protest art prompted by the April 1992 Los Angeles uprising], exh. cat., The California Afro-American Museum, Los Angeles, October 3, 1992–July 5, 1993. 60 p.

Patterns & Patents: 6 Emerging African American Artists from the Bay Area, exh. cat., Mary Porter Sesnon Art Gallery, University of California, Santa Cruz, May 8 - June 1, 1990.

St. Elmo Village: The 16th Annual Festival: The Art of Creative Survival, Los Angeles, 1986.

UCLA Oral History program, Catalog of the Collection [includes several interviews in a section titled *Los Angeles African American Artists*] compl. by Vimala Jayanti, Los Angeles: Department of Special Collections, Research Library, University of California, 1992.

Varying Directions of Contemporary Black Artists, exh. cat., Otis Art Institute Gallery, Los Angeles, January 26 - February 23, 1975. 16 p.

West Coast 74 Black Image: 1974 Invitational Exhibition, Sacramento: E. B. Crocker Art Gallery, September 13 - October 13, 1974 and two other venues. 69 p.

Asian-American Artists

Artists of Chinese Origin in North America: Directory, 1993–1994, Westmont, Ill: Artists' Magazine, 1993. 281 p.

Asia/America: Identities in Contemporary Asian American Art, exh. cat., The Asia Society Galleries, New York, February 16–June 26, 1994. 127 p.

Denker, Ellen, *After the Chinese Taste: China's Influence in America, 1730–1930*, Salem, Ma.: Peabody Museum of Salem, 1985. 80 p.

Gelburd, Gail, *The Transparent Thread: Asian Philosophy in Recent American Art*, exh. cat., Hofstra Museum, Hofstra University, Hempstead, N. Y., September 16–November 11, 1990 and other venues. 124 p.

Sullivan, Michael, *The Meeting of Eastern and Western Art*, Berkeley: University of California Press, 1989.

Asian-Californian Artists

(See bibliography for Asian Artists in chapter 23.)

Asian American Artists in Los Angeles: Transcript of Identity and Access [a public forum] collectively organized by the Japanese American National Museum and the Museum of Contemporary Art, Los Angeles, Part I, July 18, 1992. 39 p.

"Community Celebration: the Filipino American Arts Exposition," *Artweek*, v. 25, July 21, 1994, p. 2.

De Paoli, Geri, "The Missing Link: Zen-Tao in California Art," *Art of California*, v. 6, no. 3, June 1993, pp. 44–47. [Asian influence on California's Caucasian artists]

East/West: Contemporary Asian-American Art in Los Angeles, exh. cat., Montgomery Gallery, Pomona College, Claremont, Ca., March 2–30, 1986. 8 p.

Encounter 1996: Vietnamese Artists Group Exhibition: Works by 16 Contemporary Vietnamese Artists, exh. cat., Pacific Asia Museum, Pasadena, Ca., June 29–August 18, 1996. 26 p.

Expressions: The First Art Exhibit of the Filipino Artists Guild of Glendale, U.S.A., exh. cat., 500 North Brand Blvd., Glendale, June 1–July 6, 1992.

Hori, Robert, "Five Japanese Artists in Los Angeles," in *Lax/94: the Los Angeles Exhibition*, exh. cat. for exhibitions held at nine Los Angeles area museums in roughly November–December 1994. 164 p.

Jennings, Jan, "Environmental Escapes: The Art of Kwan Jung and Yee Wah Jung," *Art of California*, v. 5, no. 5, November 1992, pp. 57-59.

Junctures, Disjunctures & Fusions: Asian American Artists, exh. cat., Rancho Santiago College Art Gallery, Santa Ana, Ca., October 27 - November 22, 1988. 5 p.

Kang, Yeoung Jae, "Bone by Bone: How and Why to Research the Work of Asian American Artists," *Heresies*, v. 7, no. 25, 1990, pp. 50-52 [re: Mills college Asian American Women's Art Research Project, Oakland]

Kano, Betty, "Four Northern California Artists," [Asian-American women] *Feminist Studies*, v. 19, Fall 1993, pp. 628-42.

Landres, Jonathan Shawn, *Public Art as Sacred Space: Toward an Interpretive Theory of Asian-American Community Murals in Los Angeles*, M. A. Thesis, University of California, Santa Barbara, 1995.

Lee, Candace, *A Gathering Place: Artmaking by Asian/Pacific Women in Traditional and Contemporary Directions*, exh. cat., Pacific Asia Museum, Pasadena, Ca., n. d., 1995. 88 p.

Lee, Sarah, *Who's Afraid of Freedom: Korean-American Artists in California*, exh. cat., Newport Harbor Art Museum, March 8–May 25, 1996. 55 p.

Leong, Russell, *Moving the Image: Independent Asian Pacific American Media Arts*, Los Angeles: UCLA Asian American Studies Center, 1991. 287 p.

MacNaughton, Mary, "Asia Meets America in Los Angeles," *Arts Magazine*, v. 61, December 1986, pp. 60-64.

On Common Ground = Un Common Ground [Viet conflict in art], exh. cat., City of Irvine, Ca.: Irvine Fine Arts Center, 1991. 25 pp.

Since Viet-Nam: the War and Its Aftermath, exh. cat., Guggenheim Gallery, Chapman College, Orange Ca., September 10–October 25, 1984. 8 p.

Southern California Asian American Artists 1975, exh. cat., Sacramento: State Capitol Building, presented by the office of Governor Edmund G. Brown, October 26, 1975–January 9, 1976. 22 p.

Tastes Like Chicken: Contemporary Filipino-American Artists, exh. cat., University Art Gallery, Dominguez Hills, Ca., September 28–October 25, 1995.*

"…there were no Filipino art books…," [dialogue between 3 Bay Area Filipino artists], *Artweek*, v. 22, July 4, 1991, pp. 24+.

Traditions Transformed: Contemporary Works by Asian American Artists in California, exh. cat., Oakland Museum, November 3, 1984–January 27, 1985 and Doizaki Gallery, Japanese American Cultural and Community Center, L. A., April 13–June 3, 1985. 16 p.

Transcript of Identity and Access: Asian American Artists in Los Angeles, Part I: July 18, 1992: A Public Forum, organized and published by the Japanese American National Museum and the Museum of Contemporary Art, Los Angeles, 1992. 39 p.

With New Eyes: Toward an Asian American Art History in the West, exh. cat., San Francisco State University Art Department Gallery, September 24–October 26, 1995. 45 p.

Zimmerer, Kathy, "Silken Threads and Golden Butterflies: Asian-Americans," in Sylvia Moore, ed., *Yesterday and Tomorrow: California Women Artists*, New York: Midmarch Arts Press, 1989, pp. 179-192.

Native American Artists, General

Lester, Patrick D., *The Biographical Directory of Native American Painters*, Tulsa, Ok.: SIR Publications, 1995. 701 p.

Stewart, Kathryn, *Portfolio II: Eleven American Indian Artists*, San Francisco: American Indian Contemporary Arts, 1988. 48 p.

Native American Artists

The Extension of Tradition: Contemporary Northern California Native American Art in Cultural Perspective, exh. cat., Crocker Art Museum, Sacramento, July 13–October 6, 1985 and Palm Springs Desert Museum, December 6, 1985–February 23, 1986.

Kenagy, Suzanne G., "Eight Artists II: Contemporary Indian Art at the Southwest Museum," *American Indian Art Magazine*, v. 13, pt. 1, Winter 1987, pp. 54–61.

LaPena, Frank, "Contemporary Northern California Native American Art," *California History*, v. LXXI, no. 3, Fall 1992, pp. 386–401.

Personal Reflections: Masks by Chicano and Native American Artists in California, exh. cat., La Raza Bookstore, Sacramento, Ca., n. d., 1985? 24 p.

(For bibliography on Native American crafts, such as baskets, see Foreword; for bibliography on Native American rock painting, see chapter 20.)

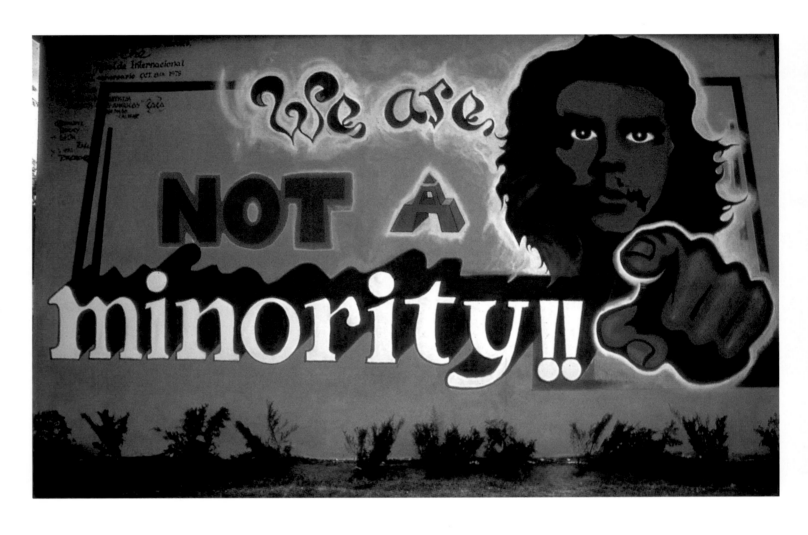

Fig. 34-2
Congresso de Artistas
Chicanos en Aztlan (CACA)
We are Not a Minority, 1979
acrylic on stucco, 24 x 32 ft.
Estrada Courts Housing
Project, East Los Angeles
Photo: Mario Torero

Beyond Modernism—Latino Artists
& California's Street Mural Renaissance

<div style="text-align: right">

34

</div>

For many Mexicans as well as Central and South Americans standing in the long lines at the United States-Mexico border crossing hoping to enter America, the wait can be well worth it. North of the chain-link fence lie the possibility of work and opportunities not available in their own countries. California has been seen as a place of opportunity successively by Native Americans, Spaniards, Mexicans, peoples of Western European background, and peoples from Pacific lands. Throughout the twentieth century, the flow of Latinos entering the United States has fluctuated with Mexico's social, political, and economic situation. Between 1900 and 1930 (during the Mexican Revolution and its aftermath) the influx amounted to about ten percent of Mexico's population. Although lack of work during America's Great Depression forced many to repatriate, World War II opened up countless opportunities in the form of jobs formerly held by Americans drafted into the armed forces or Japanese-Americans assigned to internment camps. In the postwar years, the stream of legal agricultural workers *(braceros)* and illegal migrants ("wetbacks") turned into a flood. Immigrants found themselves alternately subjected to deportation by the U. S. Immigration and Naturalization Service and to protection by federal laws passed by an American government trying to keep diplomatic peace with its southern neighbors and to prevent the hemisphere from falling to Communism. United States residents took advantage of the cheap labor yet some resented what they perceived as a negative influence in their culture, including gang violence and graffiti. Latinos are now a major presence throughout California, especially in Los Angeles County, where, as of the 1990 census, nearly thirty-eight percent of the population claims some "Hispanic" heritage. The city has the largest concentration of Mexicans outside Mexico.

What does the Latino presence in California have to do with art? For many years Mexican immigrants stoically weathered their treatment as second-class citizens for the opportunity to earn money and send it to relatives in their homelands. In the latter 1950s, no doubt aware of the blacks' attempts to force integration and of the Cuban Revolution (1959), Latinos began to voice their complaints. Cesar Chavez formed the United Farm Workers (UFW) in 1962 and led

successful boycotts of grapes and lettuce against the giant agribusinesses of California's Central Valley. He brought the attention of the public to the deplorable working conditions of field workers. His success gave urban Latinos the confidence to protest discrimination against them—police brutality, second-class housing, inadequate education that ignored the Spanish language as well as Chicano history, low-paying jobs, and the establishment's promotion of a Northern European ideal of beauty.

Latino artists worked hand-in-hand with activists to forward their cause. They made posters that carried revolutionary messages, and they drew cartoons for the UFW's bilingual, biweekly newspaper. Possibly hearing of the 1967 mural painted by black artists in Chicago, **Antonio Bernal** (active 1968) responded with California's first well-known Latino mural—the 1968 two-panel scene on the Teatro Campesino's El Centro Cultural in Del Rey (fig. 34-1), near Fresno. Borrowing its aesthetic from historical Mexican art—the processional composition is similar to one used in the Maya site of Bonampak—it presents important revolutionary role models to contemporary Latinos. Not only are Mexican and Chicano leaders represented, but black leaders Malcolm X and Martin Luther King, as well as Adelita, the female Mexican revolutionary.

Fig. 34-1
Antonio Bernal (active 1968)
Farm Worker Mural, formerly on El Centro Cultural, Del Rey, Ca., 1968
paint on plywood, 6 x 15 ft.
lost through deterioration
Photo: Robert Sommer

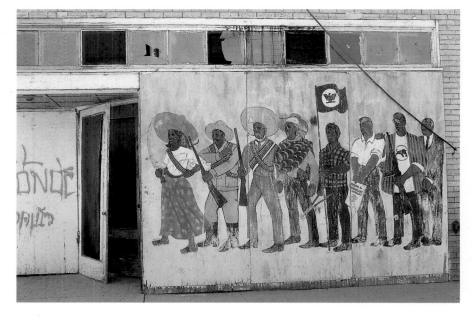

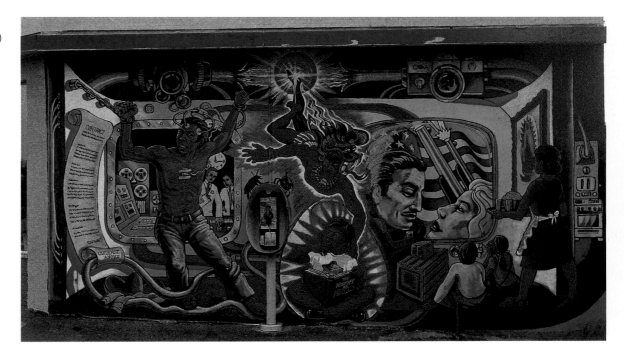

Fig. 34-3
David Rivas Botello (b. 1946)
Read Between the Lines,
August 1975
acrylic on stucco, 10 x 20 ft.
Photo: David Botello

In the years immediately following 1968, art spread with the Latino cause almost simultaneously to California's major metropolitan centers such as Los Angeles and San Francisco, to smaller cities such as Sacramento, and to every corner of the state. It was supported and fostered by the Latino's network of newly established community centers.

Murals

Outdoor mural painting, which last flourished in California in the 1930s (chapter 20), was revived in the late 1960s. Racial groups found it an excellent medium by which to proclaim their stances, and artists of all walks used it if they wanted to work in large scale or to present their work to the non-gallery-going public. Murals also proved an easy and inexpensive means for California cities to revitalize rundown neighborhoods and reduce graffiti and gang violence. The medium was fostered by the state's mild climate and its most popular construction technique: wood frame covered with stucco, its clean, smooth walls providing a perfect support for paint.

California's post-1965 mural movement was actually made up of many parallel movements, each with its own aesthetic and goals. These include murals by racial groups (Chicano, black, Asian-American), murals by establishment artists who sought broader public exposure and wanted to work in large size, murals commissioned by government entities to visually improve neighborhoods, and murals commissioned by the business community for beautification and advertising. All movements were born in the late 1960s, reached an apogee in the 1970s, and continue to thrive today. Specialists divide this thirty-year period into an initial phase of self-generated murals (c. 1965–74), the "CETA

period," when mural painting began to be funded by government agencies including the Comprehensive Employment Training Act (c. 1974–80), a third period in which volatile themes diminished and funding sources declined (1981–87), and the present period in which murals of all kinds proliferate on an equal basis.

Murals by California's Latinos

In the first, or "self-generated" phase of murals (1965–74), paintings appeared almost simultaneously throughout the state, primarily in Chicano neighborhoods. The artists' primary goals were to express themselves creatively, to get their work before an audience, and to deliver a message. Their themes were meant to give Latinos a sense of pride in themselves and their own history and then to demand equality with the white majority. *We are Not a Minority* of 1979 (fig. 34-2, p. 466) by **Congresso de Artistas Chicanos en Aztlan** (CACA) demonstrates several important points about early murals. Like many, it was painted not by an individual but a group—groups included coalitions, cooperatives, squads, and brigades, as well as inner-city youth attached to workshops. To work in a group allowed youths, gangs, and school children to give visual form to inner, personal emotions and to identify with the community where they were working. When others admired their accomplishment, they gained self-esteem. *We are Not a Minority* also demonstrates how early messages were simple and forceful. Chicano artists of Mexican heritage could look back to a rich history of murals extending from Mayan times to Mexico's muralists of the early 1920s—Diego Rivera, Jose Clemente Orozco, and the most militant, David Alfaro Siqueiros. Of all America's ethnic groups, Chicanos used the most violently revolutionary subject matter,

motifs such as the clenched fist, and the term *la raza* (a word that literally translates as "race," "people," or "breed" and that was used as a solidarity greeting or battle cry). They saw themselves as a working-class people of Indian background who were both spiritual and revolutionary. Although some might assume that murals of inflammatory subject matter would fan community resentment, in fact, the subjects did not provoke those to whom they were addressed. By painting such subject matter, the artist became a voice for the community, and, in turn, community residents identified with the story presented. By bringing submerged emotions to the surface, such murals became a vehicle for a symbolic resolution of these tensions, a way of venting steam, of making frustrated voices heard. The fact that this mural was painted at Estrada Courts Housing Project in East Los Angeles demonstrates how artists were open to using any wall that was visible and could support a painting. They used the walls on abandoned structures; on buildings belonging to friendly community organizations; on commercial businesses that either commissioned or allowed the murals; on freeway underpasses; and in rental housing projects offered by sympathetic landlords. Most were in Chicano areas—East Los Angeles, San Francisco's Mission District, and housing projects in the East Bay/Oakland. Unique to Los Angeles is the high concentration of murals in housing projects, the two most famous sites being Ramona Gardens and Estrada Courts.

Murals often served as teaching instruments. *Read Between the Lines* of 1975 (Ford and Olympic Boulevards, East Los Angeles) (fig. 34-3) by **David Rivas Botello** (b. 1946) provides wise guidelines for Chicanos. His "language" is iconography borrowed from diverse aspects of his heritage—Pre-Columbian Aztec and Maya art, the Catholic religion, Mexico's history, Mexican popular and folk art, as well as contemporary American experiences. To the left Botello has painted a contemporary Chicano being victimized by American technology along with a contract warning "Cuidense Amigos"—Be careful, friends. In the top center, the Aztec god Quetzalcoatl descends to inspire a contemporary child to study his Mexican ancestry. (Chicanos traced their roots to Pre-Columbian cultures.) To the right are two contemporary Chicano children watching American television on which a blond, blue-eyed woman is presented as an ideal for female beauty. On the wall to the right is an image of the Virgin of Guadalupe, an important Catholic image to Mexicans. Reading between the lines, one sees that Botello is urging Mexican Americans not to lose sight of their heritage, to study hard, not to be too manipulated by television and its American values, and to stick up for

their rights. Chicanos also employed iconography related to ecological issues and expressive of solidarity with oppressed peoples of Central and South America, who were also fighting for their democratic rights. They also adopted as iconography things they were against—things imposed on them by the establishment, such as commercial products, technology, nuclear war, and serving in Vietnam.

In the early 1970s, city and county institutions began to realize that these grassroots-generated murals were having a positive effect on troublesome areas. Community residents who observed the artists during the painting process learned the importance of artistic expression. Murals became the property of a community rather than of an individual; they provided a rallying point where young people could learn to cooperate rather than divide into gangs, and this in turn eased gang violence and decreased graffiti (chapter 31).

Los Angeles and San Diego distinguished themselves as the two cities that provided funding for the greatest number of murals created by gangs and youth groups. Los Angeles muralist **Willie Herron** (b. 1951) in his *The Wall that Cracked Open* of 1972 (fig. 34-4) showed Chicanos breaking down the psychological wall surrounding them. He acknowledges graffiti as an aesthetic asset rather than a sign of vandalism. During the one and a half days it took Herron to paint this

Fig. 34-4
Willie Herron (b. 1951)
The Wall that Cracked Open/4125 City Terrace, East LA, 1972
enamel and acrylic on stucco
25 x 15 ft.

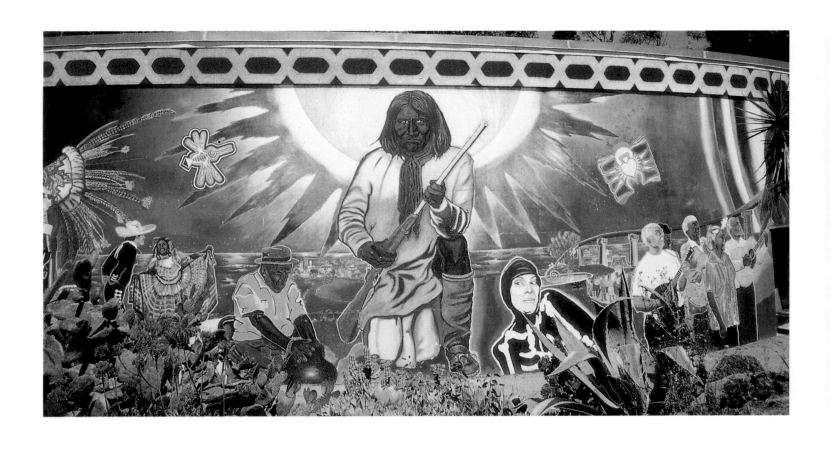

mural, he provided paints and brushes to passers-by and invited them to contribute to his painting. Their single-line block letters are characteristic of Los Angeles's graffiti typeface (chapter 31). Painted on the side of a bakery owned by a relative of the artist, the mural has survived longer than most. Although the neighborhood demographics have changed and many current residents are not aware of the significance of the mural, taggers continue to add to it, making it a kind of shrine that is continually renewed and strengthened by the community. Incorporating graffiti interested Herron in the very early 1970s. He also used it in a mural of Quetzalcoatl that he intends to reveal soon from under its partial coat of whitewash. *The Wall that Cracked Open* has great personal importance to Herron, who hoped it would convey a sense of social awareness to the youth gangs plaguing his community, particularly one gang that brutally beat his brother.

Once murals were absorbed into the mainstream through government funding, museum recognition, and documentation in art histories, some artists turned to subject matter that was less violent and addressed subjects such as ecology, sports, and community and racial togetherness. A composite scene that is primarily a celebration of Mexican achievements appears in *Geronimo* of 1981, painted by **Victor Ochoa** (b. 1948) on the Centro Cultural de la Raza, Balboa Park, San Diego (fig. 34-5). The main figure is the Apache chief Geronimo. He is regarded by Latinos as a symbol of bravery against racial oppression. He is also a border phenomenon in that he not only fought against the U.S. Cavalry but against Mexican Federales. (Latinos felt like brothers to Native Americans of the Southwest, where the Mexicans' legendary homeland Aztlan is believed to have been located.) The mural also includes vignettes showing the workshops and other cultural activities associated with the Centro. To the far left are two folk dancers and an hombre fashioning something from a hunk of clay. The skeleton-costumed person in the foreground refers to the "Day of the Dead" (celebrated on October 31, All Saints' Day, and November 1, All Souls' Day), one of the Mexican people's most important holidays. Like the European Halloween, it was originally meant to be a day for remembrance of the dead and meditation on one's own mortality, but it evolved into a joyous celebration, replete with humor and political satire. The scene to the right refers to a local San Diego scene—the park Latinos obtained for themselves at the Logan-neighborhood end of the Coronado Bay Bridge. Ochoa, who has been active in San Diego since receiving his bachelor-of-arts degree from San Diego State University in 1974, co-founded and served twice as director of the

Centro Cultural de la Raza and was co-initiator of the Chicano Park mural project. *Geronimo* and murals like it visually remind Chicanos of their history and celebrate their uniqueness.

A mural example in San Francisco is *Para el Mercado* (fig. 34-6) by the women's mural group **Las Mujeres Muralistas** (active 1973–80). Painted on the fence of a parking lot, it was meant to encourage community residents of the Mission District in San Francisco to support a neighborhood taco stand located near a planned McDonalds fast food franchise. The title explains that these Central American brothers are collecting foods for the market. As has been noted, the origins of the Latinos in Northern and Southern California differed. The majority in the Bay Area come from Central and South America, while those in Southern California come mostly from Mexico. Aesthetically one could argue that the relatively unified style in this mural demonstrates women's ascribed ability to submerge their personal styles to a group's. In fact, because of the artists' shared backgrounds in silkscreen art (which inclined them toward flat shapes and solid colors), they were already working in styles somewhat similar to each other. The mural was further unified by color. The theme is purposefully positive; the women felt men's murals contained too much violence.

Easel Painting by California's Latinos

The Chicano mural movement brought attention to Latino artists working in other media, many of whom have risen to the top echelon of the state's mainstream. California Latino easel painters work in all styles. If one is to judge from the exhibition catalogue *Mano a Mano* (Santa Cruz, 1988) many Latino painters from the Bay Area paint abstractly. However, it is this author's desire to show the merging of Latino traditional art with contemporary American, and this is most clearly seen in representational art. Most representational artists portray contemporary Chicano daily life, some with the irony of *rasquachismo*.

Carlos Almaraz (1941–1989) may have grown up in the barrio, but in the 1960s he was busy taking art classes off and on in Los Angeles and New York and seeking a place in the mainstream art world. In the early 1970s, Almaraz underwent a series of personal reversals that coincided with the rise of the Chicano movement and prompted his decision to identify with it. Early on he contributed his talents to the United Farm Workers cause, but he eventually settled on painting and drawing highly "impressionistic," almost nonrepresentational landscapes of Los Angeles, such as *Evening Traffic* of 1985 (fig. 34-7). The beams of light from streetlights and headlights, combined with the

Opposite:
Fig. 34-5
Victor Ochoa (b. 1948)
Geronimo, 1981
acrylic on concrete, 22 x 70 ft.
Centro Cultural de la Raza,
San Diego

Opposite:
Fig. 34-6
Las Mujeres Muralistas
(act. 1973–80)
Para el Mercado, 1974
acrylic paint on wood wall
paneling, 24 x 76 ft.
Consuelo Mendez, Mujeres
Muralistas
Photo: Tim Drescher

Fig. 34-7
Carlos Almaraz (1941–1989)
Evening Traffic, 1985
oil on canvas, 30 x 48 in.
The Buck Collection, Laguna
Hills, California
Photo: Bliss

streets. After ten years of using noncontroversial subject matter and with his place in the mainstream secure, he painted his first political subject, *The Closing of Whittier Boulevard,* in 1984 (fig. 34-8). This work has both the grand size and ambitious composition seen in traditional European Grand Manner history paintings. The picture records the story behind the Saturday night closure of Whittier Boulevard by police to prevent youths from "cruising" it in their cars, a measure still in effect today. (It is a Spanish tradition for young Latino men and women to meet each other by strolling the *zocalo* or main street in opposite directions.) The numbers of unsupervised youth who turned out on Whittier Boulevard on Saturday night frightened local shop owners and residents.

Each of America's geographical areas has a unique set of Latino iconography, usually stemming from that area's recent history. California's Chicanos differ from New York's Puerto Ricans, Florida's Cubans, and Texas's Tex-Mex residents. Los Angeles's Chicanos of Mexican background differ from the Bay Area's Latinos from Central America. Angelenos use the iconography associated with the Zoot Suiters of the World War II years, Cesar Chavez, low-rider cars, graffiti, and Ruben Salazar. Salazar was a *Los Angeles Times* reporter who was killed by tear gas while covering an anti-Vietnam war protest by Chicanos on August 29, 1970. The resulting riot left many buildings and vehicles along Whittier Boulevard burned and several people dead.

sunset and reflections off the foreground lake, as well as the stars and the clouds lit from the underside, turn a contemporary city into a romantic visual spectacle. The work shows Almaraz's exceptional control over his pastel medium. His rapid scratching and strokes demonstrate virtuosity, and his work is admired for its bravura style.

The work of **Frank Romero** (b. 1941) is easily recognizable for its cartoon-like cars traversing urban

Fig. 34-8
Frank Romero (b. 1941)
Closing of Whittier Boulevard,
1984
oil on canvas, 8 x 12 ft.
Private Collection
Photo courtesy the artist

With the recent art world interest in producing paintings of social and political import (chapter 36), Romero has started a series on barrio issues and, more recently, on Central American issues. So far these include *The Closing of Whittier Boulevard, The Death of Ruben Salazar,* and *The Arrest of the Paleteros,* the street vendors of such things as ice cream and mangos. Although these paintings address Latino situations, Romero considers his work more concerned with art than social issues. He is admired for the masterful way he draws with his brush and his rich, unctuous paint. His bright colors are said to be inspired by Mexican folk art; but his toylike vehicles seem influenced by Hollywood's animated cartoons.

The work of **Gronk** (Glugio Gronk Nicandro) (b. 1954) essentially deals with the human condition and the inner person. His paintings explore American society, particularly the psychological relationships, sexual mores, and political currents of contemporary life. Although a Chicano, Gronk does not necessarily paint with a "Chicano" look but is known as a colorist with an expressionistic style. Such works as *Bellhop* of 1988 (fig. 34-9) are from his Grand Hotel Series. The hotel is fictitious, although based on a former "grand hotel" on Los Angeles's lower Spring Street. The building is currently in the center of a degraded area and serves as a flophouse for alcoholics, drug addicts, and prostitutes. Gronk documents people and events from the hotel's days of glory, such as the bellhop, as well as from its current condition. Relevant to contemporary interest in addressing society's problems (chapter 36), Gronk represents the hotel's residents as a metaphor for all of today's anonymous Americans who are deprived and ignored and forced to live in poverty.

John Valadez (b. 1951), who was raised by a single working mother, describes himself as an introvert who escaped into the world of his mind. Working in the mainstream style of Photorealism, he depicts urban Chicanos, not as specific individuals but as a distillation or a type. His subjects include a girl in a wedding dress posing with her mother-in-law; a young mother and her baby; and an attractive and liberated Chicana complete with tattoos, such as *La Butterfly (Mariposa)* of 1983 (fig. 34-10). Valadez's approach is journalistic and factual rather than romantic, yet his presentation is compassionate. His people reaffirm Chicano history and the group's identity. After trips to Europe in the late 1980s, Valadez developed allegorical, mannerist, and personal imagery that provokes questions about society as a whole.

Some women Latino artists (or *Chicanas*) have also emerged from the *movimiento.* Among them is the San Francisco painter **Carmen Lomas-Garza**

Fig. 34-9
Gronk (Glugio Gronk Nicandro) (b. 1954)
Bellhop, 1988
acrylic on canvas
49½ x 49½ in.
Private Collection, Courtesy of the Daniel Saxon Gallery, Los Angeles

Fig. 34-10
John Valadez (b. 1951)
La Butterfly (Mariposa), 1983
pastel on paper, 30 x 44 in.
Collection of Ann Calhoun

(b. 1948). Chicanas seem as interested in advancing feminist interests as in promoting those of Latinos, fighting not only racism but sexism. Women especially have admired Frida Kahlo, the artist and wife of muralist Diego Rivera, who, in spite of a spinal injury that left her in pain her entire adult life, continued to create art in a style distinct from that of her husband. As in *Barriendo de Susto* of 1986 (fig. 34-11), Lomas-Garza's subjects are derived from the Texas environment in which she grew up, especially the female milieu: home, women's work, religion, clothing and hair fashions, and decorative objects. Here we see a sick woman undergoing a folk cure. When Lomas-Garza was fourteen, she happened to be visiting a neighborhood friend when that friend's mother was called upon to give a cure. The sick woman was suffering from *susto,* fright and shock, brought on by her husband's work-related loss of an arm and the consequent trauma. The traditional cure is to sweep the sick person with branches from a ruda plant; here the neighbor has substituted a household broom. Lomas-Garza's mother and two sisters were also artistically inclined, and she decided as a teen that she, too, would become an artist. Her study and pursuit of an art career coincided with the rise of the Chicano movement. Her work is not "naïve" but is deliberately simplified to eliminate extraneous elements that might detract from the narrative.

Chicano artists have enriched mainstream painting in many ways—by using new materials such as the

ballpoint pen and aerosol paint. They have introduced new iconography, intentional "bad taste" (Chicano kitsch), subject matter of the California Chicano experience, and the quirky wit of *rasquachismo.* Like "Funk," *rasquachismo* is an irreverent, antiestablishment attitude that Chicano artists express by going to excess, as when they load a folk art form such as home altars with plaster saints and plastic flowers. In turn, Chicano painting has influenced a whole group of easel artists in Mexico, whose movement is known as Neomeximismo.

California's Latinos have also made important contributions to media other than painting. Their top performance group, Los Angeles's Asco, acted out Chicano situations. Chicana artists favored the making of assemblages in the shape of the home altar, but they brought it up to date with nonreligious "offerings" and secular messages. Chicanos also showed a natural affinity for graphics, their interest coinciding with the rise of mainstream graphics workshops and the inexpensive technique of serigraphy. (See Ester Hernandez's *Sun Mad* of 1982, fig. 28-3.)

The first exhibitions of Chicano easel art were held in "alternative" spaces, such as the many Latino neighborhood community centers, but after 1973, when the book *Mexican American Artists* (Austin: University of Texas Press) was published, museums began to organize retrospectives of the work. Some of the first were in Los Angeles. The Mexican Museum was established in San Francisco in 1973; Los Angeles's Latino Museum is scheduled to open in downtown Los Angeles in 1998.

Murals, 1975–1990 (Latino and Others)

When government officials began to realize that murals might be an inexpensive way to revitalize depressed areas, to beautify them, to "cool off" inner-city youth, and to instill pride in residents, funding soon issued from federal, state, county, and city sources. Federal moneys included the mid-1970s block grant money from Housing and Urban Development (HUD), funds from the 1975 to 1980 Comprehensive Employment and Training Act (CETA), and grants from the National Endowment for the Arts (NEA). State funding came from the California Arts Council (CAC). Individual cities and counties also made money available for mural projects.

***Los Angeles and the Mural Movement*.** Los Angeles public relations firms tout the city as the outdoor mural capital of the world—numbers range above two thousand. Some art historians argue that the "movie" town has a mind-set for the creation of large-scale narratives and of fantasies. Add to this the year-round

sunshine, the sense of grand scale, and the imaginative daring that also creates fast food stands in the shape of hot dogs. Outdoor art on a grand scale is particularly appropriate for Angelenos, who spend so many hours at high speeds on freeways. Murals provide a kind of "windshield art show."

Los Angeles City and County have generously supported mural painting. In 1973 the city started its Inner City Mural Project and in 1974 the Citywide Mural Program (CMP). In 1976 Judy Baca (b. 1946) founded the Social and Public Art Resource Center (SPARC) to raise private moneys for murals.

The best-known mural is the *Great Wall of Los Angeles* painted on an out-of-the-way flood control channel in Tujunga Wash Drainage Canal in the San Fernando Valley, northwest of downtown Los Angeles. The channel, built by the Army Corps of Engineers, created a blighted area, and the Corps' Aesthetic Planning Division believed murals might alleviate the grimness with a touch of color and beauty. The project began in 1976 and was continued in 1978, 1980, 1981, and 1983, eventually involving hundreds of teenagers of all races and many gallons of paint. Many murals later, the abutted paintings extend for almost a mile, making it the longest mural in the world. The project was overseen by Judy Baca, who brought with her two years of experience with the Department of Parks and Recreation as a teacher painting murals with gang members of East Los Angeles. Baca chose the theme: the little-known ethnic history of Los Angeles. The murals show recent important events in the history of Los Angeles's diverse racial groups, revealing changing social attitudes and showing racial and social harmony.

Other government funds were generated for Los Angeles murals in conjunction with the 1976 Bicentennial of America, the 1981 Bicentennial of the city, and the 1984 Olympic Games held in Los Angeles. Since June 1989, mural funding has also come from Art for Rail Transit, a one-half of one percent of the overall budget that the Los Angeles County Transportation Commission (LACTC) has allotted to the construction of Metro Rail. Smaller cities have also seen the benefit of murals. Hollywood has funded several through its Hollywood Economic Revitalization Effort (HERO), and Long Beach and Santa Monica through their Departments of Parks and Recreation.

As more people noticed the murals showing up in the barrios, others became interested in the medium and how it could serve their own needs. After 1974 murals began to appear all across Los Angeles's urban sprawl. Most of these were by mainstream artists who used styles such as Photorealism, abstraction, and Pop.

Murals outside the barrios were painted by artists with a variety of goals. Many were decorative, meant to beautify run-down neighborhoods; they depicted subjects tailored to the tastes of their neighborhood residents or to those who traversed it. They were painted by artists pursuing personal quests who wanted to expose their art to a non-gallery audience and to work in large scale as well as those hired privately or by cities or communities. *The Fairfax Community Mural* of 1985 (fig. 34-12), sponsored by the Jewish Federation Council of Greater Los Angeles, was intended to revitalize the mostly Jewish Fairfax district. It tells Jewish history through seven monochromatic panels made up of montages derived from thousands of archival

Fig. 34-12
Art Mortimer (b. 1941), et al.
The Fairfax Community Mural, September, 1985
acrylic on stucco, 12 x 110 feet
Youth Department of the Jewish Federation Council of Greater Los Angeles

photographs. Many artists participated in making the painting, including many senior citizens.

In the affluent west side beach cities, a few murals address ecological issues, for example, *Gray Whale Migration* (fig. 34-13) by **Wyland** (b. 1956), dedicated in Redondo Beach in 1991. Hollywood murals contain portraits of motion picture stars. Murals also beautify the Korean-American areas as well as Little Tokyo. Many murals funded by commercial manufacturers, such as the athletic shoe Nike, are meant to beautify a community as well as promote products; they often contain no advertising copy and convey their "message" through subtly placed logos. A whole group of murals in predominantly Anglo neighborhoods are painted by easel artists who just like to work big, who want to keep their art out of what they feel are elitist commercial galleries, and who want to communicate to the average person. Murals have lately climbed up onto commercial billboards. Designed by fine artists or advertising artists, some are realized by billboard painters at the studios of Los Angeles's outdoor advertising firm of Foster and Kleiser. Others carry conceptual ideas when they deconstruct the idea of advertising itself. Among the many privately funded murals, the best known are the several commissioned from various artists by the art-sympathetic owner of Victor Clothing Company at 240 South Broadway. The building has murals inside and out and contains studios for artists.

Bay Area Murals. San Francisco can lay claim to having the highest number of murals per capita of any city in the world. Its mural movement has gone through the same evolution as that of Los Angeles—from a phase of racial activism to one of city improvement, decoration, and advertising. The city has established several funding sources. The late-1960s Neighborhood Arts Program was designed to bring all aspects of the arts to neighborhoods, especially the inner city. But most funds were issued after the mid 1970s. Funds from the Mayor's longstanding Office of Community Development (OCD) are administered through the Mural Resource Center (MRC). The city's Department of Parks and Recreation has also provided mural support. The 1976 Bicentennial resulted in three Neighborhood Beautification Fund murals. Other funding comes from private and corporate moneys. This has resulted in murals throughout the mostly Latino Mission District, the hippie stronghold of Haight-Ashbury, and the black areas of Hunter Point-Bayview, the Western Addition, and the Fillmore. The East Bay has murals throughout Oakland and Berkeley.

Among the unique mural types that have evolved in San Francisco are the psychedelic murals in Haight-Ashbury. Bordering Golden Gate Park, this area saw the earliest community mural in San Francisco, the 1967 *Evolution Rainbow* by Joana Zegri (active late 1960s) (not pictured). *Rainbow People* of 1974 (fig. 34-14), painted by the **Haight-Ashbury Muralists** on an auto parts store (repainted in 1974 and relocated to the side of Seeds of Life Grocery), contains the expected hippie references to rainbows and to people of all races living in harmony. A few murals incorporate comix figures. Asian Californians have not employed the mural medium to any great extent, but in San Francisco's Chinatown some examples can be seen. These

Fig. 34-13
Wyland (b. 1956)
Gray Whale Migration,
dedicated June 24, 1991
(Whaling Wall XXXI)
100 x 622 feet
Southern California Edison

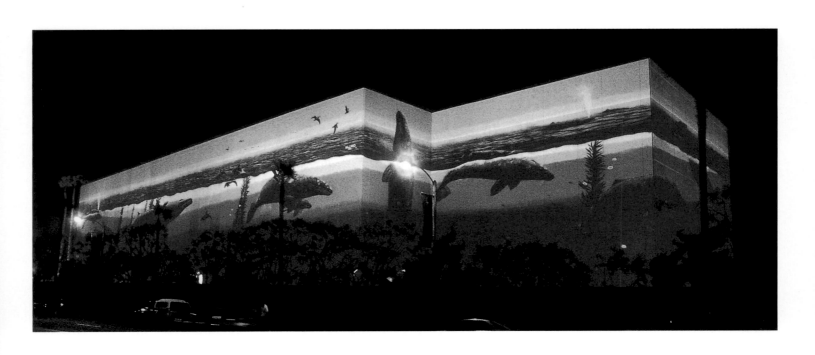

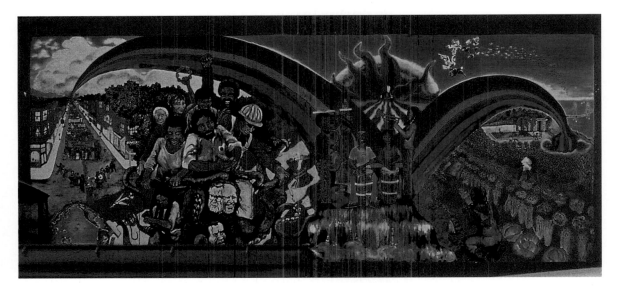

Fig. 34-14
Haight-Ashbury Muralists
Rainbow People, 1974
acrylic on Masonite, 8 x 20 ft.
Haight-Ashbury Muralists
Photo: Tim Drescher

tend to be decorative rather than political. An example is **James Dong**'s (active 1980s) *Fish Struggling Upstream* of 1983 (fig. 34-15), painted on the asphalt surface of a playground at the Ping Yuen Housing Project. The magazine *Community Murals* was published in San Francisco between 1978 and 1987.

Murals are created with all types of materials and techniques. Most are painted with contemporary paints such as acrylic, Liquitex, or oil, directly on stucco, bricks, concrete, or wood. (Historical techniques such as fresco have not been popular with recent artists.) Every day new murals come into being while old works disappear; they are painted over with new murals, deteriorate naturally or by vandalism, become blocked visually by newly erected buildings or vegetation, or they may crumble as their supporting structures are torn down. To help preserve the legacy, Los Angeles has evolved a Mural Conservancy. In addition, Los Angeles's SPARC oversees a mural restoration program called the Mural Emergency Relief Fund. The organization also maintains a slide archive of California murals. Books have been published documenting the murals (see bibliography), and tours of the city's murals are given by various individuals. In San Francisco, the twenty-year-old Precita Eyes Muralists serves as an information source for murals; it leads regular mural tours and, in the 1990s, has been sponsoring Mural Awareness Week.

Outdoor artists also "corrected" billboards. People generally object to billboards, but residents of poorer areas especially resent the "control" exerted by mainstream advertising for addictive products such as cigarettes and liquor. Neighborhood artists countered such ads by slightly altering the designs and messages to nullify the salesmanship and to invert the message so

that it debunks itself. An example is the well-known Winston cigarette advertisement showing a man's head and a box of cigarettes. An unknown artist has changed the words "The Box" to "The Pox" and has dotted the man's face with pox marks.

The postmodern styles discussed in these last three chapters have all been representational and have been easy to group because they share common attributes. This is not the case for the art yet to be discussed. Its "anything goes" attitude has led to the period after 1970 being called "pluralist." Whether that term represented progress or anarchy will be explored in the next chapter. ✿

Fig. 34-15
James Dong (active 1980s)
Fish Struggling Upstream,
1983
various media on asphalt
playground, 35 x 30 ft.
James Dong
Photo: Tim Drescher

Bibliography

Latin American Art in Relation to the United States

Beardsley, John and Jane Livingston, *Hispanic Art in the United States*, [some California artists] Museum of Fine Arts, Houston and Abbeville Press, New York, 1987. 260 p.

Cancel, Luis R., et al., *The Latin American Spirit: Art and Artists in the United States, 1920–1970*, Bronx Museum of the Arts in association with Harry N. Abrams, Inc., New York, 1988.

Goldman, Shifra M., *Dimensions of the Americas: Art and Social Change in Latin America and the United States*, Chicago: University of Chicago Press, 1994. 494 p.

The Papers of Latino & Latin American Artists, Washington, D.C.: Archives of American Art, Smithsonian Institution, c. 1996. 28 p.

Latino History

AZTLAN: Chicano Journal of the Social Sciences and the Arts, Los Angeles: Chicano Studies Research Center, University of California, Los Angeles, 1970-1987.

Mesa-Bains, Amalia and Tomas Ybarra-Frausto, *Lo del Corazon: Heartbeat of a Culture*, exh. cat., The Mexican Museum, San Francisco, April 16–June 15, 1986. 24 p.

Quirarte, Jacinto, ed., *Chicano Art History: A Book of Selected Readings*, San Antonio, Tx.: Research Center for the Arts and Humanities, 1984. [covers entire Southwest]

Rios-Bustamante, Antonio and Pedro Castillo, *An Illustrated History of Mexican Los Angeles 1781–1985* (Chicano Studies Research Center Publications, Monograph 12), Los Angeles: University of California, 1986. 196 p.

Latino Art, General

Aguilar, John, Shifra Goldman, and Tomas Ybarra-Frausto, *Chicano Aesthetics: Rasquachismo*, Phoenix, Az.: MARS (Movimiento Artistico del Rio Salado), Inc., 1989. 14 p.

Barrio, Raymond, *Mexico's Art & Chicano Artists*, Guerneville, Ca.: Ventura Press, 1978. 70 p.

Califas, Chicano Art and Culture in California [180 video cassettes], University of California, Santa Cruz, 1986.

Califas: Chicano Art and Culture in California, Transcripts, Santa Cruz: University of California, 1986. 7 v.

The California Directory of Chicano/Latino Artists: 1984-1985, Los Angeles, Ca.: Concilio de Arte Popular, Coalition of California Chicano/Latino Artists, 1985?

Chicanarte, exh. cat., Los Angeles Municipal Art Gallery, September 14–October 12, 1976. 108 p.

Chicano Art: Resistance and Affirmation, 1965–1985, exh. cat., Wight Art Gallery, University of California, Los Angeles, and other sites 1990–1993. 373 p.

The Fifth Sun: [SF] Contemporary/Traditional Chicano & Latino Art, exh. cat., University Art Museum, University of California, Berkeley, October 12–November 20, 1977 and at Art Gallery, University of California, Santa Barbara, January 4–February 12, 1978. 44 p.

Final Report to the National Endowment for the Humanities: "Califas, Chicano Art and Culture in California," [conference at] Oakes College, April 18, 1982, Santa Cruz: University of California, 1983. 243 l.

Gamboa, Harry, "The Chicano/a Artist Inside and Outside the Mainstream," *Journal, a Contemporary Arts Magazine*, no. 46, v. 6, Winter 1987, pp. 20–29.

Goldman, Shifra and Tomas Ybarra-Frausto, *Arte Chicano: A Comprehensive Annotated Bibliography of Chicano Art, 1965–1981*, Berkeley: Chicano Studies Library Publications Unit, University of California, 1985. 778 p.

Guerena, Salvador, ed., *Chicano Visual Arts Kit/Proyecto CARI-DAD (Chicano Art Resources Information Development and Dissemination)*, [500 slides of Chicano art/murals] Special Collections, Library, University of California, Santa Barbara, 1994. [compiled by UCSB for California State University Library, Sacramento] 107 p.

Personal Reflections: Masks by Chicano and Native American Artists in California, exh. cat., La Raza Bookstore, Sacramento: n. d., 1985?

Murals, Latino, General

America Tropical/KCET-TV, LA [Siqueiros mural] distributed by Indiana University, Audiovisual Center, 1971.

Barnett, Alan W., *Community Murals: the People's Art*, Philadelphia, Pa.: Art Alliance Press, 1984. [some Calif.]

Cabutti, L., "L'Arte Messa al Muro," *Arte* (Italy), no. 129, v. 13, April 1983, pp. 60-71.*

Castellanos, Leonard, "Chicano Centros, Murals & Art," *Arts in Society*, v. 12, pt. 1, Spring–Summer 1975, pp. 38–43.

Community Murals Magazine, 1978–87 [published by CMM, Berkeley, Ca.]

Garcia, Marshall Rupert, *La Raza Murals of California 1963–1970*, M. A. Thesis, University of California, Berkeley, 1981. 129 l.

Gonzalez, Alicia M., "Murals: Fine, Popular or Folk art? [Southern California]," *Aztlan*, v. 13, pt. 1–2, 1982, pp. 149–63.

Signs from the Heart: California Chicano Murals, Venice, Ca.: Social and Public Art Resource Center, 1990. [Republished by University of New Mexico Press, Albuquerque, 1993.] 105 p.

Treguer, Annick, "The Chicanos—Muralists with a Message," *UNESCO Courier*, April 1992, pp. 22–24.

Murals, Latino, Los Angeles

(See also bibliography for graffiti, chapter 31.)

Baca, Judith F., "Whose Monument Where?," [LA] in Suzanne Lacy, ed., *Mapping the Terrain: New Genre Public Art*, Seattle: Bay Press, 1995. 292 p.

Bombing L.A. [video, 35 min.] Hollywood, Ca.: Glaser Productions, 1988.*

Boyer, G., "Los Angeles l'Art Fait le Mur," *Beaux Arts Magazine* (Fr.), no. 19, December 1984, pp. 68–73.*

Bright, Mura, *L.A. Chicano Street Art*, Los Angeles: Environmental Communications, 1974. [Text accompanying slide collection of L. A. Chicano art, sold by Environmental Communications.]*

Chicanarte, exh. cat., Los Angeles Municipal Art Gallery, Barnsdall Park, September 14–October 12, 1975. 108 p.

"The City is Their Canvas," *City*, May–June 1971, pp. 38–40.*

Clarke, Orville O., "Chicano Murals of Southern California," *Latin American Art*, v. 4, no. 3, Fall 1992, pp. 76–78.

Cook, Robert T., "Painting the Town," *Westways*, v. 66, no. 4, April 1974, pp. 42-46.

Elliott, Marco, *Le Pied du Mur*, Paris, France: Le Temps Apprivise, 1990. 93 p. [murals by youths in France and California]*

Kahn, David, "Chicano Street Murals: People's Art in the East Los Angeles Barrio," *Aztlan*, v. 6, no.1, Spring 1975, pp. 117–21. [Aztlan is a publication of the Chicano Center, UCLA]

McBride, Stuart Dill, "Chicano Arts Bloom in East Los Angeles: Mexican American Street Gangs Take Up Brushes," *Christian Science Monitor*, October 28, 1977, pp. 15–18.*

MacAdams, L., "East Los Angeles Streetscapers and the L. A. Murals," *High Performance*, v. 9, no. 3, 1986, pp. 46-47.

Murals of East Los Angeles (A Museum Without Walls) [film, 37 min.], RKO General Pictures; distributed by La Luz Cinema, 1977.

Pohl, Frances K., "The World Wall: A Vision of the Future Without Fear: an Interview with Judith Baca," *Frontiers* (U.S.A.), v. 11, pt. 1, 1990, pp. 33–43.*

Pontello, Jacqueline M., "Mural Mania [in LA]," *Southwest Art*, v. 21, February 1992, pp. 22+.

Rickey, C., "Writing on the Wall [Great Wall]," *Art in America*, v. 69, May 1981, pp. 54-57.

Romotsky, J. & S., "California Street Scene: Wall Writing in L. A.," [graffiti] *Print* (USA), v. 25, pt. 3, May–June 1974, pp. 60–65.*

Romotsky, J & S., "Placas and Murals," [graffiti] *Arts in Society* (USA), v. 11, pt. 2, Summer 1974, pp. 288–99.*

Romotsky, J., "L. A. Human Scale: Street Art of Los Angeles," *Journal of Popular Culture*, v. 10, pt. 3, Winter 1976, pp. 653-61.*

Sanchez-Tranquilino, Marcos, *Mi Casa no es su Casa: Chicano Murals and Barrio Calligraphy as Systems of Signification at Estrada Courts 1972–1978*, M. A. Thesis, University of California, Los Angeles, 1991. 205 l.

Simpson, Eve, "Chicano Street Murals," *Journal of Popular Culture*, v. 10, pt. 3, Winter 1976, pp. 642–52 and v. 13, pt. 3, Spring 1980, pp. 516–25.

"Street Art Explosion in Los Angeles," *Sunset*, v. 150, no. 4, April 1973, pp. 110-13.

Vautier, Mireille, *Die Zweite Dimension: Wandmalereien in Los Angeles*, Dortmund: Harenberg, 1984. [Bibliophilen Taschenbucher, no. 448] 128 p.

Zucker, Martin, "Walls of Barrio are Brought to Life by Street Gang Art," *Smithsonian*, v. 9, pt. 7, October 1978, pp. 105–11.

Murals, Latino, Bay Area

Burns, Rebecca, "Mural, Mural on the Wall: Latino Art and Soul Thrive in the Mission District," *Travel and Leisure*, v. 23, no. 11, November 1993, pp. C6+.*

Garcia, Rupert, *Raza Murals and Muralists: An Historical View*, San Francisco: Galeria de la Raza, 1974. 32 p.

Mesa-Bains, Amalia, and Ray Patlan, *Social History Through Murals*, San Francisco United School District, 1988.*

Quintero, Victoria, "A Mural is a Painting on a Wall Done by Human Hands," [Mujeres Muralistas] *El Tecolote*, v. 5, no.1, September 13, 1974, pp. 6,7,12.

Wagner, Kathie and Lori Lujan, "Public Works: San Francisco and Beyond the City," *San Francisco Sunday Examiner and Chronicle, California Living Magazine*, September 21, 1975, pp. 26–30 and September 28, 1975, pp. 26–34.

Murals, Latino, San Diego

Border Art Workshop 1984–1991, a Continuing Documentation of Seven Years of Interdisciplinary Art Projects, exh. cat. for *Destination L.A.*, Los Angeles Contemporary Exhibitions, December 20, 1991–February 9, 1992. 99 p.

The Border Art Workshop (BAW/TAF), 1984–1989, San Diego: Border Arts Workshop, 1988. 93 p.

Broken Line/La Linea Quebrada (magazine of the Border Art Workshop/Taller de Arte Fronterizo, San Diego, 1986+).

Brookman, Philip and Guillermo Gomez-Pena, eds., *Made in Aztlan* [Centro Cultural de la Raza, Fifteenth Anniversary], San Diego: Centro Cultural de la Raza, 1986. [exh. cat., September 14–October 27, 1985] 116 p.

Chicano Park [San Diego] [video, 59 min.] produced by Mario Barrera and Marilyn Mulford, Redbird Films, Berkeley, 1988. [reprod. New York Cinema Guild, 1988–91]

Cockcroft, Eva, "The Story of Chicano Park," *Aztlan*, v. 15, no. 1, Spring 1984, pp. 79–103.*

Joselit, David, "Living on the Border," [San Diego/Tiajuana] *Art in America*, v. 77, December 1989, pp. 120–29.

Oas, Jim, "Chicano Park, a Cultural Flowering [San Diego]" *Craft International*, v. 3, pt. 4, April–June 1984, p. 13.

Art, Latino, Women

Chicana Voices & Visions [partly California artists], exh. cat., Social and Public Art Resource Center, Venice, Ca., December 3, 1983–January 21, 1984. [curated and with a text by Shifra Goldman] 26 p.

Garcia, L., "Chicana Art in California," *Women Artists News*, v. 6, pt. 2–3, Summer 1980, p. 17.*

Goldman, Shifra M., "Mujeres de California: Latin American Women Artists," in Sylvia Moore, ed., *Yesterday and Tomorrow: California Women Artists*, New York: Midmarch Arts Press, 1989. 376 p.

Ochoa, Maria, *Creative Collectives: a Study of Chicana Artistic Expressiveness*, Ph. D. Dissertation, University of California, Santa Cruz, 1995. 303 l.

Ontiveros, Mario, *Circumscribing Identities: Chicana Muralists and the Representation of Chicana Subjectivity*, M. A. Thesis, University of California, Riverside, 1994. 124 l.

Venegas, Sybil, *Image & Identity: Recent Chicana Art from "La Reina del Pueblo de Los Angeles de la Porcincula*," (*Art of Greater Los Angeles in the 1990's*, v. II, no. 1), exh. cat., Laband Art Gallery, Loyola Marymount University, September 18–November 3, 1990. 10 p.

W x W Women by Women: an Evening of Exchange, Galeria de la Raza/ Studio 24, May 29, 1985 [video, 60 min.] produced by I. V. Studios, Berkeley and distributed by Art COM, San Francisco, 1985.

Art, Latino, Southern California

La Casa de la Raza & the [Santa Barbara] Chicano Artist Community [video, 57 min.] produced by Armando Vallejo for the local PBS, 1985.

Chicano and Latino Artists of Los Angeles: [portrait] *Photography by Alejandro Rosas*, Department of Photography, Santa Monica City College with a grant from the City of Los Angeles Department of Cultural Affairs, 1993. 47 p.

Le Demon des Anges: 16 Artistes "Chicanos" al Voltant de "Los Angeles," exh. cat., Centre d'Art Santa Monica, Barcelona, Spain, November–December 1989. 245 p.

Durland, Steven and Linda Burnham, "Art with a Chicano Accent," *High Performance*, v. 9, pt. 3, issue 35, 1986, pp. 40-57.

Hicks, Emily, "The Artist as Citizen," *High Performance*, v. 9, no. 3, 1986, pp. 32-38.

Romero, Frank, et al., "Hispanic Ceramic Artists Los Angeles/Miami," *Studio Potter*, v. 17, June 1989, pp. 5–31.

Van Kirk, Kristina, "L. A. Chicano Art," *Flash Art* (Italy), no. 141, Summer 1988, pp. 116–17.

Vasquez, Emigdio, "Ethnic Expressions: A Sample of Orange County Latino Artists," *Journal of Orange County Studies*, Fall 1989/Spring 1990, pp. 70-74.

Art, Latino, Northern California

Artistas Mexico Americanos de San Francisco, Ca., exh. cat., Salon de Sorteos, Mexico City, September 11–October 2, 1987. 40 p.

Collins, Willie R., ed., *Chicano/Mexicano Traditional and Contemporary Arts and Folklife in Oakland*, Oakland, Ca.: Cultural Arts Division, 1995. 32 p.

Mano a Mano, Abstraction/Figuration: 16 Mexican-American & Latin-American Painters from the San Francisco Bay Area, exh. cat., Art Museum of Santa Cruz County, the Mary Porter Sesnon Gallery, University of California, Santa Cruz, April 17–June 5, 1988 and two other venues. 63 p.

Latino Iconography

"Aerosol Art aka Graffiti Art," in Dunitz, *Street Gallery*, Los Angeles: RJD Enterprises, 1993, pp. 17+.

Cohen, Michael, "Pachuco Style…," *Flash Art*, v. 27, May/June 1994, pp. 87-90.

Goldman, Shifra, "The Iconography of Chicano Self-Determination: Race, Ethnicity, and Class," *Art Journal*, v. 49, no. 2, Summer 1990, pp. 167–73.

Imagenes de la Raza [Self-Portrayals of Mexican-American Culture], exh. cat., Amerika Haus, Berlin in conjunction with Horizonte '82—2nd Festival of World Cultures, Berlin, June–July 1982. 69 p.

Sanchez-Tranquilino, Marcos, "Mano a Mano: An Essay on the Representation of the Zoot Suit and Its Misrepresentation by Octavio Paz," *LAICA Journal*, no. 46, v. 6, Winter 1987, pp. 34–42.

Assemblages/Altars/Posters, Latino

Goldman, Shifra, "A Public Voice: Fifteen Years of Chicano Posters," *Art Journal*, v. 44, no. 1, Spring 1984, pp. 50–57.

Heisley, Michael, *More than a Tradition: Mexican American Nacimientos in Los Angeles*, exh. cat., Southwest Museum, Highland Park, Ca., December 6, 1991–February 2, 1992. 47 p.

Offerings: The Altar Show, Venice, Ca.: Social and Public Arts Resource Center, December 1, 1984–February 8, 1985. 16 p.

Offrendas: Ray Yanez, Carmen Lomas Garza, Armando Cid, Amalia Mesa-Bains, Sacramento: La Raza Bookstore/Galeria Posada, October 7–November 17, 1984. 16 p.

Performance, Latino
(See also bibliography for California Performance in chapter 29.)

Mi Otro Yo = My Other Self [LA Chicano performance] [video, 28 min.] produced by Philip Brookman, San Diego: Cinewest Productions: A Brookman and P. Brookman, 1988.

Murals, General, California, 1975+
Burnham, J. W., "San Quentin Prison Mural Project," *New Art Examiner*, v. 4, pt. 8, May 1977, pp. 4–5.*

Clark, Yoko and Chizu Hama, *California Murals*, Berkeley, Ca.: Lancaster-Miller, 1979. 57 p.

Drohojowska, H., "West Coast Decorative Painters: Traditional Disciplines Applied with Contemporary Spirit," *Architectural Digest*, v. 48, May 1991, pp. 96+.

Dunitz, Robin J. and James Prigoff, *Painting the Towns: Murals of California*, Los Angeles: RJD Enterprises, 1997. 300 p.

Kuzdas, Heinz J. and Michael Nungesser, *Mural Art: Berlin, Los Angeles, Mexico, D. F.*, Germany: Schwarzkopf & Schwarzkopf, 1995. 93 p.

"Landscape of the California Mural [10 article special section]," *Artweek*, v. 23, pt. 13, April 9, 1992, pp. 4–5, 16–23.

MacPherson, Jena, "Walls of History," [murals...Lompoc] *Sunset* (Central West edition), v. 189, July 1992, pp. 66–69.

Merken, Stefan, *Wall Art: Megamurals & Super Graphics*, Philadelphia, Pa.: Running Press, 1987. 128 p.

Rubenstein, Leonard S., "Big Art" [easel art moved to billboards, Calif.], *Graphis*, v. 34, September 1978, pp. 448–57.

Walker, Cummings G., "Public Art for Palo Alto," *Communication Arts*, v. 19, pt. 1, March–April 1977, pp. 70–72.

Murals, Billboards, General, Los Angeles, 1975+
Anderson, Ross, "California 'Frescoes': The Distinctive Styles & Craftsmanship of Schoonhoven and Twitchell," *Art of California*, v. 6, no. 3, June 1993, pp. 28–31.

Bijvoet, Marga, "...Underground Spectacle in Los Angeles," [Metro art] *Archis*, no. 3, March 1994, pp. 72–80.

Clifton, Leigh Aann, "America's Largest Mural [Whaling Wall XXXI, Redondo Beach, Ca.]," *Artweek*, v. 23, February 27, 1992, pp. 2+.

Cockcroft, E., "Documenting Los Angeles murals [documentary film titled "Murs Murs"]," *Artweek*, v. 12, November 21, 1981, p. 13.

Cockcroft, E., "Writing on the Wall: Los Angeles's Mural Boom," *New Art Examiner*, v. 19, November 1991, pp. 20-24.

Community Redevelopment Agency of the City of Los Angeles, *Public Art in Downtown Los Angeles*, 1986. 114 p. [pocket guide with maps]

Doss, Erika, "Raising Community Consciousness with Public Art: Contrasting Projects by Judy Baca....," *American Art*, v. 6, no. 1, Winter 1992, pp. 63–81.

Dunham, Judith L., "Messages on the Skyline," [billboards] *Artweek*, v. 10, no. 32, October 6, 1979, pp. 7–8.

Dunitz, Robin J., "Neighborhood Pride [LA mural program]," *Southwest Art*, v. 21, June 1991, pp. 46+.

Dunitz, Robin J., *Street Gallery (Guide to 1000 Los Angeles Murals)*, Los Angeles: RJD Enterprises, 1993. 468 p.

Harrington, Laine Meredith, *Secular Evangelism in Contemporary Public Art: A Selection of Street Murals in Los Angeles and Oakland and their Calls to Meaning*, D. Min. Thesis, Pacific School of Religion, Berkeley, 1993. 121 l.

Levick, Melba, *The Big Picture: Murals of Los Angeles*, Boston: Little, Brown and Co., 1988. 128 p.

Map and Guide to the Murals of Los Angeles [top 250], Mural Conservancy of Los Angeles, 1995. 30 p.

McGarry, Susan H., "The Conquest of California: A Mural Series," *Southwest Art*, v. 17, December 1987, pp. 60–65.

Pontello, Jacqueline M., "Mural Mania [in Los Angeles]," *Southwest Art*, v. 21, February 1992, pp. 22+.

Stewart, Doug, "In Los Angeles Billboards are seen as High Art," *Smithsonian*, v. 21, no. 6, September 1990, pp. 98+.

Street-Porter, Tim, "Skyline Painting," [Foster & Kleiser painted billboards in Hollywood] *Design* (U. K.) no. 300, December 1973, pp. 56–59.

Walking Tour and Guide to the Great Wall of Los Angeles, Venice: Social and Public Art Resource Center, 1983.

Wilson, William, "The L.A. Fine Arts Squad: Venice in the Snow and Other Visions," *Art News*, v. 72, Summer 1973, pp. 28–29.

Murals, General, Bay Area, 1975+
Drescher, Tim and Victoria Scarlett, *A Checklist of San Francisco Murals 1914–1986*, San Francisco: Library of San Francisco State University, 1986. 33 p.

Drescher, Tim, *San Francisco Murals, Community Creates Its Muse, 1914–1990*, St. Paul: Pogo Press, 1991. 104 p.

Tanner, Marcia, "Poolside Manners [mosaic-tile mural, S. F.]," *Art News*, v. 92, October 1993, p. 33.

THE LAST

TWENTY YEARS

1975–1995

Fig. 35-1
The Museum of
Contemporary Art, Los
Angeles, at California Plaza
Courtesy the Museum of
Contemporary Art, Los
Angeles
Photo: Tim Street-Porter

The Postmodern Era—Abstraction

Learning about and organizing California's art of the last thirty years has been difficult. Generally art historians avoid making authoritative pronouncements about art that is less than twenty years old, because not enough time has elapsed to allow the trends and movements to be seen clearly. In California's case critics have been willing to report activities, but no one has yet summarized or thoroughly analyzed the state's painting trends or identified the top artists. Most people are confused about what has been happening in the last thirty years and would appreciate a preliminary analysis. The trends and patterns that are described in this and the following chapters were identified after a page-by-page perusal of *Artweek* (a magazine for West Coast art) from 1978 to 1996 and glances at catalogues of contemporary art exhibitions. The results were filtered through the knowledge of historical art as presented in this book's earlier chapters. The organization of the material that follows represents this historian's view and is merely one structure among many by which recent art can be classified.

Infrastructure

The years since 1970 have been tumultuous—a seesaw of inflation and recession, of boom and bust, of political and military surprises, and of good news and bad news in the world of art.

In the 1970s several social and economic changes influenced the course of art. The last United States troops pulled out of Vietnam in 1973, rendering irrelevant additional protests against the war as well as art that expressed antiwar sentiments, while pollution and concern for the planet's ecology opened up environmental themes. In the mid 1970s the matter on everyone's lips as they stood in line at the gas pumps was the oil crisis. Fear of not being able to get enough gasoline ignited fears of shortages of other goods and led to rampant inflation in the second half of the 1970s. Frightened citizens rushed to put their money into tangible property—real estate, jewelry and art. In 1978, Californians passed Proposition 13, which rolled back escalating property taxes to the assessed valuation of 1975–76 and drastically reduced tax revenues. In turn, state programs for so-called nonessentials such as art were cut by as much as sixty percent.

The 1980 election of Ronald Reagan as United States president ushered in a decade of conservative government. During his first years in office, the Federal Reserve Board continued to raise interest rates (to unprecedented heights) to curb runaway inflation. While the move was successful, President Reagan's Republican government also rolled back or cut many social and educational programs that had originated in the Democratic Kennedy years, including many that supported art. More importantly, during Reagan's term, income tax laws were changed. Although some changes provided a better business climate for America, tax rules governing deductions for donations of property to nonprofit institutions were restructured in a way that negatively affected art—the so-called alternative tax option. Donors to nonprofit institutions could no longer benefit as greatly from fair-market value appraisals, greatly diminishing gifts to museums and leaving art institutions to scrape up funding from whatever sources they could. At the same time, new laws were passed by the state and federal government to protect artists in the areas of copyright, royalties, contracts, and from damage that might occur to their art created for public spaces. These laws include the Resale Royalties Act, effective January 1, 1977, and the Visual Artists' Rights Act of 1990. (To explain these to artists, the series "Art Law," authored by Peter H. Karlen, ran in *Artweek* on and off through the 1980s. California Lawyers for the Arts, founded in 1974 in Berkeley [as Bay Area Lawyers for the Arts], published materials informing artists of their rights, held seminars, gave legal advice over the telephone, and defended artists in court.)

Natural disasters and political events unique to the state have also affected its art. In Palo Alto, the Loma Prieta earthquake of 1989 caused the closure of the Art Museum at Stanford University and caused several structures in the Bay Area to require expensive retrofitting to bring them up to structural standards. Several alternative spaces unable to afford retrofitting were forced to close. The Northridge earthquake of 1994, centered in the valley north of Los Angeles, severely damaged CalArts in nearby Valencia and collapsed several structures at California State University, Northridge. The October 1991 fire in the Oakland hills and the several fires in coastal Malibu and Laguna Beach in Southern California burned through areas occupied by the wealthy, some of them art collectors,

and destroyed many art works. In late spring 1986 an explosion at Bayview Industrial Park in San Francisco caused by an illegal fireworks factory destroyed twenty studios, assorted equipment, and art, and killed eleven people, including three craftspeople. The Rodney King beating in Los Angeles and the judgment that ignited riots in the black community in April 1992 inspired the exhibit *No Justice, No Peace? Resolutions...* at the California Afro-American Museum in Los Angeles.

In the 1980s, in spite of cutbacks in government art programs, the art world experienced tremendous growth. In California this growth was supported by the surplus private wealth stockpiled not only by entrepreneurs in real estate and the motion picture industry but by "yuppie" career couples. People wanted "quality of life." This meant culture and, more specific to this book's interests, art. Art was supplied by museums as "entertainment" and sold as investment; it decorated the interiors of houses, served as fodder for cocktail party conversations, and was placed in revitalized inner cities to improve them.

People continued to put their money into tangible, real property, including art. With eager bidders at auctions, art began to look like an easily tradable commodity that garnered higher returns than the stock market. Auction galleries chalked up record prices at each sale, privately influencing the rise by lending money to buyers and advancing money to consignors. Entrepreneurs tapped into this trend by opening commercial galleries, and they sold art not as items of aesthetic beauty but as status symbols and financial investments. Speculation resulted. A lust for money seized the art world. Collectors consulted with art experts and took notice of who was collecting what works in hopes of identifying rising stars and trends. Museum curators wrote essays for commercial gallery catalogues and acquired art for their own collections, jeopardizing their objectivity and raising claims of conflict of interest. Everyone's motives were suspect. What about collectors who lent their works to museum exhibitions—were they selflessly sharing their beloved objects with the public or serving their own interests by obtaining museum validation of their assets?

Los Angeles. Downtown Los Angeles got an infusion of art. Parts that had become run down were being redeveloped; the city was becoming a business center for the Pacific Rim. Many corporations (ARCO, Wells Fargo, Security Pacific) were establishing their headquarters there, building skyscrapers and returning profits to the community by opening their own private museums or collecting art. The city was flourishing: in 1981 it celebrated its bicentennial with retrospectives of its own art; in 1984 it hosted the summer Olympics, accompanied by its many art programs; and in the spring 1987 it opened the first of what would be several annual LA International Art Fairs, a world exposition for contemporary art held at the convention center. Artists began to move back into downtown. Part of the attraction was Bunker Hill, a wealthy residential area at the turn of the century, that was under redevelopment and that would ultimately boast the art centerpiece, the Museum of Contemporary Art (MOCA) (opened December 1986) (fig. 35-1). Locating in the area in 1975 was the Woman's Building. In the late 1970s the city's two most important alternative spaces for the display of contemporary art opened doors: Los Angeles Institute of Contemporary Art (LAICA), headquartered in Westwood, maintained a satellite space for three years on Traction Avenue. And Los Angeles Contemporary Exhibitions (LACE) occupied two sites in downtown between 1978 and 1993. In 1983 MOCA's Temporary Contemporary opened as an interim space for exhibitions during the construction of the permanent museum. It was soon joined by the Japanese-American National Museum in Little Tokyo (1985). The Latino Museum of History, Art and Culture opened on Main Street, May 9, 1998. In a recent master plan to revitalize downtown, important tourist entities (such as the various downtown museums) within a ten-minute walk of the Civic Center will be joined by special walkways.

Attractive to artists were the cheap rents and large spaces available in the several square blocks of warehouses between Little Tokyo and "skid row." The trickle of artists into this area in the early 1970s turned into a flood in the 1980s. In 1983 legislation made live/work studios legal, and some commercial developers went so far as to remodel whole buildings tailored to artists. Downtown was also being beautified with public art. City supporters realized that an art image was a positive asset for any city: it attracted tourists and corporations that liked to be associated with the arts; and it

implied a quality lifestyle. Funding for public art came from a one-percent art tax on new construction, and in 1989 a tax was put on hotel beds to raise the amount of money for city arts funding to $20,000,000. In spite of funding cuts in federal, state, and city sources, Mayor Tom Bradley and Councilman Joel Wachs continued to fight for the arts.

Throughout the Los Angeles basin, individual communities followed suit, improving their own civic centers with art and revitalizing "old towns." In the mid-Wilshire area, the Los Angeles County Museum of Art (LACMA), which had a reputation for not supporting local contemporary artists, opened the Anderson Wing devoted to modern art in 1986. Toward the late 1980s, Santa Monica, the coastal town directly west of Los Angeles and adjacent to Malibu, where many of the city's new moneyed individuals were settling, began to develop an art personality. These residents resented having to travel vast distances over Los Angeles's increasingly crowded freeways and preferred doing business near home. Contemporary commercial galleries moved from La Cienega Boulevard to areas along Colorado Street, Main Street, and to Bergamot Station, a grouping of former warehouses near the railroad tracks. The Santa Monica Museum of Art (devoted to contemporary art) was founded in 1985 and helped to revitalize the city's historic Main Street until the institution moved to Bergamot Station in 1998. To the northeast of downtown Los Angeles, Pasadena, which had lost a contemporary site when the Baxter Art Gallery of California Institute of Technology closed in 1985, gained back a contemporary venue when the old Armory in the renovated "old town" was opened as a nonprofit art center. To the northwest, in the San Fernando Valley, the Autry Museum of Western Heritage opened in Griffith Park in 1984. At least two of Los Angeles's wealthy collectors of contemporary art tried to found their own museums (Frederick Weisman and Eli Broad). Los Angeles was also home to several new (albeit short-lived) contemporary art magazines (see bibliography) not to mention publications put out by special interest art groups, by commercial art galleries, by alternative spaces, and by museums.

Orange County, adjacent to Los Angeles on the south, saw extraordinary growth. The newly developing upscale area continued its interest in culture. In

1994, civic leaders in its oldest town, Santa Ana, decided to revitalize the city's historic downtown to create an Artists Village of galleries, living/studio spaces, theaters, photography studios, printmaking facilities, and retail shops. At its center was the artist-run Orange County Center for Contemporary Art, which held important exhibitions in the 1980s. There was even a possibility that California State College, Fullerton, would develop the former Grand Central Market Place there into an art center. Most recently, in 1996 Newport Harbor Art Museum, which had a thirty-year record of avant-garde exhibitions, took over the adjacent city library building and merged with neighboring Laguna Art Museum to become the Orange County Museum of Art. The new entity retained the mission of the Laguna Art Museum—to show the whole span of California as well as American art. Less than a year later, a new group took over the Laguna Art Museum site, which is now run autonomously.

In the San Diego area the former La Jolla Museum of Contemporary Art changed its name to the Museum of Contemporary Art, San Diego (fig. 35-2), remodeled, and opened a downtown San Diego branch. Alternative galleries included Sushi and Installation. San Diego's old town, immediately east of Horton Plaza, was revitalized with galleries and restaurants. Escondido, in the county's northern edge, opened the California Center for the Arts in 1992, part of an extensive civic-center complex.

In 1976 Santa Barbara witnessed the opening of the Santa Barbara Contemporary Arts Forum, and recently the Museum of Art purchased an adjacent

Fig. 35-2
Museum of Contemporary Art, San Diego
Courtesy the Museum of Contemporary Art, San Diego
Photo: Timothy Hursley

Fig. 35-3
San Francisco Museum of
Modern Art
© SFMOMA/Richard
Barnes 1994

row of shops that it has remodeled into still more exhi-
bition space, including a special gallery for the display
of historical California art.

Bay Area. The biggest boost to San Francisco's
art scene also came as a benefit of downtown redevel-
opment. As early as the 1960s the city had been try-
ing to upgrade an area called South of Market (SoMa),
a run-down area of warehouses and bars south of down-
town near where the Bay Bridge descends to the penin-
sula. (This is also referred to as the Yerba Buena Project
and as the area around the Moscone Convention Cen-
ter.) After years of legislation, about the early 1980s
the plan began to be realized. The centerpiece is the
San Francisco Museum of Modern Art (SFMMA),
which had been housed on the top floors of the Vet-
erans Building since 1935 (fig. 35-3). Across the street
is the Center for the Arts at Yerba Buena, a block-
square complex of buildings and gardens. Within walk-
ing distance are the Ansel Adams Center for Photography,
several printmaking workshops (Crown Point Press
and Aurobora Press), alternative exhibition spaces, the

Cartoon Art Museum, and the American Indian Con-
temporary Arts gallery. These are mixed in with com-
mercial galleries, motion picture theaters, low-cost
senior housing, and parks. Future institutions slated
to relocate there include the California Historical Soci-
ety and possibly the Mexican Museum and the Jew-
ish Museum. The Asian Art Museum will take over
the former post office. In an attempt to get art to a
broader audience, the San Francisco Airport turned
unadorned waiting areas into art galleries.

The East Bay benefited from the rise of San Fran-
cisco's loft rents. Downtown Oakland became the
cheaper place to live and work. The Oakland Arts
Council, created in 1979, coordinated with the city's
redevelopment agency to develop a broad-based arts
program in the central business district. The city was
already home to The Oakland Museum (new building
opened 1969); it was recently renamed the Oakland
Museum of California to make it clear that the city's
institution served the whole state. To longtime art
institutions located in the city, mentioned in earlier

chapters, were added the Lillian Paley Center for the Visual Arts, the Ebony Museum of Art (for black art), the Asian Resource Gallery, Creative Growth (for outsider art), and the commercial gallery of Victor Fisher for contemporary watercolors. "Open houses," where commercial galleries and even museums joined forces to hold huge exhibitions, included San Jose's *Art Marathon* (October 1980), San Francisco's annual *Introductions,* and shows coordinated with symposia or meetings.

Throughout Northern California, art institutions expanded or were newly founded. San Jose, south of the Bay Area, completed a major expansion of its museum in June 1990. The Monterey Peninsula, which had always had a reputation for art support, saw an expanded Monterey Peninsula Museum of Art. This accounting names just a few of the many institutions that have opened or expanded in the 1970 to 1998 period.

The 1980s was a great period for art writing: art reviews, artists' books (chapter 28), exhibition catalogues, and art history books, many on the subject of California art, were published. Irving Sandler, in his *Art of the Postmodern Era* (New York: Harper Collins, 1996), speaks of the New York art world when he describes the period as one of power-hungry, self-serving critics who spent hours writing impenetrable prose in art-theoretical tongues and holding long-running battles with advocates of opposing stances. California critics and writers, true to the state's more casual attitude toward life and art, are less inclined to take such serious and combative stances. The art-critical structure, once considered very weak, has strengthened in the 1980s and 1990s.

(For the 1989 recession, see chapter 37.)

Postmodern era

In the mid 1970s, West Coast writers were reluctantly admitting that Los Angeles's hope of replacing New York as America's first art city were dashed. Los Angeles's failure, as critics explained, came from the standard old problems: the spread-out city, its citizens' reverence for the out of doors over intellect and humanism, tepid art criticism (that forced California to see its artists through the eyes of New York critics), as well as the lack of support of contemporary local artists by local museums. Experts claimed the city's artists had no historical base, no understanding of their own historical modern artists, and no good examples of art in museums from which to learn. Local collectors purchased art from New York rather than local galleries, even when they bought work by Los Angeles artists. New Yorkers still regarded West Coast art as provincial

and naive, too full of a joy of life, too polite and politically correct, and too dependent on landscape to be important, serious, or profound.

Some Angelenos were departing the city for New York, Arizona, or New Mexico. The local art scene had slowed, drugs were too openly available, and many artists heading to the Southwest wanted to get back to basic living. However, Angelenos who went to New York, no longer went in the guise of provincial cousins hoping for acceptance by city relatives. They went because their particular personalities wanted or needed the urban, museum-dominated, tight social and political art worlds. Or Californians used the city, living and exhibiting there long enough to get critical attention. It was thought that in New York an artist could make a living from painting, whereas in California he or she made it from teaching. Many graduates of CalArts took up their careers in New York, and some were responsible for the city's art movement Media Art (showcased as *Pictures* at Artists' Space, 1977). CalArts graduates who are most well known for their successes in New York include the figure painters David Salle (b. 1952) and Eric Fischl (b. 1948) and performance artist Mike Kelley (b. 1954).

Some California artists felt more sympathetic to Europe and established their reputations there, bypassing New York entirely. However, since World War II, the art scene in Europe had had only on-and-off stylistic influence on America. Europeans, who resented and feared New York's postwar leadership in art, downplayed America's contribution by scorning its commodification of art. New Yorkers, strongly believing in their own product, openly expressed disdain for the West Coast and its art. (New Yorkers were willing to acknowledge West Coast artists who fit into their movements or who reinforced the stereotype of what the city's critics perceived West Coast art to be.) On the West Coast, although some artists continued to revere New York and European artists, distance and a more casual attitude led most to ignore, scorn, or ridicule the more intense older art centers.

As the 1970s ended and the 1980s unrolled, the question of who earned the title of America's first art city declined in importance. At first it seemed that egalitarian attitudes brought about by the Civil Rights revolution and instant communication provided by new technological devices such as the computer had made the art world a truly international community; everybody was equal. However, it soon became clear that California art, especially Southern California art, was gaining a second wind and was taking off in an entirely different and potent new direction that was impacting the rest of the world.

To the uninitiated, art of the last thirty years looks like a dense patch of intertwining brush with no tall trees, a lot of activity but no direction. (Some dealers and critics active during the exciting 1960s go so far as to claim that nothing new or important has been created since then.) However, there has been both direction and progress, specifically a gradual move away from modernism, with its belief in object art, toward humanism, with its belief in idea art. This includes a decrease in interest in the formal qualities of art and an increase in humanist themes. Abstraction has slowly lost ground to representationalism. Additionally, art gained new momentum as boundaries between media broke down and as mainstream art absorbed energy and iconography from emerging minority groups, from various countercultures, and from popular art (chapter 36). The various new electronics technologies have brought significant changes to all art forms.

In the attempt to keep the discussion of California's art of the last thirty years simple, this author chooses to break Postmodernism (art after 1970) into two broad movements: pluralism of the 1970s and humanism, which began to dominate in the early 1980s.

Pluralism

Pluralism is an umbrella term that covers the many parallel art styles and media that were being explored in the crossroads decade of the 1970s. These include all the *painting* styles and movements discussed in chapters 31 through 34 *plus* all the *non-painting* media discussed in chapters 27, 28, and 29. In the 1970s artists pushed old boundaries, extended old ideas, reworked root sources, which led the period to be called the "Neo" decade. At first, the multiple parallel movements unsettled an art world that had felt secure with modernism's one sanctioned path for the preceding twenty-five years. Pluralism was thought to be a weakness, a result of a decadent and permissive society. For a few years, some art aficionados hoped another style would rise to dominance. Critics leapt on potential new candidates, praising them and nurturing them, only to find each was a flash-in-the-pan. Art history wasn't working the way it used to. Finally, critics began to acknowledge the pursuit of *many* styles, media, and technologies as a positive result of postmodern thinking and as a

movement in itself—thus the term "pluralism."

After 1970 painting's adherents decline in proportion to those working in other media, particularly in site installations, performance, photography, and video. Some art critics in the late 1960s even decreed that painting was dead. Its formal challenges seemed exhausted, and it was seen as an elitist practice, a remnant of an eclipsed modernist culture, not suited to the '70s generation, for which it could not be meaningful.

Nonetheless, painters did emerge from art schools. And, these graduates were the most educated and informed body of artists in history. Most had years of public schooling, years of exposure to the media (television, periodicals, and computers), and had practiced art techniques and studied art history at art school or college and university art departments. Most still believed in the idea of the avant-garde—that art evolved and was advanced by innovation. Although their knowledge of art history and the great successes of the past might have intimidated them, they countered it with their youthful exuberance and a typical California defiance of authority coupled with the "permission" granted by art schools and the mainstream art world to pursue personal art directions. As a result, they pushed painting in every way possible.

After 1970 the definition of painting must be broadened in order to incorporate all the innovations in style, media, and techniques made by artists struggling to say something new. "Paint" can be oil, acrylic, watercolor, enamels, epoxy, and natural-colored liquids such as tar, blood, and berry juice. Support can be the traditional rectangular flat ground or any other object, even three-dimensional items that could receive paint. Once-discrete media merged to become multimedia; other media were incorporated into paintings, and paintings were incorporated into other media. Painters made use of newly invented electronic devices such as video, photocopiers, and verifax.

The following discussion of painting after 1970 is divided into the broadest terms possible—nonobjective/abstract (below), and representational (chapters 36 and 37). Nonobjective/abstract painters concentrate on style and on aesthetic formal issues, while representational artists become increasingly interested in content and delivering humanistic messages.

Postmodernist Abstraction

It might be asked why a painter would continue to make abstract works after 1970 when the "subject" seemed to have been pushed to its logical modernist end in the late 1960s. The answers are legion—personal preference; postmodernist permission to follow any chosen path; a belief that a painter could make additional stylistic contributions; and the use of abstraction to convey ideas. California had no specific abstract painting "movements" such as New York's Neo Geo of 1986 that deconstructed 1960s Geometric Abstraction. Californians, like most Americans, are generally not interested in group movements and manifestoes, and seem less interested in art theory and more interested in working independently to reach a personal aesthetic goal.

Stylistically, most abstractions made after 1970 are hybrids—crossbreeds of the "purist" styles of Geometric (Hard-Edge) Abstraction, Expressive (Painterly) Abstraction, and Process Art (below). Abstraction was additionally extended when artists mixed media—either incorporating other media into painting or incorporating painting into other art forms (such as room installations). Two advances stand out. Under the influence of Conceptual art, some abstractionists employ the styles and motifs found in modernism to remark on the movement. Other abstractionists turn to new technologies to extend the ideas begun by the light-and-space artists. No matter what the combination of style, technique, and medium, all results are valid in today's world.

Geometric Abstraction. Many painters continue to investigate the potential of Geometric Abstraction, the tradition that began in the early twentieth century with Russian Constructivism and that has resurfaced at various times under different names. A certain percentage of artists will always find the pursuit of formal issues a challenge. Most who pursued it after 1970, however, were historically informed, aware of how earlier painters had solved formal problems, and thus approached aesthetic questions self-consciously. They took Geometric Abstraction in as many directions as there were artists. Santa Barbara's Guy Williams (b. 1932), in works such as *Meridian Mix* of 1979, rejects Geometric Abstraction's insistence on a centrally placed shape by painting circles asymmetrically

Fig. 35-4
David Simpson (b. 1928)
Gradiva's Palace, 1976
acrylic on canvas, 84 x 84 in.
Collection of the Oakland
Museum of California; Gift
of the artist
Photo: M. Lee Fatherree

over the entire canvas and further rejects the style's reverence for primary geometric shapes by dissecting and breaking them apart. The black bars that cover John Miller's (b. 1951) white canvas in an orderly pattern from edge to edge reject Geometric Abstraction's traditional single central shape, and their regularly spaced repetition is optically kinetic and hypnotic. In a work such as *Gradiva's Palace* of 1976 (fig. 35-4), **David Simpson** (b. 1928) seeks to solve a predetermined formal aesthetic problem while also creating the humanist quality of psychic space. His formal interests include working with a limited palette and tonalities. He achieves "space" when he assigns his subject matter (the thin strips of color) to the perimeter of the canvas and leaves the vacant center as a vast field in which a viewer can become lost psychically. Some painters of Hard Edge Abstractions, compelled by nostalgia and a taste for New Wave, revive the floating triangles and lines and the aqua/pink/black coloration of 1950s design. Others approach realism when they paint tartan plaids, or enter the world of assemblage when they join painted geometrically shaped pieces of Masonite or wood to make a painting. Still others corrupt the purity of paint by using industrial materials,

Fig. 35-5
Richard Diebenkorn
(1922–1993)
Ocean Park #36, 1970
oil on canvas, 93 x 81½ in.
Collection of the Orange
County Museum of Art; Gift
of David H. Steinmetz

are the *Ocean Park* works of **Richard Diebenkorn** (chapter 26), the former Bay Area Figurative painter who settled in Southern California in 1966. In works such as *Ocean Park #36* of 1970 (fig. 35-5), the fact that the shapes seem taken from the architecture, light, and colors of his studio has caused some art historians to describe these works as a dialogue between landscape and abstraction. The transparency of the pigment reflects the Southland's translucent light and reveals Diebenkorn's process.

In the last twenty years, many abstractions have come to serve as metaphors—usually a personal, social, or political message. A pioneer in this area is **Raymond Saunders** (b. 1934), who introduces into his abstract works elements such as representational imagery, collaged items, and metaphoric subject matter. Saunders's paintings, such as *1, 2, 3, 4, 5* of 1974 (fig. 35-6), read successfully from a formal perspective, with their sophisticated color, composition, and brushwork; however, on closer inspection, details reveal deeper levels of meaning. Imagery from urban America—graffiti, blackboard scribblings, references to God and the church, and text referring to problems encountered by marginalized peoples—allude to Saunders's own background as well as black culture in general. The artist refuses to interpret the meaning of his paintings, stating that the intuitively painted works are meant to be read and appreciated in a fluid, free-form manner, like jazz, and to evoke a mood rather than deliver a predetermined message. His enigmatic and mysterious soup of memory-filled imagery succeeds in communicating both feelings and ideas to the viewer. Saunders's work is at once sublime and playful, aesthetically satisfying, and reflective of the simultaneity of life and art.

such as cement and sheet metal; or break down the formerly sacrosanct two-dimensional surface by reintroducing illusion through stippling or patterning, by overlapping geometric shapes, or by painting illusionary shadows. The combinations are endless.

Expressive Abstraction. Many artists continue to be interested in paint for its tactile quality and its potential for expression. (In the Bay Area the interest in painterly abstraction may represent a holdover from the area's groundbreaking movements in Abstract Expressionism and Bay Area Figurative painting (chapter 26).) Such artists explore color, texture, and brushwork through well-known techniques such as brushing, dripping, pooling, scribbling, and splattering to create multilayered amalgams of gesture and texture. However, most of the recent work in this genre is eclectic or of a hybrid nature. Commonly these artists use opposites in one composition. Paintings that blend the geometric shapes or large color fields of Hard-Edge Abstraction with the brushy quality of Expressive Abstraction

Other Expressive Abstractionists push traditional boundaries in their own ways. Karen Carson (b. 1943) has worked in circular formats. In some works she takes traditional brushwork and impasto to an extreme by building three-dimensional hard-edged or organic shapes with paint and other viscous materials. Other artists work planar; they paint on several flat supports and overlap or join them. Ed Moses rejects abstraction's usual two-dimensional space when he paints overlapping diagonal lines. As demonstrated in the exhibition *Los Angeles: Not Paintings?* (Santa Barbara Contemporary Arts Forum, 1993), many "painters"

use nontraditional materials—exotic woods, blown-glass candy, Formica, glitter on sheet metal, spray paint on Plexiglas, aluminum squares covered with powdered pigment, collaged items, and biochemical compounds.

Process Art. Process Art came into being in the 1960s. The name comes from the fact that it is art made from materials that assume their shape or form during or even after the process of making the work. The "subjects" of such art are the materials themselves and the processes exerted to form them, such as gravity and organic deterioration. Process Art can be traced back to the "happy accidents" of Surrealism's automatism, the "create-as-you-paint" technique of the Abstract Expressionists, and the seeking out of new materials and techniques that occurred in the 1960s. Process Art is anti-modernist in that it rejects perfection; it is formless, lawless, unplanned, visceral, and romantic and depends primarily on organic materials with "lives of their own." It is quasi-political in that its use of poor materials, such as latex, fibers, and sheet rock, is a sociopolitical stance against the art establishment (and in this way is related to Italy's Arte Povera).

Examples of Process Art are art made by sandblasting photographs, "painting" with once-popular materials such as sand or wax (encaustic), focusing sunbeams through a magnifying glass to burn paper; and mixing oil and water. In a specific California situation, one artist lets a paint-covered cord flop on a canvas; another lets paint drip and seep between abutted planks or rusted steel plates; still another lets oil soak into cardboard, or allows metallic paints to take their own shapes. In the 1970s Charles Christopher Hill (b. 1948) made art of painted, stitched, and buried newspapers. Obviously, chance effects result in nonobjective rather than representational imagery. Art works can range from flat and hard-edged to painterly and expressive. They can be emotionally poetic and metaphysical and serve as metaphors for the element of decay found in every living thing.

Pattern and Decoration (Pattern and Ornament). Since the rise of so-called fine art, decoration has been relegated to a second place status in the art world, associated with craftsmen and middle-class tastes, identified with the joyful and superficial rather than the serious and profound, and associated with the repetition of traditional motifs rather than the invention of new imagery. In late 1969 and early 1970, at the University of California at San Diego, visiting professor of art criticism and aesthetic theory Amy Goldin held discussions with students Kim MacConnel and Robert Kushner (b. 1949) on the issue of decoration in relation to "high" art. MacConnel admired decorative work such as Oriental rugs and third-world fabrics, and the

three concluded that decoration could be discussed using the same formal terms as for modern art. In the spring of 1971 MacConnel and Kushner held a joint exhibit; MacConnel's "Decorations" consisted of shamanistic tools made with contemporary or inorganic materials and Kushner's "Costumes for Moving Bodies" added a kinetic element to decoration. By the mid 1970s several independently working artists were basing their art on pattern and decoration, showing at the Whitney Biennial of 1975 and joining the stable of Holly Solomon Gallery in New York that took an interest in the theme. At the same time, in New York discussions were being held at various sites among artists, writers, and curators (including Miriam Schapiro, who in 1972 had initiated the use of pattern and decoration in Feminist Art, chapter 33) to make the trend an official movement; called Pattern and Decoration it

Fig. 35-6
Raymond Saunders (b. 1934)
"1, 2, 3, 4, 5," 1974
oil and mixed media on canvas, 89 x 64 in.
Courtesy of Steven & Nancy Oliver and Stephen Wirtz Gallery, San Francisco

Fig. 35-7
Kim MacConnel (b. 1946)
Red Lantern, 1975
acrylic on cotton, 84 x 108 in.
Collection Museum of
Contemporary Art, San
Diego; Photo courtesy Holly
Solomon Gallery, New York

was launched via an article in a German publication in 1978. The style peaked in the second half of the 1970s, taken up by artists opposing modernism, those who appreciated it for its visual properties, and those who used it to comment on decoration itself.

Kim MacConnel (b. 1946) has lived in California since 1967, although his long-term association with the Holly Solomon Gallery in New York has also identified him with that city. His show of "Decorations" with fellow student Robert Kushner in the spring of 1971 makes him one of the earliest artists in what later became an official movement. And his pursuit of decoration through the second half of the 1970s, when the Pattern and Decoration movement was at its height, makes him one of the style's major proponents. MacConnel investigates the "high" art validity of decoration as in *Red Lantern* of 1975 (fig. 35-7). A typical piece consists of irregular lengths of fabrics painted with differing patterns and pinned to a wall. He sometimes paints on supports associated with the middle-class (such as inexpensive or mass-produced household furnishings). His earlier large-scale wall hangings bore painted designs based on Near Eastern textiles, while his later works look to designs inspired from the entire third world. By pinning the completed painting to the wall, rather than stretching it over wooden bars, he used his art to soften the rigid architecture within which artworks usually hang. His use of decoration in "high" art raises issues of class distinction, challenges false hierarchies of taste, and confronts prejudice toward things associated with females and utilitarian objects.

Writers have attributed the popularity of pattern and decoration among California artists to the state's optimistic and rebellious attitude, the potent influence of its countercultures and subcultures, and its artists' love of color and light. Today the Pattern and Decoration label is applied to a wide variety of paintings characterized by excessive, allover, lush and profuse design and by elaborately baroque convulsing forms, visual movement, playfulness, and joy. Originally inspired by decorative arts from around the world, in more recent years the style has absorbed contemporary decorative elements such as New Wave colors, materials such as glitter, and iconography from popular culture. Today, instead of copying patterns, most artists originate their own. Artists whose work fits the general description of Pattern and Decoration, although the individual artists may not identify themselves with the movement, include the following: Lari Pittman (b. 1952), with his lush forms, sometimes painted in New Wave colors; Tony Berlant (b. 1941), with his collages of printed tin; and Takako Yamaguchi (1902–1983), who joins Japanese fabric designs in an abstract format.

At the beginning of the 1970s, possibly half of California's artists worked in an abstract mode, and many exhibitions of abstract painting were held.* But through the decade abstraction decreased as humanist-oriented art burgeoned. It is humanist art's styles and techniques that will be covered in the final two chapters. 🐾

*Post-1978 shows of abstract art whose catalogues, if any, were not readily located include *Color Consciousness* at Lang Art Gallery, Scripps College, 1978; *Los Angeles Abstract Painting* at University of California, Riverside, 1979; *California Dialogues* at the Santa Barbara Museum of Art in 1980; *Abstractions* at the San Francisco Art Institute in 1981; *Moving Paint: Turbulent and Tranquil* at the Irvine Fine Arts Center in 1982; *The Planar Dimension: Geometric Abstraction by Bay Area Artists* at the Walnut Creek Civic Arts Gallery in 1983; *The Four-Sided Circle—Expanding Geometrics* at Downey Museum in 1984; *Abstract Dimensional Painting* at Richmond Art Center, 1986; *Image of Abstraction* at Temporary Contemporary in Los Angeles, 1988; *New Physical Abstraction in Los Angeles* at Ace Gallery, 1988, followed by *New Psychological Abstraction in Los Angeles*; *Almost Monochrome Painting* at Studio Raid Gallery, 1993; *Simple in Appearances* [monochrome painting] at Marc Richards Gallery, 1989; *Quiet* at Oakland Art Museum, about 1988.

Bibliography

Magazines featuring California Art Published in California

Animation Magazine, v. 1+, 1987+ (published in Agoura Hills).

Antiques & Fine Art, v. 1+, c. 1983–1992 (published in San Jose).

Art Coast, v. 1+, 1989 (two issues published, Santa Monica).

Art Issues, v. 1+, 1989+ (published in Los Angeles).

Art of California, v. 1+, 1989–1993 (published in Saint Helena).

Artforum, v. 1+, 1962 (published in San Francisco, then Los Angeles, then New York).

Arts and Architecture, v. 1+, 1944 + (published in Los Angeles).

Artspace, v. 1+, 1976+ (published in Los Angeles/Albuquerque).

Artweek, v. 1+, 1970+ (published in various towns in Northern California).

Coagula, v. 1+, c. 1993+ (published in Los Angeles).

Fine Print, v. 1+, 1975+ (published in San Francisco).

High Performance, v. 1+, 1978 (published in Los Angeles).

Images and Issues, v. 1+, 1980 (published in Santa Monica).

LAICA Journal, v. 1+, 1974+ (published by the Los Angeles Institute of Contemporary Art).

L. A. Weekly, v. 1+, c. 1978+ (published in Los Angeles).

La Mamelle [performance], v. 1+, 1976+ (published in San Francisco).

Museum of California, v. 1+, 1980+ (published by the Oakland Museum of California).

Ornament, v. 1+, 1979+ (published at various times in various cities in Southern California).

San Francisco Camerawork, v. 1+, 1982+ (published in San Francisco).

Umbrella [artists books, mail art, art works on paper], v. 1+, 1978 (published in Glendale).

Visions: The Los Angeles Art Quarterly, v. 1, no. 1, November 1, 1986–1993 (published in Los Angeles).

Visual Dialog: Quarterly Magazine of the Visual Arts, v. 1, no. 1, September–November 1975+ (published in Los Altos).

Infrastructure, 1975+, General California

"Alternatives: Pt. I," [6 articles on spaces and funding] *Artweek*, v. 26, no. 12, December 1995, pp. 12–17.

"Alternatives: Pt. II," [Web, Victoria Room, artist/curators/ Santora Arts Complex, Orange County Center for Contemporary Art] *Artweek*, v. 27, no. 1, January 1996, pp. 12–17.

Art Expo West, exh. cat., Los Angeles Convention Center, September 4–8, 1980.

"Art Literacy," [5 articles on the need for artists to educate the general public on art] *Artweek*, v. 26, no. 8 August 1995, pp. 13–16.

"Art Schools," *Artweek*, v. 24, no. 9, May 6, 1993, pp. 15-19.

"Arttalk: John Caldwell, San Francisco Museum of Modern Art," *Artweek*, v. 21, no. 4, February 1, 1990, p. 3; "Burnham and Miller, Highways founders," *Artweek*, v. 21, no. 8, March 1, 1990, p. 3; "Harry S. Parker, III, Director of the Fine Arts Museums of San Francisco," *Artweek*, v. 21, no. 11, March 22, 1990, p. 3; "Adolfo V. Nodal, General Manager of Cultural Affairs, Los Angeles," *Artweek*, v. 21, no. 16, April 26, 1990, p. 3; "I. Michael Danoff, Director of the San Jose Museum of Art," *Artweek*, v. 21, no. 19, May 17, 1990, p. 3; "Suzy Kerr, Director, Los Angeles Center for Photographic Studies," *Artweek*, v. 21, no. 20, May 24, 1990, p. 3; "Phil Linhares, Chief Curator of Art at Oakland Museum," *Artweek*, v. 21, no. 24, July 19, 1990, p. 3; "Hugh M. Davies, Director of San Diego Museum of Contemporary Art," *Artweek*, v. 21, no. 28, September 6, 1990, p. 3, and other personalities.

"Artweek Focus: Art and Money," *Artweek*, v. 21, no. 28, September 6, 1990, pp. 21–25.

"Artweek Focus: [Private] Museums," *Artweek*, v. 22, no. 1, January 10, 1991, pp. 21–24.

"Artweek Focus: The Art Museum Today," *Artweek*, v. 22, no. 41, December 5, 1991, pp. 17–19.

"Artweek Focus: Not For Profits," *Artweek*, v. 23, no. 21, August 6, 1992, pp. 4–5, 16–18.

"Artweek Focus: Other Museums," [Japanese American, Jewish, Mexican, Getty, and corporate collecting] *Artweek*, v. 23, no. 19, July 9, 1992, pp. 4–5, 24–29.

Baum, Hank, ed., *The California Art Review*, Millbrae, Ca.: Celestial Arts, 1981.

Beyond Fragments: After the Earthquake, exh. cat., Pro Arts Tempspace, September 12–October 20, 1990. 31 p.

Bishop, John Melville, *California Artists: At the Crossroads*, Sacramento, Ca.: Published for the California Arts Council, Traditional Folk Arts Program by Media Generation, 1991.

"California Art Explosion," [3 article anthology] *New Art Examiner*, v. 16, March 1989, pp. 13–14, 22–28.

California Art Review: An Illustrated Survey of the State's Museums Galleries and Leading Artists, Chicago, Ill.: Les Krantz American References, Inc., 1989. 1329 p.

California Arts Council's Artists-in-Social-Institutions Program: Hearing Transcript, State Capitol, Sacramento, May 9, 1984, Sacramento, Ca.: California Legislature, Joint Committee on the Arts, 1984.

California Legislature, Joint Committee on the Arts, *Hearing Transcript, California Arts Council's Budget & Programs*, State Capitol, Sacramento, March 27, 1985.

Clifton, Leigh Ann, "New Problems for Veteran Nonprofit Arts Venues," [earthquake] *Artweek*, v. 25, no. 7, April 7, 1994, p. 13.

Coming of Age in California: Museums of Modern and Contemporary Art: Panel Discussion, Stanford Court, San Francisco, California, March 21, 1981, Washington, D. C.: Archives of American Art, Smithsonian Institution, 1981. 51 leaves.

Frank, Peter, "Patterns in the Support System for California Art," *LAICA Journal*, no. 19, June/July 1978, pp. 42–43.

Friedman, K. S., "California: an Overview of its Multi-Faceted Art Scene," *Art Voices/South* (USA), v. 3, pt. 1, January–February 1980, pp. 51–55.

Geldzahler, Henry, "California As World Art Capitol," *California Magazine*, v. 9, no. 4, April 1984, pp. 78–85.

Goldbard, A., "Forum: Proposition 13, How Has it Affected the Arts in California," *American Artist*, v. 43, November 1979, pp. 14-15+.

Hopkins, Henry, "The Golden State of California Museums," *New Art Examiner*, v. 16, no. 7, March 1989, pp. 22-24.

Hoving, Thomas, "The Grand Tour: Rating California's Art Museums and their Contents," *Connoisseur*, v. 217, February 1987, pp. 94–103.

McMaster, Carolyn, "Inside the Museums: Four Young Curators at Work in California Today," *Artweek*, v. 22, October 10, 1991, p. 9.

Moser, Charlotte, "The New West Coast Art Academia," [College Art Assn. meeting] *Artweek*, v. 21, March 8, 1990, pp. 18, 20.

Webb, Catherine J. & Associates, *Art for Everyone*, Albany, Ca.: C. J. Webb, 1986.

"Westward Ho!," [14 article special section on California] *Connoisseur*, v. 217, February 1987, pp. 61–130. except for pp. 117–130 and pp. 61–70.

Who's Who in the California Art Club, Inc.,: Roster and By-laws, 1984, (75th Anniversary edition).

Art Law

Abouaf, Jeffrey R., *Tax and the Individual Artist*, San Francisco, Ca.: Bay Area Lawyers for the Arts, 1977. 34 p.

Alternative Dispute Resolution Training Manual, Los Angeles, Ca.: California Lawyers for the Arts, Arts Arbitration and Mediation Services, 1988.

"Artweek Focus: First Amendment Rights," [5 articles on art censorship in California] *Artweek*, v. 21, no. 23, July 5, 1990, pp. 17–23.

California Lawyers for the Arts, The Art of Deduction [Income Taxation for Performing, Visual and Literary Artists], San Francisco: California Lawyers for the Arts, 1989.

"The California Resale Royalties Act; Rights of Artists: the Case of the Droit de Suite," [4 articles] *LAICA Journal*, no. 13, January/February 1977, pp. 35–55.

Freedman, Robert B., *Basic Law for the Artist*, San Francisco: Bay Area Lawyers for the Arts, 1975.

Goetzel, Thomas M., "Recent Arts Legislation - an Overview," *Artweek*, v. 9, January 14, 1978, pp. 15–16.

Hugo, Joan, "The Issues of Survival," [report on the Visual Artists symposium] *Artweek*, v. 13, no. 2, January 16, 1982, p. 3.

Karlen, Peter H., [periodic articles on California's art law] *Artweek*, c. 1980–present.

Koch, Harry Walter, *California Law for the Visual Arts*, San Francisco, Ca.: Ken Books, 1983. 81 p.

Legislative Masterpieces: A Guide to California Arts Legislation, San Francisco, Ca.: California Lawyers for the Arts, 1989. 70 l.

Live-work: Form & Function [based on a one day workshop on the development of live/work space, held October 24, 1987 and again June 25, 1988], San Francisco: Art House [joint project of California Lawyers for the Arts and the State-Local Partnership program of the San Francisco Arts Commission], 4 ed., 1989. 96 l.

McMaster, Carolyn, "The Good Fight: California Lawyers for the Arts," *Artweek*, v. 23, June 18, 1992, p. 13.

Moore, Linda Wolcott, "Child Pornography and California Law," *Photo Metro*, no. 80, v. 8, June–July 1990, pp. 20–21.

O'Brien, John, "Acting on Choices: Accessible ARTtorneys for Art," *Artweek*, v. 21, June 7, 1990, p. 14.

Price, Monroe E. and Hamish Sandison, *A Guide to the California Resale Royalties Act*, Los Angeles: Advocates for the Arts, UCLA School of Law, 1976. 36 p.

Sandison, Hamish, ed., *A Guide to the New California Artist-Dealer Relations Law*, Berkeley, Ca.: Bay Area Lawyers for the Arts, 1975. 30 p.

Sandison, Hamish, ed., *The Visual Artist & the Law: Handbook for a Seminar on the Legal Problems of Artists and Art Groups*

sponsored by *Bay Area Lawyers for the Arts in Collaboration with the Earl Warren Legal Institute,* Boalt Hall School of Law, University of California, Berkeley, Saturday, March 8, 1975.

Stein, M. L., "David Takes on Goliath," [State of California attempts to tax small newspaper for comics and political cartoons] *Editor and Publisher,* v. 128, no. 46, November 18, 1995, pp. 9+.

Visual Artist's Seminar [reprinted with permission from the Beverly Hills Bar Association Barrister's Committee for the Arts] San Francisco, Ca.: California Lawyers for the Arts, 1989. 154 p.

Infrastructure, 1975+, Southern California

Alcala, Angel M., *Regional Art Center for East Los Angeles,* Project (M. Arch), University of California, Los Angeles, 1990.

Anawalt, K., "Why Not L. A.," [alternative spaces] *High Performance,* v. 3, nos. 3–4, Fall/Winter 1980, pp. 132–36.

"Alternatives: Part II," [various exhibition sites and options] *Artweek,* v. 27, no. 1, January 1996, pp. 12–17.

Armstrong, R., "Portrait: Los Angeles," *Portfolio* (USA), v. 2, pt. 4, September–October 1980, pp. 98–104.

Artcoast (magazine of contemporary art east and west, published in Santa Monica) v. 1, no. 1, March/April 1989 and v. 1 no. 2, May/June 1989. May not have survived others.

Artscene, published, Los Angeles: The Thinking Eye, 1982+

"Artweek Focus: On Hollywood Boulevard," [new home for LACE, LACPS and EZTV, etc.] *Artweek,* v. 25, no. 15, August 4, 1994, pp. 14–20, 32.

Ballatore, Sandy, "High Points, Low Points, and No Points: Los Angeles 1980," *Images and Issues,* v. 1, pt. 3, Winter 1980–81, pp. 17–21.

Ballatore, Sandy, "Two Spaces one World: [exodus] from Los Angeles to New Mexico," *Artspace,* v. 13, May–June 1989, pp. 70–74.

Barron, Mary Lou, *You've Got to Start Somewhere! Fine Art Facts and Facilities in Orange County,* Fountain Valley, Ca.: Barron, 1975.

Belsky, Aaron, "Art Barn," [Frank Israel art barn, private art museum, LA] *Architectural Record,* v. 180, no. 2, February 1992, pp. 66+.

Brenner, Douglas, "L. A. Dream House: Vena-Mondt Studio/Residence, Los Angeles [lofts]," *Architectural Record,* v. 173, February 1985, pp. 134–41.

Brown, David, et al., "Art Center College of Design, Pasadena," *Design World* (Australia), no. 26, May 1993, pp. 2-13.

Brumfield, John, "The Olympics California Sculpture Show," *Artweek,* v. 15, no. 27, July 28, 1984, p. 1?

Cameron, Dan, John Welchman, Kristina Van Kirk and Marc Selwyn, "L. A.: An Eye on the West," *Flash Art,* special supplement 6, no. 141, Summer 1988, pp. 101–17.

Cameron, Dan, "Changing Priorities in American Art," [Chicago & LA usurping NY] *Art International* (Switzerland), no. 10, Spring 1990, pp. 89–90.

Canvassing L.A.: An Artful Guide to Contemporary Art Galleries, Museums and Restaurants, Pasadena, Ca.: Pasadena Art Alliance, 1988. 81 p.

Chattopadhyay, Collette, "Forget New York: Los Angeles, Area Museums Now Seek an International Impact," *Artweek,* v. 25, September 8, 1994, p. 13.

Chattopadhyay, Collette, "Social Sight: Artist Residencies at Santa Monica Place," *Artweek,* v. 24, June 17, 1993, p. 26.

Clifton, Leigh Ann, "Artist-friendly Developments in Santa Ana," *Artweek,* v. 25, September 8, 1994, p. 2.

Clifton, Leigh Ann, "Think Tank: Artists Develop Ideas at Local Alternative Art Spaces," *Artweek,* v. 24, no. 23, December 2, 1993, pp. 20–21.

Clothier, Peter, "L.A.: Outward Bound," *Artnews,* v. 88, no. 10, December 1989, pp. 126–31. [art scene]

Clothier, Peter, "The Next Wave," *Artnews,* v. 89, no. 10, December 1990, pp. 112–17. [current LA art scene]

Clothier, Peter, "Smoggy Euphoria," *Artnews,* v. 88, no. 5, May 1989, pp. 50–53. [growth of LA art scene]

Clothier, Peter, "Westward Expansion," [LA's Bergamot Station] *Art News,* v. 93, November 1994, pp. 44+.

Cohen, William K., *Art of Our Time in Southern California: A Guide to the Documentation of Contemporary Art,* New York: Garland, 1986. (Garland Reference Library of the Humanities, v. 657) 132 p.

Conrad, Barnaby, "Los Angeles: the New Mecca," *Horizon,* v. 30, January–February 1987, pp. 17–30. [L.A. as art center]

Davies, Hugh M. and Anne Farrell, *Learning from La Jolla* [about the Museum of Contemporary Art, San Diego], San Diego: Museum of Contemporary Art, 1996. 48 p.

deMayo, Cathy, "Orange County: A Place in the Sun," *Horizon,* v. 30, January-February 1987, pp. 56–62.

Educating Artists: Fine Arts at Art Center, Art Center College of Design, Pasadena, 1983. 48 p.

Face to Face: Ten Santa Barbara County Artists on the Creative Process, Santa Barbara, Ca.: B. Parmet, 1988. 20 p.

Farling, Patricia, "Los Angeles Gets New Temple of Art," *ARTnews,* v. 85, pt. 9, November 1986, pp. 8–94.

58 F Plaza: A Time Remembered [CSU, Fullerton], exh. cat., Art Gallery, California State University, Fullerton, February 9–March 10, 1985. 64 p.

Gabrielson, Walter, "The Ironic Los Angeles Artist," *LAICA Journal,* no. 12, October–November 1976, pp. 24–28.

"A Gallery in Review," [homage to Newspace gallery by SDSU] *Artweek,* v. 10, no. 37, November 10, 1979, p. 6.

"The Getty Center: Combining Form and Function," *Art of California,* v. 5, no. 2, May 1992, pp. 52-53.

Greenstein, M. A., "Edgy in Edge City: Los Angeles and Alternative Spaces in the Nineties," *Artweek,* v. 24, April 22, 1993, pp. 16–17.

Henry, Clare, "Los Angeles Art Boom," *Studio International* (U.K.) v. 200, May 1987, pp. 38-41.

Hoffs, Ellen, "L.A.'s Modern & Contemporary Museums, Open with a Bang!," *Antiques & Fine Art,* v. 4, no. 4, May/ June 1987, pp. 56-57.

Installation 1981–1986, exh. cat., Installation [a non profit space], San Diego, 1986.

"L. A. Today: A Special Section," *Art in America,* v. 69, May 1981, pp. 41-65, includes Carrie Rickey, "Art Attack," [LA art scene]; P. Clothier, "Moving Downtown"; Sarah McFadden, "L. A.'s Museum of Contemporary Art: An Update"; Carrie Rickey, "The Writing on the Wall"; Peter Clothier, "Brick, Brushes, Barbells"; Walter Gabrielson, "Pasadena Pluralism: The Painting '70s."

LACE: 10 Years Documented, Los Angeles: Los Angeles Contemporary Exhibitions, 1988. 111 p.

Larsen, Susan C., "Los Angeles: Downtown Moves Up," *Art News,* v. 81, pt. 1, January 1982, pp. 80–84.

Leone, Genevieve, "Live/Work's New Zoning: Artists Want Citywide Controls," *Northern California Real Estate Journal,* v. 2, no. 22, April 18, 1988, p. 5.

Lineberry, Heather S., "Newport Harbor Art Museum," *Art of California,* v. 4, no. 4, July 1991, pp. 18–21.

Lopez, Elizabeth Christine, *Community Arts Organizations in Los Angeles: a Study of the Social and Public Art Resource Center, Visual Communications and the Watts Towers Art Center,* M. A. Thesis, University of California, Los Angeles, 1995. 69 l.

"Los Angeles Bicentennial," [items designed for] *Graphic Design,* no. 82, June 1981, pp. 35–42.

Los Angeles California—Art Scene [2 videos, 56 min. ea.] produced and directed by David Howard, San Francisco, Ca.: Visual Studies, distributed by Art COM, 1986.

Los Angeles Institute of Contemporary Art Oral History Transcript: the First Ten Years, Oral History Program, University of California, Los Angeles, 1986. 172 l.

"Los Angeles West Coast Gateway," [sculpture] *A + U,* no. 283, April 1994, pp. 108–21.

Lovoos, Janice, and Elizabeth Hopkins, "City Views: Laguna Beach," *Southwest Art,* v. 13, December 1983, pp. 128–35.

Maleski, Stash, "Signs of the Times: a Conversation with Mary Carter, Director of the Museum of Neon Art," *Artweek,* v. 24, February 4, 1993, p. 34.

Market Assessment and Land Use Analysis for Proposed Artist Community in Downtown Santa Ana, California: Final Report, Santa Ana, Ca.: City of Santa Ana, 1994. 1 v. various pagings.

Marks, Ben, "Growing Pains at CalArts," [and other schools] *Artweek,* v. 21, no. 9, March 8, 1990, pp. 20–21.

Marrow, Marva, *Inside the L. A. Artist,* Salt Lake City, Ut: Gibbs M. Smith, Inc., 1988.

McManus, Michael, "An Anxious Space," [San Diego storefront window display of fine art] *Artweek,* v. 18, April 25, 1987, p. 6.

Miller, Elise, "College Art Rush," [Miracosta and Palomar] *San Diego Magazine,* v. 33, no. 6, April 1981, pp. 118–21.

Miller, Elise, "The Flowering of North County: The Art Boom," *San Diego Magazine,* v. 31, no. 5, March 1979, pp. 92–95.

Miller, Elise, "The Gaslamp Quarter," *San Diego Magazine,* v. 32, no. 9, July 1980, pp. 213–15.

Muchnic, Suzanne, "Bliss, Food House and Hello Artichoke [Southern California art scene]," *Art News,* v. 93, no. 5, May 1994, pp. 124–27.

Nelson, Sandy, "Celebrating Los Angeles Art—1984," *Images & Issues,* v. 5, pt. 1, July–August 1984, pp. 30–35.

Plagens, Peter, "Decline and Rise of Younger Los Angeles Art," [15 artists] *Artforum,* v. 10, May 1972, pp. 79–81.

Plagens, Peter, "Los Angeles: Two for the Show [new MOCA and LACMA Anderson Bldg.]" *Art in America,* v. 75, pt. 5, May 1987, pp. 146–52+.

Rugoff, Ralph, "Liberal Arts," [CalArts] *Vogue,* v. 179, no. 8, August 1989, pp. 328+.

Ryan, R., "Art Annex," [Frank Israel Art Barn in Bel Air] *Architectural Review,* v. 191, September 1992, pp. 34-37.

San Diego Museum of Contemporary Art: Selections from the Permanent Collection, La Jolla: The Museum, 1990. 119 p.

Santa Barbara Museum of Art: Selected Works, Santa Barbara Museum of Art, 1991. 109 p.

Saunders, Wade and Craig Gholson, "Los Angeles," *Bomb* (USA) no. 22, Winter 1988, pp. 74–85. [L.A. art scene]

Scarborough, James, "Le Paysage Artistique de Los Angeles," *Art Press* (France), no. 184, October 1993, pp. 29–31.

Schemmerling, C. and P. Selz, "Actual Symposium" [Santa Barbara Contemporary Arts Forum] *Arts*, v. 56, September 1981, pp. 174-76.

Schjeldahl, Peter, "L. A. De-Mystified," *LAICA Journal*, no. 31, Winter 1981, pp. 21–25.

Seemayer, Stephen, *The Young Turks* [downtown LA art scene: documentation, notes, shooting script, and stills from a new film], Los Angeles: Astro Artz. 186 p.

[several articles comparing New York to Los Angeles], *LAICA Journal*, no.10, March-April 1976, pp. 10–31.

"Special Section: Los Angeles," [4 article anthology] *Art in America*, v. 70, January 1982, pp. 80–110.

"Special Supplement: Los Angeles," [4 article anthology] *Flash Art*, no. 14, Summer 1988, pp. 102–17.

Tumlir, Jan, "Homebodies: P. O. P. at 1529 Wellesley," [new alternative space in Los Angeles] *Artweek*, v. 24, March 18, 1993, p. 19.

University of California, Irvine, Fine Arts Gallery 1985–1986, 20th Anniversary, Irvine: The Gallery, 1986. 48 p.

Venice Art Walk, Venice Family Clinic, Admiralty Place Art Pavilion, Marina del Rey, Ca., 1988.

Vincent, Steven, "Laguna Blues," [merger of Laguna Art Museum with Newport Harbor Art Museum], *Art & Auction*, v. XIX, no. 3, October 1996, pp. 46–52.

"Walking for a Cause—the Venice Family Clinic," *Artweek*, v. 24, May 20, 1993, p. 2.

Welchman, J., "World Chronicles: Los Angeles," *Art International*, no. 3, Summer 1988, pp. 54–58.

Whiteson, Leon, "Arts Fusion: California Center for the Arts, Escondido," *Architecture*, v. 83, December 1994, pp. 48–57.

Wortz, Melinda, "Myth and Maturity in the L. A. Art Scene: a Personal View, 1981" *Images and Issues*, v. 2, Winter 1981–82, pp. 54–55.

Infrastructure, 1975+, Northern California

Albright, Thomas, "San Francisco: Different and Indifferent Drummers," *Art News*, v. 81, pt. 1, January 1982, pp. 86–90.

"Artweek Focus: Alternative San Francisco," [3 articles on alternative spaces] *Artweek*, v. 25, no. 11, June 9, 1994, pp. 14–16.

Atkins, Robert, "Trends, Traditions and Dirt: An Opinionated Guide to the Current State of Art in Northern California," *LAICA Journal*, no. 31, Winter 1981, pp. 29–33.

Aziz, Anthony, "Friends of the Family: The Ansel Adams Center Debuts," *Artweek*, v. 20, September 30, 1989, p. 3.

Baer, Virginia Hubbell, *Artsfax '81: A Report on the Finances, Personnel, and Programs of Bay Area Arts Oranizations*, San Francisco, Ca.: San Francisco Foundation, 1981. 161 p.

Berkeley and the Arts, Berkeley, Ca.: Berkeley Public Library, 1978.

Berkson, Bill, "The Salon at Mission and Third" [Yerba Buena Gardens Center, San Francisco], *Art in America*, v. 82, June 1994, pp. 40–41.

Bonetti, David, "Bay Area Art: The Last Bohemia," *Artnews*, v. 89, no. 10, December 1990, pp. 118–23.

Brunson, Jamie, "Fresh Starts: New galleries inject life into downtown Oakland," *Artweek*, v. 21, March 1, 1990, pp. 10–11.

Brunson, Jamie, "Of a Different Order: Headlands Art Center," *Artweek*, v. 20, no. 39, November 23, 1989, pp. 1, 17.

California College of Arts and Crafts, Oakland, [Annual Prospectus], published annually in the 1960s and the 1970s.

California College of Arts and Crafts: Seventy-Five Years, 1907–1982, Oakland, Ca.: The College, 1982. 12 p.

Clifton, Leigh Ann, "Museums Hit the Road: San Jose Museum of Art Strikes a Deal," [rents art from Whitney] *Artweek*, v. 23, November 19, 1992, pp. 28–29.

Clifton, Leigh Ann, "New Problems for Veteran Nonprofit Arts Venues," [earthquake damage] *Artweek*, v. 25, April 7, 1994, p. 13.

David, M. O., "San Francisco Post-Hip," *High Performance*, v. 4, no. 4, Winter 1981–82, pp. 3–7.

Dixon, Albert G., Jr., "The Troubled San Jose Museum of Art," *Artweek*, v. 18, March 7, 1987, pp. 18–19.

Dunham, Judith L., "The Airport Becomes a Museum," *Artweek*, v. 12, no. 16, April 25, 1981, p. 7.

Exhibiting Spaces 1975–76: Artists' Bay Area Marketing Handbook, Felicity Pruden, comp., San Francisco: Mother's Hen, 1975. 222 p.

Farling, P., "California in Context: Henry Hopkins and the San Francisco Museum of Modern Art," *Art News*, v. 84, April 1985, pp. 79–84.

Hartigan, Patti, "The Morphing of Fort Ord," [conversion to multi-purpose facility for the arts] *American Theatre*, v. 13, no. 1, January 1996, pp. 30+.

Heartney, Eleanor, "Bay Area Modern [San Francisco Museum of Modern Art]," *Art in America*, v. 83, May 1995, pp. 92–97.

"Introductions '93 San Francisco Art Dealers Association," *Artweek*, v. 24, no. 15, August 5, 1993, pp. 14–18.

Jordan, Jim, "East Bay Artists Unite: the Reincarnation of Pro Arts," *Express* (Berkeley), v. 7, no. 37, June 28, 1985, pp. 3, 8.

Kibbe, Barbara, *Live/Work: The San Francisco Experience*, San Francisco, Ca.: San Francisco Arts Commission, 1985. 79+ p.

Kremer, Naomie, "The Bus Shelter Gallery," [S. F.] *Artweek*, v. 23, pt. 29, December 3, 1992, p. 17.

McGreehan, Cheryl, "SAMCO Loan Helps Artists Retain their Live-in Warehouse Studios," *Perspectives*, v. 3, no. 1, Winter–Spring 1987, pp. 10, 23.

Mingo, Jack, "The Art of the Deal [land use controversy regarding Fifth Avenue Point Artist Colony in Oakland], *Express* (Berkeley) v. 19, no. 34, May 30, 1997, pp. 1, 7–10.

"A New Home for the San Francisco Museum of Modern Art," *Art of California*, v. 5, no. 4, September, 1992, pp. 62-63.

New Langton Arts, the First Fifteen Years, San Francisco, Ca.: New Langton Arts, 1990. 88 p.

1981 California College of Arts and Crafts Alumni Directory, Montgomery, Ala.: College & University Press, 1981. 140 p.

O'Brien, Bill, "Artists, an Emeryville Endangered Species?: Inexpensive Workspace for Artists is in the Path of Phenomenal Development Pressure," *Express* (Berkeley), v. 18, no. 38, June 28, 1996, pp. 2–3, 16.

Open Studio: Santa Cruz County [September 27–28, 1986], Santa Cruz, Ca.: Cultural Council of Santa Cruz County, 1986. 33 p.

Open Studio: 1987 [September 26–27], Santa Cruz, Ca.: Cultural Council of Santa Cruz County, 1987. 56 p.

Open Studio [October 8–9, 15–16], Santa Cruz, Ca.: Cultural Council of Santa Cruz County, 1988. 64 p.

Open Studios 1992, Aptos, Ca.: Cultural Council of Santa Cruz County, October 10–11, 17–18, 24–25, 1992. 104 p.

Open Studios 1993, Aptos, Ca.: Cultural Council of Santa Cruz County, October 9–10, 16–17, 23–24, 1993. 106 p.

Open Studios 94: Event Guide and Year-Round Directory of the Visual Artists of Santa Cruz County [October 8–9, 15–16, 22–23], Aptos, Ca.: Cultural Council of Santa Cruz County, 1994. 119 p.

Open Studios 96: Self-Guided Art Tours of Santa Cruz County, October 5–6, 12-13, 19–20, 1996, Aptos, Ca.: Cultural Council of Santa Cruz County, 1996. 119 p.

Perry, David, "Arts and Social Change: [program at San Francisco's] New College of California," *High Performance*, v. 15, pt. 4, Winter 1992, pp. 28–9.

Report on the 1984 South of Market Artist Live/Work Space Survey, San Francisco, Ca.: Department of City Planning, 1985. 36 l.

San Francisco, California Art Scene [2 part video, 56 min. ea.] directed by David Howard, San Francisco, Ca.: Visual Studies, distributed by Art COM, 198? and pt. 2 1986.

San Francisco Museum of Modern Art, The Making of a Modern Museum, San Francisco: The Museum, 1994. 153 p.

Santa Cruz Scrapbook: Artist & Craftspeople 1974, exh. cat., Santa Cruz City Museum and Santa Cruz Public Library, September 27–November 15, 1974. 46 p.

Santiago, Chiori, "A Vibrant New Heart for Art in San Francisco," [SFMMA], *Smithsonian*, v. 26, July 1995, pp. 60–68.

Schapiro, Mark, "The Bay Area: The Persistence of Light," [Hunter's Point artists] *Art News*, v. 88, December 1989, pp. 132-37.

Schmidt, Lisa, "Warehouse Life: Gentrification Hits Emeryville," *Express* (Berkeley, Ca.), v. 8, no. 25, March 28, 1986, pp. 3, 19.

Solnit, Rebecca, "Forgotten Connections: Subversive Excellences," [King Ubu Gallery] *Artweek*, v. 20, January 21, 1989, p. 7.

Steidtmann, Nancy, "Oakland in the Arts Spotlight," [growing art community] *Horizon*, v. 30, January–February 1987, pp. 42–46.

Stofflet, M., "James Elliott, Director of the University Art Museum, Berkeley, California," *La Mamelle Magazine: Art Contemporary* (USA), v. 2, pt. 2–3, 1977, pp. 8–9, 55.

Stofflet, Mary, "Thriving—if not Exploding: Bay Area 1980," *Images and Issues* (USA), v. 1, pt. 3, Winter 1980–81, pp. 12–16.

Stowens, Susan, "On Tour in S. F…," *American Artist*, v. 45, April 1981, pp. 66-69+.

Taylor, Ted M., "Monterey Peninsula Museum of Art," *Art of California*, v. 6, no. 4, August 1993, pp. 34–5.

Tyson, Janet E. S., "Art Marathon, San Jose," [13 spaces, Art Associations of the South Bay hold Art Marathon] *Artweek*, v. 11, October 25, 1980, p. 13.

Weiffenbach, Jean-Edith, "What Bay Area?" [alternative art] *Art Journal*, v. 53, Fall 1994, pp. 46+.

Faculty and Student Exhibitions, 1970+

All Colleges Art Faculty Exhibition, exh. cat., Florence Rand Lang Art Gallery, Scripps College, Claremont, Ca., n. d., 1970. 64 p.

Artists Forum: Selected Faculty Artists from the California State University, exh. cat., California State University, Los Angeles, Fine Arts Gallery, October 28–November 8, 1985 and four other venues.

California State University, Hayward, Art Department, *Art Student Portfolio,* 1974 (Fremont, Ca.: The Fault, July 1974).

Claremont Colleges Faculty Exhibition, exh. cat., Lang Art Gallery, Scripps College, Claremont, Ca., January 15–February 20, 1977. 30 p.

The Early Sixties at UCLA, exh. cat., Frederick S. Wight Art Gallery, University of California, Los Angeles, January 8–February 19, 1977. 75 p.

18 Bay Area Artists: An Exhibition in Two Parts, exh. cat., University Art Museum, University of California, Berkeley, February 1–April 24, 1977. 54 p.

18 UCLA Faculty Artists, exh. cat., Frederick S. Wight Art Gallery, University of California, Los Angeles, September 30–October 26, 1975. 39 p.

Emerging Artists/UCLA [published annually, 1974-84], Los Angeles: Department of Art, University of California, Los Angeles [11 portfolios].

Exhibition, an Exhibition of Current Works by Artists who are Alumni of the School of Art and Design of California Institute of the Arts, exh. cat., California Institute of the Arts, Valencia, September 21–October 9, 1981. 120 p.

Faculty Exhibit, exh. cat., Los Angeles County Art Institute, December 10, 1959–January 17, 1960. 29 p.

Faculty Exhibit, exh. cat., Los Angeles County [Otis] Art Institute, March 14–April 28, 1968. 28 p.

Faculty Exhibition, exh. cat., University Art Gallery, Sonoma State University, Rohnert Park, Ca., September 18–October 25, 1981. 34 p.

Faculty Exhibition, exh. cat., University Art Gallery, Sonoma State University, Rohnert Park, Ca., September 10–October 25, 1987. 37 p.

Faculty Retrospective Exhibition, exh. cat., Mills College Art Department celebrates the opening of the Jane Baerwald Aron Art Center, September 25, 1986.

Faculty 77, exh. cat., Art Galleries, California State University, Long Beach, September 12–October 2, 1977. 40 p.

Faculty '68, exh. cat., University of California, Irvine, Art Gallery, April 16–May 5, 1968. 26 p.

15 UCLA Design Faculty Artists, Frederick S. Wight Art Gallery, University of California, Los Angeles, February 1–March 13, 1977. 34 p.

Image: Master of Fine Arts Graduates 1975, exh. cat., Otis Art Institute, Los Angeles, 1975.

1985 Art Faculty, California State University, Fresno, exh. cat., Phebe Conley Gallery, California State University, Fresno, December 13, 1985 - January 26, 1986. 12 leaves of plates in folder.

1977 Art Faculty, California State University Fresno, exh. cat., California State University, Fresno, 1977. 18 sheets.

Obliquities; Los Angeles: Recent Work from the Teaching Artists at Loyola Marymount University, exh. cat., Laband Art Gallery, Loyola Marymount University, Los Angeles, September 2–October 10, 1992. 36 p.

Otis '74, exh. cat., Otis Art Institute of Los Angeles County, n. d., 1974.

Painters Behind Painters: An Exhibition of Central California Artists Teaching at the College Level, exh. cat., California Palace of the Legion of Honor, San Francisco, May 13–June 25, 1967.

Paintings by U.C. Artists: Faculty of the Departments of Art, University of California, Berkeley and Davis, exh. cat., University Art Gallery, University of California, Berkeley, July 13–August 31, 1965. 27 p.

Roth, Moira, et al., eds., *U.C. San Diego Faculty Art Exhibitions/Department of Visual Arts, University of California San Diego,* La Jolla: Mandeville Art Gallery, UCSD, 1976.

Recent Work by Master of Fine Arts Graduates of UCSB, exh. cat., Santa Barbara Museum of Art, May 11–June 9, 1974. 72 p.

Reflections: Alumni Exhibitions, San Francisco Art Institute, exh. cat., San Francisco Art Institute, January 1981. 60 p.

Teaching Artists: the UCLA Faculty of Art and Design, exh. cat., Wight Art Gallery, University of California, Los Angeles, October 7–November 9, 1986. 88 p.

Painting, 1970s

Alliata, V., "West Coast [state of art]," *Bolaffiarte* (Italy), no. 51, v. 6, June–July 1975, p. 40–45.

Annual, exh. cat., San Francisco Art Institute, September 12, 1975–August 27, 1976. [year-long exhibition, each artist given 1 week show]. 50 p. [Another with same title held in 1980.]

Baja [Calif. artists response to], exh. cat., San Francisco Museum of Art, December 27, 1974 - February 9, 1975 and in New York. 32 p.

Bolles, J., "An American City's Tradition of Art," *American Institute of Architects Journal,* v. 60, September 1973, pp. 18–23.

Danieli, Fidel, "Mainstream California Individualism," [review of exh. at 2 Venice galleries] *Artweek,* v. 12, no. 29, September 12, 1981, p. 1.

Discovery 73: California Youth in Art; an Exhibition by California High School Students, exh. cat., California Arts Commission, Sacramento, May, 1973. 32 p.

Five from California, exh. cat., Mendel Art Gallery, Saskatoon, Canada, August 16 - September 11, 1978. 24 p.

Goldstein, Ann, *Reconsidering the Object of Art: 1965–1975,* Los Angeles: Museum of Contemporary Art/ Cambridge, Ma.: MIT Press, 1995.

Hawkins, Lucinda, "California," [state of art] *Studio International* (U. K.), v. 190, September–October 1975, p. 157.

Hazlitt, Gordon J., "Do California Artists Have More Fun?," [6 artists rejection of mainstream modernism, humor, laid back, not serious] *Art News,* v. 77, pt. 2, February 1978, pp. 64–68.

Hughes, Robert, "View from the Coast," *Time,* February 1, 1971, p. 58.

Impetus, the Creative Process, exh. cat., Los Angeles Municipal Art Gallery, October 29–November 30, 1975. 64 p.

Institute of Creative Arts: A Traveling Exhibition [University of California, Santa Barbara], exh. cat., Sheldon Reich Art Gallery, University of California, Santa Barbara, n. d., 1969. 52 p.

Kompas 4: West Coast USA, exh. cat., Stedelijk Van Abbemuseum, Eindhoven, Netherlands, November 21, 1969–January 4, 1970. 50 p.

Looking West 1970, exh. cat., Joslyn Art Museum, Omaha, Ne., October 18–November 29, 1970. [California painters and sculptors] 81 p.

"Painting," *Visual Dialog,* v. 3, no. 2, December 1977-February 1978.

6 From California, exh. cat., Museum of Art, Washington State University, Pullman, October 29–November 20, 1976. 40 p.

"Special Issue: Painting," *LAICA Journal,* no. 27, June–July 1980, pp. 16–49.

State of California Painting, exh. cat., Govett-Brewster Art Gallery, New Plymouth, New Zealand, May 23–June 15, 1972 and several other venues. 84 p.

Svare, Craig Vista, *Theology and Visual Art,* [re California artists] Ph. D. thesis, Graduate Theological Union, Berkeley, Ca., 1993. 2 v.

Swanson, John Howard, ed., *21 California Artists,* San Francisco: Swanson Art Galleries, 1979. 196 p.

USA West Coast, exh. cat., Kunstverein, Hamburg, and three other venues, 1972. 150 p. [in German]

Watercolors and Related Media by Contemporary Californians, exh. cat., Baxter Art Gallery, California Institute of Technology, Pasadena, September 29–October 30, 1977. 51 p.

Painting, 1970s, Southern California

Both Kinds: Contemporary Art from Los Angeles, exh. cat., University Art Museum, University of California, Berkeley, April 1–May 18, 1975. 14 p.

Browder, Amy and Nanette Wiser, "Creative Spaces: Four Artists, their Studios, and How they Work," [Nodelman, Fuller, Foster, White] *San Diego Magazine,* v. 31, no. 11, September 1979, pp. 215–20.

Cleigh, Zenia, "Four Artists of North County: Baldwin, Creston, MacConnel, Rosler," *San Diego Magazine,* v. 30, no. 8, June 1978, pp. 150–57.

Color Consciousness: Seven Los Angeles Artists: Craig Antrim..., exh. cat., Galleries of the Claremont Colleges, January 30–February 28, 1978. 24 p.

11 Los Angeles Artists Altoon, Bell, Diebenkorn,... Ruscha, Wegman, exh. cat., Hayward Gallery, London, September 30–November 7, 1971. 64 p.

Eleven San Pedro Artists, exh. cat., Chapman College, Guggenheim Gallery, March 25–April 20, 1977. 23 p.

Exhibitions: '76 '77 (a catalogue of exhibitions presented at Cedars-Sinai Medical Center by the Exhibitions Committee, Advisory Council for the Arts, Cedars-Sinai Medical Center, Los Angeles, California). [Following an introduction by Melinda Wortz, this book reprints 10 catalogues of group shows on various subjects and media by contemporary Southern California artists that were displayed bi-monthly between May 1976 and October 1977.] 122 p.

15 Los Angeles Artists, exh. cat., Pasadena Art Museum, February 22–March 29, 1972. 40 p.

Fifty Paintings by Thirty-Seven Painters of the Los Angeles Area, exh. cat., Art Galleries, University of California, Los Angeles, 1960. 20 p.

4 x 8 + 4 x 4 [So. Calif.], exh. cat., Newport Harbor Art Museum, Newport Beach, Ca., May 10 - June 15, 1975. 32 p.

Gamwell, Lynn, "A Closer Look at Orange County," [rev. of exh. *New Art in Orange County* at Newport Harbor Art Museum] *Artweek,* v. 10, October 20, 1979, p. 6.

Haskell, Barbara, *Southern California: Attitudes 1972,* exh. cat., Pasadena Art Museum, September 19 - November 5, 1972. 40 p.

Hugo, Joan, "Los Angeles Survey: Oversight and Overreach," [review of LACMA show] *Artweek,* v. 12, no. 31, September 26, 1981, pp. 1, 16.

L. A. 8, Painting and Sculpture 76, exh. cat., Los Angeles County Museum of Art, April 6–May 30, 1976. 20 p.

Laguna Beach Art Association Gallery Presents 10 Selected California Artists from Comara Gallery, exh. cat., Laguna Beach Art Association in conjunction with Comara Gallery, Los Angeles, 1971. 26 p.

Levin, Kim, "Los Angeles Artists," [Oriental infl.] *Arts Magazine*, v. 51, January 1977, p. 15.

New Painting in Los Angeles, exh. cat., Newport Harbor Art Museum, Newport Beach, Ca., April 28–June 20, 1971. 15 l.

Poling, Clark V., *Contemporary Art in Southern California*, exh. cat., High Museum of Art, Atlanta, Ga., April 26–June 8, 1980. 56 p.

Ross, Richard, "At Large in Santa Barbara," *LAICA Journal*, no. 28, September–October 1980, pp. 43–47.

35 x 35, exh. cat., Riverside Art Center and Museum, n. d., 1982. 44 p.

24 From Los Angeles: New Works by Emerging Artists, exh. cat., Los Angeles Municipal Art Gallery, October 30–December 1, 1974. 52 p.

Painting, 1970s, Northern California

Albright, Thomas, "A Time of Change: Bay Area Art," *Horizon*, v. 23, July 1980, pp. 24–35.

Art Space 4, exh. cat., E. B. Crocker Art Gallery, Artspace/Open Ring, n. d., 1977.

Art Space 12, exh. cat., E. B. Crocker Art Gallery, Artspace/Open Ring, n. d., 1978.

18 Bay Area Artists: An Exhibition in 2 Parts, University Art Museum, University of California, Berkeley, February 1–April 24, 1977. 54 p.

Interstices: An Exhibition of Painting, Drawing and Printmaking by Artists of Northern California, exh. cat., Cranbrook Academy of Art, Bloomfield Hills, Mi., n. d., 1975. 14 p.

Ratcliff, Carter, "Report from San Francisco," *Art in America*, v. 65, May 1977, pp. 55–62.

Sacramento Sampler I [and] *II*, exh. cat., E. B. Crocker Art Gallery, Sacramento, April 1–May 7, 1972 and January 27–February 25, 1973.

"A Survey of Bolinas Artists," *Artweek*, v. 9, no. 1, January 7, 1978, p. 8.

Terwoman, Beverly, "Artists of Marin," *Artweek*, v. 10, no. 29, September 15, 1979, pp. 4-5.

Three Bay Area Artists: Cheryl Bowers, Barbara Foster, Terry Schutte, University Art Gallery, University of California, Riverside, November 10 - December 17, 1976.

Painting, American, General, Pluralism and Post-Modernism

Robins, Corinne, *Pluralist Era: American Art, 1968–1981*, New York: Harper & Row, 1984. 250 p.

Singerman, Howard, ed., *Individuals: A Selected History of Contemporary Art 1945–1986*, exh. cat., Museum of Contemporary Art, Los Angeles, December 10, 1986 - January 10, 1988, in association with New York: Abbeville Press, 1986. 371 p.

Pluralism, Abstraction

"Abstract Painting," [5 articles] *Artweek*, v. 27, no. 9, September 1996, pp. 11–16.

Abstract Painting from Southern California, exh. cat., Emily H. Davis Art Gallery, University of Akron, Akron, Ohio, November 7–December 3, 1977 and one other venue. 13 p.

Abstractions/Sources/Transformations, exh. cat., Los Angeles Municipal Art Gallery, n. d., 1979. 6 p.

Aspects of Abstract: Recent West Coast Abstract Painting and Sculpture, exh. cat., Crocker Art Museum, Sacramento, October 27–November 24, 1979. 24 p.

Besimer, Linda, et al., "How We Talk About Abstraction Now," [statements by contemporary abstract artists] *Artweek*, v. 26, September 1995, pp. 15–21.

Bond, Ralph, "Moving Paint," [4 abstract painters exh.] *Artweek*, v. 13, no. 36, October 30, 1982, p. 5.

Brunson, Jamie, "In a Hybrid Idiom," [review of *Abstract Dimensional Painting*, i.e. planar painting] *Artweek*, v. 17, November 8, 1986, p. 3.

Current Abstractions, exh. cat., City of Los Angeles Cultural Affairs Department and the Municipal Art Gallery, February 22–April 17, 1994. 1 v.

Curtis, Cathy, "The Eclecticism of Contemporary Abstractions," *Artweek*, v. 12, no. 13, April 4, 1981, p. 16. [review of the show *Abstractions* at the SFAI, SF]

15 Abstract Artists: Los Angeles, exh. cat., Santa Barbara Museum of Art, January 19 - March 10, 1974. 24 p.

Frank, Peter, "The 'Still-Small Voice' in Organic Abstraction," *Artweek*, v. 20, no. 33, October 14, 1989, p. 4.

"LA Abstraction," [3 short articles] *Artweek*, v. 24, no. 10, May 20, 1993, pp. 12–14.

Levy, Mark, "Four Bay Area Abstract Painters," *Artspace*, v. 15, January–February 1991, pp. 50–57.

Liss, Andrea, "Bay Area Geometric Abstraction," *Artweek*, v. 14, no. 18, May 7, 1983, p. 1.

Los Angeles: Not Paintings? [abstractions made from unusual materials], exh. cat., Santa Barbara Contemporary Arts Forum, April 3–May 22, 1993. 41 p.

Marmer, Nancy, "Report from Los Angeles: Unstretched Surfaces," [painting on unstretched canvases originated in California and is also popular in France] *Art in America*, v. 66, May–June 1978, pp. 56–57.

McDonald, Robert, "Geometric Uses of Materials," *Artweek*, v. 11, November 1, 1980, p. 6 [review of *Nine Squares* at 552 5th Avenue, San Diego]

Singerman, Howard, "Unstretched Surfaces," *LAICA Journal*, no. 17, January-February 1978, pp. 25-27.

Unstretched Surfaces: Los Angeles—Paris, exh. cat., LAICA (Los Angeles Institute of Contemporary Art), November 5–December 16, 1977.

Wood, James, "Associative Abstractions," *Artweek*, v. 11, October 11, 1980, p.13 [review of *California Dialogues* at the Santa Barbara Museum of Art]

Woodard, Josef, "Contemplations of Quiet Strength," [review of *Abstract Options*, U of C, Santa Barbara] *Artweek*, v. 20, February 18, 1989, p. 1.

Pattern & Decoration

Bettelheim, Judith, "Pattern Painting: The New Decorative, A California Perspective," *Images and Issues*, v. 3, March–April 1983, pp. 32–36.

Broude, Norma, "The Pattern and Decoration Movement," in Norma Broude and Mary D. Garrard, eds., *The Power of Feminist Art*, New York: H. N. Abrams, 1994, p. 208+.

Curtis, Cathy, "Gaudy Art Running Rampant," *Artweek*, v. 14, no. 40, November 26, 1983, pp. 5, 6.

Kelley, Jeff, "Los Angeles Patterns," [pattern painters] *Vanguard* (Canada), v. 12, September 1983, pp. 31–33.

Los Angeles Pattern Painters, exh. cat., ARCO Center for Visual Art, Los Angeles, February 22–April 2, 1983. 32 p.

Miller, Elise, "A Really Big Show of Really Big Decorative Art," [review of *Decorative Impulse* at UCSD], *San Diego Magazine*, v. 32, no. 1, November 1979, pp. 138–41.

"On and Off the Wall: Shaped and Colored," [Gaudy Art] *American Craft*, v. 43, pt. 6, December 1983–January 1984, pp. 42–43.

On and Off the Wall: Shaped and Colored, exh. cat., Oakland Museum, and six other venues between October 8, 1983 and February 24, 1985. 52 p.

VOLUBLE LUMINIST PAINTING
FOR MAX KOZLOFF

ILLUSIONIST SPACE
PRE-DETERMINED STRUCTURAL THEMES
OBJECT-ORIENTED
TOTAL INTEGRITY
LITERALIST ART
STEREOMETRIC
ATOMIZE
LYRICISM / DIFFIDENCE
POST-ROTHKO
SLOW VALUE CHANGE
MODULAR
RESTRICTED VOCABULARY
TACITURNITY
VACANCY
REDUCTIVE
RELATIONSHIPS
STASIS
STRUCTURELESS

SURROGATE FOR PATTERN
MATRIX
ADVANCE / RECESSION
HOVERING
CALIF. PALETTE
SUBTERRANEAN PICTORIAL LIFE
TAUTNESS
METAPHORICAL
ELIDED
HYPER-ACUTENESS
VIEWER'S SPACE
ENTASIS
PERVERSE GLAMOUR
FADING SATURATION
ARBITRARILY PROGRESSIVE
PENUMBRAL
MODALITY
VAGRANT

The Postmodern Era
—New Technology & Themes

The Postmodern Era—New Technologies and Themes

In today's "painting," idea or concept assumes prime importance, and meaning is often intentionally ambiguous. Most paintings are composed of images borrowed from earlier art, and much of this imagery comes from the popular arts. Borrowing imagery leads to "collage" type compositions resulting in two dimensional space and multipoint perspective. Most of this "look" can be traced to aesthetic innovations that arose in the pluralistic 1970s when, in addition to the many traditional art forms extended by artists (chapters 32–35), several new ideas, styles, or techniques emerged that affected the look of today's art. In the ascendance was Conceptual Art, the use of electronic devices to make art, the breakdown of barriers between "high" and "low" art, and the reemergence of humanist themes.

Conceptual Painting

In the 1960s, when artists began to regard "idea" as the *raison d'etre* of their art, they probably did not realize that "idea" would soon permeate all art media and eventually drive the art world. Throughout history the purpose of most art has been to deliver messages, but when Conceptual Art originated about 1960, it differed from traditional message forms such as historical painting, illustration, and advertising in that it conveyed *intangible* ideas. In the early years these ideas were *cerebral*, about art itself, about language (the investigation of the meanings of words and phrases, verbal puns, wordplay), or about social issues, such as the increasing control by the government and the communications media over the lives of the average American. Initially Conceptual Art ideas were expressed in non-object or ostensibly unmarketable forms of art—performance, diagrams and plans, documentary photographs, earth art, etc. (This was intended to counter the commercialism of the 1960s to which idealistic artists objected.) When pictorial, the presentation was often in the form of an image juxtaposed with text (as in advertising), a compositional type that has survived to the present and is now commonly referred to as "Image and Text." First-generation conceptual artists of the 1960s presented their image and text to elicit clear-cut conclusions about their cerebral issues, while

later, second-generation conceptual artists (after c. 1970), more frequently composed enigmatic scenarios and let viewers draw their own conclusions about the personal, social, or political messages. Because of Conceptual Art, today's art cannot be experienced on a sensory level alone; a viewer must be willing to engage his mind to interpret it.

One of America's most important early Conceptual artists is the Californian **John Baldessari** (b. 1931). By 1966 he was producing works he called "Word Paintings." There were two types: those that contained photographs and words and those made up of only words. An example of the latter is *Voluble Luminist Painting for Max Kozloff* of 1968 (fig. 36-1). (Max Kozloff is a New York art critic who, briefly, in the mid 1970s, served as editor of *Artforum,* American contemporary art's most prestigious magazine.) Throughout history, lettering had been used in art for its graphic properties, but Conceptual artists used words for their dictionary definitions or connotations. The words in *Voluble Luminist Painting* are familiar to anyone who has read an art history text. By isolating the words from their text and presenting them to the viewer, Baldessari makes the viewer think about them. By treating them as simple rote items in anonymous columns, he satirically makes fun of their self-importance. With his Conceptual artist's disinterest in "beauty" and desire for an objective presentation (including the negation of style and autobiographical content as exposed in brushwork), Baldessari hired a sign painter to apply his wording to the canvas.

About 1970 Baldessari joined the teaching staff of the California Institute of the Arts. Through the 1960s, when Walt Disney was designing the school, he had in mind several ideas not part of traditional art schools. To the Chouinard Art Institute, which he was financially backing, he wanted to join other creative disciplines such as drama, dance, film, and music. CalArts was to be a creative counterpart to Pasadena's CalTech (California Institute of Technology). Instead of a traditional program in which students learned a craft by stages and advanced through ever more technically challenging classes, teaching was to be based on the "brainstorming" approach. The school was to be self-supporting through the sale of its students' products. To facilitate this, the campus was placed adjacent

Fig. 36-1
John Baldessari (b. 1931)
Voluble Luminist Painting for Max Kozloff, 1968
acrylic on canvas, 59 x 59 in.
Collection of the Orange County Museum of Art, Gift of Betty and Monte Factor Family Collection

to the 5 Freeway, the main route between Los Angeles and San Francisco, and its original plan included numerous sales rooms. However, by the time the school opened at its Valencia campus, many of the more commercial ideas had been discarded.

In the beginning, the CalArts fine art department had three components: painting, multimedia events (happenings/performance), and Feminist Art. After the Feminist contingent relocated to the Woman's Building in Los Angeles in the early 1970s (chapter 33), the faculty, for a time, was all male. Teachers were of the most avant-garde, some from the East Coast. In 1976, the first-generation New York conceptualist Douglas Huebler (1924-1997) accepted a position. On the staff were other advanced thinkers, including Michael Asher (b. 1943) and David Antin (b. 1932). The school has come to be regarded as the most important American (possibly world) art school of the last thirty years for fostering idea art. The school accepted students who just had something to say as well as the technically talented. CalArts teachers' and students' open-minded attitudes and willingness to explore new methods of creating art have resulted in many innovations. The school taught art history, allowing its students to see where they stood in the course of art and

introducing them to imagery that many began to utilize in their artworks. CalArts teachers approved, even fostered the use of appropriated imagery (below), of presentation formats evolved outside the world of fine art (in popular art and advertising), of traditional forms used in nontraditional ways, and of applying non-art techniques to art. "Courses" did not teach craftsmanship but rather consisted of discussions between teachers and students and among students themselves about new ways to realize ideas. CalArts' success in turning out art "stars" additionally can be traced to its teaching the principles of art production and marketing. Teachers and students maintain close relationships with art galleries, and many students are given gallery shows before they graduate.

Most important for this discussion is the fact that CalArts approved painting as a medium to convey ideas. (Earlier conceptualists had avoided expressing themselves in paint, associating painting with the commodification of art. They also regarded the tactile quality of paint and the personal expression revealed in brushwork as antithetical to Conceptual art's goal of a neutral text-and-image presentation.) In the early years at CalArts there was a sharp distinction between the "conceptualists" (or *non*-painters) and the painters, but divisions broke down as media and ideas intermingled. CalArts teachers and students resolved the "negatives" of painting, which allowed them to capitalize on the medium's familiar and understood conventions to convey their ideas to the average art lover.

In spite of the location of CalArts in Southern California, a geographical region supposedly oriented to high-tech art and peopled by sun-loving hedonists, it emerged as the most avant-garde art school of its era. It attracted students from all over the United States. Some used it as a stepping stone to the New York art world. CalArts graduates were responsible for the New York movement Media Art; and two of its most important former students, the expressive figural painters David Salle and Eric Fischl, occupied top places in New York. Most former students, however, chose to pursue their careers in Southern California, where the mid 1980s explosion of institutions supporting contemporary art and the ease of transcontinental and international travel made Los Angeles a booming art town in an international art community. Many graduates became teachers at other area art schools, spreading the CalArts philosophy and making Southern California an important center for art education and a factory for artists with advanced ideas.

Some of Baldessari's mid 1960s word paintings had incorporated photographs that he had taken. In the early 1970s he began using images from the media

(stills from old movie films, TV, and video). An example is *Violent Space Series: Nine Feet (of Victim and Crowd) Arranged by Position in Scene* of 1976 (fig. 36-2). In this work, Baldessari used a found photograph of people standing in a group. He extracted their feet and applied the circular cutouts to a piece of cardboard, placing them in the same position they had held in the original photograph. While the artist wasn't the first to use photographs in his art, he was one of the first to purposefully disassociate motifs from their original context and reuse them, reassociate them, in a new context to evoke totally different meanings. Like Neo-Conceptual or second-generation Conceptual Art, this work does not try to evoke a specific conclusion from the viewer. Baldessari sees himself as presenting the viewer with a collection of codes and stereotypes whose purposeful ambiguity forces the viewer to call up personal life experiences to interpret what he sees. Meanings thus differ from person to person. In the most successful Conceptual Art, the artist makes a work ambiguous enough to allow multiple readings, yet not so ambiguous that the viewer can't comprehend the main point. Stylistically most Conceptual Art has the qualities of collage—a nonrational, multipoint space leading to a fluid, free-form, free-association reading—a compositional type that becomes increasingly popular as the century progresses.

The term Conceptual Art is now often applied to art of any medium that contains ideas. Exhibitions of Conceptual Art include a wide range of media from performance pieces and site installations to three-dimensional sculpture and art hung on the wall. Imagery in Conceptual Art includes anything that engages a viewer's thought processes. Often it is wording that either stands alone or is mixed with a painted or photographed image, the text-and-image format. Text can be borrowed from any source or can be composed by the artist. Painters known for their conceptual use of wording include Allen Ruppersberg (b. 1944), whose twenty canvases covered with the entire text of Oscar Wilde's *The Picture of Dorian Gray* of 1974 is considered an early milestone. Raymond Pettibon's (chapter 28) mix of textual fragments and comic-book-style images are considered particularly poetic. Conceptual Art can also consist of image alone, as when two or more are juxtaposed for comparison by the viewer.

By the early 1970s conceptual themes were moving away from neutral cerebral issues of language and signs to more concrete issues of society and politics. The California conceptual artists Helen Mayer Harrison and Newton Harrison have, since 1971, used texts, maps, and hand-worked photos to convey their concerns about ecology and to suggest solutions to specific environmental problems. Political issues might be elicited by the phrase "Are you now or have you ever been," meant to trigger a viewer's memories of the McCarthy era and its hunt for Communists. Social questions might be raised by a sequence of images captioned: "Our Galaxy," "Our Solar System," "Our Planet," "Our Country," and finally "Home"—the viewer to draw his or her own conclusions about humans' place in the cosmos.

California Conceptual Art differs in subtle ways from that produced by artists on the East Coast. Californians tend to be less intense in their stances and less interested in deconstruction (see below). In spite of Conceptual Art's avowed disinterest in "beauty," California artists remain sensitive to aesthetics. And California artists are open to fantasy and to humor, including puns, riddles, in-jokes, irony, and satire. California Conceptual Art is also distinguished by its California imagery. If Los Angeles artists are known for any particular format, it might be their fascination with elaborate systems of classification such as extensive photographic mapping and documentation of things such as parking lots, gas stations, telephone poles, and buildings. Artists sometimes present the images in book form to facilitate comparison.

Breakdown of Barriers Between "High" and "Low" Art and the Technique of Appropriation

Over the last thirty years, imagery in so-called fine paintings has been increasingly appropriated from art created prior to 1970. A large proportion has come from so-called "low" art sources. These include commercial art (advertising), popular art (comic books), the mass media (television, mass-market publications, and Hollywood films), art created by various countercultures, and art coined by marginalized groups such as those that emerged during the Civil Rights Revolution (chapters 33, 34).

There seem to be many reasons for this. The trend may have been initiated by the breakdown of social barriers that occurred in the postwar era and during the Civil Rights Revolution. But, the direction was certainly supported by the need of Conceptual Art for images that already had built-in meaning. The tendency was no doubt fostered by the large quantity of formerly excluded artists (women, gays and lesbians, racial minorities, and countercultural artists) now active in the mainstream who "speak" with their own iconographic languages, ideas, and techniques (chapters 33 and 34).

When the practice of borrowing imagery was recognized as a trend, it was given a name—appropriation.

Writers have used the term in various ways—as if it were a movement and to describe the general tendency of using borrowed imagery. Borrowed images may be used in a straightforward manner, but when they are used to debunk the ideas contained in them, the act is called "deconstruction." While most post-1970s painters appropriate visuals and words to some extent, a few have made appropriation their main interest.

Some pictorial artists appropriate imagery for color, texture, or shape. In the mid-to-late 1960s, **Paul Sarkisian** (b. 1928), a maker of collages since the mid-1950s and an advocate of photo-based art, developed "found" images into huge-sized paintings. In a work such as *Untitled—For John Altoon* of 1970 (fig. 36-3), Sarkisian used images culled from publications as well as photographs he took himself, selecting them as he had for his collages, for their texture, shapes, and color and how they worked together aesthetically. It fascinated him to contrast the soft shapes of contemporary female nudes with the sharp detail of antique machinery. But he also frequently included a rocky pinnacle backed by clouds and an expansive sky to create a

composition that conveyed a sense of vast space. Many of his paintings were homages to artists he admired, such as Picasso, Philip Hefferton or, as here, the Los Angeles painter John Altoon (see fig. 26-6). Very "California" are his postcard colors and the photorealistic technique.

Most of today's artists appropriate images for the ideas they contain. An image is not just a visual entity composed of lines and colors; it also embodies emotions, memories, and ideas. Once imbued with ideas, an image can take on a life of its own, can be taken out of its original context and reused. For example, an image of the Statue of Liberty can be removed from its New York setting and reused to symbolize a variety of intangible principles including immigration to America and America as a land of freedom. To depict the Statue of Liberty handcuffed is an example of turning an image back on itself, tearing apart its associated ideas—deconstruction. Employing meaningful symbols has been the basis of man's communication since the dawn of history, when he conceived pictographs derived from nature and devised abstract alphabetical

characters to symbolize the sounds of verbal language. Today these signs and symbols have been supplemented by a mind-boggling but rich quantity of pictorial imagery. This includes images visualizing the world's accumulated store of myth, history, and scientific discovery, any artwork, and any images disseminated by the media (film, cartoons, television, video, computers, not to mention print media like newspapers, magazines and books).

Much of the art discussed in chapters 35, 36, and 37 uses appropriated imagery. John Baldessari appropriated the feet of individuals from a photograph for his *Violent Space Series: Nine Feet (of Victim and Crowd)*. Raymond Saunders uses actual photographic images in his paintings. Artists of racial minorities reuse images from their homeland cultures or that generated by their group in America in order to convey a wide variety of personal, social, and political statements (chapters 33 and 34). Artists of "popular culture narratives" (chapter 37) borrow imagery from old Hollywood movies and comics to compose fantasy worlds.

Many artists appropriate in order to deconstruct. In California, a number of these deconstruct art history. Some make precise copies of Old Masters to question the preciousness of art, its uniqueness, importance, and originality; while others borrow from historic art to reconnect with the past and to impart an antique quality to their own art. (For examples, see the exhibitions *Second Sight,* San Francisco Museum of Modern Art, 1984, and *New Old Masters,* Center for the Arts, Yerba Buena, 1994.) Other artists appropriate images and devices from advertising to deconstruct America's consumer society and corporate structure. (These range from artists such as Jim Shaw [chapter 37] to the artists who created art on billboards along Sunset Strip [chapter 34].)

Since artists often convey their points through juxtaposed imagery, a large proportion of art using appropriated images has a collage or pastiche look. The blend of pictorial elements is fragmented and discontinuous, resulting in abrupt shifts in perspective. The eclectic quality of Appropriation Art has led it to be called "the pastiche aesthetic," "quotation art," and "art school art," and its practitioners have been accused of "ransacking" and "romping through" art history and of being "image junkies."

Appropriation has enjoyed extreme popularity in Southern California; some have claimed that this is because Los Angeles's artists are more comfortable with the concrete and "real." But it is probably equally due to the area's open-minded attitudes and to the approval of the technique by teachers at CalArts and other local art schools. It is in Southern California that much of the imagery now appropriated by artists was originated: in Hollywood's movie industry, in television and publications, in the countercultures, and in the barrios. At the moment, Southern California's enthusiasm for appropriating popular imagery is spreading to artists in other parts of the world.

Art and Technology/Electronics/Computers

Throughout history artists have turned to new technologies, eager to explore their creative potential. The latest family of technologies to be adopted by the fine arts is electronics. Within this realm exist the Verifax machine, the photocopier, the fax machine, the video camera, and the computer, among others.

In spite of tremendous potential, the influence of electronic devices on art has been spotty and sometimes problematical. Electronics have been equated with science, and traditionally science and art have been seen as opposites, the one logical and empirical, the other emotional and intuitive. Artists must decide whether to use electronics to extend "art," as the world currently defines it, or to let electronics' capabilities lead them into unexpected realms that, in turn, can be labeled "art." Even if an artist comes to accept electronically generated art, he still has to face the fact that many of his intended audience won't.

The new electronics technologies have been most effective *outside* the arena of painting, extending the expected areas of works on paper, photography, and sculpture, as well as opening up the new medium of cyberspace. The variety of creative uses has proved unending. Paper artists using photocopy and fax machines have given birth to the new fields of Xerography and FAX art. California's Wallace Berman was one of the earliest to use Verifax (a copy method predating Xerography) when he created his *Semina* (chapter 25). Photography particularly has benefited. A whole field of art has arisen around the video camera or camcorder, first made commercially available in the late1960s;

since 1970, California artists have been responsible for one of the richest and most important outpourings of video art (chapter 29). Still photography is currently profiting from digital imaging (the reduction of an image to dots or pixels) that allows artists with computers to modify imagery within photographs and to move images between photographs. The properties of sculpture have been extended by electronics to include calculated movement and interactivity.

Cyberart, a merging of the term cybernetics (the science of the control and operation of complex machines) with the word art, has become an especially large field. Early examples from the Bay Area include the 1960s techno-machines of Charles Mattox (b. 1910), built from mixed electronic components and infused with humor and whimsy. Since the early 1970s Clayton Bailey (b. 1939) (alias Professor Gladstone) has used discarded or out-of-date equipment to sculpt robots that move and make sound. Most recent sculpture made from electronic equipment conveys statements about society, culture, and humanity. Such sculpture does not take a biological form but instead retains the look and shape of its components. It can convey humanistic ideas when it inspires emotion or humor, when the work comments on technology's impact on humans, when it takes up social and political banners, or when it allows interactivity. For example, in the assemblage/site installation *Organic Assembler* of 1976–88 (not pictured), by pioneer Carl Cheng (b. 1942), the placing of fetishistic objects in a display case resembling a piece of laboratory equipment makes the viewer question the relationship between the natural world and technology and possibly to agree with Cheng's views that they are not adversaries but two aspects of human existence. An increasing amount of electronically generated art can only be seen on a CRT (cathode ray tube or computer monitor) or on a video screen. This includes new "media" like the conceptually based Information Art and Mail Art as well as "text-and-image" art on websites. The post-1980 practice of using computers' instant communication to "speak" with other artists worldwide has turned the globe into one community, equalizing artists and countries having very different standards of living. Museums use websites to present information about museum events as well as their permanent collections.

In the arena of pictorial art, the computer has had a tremendous and varied impact, especially as a design tool. Today computers are so widely disseminated in schools and homes and new software packages so user-friendly that it is rare for an emerging artist not to have been exposed to one. In the early to mid 1950s, the state of the graphics software packages enabled artists only to achieve remedial levels of drawing and manipulation of patterns with light pens and graphics plotters. Since the mid 1980s, however, as computers have reached rapid computing speed and vast storage capacity and since elaborate graphics software packages have become widely and commercially available, computers have become useful tools for all manner of designers, including graphics artists, architects, engineers, designers of textiles and interiors, and so forth. Once an artist lets the computer's colored lights and screen take the place of his traditional sketching materials, he discovers the freedom and liberation from self-consciousness that the computer gives him. When designing, he can move shapes and colors repeatedly around a screen with none of his former inhibitions or waste of art materials; he is no longer limited to a few colors, and he is just as open to the happy accident. Some of today's software even uses meshlike lines to pictorialize in three dimensions, making it possible for an artist to "model" an object on the screen, just as he would formerly have modeled a physical material like clay. Hollywood animation studios and special effects departments now rely almost completely on computers to shorten the laborious process of hand-creating thousands of cels; studios and businesses working for the studios are even writing their own software to facilitate the creation of cartoons and special effects in films. The computer, in turn, affects the aesthetics of their animation. Making inroads into the popular style of flat shapes and outline are now three-dimensional figures with a robot-like look. Studios are also setting up training programs to teach the new skills, just as Disney trained his own animators in the 1930s.

Electronics have been less revolutionary in regard to painting—if one defines painting in the traditional way, as an application of paint on a support or as any flat, wall-hung work. So far, computers have not been completely successful in initiating and creating an original work of art—although artists such as Harold Cohen

(b. 1928), a professor at the University of California in San Diego, are working on the task. The machines still lack the ability to understand meaning and to be intuitive. Computers *can* copy perfectly; they can reproduce famous masterpieces with frightening accuracy—it is difficult even for specialists to tell the difference—and so inexpensively that it is now possible for the average person to display the near equivalent of a masterpiece in his home. Computers can translate a scanned image into tiny dots of color and then cue a spray paint machine to create the final image. Painters sometimes use computers as tools to design their paintings.

Electronics have been more effective in making "paintings" in the broader sense—works whose image appears on an electronic support like a CRT or a liquid crystal screen. Since electronic "paintings" depend primarily on light for their "pigment" they have a very different aesthetic than an artwork made with traditional textured and opaque pigments. (See earlier examples of "light" art in chapters 29 and 30.) Electronics expands "paintings" into areas impossible for traditional paintings; they now can include movement and sound, and the "paintings" can interact with viewers.

The majority of electronic "painting" is nonobjective and is concerned with those issues traditionally associated with nonobjective pigment paintings—style and formal aesthetic questions. Today's electronic painters utilize a variety of technologies.

Anait [Arutunff Stephens] (b. 1922), daughter of a scientist and inventor, naturally drifted to the most up-to-date technology when she went professional with her art in Los Angeles in the 1960s. In the late 1960s she became interested in holography, a new type of photography in which lasers are used to produce an image on a photographic plate. After recording, the image can be reconstituted in simulated three dimensions by shining a laser beam *through* it (transmission hologram) or shining a spotlight *on* it (reflection hologram); the image results from interference patterns of the light waves. The technology was cutting edge, and Anait, finding no place in Los Angeles to learn about it, took a couple of classes at the School of Holography in San Francisco, which was housed in a warehouse and operated by artist Jerry Pethic and scientist Lloyd Cross. She made her first hologram in 1971. In *Red Shift* of 1980 (not illustrated) she lines up seven

holographic plates on a wall. Her subject is lines (as opposed to a representational object) and through them she explores the space and volumes inherent in holography. As the viewer walks past the plates, he or she not only sees the three-dimensional lines projected by the plates but real painted horizontal and vertical lines on the wall and across the surface of the plates that the artist uses to tie the plates together. Overall, the central three images created from reddish-colored plates are designed to appear in space in *front* of the plates, while the embedded images in the blue-green plates at the two ends appear in space about two inches *behind* the plates. The title *Red Shift* references the way astronomers determine which direction in space a body is moving relative to the earth—if away, the light received from the celestial body will be shifted to the red end of the spectrum; if toward the earth, toward the blue end. It amuses Anait to twist this and make the central triptych red and its lines advance toward the viewer.

Merging computers with "painting" now allows painting to be interactive. Traditionally, fine art has been interactive in two ways—physically, when viewers stroll among parts of a multiple-piece sculpture or into a site installation, and conceptually, when onlookers are asked to mentally interpret the meaning of a work. Computers extend this by allowing a viewer to change the look of a piece of art. This can be unintentional, as when a spectator's body heat, movements, or sounds are picked up by sensors that a computer program uses to modify an artwork's color, lighting, sound, or movement. (If computer-generated changes prove too static or predictable, a randomizer can be built into the program to approximate the element of chance.) Interaction can also be intentional, as when a viewer communicates with an artwork through devices such as a mouse, a keyboard, a touch-tone telephone, or a touch-sensitive screen.

Computer interactivity has evolved rapidly in type and sophistication. One of the earliest California artists to explore it was performance/video artist Lynn Hershman in her *Deep Contact* (fig. 29-5). The course of her narrative, which a viewer could change by touching parts of the screen, was made possible by the invention of the laser disk, which can store segments of a narrative that can be accessed in any order requested

by a read head touching down on the spinning disk. Interaction has been facilitated by the "hypercard" invented by Apple Computer in Silicon Valley and explained to artists in the book *Multimedia Design with Hyper Card* (Englewood Cliffs, N. J., 1991) by Stephen Wilson (b. 1944), an artist and head of Conceptual and Information Arts at San Francisco State University. (Wilson currently maintains a website—http://user-www.sfsu.edu/~infoarts—that will ultimately link to websites of artists all over the world.) Extremely sophisticated communication can be exchanged between user and computer through mechanical devices worn by the viewer, including those that register eye movement or brain waves or data gloves that sense hand and finger position. With give and take between art object and beholder, art becomes tailored to each observer.

San Francisco's hands-on science museum, the Exploratorium, provides interactive electronic stations where visitors can create phenomena that are both scientific and artistic. At least two of the devices allow visitors to "paint." At one, a museum patron can use a mouse to alter the color and trajectory of randomly moving dots on a CRT to arrive at a final composition. At another, a video camera photographs areas on a horizontal sheet of Plexiglas that a participant has touched with a hand or a paintbrush and projects them on a CRT. Viewers/artists are provided with buttons to choose and alter the artwork's colors.

In 1981, when **Ed Tannenbaum** (b. 1953), a video artist and recipient of an Exploratorium artist-in-residence grant, created *Recollections* (fig. 36-4), the as-yet-limited state of technology forced him to create some of the software and hardware. Tannenbaum had a background in color field painting and color photography. He was intrigued with how artists of the past had tried to represent the human figure in motion. These include painters such as the Italian Futurists and Marcel Duchamp, with his famous *Nude Descending a Staircase, No. 2,* 1912 (Philadelphia Museum of Art), as well as some of the art filmmakers of the 1930s and 1940s. Video, computers, and other new electronic media seemed to offer Tannenbaum a chance to extend their explorations. *Recollections* consists of a eight by twelve-foot rear-projection screen that displays the movements of a spectator standing in front of it. Viewers "paint" by moving their bodies, and Tannenbaum's equipment translates their movements into art, reducing the human body to a silhouette, adding profiles, and modifying the image with a preprogrammed sequence of color and other effects. By retaining the human image, Tannenbaum's work avoids one of the common complaints about electronic art—a lack of human values. The result is very lyrical. Although the moving shapes are recognizable as human, the viewer is primarily aware of motion and color. Sometimes sound is added.

Fig. 36-4
Ed Tannenbaum (b. 1953)
Recollections, 1981–98
(Miyuki Fukumoto demonstrates Recollections II at the Metropolitan Museum of Art, Fresno, California)
video camera, video projector, computer, proprietary hardware and software
8 x 12 x 13.5 ft.
Photo courtesy Ed Tannenbaum © 1995

The crucial factor in artists utilizing electronic devices seems to be gaining access to the expensive technology. Many California institutions have programs to bring artists and electronics together. One of the first instances occurred between 1967 and 1971, when the *Art and Technology* program of the Los Angeles County Museum of Art joined artists with research and development personnel at California companies. In recent years, the Center for Science and Art at the University of California at Los Angeles and departments at the University of California, San Diego, have added technology to their art curriculums. The heart of the inquiry, however, is occurring in Northern California. In the Bay Area, the Exploratorium offers three artist-in-residence programs, and a number of Bay Area universities encourage interaction between their Computer Science and Art departments. Pairing is also achieved by several private or nonprofit ventures such as Art Tec and Artist Digital Access. South of the Bay Area in San Jose, as well as nearby Santa Clara and Palo Alto, an area nicknamed Silicon Valley because it serves as headquarters for large corporations devoted to computer technology, several corporations have artist-in-residence programs or employ artists, including Xerox Corporation's Palo Alto Research Center, Silicon Graphics, and Viacom. Producers of software and computers are realizing that artists working intuitively can contribute innovations to technology that people trained only in engineering cannot.

Artists interested in technology have banded together to support each other's efforts and to share advice. Computer knowledge is communicated to artists through conferences, such as the 1984 CADRE (Computers in Art and Design, Research and Education) conference held by Mission College, Santa Clara, which dazzled 500 participants with art exhibitions, demonstrations, and lectures. Northern California has developed an infrastructure of museums and alternative galleries that exhibit the work and journals such as *Science & Art* that document it. There are now so many artists using electronics, they are listed in their own directory, *Directory of Artists Using Science and Technology* (Orinda, Ca.: YLEM, an "annual" published 1987+; write P. O. Box 749). (Ylem is a physics term for the primal stuff of which the universe is made.) Ylem also maintains a website, http://www.ylem.org.

Return to Humanist Themes

It is entirely logical that the antimodernist atmosphere of the last thirty years would foster a humanist-oriented art. The opposite of modernism, humanist art is marked by representation, embedded ideas, and emotions. This author chooses to use the term "humanism" to describe this postmodern impulse because the term is more immediately clear to the average reader than the art historical term, "postmodernism."

Expressive Figuration. Through the 1970s, the antimodernist impulse that led the world's painters away from abstraction and toward representation also led many away from modernism's neutrality toward emotion. Many of these artists took up the figure and narrative. The large body of painters making expressive figurals in the 1980s is often erroneously called Neo-Expressionist. In fact, hundreds of variations have resulted from artists combining figurative subject matter with expressive brushwork, and few of them actually descend in a pure form from Germany's Neo-Expressionism. For ease of discussion this author has chosen to put all under the umbrella of "Expressive Figuration." What defines Expressive Figuration? Foremost is an interest in raw brushwork and the human figure. Depending on the inspiring source, brushwork can be "primitive," have a folk or naïve look, can be "bad," or can have punk qualities, to name a few. Other characteristics can be appropriated imagery, a surreal or romantic quality, and the use of figures and narratives as metaphors for psychological states or to convey messages.

Some authors might like to trace the sources of California's various forms of Expressive Figuration to the better known movements that occurred on the East Coast and in Europe—New York's "Bad," New Image, Neo-Expressionism, Naif Nouveau, East Village, and Pathetic painting, as well as Germany's Neo-Expressionism and Italy's Transavantgardia. Traditionally, California artists have gained some inspiration from the older centers, and there is no doubt that with today's rapid communications California artists are aware of those movements. Many probably have emulated the various styles, wanting to explore the new trends. But Californians have important antecedents of their own.

Realism, expressive brushwork, and figuration never completely died out in California, even in the decades when modernism was most dominant (1945–65). In 1960s Los Angeles, for example, several independent painters pursued figuration with differing styles. Joyce Treiman (1922–1991), James Strombotne (b. 1934), John Paul Jones (b. 1924), James Jarvaise (b. 1931/2), Morris Broderson (b. 1928), and Roger Kuntz (1926–1975) painted figures alongside a number of accomplished figural artists who taught at UCLA, including Sam Amato (b. 1924) and William Brice (b. 1921). The genre was supported by Felix Landau Gallery and Ceeje Gallery. The latter became the main outlet for figurals by UCLA teachers and graduate students. Ceeje stood out as a maverick in Los Angeles of the

Fig. 36-5
Roger Herman (b. 1947)
Mutter II, 1981
oil on canvas, 120 x 80 in.
Collection Bette Midler and
Martin von Haselberg, New
York
Photo: Ace Gallery,
New York

former members of the Hairy Who in Chicago, who passed on their "outsider" style to their students at Sacramento State College.

By 1980 many California painters were succumbing to the worldwide fashion for Expressive Figuration. Figurals could take the form of traditional figure paintings, in which the human body was treated like a still-life object. In most cases, however, figures acted out narratives and/or were metaphors or symbolic of ideas or psychological states. Generally the activity of figures in scenes was enigmatic—women kneeling before an altar or charming a snake, figures climbing a ladder, a man with doors on his chest, a man running crazily, a man observing an atomic bomb blast, a man torn and bleeding, a person wielding an ax, or figures hurtling through the air, to name a few. Styles ranged widely, from shapes that took on three dimensions to flat, "cookie-cutter" figures. Compositions could contain a few figures or be cluttered and have a collage look.

A key element in most of these works is their emotional intensity. After years of Minimalist art, it was time for emotion to return. But the emotions in 1980s art were psychologically disturbed: disorder, incongruity, anxiety, malevolence, and persecution, to name a few. In an era of relative peace and strong economy, this Pandora's Box of negativity seems surprising and inexplicable. However, a negative trend had been growing since the social and political turmoil of the 1960s, and it was given regular feedings by new infusions of social discontent. Angst may have entered California art with the importation of Germany's Neo-Expressionism, but California had its own generating sources: memories of soldier-artists from World War II; photographs of wars, revolutions, and famines reproduced by the mass media; violence pictured in animated cartoons, comix, films, and television; and the antisocial attitudes of California's several counter- and underground cultures, particularly Punk of the late 1970s. Negative attitudes also came from changed perceptions of the world as a result of psychoanalysis, high technology, and scientific investigation into the workings of the brain and sensory cognition. Some artists expressed personal angst, others felt a need to cry out against specific social injustices, while yet others simply addressed a general societal malaise (see also End of Century Malaise, chapter 37). The divisions between the many stylistic and emotional variations are not clear cut due to artists' eclectic use of media and styles and today's fashion for enigmatic and nebulous subject matter. Because there are so many individual styles and so many talented practitioners, it is impossible to isolate one artist whose work could represent the movement as a whole.

1960s. In the decade when Ferus artists were making headlines for their cool "L.A. Look" (chapter 30), Ceeje's stable of artists made paintings characterized by opposite qualities: expressive brushwork, representation, figuration, appropriated imagery, and disjointed and multipoint perspective. They had an interest in mythical, historical, and fictional worlds as well as racial and personal issues. When these qualities became mainstream in the1980s, Ceeje was revealed as prophetic and far ahead of its time. One of Ceeje's most important artists was Charles Garabedian (b. 1923).

Northern Californians, too, were producing expressively painted figurals in the 1960s and 1970s. Many continued to work in the Bay Area Figurative style (chapter 26), while others, such as Joan Brown and Robert Colescott (fig. 37-2), employed a naïve/folk/primitive style. In the Sacramento area, the early 1970s saw the arrival of the husband-and-wife team Jim Nutt (b. 1938) and Gladys Nilsson (b. 1940),

In his native West Germany, **Roger Herman** (b. 1947) was studying law when he gave it up to take four years of formal art training. In 1979, intrigued with the work of the Bay Area Figure Painters, he immigrated to San Francisco. When Herman first arrived in California, critics associated his expressively painted figurals such as *Mutter II* of 1981 (fig. 36-5) with the then newly fashionable Neo-Expressionism, a style prevalent in his homeland shortly before his departure for the United States and one that invaded America. His work was also compared to the much earlier Bay Area Figurative paintings (chapter 26). However, Herman shares little with either of these styles. His work is full of paradox. His brushwork, while expressive, does not contain the "gut-wrenching" element he considers essential in true Expressionism. He purposefully nullifies primitive vigor. His work has no angst but does leave the viewer with a feeling of unease. *Mutter II* is one of four similar paintings that Herman made from one of several photographs of his parents he found in a family album. One posed photo taken when Herman was only one year old showed his mother, wearing a pretty summer dress, standing near a cabinet. His reworking of the photograph in paint is not an attempt to reconnect with a mother who died when he was nineteen but an exploration of the mother as a multifaceted symbol. Although he ennobles his mother by seeing her from the floor-level viewpoint of a one-year-old child or the position of a theatergoer viewing images on a movie screen, he does not portray her as a hero or as an object to be revered. Tied up in the image are distant memories, yet its large size takes it out of the realm of the personal and makes it universal, ideal, archetypal. Also paradoxical is the translation of the small photo into a painted image almost ten feet tall. Herman frequently employs a limited palette with sharp contrasts of dark and light and strong, sometimes strident colors—in this work, black, white, and yellow—which enhance his work's physicality and presence.

One of the most admired of the artists who grew up and painted expressive figurals in Southern California was **Andy Wilf** (1949–1982). Although nearly all the figurals of the 1980s are characterized by a disturbed emotional quality, Wilf's work stands out for its power and intensity. Ironically, this talented artist spent his first few years as a Photorealist specializing in exacting portraiture. But in the mid 1970s, he began to move toward expressionism. While still deriving his paintings from photographs, he began to interpret the images with looser brushwork, by distorting the shapes, and by altering color. His increasingly expressive work began to garner attention, but his inability to handle fame, a guilt stemming from his rejection of his Mormon upbringing for a fast-paced life of alcohol, drugs, and violence, and a lifelong problem with asthma, eroded his emotional and physical health. At the age of thirty-two he was found dead from an overdose of alcohol and drugs. In *Judged* of 1980 (fig. 36-6), right-facing hooded Ku Klux Klan members are silhouetted

Fig. 36-6
Andy Wilf (1949–1982)
Judged, 1980
acrylic and wax on canvas
90 x 136 in.
Los Angeles County
Museum of Art, Modern and
Contemporary Art Council,
Young Talent Purchase
Award

against a night sky. The horror of the scene is conveyed by the lush paint—acrylic pigment mixed with wax to build a textured surface—by the high-contrast black and white tones, by the TV-influenced cropped-and-framed composition, by the raw brushwork, and by the fire-engine red open mouth of one of the Klansmen.

Hundreds of other California artists created work that fits under the umbrella of Expressive Figuration. Some historians have identified submovements in the state. For example, artists who place a single, badly painted object in the center of their composition could be called New Image painters, while those who apply gaudy colors and use unusual materials such as glitter, graffiti, or violent and antisocial imagery might be classed under New Wave and Punk Art. Equally valid arguments might associate California painters with New Figuration, Neo-Expressionism, Bad Painting, and New Pathetic to name a few. However, most California artists were recipients of multiple influences and rabidly mixed styles and ideas; they came up with their own variations. A few of the more notable figural artists from Southern California include David Amico (b. 1951), who appropriated imagery from Mexican comics, Jonathan Borofsky (b. 1942), and Peter Liashkov (b. 1939); from Northern California comes M. Louise Stanley (b. 1942).

Fig. 36-7
Suzanne Caporael (b. 1949)
Portrait of Felix Krull, 1985
oil on canvas, 90 x 78 in.
Collection of the Orange County Museum of Art;
Anonymous Gift
Photo: Douglas Parker

As the century/milennium draws to an end, the negative emotions prevalent in some Expressive Figuration have come to be identified with the century's turn and have been relabeled End of Century Malaise (chapter 37).

Surrealistic/Romantic Landscapes. Very closely allied with Expressive Figuration in its dependence on emotion and on purposefully inept brushwork are Surrealistic/Romantic landscapes. These "dreamscapes" are real-looking landscapes with mysterious or enigmatic overtones. Most are metaphors for states of mind. Typical scenes range from straightforward deserted landscapes to complex, contrived compositions of darkly "romantic" elements, such as thick nighttime forests highlighted with fire or erupting volcanoes, overarched with sunsets and sunrises, or disturbed by whirlwinds or whirlpools. The viewer perceives an underlying fear as he sees a deer struggling to swim a lake, a canoe balancing on the brink of a waterfall, and leafless trees. The paint handling is intentionally rough, a seeming mix of Neo-Expressionism, Romanticism, and Surrealism with a little New Image and "bad" painting (in the 1970s sense) thrown in. Among the artists who created work of this type are Margaret Nielsen (b. 1948), Pierre Picot (b. 1948), and Phoebe Brunner (b. 1951).

Suzanne Caporael's (b. 1949) *Portrait of Felix Krull* of 1985 (fig. 36-7) is a "landscape" that is actually a metaphor for the artist's personal emotional state at a certain stage of her life. Felix Krull is the hero of the novel *Felix Krull, Confidence Man* by Thomas Mann. As the artist stated to the Newport Harbor Art Museum at the time of her gift of the painting, "Krull, finding himself in reduced circumstances, invents a new and improved self, and goes out into the world to try it out, with a variety of comic and tragic results. [The work] was painted during a time in my life where my entire existence was located within the four walls of my (very small) studio." In Caporael's paintings of that period, nature and man (or his psyche) exist in an uneasy tension. The red-colored numerals 3, 6, 7 and 9 make up the profile of a human face whose enigmatic features float in front of the stylized water.

As the 1990s approached, humanist themes evolved away from those projecting vague anxiety to those that addressed concrete issues and specific topics. The next, and final, chapter will discuss how the 1989 recession helped change the course of art and how artists turned "idea art" to the investigation of personal identity and the examination of today's social and political situation. 🎔

Bibliography

Art, General, 1980s

"Artweek Focus: Beyond Pluralism, an Art Movement that Resists Categorization," *Artweek*, v. 20, November 9, 1989, pp. 19–24.

Fox, Howard N., *Avant-Garde in the Eighties* [not Calif.], exh. cat., Los Angeles County Museum of Art, June 4–August 30, 1987 April 23–July 12 and other venues.

Rose, Barbara, *American Painting: The Eighties*, exh. cat., Grey Art Gallery, New York University, n. d., 1979. 112 p.

Sandler, Irving, *Art of the Postmodern Era: From the Late 1960s to the Early 1990s* [emphasis on New York], New York: IconEditions HarperCollins, 1996. 636 p.

Painters, 1980s, General, California

After Abstract, exh. cat., Art Center College of Design, Pasadena, Ca., September 24–October 29, 1988. 48 p.

Brown, Lora Pethick, *Nine and the Wall*, exh. cat., Art Gallery, California State University, Fullerton, February 6–March 12, 1981. 48 p.

"California Contemporary Art," *Art & Antiques*, v. 5, September 1988, pp. 72+.

California Contemporary: Recent Work of Twenty-three Artists, exh. cat., Monterey Peninsula Museum of Art, May 1–29, 1983. 63 p.

Cotter, H., "Eight Artists Interviewed," *Art in America*, v. 75, May 1987, pp. 162–79.

Creative Dimensions, Women Painters West [Juried Exhibition], exh. cat., Brand Library Art Galleries, Glendale, Ca., March 5–29, 1983. 48 p.

Face to Face, Back to Back, exh. cat., Main Art Gallery, Visual Arts Center, California State University, Fullerton, April 7–May 9, 1984. 32 p.

Faculty Exhibition: Sonoma State University 1987, exh. cat., University Art Gallery, Sonoma State University, Rohnert Park, September 10–October 25, 1987. 37 p.

Hopkins, Henry, *California Painters New Works*, San Francisco: Chronicle Books, 1989. 143 p.

Hopkins, Henry, *50 West Coast Artists: A Critical Selection of Painters and Sculptors Working in California*, San Francisco: Chronicle Books, 1981?

Hopkins, Henry, "Is the Mainstream Flowing West," *Art News*, v. 18, pt. 1, January 1982, pp. 73-79.

Interchange [photos used in art], exh. cat., Fine Arts Gallery, Mount St. Mary's College, Los Angeles, January 16–February 26, 1978. 42 p.

Muchnic, Suzanne and Gary Kamiya, "California Currents: Artists Choose Artists," *ARTnews*, v. 90, no. 9, November 1991, pp. 96–101.

Summer 1985 [9 artists], exh. cat., Museum of Contemporary Art, Los Angeles, 1985. 1 v.

Painters, 1980s, General, Southern California

Artists of Southern California: The Fine Art Catalogue, Albuquerque, N. M.: Mountain Productions of Texas, 1989.

A Broad Spectrum: Contemporary Los Angeles Painters and Sculptors '84 (In Celebration of the 23rd Olympics), exh. cat., Pacific Design Center of Los Angeles, June 7–August 15, 1984. 24 p.

California Viewpoints [series of one-man shows on Santa Barbara artists], Santa Barbara Museum of Art, 1980s.

Changing Trends, Content and Style: Twelve Southern California Painters, exh. cat., Laguna Beach Museum of Art, November 18, 1982–January 3, 1983. 86 p.

Contemporary Art in Southern California, exh. cat., The High Museum of Art, Atlanta, Georgia, April 26–June 8, 1980. 54 p.

Cotter, Holland, "Eight Artists Interviewed [compare state of art in LA and NY]," *Art in America*, v. 75, pt. 5, May 1987, pp. 162–79+.

Drohojowska, Hunter, "The Artists Who Matter: L.A.'s New Scene Makes History," *Antiques & Fine Art*, v. 4, no. 4, May/ June 1987, pp. 48–55.

Five Artists, exh. cat., Santa Barbara Museum of Art, April 30–June 26, 1985. 32 p.

Five Artists—Southern California: Don Gregory Anton, Stephen L. Berens, Grey Crawford, Stephanie Sanchez, Jon Swihart, exh. cat., Baxter Art Gallery, California Institute of Technology, Pasadena, February 29–April 21, 1984.

Hugo, Joan, "Los Angeles/New York," [rev. of exh. *Eleven Former L. A. Artists Who Went to N. Y.* at Koplin Gallery] *Artweek*, v. 13, no. 19, May 15, 1982, p. 5.

Inside the L.A. Artist, Salt Lake City, Ut.: Peregrine Smith, 1988. 104 p.

Joselit, D., "Living on the Border," *Art in America*, v. 77, December 1989, pp. 120–29.

Larsen, Susan, *Sunshine and Shadow: Recent Painting in Southern California*, exh. cat., Fisher Gallery, University of Southern California, January 15–February 23, 1985. 78 p.

LA: Hot and Cool—The Eighties, exh. cat., List Visual Arts Center, Massachusetts Institute of Technology, December 19, 1987 - February 7, 1988 and *Pioneers*, exh. cat., Bank of Boston Art Gallery, November 23, 1987–January 15, 1988. 72 p.

Long Beach Artists, sponsored by City of Long Beach, Department of Recreation and Human Services, exh. cat., Long Beach Museum of Art, July 12–August 9, 1982. 23 p.

Los Angeles and the Palm Tree: Image of a City, exh. cat., ARCO Center for Visual Art, Los Angeles, July 31–September 22, 1984. 24 p.

McDonald, Robert, "Artists Emerging in San Diego," *Artweek*, v. 16, April 20, 1985, pp. 1–2.

Menzies, Neal, "Sampling L. A. Art," [*L. A. Times* show at San Diego State University] *Artweek*, v. 13, no. 7, February 20, 1982, p. 7.

Obten, Vanessa, *Guide to Artists in Southern California*, Santa Monica, Ca.: Art Resource Publications, 1994. 122 p.

Off the Street: A One Time Art Exhibit [48 LA artists], sponsored by the Cultural Affairs Department, City of Los Angeles, exh. cat., Old City Print Shop, April 27–May 26, 1985. 32 p.

Parmet, Barbara, *Face to Face: Ten Santa Barbara County Artists on the Creative Process*, Santa Barbara, Ca.: B. Parmet, 1988.

Perine, Robert, et al., *San Diego Artists*, Encinitas, Ca.: Artra, 1988. 223 p.

Perpetual Motion: Karen Carson; Margaret Nielsen; John Rogers; Tom Wudl, exh. cat., Fellows of Contemporary Art, Los Angeles in cooperation with the Santa Barbara Museum of Art, November 17, 1987 to January 24, 1988. 96 p.

Plagens, Peter, "Bee-bop da Reebok in L. A.," [critique on current art styles] *Art in America*, v. 73, pt. 4, April 1985, pp. 138–49.

Post Olympic Art, exh. cat., LACE (Los Angeles Contemporary Exhibitions), September 5–October 6, 1984 and Beau Lezard Gallery, January 7–February 9, 1985. 28 p.

Resource/ Response—Fresh Paint: Fifteen California Painters, exh. cat., San Francisco Museum of Modern Art, n. d., 1982. 6 p.

A San Diego Exhibition: Forty-two Emerging Artists, exh. cat., La Jolla Museum of Contemporary Art, March 23–April 28, 1985. 36 p.

San Pedro Artists, exh. cat., Palos Verdes Art Center, Rancho Palos Verdes, Ca., Pt. 1, September 13–October 20, 1985 and Pt. 2, October 25–December 1, 1985. 24 p.

Selwyn, Marc, "New Art L. A.: Eight Young Artists Discuss Their Work," *Flash Art* (Italy), no. 141, Summer 1988, pp. 109–15.

Shift LA–NY, NY–LA, exh. cat., Newport Harbor Art Museum, Newport Beach, Ca., October 7–November 27, 1982. 82 p.

Smith, Richard, "Tradition and Transition in Southern California Art," *New Art Examiner*, v. 16, March 1989, pp. 25–28. [current work in light & space, conceptual, assemblage, sculpture, painting, video]

Ten Years Later: Ed Blackburn, Tony Costanzo, Robert Rasmussen, John Roloff, Richard Shaw, exh. cat., Main Art Gallery, Visual Arts Center, California State University, Fullerton, February 7–March 8, 1987. 48 p.

Variations: Five Los Angeles Painters, exh. cat., University Art Galleries, University of Southern California, Los Angeles, Ca., October 20–November 23, 1980. 52 p.

Variations II: Seven Los Angeles Painters, exh. cat., Security Pacific National Bank, Los Angeles, Ca., May 9–June 3, 1983. 51 p.

Variations III: Emerging Artists in Southern California, exh. cat., LACE (Los Angeles Contemporary Exhibitions), April 22–May 31, 1987 and two other venues. 79 p.

Visions & Figurations, exh. cat., Art Gallery, California State University, Fullerton, November 7–December 11, 1980. 47 p.

Wood, Denis, *20 Artists/Los Angeles*, exh. cat., City Gallery of Contemporary Art, Raleigh, N. C., November 4, 1988–January 22, 1989. 28 p.

Wortz, Melinda, "The LA/NY Shift," [LA artists who moved to NY] *Art News*, v. 82, pt. 1, January 1983, pp. 67–71.

Painters, 1980s, General, Northern California

Albright, Thomas, "San Francisco: Coming Up From Underground," *Art News*, v. 82, January 1983, pp. 76–79.

Atkins, Robert, "Trends, Traditions and Dirt: An Opinionated Guide to The Current State of Art in Northern California," *LAICA Journal*, no. 31, Winter 1981, pp. 29–33.

Bay Area: Fresh Views, exh. cat., San Jose Museum of Art, October 21–December 10, 1989. 1 v.

Brown, Christopher and Judith Dunham, *New Bay Area Painting and Sculpture*, San Francisco, Ca.: Squeezer Press, 1982. [Exhibition held at Art Gallery, California State University, Northridge, Ca., October 25–November 24, 1982.] 79 p.

Burstein, Joanne, "From the Sunny Side: Six East Bay Artists," *Artweek*, v. 13, no. 35, October 23, 1982, pp. 1+.

Christensen, Judith, et al. "Studio Scenes: A Glimpse Inside Artists' Studios: Mineko Grimmer; Carolyn Guile, Joanne Hayakawa, Diana Schoenfeld, Gary Stutler," *Art of California*, v. 6, no. 5, October 1993, pp. 57–60.

Currents: 10 Monterey Bay Artists, exh. cat., Art Museum of Santa Cruz County, Santa Cruz, Ca., June 12–July 25, 1993.

Curtis, Cathy, "The Art of Compromise," [rev. of *At this Point in Time* at San Francisco Arts Commission] *Artweek*, v. 14, no. 29, September 10, 1983, p. 5.

Curtis, Cathy, "Seeking the New Bay Area: Painting and Sculpture," [exh. at SFAI] *Artweek*, v. 13, no. 44, December 25, 1982, pp. 1, 16.

Exhibition: Swiss Artists in the Bay Area, exh. cat., Fort Mason Center, San Francisco, September 6–9, 1984. 21 l

Kelley, Jeff, "New Bay Area Painting and Sculpture," [review of CSN show] *Vanguard* (Canada), v. 12, April 1983, pp. 16–19.

Mochary, Alexandra, "[contemporary] Bay Area Art: Take Another Look," *Antiques & Fine Art*, v. 5, no. 1, November/ December 1987, pp. 70–75.

Newport Biennial (2nd : The Bay Area), exh. cat., Newport Harbor Art Museum, October 3–November 23, 1986. 56 p.

Rascon, Armando, *Art After Eden, An Un-Natural Perspective*, exh. cat., San Francisco: Southern Exposure Gallery, October 15–November 9, 1986. 44 p.

Roder, Sylvie, "Bay Area Roundup," [rev. of exh. *Bay Arts '82* at the San Mateo County Arts Council] *Artweek,* v. 13, no. 21, June 5, 1982, p. 20.

San Francisco Bay Area Painting, exh. cat., Sheldon Memorial Art Gallery, Lincoln, Ne., September 9–October 29, 1984. 48 p.

Sixth Annual California Watercolor & Drawing Survey, exh. cat., Humboldt Cultural Center, Eureka, Ca., n. d., 1986. 12 p.

Subjective Realities: Seven Bay Area Artists, exh. cat., Achenbach Foundation for Graphic Art, Fine Arts Museums of San Francisco and California Palace of the Legion of Honor, June 5–August 22, 1982. 44 p.

Conceptual Art/ CalArts.

CalArts: Skeptical Belief(s), exh. cat., The Renaissance Society at the University of Chicago in cooperation with the Newport Harbor Art Museum, May 6–June 27, 1987 and January 24–March 20, 1988. 80 p.

Cohn, Terri, "The Essence of Semiotic Discourse," [rev. exh. *Signs of the Times,* Syntex Gallery], *Artweek,* March 12, 1988, p. 7.

Cook, Katherine, "Language into Image," [rev. exh. *The Painted Word,* Richmond Art Center], *Artweek,* September 6, 1990, pp. 14–15.

Exhibition: An Exhibition of Current Works by Artists who are Alumni of the School of Art and Design of California Institute of the Arts, exh. cat., California Institute of the Arts, Valencia, Ca., September 21–October 9, 1981. 120 p.

A Forest of Signs: Art in the Crisis of Representation, exh. cat., Museum of Contemporary Art, Los Angeles, May 7–August 13, 1989. 176 p.

French, Christopher, "The Artist as Garbage Collector in the Field of Ideas," *Artweek,* v. 18, July 11, 1987, p. 8.

Goldstein, Ann and Anne Rorimer, *Reconsidering the Object of Art: 1965–1975,* [conceptual art] Los Angeles: Museum of Contemporary Art and Cambridge, Ma.: MIT Press, 1995. 335 p.

Helfand, Glen, "Power to the Word," [*The Word* at New Langton Arts] *Artweek,* v. 21, February 8, 1990, pp. 15–16.

Johnstone, Mark, "Messages from the Media," [use of photography in art] *Artweek,* v. 18, September 5, 1987, p. 8.

Knaff, Devorah, "World in a Mailbox," [rev. of 2 Orange Co. shows] *Artweek,* v. 24, February 4, 1993, p. 25.

La Palma, Marina, "Beware the Grids," [rev. *TV Generations*] *Artweek,* v. 17, March 29, 1986, p. 1.

Lovelace, Cary, "California Institute of the Arts & the Rematerialization of the Art Object," [paintings by some CalArts grads active in New York] *High Performance,* no. 25, v. 7, no. 1, 1984, pp. 36–8.

Spiegel, Judith, "The Pleasure of Interpretation," [photo/text] *Artweek,* v. 19, February 13, 1988, p. 5.

Torphy, Will, "Making Signs," [rev. exh., *Toward the One: Mystery of Sign,* Center for the Visual Arts, Oakland], *Artweek,* January 17, 1987, p. 4.

TV Generations, exh. cat., LACE (Los Angeles Contemporary Exhibitions), February 21–April 12, 1986. 71 p.

Watten, Barrett, "The Writing on the Wall," [rev. *Women and Language* at CCAC] *Artweek,* v. 21, no. 23, July 5, 1990, p. 12-13.

Welchman, John, "Cal-Aesthetics," *Flash Art,* Summer 1988, pp. 106–8.*

Breakdown of Barriers Between "High" and "Low" Art

Art and Film Since 1945: Hall of Mirrors, exh. cat., Museum of Contemporary Art, L.A. and Monacelli Press, N.Y., 1996.

Don, Abbe, "Re-Viewing Representation," [review of *Playing it Again: Strategies of Appropriation* at the Los Angeles Center for Photographic Studies] *Artweek,* v. 16, May 25, 1985, p. 12.

Jones, Amelia, "Returning the Origin to the Antioriginal," [review of *Redux* at Maloney Gallery] *Artweek,* v. 19, April 2, 1988, p. 7.

New Old Masters, exh. cat., Center for the Arts at Yerba Buena, San Francisco, April 13–June 12, 1994. 24 p.

Pincus, Robert L., "Art as Artifact or the Rise of Historicism," [historical references in the art of Southern California painters] *Flash Art,* no. 123, Summer 1985, pp. 39–41.

Second Sight: Biennial IV, exh. cat., San Francisco Museum of Modern Art, September 21–November 16, 1986. 76 p.

Solnit, Rebecca, "Connections with the Past," [review of *Past Presence/Contemporary Sources* at College of Notre Dame Gallery] *Artweek,* v. 16, April 20, 1985, p. 4.

Tanner, Marcia, "Usable Past," [review of *New Old Masters* at Center for the Arts] *Artweek,* v. 25, May 19, 1994, p. 26+.

Van Proyen, Mark, "Inversion and Invocation," [*The Difficult Image* at New Langton Arts] *Artweek,* v. 21, July 5, 1990, p. 12.

Van Proyen, Mark, "Object into Art," *Artweek,* v. 22, no. 3, January 24, 1991, pp. 3,10.

New Media: Computers, Technology

Approaches to Xerography, exh. cat., Los Angeles Municipal Art Gallery, June 5–July 7, 1979.

Aziz, Anthony, "Fax Art," [*Information* show at Terrain Gallery] *Artweek,* v. 21, no. 2, January 18, 1990, p. 9?.

Barsky, Brian A., ed., *SIGGRAPH '85 [Conference on Computer Graphics and Interactive Techniques 12th 1985] Conference Proceedings, July 22–26, 1985, San Francisco, California,* New York: Association for Computing Machinery's Special Interest Group on Computer Graphics, 1985. 332 p. [*Computer Graphics,* v. 19, no. 3]

Burkhart, Dorothy, "Copy Graphics," [Xerox art] *Artweek,* v. 10, no. 15, April 14, 1979, p. 6.

Cebulski, Frank, "With Technology and Deadly Humor," [robots] *Artweek,* v. 12, no. 43, December 19, 1981, p. 1.

Christensen, Judith, "Playing with Fractured Images," [rev. of *Hard Copy* at UC, San Diego] *Artweek,* v. 21, January 25, 1990, pp. 11–12.

Clifton, Leigh Ann, "Artists & Technology: Some Issues of Individual Application," *Artweek,* v. 26, February 1995, pp. 22–23.

Computer Geoscience as Art, exh. cat., Bakersfield Museum of Art, April 2–May 2, 1998. 26 p.

Dietrich, "Frank, "The Computer: A Tool for Thought-Experiments," *Leonardo,* v. 20, no. 4, 1987, pp. 315–25.

Electronic Editions, exh. cat., Union Gallery, California State University, San Jose, n. d., 1979. 62 p.

"Electronic Mural Project," *Leonardo,* v. 26, no. 3, 1993, p. 250.

Fischer, Hal, "Journals of Experience," [rev. of *Flash! Copy Art, 32 Bay Area artists* at Chevron Gallery] *Artweek,* v. 13, no. 22, June 19, 1982, p. 7.

Floss, Michael, "Art 101: the Sequel or Conceptualizing a Techno-Arts Curriculum," [at the California College of Arts and Crafts, Oakland] *Artweek,* v. 26, March 1995, pp. 15–17.

Friedhoff, Richard Mark, *Visualization: The Second Computer Revolution,* New York: H. N. Abrams, 1989. 215 p.

Hershman, Lynn, "Touch-Sensitivity and Other Forms of Subversion: Interactive Artwork," *Leonardo,* v. 26, no. 5, 1993, pp. 431–36.

Horgan, John, "Robots Rampant: California Artists Spawn Technological Monsters," *Scientific American,* v. 259, no. 2, August 1988, p. 28.

Irwin, James, "The Science of Art," [Exploratorium] *Artweek,* v. 14, no. 27, August 13, 1983, p. 12.

Jan, Alfred, "No Faith in Science," [2 artists at San Jose Museum] *Artweek,* v. 21, no. 11, March 22, 1990, pp. 1, 20.

Jelenfy, Karen, "Indiscreet Computers," [rev. *Revealing Conversations* at Richmond Art Center] *Artweek,* v. 20, November 16, 1989, p. 10–11.

Jordan, Jim, "Art and the Electron," [digital photography] *Artweek,* v. 19, June 25, 1988, p. 11.

Keil, Bob, "Electronic Art," [thoughts on] *Artweek,* v. 11, May 3, 1980, p. 7.

Lee, Clayton, "Artist: Computer: Computer: Artist?," *Artweek,* v. 14, no. 7, February 19, 1983, p. 1.

Leigh, Mary, "AARON: Portrait of the Young Machine as a Male Artist [computer created art]," *RACAR, Revue d'Art Canadienne/Canadian Art Review,* v. 20, no. 1–2, 1993, pp. 130–39.

Minard, Lawrence, "Hollywood's New Stars," [animation], *Forbes,* v. 153, no. 5, February 28, 1994, p. 10.

National Computer Graphics Association (U. S.) Conference and Exposition, 13th, 1992, NCGA Presents CAD & Engineering Workstations '92 and Business Graphics '92 Conference & Exposition Under One Roof: Conference Proceedings, March 9 –12, 1992, Anaheim Convention Center, Anaheim, California, Fairfax, Va.: National Computer Graphics Association, 1992. 793 p.

Newman, M., "Project for Electric Art Block, Venice, California," *Progressive Architecture,* v. 73, August 1992, pp. 52–55.

Norklun, Kathi, "Science Fiction Mystifications," [review of *San Francisco/Science Fiction* at Otis/Parsons] *Artweek,* v. 16, April 6, 1985, p. 6.

"Out of Sight: Imaging/Imagining Science," Santa Barbara Museum of Art *View,* March/April 1998, pp. 4–5.

Portner, Dinah, "Contemporary Xerography," [review of *Approaches to Xerography* at L.A. Municipal Art Gallery] *Artweek,* v. 10, no. 23, June 30, 1979, p. 15.

Proceedings of the Third Annual Conference and Exposition of the National Computer Graphics Association, Inc., Anaheim Convention Center, Anaheim, California, June 13-17, 1982, Fairfax, Va.: National Computer Graphic Association, 1982. 2 v.

Rapko, John, "The Box," [rev. of *Thresholds and Enclosures* at SFMOMA and *TV Times* at Richmond Art Center] *Artweek,* v. 24, July 8, 1993, p. 30.

Rapoport, Sonya, "Color in the shadows: Bay Area Cyberart," *Leonardo,* v. 28, no. 1, 1995, pp. 77–78.

Reichardt, Jasia, "Machines and Art," *Leonardo,* v. 20, no. 4, 1987, pp. 367–72.

Reveaux, Anthony, "Pursuit of Trivia via Videodisk," *Artweek,* v. 15, December 8, 1984, p. 6.

Reveaux, Tony, "Digital Derring-do," [electronic photography] *Artweek,* v. 22, June 20, 1991, p. 11.

Reveaux, Tony, "Polytechnical Diversity," [rev. of *Bay Area Media* at SFMOMA] *Artweek,* v. 21, no. 15, April 19, 1990, pp. 1, 20.

Rodee, Howard, "Machine Esthetic—Two Sides," [sculpture of Charles Mattox] *Artweek,* v. 11, September 20, 1980, p. 13.

San Francisco Science Fiction, exh. cat., San Francisco Arts Commission Gallery, June 5–30, 1984 and the Clocktower, September 27–October 28, 1984. 50 p.

Scarborough, James, "Motion Studies," [review of *System/Situation: The Narrative in Kinetic Sculpture* at Muckenthaler] *Artweek,* v. 22, February 28, 1991, p. 10.

Second Computer Graphics Workshop, Monterey, 1985, Proceedings, December 12–13, 1985..., Berkeley, Ca.: USENIX Association, 1986. 88 p.

SIGGRAPH '87: Fourteenth Annual Conference on Computer Graphics and Interactive Techniques, Anaheim, California, July 27 - 31, 1987, Conference Proceedings, New York: Association for Computing Machinery, 1987. 352 p.

"Technology...Art," [several articles on] *Artweek,* v. 26, no. 2, February 1995, pp. 14–23.

"Technology and Art," [art related sites on Internet, WEB, EZTV] *Artweek,* v. 27, no. 2, February 1996, pp. 11–16.

Walker, James Faure, "Painting with the Computer," [not Calif.] *Modern Painters,* v. 5, no. 2, summer 1992, pp. 56–59.

Watten, Barrett, "Science Fair...Bay Area Cyberart at CCAC," *Artweek*, v. 25, February 17, 1994, p. 11–12.

Wiley-Robertson, Salli, "Addressing Computers and Art," [review of exhibit associated with CADRE—Computers in Art and Design, Research and Education conference at Santa Clara] *Artweek*, v. 15, no. 6, February 11, 1984, p. 13.

Wood, James, "Painterly Holography," *Artweek*, v. 11, September 27, 1980, p. 3.

Woodard, Josef, "Behind the Celestial Whoosh," [rev. of *Improbable Machines* at Santa Barbara Museum of Art] *Artweek*, v. 21, no. 34, October 18, 1990, p. 16.

Human Themes, Figural Painting, Narrative

"Artweek Focus: The Body in Art," *Artweek*, v. 21, no. 32, October 4, 1990, pp. 21–25.

Brzezinski, Jamey, "Reassurance," [review of *The Figure Identified* at Richmond Art Center] *Artweek*, v. 22, no. 34, October 17, 1991, p. 1, 16

California Figurative Artists, exh. cat., Tortue Gallery, Los Angeles, Fall 1977.

Cohn, Terri, "Looking at Figures," [review of *The Figure in Context* at the Richmond Art Center] *Artweek*, v. 19, February 27, 1988, p. 6.

"Contemporary Narrative Imagery," *Visual Dialog*, v. 4, no. 3, April–June 1979.

Curtis, Cathy, "The Abrasive Gesture," [*Impolite Figure* at two S. F. galleries] *Artweek*, v. 14, no. 25, July 16, 1983, p. 24.

Cutajar, Mario, "Figurative Painting: In Vogue: Photography and Figurative Painting," *Artweek*, v. 27, June 1996, pp. 12–13.

Ewing, Robert, "Esthetic Badness," *Artweek*, v. 13, no. 43, December 18, 1982, p. 4.

Ewing, Robert, "Figures and Narratives," [review of *Visions and Figurations* at Cal. State Univ. Fullerton] *Artweek*, v. 11, November 29, 1980, p. 1.

Figuration, exh. cat. University Art Museum, Santa Barbara, January 6–February 7, 1982.

Figuration/Imagination [3 artists] exh. cat., California State University, San Bernardino and other sites, n. d., 1987.

"Figurative Painting," [6 articles] *Artweek*, v. 27, no. 6, June 1996, pp. 12-18.

The Figure in Context, exh. cat., Richmond Art Center, February 1988?

French, Christopher, "Considering the Figurative Dilemma," [review of the symposium *Figurative Expressionism: Art of the Human Dilemma* at San Francisco Museum of Modern Art] *Artweek*, v. 15, July 28, 1984, p. 8.

Gordon, Allan, "Body Parts," [review of *de-Persona* at the Oakland Museum] *Artweek*, v. 22, no. 23, July 4, 1991, pp. 1, 16, 17.

Hugo, Joan, "Dreams of Games and Figures," [rev. of *Personal Iconography: The Figure* at Security Pacific National Bank] *Artweek*, v. 18, October 17, 1987, p. 1.

The Human Condition: SFMMA Biennial III, exh. cat., San Francisco Museum of Modern Art, June 28–August 26, 1984. 23 p.

Impolite Figure, exh. cat., Southern Exposure Gallery and Bannam Place Exhibition Space, San Francisco, July 1983?

Kohn, Michael, "The Figurative Style of the Sixties: Brice, Lebrun and Warshaw," *LAICA Journal*, no. 34, v. 4, Fall 1982, pp. 56-60.

Leonard, Michael, "Bay Area Figurative's Descendants," [rev. of *New Painterly Figuration* at SFAI] *Artweek*, v. 17, October 11, 1986, p. 3.

Levy, Mark, "Confronting the Human Condition," [rev. of *European and American Figurative Expressionists* at the San Francisco Museum of Modern Art] *Artweek*, v. 15, August 11, 1984, p. 1.

Lynch, Sheila, "Failure as a Medium [rev. of *Just Pathetic* at Rosamund Felsen Gallery]," *Artweek*, v. 21, September 13, 1990, p. 13-14.

Mallinson, Constance, "Rebels with a Cause," [4 figurative artists] *Artweek*, v. 11, December 20, 1980, p. 16.

New Painterly Figuration in the Bay Area, exh. cat., San Francisco Art Institute, September 17–October 18, 1986. 16 p.

Personae: Southern California Figurative Art, exh. cat., California State University, Los Angeles, March? 1985.

Personal Iconography: The Figure, exh. cat., Security Pacific National Bank, n. d., 1987. 2 p.

Portraits '79, exh. cat., Los Angeles Municipal Gallery, Barnsdall Park, May 1979.

Rugoff, Ralph, *Just Pathetic*, exh. cat., Rosamund Felsen Gallery, Los Angeles, August 4-31, 1990. 20 p.

Visions and Figurations, exh. cat., California State University, Fullerton, November 1980?

Weisberg, Ruth, "The Figure and its Postures in Southern California," *Artweek*, v. 12, March 14, 1981, p. 5.

Weisberg, Ruth, "Synthesizing Figurative References," *Artweek*, v. 13, no. 4, January 30, 1982, p. 1.

Williams, Gloria, "Surveying the Figure," [review of *Personae: Southern California Figurative Art* at California State University, L.A.] *Artweek*, v. 16, March 2, 1985, p. 3.

Surreal/Myths/Narratives

Brunson, Jamie, "An Emerging Romanticism," [rev. of *New Romantics* at Richmond Art Center] *Artweek*, v. 17, March 8, 1986, p. 3.

Jan, Alfred, "A View of Surrealism," [rev. of *Contemporary Surrealism: Classical, Visionary and Social* at the De Anza College] *Artweek*, v. 15, October 20, 1984, p. 4.

Laurence, Michael, "The Mythical and Monstrous," [rev. of *Myth and Mystery* at Maloney Gallery, Santa Monica] *Artweek*, v. 18, October 3, 1987, p. 4.

Meidav, Edie, "Creating the System," [rev. of *Mythologies* at the San Francisco Art Commission Gallery] *Artweek*, v. 24, July 8, 1993, pp. 20–21.

Surrealism is Alive and Well in the West, exh. cat., Baxter Art Gallery, California Institute of Technology, Pasadena, Ca., February 25–April 14, 1972. 48 p.

Thomas, Sherry Lee, "The What-is-Between," [rev. of *The New Narratology* at Artspace, S. F.] *Artweek*, v. 20, April 8, 1989, p. 6.

"Where the Wild Things Are," [animals in West Coast art] *Artweek*, v. 24, no. 11, June 3, 1993, pp. 4–5, 14–17.

Fig. 37-1
David Cannon Dashiell
(1952–1993)
Queer Mysteries, 1993 (detail)
acrylic on acrylic sheets
28 panels; each 100½ x 51¼ in.
San Francisco Museum of
Modern Art, Gift of the
Estate of the Artist and Rush
Nash Fund

The Postmodern Era
—Humanism of the 1990s

The elimination of the Iron Curtain in August 1989 brought an end to the boom of the 1980s and initiated an economic domino effect. With the breakup of the USSR, there was no longer a need for a giant American military organization and its associated defense spending. Several of California's military bases were closed, and at aircraft and defense plants pending orders for planes and other equipment were canceled. As the recession came on, corporations trimmed "fat" and downsized their workforces. In California, many unemployeds left the state to search for work elsewhere resulting in a glut of houses for sale and the crash of the highly inflated California real estate market. Lending institutions holding the loans on these properties found themselves with severely depressed portfolios. Many had to be rescued by the federal government or went through a lengthy process of merging with healthy financial entities.

The falling economy affected art. Universities cut their payrolls, putting artist-teachers out of work. Since many of the donors to museums and many of the collectors of California art had gained their fortunes from real estate, many stopped collecting art and donating art and money to museums. Cuts in funding from corporate foundations and government entities drove museums and alternative spaces to find other forms of support, including private foundations.

Most important for the evolution of art, the recession savagely hit the commercial galleries riding the boom of the 1980s. As the bottom fell out of the art market, the dominant contemporary product—high-priced art produced by art world stars of the 1950s and 1960s—lost its speculative value. The need for more reasonably priced art opened the doors to artists from former minority groups, from countercultures, and those just emerging into the art world. Their work, evincing a fresh and new approach, was willingly exhibited by a host of new, low-budget alternative spaces, some run on a shoestring and occupying no more space than a room in someone's home.

Most art of the 1990s qualifies as "humanist" in that it is representational and concerned with emotions or ideas. It takes two forms: public art, such as public arts programs and education, and private, including individual pieces of art for purchase. Its characteristics were shaped by the trends discussed in the previous chapter: an interest in expressing ideas, multiculturalism, the use of new technologies, and the assimilation of popular art and ideas into fine art.

Public Art and Education

Since the beginning of recorded human history, art has been intentionally placed where the public could see it. Commissioned by the ruling party or institutions, it has been the means to teach values or immortalize individuals. The current era of public art began in the mid 1960s. Between 1965 and 1980, art qualified as "public" simply by its location in a public space. Outdoor works were placed in revitalized downtowns (in rehabilitated public squares, plazas, and parks), on campuses, on the edges of freeways, and at public transportation stations. Indoors, it was found in the lobbies and other general traffic areas of public and private buildings. It was fostered by big business: times were financially prosperous, tax laws advantageous, and the trend was for business to turn back some of its profits to benefit consumers. Such art usually took the form of modernist, large-scale sculpture by established artists (chapter 27). (It was "humanist" in its public goals but not necessarily in its aesthetic.) In the 1990s public art likewise appeared in public spaces but it was intrinsically humanist; often it was representational and funded by government entities aware of the psychological and aesthetic value of art to its populace.

Since 1980 the primary purpose of public art has been to improve the quality of life in urban neighborhoods. Ideally, today's creators of public art try to make it serviceable and relate visually and thematically to its constituency, although success varies with individual pieces. In a perfect situation, the aesthetic content of the public work will appeal to the average viewer (vandalism on disliked art is a common problem), avoid triteness, and yet qualify it as an important piece of contemporary art. Today's public artist is no longer an isolated individual realizing a personal idea but must be prepared to work with committees of architects, landscape designers, public officials, and community groups to create an artwork that expresses the concerns of its community.

Today's public art takes many forms, from the traditional media of murals and sculpture to newer art forms such as site installations, earthworks, performances,

posters, and even art on bus benches and signs. Contrary to modernist public art, for which style was the *raison d'etre*, recent public art takes up humanist themes, such as ecology, and social and political problems, such as crime, border relationships (San Diego), and the plight of undocumented workers. Public art that uses a conceptual vocabulary (a "style" generally incomprehensible to the average person) usually fails to engage the interest of average person. This leads some observers to believe that the only true public art is made by people residing in the community itself, who are working in easily understood forms such as folk art, murals, and graffiti (chapters 31, 34).

Funding for public art is growing. In spite of a decline in government arts funding during the Reagan administration and following the 1989 recession, more responsibility for funding public art is being assumed by private and corporate foundations. Many communities now have percent-for-art programs, which require that a certain percentage of the budget for new construction projects be spent on art. Several cities, such as Brea in Southern California, now take pride in their public art and have issued self-guided walking tours and other publications that document it.

Art Education. Today's art education does more than transfer information about techniques and styles. It plays an essential role in the smooth working of a multicultural society.

The 1980s cutbacks in government funding to both the arts and the arts programs in schools ironically coincided with an increased need for art in people's lives. Support for art education has shifted from the public schools to entities such as museums. Museums no longer see themselves as elitist archival institutions but as educators. Art museum displays have gone from paintings on the walls to multimedia presentations incorporating didactic labels, photographs, three-dimensional objects, and interactive displays that allow the visitor to delve further into areas of personal interest. Museums have traditionally offered classes, lectures, and seminars, but in recent years, on-site art classes for children and adults have been increased, and museums offer special tours of their galleries for school children. Museum outreach programs include museums-on-wheels and museum-trained educators who travel to schools and teach art courses integrated into the curriculum. Museums also display art in places where the non-museum-goer can experience them—such as shopping malls and airports.

Teaching art to children has become a new goal for individual artists who see it as a remunerative occupation, enjoy working with youth, and believe that children need group experiences in order to avoid the current social trend of living isolated lives and functioning only within a limited stratum of peers. As classes are composed of individuals from differing ethnic or social backgrounds and participants are taught appreciation and tolerance of many different art forms and the diverse peoples associated with them, art education becomes an important advocate for multiculturalism and eradicates prejudice. In group situations, where members are given respect for their opinions and permission to use iconography from their respective backgrounds, children gain self-worth, empowerment, a means of communication, and an opportunity to understand themselves.

The Search for Personal Identity

Painting after 1980 cannot be discussed in the traditional way—as an evolving style or medium or as a history of the work of white males. Today's multicultural artist is intent on conveying ideas and chooses any style, medium, or combination of styles and media that serves him. He often opts for non-painting media such as photography, video, performance, assemblage, and site installations. Since today's emphasis is on ideas, group exhibitions are usually developed around topics addressed. Since 1970, art has focused on humanist themes, and these have evolved from nonspecific subjects (such as the anxiety seen in some Expressive Figuration) to very specific topics (such as the search for personal identity, creation of invented worlds, and activist art that champions group social or political concerns).

Personal identity has become an increasingly important issue. Today's society is seen as a vast sea of semi-anonymous individuals, identified only by government-issued documents (social security number, driver's license, mailing address, and telephone number) and by statistics, like dots on a demographic map.

Art became a medium for expressing *personal* issues as early as the mid-nineteenth century, when photography relieved painters from having to be illustrators.

The trend escalated after 1960, when the groups behind the Civil Rights Revolution used art to forward their causes and to define their identities. Today's interest in the theme of personal identity and the use of autobiographical content is a legacy of the Feminist technique of consciousness raising, of plumbing one's own soul for subject matter. The theme and technique grew in popularity during the "me" generation of the 1970s.

Artists investigate personal identity through creating portraits and self-portraits, by deconstructing gender or racial stereotypes, by pictorially recreating scenes from their youth, or by staging narratives to metaphorically suggest adult emotions or formative incidents. By expressing their emotions in art, artists work through concerns, define themselves, build self-awareness and self-esteem, and diffuse anger. At the same time, artists hope their solutions will help others.[1]

Neo-Feminism and Women's Issues. After a quiescent period in the 1980s, women have again become one of the most vocal groups of artists. Their resumed activity (see Feminism, chapter 33) constitutes a kind of Neo-Feminism or Post-Feminism; its focus is on personal issues rather than the group emancipation themes that concerned Feminists of the 1970s. The greater popularity of personal-identity subjects among women has been ascribed to women's greater sensitivity, their greater willingness to address emotions and to publicly expose them, and their desire to heal or resolve a difficult situation without resorting to major conflict.

One of the most frequently addressed themes in Neo-Feminist Art is beauty. Although societies have always established norms for beauty, today's Feminists resent the ideal set in America today. They object to the premium placed on external appearance, the superficial standards established by motion pictures, television, and advertising, and the fact that a personal issue has been made public. Feminists take issue with the way these norms make women feel bad about themselves and compel them to meet unrealistic standards through diets, plastic surgery, the wearing of designer clothing, and the purchase of expensive beauty products.

Other themes are revealed in the titles of some of the many recent exhibitions devoted to Feminist Art or themes. *Backtalk* contained art that expressed the feelings of helplessness, mistrust, anger, personal injury,

and victimization experienced by women artists as a result of rape, incest, or battering. The art in *Her Story* looked back on the individual artists' lives to review old memories and, through the act of remembering and creating, to make the artist more self-aware, possibly even to revise her history. The imagery in *Family Album* proved that there is no longer a "typical" American family: it is now socially and racially diverse and may be headed by gays or lesbians. Other shows have explored issues such as breast cancer, culturally established gender roles, ethnicity and class, empowerment, relationships, home and family, and a whole range of sexual issues including AIDS. The "Relative" series of paintings by Squeak Carnwath (b. 1947), is an elegy to her mother who died after a long illness in August 1996. Instead of overtly depicting the death, Carnwath suggests it by incorporating selected representational imagery into her abstract canvases: calendars that call to mind the limited days of life left to her mother, lists of discomforts her mother no longer has to bear, menus catering to the sick, and words describing emotions the artist felt. Exhibitions of art by or about women have been frequent, but most have not been documented by catalogues.[2] Fresno Art Center (now Museum) put itself on the map in the late 1980s with its four-part *Passages: A Survey of California Women Artists 1945 to Present*. Annually for the past eleven years its Council of 100 has identified a Distinguished Woman Artist (from California artists over sixty years of age) who has been given an exhibition, accompanied with a catalogue or brochure.

Gays and Lesbians. Art *about* gays has always focused on the issue of identity. With the acceptance of gay subject matter into the non-gay mainstream in the 1980s (chapter 33), entire exhibitions have been mounted to display art by gays and about gay issues. The major gay themes remain sexual difference and the basic human need for relationships. Artists raised to believe in heterosexual ideas of marriage and children fight to resolve traditional family ideas with their own lifestyles. In most recent times, gay identity has become so complex that the show *In a Different Light* (University Art Museum, Berkeley, 1995) breaks it down into nine categories: Void, Self, Drag, Other, Couple, Family, Orgy, World, Utopia. Vaginal and anal imagery are thus isolated from other issues such as

gender, switching gender through cross dressing, relationships with others, attempts to construct gay "families," and so forth. Artists' approaches are the standard ones of portraiture, deconstruction of stereotypes, and the creation of narratives.

Gay subject matter underlies some of the lavish imagery in paintings by Los Angeles's Lari Pittman (b. 1952), while it is overtly addressed in the narrative mural *Queer Mysteries* of about 1993 (fig. 37-1, p. 514) created by San Francisco's **David Canon Dashiell** (1952–1993), who died of AIDS. Dashiell received an MFA from California Institute of the Arts in 1976 but did not devote himself to creating his own art until the mid 1980s, when he produced several ambitious installations composed of multiple painted panels. Each was inspired by an important work of the past: his *Plague Journal* of 1985 by Daniel Defoe's *A Journal of the Plague Years;* his *A Lover's Discourse* of 1987 by Roland Barthes's philosophical investigation of obsessive love; his *Invert, Oracle* of 1987–88 by Tarot cards; and his *The Pantocrator's Circus* of 1990 by Hieronymous Bosch's *The Tabletop of the Seven Deadly Sins and the Four Last Things. Queer Mysteries* is inspired by the mural of 88

A.D. in the Villa of Mysteries at Pompeii. It represents the initiation of a new member into a Dionysian mystery cult for women. In more than thirty panels, each measuring 4 x 8 feet, he recreates the mural in expanded size and replaces the Roman figures with gay men dressed like actors from an Edwardian horror film and lesbians dressed like aliens from a 1950s sci-fi film. Dashiell's figures undergo an imaginary ritual for coming out as a member of the gay community; the lesbian narrative reads left to right while the gay narrative mirrors it, reading right to left. Details of the "ceremony" are unimportant—even the meaning of that in the Pompeiian mural is in doubt. The narrative is intentionally ambiguous and vague, in order to inspire viewer reflection. Dashiell learned his conceptual thinking at CalArts. By showing gays and lesbians undergoing initiation and transformation he explores queer identity, the ceremonies of belonging, and issues of alienation. His work has great appeal with its Pop/cartoonlike simplified forms, its bright colors, and the slickness achieved by painting on the reverse of acrylic panels.

Multiculturalism. America's racial groups are no longer described by the word "minority" or even with the second-generation terms "marginal," "other," and "third world," but are now considered equal members in a "multicultural" society. Multiculturalism is promoted at all levels of government and in many arts organizations. California has hosted two major multicultural festivals—the L. A. Festival and San Francisco's Festival 2000. However, artists from racial minorities still struggle with many issues of identity and acceptance. They hope for equal assimilation into American society as well as into America's art world. Questions they ask include "How can one be a full member of the mainstream and keep one's ethnic identity at the same time?" and "Is one's art being accepted into mainstream exhibitions for its aesthetic quality or because of 'quotas'?" Multicultural artists often carry the heavy responsibility of being translators/transmitters of their culture to others.

One of the earliest artists to *deconstruct* ethnic stereotypes was **Robert Colescott** (b. 1925). Colescott trained at the University of California, Berkeley, and for one year in the late 1940s in the studio of the French artist Fernand Léger. At a crucial point in the early to mid 1960s, when he was determining the direction of

Fig. 37-2
Robert Colescott (b. 1925)
Les Demoiselles d'Alabama: Vestidas, 1985
acrylic on canvas, 96 x 92 in.
Courtesy of Phyllis Kind Gallery, New York

his art, Colescott spent two years in Cairo, Egypt. This not only freed him from any mainstream modernist dogma but also introduced him to Egyptian art and reinforced his bent toward representationalism. On his return to the United States, the Civil Rights Revolution was underway. Colescott began to insert black figures into compositions famous in Eurocentric art history and to paint the whole in a cartoonlike, naive style with irony and humor. This highly individual approach was not only contrary to the black official stance—for artists to paint positive images of blacks and black heroes—but went to European and American popular culture for its images rather than to the sanctioned Central African art. In this way, Colescott proved himself to be *far* ahead of his time.

In *Les Demoiselles de Alabama: Vestidas* of 1985 (fig. 37-2) and its companion *Les Demoiselles d'Alabama: Desnudas* (Greenville County Museum of Art, Greenville, South Carolina), Colescott reuses the composition of Picasso's *Les Demoiselles d'Avignon,* 1907 (Museum of Modern Art, New York). Like the majority of fine arts artists after 1960, Colescott does not deliver his message as an illustrator but conceptually, by neutrally presenting an image from which others must draw conclusions. Like the most successful work done in this manner, his art functions on several levels, following up the viewer's immediate impression with multiple layers of meaning. In *Vestidas,* he replaces Picasso's figures with contemporary young women whose dress and manners spoof the social issue of female beauty as established among various American ethnic groups. At the same time, by choosing to rework a famous canvas by a Caucasian male from Western European art history, he comments on western art history's Eurocentrism. Picasso's *Demoiselles d'Avignon* was considered a breakthrough painting by modernist critics largely because of Picasso's absorption of African imagery. Colescott reverses the process by replacing Picasso's abstracted figures with illusionistic (albeit naive) figures. By using humor and choosing a cartoon/naive style, he makes his message palatable to the audience that needs most to receive it—the white majority. Forcing viewers to look at his images and to consider their meaning serves to disempower them. By absorbing low art ("bad" painting, humor, and cartoon) into high art, Colescott joins today's trend to break down the barriers between the

two. (Masami Teraoka and Hung Liu also address the question of bicultural existence and identity in their art, chapter 33.)

Other artists of third-world extraction use their art to speak out on political issues. Some Chinese Americans have adopted the propaganda style of Communist China to comment on the recent political and cultural tensions there, to bring the 1989 events in Tienanmen Square to the American public. Blacks have made works to commemorate the Civil Rights leader Martin Luther King and to memorialize the beating of Rodney King. Latinos are interested in border issues and the plight of undocumented workers, the debunking of Christopher Columbus, and the Free Trade Agreement between the U. S. and Mexico. Native Americans try to reconcile the colonization of the Americas by Western Europeans.

In recent years the roster of ethnically based art groups has been supplemented by Italian Americans, Armenian Americans, and Jewish Americans. Well assimilated into American culture, artists in these groups exhibit together because they feel pride in their national origins. They use symbols, iconography, and themes associated with their background cultures and countries or the images that have evolved in America regarding them. Italian American artists have been known to incorporate motifs from the Italian Renaissance and the Catholic Church. Jewish artists turn to biblical imagery, the Holocaust, Israel, Cabalistic mysticism, and personal identity within their Jewish heritage.[3]

End of Millennium/End of Century

Traditionally the ends of centuries and millennia have provided a logical point for religious leaders to prophesy the end of the world, for nostalgia buffs to relive memories and events, for analysts to assess the current state of the world, and for seers to predict what the new century or millennium will bring. The ends of centuries are seen as prompting a range of human feelings—people feel let down, depressed, and tired from the long haul, and desire a fresh start in the century or millennium to come.

California artists are meeting the approaching end of the millennium with a full range of emotions, but with an emphasis on the negative ones. Today's artistic negativism has been building since shortly after World War II and has been fed with regular infusions of anarchistic energy from the social revolutions of the 1960s and the state's various countercultures, particularly the Punk movement of the late 1970s. The downbeat tone has been fostered by the mass media. Newspapers, periodicals, radio, and TV, lacking a major war or disaster, keep a persistent crisis situation with stories about

the declining safety of citizens, AIDS, the rise of racism and homophobia, homelessness, poor public education, America's out-of-date infrastructure, and prophesied environmental catastrophes. Tabloid journalism focuses on the worsening plight of the poor, violence against women, random assaults, and cults. The pessimistic tone is echoed in motion pictures, stage plays, music, and the fine arts, where the fashion is to create "thrillers" based on drugs, serial killers, and hard-core sex.

Depression and anxiety are further prompted by current events: wars around the world, city crime, banking swindles, and junk bond fiascoes. Man has found himself unwillingly caught up in nuclear conflicts, persecuted by government agencies, dealing with corrupt officials, and threatened by invasive technology. Americans have become disenchanted with technology's unfulfilled promise of a better world. The 1980s witnessed an increasing separation between the rich and poor. While some individuals were able to pursue wealth and status as well as good times and self-gratification, the majority of people realized the "good life" had grown out of their financial grasp, and the numbers of homeless were growing. For Californians a succession of earthquakes, brush fires, and torrential rains resulting from the El Niño condition has brought to mind subjects like the Apocalypse.

How are artists reacting to this rush of disasters? In the 1970s and 1980s some expiated their feelings in expressively painted figure paintings (chapter 36). Today, artists react in a variety of ways: they ignore the situation, try to mentally escape it, defuse it with humor, or turn activist and try to change it.

Non-Reality Worlds: Neo Spirituality. Throughout the twentieth century a small percentage of artists has explored symbolic or spiritual ideas in art or created imaginary fantasy worlds. This trait has been particularly evident among California artists. The state has a reputation for fiction and fantasy supported and fueled by its many alternative religions, its several countercultures, the drug scene, and Hollywood's "dream" machine, to name a few. The creation of spiritual art and fantasy worlds has increased in the 1990s and is being tied to the end-of-the-millennium syndrome.

Recent spiritual subject matter is prompted by many motives, including artists' search for emotional support, curiosity about humanity's relationship to the rest of the universe, fascination with the institutions of "other" groups, and the attraction of spirituality's enigma and mystery. Artists from racial minorities sometimes try to reconnect with their religious heritage.

Most artists on a spiritual quest reject conventional organized religions and instead investigate and explore alternative religions, philosophies, magic, and beliefs from around the world. From each belief system artists appropriate ideas or iconography that are meaningful to them, and their artistic responses span the gamut from abstraction to representationalism. Art inspired by tribal cultures often takes the form of multimedia assemblages made of found objects (reminiscent of tribal fetishes and medicine bundles) or the shape of tribal artifacts: totems, reliquaries, shrines, stools, cloaks, masks, rattles, and necklaces. Materials are organic, such as bone, hide, hair, blood, and feathers. Artists impressed with the graphs, maps, diagrams, and mandalas that nonscientific peoples have developed over the centuries to organize the universe often create hieratic charts. The Neo-Academic painter Jon Swihart (b. 1954) turns to Greek and Roman pagan ideas when he sets up enigmatic narrative scenes in which the participants seem involved in rituals, often at a shrine. A number of artists appropriate compositions or formats from organized Christian religion. Michael Schrauzer (b. 1960) chooses the format of the two-fold or three-fold altar to hold his contemporary scenes painted in a Neo-Academic style. Others pose contemporary figures in compositions developed by the Catholic Church, such as the annunciation (Mary being told by an angel that she is to be the mother of God), the crucifixion, the deposition (Christ being taken down from the cross), and the apotheosis (the rise of a person to heaven). Still other artists metaphorically suggest the purity of the spirit by painting abstractly or by depicting light or any subject in a clean, pristine style.

The new meanings that today's artists give to old imagery are highly personal. A recent exhibition of "crucifixion" art demonstrated that artists had *not* chosen the well-known image for its Christian symbolism, but to express emotions such as pain, persecution, sadism, disfigurement, torture, anguish, and man's lack of control of his surroundings.[4]

Non-Reality Worlds: Popular Culture Narratives. Fantasy worlds, an increasingly popular theme with California artists since their exposure to Surrealism, have been reborn in a new variation in the 1990s. An artist who has been recognized retrospectively as a pioneer in the current movement centered in Los Angeles is **Robert Williams** (b. 1943). Williams grew up in Albuquerque, New Mexico, reading car magazines that reproduced artwork by Von Dutch and another car-culture "original," Ed "Big Daddy" Roth (chapter 31). Pursuing his life's dream, Williams moved to Southern California with the intention of becoming an artist. He ended up working for Roth, with whom he invented much of the popular imagery later identified with Southern California of the 1950s: surfers,

souped-up cars, bikini clad "babes," promiscuous sex, and abuse of liquor. Their art depended on intentionally unattractive exaggeration, grossness, and vulgarity and promoted the "weird" and "crude."

Williams had been creating oil paintings since the late 1950s but turned to the medium in earnest in the late 1960s as modernism was collapsing and realism reentering the establishment art world (chapter 32). *Hot Rod Race* of 1976 (fig. 37-3) takes up a typical theme—Southern California's youth counterculture of the 1950s. Seen through Williams's eyes, this was a male-dominated world of hot rods and motorcycles: overtly sexual, high-school-age girls; machines of power and speed; and self-indulgent youth active in a setting of the drag strip, the speedway, the highway, and the gas station. Unlike some countercultural artists who ridiculed the establishment, Williams's humor was turned on his own social circle. His cynicism emerges in his distortions of human figures, caricatures of vulgar actions, and exaggerated sexism and eroticism. Unlike his contemporaries, the hippie artists who created ideal worlds, Williams creates a world of coarseness and vulgarity. Like the comix on which he occasionally worked, his paintings are narratives presented with energy-packed action. As his style developed, his works became more compositionally complex. The collage look and a multipoint perspective come from the use of appropriated imagery as well as from a desire to compress scenes from several time periods into one composition, a technique compared by some to the abrupt scene jumps in motion pictures. Williams also incorporates words, signage, and comic-book visual techniques such as zigzagged lines that imply explosiveness. He has been called a "garage Surrealist," his work "an exploration of the coarse underbelly of Los Angeles" and "visionary vulgarity." He brought "weird" and "gross" into the realm of fine art.

When the 1989 recession brought on the collapse of the booming art establishment, a new generation of artists who had grown up in the 1960s weaned on comic books, rock music, and television and/or associated with the Punk scene (chapter 31) were suddenly noticed and given the chance to flower. Many of these artists created fantasy worlds. Like artists of any century, they utilized the imagery and literature with which they had grown up. Many looked to Williams as an

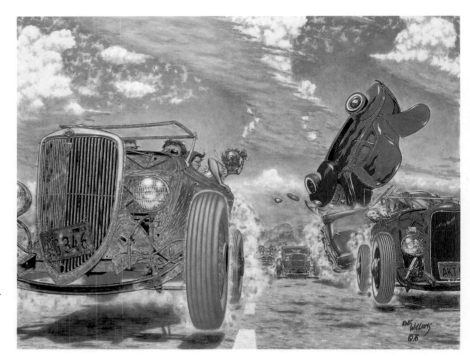

artistic guide. The center of this movement is Los Angeles, although some followers also live in Seattle, New York, and Austin (Texas), as well as Japan, Australia, and England. The trend has no manifesto; each artist has his own reasons for gravitating to a particular set of popular imagery and would probably resent being clumped into a movement. Although the trend has not been described in any mainstream art journal, the three-year-old magazine *Juxtapoz,* published in San Francisco, has featured top practitioners such as Krystyne Kryttre (b. 1958), The Pizz (b. 1958), Chris Cooper (b. 1968), and Robert Armstrong (b. 1950), to name a few.

Popular Culture Narratives have no moral or message. They are representational fantasy worlds created from a free mix of characters from comic books, figures from animated cartoons, personalities from the car and motorcycle culture, characters from TV sitcoms of the 1950s, stars from films of the 1940s and 1950s, as well as individuals from the real world's fringe societies: brothels, bars, discos, run-down areas of cities, and gambling dens. Additional important iconography comes from the punk scene, graffiti, the tattoo world, tribal cultures, and the visuals identified with various racial minorities, particularly the Chicanos. Strongly influenced by the presentation methods of popular culture, narrative is usually shown at the moment of highest energy, in comic book or motion picture fashion. Themes often entail violent encounters between real or imagined animals, between animals and men, or between humans. Often the art is marked by a kind

Fig. 37-3
Robert Williams (b. 1943)
Hot Rod Race, 1976
acrylic on board
12¾ x 16¼ in.
Private Collection; Photo courtesy Robert Williams

of vulgar tongue-in-cheek humor. Pejoratively called "illustrators" by the "idea" artists, these artists are proud of their technical abilities to render three-dimensional objects. Daily this Los Angeles-based movement is garnering new advocates, many from other parts of the world. In late 1997 the show *Masters of Lowbrow* at Ozone Gallery in New York chronicled this trend.

Other narratives based on the same pool of popular imagery but whose purpose is to convey ideas are painted by artists such as **Jim Shaw** (b. 1952). He emerged artistically in the mid 1980s with a series titled *My Mirage.* These self-investigative, autobiographical works chronicled the world of a late 1960s adolescent he called Billy, whose thoughts Shaw defined with the images with which he grew up: hot rods, music album covers, and comic books, to name a few. *Arrows* of 1991 (reproduced in *Helter Skelter: L.A. Art in the 1990s,* The Museum of Contemporary Art, Los Angeles, January 26–April 26, 1992, p. 149) comes from a series in which the artist expanded the role of narrative by creating each piece in the series in a different style. *Arrows* demonstrates many traits associated with Shaw. Its magazine size is an allusion to the mass media images with which he grew up, and its relative smallness reflects

his rebellion against the grandiose canvases produced by some establishment artists around him. Shaw fully ascribes to the postmodernist taste for appropriation and even sardonically describes himself as a vampire living off earlier art. In *Arrows,* his perverse humor is directed at the corporate world. Playing on the well-known advertising for Arrow shirts, he juxtaposes corporate stereotypes dressed in suits and ties with the individuals originally associated with the brand name, Native Americans wearing loin cloths. Humor is also revealed in the caption "Arrows—a game of corporate strategy"—which shows he equates American business to game playing. Shaw's art is packed with imagery, a quality he attributes to his horror of a vacuum, an anal retentive behavior, and a belief in "more is more." As in any conceptually oriented work of art, the complex imagery in this piece has to be read and studied for its message.

Artist Activists: Social and Political Themes. Throughout history, art has been used as a medium for social criticism, but the practice has remained minor and has been restricted primarily to popular art such as editorial cartoons. During America's Great Depression social criticism and high art merged in Social Realism (chapters 18, 19). Today, art of social and political subject matter has reentered the world of high art as the result of the popularity of idea art, an interest in humanist themes, and the large number of social, political, and environmental problems that artists' want to see rectified. Many of today's activist artists believe their art will awaken viewers to society's ills and, in turn, lessen or eradicate them. Themes fall into two broad and sometimes intermixed categories: social themes and political themes.

Social themes, in the context of this essay, include subjects such as homelessness, environmental problems, AIDS, and inner-city deterioration as well as problems associated with society's fringe groups, such as street crime, gangs, and graffiti. Receiving less press notice but nonetheless in evidence are white-collar crime, the Mafia, and government corruption. [5]

An artist whose work jars America's complacent majority into noticing the ills of today's society is **Manuel Ocampo** (b. 1965). Born in the Philippines, Ocampo grew up in a country ravaged by Spanish and American colonialism. The artist does not consider himself "political"; rather he uses political imagery as an aesthetic style. Although the way he places figures within a landscape setting might suggest a narrative reading of his scenes, his technique, instead, is to present the viewer with a barrage of symbols and meaning-laden images that together reveal his picture of today's world and lets the viewer draw his own conclusions. The look

of his paintings depends strongly on two artistic experiences of his youth: the editorial cartoons he published in his mother's newspaper in Quezon City and the facsimile works he made as a young apprentice creating "Spanish colonial folk paintings" for sale to foreign collectors. Apart from those experiences, Ocampo is largely self-taught. As in *Heridas de la Lengua* of 1991 (fig. 37-4), Spanish for "Wounds of the Tongue," most of his work can be read on two levels: the immediate emotional reaction to the presentation and imagery and the many layers of meaning that emerge once the symbols and their interrelationships are interpreted. Ocampo's background as a painter of antique Catholic subjects provides the source for much of his imagery in this work, specifically the vignette of the Madonna and child, the martyred headless figure in the center of the composition, and the *trompe l'oeil* piece of folded paper inscribed with the title. It is also exposed in the artist's intentional "antiquing," i. e., the toning of the colors and the abrading of the paint. His work reveals a strong anti-Catholic bent, but instead of moralizing, it parodies. His manufacture of an "antique" becomes a subtle stab at the official world of art history. Other iconography, which has been dredged from his subconscious as if from a surreal nightmare, includes knives, gashed bodies, floating swastikas, and crosses. Ocampo does not employ these for gratuitous violence. He believes such subject matter has lost its potency through overuse in today's society and has been rendered impotent by its proliferation in the media. Like life itself, Ocampo's work is full of contradictions: he places beauty and ugliness side by side, kitsch elements alongside high art. Although he takes a neutral stance in presenting his varied iconography, his overall excessive presentation is meant to jolt viewers into an awareness of the dangerous state of today's society.

The *environment* has become a major issue with peoples of Western European descent as they acknowledge their decades of conspicuous consumption and pollution and as they realize the potential worldwide disaster that could bring an end to the human race. Artists now address all aspects of the earth's biology from the tiny microorganisms found in water to the atmosphere of the planet. California's best-known environmental artist-activists are the husband-wife team of Helen Mayer Harrison and Newton Harrison (chapter 29). Their text and image displays, their input to commissioning government agencies, and their talks before the public are highly admired and have been fruitful in awakening residents and city governments to the potential of reshaping despoiled areas and bringing them back to nature and to "friendly" public use. But champions of the environment express their ideas

in such a variety of ways none can be called "typical." Some artists have been hired to redesign dump sites and to make facilities and equipment attractive to users. Friends of the Los Angeles River holds performances and takes photographs to inform the populace about the current state of the area's main river (which is polluted and banked by cement walls); they advocate bringing it back to a natural state in which it can be visually beautiful and used for recreation. *Materials for the Arts, L. A.* is a joint project of the Los Angeles Cultural Affairs Department and the city's Solid Waste Management Office to make discarded materials available free to artists. A number of artists make art from recycled materials and waste.[6]

Tom Jenkins (b. 1943) is one of today's few painters to address ecology. Jenkins's *View from Indian Rock* of 1990 (fig. 37-5) is typical of his grand panoramas of the Los Angeles basin. This view encompassing the city of Santa Monica and the bay southward to the Palos Verdes peninsula is representative of his later works that feature the coastal mountains; these have attracted his interest since his move from Los Angeles to neighboring Ventura County. At first glance these purposefully folk-style works appear to be straightforward landscapes, but a closer reading of the details reveals a complex narrative. Lilliputian inhabitants manning tiny, ecologically destructive earthmovers are reconfiguring valuable view property into pads for high-priced houses. Plastic tarps held down by sandbags protect denuded slopes from potential erosion in a rainstorm. The rock in the foreground bears Chumash pictographs (chapter 18), the artist's comment on capitalism's lack of respect for ancient monuments as well as his

Opposite:
Fig. 37-4
Manuel Ocampo (b. 1965)
Heridas de la Lengua, 1991
oil on canvas, 71 x 61 in.
Collection Tony Shafrazi,
New York

Below:
Fig. 37-5
Thomas W. Jenkins (b. 1943)
View from Indian Rock, 1990
oil on metal, 48 x 72 in.
Courtesy of the artist

reference to earlier, less destructive inhabitants. In other of Jenkins's works, L. A.'s carpet of suburban housing is crisscrossed by freeways, clogged by autos, and overhung with toxic fumes. Jenkins points out the paradox of contemporary society—the desire for progress and the respect for individual enterprise conflicting with the need for a clean and healthful environment. He emphasizes the irony of the situation by using sweet, seductive colors. Ecological disaster hides in paradise like a piece of poisoned candy.

AIDS, the deadly, rapidly spreading auto immune deficiency syndrome for which there is currently no cure is a major concern to all strata of society. AIDS-related activity in California has been widespread and varied. AIDS-related art began to be exhibited in the state in the mid 1980s. Early works were meant to educate about the dangers of the disease, to chastise the American government for not doing enough to halt the infection, and to accuse drug companies of profiteering. AIDS art informed the public about the spread of the disease and raised money for research and healthcare for those stricken.

Today, at the end of the century, artists from all walks of life are addressing the theme and in a variety of ways. California observes the annual AIDS Awareness Day, alternately called "A Day Without Art," a national symbolic acknowledgment of the disease, first held on December 1, 1989. In San Francisco the group Visual Aid provides grants to infected artists so that they can continue to create. Powers of Desire, eight art-world related people based in Los Angeles, puts on informative displays. Lawyers are advising AIDS patients on estate planning, making certain artists' art and archives are preserved according to their wishes.

Most AIDS-related art is in the form of photographs, site installations, text-and-image displays, and performance. The AIDS quilt originated in California. Within painting, a favorite theme is portraiture or self-portraiture. Many sick artists use their art for self-investigation, to document their emotions and thoughts as the disease takes over their bodies. Following the trends of the times, much of AIDS art is searingly political and expresses personal anger; sometimes it takes the form of a meditation on death.

Art infused with *political* messages has remained minor in California as compared to the traditionally socialist/Marxist New York. Most of California's political art has been produced in Northern California and ranges from Social Realist art produced in the Depression, to Beat art of the 1950s, and art generated during the 1960s Civil Rights Revolution. Traditionally, political art has led an uneasy existence with the fine arts community, which considers it propaganda and permeated with controversial and topical content. The 1990s are notable for activist art, and political art takes two general forms: art that advocates a positive stance toward an issue and art that condemns events that have passed or are occurring at the time of the painting.

While America is currently experiencing no catastrophic political events on its own soil, politically minded artists regard as fair game any United States political activity in any part of the world. Political themes can be general, such as arms control or criticism of the capitalist system, Fascism, and Neo-Nazism. Such art can unmask politicians (who are seen as two-faced and self-serving, possibly receiving kickbacks) and expose the CIA (which is regarded as secretive and suspicious). It can also address social problems such as abortion, AIDS, illegal drugs, inequality for racial minorities, and activities of radical groups such as the Ku Klux Klan. The average man is frequently portrayed as a victim of some malevolent power such as a political system, a government, or a military faction. The victim suffers violation of his human rights through persecution or oppression, specifically through interrogations, torture, mutilation, bondage, sadism, and murder. Or themes can be specific, such as Yankee intervention in El Salvador and Nicaragua, the Rodney King beating in Los Angeles, Native American and Latino reaction to the 500th anniversary of the landing of Columbus, or the internment of Japanese Americans during World War II, to name a few.

One of the major themes from the early 1960s to the present has been the Vietnam War, in which tens of thousands of Americans fought between about 1965 and complete withdrawal in 1973. War art produced at the time of the Vietnam conflict usually opposed America's involvement. Subsequent art is primarily made by veterans, who address abstract concepts such as the toll that warfare exerts on soldiers and their families, the role of the mass media in war, and soldiers' personal memories.

One of California's best known artists to take on political subject matter is **Robbie Conal** (b. 1941). The child of New York union activists, Conal trained as an Abstract Expressionist. He turned to political subject matter after a trip to Rome exposed him to the figures in Michaelangelo's *Last Judgement* and after Ronald Reagan assumed the presidency. Since the mid 1980s, starting with his *Men with No Lips*, Conal has worked in series. These include the *Dis* series about the Rodney King beating, and the *Gag Me* suite covering the Supreme Court justices who upheld the gag rule on abortion. Most of Conal's paintings take the format of posters, into which they are eventually turned for display throughout the country. (It is important to Conal that his art escape the confines of galleries and the art world.) Posters have established graphic conventions, including simple presentation of text and image for maximum impact and immediate communication of ideas. The technique of appropriation has been a boon to contemporary political artists, allowing them to reuse an image with an understood meaning or to juxtapose two images to arrive at a simple, quickly understood statement. Conal, in his recent series of "deconstructive" portraits of political figures, uses caricature, the traditional technique that employs satire and humor to subvert the power of political figures. In a typical work such as *Petey Mouse* of 1996 (fig. 37-6), showing Governor Pete Wilson wearing Mouseketeer ears against a background of computer-generated happy faces, Conal begins with a black-and-white photograph obtained from a wire service and develops a painterly portrait set against a background of popular imagery. Conal calls works of this kind "adversarial" portraiture (as opposed to "aggrandizing" portraiture). He wants to show how the impulse that drives men to absolute power has changed them as human beings. In this work Conal restricted his colors to black and white to reference what he sees as the old-fashioned nature of Wilson's beliefs, which have retarded California's educational system. Many political activist artists hope their art will cause viewers to acknowledge political situations and to correct them. In Conal's own words, "My real goal is to tickle regular people on the street into thinking along with me about public issues that I think are important."

Fig. 37-6
Robbie Conal (b. 1941)
Petey Mouse, March 1996
oil painting on computer generated photograph
60 x 38 in.
Courtesy of Koplin Gallery, Los Angeles
Photo: Alan Shaffer

Psychological Malaise

Theoretically, human fears about the ends of centuries or millennia evoke dark emotions such as depression and anxiety. The psychological malaise and discontent that has been growing since World War II, that was exposed in Expressive Figuration (chapter 36), and that pervades the art world today, has been rechristened by writers in the 1990s as an End-of-Century phenomenon. (The 1992 *Helter Skelter* exhibition at the Museum of Contemporary Art in Los Angeles is one of several recent shows and articles noting the existence and growth of pessimism in art.) The phenomenon is well-enough understood that historians have codified it. The Dutch sociologist Fred Polak defines five ways humans perceive their situation at the ends of millennia: Nonsensical (human life as disintegrated), Existential (humans as isolated), Perverse (enjoyable portrayal of the morbid, ugly, or obscene), Demonic (forces of darkness and evil), and Negative (apocalyptic, chaos) (*The Image of the Future*, New York: Elsevier Scientific Publ., 1973). Most of the art discussed in this chapter fits into one or another of those categories.

The artist whose work best demonstrates the end-of-century malaise is **Llyn Foulkes** (b. 1934), who has been a major figure in the Los Angeles art scene from the early 1960s. After experimenting with several very

Fig. 37-7
Llyn Foulkes (b. 1934)
Rape of the Angels, 1991
mixed media, 60 x 104 in.
Teri and John Kennady

different themes, he seems to have found his voice in his current social commentary. In *Rape of the Angels* of 1991(fig. 37-7) he sets up a two-part scene. To the left is the interior of the LALA Land Company. "LALA land" is both a slang term for Los Angeles and a reference to the habitat of a person not mentally grounded in reality. The "Land Company" refers to the business of Los Angeles real estate, in which many people have and are still making fortunes. Foulkes often partially obscures faces or fronts them with masks to make his figures enigmatic. Here, the facial features of this servant of the populace—a fist clutching money—symbolize the thoughts going through his head as he studies a map, ostensibly to objectively determine the location of further development. The skyline of sky-scrapers references the "revitalization" of downtown Los Angeles that took place in the 1980s and turned it into a corporate center. To the right is a self-portrait of the artist expressing his opinion of this change. Foulkes's recent works show people leading outwardly banal lives but inwardly feeling lonely, alienated from, and possibly resentful of their society. Foulkes's char-acters are jaded, worn down by interpersonal estrange-ment and private failure. It was only in the 1990s, after the art world turned back to figuration and toward introspective subject matter, that Foulkes's personal tastes for Surrealism and Hollywood films coincided with the mainstream. Like others of the 1990s, he appropriates compositional devices from popular art—the comic-book device of "balloons" to hold people's

thoughts, the conceptual use of wording, and dark humor. The Mickey Mouse figure, singing "Sue city Sue" in this work, is frequently employed by the artist, for whom it serves as a metaphor for the trivialization of American life and values.

Apocalyptic visions come in many guises, usually landscapes showing mass destruction. For such com-positions California can provide a plentiful supply of imagery including the state's fall wildfires, its intense rains, its earthquakes, and its race riots. Among the earliest artists to treat this theme were the members of Los Angeles's Fine Arts Squad, photorealist mural-ists of the 1970s, whose *Isle of California* (fig. 32-11) shows a broken freeway overpass ostensibly severed by an earthquake. Apoclyptic visions mixed with humor are created by some Popular Culture Narrative artists above. And visions with religious overtones are cre-ated by Neo-Spiritualists.[7]

In spite of the downbeat tone evinced by some end-of-the-century paintings, most Californians are *not* wringing their hands with despair but are leading gen-erally normal and happy lives. Their buoyant attitudes will no doubt result in more end-of-the-century cel-ebratory parties than suicides. In fact, the millennial change is having many positive repercussions in the art community. It is serving as a prompt for Califor-nia institutions to put on exhibitions and programs surveying California's achievements in history, culture, and science and for publishers to produce books about

California (chapter 38). Already we are seeing signs of an artistic backlash to today's idea art and violence. Exhibitions are being mounted on beauty in art, on art that can be appreciated from a visceral level apart from ideas, and art that advocates peace rather than violence. [8]

At this point it might be appropriate to summarize what makes California art different from that produced in other American states, or to point out how the state's artists have made sound contributions to American art in general, and to boast of their innovations. However, this author hopes those points have been made in the text and feels they would be redundant here. Art is an ongoing process, and summaries can be only temporary. Even now, this book's next chapter is being written, and in imaginative ways that none of us can prophecy. ❧

[1] Exhibitions of art about personal identity for which catalogues, if any, were not readily found: *Portraits* at L.A. Municipal Arts Gallery, 1979; *Persona—Contemporary Portraiture* at Mills House, Garden Grove, 1979; *Inside Out-Self Portraits by Bay Area Artists* at Ames Gallery, Berkeley, 1979; *Portrait/Self-Portrait* at Artspace, 1987; *Recent Portraits* at Tatistcheff, Santa Monica, 1989; and *In Their Own Image* [self-portraiture], San Jose Institute of Contemporary Art, 1991.

[2] Exhibitions of art on female themes for which catalogues, if any, were not readily found: *Liberty and Justice for All* at Orange County Center for Contemporary Art, Santa Ana, 1981; *Women's Images* at Santa Ana College Art Gallery, 1983; *Exchange of Sources: Expanding Powers* at Art Gallery, California State College, Stanislaus, 1983; *Generations* [women and families] at Conejo Valley Museum, 1983; *Visual Conversations* at SPARC, Venice, 1983; *Small Shrines* at Thinking Eye Gallery, L.A., 1986; *Connected by Nature* at Pro Arts, Oakland, 1986; *Personal Histories* at Through the Flower, Benecia, 1988; *Family Album* at Woman's Building, 1988; *Lingua Franca* [feminist] at Falkirk Cultural Center, 1991; *Connections* [Latino and Chicano] at Center for the Arts, Yerba Buena, 1991; *Erotic Drawings* [20 Bay Area artists] at Artspace, L.A., 1991; *Childhood Revisited* [autobiography] at Rena Bransten Gallery, S. F., 1992; *Women Self Images* at Gallery Arcade, Oakland, 1992; *Memories, Milestones & Miracles* [breast cancer] at Bowers Museum, Santa Ana, 1993; *Just Take This: Women/Pain/Medical Histories* at Side Street Project, Santa Monica, 1994; *Altered Egos* [identity] at Santa

Monica Museum of Art, 1994; *Home Show II* at Santa Barbara, 1996; *Veiled Memories* at San Francisco Art Commission Gallery, 1996; *Measured Movement: The Art of Labor* [feminist] at San Jose State University, 1996; *Beyond the Shadow: California Artists who have Survived Breast Cancer* at Alta Bates Medical Center, Berkeley, 1997).

[3] Exhibitions of art by racial groups for which catalogues, if any, were not readily found: *The Jewish Experience in Prints and Drawings* at Judah L. Magnes Memorial Museum, 1984; *The Power of the Image* [Hispanic figure] at William Grant Still Community Center, 1989; *Acknowledging our Host: Communal Sources* [Native Americans] at Richmond Art Center, 1992; *Burning Desire: Art of the Spray Can* at Mexican Museum, San Francisco, 1991; *Indigenous Peoples: No Boundaries* [Chicano and Native American] at Art Galleries in San Francisco, 1992; *East is East* [Asian American] at John Pence Gallery, S. F., 1992; *Unification: Cultures in Collision* at FHP Hippodrome, Long Beach, 1993; *Utopian Dialogues* [black/ Rodney King] at Los Angeles Municipal Art Gallery, 1993; *Reshaping LA/The Search for Inclusion/In Praise of Diversity* at Angels Gate Cultural Center and L. A. Harbor College, 1993; *The Mystical in Art: Chicano/Latino Painting* at Carnegie Art Museum, Oxnard, 1994; *Double Vision: Works by Bay Area Vietnamese Artists* at San Francisco Art Commission Gallery, 1996; *New Works/First People* [Native American] at Solomon Dubnik Gallery, 1996.

[4] Exhibitions of spiritual themes for which catalogues, if any, were not readily found: *Metaphysics and Symbolism* at Orange County Center for Contemporary Art, Santa Ana, 1984; *Art as Religion* at Richard Bennett Gallery, 1989.

[5] Exhibitions of social/political themes for which catalogues, if any, were not readily found: *Artist as Social Critic* at L.A. Municipal Arts Gallery, 1979; *Social Works* at Los Angeles Institute of Contemporary Art, 1979; *Location/Dislocation* [urban views] at Berkeley Art Center, 1980; *Los Angeles/New York: Urban Activist Art* at Social and Public Art Resource Center, Venice, 1982; *American Dream: Mediated* at Los Angeles Contemporary Exhibitions, 1982; *Art and Social Issues* symposium at Santa Ana College Art Gallery, 1984; *Crime and Punishment* [American] at Triton, Santa Clara, 1984; *Agit/Prop* [6 political artists] at Otis/Parsons, Los Angeles, 1988; *Bridges: Artists Respond to Disaster* [Oct. 17, 1989 earthquake] at Berkeley Art Center, 1990; *Themes: Social and Political* [7 LA artists] at Mount Saint Mary's College, 1991; *Addictions* [drugs, gambling, drink] at Santa Barbara Contemporary Arts Forum, 1991; *Concrete Issues and Barbed Wire* [urban living] at Occidental College, 1994.

[6] Exhibitions on the environment for which catalogues, if any, were not readily found: *Fragile Ecologies* at Laguna Art Museum, 1994; *Natural Phenomena: Exploring the Forces*

of Nature at Bedford Gallery, 1996; *Refound* [recycled] at San Francisco Museum of Modern Art rental gallery, 1996; *Discarded Object—Refound Image* at San Francisco Art Commission Gallery, 1984.

[7] Exhibitions on end-of-century malaise for which catalogues, if any, were not readily found: *Anxious Interiors* at Laguna Art Museum, 1984; *In Out of the Cold: The End of the Cold War, Dislocation, Diaspora, and Identity* at Center for the Arts at Yerba Buena, 1993.

[8] Exhibitions about positive things for which catalogues, if any, were not readily found: *Embarrassment of Riches* at Huntington Beach Art Center, 1996; *Exalting the Visceral* [as opposed to idea] at Fahey/Klein, Los Angeles, 1990.

Bibliography

Art, General, 1990s

Greenstein, M. A., "Culture in Crisis: On Interdisciplinary Art Today," *Artweek*, v. 24, October 21, 1993, pp. 12–14.

Most Art Sucks: Coagula Art Journal and the Art of the 1990s, Santa Monica, Ca.: Smart Art Press, 1998. 200 p.

Recession of 1989–1996, Infrastructure

"California: Into the '90s," [7 article anthology] *Art News*, v. 88, December 1989, pp. 99–100, 105–6, 190–10, 113–14, 120–27.

"California Pumping Up," [4 article anthology] *Art News*, v. 89, December 1990, pp. 112–35.

Clifton, Leigh Ann, "Funding Wars," [California Confederation of the Arts] *Artweek*, v. 23, pt. 24, September 17, 1992, p. 4.

Clifton, Leigh Ann, "Still Caught in the Crunch: The CAC Ponders Privatization," *Artweek*, v. 24, March 4, 1993, p. 22.

Cushing, Linda, "The Shakedown Part I," [Santa Monica Art Scene], *Artweek*, v. 25, no. 15, August 4, 1994, p. 21 and "The Shakedown, Part II," *Artweek*, v. 25, no. 16, August 18, 1994, p. 14.

Darling, Michael, "Thinned-out, Pared-down, Rescaled: The Opening of the Santa Monica/Venice Art Dealers Association Fall Season," *Artweek*, v. 24, no. 19, October 7, 1993, p. 12.

Geer, Suvan, "Lean and Mean: the Survival of the [LA] Artist in the Nineties," *Artweek*, v. 24, no. 24, December 16, 1993, pp. 12–13.

Kelley, Jeff, "NEA Cuts—Thoughts on the Shift from Public to Private Patronage," *Artweek*, v. 12, no. 23, July 4, 1981, p. 3.

Kelley, Jeff, "Epitaph—Thoughts on the Shift from Public to Private Patronage, Year 2," *Artweek*, v. 13, September 25, 1982, pp. 12–13.

Martin, Victoria, "Sound Like a Plan?" [L. A. arts funding master plan], *Artweek*, v. 22, February 7, 1991, p. 1.

McMaster, Carolyn, "Art in a Diminished Economy: Foundations Expand Art Funding," *Artweek*, v. 23, February 13, 1992, pp. 9, 16.

"Money," [5 articles on cutting of arts funding and the formation of private arts groups] *Artweek*, v. 26, no. 4, April 1995, pp. 14–18, 19–20.

Nixon, Bruce, "The Cost of Creating an Arts Capital," [Calif. Arts Council], *Artweek*, v. 21, September 6, 1990, pp. 21–3.

Support for the Arts in Unsupportive Times: Summary of a Workshop [in Los Angeles] (sponsored by Frederick R. Weisman Art Foundation), December 4–5, 1990. 50 p.

Tanner, Marcia, "Recessionary Measures: Hard Times for Non Profit Spaces," *Artweek*, v. 24, no. 1, January 7, 1993, pp. 15–16.

Art Criticism

"Artweek Focus: Who Determines What is Art?," *Artweek*, v. 21, no. 37, November 8, 1990, pp. 21–23.

Van Proyen, Mark, "Partisanship and Publicity: The Abnegation of Critical Judgment," *Artweek*, October 25, 1990, pp. 3+.*

Wilson, Malin, *Last Chance for Eden: Selected Art Criticism by Christopher Knight 1979–1994*, Los Angeles: Art Issues Press, 1995.

Public Art

The Art in Public Buildings Report, Sacramento, Ca.: Office of the State Architect, Department of General Services, State of California, July 1978. 49 p.

Art in the Public Eye, Los Angeles: Security Pacific National Bank, 1981. 56 p.

Art in the Public Eye: Selected Developments, Costa Mesa, Ca.: Security Pacific Gallery, 1989. 48 p.

Art in San Francisco Redevelopment Areas, San Francisco: Redevelopment Agency, 1979. 36 p.

"Art on Water: A Public Art Renaissance Brings Diverse Creations to Waterfronts," *California Waterfront Age,* v. 3, no. 3, Summer 1987, pp. 20–29.

"Artweek Focus: Public Art: A Genre in Flux," *Artweek,* v. 21, no. 1, January 11, 1990, pp. 19–22, 24–25.

Barnes, William L., "Art Integration: an Essential Design Component and Vehicle for Community Commitment in Santa Clara County" in *Seventh National Conference on Light Rail Transit,* v. 1, Washington, D. C.: National Academy Press, 1995, pp. 87–95.

Boettger, Suzaan, "Art in Search of a Public," [SF public sculpture] *LAICA Journal,* no. 35, Winter 1983, pp. 49–53.

Boettger, Suzaan, "Civic Art and City Politics," *Artweek,* v. 13, no. 3, January 23, 1982, p. 3.

Budhos, Marina T., *Neighborhood Rhythms, 20 Years of the San Francisco Neighborhood Arts Program,* San Francisco: Arts Commission of San Francisco, 1987. 35 p.

California, Office of the State Architect, *The Art in Public Buildings Report,* Sacramento, Ca.: The Office, July 1978. 49 p.

Chattopadhyay, Collette, "Public Art: Recent Work in Downtown L. A.," and David diMichele, "New Public Art Projects in Long Beach," *Artweek,* v. 25, February 3, 1994, pp. 13–14.

City of Palm Desert Art in Public Places Program Manual, Palm Desert, Ca.: The City, 1990. 12 p.

Cleigh, Zenia, "The Vista Experiment," [public art] *San Diego Magazine,* v. 31, no. 3, January 1979, pp. 136–39+.

Clifton, Leigh Ann, "A Day in the Park: Arts Groups Eye the Presidio," *Artweek,* v. 24, January 21, 1993, p. 25.

Clifton, Leigh Ann, "Ridin' that Train," [LA Metro Rail art], *Artweek,* v. 23, pt. 29, December 3, 1992, p. 25.

Community Redevelopment Agency of the City of Los Angeles, *Public Art in Downtown Los Angeles,* Los Angeles: The City, 1986. 118 p.

Evans, Robin C., "Art for Business' Sake," *San Francisco Business,* v. 24, no. 8, August 1989, pp. 9–11.

Ferguson, Janene Ann, *The Mind, Heart, and Soul of Los Angeles: Discovering the Public Art of Downtown Through Walking Tours,* M. A. Thesis, University of Southern California, 1995. 67 p.

Field, Jean, "Art for Oakland's Sake," *The San Francisco Bay Guardian,* v. 23, no. 20, February 22, 1989, pp. 17, 20.

A Guide to East Bay Public Art, Alameda County Neighborhood Arts Program, 1979.

Hayden, Dolores, *The Power of Place: Urban Landscapes as Public History,* [public art in LA] Cambridge, Ma.: MIT Press, 1995. 296 p.

Hobson, Carol, *San Diego Unified Port District Public Art Master Plan,* San Diego, Ca.: Port of San Diego Unified Port District, 1991. 32 p.

"Issues in Public Art," [6 article special section: Metro rail art, neighborhood programs, libraries, S. F. Art Commission] *Artweek,* v. 27, no. 5, May 1996, pp. 12–19.

Jan, Alfred, "New Image for Public Art: In the Public Eye at De Anza College," *Artweek,* v. 21, November 22, 1990, pp. 12–13.

Katz, Bernard S., *Fountains of San Francisco,* Lagunitas, Ca.: Lexikos, 1989. 139 p.

Knight, Christopher, "Downtown Public Art," [series of articles in *Los Angeles Herald Examiner,* August 28–31, 1983]. 12 p.

Koros, Thomas Peter, *Public Art in Corporate Downtown Los Angeles,* M. A. Thesis, University of Southern California, 1995. 45 p.

Landres, Jonathan Shawn, *Public Art as Sacred Space: Toward an Interpretive Theory of Asian-American Community Murals in Los Angeles,* Ph. D. Dissertation, University of California, Santa Barbara, 1995. 53 l.

Linebarger, Charles, *Lost Art* [1974 Public Sculpture Exhibit in Oakland] *Express* (Berkeley), v. 7, no. 18, February 15, 1985, pp. 1, 13–15.

Lopez, Elizabeth Christine, *Community Arts Organizations in Los Angeles: A Study of the Social and Public Art Resource Center, Visual Communications and the Watts Towers Art Center,* M. A. Thesis, University of California, Los Angeles, 1995. 69 l.

Los Angeles Task Force on the Arts Report, Los Angeles: The City, 1988. 85 p.

Los Angeles Visual Arts, Los Angeles: Modernage, 1982. [LAVA Festival held September 11 & 12, 1982 at the Japanese-American Cultural and Community Center]

Market Street Art in Transit Master Plan, San Francisco, Ca.: The Arts Commission, 1991.

Nodal, Adolfo, "Art in Public Places," [MacArthur Park program] *LAICA Journal,* v. 6, Winter 1987, pp. 43–49.

Nodal, Adolfo V., *How the Arts Made a Difference, the MacArthur Park Public Art Program,* Los Angeles: Hennessey & Ingalls, 1989. 151 p.

O'Brien, John, "Taking to the Streets: Sushi Gallery exhibit of Public Art in San Diego," *Artweek,* v. 21, March 29, 1990, p. 18.*

Otis Art Institute of Parsons School of Design, *Los Angeles, MacArthur Park Public Art Program Phases I–IV,* Los Angeles: Otis, 1984. 71 p.

Out of the Shadows: SPARC/ Cal Arts Bridge Project, exh. cat., Social and Public Art Resource Center, Venice, Ca., July 13–August 28, 1992. 23 p.

Public Art in Downtown Los Angeles, Los Angeles, Ca.: The City (Community Redevelopment Agency of the City of Los Angeles), 1986.

Public Art Reference Manual/California Arts Council, Sacramento, Ca.: California Arts Council, 1995. [Government Document A 1281 P823] 212 p.

Public Sculpture/Urban Environment, exh. cat., Oakland Museum, September 29–December 29, 1974. 71 p.

Robertson, David, *Context and Collaboration for Contemporary Art: The Sculptural Program for 580 California Street* [S.F.], exh. cat., Dickinson College, May 7–September 12, 1986.

Roder, Sylvie, "Sculpture in the Landscape, Maquettes in the Gallery," [rev. of *Sculpture in Public Spaces* at Twin Pines Cultural Center, Belmont] *Artweek,* v. 11, November 8, 1980, p. 13.

San Francisco Civic Art Collection: A Guided Tour to Publicly Owned Art of the City and County of San Francisco, San Francisco, Ca.: The Arts Commission, 1989. 151 p.

Scott, Mel, *Partnership in the Arts; Public and Private Support of Cultural Activities in the San Francisco Bay Area,* (Institute of Governmental Studies), Berkeley: University of California Press, 1963. 55 p.

Several, Michael, *Little Tokyo* [LA] *(The Public Art of Los Angeles, Pt. 2),* Los Angeles: n. p., 1994. 48 p.

Solnit, Rebecca, "A New Place for Art: Art as Place—Part I," *Artweek,* v. 18, September 5, 1987, p. 21, and "Part II," *Artweek,* v. 18, October 17, 1987, p. 11.

Solnit, Rebecca, "Public Art Works: Bringing the Mountains to Mohammed," *Artweek,* v. 20, September 9, 1989, p. 7.

Thymos: Preludes to Interdependence [Part of a project of the Museum Without Walls funded by National Endowment for the Arts to weave art and community life together] Santa Cruz, Ca.: Thymos, 1975. 126 p.

Urban Sculpture, Architectural Concerns, exh. cat., Gallery at the Plaza, Security Pacific National Bank, September 9, 1983–January 4, 1984. 40 p.

Voice of Citizenry: Artists and Communities in Collaboration: 112th Annual Exhibition, San Francisco Art Institute, exh. cat., San Francisco Art Institute, August 26 - September 25, 1993. 32 p.

Watten, Barrett, "Social Service: The Days of Our Lives by Margaret Crane and Jon Winet," *Artweek,* v. 24, July 22, 1993, p. 13.

Webster, Mary Hull, "The Public Soul: A Sense of Place: Public Art Projects & Proposals, Richmond Art Center," *Artweek,* v. 24, March 4, 1993, p. 4.

Woodbridge, Sally Byrne, *San Francisco Architecture: the Illustrated Guide to over 1000 of the Best Buildings, Parks, and Public Artworks in the Bay Area,* San Francisco: Chronicle Books, 1992. 264 p.

(See also Sculpture Gardens in Chapter 27.)

Art Education

Abrahamson, Joan and Sally B. Woodbridge, *The Alvarado School Community Art Program,* San Francisco: Alvarado School Workshop, Inc., 1973. 104 p.

"Art Education," [6 articles on: two programs "Information Arts" and "Conceptual Design" the first computer arts program in the Bay Area at San Francisco State University] *Artweek,* v. 26, no. 3, March 1995, pp. 14–28.

"Art Education," [5 articles and list of art schools] *Artweek,* v. 27, no. 3, March 1996, pp. 12–26.

"Artweek Focus: Art Education," [7 articles] *Artweek,* v. 25, no. 9, May 5, 1994, pp. 13–25.

California. Art Framework Subcommittee, Art Education Framework for California Public Schools, Kindergarten through Grade Twelve, Sacramento: Office of State Printing, 1971. 52 p.

Capet, Mitjl, *An Exploratory Study of Teaching Visual Arts Grades One Through Eight,* Thesis Ed.D., University of California at Los Angeles, 1986. 389 l.

Discovery 73: California Youth in Art: An Exhibition by California High School Students, exh. cat., California Arts Commission in cooperation with the California Art Education Association and the Alliance of California Arts Councils, May 1973. 32 p.

Education in Art: Future Building [proceedings of a National Invitational Conference sponsored by the Getty Center for Education in the Arts, Los Angeles, February 2–4, 1989], Los Angeles, Ca.: The Getty Center for Education in the Arts, 1989.

Goldsworthy, Philoma, *Types of Services Rendered by Supervisors in Art Education in the Elementary Schools of California,* M.A. Thesis, Stanford University, 1948. 174 l.

Hayman, Darcy S., *A Survey of Repositories in the Los Angeles Area and Their Potential Contribution to the Teacher of Art in the Secondary Schools of the Los Angeles City School System,* M. A. Thesis, University of California, Los Angeles, 1953. 81 l.

Jepson, Andrea I., *The Alvarado Experience: Ten Years of a School-Community Art Program,* San Francisco: Alvarado School Workshop, 1978. 76 p.

Lowe, Margaret Irene, *A Study of the Art Program in the Secondary Schools of the Santa Barbara High School District in order to determine its Strengths and Weaknesses as a Preliminary Survey for a California State Guide,* Provo: Brigham Young University, 1968. 80 l.

McMaster, Carolyn, "Border Crossing: Towards a Culturally Inclusive Arts Education at SFAI," *Artweek,* v. 22, October 24, 1991, pp. 9–10.

Melendrez, D'liese Marie, *Realizing the Dream: A Case Study of California Arts High Schools,* Ed.D, University of La Verne, Ca., 1991.

Merchant, Carolyn A., *The California Primary Prevention Project: A Therapeutic Art and Play Program for Children Grades K-3 with Early or At Risk of School Adjustment Problems and its Proposed Implementation at Nesbit School, Belmont, Ca.,* M.A. Thesis, College of Notre Dame, Belmont, Ca., 1987. 70 p.

Nathan, Natasha, *Grant Proposal for an Art Therapy Program at Sunnybrae Elementary School in San Mateo, California,* M. A. Thesis, College of Notre Dame, Belmont, Ca., 1995. 37 p.

The 1986 Invitation to Submit for Adoption in California Basic Instructional Materials in the Area of Mathematics and Special Adoption (Four Years) in the Area of Art, Sacramento: California State Board of Education, California State Department of Education, 1985. 1 v.

Pomona, Ca., City Schools, *Suggestions for Art Instruction,* Pomona? 1941? 39+ l.

Promising Programs in Art Education for California Public Schools, Bureau of Publications, California State Department of Education, Sacramento: The Department, 1976. 32 p.

Randall, Lucretia Tenney, *A Survey of Art Appreciation in the Los Angeles City Schools,* M. A. Thesis, University of California, Los Angeles, 1965. 109 l.

Richard, Olga M., *Art Education in Los Angeles Elementary Schools: an Investigation,* M. A. Thesis, University of California at Los Angeles, 1957. 128 l.

A Suggestive Course of Study in Industrial Art for Rural Schools, submitted by the Division of Rural Education, Sacramento: California State Printing Office, 1928. 62 p.

Tanner, Marcia, "Auspicious Entries: Artists who Collaborate with Youth," *Artweek,* v. 23, May 21, 1992, p. 24–25.

Virshup, Evelyn, ed., *California Art Therapy Trends,* Chicago: Magnolia Street Publishers, 1993. 431 p.

Visual and Performing Arts Framework for California Public Schools: Kindergarten Through Grade Twelve, Sacramento, Ca.: California State Department of Education, 1989. 167 p.

(See also publications by California Legislature, Joint Committee on the Arts and by California School Supervisors Association, Professional Committee on Art Education, found in any public library.)

Artist Collaborations

Blumberg, Mark, "The Joy of Joint Authorship: Artists who Work in Pairs," *Artweek,* v. 23, May 7, 1992, pp. 18-19.

Cohn, Terri, "Some Collaborations," *Artweek,* May 1995, p. 37.*

Painters, 1990s, General, California

Art Press (France), no. 184, October 1993, pp. 29–31.

"Artweek Focus: Cast into the Marketplace," [recent MFA shows in LA and the Bay Area], *Artweek,* v. 22, no.23, July 4, 1991, pp. 14–16.

"Artweek Focus: State of Painting Today," *Artweek,* v. 22, no. 32, October 3, 1991, pp. 1, 11–16, 24.

Cutajar, Mario, "A Painter's Blues," *Artweek,* v. 23, January 9, 1992, p. 11.

Facing the Finish: Some Recent California Art, exh. cat., initiated and principally supported by Fellows of Contemporary Art, Los Angeles and held at San Francisco Museum of Modern Art, and two other California museums in 1991 and 1992. 62 p.

5 Artistas de California = 5 California Artists, exh. cat., Museo de la Acuarela Mexicana, August 1992 or 93. 32 p.

Frank, Peter, "Blickpunkt Westcoast," *Kunstforum International* (Germany), no. 119, 1992, pp. 175–78.

From the Studio: Recent Painting and Sculpture by 20 California Artists, exh. cat., Oakland Museum, June 27–September 20, 1992. 32 p.

Individual Realities in the California Art Scene, exh. cat., Sezon Museum of Art, Tokyo, May 11–June 10, 1991.

LaPalma, Marina, "Conjunction of Affinities," [rev. of exh. *Kindred Spirits,* LA Municipal Art Gallery] *Artweek,* v. 17, May 17, 1986, p. 1.

New Work: A New Generation, exh. cat., San Francisco Museum of Modern Art, February 22–April 22, 1990. 22 p.

"Painting," [5 articles] *Artweek,* September 1995, pp. 13–21.

Painting: Works on Paper:1992 WESTAF/NEA Regional Visual Arts Fellowship Recipients, Santa Fe, N. M.: WESTAF (Western States Art Federation), 1992. 54 p.

Pincus, Robert L., *Art Reviews and Commentaries...snipped from the San Diego Union: A Scrapbook,* compiled by Wendell C. Thomas, Denver, 1993.

Rapko, John, "At the End of Art: Why Painting—Part II," [exh. at Susan Cummins Gallery] *Artweek,* v. 23, May 21, 1992, p. 30.

Stein, Donna, *Between Reality and Abstraction: California Art at the End of the Century* [Duker Collection], Los Angeles: Hillcrest Foundation, 1995.

Van Proyen, Mark, "The New Pusillanimity: California Art and the Post-Regional Climate," *Art Criticism,* v. 8, no. 1, 1993, pp. 81–96.

Painters, 1990s, General, Southern California

Absolut L. A. International Biennial Art Invitational, organized by Santa Monica/Venice Art Dealers Association in cooperation with galleries throughout Los Angeles, Summer 1995. [annual repeated in 1996 and 1997]

Breakdown: Michael Grey, ...Levine, ...McBride, ...Pardo, exh. cat., Museum of Contemporary Art, San Diego, April 15–June 23, 1994. 39 p.

California in Three Dimensions, exh. cat., California Center for the Arts Museum, Escondido, Ca., May 21–August 25, 1995. 44 p.

Duncan, Michael, "L. A. Rising: Guide to L. A.'s Grass-Roots Art Scene," [innovative artists] *Art in America,* v. 82, pt. 12, December 1994, pp. 72–83.

Duncan, Michael, "Report from Los Angeles: LAX Lifts Off," *Art in America,* v. 81, no. 4, April 1993, pp. 50-55.

Duncan, Michael, "Straddling the Great Divide [inSITE 94]," *Art in America,* v. 83, no. 3, March 1995, p. 51. [San Diego-Tiajuana border]

Gilbert-Rolfe, Jeremy, "Slaves of L. A.; and Others: Young L. A. Artists," *Artspace,* v. 15, Summer 1991, pp. 73–79.

Inner Natures: Four Contemporary [Santa Barbara] Painters, exh. cat., Santa Barbara Museum of Art, November 23, 1990–February 10, 1991. 40 p.

Jamrozik, Wanda, "Celebrities Hit the Galleries," *Art and Text* (Australia), no. 37, September 1990, pp. 27–29 [in LA].

L A Times: 11 Los Angeles Artists, exh. cat., Boise Art Museum, Boise, Id., August 31–October 27, 1991 and one other venue. 1 v.

LAX/94: The Los Angeles Exhibition [exhibitions of contemporary art at 10 LA sites organized by Los Angeles Municipal Art Gallery], c. November 1994–January 1995. 164 p.

LAX/92: The Los Angeles Exhibition, [exhibitions of contemporary art at 8 LA sites] c. November 1992 through February 1993.

Mapping Histories: Third Newport Biennial [installations], exh. cat., Newport Harbor Art Museum, Newport Beach, Ca., October 6, 1991–January 5, 1992. 80 p.

Newport Biennial [4th: 1993] [*Southern California—1993*], exh. cat., Newport Harbor Art Museum, Newport Beach, Ca., October 2, 1993–January 30, 1994. 56 p.

Nowlin, Stephen, "In Perfect Silence," [LA contemporary action painters] *Artspace,* v. 15, pt. 2, January–February 1991, pp. 53–57.

Oddly: Works by Four Los Angeles Artists: Greg Colson, Lilla LoCurto, Ross Rudel, Daniel Wheeler, exh. cat., The Oakland Museum, May 16–August 9, 1992. 15 p.

"Open House '92," [Venice Art Dealer's Association shows] *Artweek,* v. 23, no. 25, October 8, 1992, pp. 15–20.

Satellite Intelligence: New Art from Boston and San Diego, exh. cat., La Jolla Museum of Contemporary Art, June 9–August 5, 1990 and at Massachusetts Institute of Technology. 36 p.

Staniszewski, Mary Anne, "Border Art in San Diego," *Art and Text* (Australia), no. 36, May 1990, pp. 45-51.

Vital Signs, exh. cat., City of Los Angeles Cultural Affairs Department and the Municipal Art Gallery, September 13–November 12, 1995.

The Works [1992-06-25]/KCET [video 60 min.] executive producer Patricia Kunkel. Los Angeles: Community Television of Southern California/KCET, 1992.

Painters, 1990s, General, Northern California

"Artweek Focus: Introductions '94," [new artists presented by San Francisco Art Dealer's Association] *Artweek,* August 4, 1994, pp. 14–20, 32.

California A-Z and Return, [primarily Northern California painters] exh. cat., The Butler Institute of American Art, Youngstown, Ohio, June 23–August 19, 1990. 92 p.

Intercurrents [descriptions and checklists for five exhibitions], Mary Porter Sesnon Art Gallery, Porter College, University of California, Santa Cruz, February–December 1991. 20 p.

"Introductions '92," *Artweek,* August 6, 1992, pp. 20–25, 34.

9: Marlene Angeja, Ann Chamberlain, etc. [all women], San Francisco Art Institute, August 27–September 26, 1992.

Oakland's Artists '90, exh. cat., Oakland Museum, March 24–July 1, 1990. 20 p.

Schenker, H., "Picturing the Great Central Valley," *Landscape* (Berkeley), v. 32, no. 2, 1994, pp. 1–11.

The Sensual Palette [8 Bay Area painters], exh. cat., Security Pacific Gallery, San Francisco, January 15–March 9, 1991. 16 p.

Realism (See Environment, below.)

"Artweek Focus: Contemporary Landscape Painting," [6 articles] *Artweek,* v. 23, September 3, 1992, pp. 4–5, 15–25.

"Landscape," [6 articles] *Artweek,* v. 26, no. 6, June 1995, pp. 14–21.

Marks, Ben, "Painting to Save the Land," [Oaks Group, Santa Barbara] *Sunset,* v. 193, no. 5, November 1994, pp. 92–95.

Ranchos: Santa Barbara Land Grant Ranches, Santa Barbara, Ca.: The Easton Gallery, 1996. [Catalogue for an exhibition at the Easton Gallery December 5, 1995–January 20, 1996. Lavishly illustrated with paintings by contemporary Santa Barbara realist artists.] 152 p.

Personal Identity: Portraits and Self Portraits

Artist's Images: Images of Artists by Artists, exh. cat., Security Pacific Corporation, Gallery at the Plaza, Los Angeles, January 29– March 27, 1988 and one other venue. 24 p.

Artists of California: A Group Portrait in Mixed Media, exh. cat., Oakland Museum, November 14, 1987–January 10, 1988 and two other sites. 12 p.

As I See Myself: Self Portraits by Contemporary California Artists in Enamel and One Work by Each Artist in their Chosen Medium, exh. cat., University Art Gallery, California State University, Dominguez Hills, , n. d., 1985. 24 p.

De-Persona [works of various media featuring the disenfranchised human figure], exh. cat., The Oakland Museum, May 18–September 22, 1991. 104 p.

Gordon, Allan, "Body Parts," [rev. of *de-Persona* at Oakland Museum] *Artweek,* v. 22, no. 23, July 4, 1991, pp. 1, 16.

Inside/Out, Self Beyond Likeness [American art with emphasis on California and New York] Newport Harbor Art Museum, May 22–July 12, 1981 and two other venues. 103 p.

McCloud, Mac, "Surveying Portraiture," [*Facings* at Downey Museum of Art] *Artweek,* v. 14, no. 23, June 18, 1983, p. 8.

Schjeldahl, Peter, "The Hydrogen Jukebox," [demoralization of current art, narcissism] *LAICA Journal,* no. 20, October–November 1978, pp. 44–46.

Self-Portraits by Women Artists, exh. cat., Gallery at the Plaza, Security Pacific National Bank, Los Angeles, January 26–April 7, 1985. 44 p.

Neo-Feminism, Women

All But the Obvious: Writing, Visual Art, Performance, Video by Lesbians, exh. cat., LACE (Los Angeles Contemporary Exhibitions), November 2–December 23, 1990. 27 p.

All Our Lives: 500 Years of Making Art: a Retrospective of Seven Monterey Bay Women Artists, presented by the Monterey Bay Women's Caucus for Art, Aptos, Ca.; exh. cat., Michaelangelo Gallery, Santa Cruz, Ca. February 3 - 24, 1995.

"Artweek Focus: The Women's Art Movement Today," *Artweek,* v. 21, no. 5, February 8, 1990, pp. 20–25.

Backtalk, exh. cat., Santa Barbara Contemporary Arts Forum, September 11 - October 30, 1993.

Fisher, Barbara, "United Front," [review of *Family Album* at Luggage Store Gallery] *Artweek,* v. 25, July 7, 1994, p. 18.

Guerrilla Girls Talk Back: The First Five Years: A Retrospective, 1985–1990, exh. cat., Falkirk Cultural Center, San Rafael, Ca., May 16–August 25, 1991. 48 p.

Her Story: Narrative Art by Contemporary California Artists, exh. cat., Oakland Museum, January 12–March 24, 1991.

Knaff, Devorah, "Sacred and the Mundane: Gender and Southern California Art World Politics," *Artweek,* v. 24, July 22, 1993, p. 15.

Knaff, Devorah, "Sex & Gender: Current Art Issues," *Artweek,* v. 22, no. 8, February 28, 1991, pp. 1, 17.

LaPalma, Marina, "Women Look at Themselves," [rev. of exh. at Security Pacific] *Artweek,* v. 16, February 23, 1985, p. 1.

Lazzari, Margaret, "Contemplating the Self," [rev. of *Self-Evidence* at LACE] *Artweek,* v. 20, May 27, 1989, p. 5.

Leddy, Pat, "Flesh and Blood," [rev. of *Backtalk* at Santa Barbara Contemporary Arts Forum] *Artweek,* v. 24, October 21, 1993, p. 15.

Matthews, Lydia, "Stories History Didn't Tell Us," [review of *Her Story: Narrative Art by Contemporary California Artists* at the Oakland Museum] *Artweek,* v. 22, no. 6, February 14, 1991, pp. 1, 15.

Meidav, Edie, "Our Tangled Hearts," [review of *Images of Us: Views of Identity and Relationship by Fourteen Women Artists* at the Bedford Gallery] *Artweek,* v. 23, February 27, 1992, p. 10.

"Memory and Time," [remarks by artists on] *Artweek,* v. 25, April 7, 1994, pp. 18–22.

Moser, Charlotte, "Down Home," [review of *Home Front: Comprehending a Common Language* at Falkirk Cultural Center] *Artweek,* v. 23, June 4, 1992, p. 16.

Paley, Laurel, "Images of Celebration," [rev. of *Ageless* at Woman's Building] *Artweek,* v. 21, February 15, 1990, p. 12.

Raven, Arlene, ed., *Crossing Over: Feminism and Art of Social Concern,* Ann Arbor, Mi.: UMI Research Press, 1988. 222 p.

Roder, Sylvie, "Tight Formats for Diffuse Anger," [rev. of first annual juried show sponsored by Women's Caucus for Art held at San Mateo County Arts Council Gallery] *Artweek,* v. 14, no. 34, October 15, 1983, p. 5.

Roth, Charlene, "Parafeminism," *Artweek,* v. 27, no. 7, July 1996, pp. 18-19.

Self-Evidence, exh. cat., LACE (Los Angeles Contemporary Exhibitions), n. d., 1989. 48 p.

Showcase 86: Contemporary Works by 23 California Women Artists, exh. cat., ASI/University Union Gallery, California State Polytechnic University, Pomona, February 19 - March 26, 1986. 49 p.

Stich, Sidra, *New World (Dis) order: Northern California Council of the National Museum of Women in the Arts,* exh. cat., Center for the Arts at Yerba Buena Gardens, San Francisco, February 10 - April 4, 1994 and three other venues through 1995. 59 p.

Three Bay Area Artists: Cheryl Bowers, Barbara Foster, Terry Schutte, exh. cat., University Art Gallery, University of California, Riverside, November 10 - December 17, 1976. 31 p.

Victor, Polly, "Women Artists—Restoring the Balance," [year of exhs. on California women artists at Fresno Arts Center] *Artweek,* v. 18, April 11, 1987, p. 1.

Webster, Mary Hull, "Manipulated Desires," [review of *Mirror, Mirror...Gender Roles and the Historical Significance of Beauty* at California College of Arts and Crafts] *Artweek,* v. 25, July 21, 1994, p. 24.

Gay and Lesbian

(See also Social Issues: AIDS; and bibliography in chapter 33)

Blake, Nayland, et al., *In a Different Light,* San Francisco: City Lights Books, 1995. 351 p.

"In a Different Light at UAM Berkeley," [gay and lesbian] *Artweek,* v. 26, April 1995, pp. 21–22.

Spiegel, Judith, "Brave and Troubled Voices," [rev. of *Against Nature* at LACE] *Artweek,* v. 20, February 4, 1989, p. 1.

Multiculturalism

(See also bibliography in chapters 33 and 34.)

Artifacts for the Seventh Generation: Multitribal-multimedia Visions, exh. cat., American Indian Contemporary Arts, San Francisco, n. d., 1990.

"At the Border," [3 articles, Mexico/US] *Artweek,* v. 24, no. 8, April 22, 1993, pp. 13–15.

Bishop, John Melville, *California Artists: At the Crossroads,* Sacramento, Ca.: Published for the California Arts Council, Traditional Folk Arts Program by Media Generation, 1991. 95 p.

Brunson, Jamie, "Visions of Humanity: Personal Landscapes at Judah Magnes Museum," [Jewish] *Artweek,* v. 21, April 12, 1990, p. 12–13.

Brzezinski, Jamey, "Reassurance," [rev. of exh. *The Figure Identified* at the Richmond Art Center] *Artweek,* v. 22, no. 34, October 17, 1991, pp. 1, 16.

Carlson, Lance, "L. A. Issues: A Minefield called Multiculturalism," *Artweek,* v. 22, July 18, 1991, p. 3.

Cebulski, Frank, "Vision and Counterculture: Artifacts for the Seventh Generation at American Indian Contemporary Arts," *Artweek,* v. 21, November 1, 1990, pp. 15–16.

Chicano/Mexicano Traditional and Contemporary Arts and Folklife in Oakland, Willie R. Collins, ed., Oakland, Ca.: City of Oakland?, Cultural Arts Division, 1995. 32 p.

Christensen, Judith, "Disparate Influences, Shared Attitudes," [rev. of exh. *Cultural Currents* at San Diego Museum of Art] *Artweek,* v. 19, August 6, 1988, p. 8.

"Community Celebration: The Filipino American Arts Exposition," *Artweek,* v. 25, no. 14, July 21, 1994, p. 2.

Completing the Circle: Six Artists [Chinese-Americans] exh. cat. issued by Asian Heritage Council, Mountain View, Ca., and shown at Southern Exposure Gallery, October 10–November 8, 1990 and one other venue.

Cultural Currents, exh. cat., San Diego Museum of Art, n. d., 1988. 14 p.

Curtis, Cathy, "Cross-Cultural Eclecticism," *Artweek,* v. 12, January 31, 1981, p. 5.

Durant, Mark Alice, "Migrating Borders, Unofficial Languages," *Artweek,* v. 20, August 12, 1989, p. 1.

Fazzolari, Bruno, "New World: Six Italian-American Artists at the Museo ItaloAmericano," *Artweek,* v. 24, August 19, 1993, p. 24.

Goldman, Shifra, "Chicano Art -Looking Backward," *Artweek,* v. 12, no. 22, June 20, 1981, p. 3.

Gordon, Allan M., "A Mosaic of Cultures and Forms," [review of *Mosaic* at University of California, Davis] *Artweek,* v. 11, February 2, 1980, p. 6.

Gottlieb, Shirle, "Balance of Opposites: Four Korean American Painters at Angels Gate [Cultural Center, San Pedro]," *Artweek,* v. 21, no. 32, October 4, 1990, pp. 15-16.

Gottlieb, Shirle, "Black Sensibilities: Voices from the African-American Community in Long Beach," *Artweek,* v. 21, September 20, 1990, p. 14.

Hinton, Susan, "Artists in Transition," [review of *New Art by Bay Area Southeast Asians*] *Artweek,* v. 19, May 21, 1988, p. 6.

Liss, Andrea, "History as Fact and Metaphor," [black art in LA in the '60s] *Artweek,* v. 20, August 26, 1989, p. 1.

Miller, Betsy, "Common Heritage: Patterns & Patents: 6 Emerging African American Artists from the Bay Area at University of California, Santa Cruz," *Artweek,* v. 21, June 21, 1990, p. 14.

Moser, Charlotte, "Sampling Ethnic Diversity," [rev. *Completing the Circle: Six Artists* (Chinese Americans from Northern California)] *Artweek,* v. 21, November 1, 1990, p. 15.

19 Sixties: A Cultural Awakening Re-Evaluated, 1965–1975 [black artists] exh. cat., California Afro-American Museum, Los Angeles, April 7–October 2, 1989. 63 p.

Nixon, Bruce, "The Artist's Vocation: Native America at American Indian Contemporary Arts," *Artweek,* v. 24, June 17, 1993, pp. 12–14.

Patterns & Patents: 6 Emerging African American Artists from the Bay Area, exh. cat., Mary Porter Sesnon Art Gallery, University of California, Santa Cruz, May 8–June 1, 1990. 16 p.

Personal Landscapes, Universal Visions: a Northern California Contemporary Jewish Themes Triennial, exh. cat., Judah L. Magnes Museum, February 25–May 20, 1990. 12 p.

[Qapsara] = Apsara: the Feminine in Cambodian Art: an Exhibition and Publication on the Arts of Cambodian Women in the Los Angeles Area, exh. cat., Woman's Building, Los Angeles, December 1, 1987–January 6, 1988. 36 p.

Resource Guide of Asian and Asian American Artists in the San Francisco Bay Area, San Francisco, Ca.: Asian Art Museum and Kearny Street Workshop, 1996. 34 p.

Ross, Jeanette, "Healing the World's Ills: Californian Indian Shamanism at C. E. Smith Museum, Hayward," *Artweek,* v. 21, May 10, 1990, pp. 12–13.

Simmons, Chuck, "Seeking a Cultural Bond," [Armenian-American] *Artweek,* v. 14, no. 37, November 5, 1983, p. 3.

Soe, Valerie, "Voices Beyond the Dominant Culture," [rev. of *Voices of a Distinct Majority,* multicultural symposium] *Artweek,* v. 20, September 23, 1989, p. 4.

Torres, Anthony, "Linkage," [review of *Generation/Relation* at San Jose Center for Latino Arts] *Artweek,* v. 25, July 7, 1994, p. 28.

Tradition in Transition: Bruria, Gilah Yelin Hirsch, Beth Ames Swartz, Michele Zakheim, [Jewish subject matter] exh. cat., Fine Arts Gallery, University of California, Irvine, January 21–February 20, 1982. [bound in *LAICA Journal,* no. 31, Winter 1981]

201: Homenaje a la Ciudad de Los Angeles: Latino Experience in Literature & Art, Los Angeles, Ca.: Latino Writers Assn., 1982. 67 p.

Van Proyen, Mark, "The Assimilated Image," [review of *Traditions Transformed: Contemporary Works by Asian American Artists in California* at Oakland Museum] *Artweek,* v. 16, January 5, 1985, p. 1.

Van Proyen, Mark, "Ethnicity, Culture and Vitality," *Artweek,* v. 20, April 1, 1989, p. 1.

Imaginative Worlds: Neo-Spirituality

Burning Lights: Spirituality, Tradition and Craft in Recent Art from the City of Angels (The Art of Greater Los Angeles in the 1990s, v. 4, no. 1) exh. cat., Laband Art Gallery, Loyola Marymount University, Los Angeles, Ca., October 26–December 3, 1994 and 3 other venues.

Concerning the Spiritual: The Eighties, exh. cat., San Francisco Art Institute, August 21–September 28, 1985. 32 p.

Jones, Nancy Ann, "Explorations of the Numinous," [rev. *Mystical Objects, Sacred Places* at Security Pacific] *Artweek,* v. 20, November 4, 1989, p. 4.

The Spiritual in Art: Abstract Painting 1890–1985, exh. cat., Los Angeles County Museum of Art and Abbeville Press, 1986.

Popular Culture Narrative

Juxtapoz magazine (San Francisco) (v. 1+, 1994+).

Social Themes: Environment

"Artweek Focus: Environment," *Artweek,* v. 21, no. 13, April 5, 1990, pp. 17–20.

Cadden, Wendy, "A Culture's Resilience," [rev. *The Making of a Legend: Chief Seattle's Reply* at Hatley Martin Gallery, S.F.] *Artweek,* v. 21, May 24, 1990, pp. 11–12.

"Fixing the Earth, Part I," [8 articles] *Artweek,* v. 24, no. 17, September 9, 1993, pp. 16–23.

"Fixing the Earth, Part II," *Artweek,* v. 24, no. 18, September 23, 1993, pp. 13–16, 24–26.

Gadon, Elinor W., "Spiritual Journey into Consciousness," [Geomantic Arts, Point Reyes Station] *Artweek,* May 24, 1990, p. 11.

Gaulke, Cheri, "Teaching Environmental Art in Los Angeles," *Artweek,* v. 24, pt. 18, September 23, 1993, pp. 24–25.

Lynch, Sheila, "The Future is Here," [rev. *Environmental Legacies: Countdown to the Millennium* at the Armory] *Artweek,* v. 20, no. 18, May 9, 1991, pp. 1, 15.

Ross, Jeannette, "Intrinsic Value of the Ordinary," [rev. *Artists Respond to the Environment* at Palo Alto Cultural Center] *Artweek,* v. 21, no. 13, April 5, 1990, pp. 1, 24.

Solnit, Rebecca, "The Depths and the Shallows," [rev. *Off Site: Artists in Response to the Environment*] *Artweek*, v. 20, February 25, 1989, p. 1.

Tamblyn, Christine, "Backward Looks at Nature," [rev. *Post Nature: Flora, Fauna and the Collapse of the Natural* at New Langton Arts] *Artweek*, v. 19, June 11, 1988, p. 3.

Social Themes: Environment: Recycling

Fazzolari, Bruno, "Reduce Reuse Recycle," [review of *Living in Balance* at Richmond Art Center] *Artweek*, v. 25, June 9, 1994, p. 22.

Santiago, Chiori, "A New Wave of Recycled Art and Design," *The Museum of California*, v. 21, no. 1, Winter 1997, pp. 6–9, 22.

Santiago, Chiori, "Hello Again: the Sequel: Conceptual Recycling," *The Museum of California*, v. 21, no. 2, Spring 1997, pp. 12–14.

Tanner, Marcia, "Salon des Refuses," [review of *Rising Above Our Garbage* conference at SF] *Artweek*, v. 25, March 24, 1994, p. 16.

Social Themes: AIDS

(See also bibliography for Gay and Lesbian, chapter 33.)

AIDS: Cultural Analysis/Cultural Activism, Cambridge, Ma.: MIT Press, 1988.

Art About AIDS, exh. cat., Pacific Design Center, Los Angeles, December 15, 1988–February 5, 1989. 88 p.

Art Against Aids, Los Angeles, exhibition and sale, Pacific Design Center, Los Angeles, December 15, 1988–February 5, 1989. 88 p.

Art Against Aids, San Francisco, exh. cat., Butterfield & Butterfield, San Francisco, May 18–June 18, 1989. [sale catalogue, mostly California]

Art and Self-Healing: Living Well with the Epidemic, New Langton Arts, San Francisco, August 1–12, 1989. 12 p.

"Artweek Focus: Artists and Aids," [7 articles on] *Artweek*, v. 23, September 17, 1992, pp. 13–19.

Barden, Lane, "An Activist Art Struggles to Grow Amid Voices of Conflict," *Artweek*, v. 24, March 18, 1993, p. 18.*

Carlson, Lance, "An Art that is Also Responsible," [MOCA] *Artweek*, v. 22, May 9, 1991, pp. 3, 15.

Carlson, Lance, "Celebrative Endurance," [rev. the *Indomitable Spirit and Raging at the Visible* at LA Municipal Art Gallery] *Artweek*, v. 21, no. 22, June 21, 1990, pp. 1, 24.

Clifton, Leigh Ann, "Estate Planning in the time of AIDS," *Artweek*, v. 24, December 2, 1993, p. 3.

Davis, Jennie, "Engaged and Enraged," [L.A. AIDS activist art, performance, assemblage] *New Art Examiner*, v. 20, April 1993, pp. 14–17.

"A Day Without Art," [AIDS Awareness Day] *Artweek*, November 30, 1989, p. 15.

Friedman, Robert, "Legacy of Loss," [rev. *The Visual Aid* at SFMOMA Rental Gallery] *Artweek*, v. 24, March 4, 1993, p. 21.

Grover, Jan, "Aids as an Art Issue," [So. Calif. first exh. of AIDS art, at SPARC] *Artweek*, v. 17, November 1, 1986, p. 6.

Helfand, Glen, "Aids Reality Enters Art," *Artweek*, v. 20, no. 40, November 30, 1989, pp. 1, 14, 15.

Merrill, R. J., "Rubber Soul," [rev. of *Powers of Desire* at LACE bookstore] *Artweek*, v. 22, October 3, 1991, p. 10.

Scarborough, James, "The Metaphor Restated," [rev. *Living with AIDS* at California Museum of Science and Industry] *Artweek*, v. 21, September 13, 1990, p. 12.

Watten, Barrett, "Eye to Eye," [rev. *The Face of AIDS* at Palace of the Legion of Honor] *Artweek*, v. 22, no. 18, May 9, 1991, pp. 1, 16.

Social Themes: Other

Scarborough, James, "No Walls," [review of *Who I am Not*, i.e. homeless at Irvine Fine Arts Center] *Artweek*, v. 22, January 17, 1991, p. 13.

Thomas, Sherry Lee, "The Enigma of Mental Illness," [rev. *Chance and Circumstance* at Capp Street Project] *Artweek*, v. 20, December 21, 1989, p. 11.

Political Themes

Artists Call—Against U. S. Intervention in Central America, exh. cat., San Francisco Art Institute Mission Cultural Center, Stephen Wirtz Gallery, 1984.

"Artweek Focus: Our Art, Our Culture, and the [Gulf] War," *Artweek*, v. 22, April 4, 1991, pp. 16–20.

Barnes, Lucinda, "Remembering the Vietnam War," [rev. *Since Vietnam: The War and its Aftermath* at Chapman College] *Artweek*, v. 15, January 14, 1984, p. 7.

Brunson, Jamie, "The Horrors of War Remembered," [rev. of *15 Vietnam 15* at University of the Pacific Art Gallery] *Artweek*, v. 18, February 28, 1987, p. 4.

Dialogue, Prague/Los Angeles, exh. cat. at 3 L. A. venues: Otis/Parsons Gallery, Los Angeles, Santa Monica Museum of Art, and Arroyo Arts Collective, Highland Park, early summer 1990.

Fazzolari, Bruno, "Blame it on Columbus," [review of *Beyond 1992* at Berkeley Art Center] *Artweek*, v. 23, June 4, 1992, p. 4.

Goldman, Shifra M., "Art and Politics in the 1980s," *Artweek*, v. 15, no. 16, April 21, 1984, p. 13.

In out of the Cold [politics and art], exh. cat., Center for the Arts at Yerba Buena Gardens, San Francisco, October 12–December 5, 1993. 79 p.

Kramer, Hilton, "Art & its Institutions: Notes on the Culture War," [art now judged more by leftist political statements than aesthetics] *New Criterion*, v. 12, pt. 1, September 1993, pp. 4–7.

Nixon, Bruce, "Across the Ocean Blue," [review of *500 Years Since Columbus* at Triton Museum] *Artweek*, v. 23, no. 7, February 20, 1992, p. 1, 9–11.

Nixon, Bruce, "Life During Wartime," [review of *From Devastation to Creation: Art by Twelve Vietnam Era Veterans* at Regional Center for the Arts] *Artweek*, v. 23, May 21, 1992, p. 14–16.

Solnit, Rebecca, "Hammers to Beat Society into Shape," *Artweek*, v. 20, November 4, 1989, pp. 1, 4.

Solnit, Rebecca, "The Protests of Artists," [review of book *Art Against War*] *Artweek*, v. 16, February 2, 1985, p. 13.

Veneciano, Jorge Daniel, "Spray Cats," [rev. of *Hip Hope: Aerosol Art in Celebration of the Legacy of Martin Luther King, Jr.*, Occidental College, 1993], *Artweek*, v. 24, February 18, 1993, p. 26.

Wells, Carol A., *Los Angeles: At the Center & On the Edge*, Santa Monica, Ca.: Smart Art Press, 1997. [political protest posters] 48 p.

Psychological Malaise: Alienation, Perversion

"Artweek Focus: Art and Psychoanalysis," [3 articles] *Artweek*, v. 22, March 7, 1991, pp. 18–21.

Barden, Lane, "At the End of the Century," [review of *Love in the Ruins* at Long Beach Museum of Art] *Artweek*, v. 25, April 21, 1994, p. 11.

Carlson, Lance, "Darkness and Light," [review of *Helter Skelter* at MOCA, LA] *Artweek*, v. 23, no. 11, March 19, 1992, pp. 1, 9.

Drohojowska-Philp, Hunter, "LA Raw," [review of *Helter Skelter* show], *Artnews*, v. 91, pt. 4, April 1992, pp. 78–81.

Duncan, Michael, "L. A.: The Dark Side," *Art in America*, v. 81, March 1993, pp. 40–43. [LAX show in Vienna]

Durant, Mark, "Suspicious Secrets," [rev. *Unavailability: The Small, the Secret, The Suspect* at New Langton Arts] *Artweek*, v. 18, August 22, 1987, p. 5.

Durant, Mark, "Vertiginous Experiences," [rev. of *Vertigo: The Poetics of Dislocation* at SFAI] *Artweek*, v. 18, October 17, 1987, p. 3.

Gordon, Allan, "Premillennial Syndrome," [review of art in 9 Sacramento galleries] *Artweek*, v. 23, May 21, 1992, p. 22.

Helter Skelter: L.A. Art in the 1990s, exh. cat., Museum of Contemporary Art, Los Angeles, January 26–April 26, 1992. 181 p.

Heyward, Carl, "Apocalypse Now," [review of *1992 Pro Arts Annual*] *Artweek*, v. 23, April 23, 1992, p. 21.

James, David, "Esp-ion-age," [rev. *Surveillance* at LACE] *Artweek*, v. 18, March 28, 1987, p. 1.

Leddy, Pat, "But Still No Joke," [rev. *Laughing Matters* at L. A. Municipal Art Gallery] *Artweek*, v. 24, April 8, 1993, p. 30.

Leddy, Pat, "Dreamtown," [rev. *L.A. Stories* at Jack Rutberg] *Artweek*, v. 24, March 4, 1993, p. 28.

Marmer, Nancy, "L.A. 1976: the Dark Underside," *Artforum*, v. 14, pt. 10, June 1976, pp. 32–35.

The Monster Show, exh. cat., Museum of Contemporary Art, North Miami, Fl., October 13–November 25, 1995. [half Calif.] 24 p.

Rapko, John, "Beyond Appearances," [review of *Corollaries of Apprehension* at CCAC] *Artweek*, v. 23, no. 8, February 27, 1992, pp. 1, 15.

Roth, Charlene, "The Stain: Some Issues Related to Abjection," *Artweek*, v. 25, September 8, 1994, p. 17.

Van Proyen, Mark, "Myths and Politics," [review of *Responsive Witness* at the Palo Alto Cultural Center] *Artweek*, v. 22, no. 28, September 5, 1991, pp. 1, 20.

Watten, Barrett, "In the In-between," [review of *Oddly: Works by Four Los Angeles Artists* at Oakland Museum] *Artweek*, v. 23, June 18, 1992, pp. 16–17.

Webster, Mary Hull, "Mysteries of Death and Light," [review of *The Crucifixion Through the Modern Eye* at Hearst Art Gallery] *Artweek*, v. 23, April 23, 1992, p. 20.

Willette, J. S. M., "Perversities," [rev. of *Spectral Delinquency* at Stuart Katz' Loft] *Artweek*, v. 24, June 3, 1993, p. 22.

Backlash to Negativism

Anderson, Carolyn G., "Exalting the Visceral," [rev. *Heart in Mouth* at Fahey/Klein] *Artweek*, v. 21, November 22, 1990, p. 14.

Mallinson, Constance, "Aspirations and Hope," [rev. *Peace Show* at Santa Monica College Art Gallery] *Artweek*, v. 13, December 18, 1982, p. 5.

Pure Beauty: Some Recent Work from Los Angeles, exh. cat., The Museum of Contemporary Art, Los Angeles, September 25, 1994–January 8, 1995.

"The Return of Beauty [5 article anthology]," *Artweek*, v. 27, no. 4, April 1996, pp. 12–18.

Roberts, Bennett, *Painting Beyond the Idea*, exh. cat., Manny Silverman Gallery, Los Angeles, September 16–October 28, 1995. 32 p.

California Art Emerges as a Historical Discipline

38

Since California artists began creating art, archivists have been saving information about it, historians documenting it, curators exhibiting it, critics analyzing it, gallery owners promoting it, and collectors acquiring it. This infrastructure has grown exponentially throughout the twentieth century, as described in earlier chapters, and exists as an entity to be studied in its own right.

As early as the nineteenth century, art collectors were acquiring paintings and historians were accumulating facts that could be used by today's writers on California art history. Among the best known of the art collectors were the Northern California money barons such as Leland Stanford (in Palo Alto), Louis and Blanche Haggin (in Stockton), Edwin Bryant Crocker (in Sacramento), as well as others in San Francisco who purchased and commissioned paintings to adorn their grand mansions in town and country. Although many of Northern California's great early paintings were destroyed in the San Francisco earthquake and fire of 1906, many of those that hung in houses outside San Francisco's downtown eventually ended up in museums, including those founded by the Stanfords, the Haggins, and the Crockers.

By the early twentieth century, many Californians had become aware of their state's history and felt that it deserved to be documented. Mae Helene Bacon Boggs (1863–1963), who had grown up in a gold mining town and entered San Francisco society in 1902, felt nostalgic about the California of her childhood and began to collect historical artifacts as well as paintings by California artists. And paintings were amassed by the state's various historical societies such as the California Historical Society in San Francisco, the California Society of Pioneers, and the Native Sons of the Golden West.

In Southern California most 1880s and 1890s "collectors" seemed more intrigued with "California antiquities"—Indian pots, baskets, and mission material. But in the early twentieth century this interest was transferred to fine art. A few historical California paintings found their way into Los Angeles's two museums, the Southwest Museum and the Museum of History, Science and Art (founded 1913), or were purchased to decorate the city's several private clubs.

A few early-twentieth-century publications attempted to characterize California art. The most notable is *Art of California,* the book that accompanied the display at the Panama-Pacific Exposition in San Francisco in 1916. Its several essays, like most publications of its time, were well intentioned and somewhat helpful to today's historians, but not substantive. In the 1930s, spurred by a nationwide interest in documenting American art, several Californians made serious attempts to quantify the state's art. Regionalism's premise—that each area of the country had value of its own—induced various individuals to collect and preserve information on Southern California's art. Ferdinand Perret, a Los Angeles historian, working on his own cognition, began to compile a card file and scrapbooks of clippings that, in 1940, he intended to publish under the title "California Artists of the First 150 Years." (The material is now preserved in the Archives of American Art as the Perret file.) In the late 1930s the Laguna Beach Art Association, realizing that its early artist/members were passing away, began to build a memorial collection of works. In September 1939 Millard Sheets included a small number of historical California artists in a show he organized for the Los Angeles County Fair, perhaps inspired by that year's display of American and California art at the Golden Gate Exposition. And in 1942 the Foundation of Western Art held the exhibition *Only Yesterday,* composed of works by deceased California painters.

The late 1940s marked a turning point in California art. The innovative postwar style of Abstract Expressionism broke completely with the representational past, suddenly creating two camps of California art: the historical, with its collectors and exhibitions, and the contemporary, with its collectors and exhibitions. The field was additionally split when Southern California collectors developed an interest in the art of their own region, while Northern California collectors focused on art from their part of the state. The years 1947, 1949, and 1950 each represented some centennial anniversary for the state—the end of the Mexican-American War, the Gold Rush, and statehood—providing impetus for retrospective art exhibitions and publications.

In the 1950s the first serious collectors of California art emerged, and they fell into two camps. One group consisted primarily of historians and California

buffs who were interested in art made in the state during frontier days (chapters 1, 2). They were following a national trend among collectors to acquire art made during the American West's era of exploration and settlement. Although most of these collectors lived in Northern California, where most of California's early art was produced, ironically, the most well known, Robert B. Honeyman, Jr., resided on a ranch near Mission San Juan Capistrano in Southern California. The prints, watercolors, drawings, and oils illustrating life in Northern California up to about 1900 that he collected could then be commonly found in bookstores and with print dealers. Honeyman's collection, which ultimately numbered nearly eight-hundred items, was exhibited throughout the state in the 1950s, accompanied by illustrated catalogues. (In 1963 the collection was given to the Bancroft Library at the University of California, Berkeley, where it still represents the premier body of pre-1900 California prints, watercolors, and drawings.)

Helping Honeyman with his quest, but also competing with him, were Bay Area collectors, art historians, and dealers Warren Howell, a San Francisco rare-book dealer; Elliott Evans, the director of the California Society of Pioneers; James Abajian, a librarian and researcher at the California Historical Society; George Lyman, a pediatrician, author, and collector; Lewis Ferbrache, a gallery owner and then a curator at the Oakland Art Gallery; Fred Maxwell, an owner of a San Francisco gallery for historical art; and Susanna Bryant Dakin, a long time member of the California Historical Society board of directors.

This handful of aficionados, along with the California Historical Society and the Book Club of California, were also responsible for the first serious publications on California art. In 1948 Jeanne Van Nostrand's *California Pictorial* was published, and the state's centennial celebration in 1949 prompted the show *California Centennial,* which was accompanied by a catalogue with reproductions of paintings.

It was during this embryonic period that Paul Mills, who became curator of the Oakland Art Gallery in 1953, decided to give the small gallery its own distinctive personality by devoting it to the collection of California art. In 1954 he began the Archives of California Art to preserve documentary material. And, thanks to a 1965 gift of $125,000 from the Kahn Foundation, Mills was able to purchase important nineteenth-century masterpieces that have since become the foundation of the Oakland Museum's permanent collection. The gallery, in turn, began to produce catalogues and to display collections such as that of William and Zelma Bowser (Oakland Museum, 1970).

In 1950s Southern California, interest in historical California art was as yet minimal. In 1959 Los Angeles's Henry W. Splitter, a historian who had combed old newspapers to write on culture and education, wrote a three-part article, "Art in Los Angeles Before 1900," which was serialized in the *Quarterly* of the Southern California Historical Society. Between 1957 and 1966 the Long Beach Museum of Art mounted a series of nineteen exhibitions titled *Arts in Southern California.* Although most dealt with contemporary art—painting, ceramics, design, and filmmaking—a few were surveys from the times of California's Mission Indians to the present.

Activity in historical art began to speed up in the 1960s and 1970s. One of the most indefatigable Northern California scholars was Dr. Joseph Armstrong Baird, Jr., who came to the Bay Area to teach architectural history at the University of California, Davis, and soon turned to codifying art. As a curator at the California Historical Society, he organized a series of exhibitions of the work of nineteenth-century painters. In 1968 he catalogued the Honeyman collection after it was given to the Bancroft Library, University of California, Berkeley. He also opened the North Point Gallery, located a block from Fisherman's Wharf, to sell early California paintings. And in the mid 1960s and again in the late 1970s, he had his students at University of California, Davis, research and publish catalogues for several exhibitions on the history of Northern California art to 1939 (the favorite cutoff point for Northern California art historians is the Golden Gate Exposition). His work established the foundations for the study of pre-World War II Northern California art. His extensive archive on California and Western artists became the Baird Archive of the University of California, Davis. The Oakland Museum took up the banner of research and, through the 1970s, continued to produce sophisticated art publications thanks to scholars such as Marjorie Dakin Arkelian. Researching and writing independently were Lewis Ferbrache, Jeanne Van Nostrand, and Mildred Albrondra.

In Southern California the 1960 to 1970 period is marked by an increase in the number of collectors of historical California art and artifacts. Some of the earliest were associated with the Collegium of Western Art, an offshoot of the Westerner's Los Angeles Corral, a group of men interested in California and Western history. In the 1970s they included Carl Dentzel, then director of the Southwest Museum, as well as Tom McNeil, Tony Kroll, Jim Gulbranson, Phil Kovinick, Cornell Norby, and Larry Robinson. Newer collectors (1970s) included Joseph L. Moure, Kay Haley, Dr. Irwin Schoen, Reuben Lucero (also a fine restorer), and Frederik Grue (a talented artist).

Historical art in Southern California began to be seriously documented in the early 1970s. Nancy Moure put together a small exhibition of paintings for the Montgomery Art Gallery, Pomona College, Claremont, titled *Los Angeles Painters of the 1920s*. Its catalogue was followed in the mid 1970s with three publications: *The California Water Color Society, Artists' Clubs and Exhibitions in Los Angeles Before 1930*, and *Dictionary of Art and Artists in Southern California before 1930*. These publications represented the first substantial body of information on historical artists of the area. The alphabetically organized biographies conveniently coincided with the new fashion for perusing flea markets, antique stores, thrift shops, used furniture stores, and garage sales where such "useless and unimportant" paintings often surfaced. The 1974 show *California Design 1910*, the first to retrospectively document Pasadena's craftsman movement, displayed some of the area's early landscapes among the crafts, inspiring crafts collectors to purchase fine arts. The "gold rush" for historical Southern California art was on.

In the second half of the decade, others began to research, exhibit, and publish catalogues on specialized subjects. These included, in 1976, two important surveys: *Painting and Sculpture in California: The Modern Era*, put on by the San Francisco Museum of Modern Art, and *New Deal Art: California* at the DeSaisset Art Gallery, University of Santa Clara. The first Southern California museum to show a serious interest in historic California art was the Laguna Art Museum. (Many of the now collectible artists had founded the organization as the Laguna Beach Art Association in 1918.) In 1977 and 1979 respectively, Laguna Beach Museum of Art (later the Laguna Art Museum) put on a display of work by William Wendt and a retrospective survey *Southern California Artists 1890–1940*, in addition to a number of smaller one-person shows of historical artists. The decade's interest was capped in 1980 and 1981 when the Los Angeles County Museum of Art, spurred by the city's bicentennial, mounted several first-time surveys covering the most important media of early Los Angeles art, including Nancy Moure's *Painting and Sculpture in Los Angeles 1900–1945* and Ebria Feinblatt's *Los Angeles Prints 1883–1980*. *Southern California Photography 1900–1965* was published by the Photography Museum, Los Angeles, but shown at LACMA. Maurice Tuchman, the Museum's Curator of Contemporary Art, had an ongoing program of exhibitions that documented Los Angeles's contemporary artists. To complete the media covered, in 1982 Nancy Moure put together *Drawings and Illustrations by Southern California Artists before 1950* for the Laguna Art Museum. All these shows were accompanied with substantial illustrated catalogues.

Collectors of historical (pre-1945) California art began to surface in the 1970s. In Northern California, the antique dealer Jim Finlinson cultivated a circle that included John Garzoli (a future dealer) and James L. Coran and Walter A. Nelson Rees (future collectors). In Southern California, without any galleries devoted to pre-1945 California paintings, collectors had to seek out art in older establishments that still had works left from when the artists had been alive, including Armand Duvannes in West Hollywood and Poulsen's in Pasadena, as well as the bookstores of Jake Zeitlin and Glen and Muir Dawson (Dawson's Bookshop). However, acknowledging the rising, mid-1970s interest, some newer shops began to offer historic works, including that of antique dealer Gary Breitweiser in Santa Barbara and the fledgling art galleries opened by Frank Leonard and Marian Bowater in Los Angeles. Prices were very low; the dealers really didn't have a sense of what they could ask for art; they just put on a price and tried it. A solution for this "problem" arose in 1977, when the Los Angeles County Museum of Art, suffering under bursting storerooms, decided to hold a museum-wide deaccessioning. The American collections were culled drastically, including many paintings by California artists. When they were hammered down at Sotheby's in Los Angeles on November 8, 1977, they set the first recorded auction prices for Southern California paintings, with record prices in the $5,000 range for some Guy Rose landscapes.

The 1980s were boom years for all aspects of historical California art. Exhibitions and publications began to appear at an exponential rate, usually addressing specialized areas such as Impressionist-style landscapes, watercolor painting, Regionalist art, art of the 1940s, styles such as Bay Area Figurative or Abstract Expressionism, the Society of Six, Modernism, Surrealism, Tonalism, and still life, to name a few. In Northern California Ellen Halteman Schwartz compiled indexes of art exhibition catalogues prior to 1915 and Edan Hughes issued his dictionary of *Artists in California, 1786–1940*. The 1980s also saw the beginning of two magazines devoted primarily to historic California art: *Antiques and Fine Art*, begun about 1985, and *Art of California*, first published November 1988. Before both met their demise with the economic downturn of the early 1990s, they were the major forums for news on historical California art. (Many periodicals documented contemporary California art; some are listed in the bibliography in chapter 35.)

Writers of the 1980s who documented pre-1945 Northern California art include Harvey Jones of The Oakland Museum, the independent dealer Alfred Harrison, the art historian Nancy Boas, the dealer/collector Walter A. Nelson-Rees, the teacher/writer Raymond

L. Wilson, the writers Anthony White and Betty Hoag McGlynn of Monterey/Carmel, and the historian/curator Janice Driesbach of the Crocker Art Museum in Sacramento. The collector Peter Bedford briefly ran the Bedford Arts Press that published, among other things, the book *O' California*. Northern California collectors of pre-1945 paintings are too numerous to mention. In the economically booming mid-to-late 1980s, many new dealers in both historical and contemporary art opened for business in San Francisco and Carmel.

Writers on pre-1945 Southern California art include the University of Southern California teachers Susan Ehrlich and Susan Larsen, addressing California Modernists of the 1930s and 1940s and contemporary artists; the writer/dealer Gordon McClelland on orange crate labels and watercolorists of the 1930s; the historian/consultant Janet Dominik on Impressionism and watercolors of the 1930s; curator-now-independent-consultant Susan Anderson on Regionalist watercolors and on Surrealists; the teacher Orville Clark on government art project murals and photography; while Margarita Nieto and Shifra Goldman analyzed the work of Latino artists. In San Diego, Bruce Kamerling of the Historical Society, Martin Petersen of the Museum of Art, and Bram Dijkstra of the University of California, San Diego, were the main historians to document that city's artists. Two current commercial galleries to follow in the steps of Petersen Galleries in publishing catalogues about artists they represent are William Karges and North Point Gallery.

The 1980s were also boom years for collecting historical California art. Publications informed an increasing number of collectors about the early movements. Especially "hot" areas were the Impressionist-style landscapes produced by Southern California artists in the 1920s and art by Los Angeles's Glass and Plastics group of the 1960s. However, all California art benefited from the rising prices that fanned talk of "investment," and that in turn inspired additional purchases. California art's main auction gallery was Butterfield & Butterfield headquartered in San Francisco, but as the prices of California art rose, John Moran of Pasadena began holding sales, and the state's art was also accepted by East Coast auction houses such as Sotheby's and Christie's.

With so much community interest, in the 1980s museums began to respond to their constituencies. Some of the older institutions that had stored historical California art in their basements began to give it a second look and to display it. Other museums, looking for a mission to make themselves unique, chose California art—the original Laguna Art Museum, now

part of the Orange County Museum of Art, is the most important of these. The Oakland Museum, now called the Oakland Museum of California, continues strong and remains the most important of the older museums devoted to California art. Other museums have initiated or hosted traveling shows featuring California art. Exhibitions that had once been of interest only to California museums are now traveling to venues in the Midwest and on the East Coast. The San Marino branch of the Archives of American Art, Smithsonian Institution, has acquired many letters, photographs, and files relating to California artists. As for writers, the old guard of historians has been supplemented with a new group of art historians with a greater tendency to aesthetically interpret art, bringing a fresh view to the earlier historical and biographical approaches. These writers include Ilene Fort, Patricia Trenton, Susan Landauer, Debra Solon, and Janice Driesbach. Respected East Coast art historians such as William Gerdts are also being induced to write on pre-1945 California art—to give their East Coast viewpoints and to validate it with their names and reputations.

Modern and Contemporary Art. All art is "modern" or "contemporary" at the time it is produced. However, the art world traditionally uses the term "modern" to refer to those art styles that were coined in Western Europe in the early years of the twentieth century and that were emulated by American artists of the 1920s, 1930s, and 1940s. It also describes the era of modernism in America between 1945 and 1965.

This art, too, has had its advocates in California. Much of their history is covered in the text of the preceding chapters. In the 1950s, interest among collectors, writers, dealers, and critics was spurred by the Bay Area's strong contributions to the Abstract Expressionist movement and its origination of the Bay Area Figurative style. In the 1960s interest was furthered by the success of the Glass and Plastics artists associated with the Ferus Gallery in Los Angeles. Of an entirely different mentality and social circle than the historians and the aficionados of historical California art, the collectors of modern art were usually young, aggressive, successful business professionals and corporations who liked the atmosphere of "happening" type art openings, hobnobbing with the artists, and being on the bandwagon of a winning art movement. (Many of these collectors are listed in the exhibition catalogue *Painting and Sculpture in California: The Modern Era*.)

The 1960s and early 1970s were decades of art world euphoria in California. The state's many new colleges and universities turned out numbers of graduates in the fashionable new discipline of art history, and they obtained jobs as curators in museums. Many

new museums were begun, and many of them were devoted to contemporary art. Tax laws favored the arts by fostering donations to museums and the foundation of private, nonprofit museums. Grants supported artists and nonprofit "alternative" galleries as well as exhibitions and publications (chapter 27). In both halves of the state the first real scholarly texts on the modern art of the respective region were produced. Documenting art as it happened were Gerald Nordland, Henry Seldis, Philip Leider, John Coplans, Jane Livingston, Nancy Marmer, James Monte, William Wilson, Henry Hopkins, Melinda Wortz, and Jan Butterfield. Retrospectively documenting Northern California's post-1945 art was Thomas Albright in his *Art in the San Francisco Bay Area 1945–1980,* while Southern California's modernism was chronicled by Peter Plagens in *Sunshine Muse* (1974).

In the 1980s art boom many new art museums were founded and constructed. About thirty devoted themselves to contemporary art (primarily that of California); another thirty showed a serious interest in pre-1945 California art; and yet another thirty were dedicated to a specialized field (such as a third world group, a subject like folk art, or a medium such as photography). Rising inflation and a positive business climate led to rampant collecting (chapter 35) and runaway prices. Collectors became too numerous to mention. While the 1989 recession (chapter 37) struck a severe blow to the art world and put many galleries dealing in all aspects of California art out of business, at this writing, the market seems to be turning around. Since all California art, except that created in the last five or ten years, is now *historic,* the former fields of "modern" and "contemporary" art are now being analyzed by historians using the standard rules of historical research. Most recently, news about California art is being spread by video. KOCE, the public television station for Orange County, has aired two video series by Paul Bockhorst— a three-part video on California Regionalist painting (1994) and a four-part video on California Impressionism (1996). These programs have spread the word about California art to a wider audience.

And, 225 years after the first painting is believed to have been made in California, this book is giving Californians an overall picture of what their artists have accomplished.

Bibliography

Public and Museum Collections, Northern California

Arkelian, Marjorie, *The Kahn Collection of Nineteenth-Century Paintings by Artists in California,* Oakland: The Oakland Museum, 1975.

Arts and Antiques of the State Capitol, Sacramento, California, Sacramento: California State Legislature Joint Committee on Rules, 1984.

Baird, Joseph Armstrong, Jr., compl., *Catalogue of Original Paintings, Drawings and Watercolors in the Robert B. Honeyman, Jr., Collection,* The Friends of the Bancroft Library, University of California, Berkeley, 1968. 196 p.

Berney, Charlotte, "A Founder's Legacy: Works by Ferdinand Burgdorff at the Carmel Art Association," *Antiques & Fine Art,* v. 7, no. 5, July/August 1990, pp. 77–80.

"California State Fair Art Collection," *West Art,* v. 13, no. 4, November 8, 1974, pp. 8+.

Carlisle, Lynn, "Fresno Art Museum," *Art of California,* v. 3, no. 2, March 1990, pp. 28–35.

Crocker Art Museum, *Handbook of Paintings,* Sacramento, Ca.: The Museum, 1979.

A Decade in the West/Painting, Sculpture and Graphics from the Anderson Collection, exh. cat., Museum of Art, Stanford University, June 12–August 22, 1971 and one other venue. 23 p.

Dodge, Jackson, "The San Francisco Museum of Art," *Art of California,* v. 2, no. 1, February/March 1989, pp. 50–56.

duPont, Diana C., et al., *San Francisco Museum of Modern Art: The Painting and Sculpture Collection,* New York: Hudson Hills Press in assoc. with The Museum, 1985.

Harrison, Alfred C., Jr., "The Crocker Art Museum," *Art of California,* v. 2, no. 1, February/March 1989, pp. 28–36.

Harrison, Alfred C., Jr., "The Haggin Museum," *Art of California,* v. 1, no. 2, December/January 1989, pp. 10–19.

Harrison, Alfred C., Jr., "St. Mary's William Keith Collection," *Art of California,* v. 1, no. 1, October/November 1988, pp. 40–45.

McGlynn, Betty Hoag, *Carmel Art Association: A History,* Carmel: the Association, 1987.

Orr-Cahall, Christina, ed., *The Art of California: Selected Works from the Collection of the Oakland Museum,* Oakland: The Museum, 1984. 199 p.

San Francisco General Hospital Medical Center Collection: A Project of the Art Commission, City & County of San Francisco, San Francisco: Art Commission, 1978. 75 p.

Sanders, Patricia B., *The Haggin Collection,* Stockton, Ca.: The Haggin Museum, 1991. 201 p.

Scharlach, Bernice, "Patron of the Palace," *Antiques & Fine Art,* v. 8, no. 6, September/October 1991, pp. 90–95.

Shuken, Christine, "A Passion for Preservation: The Sun House and Grace Hudson Museum," *Antiques & Fine Art,* v. 8, no. 2, March/April 1991, pp. 104–11.

Snipper, Martin, *A Survey of Art Work in the City and County of San Francisco (San Francisco Bicentennial Project),* San Francisco: Art Commission, City & County of San Francisco, 1975. 1 v.

Taylor, Ted M., "Monterey Peninsula Museum of Art," *Art of California,* v. 6, no. 4, August 1993, pp. 34–35.

Tilsner, Julie, "The 10 Best Museums in the Far West," *Antiques & Fine Art,* v. 5, no. 5, July/August 1988, pp. 89–94.

Timberman, Marcy, "E.B. Crocker: Pioneer Patron of California Painting," *Antiques & Fine Art,* v. 6, no. 3, March/April 1989, pp. 51–54.

Ward, Jennifer Kate, "Gold Rush Silverware [by Tiffany for James Birch, Coll. University of California, Berkeley]," *Antiques & Fine Art,* v. 8, no. 2, January/February 1991, pp. 102–109.

Ward, Jennifer Kate, "San Simeon Revisited," *Antiques & Fine Art*, v. 8, no. 3, March/April 1991, pp. 120–27.

Wilson, Raymond L., "The Oakland Museum Collection," *Art of California*, v. 1, no. 1, October/November 1988, pp. 22–27.

Public and Museum Collections, Southern California

Archives of American Art, Smithsonian Institution, at the Henry E. Huntington Library and Art Gallery, San Marino, Ca., has extensive ephemera on California artists.

Barton-Klyver, Cheryl, "Founding Father: The Southwest Museum in Los Angeles," *Antiques & Fine Art*, v. 8, no. 4, May/June 1991, pp. 58–63.

Changing Times/Changing Styles: The Ruth Stoever Fleming Collection of Southern California Art, Newport-Mesa Unified School District, Newport Beach and Costa Mesa: The School District, 1985. 78 p.

Fort, Ilene Susan and Michael Quick, *American Art: A Catalogue of the Los Angeles County Museum of Art Collection*, Los Angeles: LACMA, 1991. [Includes history of the American collection; California Water Color Society collection; California art.]

Framing Four Decades: The University Art Museum Celebrates the Collections 1949–1989, exh. cat., California State University, Long Beach, August 25–October 29, 1989. 24 p.

Gebhard, David, et al., *A Catalogue of the Architectural Drawing Collection*, The University Art Museum, University of California, Santa Barbara, 1983. 2 vol. 873 p.

"The Irvine Museum," *Art of California*, v. 6, no. 2, April 1993, pp. 60–61.

Kamerling, Bruce, *100 Years of Art in San Diego: Selections from the Collection of the San Diego Historical Society*, San Diego: The Society, 1991. 108 p.

Lineberry, Heather Sealy, "The Newport Harbor Art Museum," *Art of California*, v. 4, no. 4, July 1991, pp. 18–21.

MacNaughton, Mary Davis, *Revolution in Clay: The Marer Collection of Contemporary Ceramics*, Claremont, Ca.: Scripps College, 1994.

Moure, Nancy Dustin Wall, *Partners in Illusion: Alberta Binford and William J. McCloskey*, [the McCloskey collection owned by the Bowers Museum], Santa Ana: Ca.: The Bowers Museum of Cultural Art, 1996.

The National Orange Show Art Collection Catalogue, San Bernardino, Ca.: National Orange Show Art Committee, c. 1980. 55 p.

Palette of Light: California Paintings from The Irvine Museum, exh. cat., The Art Museum of Santa Cruz County, July 1–September 3, 1995 and seven other museums. 64 p.

Petersen, Martin E., "San Diego Museum of Art," *Art of California*, v. 3, no. 5, September 1990, pp. 41–45.

Selections from The Irvine Museum, exh. cat. for the Irvine Museum and two other venues, March 1, 1993–February 20, 1994. 128 p.

A Selection of Paintings by Early San Diego California Artists: from the Collection of the San Diego Museum of Art (lent to the Art in Embassies program), San Diego: The Museum, 1987. 33 p.

Selections from the Virginia Steele Scott Foundation, exh. cat., Laguna Beach Museum of Art, Laguna Beach, Ca., April 4–May 28, 1978. 83 p.

75 Works 75 Years: Collecting the Art of California, exh. cat., Laguna Art Museum, Laguna Beach, Ca., April 2–July 11, 1993. 139 p.

Sotheby Parke Bernet, Los Angeles, *An Auction of Property De-Accessioned by the Los Angeles County Museum of Art to Benefit New Acquisitions*, November 7, 8, 9, 1977 (Sale 217). [contains about 100 California paintings]

Sotheby Parke Bernet, Los Angeles, *Paintings, Drawings and Sculpture from the Collection of the University of Southern California*, sales cat., Monday, May 3, 1982 (Sale 336A).

Springville Museum of Art, Springville, Utah, Permanent Collection Catalogue, 1972. [Steed Collection of California Art]

Ten Years of Contemporary Art Council Acquisitions, exh. cat., Los Angeles County Museum of Art, December 19, 1972–March 4, 1973. 26 p.

Virginia Steele Scott Memorial Collection and Examples from the Permanent Collection, exh. cat., Laguna Beach Museum of Art, Laguna Beach, Ca., April 10–June 23, 1980. 132 p.

Business and Corporate Collections

A Century of California Landscapes: Gibson, Dunn & Crutcher Art Collection, Los Angeles, Ca.: Gibson, Dunn & Crutcher, 1983. 52 p.

Contemporary California Art from the Lytton Collection, exh. cat., Lytton Center of the Visual Arts, Los Angeles, Summer 1966. 24 p.

The Fieldstone Collection of Early California Art, Irvine, Ca.: The Corporation, 1985. 44 p.

Heartney, Eleanor, "The New Patronage [private foundations in LA]," *Art in America*, v. 80, January 1992, pp. 72–79.

Hendrickson, Mary, "The Fieldstone Collection," *Art of California*, v. 1, no. 1, October/November 1988, pp. 54–57.

Lineberry, Heather Sealy, "The Fleischer Museum," *Art of California*, v. 3, no. 4, July 1990, pp. 56–59.

Masterworks of California Impressionism: The FFCA, Morton H. Fleischer Collection, Phoenix, Ar.: Franchise Finance Corporation of America, 1986. 179 p.

Miller, T. R., Susan C. Larsen, Jan Butterfield, Van Deren Coke, et al., *The Security Pacific Collection. 1970-1985: Selected Works*, Los Angeles: Security Pacific Corporation, 1985. 233 p.

Moure, Nancy Dustin Wall, "Rooms Full of Views: The Jonathan Club in Los Angeles Continues to Add to its Collection of Art," *Antiques & Fine Art*, v. 6, no. 6, September/October 1989, pp. 108–15.

The O'Melveny & Myers Collection, Los Angeles, Ca.: O'Melveny & Myers, 1981. 73 p.

Trenton, Patricia, "The Feeling of Home: Los Angeles Athletic Club Collection," *Southwest Art*, v. 23, November 1993, pp. 52–59.

Wortz, Melinda, ed., *The Irvine Company Collection*, Newport Beach, Ca.: The Irvine Co., 1984. 71 p.

Private Collectors, 19th Century

(See Crocker, Stanford, Lummis, above.)

Christie, Manson & Woods, Intl., *The Estelle Doheny Collection from the Edward Laurence Doheny Memorial Library...1987–9*, 7 vol. ("Nineteenth Century European and American Painting..." St. John's Seminary, Camarillo, Ca., February 3, 4, 1988. 204 p.)

Joseph Basch Co., *Catalogue, Part 2, The Gallery of Rare and Valuable Paintings Removed from Arbor Villa, the Oakland Home of F. M. (Borax) Smith*, San Francisco, October 8, 9, 10, 1931.

Russell, David E., "Villa Montezuma: Boom Town Salon, Jesse Shepard's Home Served as a Cultural Center for Early San Diego," *Antiques & Fine Art*, v. 6, no. 6, September/October 1989, pp. 116-23.

Private Collectors, 1900-1930

Higgins, Winifred, *Art Collecting in the Los Angeles Area, 1910–1960*, Ph.D. Thesis, University of California, Los Angeles, 1963. 504 l.

Peterson, Martin E., "The Everett Collection [at the San Diego Museum of Art]," *Art of California*, v. 3, no. 3, May 1990, pp. 48–55.

A Private Collection of Paintings Comprising Representative Works of Some of the Living Artists of Southern California (Harry C. Bentley), exh. cat., Columbus Gallery of Fine Arts, January, 1929. [another version of this catalogue was produced by the Newark Museum, Newark, N. J., March 5–April 2, 1929. 50 p.]

Private Collectors, 1930s

The Boggs Collection: Paintings by Artists in California, Shasta: Williamson Lyncoya Smith Memorial Gallery, Shasta State Historic Park, California Department of Parks and Recreation, 1978, research by Donna Penwell. 20 p.

Dodge, Jackson M., "Patrons and Collectors: B. Albert Bender and the Early Years of the San Francisco Museum of Art," in J. Baird, *From Exposition to Exposition*, Sacramento: Crocker Art Museum, 1981, pp. 41–44.

Stern, Jean, *Gardena High School Art Collection*, exh. cat., California State College, Dominguez Hills, planned for January 1999.

Private Collectors, 1940s

Hollywood Collects, exh. cat., Otis Art Institute of Los Angeles County, April 5–May 15, 1970. 176 p.

Private Collectors, 1950s

"Collecting," in *Painting and Sculpture in California: The Modern Era*, exh. cat., San Francisco Museum of Modern Art, September 3–November 21, 1976, pp. 76–80.

Early Paintings of California in the Robert B. Honeyman Jr., Collection, exh. cat., The Archives of California Art, Oakland Art Museum, 1956. 47 p.

Lure of the West: the Carl S. Dentzel Collection of Western American Art, exh. cat., Phoenix Art Museum, October 1–December 13, 1987. 40 p.

Moure, Nancy Dustin Wall, "Carl Dentzel Bequest to the Laguna Art Museum," *Historical Collections Council Newsletter*, v. 7, no. 3, May 1992, pp. 7–10.

Sussmann, M. Hal, "California Connections [Katherine Haley Collection]," *Southwest Art*, v. 18, June 1988, pp. 27–30.

Sweeney, J. Gray, "The Lure of the West [The Carl Schaefer Dentzel Collection]," *Southwest Art*, v. 18, February 1989, pp. 34–6, 38+.

Private Collectors, 1970s+, Historic California Art

American Arts & Crafts From the Collection of Alexandra & Sidney Sheldon, exh. cat., Palm Springs Desert Museum, February 17–June 6, 1993. 103 p.

American Impressionism: California School, Fleischer Museum, Scottsdale, Arizona, Perimeter Center, 1989. 111 p.

Berney, Charlotte, "Collecting the Art of California," *Antiques & Fine Art*, v. 4, no. 5, July/August, 1987, pp. 35–41.

Berney, Charlotte, "Pacific Vistas: The Collection of Drs. Ben and A. Jess Shenson," *Antiques & Fine Art*, v. 7, no. 6, September/October 1990, pp. 89–92.

Brown, Julia and Bridget Johnson, eds., *The First Show: Painting and Sculpture from Eight Collections, 1940–1980*, Museum of Contemporary Art, Los Angeles, n. d., 1983. 293 p.

Brown, Michael D., *Views from Asian California 1920–1965* [Michael D. Brown Collection], San Francisco: Michael D. Brown, 1992.

Bruckner, Rebecca G., *Artists of the American West (1880s to 1930s)* [Walter Kirk Collection], exh. cat., Kinsey Gallery, Seattle University, Seattle, Washington, January 18–March 3, 1994.

The California Collection of William and Zelma Bowser, exh. cat., Oakland Museum, May 26–September 27, 1970. 42 p.

California Grandeur and Genre, exh. cat., Palm Springs Desert Museum and four other venues, December 13, 1991–March 14, 1993. [WIM collection that burned in the Oakland fire of October 20, 1991]

California Impressions: A Collection of Paintings: Ty Oliver Denward Brenner Collection, exh. cat., Long Beach Museum of Art, January 22–February 19, 1978. 8 p.

"California School" From the Private Collection of E. Gene Crain, exh. cat., Gualala Arts Center, Gualala, California, May 24–July 20, 1986. 64 p.

"Connoisseurs of American Art: Roy Rose, Dr. Oscar Lemer, Dr. & Mrs. Edward H. Boseker," *Antiques & Fine Art*, v. 4, no. 5, July/August 1987, pp. 42–47.

Coran, James L. and Walter A. Nelson-Rees, *If Pictures Could Talk: Stories about California Paintings in Our Collection*, Oakland, Ca.: WIM, 1989. 382 p.

Dominik, Janet B., "The E. Gene Crain Collection," *Art of California*, v. 2, no. 1, February/March 1989, pp. 43–49.

Fahey, David and Linda Rich, *Masters of Starlight: Photographers in Hollywood*, [Sid Avery collection] exh. cat., Los Angeles County Museum of Art, 1987. 287 p.

Fort, Ilene Susan with Trudi Abram, *American Paintings in Southern California Collections: From Gilbert Stuart to Georgia O'Keeffe*, exh. cat., Los Angeles County Museum of Art, March 17–May 26, 1996. 112 p.

Haldeman, Peter, "Architectural Digest Visits Candice Bergen," *Architectural Digest*, November 1994, pp. 138+.

Harrison, Alfred C., Jr., "California Watercolors: Paintings in the Collection of Edward McLaughlin," *Art of California*, v. 3, no. 6, November 1990, pp. 46–53.

Harrison, Alfred C., Jr., "Collections: California Paintings in the Collection of Dr. Albert Shumate," *Art of California*, v. 2, no. 4, August/September 1989, pp. 30–36.

Holding Patterns: Selections from the Collection of W. Donald Head, exh. cat., San Jose Museum of Art, October 1997–February 1998. 56 p.

Hough, Katherine Plake, "American Arts & Crafts: The Collection of Alexandra & Sidney Sheldon," *Art of California*, v. 6, no. 2, April 1993, pp. 26–27.

Mochary, Alexandra, "Marrin Collection: One of the foremost collections of Arts and Crafts…," *Antiques & Fine Arts*, v. 6, no. 1, November/December 1988, pp. 55–58.

Moure, Nancy Dustin Wall, "A Search for Excellence: The Art Collection of Joseph L. Moure," *Antiques & Fine Art*, v. 7, no. 1, December 1989, pp. 69–72.

Moure, Nancy Dustin Wall, "California Eclectic: Collectors Frank and Julia Tan," *Antiques & Fine Art*, v. 8, no. 2, January/February 1991, pp. 69–72.

Moure, Nancy Dustin Wall, "The Gail and Edwin Gregson Collection of California Art," *Southwest Art*, v. 26, no. 5, October 1996, pp. 116–21.

A Painter's Paradise: Artists and the California Landscape, exh. cat., Santa Barbara Museum of Art, November 29, 1996–February 16, 1997. 96 p.

Reflections of California: The Athalie Richardson Irvine Clarke Memorial Exhibition, exh. cat., The Irvine Museum, Irvine, Ca., 1994. 185 p.

Scarborough, James, "Preserving California's Past: A Day at the Oaks with Joan Irvine Smith," *Art of California*, v. 6, no. 2, April 1993, pp. 12–14.

Sussmann, M. Hal, "Collector's Eye: Collecting the California Plein-Air School," [Fleischer] *Southwest Art*, v. 17, March 1988, pp. 22–26.

Timberman, Marcy, "James B. Delman: The Look of Early California," *Antiques & Fine Art*, v. 6, no. 4, May/June 1989, pp. 57–58.

A Time and Place: From the Ries Collection of California Painting, exh. cat., Oakland Museum, December 1, 1990–March 3, 1991 and two other venues. 175 p.

Walker, Ronald E., *Early California Impressionists*, Portland, Or.: Masterpiece Publications, 1993; exh. cat., Reno: Nevada Museum of Art, May 28–July 18, 1993.

Ward, Jennifer Kate, "A Private Vision: The Ries Collection," *Antiques & Fine Art*, v. 8, no. 1, November/December 1990, pp. 104–11.

Welsh, Clarissa J., "Head's Castle," *Antiques & Fine Art*, v. 9, no. 4, May/June 1992, pp. 36–39.

Private Collectors, 1970s and 1980s, Modern California Art

(See also collections of modern art as mentioned in *Last Time I Saw Ferus, 1957–1966*, exh. cat. Newport Harbor Art Museum, March 7–April 17, 1976 and in *Painting and Sculpture in California: The Modern Era*, exh. cat., San Francisco Museum of Modern Art, September 3–November 21, 1976. See bibliog. for modern collectors in chapter 27.)

"Artweek Focus: Buying Art," [5 articles] *Artweek*, v. 25, no. 6, March 24, 1994, pp. 12–15.

A Bay Area Connection: Works from the Anderson Collection 1954–84, exh. cat., Triton Museum of Art, Santa Clara, November 1, 1995–January 28, 1996.

California Collects, North and South, exh. cat., Art Galleries of the University of California, Los Angeles, January 20–February 23, 1958 and the California Palace of the Legion of Honor, San Francisco, March 7–April 6, 1958. 41 p.

California Connection: Sixteen Paintings from the Gifford and Joan Phillips Collection, exh. cat., Museum of Fine Arts (Museum of New Mexico), October 21, 1983–February 19, 1984. 32 p.

California Perceptions: Light and Space [Wortz Coll.], exh. cat., Art Gallery, California State University Fullerton, November 16–December 13, 1979. 44 p.

Clothier, Peter, "For Love not Money: L. A. Collects," *Artnews*, v. 89, no. 10, December 1990, pp. 130–35.

"Collectors," *Visual Dialog*, v. 3, no. 1, September–November 1977.

Contemporary Art: North Orange County Collectors, exh. cat., Muckenthaler Cultural Center, Fullerton, January 11–February 9, 1975. 24 p.

Curtis, Cathy, "Hollywood Collects," *Artnews*, v. 90, no. 9, November 1991, pp. 102–07.

Faculty Art Collectors, University of California at Davis, an Exhibition Prepared by Students in Art 189: Museum Methods and Connoisseurship, exh. cat., Memorial Union Art Gallery, University of California, Davis, May 9–June 15, 1968. 82 p.

Gardner, P., "The Hollywood Collectors," *Art News*, v. 74, pt. 1, January 1975, pp. 38–42.

Here and Now: Bay Area Masterworks from the di Rosa Collection, exh. cat., Oakland Museum, March 11–May 8, 1994. 40 p.

Irmas, Deborah, "Eli Broad, Art Collector," *Artweek*, v. 22, July 4, 1991, pp. 3, 21.

Jones, Amanda, "Modern Reality [Bill Janss collection]," *Antiques & Fine Art*, v. 9, no. 3, March/April 1992, pp. 48–49.

Nilson, Lisbet, "A Rich Harvest," *Art News*, v. 88, no. 10, December 1989, pp. 99–100. [Hess collection of contemporary American art housed at winery in Napa]

Ratcliff, C., "The Collectors: California Outlook," [Betty & Monte Factor], *Architectural Digest*, v. 41, April 1984, pp. 134–41.

Runbeck, Kathryn, "Regional Loyalty and Pride: The Bay Area Collection of Paul Andrieu & Barrett Willson," *Art of California*, v. 6, no. 3, June 1993, pp. 56–58.

Smith, Richard, "Eileen and Peter Norton," *Artweek*, v. 22, February 7, 1991, pp. 18, 20.

Three Young Collections: Selections from the Collections of Donald and Lynn Factor, Dennis and Brooke Hopper, Andre and Dory Previn, exh. cat., Santa Barbara Museum of Art, January 15–February 26, 1967. 38 p.

Weisman, Marcia S., *Collecting, Sharing, and Promoting Contemporary Art in California*, interviewed by George M. Goodwin, Oral History Program, University of California, Los Angeles, 1983. 478 p.

Historians

"Interview [Philip E. Linhares, Chief Curator of Art at the Oakland Museum]," *Art of California*, v. 3, no. 4, July 1990, pp. 34–37.

Kite, Patricia, "Preserving the Past, Paul Karlstrom of the Archives of American Art," *Antiques & Fine Art*, v. 8, no. 2, January/February 1991, pp. 61–62.

McIsaac, Cathleen, "Hiyo Cowboy," [dealer Harold Davidson] *Santa Barbara Magazine*, Winter 1997, pp. 20+.

Misrach, Myriam Weisang, "Through the Lens of Time: Peter Palmquist, Photography Historian," *Antiques & Fine Art*, v. 8, no. 6, September/October 1991, pp. 39–42.

Wilson, Raymond L., "In Memory: Dr. Joseph Armstrong Baird, Jr.," *Art of California*, v. 6, no. 2, April 1993, p. 62.

Auctions; Art Market; Fakes

Bamberger, Alan S., "Art Dealers," *Art of California*, v. 2, no. 2, April/May 1989, pp. 51–53.

Bamberger, Alan S., "Forgery: Forgeries Increase Along with California's Art Values," *Art of California*, v. 1, no. 2, December/January 1989, pp. 36–39.

Berney, Charlotte, "Collecting the Art of California," *Antiques & Fine Art*, v. 4, no. 5, July/August 1987, pp. 34–41. [dealers and market]

Butterfield & Butterfield auction, Los Angeles & San Francisco, catalogues for American paintings, California paintings, Modern and Contemporary paintings, Works on Paper, from c. 1980+

Dominik, Janet B., "Early California Art: State of the Business Today," *Art of California*, v. 1, no. 2, December/January 1989, pp. 30–35.

"Fakes, Frauds & Thefts," *Antiques & Fine Art*, v. 9, no. 4, May/June 1992, p. 31.

"Fast Facts: Computer Databases for the Art World," *Antiques & Fine Art*, v. 9, no. 2, January/February 1992, p. 31.

Harrison, Alfred C., Jr., "The Excitement Continues: The Recent Butterfield & Butterfield Sale of Early California Art Paints a Picture of Continued Growth," *Antiques & Fine Art*, v. 6, no. 4, May/June 1989, pp. 45–48.

Hunter, Florence L., "Masterworks on the Block: California Paintings to be Auctioned at the San Jose Museum of Art," *Antiques & Fine Art*, v. 5, no. 4, May/June 1988, pp. 84–86.

"Interview [with Bernard A. Osher of Butterfields]," *Art of California*, v. 4, no. 1, January 1991, pp. 28-30.

John Moran Auction, Pasadena, catalogues for *American and Californian Paintings*, from c. 1987+.

"Lost and Found in Los Angeles: Detective Bill Martin," *Antiques & Fine Art*, v. 6, no. 3, March/April 1989, pp. 39–42.

Moran, John, "Trading in Treasures," [J. Moran auctions] *Pasadena Magazine*, Spring 1996, pp. 6-8.

Penrose, Christene, "Art of the Golden State Comes Into Its Own: An Analysis of the Artists and Art of California at Auction," *Antiques & Fine Art*, v. 4, no. 5, August 1987, pp. 48-51.

Whitington, Luther, "Western Windfall: is the Predicted Market Surge in California Impressionist Paintings Fact or Fantasy," *Art & Antiques*, v. 6, December 1989, pp. 57-58.

Archival Sources

Cohen, William K., *Art of Our Time in Southern California: A Guide to the Documentation of Contemporary Art*, New York: Garland Publ. 1986. 132 p.

Jayanti, Vimala, compl., "Art" in *The UCLA Oral History Program Catalogue of the Collection: Second Edition*, Los Angeles: Oral History Program, Department of Special Collections, University of California, 1992. 319 p.

Moure, Nancy Dustin Wall, "Historical Collections Council Newsletters 1986-1998," in *Publications in Southern California Art 4, 5, 6, 7*, Los Angeles: Dustin, 1998.

Nixon, Diane S., compl., *Directory of Archival and Manuscript Repositories in California*, 4th edition, Society of California Archivists, 1996. 488 p.

"Perrett File," "Stendahl Papers," and other collections in Archives of American Art, Smithsonian Institution, Washington, D. C.

Smith, D. R., "Treasures from Disneyland," [Disney Archives, Burbank] *Everything has a Value* (U. K.), no. 3, December 1980, pp. 26–27.*

See also the many pages of bibliography on collectors and collections in Baird, Joseph Armstrong, *Northern California Art an Interpretive Bibliography to 1915*, Davis, Ca.: Library Associates, University of California, Davis, 1977, 42 p.

Timeline Chart 1 (1000–1885)

	1000	1542	1769	1822	1846/7	1849	1865	1885
ERA	STONE AGE	AGE OF EXPLORATION	SPANISH ERA	MEXICAN ERA		GOLD RUSH	CIVIL WAR	INDUSTRIAL REVOLUTION
INFRASTRUCTURE	tribal		missions	ranchos		Northern California cities develop art communities		railroad lines constructed
INFLUENCES			religion	personal interest				German art study: Duesseldorf & Munich
NON-PAINTING								
SCULPTURE		steatite carvings						Neo-classical sculpture (1880s)
PRINTMAKING						illustrations: wood engravings/chromolithographs (1849-90); bird's-eye views (1849-90)		
WORKS ON PAPER		surveys, maps, topographical drawings (1600-1900)						
PHOTOGRAPHY						Daguerreotypes	glass plate negatives/ landscape photography	
CRAFTS	baskets							
PAINTING								
PAN-CALIFORNIA	body painting		murals in missions					
NORTHERN CALIFORNIA						Gold Rush themes (1849-60); portraiture and still life (1840-1900); mission theme in art (1830-1930)	history and literary themes, genre (1880+); Golden Age of Landscape (1860-85)	
SOUTHERN CALIFORNIA	pictographs, petroglyphs							

Timeline Chart 2 (1885–1939)

	1885	1900	1906	1914/18	1920	1929	1930	1939
ERA	TURN OF THE CENTURY		EARTHQUAKE	WWI	ROARING TWENTIES	STOCK MARKET CRASH		DEPRESSION
INFRASTRUCTURE	Southern California develops art communities			Pan-Pacific Exposition	height of art colonies/ proliferation of automobile			Federal Art Projects/Great Age of Hollywood Studios; GGIE
INFLUENCES	French influence: Paris						American values return/ folk traditions/ Hollywood supports modernism	American Scene/ Social Realism
NON PAINTING								
SCULPTURE	Naturalistic and Beaux Arts sculpture (1890-1915)				carved stone sculpture			government art project sculpture
PRINTMAKING	Painter-Etcher movement (1880-1935); monotypes (1900-15); color woodblock prints (1900-35)							lithography/wood engraving
WORKS ON PAPER	S. F. center of illustration (1890-1906)					art works for animated and live action films (1925-50)		Index of American Design (1935-40)
PHOTOGRAPHY	documentary photography (1890s); Camera Pictorialism (1890-1910)				f.64 (German Straight) photography (1920-40); Japanese Camera Pictorialists (1915-40); Hollywood glamour photography (1925-35); photojournalism (1935+)		social documentary photography (1930s)	
CRAFTS	Arts & Crafts movement (ceramic vessels/ furniture/ objects d'art)				tiles			ceramic dinnerware and figurines
PAINTING								
PAN-CALIFORNIA	Barbizon and Tonalist styles; symbolist themes (1890-1930); cowboy and Indian themes (1895-1940); English style watercolors (1830-1930); genre paintings of "primitive" peoples (1890s)			Impressionism	Post-Impressionism		American Scene (Regionalism/ Social Realism) (1928-45); Federal Art Project murals (1933-43)	
NORTHERN CALIFORNIA	California Renaissance themes				Society of Six (1916-30)			Berkeley watercolor style (1935-45)
SOUTHERN CALIFORNIA				Synchromism (1913-25)				California Watercolor Style (1932-45); Post-Surrealism (1934/Deco/abstraction); academic figure and still life (1925-45)

California Art Timeline — 1940 to 2000

1940 – 1970

	1940	1950	1960	1970
ERA	WWII	POSTWAR ERA	CIVIL RIGHTS REVOLUTION	
INFRASTRUCTURE	war/ photogr. advances	G. I. Bill	Art Renaissance tax incentives/ grants for art	
INFLUENCES	refugee artists	(Consumerism/mass media/TV/sexual revolution) boom in culture/ universities take over art teaching	hippie culture car/surfer countercultures	
		SF develops as center of Beat culture		
		electronics begin to influence art	"Idea" art human perception	
NON-PAINTING SCULPTURE		era of modernism (1945-65)	Minimalist sculpture/ corporate sculpture gardens (1960-75)	installations
		kinetic and welded sculpture (1945-60)		
			ceramic sculpture movement (1965+)	
		folk environments		
		assemblage (1955-65+)		
PRINTMAKING	serigraphy/ intaglio (1940s)		printmaking workshops (lithography, serigraphy, mixing of media)	
WORKS ON PAPER		collage	posters: psychedelic (1960s)	
		drawing fluorescence		
PHOTOGRAPHY	rayographs	darkroom manipulation	conceptual photography (1960-1980)	
CRAFTS	Studio Crafts movement (wheel thrown ceramics/ furniture/ weavings/ jewelry) (1935-65)		crafts become "fine art" (ceramics/ furniture/ jewelry/ glass/ fiber) (1965+)	
PAINTING PAN-CALIFORNIA	Society for Sanity in Art (1940s)		Pop art (early 1960s) Photorealism (1965-80)	
	battlefront artists (1943-44)			
	art from internment camps (1942-45)			
	Surrealism (1940s)			
NORTHERN CALIFORNIA		Dynaton (1951)	Personal Mythologies (Dude Ranch Dada) (1965-75)	
		Beat (Funk) painting (1955-65)		
		Abstract Expressionism (1947-57)		
		Bay Area Figurative (1950-65)		
SOUTHERN CALIFORNIA		Abstract Classicism (1950s)	L. A. Glass and Plastic (mid 1960s)	

1970 – 2000

	1970	1980	1990	2000
ERA	"ME" GENERATION	REAGAN YEARS	RECESSION 1989-96	END-OF-CENTURY
INFRASTRUCTURE	CalArts	art "boom" of the 1980s	economic tightening	public art and education
INFLUENCES	artists of sexual and racial minority emerge	Punk/ New Wave	Multiculturalism	psychological malaise
	Postmodernism Pluralism	Humanism		
		Neo-Feminism		
NON-PAINTING SCULPTURE	site installations/earthworks			
	ceramic sculpture movement			
PRINTMAKING	(All art forms and media flourish. Non-painting art forms assume prominence over painting; the most avant-garde are the newly coined forms of the 1960s (performance, video, site-installations) and photography. These were continually refreshed when artists merged them with traditional art forms and with each other and when artists used them to express ideas, usually of a social, political, or personal nature. All media were additionally updated when new electronics technologies were applied to them and when "high" art began to absorb the iconography, techniques, and aesthetics of so-called low art (advertising, comics and cartoons, etc.).)			
WORKS ON PAPER	artist's books			
	paper and pump emerge as art forms			
	social serigraphy			
PHOTOGRAPHY	color photography (1970s)			
	digital imaging and computer enhancement; web sites			
CRAFTS	crafts continue as "fine art"			
NEW MEDIA	video, performance, installations (1968+)			
PAINTING PAN-CALIFORNIA	New Realism (landscape, figure, still life) (1970+)	Expressive Figuration (1980s) +	Protest art (social, political, personal)	
	florescence of art by artists of racial and sexual minority		worlds of the imagination (spiritual, fantasy – Popular Culture Narrative) (1990s)	
	street mural renaissance (1970+) graffiti and tattoo (1975+)		search for personal identity	
	hybrid abstractions/ Process Art (1970+)			
NORTHERN CALIFORNIA	Visionary painting (1970s)			
SOUTHERN CALIFORNIA	Feminist Art (1970s)			
	Conceptual painting (1970+)			
	Light and Space "paintings" Pattern & Decoration (1970s)			

Monographs

(The publications below represent a selection of the largest, most recent, or most thorough publication on the respective artist. In most cases, dates of activity are approximate.)

Akawie, Tom (b. 1935). Painter, Visionary, Northern California, 1965+. *Alternative Realities*, exh. cat., Museum of Contemporary Art, Chicago, Il., January 10–February 29, 1976; *Egypt and Other Imaginary Places, an Exhibition of Paintings and Objects by Thomas Akawie*, exh. cat., San Jose Museum of Art, 1977; "Tom Akawie Perspective, 60's and 70's at the Berkeley Art Center," *Artweek*, v. 3, no. 8, February 19, 1972, p. 8.

Alden, James Madison (1834-1922). Painter, Topographical, mid 1800s. Franz Stenzel, *James Madison Alden, Yankee Artist of the Pacific Coast, 1854–1860*, Fort Worth, Tx.: Amon Carter Museum of Western Art, 1975.

Alexander, Henry (1860-1894). Painter, Genre, San Francisco, Late Nineteenth Century. Paul J. Karlstrom, "The Short, Hard and Tragic Life of Henry Alexander," *Smithsonian*, v. 12, March 1982, pp. 108-17; Wilson, Raymond J., "Henry Alexander: Chronicler of Commerce," *Archives of American Art Journal*, v. 20, no. 2, 1980, pp. 10-13.

Alexander, Peter (b. 1939). Painter/Sculptor, Los Angeles, 1960+. *Peter Alexander A Decade of Sunsets*, exh. cat., Los Angeles Municipal Art Gallery, January 23, 1982–February 20, 1983. 32 p.; *Peter Alexander—L.A.X.*, exh. cat., James Corcoran Gallery, Santa Monica, 1989. 32 p.

Alf, Martha (b. 1930). Painter/Draftswoman, Los Angeles, 1960+. *Martha Alf, Retrospective*, exh. cat., Los Angeles Municipal Art Gallery, March 6–April 1, 1984 and at San Francisco Art Institute, October 31–December 12, 1984; D.C. Hines, "Martha Alf Explores Simple Forms," *American Artist*, v. 40, December 1976, pp. 56-61.

Al-Hilali, Neda (b. 1938). Fiber/Paper Artist, Los Angeles, 1970+. *Fiber Structures & Fabric Surfaces*, exh. cat., Gallery, Herron School of Art, Indiana University-Purdue University at Indiana, Indianapolis, 1979. 60 p.; *Fibrework-17*, exh. cat., Emily Lowe Gallery, Hofstra University, April 29–May 27, 1973. 20 p.; *Sculpture in Fiber: Twelve Artists Working with Off Loom Techniques*, exh. cat., Museum of Contemporary Crafts of the American Crafts Council, New York, January 27–April 2, 1972. 40 p.

Allan, William (b. 1936). Painter, Personal Mythology, Northern California, 1960+. *Transient Poet: William Allan Retrospective*, exh. cat., Crocker Art Museum, Sacramento, January 14–March 6, 1994. 59 p.

Almaraz, Carlos (1941-1989). Painter, Chicano, Los Angeles, 1970+. *Carlos Almaraz—Selected Works 1970-1984 Paintings and Pastel Drawings*, exh. cat., Los Angeles Municipal Art Gallery, July 24–August 26, 1984. 32 p.

Altoon, John (1925-1969). Painter, Abstract Expressionist, Los Angeles, 1960s. *John Altoon*, exh. cat., Museum of Contemporary Art, San Diego, December 7, 1997-March 11, 1998. 56 p.

Alvarez, Mabel (1891-1985). Painter, Impressionist/Post-Impressionist/Symbolist, Los Angeles, 1915+. Moure, Nancy Dustin Wall, "A Quest for Excellence: Chronicling the Life of Mabel Alvarez," *Antiques & Fine Art*, v. 7, no. 4, May/June 1990, pp. 94-101.

Anait [Arutunff Stephens] (b. 1922). Holographic Art, 1970+. Anait, "My Art in the Domain of Reflection Holography," *Leonardo*, v. 11, 1978, pp. 306-7; *Anait Retrospective 1966-1979*, exh. cat., Museum of Holography, New York, 1979.

Anderson, Jeremy (1921-1982). Sculptor, Painted Wood, San Francisco, 1960+. Hernandez, Jo Farb, *Jeremy Anderson: the Critical Link*, exh. cat., Monterey Peninsula Museum of Art, September 22–November 26, 1995 and Oakland Museum, February 24–June 30, 1996. 89 p.

Antonio, Juan (active c. 1820). Painter, Mission San Fernando, ca. 1820. Neuerburg, Norman, "The 'Why?' and the 'How?' of the Indian Via Cruces from Mission San Fernando," *Quarterly of the Southern California Historical Society*, v. 79, no. 3, Fall 1997.

Arnautoff, Victor (1896-1979). Painter, PWAP, San Francisco, 1930+. "Victor Arnautoff," *California Art Research*, San Francisco: Works Progress Administration, 1936-37, v. 20, no. 1, pp. 105-24; "Victor Arnautoff," in Yvonne Greer Thiel, *Artists and People*, New York: Philosophical Library, 1959.

Arneson, Robert (1930-1992). Sculptor, Ceramics, Academic Funk, Northern California, 1960+. Benezra, Neal David, *Robert Arneson a Retrospective*, exh. cat., Des Moines, Ia. Art Center, February 8–April 6, 1986 and two other venues. 104 p.; Hill, Laura & Scott, "The Elevation of Ceramics: Robert Arneson and his Art," *Art of California*, v. 6, no. 5, October 1993, pp. 61-63; Nash, Steven A., *Arneson and Politics: a Commemorative Exhibition*, exh. cat., Fine Arts Museums of San Francisco, June 2–August 15, 1993. 56 p.

Arriola, Fortunato (1827-1872). Painter, Landscape, San Francisco, 1860s. *Fortunato Arriola (1827-1872)*, essay by Catherine Hoover, exh. cat., California Historical Society, San Francisco, 1974.

Askenazy, Mischa (1884/88-1961). Painter, Impressionist, Los Angeles, 1920+. *Mischa Askenazy 1884/88-1961 Paintings*, exh. cat., Grand Central Art Galleries, New York and DeVille Galleries, Los Angeles, published by DeVille Galleries, 1990.

Bachardy, Don (b. 1934). Painter, Figuratives, Los Angeles, 1960+. *Don Bachardy Drawings*, exh. cat., New York Cultural Center in association with Fairleigh Dickinson University, 1974. 28 p.; *Don Bachardy, One Hundred Drawings*, Los Angeles: Twelvetrees Press, 1983. 112 l.

Backus, Standish (1910-1989). Watercolorist, California Style, Santa Barbara, 1935+. "Standish Backus, Jr." in Ruth Westphal, et al., *American Scene Painting: California, 1930s and 1940s*, Irvine, Ca.: Westphal Publishing, 1991.

Baldaugh, Anni (1881-1953). Painter, Figures, Los Angeles and San Diego, 1925+. Kamerling, Bruce, "Anni (Von Westrum) Baldaugh (Ball-Dough)," in *Journal of San Diego History*, v. 40, no. 3, Summer 1994, pp. 83-95.

Baldessari, John (b. 1931). Painter, Conceptual, San Diego and Los Angeles, 1955+. Snoddy, Stephen, ed., *This not That*, Manchester: Cornerhouse, 1995; Tucker, Marcia, et al., *John Baldessari*, New York: New Museum, 1981. 77 p.; van Bruggen, Coosje, *John Baldessari*, New York: Rizzoli Intl. Publ., 1990. 256 p.

Baranceanu, Belle (1902-1988). Painter, Post-Impressionist, Muralist, Los Angeles/San Diego, 1930+. Brown, Suzanne Blair, "The Prime of Belle Baranceanu," *San Diego Magazine*, v. 37, no. 9, July 1985; Dijkstra, Bram and Anne Weaver, *Belle Baranceanu—A Retrospective*, exh. cat. Mandeville Gallery, University of California, San Diego, November 8– December 15, 1985.

Barbieri, Leonardo (c. 1810-c. 1873). Painter, Portrait, mid 1800s. Kamerling, Bruce, "The Portraits of Signor Barbieri," *California History*, December 1987, pp. 262-77.

Barnes, Ursula (1872-1958). Painter, Folk, Northern California, first half Twentieth Century. *Cat and a Ball on a Waterfall: 200 Years of California Folk Painting and Sculpture*, exh. cat., Oakland Museum, March 22–August 3, 1986.

Batchelder, Ernest (1875-1957). Arts and Crafts. Los Angeles, Early Twentieth Century. *Batchelder, Ernest Allen, Design in Theory and Practice*, New York: Macmillan, 1925. 271 p.

Baumgartner, John Jay (1865-1946). Watercolorist, San Francisco, Early Twentieth Century. Hughes, Edan, *Artists in California, 1786-1940*, San Francisco: Hughes Publishing Co., 1989.

Beaumont, Arthur Edwaine (1890-1978). Watercolorist, Ship Subjects, Los Angeles, 1930+. Dominik, Janet Blake, *Arthur Edwaine Beaumont: Naval Artist 1890-1978*, Long Beach, Ca.?: The Beaumont Publishing Co., 1989.

Bechtle, Robert (b. 1932). Painter, Photorealism, Bay Area, 1965+. "Robert Bechtle," in Louis K. Meisel, *Photorealism*, New York: Abradale Press, Harry N. Abrams, Inc., 1989; *Robert Bechtle: A Retrospective Exhibition*, exh. cat., E.B. Crocker Art Gallery, Sacramento, September 15–October 14, 1973 and at the Fine Arts Gallery of San Diego. 48 p.

Beechey, Richard B. (1808-1895). Painter, Topographical, Early 1800s. Van Nostrand, Jeanne, *The First Hundred Years of Painting in California 1775-1875*, San Francisco: John Howell-Books, 1980.

Bell, Larry (b. 1939). Painter/Sculptor, Glass and Plastic, Los Angeles, 1960+. *Larry Bell, New Work*, exh. cat., Hudson River Museum, Yonkers, N. Y., January 31–March 22, 1981 and two other venues. 88 p.; *Larry Bell: The Sixties*, exh. cat., Museum of New Mexico, Museum of Fine Arts, Santa Fe, 1982; *Zones of Experience: The Art of Larry Bell*, exh. cat., Albuquerque Museum, Albuquerque, N. M., February 16–May 18, 1997. 160 p.

Bengston, Billy Al (b. 1934). Painter, "Los Angeles Look," 1960+. *Billy Al Bengston: Paintings of Three Decades*, exh. cat., Contemporary Arts Museum, Houston, Tx., Oakland Museum, and Chronicle Books, S. F., 1988. 143 p. chiefly illus.

Benjamin, Karl (b. 1925). Painter, Abstract Classicist, Southern California, 1950+. *Karl Benjamin: Selected Works 1979-1986*, exh. cat., Los Angeles Municipal Art Gallery, January 28–March 2, 1986. 48 p.; *Karl Benjamin* interviewed by Robin I. Palanker, Oral History Program, University of California, Los Angeles, 1977. 199 l.

Benton, Fletcher (b. 1931). Sculptor, Minimalist, San Francisco, 1960s+. *Fletcher Benton: Dole Street Studio*, Videorecording, 1 cassett, 26 minutes (collection Los Angeles County Museum of Art, Library); Lucie-Smith, Edward, *Fletcher Benton*, New York: H. N. Abrams, 1990. 336 p.

Berlandina, Jane (1898-1970). Painter, PWAP, San Francisco, 1930s. "Jane Berlandina (1898-1970)," in Stacey Moss, *The Howards: First Family of Bay Area Modernism*, exh. cat., Oakland Museum, May 14 - August 7, 1988; "Jane Berlandina...Biography and Works," in *California Art Research*, FAP, San Francisco, 1936-37, v. 17, pp. 110-48.

Berman, Eugene (1899-1972). Painter, Romantic Surrealist, Hollywood, 1940+. *Berman, Eugene, Imaginary Promenades in Italy*, New York: Pantheon Books, 1956; *Eugene Berman and the Theatre of Melancholia*, exh.

cat., San Antonio, Tx., Marion Koogler McNay Art Museum, n. d., 1984; *The Graphic Work of Eugene Berman*, New York: C. N. Potter, 1971. 332 p.

Berman, Wallace (1926-1976). Assemblage, Los Angeles and San Francisco, 1950+. *Wallace Berman: Support the Revolution*, exh. cat., Institute of Contemporary Art, Amsterdam, n. d., 1992; *Wallace Berman Retrospective*, exh. cat. (initiated and sponsored by The Fellows of Contemporary Art, Los Angeles) and held at Otis Art Institute Gallery, Los Angeles, October 24–November 26, 1978 and two other venues. 118 p.

Bernal, Antonio (active 1968). Muralist, Middle California, Chicano, 1968+.

Biberman, Edward (1904-1986). Painter of Figures/ Architecture/Social Realism subjects, Los Angeles, 1936+. *Edward Biberman*, interviewed by Emily Corey, Oral History Program, University of California, Los Angeles, 1977, 244 l; *The Best Untold: A Book of Paintings by Edward Biberman*, New York: Blue Heron Press, 1953; Biberman, Edward, *Time and Circumstance: Forty Years of Painting*, Los Angeles: Ward Ritchie Press, 1968.

Bierstadt, Albert (1830-1902). Painter, Landscape, San Francisco, Early 1860s. Anderson, Nancy, *Albert Bierstadt, Cho-looke, the Yosemite Fall*, exh. cat. Timken Art Gallery, San Diego, May 3–June 15, 1986. 36 p.; Anderson, Nancy K. and Linda S. Ferber, *Albert Bierstadt: Art & Enterprise*, New York: Hudson Hills Press in association with Brooklyn Museum, 1990; Henricks, Gordon, *Albert Bierstadt: Painter of the American West*, New York: H. N. Abrams, 1974.

Bischoff, Elmer (1916-1991). Painter, Bay Area Figurative, 1950+. Frash, Robert M., *Elmer Bischoff, 1947-1985*, exh. cat., San Francisco Museum of Modern Art and other venues, including the organizer Laguna Art Museum, Laguna Beach, Ca., December 5, 1985–January 4, 1987. 72 p.; McGovern, Kevin, "Elmer Bischoff," *Art of California*, v. 4, no. 3, May 1991, pp. 10-15.

Bischoff, Franz A. (1864-1929). Painter, Flower Still Lifes, Los Angeles, Early Twentieth Century. *The Paintings of Franz A. Bischoff (1864-1929): A Retrospective Exhibition*, exh. cat., Petersen Galleries, Beverly Hills, Ca., March 27–April 19, 1980; Jean Stern, "California Impressionist: Franz A. Bischoff," *Art and Antiques*, v. 4, pt. 3, May/June 1981, pp. 82-89; Jean Stern, "Franz Bischoff: From Ceramist to Painter," in Patricia Trenton, *California Light 1900-1930*, exh. cat., Laguna Art Museum, Laguna Beach, Ca., and two other venues between June 22, 1990 and March 15, 1991, pp. 157-70.

Blair, Lee (1911-1993). Watercolorist, Los Angeles, 1930+. Typescript of interview between Nancy Moure and Lee Blair at Archives of American Art, Smithsonian Institution, Washington, D.C.; "Lee Blair," in Ruth Westphal, et al., *American Scene Painting*, Irvine, Ca.: Westphal Publishing, 1991.

Bojorquez, Chaz (b. 1949). Painter, Easel/Graffiti, Los Angeles. Bojorquez, Chaz [text] and Cesaretti, Gusmano [photographs] *Street Writers: A Guided Tour of Chicano Graffiti*, Los Angeles: Tony Cohan/Acrobat Books, 1975; Dubin, Zan, "Putting the Wrong Tags on Graffiti, Rap?" *Los Angeles Times* Orange County Edition, Tuesday, April 12, 1994, Calendar; Gunnin, John, "The Subversive Tradition: The Art of Chaz Bojorquez," *Juxtapoz*, v. 3, no. 2, Spring 1987, pp. 50-51; Mat-C, "Chaz Bojorquez, Hero of LA's Cholo Style Graffiti," *Downlow* [The British Magazine for the Hip Hop nation], v. 2, no. 1, Autumn 1996, pp. 23-26; Sanchez-Tranquilino, Marcos, "Profile Chaz Bojorquez," *Visions Art Quarterly*, Winter 1994, pp. 42-43.

Borein, Edward (1873-1945). Painter, Western Scenes, Santa Barbara, 1920+. Davidson, Harold G., *Edward Borein Cowboy Artist*, Garden City, N. Y.: Doubleday, 1974; Davidson, Harold, *Edward Borein, the Update*, Santa Barbara, Ca.: H.G. Davidson, 1991. 219 p.; Davidson, Harold G., *The Lost Works of Edward Borein*, Santa Barbara, Ca.: Davidson, 1978. 272 p.; *The West Remembered: The Art of Edward Borein*, exh. cat., Ventura County Museum of History and Art, June 24–September 4, 1988.

Borg, Carl Oscar (1879-1947). Painter, Landscapes/ Indians of Southwest, Southern California, Early Twentieth Century. *Carl Oscar Borg: California Images*, exh. cat., Santa Barbara Historical Society, April 8–June 3, 1990; Hough, Katherine Plake, et al., *Carl Oscar Borg: A Niche in Time*, exh. cat., Palm Springs Desert Museum, January 6–March 18, 1990. 80 p.; Laird, Helen, *Carl Oscar Borg and the Magic Region*, Layton, Ut.: Gibbs M. Smith, Inc., 1986. 248 p.; Laird, Helen, "Carl Oscar Borg," *Antiques & Fine Art*, v. 7, no. 2, January/February 1990, pp. 100–107.

Borglum, John Gutzon (1867-1941). Painter/Sculptor, Los Angeles, Late Nineteenth Century. Casey, Robert J., *Give the Man Room*, Indianapolis, In.: Bobbs-Merrill, 1952. 379 p.; *Gutzon Borglum (1867-1941): Before Mount Rushmore*, exh. cat., Art Museum of South Texas at Corpus Christi, October 12–December 2, 1990; Shaff, Howard and Audrey Karl Shaff, *Six Wars at a Time: The Life and Times of Gutzon Borglum Sculptor of Mount Rushmore*, Sioux Falls, S. D.: The Center for Western Studies, Augustana College, 1985. 379 p.

Borthwick, John David (1825-c. 1900). Illustrator, Gold Rush, Northern California, Mid 1800s. Mather, Ruth E. and F.E. Boswell, *John David Borthwick: Artist of the Goldrush*, Salt Lake City, Ut.: University of Utah Press, 1989. 216 p.

Botello, David Rivas (b. 1946). Muralist/Painter, Chicano, Southern California, 1960+. Barnett, Alan W., *Community Murals: the People's Art*, Philadelphia, Pa.: Art Alliance Press, 1984; Dunitz, Robin J. and James Prighoff, *Painting the Towns: Murals of California*, Los Angeles: RJD Enterprises, 1997, pp. 174, 180-81; Pompa, Christina, "Mural Man," *Estylo* [Latina Lifestyles], v. 1, no. 1, Fall 1997, pp. 96-97.

Bothwell, Dorr (b. 1902). Painter/Printmaker, Symbolic Surrealist, Los Angeles/San Francisco, 1930+. Bothwell, Dorr, *Notan*, New York: Dover, 1991; Trenton, Patricia, ed., *Independent Spirits: Women Painters of the American West 1890-1945*, Autry Museum of Western Heritage in association with the University of California Press, Berkeley, 1995.

Botke, Jessie Arms (1883-1971). Painter, Decorative, Southern California, 1930+. Trenton, Patricia and Deborah Epstein Solon, *Birds, Boughs & Blossoms: Jessie Arms Botke (1883-1971)*, exh. cat. William A. Karges Fine Art, Carmel and Los Angeles, Spring 1995. 90 p.

Brandriff, George Kennedy (1890-1936). Painter, Impressionist, Allegories, Laguna Beach, 1920+. *The Allegorical Still Lifes of George Kennedy Brandriff*, exh. cat., Laguna Art Museum, November 10, 1989–January 21, 1990; Anderson, Susan, "George Brandriff," *Art of California*, v. 3, no. 1, January 1990, pp. 16-22; Baker, Elaine Smith, "George Brandriff: Portait [sic.] of a Painter," *Orange Countiana: a Journal of Local History*, v. II, 1980, pp. 46–51.

Brandt, Rex (b. 1914). Watercolorist, Southern California, 1930+. Champa, Paula, "Rex Brandt," *American Artist*, v. 57, no. 611, June 1993, pp. 30+; *Four Decades of Alfresco Painting*, Corona del Mar, Ca.: Brandt Painting Workshop, 1962; *Two from California* [Rex Brandt and Joan Irving], exh. cat., Riverside Art Center and Museum, November 10–December 26, 1984. 52 p.

Braun, Maurice (1877-1941). Painter, Impressionist Landscapist, San Diego, 1910+. "Maurice Braun," in Martin E. Petersen, *Second Nature: Four Early San Diego Landscape Painters*, exh. cat., San Diego Museum of Art, June 1–August 18, 1991.

Bremer, Anne (1868-1923). Painter, Post-Impressionist, San Francisco, 1900+. "Anne Bremer," *California Art Research*, San Francisco, 1936-37, v. 7, pp. 88-128; "Anne Bremer," in Ruth Lilly Westphal, *Plein Air Painters of California: The North*, Irvine, Ca.: Westphal Publishing, 1986; Dare, Helen, et al., *Tributes to Anne Bremer*, San Francisco, Ca.: printed for A. M. Bender by J. H. Nash, 1927. 31 p.

Breuer, Henry Joseph (1860-1932). Painter, Landscapist, All California, 1890+. "Henry J. Breuer," *California Art Research*, San Francisco, Ca., 1936-37, v. 5, pp. 63-94; "Henry Joseph Breuer," in Ruth Westphal, *Plein Air Painters of California: the North*, Irvine, Ca.: Westphal Publishing, 1986; *Press Notices, Criticisms and Comments on the Work of Henry Joseph Breuer of San Francisco, California*, San Francisco: Printed by The Stanley-Taylor Company, n. d. 46 p.

Brewerton, George Douglas (1827-1901). Painter, Topographical, mid 1800s. Brewerton, George Douglas, *Overland with Kit Carson, a Narrative of the Old Spanish Trail in '48*, New York: Coward-McCann, 1930 (reprinted by Lincoln: University of Nebraska Press, 1993).

Brigante, Nicholas (1895-1989). Painter, American Scene/Abstractions, Los Angeles, 1915+. DePaoli, Geri, "Spirit Resonance in the Art of Nicholas Brigante," *Art of California*, v. 5, no. 4, September 1992, pp. 33-35; *Nicholas Brigante (to Honor, Celebrate and Mark Nick Brigante's Eightieth Birthday, June 29, 1975)*, Los Angeles: American Art Review Press, 1975; Young, J. E., "Nicholas Brigante: An Elegant Timelessness," *Art News*, v. 74, pt. 1, January 1975, pp. 44-46.

Brigman, Anne (1869-1950). Photographer, Pictorialist, Bay Area, Early Twentieth Century. Ehrens, Susan, *A Poetic Vision: The Photographs of Anne Brigman*, exh. cat., Santa Barbara Museum of Art, September 2–November 5, 1995 and three other venues. 96 p.; Stern, Jenny, "Unleashing the Spirit: The Photography of Anne Brigman," *Art of California*, v. 5, no. 4, September 1992, pp. 58-61.

Brookes, Samuel Marsden (1816-1892). Painter, Still Lifes, San Francisco, 1870-1890. Driesbach, Janice T., *Bountiful Harvest: Nineteenth Century California Still Life Painting*, exh. cat., Crocker Art Museum, November 15–December 29, 1991 and Oakland Museum, January 25–April 19, 1992; Marshall, Lucy Agar, "Samuel Marsden Brookes," *California Historical Society Quarterly*, v. 36, September 1957, pp. 193-203; *Samuel Marsden Brookes (1816-1892)*, exh. cat., California Historical Society and the Oakland Art Museum, November 10-December 29, 1962. 38 p.

Brooks, Mildred Bryant (1901-1995). Etcher, Pasadena, 1930+. "Mildred Bryant Brooks," in *Southern California Artists 1890-1940*, exh. cat., Laguna Beach Museum of Art, July 10–August 28, 1979.

Browere, Alburtus del Orient (1814-1887). Painter, Landscape/Genre, Gold Rush, Mid-Nineteenth Century. Conkling, Roscoe P., "Reminiscences on the Life of Alburtis Del Orient Browere," *Los Angeles Museum Quarterly*, v. 8, Spring 1950, pp. 2-6; Driesbach, Janice T., et al., *Art of the Gold Rush*, exh. cat., The Oakland Museum of California, January 24–May 31, 1998 and two other venues; Reynolds, Gary, *The Life and Work of Alburtus Del Orient Browere (1814-1887)*, M.A. Thesis, Brooklyn College, 1977; Smith, Mabel P. and MacFarlane, Janet R., "Unpublished Paintings by Albertis del Orient Browere," *Art in America*, v. 46, Fall 1958, pp. 68-71; Wright, Charles C., "Alburtus D. O. Browere, 1814-1887: A Genre Painter of the Hudson River School and Resident of Catskill, N. Y., 1840-1887," 1971, typescript on deposit with the Greene County Historical Society, Catskill, N. Y.

Brown, Benjamin Chambers (1865-1942). Painter, Landscapes, Pasadena, Early Twentieth Century. "Benjamin Chambers Brown," in Ruth Lilly Westphal, *Plein Air Painters of California: The Southland*, Irvine, Ca.: Westphal Publishing, 1982; Walker, John Alan, *Benjamin Chambers Brown (1865-1942) a Chronological and Descriptive Bibliography*, Big Pine, Ca.: J. A. Walker Bookseller, 1989. 35 p.

Brown, Joan (1938-1990). Painter, Bay Area Figurative/Neo-naive, Mid 1950+. Levy, Mark, *Joan Brown: The Golden Age*, exh. cat., University Art Gallery, San Diego State University, April 12–May 15, 1986. 40 p.; Richardson, Brenda, *Joan Brown*, exh. cat., University Art Museum, University of California, Berkeley, March 6–April 21, 1974. 48 p.; Tsujimoto, Karen, *The Art of Joan Brown*, exh. cat., Oakland Museum of California and University of California Press, Berkeley, 1998.

Bruff, J. Goldsborough (1804-1889). Goldseeker/Writer/Draftsman, Northern California, Mid Nineteenth Century. *Gold Rush: the Journals, Drawings and Other Papers of J. Goldsborough Bruff*, New York: Columbia University Press, 1949. 794 p.

Bufano, Beniamino Benvenuto (1898-1970). Sculptor, San Francisco, 1920+. "Beniamino Bufano," *California Art Research*, San Francisco, 1936-37, v. 14, pp. 92-138; Falk, Randolph, *Bufano*, Millbrae, Ca.: Celestial Arts, 1975. 135 p.; Lewen, Virginia, *One of Benny's Faces*, Hicksville, N. Y.: Exposition Press, 1980. 226 p.; McGinty, B., "Blessings from Benny Bufano," *American Artist*, v. 42, July 1978, pp. 42-45+; Rather, Lois, *Bufano and the U.S.A.*, Oakland, Ca.: Rather Press, 1975. 125 p.; Wilkening, Howard and Sonia Brown, *Bufano: An Intimate Biography*, Berkeley, Ca.: Howell-North Books, 1972. 232 p.

Buff, Conrad III (1886-1975). Painter, Desertscapes, Los Angeles, 1920+. "Conrad Buff," in Ed Ainsworth, *Painters of the Desert*, Palm Desert, Ca.: Desert Magazine, 1960; *Conrad Buff: Artist*, Oral History Program, University of California, Los Angeles, 1968. 309 l.

Burkhardt, Hans (1904-1994). Painter, Abstracts, Los Angeles, 1940+. *Hans Burkhardt*, oral interview conducted by Susan Einstein, Oral History Program, University of California, Los Angeles, 1976; *Hans Burkhardt*, interviewed by Paul Karlstrom November 25, 1974 for Archives of American Art, Smithsonian Institution; Gardner, Colin, "An Interview with Hans Burkhardt," *Arts*, v. 59, no. 6, February 1985, pp. 104-11; *Hans Burkhardt: The War Paintings, A Catalogue Raisonne*, Los Angeles: Jack Rutberg Gallery, 1984.

Burr, George Elbert (1859-1939). Painter/Etcher, Landscapes, Santa Barbara, c. 1907. *George Elbert Burr 1859-1939: Critical Comments by his Peers*, Scottsdale, Ar.: Stephen V. O'Meara, Inc., 1990. 78 p.; Seeber, Louise Combes *George Elbert Burr 1859-1939, Catalogue Raisonne...*, Flagstaff, Ar.: Northland Press, 1971.

Bush, Norton (1834-1894). Painter, Tropical Landscapes, San Francisco, Late Nineteenth Century. Arkelian, Marjorie, *The Kahn Collection of Nineteenth-Century Paintings by Artists in California*, The Oakland Museum, Art Department, 1975; "Norton Bush," in *California Landscape Painting, 1860-1885: Artists around Keith and Hill*, exh. cat., Stanford Art Gallery, Stanford University, December 9, 1975–February 29, 1976, pp. 19-25; *Tropical: Tropical Scenes by the Nineteenth Century Painters of California*, exh. cat., The Oakland Museum, October 5–November 14, 1971.

Butman, Frederick A. (1820-1871). Painter, Landscapes, San Francisco, Late Nineteenth Century. "Butman's Pictures," *Watson's Art Journal*, v. 8, November 23, 1867, p. 76; Driesbach, Janice T., et al., *Art of the Gold Rush*, exh. cat., The Oakland Museum of California, January 24–May 31, 1998 and two other venues; "Frederick A. Butman," in *California Landscape Painting, 1860-1885: Artists around Keith and Hill*, exh. cat., Stanford Art Gallery, Stanford University, December 9, 1975 –February 29, 1976, pp. 16-18; Van Nostrand, Jeanne, *The First Hundred Years of Painting in California*, San Francisco: John Howell-Books, 1980.

Cadenasso, Giuseppe Leone (1858-1918). Painter, Landscapes, Tonalist, Bay Area, Turn of the Century. *Cadenasso, Cuneo, Piazzoni, Painters of the California Landscape*, exh. cat., Museo Italoamericano, San Francisco, April 6–May 27, 1990; "Giuseppe Cadenasso," *California Art Research*, San Francisco, 1936-37, v. 11, pp. 1-33.

Calder, Alexander Stirling (1870-1945). Sculptor, Beaux Arts, San Francisco, c. 1915. Hayes, Margaret Calder, *Three Alexander Calders: A Family Memoir*, New York: Universe Books, 1987. 300 p.

Caporael, Suzanne (b. 1949). Painter, Expressive Figuratives, Southern California, 1980+. *Suzanne Caporael*, exh. cat., Newport Harbor Art Museum, Newport Beach, Ca., 1985; *Suzanne Caporael*, exh. cat., Santa Barbara Museum of Art, April 18–June 8, 1986. 16 p.

543

Cardero, Jose (1768-?). Spanish Artist/Sailor, Monterey, Late 1700s. Van Nostrand, Jeanne, *The First Hundred Years of Painting in California,* San Francisco: John Howell-Books, 1980.

Carlsen, Soren Emil (1853-1932). Painter, Still Lifes, San Francisco, Late Nineteenth Century. "Emil Carlsen," *California Art Research,* San Francisco, 1936-37, v. 4, pp. 27-63; Sill, G., "Emil Carlsen: Lyrical Impressionist," *Art & Antiques,* v.3, pt. 2, 1980, pp. 88-95; Stewart, J., "Soren Emil Carlsen," *Southwest Art,* v. 4, pt. 10, April 1975, pp. 34-37; Wortsman-Rowe Galleries, *The Art of Emil Carlsen,* 1853-1932, San Francisco, 1975. 98 p.

Cederquist, John (b. 1946). Furniture Maker, Illusionary, Southern California, 1970+. Emanuelli, S. K., "John Cederquist, Deceptions," *American Craft,* v. 43, pt. 5, October/November 1983, pp. 24-27; *John Cederquist,* exh. cat., The Oakland Museum of California, September 13- November 30, 1997. 132 p.; Rothrock, Kate, "John Cederquist: the Reality of Illusion," *The Museum of California* [publication of The Oakland Museum], v. 21, no. 3, Summer 1997, pp. 6-9, 24+; Smith, Karen Sandra, "The Art of the Illusion: Furniture by John Cederquist," *Art of California,* v. 5, no. 5, November 1992, pp. 52-53.

Chamberlin, Frank Tolles (1873-1961). Painter/Teacher, Academic, Los Angeles, 1920s+. "Frank Tolles Chamberlin," in Ruth Westphal, et al., *Plein Air Painters of California: The Southland,* Irvine, Ca.: Westphal Publishing, 1982; *F. Tolles Chamberlin: Retrospective Exhibition,* exh. cat., Pasadena Art Museum, February 27-March 27, 1955. 18 p.

Chase, William Merritt (1849-1916). Painter, Impressionist, Carmel, 1914. Bryant, Keith L., *William Merritt Chase, a Genteel Bohemian,* Columbia, Mo.: University of Missouri Press, 1991. 325 p.; Gallati, Barbara Dayer, *William Merritt Chase,* New York: Harry N. Abrams in association with the National Museum of American Art, Smithsonian Institution, 1995. 143 p.; Pisano, Ronald G., *Summer Afternoons: the Landscape Paintings of William Merritt Chase,* Boston: Bulfinch Press, 1993. 148 p.; Roof, Katharine M., *Life and Art of William Merritt Chase,* New York: Hacker Art Books, 1975.

Chicago, Judy (b. 1939). Painter/Site Installations, Teacher, Feminist, Los Angeles, 1960+. Chicago, Judy, *Beyond the Flower,* New York: Viking, 1996. 282 p.; Chicago, Judy, *The Dinner Party,* New York: Penguin, 1996. 234 p.; Chicago, Judy, *The Dinner Party, A Symbol of Our Heritage,* Garden City, N. Y.: Doubleday/Anchor, 1979. 255 p.; Chicago, Judy, *Through the Flower: My Struggle as a Woman Artist,* Garden City, N. Y.: Doubleday, 1975 (republished New York: Penguin, 1993); Meyer, Laura Dawn, *Central Core Imagery and the Language of Fetichism in Womanhouse and The Dinner Party,* M. A. Thesis, University of California, Riverside, 1994. 178 l.; *Sexual Politics: Judy Chicago's Dinner Party in Feminist Art History,* exh. cat., UCLA at the Armand Hammer Museum of Art and Cultural Center in association with University of California Press, 1996. 264 p.

Chittenden, Alice Brown (1859-1944). Painter, Floral Still Lifes, San Francisco, Late Nineteenth-Early Twentieth Century. Trenton, Patricia, ed., *Independent Spirits: Women Painters of the American West 1890-1945,* Autry Museum of Western Heritage in association with the University of California Press, Berkeley, 1995.

Christo and Jeanne Claude (both 1935). Environmental Artists, Second Half of the Twentieth Century. [Christo's umbrellas] *Artweek,* October 31, 1991, pp. 1, 9-10; *Christo and Jeanne-Claude, Prints and Objects, 1963-95: A Catalogue Raisonne,* Munchen & New York: Edition Schellman, 1995. 227 p.; *Christo: The Running Fence,* Stuttgart: G. Hatje, 1977. 21 p.; Vaizey, Marina, *Christo,* New York: Rizzoli, 1990. 128 p.

Clapp, William Henry (1879-1954). Painter, Society of Six, Oakland, 1915+. "William Clapp," in Nancy Boas, *Society of Six: California Colorists,* San Francisco: Bedford Arts Publishers, 1988.

Clark, Alson Skinner (1876-1949). Painter, Impressionist Landscapes, Pasadena, 1920+. Stern, Jean, *Alson S. Clark,* Los Angeles, Ca.: Petersen Publishing Co., 1983. 115 p.; Stern, Jean, "Alson Clark: An American at Home and Abroad," in Patricia Trenton and William H. Gerdts, *California Light,* exh. cat., Laguna Art Museum, Laguna Beach, Ca., October 12, 1990-January 6, 1991 and several other venues, pp. 113-36.

Colburn, Elanor (1866-1939). Painter, Figures, Dynamic Symmetry, Laguna Beach, 1920+. *Southern California Artists, 1890-1940,* exh. cat., Laguna Beach Museum of Art, July 10-August 28, 1979; Trenton, Patricia, ed., *Independent Spirits: Women Painters of the American West 1890-1945,* Autry Museum of Western Heritage in association with the University of California Press, Berkeley, 1995.

Cole, Joseph Foxcroft (1837-1892). Painter, Landscapes, Southern California, 1887. Craven, W., "J. Foxcroft Cole...," *American Art Journal,* v. 13, pt. 2, Spring 1981, pp. 51-71; Moure, Nancy Dustin Wall, *Loners, Mavericks & Dreamers,* exh. cat., Laguna Art Museum, November 26, 1993-February 20, 1994.

Colescott, Robert (b. 1925). Painter, Figuratives, Northern California, 1965+. *Robert Colescott: A Retrospective, 1975-1986,* exh. cat., San Jose Museum of Art, April 5-May 31, 1987 and eight other venues. 34 p.

Colman, Samuel (1832-1920). Painter, Landscapes, Southern California, 1888. *The Romantic Landscapes of Samuel Colman at Kennedy Galleries,* exh. cat., Kennedy Galleries, New York, September 20-October 15, 1983. 24 p.

Conal, Robbie (b. 1941). Painter, Political, Los Angeles, 1980+. Conal, Robbie, *Art Attack: The Midnight Politics of a Guerilla Artist,* New York: Harper Perennial, 1992. 63 p.; *Unauthorized History: Robbie Conal's Portraits of Power,* exh. cat., Pasadena Art Alliance: The Armory Center for the Arts, September 8-November 9, 1990. 56 p.

Congreso de Artistas. Mural Group, Chicano, San Diego, 1970+. Dunitz, Robin J. and James Prigoff, *Painting the Towns: Murals of California,* Los Angeles: RJD Enterprises, 1997, p. 172.

Connell, Will (1898-1961). Photographer, Hollywood, 1930+. Coke, Van Deren, *Photographs by Will Connell,* exh. cat., The San Francisco Museum of Modern Art, October 9-November 29, 1981. 19 p.; Connell, Will, *About Photography,* New York: T. J. Maloney Co., 1949. 64 p.

Cooper, Colin Campbell (1856-1937). Painter, Impressionist, Santa Barbara, 1920+. Barker, Albert W., "A Painter of Modern Industrialism, the Notable Work of Colin Campbell Cooper," *Booklover's Magazine,* ca. 1905, pp. 327-30; Cooper, Colin Campbell, "Skyscrapers and How To Build Them in Paint," *Palette and Bench,* v. 1, 1909, pp. 90-92 and 106-108; *An Exhibition of Paintings by Colin Campbell Cooper,* exh. cat., James M. Hansen, Santa Barbara, May 3-16, 1981. 64 p.

Corbett, Edward (1919-1971). Painter, Abstract Expressionist, San Francisco, 1945+. Landauer, Susan, *Edward Corbett: A Retrospective,* exh. cat., Richmond Art Center, Richmond, Ca., September 23-November 18, 1990 and one other venue. 60 p.; Landauer, Susan, "The Quiet Mystery of Edward Corbett," *Art of California,* v. 4, no. 1, January 1991, pp. 18-22; Landauer, Susan, *The San Francisco School of Abstract Expressionism,* exh. cat., Laguna Art Museum, Laguna Beach, Ca., January 27-April 21, 1996.

Corita [Kent], Sister Mary (1918-1986). Serigrapher, Los Angeles, 1950+. *Corita Kent* interviewed by Bernard Galm, Oral History Program, University of California, Los Angeles, 1977. 158 l; *Corita Prints, 1951-1984,* North Hollywood, Ca.: Corita Prints, 1984; Kent, Mary Corita, et al., *Sister Corita,* Philadelphia: Pilgrim Press, 1968. 80 p.; *Sister Mary Corita,* Los Angeles: Immaculate Heart College, 1966? 36 p.

Cornwell, Dean (1892-1960). Muralist, Los Angeles, Late 1920s. Broder, Patricia Janis, *Dean Cornwell, Dean of Illustrators,* New York: Watson-Guptill, 1978. 239 p.

Coronelli, (P.) (active c. 1685-1700). Cartographer, Republic of Venice, Italy, 1690. Portinaro, Pierluigi and Franco Knirsch, *The Cartography of North America 1500-1800,* New York: Facts on File, Inc., 1987.

Coulter, William A. (1849-1936). Painter, Marinescapes, San Francisco, Late Nineteenth Century. *W.A. Coulter Marine Artist,* published by James V. Coulter in conjunction with the Sausalito Historical Society, 1981. 12 p.

Crumpler, Dewey (b. 1949). Painter/Muralist, African-American, San Francisco, 1970+. Bellow, Cleveland, Marva Cremer, *Dewey S. Crumpler,* exh. cat., San Francisco Museum of Modern Art, 1977. 6 p.; Cohn, Terri, "Dewey Crumpler," *Artweek,* v. 22, November 14, 1991, pp. 15-16; Drescher, Tim, *San Francisco Bay Area Murals: Communities Create Their Muses, 1904-1997,* St. Paul, Mn.: Pogo Press, 1998; Gordon, Allan, "A Conversation with Dewey Crumpler," *Artweek,* v. 25, October 20, 1994, p. 17.

Cuprien, Frank William (1871-1948). Painter, Impressionist, Marinescapes, Laguna Beach, 1912+. "Frank Cuprien," in Ruth Lilly Westphal, *Plein Air Painters of California: The Southland,* Irvine, Ca.: Westphal Publishing, 1982.

Dahlgren, Marius (1844-1920). Painter, Landscapes, Bay Area, Late Nineteenth Century. "Carl Christian Dahlgren.., Marius Dalgren...," in Marjorie Arkelian, *The Kahn Collection of Nineteenth-Century Paintings by Artists in California,* Oakland, Ca.: The Oakland Museum Art Department, 1975.

Dali, Salvador (1904-1989). Painter, Surrealist, California, Late 1930s, Early 1940s. Ades, Dawn, *Dali,* London: Thames and Hudson, 1995. 216 p.; Catterall, Lee, *The Great Dali Art Fraud and Other Deceptions,* Fort Lee, N. J.: Barricade Books, 1992. 417 p.; Dali, Salvador, *The Secret Life of Salvador Dali,* New York: Dover, 1993. 400 p.; Descharnes, Robert, *Salvador Dali 1904-1989: the Paintings,* Koln: Bendikt Taschen, 1994. 2 v. (780 p.); Descharnes, Robert, *Salvador Dali: The Work, the Man,* New York: Harry N. Abrams, 1984.

Dashiell, David Cannon (1952-1993). Painter/Site installations, San Francisco, 1985-1993. Dashiell, David Cannon, *Invert, Oracle,* San Francisco: Ethan J. Wagner, 1989. 120 p.; *Queer Mysteries: David Cannon Dashiell, 1993 Adaline Kent Award Exhibition,* exh. cat., Walter/McBean Gallery, San Francisco Art Institute, June 3-July 3, 1993. [Box of cards; edition of 1000.]

Davis, Ronald (b. 1937). Painter, Los Angeles Glass and Plastic, 1960+. *Ronald Davis, Painting, 1962-1976,* exh. cat., Oakland Museum, July 13-September 5, 1976. 47 p.

Day, Frank L. (1902-1976). Painter, Native American, Northern California, 1960+. Dobkins, Rebecca, *Memory and Imagination: The Legacy of Maidu Indian Artist Frank Day,* exh. cat., The Oakland Museum of California, March 15-August 3, 1997. 106 p.; Wasserman, Abby, "Memory and Imagination: The Art of Frank Day," *The Museum of California,* v. 21, no. 2, Spring 1997, pp. 6-11, 26.

Deakin, Edwin (1838-1923). Painter, Landscapes (Missions), San Francisco, Late Nineteenth-Early Twentieth Century. Deakin, Edwin, *The Twenty One Missions of California,* San Francisco: Murdock Press, 1899; Mahood, Ruth I., ed., *A Gallery of California Mission Paintings by Edwin Deakin,* Los Angeles: Ward Ritchie Press, 1966.

de Erdely, Francis (1904-1959). Painter, Figures, Los Angeles, 1940+. *Francis de Erdely, 1904-1959,* exh. cat., Pasadena Art Museum, Pasadena, Ca., June 14-July 14, 1960. 21 p.; Timberman, Marci, "Capturing the Drama of Humanity: The Work of Francis DeErdely," *Art of California,* v. 6, no. 2, April 1993, pp. 18-21.

DeFeo, Jay (1929-1989). Painter, Beat, San Francisco, 1950+. Charles Shere, "Jay De Feo," *Art of California,* v. 3, no. 2, March 1990, pp. 36-39; *Jay DeFeo: Selected Works, Past and Present,* exh. cat., San Francisco Art Institute, April 18-May 12, 1984. 32 p.; Nixon, Bruce, "The Resurrection of [Jay DeFeo's the Rose]," *Artweek,* October 1995, pp. 24-25.

De Forest, Roy (b. 1930). Painter, Personal Mythology, Northern California, 1960+. Nixon, Bruce, "Roy De Forest," *Art of California,* v. 4, no. 3, May 1991, pp. 42-47; *Roy De Forest,* exh. cat., Natsoulas/Novelozo Gallery, Davis, Ca., June 15-July 15, 1990. 54 p.; *Roy De Forest: Retrospective,* exh. cat., San Francisco Museum of Art, March 29-May 12, 1974 and three other venues. 46 p.; Schlesinger, Ellen, "Adeliza and the Candy Store Bunch," *Connoisseur,* v. 217, November 1987, pp. 100+; Tromble, Meredith, "Conversation with Roy De Forest," *Artweek,* v. 24, June 3, 1993, p. 14.

DeLongpre, Paul (1855-1911). Watercolorist, Floral Still Lifes, Los Angeles, 1900+. Moure, Nancy Dustin Wall, *Loners, Mavericks & Dreamers,* exh. cat., Laguna Art Museum, Laguna Beach, Ca., November 26, 1993-February 20, 1994.

Denny, Gideon Jacques (1830-1886). Painter, Marines, San Francisco, Late Nineteenth Century. Arkelian, Marjorie, *Kahn Collection,* Art Department, The Oakland Museum, 1975.

De Patta, Margaret (1903-1964). Jeweler, Bay Area, 1940+. Cardinale, Robert and Hazel Bray, "Margaret de Patta: Structure, Concepts and Design Sources," *Metalsmith* v. 3, no. 2, Spring 1983, p. 12; *The Jewelery of Margaret de Patta,* exh. cat., The Oakland Museum, February-March 28, 1976. 73 p.

Deppe, Ferdinand (active California 1828-37). Painter, Landscapes, c. 1830s. Lichtenstein, Hinrich, *Ferdinand Deppe's Travels in California in 1837...,* Translated from the German by Gustave O. Arlt, Los Angeles: Dawson, 1953. 27 p.; Van Nostrand, Jeanne, *The First Hundred Years of Painting in California 1775-1875,* San Francisco: John Howell-Books, 1980.

Diebenkorn, Richard (1922-1993). Painter, Abstract Expressionist, Bay Area Figurative, 1945+. Nordland, Gerald, *Richard Diebenkorn,* New York: Rizzoli, 1987. 248 p.; Plous, Phyllis, *Richard Diebenkorn: Intaglio Prints 1961-1978,* exh. cat., Art Museum, University of California, Santa Barbara, 1979; *Richard Diebenkorn,* exh. cat., Whitechapel Art Gallery, London, October-December 1, 1991 and two other European venues. 149 p.; *Richard Diebenkorn, Etchings and Drypoints 1949-1980,* Houston: Houston Fine Art Press, 1981; *Richard Diebenkorn: Paintings and Drawings, 1943-1976,* exh. cat., Albright-Knox Art Gallery, Buffalo, N. Y., November 12, 1976-January 9, 1977 (published by Rizzoli, N. Y., 1980).

Dike, Philip Latimer (1906-1990). Watercolorist, Claremont, 1930+. Lovoos, J., "Phil Dike the Poetry of Painting," *American Artist,* v. 49, December 1979, pp. 34-37+; Lovoos, Janice and Gordon T. McClelland, *Phil Dike,* Beverly Hills: Hillcrest Press, 1988. 63 p.

Dixon, James Budd (1900-1967). Painter, Abstract Expressionist, San Francisco, 1945+. Landauer, Susan, *The San Francisco School of Abstract Expressionism,* exh. cat., Laguna Art Museum, Laguna Beach, Ca., January 27-April 21, 1996.

Dixon, Lafayette Maynard (1875-1946). Painter/Muralist, Subjects of the American West, San Francisco, 1900+. Burnside, Wesley M., *Maynard Dixon: Artist of the West,* Provo, Ut.: Brigham Young University Press, 1971. 237 p.; Hagerty, Donald J., *Desert Dreams: The Art and Life of Maynard Dixon,* Layton, Ut.: Gibbs-Smith Publisher, 1993. 272 p.; Schnoebelen, Anne, "Relics of Ephemeral Glory: The Treasure Island Murals of Maynard Dixon," *Art of California,* v. 5, no. 4, September 1992, pp. 53-55.

Dong, James (active 1970+). Muralist/Painter, San Francisco, 1970+. Drescher, Tim, *San Francisco Bay Area Murals: Communities Create Their Muses, 1904-1997,* St. Paul, Mn.: Pogo Press, 1998; "Social Documentation," *Artweek,* v. 10, April 28, 1979, p. 12.

Dowd, Robert (1936-1996). Painter, Pop, Los Angeles, 1960+. Fox, Louis, "Pop Art's Forgotten Paragon," *Artweek,* v. 18, April 11, 1987, p. 3; *L A*

Pop in the Sixties, exh. cat., Newport Harbor Art Museum, Newport Beach, Ca., April 20–July 9, 1989 and four other venues; Schreck, Edward H., *Robert Dowd: Work of the '60s,* New York: Edward H. Schreck, 1987. 1 vol.

Duhaut-Cilly, Auguste Bernard (1790-1849). Painter, Topographical, California, 1827-28. Van Nostrand, Jeanne, *First Hundred Years of Painting in California,* San Francisco: John Howell-Books, 1980.

Duvall, Fannie Eliza (1861-1934). Painter, Impressionist, Los Angeles, Late Nineteenth-Early Twentieth Century. Trenton, Patricia, ed., *Independent Spirits: Women Painters of the American West 1890-1945,* Autry Museum of Western Heritage in association with the University of California Press, Berkeley, 1995.

Eaton, Charles Frederick (1842-1930). Craftsworker, Santa Barbara, Turn of the Twentieth Century. Trapp, Kenneth R., et al., *Living the Good Life: The Arts and Crafts Movement in California,* The Oakland Museum in association with Abbeville Press, New York, 1993.

Edmondson, Leonard (b. 1916). Etcher/Painter, Los Angeles, Post-WWII. *Leonard Edmondson interviewed by Merle Solway Schipper,* Oral History Program, University of California, Los Angeles, 1983. 167 l.; *Edmondson: Color Etchings 1951-1967,* exh. cat., San Francisco Museum of Art, October 31–November 26, 1967. 19 p.; Edmondson, Leonard, *Etching,* New York: Van Nostrand Reinhold Co., 1973. 136 p.

Edouart, Alexander (1818-1892). Painter, Landscapes, Northern California, Late Nineteenth Century. Driesbach, Janice T., et al., *Art of the Gold Rush,* exh. cat., The Oakland Museum of California, January 24–May 31, 1998 and two other venues; Giffen, Helen S., *Blessing of the Enrequita Mine, New Almaden,* San Francisco: Book Club of California Treasures of California Collections no. 2, 1956.

Falkenstein, Claire (1908-1997). Sculptress, Welded Metal, Los Angeles, Post-WWII. Brown, Betty, "The Decentered Artist," *Artweek,* v. 20, December 7, 1989, pp. 15-16; *Claire Falkenstein: Chance and Choice,* exh. cat., Jack Rutberg Fine Arts, Los Angeles, c. 1988; *Claire Falkenstein,* interviewed by Marjorie Rogers, Oral History Program, University of California, Los Angeles, 1982. 380 l.; Henderson, Maren Henry, *Claire Falkenstein, Problems in Sculpture and Its Redefinition in the Mid-Twentieth Century,* Ph. D. Thesis, University of California, Los Angeles, 1991. 341 l.; Larinde, N., "Claire Falkenstein," *Woman's Art Journal,* v. 1, Spring-Summer 1980, pp. 50-55; Plante, Michael, "Sculpture's Autre," *Art Journal,* v. 53, Winter 1994, pp. 66-72; Wolf, Toni, "Claire Falkenstein's Never-Ending Universe," *Metalsmith,* v. 11, Summer 1991, pp. 26-31.

Feitelson, Lorser (1898-1978). Painter, Post-Surrealist/ Hard-edge Abstraction, Los Angeles, 1930+. Heisler, Barry, "Lorser Feitelson," *Art of California,* v. 3, no. 4, July 1990, pp. 44-48; *Lorser Feitelson and Helen Lundeberg: A Retrospective Exhibition,* exh. cat., San Francisco Museum of Modern Art, October 2–November 16, 1980 and one other venue. 80 p.; *Lorser Feitelson,* interviewed by Fidel Danieli, Oral History Program, University of California, Los Angeles, 1982. 218 l.; Moran, D., "Post Surrealism," *Arts Magazine,* v. 57, December 1982, pp. 124-28.

Firks, Henry (active California 1849). Maker of a Town View, San Francisco, 1849. Hughes, Edan Milton, *Artists in California, 1786-1940,* San Francisco: Hughes Publishing Co., 1989, 2000.

Fisch, Arline (b. 1931). Jewelry maker, San Diego, 1960+. Fell, Jeannie Keefer, "Arline Fisch: the Art of Wearable Magic," *Metalsmith,* v. 8, Summer 1988, pp. 14-19; Fisch, Arline, *Textile Techniques in Metal: for Jewelers...,* Asheville, N. C.: Lark Books, 1996; Ramshaw, Wendy, "Ornamenting the Body," *American Craft,* v. 46, April/May 1986, pp. 10-17.

Fischinger, Oskar (1900-1967). Painter/filmmaker, Modernist, Los Angeles, 1936+. *Bildmusik: Art of Oskar Fischinger,* exh. cat., Long Beach Museum of Art, June 28–July 26, 1970. 24 p.; Moritz, Dr. William, "The Films of Oskar Fischinger," *Film Culture,* Nos. 58-60, New York: H. Gantt, 1974, pp. 37-188.

Ford, Henry Chapman (1828-1894). Landscapist, Santa Barbara, Late Nineteenth Century. Berney, Charlotte, "The Return of the Missions: Henry Chapman Ford's Serenely Beautiful Images are Windows on California History," *Antiques & Fine Art,* v. 6, no. 2, February 1989, pp. 59-62; Ford, Henry Chapman, *Etchings of California,* Santa Barbara?, Ca.: E. S. Spaulding, 1961. 92 p.; "Henry Chapman Ford Paintings on Display in March," *Mission Inn Foundation Newsletter,* February 1992, p. 1; Neuerburg, Norman, *An Artist Records the California Missions: Henry Chapman Ford,* San Francisco: Book Club of California, 1989. 100 p.; Neuerburg, Norman, "Ford Drawings at the Southwest Museum," *The Masterkey,* v. 54, no. 2, April–June 1980, pp. 60-64; Schiffer, Tim, "An Artist in Eden," [H. C. Ford] *Santa Barbara Magazine,* Winter 1997, pp. 50+.

Fortune, Euphemia Charlton (1885-1969). Landscapist, Monterey, Early Twentieth Century. Hernandez, Joe Farb, *Colors and Impressions: The Early Work of E. Charlton Fortune,* exh. cat., Monterey Peninsula Museum of Art, September 23, 1989–January 14, 1990, and two other venues; McGlynn, Betty Hoag, "By the Sea: The Lives and Works of M. DeNeale Morgan and E. Charlton Fortune...," *Antiques & Fine Art,* v. 7, no. 2, January/February 1990, pp. 84-91.

Foulkes, Llyn (b. 1934). Painter, Los Angeles, 1960+. *Llyn Foulkes: Between a Rock and a Hard Place,* exhibition initiated and sponsored by Fellows of Contemporary Art, Los Angeles, organized by Laguna Art Museum, Laguna Beach, Ca., October 28, 1995–January 21, 1996. 104 p.

Francis, Sam (1923-1994). Painter, Los Angeles, 1960+. Michaud, Yves, *Sam Francis,* Paris: Editions Daniel Papierski, 1992. 269 p.; *Monotypes of Sam Francis,* Stuttgart, Ger.: Daco-Verlag, 1994. 346 p.; *Sam Francis: Les Annees Parisiennes, 1950-1961,* exh. cat., Galerie Nationale du Jeu de Paume, Paris, December 12, 1995–February 18, 1996. 231 p.; *Sam Francis, Paintings, 1947-1972,* exh. cat., Albright-Knox Art Gallery, Buffalo, N. Y., September 11, 1972–March 18, 1973. 152 p.; *Sam Francis: the Shadow of Colors,* exh. cat., Kunstverein Ludwigsburg, and two other venues, published by Editions Stemmle, Zurich, 1995. 119 p.; *Sam Francis/ Pontus Hulten,* exh. cat., Kunst- und Ausstellungshalle der Bundesrepublik Deutschland, Bonn, February 12–April 4, 1993, and at the Los Angeles County Museum of Art. 471 p.; Selz, Peter, *Sam Francis,* [rev. ed.] New York: Abrams, 1982. 296 p.

Fries, Charles Arthur (1854-1940). Painter, Landscapes, Impressionist, San Diego, Early Twentieth Century. "Charles Fries," in Petersen, Martin E., *Second Nature: Four Early San Diego Landscape Painters,* exh. cat., San Diego Museum of Art, June 1–August 18, 1991; Dixon, Ben F., compl., ed., *"Too Late," The Picture and the Artist; a Tribute to the Dean,* [Associated Historians of San Diego Bicentennial, no. 5] San Diego, Ca.: D. Diego's Libreria, 1969. 106 p.

Frost, George Albert (1843-1907). Painter, Landscapes, Northern California, c. 1870s. Woodward, Kesler E., *Painting in the North: Alaskan Art in the Anchorage Museum of History and Art,* Anchorage, Alaska: Anchorage Museum of History and Art, 1993, p. 28.

Frost, John (1890-1937). Landscapist, Impressionist, Pasadena, 1919+. *Selections from the Irvine Museum,* exh. cat., The Irvine Museum, Irvine, Ca., July 10–September 11, 1993 and two other venues, p. 108.

Gamble, John Marshall (1863-1957). Landscapist, Impressionist, San Francisco/Santa Barbara, Early Twentieth Century. "John Marshall Gamble," in Ruth Westphal, *Plein Air Painters of California: the North,* Irvine, Ca.: Westphal Publishing, 1986.

Gaw, William Alexander (1891-1973). Painter, Still Lifes, Bay Area, 1920+. Moure, Nancy Dustin Wall, "William Gaw: The Science of Color," *Art of California,* v. 5, no. 5, November 1992, pp. 19-21.

Gay, August Francois Pierre (1890-1949). Painter, Society of Six, Oakland/Monterey, 1915+. "Gay," in Nancy Boas, *Society of Six: California Colorists,* San Francisco: Bedford Arts Publishers, 1988; Hernandez, Jo Farb, *Wonderful Colors: The Paintings of August Francois Gay,* exh. cat., Monterey Peninsula Museum of Art, January 30–May 30, 1993 and at Hearst Art Gallery, June 13–September 12, 1993. 28 p.

Gearhart, Frances (1869-1958). Printmaker, Pasadena, Early Twentieth Century. *Frances H. Gearhart: California Block Prints,* exh. cat., Cheney Cowles Museum, Eastern Washington State University, Spokane, 1990. 20 p.; *The Gearhart Sisters,* Los Angeles: Dawsons Book Shop, 1982.

Gee, Yun (1906-1963). Painter, Modernist, San Francisco, 1920s. Brodsky, Joyce, *The Paintings of Yun Gee,* exh. cat., William Benton Museum of Art, University of Connecticut, Storrs, and other museums between October 1979–November 1980. 72 p.; Cochrane, D., "Yun Gee Forgotten Synchromist Painter," *American Artist,* v. 38, March 1974, pp. 46-51+; Tannenbaum, J., "Yun Gee a Rediscovery," *Arts Magazine,* v. 54, May 1980, pp. 164-67.

Gilbert, Robert (1907-1988). Painter, Regionalist, Santa Ana, 1930s. "Robert Gilbert," in *A Time and Place: From the Ries Collection of California Painting,* exh. cat., The Oakland Museum, December 1, 1990–March 3, 1991, and two other venues.

Gile, Selden Connor (1877-1947). Painter, Society of Six, Oakland, 1915+. *A Feast for the Eyes: The Paintings of Selden Connor Gile,* exh. cat., Civic Arts Gallery, Walnut Creek, June 9–July 10, 1983; *Paintings by Selden Connor Gile 1877-1947...from the Collection of James L. Coran and Walter A. Nelson-Rees,* exh. cat., Sohlman Art Gallery, Oakland, Ca., December 5, 1982–January 31, 1983. 71 p. and Volume II published by WIM Fine Arts, Oakland, 1983; "Selden Gile," in Nancy Boas, *Society of Six: California Colorists,* San Francisco: Bedford Arts Publishers, 1988.

Goings, Ralph (b. 1928). Painter, Photorealist, Sacramento, Mid 1960+. "Ralph Goings," in Louis K. Meisel, *Photorealism,* New York: Abradale Press, Harry N. Abrams, Inc., 1989; Chase, Linda, *Ralph Goings,* New York: Abrams, 1988. 120 p.

Golitzen, Alexander (b. 1908). Motion Picture Art Director, Los Angeles, 1931+. Hall, Barbara, interviewer, *Alexander Golitzen,* Oral History Program, Academy of Motion Picture Arts and Sciences; Center for Motion Picture History, 1992.

Goode, Joe (b. 1937). Painter, Pop, Los Angeles, 1960+. *Joe Goode,* exh. cat., Orange County Museum of Art, January 26–April 13, 1997. 82 p.; *Joe Goode: Work until Now,* exh. cat., Fort Worth Art Center, Fort Worth, Tx., n. d., 1972. 30 p.; *Joe Goode,* exh. cat., Orange County Museum of Art, Newport Beach, Ca., January 26–April 13, 1997; *LA Pop in the Sixties,* exh. cat., Newport Harbor Art Museum, Newport Beach, Ca., April 20–July 9, 1989 and four other venues; Scott, Sue, *Joe Goode, Jerry McMillan, Edward Ruscha,* exh. cat., Oklahoma City Art Museum, July 14–September 3, 1989 and one other venue. 112 p.

Graham, Robert (b. 1938). Sculptor, Realist, Los Angeles, 1960+. *Robert Graham,* exh. cat., Instituto Nacional de Bellas Artes, Museo del Palacio de Bellas Artes, Mexico, Agosto a Noviembre, 1997. 191 p.

Gramatky, Hardie (1907-1979). Watercolorist, Los Angeles, 1930+. *Hardie Gramatky Painter (1907-1979): A Retrospective View,* exh. cat., Stary Sheets Art Gallery, Gualala, Ca., July 1–26, 1989.

Gray, Henry Percy (1869-1952). Watercolorist, Tonalist, Bay Area, Early Twentieth Century. *Percy Gray (1869-1952) an Exhibition and Sale of Thirty Works by this Major Artist,* Stewart Galleries, Palm Springs, January 5–20, 1991. 21 p.; Whitton, Donald C. and Robert E. Johnson, *Percy Gray 1869-1952,* exh. cat., California Historical Society, San Francisco, December 1, 1970-January 23, 1971. 94 p.

Greene, Charles Sumner (1868-1957) & Greene, Henry Mather (1870-1954). Architects, Furniture Designers, Craftsman Style, Pasadena, Early Twentieth Century. Makinson, Randell, *Greene & Greene,* Salt Lake City, Ut.: Peregrine Smith, c. 1977-1979. 2 vol.

Grey, Camille (active 1972). Site Installations, Feminist, Los Angeles, 1960s. Broude, Norma, ed., *The Power of Feminist Art,* New York: Harry N. Abrams, Inc., 1994.

Griffith, William Alexander (1866-1940). Painter/Pastellist, Landscapes, Laguna Beach, 1910+. "William Alexander Griffith," in Ruth Westphal, *Plein Air Painters of California: the Southland,* Irvine, Ca.: Westphal Publications, 1982.

Gronk (Glugio Gronk Nicandro) (b. 1954). Painter, Chicano, Los Angeles, 1970+. Yanez, Rene, *Gronk! A Living Survey 1973-1993,* exh. cat., Mexican Museum, San Francisco, August 4–November 21, 1993 and two other venues. 40 p.

Hahn, Karl Wilhelm (William) (1829-1887). Painter, Portraits/Genre, San Francisco, 1872-84. Arkelian, Marjorie Dakin, "William Hahn: German-American Painter of the California Scene," *American Art Review,* v. 4, August 1977, pp. 102-15; Arkelian, Marjorie Dakin, *William Hahn Genre Painter 1829-1887,* exh. cat., The Oakland Museum, June 15–August 29, 1976. 81 p.

Haight-Ashbury Muralists. Muralists, San Francisco, Late 1960s. Drescher, Tim, *San Francisco Bay Area Murals: Communities Create Their Muses, 1904-1997,* St. Paul, Mn.: Pogo Press, 1998, pp. 29-31.

Haley, John (1905-1991). Watercolorist, Modernist, Berkeley, 1935+. *John Haley a Retrospective,* exh. cat., Richmond Art Center, Richmond, Ca., September 22–November 21, 1993 and one other venue. 63 p.

Hammersley, Frederick (b. 1919). Painter, Hard-Edge Abstractions, Los Angeles, 1950+. *Frederick Hammersley: A Retrospective Exhibition,* exh. cat., Art Museum, University of New Mexico, Albuquerque, N. M., October 12–November 16, 1975; Shields, Kathleen, "Paintings from Left Field," *Art in America,* v. 79, January 1991, pp. 124-27.

Hamrol, Lloyd (b. 1937). Site Installations, Los Angeles, 1960+. *Lloyd Hamrol: Works, Projects, Proposals,* exh. cat., Municipal Art Gallery, Los Angeles, March 18–April 13, 1986; Schipper, M., "Public Sculpture and the Urban Community: Recent Work by Lloyd Hamrol," *Journal: a Contemporary Arts Magazine,* v. 3, September-October 1981, pp. 32-36.

Hansen, Armin Carl (1886-1957). Painter, Post-Impressionist, Monterey, Early Twentieth Century. *Armin Hansen: The Jane and Justin Dart Collection,* Monterey, Ca.: Monterey Peninsula Museum of Art, 1993. 75 p.; Seavey, Kent L., "Armin Hansen," *Monterey Life,* March 1982; White, Anthony, *Graphic Art of Armin C. Hansen: A Catalogue Raisonne,* Los Angeles: Hennessey & Ingalls, 1986. 194 p.

Hansen, Ejnar (1884-1965). Painter, Figures and Still Lifes, Pasadena, 1925+. *Ejnar Hansen 1884-1965: A Retrospective Exhibition,* exh. cat., James M. Hansen, Santa Barbara, Ca., September 30–October 31, 1984. 24 p.; Moure, Nancy Dustin Wall, "Ejnar Hansen," *Art of California,* v. 3, no. 1, January 1990, pp. 29-34.

Hansen, Herman Wendelborg (1854-1924). Watercolorist, Western Subjects, San Francisco, Turn of the Twentieth Century. "H. W. Hansen," *California Art Research,* San Francisco, Ca., 1936-37, v. 9, pp. 89-104.

Hardy, Don-Ed (b. 1945). Tattooist/Painter, San Francisco, 1960+. *Don Ed Hardy Permanent Curios,* Santa Monica, Ca.: Smart Art Press, 1997. 22 p.

Harmer, Alexander Francis (1856-1925). Painter, Historical Genre, Santa Barbara, Late Nineteenth-Early Twentieth Century. *Alexander F. Harmer 1856-1925,* exh. cat., James M. Hansen Galleries, Santa Barbara, Ca., September 27–October 16, 1982.

Harrington, Joseph A. (1841-1890). Portrait Painter, San Francisco, Late Nineteenth Century. Jones, Harvey L., *San Francisco The Painted City,* Salt Lake City, Ut.: Gibbs-Smith Publisher, 1992.

Harris, Sam Hyde (1889-1977). Painter, Impressionist Landscapes, Los Angeles, 1920+. *Paintings of Sam Hyde Harris (1889-1977): A Retrospective Exhibition,* exh. cat., Petersen Galleries, Beverly Hills, Ca., 1980. 64 p.

Hassam, Frederick Childe (1859-1935). Painter, Impressionist, Northern California, 1914. Hiesinger, Ulrich, *Childe Hassam: American Impressionist,* New York: Prestel, 1994. 191 p.

Hayakawa, Miki (1904-1953). Painter, Bay Area/New Mexico, 1930+. Brown, Michael D., *Views from Asian California, 1920-1965,* San Francisco: Michael Brown, 1992.

Hayter, Stanley William (1901-1988). Etcher, Experimental, San Francisco, Summer 1940, 1948. Anderson, Susan M., *Pursuit of the Marvelous: Stanley William Hayter, Charles Howard, Gordon Onslow Ford,* exh. cat., Laguna Art Museum, October 5, 1990–January 13, 1991. 64 p.; Black, Peter, *The Prints of Stanley William Hayter: a Complete Catalogue,* Mount Kisco, N. Y.: Moyer Bell, 1992. 400 p.

Hedrick, Wally (b. 1928). Painter/Teacher, Bay Area, 1955+. *Wally Hedrick Selected Works,* exh. cat., San Francisco Art Institute, April 10–May 11, 1985. 32 p.

Heinecken, Robert (b. 1931). Photographer/Teacher, University of California, Los Angeles, 1960+. *Heinecken,* Carmel, Ca.: Friends of Photography in association with Light Gallery, 1980. 158 p.

Helder, Zelma Vanessa (1904-1968). Watercolorist, Precisionist, Los Angeles, 1940+. Gordon, Joni, "Z. Vanessa Helder," *LAICA Journal,* no. 5, April-May 1975, pp. 40-41; Trenton, Patricia, ed., *Independent Spirits: Women Painters of the American West, 1890-1945,* Autry Museum of Western Heritage, Los Angeles, in association with the University of California Press, Berkeley, 1995.

Herman, Roger (b. 1947). Painter, Expressive Figurals, Bay Area/Los Angeles, 1980+. Brody, Jacqueline, "Roger Herman: A New Expressionist?" *Print Collector's Newsletter,* v. 15, January-February 1985, pp. 200-5; *Hanne Braun, Galli, Roger Herman, Max Neumann,* exh. cat., Stadtgalerie Saarbrücken, April 10 – May 25, 1986. 62 p.; *Roger Herman: Malerei,* Lichthof der Staatlichen Akademie der Bildenden Kunste, Karlsruhe, June 25–July 17, 1982. 40 p.

Hernandez, Ester (b. 1944). Printmaker, Chicano, San Francisco, 1970+. Mesa-Bains, Amalia, *Ester Hernandez,* San Francisco, Ca.: Galeria de la Raza, 1988. 4 p. [Artist Monograph series, no. 1]

Herron, Willi (b. 1951). Muralist, Chicano, Los Angeles, 1970s. See his website.

Hershman, Lynn (b. 1941). Video/Performance Artist, Northern California, 1960+. Dent, Tory, "First Person Plural, The Work of Lynn Hershman," *Arts Magazine,* v. 65, November 1990, pp. 87-89; Hershman, Lynn, "Bodyheat: Interactive Media and Human Response," *High Performance,* v. 10, no. 1, 1987, pp. 45-47; Hershman, Lynn, "The Fantasy Beyond Control: Lorna and Deep Contact," *Art and Design,* v. 9, November/December 1994, pp. 32-37; Hershman, Lynn, "Touch Sensitivity and Other Forms of Subversion: Interactive Artwork," *Leonardo,* v. 26, no. 5, 1993, pp. 431-36; Jan, Alfred, "Lynn Hershman: Processes of Empowerment," *High Performance,* v. 8, no. 4, 1985, pp. 36-38; *Lynn Hershman,* Montbeliard, Belfort [Fr.]: Edition du Centre International de Creation Video, 1992. 135 p.; Reiter, Michael, "Lynn Hershman: the Individual as a Victim of Media Aggression," *Novum,* September 1996, pp. 46-49; Tamblyn, Christine, "Lynn Hershman's Narrative Anti-Narratives," *Afterimage,* v. 14, Summer 1986, pp. 8-10.

Herter, Adele (1869-1946). Painter/Muralist, Santa Barbara, 1920+. Trenton, Patricia, ed., *Independent Spirits: Women Painters of the American West, 1890-1945,* Autry Museum of Western Heritage, Los Angeles, in association with the University of California Press, Berkeley, 1995.

Herter, Albert (1871-1950). Painter/Muralist, Santa Barbara, 1920+. Howe, Katherine S., et al., *Herter Brothers: Furniture and Interiors for a Gilded Age,* New York: H. N. Abrams and Museum of Fine Arts, Houston, 1994.

Herzog, Herman (1831-1932). Painter, Landscapes, California, 1874. Lewis, Donald S., Jr., et al., *American Paintings of Herman Herzog,* exh. cat., Brandywine River Museum, Chadds Ford, Pa., September 12–November 22, 1992 and two other venues; Lewis, Donald S., Jr., "Herman Herzog (1831-1932) German Landscapist in America," *American Art Review,* v. 3, July-August 1976, pp. 52-66.

Hibi, Matsusaburo ("George") (1886-1947). Painter, Bay Area, Topaz Relocation Camp, 1930+. Brown, Michael D., *Views from Asian California, 1920-1965,* San Francisco: Michael Brown, 1992; *The View from Within: Japanese American Art from the Internment Camps, 1942-1945,* exh. cat., Japanese American National Museum and UCLA Wight Art Gallery, October 13–December 6, 1992.

Hill, Thomas (1829-1908). Painter, Landscape, Northern California, Second half Nineteenth Century. Arkelian, Marjorie Dakin, *Thomas Hill: The Grand View,* exh. cat., Oakland Museum Art Department, September 23 –November 16, 1980 and four other venues. 64 p.; Driesbach, Janice T., *Direct from Nature: The Oil Sketches of Thomas Hill,* Yosemite Association in association with the Crocker Art Museum, Sacramento, Ca., 1997 [cat. of exh. held January 24–March 9, 1997 and at other venues]. 126 p.; George, Hardy, "Thomas Hill's Driving of the Last Spike, A Painting Commemorating the Completion of America's Transcontinental Railroad," *Art Quarterly,* v. 27, Spring 1964, pp. 83-93; George, Hardy, *Thomas Hill (1829-1908),* M.A. Thesis, University of California, Los Angeles, 1963. 2 v.

Hinkle, Clarence Keiser (1880-1960). Painter/Teacher, Post-Impressionist, Santa Barbara, c. 1915+. "Clarence Hinkle," in Ruth Westphal, *Plein Air Painters of California: The Southland,* Irvine, Ca.: Westphal Publishing, 1982.

Hobart, Clark (1868-1948). Painter, Post-Impressionist, Northern California, Early Twentieth Century. "Clark Hobart," in Ruth Lilly Westphal, *Plein Air Painters of California: The North,* Irvine, Ca.: Westphal Publishing, 1986; "Clark Hobart," *California Art Research,* San Francisco: Works Progress Admin., 1936-37, v. 12, pp. 77-103; Moser, Joann, *Singular Impressions: The Monotype in America,* published for the National Museum of American Art by Smithsonian Institution Press, Washington and London, 1997.

Hockney, David (b. 1937). Painter, Pop, Los Angeles, Mid 1960+. Livingstone, Marco, *David Hockney,* New York: Thames & Hudson, 1996; Livingstone, Marco, *Hockney in California,* Tokyo: Art Life, 1994. 157 p.

Hord, Donal (1902-1966). Sculptor, Regionalist, San Diego, 1925+. Ellsberg, H., "Donal Hord: Interpreter of the Southwest," *American Art Review,* v. 4, December 1977, pp. 76-83, 126-30; Kamerling, Bruce, "Like the Ancients: The Art of Donal Hord," (including catalogue raisonne), *Journal of San Diego History,* v. XXXI, no. 3, Summer 1985.

Howard, Charles Houghton (1899-1978). Painter, Abstract Surrealist, San Francisco, 1940+. Anderson, Susan, *Pursuit of the Marvelous: Stanley William Hayter, Charles Howard, Gordon Onslow Ford,* exh. cat., Laguna Art Museum, Laguna Beach, Ca., October 5, 1990–January 13, 1991. 64 p.; *Charles Howard 1899-1978, Drama of the Mind,* exh. cat., Hirschl & Adler Galleries, N. Y., May 1–June 18, 1993. 43 p.

Howard, John Langley (b. 1902). Painter, Regionalist, Bay Area, 1930+. "John Langley Howard," in Ruth Westphal, et al., *American Scene Painting: California, 1930s and 1940s,* Irvine, Ca.: Westphal Publishing, 1991; Moss, Stacey, *The Howards: First Family of Bay Area Modernism,* exh. cat., The Oakland Museum, May 14–August 7, 1988.

Howard, Robert Boardman (1896-1983). Sculptor, Bay Area, Mid Twentieth Century. Moss, Stacey, *The Howards: First Family of Bay Area Modernism,* exh. cat., The Oakland Museum, May 14–August 7, 1988. 120 p.

Hrdy, Olinka (1902-1987). Painter/Designer, Abstractionist, Los Angeles, mid 1930+. d'Ucel, Jeanne, "Olinka Hrdy: Her Genius Wins Applause in the Art World Through Modern Masterpieces," *The Sooner Magazine,* July 1929, pp. 344-45, 368, 370; *Olinka Hrdy,* Oral Interview, Archives of American Art, Smithsonian Institution, Washington, D. C., 1965; Trenton, Patricia, ed., *Independent Spirits: Women Painters of the American West 1890-1945,* Autry Museum of Western Heritage in association with the University of California Press, Berkeley, 1995.

Hubbell, James (b. 1931). Sculptor/Glassmaker, San Diego, Second Half Twentieth Century. Cleigh, Zenia, "Paradise Found: Jim Hubbell's Mythical Realm Near Julian," *San Diego Magazine,* v. 31, no. 4, February 1979, pp. 102-15; Rigan, Otto, *From the Earth Up* [biography of James Hubbell], New York: McGraw-Hill, 1979. 113 p.

Hudson, Grace Carpenter (1865-1937). Painter of Native Americans, Ukiah, Turn of the Twentieth Century. Boynton, Searles R. *The Painter Lady: Grace Carpenter Hudson,* Eureka, Ca.: Interface California, 1978. 186 p.; Hjalmarson, B., "Grace Carpenter Hudson 1865-1937: Illuminating the Pomo Lifeway," *Southwest Art,* v. 13, July 1983, pp. 62-69; *The Pomo: Gifts and Visions: Paintings of Pomo Indians by Grace Carpenter Hudson (1865-1937),* exh. cat., Palm Springs Desert Museum, February 4–June 3, 1984 and at other venues.

Hudson, Robert (b. 1938). Sculptor, Polychrome School, San Francisco, 1960+. *Robert Hudson, a Survey,* exh. cat., San Francisco Museum of Modern Art, June 27–August 8, 1985. 80 p.; *Robert Hudson, Sculpture, William T. Wiley, Painting,* exh. cat., Rose Art Museum, Brandeis University, Waltham, Ma., May 12–July 28, 1991. 50 p.

Hunt, Thomas Lorraine (1882-1938). Painter, Impressionist Landscapes, Southern California, 1925+. "Thomas Hunt," in Ruth Lilly Westphal, *Plein Air Painters of California: The Southland,* Irvine, Ca.: Westphal Publishing, 1982.

Hurrell, George (1904-1992). Photographer, Hollywood Glamour, 1930+. *Hurrell's Hollywood: Photographs 1928-1990,* New York: Saint Martin's Press, 1992; Stine, Whitney, *The Hurrell Style: 50 Years of Photographing Hollywood,* New York: The John Day Company, 1976 (republished New York: Greenwich House, 1983). 218 p.

Hyde, Helen (1868-1919). Printmaker, Color Woodblocks, San Francisco, Turn of the Twentieth Century. Jaques, Bertha E., *Helen Hyde and Her Work: an Appreciation,* Chicago: The Libby Co., 1922. 41 p.; Mason, Tim and Lynn Mason, *Helen Hyde,* Washington, D. C.: Smithsonian Institution Press, 1991. 120 p.

Inness, George (1825-1894). Painter, Tonalist, Bay Area, 1891. Quick, Michael, *George Inness,* exh. cat., Los Angeles County Museum of Art with New York: Harper & Row, 1985.

Irwin, Robert (b. 1928). Painter, Minimal/Perception, 1960+. Irwin, Robert, *Being and Circumstance: Notes Toward a Conditional Art,* Lapis Press: Larkspur Landing, Ca., 1985 [published in conjunction with a show at The Pace Gallery, N. Y., September 13–October 12, 1985 and at the San Francisco Museum of Modern Art, September 29–November 24, 1985]. 157 p.; Plagens, P., "Robert Irwin's Bar Paintings," *Artforum,* v. 17, March 1979, pp. 41-43; "Robert Irwin," in Jan Butterfield, *The Art of Light and Space,* New York: Abbeville Press, 1993; *Robert Irwin,* exh. cat., Museum of Contemporary Art, Los Angeles, June 20–August 15, 1993. 208 p.; *Robert Irwin,* interviewed by Frederick S. Wight, Oral History Program, University of California, Los Angeles, 1977. 284 l.; Weschler, Lawrence, *Seeing is Forgetting the Name of the Thing One Sees: A Life of Contemporary Artist Robert Irwin,* Berkeley: University of California Press, 1982. 212 p.

Jackson, Everett Gee (1900-1995). Painter, Regionalist, San Diego, 1930+. Jackson, Everett Gee, *Burros and Paintbrushes: A Mexican Adventure,* College Station, Tx.: Texas A & M University Press, 1985. 151 p.; Jackson, Everett Gee, *Four Trips to Antiquity,* San Diego: San Diego State University, 1991. 173 p.; Jackson, Everett Gee, *Goat Tails and Doodlebugs: a Journey Toward Art,* San Diego: San Diego State University Press, 1993. 250 p.; Jackson, Everett Gee, *It's a Long Road to Comondu, Mexican Adventures since 1928,* College Station, Tx.: Texas A & M University Press, 1987. 160 p.

Jenkins, Thomas W. (b. 1943). Painter, Ecologist, Los Angeles, Late Twentieth Century. Howell, John, "Artist in Lotusland," *High Times,* October 1985, pp. 46-49; Lazzari, Margaret, "Decline and Fall of the Metropolis," *Artweek,* v. 19, no. 42, December 10, 1988, cover and p. 2; Weisberg, Ruth, "Continuing and Recommended: Tom Jenkins," *Artscene,* January 1984, pp. 7-8; Weisberg, Ruth, "Tom Jenkins, Natural Magic, Human Folly," *Images & Issues,* September/October 1982, pp. 28-30.

Jess (Collins) (b. 1923). Collage Artist/ Painter, San Francisco, 1950+. Auping, Michael, *Jess: Paste-Ups (and Assemblies) 1951-1983,* exh. cat., The John and Mable Ringling Museum of Art, Sarasota, Fla., December 9, 1983–February 5, 1984; Auping, Michael, et al., *Jess: a Grand Collage, 1951-1993,* exh. cat., Albright-Knox Art Gallery, Buffalo, N. Y., 1993.

Jewett, William Smith (1812-1873). Portrait Painter, Northern California, Late Nineteenth Century. Driesbach, Janice T., et al., *Art of the Gold Rush,* exh. cat., The Oakland Museum of California, January 24–May 31, 1998 and two other venues; Evans, Elliot A. P., "The Promised Land," *Society of California Pioneers, Quarterly Newsletter,* v. 8, November 1957, pp. 2-12; William Truetner, "Reinterpreting Images of Westward Expansion," *Magazine Antiques,* v. 139, March 1991, pp. 542–55.

Johnson, Frank Tenney (1874-1939). Painter, Themes of the American West, Los Angeles, 1925+. McCracken, Harold, *The Frank Tenney Johnson Book: A Master Painter of the Old West,* Garden City, N. Y.: Doubleday, 1974. 207 p.; Ryner, J., "A Classic: Frank Tenney Johnson," *Southwest Art,* v. 9, October 1979, pp. 72-77.

Johnson, Sargent Claude (1888-1967). Sculptor, Regionalist, San Francisco, 1930+. "Sargent Johnson," in Yvonne Greer Thiel, *Artists and People,* New York: Philosophical Library, 1959; *Sargent Johnson: Retrospective,* exh. cat., The Oakland Museum, February 23–March 21, 1971. 35 p.

Johnston, Ynez (b. 1920). Painter, Fantasy, Los Angeles, Post-WWII+. Berry, J., "View from the Wind Palace," *Mankind* (Magazine of Popular History), v. 5, pt. 1, 1975, pp. 43-45+; Nordland, Gerald, *Ynez Johnston,* Kennedy Museum of American Art, Ohio University, in conjunction with Grassfield Press, Miami Beach, Fla., 1996; *Ynez Johnston: Graphic Work, 1949-1966,* San Francisco Museum of Art, 1967.

Joseph, Richard (b. 1939). Painter, New Realism, Figures, Los Angeles, 1970+. Gerrit, Henry, "Richard Joseph at Benedek," *Art in America,* v. 63, March/April 1975, pp. 91-92; Kultermann, Udo, *The New Painting,* Boulder, Colo.: Westview Press, 1977; Kulterman, Udo, *New Realism,* Greenwich, Ct.: New York Graphic Society, 1972; Powell, Earl, *Catalogue of the James A. Mitchener Collection,* University of Texas, 1977; Ward, John L., *American Realist Painting 1945-1980,* Ann Arbor, Mi.: UMI Research Press, 1989, pp. 338-40.

Judson, Charles Chapel (1864-1946). Painter, San Francisco/Monterey, Late Nineteenth Century. Hughes, Edan, *Artists in California 1786-1940,* San Francisco: Hughes Publishing Co., 1989.

Kadish, Reuben (1913-1992). Muralist, Post-Surrealist, Los Angeles, 1930s. *Reuben Kadish,* exh. cat., University Art Gallery, State University of New York, Stony Brook, June 10–August 1, 1992; *Reuben Kadish Survey: 1935-1985,* exh. cat., Artists Choice Museum, New York, January 11–February 22, 1986. 24 p.

Kassler, Charles Moffat Jr. (1897-1979). Muralist, FAP, Los Angeles, 1930s. Hughes, Edan, *Artists in California, 1786-1940,* San Francisco: Hughes Publishing Co., 1989, 2000.

Katz, Leo (1887-1982). Muralist, PWAP, Los Angeles, 1930s. Moure, Nancy D. W., *Painting and Sculpture in Los Angeles, 1900-1945,* exh. cat., Los Angeles County Museum of Art, September 25–November 23, 1980, p. 47; Schwankovsky, F.J., "Mural in Search of a Wall," *California Arts and Architecture,* v. 48, October 1935, pp. 15ff.

Kauffman, Craig (b. 1932). Painter, "Los Angeles Look," 1960+. *Craig Kauffman: A Comprehensive Survey, 1957-1980,* exh. cat., La Jolla Museum of Contemporary Art, March 14–May 3, 1981. 94 p.; *Craig Kauffman,* interviewed by Michael Auping, Oral History Program, University of California, Los Angeles, 1984. 239 l.

Keith, William (1838-1911). Painter, Landscapes, Northern California, 1860+. Cornelius, Brother, *Keith, Old Master of California,* New York: Putnam, 1942-57. 2 v.; Harrison, Alfred C., Jr., *William Keith: The Saint Mary's College Collection,* exh. cat., Hearst Art Gallery, Saint Mary's College of California, Moraga, Ca., June 11–October 9, 1988. 115 p.; *Watercolors of William Keith: 1838-1911,* exh. cat., Hearst Art Gallery, Saint Mary's College, January 14–March 7, 1979. 30 p.

Kienholz, Edward (1927-1994). Assemblage Artist, Los Angeles, 1950+. *Kienholz: A Retrospective,* Whitney Museum of American Art in association with D. A. P., February 29–June 2, 1996 and two other venues; Olson, Vibeke, *Woman's Image and its Role in the Art of Edward Kienholz,* 1990, Master's Thesis, California State University, Northridge, 1990; Pincus, Robert L., *On a Scale that Competes with the World: The Art of Edward and Nancy Reddin Kienholz,* Berkeley: University of California Press, 1990.

King, Albert Henry (1900-1982). Ceramist, Los Angeles, 1930+. Bray, Hazel V., *The Potter's Art in California, 1885-1955,* exh. cat., The Oakland Museum, August 22–October 1, 1978 and one other venue, pp. 52-53.

King, Susan E. (b. 1947). Book Artist, Los Angeles, Late Twentieth Century. "Artists' Writings: Susan E. King's I Spent the Summer in Paris," *Art Journal,* v. 49, Winter 1990, pp. 348-55; Davids, Betsy, "Lessons from the South," *Fine Print,* v. 13, April 1987, pp. 98-100; Hoffberg, Judith A., "Fusing Text and Image, A Conversation with Susan E. King," *Artweek,* v. 22, June 6, 1991, pp. 19-20; King, Susan E., *Threading the Maze: an Artist's Journey Through Breast Cancer,* San Francisco: Chronicle Books, 1997.

Kingman, Dong (b. 1911). Watercolorist, San Francisco/New York, 1950+. Gruskin, Alan D., *The Water Colors of Dong Kingman and How the Artist Works,* New York: Studio Publications, 1958. 136 p.; Kingman, Dong and Helena Kuo Kingman, *Dong Kingman's Watercolors,* New York: Watson-Guptill, 1980. 143 p.; Kingman, Dong, *Paint the Yellow Tiger,* New York: Sterling Publ. Co., 1991. 182 p.; Wilson, Raymond L., "Dong Kingman," *Art of California,* v. 3, no. 6, November 1990, pp. 60-64.

Kleitsch, Joseph (1882-1931). Painter, Laguna Beach, 1920s. Trenton, Patricia, "Joseph Kleitsch: A Kaleidoscope of Color," in Patricia Trenton and William H. Gerdts, *California Light 1900-1930,* exh. cat., Laguna Art Museum, Laguna Beach, Ca., and several other venues, 1990, pp. 137-56.

Kosa, Emil, Jr. (1903-1968). Painter, Watercolors/Oils, Landscapes/Figures, Los Angeles, 1930+. McClelland, Gordon T., *Emil Kosa Jr. 1903-1968,* Beverly Hills, Ca.: Hillcrest Press, 1990. 71 p.

Krasnow, Peter (1887-1979). Painter/Sculptor, Modernist, Los Angeles, 1925+. *Drawings,* Los Angeles, 1967. 78 p. chiefly illus.; *Peter Krasnow: a Retrospective Exhibition,* exh. cat., Los Angeles Municipal Art Gallery, February 26–March 23, 1975. 18 p.

Kuntz, Roger (1926-1975). Painter, Realist, Los Angeles, 1950+. McGee, Mike, "Roger Kuntz," *Art of California,* v. 3, no. 6, November 1990, pp. 30-35.

L. A. Fine Arts Squad. Mural Group, Photorealism, Los Angeles, early 1970s. *Vapor Dreams in L.A.: Terry Schoonhoven's Empty Stage,* exh. cat., University Art Museum, California State University, Long Beach, November 15–December 12, 1982. 40 p.

Lacy, Suzanne (b. 1945). Performance Artist, Writer, Feminist, 1970+. Fisher, Jennifer, "Interperformance," *Art Journal,* v. 56, Winter 1997, pp. 28-33; Lacy, Suzanne, "Love, Memory, Cancer: A Few Stories," *Public Art Review,* v. 7, Spring/Summer 1996, pp. 5-13; *Making Space: Suzanne Lacy...,* exh. cat., Presentation House Gallery, Vancouver, 1988. 28 p.

Landacre, Paul Hambleton (1893-1963). Wood Engraver, Los Angeles, 1930+. Landacre, Paul, *California Hills and other Wood Engravings,* foreword by Arthur Millier, Los Angeles: B. McCallister, 1931. 19 p.; Lehmann, Anthony, *Paul Landacre: A Life and a Legacy,* Los Angeles: Dawsons, 1983. 198 p.; "Paul Landacre," *Art of California (Fine Art & Antiques International),* v. 6, no. 6, November-December 1993, pp. 70-71.

Lange, Dorothea (1895-1965). Photographer, Depression Documentary, Bay Area, 1935+. *Dorothea Lange: the Making of a Documentary Photographer,* interview by Suzanne Riess, Regional Oral History Program, University of California, Berkeley, 1968. 257 l.; Gelber, Steven M., "The Eye

of the Beholder: Images of California by Dorothea Lange and Russell Lee," *California History,* Fall 1985, pp. 264+; Heyman, Therese Thau, *Dorothea Lange: American Photographs,* San Francisco: San Francisco Museum of Modern Art and Chronicle Books, 1994. 192 p.; Partridge, Elizabeth, *Dorothea Lange—a Visual Life,* Washington: Smithsonian Institution Press, 1994. 168 p.; Tsujimoto, Karen, *Dorothea Lange: Archive of an Artist,* Oakland, Ca.: The Oakland Museum of California, 1995. 70 p.

Laurence, Sydney Mortimer (1865-1940). Painter, Landscapes, Los Angeles, 1920+. Laurence, Jeanne, *My Life with Sydney Laurence,* Seattle, Wa.: Salisbury Press Book, 1974. 159 p.; Woodward, Kesler E., *Sydney Laurence, Painter of the North,* exh. cat., Anchorage Museum of History and Art, Alaska, May 20–September 9, 1990. 140 p.

Lebrun, Frederico (1900-1964). Draughtsman/Painter, Figures, Los Angeles, 1940+. Goldman, Saundra Louise, *Interpretations of Dante in the Twentieth Century: Inferno Drawings by Rico Lebrun...,* M. A. Thesis, University of California, Berkeley, 1985. 143 l.; Oppler, Ellen C., *Rico Lebrun: Transformations/ Transfiguration,* exh. cat., Joe and Emily Lowe Art Gallery, Syracuse University School of Art, Syracuse, N. Y., November 13, 1983–January 18, 1984. 44 p.; *Rico Lebrun Drawings,* Berkeley: University of California Press, 1961. 100 p.; *Rico Lebrun (1900-1964),* exh. cat., Los Angeles County Museum of Art, December 5, 1967–January 14, 1968 and other venues. 78 p.; Weeks, Janet, *Mourning the Masses: Metaphorical Use of Crucifixion and the Magdalene as Evidenced in Artistic and Popular Response to World War II,* Ph. D. Thesis, Graduate Theological Union, Berkeley?, 1993. 74 l.

Lee, Chee Chin S. Cheung (1896-1966). Painter, Bay Area, 1920s/30s. Brown, Michael D., *Views from Asian California, 1920-1965,* San Francisco: Michael Brown, 1992; "Chee Chin S. Cheung Lee," *California Art Research,* San Francisco: Works Progress Administration, 1936-37, v. 20, pp. 16-31.

Lee, Joseph (1827-1880). Painter, Marine Scenes, Bay Area, Late Nineteenth Century. "Joseph Lee" in *California's Western Heritage,* exh. cat., Palm Springs Desert Museum, March 8–June 8, 1986, p. 54.

Leighton, Kathryn Woodman (1876-1952). Painter, Native Americans, Los Angeles, 1920+. Trenton, Patricia, ed., *Independent Spirits: Women Painters of the American West, 1890-1945,* Autry Museum of Western Heritage, Los Angeles, in association with the University of California Press, Berkeley, 1995.

Lewis, John Hardwicke (1842-1927). Painter, Landscapes, Los Angeles, mid 1800s. Moure, Nancy D. W., *Loners, Mavericks & Dreamers,* exh. cat., Laguna Art Museum, Laguna Beach, Ca., November 26, 1993–February 20, 1994.

Ligare, David (b. 1945). Painter, New Realist, Figures, Southern California, 1970+. *David Ligare: Paintings and Drawings,* exh. cat., Andrew Crispo Gallery, New York, September 23–October 14, 1978. 28 p.; Doherty, M. Stephen, "David Ligare," *American Artist,* v. 48, September 1984, pp. 34-39; White, Robin, "A Conversation with David Ligare," *Artweek,* v. 23, December 3, 1992, p. 26.

Light, Alvin (1931-1980). Sculptor, Abstract Expressionist, San Francisco, 1960+. *The Expressive Sculpture of Alvin Light,* exh. cat., Monterey Peninsula Museum of Art, Monterey, Ca., 1990. 45 p.

Lipofsky, Marvin (b. 1938). Glass Artist, East Bay, 1960+. Porges, Maria, "Artist and Educator: Marvin Lipofsky," *Neues-Glas,* no. 4, 1991, pp. 8-15; White, Cheryl, "Marvin Lipofsky: Roving Ambassador of Glass," *American Craft,* v. 51, October/November 1991, pp. 46-51.

Liu, Hung (b. 1948). Painter, Asian-American, 1970+. Ariell, Allison, "Cultural Collisions," *Woman's Art Journal,* v. 17, Spring-Summer 1996, pp. 35-40; *Hung Liu,* exh. cat., Rena Bransten Gallery, San Francisco, November 11–December 11, 1993. 28 p.; "Hung Liu," *Bulletin of the Allen Memorial Art Museum,* v. 47, no. 2, 1994, pp. 32-39; *Hung Liu: The Year of the Dog 1994,* exh. cat., Steinbaum Krauss Gallery, N. Y., February, 1994.

Lobdell, Frank (b. 1921). Painter, Abstract Expressionism, San Francisco, 1945+. *Frank Lobdell: Paintings and Monotypes,* exh. cat., San Francisco Museum of Modern Art, January 20–March 27, 1983. 55 p.; Jones, Caroline A., *Frank Lobdell: Works, 1947-1992,* exh. cat., Stanford University Museum of Art, January 12–April 25, 1993. 36 p.; Landauer, Susan, *The San Francisco School of Abstract Expressionism,* exh. cat., Laguna Art Museum, Laguna Beach, Ca., January 27–April 21, 1996.

Logan, Maurice George (1886-1977). Painter, Society of Six, Oakland, 1915+. "Maurice Logan" in Nancy Boas, *Society of Six: California Colorists,* San Francisco: Bedford Arts Publishers, 1988; Schenck, Marvin A., "Maurice Logan," *Art of California,* v. 4, no. 4, July 1991, pp. 12-17.

Lomas-Garza, Carmen (b. 1948). Painter, Chicana, San Francisco, 1975+. Mears, Peter and Amalia Mesa-Bains, *Carmen Lomas-Garza: Pedacito de mi Corazon,* exh. cat., Laguna Gloria Art Museum, Austin, Tx., October 26–December 8, 1991 and six other sites. 56 p.

Long, Richard (b. 1945). Earth Artist, England/California, 1970+. Christensen, Judith, "Re-creating Natural Harmony [red Baja California Circle]," *Artweek,* v. 20, September 23, 1989, p. 6; Long, Richard, *Mountains*

and Waters, New York: George Braziller, 1993; Long, Richard, *A Cooks Tour of World War II: from Yosemite to Utah Beach,* Ann Arbor, Mi.: Sabre Press, 1990; Long, Richard, *Walking in Circles,* New York: G. Braziller, 1991. 263 p.; Long, Richard, *Surf Roar,* La Jolla Museum of Contemporary Art, 1989; *Richard Long...,* New York: Thames & Hudson and Solomon R. Guggenheim Museum, 1986. 237 p.; Zelevansky, Lynn, "[Little Tejunga Canyon Line]," *Art News,* v. 83, October 1984, pp. 175+.

Loran, Erle (b. 1905). Watercolor/Gouache, Landscapes, Berkeley, mid 1935+. "Erle Loran" in Ruth Westphal, et al., *American Scene Painting: California, 1930s and 1940s,* Irvine, Ca.: Westphal Publishing, 1991.

Lukens, Glenn (1887-1967). Ceramist, Southern California, 1930+. Levin, E., "Glen Lukens," *Ceramics Monthly,* v. 30, May 1982, pp. 40-44; Levin, Elaine, *Glen Lukens: Pioneer of the Vessel Aesthetic,* exh. cat., Fine Arts Gallery, California State University, Los Angeles, January 4–February 11, 1982 and two other venues. 36 p.

Lundeberg, Helen (b. 1908). Painter, Post-Surrealist, Los Angeles, 1930+. *80th, a Birthday Salute to Helen Lundeberg,* exh. cat., Los Angeles County Museum of Art, October 27, 1988–January 8, 1989. 21 p.; *Helen Lundeberg,* interviewed by Fidel Danieli, Oral History Program, University of California, Los Angeles, 1977. 82 l.; *Lorser Feitelson and Helen Lundeberg: A Retrospective Exhibition,* exh. cat., San Francisco Museum of Modern Art, October 2–November 16, 1980. 80 p.

Lungren, Fernand Harvey (1859-1932). Painter/Illustrator, Desert Landscapes, Santa Barbara, 1905+. Berger, John A., *Fernand Lungren: A Biography,* Santa Barbara, Ca.: The Schauer Press, 1936. 347 p.; Greenwald, Bill, "The Lost Legacy of Fernand Lungren," *Santa Barbara Magazine,* Fall 1994, pp. 46-51.

MacConnel, Kim (b. 1946). Painter, Pattern & Decoration, San Diego, 1965+. *Arabesque: Joyce Kozloff, Robert Kushner, Kim MacConnel...,* exh. cat., Contemporary Arts Center, Cincinnati, Oh., October 6–November 17, 1978. 28 p.; *Pattern[ing?] Painting* [8 artists], exh. cat., Palais des Beaux Arts, Brussels, 1979. 58 p.

Machell, Reginald Willoughby (1854-1927). Painter/Sculptor, Symbolist, San Diego, Turn of the Twentieth Century. Kamerling, Bruce, "Theosophy and Symbolist Art," *Journal of San Diego History,* v. XXVI, no. 4, Fall 1980, pp. 230-55.

Maldonado, Alexander (1901-1989). Folk Artist, San Francisco, 1950+. *Cat and a Ball on a Waterfall: 200 Years of California Folk Painting and Sculpture,* exh. cat., The Oakland Museum Art Department, March 22–August 3, 1986; *Visions from the Left Coast: California Self-Taught Artists,* exh. cat., Santa Barbara Contemporary Arts Forum, August 26–October 21, 1995.

Malibu Tile Co. Tile Manufacturer, Hispano-Moresque, Malibu, 1920s. Rindge, Ronald L., *Ceramic Art of the Malibu Potteries 1926-1932,* Malibu, Ca.: Malibu Lagoon Museum, 1988.

Maloof, Sam (b. 1916). Furniture Designer, Southern California, Post-WWII. Fairbanks, Jonathan L., "A Natural Devotion: Studio Furniture Maker Sam Maloof," *Antiques & Fine Art,* v. 8, no. 4, May/June 1991, pp. 64-69; *Sam Maloof* [Arts Illustrated] produced by Patricia Kunkel, shown on KCET, Los Angeles, 4-16-1986; *Sam Maloof Woodworker,* Tokyo and New York: Kodansha Intl., 1983. 223 p.

Mannheim, Jean (1863-1945). Painter, Figures, Pasadena, 1908+. "Jean Mannheim" in Ruth Westphal, et al., *Plein Air Painters of California: The Southland,* Irvine, Ca.: Westphal Publishing, 1982.

Marioni, Paul (b. 1941). Glassmaker, Northern California, 1970+. Rigan, Otto B., *New Glass,* New York: Ballantine Books, 1976; Wichert, G., "Light, Motif: the Glass of Paul Marioni," *American Craft,* v. 43, December 1983/January 1984, pp. 28-31.

Marshall, Albert (1891-1970). Watercolor Landscapes, California, 1930+. *Jonathan* (publication of the Jonathan Club, Los Angeles) unknown issue c. 1986.

Martin, Bill (b. 1943). Painter, Visionary Worlds, Bay Area, 1965+. Martin, Bill, *Lost Legends,* San Francisco: Pomegranate Artbooks, 1995.

Martin, Fletcher (1904-1979). Painter, Regionalist, Los Angeles, 1930s. Cooke, H. Lester, Jr., *Fletcher Martin,* New York: Harry N. Abrams, Inc., 1977. 232 p.

Martinez, Xavier (1869-1943). Painter, Tonalist, Northern California, Turn of the Twentieth Century. Neubert, George W., *Xavier Martinez (1869-1943),* exh. cat., The Oakland Museum, February 12–April 7, 1974. 71 p.; "Xavier Martinez," *California Art Research,* San Francisco, Ca.: Works Progress Administration, 1936-37, v. 10, pp. 35-60.

Mathews, Arthur Frank (1860-1945). Painter/Muralist/Furniture Maker, American Renaissance Style, San Francisco, Turn of the Twentieth Century. "Arthur Mathews," *California Art Research,* San Francisco, Ca.: Works Progress Administration, 1936-37, v. 7, pp. 1-30; Giberti, Bruno, *Rooms for a Renaissance: Interior Decoration as Practiced by Arthur and Lucia Mathews at the Furniture Shop, 1906-1920,* Master of Architecture Thesis, University of California, Berkeley, 1989. 85 l.; Jones, Harvey L., *Mathews:*

Masterpieces of the California Decorative Style, The Oakland Museum (republished by Gibbs M. Smith, Inc., and Peregrine Smith Books 1985); King, Jon, "Arthur & Lucia Mathews Furniture & Decorative Arts," *Antiques & Fine Art,* v. 5, no. 3, March/April 1988, pp. 48-54.

Mathews, Lucia (1870-1955). Painter, Furniture Decorator, San Francisco, Turn of the Twentieth Century. Bibliog. same as for Arthur Mathews; Trenton, Patricia, ed., *Independent Spirits: Women Painters of the American West 1890-1945,* Autry Museum of Western Heritage in association with the University of California Press, Berkeley, 1995.

McCloskey, William Joseph (1859-1941) and Alberta Binford McCloskey (c. 1855-c. 1911). Painters, Portrait/Still Life, Los Angeles/San Francisco/New York, Turn of the Twentieth Century. Moure, Nancy Dustin Wall, *William and Alberta McCloskey,* Santa Ana, Ca.: Bowers Museum, 1995.

McComas, Francis John (1875-1938). Watercolorist, Landscapes, Tonalist, Northern California, Turn of the Twentieth Century. *The Botkes, The McComases, The Seidenecks,* exh. cat., Carmel Art Association, August 4–September 6, 1988; "Francis John McComas," *California Art Research, Monographs,* WPA Project 2874, O.P. 65-3-3632, 20 vols. San Francisco: Works Progress Administration, 1937, v. 9, pp. 64-88; Seavey, Kent L., *Francis John McComas,* exh. cat., California Historical Society, San Francisco, January 15–March 20, 1965. 20 p.

McCray, James (1912-1993). Painter, Abstractions, San Francisco, 1940+. *McCray,* exh. cat., San Francisco Art Association Gallery, California School of Fine Arts, November 16–December 16, 1955; "New Works by Three Painters," *San Francisco Art Association Bulletin,* v. 16, no. 10, October 1950, p. 1.

McFee, Henry Lee (1886-1953). Painter, Formalist Still Lifes, Southern California, 1940+. Baker, John, *Henry Lee McFee and Formalist Realism in American Still Life, 1923-1936,* London and Toronto: Associated University Presses, 1987 [exh. cat. circulated to Galleries of the Claremont Colleges, January 18–February 19, 1987]. 148 p.

McLaughlin, John (1898-1976). Painter, Hard Edge Abstractions, Dana Point, 1945+. *John McLaughlin* interviewed by Fidel Danieli, Oral History Program, University of California, Los Angeles, 1977. 47 l.; *John McLaughlin, Western Modernism Eastern Thought,* essays by Susan C. Larsen and Peter Selz, exh. cat., Laguna Art Museum, Laguna Beach, Ca., July 20–October 6, 1996 and other venues.

McLean, Richard (b. 1934). Painter, Photorealist, Bay Area, 1965+. "Richard McLean" in Louis K. Meisel, *Photorealism,* New York: Abradale Press, Harry N. Abrams, Inc., 1989.

Merrild, Knud (1894-1954). Painter, Modernist/Flux, Los Angeles, 1925+. Dailey, Victoria, "Knud Merrild," *Art of California,* v. 4, no. 6, November 1991, pp. 52-56; *Knud Merrild: Works from the 1930's + 1940's,* with an essay by Victoria Dailey, exh. cat., Steve Turner Gallery, Los Angeles, September 17–November 16, 1991. 32 p.; *Knud Merrild 1894-1954,* exh. cat., Los Angeles County Museum of Art, November 26–December 26, 1965; Miller, Henry, *Knud Merrild a Holiday in Paint,* Huntsville, Al.: Bern Porter, 1965. 32 p.

Messenger, Ivan (1895-1983). Printmaker, Regionalist, San Diego, 1930+. Messenger, Ivan, *Not for Tourists Only: An Early Portrait of San Diego from an Artist's Portfolio,* San Diego: Ivan Messenger, 1969.

Messick, Benjamin Newton (1891-1981). Painter, Regionalist, Los Angeles, 1925+. *Catalogue Raisonne of Ben Messick's Lithographs,* Redlands, Ca.: Eclectic Framer and Laguna Beach, Ca.: David and Sons, c. 1987; Lafferty, James R., Sr., *Ben Messick,* Redlands, Ca.: Rifleman Publications, 1993. 1 vol.

Meyers, William Henry (1815-?). Painter, Naive, California, 1840s. *Naval Sketches of the War in California, Reproducing Twenty-Eight Drawings Made in 1846-47 by William H. Meyers,* introd. by Franklin D. Roosevelt, New York: Random House, 1939; Meyers, William Henry, *Journal of a Cruise to California and the Sandwich Islands in the United States Sloop-of-war Cyanne by William H. Meyers, Gunner, U.S.N. 1841-1844,* ed. by John H. Kemble, San Francisco: The Book Club of California, 1955.

Miller, Barse (1904-1973). Watercolors, California Style, Southern California, 1930+. "Barse Miller" in Ruth Westphal, et al., *American Scene Painting: California, 1930s and 1940s,* Irvine, Ca.: Westphal Publishing, 1991.

Miller, Henry (active California 1856 and 1857). Draughtsman, California, 1856-1857. *Account of a Tour of the California Missions & Towns 1856, the Journal & Drawings of Henry Miller,* Santa Barbara, Ca.: Bellerophon Books, 1985 (and San Francisco: Book Club of California, 1952). 63 p.; 13 *California Towns from the Original Drawings* [by Henry Miller], San Francisco: The Book Club of California, 1947.

Misrach, Richard (b. 1949). Photographer, Bay Area, 1970+. *Richard Misrach,* exh. cat., San Francisco: Grapestake Gallery, 1979. 54 l.; Tucker, Anne, *Crimes and Splendors: The Desert Cantos of Richard Misrach,* Boston: Bulfinch Press/Little Brown and Co., 1996. 192 p.

Mitchell, Alfred R. (1888-1972). Painter, Post-Impressionist, San Diego, 1910+. Anderson, Thomas R. and Bruce Kamerling, *Sunlight and Shadow:*

The Art of Alfred R. Mitchell, 1888-1972, exh. cat., San Diego Historical Society, June 18–July 31, 1988. 83 p.

Moran, Thomas (1837-1926). Painter, Landscapes, Northern California, Late Nineteenth Century. Clark, Carol, *Thomas Moran: Watercolors of the American West,* Austin, Tx.: University of Texas Press, 1980. 180 p.; Kinsey, Joni, *Thomas Moran and the Surveying of the American West,* Washington, D.C.: Smithsonian Institution Press, 1992. 237 p.; *The Prints of Thomas Moran in the Thomas Gilcrease Institute of American History and Art,* Tulsa, Ok.: Thomas Gilcrease Museum Association, 1986. 255 p.; *Thomas Moran, the Field Sketches, 1856-1923,* Norman: University of Oklahoma Press, 1996. 313 p.; Patrick, Darryl, *The Iconographical Significance in Selected Western Subjects Painted by Thomas Moran,* Ph.D. Thesis, North Texas State University, 1978. 283 p.; Wilkins, Thurman, *Thomas Moran: Artist of the Mountains,* Norman: University of Oklahoma Press, 1966. 315 p.

Morse, Vernon Jay (1898-1965). Painter, Post-Impressionist, San Francisco/Los Angeles, 1920+. Hughes, Edan, *Artists in California, 1786-1940,* San Francisco: Hughes Publishing Co., 1989, 2000.

Mortimer, Art (b. 1941). Muralist, Los Angeles, Late Twentieth Century. Barnett, Alan, *Community Murals,* Philadelphia: Art Alliance Press, 1984; *The Big Picture: Murals of Los Angeles,* photographs by Melba Levick, commentaries by Stanley Young, Boston: Little Brown & Co., 1988; Dunitz, Robin, *Painting the Towns,* Los Angeles: RJD Enterprises, 1997, pp. 35, 132, 202; [Fairfax Community Mural] *Dreams and Visions,* video produced by Jewish Federation of Los Angeles, c. 1984; listed on Los Angeles Mural Conservancy website: http//www.LAmurals.com; [Jews in LA] *Out of the Melting Pot,* video produced by Jeremy Cooper for the BBC, c. 1994.

Mujeres Muralistas. Muralists, Chicanas, San Francisco, 1973-80. Drescher, Tim, *San Francisco Bay Area Murals: Communities Create Their Muses, 1904-1997,* St. Paul, Mn.: Pogo Press, 1998, p. 22.

Mullican, Lee (b. 1919). Painter, Dynaton, San Francisco, 1950+. *Lee Mullican* interviewed by Joann Phillips, Oral History Program, University of California, Los Angeles, 1977. 183 l; *Lee Mullican: Paintings, 1965-1969,* exh. cat., Art Galleries, University of California, Los Angeles, September 15–October 19, 1969. 32 p.; *Lee Mullican: Selected Works 1948-1980,* Basil & New York: Galerie Schreiner, 1980 [held in conjunction with an exhibit at the Los Angeles Municipal Art Gallery, October 28–November 23, 1980]. 80 p.

Mundt, Ernest (1905-1993). Sculptor, Metal, San Francisco, 1945+. Mundt, Ernest, *Birth of a Cook: Gastronomical Autobiography,* New York: Knopf, 1956 [first two chapters consist of biography]; Mundt, Ernest, *Art Form and Civilization,* Berkeley: University of California Press, 1952; Mundt, Ernest, *A Primer of Visual Art, the Basis of Advertising...,* New York: Pellegrine & Cudahy, 1942.

Munras, Esteban (active 1821-22). Muralist, Mission San Miguel, 1821-22. Neuerburg, Norman, *The Decoration of the California Missions,* Santa Barbara: Bellerophon Books, 1987.

Muybridge, Eadweard (1830-1904). Photographer, Northern California, Late Nineteenth Century. Haas, Robert Bartlett, *Muybridge: Man in Motion,* Berkeley: University of California Press, 1976. 207 p.; Hendricks, Gordon, *Eadweard Muybridge: The Father of the Motion Picture,* London: Secker and Warburg, 1975. 271 p.; Stanford University Department of Art, *Eadweard Muybridge; the Stanford Years, 1872-1882,* Stanford, Ca., 1972. 135 p.

Nahl, Charles Christian (1818-1878). Painter, Genre, Northern California, Second Half of Nineteenth Century. *Charles Christian Nahl, Letters to his Family, 1846-1854,* portfolio of original letters in the Bancroft Library, University of California, Berkeley; Driesbach, Janice T., et al., *Art of the Gold Rush,* exh. cat., The Oakland Museum of California, January 24–May 31, 1998 and two other venues; Stevens, Moreland L., *Charles Christian Nahl, Artist of the Gold Rush 1818-1878,* Sacramento: E. B. Crocker Art Gallery, 1976.

Narjot, Ernest (1826-1898). Painter, Genre, Northern California, Second Half of Nineteenth Century. Dressler, Albert, *California's Pioneer Artist, Ernest Narjot...,* San Francisco: Albert Dressler, 1936. 14 p.; Driesbach, Janice T., et al., *Art of the Gold Rush,* exh. cat., The Oakland Museum of California, January 24–May 31, 1998 and two other venues.

Natzler, Otto (b. 1908) and Gertrud Natzler (1908-1971). Ceramists, Studio Pottery Movement, Los Angeles, 1940+. *The Ceramic Work of Gertrud and Otto Natzler,* exh. cat., Los Angeles County Museum of Art, June 15–August 14, 1966. 46 l.; *Form and Fire: Natzler Ceramics 1939-1972,* exh. cat., Renwick Gallery of the National Collection of Fine Arts, Washington, D.C., published by the Smithsonian Institution Press, 1973. 120 p.; *Gertrud and Otto Natzler: Ceramics* [catalog of the collection of Mrs. Leonard M. Sperry], Los Angeles: Los Angeles County Museum of Art, 1968. 80 p.; Kardon, Janet, et al., *Gertrud and Otto Natzler: Collaboration, Solitude,* exh. cat., American Craft Museum, New York, July 15–October 10, 1993. 96 p.

Nepote, Alexander (1913-1986). Watercolorist, Landscapes, Northern California, 1930+. "Alexander Nepote" in Ruth Westphal, et al., *American Scene Painting: California, 1930s and 1940s,* Irvine, Ca.: Westphal Publishing,

1991; "Alexander Nepote" in Yvonne Greer Thiel, *Artists and People,* New York: Philosophical Library, 1959; Nelson, Mary Carroll, "Layering," *Leonardo,* v. 19, no. 3, 1986, pp. 223-29.

Nimmo, Louise Everett (1899-1959). Painter, Cactus and Succulent Themes, Los Angeles, 1930+. Trenton, Patricia, ed., *Independent Spirits: Women Painters of the American West, 1890-1945,* Autry Museum of Western Heritage, Los Angeles, in association with the University of California Press, Berkeley, 1995.

Obata, Chiura (1885-1975). Watercolorist/Color Woodblock Maker, Bay Area, 1930+. "Chiura Obata," *California Art Research,* San Francisco, Ca.: Works Progress Administration, 1936-37, v. 20, pp. 120-60; *Chiura Obata, a California Journey,* exh. cat., Oakland Museum, May 10–June 19, 1977. 23 p.; Driesbach, Janice T. and Susan Landauer, *Obata's Yosemite: The Art and Letters of Chiura Obata from his Trip to the High Sierra in 1927,* Yosemite Association, Yosemite National Park, Ca., 1993. 151 p.

Ocampo, Manuel (b. 1965). Painter Activist, Los Angeles, Late Twentieth Century. *Manuel Ocampo: Heridas de la Lengua,* Santa Monica, Ca.: Smart Art Press, 1997. 80 p.

Ochoa, Victor (b. 1948). Muralist, Chicano, San Diego, 1970+. Dunitz, Robin J. and James Prigoff, *Painting the Towns,* Los Angeles: RJD Enterprises, 1997, pp. 27, 265-67, 270-71; *La Frontera/The Border,* exh. cat., Centro Cultural de la Raza, Museum of Contemporary Art, San Diego, March 5–May 22, 1993 and five other venues.

Oldfield, Otis (1890-1969). Painter, Figures/Landscapes, San Francisco, 1920+. "Otis Oldfield," *California Art Research,* San Francisco, Ca.: Works Progress Administration, 1936-37, v. 19, pp. 29-73; *Otis Oldfield and the San Francisco Art Community* [an interview with Helen Oldfield], Regional Oral History Program, Bancroft Library, University of California, Berkeley, 1982. 169 l.; *Otis Oldfield Centennial 1890-1990,* published by J. M. O. B.'s Inkwell Publishing, San Francisco, on the occasion of the Centennial retrospective at the Jan Holloway Gallery in San Francisco opening September 14, 1990; Wilson, Raymond L., "Otis Oldfield: A Painter for his Times," *Antiques & Fine Art,* v. 8, no. 1, November/December 1990, pp. 132-37.

Oliveira, Nathan (b. 1928). Painter/Printmaker (Monotypes), Northern California, 1955+. Ball, Maudette, *Nathan Oliveira: Print Retrospective 1949-1980,* exh. cat., California State University Art Museum and Galleries, Long Beach, Ca.; March 24–April 27, 1980. 68 p.; *Nathan Oliveira: A Survey Exhibition 1957-1983,* exh. cat., San Francisco Museum of Modern Art, 1984. 80 p.; *Nathan Oliveira: A Survey of Monotypes 1973-1978,* exh. cat., Baxter Art Gallery, California Institute of Technology, Pasadena, September 20–October 28, 1979 and two other venues. 56 p.; *Nathan Oliveira: Print Retrospective: 1949-1980,* exh. cat., Art Galleries, California State University, Long Beach, March 24–April 27, 1980. 68 p.

Onslow-Ford, Gordon (b. 1912). Painter, Dynaton, San Francisco, Post-WWII. Anderson, Susan, *Pursuit of the Marvelous,* exh. cat., Laguna Art Museum, Laguna Beach, Ca., October 5, 1990–January 13, 1991; *Gordon Onslow-Ford, Retrospective Exhibition,* exh. cat., Oakland Museum, March 22–May 29, 1977. 72 p.; *Insights: Gordon Onslow Ford,* exh. cat., Petaluma, Ca.: Lapis Press, 1991. 65 p.; Neufert, Andreas, *Gordon Onslow-Ford Paintings,* Munchen: Hocherl Verlag, 1994. 83 p.; Onslow Ford, Gordon, *Creation,* Basel: Galerie Schreiner AG, 1978. 123 p.; *The Quest of the Inner-Worlds: Paintings by Gordon Onslow Ford,* exh. cat., Arts and Consciousness Gallery, John F. Kennedy University, Berkeley, Ca., November 1-27, 1996. 64 p.; *Towards a New Subject in Painting: Gordon Onslow-Ford,* exh. cat., San Francisco Museum of Art, 1948. 54 p.

Orozco, Jose Clemente (1883-1949). Muralist, Mexican, Active Claremont, California 1930. *Jose Clemente Orozco,* New York: Delphic Studios, 1932 (reprinted New York: Hacker Art Books, 1985). 272 p.; *Jose Clemente Orozco, an Autobiography,* translated by Robert C. Stephenson, Austin: University of Texas Press, 1962. 171 p.; Perez, Edward Ross, *Jose Clemente Orozco's American Murals: His Concept of an Indigenous American Art,* M.A. Thesis, University of California, Riverside, 1977. 169 l.; Rochfort, Desmond, *Mexican Muralists: Orozco, Rivera, Siqueiros,* London: Laurence King, 1993. 230 p.; Scott, David W., "Orozco's Prometheus," *College Art Journal,* v. XVII, no. 1, Fall 1957, pp. 2-18.

Orr, Eric (b. 1939). Light and Space Artist, 1970+. Butterfield, Jan, *The Art of Light & Space,* New York: Abbeville Press, 1993; *Eric Orr, a Twenty-Year Survey,* University Art Gallery, San Diego State University, April 14–May 12, 1984. 45 p.; *Eric Orr "Time's Shadow,"* New York: Hanson, Scott Gallery, 1987. 34 p.

Paalen, Wolfgang (1905-1959). Painter, Dynaton, San Francisco, Post-WWII. *Wolfgang Paalen: Retrospectiva,* exh. cat., Museo de Arte Contemporaneo Alvar y Carmen T. de Carrillo Gil, Mexico City, July–September, 1994. 277 p.; *Wolfgang Paalen: Zwischen Surrealismus und Abstraktion,* exh. cat., Museum des 20. Jahrhunderts, Vienna, September 24–November 7, 1993. 287 p.; *Wolfgang Paalen,* Paris: Editions Filipacchi, 1980.

Pages, Jules Eugene (1867-1946). Painter, Impressionist Landscapes, San Francisco/ Paris, Early Twentieth Century. Garcia, Monica E., "Jules Pages," *Art of California,* v. 3, no. 2, March 1990, pp. 16-22; "Jules Pages" in Ruth Westphal, et al., *Plein Air Painters of California: The North,* Irvine, Ca.: Westphal Publishing, 1986.

Paradise, Philip Herschel (1905-1997). Painter, Regionalist, Los Angeles, 1930+. Lovoos, Janice, "Paradise Revisited," *American Artist*, v. 53, August 1989, pp. 64-67+; "Phil Paradise" in Ruth Westphal, et al., *American Scene Painting: California, 1930s and 1940s*, Irvine, Ca.: Westphal Publishing, 1991.

Park, David (1911-1960). Painter, Bay Area Figurative, 1950+. Armstrong, Richard, *David Park*, exh. cat., Whitney Museum of American Art, New York, November 4, 1988-January 15, 1989 and Oakland Museum, May 20-August 6, 1989. 152 p.; Mills, Paul, "David Park," *Art of California*, v. 3, no. 2, March 1990, pp. 46-53; Mills, Paul, *The New Figurative Art of David Park*, Santa Barbara, Ca.: Capra Press, 1988. 127 p.

Parshall, Douglass Ewell (1899-1990). Painter, Figure, Santa Barbara, 1920+. "Douglass Parshall" in Ruth Westphal, et al., *American Scene Painting: California, 1930s and 1940s*, Irvine, Ca.: Westphal Publishing, 1991.

Patrick, James H. (1911-1944). Watercolorist, Los Angeles, 1930s. "James Patrick" in Ruth Westphal, et al., *American Scene Painting: California, 1930s and 1940s*, Irvine, Ca.: Westphal Publishing, 1991.

Payne, Edgar Alwin (1882/3-1947). Painter, Impressionist, Landscapes, Los Angeles, 1915+. Coen, Rena Neumann, *The Paynes, Edgar & Elsie: American Artists*, Minneapolis, Mn.: Payne Studios, Inc., 1988.

Payzant, St. George Charles (1898-1980). Watercolors, California Style, 1930+. "Charles Payzant" in Ruth Westphal, et al., *American Scene Painting: California, 1930s and 1940s*, Irvine, Ca.: Westphal Publishing, 1991.

Peabody, Ruth Eaton (1898-1967). Painter, Figures/Still Lifes, Laguna Beach, 1927+. *Southern California Artists 1890-1940*, exh. cat., Laguna Beach Museum of Art, July 10-August 28, 1979; Trenton, Patricia, ed., *Independent Spirits: Women Painters of the American West 1890-1945*, Autry Museum of Western Heritage in association with the University of California Press, Berkeley, 1995.

Pelton, Agnes (1881-1961). Painter, Symbolic Abstracts, Cathedral City, 1932+. Perlmutter, Penny L., "Toward the Light: Agnes Pelton's Transcendental Paintings," *Antiques & Fine Art*, v. 7, no. 3, March/April 1990, pp. 92-99; Stainer, Margaret, *Agnes Pelton*, exh. cat. Ohlone College Art Gallery, Fremont, Ca., October 9-November 5, 1989. 39 p.; Zakian, Michael, *Agnes Pelton: Poet of Nature*, exh. cat., Palm Springs Desert Museum, February 28-April 30, 1995 and other sites. 128 p.

Penelon, Henri Joseph (1827-1885). Painter, Portraits, Los Angeles, 1850+. DeWar, John, *Adios Mr. Penelon*, Los Angeles: Los Angeles County Museum of Natural History, 1968.

Peters, Charles Rollo (1862-1928). Painter, Tonal Nocturnes, Monterey, Turn of the Twentieth Century. "Charles Rollo Peters" in Ruth Westphal, *Plein Air Painters of California: the North*, Irvine, Ca.: Westphal Publishing, 1986; "Charles Rollo Peters," *California Art Research*, San Francisco, Ca.: Works Progress Administration, 1936-37, v. 10, pp. 61-90; McGlynn, Betty Hoag, *Charles Rollo Peters*, in preparation.

Pettibon, Raymond (b. 1957). Pen and Inks, Los Angeles, 1977+. Deitcher, David, "The Library in Your Good Hands," *Artforum*, v. 31, October 1992, pp. 74-77+; Gordon, Kim, "American Prayers," *Artforum*, v. 23, April 1985, pp. 73-77; *Raymond Pettibon*, exh. cat., Kunsthalle, Bern, Switz., January 28-March 12, 1995 and 14/16 Verneuil-Marc Blondeau, Paris, May 20-July 15, 1995. 134 p.; "Raymond Pettibon," *Parkett*, no. 47, 1996, pp. 56-95.

Piazzoni, Gottardo Fidele Ponziano (1872-1945). Painter, Symbolical Works, San Francisco, First Half of the Twentieth Century. "Gottardo Piazzoni," *California Art Research*, San Francisco: Works Progress Administration, 1936-37, v. 7, pp. 31-87; Tangel-Cate, Dianne, "California Dreaming: Through the Eyes of Gottardo Piazzoni," *Art of California*, v. 6, no. 3, June 1993, pp. 48-51.

Post, George Booth (1906-1997). Watercolorist, San Francisco, 1930+. *George Post: a California Watercolorist*, Regional Oral History Program, Bancroft Library, University of California, Berkeley, 1984. 134 p.; McClelland, Gordon T., *George Post*, Beverly Hills, Ca.: Hillcrest Press, 1991.

Price, Clayton Sumner (1874-1950). Painter, Modernist, Monterey, 1918-1928. *C.S. Price: The Man and His Works*, exh. cat., Fine Arts Patrons of Newport Harbor, February 8-March 19, 1967.

Putnam, Arthur (1873-1930). Sculptor, Romantic, Animals, San Diego/San Francisco, Turn of the Twentieth Century. "Arthur Putnam," *California Art Research*, San Francisco, Ca.: Works Progress Administration, 1936-37, v. 6, pp. 1-59; Heyneman, Julie Helen, *Arthur Putnam, Sculptor*, San Francisco: Johnek & Seeger, 1932 (republished as Heyneman, Julie Helen, *Desert Cactus, the Portrait of a Sculptor*, London: G. Bles, 1934. 228 p.); Kamerling, Bruce, "Arthur Putnam, Sculptor of the Untamed," *Antiques & Fine Art*, v. 7, no. 5, July/August 1990, pp. 122-29; Osborne, C. M., "Arthur Putnam, Animal Sculptor," *American Art Review*, v. 3, September-October 1976, pp. 71-81.

Raffael, Joseph (b. 1933). Painter, Realist, Northern California, 1969-78. Garver, T. H., "Joseph Raffael: a Decade in California," *Southwest Art*, v. 9, May 1980, pp. 88-95; *Joseph Raffael: The California Years 1969-1978*,

exh. cat., San Francisco Museum of Modern Art, January 20-March 5, 1978. 64 p.

Ramos, Mel (b. 1935). Painter, Pop, Bay Area, 1960+. *The Girls of Mel Ramos*, Chicago: Playboy Press, 1975; *Mel Ramos*, London: Mathews Miller Dunbar, 1975. 158 p.; *Mel Ramos: a Twenty Year Survey*, exh. cat., Rose Art Museum, Brandeis University, Waltham, Ma., April 13-May 16, 1980. 52 p.; *Mel Ramos: Pop Art Images*, Koln: Benedikt Taschen, 1994. 95 p.

Ramos-Martinez, Alfredo (1872-1946). Painter, Mexican Aesthetic, Los Angeles, 1930+. *Alfredo Ramos Martinez (1871-1946): Una Vision Retrospectiva*, exh. cat., Museo Nacional de Arte, Mexico City, Abril-Junio, 1992. 231 p.; *Alfredo Ramos Martinez (1872-1946)*, exh. cat., Louis Stern Galleries, Beverly Hills, Ca., October 1, 1991-January 6, 1992. 104 p.; Lovoos, J., "Alfredo Ramos Martinez 1872-1946," *Southwest Art*, v. 7, October 1977, pp. 82-85; Nieto, Margarita, "Art Without Borders: Alfredo Ramos Martinez," *Antiques & Fine Art*, v. 9, no. 1, November/December 1991, pp. 66-75; Small, George Raphael, *Ramos Martinez: His Life & Art*, Westlake Village: F & J Publ., 1975; Small, G. R., "Ramos-Martinez, Mexican Muralist," *Americas*, v. 29, pt. 4, 1977, pp. 19-22; Sodi de Ramos Martinez, Maria, *Alfredo Ramos Martinez*, translated by Berta de Lecuona, Los Angeles: Martinez Foundation, 1949.

Raphael, Joseph Morris (1869-1950). Painter, Impressionist, San Francisco/Belgium, First Half Twentieth Century. "Joseph Raphael," *California Art Research*, San Francisco: Ca.: Works Progress Administration, 1936-37, v. 5, pp. 32-94; "Joseph Raphael" in Ruth Westphal, et al., *Plein Air Painters of California: The North*, Irvine, Ca.: Westphal Publishing, 1986; *Joseph Raphael 1869-1950*, exh. cat., Singer Museum, Larin, Netherlands, December 13, 1981-January 31, 1982. 12 p.

Raschen, Henry (1854/6-1937). Painter, Indian Subjects, Northern California, Turn of the Twentieth Century. Flayderman, Harry, *Henry Raschen, Painter of the American West*, n. p., 1958.

Rauschenberg, Robert (b. 1925). Painter/Printmaker, New York, active Los Angeles mid 1960s. Hopps, Walter, *Robert Rauschenberg, a Retrospective*, exh. cat., Guggenheim Museum, New York, September 19, 1997-January 7, 1998 and three other museums. 629 p.

Ray, Man (Emanuel Radnizky) (1890-1976). Painter/Sculptor, Dada/Surrealism, Hollywood, 1940s. Baldwin, Neil, *Man Ray: American Artist*, New York: Clarkson N. Potter, Inc., 1988. 449 p.; Foresta, Merry, "Exile in Paradise: Man Ray in Hollywood, 1940-1951," in *Perpetual Motif: The Art of Man Ray*, New York: Abbeville Press for National Museum of American Art, Smithsonian Institution, Washington, D. C., 1988. 348 p.; *Man Ray: Paris >> Los Angeles*, Santa Monica: Smart Art Press, 1996. 128 p.; "Man Ray: Inventory of a Woman's Head," *Flash Art*, v. 114, November 1983, pp. 36-39; Ray, Man, *Self Portrait: Man Ray*, Boston: Little, Brown and Co., 1963.

Redlands Pottery. Pottery, Craftsman, Redlands, 1902-09. Trapp, Kenneth R., et al., *Living the Good Life: The Arts and Crafts Movement in California*, The Oakland Museum in association with Abbeville Press, New York, 1993.

Redmond, Granville Richard Seymour (1871-1935). Painter, Impressionist, Landscapes, Los Angeles, 1900+. *Granville Redmond*, exh. cat., The Oakland Museum, December 3, 1988-January 29, 1989 and two other venues. 111 p.

Redmond, James (1900-1944). Painter/Muralist, Los Angeles, 1930s. Hughes, Edan, *Artists in California, 1786-1940*, San Francisco: Hughes Publishing Co., 1989, 2000.

Reep, Edward (b. 1918). Painter, Abstract/Realist, Los Angeles, 1945+. Reep, Edward, *A Combat Artist in World War II*, Lexington: University Press of Kentucky, 1987. 206 p.; Reep, Edward, *The Content of Watercolor*, New York: Van Nostrand Reinhold, 1983. 176 p.

Reiffel, Charles (1862-1942). Painter, Post-Impressionist, San Diego, 1930s. "Charles Reiffel" in Martin E. Petersen, *Second Nature: Four Early San Diego Landscape Painters*, exh. cat., San Diego Museum of Art, June 1-August 18, 1991; Petersen, Martin E., "Charles Reiffel," *Art of California*, v. 4, no. 4, July 1991, pp. 34-39.

Rice, William S. (1873-1963). Printmaker, Watercolorist, East Bay, Early Twentieth Century. *William S. Rice Dry-Points (Linear)* [25 Dry-points], California State Library; *William S. Rice: An Exhibition of Color Woodcuts from 1910-1940*, exh. cat., Annex Gallery, Santa Rosa, Ca., December 1, 1984-January 19, 1985. 16 p.

Rich, John Hubbard (1876-1954). Painter, Figures, Los Angeles, 1915+. Moure, Nancy Dustin Wall, *Publications in Southern California Art 1, 2, & 3*, Los Angeles: Dustin Publications, 1984.

Ritschel, William Frederick (1864-1949). Painter, Impressionist, Marinescapes, Carmel, 1910+. Dominik, Janet B., "William Ritschel," *Art of California*, v. 2, no. 1, February/March 1989, pp. 20-27; "William Ritschel," in *Southern California Artists 1890-1940*, exh. cat., Laguna Beach Museum of Art, July 10-August 28, 1979, pp. 164-65; "William Ritschel" in Ruth Westphal, et al., *Plein Air Painters of California: The North*, Irvine, Ca.: Westphal Publishing, 1986.

Rivera, Diego (1886-1957). Painter/Muralist, Mexican, San Francisco, 1930-31, 1940. Cockroft, James D., *Diego Rivera*, New York: Chelsea House, 1991. 119 p.; *Diego Rivera*, exh. cat., California Palace of the Legion of Honor, San Francisco, November 15-December 25, 1930. 39 p.; *Diego Rivera: A Retrospective*, exh. cat., Detroit Institute of Arts, Detroit, Mi., February 10-April 27, 1986. 372 p.; *Diego Rivera; Drawings and Watercolors from the Collection of the San Francisco Museum of Art and the Collection of the San Francisco Art Association*, San Francisco: The Museum of Art, 1940. 31 p.; Fuentes Rojas de Cadena, Elizabeth, *Three San Francisco Murals of Diego Rivera: a Documentary and Artistic History*, M. A. Thesis, University of California, Davis, 1980. 177 l.; Fuentes Rojas, Elizabeth, *Diego Rivera en San Francisco: Una Historia Artistica y Documental*, Guanajuato: Gto.: Gobierno del Estado de Guanajuato, 1991. 140 p.; Rochfort, Desmond, *The Murals of Diego Rivera*, exh. cat., Hayward Gallery, South Bank Centre, London, October 29, 1987-January 10, 1988. 103 p.

Rix, Julian Walbridge (1850-1903). Painter, Landscapes, Tonalist, Northern California, Late Nineteenth Century. "Julian Walbridge Rix" *California Art Research, Monographs*, WPA Project 2874, O. P. 65-3-3632, 20 vols. San Francisco: Works Progress Administration, 1937, v. 4, pp. 114-37; "Julian W. Rix" in *California Landscape Painting, 1860-1885: Artists Around Keith and Hill*, exh. cat., Stanford Art Gallery, Stanford University, December 9, 1975-February 29, 1976, pp. 41-43.

Robinson, Charles Dorman (1847-1933). Painter, San Francisco, Late Nineteenth Century-Early Twentieth Century. "Charles Dorman Robinson" in Marjorie Arkelian, *The Kahn Collection of Nineteenth-Century Paintings by Artists in California*, Oakland, Ca.: The Oakland Museum Art Department, 1975; "Charles Dorman Robinson," *California Art Research*, San Francisco: Works Progress Administration, 1936-37, v. 3, pp. 73-95; Seavey, Kent L., *Charles Dorman Robinson*, San Francisco: California Historical Society, 1965.

Rodia, Simon (1875-1965). Folk Environments, Watts, Mid Twentieth Century. Goldstone, Bud and Arloa Paquin Goldstone, *The Los Angeles Watts Towers*, Los Angeles: The Getty Conservation Institute and the J. Paul Getty Museum, 1997; *Simon Rodia's Towers in Watts*, Los Angeles, Ca.: Los Angeles County Museum of Art, 1962. 48 p.; Whiteson, Leon, *The Watts Towers*, Oakville, Ontario, Can.: Mosaic Press, 1989.

Romero, Frank (b. 1941). Painter, Chicano, Los Angeles, 1965+. Lineberry, Heather Sealy, "Frank Romero," *Art of California*, v. 3, no. 5, September 1990, pp. 21-25; Nieto, Margarita, "Conversation with Artist Frank Romero," *Latin American Art*, v. 3, no. 1, Winter 1991, pp. 23-24.

Roos, Charles (active 1881). Folk Artist, San Francisco, Late Nineteenth Century. Van Nostrand, Jeanne, *San Francisco, 1806-1906*, San Francisco: The Book Club of California, 1975, p. 45.

Rose, Guy (1867-1925). Painter, Impressionist, Los Angeles, 1914+. Fort, Ilene Susan, "The Cosmopolitan Guy Rose" in Patricia Trenton and William H. Gerdts, *California Light*, exh. cat., Laguna Art Museum, Laguna Beach, Ca., October 12, 1990-January 6, 1991 and several other venues, pp. 93-112; South, Will, *Guy Rose: American Impressionist*, The Oakland Museum and The Irvine Museum, 1995. 119 p.

Rosenthal, Tobias Edward (1848-1917). Painter, Genre, San Francisco/Germany, Late Nineteenth Century. Kramer, William M. and Norton B. Stern, "The Great 'Elaine' Robbery: The Crime against Civilization," *Journal of the West*, v. 10, October 1971, pp. 585-608; Kramer, William M. and Norton B. Stern, *San Francisco's Artist Toby E. Rosenthal*, Northridge: California State University, Santa Susana Press, 1978. 276 p.; Palace of Fine Arts, *Toby E. Rosenthal: Memorial Exhibition*, essay by J. Nilsen Laurvik, San Francisco, 1919. 70 p.; "Toby Rosenthal," *California Art Research*, San Francisco, Ca.: Works Progress Administration, 1936-37, v. 3, pp. 1-23.

Ruscha, Ed (b. 1937). Painter/Printmaker, Los Angeles Look/Pop, Los Angeles, 1960+. Bogle, A., *Graphic Works by Edward Ruscha*, exh. cat., Auckland City Art Gallery, 1978; *Guacamole Airlines and Other Drawings by Edward Ruscha*, N. Y.: Harry N. Abrams, Inc., 1976; *The Works of Edward Ruscha*, Hudson Hills Press, New York in association with the San Francisco Museum of Modern Art, 1982.

Samerjan, George E. (b. 1915). Watercolorist, Northern California, 1930+. Kent, Norman, *100 Watercolor Techniques*, New York: Watson Guptil, 1968; *Regionalism, the California View, Watercolors 1929-1945*, exh. cat., Santa Barbara Museum of Art, June 25-August 14, 1988; scrapbook prepared by the artist for the Archives of American Art, Smithsonian Institution, Washington, D. C.

Sample, Paul Starrett (1896-1974). Painter, Regionalist, Los Angeles 1930s. Haletsky, John T., *Paul Sample:Ivy League Regionalist*, exh. cat., The Lowe Art Museum, University of Miami, Coral Gables, Fl., 1984. 48 p.; McGrath, Robert L. and Paula F. Glick, *Paul Sample: Painter of the American Scene*, exh. cat., Hood Museum of Art, Dartmouth College, Hanover, N. H., June 4-August 28, 1988. 112 p.

Sandham, J. Henry (1842-1912). Painter/Illustrator, Southern California, c. 1880s. Moure, Nancy Dustin Wall, *Loners, Mavericks & Dreamers*, exh. cat., Laguna Art Museum, Laguna Beach, Ca., November 26, 1993-February 20, 1994.

Sandona, Matteo (1881-1964). Painter, Portraits, San Francisco, Early Twentieth Century. "Matteo Sandona," *California Art Research*, San Francisco, Ca.: Works Progress Administration, 1936-37, v. 13, pp. 1-50.

Sanzenbach, Keith (1930-1964). Beat Painter, San Francisco, mid Twentieth Century. *Art as a Muscular Principle: 10 Artists and San Francisco 1950-1965...Keith Sanzenbach...*, exh. cat., Gallery, Mount Holyoke College, South Hadley, Ma., 1975? 97 p.

Sarkisian, Paul (b. 1928). Painter, Photorealist, Los Angeles, 1970+. *Paul Sarkisian: an Exhibition of Six Paintings*, exh. cat., Santa Barbara Museum of Art, October 23–November 15, 1970. 13 p.; Price, V. B., "Paul Sarkisian," *Artspace*, v. 2, Summer 1978, pp. 24-29.

Saunders, Raymond (b. 1934). Painter, African-American, Abstracts, Oakland, 1960+. Nash, Steven, *Raymond Saunders: Black Paintings*, exh. brochure, M. H. DeYoung Memorial Museum, San Francisco, Ca., February 22–April 30, 1995. 7 p.; Powell, Richard J., "The Art of Raymond Saunders: Colored," *New Observations*, issue # 97, September/October 1993; *Raymond Saunders Forum*, exh. cat., Carnegie Museum of Art, Pittsburgh, Pa., April 13–July 7, 1996. 20 p.; *Raymond Saunders Recent Work*, exh. cat., The Oakland Museum, June 11–August 21, 1994. 36 p.

Sayre, F. Grayson (1879-1939). Painter, Desertscapes, Los Angeles, Early Twentieth Century. Redfern, Ray, *The Paintings of Fred Grayson Sayre (1879-1939)*, exh. cat., Redfern Gallery, Laguna Beach, Ca., 1987. 76 p.

Scarlett, Rolph (1889-1984). Painter, Abstractions, Los Angeles c. 1930. "Realism or Abstraction?" *Los Angeles Times*, February 9, 1930, pt. III p. 17, col 1–2; "Settings Win Attention in Shaw Play," *Pasadena Star News*, November 8, 1929; Tannin, Harriet, *Behind the Guggenheim: The Rebay Years*, unpublished manuscript available from author Bearsville, New York, 1982.

Schaad, Bentley (b. 1925). Painter, Formalist Still Lifes, Los Angeles, 1945+. Schaad, Bentley, *The Realm of Contemporary Still Life Painting*, New York: Reinhold, 1962. 127 p.

Schafer, Frederick Ferdinand (1839-1927 or 1841-1917). Painter, Landscapes, Northern California, Late Nineteenth Century. "Frederick Schafer" in *California Landscape Painting, 1860-1885: Artists Around Keith and Hill*, exh. cat., Stanford Art Gallery, Stanford University, December 9, 1975–February 29, 1976, pp. 48-50.

Schapiro, Miriam (b. 1923). Painter, Feminist, Pattern & Decoration Movement, Los Angeles, Early 1970s. Bradley, Paula W., *Miriam Schapiro: the Feminist Transformation of an Avant-garde Artist*, Ph. D., Thesis, University of North Carolina at Chapel Hill, 1983. 208 p.; Gouma-Peterson, Thalia, "The Theater of Life and Illusion in Miriam Schapiro's Recent Work," *Arts Magazine*, v. 60, March 1986, pp. 38-43; *Miriam Schapiro: A Retrospective, 1953-1980*, exh. cat., College of Wooster Art Museum, Wooster, Oh., September 10–October 25, 1980. 122 p.; Schapiro, Miriam, "Anatomy of a Kimono," *Art Journal*, v. 54, Spring 1995, pp. 74-75.

Schmid, Rupert (1864-1932). Sculptor, Beaux Arts, San Francisco, End of Nineteenth Century. *100 Years of California Sculpture*, exh. cat., The Oakland Museum, Oakland, Ca., August 7–October 17, 1982.

Schneider, Otto Henry (1865-1950). Painter, Post-Impressionist, San Diego, 1923+. "Otto Schneider" in Ruth Westphal, et al., *Plein Air Painters of California: The Southland*, Irvine, Ca.: Westphal Publishing, 1982.

Schuster, Donna Norine (1883-1953). Painter, Impressionist, Los Angeles, 1913+. *Downey Museum of Art Celebrates its Twentieth Anniversary in the Twenty-first Century Style of Elegance with a Retrospective Exhibit of the Oil Paintings and Water Colors by Donna Norine Schuster: 1883-1953*, exh. cat., Downey Museum of Art, Downey, Ca., 1977. 20 p.; Gittens, Roberta, "Donna Schuster," *Art of California*, v. 4, no. 3, May 1991, pp. 16-20; Trenton, Patricia and Roberta Gittens, "Donna Norine Schuster: Afloat on Currents of Change," *Southwest Art*, February 1993, pp. 68-74+.

Seeds, Elise (1902-1963). Painter, Modernist, Los Angeles, mid 1930s+. Armitage, Merle, *Elise*, New York: E. Weyhe, 1934; *Catalogue One: Twentieth Century American Art*, exh. cat., Steve Turner Gallery, Los Angeles, 1995; Trenton, Patricia, ed., *Independent Spirits: Women Painters of the American West 1890-1945*, Autry Museum of Western Heritage in association with the University of California Press, Berkeley, 1995.

Serisawa, Sueo (b. 1910). Painter, Figures, Abstracts, Los Angeles, Post-WWII. *Sueo Serisawa*, exh. cat., Dalzell Hatfield Galleries, Los Angeles, 1948. 12 p.; Brown, Michael D., *Views from Asian California, 1920-1965*, San Francisco: Michael Brown, 1992, pp. 52-53.

Shaw, Jim (b. 1952). Painter, Los Angeles, Late Twentieth Century. Albertini, Rosanna, "Jim Shaw: Reveries of a Conceptual Artist," *Art Press*, no. 223, April 1997, pp. 47-51; Rugoff, Ralph, "Jim Shaw," *Flash-Art*, no. 163, March/April 1992, pp. 91-93; Shaw, Jim, *Dreams*, Santa Monica: Smart Art Press, 1995. 150 p.

Shaw, Richard (b. 1941). Ceramist, Sculptor, Trompe l'oeil Super Object, Davis, 1970+. *Richard Shaw, Ceramic Sculpture*, exh. cat., Newport Harbor Art Museum, October 3–November 29, 1981 and other sites. 27 p.; *Richard*

Shaw: Illusionism in Clay 1971-1985, exh. cat., Art Museum of South Texas, Corpus Christi and other venues, organized by Braunstein Gallery, San Francisco, 1985. 26 p.; *Robert Hudson/Richard Shaw, Work in Porcelain*, exh. cat., San Francisco Museum of Art, May 11–July 1, 1973. 35 p.

Sheets, Millard Owen (1907-1989). Painter, Watercolorist, Regionalist, Los Angeles, 1925+. Lovoos, Janice and Edmund F. Penney, *Millard Sheets: One-Man Renaissance*, Flagstaff, Ar.: Northland Press, 1984. 155 p.; *Millard Sheets*, interviewed by George M. Goodwin, Oral History Program, University of California, Los Angeles, 1977. 588 l.; *Millard Sheets: Six Decades of Painting*, exh. cat., Laguna Beach Museum of Art, September 23–November 13, 1983 and two other venues. 71 p.

Shimojima, Kaye (active Los Angeles 1920s). Photographer, Camera Pictorialist, Los Angeles, 1920s. *Pictorialism in California: Photographs 1900-1940*, exh. cat., J. Paul Getty Museum, Malibu, and The Henry E. Huntington Library and Art Gallery, San Marino, September 13–November 27, 1994.

Shore, Henrietta (1880-1963). Painter, Modernist, Los Angeles/ Carmel, 1915+. Aikin, Roger, "Henrietta Shore and Edward Weston," *American Art*, v. 6, no. 1, Winter 1992, pp. 42-61; Armitage, Merle, *Henrietta Shore*, New York: Weyhe, 1933. 54 p.; *Henrietta Shore: A Retrospective Exhibition: 1900-1963*, exh. cat., The Monterey Peninsula Museum of Art, December 12, 1986–January 25, 1987. 72 p.

Siegriest, Louis Bassi (1899-1989). Painter, Society of Six, Oakland, 1915+. *Louis Bassi Siegriest Reminiscences*, interviewed by Corinne L. Gilb, Regional Oral History Office, Bancroft Library, University of California, Berkeley, 1954. 95 l.; "Louis Siegriest" in Nancy Boas, *Society of Six: California Colorists*, San Francisco: Bedford Arts Publishers, 1988; St. John, Terry, *Louis Siegriest: Retrospective*, exh. cat., Oakland Museum, October 10–November 12, 1972. 36 p.

Simpson, David (b. 1928). Painter, Abstract Color Field, San Francisco, 1960+. *David Simpson, 1957-1967*, exh. cat., San Francisco Museum of Art, March 15–April 23, 1967. 31 p.; *David Simpson Paintings*, exh. cat., The Oakland Museum, October 17–December 3, 1978; Timberman, Marcy, "Luminous Meditations," *Artweek*, v. 21, March 8, 1990, p. 15; Van Proyen, Mark, "Familiar Conventions Revitalized," *Artweek*, v. 19, February 27, 1988, p. 5.

Siqueiros, David Alfaro (1896-1974). Muralist, Mexican, Southern California, 1932. Goldman, Shifra, M., "Siqueiros and Three Early Murals in Los Angeles," *Art Journal*, v. 33, Summer 1974, pp. 321-27; Hurlburt, Laurance P., *The Mexican Muralists in the United States*, Albuquerque: University of New Mexico Press, 1989. 320 p.; Stein, Philip, *Siqueiros: His Life and Works*, New York: International Publishers, 1994. 402 p.

Slinkard, Rex (1887-1918). Painter, Modernist, Los Angeles, 1910s. Biography [typescript], Stanford Museum of Art, Archives; Walker, John Alan, "Rex Slinkard (1887-1918) Pioneer Los Angeles Modernist Painter," *Los Angeles Institute of Contemporary Art Journal*, no. 3, December 1974, pp. 20-23.

Smith, Hassel (b. 1915). Painter, Abstract Expressionist, San Francisco, 1945+. *Hassel Smith: Paintings 1954-1975*, exh. cat., San Francisco Museum of Art, October 3–November 16, 1975. 16 p.; Nixon, Bruce, "Hassel Smith," *Art of California*, v. 2, no. 5, October/November 1989, pp. 33-37.

Smith of Visalia (active 1865). Folk Painter, Visalia, Late Nineteenth Century. *Cat and a Ball on a Waterfall: 200 Years of California Folk Painting and Sculpture*, exh. cat., Oakland Museum, March 22–August 3, 1986.

Smyth, William (1800-1877). Painter, Topographical, Northern California, 1826-27. Van Nostrand, Jeanne, *First Hundred Years*, San Francisco: John Howell-Books, 1980; *Aquarelas de William Smyth, 1832-1834* [of Brazil], UNIPAR, 1987. 1 portfolio.

Spohn, Clay (1898-1977). Painter, Assemblage, Fantasy, San Francisco, 1940+. Fuller, Mary, "Clay Spohn," *Art in America*, v. 51, no. 6, December 1963, p. 80; *Twentieth Century American Art*, exh. cat., Steve Turner Gallery, Los Angeles, 1995.

Stackpole, Peter (1913-1997). Photographer, Photojournalism, San Francisco/Hollywood, 1935+. Frye, L. Thomas, *Peacetime, Wartime & Hollywood, Photographs of Peter Stackpole*, Oakland Museum, 1992. 42 p.; *Peter Stackpole: Life in Hollywood, 1936-1952*, Livingston, Mt.: Clark City Press, 1992. 248 p.

Stackpole, Ralph (1885-1973). Sculptor, Taille Direct, San Francisco, 1912+. Mahan, William E., *Ralph Stackpole's Fresco at Sacramento City College* [published in conjunction with the opening of the Ralph Stackpole exhibition in the Gregory Kondos Art Gallery, Sacramento City College, May 11, 1984], Sacramento: City College, 1984. 25 p.; "Ralph Stackpole," *California Art Research*, San Francisco, Ca.: Works Progress Administration, 1936-37, v. 14, pp. 1-62; *Ralph Stackpole: Musee Bargoin*, exh. cat., Musee Bargoin, Ville de Clermont-Ferrand, July 5–October 1, 1978. 47 p.; Ralph Stackpole papers, ca. 1920-1980, Bancroft Library, University of California, Berkeley.

Stanley, George (1903-1973). Sculptor, Art Deco, Los Angeles, 1925+. Millier, Arthur, "Our Artists in Person," *Los Angeles Times*, November 23, 1930, pt. 3, p. 19, col. 7-8+.

Stetson, Charles Walter (1858-1911). Painter, Symbolist, Tonalist, Pasadena, 1890s. *Charles Walter Stetson Letters, 1888-1899*, Bancroft Library, University of California, Berkeley; Eldredge, Charles C., *Charles Walter Stetson: Color and Fantasy*, Lawrence, Ka.: Spencer Museum of Art, August 22–October 3, 1982 and two other venues. 168 p.; Hill, Mary Armfield, ed., *Endure: the Diaries of Charles Walter Stetson*, Philadelphia: Temple University Press, 1985. 373 p.

Still, Clyfford (1904-1980). Painter, Abstract Expressionist, San Francisco, Second Half 1940s. *Clyfford Still*, New York: Metropolitan Museum of Art, 1979. 222 p.; *Clyfford Still*, exh. cat., San Francisco Museum of Modern Art, early, 1976. 141 p.; *Clyfford Still, 1904-1980: the Buffalo and San Francisco Collections*, Munich, Germany: Prestel, 1992. 175 p.; Landauer, Susan, *The San Francisco School of Abstract Expressionism*, exh. cat., Laguna Art Museum, January 27–April 21, 1996.

Stowitts, Hubert Julian (1892-1953). Painter, Art Deco, Los Angeles, 1930+. *Collection of Materials Relating to Hubert Stowitts and to the Dance*, Bancroft Library?, University of California, Berkeley; *Drawings and Decorations by Hubert Stowitts*, exh. cat., Knoedler, New York, 1923. 19 p.; *The Heritage of India by Stowitts*, exh. cat. Monterey Peninsula Museum of Art, June 14–July 27, 1986 and Los Angeles County Museum of Natural History, October 3, 1986–January 19, 1987; Holliday, Anne, *Nijinsky Dancing! From The Golden Age of the Ballet Russes: Paintings by Stowitts*, Pacific Grove, Ca.: The Stowitts Museum and Library, 1996. 22 p.; McEnroe, Kay, "Hubert Julian Stowitts," *Antiques & Fine Art*, June/July 1986, pp. 18-21; Pal, Pratapaditya, "Stowitts: An American Artist in India," *Terra* (the Members' Magazine of the Natural History Museum of Los Angeles County), v. 25, no. 1, September/October 1986, pp. 12-19.

Strong, Joseph Dwight, Jr. (1852-1899). Painter, Figure, San Francisco, Late Nineteenth Century. Forbes, David W., *Encounters with Paradise: Views of Hawaii and Its People, 1778-1941*, exh. cat., Honolulu Academy of Arts, January 23–March 22, 1992; Greene, Charles S., "California Artists, II: Joseph D. Strong, Jr.," *Overland Monthly*, v. 24, May 1896, pp. 501-10.

Sully, Alfred (1820/1-1879). Painter, Monterey, Late 1840s. Sully, Langdon, *No Tears for the General. The Life of Alfred Sully 1821-1879*, Palo Alto, Ca.: The American West, 1974. 255 p.

Symons, George Gardner (1861-1930). Painter, Impressionist, Laguna Beach, Early Twentieth Century. *Gardner Symons (1861-1930): Small Paintings*, exh. cat., Coe Kerr Gallery, New York, 1986. 24 p.; "George Gardner Symons" in Ruth Westphal, et al., *Plein Air Painters of California: The Southland*, Irvine, Ca.: Westphal Publishing, 1982.

Tannenbaum, Eddie (b. 1953). "Painter" with Technology, Northern California, Late Twentieth Century. Chamberlain, Marcia, *Cadre '84*, San Jose State University Art Department, 1983, p. 78; Goodman, Cynthia, *Digital Visions*, New York: H. N. Abrams, 1987, pp. 182-83; Salvemini, Mauro, *Computer Image*, Milan or Rome, It.: Grupo Editoriale Jackson, 1985, p. 22; see website: www.et-arts.com.

Tavernier, Jules (1844-1889). Painter, Landscapes, Northern California/Hawaii, Late Nineteenth Century. Ewing, Robert Nichols, *Jules Tavernier (1844-1889): Painter and Illustrator*, Ph.D. Thesis, University of California, Los Angeles, 1978. 456 p.; Forbes, David W., *Encounters with Paradise: Views of Hawaii and Its People, 1778-1941*, exh. cat., Honolulu Academy of Arts, January 23–March 22, 1992; "Jules Tavernier," *California Art Research*, San Francisco, Ca.: Works Progress Administration, 1936-37, v. 4, pp. 1-26a.

Teraoka, Masami (b. 1936). Painter, Asian American, Los Angeles, 1960+. *Masami Teraoka: From Tradition to Technology, the Floating World Comes of Age*, Seattle and London: University of Washington Press, 1997. [catalogue for an exhibition at the Chikumagawa Highway Museum in Obuse, Japan, July 5-November 1997]

Teske, Edmund (1911-1996). Photographer, Los Angeles, 1943+. *Edmund Teske*, exh. cat., Los Angeles Municipal Art Gallery, September 18–October 20, 1974. 29 p.; *Images from Within: The Photographs of Edmund Teske*, Carmel, Ca.: Friends of Photography, 1980. 88 p.

Thiebaud, Wayne (b. 1920). Painter, Pop, Northern California, 1950+. Tsujimoto, Karen, *Wayne Thiebaud*, exh. cat., San Francisco Museum of Modern Art, 1985. 207 p.; *Wayne Thiebaud Survey 1947-1976*, exh. cat., Phoenix Art Museum, Phoenix, Ar., September 10–October 17, 1976. 117 p.

Thomas, Lew (b. 1932). Photographer, Conceptual, San Francisco, 1960+. Thomas, Lew, *8 x 10*, San Francisco: NFS Press, 1975; Thomas, Lew, ed., *Photography & Language*, San Francisco: NFS Press, 1976; Thomas, Lew, ed., *Photography & Ideology*, ed., Los Angeles: Ox Press, 1977; Thomas, Lew, *Picture Book (an Autobiography)*, New Orleans: NFS Press, 1994. 48 p.; Thomas, Lew, *Structuralism & Photography*, San Francisco: NFS Press, 1979.

Tilden, Douglas (1860-1935). Sculptor, Beaux Arts/Naturalism, San Francisco, Turn of the Twentieth Century. Albronda, Mildred, *Douglas Tilden: the Man and his Legacy*, Seattle, Wa.: Emerald Point Press, 1994. 183 p.; Albronda, Mildred, *Douglas Tilden: Portrait of a Deaf Sculptor*, Silver Spring,

Md.: T. J. Publishers, Inc., 1980. 142 p.; Albrondra, Mildred, "Douglas Tilden Sculptor," *Art of California*, v. 2, no. 2, April/May 1989, pp. 42-50; Douglas Tilden papers, 1860-1970, Bancroft Library, University of California, Berkeley.

Tilesius von Tilenau, Wilhelm Gottlief (1769-1857). *Langsdorff/Rezanov Expedition Drawings, 1803-1810*, Bancroft Library, University of California, Berkeley.

Tojetti, Domenico (1806/17-1892). Painter, American Renaissance, San Francisco, Late Nineteenth Century. "Domenico Tojetti," *California Art Research*, San Francisco: Works Progress Administration, 1936-37, v. 3, pp. 24-41; "Domenico Tojetti" in Marjorie Arkelian, *The Kahn Collection of Nineteenth-Century Paintings by Artists in California*, Oakland, Ca.: The Oakland Museum Art Department, 1975; Gleeson Library Associates of the University of San Francisco, *Domenico Tojetti 1817-1892*, 1959.

Torrez, Eloy (b. 1954). Painter, Realist, Los Angeles, 1970+. Crockett, Tobey, "[Julie Rico Gallery exh.]," *Art in America*, v. 81, April 1993, pp. 137-38; Rosas, Alejandro, *Chicano and Latino Artists of Los Angeles*, Glendale, Ca.: C.P. Graphics, 1993?; *16 Artistes Chicanos; Le Demon des Anges*, exh. cat., Centre de Recherche pour le Developpement Culturel, Nantes, 1989, pp. 136-45.

Tse, Wing Kwong (1902-1993). Painter, Chinese-American, San Francisco, 1930+. Brown, Michael D., *Views from Asian California, 1920-1965*, San Francisco: Michael Brown, 1992.

Turrell, James (b. 1943). Light and Space Artist, Los Angeles, 1965+. Butterfield, Jan, *The Art of Light & Space*, New York: Abbeville Press, 1993.

Tuttle, Franklin D. (b. 1957). Painter, Native American, Northern California, 1975+. Abbott, Lawrence, ed., *I Stand in the Center of the Good*, Lincoln and London: University of Nebraska Press, 1994, pp. 249-68; Nash, Steven A., *Facing Eden*, exh. cat., The Fine Arts Museums of San Francisco and the University of California Press, 1995, p. 160; Penney, David W., and George Longfish, *Native American Art*, Hong Kong?: Hugh Lauter Levin Assoc., Inc., 1994, p. 304; Webster, Mary Hill, "A Conversation with Frank Tuttle," *Artweek*, v. 24, pt. 12, June 17, 1993, pp. 13-14.

Ueyama, Tokio (1889-1954). Painter, Los Angeles/Amache, 1920+. *The View from Within: Japanese American Art from the Internment Camps, 1942-1945*, exh. cat., Japanese American National Museum and UCLA Wight Art Gallery, October 13–December 6, 1992.

Valadez, John (b. 1951). Painter, Chicano, Photorealist, Los Angeles, 1975+. Nieto, Margarita, "John Valadez," *Latin American Art*, v. 2, no. 1, Winter 1990, pp. 58-59; *Sense of Place: D. J. Hall, F. Scott Hess, John Valadez*, exh. cat., Fisher Gallery, University of Southern California, Los Angeles, November 4–December 19, 1987. 24 p.

Valentine, Dewain (b. 1936). Sculptor, Los Angeles Glass and Plastic, 1960+. *DeWain Valentine*, exh. cat., La Jolla Museum of Contemporary Art, June 28–August 3, 1975. 26 p.; Livingston, Jane, "Artist's Dialogue: DeWain Valentine," *Architectural Digest*, v. 43, February 1986, pp. 178+.

Van Sloun, Frank Joseph (1879-1938). Painter, San Francisco, Early Twentieth Century. Desgrey, John Maxwell, *Frank Van Sloun: American Realist*, S. F.?: 1975?; Desgrey, J. M., "Frank Van Sloun: California's Master of the Monotype and the Etching," *California Historical Quarterly*, v. 54, pt. 4, 1975, pp. 345-58; "Frank Van Sloun," *California Art Research*, San Francisco: Works Progress Admin., 1936-37, v. 8, pp. 102-25?

Viola, Bill (b. 1951). Video/Site Installation, Los Angeles, Late Twentieth Century. *Bill Viola*, exh. cat., Whitney Museum of American Art, New York and two other venues including the Los Angeles County Museum of Art, 1997. 205 p.; Viola, Bill, *Reasons for Knocking at an Empty House: Writings, 1973-1994*, Cambridge, Ma.: MIT Press, 1995. 301 p.

Vischer, Edward (1809-1878). Painter/Historian, Topographical, c. 1860-80. Van Nostrand, Jeanne, *Edward Vischer's Drawings of the California Missions 1861-1878*, San Francisco: Book Club of California, 1982; Vischer, Edward, *Vischer's Pictorial of California*, San Francisco: J. Winterburn, 1870.

Von Dutch (Kenneth Howard) (1929-1992). Painter/Pin Striper, Kustom Kulture, Los Angeles, 1945+. Krafft, Charles, "Mechanical Dreams," *Artforum*, v. 32, pt. 3, November 1993, pp. 93-97; Stecyk, C. R. with Bolton Colburn, *Kustom Kulture: Von Dutch, Ed "Big Daddy" Roth, Robert Williams and Others*, exh. cat., Laguna Art Museum, Laguna Beach, Ca., July 17–November 7, 1993 and other venues. 96 p.

von Eichman, Bernard James (1899-1970). Painter, Society of Six, Oakland, 1920+. "Bernard von Eichman" in Nancy Boas, *Society of Six: California Colorists*, San Francisco: Bedford Arts Publishers, 1988.

Voulkos, Peter (b. 1924). Sculptor/Ceramist, Abstract Expressionism, Los Angeles/East Bay, 1950+. *Peter Voulkos, a Dialogue with Clay*, New York: Museum of Contemporary Crafts, 1977. 180 p.; *Peter Voulkos Retrospective*, exh. cat., Sezon Museum of Art, Tokyo, January 2–February 20, 1995; Tsujimoto, Karen and Rose Slivka, *The Art of Peter Voulkos*, exh. cat., Oakland Museum and Kodansha International, July 22–November 12, 1995. 191 p.

Vroman, Adam Clark (1856-1916). Photographer, Indians of the Southwest, Pasadena, Turn of the Twentieth Century. "A.C. Vroman–Photographer & Collector," *Anthropology of the Americas: Masterkey* (Southwest Museum, L. A.), v. 63, no. 1, Spring 1989; *Dwellers at the Source: Southwest Indian Photographs of A.C. Vroman, 1895-1904*, Albuquerque, N. M.: University of New Mexico Press, 1987; Hemmerdinger, Catherine Cooper, *The Historical and Cultural Meaning of Adam Clark Vroman's Indian Photographs*, M. A. Thesis, University of California, Riverside, 1983. 122 l.; Mahood, Ruth L., ed., *Photographer of the Southwest: Adam Clark Vroman, 1856-1916*, Los Angeles: Ward Ritchie, 1961. 127 p.

Vysekal, Edouard Antonin (1890-1939). Painter, Post-Impressionist, Los Angeles, 1920+. Fort, Ilene Susan, *American Art: A Catalogue of the Los Angeles County Museum of Art Collection*, Los Angeles: Los Angeles County Museum of Art, 1991, pp. 318-19; Moure, Nancy Dustin Wall, *Dictionary of Art and Artists in Southern California before 1930*, Los Angeles: Privately Printed, 1975.

Wachtel, Elmer (1864-1929). Painter, Barbizon/Impressionist Landscapes, Los Angeles, 1890+. Anderson, Antony, *Elmer Wachtel a Brief Biography*, Los Angeles: Printed by Carl A. Bundy Quill & Press, 1930. 47 p.; "Elmer Wachtel" in Ruth Westphal, et. al., *Plein Air Painters of California: The Southland*, Irvine, Ca.: Westphal Publishing, 1982.

Wachtel, Marion Kavanagh (1876-1954). Painter/Watercolorist, Barbizon/Impressionist, Los Angeles, Early Twentieth Century. Dominik, Janet, "Marian Kavanagh Wachtel," *Art of California*, v. 1, no. 1, October/November 1988, pp. 48-53; Trenton, Patricia, ed., *Independent Spirits: Women Painters of the American West 1890-1945*, Autry Museum of Western Heritage in association with the University of California Press, Berkeley, 1995.

Walker, James (1819-1889). Painter, Californio, Second Half Nineteenth Century. Moure, Nancy Dustin Wall, *Loners, Mavericks & Dreamers*, exh. cat., Laguna Art Museum, November 26, 1993–February 20, 1994, bibl.; Van Nostrand, Jeanne, *The First Hundred Years of Painting in California 1775-1875*, San Francisco: John Howell-Books, 1980.

Warshaw, Howard (1920-1977). Painter, Southern California, Mid Twentieth Century. *Howard Warshaw*, Oral History Project, University of California, Los Angeles, 1977. 198 l.; *Howard Warshaw, A Continuing Tradition*, exh. cat., Art Museum, University of California, Santa Barbara, August 2–September 4, 1977. 35 p.; *Howard Warshaw Master Draftsman*, exh. cat., Art Gallery, Sonoma State University, Rohnert Park, Ca., 1988. 97 p.; *Warshaw A Decade of Murals*, exh. cat., Bowdoin College Museum of Art, Brunswick, Me., September 22–November 5, 1972 and Santa Barbara Museum of Art, February 10–March 11, 1973. 36 p.

Watson, Adele (1873-1947). Painter, Symbolist, Pasadena/New York, 1915+. Trenton, Patricia, ed., *Independent Spirits: Women Painters of the American West 1890-1945*, Autry Museum of Western Heritage in association with the University of California Press, Berkeley, 1995.

Wayne, June (b. 1918). Printmaker, Tamarind Lithography Workshop, Los Angeles, 1960+. Baskett, Mary W., *The Art of June Wayne*, New York: H. N. Abrams, 1969. 99 p.; *June Wayne*, interviewed by Kathryn Smith, Oral History Program, University of California, Los Angeles, 1982.

Welch, Thaddeus (1844-1919). Painter, Barbizon Style, Bay Area/Santa Barbara, 1890+. Broekhoff, Helen V., *Thad Welch Pioneer and Painter*, Oakland Art Museum, 1966; "Thaddeus Welch," *California Art Research*, San Francisco, Ca.: Works Progress Administration, 1936-37, v. 3, pp. 42-72.

Wenderoth, Frederick August (1819-1884). Painter, Genre, Northern California, Mid Nineteenth Century. Stevens, Moreland L. with the assistance of Marjorie Arkelian, *Charles Christian Nahl: Artist of the Gold Rush 1818-1878*, Sacramento: E. B. Crocker Art Gallery, 1976.

Wendt, William (1865-1946). Painter, Impressionist, Landscapes, Los Angeles/Laguna Beach, Early Twentieth Century. *In Praise of Nature: The Landscapes of William Wendt*, exh. cat., University Art Museum, California State University, Long Beach, November 14–December 17, 1989. 64 p.; Moure, Nancy Dustin Wall, *William Wendt 1865-1946*, exh. cat., Laguna Beach Museum of Art, Laguna Beach, Ca., February 5–27, 1977. 64 p.; Walker, John Alan, *Documents on the Life and Art of William Wendt (1865-1946) California's Painter Laureate of the Paysage Moralise*, Big Pine, Ca.: J. A. Walker, 1992. 213 p.

Weston, Edward (1886-1958). Photographer, f.64, Los Angeles/Carmel, 1915+. Bunnell, Peter C. and David Featherstone, eds., *EW:100, Centennial Essays in Honor of Edward Weston (Untitled, no. 41)*, Carmel, Ca.: Friends of Photography, 1986. 136 p.; Danly, Susan, *Edward Weston in Los Angeles*, exh. cat., Huntington Library, San Marino, Ca., November 25, 1986 - March 29, 1987 and another museum. 64 p.; *Edward Weston: Forms of Passion*, New York: H. N. Abrams, 1995. 367 p.; Enyeart, James, *Edward Weston's California Landscapes*, Boston: Little, Brown, 1984. 143 p.; Maddow, Ben, *Edward Weston, his Life*, New York: Aperture, 1989. 281 p.; *Supreme Instants: The Photography of Edward Weston*, Tucson, Ar.: Center for Creative Photography, University of Arizona, 1986. 192 p.

Wheeler, Douglas (b. 1939). Light and Space Artist, Los Angeles?, 1965+. "Douglas Wheeler" in Jan Butterfield, *The Art of Light and Space*, New York: Abbeville Press, 1993.

White, Edith (1855-1946). Painter, Still Lifes, Pasadena/San Diego, Turn of the Twentieth Century. Kamerling, Bruce, *100 Years of Art in San Diego*, San Diego: San Diego Historical Society, 1991; Moure, Nancy Dustin Wall, *Loners, Mavericks & Dreamers*, exh. cat., Laguna Art Museum, Laguna Beach, Ca., November 26, 1993–February 20, 1994; Trenton, Patricia, ed., *Independent Spirits: Women Painters of the American West 1890-1945*, Autry Museum of Western Heritage in association with the University of California Press, Berkeley, 1995.

Widforss, Gunnar Mauritz (1879-1934). Watercolorist, Landscapes, Northern California/Arizona, 1920+. Belknap, Bill and Frances Spencer Belknap, *Gunnar Widforss: Painter of the Grand Canyon*, Flagstaff, Ar.: Northland Press, 1969. 86 p.

Wight, Clifford (c. 1900-1960s). Muralist, PWAP, San Francisco, 1934. Jewett, Masha Zakheim, *Coit Tower, San Francisco: Its History and Art*, San Francisco: Volcano Press, 1983.

Wiles, Lemuel Maynard (1826-1905). Painter, Landscape, California, 1874. Moure, Nancy Dustin Wall, *Loners, Mavericks & Dreamers*, exh. cat., Laguna Art Museum, Laguna Beach, Ca., November 26, 1993–February 20, 1994.

Wiley, William (b. 1937). Sculptor/Painter, Academic Funk, Davis, 1960+. Brooks, Rosetta, *Collaborations: William Allan, Robert Hudson, William Wiley*, exh. cat., Desert Museum, Palm Springs, 1998; Gregor, Katherine, "Zen and the Art of William T. Wiley," *Art News*, v. 88, April 1989, pp. 184-89; *Wiley Territory*, exh. cat., Walker Art Center, Minneapolis, December 9, 1979–January 27, 1980. 80 p.; *William T. Wiley*, exh. cat., University Art Museum, University of California, Berkeley, 1971. 73 p.; *William T. Wiley, Graphics, 1967-1979*, Chicago, Il.: Landfall Press, 1980. 79 p.; *William T. Wiley: Struck! Sure? Sound/Unsound/ Terrie Sultan*, exh. cat., Corcoran Gallery of Art, May 11–July 28, 1991 and three other venues. 44 p.

Wilf, Andy (1949-1982). Painter, Photorealist/Expressive Figuration, Los Angeles, 1970s. *Andy Wilf*, exh. cat., Los Angeles County Museum of Art, July 14–August 14, 1983. 8 p. folded sheet

Williams, Robert (b. 1943). Painter, Countercultural Narratives, Los Angeles, 1955+. Seward, Keith, "La Gia-Honda," *Artforum*, v. 32, no. 3, November 1993, pp. 94-95; Stecyk, C.R. with Bolton Colburn, *Kustom Kulture: Von Dutch, Ed "Big Daddy" Roth, Robert Williams and Others*, exh. cat., Laguna Art Museum, Laguna Beach, Ca., July 17–November 7, 1993 and other venues. 96 p.

Wilson, Wes (b. 1937). Rock Poster Artist, Psychedelic, San Francisco, 1965+. Grushkin, Paul, *The Art of Rock*, New York: Abbeville Press, Inc., 1987; Lemke, Gayle, *The Art of the Fillmore*, Petaluma, Ca.: Acid Test Productions, 1997; Medeiros, Walter, *San Francisco Rock Concert Posters: Imagery and Meaning*, M.A. Thesis, University of California, Berkeley, 1972; Medeiros, Walter, *San Francisco Rock Poster Art*, exh. cat., San Francisco Museum of Modern Art, October 6–November 21, 1976. 32 p.; Tomlinson, Sally A., *San Francisco Rock Posters, 1965-1971*, M. A., Thesis, University of Victoria, Canada, 1991.

Wonner, Paul (b. 1928). Painter, San Francisco/Los Angeles, Second Half Twentieth Century. *Paul Wonner*, exh. cat., Coe Kerr Gallery, New York, March 10–April 4, 1992. 20 p.; *Paul Wonner*, exh. cat., Hirschl & Adler Gallery, New York, October 1-29, 1983. 19 p.; *Paul Wonner, Abstract Realist*, exh. cat., San Francisco Museum of Modern Art, October 1–November 22, 1981 and two other venues. 72 p.

Wores, Theodore (1858/9-1939). Painter, Genre, San Francisco, Turn of the Twentieth Century. *Art of Theodore Wores*, exh. cat., Asahi Shimbun, Tokyo, 1986. 129 p.; Baird, Joseph A., *Theodore Wores, the Japanese Years*, exh. cat., The Oakland Museum, March 16–May 16, 1976; Ferbrache, Lewis, *Theodore Wores: Artist in Search of the Picturesque*, 1968. 63 p.; Mandeles, Chad, "Theodore Wores's Chinese Fishmonger in a Cosmopolitan Context," *American Art Journal*, v. 16, Winter 1984, pp. 65-75; Reynolds, G. A., "A San Francisco Painter, Theodore Wores," *American Art Review*, v. 3, September-October 1976, pp. 101-17; *Theodore Wores: An American Artist in Meiji Japan*, essays by William H. Gerdts and Jan Newstrom Thompson, exh. cat., Pacific Asia Museum, Pasadena, Ca., 1993; *Theodore Wores, 1859-1939: a Retrospective*, exh. cat., Huntsville Museum of Art, Huntsville, Al., March, 1980. 54 p.; Thompson, Jan, "Theodore Wores," *Art of California*, v. 3, no. 3, May 1990, pp. 16-24.

Wright, Stanton Macdonald (1890-1973). Painter, Synchromist, Los Angeles, 1919+. *The Art of Stanton MacDonald Wright*, exh. cat., National Collection of Fine Arts, Smithsonian Institution, Washington, D.C., May 4–June 18, 1967. 100 p.; Levin, G., "The Tradition of the Heroic Figure in Synchromist Abstractions," *Arts Magazine*, v. 51, June 1977, pp. 138-42; South, Will, *Stanton Macdonald-Wright and the Emergence of Vanguard Painting in Southern California*, Ph. D. Dissertation, City University of New York, c. 1991, and exhibition planned; Watson, Dori Jean, *Stanton Macdonald-Wright*, M.A. Thesis, University of California, Los Angeles, 1957. 136 l.

Wyland (b. 1956). Muralist, Marine Subjects, Southern California, Late Twentieth Century. Doyle, Mark, *The Art of Wyland*, Laguna Beach, Ca.:

Wyland Studios, 1993. 180 p.; Doyle, Mark, *Celebrating 50 Wyland Whaling Walls*, Laguna Beach, Ca.: Wyland, 1995; Teichroew, Jean Kaplan, "Whale of a Wall," *National Geographic World*, no. 228, August 1994, pp. 28+; *The Undersea World of Wyland*, Alexandria, Va.: Time-Life Books, 1998; *Whale Tales: Tales from America's Leading Marine Life Artist*, Laguna Beach, Ca.: Wyland Studios, 1995. 248 p.

Yavno, Max (1911-1985). Photographer, Photojournalist, Los Angeles, Post-WWII. Maddow, Ben, *The Photography of Max Yavno*, Berkeley: University of California Press, 1981. 150 p.

Yelland, Raymond Dabb (1848-1900). Painter, Landscapes, Luminist, Bay Area, Late Nineteenth Century. *Raymond Dabb Yelland (1848-1900)*, essay by Kent L. Seavey, exh. cat., California Historical Society, San Francisco, May 15–July 10, 1964. 19 p.; "Raymond D. Yelland" in *California Landscape Painting, 1860-1885: Artists Around Keith and Hill*, exh. cat., Stanford Art Gallery, Stanford University, December 9, 1975–February 29, 1976, pp. 44-47.

Zakheim, Bernard Baruch (1896-1985). Muralist, Coit Tower, PWAP, Regionalist, San Francisco, 1930+. "Bernard Zakheim," *California Art Research*, San Francisco: Works Progress Administration, 1936-37, v. 20, pp. 32-113; Jewett, Masha Zakheim, *The Art of Medicine: the Zakheim Frescoes at UCSF*, July 1991. 120 l.; Jewett, Masha Zakheim, *Coit Tower, San Francisco: Its History and Art*, San Francisco: Volcano Press, 1983.

Index

A